THE RARE ART TRADITIONS

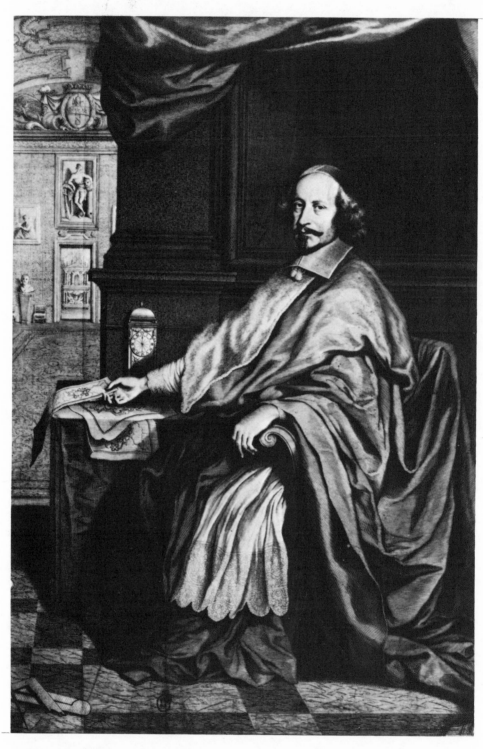

Robert Nanteuil: Le Cardinal Mazarin dans la Galerie Haute de Son Palais, *Paris, Bibliothèque Nationale*

Joseph Alsop

THE RARE ART TRADITIONS

THE HISTORY OF ART COLLECTING
AND ITS LINKED PHENOMENA
WHEREVER THESE HAVE APPEARED

THAMES AND HUDSON

Some of this material has appeared in different form in the *Times Literary Supplement* and the *New York Review of Books*.

The Andrew W. Mellon Lectures in the Fine Arts delivered at the National Gallery of Art in Washington in 1978 were entirely based on this essay. The Mellon Lectures are issued as part of the Bollingen Series published in the U.S.A. by Princeton University Press. Much earlier versions of the first chapters were also the basis of the Yaseen Lectures, delivered at the University of the State of New York at Purchase in 1976.

First published in Great Britain in 1982
by Thames and Hudson Ltd, London

Printed and bound in the U.S.A.

For Millard Meiss, Wolfgang Stechow
and Rudolf Wittkower,
three regretted friends, who encouraged
the work here presented during the
doubtful early years.

CONTENTS

Preface *xv*

Acknowledgments *xix*

 I. THE ALTERED APOLLO 1

 Interchapter 1.

 THE RARE ART TRADITIONS 25

 II. ART FOR USE 33

 III. ART COLLECTING 68

 IV. THE LITMUS TESTS 86

 Interchapter 2.

 THE BLUEPRINT 102

 V. THE SIAMESE TWINS 107

 VI. THE OTHER BY-PRODUCTS OF ART 137

 Interchapter 3.

 THE PROOF—AND THE QUESTION 168

 VII. "THE GREEK MIRACLE" 170

VIII. THE PATTERN REPEATS 212

 IX. THE PATTERN VANISHES—AND RETURNS 257

 Interchapter 4.

 THE DEVELOPED HISTORICAL SENSE 293

 X. ART COLLECTING REVIVES 298

XI. THE ROLE OF COSIMO 337

XII. THE LESSON OF LORENZO 373

 Interchaper 5.

 ON PROGRESSION IN ART 411

XIII. THE CLIMAX IN THE WEST 419

XIV. THE SEVENTEENTH CENTURY 451

 ENVOI 474

Notes 477

Bibliography 615

Index 667

ILLUSTRATIONS

frontispiece

Robert Nanteuil: Le Cardinal Mazarin dans la Galerie Haute de Son Palais (*Photographie Giraudon*)

following page 102

1. Apollo Belvedere (*Alinari/Editorial Photocolor Archives*)
2. *Apollonios:* The Belvedere Torso (*Buochs, Switzerland, Leonard von Matt*)
3. The Goddess Tlazoteotl (*Ursula Pariser, photographer, Dumbarton Oaks*)
4. *Claus Sluter and Claus de Werve:* Three Mourners from the Tomb of Philip the Bold (*The Cleveland Museum of Art*)
5. *Leonardo da Vinci:* Ginevra de Benci (*Washington, D.C., National Gallery of Art*)
6. Bourdalou from Chantilly (*London, Sotheby Parke Bernet & Co.*)
7. *Piero della Francesca:* The Resurrection (*Alinari/Editorial Photocolor Archives*)
8. *Michelangelo:* Pietà (*Alinari/Editorial Photocolor Archives*)
9. Acheulian Hand Ax (*Lee Boltin*)
10. *Raphael:* The Sistine Madonna (*Alinari/Editorial Photocolor Archives*)
11. *Hendrik Staben:* Albert and Isabella in Rubens' Studio (*Brussels, A.C.L.*)
12. The Wilton Diptych (*Courtesy of the Trustees of the National Gallery, London*)
13. Sutton Hoo Helmet (*Courtesy of the Trustees of the British Museum*)
14. Eagle Vase of Abbot Suger (*Paris, Musées Nationaux*)
15. *Robert Rauschenberg:* Monogram 1955–59 (*New York, courtesy Leo Castelli Gallery*)
16. The Thorn Reliquary (*Courtesy of the Trustees of the British Museum*)
17. *Rembrandt:* Jan Six (*Amsterdam, The Six Collection*)
18. *Shōsōin:* Emperor's Kimono Stand
19. Tutankhamen's Gold Mask (*Cairo Museum*)

20. *Dürer:* Frederick the Wise, Elector of Saxony (*Washington, D.C., National Gallery of Art*)

21. *Frederic Edwin Church:* The Icebergs (*David Wharton, photographer, Dallas Museum of Fine Arts*)

22. *Matthias Grünewald:* The Small Crucifixion (*Washington, D.C., The National Gallery of Art*)

23. St. Catherine. Modern Forgery in the Grünewald Style (*Cleveland Museum of Art*)

24. *Mino da Fiesole:* Piero de' Medici (*Alinari/Editorial Photocolor Archives*)

following page 198

25. Sainte-Chapelle Interior (© *Arch. Phot/Spadem, Vaga, New York, 1982*)
26. *Pontormo:* Cosimo de' Medici (*Alinari/Editorial Photocolor Archives*)
27. The Temple of the Inscriptions, Palenque
28. Profile of Cosimo de' Medici, Plate XVI, from *Medals of the Renaissance* by G. F. Hall. Copyright 1920 by G. F. Hall (Oxford, Clarendon Press)
29. *Pol de Limbourg:* January, from the Très Riches Heures du Duc de Berry (*Photographie Giraudon*)
30. *Hans Memling:* Tommaso Portinari (*Metropolitan Museum of Art*)
31. *Titian:* Philip II of Spain (*Alinari/Editorial Photocolor Archives*)
32. *Ghirlandaio:* Portrait of Giovanna Tornabuoni (*Alinari/Editorial Photocolor Archives*)
33. *Matisse:* La Danse, 1933 (*Merion Sta., Pa.,* © *The Barnes Foundation*)
34. *Giovanni Bellini:* The Feast of the Gods (*Washington, D.C., National Gallery of Art*)
35. *Leonardo da Vinci:* Isabella d'Este (*Paris, Musées Nationaux*)
36. Armilla of Frederick I Barbarossa (*London, Sotheby Parke Bernet & Co.*)
37. *Jean Dubuffet:* Group of Four Trees, 1971 (*New York, Courtesy of The Museum of Modern Art. Tubular steel frame with walls of aluminum honeycombed epoxy coating, reinforced with layers of fiberglass, 40'h × 16' × 16'*)
38. *Botticelli:* Madonna of the Pomegranate (*Alinari/Editorial Photocolor Archives*)
39. *Filippino Lippi:* Self-Portrait (*Alinari/Editorial Photocolor Archives*)
40. *Piero della Francesca:* Duke and Duchess of Urbino (*Alinari/Editorial Photocolor Archives*)
41. *Duccio:* Crucifixion (*Christie's, New York*)
42. *Vermeer:* View of Delft (*The Hague, Mauritshuis*)
43. *Raphael:* Pope Leo X with His Nephews (*Alinari/Editorial Photocolor Archives*)
44. *Jean-Honoré Fragonard:* Psyche Showing Her Sisters Her Gifts from Cupid (*Courtesy of the Trustees of the National Gallery, London*)
45. Tomb of Hatshepsut, Deir-el-Bahri (*Munich, Hirmer Fotoarich*)
46. Head of Ptolemy I Soter (*Courtesy of the Trustees of the British Museum*)

47. *Lysippos:* The Getty Bronze (*The J. Paul Getty Museum*)
48. Parthenon Relief-Cavalry (*Courtesy of the Trustees of the British Museum*)
49. Ludovisi Throne: Birth of Venus (*Georgina Masson, photographer*)

following page 294

50. The Antikythera Youth (*Athens, National Archaeological Museum*)
51. *Calamis:* Poseidon/Zeus (*Athens, Photo Dai*)
52. *Piraeus:* Apollo (*Athens, National Archaeological Museum*)
53. *Fan K'uan:* Traveling Among Streams and Mountains (*Taichung, National Palace Museum Collection*)
54. *Ku K'ai-Chih:* A Lady and Her Husband (*Courtesy of the Trustees of the British Museum*)
55. *Ni Tsan:* Woods and Valleys of Yü-Shan (*Metropolitan Museum of Art*)
56. *Kaigetsudo Ando:* Figure of a Courtesan (*Washington, D.C., Courtesy of the Freer Gallery of Art, Smithsonian Institution*)
57. Emperor Shah Jahan, Folio 45 Album of Miscellaneous Islamic Leaves (*Baltimore, Walters Art Gallery*)
58. Fang Ding, 16th–14th century B.C. (*Beijing, Cultural Relics Publishing House*)
59. Bird-shaped Zun, 13th–11th century B.C. (*Beijing, Cultural Relics Publishing House*)
60. Cavalryman & Saddle Horse, 220–206 B.C. (*Beijing, Cultural Relics Publishing House*)
61. Nineteen-inch Jade Blade, 2000–1500 B.C. (*Cultural Office of Henan Yanshi Xian*)
62. Gilt Bronze Lamp, 1st half 2nd century B.C. (*Beijing, Cultural Relics Publishing House*)
63. Majesté de Ste. Foy, Cathedrale de Conques (*Buochs, Switzerland, Leonard von Matt*)
64. Trajan's Column—Detail (*Alinari/Editorial Photocolor Archives*)
65. Autun Tympanum (*James Austin Photo*)
66. *Giotto di Bondone:* The Lamentation (*Alinari/Editorial Photocolor Archives*)
67. Chartres Cathedral, West Portal, Jamb Figures (*Photo Marburg*)
68. Porta della Mandorla (*Alinari/Editorial Photocolor Archives*)
69. *Ghiberti:* The Sacrifice of Isaac (*Alinari/Editorial Photocolor Archives*)
70. *Ghiberti:* Self-Portrait (*Alinari/Editorial Photocolor Archives*)
71. *Donatello:* David (*Alinari/Editorial Photocolor Archives*)
72. *Manner of Fiorentino:* Filippo Strozzi (*Washington, D.C., National Gallery of Art*)
73. *Filippino Lippi:* Strozzi Chapel, St. Philip Exorcising the Demon (*Alinari/ Editorial Photocolor Archives*)

following page 390

74. *Manner of Fiorentino:* Marsilio Ficino (*Washington, D.C., National Gallery of Art*)

75. Courtyard of the Palazzo Medici-Riccardi (*Florence Raffaello Bencini*)

76. *Donatello:* Judith and Holofernes (*Alinari/Editorial Photocolor Archives*)

77. *Andrea del Verrocchio:* Lorenzo de' Medici (*Washington, D.C., National Gallery of Art*)

78. *Andrea del Verrocchio:* Giuliano de' Medici (*Washington, D.C., National Gallery of Art*)

79. *Melozza da Forli:* Head of Sixtus IV (*Alinari/Editorial Photocolor Archives*)

80. Gemma Augustea (*Vienna, Kunsthistorisches Museum*)

81. *Fra Angelico and Fra Filippo Lippi:* The Adoration of the Magi (*Washington, D.C., National Gallery of Art*)

82. *Masaccio:* Birth Salver, the Confinement Room of a Florentine Lady (*West Berlin, Staatliche Museum, Photo Jörg P. Anders*)

83. *Jan van Eyck:* St. Jerome in His Study (*City of Detroit Appropriation, Detroit Institute of Arts*)

84. *Jean Clouet:* Francis I (*Photographie Giraudon*)

85. *Titian:* Cardinal Pietro Bembo (*Washington, D.C., National Gallery of Art*)

86. *Leone Lioni:* Emperor Charles V (*Washington, D.C., National Gallery of Art*)

87. Aztec Mask (*Courtesy of the Trustees of the British Museum*)

88. Aztec Feather Crown (*Vienna, Museum of Ethnology*)

89. *Raphael:* Pope Julius II (*Courtesy of the Trustees of the National Gallery, London*)

90. *Velázquez:* Philip IV in Hunting Costume (*Alinari/Editorial Photocolor Archives*)

91. *Van Dyck:* Charles I (*Alinari/Editorial Photocolor Archives*)

92. *Rembrandt:* Portrait of Baldassare Castiglione (*Vienna, Graphische Sammlung Albertina*)

93. *Michelangelo:* The Bruges Madonna (*Alinari/Editorial Photocolor Archives*)

94. *Raphael:* Saint George and the Dragon (*Washington, D.C., National Gallery of Art*)

95. *Mantegna:* The Dead Christ (*Alinari/Editorial Photocolor Archives*)

PREFACE

This book needs a preface because the course followed and the method adopted to produce it have both been unusual. In brief, the work started in 1964. The original conception was an essay on the history of art collecting as a social habit, which I began in the belief I could consult the best authorities in the languages known to me, add my own suggestions where these might be useful, and thus make a synthesis of some value to persons interested in the subject. I soon made two main discoveries, however, which combined to demand a quite different approach.

The first discovery was that the subject was both vastly more complex and vastly more significant than I had imagined. Yet the significance could not be demonstrated without bringing in a whole series of branches of art history, all more or less remote from our Western art history. Since I had then been intermittently reading most branches of art history for a good many decades, the second discovery was even more daunting. There were no best authorities to consult; and no one had ever troubled to provide the minimal definitions, beginning with a definition of art collecting itself, which were obviously needed for the serious and comprehensive history I planned. This meant, in turn, that the only course was to find the needed data and evolve the necessary definitions by a long search through a fairly staggering variety of publications in no less than nine languages, English, French, Italian, German, Latin, Greek, Chinese, Japanese and Arabic, plus one or two more, like Dutch and Spanish, of less importance to me.

This was a tall order. Besides English and French, I can read Italian and Latin with the help of a dictionary, with irritating slowness, and with constant uncertainty; nor can I safely rely on my own versions of troublesome passages in Italian and Latin texts. In a way, however, I was relieved that the order was so tall, for I could therefore hope no one would blame

me if I sought help. One kind of help came through translations of key texts, which fortunately exist in great numbers. But another kind of help was plainly needed, too.

Hence I sought and was lucky enough to obtain research assistance from a series of younger scholars beginning promising careers as art historians working on the various art traditions I had to cover in order to write a comprehensive history. By my research assistants I have been guided to countless texts of importance for my enterprise. From my research assistants, too, I have received either a *précis*, or a fairly extensive summary, or even a partial rough translation of each relevant, untranslated text in a language inaccessible to me. I have included all the texts used in the many years of work on this book in my bibliography, not as a claim that I have read every one of these texts in their original form in so many different languages, but because these texts were indeed consulted, either directly, or in translation, or by my research assistants; and scholars specialized in the various art traditions may wish to know the titles, the editions, etc.

In a very real sense, this book has been a joint enterprise, and this fact is merely underlined by the range of the bibliography and the volume and character of the acknowledgments. Joint enterprise is the essence of any successful cottage industry; and with good fortune to aid me, I managed to organize a small cottage industry of scholarship. Nonetheless, none of my research assistants should be blamed if the reader finds what may seem to be errors of fact or detail, or faulty arguments, or wrong-headed opinions. For all this, the blame, if any, is entirely mine, and infelicities of wording are also my infelicities.

Next, a few words must be said about the way I have spelled names in Greek, Chinese and Arabic. After long havering and wavering, I have finally adopted the method of the *Oxford Classical Dictionary* for spelling Greek names. This seemed to me marginally better than spelling these names one way in observations of my own, and another way in quotations from the Latin authors to whom we owe the bulk of ancient Greek art history. Greek words are given in the Greek spelling but in italics; and in both notes and bibliography, titles of texts and authors' names are cited exactly as published without regard to spelling inconsistencies, as are direct quotations from various authorities in the text of my book and the notes.

For Arabic names and words, I have been content to follow the system of spelling which is now in use at Harvard and is therefore familiar to my research assistants in the Islamic field. Another thorny decision, however, was required by the dire matter of romanizing Chinese names and words. With infinite reluctance, and only because I fear it is the spelling of the future, I have chosen the new "pinyin" system of romanization

adopted at the command of Mao Zedong rather than the old Wade-Giles romanization, to which I have been accustomed by a half century of Chinese historical and art historical reading.

Pinyin is used exclusively in the text of this book, except in Chapter VIII. Since Chapter VIII covers the Chinese aspect of my subject in detail, I have thought it best to spare old-fashioned readers of Chinese art history like myself by giving the Wade-Giles romanization of each Chinese name, but only the first time each name is used and only in parenthesis after the pinyin romanization. Again, however, for book and article titles, for Chinese authors' names, and in direct quotations from various authorities, the spelling used in the original publication has been followed. However, I have ventured to pinyinize the Chinese names in the particularly numerous quotations from the invaluable collection of Chinese art historical documents translated by W. R. B. Acker, since this will save the reader from endless chopping and changing. But when saying the subtitles Acker provides from the texts by various authors collected by him, I have followed Acker's spellings, although the titles of books and names of authors given in my own text have been regularly pinyinized after the first use in the way described above.

Finally, I must apologize to those who may think my annotation is over-ample, as some have already done who were kind enough to glance at my manuscript. The truth is that much of what I have to say is fairly novel, and if my arguments carry conviction, further exploration of the subject will be in order by others. Hence I have thought it worthwhile to cite all sources, whether consulted by me or with the help of my research assistants.

ACKNOWLEDGMENTS

As the preface will have warned the reader, the way this book came into being was more than a little peculiar. Nothing in its story was more unexpected, moreover, than this story's turning point. This occurred a good many years ago, when I was already sure I had something worthwhile to say but far from sure how it should be said. At this juncture, an art historian-friend with whom I had discussed the book, Professor Hannelore Glasser, in turn discussed my project with Professor Ulrich Middeldorf, Director Emeritus of the Kunsthistorisches Institut in Florence.

Professor Middeldorf then took the trouble to read an early draft of my large manuscript—a draft which I can no longer read myself without blushing for its inadequacies. Generously, he paid more attention to the new points I had to make and the interest of my subject than to my draft's obvious weaknesses. We had not then met, yet he wrote me that my draft had impressed him, although he had to tell me that the scholarly apparatus, as it then existed, was really impossibly bad. With unimaginable kindness, he even offered to help me with the scholarly apparatus if I wished him to do so.

This overjoyed me, yet it was an offer I felt I could not accept as it stood. I wrote Professor Middeldorf of my joy and gratitude, but added that I could only permit myself to trouble him if he could find a research assistant in Florence who would then work under his direction. The answer was the nomination of Dr. Charles Davis as my first Florentine research assistant, plus a list of fifty (I counted them!) books and scholarly articles it would be useful to read in addition to those I had already consulted. This letter from Professor Middeldorf was a turning point in more ways than one, for besides leading to the scholarly apparatus now provided with this book, it led me to a crucial decision which I had been resisting. Thereafter I hesitated no longer about trying to find research assistants

not just in Florence and Washington, but wherever I felt the need of help.

A main feature of this long culminating stage of my work was Professor Middeldorf's recruitment as his own research assistant of Dr. Sabine Eiche, after Dr. Davis felt compelled to concentrate on his own scholarly projects. Thereafter, Dr. Eiche also served as my own chief research assistant; and in tandem with Professor Middeldorf, she proved to be an almost demonic fact-checker and advocate of precision in all things. Overall, meanwhile, Professor Middeldorf has been the presiding godfather of my enterprise, taking endless trouble with no return except my thanks. It is the sort of thing no other man I have ever known would have thought of doing.

Next on this list of those to whom I owe much must obviously come the many research assistants who have aided me at different times. It is a matter of pride to me that I now count all of them as my friends, although some are nearly young enough to be my grandchildren. They are:

In Florence, Dr. Davis and Dr. Eiche already mentioned; for Chinese art, Dr. Christian Murck and Alfreda Murck; for Japanese art, Dr. Carolyn Wheelwright; for later Islamic art, Dr. Jonathan Bloom and Dr. Shreve Simpson; for medieval and other out-of-the-way texts, Miss Beverly Bullock; for the chapter on classical art, Dr. Paul Rahe; for Egyptian and Middle Eastern art, Dr. Richard Fazzini and Dr. R. S. Bianchi; for Khmer art, Dr. Stanislaw Czuma; in London, Dr. Susi Lang and Miss Frances Buckland; and successively in my office, to manage my all but unmanageable files and to do spot research as needed, Miss Marla Price, Miss Judith Lanius and Mr. William Connell. To all of these, my debt is enormous, and to some I owe extra rations of gratitude.

Sabine Eiche in a whole series of areas and Alfreda and Christian Murck in the complex Chinese area have made special contributions; and without William Connell, a most careful young scholar, my unwieldy annotation could never have been put in publishable shape and my book would be peppered with minor errors. There must still be a few errors in an enterprise of this scope, but he and I have done our best together to eliminate them preventively.

Next in these acknowledgments must come a trio who gave me very special help. As long as he lived, the late Theodore Rousseau, of the Metropolitan Museum of Art, regularly aided me to gain access to text-sources otherwise all but inaccessible, and I regret his loss as much as the loss of the three great scholars to whom this book is dedicated. From the inception of my project, Professor Anna Modigliani Lynch of Trinity College in Washington also aided me in a hundred ways, above all by repeatedly supplying translations of key passages in Italian texts which I could not translate with confidence myself because of my shaky Italian. In the

same way, Dr. Bernard Knox of the Institute for Hellenic Studies again and again took the generous trouble to translate for me knotty passages in Latin texts.

In addition, I owe particularly warm thanks to a series of great art historians who found time on many occasions to discuss my ideas with me. Besides clarifying issues and warning of traps to be avoided, these eminent scholars sometimes suggested where I could find competent research assistants in their fields and interests. Their names will be found, among all too many others, in the following list of acknowledgments. If this list seems long, it is because I have been bold enough—some would say shameless enough—to ask questions of anyone who seemed able to answer. I have been asking my questions over so long a period that I suspect some of those listed hereafter will have forgotten they ever had any communication with me, but my files show that they did so.

As preface to the list, finally, it should be noted that none of those named already or to be named hereafter has the smallest responsibility for any statement of fact or opinion anywhere in my book. The list follows:

Frank Asaro, Dr. Esin Atıl, Professor Ernst Badian, Dr. Robert W. Bagley, Roland Balaÿ, Sir Isaiah Berlin, Professor Luciano Berti, Professor Margarete Bieber, Dr. Phyllis Bober, Fr. Edward W. Bodnar, S.J., Dr. Peter Boettger, Dr. Elizabeth H. Boone, Dr. Hans Brill, Sidney A. Brintle, Professor Clifford Brown, J. Carter Brown, Professor James Cahill, Dr. Liselotte Camp, Dr. D. Redig de Campos, Edward Cave, Professor André Chastel

Chea Thay Seng, Countess Anna Maria Cicogna Volpi di Misurata, Professor J. Desmond Clark, Lord Clark of Saltwood, Professor Michael Coe, John Y. Cole, Professor Kenneth J. Conant, John Cornforth, Professor Edwin A. Cranston, Professor Herrlee G. Creel, Lord Dacre of Glanton, Professor Mirella Levi D'Ancona, Martin Davies, Dr. Caecilia Davis-Weyer, Peter Day, Professor Otto Demus, Professor Sterling Dow, Professor Rackstraw Downes, John Duffy, Dr. I. H. van Eeghen, Professor Henri van Effenterre, Lord Egremont

Professor Albert Elsen, Patricia Erhart, Jean Feray, Madeleine Fidell-Beaufort, Professor Wen Fong, Dr. Roland Force, Mrs. Max Frankel, Dr. Alison Frantz, Professor Sydney Freedberg, Dr. Jiri Frel, René Gaborit, Dr. Christopher Gaugler, Dr. Albertine Gaur, Professor Creighton Gilbert, Professor Hannelore Glasser, Professor Richard A. Goldthwaite, Professor Sir E. H. Gombrich, Mrs. John Dozier Gordon, Professor Oleg Grabar, Dr. Hannah Gray, Deborah Gribbon, Margot Grier, Robert V. Gross, Madeline Gunther, Eleanor Guralnick

Dr. Rollin V. Hadley, Anne d'Harnoncourt, Professor Francis Haskell, Dr. Rudiger an der Heiden, Professor Julius S. Held, John S. Herbert, Professor David Herlihy, Linda V. Hewitt, Professor L. H. Heydenreich, Amb. Martin J. Hillenbrand, Karen Horn, Professor G. L. Huxley, August

A. Imholtz, Jr., Professor H. W. Janson, Professor J. Edward Kidder, Dr. Henry A. Kissinger, Dr. Friderike Klauner, Professor Richard Krautheimer, Professor George Kubler, Dr. Michel Laclotte, Dr. Hanspeter Landolt

Lewis J. Lapham, Dr. Thomas Lawton, Professor Lothar Ledderose, Rosemary Levai, George Levitine, Dr. Douglas Lewis, Wilmarth S. Lewis, Dr. Li Chi, Professor Max Loehr, Dr. Anne Marie Logan, Professor Wolfgang Lotz, Amb. Charles Lucet, Alison Luchs, Professor James B. Lynch, Jr., William L. MacDonald, Dr. Paul MacKendrick, Professor Cyril Mango, Gregory Martin, Jody Maxmin, Professor James Mellaart, Paul Mellon, André Meyer, Karl E. Meyer

Edward J. Miller, J. Mironneau, Professor Charles Mitchell, Dr. Agnes Mongan, Philip Mooney, Dr. Geoffrey Muller, Dr. Oscar W. Muscarella, Viscount Norwich, Professor Konrad Oberhuber, Linda Pellecchia, Dr. Jeno Platthy, Professor J. H. Plumb, Professor J. J. Pollitt, Dr. John Pope, Sir John Pope-Hennessy, Professor Edith Porada, Dr. Froelich Rainey, Mrs. Richard H. Randall, Professor A. C. Renfrew, H. E. Richardson

William Rieder, Dr. S. Dillon Ripley, Helmut Ripperger, Professor Martin Robertson, Professor Jakob Rosenberg, Professor John Rosenfield, Lessing J. Rosenwald, the Baronne Élie de Rothschild, Dr. Christopher Rowe, Professor John H. Rowe, Sir Steven Runciman, Dr. Samuel Sachs, Mme. Pierre Salinger, Professor Meyer Schapiro, Diana Scarisbrick, Professor Edward G. Seidensticker, Mrs. Ihor Ševčenko, Professor Ihor Ševčenko, Professor Joseph W. Shaw, Professor T. Leslie Shear, Leonard Sidlow, Professor William Kelly Simpson

Dr. Ake Sjöberg, Robert Skelton, Professor Seymour Slive, Mrs. Evelyn Lord Smithson, Professor Alexander Soper, Francis Spar, Dr. Erich Steingräber, Dr. Harold P. Stern, Dr. Roy Strong, Sir Michael Stuart, Professor James Stubblebine, Dr. George Szabo, Professor Andrew Szegedy-Maszak, Hugh Tait, The Right Rev. John Vernon Taylor, Professor Homer Thompson, Peter Thornton, David F. Trask, Professor Egon Verheyen, Dr. Pierre Verlet, Dr. Cornelius C. Vermeule, Professor Emily Vermeule, Dr. Michael Vickers

Dr. Gary Vikan, Anna M. Voris, John Walker, Dr. Mary Ann Jack Ward, Sir Francis J. B. Watson, Professor William Watson, Professor Kurt Weitzmann, Professor Harold E. Wethey, Arthur K. Wheelock, Jr., Walter M. Whitehill, Professor Helmut Wohl, Dr. Ann Yonemura, John G. Younger.

In addition, I owe warm thanks to the staffs of a whole series of great institutions and major libraries who have responded generously, efficiently and patiently to requests from me over a period of nearly two decades: first and foremost, the staff of the Library of Congress, without whose help I could have accomplished nothing whatever; but also persons on the staffs of the National Gallery, the Freer Gallery, Dumbarton Oaks,

the Metropolitan Museum, and Fenway Court; and also the staffs of the Newberry Library, the Boston Athenaeum, and the Center for Hellenic Studies. I also owe special thanks to Anne von Rebhan, of the National Gallery, for splendid work on the illustrations.

Nor would these acknowledgments be complete without noting that my editor at Harper & Row, Frances Lindley, has given unfailing support and invaluable guidance to my project through all its phases, and that Stanley Baron, of Thames and Hudson, and Christine Ivusic, of the Princeton University Press, have also been most helpful. Finally, the essential job of typing and retyping my cumbersome manuscript and its scholarly apparatus has been valiantly and admirably done by Evelyn Tehaan and Michelle Revenaugh.

THE RARE ART TRADITIONS

I

THE ALTERED APOLLO

A few cultures in history, each strikingly different from all the rest, have nonetheless nourished art traditions which exhibit a conspicuous and unifying peculiarity. The art traditions in question have been every bit as diverse as their nourishing cultures, yet all these traditions have been alike in generating a series of schematically identical by-products. To deepen the mystery, not one of the by-products of art—for that is the simplest label for them—has ever been generated by the vast majority of art traditions of the past which are now known to us. Hence the rare art traditions of this essay's title are simply the small number marked off from all the rest by the by-products of art.

"By-products of art" may seem a most eccentric way to describe art collecting and art history, collectors' art markets, art museums and the other art-related phenomena, such as art faking, which are so familiar to everyone interested in the visual arts today. Centuries of familiarity have in fact caused these phenomena to be taken for granted. They are not seen as what they really are—highly idiosyncratic, exceedingly complex and in some degree, quite irrational cultural-behavioral developments. Art collecting and the other phenomena are not even recognized as constituting an integrated, closely interacting cultural-behavioral system with frequent and far-reaching effects on art itself.

The components of this system are not treated as special by-products of art, either, although this is precisely what they obviously are. Above all, the singularity of the rare art traditions which have generated these by-products has never been seriously examined anywhere in the vast literature of art. In sum, there is work to do here.

These being the facts, I should much prefer to plunge into the midst of my subject forthwith. But this is not a subject, alas, which lends itself to beginning at the beginning and ending at the end. It has been too

little explored. Too many definitions are missing. Even the identification of the rare art traditions must therefore be deferred for a while. It is more important, now, to identify the by-products of art more precisely and completely than has been done above, and to show how powerfully the modern situation of the arts has been affected by the system comprising these by-products. Even before these steps are taken, moreover, another, more fundamental problem must be tackled.

The truth is that no history of art collecting and the linked phenomena can ever be fully comprehensible until a plain but seldom-acknowledged fact has been squarely faced. The fact is that even if we are looking at pictures, buildings, pieces of sculpture or other products of the visual arts which are untouched by time and vandalism over the ages, we do not *see* today what our forefathers saw.

These time-wrought changes of vision have by no means been limited to our Western culture; but if you doubt the possibility of such changes, it is best to make a simple test on our own culture's home grounds. Only take the time to visit the Apollo Belvedere in the Vatican's Museo Pio-Clementino. Nowadays, few serious people make this pilgrimage that every art lover in Rome used to make; so you may well be a lonely visitor. At first, too, you are likely to find the visit hardly worthwhile. The Apollo is an exceptionally complete Greco-Roman marble, of larger size and finer quality than most, but to modern eyes the statue appears disturbingly mechanical and pseudo-grandiose.

History explains the somewhat machine-made look of the Apollo's stony surfaces.[1] This is a marble copy of a bronze original that was perhaps the work of Leochares, a fairly shadowy, probably Athenian sculptor of the late fourth century B.C.[2] Such Greek masterpieces of the great periods were copied by the thousands, mainly at second hand, and hundreds of years after their own time, in semi-industrial Greek statuary workshops that supplied a strong demand in Rome.[3] Beyond doubt, the same work-shops further contributed to the quantities of sculpture of other types, which were also in demand in the centuries of the Roman Empire's prosperity. Naturally, too, a few individual sculptors got special orders, even for copies, like the commission to Glycon for the Farnese Hercules.[4] Yet humble, rather routine decorative usefulness seems to have been the main requirement for most of the statues, both copies and non-copies, that were deployed in such amazing numbers[5] to ornament Roman public buildings, the town and country houses of the Roman rich, and the grand gardens the rich Romans loved. Thus an American scholar has shown that the models were often chosen primarily to make symmetrical arrangements, with gesture answering bronze or marble gesture from niche to niche.[6] Sometimes a mirror-image copy was actually paired with a straight copy of the same Greek work, thereby confronting the beholder with two statues

identical in every detail except their orientations. This was close to treating sculpture as wallpaper-in-the-round!

Nonetheless, when these long-buried items of Roman architectural or horticultural décor began to be dug up again in the early Renaissance, mere fragments evoked wonder and delight. Lorenzo Ghiberti, the great sculptor of the Florentine Baptistery's Doors of Paradise, was proud to own a single Greco-Roman leg of bronze.[7] Hence the imposingly big, nearly intact marble Apollo was automatically destined for high fame as soon as it was unearthed in the environs of Rome during the last decades of the fifteenth century.[8] It was acquired by Pope Julius II while he was still a cardinal. It got its customary name early in the sixteenth century, when it was almost literally enshrined in the sculpture court of Bramante's Belvedere, where the Pope displayed his classical collection.[9] It had hardly become the Apollo Belvedere, moreover, before it also became "the most admired piece of sculpture in the world";[10] and its glory never dimmed for over three hundred and fifty years.

To be sure, the Apollo acquired a permanent rival when the Laocoön was found in Rome on January 14, 1506, amid such excitement that odes were written.[11] Michelangelo hastened to the scene and reportedly pronounced the Laocoön the "unique miracle of art."[12] In the seventeenth century, Bernini put both the earlier-discovered Belvedere Torso and the Laocoön above the Apollo.[13] All agreed, nonetheless, that the Apollo also had a place at the very summit. Michelangelo himself borrowed from the Apollo when he painted the mighty Christ of his Last Judgment, and in at least one other instance as well.[14] Bernini did the same thing with his Apollo and Daphne,[15] and the list of other major creators who used the Apollonian image could be extended to an inordinate length.[16] So could the list of critics and art lovers who were bowled over, but one example will suffice.

In his youth, Goethe recorded in his *Italienische Reise* that the Apollo, more than any other thing in Rome, "swept me off my feet";[17] and much later, in his autobiography, *Dichtung und Wahrheit*, he declared that the statue "by the moderation of its colossal size, its slender shape, its free movement, its conquering glance, carries off the victory before all others."[18] Finally—and most impressively—the Apollo Belvedere used to enjoy the kind of popular fame that is never accorded, at any time in history, to more than a tiny number of buildings and works of art. Along with the Laocoön, it headed the list of celebrated statues and paintings that the French art looters carried off from Italy after Napoleon's first victories there. In Paris, the sequel was an imitation Roman triumph called "*la Fête de la Liberté et des Arts*," in which the Apollo and other pieces of Greco-Roman sculpture were carried in procession through the streets. The French sentiment was expressed in the quatrain, inaccurate both art

historically and as to the future: *"La Grèce les céda/Rome les a perdu/ Leur sort changea deux fois/Il ne changera plus."*[19] Meanwhile, the people of Rome felt as the people of Paris might now feel if a conqueror carried off the Mona Lisa. In consequence, Canova made his first Triumphant Perseus partly with the Head of Medusa to console the Romans for the loss of their Apollo.[20]

What, then, did Canova, Goethe, and so many others see, that we do not see now?

The question can be put in other ways, too. For centuries in our own art tradition, the Apollo Belvedere was one of the works that were truly central to esthetic experience; and it is anything but central for us. But why? And why did earlier generations respond so intensely and glowingly to the Apollo, whereas our response to this outwardly unaltered[21] piece of sculpture is so pallid and uncaring? Unless you choose to be totally subjective, you cannot answer that we judge the Apollo more accurately than Goethe, or, conversely, that Goethe knew better than we do. The history of taste, which is one of the themes of this essay, must always be sternly neutral. Objectively, there is no such thing as "good taste" or "bad taste." There is only the taste of the particular time and place, as revealed by the surviving data on the works of art that men have loved or scorned.[22] Studying such data, to be sure, one sometimes wonders whether differences of epoch and social circumstance have caused men to see works of art as differently as they would be seen by insects, with their hundreds of ommatidia, and dogs, which cannot distinguish colors, and great apes, whose vision resembles our own. Yet who is to say that the taste of Titian or Michelangelo was inferior—or superior—to the taste of Matisse or Picasso? Either way, this is a proposition wholly incapable of proof, and downright silly besides.

The Way of Seeing

A different, more serious proposition can be solidly proved, however. In brief, the actual *way of seeing* changes with the passage of time; and here is where clues can be found to the mystery of the sad fate of the Apollo Belvedere. The phrase is borrowed from Gertrude Stein, who once remarked, with characteristically mingled paradox and gnomic shrewdness, "People do not change from generation to generation. . . . Nothing changes from generation to generation except the things seen and the things seen make that generation, that is to say nothing changes in people from one generation to another except the way of seeing. . . ."[23] Differences in the way of seeing are not superficial, either. The truth is that *what* people see is significantly affected by *how* they see it; and how they see is in turn profoundly influenced by culture, history, social conditions, and all

sorts of other factors, big and little. To give a simple cultural example, Europeans and Americans see white as the color of purity and joy, of the dresses of young brides and of children at their first communion, and even of the raiment of the Blessed on the Day of Judgment; whereas the Chinese see white as the color of evil, of sadness, of mourning garments, of funerals, and of death itself.

In the case of works of art, there are far greater complexities, especially in the art traditions here labeled rare. Above all, how works of art are seen, and therefore what is seen in them, has been repeatedly and radically transformed by time-wrought changes in the total stock of familiar works of art. If this seems complicated and improbable, merely think first of Boccaccio. In the mid-fourteenth century, he knew only the kind of Italian painting that preceded Giotto, and he therefore saw the works of Giotto as incomparable triumphs of the most literal realism.[24] Then think of Giorgio Vasari writing the West's first mature art history in the mid-sixteenth century.[25] When he compiled his *Lives* of the "most excellent" artists, Vasari saw the works of Giotto against the backdrop of the whole marvelous course of the Renaissance. He therefore admired Giotto primarily as the precursor of the "more perfect" artists who came later. These were more perfect in Vasari's eyes mainly because they had fully mastered the techniques of realistic representation. Giotto's works, he wrote, would not deserve "more than a moderate amount of praise . . . if they were to be compared with the works produced after their time."[26] Even if Vasari had tried his best to do so, moreover, he could never have seen Giotto's painting as Boccaccio saw it. Nor could we. Knowledge of more and later paintings had imposed a different way of seeing on Vasari—as it has on us, although our way again differs greatly from Vasari's way.

The way of seeing, then, is a concept rich in content, which is also an indispensable tool for anyone investigating the history of taste. The tool will not work well, however, unless three limitations on its use are borne in mind. First of all and above all, you have to remember that it is possible to identify only what may be called the dominant way of seeing of any period. In the fourteenth century, Boccaccio forthrightly indicated that Giotto's painting was not for the "ignorant,"[27] and Petrarch said much the same thing some decades later.[28] Yet no one can read Giotto's commission as master of the work and artistic overseer of Florence's beloved Duomo without concluding that the dominant way of seeing was that shared by Boccaccio and Petrarch.[29] Today the same rules even more conspicuously apply to many works of art that the critics, the art historians, and the museum curators loudly admire, and collectors compete for ferociously, though they are not admired, or are even actively disliked, by most people of the sort Boccaccio a bit snobbishly called the "ignorant."

In the second place, even if you always bear the first limitation in

mind, it is still necessary to describe ways of seeing rather broadly. Concerning most periods in history that we know much about, you can safely say, "These works of art were held to be the standards of all excellence; and these others were ignored or scorned"; and these broad limits will at least roughly define the dominant way of seeing for the particular period.[30] But within these limits, in the third place, you must also leave ample room for normal differences of individual preference, as well as the exceptions that prove rules.

For a more than usually violent but still normal difference of individual preferences, consider the debate between the admirers of Rubens and the partisans of Poussin. This made such a stir in later-seventeenth-century Paris that satirical poems about it were widely circulated.[31] Yet the sole question at issue was whether Poussin with his *dessein*, or Rubens with his color, had been the true continuator of the universally acknowledged great masters of the past.[32] No one argued about these earlier great masters' identity. They were the "ancients"—mainly as revealed by the Apollo Belvedere and other pieces of Greco-Roman sculpture—plus the giants of the High Renaissance in Italy. Nor did anyone argue about the need for both Poussin and Rubens to follow in these great masters' footsteps. In sum, although the verdicts differed sharply, all the debaters judged Poussin and Rubens by exactly the same basic standards; and the whole debate therefore took place within the limits of the shared way of seeing of that time.

As for the exceptions that prove rules, they are the unusually sensitive, or insensitive, or eccentric persons, with strikingly idiosyncratic ways of seeing. For an uncommonly repellent example, consider Lord Chesterfield of the *Letters,* who evidently had the kind of fashionable taste that Marcel Proust mocked in his mordant passage on the taste of the Guermantes.[33] Until the nineteenth century—to be fair—the dominant way of seeing always imposed certain critical reservations about Rembrandt. His nudes, especially, were thought to be "horrifying," even by otherwise passionate admirers.[34] Yet Lord Chesterfield achieved a most unpleasant man-of-fashion's parody of this kind of reservation about Rembrandt when he wrote his son: "As for the Rembrandt you mention [which the unhappy Philip Stanhope wanted him to buy], though it is very cheap if good, I do not care for it. I love *la belle nature:* Rembrandt paints caricaturas."[35] Or if you prefer a case of an idiosyncratic way of seeing that is charming instead of repellent, consider Albrecht Dürer's response to the loot of pre-Columbian America. The first pickings that Hernàn Cortez sent home from Mexico were shown to Dürer in Brussels, when he visited the court of the young Emperor Charles V and his powerful Regent-aunt, Margaret of Austria. In his travel diary, on August 27, 1520, Dürer wrote:[36] "I saw the things which have been brought to the King from the new land of gold,

a sun all of gold a whole fathom broad and a moon all of silver of the same size, also two rooms full of the armor of the people there, and all manner of wondrous weapons of theirs, harness and darts, wonderful shields, strange clothing, bedspreads, and all kinds of wonderful objects of various uses, much more beautiful to behold than prodigies. . . . All the days of my life I have seen nothing that has gladdened my heart so much as these things, for I saw amongst them wonderful works of art, and I marveled at the subtle *Ingenia* of men in foreign lands. Indeed, I cannot express all that I thought there."[37]

One does not know, to be sure, what Dürer would have thought if the spoils of Cortez had included specimens of Aztec sculpture of the grimmer sort, like the superb statue at Dumbarton Oaks of the Goddess Tlazolteotl Giving Birth to the Maize God.[38] Yet it is more important to note that after a first proud trophy stage, the spoils that seemed so beautiful to Dürer seemed merely curious and rare—or, worse still, plain downright hideous—to just about everyone else until only a little while ago. Before the sixteenth century ended, all that so enchanted Dürer was melted down for the value of the metal, or sold to the few people who gathered ethnographical curiosities for their *Wunderkammern*,[39] or thrown on the dust heap.[40] The early decades of the present century were in fact the first time a few bold persons again began to see pre-Columbian works of art as Dürer had seen them four hundred years earlier. Only thereafter, at long last, did these marvels begin to be slowly transferred from dusty ethnographical repositories to museum collections;[41] and this was only one of many aspects, as we shall see, of a gigantic transformation of the way of seeing in the West.

The Apollo's Glory

With the concept of the way of seeing thus briefly introduced, it is time to turn back to the fate of the Apollo Belvedere. To begin with, the Apollo owed its centuries of fame and glory to the very special kind of change in the way of seeing that results from a fundamental change of creative direction. At long intervals, and for causes never demonstrated, the impulses behind these tremendous changes of direction—the beginning of classical art in Greece, the Renaissance in Italy—have mysteriously welled up from the very depths of culture. It was the Italian Renaissance, of course, that made the "ancients" the grand exemplars, and the remains of classical antiquity the models of all art.

Once these models had been universally adopted, the Apollo Belvedere fully deserved the proud place it was given for so long, simply because the statue is an exceptionally fine specimen of its large class. This class may be defined as all of classical antiquity's sculptured remains known

in the West before the eighteenth century ended. It must be remembered that all the really major Greek originals we now know so well were then effectively *un*known to the European world of art.[42] The great mass of classical sculpture already in private and public collections by the eighteenth century's close in fact formed a true class, because it was all but exclusively Greco-Roman. The Laocoön and the Belvedere Torso may be—though they are not certainly—late Hellenistic works of the first century B.C.,[43] but these two were the only possible exceptions among the pieces of classical sculpture with Europe-wide fame.[44] The reason for this was practical. After the fall of Constantinople in 1453, Renaissance and post-Renaissance mining for classical statuary was largely confined to Roman imperial sites, mainly in Italy, where Greco-Roman sculpture overwhelmingly predominated.[45]

The former reverence for this class as a whole is also far more significant than the former fame of the Apollo. It went so far that on the rare occasions when Greek originals were found, the restorers used to make them *look* like Greco-Roman copies. Gathering dust in corners of museums or elsewhere, there must be a fair number of ex-masterpieces by Greek sculptors of the great periods; for these were the prime prizes of Roman art collectors. When dug up again, however, they were literally skinned by the restorers in the seventeenth, eighteenth, and early nineteenth centuries.[46] The restorations had to be concealed, and no one seems to have cared for the subtlety of surface that is one of the chief marks of a major Greek original. Because the nose had to be restored, for example, this partly happened to the Petworth Aphrodite, which is quite possibly the head of a half-legendary work by Praxiteles.[47] Whether copies or no, moreover, all the Greco-Roman sculpture was fervently studied by creators, and bowed down before by critics, and viciously competed for by collectors during nearly four hundred years.

By the early sixteenth century, the appetite for such souvenirs of the "ancients" was already spreading out from Italy into Europe beyond the Alps. Thus King François I of France sent Primaticcio to Rome to bring back casts of the most famous classical statues discovered by then—of course including the Apollo Belvedere—so that bronze reproductions could be made for Fontainebleau.[48] Seeing the finest sculpture of the "ancients" was a prime motive of art lovers' journeys to Italy;[49] and even if homebodies, all art-loving Europeans shared the same *Musée Imaginaire*, in which one of the two main galleries gleamed chiefly with the cold whiteness of Greco-Roman marbles, with a few bronzes thrown in, while the other main gallery was allotted to the most celebrated masterpieces of the High Renaissance. In and of itself, this first Western *Musée Imaginaire* was also powerful enough to inspire major results—although we may find the process puzzling before the time of the photographs and reproductions

that André Malraux credited with creating our modern, immeasurably larger Museum of the Imagination.[50] Dürer used the image of the Apollo Belvedere for Christ, for Sol Invictus and for Adam without ever having seen the statue.[51] The pioneer of the second, scientific phase of Western art history, Johann Joachim Winckelmann, also wrote his essay on "The Imitation of Greek Works" in Dresden in 1755. Hence this seminal essay, with the Laocoön as a centerpiece, was actually composed before Winckelmann first went to Rome and saw the Laocoön.[52]

For the skeptics' sake, it may also be useful to consider Rubens, who is such an excellent case in point for the very reason that no one could possibly call him a neoclassical painter. A main complaint against him by the Poussin supporters in the Paris debate already mentioned was that Rubens had never properly learned from antiquity.[53] On this point, furthermore, Rubens's leading partisan, the critic Roger de Piles, evidently felt he could enter only a weak defense. He had to admit, sadly, that his hero too often "fell into a Flemish character, and sometimes made an ill choice, offending against the regularity of design"[54]—by which one may be sure Roger de Piles meant that Rubens's nudes look most unlike Greco-Roman nudes. From Rubens's own pen we fortunately have an illuminating comment on this stylistic choice that later shocked the theorists of the newly founded French Academy and even disturbed Roger de Piles. The master once wrote that the imitation of ancient sculpture was "for some most useful, for others detrimental to the extent of the very annihilation of their art. I am convinced that in order to achieve the highest perfection one needs a full understanding of the statues, nay a complete absorption in them; but one must make judicious use of them and before all avoid the effect of stone."[55]

Rubens firmly made his nudes fleshy instead of stony; but as this excerpt plainly intimates, Rubens studied classical sculpture with extreme attention.[56] At one time, he planned to publish a compendium of classical carved gems in partnership with his friend the great French antiquary and collector, N.-C. Fabri de Peiresc.[57] He was an ardent classical collector himself; and in one famous exchange, he traded several thousand florins' worth of his own paintings, plus some other pictures, plus two thousand florins in cash, for a large but extremely miscellaneous group of classical marbles acquired by the British diplomat Sir Dudley Carleton (later Lord Dorchester) when he was ambassador in Venice.[58] Most astonishing of all, Rubens further wrote in his already-quoted *De Imitatione Antiquarum Statuarum* that "perhaps it is true that in former centuries, the human body, closer to the origin and perfection of things, was granted freely that strength which now, through the fault of decadent ages and of corrupting influences, has come to naught, abandoning its perfection to the growing vices. . . ."[59] In other words, Rubens not only admitted the absolute

superiority of classical sculpture; he was even inclined to explain this superiority on the ground that the people of the classical world had more beautiful bodies than people in his own time had. And sure enough, when Rubens needed a model for the figure of Apollo in his extraordinary cycle of paintings glorifying Marie de' Medici, he used the Apollo Belvedere.[60]

The Apollo's Fall

Through centuries of wonderfully rich creativeness, in sum, all those who shared in the Western art tradition were deeply stirred and strongly influenced by a kind of sculpture which largely molders in neglect today—except for the art historians, of course, and a tiny number of fairly recent collectors like the late J. Paul Getty.[61] Furthermore, the pedestal began to tremble under the Apollo Belvedere only at the moment of the Apollo's final apotheosis by the neoclassicists of the later eighteenth and early nineteenth centuries. The story of the apotheosis is adequately told by Goethe's previously quoted verdicts on the Apollo, plus the character of the neoclassical sculpture of Canova. In 1814, however, by vast efforts and enormous, ill-requited outlays, the earnest, unfortunate Earl of Elgin confronted his countrymen and the art lovers of all of Europe with the first large group of original Greek works of high quality from a great period which they had ever seen.

The immediate result was an unholy row in London. It is tempting to describe at length how the leading English connoisseur of the time, Richard Payne Knight, indignantly dismissed the Elgin marbles as sadly inferior, not merely to the Apollo Belvedere,[62] but also to the famous Hercules belonging to the first Marquess of Lansdowne, which was then considered the finest piece of classical sculpture in England.[63] It is again tempting to relate how Canova in person came to Lord Elgin's rescue,[64] and how the British government finally bought the marbles, after long reluctance, and for less than half their cost to poor Lord Elgin.[65] But the downgrading of the Greco-Roman marbles that started with the electrifying appearance in London of Lord Elgin's loot from Athens is a story that cannot be told in detail in the confines of this essay. It will be enough, here, to indicate how the story ended.

The episode best symbolizing the story's end was the sale by the sixth Lord Lansdowne of his forebear's celebrated collection. At this auction in London in March 1930, the Lansdowne Hercules, now considered a far from extraordinary specimen of Greco-Roman sculpture, actually failed to make its reserve of £5,000[66]—whereas by 1930, even in that bad year, any one of the Elgin marbles would surely have brought twenty, or thirty, or even forty times this amount. By way of further contrast, a small, unrestored Attic relief from the fourth century B.C., which had half strayed

into the Lansdowne collection for a derisory price, went for £5,250,[67] or substantially more than was bid for the Hercules itself. Here the main point is that in the history of taste, for good or ill, the current prices always crassly tell you approximately where you are at the moment. What happened at the Lansdowne sale therefore betokened a crucial change of taste. By 1930—indeed, close to half a century before 1930—the Apollo Belvedere and all the other Greco-Roman marbles had been cleared out of the main gallery they had occupied so long in the West's Museum of the Imagination. Instead, the Museum of the Imagination now boasted an altogether new and somewhat smaller classical main gallery, exclusively stocked with genuine Greek masterpieces like the Delphic Charioteer, the Poseidon-Zeus by Calamis,[68] and of course the Elgin marbles—in fact works of a sort that Michelangelo, Bernini, Rubens, and before Lord Elgin, Goethe[69] and Canova had never seen and never imagined.

Revolution II

In and of itself, this was an enormous revolution in the Western way of seeing. Yet it was only one of three such revolutions, and it was also the easiest to explain. After all, Winckelmann only had to consult the classical texts to discover the absolute primacy of Greek art—although the second place thus given to Rome greatly upset Piranesi.[70] Despite Payne Knight, again, the inferiority of the Greco-Roman copies sprang to the eye as soon as significant numbers of Greek originals became available for study.[71] The Gothic Revival was a far more bewildering process, precisely because the glories of Gothic art never ceased to be available for study. Instead, they had simply ceased to be seen as glories during the Renaissance. Filarete in the fifteenth century and Vasari in the sixteenth both roundly condemned Gothic architecture as "barbarous."[72]

It is the fashion, nowadays, to treat these condemnations as cranky and counterindicative. Instead, they were merely a bit more sweeping than later views, as one example will suffice to show. During the eighteenth century, Paris cheerfully tolerated four successive desecrations of Notre Dame. In 1708, Robert de Cotte made fairly drastic alterations in the cathedral's fabric.[73] In 1741–43, most of the stained glass was replaced with clear panes.[74] In 1771, J.-G. Soufflot made further alterations, partially destroying the tympanum of the Last Judgment.[75] And in 1787, numerous damaged gargoyles and other ornaments were briskly scraped off and thrown away as refuse.[76] To be sure, Soufflot himself composed a *Mémoire sur l'architecture gothique* praising the Gothic architects' boldness and ingenuity long before he mutilated the great tympanum. Robert de Cotte, too, made an early neo-Gothic design for the façade of the uncompleted Cathedral of Ste.-Croix in Orléans.[77]

Because modern scholars are made acutely uncomfortable by the fact that our most admired forefathers' way of seeing Gothic art was quite different from our own, they tend to emphasize bits of evidence like Soufflot's *Mémoire* while rapidly passing over what Soufflot actually did to Notre Dame. From the completion of Milan Cathedral[78] to Hawksmoor's work on Westminster Abbey and at All Souls' College, Oxford,[79] every particle of this evidence that Gothic art was never absolutely rejected has been studied at length.

Meanwhile, no one has emphasized the real point—that the successive desecrations of Notre Dame caused no protest whatever from Soufflot or anyone else. And no one has computed exactly the dreadful, quite needless losses, which also tell the true story. The Gothic Revival had already been going on for about half a century at the time of the fearful destructions after the French Revolution—great monastic churches used as stone quarries;[80] Claus Sluter's masterly Mourners from the Chartreuse de Champmol barely saved by local people who bought them for nothing;[81] the ancient reliquary of the Crown of Thorns from St. Louis's Sainte-Chapelle broken up for its precious stones and melted down for its metal;[82] and so on. Even after the Revolution, when the antimonarchical, anticlerical fever had subsided, there was no prompt turn for the better. The abbey church at Cluny, the greatest Christian place of worship in Europe before the second St. Peter's in Rome, was not merely pierced by a road. The other parts of the huge structure were used as stables—until all was leveled at last in 1823.[83] This was not many years before the Gothic Revival reached its second stage, when Augustus Welby Pugin proclaimed that it was downright immoral *not* to use the Gothic style for any religious edifice.[84] And even then, there was a considerable further interval before equal reverence was given to Chartres and the Parthenon.

Revolution III

Furthermore, the process that finally made Chartres one of the world's chief pilgrimage-shrines of art was no more remarkable, no more radical, than still another revolution in the way of seeing. This third great revolution is hardly known of, even today, since too few people understand the full aftermath of the High Renaissance. For about three hundred years the High Renaissance "drowned" all that preceded it, in the words of Frits Lugt. In other words, the great Italian masters of the fourteenth and fifteenth centuries, from Cimabue and Giotto down through Botticelli and Piero della Francesca, were seen solely as historical preparers-of-the-way for the High Renaissance's canonical great masters, but not as great masters themselves. The real character of the way of seeing before the third great revolution we are speaking of is therefore revealed by the ac-

cepted values of art-dealing, art-loving Amsterdam in the seventeenth century. Of these values, Frits Lugt wrote further: "The masters of the [fourteenth and fifteenth centuries] did not count; the public did not have an eye for them. . . . Painting was considered to start with Raphael and Titian; [only] by way of exception Giovanni Bellini and Mantegna were taken into account. [All the earlier masters] remained empty names."[85]

As an eighteenth-century witness one may also call the Président Charles de Brosses. On his trip to Italy in 1739–40, this cultivated French intellectual inspected the Rucellai Madonna, then attributed to Cimabue, and decided that Cimabue was hardly "fit to paint an indoor tennis court"[86]—the point being that *jeux de paume* were then painted solid black or very dark brown to show off the tennis ball in flight.[87] De Brosses further considered that Giotto was only a little better. Seeing the Eremitani in Padua, he remarked that although Mantegna had skill, his work was sadly marred by the *"méchant goût"*[88] of the fifteenth century, and he further described the whole period before the High Renaissance as the *"méchant temps."*[89] As for Ghiberti's gates of the Florentine Baptistery, he thought them far inferior to the gates of the Château de Maisons.[90]

The Président de Brosses was of course a fairly extreme case, and there are not a few isolated opinions to cite on the opposite side of the balance sheet, like Sir Joshua Reynolds's celebrated appreciation of Masaccio.[91] All the same, the evidence is abundant that another revolution in the way of seeing was needed to produce the modern situation—in fact, the third great rearrangement of our Museum of the Imagination, to give Giotto, Piero della Francesca, and the others places in the museum fully equal to the places of the giants of the High Renaissance. This same vast change at long last opened the way for Rembrandt to be enshrined among the very greatest masters, and led to other dramatic rearrangements of the hierarchy. It was a far-reaching process, in short. Just how the process began in the eighteenth century will be examined in a later chapter. Only one further point needs to be made here. Add the Gothic Revival to the radical change in the way of seeing classical works of art. To the Gothic Revival, then add the radical change in the way of seeing the earlier masters of our own tradition, with all its ramifying consequences. The sum of these three concurrent revolutions was the final rejection of the standards of excellence and error established by the Renaissance, and thus the final abandonment of the long-enduring canon of art resulting from the Renaissance.

The drama by no means ended there, however, for the twentieth century had a further, stranger tale to tell. With the former canon abandoned, in fact, all art gradually became equal—although some people's art has never ceased to be more equal than other people's. Group by group, culture after culture, the products of all the known non-Western cultures, whether

surviving above ground or wrenched from the shelter of the silent earth, were scrutinized anew with altered eyes.[92] Grimy archeological finds and obscure ethnographical specimens, curios from family whatnots, souvenirs of life on far frontiers, and loot from half-forgotten military expeditions to the remoter corners of the globe—all these came to be seen as works of art deserving the grave, minute attention of art historians, the angry rivalry of art collectors, and the more polite but no less cutthroat pursuit of museum curators. In the upshot, the descendant of the obscurest British officer who brought back bronzes from the sack of Benin in 1897 became a luckier man by far than the inheritor of Greco-Roman marbles eagerly, expensively collected by one of the greatest Whig grandees of eighteenth-century England.[93] And as these words are written, New York's Metropolitan Museum is building a whole wing to be devoted to "primitive art."

The By-products of Art

It is astonishing that so little attention has as yet been paid to such an intellectual and esthetic upheaval as the absolute transformation of the Western way of seeing, which has now been briefly reviewed. Certain aspects of the transformation have attracted scholarly interest, to be sure. Long ago, Lord Clark pioneered work in English on the Gothic Revival.[94] Important work is now being done on a broader front by Professor Francis Haskell of Oxford.[95] Even today, however, there is no convenient short description of the entire amazing phenomenon. Its essence was, and is, a drastic revision of many long-existing esthetic values. Hence I shall boldly call the phenomenon *revaluation*. For one who wishes to understand the modern climate of taste and creation, historical understanding of revaluation is obviously essential. It has not merely left us unable to see today what our forefathers saw, as was said at the outset. It still continues, with many further effects on the current way of seeing. Nowadays, indeed, revaluation's pace grows more hectic year by year. Before long we may perhaps expect the Apollo Belvedere to be *re*-revalued, for re-revaluation is a strong new trend.[96]

It can be understood then, why revaluation will later require further scrutiny. At this juncture, however, I must instead make a confession to the reader. I began this essay with the fate of the Apollo Belvedere partly in the spirit of a traveling salesman with unfamiliar wares in his sample case. Cunningly, he brings out first whatever he thinks will be most eye-catching, in order to interest buyers in the rest of the items in his "line."

This is what I have done, too. I am afraid, furthermore, that my "line" is alarmingly extensive. Revaluation is in fact only one of the by-products of art, and belongs to the complex, integrated *system* I mentioned at the outset. Within this larger system, moreover, revaluation is by no means

primary. Overall revaluation could never have begun without other phenomena already in existence: art collections to furnish material for comparison; art history to provide a framework for comparative analysis; and of course an art market to supply the art collectors. The Elgin marbles, for instance, would have been impossible to place, so to say, if art history had not then given all the Parthenon's sculpture to Phidias. This attribution to Phidias, plus Phidias' standing as one of the giants in the whole history of art, were the prime motives of Lord Elgin's costly but successful effort to secure the marbles. By the same token, one of the main lines of attack on the marbles in the row in London was to deny that Phidias could have had anything to do with them. It was said that they were sculpture from the time of the Emperor Hadrian—which was miserably bad art history, but still art history of a sort.[97] One may even doubt whether Lord Elgin would have laid out £75,000 to get his marbles and bring them to England[98] if he had not been spurred on, at least subconsciously, by the high money value art collectors and thus the art market had long placed on classical sculpture.[99] In all sorts of ways like this, art collecting and art history, the art market and revaluation are intimately interlinked. All four phenomena are in fact parts of the same integrated system—which has some other parts as well.

Obviously, the entire system has great import for the social history of art. Study this system, furthermore, and you find yourself confronted with several significant but unsuspected questions about true art history. Yet once again there is a difficulty. Where revaluation has attracted remarkably little scholarly attention, the system that revaluation belongs to has literally attracted no attention at all. It has never once been examined *as a system;* and, as a system, it lacks an accepted description. Once again, therefore, it has been essential to supply a label. As the reader is already aware, I have chosen "the by-products of art." It may be an inelegant-sounding label, yet I have searched in vain for over a decade for another simple, exact label for the total system that would do as well. The total system cannot be called "the phenomena of art," as I once planned, because the components are properly epiphenomena—which sounds unbearably pompous and pseudo-scientific. Other alternatives have other drawbacks. In short, "by-products of art" best and most precisely describes the phenomena which are this essay's subject.

To this a warning must be added. The by-products of art comprise no less than eight fairly distinct phenomena, all of which, I repeat, constitute an integrated system. Detailed historical analysis of the entire system as it has appeared in different cultures would therefore require several volumes. Hence I shall concentrate hereafter on the history of art collecting, which seems to me to be the system's basic and most essential part. Again to avoid a work in several volumes, I shall carry the account of

the history of each by-product of art no further than the stage of first mature development. In each of the art traditions showing evidence of these by-products, there were also long subsequent stages, of course. In the case of our own tradition, for example, over three hundred years separated Giorgio Vasari from the rise of scientific modern art history in the nineteenth century, while Western art collecting reached maturity in the seventeenth century, or three hundred years ago, and the first public art museum in the West was opened in the late sixteenth century, or four hundred years before the present Museum Age.

Yet my real subject is the integrated cultural-behavioral system which the by-products of art always constitute. Even if I observe the limitations above-described, enough will still be said about each part of the system to show the inner workings of all these phenomena, and also to indicate the interconnections and resulting interactions within the system as a whole. So here, finally, is a complete list of all the by-products of art, in the order imposed by their significance and their links with one another:

1. *Art Collecting:* This is the basic by-product of art simply because the rest of the system has never developed without art collecting. It seems certain, indeed, that the other parts of the system cannot develop in art collecting's absence.

2. *Art History:* As will be shown later, art history goes hand in hand with art collecting at all times.

3. *The Art Market:* Third place goes to the art market, because you cannot have a true art market without art collecting, and art collecting automatically begets an art market to supply the collectors.

These three are the primary by-products of art, simply because all three are to be found wherever art collecting is found. Later chapters will explain why the three primary by-products are effectively inseparable and therefore constitute the irreducible minimum of the system they belong to. Meanwhile, it must be noted that the system may also comprise up to five further phenomena, which are secondary because they are not inseparable. Continuing the number sequence, these secondary by-products of art are as follows:

4. *Art Museums:* Historically, this phenomenon is the most uncommon of the lot, but it takes fourth place today because we now so conspicuously live in the Museum Age.

5. *Art Faking:* Wherever there is a booming art market serving competitive art collectors, faking is an automatic development.

6. *Revaluation:* In the way already briefly examined, revaluation has now produced a kind of stock market of taste, on which works of art of all sorts go up and down in estimation all over the world.

7. *Antiques:* This use by both the rich and middle classes of borrowed decorative plumage plucked from the past to ornament the present differs from ordinary art collecting because it always starts much later and also introduces the new theme of old-for-old's-sake.

8. *Super-prices:* The payment of super-prices for works of art always announces the last and most luxuriant phase of development of the by-products of art.

Among the phenomena on this list, only the eighth continues to startle a good many people, and the super-prices of the last half of the twentieth century undoubtedly are a bit startling. It is best to ignore the recent, much-publicized "auction records"—which are not real records because of the gross, continuous inflation of recent years. In real terms, the highest price thus far known was probably paid to Prince Liechtenstein by the late Ailsa Mellon Bruce, for Leonardo da Vinci's little portrait of Ginevra de' Benci for our National Gallery. The best guess is $6,000,000, plus or minus.[100] A bit later, $5,400,000 was given by the firm of Wildenstein for Velázquez's portrait of his mulatto servant, Juan de Pareja, for the Metropolitan Museum.[101] If you think about it, however, these sums, though equivalent to almost double the amounts named in current money, are far less astounding than the prices fetched by products of the minor arts, such as $1,104,000 for a pair of Louis XV soup tureens by Juste-Aurèle Meissonnier,[102] or $1,000,000 paid by the Metropolitan Museum for an Athenian crater painted by Euphronius in the later sixth century B.C.;[103] or $1,008,600 bid in London for a large dragon-painted bottle of Ming blue-and-white porcelain of the Yong Le reign;[104] or even $573,000 paid at another London auction for an underglaze red-and-blue Chinese porcelain wine jar of the early fourteenth century[105]—a staggering rarity, about thirteen and a half inches high, which a family in Holland had been using as an umbrella stand until it was spotted, still crammed with umbrellas, by the London auction house's valuation expert.[106] Even these sums, in turn, are less incredible than the $51,600 given at another sale in London for a mere decorative trifle, a small French nineteenth-century paperweight of colored glass.[107]

Yet those who marvel at these fortunes paid for major and/or minor works of art, and even semi-art, have never seriously studied the by-products of art, or considered how they work together as a system. The links within the system are in fact revealed with special clarity by super-prices, which are not, as will be shown, a uniquely modern or uniquely Western phenomenon. To begin with, these staggering prices for works of art plainly cannot prevail without art collectors' competing to pay them. Then, too, authentication by the art historians is always required for the payment of a super-price. Adroit puffery and crafty manipulation by the leaders of the art market obviously enter in; and so does the current stage reached

by revaluation—for a fine piece of Greco-Roman sculpture would not command a genuine super-price today, whereas a price to knock your eye out would surely be offered if the Reliquary of the Crown of Thorns, from the Sainte-Chapelle, had somehow escaped the French Revolution's destructions and should now come up for sale.

Finally, there is the simple fact that we now live in the Museum Age, which has effects on prices that are best suggested by a true story my brother Stewart used to tell. He once made a study of extreme sociological interest of the Americans who had piled up the largest fortunes since the Second World War.[108] One of them had just paid a huge sum for an alleged Rembrandt, and my brother asked him why. In reply, his interlocutor reeled off two statistics—on the large number of Rembrandts already locked away in museums and the tiny number of Rembrandts still in private hands. Then he added, "But everybody, just everybody, still wants a Rembrandt. So where has this one got to go, do you think?" Whereupon he jerked his thumb skyward.

The System Today

This particular approach to works of art may not command respect; but that is unimportant. The real point is that on all sorts of levels and in all sorts of ways, the eight by-products of art and their complex interactions deeply influence the modern climate of taste and creation. Here, in truth, we have touched upon a major common error.

Ask your more thoughtful friends the question: "What most strikingly sets apart the creative process in the later twentieth century?" A normal answer would surely be, "The practice and official acceptance of anti-art." Anti-art, of course, simply means works of art designed to mock, or to transcend, or to transmute into something quite different, the very act of artistic creation. Anti-art's official acceptance is undeniably odd, if only because the destruction of art museums had such a high priority in the original program[109] of the Dada movement, from which the anti-artists unquestionably descend. Yet most of the surviving works of Marcel Duchamp, the brilliant pioneer of anti-art, have now received museum entombment in Philadelphia.[110]

The ironies are obvious. Yet, surprising though it may seem, this aspect of the modern situation is not without precedent. In the long Chinese art tradition, to be specific, there were undoubted anti-artists in the later Tang dynasty, toward the close of the eighth century A.D.[111] We know nothing about them at first hand. We have not a single picture by any of these "untrammeled," or "Yi Pin," Tang painters. But an eminent Japanese scholar has described how one of the most admired, Master Gu, "would first lay out dozens of pieces of silk on the floor . . . [then]

when he had become a bit tipsy, he would run around the silk several
dozen times, finally taking the ink and spilling it all over. Next he would
sprinkle on the colors. The places where they spilled he would cover
with a large cloth, and have someone sit on it, while he himself grasped
[the cloth] by one corner and pulled it around."[112] Master Gu ended
by adding a few normal brush strokes to his action-painted blotches, to
give a faint suggestion of landscape; but Professor Shimada Shujiro has
also shown that another untrammeled Tang painter sometimes poured
ink into his hair and used his head as a brush.[113] The parallel with a
good many of our modern anti-artists is fairly evident. It is evident, too,
that Master Gu had no more trouble finding support than the leading
anti-artists today.

The gaps in the majestic Chinese record are so numerous that no one
can really say what stimuli drove Master Gu and the other untrammeled
late Tang painters to their form of anti-art. In our own time, however,
it seems obvious that, in part at least, anti-art directly reflects the feedback
into the creative process of the whole system of the by-products of art.
This system has now attained bullying, omnipresent power; and this power,
surely, is a major—if not *the* major—stimulus of anti-artists. If the anti-
artists have been driven to rebel against this power, moreover, one can
easily see why. On what is called "the art scene," after all, collectors
and dealers, curators, critics and art historians nowadays often loom larger
than creators.[114] Their complex, unceasing, sometimes self-serving dia-
logues; their rivalries and coups; the new trends which they launch and
the old ones they abort; the ever more extensive revaluation of the art
of the past and present which they carry on among themselves; even the
rising (or falling) prices which reflect the shifting winds of opinion blowing
across the "art scene's" odd but opulent expanses—such are the influences
that quite largely control the dominant way of seeing of our time. This
being the character of the current "art scene," all should have much sympa-
thy for the rebellious anti-artists, and indeed, for all other aspiring creators
now at work among us.

As the foregoing may suggest, some of my views run counter to the
views of many other people in our time. Since the by-products of art
began to loom so large in the West, they have also been more and more
talked about in tones of awe. One hears endlessly of "pioneer" art collec-
tors. A proto-museum was described as a "temple of art" as long ago as
the early nineteenth century.[115] Even the art market is sometimes romanti-
cized; and the payment of super-prices for works of art is widely taken
as proof of art's essential sacredness.

All this seems nonsense to me. Super-prices strike me as morbid symp-
toms. All art markets have been habitually sordid and fake-ridden since
the first successful art market was organized. While I much respect the

collectors who have perceived beauty before others perceived it, I cannot forget the frequent recurrence of vulgar status-seeking, crude rapacity, and cold-blooded financial speculation through much of the record of art collecting. As to art museums, it is arguable that they are just as much art's tombs as art's temples. I would only make an absolute exception for art history, which has now grown into a major scholarly discipline with the highest possible standards. Even so, I ask myself whether the art historians' careful dissections and explications of the art of the past and present can really be taken as signs of the creative health and vigor of our own time.

There is another point to note, too. The history of the by-products of art abounds in curious characters, entertaining episodes, singular and often cruel vagaries of fortune, and much else that is either enlightening, or surprising, or squalid, or plain peculiar. Yet serious history does not normally have much room for experts' pratfalls, the follies and vanities of the rich and great, the movements of fashion, and the double dealings of clandestine commerce—all of which are woven into the very warp and woof of the history of art collecting and the rest of the system. Thus the wholly serious story this essay seeks to tell must sometimes be told in terms that do not appear serious. I can only hope the reader will be amused when amusement seems in order, but remember that beneath the surface there are two grave and seldom explored themes: the place of art in different forms of human society; and the effects of this on art itself. These are problems on which the story of the by-products of art casts invaluable light, not least by underlining the absolute uniqueness of the modern situation.

On the Modern Situation

Obviously, art collecting and the other phenomena in the system are not the only factors in the uniqueness of the modern situation. Any sane man knows that no decade is ever precisely like any previous decade, and any historically minded man knows that the later twentieth century differs from all but the most recent past by quite new orders of magnitude. Eons of time formerly passed without producing such changes as are now produced by a few years. The fundamental cause is the triumph of modern high-technical society, which is transforming the whole world—its crust, its oceans, its biosphere and atmosphere—in ways that were formerly un- imaginable. So much is an old story. Yet the effect on the arts of high-technical society is not an old story; or at least it is a story that has not yet been adequately investigated and discussed.

The primary effect has been a mass massacre of independent art tradi-tions in every inhabited region of the globe. In and of itself, to be sure,

this kind of cultural homicide is far from novel. The Koreans had a markedly individual art of their own before their Chinese neighbors subjugated part of Korea for a while, and more important, culturally subjugated all of Korea. The Yue peoples of China—of whom the Vietnamese are the southern extension—undoubtedly had their own art, too, although precious little is known about it. The Koreans and later the Southern Yue, namely the Vietnamese, finally threw off the rule of China. Thereafter, both usually acknowledged formal and near-meaningless Chinese suzerainty, but both enjoyed substantive political independence until Vietnam was incorporated in the French Empire and Korea in the new Empire of Japan. Nonetheless, the cultural conquest by China was never reversed. Many other, often more bloodstained cases of the same sort can also be cited. A long series of vigorous pre-Columbian art traditions died in the aftermath of the conquests of Cortez and Pizarro. The traditions of the North American Indian tribes were largely destroyed (along with many of the tribes) in the course of the westward expansion of the United States.

The mass massacre of art traditions in recent times has been different in character, however. In many regions, the process no doubt began in the nineteenth-century heyday of Western imperialism. Yet the essence of the process has been something never seen before, in fact worldwide cultural homogenization. Because of the power of high-technical society, homogenization has actually gained momentum since the twentieth-century retreat of the Western imperial powers. Right around the globe, just about all the surviving independent art traditions, whether nourished by little tribes or great races of men, have been destroyed by the impact of high-technical society. Or at best they have been debased to market production of new kinds of art, often for airport shops for tourists.

In the perspective of the world history of art, this mass massacre has been an awe-inspiring development, in scale unlike anything seen before. For the purposes of this essay, it is also a profoundly important development; for it has had its own far-reaching effects on the modern way of seeing. Here I am not speaking of the primary changes in the way of seeing with which Western revaluation began, already briefly covered in this chapter. But there is no past parallel, anywhere in the history of art, for the second stage of Western revaluation, which has extended to all the arts of all the peoples on earth in all epochs of history whose works are still known to us. It seems reasonably clear, too, that there is a direct link between the mass massacre already summarized and this second stage of Western revaluation.

On the most superficial level, it is a truism of the art market that the works of a dead but still-admired master are more valued than the works of a master still alive and currently productive. Death limits the

supply; the law of supply and demand begins to operate; and so $2,000,000 comes to be paid for a Jackson Pollock, significantly described as one of the last of Pollock's major works to be available.[116] In the same fashion, collectors', museums', and the market's interest in American Indian artifacts has been growing rapidly for a good many decades.[117] Yet it seems most unlikely that this would be the case if the West were still dotted with trading posts where an illegal bottle of rotgut could still be exchanged for admirable examples of quill work and beadwork, featherwork, blankets, pottery, wood carvings, and the like. While that was the situation, no one was interested in Indian artifacts except for a tiny number of ethnologically minded persons.

There is also a far deeper reason, however, for the singular catholicism of the modern way of seeing. Besides the massacre of so many independent art traditions, the triumph of high-technical society has had another all-transforming effect. In brief, the mark of the human hand has been progressively and rapidly vanishing from the things men need for use and ornament; from their clothes and their kitchens; from the structures they erect, and all the other circumstances of men's daily lives. As the mark of the human hand has grown rarer and rarer, this vivifying mark has come to be more and more cherished, and more and more for itself alone. One consequence has obviously been the kind of modern revaluation which has now extended the realms of art history and art collecting to include American Indian artifacts. But there has been another consequence as well. Our ideas about what can be a true work of art have been quite radically altered. In fact, the concept of art itself has more and more tended to extend to almost anything bearing the mark of the human hand. In some circles, preindustrial farm tools, called "by-gones" by English collectors,[118] have even come to be treated as a branch—a humble branch, no doubt, but still a branch—of folk art.[119]

Since this essay's subject is art collecting and its linked phenomena, it is obviously essential to decide whether the concept of art can be justifiably extended in this manner. "What is art?" is certainly a question that can be endlessly argued. In my own case, reflection on two special cases has helped to define the concept. From the sixteenth century onward, the Japanese masters of the tea ceremony have been widely accepted as the arbiters of Japanese esthetic values.[120] For a very long time, too, tea masters have chosen examples of the rougher sorts of Japanese peasant pottery for use in the ceremony as tea bowls, water jars, flower vases, and the like.[121] Not seldom, the pieces chosen are those that have suffered accidents in firing, and these scars and deformations have seemed positive virtues to the tea masters, who might also combine the crudest kind of Bizen water jar with a tea bowl from the China of the Song dynasty, faultlessly potted and exquisitely pure in form and glaze.

If I am to be honest, most pieces of peasant ware chosen by the Japanese tea masters strike me as no more than exceptionally pleasing. I cannot respond to them with the deep emotion which cultivated Japanese undoubtedly feel. I recall particularly a crudely potted but strongly formed late sixteenth-century flower vase of Iga ware, with a rough brown-and-black body, a slight, haphazard glaze of blue and white, and a side conspicuously dented in the kiln. Like the more famous diamonds, the jar has a name of its own, the Juro-jin;[122] and it is regarded as one of the great prizes of the Nezu Museum in Tokyo. When I visited the museum years ago, my Japanese companions considered the Juro-jin quite on a level with the museum's magnificent set of giant Shang ritual bronzes, or Korin's superb iris screens. I could not do so, but who was I to argue?

Perhaps, however, such tea-ceremony objects are not decisive examples. Famous tea masters have chosen these vessels, not just for their strength and simplicity, but also, in some measure, for their happily accidental aspects; and the role of accident in art is a perilous subject to embark upon. Consider, then, an exhibition of *bourdalous* held some years ago in Paris. This odd French name for bedpans commemorates a famously eloquent seventeenth-century Jesuit preacher, Père Louis Bourdaloue. His sermons attracted great crowds; but he was so long-winded that pious ladies often brought vessels like narrow bedpans to church, for use under their skirts in case of need.

A few bold French collectors now concentrate on eighteenth-century *bourdalous*, and the Paris exhibition comprised their best examples.[123] Some of the *bourdalous* shown, in Chantilly, Meissen, and other fine wares,[124] were downright enchanting, once one had forgotten their original use. As I studied these unexpectedly attractive eighteenth-century objects, I kept remembering the modern industrial products you see in hospitals, of grim white enameled iron, or yellow plastic, or pressed tin. I concluded, not that the eighteenth-century *bourdalous* were works of art of a high order, but at least that they had to be classed as works of art of a special kind. So one is driven—or at least I have been driven—to the widest definition of art, as follows:

Art is whatever the human hand makes with art, and making with art is making to please the eye.

"Making with art" is a legitimate concept, in turn, since it denotes the special intention and the extra skill involved in making a Chantilly *bourdalou* instead of a normal bedpan, or for that matter, in painting Piero's Risen Christ instead of producing a religious chromo.

This definition has the practical virtue of covering the immense range and variety of objects now sought by art collectors of one breed or another; and if some readers think the definition too all-embracing, they should blame the unique character of the modern situation, and the resulting

tendency to see art in almost anything human hands have made, even if the maker had no conscious esthetic intention. Here, too, is where the modern situation's unique character has most strongly fed back—and is still feeding back—into the system that is my subject. Historically, the by-products of art now have their own uniqueness, for this is the first era in which art collecting anywhere has ever gone so far toward omni-collecting.

In China, from about the fourteenth century onward, the collectors' prizes became enormously diverse;[125] but Chinese collectors rarely went further afield than the borders of their own culture-area[126]—except for curiosities. Nowadays, in contrast, someone, somewhere, is sure to be eager to bid against someone else, somewhere else, for just about any surviving object bearing the precious mark of the human hand. Today, it is difficult to name any class of object bearing this special mark, from whatever region of the globe and from whatever time since Homo sapiens began his violent career of creation and destruction, that is not pursued by collectors of one sort or another.

Moreover, this is no more than the beginning of the story. In part because of worldwide cultural homogenization, ours is also the first era of worldwide art collecting competitively, almost belligerently, carried on in every human society whose members have the spare cash to finance this costly pursuit.

Unavoidably, because of the law of supply and demand, the first era of worldwide art collecting has in turn brought into being a worldwide art market of a sort never seen before. The enormous scale of modern art faking is a natural consequence. Among other peculiarities, too, this modern art market quite often shares the clandestinity and illegality of the world market in hard drugs. As to art museums and art history in our era, one can find a few art museums and a fair number of art historians in the remoter past, but there has never been a Museum Age before, and art history has never before been a major scholarly discipline. Nor are there any complete precedents for the universality of modern antique gathering, or for the standardized immensity of our super-prices for works of art.

In short, art collecting and all the other components of the system under study have now reached an unprecedented stage, combining swollen luxuriance with swollen influence. The effects on the climate of taste and creation are there for all to see. As compared with the past, our time is abnormal in almost every possible way; but in the realm of the arts, nothing is more abnormal than the current development of the by-products of art.

INTERCHAPTER 1

THE RARE ART TRADITIONS

All the same, why should the history of the by-products of art be a signifi-cant subject? The bizarre contemporary development of these phenomena certainly calls for thought. But do they really have a *history* of serious interest? The essence of the whole story, if there is a story to be told, is the history of art collecting, the undoubted basic component of the system. Yet just about everyone supposes art collecting is much like clothing—that just as clothes began with skins for warmth early in the Old Stone Age, art collecting, too, is timeless and universal; so its history can be no more than a chronicle of changes of taste and fashion.

Nothing can be further from the truth, as the title of this essay is intended to suggest. Instead, as was briefly stated at the outset, the system that begins with art collecting is the most conspicuous mark of the rare art traditions which have alone generated these by-products. This means, of course, that art collecting has a history that is both significant and previously untold. Such is the first truly major surprise in the story of art collecting.

In the modern era of all but worldwide omni-collecting, it is not easy to perceive that anything like true art collecting was quite unheard of in most parts of the world throughout most of the history of art on earth. The evidence for this is massive, however—too massive to be presented in its entirety at this juncture. But it will be useful to set down forthwith the hardest of all the evidence from the more normal past, which is the story of the abandoned monuments and unguarded tombs.

Today, every ancient tomb and monument anywhere on earth is in danger of attack, merely because of the value on the world art market of all ancient works of art. In the past, however, abandoned monuments were solely in danger for practical reasons, such as the raw material value of their marble if they had it;[1] and tombs were not in danger, even if

unguarded, unless they were thought to contain treasures. Only where there was art collecting were the tombs and monuments also in danger for the value of their works of art, as they are everywhere today. In the first century B.C., the Roman collector, Gaius Verres, used his political leverage to seize Greek Archaic sculpture that had stood before the great temple of Hera on Samos since the temple was built by the sixth-century tyrant, Polycrates,[2] just as Lord Elgin used his leverage two millennia later to get the marbles from the Parthenon.

In most regions of the globe and in most eras in history, however, there were no art collectors; and practical considerations were the sole test. Whatever was made of valuable raw materials[3]—any treasure above all—was always wanted. Or the mere space occupied by a tomb or abandoned monument might be wanted. Or a tomb, monument or even work of art might be wanted for another use, which would then save money, as happened when the Pantheon[4] and Parthenon[5] became Christian churches.[6]

But otherwise mere works of art in unguarded tombs or on ancient, abandoned monuments were never wanted;[7] for they had no value at all simply as works of art, once the monument had lost its function or the tomb had been closed. Thus benign neglect normally prevailed, and this preserved countless glorious works of art *in situ* until the modern era's archeologists came along with their spades, or the modern art market's agents appeared with their electric saws. Two short case studies will be enough to illustrate the before and after.

In the fourteenth and fifteenth centuries, Angkor Wat and all the other great Khmer monuments were abandoned because of the pressure on the Khmers by the Thais, who were then pushing into Southern Thailand from the North.[8] Before this happened, as we know from proud inscriptions on the monuments by the Khmer emperors who built them, temples like Angkor Wat had huge revenues from royal grants of land. The same inscriptions leave no doubt the temples were further enriched with gold and silver vessels, diamonds and other precious stones, pearls in tens of thousands, Chinese silks, sandalwood and camphor for incense, and much else that was costly, too.[9] All these portable valuables were of course taken as soon as the monuments had to be abandoned. Thereafter, many of the great monuments' stones were also prized apart, but solely by the jungle vegetation invading them. Hundreds of years passed, meanwhile, before the hand of man offered any threat to the innumerable works of art of Angkor Wat and the other monuments, with one very minor exception.

The exception was the odd free-standing piece of sculpture which might be removed from one of the monuments, if the sculpture in question happened to be suitable for re-use as an inexpensive cult image in some

village shrine. One such, very ancient and re-used as a rural Buddha, formerly stood in the Phnom Penh Museum still covered with radiator paint-gilding the villagers had applied. The museum staff could not clean off the radiator paint because the villagers still brought flowers and prayed before their Buddha in his new home.[10] But all that, no doubt, has been put a stop to by the Communists.

Meanwhile, the benign neglect of abandonment by no means meant that Angkor Wat and the other great temples were forgotten by all men. On the contrary, Angkor Wat was refurbished and parts of it were re-gilded when the Khmers briefly pushed forward against the Thais.[11] Moreover, people never ceased to marvel at Angkor Wat, particularly, throughout its long abandonment. It was described with astonishment by Portuguese and other travelers in Southeast Asia[12] many years before the French "discovered" it. In the mid-nineteenth century, King Rama IV of Thailand even had a model made of the famous temple for display in the courtyard of the Temple of the Emerald Buddha in Bangkok. The model was wanted because Angkor was a wonder of King Rama's kingdom,[13] which then included Western Cambodia.

When this model was made, however, the adventurous French naturalist, Henri Mouhot, had just sent the report to Paris which led, over time, to Europe's great interest in the Khmer monuments. Mouhot's first excited report on the monuments was published in 1864.[14] In 1866, the French then bullied Thailand into yielding Western Cambodia, and from there the next steps were inevitable. First, French scholarship took the Khmer monuments in hand. Western art collecting soon followed art history; and these developments together automatically produced the new situation which endured until the Communists came. In this new situation, guards had to be posted to protect the works of art of Angkor Wat and the other Khmer monuments from all sorts of people like André Malraux, who wanted Khmer sculpture for their own collections, or for museum collections, or for sale on the market.[15]

As for the story of the ancient tombs, it is perhaps most clearly told by the kurgans, or barrows, which were heaped up for nomadic steppe chieftains of the sixth to fourth centuries B.C. in the Pazyryk region of the high Altai,[16] near the junction of Siberia, Outer Mongolia, and China's Xinjiang province. As soon as each steppe chieftain had been magnificently buried, his barrow was promptly burrowed into and robbed[17] apparently by the more sedentary local people who had been forced to do the work; and this rather strangely helped to turn each barrow into a pre-modern deep freeze. The rain and ground water flowed in through the robbers' burrows, and in that high, cold climate, the water then formed huge lenses of ice, which never melted under the insulating earth of the overlying barrows.[18] But although "all the kurgans had been robbed in antiquity

. . . the robbers *only* took objects made of precious metal, leaving the rest of the contents strewn about."[19] (Italics added).

Thus all kinds of wonderful products of steppe art were found preserved in the ice when the kurgans were excavated after close to two and a half millennia—magnificent ceremonial trappings of the numerous sacrificed horses;[20] fine textiles and fragments of textiles;[21] elaborate leatherwork and furs richly designed;[22] small sculpture in wood, bone and even felt;[23] not to mention apparatus for hashish inhalation[24] and even the frozen *disjecta membra* of a steppe chieftain and his wife who had literally been hacked to bits to make their jewels easy to remove.[25]

The main excavators were the Soviet archeologists, S. I. Rudenko and M. P. Gryaznov.[26] They were not agents of the art market, but besides being students of the ancient steppe cultures, they were active agents for the museum-branch of art collecting. So all that the tomb robbers had left behind was gathered up, to be internationally exhibited and finally re-entombed in Soviet museums.[27] Even the dismembered chieftain (or rather, parts of his skin) underwent discreet museum conservation.[28] He had been ornately tattooed, and the tattoos were now regarded as remarkable specimens of the vigorous animal art of the steppe peoples.[29]

Each of the foregoing cases is representative and could be multiplied many times, and with respect to almost every monument and tomb that has endured from the past into our own time, all over the world. As soon as the monuments lost their function or the tombs ceased to be guarded, almost all were promptly pillaged of anything intrinsically valuable, as I have said. But neither the cultures which erected the monuments and built the tombs, nor those which succeeded, had the smallest interest in the monuments' and tombs' otherwise useless works of art simply because they were works of art. From all these facts, it is entirely safe to deduce there were no art collectors in most parts of the world and most periods of history. A threat to the art of the tombs and monuments only arose when art collectors or their agents[30] appeared on the scene, eager for pillage.

But which cultures, then, have had art collectors? In the immemorially long known history of art, the first undoubted evidence of true art collecting is to be found among the Greeks. A mysterious creative mutation in the seventh century B.C. produced the glorious Greek art of the great centuries, and this led on to the world's first true art collecting in the Greek world, perhaps as early as the later fourth century B.C. This last date is speculative, however. The world's earliest fairly solidly documented art collector[31] was King Attalus I of Pergamum, who began to reign in 241 B.C.

The rest of art collecting's history in the West is simple enough. From the Greek world, it spread to Rome, and Roman millionaire collecting

strongly resembled modern millionaire collecting. But in the twilight of
the classical art tradition and the society and culture which nourished
it, art collecting dwindled and died away in the fourth and fifth centuries
A.D. To all intents, it was unknown in Europe in the Dark and Middle
Ages. It obscurely reappeared in Italy, however, toward the opening of
the fourteenth century, and in the new Western art tradition born of
the Renaissance, art collecting then developed, by stages, to the luxuriant
phase we know today.[32]

In the Far East, meanwhile, the Chinese art tradition, already very
ancient, nonetheless began to take a distinctly new direction with the
foundation of the Chinese Empire in the late third century B.C.; and this
led on to the first Chinese art collecting toward the beginning of our
era, or a little later. At different dates thereafter, the arts and cultures
of Japan, Korea, and the Vietnamese people were transformed by Chinese
influence, and art collecting was exported to these countries. What hap-
pened in Korea and Vietnam can be passed over, however, because the
arts of these two countries remained hardly more than provincial variants
of Chinese art. In Japan alone, the imports from China were fully and
rapidly digested, producing specifically Japanese kinds of art collecting,
and far more important, the fully independent Japanese art tradition which
still continues today.[33]

Finally, there is the somewhat anomalous Islamic case. In the Islamic
world, art collecting began hundreds of years after the Islamic art tradition
originated, and Islamic art collecting was always vestigial and localized.
But it existed, so the later Islamic art tradition has a place on this list.[34]

It goes without saying that whenever art collecting appeared, some
or all of the other by-products of art also appeared. For reasons that will
be suggested later, moreover, the entire resulting system has been unknown
beyond the limits of the classical art tradition which was born in Greece;
the new Western art tradition which originated in the Renaissance; the
second era of Chinese art; the Japanese tradition after its transformation
by the impact of China; and in a small way, the later art tradition of
Islam.

To cover the detailed development of art collecting and its linked
phenomena in all five of these art traditions is another task beyond this
essay's feasible scope. Furthermore, cultural diffusion was unquestionably
responsible for the appearance of art collecting and almost all the associated
phenomena in Japan; and the partial development of the same system in
later Islamic art was too restricted to have far-reaching secondary effects.
Thus what happened in these two art traditions will be somewhat summar-
ily dealt with, while I shall attempt to offer fairly full accounts of what
happened in the Greek world and later in Rome; in China after the third
century B.C.; and finally in post-Roman Western Europe, where art collect-

ing first disappeared for hundreds of years and then reappeared in four-teenth-century Italy.

Obvious practical considerations require this concentration on what happened in the classical world, in China after the foundation of the Chinese Empire, and in Europe after the collapse of the Western Roman Empire. It will still be necessary, however, to write repeatedly about all five art traditions which have known art collecting and some or all of the other by-products of art. To avoid repetition, a label is therefore needed, and as this essay's title indicates, the label I have chosen is *the rare art traditions.*

"Rare" is a strong word, to be sure, but it is justified for two main reasons. To begin with, art collecting and its linked phenomena are cer-tainly idiosyncratic enough and striking enough to mark off the rare art traditions which have produced them from all other traditions which have not done so. And in the second place, the normal art traditions—as the others may be called—have been incalculably numerous.

Here one must begin with a fact which is easy to forget in this age of worldwide cultural homogenization—the fact that the world has plainly seen many thousands of independent art traditions come and go since art began. Before cultural homogenization, it was usual for any reasonably self-contained and reasonably long-enduring human society to generate its own art tradition discernibly different from the tribal, or national, or regional art traditions of all other societies. One cannot name an exact total of art traditions in the past, simply because one cannot say how many coherent social groups, ranging from little tribes to great empires, have arisen in the course of human history; have flourished for their fate-allotted terms; and have then succumbed to the grim first rule of history: "Nothing endures."

Yet another approach is open. One can take as a basis for calculation one of the few surviving and intact traditions of tribal peoples in extremely remote areas, whose arts and ways of life have not yet been culturally homogenized. The Southeastern Nuba of the Southern Sudan are one such people, and, as it happens, a young English anthropologist has made a valuable report on their art.[35] The principal art form is the body painting practiced by the youths and younger men, who go entirely naked, depilate themselves with the utmost care, and decorate themselves from head to foot with designs of their own choice and, usually, of their own creation.[36]

If this seems an odd kind of art, it should be noted that Alois Riegl and at least one other scholar suggested long ago that body painting had probably been man's first well-defined art form,[37] actually preceding the great art of the Paleolithic caves. Moreover, Southeastern Nuba body paint-ing has its own large and complex technical vocabulary.[38] It also has its own motifs and specialties, such as brilliantly skillful and idiosyncratic

use of asymmetry.[39] It even has its own generally accepted critical standards for distinguishing good work from bad.[40] In Southeastern Nuba body painting, furthermore, there are none of the religious, magical or other undertones of the sort it is so fashionable to stress among anthropologists at the moment. Instead, the purpose of this art is purely esthetic.[41]

In short, this is an undeniable art tradition, rather more self-conscious than many another art tradition one can think of. Yet the whole tribe of the Southeastern Nuba numbers no more than 2,500 persons.[42] Take this simple fact, and then extrapolate to embrace all history. It is then clear that since the beginning, the world must have known, not just thousands, but probably tens of thousands of art traditions.

Body painting, admittedly, is a kind of art that cannot be collected; but many other works of art produced by tiny tribes can be, and are now collected.[43] Rather early in the human story, furthermore, art traditions of a more ambitious character, nourished by larger regions, and lasting for longer periods of time than most tribal traditions, clearly began to develop here and there on the globe's surface. The first major art tradition we know about was the remarkably long-lasting and rich one which produced the great art of the Paleolithic caves of Southern France and Northern Spain. Rather late in the human story, too, some human societies achieved the more complex organization which we call higher civilization; and each higher civilization almost automatically generated an art tradition recognizably its own. Such traditions all but invariably left enduring remains to tell us today the story of the higher civilization and of the art that was peculiar to it. Yet even so it would be a long job, and a tricky job as well, just to make an exact count of the number of known art traditions which were nourished throughout history by higher civilizations of one sort or another.

Instead it is easier to note, to begin with, that the list of the five rare art traditions necessarily excludes by far the longest period of art's known history on earth, from the Old Stone Age to the Greek mutation in the seventh century B.C. Then add that the list further excludes whole continents rich in art, such as most of Eurasia before quite recent times and Africa and the Americas before modern times. It is then clear that "rare" is a decidedly conservative way of describing the five art traditions which have alone developed the system I have called the by-products of art.

There may be those who will see no obvious significance in the five rare art traditions' historical monopoly of art collecting and its linked phenomena. But in the first place, each of the more important by-products of art is exceptionally complex in itself. Yet in the classical art tradition and the second era of Chinese art, in the Japanese tradition after its Chinese transformation, in later Islamic art, and in the Western art tradition origi-

nating in the Renaissance, all the by-products of art appearing in each tradition took schematically identical forms, as I have said. And this happened although the cultures nourishing the five rare art traditions were so strikingly diverse, as were their arts. The strange combination of the separateness and similarities of the five rare art traditions in fact constitutes the truly major problem of the world history of art which I mentioned earlier.

It may seem astonishing that so major a problem has thus far attracted almost no attention, but there are good reasons for this. Until the end of the eighteenth century, to begin with, the domain of art history in the West hardly extended beyond the classical and modern Western art traditions. Another hundred years were needed for the extension of the empire of art history to cover the rest of the world, and even more time was required for art history's extension into the remote past with the aid of archeology. Until rather recently, therefore, the comparative materials were lacking which are obviously needed, even for a tentative and somewhat speculative history of the by-products of art.

In addition, art collecting, the basic component of the system, is the essential key to any history of the system as a whole. Yet art collecting is not merely regarded quite falsely as timeless and universal; worse still, art collecting, though abnormal and rare, is painfully easy for the unwary to confuse with other activities, above all patronage of the arts, which really are timeless and have been almost universal since art began. Thus the first order of business must be to see what art collecting is, and just as important, what is not true art collecting. Only then can one say with assurance of the vast majority of art traditions, "These had no art collecting," and say of the rare traditions, too, "All these had art collecting in common."

II

ART FOR USE

In the *Summa Theologica*, St. Thomas Aquinas offered the only analysis of the nature of visual beauty[1] that works for all human groups, all over the world, and for all the visual arts without exception. Beauty, he concluded in effect, is simply what pleases the eye—*"quod visum placet,"* as one of the Thomist commentators put it.[2] Thus St. Thomas outflanked the troublesome fact that the beauty of one society has so often been the ugliness of another. The Goddess Tlazolteotl in childbirth would surely have struck both Phidias and Michelangelo as incomparably ugly. Yet this is a powerful image of the Maize God coming forth in bitter pain— for the Aztecs, the hard birth of the staff of life itself. Thus one may be certain the image was no more ugly in Aztec eyes than Michelangelo's Dead Christ with the Sorrowing Mother was ugly in Renaissance eyes. Since making with art is neither more nor less than making to please the eye, St. Thomas's conclusion also quite comfortably covers the world's earliest works of art, even though the special knowledge of the paleo- anthropologists has been needed to recognize the character and meaning of these lumps of flaked stone.

Surprisingly, art now appears to have begun long before the modern races of man first began to walk the earth. From the dark pygmies of the Congo rain forests to the tall, pale Scandinavians, all modern men derive from a single species, Homo sapiens sapiens, and this species all of us belong to originated about fifty millennia ago. Yet the first chapter of art history obscurely opened about two hundred millennia[3] before Homo sapiens sapiens made his dangerous debut, according to evidence rather recently assembled by the students of human origins.

At that time, the genus Homo was still represented by a substantially more primitive species, Homo erectus. Among the cultural traces left by Homo erectus, the most numerous and important assemblages are custom-

arily called Acheulian. These are characterized by a typical tool-weapon known as a hand ax;[4] and judging by the estimated age of the first, most crudely flaked hand axes, the Acheulian stone industry developed around a million to a million and a half years ago.[5] Furthermore, for hundreds of thousands of years thereafter, Acheulian stoneworkers continued to make hand axes with nothing to distinguish them beyond a very slow, barely perceptible, but continuous increase in the stoneworkers' proficiency.[6]

In late Acheulian times, however, certain stoneworkers began to "lavish" far "more skill and labor" on their hand axes than were "strictly necessary to make a usable tool."[7] This "may be" the "first evidence of the esthetic sense in man."[8] And of course it is just that, if the late Acheulian hand axes were indeed made not for use alone, but also to please the eye. On this interpretation, the late Acheulian hand axes were the first true works of art, and on St. Thomas's rule, they were also beautiful hand axes by Acheulian standards.[9]

These claims for the hand axes will of course shock those who still cling to Ruskin's opinion, once so common, that serious art has always been a monopoly of Western man, beginning with the Greeks,[10] and that all the works of lesser breeds are no better than artifacts or curiosities. Again, if there really is an unbridgeable gulf between "high art" and "mere craftsmanship," then the hand axes are not works of art. They are also excluded by Immanuel Kant's rule that true art must be, and can only be, an "end in itself" produced with no other purpose primarily in mind.[11] Surely, however, none of these views is logically tenable today.[12] Even Kant's rule breaks down at once, as soon as the origins of great works of art are superficially investigated. Michelangelo's Pietà, for instance, was emphatically not an end in itself with no purpose of use. It was made, instead, for use as a symbol of deeply held faith, and was destined from the first to serve as a major symbol in the chief edifice of that faith, St. Peter's Cathedral. The art lay in giving beauty to the symbol. And in the late Acheulian case, the art lay in making the hand axes pleasing to the eye.

In the era of Homo erectus, to be sure, the development of thought cannot have extended to such abstract concepts as "beauty" and "art." Nor can language, as far as it went then, have included any word even very roughly meaning what beauty means to us today. Hence the late Acheulian stoneworkers cannot have consciously sought to make beautiful hand axes, in the way Michelangelo sought to make his Pietà beautiful.[13] What happened, if the newly assembled evidence is not misleading, can only have happened because the gradually improving technology of the Acheulian stone industry finally began to permit displays of skill going beyond naked utility. When this stage was reached, one must suppose, some stoneworkers then sought to delight themselves and others by giving

their hand axes uncommon fineness of form, or by making hand axes showing uncommon mastery of the stone, or in both these ways.

Yet even if the stoneworkers aimed no higher, the potential significance of what they did is near to awe-inspiring. To see the significance, however, and also to see why the late Acheulian hand axes really must be classed as the earliest works of art, you must first face and accept the central mystery of art itself. The modes of art are almost limitless; for they range in character from the hand axes to the luxurious eighteenth-century *bourdalous* I saw in Paris, and from Michelangelo's Pietà to Boucher's enchantingly lubricious portrait of Miss O'Morphy. But whatever the mode may be, the same mystery presents itself.

"Why do men make with art?"

Such is the mystery; for so far as anyone can see, making with art is not in the least adaptive in the sense given that word by evolutionary theorists. Whatever its mode, art invariably calls for a substantial extra investment of time and talent. It does not contribute in any discernible way to the survival or success of the human species or of the individual human group. Except among men, the impulse to make with art has never appeared in any animal species.[14] Hence art has thus far been treated as an essentially social development—a somewhat puzzling secondary result, in other words, of the more and more complex organization of human society that started after the emergence of Homo sapiens. Yet this can hardly be correct if making with art began in the era of Homo erectus.

Assume the paleo-anthropologists have read their evidence rightly, and that superfluous energy and extra skill really were invested in special hand axes which the late Acheulians regarded as impressive, or precious, or pleasing in some other way. Then one is all but forced to the conclusion that the basic impulse to make with art and the underlying esthetic sense are inbuilt traits of the more advanced species of the genus Homo—in fact, traits not socially learned but deriving from the innate human program, in much the same way Professor Noam Chomsky holds that the deep structures of articulate speech are innately programmed. Nor can this conclusion be evaded because Homo erectus only started making with art in late Acheulian times. The impulse to make with art could not find expression until the hands of the makers gained the needed proficiency, just as abstract thought could not develop significantly until much, much later, when the speech of certain cultures began to gain the means of expressing abstractions. Thus the late Acheulian hand axes have both magnified and quite radically transformed the mystery of art.

Nor is this all. The late Acheulian stoneworkers cannot be denied their place as the first who made with art simply because they made hand axes. Instead, the stoneworkers' superfine hand axes dimly, unintentionally announced the true theme of the vast majority of subsequent works of art. This is the theme of *art-for-use-plus-beauty*. By this common theme,

indeed, the products of these late Acheulian men are strangely yet directly linked to the work of Raphael which was all but unanimously regarded by our grandfathers as the greatest single painting in the world, and still remains one of the triumphs of Western art. For at the outset, art-for-use-plus-beauty was also the underlying theme of the Sistine Madonna.[15]

In 1512–13, the monks of the ancient Benedictine Monastery of San Sisto in Piacenza were enlarging and aggrandizing their church. Pope Julius II had long been a supporter of the monastery, and the monks therefore begged for his help. The Pope responded by commissioning an altarpiece from Raphael, and Raphael provided one of the supreme religious icons of the High Renaissance, showing the Madonna and the Christ Child cloud-borne and adored on high by St. Sixtus and St. Barbara. He also endowed St. Sixtus, who was a martyred pope of the third century A.D., with a blander version of the grim features of Julius II, and he ornamented the saint's papal vestments and tiara with the Della Rovere arms. In this manner, Raphael commemorated his great patron, and commemoration of a patron is a use of sorts. Yet to serve as an icon was still the main intended use of Raphael's masterpiece, and it was long used precisely as intended. For over two centuries, the pious people of Piacenza prayed before the marvelous image of the Virgin Mary and the infant Jesus which had been provided for them by Raphael and Pope Julius.[16]

In 1745, however, the monks of San Sisto yielded to the temptation of the eighteenth century's most famous super-price for a single work of art, 17,000 gold ducats, then a truly enormous sum. A copy replaced the familiar icon over the altar in Piacenza, and the original entered the collection of Augustus III of Saxony and Poland.[17]

One story goes that when the Sistine Madonna reached Dresden, King Augustus first displayed the picture to his courtiers propped up on his own high throne, meanwhile grandiloquently exclaiming, as though to himself, "Make way for the great Raphael!"[18] Whether or not the picture was thus accorded royal honors, the story expresses a deeply important reality. The former use of Raphael's masterpiece had ceased to matter. Even the image of the Mother of God and her Saviour-Son had ceased to matter greatly, as compared with the role of "the great Raphael" in creating this image. The much-loved former icon had in fact been invisibly transmuted into a particularly splendid collector's prize, and thus art-for-use-plus-beauty had given way to *art-as-an-end-in-itself*. This is the common theme of all art collecting.

The Two Great Themes

The next chapter will attempt to provide something that does not now exist in the literature: the first precise yet comprehensive definition

of art collecting. Thus it is enough to say here that although art collections have been assembled in many ways and for many motives, the theme of art-as-an-end-in-itself has always characterized the rare way of thinking about art that gives rise to art collecting. Whenever and wherever art collecting has begun, works of art, or at least certain classes of works of art, have become ends in themselves; and they have therefore been collected without regard to usefulness or lack of use.

Nor is it surprising that Kant shared this special way of thinking about art.[19] By the eighteenth century, this way of thinking was all but universal among educated Western Europeans. In Kant's lifetime, Europe's first major public art museums were established in Vienna and Florence;[20] and Kant's great contemporary, Goethe, was the man who coined the phrase "temple of art," to describe the galleries housing the Dresden collection.[21]

How far the theme of art-as-an-end-in-itself may be carried can be seen today by any thoughtful visitor to one of the huge modern museums which bring together works of art of every sort. In the department of decorative arts, no chair will again be sat upon; no bedside table will again be opened to disclose a chamber pot. Among the jewels and the goldsmith's work, no chalice and paten will again receive the blood and body of our Lord; and no brooch or chain or pendant will again add beauty to the beautiful or pride to the proud. Where the museum shows the arts of primitive peoples and early civilizations, no ritual vessel will again be heaped with the food of sacrifice, and no mask will again be worn in the frenzy of the dance. And it will be the same in the core of the museum, the rooms of painting and sculpture. For here, if the pictures and statues did not begin as religious icons, or cult images, or family or state portraits, or memorial works of one sort or another, all but a few at least began as the planned adornments of specified architectural settings, and therefore as enhancing parts of larger wholes.[22] Whereas today, all these pictures and statues are there for themselves alone, solely to *be* art, part of nothing except the museum collection, and so beyond life, beyond death, but not beyond art history.

The way of thinking about art revealed by our museums may be regarded (and I so regard it) as richer and more rewarding than the normal way. But the point still is that this way of thinking cannot be considered normal by any interpretation of the evidence. Instead, normal thinking about art has always been characterized by the theme of art-for-use-plus-beauty, which is already detectable in the late Acheulian hand axes. "Normal thinking" in turn means the thinking about art of all cultures beyond the limits of the rare art traditions. And in each of the five rare art traditions, too, works of art were customarily designed for known uses until the moment when art collecting developed.

How far this normal way of thinking went—how extreme the contrast

was with the way of thinking about art revealed by art collections and art museums—is in turn indicated by the evidence of the abandoned monuments and unguarded tombs. Thus it may be well to repeat at this juncture that the two examples already given, of the great Khmer monuments and the Pazyryk kurgans, can be multiplied many times over.

Among the signal triumphs of the art of India, for example, are the frescoes richly decorating cave shrines hewn from the living rock in the remote valley of Ajanta in Southern India. The shrines were hewn out and the frescoes painted between the second and sixth centuries A.D.[23] But the cave shrines were dedicated to a syncretistic form of Buddhism; and soon after the last shrine was completed—probably as early as the late seventh century A.D.—the shrines were abandoned because of Buddhism's rapid final decline in India.[24] Thereafter, the Ajanta caves had no regular visitors except the bats and wild beasts that laired there, until a hunting party of young English officers stumbled upon one of the painted caves in 1815.[25] The end result of this chance discovery was automatically predictable. Today, the cult practiced in the Ajanta caves is one no Indian had ever heard of when the Buddha still had Indian votaries—in fact, the cult of art.

Again, even the local farmers knew nothing of several of the enormous Mayan monuments first rediscovered by Stephens and Catherwood[26] in the mid-nineteenth century. Many additional Mayan ceremonial centers have also been rescued from oblivion in the twentieth century, when these magnificent remnants of the past have attracted a much wider interest; and there have been great surprises, too. For instance, nothing like the frescoes of Bonampak was known or imagined before this site was discovered in the jungle in 1946,[27] and no tomb-within-a-pyramid was dimly suspected before the discovery, within the Temple of the Inscriptions, of the hidden tomb chamber, rich in beautiful jades, of the most powerful of all rulers of Palenque, Pacal the Great.[28] And now, of course, droves of art lovers make toilsome pilgrimage to Palenque, Bonampak, and all the other important Mayan sites; archeologists swarm over them; and agents of the art market clandestinely but continually steal away Mayan steles and pieces of sculpture, painted tomb pottery, carved jades, and other works of art for sale to the world's art collectors.[29]

But it would take a separate volume to pile up the complete evidence of the monuments and tombs, which always shows the same pattern. What matters, in any case, is the lesson this evidence teaches, which is worth recapitulating. In brief, the lesson is that whenever and wherever the normal way of thinking about art has prevailed, even the very greatest works of art have lost their main attraction if they lost their uses. Before this happened, to be sure, works of art could sometimes acquire special uses having nothing to do with art and nothing to do, either, with the

use they were made for—for instance, becoming family or state heirlooms,[30] or trophies of war,[31] or religious relics,[32] or whatever. Once one of these special uses was acquired, the work of art was prized for it. Or when works of art lost all use, they might still be taken for their gold or silver or jade or jewels. Or if of marble, they might be taken, too—but only to be slaked down for lime.[33] Finally, ancient works of art without use or function might still cause men to marvel and tell tales of the men of old.

Meanwhile, however, no one beyond the rare art traditions' limits ever sought to collect works of art, or to preserve them in museumlike repositories, with no thought of use and solely for their art. Whenever the prevailing theme was art-for-use-plus-beauty, in sum, the beauty ceased to count for much as soon as the use was gone.

Thus it is also worth briefly noting the astonishing multiplicity of uses for which works of art have been made. The Meissen *bourdalous* of the first chapter were no isolated case. Spittoons have also been made with art, as anyone can see who studies the exquisitely potted spittoons of the delicate Chinese white ware of the Tang and Song dynasties[34] (which the auction houses now tactfully offer under their Chinese names, or else as "leys jars," in order to spare collectors' sensibilities). As we go forward, we shall even meet with a singularly beautiful kimono stand, made with the utmost art of Japan in the eighth century A.D.[35] The truth is that every imaginable object of daily use has been made with art, at least on occasion, for those who could afford the extra expense this usually requires. But so have cult images and objects, festival decorations, embellishments of all sorts of rituals, the masks of secret societies, weapons for battle and for show, the regalia of rulers, the symbols of rank of other high personages, and the showy luxuries of successful prostitutes. And art has further been used for magic, as in the Paleolithic caves; to make records, as in some pre-Columbian codices and the finely illustrated Western travel books of the prephotographic era; and in other such ways as well.

Yet the real heart of the matter is not the limitless variety of works of art that have been made for identifiable uses of one sort or another, sometimes very high and sometimes very humble. Strange as this may seem to all of us, who are encapsulated in a late phase of one of the rare art traditions, what was formerly called high art has almost always had a use at the outset, just as the Sistine Madonna did. The great gold and ivory images of Athena and Zeus that Phidias made for the Parthenon and the Temple of Zeus at Olympia were promptly and universally recognized as superlative triumphs of Greek art.[36] Yet Phidias was far from wholly free to follow his own inspiration for the Zeus or the Athena. Both were cult images commissioned for the temples that received them;

and this meant that they had to be carefully adapted to the planned use, and not just in their dimensions. The conventions governing cult images were fairly strict, and Phidias was reportedly accused of sacrilege on the grounds that he had dared to represent himself and his patron, Pericles, on the goddess's own shield in the Parthenon.[37]

Nor is this the end of the story, by any means. In almost all human societies, fewer conventions have naturally governed artists who were called upon to adorn rulers' palaces or the dwellings of magnates. Yet appropriate adornment of a known setting is also a use. In scale and in many other ways, works of art commissioned for this use have always had to be carefully adjusted to the setting—and therefore to the use; and more often than not, the patron's commission would further specify the iconographic program that was to unify all the elements in the scheme of adornment.[38] Concerning the widespread insistence of patrons of the arts on careful adaptation of works of art to the uses planned for them, and on the resulting limits placed on artists' freedom by their patrons' commissions, Meyer Schapiro may be called as a witness:

"In Egypt, Greece, Rome, medieval Europe, Byzantium, Persia . . . most art was made with a prescribed content and even forms were sometimes dictated by authority. Even in the Renaissance, as the contracts show, the painter and sculptor carried out the minutely detailed stipulations of a patron. This state of affairs does not seem to have choked inspiration."[39] Elsewhere, Professor Schapiro has added: "In the Greek and Roman world as well as in the Renaissance, most original works of painting and sculpture were made to order for a definite purpose" such as "the decoration of a building in progress."[40]

Professor Schapiro's observations are particularly important for this essay's purposes because they lead to a basic rule of thumb: *Art collecting never enters in when works of art are made for known uses, including specific architectural uses.* (Please note the word "specific.") When works of art are instead made for no purpose except to *be* art, you may be certain that art collecting has become an established social habit. How seldom this has happened in art history can be learned from careful analysis of the ways works of art originated in most periods of the past and most regions of the world. But the significance of the rule of thumb above-given is not easy to understand nowadays, because of the situation of the visual arts in the later twentieth century.

Our Abnormal Situation

As it happens, the two papers by Professor Schapiro here quoted had a background which points directly to the strangeness of the situation of the arts in the later twentieth century. In brief, an eminent sociologist[41] had proposed the artist-patron relationship as a sociological "model," with

the highly misleading implication that in the good old days when patrons of the arts abounded, generous patrons' commissions gave artists unrestrained liberty to create what they pleased, how they pleased, and when they pleased. Hence Professor Schapiro felt the need to supply a mild corrective, and the first of his two papers was therefore written for *The American Journal of Sociology.*

No intelligent man could have made the error the eminent sociologist made, if the modern situation of the arts were even halfway normal. Instead, this situation is totally abnormal, simply because patrons of the arts have almost completely vanished from the scene, and all our leading artists now work all but exclusively for the art market. In other words, they paint or sculpt, as the case may be, with no patrons' commissions to stimulate yet limit them. Their paintings and pieces of sculpture are then offered for sale when desired, either through dealers or directly. And the success of the individual artist is ultimately measured by the demand, or lack of it, for the artist's works in the higher reaches of the art market.

No fully comparable situation has ever existed anywhere or at any time in the previous history of art. Hence it is rewarding to try and trace how and when the modern situation arose. For this essay, indeed, the effort is unavoidable, since this abnormal modern situation of the arts is the main source of the prevailing confusion about what art collecting is and what is not art collecting.

One aspect of the modern situation, of course, is the relative freedom of inspiration artists now enjoy. The freedom is only relative, because artists wanting to make their bread by producing for the market cannot produce what the market will not absorb. Yet those who are daring and also see new ground worth breaking are still free to break this new ground in the hope they will be followed onto it by the art dealers, the art collectors, and the museum curators. Nor do artists producing for the market have to shape their works to conform to the requirements—the "stipulations"—of patrons of the arts. And for this degree of freedom, there are some partial precedents in the past.

In China, to begin with, calligraphy and painting have been regarded as the only major arts for close to two thousand years; and throughout the same long period, calligraphy has always been the art of arts.[42] Rather early—in the third century A.D.—leading calligraphers began to assert the right to work as they chose, without patrons' requirements to consider. Somewhat later, the same claim began to be asserted by leading painters. But in the first place, all works of leading Chinese calligraphers rapidly became collectors' prizes pure and simple, and were therefore locked away and never shown except on special occasions. Somewhat later, the works of leading painters also ceased to be shown as we show pictures, even in our art collections; and they were then locked away with the specimens of calligraphy.[43] In short, the way the situation of the arts evolved in

China constitutes, as usual in China, a most special case.[44]

For present purposes, therefore, it is more interesting that rather late in the great centuries of Greek art, certain artists began to claim a larger freedom, not to work in any way that happened to please them in the modern manner, but at least to treat their subjects in ways of their own choosing. Before the mid-fourth century A.D., for instance, nude cult images of goddesses had never been made, although nude male cult images had been usual from the first, and female nudes of other types had of course been known in Greek art.[45] Thus Praxiteles was experimenting boldly when he made a naked Aphrodite which he purposely contrasted with a clothed image of the goddess.[46]

As it turned out, cult images of Aphrodite were wanted at that time by both Cos, which was rich, and Cnidus, which was poor. Cos, having first choice, acquired Praxiteles' clothed Aphrodite, whose head may well survive in the previously mentioned one at Petworth.[47] And poor Cnidus had to be satisfied with the naked Aphrodite.[48]

Cnidus was lucky, for the cult image the city acquired soon became the most famous single work by Praxiteles, and it was the great showpiece of the place for hundreds of years.[49] By the first century B.C., art collecting had also become a social habit in the whole area influenced by Greek culture, and rich collectors were paying great prices.[50] Hence King Nicomedes IV of Bithynia ("All the world did Caesar conquer/Nicomedes conquered him"—but only in love in Caesar's youth, if the ancient canard is correct[51]) offered to pay the entire municipal debt of Cnidus in return for Praxiteles' naked Aphrodite.[52] The Cnidians nonetheless refused Nicomedes' offer, on the grounds that this statue alone had "made Cnidus illustrious."[53]

The real point of this story, of course, is that it leaves no doubt that Praxiteles sculpted the two contrasting Aphrodites to please himself, and with no patron's commission to restrict him. Significantly, the date when he did so was also near the date when I myself believe Greek art collecting first began in a small way, albeit so obscurely as to leave no trace in the record for another century.[54] Once art collecting begins, in however small a way, the bonds of patronage are naturally loosened. And once works of art start to be seen as ends in themselves, the new way of thinking about art naturally enhances the standing of the more successful artists; and with the higher standing, wider creative freedom naturally goes hand in hand.

Art for the Market

Yet the chief precedents for the way almost all our works of art are now produced are to be found, somewhat disquietingly, not among the

summits of art history but on lower levels. Even in periods when no major works of art were ever undertaken without a patron's commission specifying a use, lesser works of art were often produced for the market in the modern way. As Professor Schapiro notes in one of his papers, Tanagra figurines were produced for the market;[55] and other figurines were similarly produced from the earliest times in Greece for use as religious ex votos.[56] Yet such mass-produced objects, not essentially different from what the English call "fairings," are less important to consider than luxury wares, which are seldom mass-produced on the highest level of luxury.

For instance, it is not entirely clear what percentage of the splendid Greek painted pottery of the great centuries was specially ordered; but much of it must certainly have been made for the market. Many of the finest pieces, including many pieces bearing *kalos* inscriptions celebrating young Athenian male beauties of the moment, have been found in the rich tombs of Etruscan noblemen.[57] The *kalos* cups and vases looklike Athenian special orders, and some of them probably were; yet Leagrus,[58] Onetorides,[59] and the other bearers of "*kalos* names" can hardly have had admirers in Etruria. It is a thousand-to-one bet, too, that the original purchaser of the Metropolitan Museum's Euphronius crater did not send a commission for his magnificent wine jar all the way to Athens from Tarquinia, or Cerveteri, or Vulci, or wherever he lived.[60] And the importance of Etruscan buyers to the Athenian potters, and their awareness of market trends, are both attested by fair numbers of Athenian potters' products that show signs of having been consciously shaped and decorated with the Etruscan market in mind.[61]

The truth is that although the products of the better Athenian potters and pottery painters of the great centuries were and are glorious works of art, and each was usually one of a kind, too, they still began as luxurious dinner wares. As such, moreover, and in their own time, they were also marks of status akin to the inordinately expensive but widely exported French crystal of today, which may cost $250 for a single champagne glass.[62] Throughout history, in fact, all sorts of things we now see solely as works of art were originally luxuries produced for the market. Among the supreme luxuries of Western Europe in both the Dark and Middle Ages were the superb silks woven in Constantinople, in the Middle East and by Arab workshops in Palermo.[63] And in the Middle Ages, and in much the same way, English alabaster reliefs from Nottingham, opus Anglicanum embroideries, and the French enamels of Limoges were all produced for the market and widely exported, too.[64]

The modes of luxury production in the past are particularly interesting nowadays, if only because the triumph of high-technical society has left almost no functional place for making with art. If you think about it, the mark of the human hand has been progressively banished, to the

point where machines mainly produce the normal human environments of the later twentieth century, and the art, if any, is pasted on later like a postage stamp. So the question arises whether art itself has not been almost reduced to the status of another luxury, which can be, and perhaps one day will be, altogether dispensed with.

But this is melancholy speculation. Meanwhile, the real origins of the abnormal modern situation of the arts must be traced to a fourteenth-century development with no real overtones of luxury. Specifically, the fourteenth century was the time when portable devotional pictures began to be made for household use, or even for the use of travelers.[65] One of the great Jacob Burckhardt's many insights was to pinpoint the beginning-output of "Hausandachtsbilder" as a true turning point in our art history.[66] A few of the devotional pictures were works of the highest quality, obviously specially commissioned, like the lovely Wilton diptych.[67] But a great many more were just as obviously painted for the market, using stock patterns,[68] and were then traded like any other commodity. Such devotional pictures of the past were in truth close to the religious chromos still manufactured for the devout poor today.

In later-fourteenth-century Florence, Benedetto di Banco degli Albizzi, a wool merchant, also carried on a trade in ready-made devotional pictures on the side[69]—which proves the existence of a brisk Florentine domestic demand. In the same period, such pictures were also quite regularly exported from Florence to Avignon by the firm of Francesco di Marco Datini of Prato[70]—but only when they could be picked up from Florentine painters at low prices, unless the Avignon branch of the Datini firm had a special order.[71] In Venice in the fifteenth century, some painters even specialized in pictures of the Virgin and were therefore known as "Madonnieri."[72] In fifteenth-century Florence, the Ricordanze of Neri di Bicci,[73] an extremely businesslike painter, show that he produced and sold no fewer than fifty-five polychromed stucco reliefs of the same half-figure Madonna. The original molds for the reliefs were apparently sold to Neri by Desiderio da Settignano. But the stucco reliefs were molded to Neri's order, sometimes in batches of three or four, by the same woodworkers who also made the frames; and Neri then sold them after doing the polychroming or having it done in his shop.[74]

In the Low Countries in the fifteenth century, moreover, the development of art for the market evidently went considerably further than it did in Italy.[75] There were full-time dealers,[76] whereas the most one can find in contemporary Italy is a Florentine commission agent, Bartolo di Pagolo di Giovanni Serragli, who dealt with artists on behalf of important patrons.[77] In the Low Countries, too, painters paid higher guild fees if they had shopwindows on the street,[78] obviously because they could then use the windows to show pictures they had painted for stock. Even ready-

made altarpieces were sometimes on sale.[79] Pictures were also sold at all the big fairs in Flanders;[80] and at the Antwerp fair, the painted panels were of a quality to tempt the representatives of the Medici branch bank in Bruges.[81]

Nonetheless, there is no valid evidence that really ambitious works of art were commonly made for the market in the fifteenth century anywhere in Europe.[82] Instead, the little evidence we have points the other way. For instance, when Dieric Bouts died in 1475 he bequeathed his unfinished pictures to his sons, and his *"tabulas et ymagines . . . perfectas vel quasi perfectas"* to his wife, Elizabeth.[83] This certainly sounds as though Bouts had left a studio full of pictures painted for the market. Yet in reality, the only two paintings from Bouts's estate which we now know about are the panels of the Justice of the Emperor Otto in Brussels.[84] One panel must have come from the sons' share, for it was finished by weaker hands;[85] whereas the other, with its portraits of real persons as courtiers of the Emperor, was pretty certainly finished by Bouts before his death, and thus came from the share of Elizabeth Bouts.[86] Far from having been painted for the market, however, both panels formed part of an important commission that Bouts had not completed when he died.[87]

Art for the Market's Rise

One must allow for special cases, of course. As a very young man, near the close of the fifteenth century, Michelangelo made his Sleeping Cupid (now lost) to show he could rival the "ancients," and thus to get commissions.[88] In the sixteenth century, there must have been a fair number of such exceptions, growing more and more numerous as it became more and more normal for collectors to gather works of art of our own art tradition,[89] and it also became a more and more common practice for people to decorate the interiors of their private dwellings with paintings and pieces of sculpture.[90]

It is not at all clear, nonetheless, just when really major masters began to paint pictures for stock, and thus for sale as ready made works of art, rather than waiting for patrons' commissions. Giovanni Bellini, for instance, was not far from being another *"Madonniere"* in certain aspects of his studio practice. As his Madonnas were in wide demand, different types of Madonna-paintings were assigned to each of his assistants, and each assistant then reproduced the type assigned to him as often as might be required.[91] This being the practice, it hardly matters whether you could walk into Bellini's studio and buy a Madonna off the wall. Yet I suspect that Titian was the first great master who sometimes disposed of his works in a proto-modern way.

Few great masters have cared more for the rewards of their art than

Titian did, and few have been so prolific. It is abundantly documented that he sometimes offered paintings to grandees in the hope they would help him get sinecures for himself or benefices for his son Pomponio.[92] It is again documented that his habit was to begin a composition, then to lay it aside, then to work on it again after an interval, and so on until the picture was finished. Hence his studio must always have been full of paintings in various stages of completion; and although he almost always had in hand major commissions from patrons, there must also have been intervals when the commissioned pictures were laid aside for the moment, in Titian's usual way.[93] Given his energy and his drive to enlarge his earnings, it would have been natural for him to use such intervals, when they occurred, for new work of his own, or else for additional work on the studio versions of certain of his paintings which were popular enough to be produced in considerable numbers. It was a sign of the times that many of those in strong demand, which also greatly contributed to the reputation of the mature Titian, were the strictly secular classical *poesie*. Both secular and religious compositions could be seen on the walls of his studio, however, and visitors could order versions for themselves.[94] And when his fame had grown great Titian could easily have freed himself from the old style dependence on patrons' commissions of his earlier years.

Whether Titian did so is another question. To begin with, there are interesting though uncertain indications that he had the habit of taking a selection of paintings along with him, over and above those already destined for patrons, on his business journeys to Milan or wherever.[95] If this was the case, the extra pictures can only have been intended for sale on the spot. Then, too, there is correspondence from an agent of Ferrante Gonzaga, the imperial Governor of Milan, about a visit to Venice and his dealings there with Titian. The Gonzaga agent complained that Titian had been less than polite to him, but nonetheless recorded his visit to the master's studio and his order for a picture desired by Gonzaga, for which a large advance was paid.[96] This certainly sounds as though the picture had been ordered from stock, but there may have been a prior patron's commission not mentioned in the letter. Finally, a letter from Aretino to Cardinal Granvelle describes how Titian's studio was positively stormed by persons wishing to buy his works before his departure for Augsburg to visit the Emperor Charles V.[97] It is now usual to dismiss the evidence of Aretino as wholly unreliable, but surely, if it was never possible to buy paintings straight off Titian's studio walls, in the way Aretino's letter seems to indicate, Cardinal Granvelle was quite knowing enough to detect the lie.

At any rate, whatever Titian's studio practice may have been, it is only logical to suppose that leading artists began to paint for the new art collectors' market as well as for patrons at some time in the sixteenth

century. In the Low Countries, particularly, masters like Joos van Cleve are known to have had their workshops make whole series of versions of different qualities of their more popular images, presumably for the market.[98] Nonetheless, so far as the evidence goes, it was only toward the beginning of the seventeenth century that art for the market really began to assume something like its present guise and to rise toward something near its present importance.

In other words, masters of recognized standing much more regularly began to produce for a collectors' market instead of in response to patrons' commissions. At the two poles were Pietro da Cortona and Salvator Rosa. The former boasted that he had never painted a picture based on an idea of his own[99]—meaning that patrons had competed for his services from the very outset. The latter was the first Western painter to insist on carrying out his own ideas in his own fashion, and then offering the results to collectors on the market in a modern way—which was one of the reasons Salvator Rosa was thought so eccentric by his contemporaries.[100]

In between these two were Poussin and Rubens. It was rare for Poussin to paint a picture on his own hook, but he clearly did so. Thus we find Fabrizio Valguarnera, a Sicilian diamond smuggler, choosing the Plague of Ashdod from the pictures in Poussin's studio when he was seeking to launder his dubious gains by buying pictures in Rome.[101] As for Rubens, he eagerly sought commissions for enormous projects like the cycle glorifying Marie de' Medici, or the Apotheosis of James I for the ceiling of the Banqueting House in Whitehall;[102] and he was not in the least troubled either by the exceptional iconographic and other demands these projects made.[103] Yet with his unparalleled fertility of imagination and power of execution—and, one must add, with a large studio organization—Rubens also produced many paintings to suit his own fancy, most of which were intended for sale to any suitable purchaser who came along. The posthumous inventory of Rubens's pictures, taken to prepare for their dispersal after his death, not only shows a remarkable collection of works by great masters of the Low Countries and Italy;[104] it also shows enough leftover paintings by Rubens himself, or by the master and his assistants, to constitute the entire oeuvre of a lesser man.[105]

In Rubens's lifetime, too, the ready-painted stock in the master's studio provided all the pictures he traded for the classical marbles acquired in Venice by Sir Dudley Carleton.[106] To satisfy "ye cruel courteous painter" (as an intermediary, Tobie Mathew, described Rubens to Carleton),[107] the English diplomat and collector also had to sweeten the deal with a large sum in cash; but this may have been partly because Carleton, significantly, wanted pictures by Rubens's own hand,[108] instead of studio works largely by his assistants. Rubens did very well out of the deal, too. We should now give all of Carleton's rather miscellaneous-sounding marbles,[109] and

much more besides, for just one of the paintings Rubens traded to him, such as the Daniel in the Lion's Den in our National Gallery.[110] But Rubens got a price of 100,000 florins from the Duke of Buckingham when he sold the Duke all Carleton's marbles and much of the rest of his classical collection, plus some of his own pictures and some from his collection.[111]

Other seventeenth-century developments also need to be briefly covered. To begin with, this was the first time when secular works of art were produced for the market in really large numbers, both by the lesser *Bamboccianti* in Rome and beginning-painters in the Low Countries, where this development went further. In the Low Countries, to be sure, many of the painters in question were no better than poor hacks, as anyone can see from the correspondence of the Antwerp art dealers, the Forchoudt family.[112] From their Spanish branch, the Forchoudts exported ready-made altarpieces for Latin American churches;[113] but most of their trade was in secular pictures. A letter of 1667 from the Vienna branch explained that there was no Viennese demand for "religious" subjects or "badly done battles," while there was a healthy demand for "small battles," "hunting scenes as contained in the last parcel," "battles of better quality," and "attractive looking fruit and fish markets."[114] Note the emphasis on the subjects: the seventeenth century was also the time when large numbers of painters far more talented than the ones the Forchoudts apparently employed began to make specialities of particular secular subjects.

This second development was in considerable degree localized in the Low Countries, especially the Netherlands, and it gave a strong new impetus to what may be called trademark painting.[115] A master becomes a trademark painter when he all but invariably paints different versions of the same subject—or, for that matter, when he sticks to painting variations on the same theme or compositional formula. Landscapes, scenes of peasant life, and church interiors were the trademarks respectively of Ruysdael and Hobbema, of Teniers, and of Sanraedam. The large output of the lesser Dutch seventeenth-century trademark painters no doubt mainly furnished the picture-stuffed farmhouses which so surprised John Evelyn when he visited the kermesse at Rotterdam.[116]

Trademark painting is important, of course, because all trademark painting is basically done for the market. Even when the artist has a special commission, the thing wanted by the man who gives the commission is the kind of painting which the artist has already made his trademark. Once begun, moreover, trademark painting never ceased. Many of the most successful nineteenth-century artists were conscious trademark painters, like the English specialist in pictures of contented cows and, sometimes, happy sheep, Thomas Sidney Cooper.[117] He became president of the Royal Academy, wrote a most curious autobiography, and founded a museum in his own honor in his native Canterbury;[118] so he prospered with his cows and sheep.

It goes without saying, too, that trademark art comes close to being the norm today, and is also accepted as a norm. The principal American avant-garde painters and sculptors of the moment are all serious artists; but they are trademark artists with few exceptions. The exceptions, like Isamu Noguchi, tend to cause grave critical disarray.[119] Furthermore, when one of the trademark artists alters his established formula, pained critical protests are likely to be heard—as happened to de Kooning, for instance.[120]

So much, then, for the origins of the way of producing works of art that is now all but universal. The detailed developments of the eighteenth, nineteenth, and early twentieth centuries need not be touched upon—although the whole subject one day deserves careful and detailed study—for the origins are what matter for this essay's purposes. The origins matter so greatly, in turn, for a good reason: the truth is that our otherwise unprecedented way of producing works of art is a prime cause of the wholly erroneous but general belief that art collecting has been immemorial and universal in art history. The error comes from seeing the normal past through the grossly distorting glass of the abnormal present.

The modern situation is not abnormal solely because patrons of the arts, all but entirely dominant in the past, have almost ceased to exist today. The other side of the same coin is the immense modern proliferation of art collectors. The modern art market, in fact, is a collectors' market, through and through, and leading artists are only recognized as such when art collectors and museum curators begin to compete for their works.

Furthermore, all persons today who acquire works of art of any consequence, even if these are entirely contemporary, not only think of themselves as art collectors: up to a point, they really are collectors, although sometimes fairly odd collectors. This is still true of the people who tell you, grandly, "We buy art," and follow the latest fashions of the art market like so many automata with bank accounts. The theme of their way of thinking about art is still art-as-an-end-in-itself, rather than art-for-use-plus-beauty. They are certainly not patrons of the arts; for they no more offer commissions to the contemporary artists they fancy than to the makers of the African masks they so often place among their Rothkos and their Stills. The contemporary works they acquire are never designed, either, with any specific use in mind. They have no purpose except to *be* art, like the works of art in a museum. In these and in all other ways, even the least inspired among the modern "art buyers" meet the next chapter's definition of art collectors point by point.

On Treasure Gathering

Having explored the abnormality of the present situation of the arts, it is now time to turn to the visual arts' situation in the past. We not only see art collecting where there was none in the past because art collec-

tors are omnipresent today. In addition, we suppose that almost all past works of art were collectors' prizes from the outset, because almost everything made with art, at any time or place in the past, is now so eagerly sought by art collectors of one sort or another. Yet this is another profound error.

The overwhelming majority of our collectors' prizes instead originated in one of three ways. Either they were produced as things of common use with the extra attraction of being made with art, like the spittoons of the Tang and Song dynasties. Or they were made as treasures. Or they were works of art resulting from patrons' commissions.

It is easy to see that art collecting played no role when finely made things of common use, such as spittoons, were acquired by their first owners. But it is less easy, at least nowadays, to see that the past's many treasure gatherers and countless patrons of the arts were very far from being true art collectors. Unless the existing muddles about these matters are entirely removed, moreover, it will always be impossible to see that true art collecting has never arisen beyond the limits of the five rare art traditions. Hence this chapter's remaining tasks of ground clearance will consist in removing these muddles.

Treasure gathering must be separately treated because it differs inherently from normal patronage of the arts—even though most of the past's conspicuous treasure gatherers were also lavish patrons. The inherent difference exists, in turn, simply because the immense intrinsic value of the raw materials differentiates treasures from all other works of art, however lovely the treasure may also be. Today, pieces of jewelry are almost our only treasures of the old type; and however finely a grand piece of jewelry may be made, everyone still thinks first of the diamonds or other precious stones—and thinks last about the art of the jeweler, if he so much as receives a passing thought.[121]

The raw materials of treasures have varied widely over the millennia. In the Neolithic Era, precious metals were unknown but obsidian for fine weapons was then exported over great distances from its few places of origin.[122] And so we know obsidian weapons were treasures in the eyes of the men of the New Stone Age. Again, green jades were the Aztecs' supreme treasures; and this puzzled Cortez and his men, since jade had no great value in Spain in those days. However, as soon as the Conquistadors realized that a single *"chalchihuitl"*—the Aztec word—could be exchanged for two man-loads of gold,[123] the status of *chalchihuitls* changed significantly. Thus on the terrible *Noche Triste,* many of Cortez's greedier followers were drowned by the sheer weight of the looted gold they carried;[124] but some Spaniards partly owed their success in escaping from Tenochtitlán to their shrewdness in carrying off no more than a few *chalchihuitls.*[125]

Whatever might be the raw materials that were highly valued in a particular time and place, however, the result was always the same. Treasures have always been collected, after a fashion—*but for their raw materials' sake.* This is the real reason the lesson of the abandoned monuments and unguarded tombs does not extend to treasures. In art collecting's absence, other works of art that had lost their use were not thought worth the bother of removing them. But treasures cannot lose their use, for being a treasure is their fundamental use. So men have taken treasures wherever they could find them since Neolithic times and perhaps earlier;[126] and most magnates in human history have also been ardent treasure gatherers.

As a first case in point, much may be learned from the wonderful English archeological find at Sutton Hoo, which has even been thought to reflect antique collecting in the modern meaning of that phrase.[127] The ship burial at Sutton Hoo, with all its entombed magnificence, commemorated an Anglo-Saxon magnate of the seventh century A.D. who is believed to have been King Raedwald of East Anglia.[128] King Raedwald's helmet and certain other things deposited in his burial-ship may indeed have been antique in the sense that the helmet was probably made in Scandinavia a couple of hundred years before it was buried.[129] Furthermore, the helmet, with its curious mustache and its eyebrows ending in boars' heads on the faceplate, and its silver-inlaid, dragon-ended crest on the scenically embossed headpiece,[130] is nowadays regarded as a rare work of art.

In its own time, however, the helmet was first of all sternly useful. Second, by that time's standards, it was intrinsically precious. Third, it was presumably an ancestral object, handed down in the line of the Wuffingas, the family of King Raedwald, and placed in his burial-ship as an important heirloom. Fourth and last, "heirloom" is the key word; for the warlike Anglo-Saxons of the seventh century A.D. most certainly did not attach the value to old-for-old's-sake that characterizes modern antique collecting. In short, it is plain nonsense to picture the man of those rough days who was honored at Sutton Hoo as viewing his heirloom-helmet in the same way that a modern American antique collector views his prize Connecticut corner cupboard. Such people in the past were not antique collectors; and more important for our purposes, and however magnificent their personal adornments and costly their grave goods, they were not art collectors, either.

Far from being an art collection, the Sutton Hoo find is a uniquely complete surviving array of the more important personal possessions of a northern war leader of the seventh century. A good many of these possessions, like the great garnet-inlaid purselid,[131] were treasures of considerable beauty. The finest works of art from the Sutton Hoo ship burial are in

truth treasures. Yet no commonsensible person with any historical knowl-
edge can suppose that an intense feeling for art-as-an-end-in-itself led King
Raedwald to gather his treasures.

As one more case in point, consider also the marvelous coins of so
many of the Greek cities in the great centuries of Greek art. Among the
most beautiful types is the large Syracusan silver decadrachm, of which
the finest is called *Demareteion*, with the lovely profile of the nymph
Arethusa surrounded by dolphins at play.[132] Today we see these coins
solely as works of art, and as such they are much sought after by collectors.
Yet what primarily mattered when the Syracusan moneyers struck the
decadrachms? What mattered, above all, was that ten Attic Owls, for in-
stance, could be obtained for the weight of silver in a decadrachm by a
traveler needing to change his Syracusan money in Athens.[133] So long as
these were the priorities, a Syracusan decadrachm remained a treasure in
the form of a coin.

Admittedly, a tricky question is raised as soon as one weighs the value
of an object's raw material against the value of the work done on the
object. It is recorded, for instance, that in the rich times when Rome
was the center of a fairly stable empire, good sculptors received about
nine times the value of the raw materials for statues in bronze or fine
marble.[134] Even for a silver chariot, a silversmith was then paid more than
half the total cost with only about 42 percent of the cost going for the
large weight of silver.[135] In contrast, Lorenzo Ghiberti received only 200
florins a year, with deductions for time spent on other work, during the
twenty years he labored on the bronze doors for the Florentine Baptistery;[136]
the cost of the bronze alone was 2,400 florins,[137] without counting other
expensive raw materials such as gold leaf, fuel for the foundry, etc.; and
Ghiberti gave the total cost of the two pairs of doors as 22,000 florins.[138]
Other artists—Uccello, Michelozzo, Donatello for a while, Bernardo di
Piero Ciuffagni, to name four—also helped Ghiberti with the doors, and
their pay was included in the total cost. But there is no way to work
the percentages to give Ghiberti and these other artists of the early Renais-
sance a share of the all-in cost approximately equal to the share received
by sculptors in Rome, even if you make a large allowance for the Romans'
studio expenses.

For another contrast, also consider the work known as Monogram,
which Robert Rauschenberg made by wreathing a junk shop's stuffed goat
with a secondhand automobile tire, and then adding a base he painted
for the purpose. This was sold to the Moderna Museet in Stockholm for
$30,000,[139] and it was further insured for $400,000 when it was returned
to the U.S. for the Rauschenberg exhibition at the National Collection
of Fine Arts.[140]

In the case of Monogram, rather obviously, the artist's conception and

work were all, his raw materials close to zero. Furthermore, despite the quite different ratio of cost between work and raw material, no one has ever for a moment regarded Ghiberti's doors for the Baptistery as anything but works of art. On the other hand, Ghiberti also made a famous tiara for Pope Eugenius IV, for which he boasted the gold and jewels alone were valued at 38,000 florins.[141] In this case, the percentage of the total cost allocated to Ghiberti's work was certainly infinitesimal, and although the work itself was much admired, the tiara of Eugenius IV was just as much a treasure in its own time as the Crown of England is today.

The tiara makes another point, too. In the past, grandees chose the best artists to make their treasures far more often than is done nowadays. The modern Crown of England is not a serious work of art by any reasonable test. In the past, nonetheless, although the work on treasures added little to their market value, a great deal of trouble was regularly taken to get the finest work. To give a twelfth-century example, Prior Wernher sent the commission for the marvelous Klosterneuberg Altar halfway across Europe to Nicholas of Verdun.[142]

Or consider the ninth-century *paliotto* of the Church of St. Ambrose in Milan, an extraordinary gold-and-silver altar enriched with jewels and enamel and decorated richly with scenes from the life of Christ on its front and the life of St. Ambrose on its back.[143] There are also scenes showing Archbishop Angilbertus II offering the church to St. Ambrose, and the goldsmith, "Wuolvinius Phaber," presenting his work to the saint.[144] Clearly, Wuolvinius's archbishop-patron was highly pleased with the beauty of the work; otherwise he would hardly have allowed Wuolvinius to portray himself on the *paliotto*. But equally clearly, the *paliotto* in its own time was a treasure first and foremost. Great good fortune was in fact needed for the *paliotto* to survive for so many centuries without being melted down for its gold and silver—the fate of most of the treasures of the past.

With tragically few exceptions, exactly this fate overtook the wonderfully numerous, wonderfully rich[145] treasures of the French royal abbey of St.-Denis, which fell victim to the French Revolutionary destructions along with so much more of the same sort. Nonetheless, the inventories of St.-Denis[146] are available to tell us that medieval treasures were never thought about in their own time as we now think about those that still survive.

Abbot Suger's Eagle, for example, is one of the exceptional survivors from St.-Denis; and no medieval work of art in the Louvre is now more admired and loved than this vessel for the Mass, formed around an antique porphyry vase by the inspired addition of an eagle's head and neck, wings and tail, and legs and feet, all in silver gilt.[147] As a world-famous work of art, the Eagle is beyond valuation today, and the curators of the Louvre

would be ignominiously driven from their posts if they sought to have the Eagle appraised by Cartier, or Boucheron, or Van Cleef and Arpels. If you look up the Eagle in the St.-Denis inventories, however, you will find the silver gilt and porphyry carefully noted, together with a valuation of 600 livres provided by a goldsmith; and there the entry ends.[148]

So it goes, moreover, throughout the St.-Denis inventories. These tell us the types and uses of the treasures, the kinds and weights of metal in them, and the number and quality of their inset precious and semiprecious stones, if any.[149] Artists and craftsmen are almost never mentioned, although patrons who gave the treasures are not infrequently named—and sometimes inaccurately named to add glamour, too, as in the case of the "écrin de Charlemagne,"[150] which is shown by a surviving drawing to have belonged stylistically to the later time of Charles the Bald.[151]

Equally clinching evidence of the way treasures were formerly seen and thought about is to be found in the way they were formerly treated by nonecclesiastical owners[152]—and one must add that ecclesiastical owners cannot be entirely omitted. The kings, princes, and great lords who owned large numbers of treasures of course made them glitter on their buffets and banquet tables on days for grandiose display;[153] but they kept them in the same vaults as their gold and silver bullion and hoards of coin. This indiscriminate lumping together of treasures with other liquid assets of their exchequer was the practice of the Austrian Hapsburgs until the new ideas of the Renaissance crossed the Alps to Vienna;[154] and it was also the practice of the rich Electors of Saxony until the early eighteenth century, when the bewildering splendors of the Grüne Gewolbe first began to be arranged to dazzle visitors to Dresden.[155]

The way the treasures were stored in turn revealed the ways they were actually used. In times of war or any other expense-creating crisis, the most exquisite objects were regularly disposed of for whatever they might bring; or gold and silver treasures were simply melted down for their bullion. Then, too, such objects were also broken up quite frequently to make their raw materials available for conversion into new treasures of more up-to-date design.[156] A treasure may indeed be defined in another way, as a device for storing liquid assets impressively and attractively, so that the assets delight the eye and announce the wealth of their owner until wanted for other purposes.

"The life of goldsmiths," Millard Meiss once wrote, "was thus somewhat like that of cooks. . . . But the goldsmiths, of course, sometimes cooked an object for years."[157] This could have sad effects on the goldsmiths which are described in Lorenzo Ghiberti's *Commentarii*.[158] Besides being the sculptor of the Florentine Baptistery's Doors of Paradise and other major works, Ghiberti was a skilled goldsmith by training, and this was one reason he was asked to make the tiara of Eugenius IV. The tiara

was soon melted down, sure enough, most probably in 1458, when Pope
Calixtus III sold the most valuable papal tiaras and even stripped of their
gold and silver the most richly bound volumes of the Vatican library,[159]
to finance the abortive war against the Turks which the Pope tried to
launch in that year.

Although in competition himself, Ghiberti asknowledged that the best
goldsmith of all was a certain "Gusmin of Cologne," clearly a Northerner
who must have lived a little before Ghiberti's own time. Ghiberti wrote
of Gusmin, "He was exacting in his work and equal to the ancient Greek
sculptors. . . . The only failure was that his statues were a little short."[160]
According to Ghiberti, Gusmin's masterpiece was a "golden table" which
"he made beautifully" for "the Duke of Anjou." This has been identified[161]
as a golden altar table known to have been owned by Louis de France,
Duc d'Anjou, who was the extravagant and feckless brother of the famous
Jean de France, Duc de Berry. Later, the Duc d'Anjou melted down "the
work Gusmin had made with such love and craftsmanship." Whereupon
Gusmin, seeing "that his labor had been in vain," threw himself upon
God's mercy, abandoned his craft forever, and took refuge in a mountain
hermitage. Ghiberti concluded sadly, "he was as perfect in [his] art as
in his saintly life."[162]

Gusmin's act of protest, one must add, was lonely and even a bit
eccentric; for the Duc d'Anjou did no more than others like him had
always done in comparable circumstances, and still did in his own time
and after his time. His brother, the Duc de Berry, also converted his own,
even more celebrated treasures into cash to pay his troops when his capital,
Bourges, was besieged by his ducal nephew, Jean Sans Peur of Burgundy.[163]
And almost all the treasures he gave the Sainte-Chapelle he built in Bourges
were destroyed by the Huguenots in the French wars of religion,[164] while
the remnant was lost in the eighteenth century when the local archbishop
seized upon the dilapidation of the building as an excuse to take control
of the Sainte-Chapelle.[165]

If you know what happened at Bourges, it is a strange experience to
visit the most important specimen of the Duc de Berry's exquisite taste
in treasures that still survives today. This is the reliquary of the Holy
Thorn, made to show a Thorn that was no doubt taken from the Crown
of Thorns itself, the proudest possession of the French kings, for which
St. Louis built the Sainte-Chapelle in Paris. After the Crown of Thorns
reached France in the thirteenth century, it suffered so many depletions
by royal gifts of single Thorns that it is nearly Thornless today.[166] The
setting the Duc de Berry had made for his Thorn is such a triumph of
goldsmith's work that one all but weeps to think of all the Duke's treasures
that were lost. But it is also ironical to see the reliquary impersonally
lodged in the British Museum,[167] with the slender Holy Thorn still rising

from its cabochon sapphire sheath, and then to remember that those who saw it in former times went down upon their knees and wept, not for lost treasures, but for the Passion of Jesus Christ.

Historically considered, in truth, the modern way of seeing the treasures of the past is of very recent origin. The first sign of anything like it in Europe is the remarkable illustrated catalogue of the early sixteenth century, the *Hallesche Heiltum,* which displays the enormous assemblage of reliquaries mainly put together by Cardinal Albrecht of Brandenburg.[168] The Cardinal not only loved treasures; he also valued relics greatly and paid large sums for them.[169] But the mere way the reliquaries are so lovingly portrayed in the *Hallesche Heiltum* is enough to indicate that their qualities as works of art also counted significantly. The contrast is dramatic with the way Abbot Suger's Eagle was recorded in the inventories of St.-Denis. Yet the implied change of priorities was only beginning, for otherwise we should not be forced to judge the goldsmith's art of Benvenuto Cellini by just one surely attributable triumph, the great Salt made for King François I, now in Vienna.

Priorities, please remember, are all I am here discussing. Because the men of the Dark and Middle Ages valued their treasures all but exclusively as treasures, this certainly did not imply a failure of the esthetic sense. On the contrary, they went to great lengths to have their treasures made with art as beautifully as possible, as I have said. Yet art-for-use-plus-beauty was still the theme, as you can see if you bear in mind that being a treasure was the prime use of every medieval treasure. The right analogy is with the lady jewel gatherers of our own time. No one would call these ladies art collectors, even if a few go to artists like Jean Schlumberger to get settings for their precious stones. If anyone doubts that being a treasure even today remains the use of a piece of diamond jewelry, however artful its setting, it is only necessary to glance at the way such pieces are described in the auction catalogues when they come up for sale. And for just the same reasons, the countless treasure gatherers of earlier times were not true art collectors—even if the esthetic sense, present in all men, often guided them to great masters to make their treasures, and the results were therefore wonderful works of art.

On Public Patronage

With the treasure gatherers thus dealt with—fairly, I hope—the largest question of this chapter must now be tackled. How can one be so sure the past's patrons of the arts really were not art collectors?

It is an important question for two reasons. On the one hand, an enormously high percentage of all the major works of art that have come down to us were undoubtedly commissioned by public or private patrons.

On the other hand, among the many eminent art historians who have shown me kindness, I have yet to meet one who did not feel that patrons of the arts differed from art collectors in most significant ways. Yet the exact differences have never been investigated, as far as I can discover; and this must now be done if art collecting's rarity in art history is ever to be understood.

Patronage of the arts, one must begin by noting, not only used to be the normal stimulus of all major artistic activity; in addition, patronage of the arts is itself an immemorial human activity. Even the world's first body painters were patrons after a fashion, for they had no mirrors and were therefore forced to call on friends to decorate the parts of their bodies they could not see. Even the masterly but unknown artists of the Paleolithic caves like Lascaux and Altamira quite possibly dealt with others who played something halfway approaching the patron's role—tribal chieftains, or shamans who controlled the hunting magic of the caves, or perhaps the leaders of sacred sodalities. But it will be more helpful to start with a more recent figure, who is amply documented and also archetypal.

Abbot Suger is a great personage in French history as the friend and councilor of two successive twelfth-century Kings of France, and as regent of the kingdom during the Second Crusade. He is a great personage in art history, too, because of his activities as abbot of St.-Denis, the ancient foundation for which he had his Eagle made. As abbot, this small, endearing, bustling, never-wearying man devoted himself wholeheartedly to two great efforts. The first effort was to restore his abbey's control of all its own wide lands, and to increase the revenue of St.-Denis in this and other ways.[170] The aim of the second effort (to Suger, one suspects, a main motive for the first) was enlarging and enriching the abbey church, which had been the burial place of kings of France since Merovingian times. Hence Erwin Panofsky once remarked that Suger's work at St.-Denis was like a reconstruction of the White House by Frank Lloyd Wright.[171] For this great work, Suger recorded that he had made an exhaustive search for the leading masters of his time, "from all parts of the kingdom";[172] and he enforced a high standard, too.

In consequence, the few existing remnants of the good abbot's program at St.-Denis, like the Louvre's Eagle, are now regarded as super-collector's prizes, altogether beyond price. Battered sculptured heads from the façade of Suger's aggrandized abbey are among the prides of the Walters Art Gallery in Baltimore.[173] And the "Chalice of Abbot Suger"—a communion cup of sardonyx, mounted in jeweled silver-gilt, which he had made for use at one of St.-Denis's main altars—is the most important early medieval object in our National Gallery in Washington.[174] As usual, therefore, the past activities of Abbot Suger have been misread in the light of the present; for he has often been called an art collector.

Nonetheless, Abbot Suger was emphatically not a true art collector. Instead, he was a great and discriminating patron[175] of the arts, with a special liking for treasures. It has been shrewdly suggested, too, that he was an extra-creative patron in the sense that he was also his own architect, at least in some degree.[176] The novelty of his work—for Suger's St.-Denis is where Gothic architecture began[177]—may well have come, in part, from his translation into building of ideas drawn from his theoretical reading,[178] which is a common habit of patron-creators. Yet Suger's ingathering of artists and craftsmen from "all parts of the kingdom," with all the resulting stylistic interchanges, must still have played the largest role in the origins of the Gothic.[179]

As to the reasons for so firmly asserting that Abbot Suger was in no sense an art collector, they are indicated by a single comparison. Unlike Suger, but like most Rockefellers, the second John D. Rockefeller was an ardent art collector. But no one thought he was acting as a collector— and he was not so acting—when he built a huge pseudo-Gothic church on Riverside Drive for Dr. Harry Emerson Fosdick. It would not have been art collecting, either, if he had gone to Tiffany for gold and porphyry altar candelabra, in order to provide the Riverside Church with a suitably modern and Protestant equivalent of Suger's Eagle.

You can say that Abbot Suger was more discriminating than the second Rockefeller in his choice of master masons and sculptors, stained-glass workers, goldsmiths, and the like. Or you can say (and probably with more reason) that Suger in the twelfth century was more fortunate than Rockefeller in the twentieth century in the artists and craftsmen he had to choose from. But no one becomes an art collector by employing the best artists and craftsmen of his time to construct or to aggrandize, to adorn or to enrich with treasures, religious edifices like Suger's St.-Denis and the Riverside Church. The same rule holds for all public monuments from the Athenian Stoa Poikile, for which Polygnotus, Micon, and Panaenus[180] were the painters, down to the Lincoln Memorial in Washington, D.C., with its cult statue by Daniel Chester French. All this—and anything like this, including the provision of Paris subway entrances designed by the Art Nouveau architect Hector Guimard[181]—is public patronage of the arts, no more, no less.

Any use of art to add splendor to public occasions of whatever sort, or to construct and adorn public edifices, is always public patronage. And art collecting only enters in when public edifices are looted of works of art, as when a fourth-century proconsul reportedly removed the originals by Polygnotus from the Stoa in Athens,[182] or when Lord Elgin took the marbles from the Parthenon,[183] or when modern collectors of Art Nouveau, which the French also call *"style bouche du Métro,"* have reportedly sought to acquire one of Guimard's subway entrances.[184] So much should

be obvious. And it should be obvious, too, that when there is public art collecting, as is so common in the Museum Age we live in now, this is quite unrelated to efforts like Suger's at St.-Denis or the second Rockefeller's on Riverside Drive.

On Private Patronage

In the history of public patronage of the arts, the theme of art-for-use-plus-beauty is plainly all-pervasive. To begin with, it is the unifying and underlying theme, for the use of all public patronage is simply the adornment of religion, or the community, or the state. But it is also the theme of all individual works of art made for public purposes, whether metopes for the Parthenon, or busts of past vice-presidents of the U.S. (one with marble spectacle frames!) for the corridors around the U.S. Senate chamber.

Private patronage of the arts presents more difficult problems, if only because private patronage so often *looks* much more like art collecting than, say, Pericles' program for a new Athenian Acropolis to replace the structures destroyed by the Persians. Throughout private patronage, nonetheless, the theme of art-for-use-plus-beauty is again all-pervasive.

The endless variety of individual uses for which works of art have been privately commissioned was adequately investigated earlier in this chapter. But all private patronage, of whatever sort, also has art-for-use-plus-beauty as its unifying and underlying theme; for the overall use of all privately commissioned works of art is to add splendor to the surroundings of fortunate individuals or otherwise to adorn their lives. Nowadays, moralists deplore the fact that throughout history, the fortunate have had a near-monopoly on major works of art for their personal uses, and perhaps the moralists are right. Yet this is still a fact that has to be squarely faced.

Perhaps it was different at the beginning. Perhaps, for instance, the vigorously ornamented objects the students of Paleolithic art call *batons de commandement* were really carved by their first owners, and could belong to anyone. But that word *"commandement"* indicates a different assumption by the specialists who first labeled these objects. It is certain, too, that works of art only began to be commissioned on a large scale for private use when human societies began to develop the kind of complexity that marks off the leaders from the led. Since then, the leaders have all but invariably been the private patrons whom artists have been called to serve. And in many cases, the patrons' positions of leadership have imposed a third kind of use on the works of art they commissioned.

The right or claim to lead has in fact been frequently symbolized and buttressed by personal splendor conferred by art. In the time before

Captain Cook, the sacred aura of the Hawaiian high chiefs was reinforced by their beautiful and distinctive cloaks and helmets.[185] And the penalty was death if any but a high chief wore one of these helmets or cloaks, which were sewn with specially brilliant red and yellow feathers painstakingly accumulated, almost feather by feather, from the plumage of great numbers of small birds.[186] In exactly the same fashion, and until quite recent times, an enormous country house both asserted and greatly strengthened an English magnate family's position in the countryside.[187] And although death did not threaten a nonmagnate who built a rural palace, the English punishment for undue presumption was bankruptcy—which some consider just as bad.

It has seldom taken long, however, for such functional private patronage of the arts to produce all sorts of nonfunctional offshoots. For example, luxury can become a habit like heroin, and the appetite for luxury lies behind such products of private patronage as the fine *bourdalous* I saw in Paris. Then, too, some people's hankering to surprise, titillate, and shock may find a vent in private patronage. Here one thinks, for instance, of the mansion on the Champs Élysées built by the highly successful lady called "La Paiva." It is now the Traveller's Club of Paris,[188] and still boasts La Paiva's celebrated onyx-and-agate bathtub lined with silver-plated bronze.[189]

On Tutankhamen and the Shōsōin

Prolonging the list of such aspects of private patronage is needless, however. Instead, the need is for case studies of the common confusion of private patronage with art collecting. Consider, first, the contents of Tutankhamen's tomb, which Francis Henry Taylor selected as the earliest art collection to be described in his popular book on this subject.[190] The late former director of the Metropolitan Museum evidently felt there was something vaguely wrong about his selection, for he somewhat defensively noted that the tomb's contents included objects from periods before Tutankhamen's time.[191]

By any rational tests, however, the existing inventories of the contents do not support Taylor.[192] Art collecting was clearly not the cause of the presence in the tomb of a number of old and fairly dingy utilitarian vessels,[193] or of the miniature gold coffin holding a lock of the hair of Tutankhamen's formidable grandmother, Queen Tyi;[194] and nothing else in the tomb originated in a period much earlier than Tutankhamen's own lifetime. Given Tutankhamen's extreme youth and his death at eighteen, art collecting was certainly not reflected, either, by the things in the tomb inherited from Tutankhamen's father, Akhenaton.[195] In reality, the tomb's contents were no more than the staggering but still normal furnishings of the daily

life of an Egyptian pharaoh at the close of the XVIIIth dynasty, plus the equally staggering but again quite normal furnishings of such a pharaoh's life after death.

Since Tutankhamen met death so early, moreover, the chances are enormously high that almost all the contents of his tomb were chosen for him in life, or provided for him in death, by royal officials with the approximate functions of master of the household and overseer of the royal workshops. In short, this was no more an art collection than the contents of an expensively showy modern apartment done up by leading interior decorators without regard to cost. The real difference is that leading decorators today cannot commission work from such suppliers as the Egyptian royal workshops at the end of the XVIIIth dynasty.

Hence the Shōsōin is a much more interesting case to consider. This is a storehouse of the eighth century A.D. in the grounds of the Tōdaiji Temple at Nara, Japan's first capital built for permanence. The curious construction, like a log cabin on stilts; the careful packing of the contents; above all the fact that the contents of the Shōsōin were only rarely examined and never exposed to the full light of day for about a thousand years—all these account for the near-perfect preservation in the Shōsōin of innumerable beautiful things which would normally have moldered into dust many centuries ago. Consequently the contents of the Shōsōin are the most remarkable unified assemblage of ancient and beautiful things that survives anywhere in the world in the twentieth century.[196]

Japanese scholars have taken no more trouble to define art collecting than their colleagues in the West; and the Japanese will therefore be unanimously shocked by the contention that the Shōsōin's contents do not constitute an art collection. Hence I hasten to point out that the inventories show the Shōsōin originally contained a small true art collection centered entirely on calligraphy—in fact, the earliest known Japanese art collection, if the definition proposed in the next chapter is accepted. At the collection's core were alleged specimens of the brushwork of Wang Xizhi and Wang Xianzhi.[197] This father and son of the fourth century A.D. are still regarded as the greatest calligraphers China ever had—although no one has seen a genuine work by either of them for a great many centuries.[198] Even in the seventh and eighth centuries, genuine specimens of the brushwork of the "two Wangs" were next to impossible to come by in China, while careful copies abounded and the works of both the Wangs had already by then been faked for around four centuries.[199]

Almost certainly, therefore, the story of the small art collection in the Shōsōin was more than a little ironical. In Japan in the first half of the eighth century, the writing system fairly recently borrowed from China had already come close to attaining calligraphy's Chinese status as the art of arts. Hence it was natural for the members of one of the Japanese

missions to the Tang court at Chang An to decide to bring home a calligraphy collection in the best Chinese style. It was also natural for the Japanese to be ignorant, as yet, of all the intricacies of Chinese connoisseurship and the Chinese art market.[200] So copies, or plain fakes, must have been smoothly palmed off by officials of the Chinese government responsible for providing gifts for foreign missions,[201] or else by the crooked dealers who were already common in China;[202] and the Japanese no doubt went home delighted with their supposed specimens of the two Wangs' precious brushwork.

The parallel between what happened in the early eighth century and what happened in the nineteenth is also curious and worth noting. In the eighth century, the Japanese wanted the best of Chinese culture; and the Japanese missions were regularly charged with bringing back this Chinese best.[203] So we have a cultural mission of a special kind carrying home Japan's first art collection in the eighth century. After the Meiji Restoration, however, what was wanted was the best the West could offer, and very early, a large special mission was sent to Europe to bring home this Western best. Among many other ideas and things, the mission returned to Japan with the idea of public art museums;[204] and the result was the first art museum ever opened by any independent Far Eastern nation.

The real point, meanwhile, is that the collection of calligraphy in the Shōsōin was wholly outweighed by the enormous accumulations of other objects, many of them very splendid. And the rest of the Shōsōin's contents should no more be regarded as having constituted an early art collection than the contents of Tutankhamen's tomb.

The Shōsōin's Story

To understand the real lesson of the Shōsōin, however, the history and character of this unparalleled assemblage must be sketched. In brief, the eighth-century Japanese Emperor Shōmu was so pious that he gravely strained his nation's resources by building the Tōdaiji Temple in Nara and a whole series of shrines in the provinces, and by providing the Tōdaiji with its giant Buddha in bronze.[205] His wife, the Empress Kōmyō, shared his Buddhist piety, and when her husband died she made a religious dedication of all his personal possessions at the Tōdaiji.[206] A little later, she added certain dedications of her own—for instance, augmenting the calligraphy collection with a "precious" screen bearing writing by her father, Fujiwara no Fubito.[207]

Incidentally, the father and daughter were key early figures in the rise of the Fujiwara family to the immense power and grandeur recorded about three hundred fifty years later in *The Tale of Genji*. The power was based on regular provision of Fujiwara empresses for emperors of Japan,

and it endured until the twelfth century, when the control of the central government by the imperial and Fujiwara clans was broken by warlike princely clans from the provinces, the Taira and then the Minamoto. The prerogative of providing Japan's empresses survived, however, and the Emperor Hirohito's marriage was strongly opposed, in the 1920s, in part because the present Empress did not come from one of "the five houses of the Fujiwara."

Returning to the Shōsōin: there were significant additions to the contents, such as a large selection of the paraphernalia of the grandiose eye-opening ceremony of the Tōdaiji's giant Buddha, over which the Emperor Shōmu and the Empress Kōmyō had presided,[208] plus a considerable assemblage of other Tōdaiji treasures. Yet the remarkably small number of subtractions from the contents of the storehouse—and in a period of over a thousand years—is really the Shōsōin's most extraordinary feature.

To begin with, the collection of calligraphy lost its greatest prizes long ago;[209] these pieces were loaned out, probably as models to aspiring Japanese calligraphers,[210] although much still remains, most of it archival. The quantities of drugs dedicated by the Empress Kōmyō were also depleted by withdrawals for use in the medical dispensary of the Tōdaiji Temple.[211] Substantial numbers of arms were taken out for use during the severe emergency of the rebellion of Emi no Oshikatsu.[212] In the ninth century, finally, twelve Chinese screens painted with landscapes and one from Korea were taken by the early-ninth-century Emperor Saga, who was so obsessed with Chinese culture that he even had his court poets write in Chinese.[213]

Thereafter, however, the records show only two minor, hardly damaging robberies[214] and three imperially approved withdrawals from the Shōsōin. All these approved withdrawals were of small pieces of the same log of aromatic wood imported from India to make the incense with which upper-class Japanese formerly loved to perfume their clothes, their houses and their shrines.[215] The log was, and is, so famous that it has its own name, the Ranjatai. Those privileged to saw off two-inch bits of the Ranjatai were the fifteenth-century Shogun Ashikaga Yoshimasa,[216] the all-conquering sixteenth-century warlord Oda Nobunaga,[217] and the Emperor Meiji himself after the Meiji Restoration in the nineteenth century.[218]

These names alone announce the quasi-sacred character which the Shōsōin and its contents acquired at an early date. From an early date, too, the doors of the storehouse were sealed; for hundreds of years before the Meiji Restoration, the seal was dignified by the brushwork of the reigning emperor; and no one ever broke the seals except for two reasons.[219] Very occasionally, the doors were ceremonially opened to allow visits by magnates of the first order, whose permissions for the visits were a sign of imperial favor. Somewhat more often, too, the Shōsōin was opened so that the contents might be checked and reverently dusted. This began

to happen annually in Meiji times, when invitations to see the opening were eagerly competed for, and those invited were required to wear full Japanese court dress or, for the few Western scholars and diplomats, full evening dress or diplomatic uniform.[220] Otherwise, the Shōsōin's contents were always entirely invisible—except when they were catalogued late in the Meiji period, and until selective display began in the new era after the Second World War. Yet such is the tendency to confuse the present with the past that the closed storehouse has regularly been called an art museum of the eighth century.[221]

At a remarkably early date, too, the contents of the Shōsōin also began to be thought of in Japan in a proto-modern way, as an incomparable art collection. In the eleventh century, for example, the Imperial Regent Fujiwara Michinaga laid down his high office in old age and went to Nara for consecration as a Buddhist priest. Of this visit his eulogist wrote that he "had the [imperially sealed] warehouse opened and viewed the treasures: there were so many things to see I could not see them all, I think the Midō [Michinaga] also felt this way."[222] Such a comment plainly implies that the great man visited the Shōsōin as one might now visit the kind of art collection everyone longs to see, not least because it is so rarely seen. Nor is this surprising. Fujiwara Michinaga was a contemporary of Lady Murasaki. Being incurably amorous, he even laid siege to her for a while.[223] And in her great *Tale of Genji*, Murasaki makes it abundantly clear that true art collecting had by her time ceased to be an exotic import, and was instead a common social habit of the Japanese aristocracy.[224] By then, too, Japanese art collecting reached far beyond specimens of calligraphy, to include painting and specialized ancient objects like fine musical instruments, of which the Shōsōin has several.[225] This of course accounts for the way the Shōsōin's contents appeared to Fujiwara Michinaga.

The Nature of Private Patronage

The real question is, however, whether the contents of the Shōsōin were an art collection at the time of their dedication in the storehouse. The answer is that with the exception already noted, they were in no sense a true art collection, at any rate by the definition of art collecting to be proposed in the next chapter. Most of them must always have been thought very beautiful, as the contents of Tutankhamen's tomb must also have been thought beautiful. The Shōsōin further contains great numbers of luxury imports besides its log of Indian wood. In the time of the Emperor Shōmu and his Empress, foreign luxuries, foreign merchants, foreign dancing girls and foreign grooms were all much sought after in Tang China,[226] whence Japan had imported its new culture; so besides fine things

from China and Korea and raw materials like the Ranjatai, the Shōsōin has objects from Persia,[227] probably Byzantium,[228] and elsewhere.

Yet just as the contents of the tomb of Tutankhamen were no more than the normal furnishings of the daily and afterlife of a pharaoh of Tutankhamen's era, so the original imperial dedications in the Shōsōin comprise all but exclusively the furnishings of the daily, ceremonial and religious lives of the Emperor Shōmu, and in lesser degree, of the Empress Kōmyō. Far from being a true art collection, in fact, the contents of the Shōsōin dedicated by the imperial couple were mainly the household goods of the Emperor Shōmu and his wife.

To be sure, the selection of these household goods reveals an acute esthetic sense. The important possessions of the imperial couple had plainly been chosen with an exceptional eye for elegance and splendor, here once again resembling the contents of Tutankhamen's tomb. But they also included all sorts of strictly utilitarian things, like the stocks of drugs[229] and huge numbers of arrowheads and arrows from the armory of the imperial guard, much furniture,[230] many pieces of clothing,[231] quantities of paper and other writing materials,[232] all sorts of tableware,[233] games and game pieces,[234] some weapons and armor,[235] regalia for secular, Shinto and Buddhist ceremonies,[236] including a splendid group of dancers' masks, and so on and on.

Except for the small calligraphy collection, moreover, just about all the finest things in the Shōsōin inventory, however richly made, had an easily discernible everyday use, like the wonderful carved-ivory-and-sandalwood kimono stand that is one of the Shōsōin's jewels,[237] or the bolts of superb silk from the imperial wardrobe. Even the much-reproduced surviving paintings—precious remnants of Tang painting as some probably are[238]—all still decorate, or at least originally decorated, useful objects such as the fine musical instruments.[239] Originally, too, the landscape screens from China and Korea taken by the Emperor Saga, like the screens still in the Shōsōin, were fine pieces of furniture used as room dividers. You can see the screens were no more than pieces of furniture in the eyes of their first owners, simply because the inventories attribute none of them to a named artist,[240] whereas each of the more important pieces in the lowest calligraphic collection is emphatically and conspicuously attributed.

In short, although so many of the things still in the Shōsōin are so exquisite, and all are so rare and so evocative of a long vanished past, "household goods" is still the most precise way to describe most of them. They were such splendid household goods because, as I have said, it is the underlying use of all private patronage of the arts to add splendor to the surroundings and the ways of life of emperors, empresses, and others who can afford splendor.

On Esthetic Discrimination

So we have come at last to what may be called the problem of discriminating patrons. This is a problem because it is no more art collecting to order room dividers or wall decorations from leading painters than it is to order chamber pots from leading makers of fine porcelain. Discrimination in choosing artists to receive commissions, or in buying luxury objects on the market, cannot make a private patron into an art collector, any more than taking to art collecting automatically makes the collector discriminating.

Nonetheless, the most obstinate of all the illusions about art collecting is the illusion that all patrons of the past who have conspicuously chosen the best artists of their times to receive commissions thereby became art collectors because of their discriminating choices. This illusion is so widespread that three more short case histories are needed to show that the collecting-discriminating link is wholly imaginary.

The first case in point is the Delphic Charioteer, a Greek work in the Severe Style of the early fifth century B.C.[241] Anyone who has seen the Charioteer must agree that the sculptor chosen for the work must have been one of the greatest Greece had to offer in a very great period of Greek art. But just what was the Charioteer? In brief, a chariot entered by one of the rich Greek tyrants of Sicily—which tyrant is much disputed[242]—had won the chariot race in the games; and the tyrant celebrated by commissioning a bronze quadriga to commemorate his victory. The Charioteer originally held the reins of the quadriga and was therefore functionally akin to one of the figures from the agreeably ludicrous group commemorating Samuel Gompers in Washington D.C.[243] And both of these bizarrely disparate bronze monuments were also results of public patronage.

Next, consider Rembrandt's glorious portrait of Jan Six, still in the Six Foundation in Amsterdam. Again, the choice of Rembrandt to paint the portrait showed much discrimination. Dr. Horst Gerson suggested that Six might have given his commission to Rembrandt because the latter owed him money;[244] but this is speculative, and the fact remains that Six did not follow the example of the other rich Amsterdam burghers of his day, whose patronage made Bartholomeus van der Helst the city's most fashionable portraitist. Those who went to Van der Helst are certainly not remembered as art collectors. Yet being painted by Rembrandt and being painted by Van der Helst were functionally indistinguishable. What was wanted was simply one of the family portraits by which all rich Amsterdam burghers of that day desired to be recorded for posterity. And commissioning a family portrait has been a common form of private patronage for around five centuries.

For the reverse case, we may now turn to the misfortunes of Algur Hurtle Meadows. A public-spirited citizen of Dallas, Texas, he decided to form a large art collection some time ago, with the ultimate intention of giving his pictures to the university art museum.[245] Unfortunately, he had a weakness for bargains, which is one of the worst faults that can afflict a novice art collector. Even more unfortunately, he fell into the hands of two young Frenchmen, Fernand Legros and Réal Lessard, who carried roguery to extreme lengths, even by art-dealing standards.[246] Thus the bargain Picassos, bargain Matisses, and just about all the other pictures the young Frenchmen provided for their client in Dallas were in fact pastiches produced by their homosexual crony, Elmyr de Hory, an aging Hungarian who had a knack for such work.[247] In the end the fraud was exposed, whereupon Algur Meadows, still public-spirited, set out to assemble another, far more costly collection from more reputable dealers. But of course he was already an art collector, albeit a collector sadly lacking in discrimination, when he was buying the de Hory pastiches with grand signatures.[248]

So I repeat, in conclusion, that the theme alone will almost always tell you which was art collecting and which was patronage of the arts or treasure gathering. If the theme was art-for-use-plus-beauty, the work of art was sought by a patron of the arts; if the raw materials were precious, then by a treasure gatherer. Only if the theme was art-as-an-end-in-itself were works of art sought by true art collectors. By this simple test, you can usually see what has *not* been art collecting in the past. But you cannot always tell, so we must go further.

III

ART COLLECTING

The all-important basic theme of true art collecting has been stated in the previous chapter, and the art-connected activities most commonly confused with art collecting have been shown to be nothing of the sort. It remains, however, to show what art collecting really *is*—in fact, to provide the definition still missing in the literature. It is strange that this should be necessary in the later twentieth century, when art collectors are omnipresent in every prosperous nation in the world. Yet even if you search the literature for a usable definition for years on end, it is a hundred-to-one bet you will find nothing that will serve.

The search will be laborious, too, for the literature in all its varieties is enormous and still increasing. There are great numbers of popular and/or coffee-table books on collecting, sometimes readable but not always dependable.[1] There are general studies of collecting, too—I know of no fewer than eight in German alone, including a light essay by Goethe, and no doubt this is an incomplete count.[2] There is an ever growing array of essays and books on different branches of collecting, like Sir Francis J. B. Watson's studies of the enthusiasm for French eighteenth-century furniture,[3] with which modern-style antique collecting mainly began after the French Revolution.[4] There is a vast wealth of scholarly work on individual collections,[5] and the publication of collectors' inventories still continues.[6] There are important compilations of results of art auctions of the past, which reveal the past's collecting trends.[7] There are essays, both serious and silly, on the motives of art collectors.[8] There are even compendia of tips for "art investors,"[9] as well as published indices of art prices to serve collectors and dealers as the Dow Jones Index serves stockbrokers.

Even so, I have not covered the historical, theoretical, and other works that have sometimes profoundly affected Western art collecting's major

patterns,[10] or the growing number of personal memoirs by collectors or about collectors,[11] or several lesser classes of essays and books one might touch upon.[12] In short, the field is too large to have been fully investigated by the sustained work of many years. But I can at least say I have searched many years and have never found a definition of art collecting both precise enough and general enough to be universally useful. Only two attempts to provide the missing definition need to be mentioned here.

Alois Riegl's *"Über antike und moderne Kunstfreunde"*[13] is a solid discussion of the subject proposed by the title. It offers all sorts of valuable nuggets, such as the assessment[14] of the prevailing grandees' taste during the prosperous centuries of the Roman Empire, when Greek works of art were the sole real prizes—despite the marked differences between the Greek art of the great era and its continuation in Imperial Rome.[15] Nonetheless, the nearest Riegl got to defining art collecting was to say that an art lover—a "Kunstfreund"—was not just "anyone who has a liking for creative art, nor one who is involved in the production or consumption (i.e., the enjoyment) of art; but, rather, one who appreciates antique art, one who consumes old rather than modern works."[16] He pointed out, however, that art lovers did not necessarily have "an aversion" to contemporary art. In addition, although Riegl did not point this out, a "Kunstfreund" need not make financial sacrifices to own the works of art he "consumes"—instead satisfying his appetite in museums. So Riegl left the problem without a real solution.

Jacob Burckhardt's *Die Sammler* is much more important.[17] Composed at the end of Burckhardt's long, productive life, *Die Sammler* is a nearly book-length essay crammed with valuable, often unexpected data on Renaissance collecting and patronage, along with many wise insights. But although Burckhardt called his essay "The Collectors," he only once said anything about what being an art collector actually meant to him, as follows: "The collector on the lowest level insists on rarity—the chance to own what scarcely anyone else has; he exerts his power and riches to acquire objects to which he has no inner relationship. . . . But the collector . . . finally can reach the highest level, when he possesses the outstanding or even best works of various masters."[18]

Burckhardt thus came closer to the missing definition than anyone else before or since. The emphasis on the true collector's lack of any "inner relationship" to his prizes is especially discerning. Anyone who reflects on the lives of individual art collectors today and the purposes for which their prizes were made in the past, will find the incongruities are often dazzlingly ironical. Somehow the Christian object most deeply imbued with fervent faith always seems to find its way into the hands of the most aggressive atheist, and the most bloodstained work of art from all New Guinea becomes the prize of the collector who would faint

dead away at the sight of a drop of human blood. Even so, however, Burckhardt did not come nearly close enough to the kind of definition that is so badly needed if art collecting is ever to be seen correctly, as a distinct and rare phenomenon of high historical significance.

For one thing, Burckhardt entirely failed to draw a clear line between art collectors and patrons of the arts; and this is an essential line to draw. Worse still, he also failed to go to the real root of the matter. Collecting in general is the root of the matter. For art collecting is only one of countless forms of collecting that men have indulged in, or indulge in today; and other mammals and birds, too, are eager collectors. Thus the sound point of departure is a general definition of all collecting, whether by human beings or creatures of other species. And here is my proposed definition:

To collect is to gather objects belonging to a particular category the collector happens to fancy, as magpies fancy things that are shiny, and a collection is what has been gathered.[19]

On the Collecting Impulse

It is tempting to list all the animal species which share the collecting impulse with magpies and men. Pack rats, for instance, are especially interesting, because their miscellaneous accumulations so strangely resemble the junk collections made by the sad old people who fill their houses with ancient newspapers, worn-out boots, and valueless pictures and pieces of china. But too many birds and mammals are habitual collectors to be covered here. It is enough to say that their collecting differs from all forms of human collecting in two main ways. (Art collecting adds a third difference, but we shall come to that later on.)

First of all except for men, all birds and mammals collect by instinct, if they collect at all. Since collecting is directed by the instinctive program of the species, moreover, all members of each collector-species, whether magpies, pack rats, or whatever, are more or less ardent collectors, and all members of each species also form similar collections. In men, by contrast, one can make a good argument that the tendency to collect is inbuilt; but the tendency only finds a vent in a minority of any human group, and this minority's collecting can also take innumerable forms.

Far more important, collecting appears to be adaptive for all the other collector-species in the animal kingdom. The ethologists—the new breed of biologists specialized in the study of animal behavior—are far from having discovered the biological purposes of the collecting behavior of every collector-species. But where they have made investigations, a solid biological purpose has always been found. Among the bird species, for example, the most remarkable collectors are the bower birds; and bower-bird collecting has been found to be a vital part of the bower-bird mating

program.[20] If human collecting similarly enhanced the collectors' chances of getting mates, it would be a rational activity. But human collecting, at least in essence, is demonstrably and fundamentally irrational.

The essential irrationality of human collecting is easy to forget nowadays, simply because some collectors are now so obviously purposeful—their purposes being to garner money profits,[21] or to make themselves fashionable by making a fashionable show,[22] or, in the United States, to cheat the Internal Revenue Service by gaining large tax exemptions.[23] Yet collectors cannot cheat the IRS unless museums stand ready to accept at inflated valuations the things collected. They cannot make a fashionable show except by forming the kind of collection that is already highly fashionable. And they cannot hope to make a profit unless there is an existing collectors' market with a potential demand for their prizes. Before any of these excrescences or outgrowths of collecting can appear, in other words, art collecting itself must first become a well-established social habit.

Meanwhile, the true essence of human collecting in all its many forms has always been gathering wholly superfluous numbers of objects belonging to chosen categories, without the least need for so many objects of the particular category,[24] and often at a heavy cost in money, or labor,[25] or even physical risk.[26] Among men, the fundamental reason for collecting is, quite simply, that collectors enjoy it. And collectors do not even enjoy collecting in a wholly rational way, for what mainly delights them is gaining possession of their prizes—in fact, successful collecting. The truth is that collecting not only transmutes all sorts of objects from things of use into ends in themselves; in addition, collecting is an end in itself as an activity.

It is all the more bewildering, therefore, that so many forms of human collecting can be detected in so many different societies over so enormously long a span of time. There is no evidence, at least as yet, for the appearance of collectors of any kind in the era of Homo erectus. But in remains from the Stone Age fairly soon after the emergence of Homo sapiens, the archeologists have found more than one indisputable collection. The find spot of the earliest[27] was the so-called Cave of the Hyena in France, which was excavated by André Leroi-Gourhan. The cave contained a small but obviously man-made assemblage of *objets trouvés*, such as a fossil skull and an oddly shaped lump of iron pyrites[28]—in fact, much the kind of collection magpies make, except that the found objects were not especially shiny.

From this remote beginning, millennium after millennium, and in all sorts of societies all over the world, collecting developed all sorts of different forms. Even animals can be collected, for example, and today we regularly speak of the "collections" of zoos.

Then consider, too, the European Middle Ages, when holy relics were

the greatest prizes. The lay and ecclesiastical collectors were so numerous and competitive that Constantinople's countless holy relics were even more sought after than its glittering treasures in the great division of loot after the city fell to the Crusaders in 1204.[29] The Crown of Thorns somehow escaped this share-out, but a little later, St. Louis purchased the Crown from the bankrupt Frankish Emperor of Byzantium, Baldwin II.[30] The price was 13,134 gold pieces[31]—in the values of that time probably as large a sum as has yet been paid for any work of art in the twentieth century, and to the cost of the Crown itself one must add the cost of the shrine for it, the Sainte-Chapelle. So one is not surprised that before making his purchase, the French King sent relic experts to examine the Crown and to certify that this was the genuine thorny circlet pressed down upon the brow of Our Lord.[32] Here one thinks of museum trustees seeking expert advice before paying a record price.

Deep piety, plus a pious belief in the beneficent effects of holy relics, were of course the mainsprings of St. Louis's decision to pay a great fortune for the Crown of Thorns. The Crown was also held so precious that the key to its reliquary was regularly carried on the French kings' persons from the time of Louis IX until Louis XIV altered the custom.[33] But mere piety plus the desire to have a good cure for toothache in case of need does not add up to an adequate explanation of Cardinal Albrecht of Brandenburg's desire for hundreds of high-priced relics in hundreds of rich reliquaries. Or think of Cardinal Albrecht's near-contemporary, Frederick the Wise of Saxony. He cannot have been blindly pious; for he was the patron of Martin Luther, the man who all but put an end to relic collecting. Yet Frederick the Wise was the proud possessor of no fewer than 5,005 relics.[34] No sane man can have wanted that many fingers, toes, and other grisly souvenirs of saints and holy men solely because of their reputed power to cure dropsy, loose bowels, or whatever.

Furthermore, relic collecting is by no means the oddest outlet which the collecting impulse has found at one time or another. In every respectable *Wunderkammer* of the late Middle Ages and the Renaissance, at least one stuffed crocodile was an essential feature.[35] In the seventeenth and eighteenth centuries, particularly, rare seashells (the "precious wentletrap" and "the glory of the sea")[36] were enthusiastically and expensively collected, quite often by men who were also art collectors.[37] In the nineteenth century, postage stamps began to be collected not long after they first came into use; and before the century's end, a murder was allegedly committed to secure a much-desired stamp.[38] In 1891, furthermore, another collector advertised an offer of marriage to "any lady" possessing "the blue two-penny stamp of Mauritius issued in late 1847."[39]

As for modern America, our "collectibles" (an ominous new coinage) range from beer cans to old motorcars. For beer-can collectors, the grand

prize is a "Phoenix cone-top"[40]—whatever that may be—and in the eyes of the collectors of old motorcars, a vintage Mercedes is worth no less than $440,000.[41] In short, the first essential point to note is that most kinds of collecting have nothing to do with art; yet all still have in common with art collecting the basic impulse that stimulates collecting, plus a strikingly standardized pattern of response to this collecting impulse.

Collecting's General Laws

With the pattern of response to the collecting impulse, the point has been reached when the general definition of collecting can be supplemented by general laws covering all mature collecting of whatever sort, including art collecting. Gathering *objets trouvés* as magpies do is not yet mature collecting, nor is collecting of the pack-rat type. The collecting impulse is clearly at work, yet these collectors' categories are anything but clear-cut. Hence, these immature forms of collecting are exempt from the general laws. But no mature collecting is exempt; and maturity is reached as soon as collectors adopt clear-cut categories of things they wish to collect.

The category may be works of art, or beer cans, or postage stamps, or old, chance-discovered bottles of American manufacture,[42] or great men's autographs,[43] or Bonaparteana such as Napoleon's old clothes and hats,[44] or God knows what. It does not matter—or, rather, does not prevent all forms of mature collecting from obeying the same general laws. The first law is as follows:

I. *All collectors' categories are created by collectors.*

The way the first law works is far more complicated than it may seem. Obviously, you cannot have stamp collecting unless there are people eager to acquire old postage stamps, just as there can be no art collecting until people decide to collect works of art. But as soon as one of these broad collectors' categories has been created, whether works of art or postage stamps or whatever, the collectors then go on to subdivide their main category into hundreds or even thousands of lesser categories. The different kinds of postage stamps and works of art that are now sought after are past counting, and each kind constitutes a lesser collectors' category—*provided* it is correctly placed in the collectors' hierarchy.

Art collectors, postage-stamp collectors, and all the rest invariably arrange all their lesser categories in these hierarchies. Thus the works of art or postage stamps or whatever, of all the kinds known at the time, are broadly grouped as ultra-desirable, desirable, worth having, and not worth having. Those not worth having are further excluded from the main collectors' category. You cannot become a stamp collector by buying

quantities of stamps at the post office, just as you cannot become an art collector by placing a large order with one of the manufacturers of motel-bedroom art. But the line between "worth having" and "not worth having" is always shifting, since compulsive collectors with limited means are constantly exploring all the things not worth having for possible prizes. These bold pioneers constantly bring new artists and even schools of artists within the range of art collecting, and the same sort of thing happens in stamp collecting, always with ramifying aftereffects.

The main aftereffect is an automatic rush by other collectors to follow the pioneers. For instance, what are called "first day covers"—that is, stamped envelopes marked "first day of issue" of the stamp in question—were of no interest to stamp collectors until the 1920s. But today, the rarer first day covers are considerable prizes, and other desirable covers are also artificially produced by special mailings on selected occasions, such as the moon landings.[45]

Odd as this may seem, the analogy is exact with American nineteenth-century landscapes. No self-respecting art collector would have been caught dead with such pictures until only a few years ago, when a narrow sect of collectors, dealers, and art historians first grew interested in the Hudson River School, and then rather clamorously discovered the virtues of Moran, Bierstadt, Church, and others. Some years thereafter, these later-nineteenth-century American landscapists were given a label of their own, "the Luminists."[46] This is a sure sign of success; and even before the success was thus signalized, it was solidly proved by the result of an attempt to raise a few hundred pounds for a convalescent home belonging to the municipality of Manchester by disposing of a large and grimy painting that had long been hanging in the house unnoticed.[47] The painting turned out to be Icebergs—an American picture so famous in its day that it was sent for exhibition to England and acquired there by a rich industrialist whose house was later converted into the convalescent home. In the upshot, this huge canvas by Frederic Edwin Church was bought by Lamar Hunt for the highest sum ever paid for an American work of art; and the convalescent home (or perhaps Manchester) consequently benefited to the tune of $2,500,000, less the auctioneer's percentage.[48] You can find no better illustration of what dramas can unfold when a new collectors' category finds favor. The drama further leads to the second general law of collecting:

II. *By creating their own categories, all collectors create their own rarities.*

This means that Jacob Burckhardt was partly wrong when he wrote that "the collector on the lowest level insists on rarity." What really happened in the period he was writing about must be examined in another

chapter. It is enough to say here that the art collectors' prizes of the Renaissance were not real rarities when they first began to be collected, in the fourteenth century.[49] When a new collectors' category is established, in truth, it is most uncommon for the things collected to be in the least rare. Rarity can hardly be claimed for beer cans, or for postage stamps, or even for American "Luminist" paintings.

In each of these categories, the supply was large when collecting started, and it continues to be large today. The rarities in these categories were instead identified only when collectors discovered that "Phoenix cone-tops," and Mauritius blues, and major works by Frederic Edwin Church were extremely hard to come by. These then *became* rarities. Without the collectors, however, Phoenix cone-tops would still be old beer cans like any others; Mauritius blues would still be useless old postage stamps; and Icebergs would still be an inconveniently large nineteenth-century painting unwanted by almost anyone. Nor is this the end of the matter, for the most important of the general laws of all collecting is the third:

III. *In all forms of collecting, the collectors' category is always controlling, since all collectors require their prizes to belong to the correct category.*

Belonging to the correct category is another way of saying that an object is what it is claimed to be and not something else. But it is a useful way of saying this, because the nature of collecting can never be fully grasped until the powerful role of collectors' categories is also grasped.

Because the role of collectors' categories is so great, in turn, collectors invariably insist that their prizes be authentic beyond argument, and they have always done so since mature collecting began. St. Louis sent relic experts to certify the authenticity of the Crown of Thorns because even the Instruments of the Passion were then being widely faked.[50] For the same reasons, stamp collectors live in fear of forged postage stamps—and no wonder, since genuine stamps are now so valuable that a small envelope of rare stamps is one of the best devices for evading government controls over the movement of capital.[51] Beer-can collectors will surely shrink with horror from imitation Phoenix cone-tops, if these ever begin to be produced; and it goes without saying that the same law governs art collectors and museum curators.

Here consider the case of the Cleveland Museum's "Grünewald." Matthias Grünewald was a powerful and haunting painter contemporary with Dürer. His works are also so rare that there is only one small Grünewald in America, in our National Gallery.[52] The rarity no doubt helped to over-tempt the Cleveland Museum when a dealer offered an alleged Grünewald. After Cleveland had paid out $1,000,000,[53] however, there was sinister news of an ingenious Grünewald faker in Germany. Arcane

scientific tests were made, leaving no trace on the picture's surface. The results showed that many of the raw materials in the paint layer of the "Grünewald" were brand new.[54]

After the tests, the Cleveland Museum honorably announced its embarrassing error;[55] and a refund was obtained from the dealer, who had seemingly been just as deceived by his own wishfulness as the Cleveland Museum staff.[56] Of course, the "Grünewald," if a beautiful work of art at all, was every bit as beautiful when condemned and disgraced as when it was bought with delight as an acquisition to announce with pride. Yet no one argued that there was anything in the least odd in these proceedings. "Grünewald" was the category, and the picture had to be condemned because it did not belong to the correct category.

The Definition at Last

With the "Grünewald's" case history, the workings of the three laws governing all collecting have been adequately illustrated. The general definition covering all collecting has also been adequately discussed. Hence it is now possible to extend the general definition, and thus to get what we have been specifically aiming for, a usable definition of art collecting. I propose the following:

To collect is to gather objects belonging to a particular category the collector happens to fancy; and art collecting is a form of collecting in which the category is, broadly speaking, works of art.

No doubt this definition of art collecting will be unacceptable, at first, to those who have not studied the habits of collectors, or the history of collecting, or art collecting's place as a most curious social habit. Above all, it seems to put works of art on the same level as all the other things people have collected, by equating the behavior of art collectors with the behavior of the collectors of postage stamps and beer cans. This undoubtedly appears disrespectful of art collecting, if not of art itself, but this is because a measure of disrespect is called for.

After all, there are more and more art collectors today who merely look upon works of art as a better investment than, say, pork-belly futures. In every major city of the West you can find totally uninteresting rich men and women who have cold-bloodedly used art collecting for no purpose except to make themselves interesting places in the world. The tax-cheating collectors are proliferating in America, too; nor is there any lack, here and elsewhere, of modern art collectors like Baron Pichon, a nineteenth-century pioneer of silver collecting from whom the French get the word *pichonnerie*, because of the Baron's habit of improving his seventeenth- and eighteenth-century silver with false silver marks.[57]

As a matter of course, any universally usable definition of art collecting must cover such deplorable collectors as well as the more admirable ones. And even the most admirable and disinterested art collectors further obey the same general laws of collecting obeyed by all other collectors, including those who collect postage stamps and beer cans.

The fact remains, however, that all truly admirable and disinterested art collectors gather their works of art because they love them. How else is one to account for the courageous and discerning collectors who have seen beauty where no others saw it and have therefore made aggressively unfashionable collections[58] which also seemed to offer no hope of other gains? Thus the same esthetic sense that causes men to make with art is also an essential factor in all but the crasser kinds of art collecting.

On the one hand, the fact that serious art collecting satisfies the esthetic sense makes art collecting considerably more rational than most other forms of human collecting. On the other hand, the role of the esthetic sense in art collecting is the third factor setting art collectors of our own species apart from all the collectors of other species in the animal kingdom. This is because the esthetic sense, properly understood and defined, is a uniquely human trait, as one can tell by having a closer look at those bower-bird collectors already mentioned. These are not only remarkable because their collecting behavior is so amazing. In addition, one can think of no other bird or mammal species whose behavior so deceptively suggests something like the human esthetic sense.

On the Bower Birds

New Guinea and Australia are the habitats of the bower birds, of which there are several dozen species. All species are medium-sized birds; most of them are handsome; and all are both architects and collectors. The bowers the males build are often elaborate structures—ranging from one species' five- or even six-foot-high tepeelike constructions of sticks[59] to other species' simpler stick palisades.[60] The males also make the collections which are displayed in and around the bowers; and these are species-specific—which simply means that Archbold's bower-bird males collect by preference things-that-are-black,[61] although they have other collecting categories, too. In the same way, Gardener bower-bird males collect several categories, but especially things-that-are-red;[62] and so on and on, species after species. The females of the different bower-bird species are also excited by impressive bowers with fine collections of the right sort, and when excited, they enter the bowers to mate with the males. Thus a male that is a bad architect and a negligent collector has much less chance of getting a mate.[63]

As collectors, the males of the various bower-bird species can be strik-

ingly discriminating, as indicated by a story told by the director of the
Smithsonian Institution, Dillon Ripley. Dr. Ripley is a leading field orni-
thologist who has studied bower birds in their native habitats. In New
Guinea, he once contributed a showy pink orchid to the jungle bower
of a male Gardener bower bird while the bird was absent. As soon as
the bird returned, it removed the orchid from its bower with a great show
of avian indignation; presumably it was the wrong pink or perhaps the
wrong shape. Yet another Gardener bower bird gathered so many of Dr.
Ripley's used cartridge cases that a large pile of cartridge cases adorned
the bower in the end.[64] This happened because the cartridge cases were
a good clear red; and male Gardener bower birds collect, and females are
excited by, things-that-are-red but care less for things-that-are-pink and
also reject the wrong pink.

The males of two species of bower birds are also artists after a fashion,
and one of these is the Satin bower bird, an Australian species.[65] Male
Satin bower birds collect things-that-are-white, such as bits of bleached
bone; things-that-are-shiny, such as automobile keys; and, above all, things-
that-are-blue such as flowers, scraps of fabric, and even discarded trolley
tickets.[66] But male Satin bower birds also macerate ferns and other green
stuff in their bills to make brushlike wads, and they use these wads to
paint the palisades of their bowers with the juices of blue or purple berries
prechewed for the purpose.[67]

The bower birds, in fact, seem to make with art as well as collect; so
it would be hard to imagine any nonhuman behavior coming closer to
true manifestations of the human esthetic sense. Yet in reality, the behav-
ioral sequences described above are part of the mating programs of the
different species of bower birds. Thus what looks like a bower-bird esthetic
sense is really something quite different.

One can understand this difference better by turning to the African
waxbill species and their whydah parasites. The young of all the African
waxbill species have brightly colored, strongly patterned gapes, and when
they display their gapes—when they open their beaks wide, in other
words—the patterns and colors are the "releasers" that trigger the feeding
response of the parent birds. The patterns and colors furthermore vary
from species to species, and parent waxbills will not feed young birds
with wrongly colored and patterned gapes.

Such are the wonders of nature's far from simple plan, moreover, that
parasite species of whydahs also have young with gapes patterned and
colored in exact imitation of the gapes of the young birds of the waxbill
species. The whydahs of each parasite species, further, know the waxbills
of their host species; they deposit their eggs only in the nests of the
host species; and thus they contrive to have their young raised by waxbills

at the expense of the waxbills' own young. The releasers, namely the patterns and colors of the gapes of the young birds of both waxbills and whydahs, entirely result from evolution. The parent waxbills' responses to the colored and patterned gapes of young waxbills and whydahs are instinctively programmed by evolution. And so is the seemingly crafty behavior of the parent birds of the various species of whydahs.[68]

Mysterious as this may seem, the behavioral sequences of the bower birds' mating program are again the results of evolution, but in the bower birds' case, learning also has a role. The learning is needed because young bower-bird males of each species build ramshackle bowers and only master the higher bower architecture proper to their species by watching mature males' bower building.[69] But what looks like the kind of discrimination practiced by human art collectors—for example, that male Gardener bower bird's rejection of Dr. Ripley's pink orchid—in reality results from an instinctively programmed compulsion of the males of each bower-bird species to collect only things of the kind that will excite females of the same species; and the same sort of program, plus some learning, produces the bower architecture of all species and the art of the two species that paint their bowers. Hence the choices of bower-bird architects, artists, and collectors, although they are real choices of a special sort, are by no means analogous to the choices of human creators and collectors.

On the Esthetic Sense

This problem of choice, in turn, is what makes the esthetic sense a uniquely human trait, as stated in the last chapter. For the esthetic sense is not an instinctive response to well-defined combinations of colors and patterns specified by evolution, as when the parent waxbills respond to the young birds' gapes. Much less is it an instinctive response to things of a certain color, as in the case of the Satin bower birds with their liking for things-that-are-blue.

The visual esthetic sense is, rather, a tendency for the human eye to derive pleasure from this and not to be pleased by that, with the "this" and the "that" including an infinite variety of patterns, shapes, textures, surfaces, colors, color combinations, and even raw materials. In the case of the esthetic sense, moreover, the pleasure "this" gives to the eye is the only reward, whereas the things-that-are-blue collected by the male Satin bower birds reward the males with females attracted to the bower. The human impulse to make with art is in turn stimulated by the esthetic sense, and even the practical rewards of artists, substantial as these have sometimes been, are essentially extraneous to what the artist does. He adds to the environment things he has made which are pleasing to the

eye; he derives satisfaction from doing so; and he thereby gives pleasure to others who share the same environment, which is also satisfying and leads to any reward the artist may receive.

As suggested in the previous chapter, the esthetic sense now appears to be a significant feature of the human genetic makeup, rather than a response to the environment instilled in the young by the cultures they grow up in. It is hard to see any other way to read the new evidence of the late Acheulian hand axes, if the paleo-anthropologists are right about them. I repeat: it is a sensational discovery that both the esthetic sense and the resulting impulse to make with art are apparently inbuilt in the more advanced species of the genus Homo. Yet the evidence to date is decidedly fragmentary, and it is obvious that the paleo-anthropologists and esthetic theorists will have to make further investigations, and subject their findings to far more extensive analysis, before certainty is reached about the roots of art among men.

The Role of Learning

The roots of art may seem to have no bearing on the subject of this essay, yet they have a real bearing because of a problem that first began to worry me in the Second World War, when I spent four years in China. During those years, in brief, I came to know a fair number of eminent Chinese scholars and connoisseurs of art.[70] Talking to these men was an education in itself, for they knew and loved the great art of their own country, and the more scholarly among them were founts of knowledge of the complex history of Chinese art. Being members of China's first actively Westernizing generation, many of them had also sought to learn about the art of the Western world, and believed they understood it. Yet what they had to say concerning Western art made it perfectly obvious that the whole subject was as foreign to them as Eskimo survival techniques in the Far North would be to the average inhabitant of Manhattan Island. The surroundings of the few Chinese scholars who were able to live in wartime above the hardship level further made it equally obvious that they had almost unerring eyes for the worst designs the Western world had to offer, whether in Thermos jugs or the few modern decorative objects they had managed to bring with them in their retreat before the advancing Japanese.

Today, I am proud to say, I count a good many Chinese of the next generation among my friends, and most of these have lived for years in the West. Yet I can still count on the fingers of one hand the cultivated Chinese known to me, like I. M. Pei, who can judge the art of the West and the art of China with equally discriminating eyes. And even these few, while easily able to perceive the greatness and power of Giotto, Masac-

cio, and Piero and the great masters of the modern age, tend to have difficulty with Titian, Rubens, and a great many other giants of the glorious centuries from the High Renaissance to the first flowering of the Impressionist movement in the nineteenth century. Even for Westernized Chinese eyes, masters like Rubens are too remote from their own art.

These personal experiences are worth considering, in turn, because of the light they cast on a major difficulty which instantly arises as soon as a comprehensive history of art collecting is attempted. What may be called cross-cultural art collecting creates the difficulty. This first appeared in the West, where the products of the Far East have been appreciated for a far longer period than most people imagine. In the second inventory of Piero de' Medici "the Gouty," taken in 1463, you will find, for example, a *"vaso di porcellana leghato in horo."*[71] Since it was porcelain, the vase was all but certainly Chinese, and since it was mounted in pure gold, it was evidently much admired and valued. It must have come either from Egypt or, perhaps more probably, from newly Turkish Constantinople, for Chinese wares were highly esteemed by the Ottoman Turks. And it is most likely to have been either a piece of Ming blue and white, or else a piece of the heavily potted export celadon the Turks purchased in large quantities.

From such beginnings, the trickle of Far Eastern objects to the West swelled, over time, to a flood. Repeatedly, moreover, these products of the Far East had direct influences on the arts of the West. Really marvelous pastiches of kakiemon porcelain from Japan were among the early triumphs of the Meissen factory, the first in the West to discover the secret of true porcelain.[72] The effect of Japanese prints on avant-garde nineteenth-century artists like Degas is also a commonplace of art history. But the point is that until very late in the game, even the Western artists and collectors with the very best eyes almost always chose the worst rather than the best by the standards of Chinese and Japanese esthetes and connoisseurs. No serious Japanese collector of the nineteenth century would have given house room to the prints Degas loved, for instance. By the same token, want of knowledge and understanding caused Western connoisseurs and collectors to miss the most golden opportunities to acquire the very best of Far Eastern art.

After the Meiji Restoration, many of the Japanese daimyo families went bankrupt and had to sell all their possessions, and many of the great Japanese families who retained high places in their country nonetheless lost all liking for the marvels they had inherited because of the powerful tide of Westernization in the early Meiji years. While the Japanese who could afford it were building themselves incomparably ugly Western-style mansions filled with ghastly furniture and still ghastlier paintings imported from London and Paris, the Japanese secondhand markets were

glutted with magnificent and irreplaceable treasures of Japanese and Chinese painting and other works of art.[73] Oddly enough, the man who did most to reverse this tide of ugliness in Japan, and also to open Western eyes for the first time to the real greatness of Chinese and Japanese painting, was the American son of an immigrant Spanish musician.[74] But that is a complex story that has no place here. The lesson is, quite simply, that an astonishing period of time was required before those with the best eyes in China and Japan ceased to choose the worst Western art had to offer instead of the best, while an equally long or even longer period was required for the reverse process in the West.

Such facts as those cited above might be multiplied many times over. They create a grave difficulty for the historian of art collecting, of course, because they raise such insistent questions about the role in art collecting of the esthetic sense, which I have been stressing so strongly. These questions are raised, in turn, because the facts so plainly suggest that true appreciation of the highest achievements of another culture's art tradition must be laboriously learned.

I cannot help but suspect, therefore, that the way out of this difficulty is provided by Professor Chomsky's theory about the bases of articulate human speech. He holds, if I understand him, that there are unique innate deep structures which serve mankind as foundations of all languages, and thus explain the features that all languages, however much they differ, still clearly have in common. I predicted, in fact, that further investigation will identify rather similar but far less complex deep structures of the visual arts. If this be true, the most important deep structure is obviously the human aesthetic sense—that is, the universal human tendency to discriminate actively in favor of what seems visibly beautiful and against what seems visually ugly. This human discrimination is certainly quite different from the animal discrimination, between different kinds of prey and different kinds of mates, which is entirely governed by the desires to be nourished and mate successfully. Probably too, the human impulse to mate with art, which derives from the aesthetic sense, but is more occasional, should be classed as still another deep structure of art.

All the divergent art traditions developed by all sorts of human societies may then be seen as built upon these innate deep structures of art, in much the way divergent languages are built upon Professor Chomsky's deep structures. And the art traditions diverge, whether widely or in many details, because they mirror the religious and other preoccupations of the societies in which they originate.

This hypothesis—and it is a most tentative hypothesis—has at least two major virtues. Most important, it helps to explain the central problem of all comparative studies of the visual arts, which is the strange combination of the fundamental unity of the visual arts with the more or less

enormous differences between the uncounted art traditions of different societies. Meanwhile, for this essay's special purposes, the hypothesis also explains the central problem of cross-cultural collecting, which is the difficulty cross-cultural collectors always encounter in knowing the best of each foreign art tradition. The fact is that an unprepared cross-cultural art collector is like a poor linguist trying to judge which are the finest works in a foreign language. Hence a cross-cultural collector must in effect learn foreign languages of art before he or she fully understand the values prevailing in other societies' art traditions.

But all the problems above-discussed are rapidly receding into past history because of the effects of worldwide cultural homogenization. I was therefore tempted to omit the foregoing long excursus. Yet it has seemed necessary to surmount the real difficulty that stands in the way of my analysis of all true art collecting as what may be called a compound form of behavior, resulting from the interaction of the universal human esthetic sense with the widespread human impulse to form collections of one sort or another.

Where This Road Leads

The end of this chapter's road is near at hand. But before conclusions are drawn, it will be well to remind the reader, once again, of the general definition of art collecting herein proposed. Repeating, the definition is as follows:

To collect is to gather objects belonging to a particular category the collector happens to fancy; and art collecting is a form of collecting in which the category is, broadly speaking, works of art.

The repetition is justified (or so I hope) by the need to underline for good and all the crucial role played by categories in art collecting, as in all other mature collecting. If art collecting did not resemble all other collecting in this respect—in fact, if the esthetic sense were art collecting's sole and unique mainspring, as so many suppose—then such episodes as the proud purchase and embarrassed disgrace of the Cleveland Museum's "Grünewald" would have to be regarded as symptoms of insanity. If all that matters to collectors, after all, is a work of art's perceived quality, no visually unchanging work of art can logically be almost beyond price at one moment and, at the next moment and in the eyes of the same persons, mysteriously become an object of contempt and a source of shame. Only the power of the role of categories in art collecting can explain such episodes, which have been repeated over and over again, and from beginning to end of the story, whenever and wherever art collecting has appeared in history.

As one more illustration of the role of categories in all art collecting, then, ask yourself whether there has ever been a serious art collection devoid of categories—a collection in which the prizes have no attributions, whether to known masters, or to great periods of art, or to specified regions of art. If you accept the fact that collections of *objets trouvés*, including *tableaux trouvés*, are *not* serious art collections—as they are not—then you will find there has never been a serious art collection, whether Japanese or Chinese, Greek or Latin, Western or later Islamic, without attributions to define the categories. The attributions may not be publicly displayed as labels, even today, and in some periods and areas, they were never so displayed. But they were always *there,* nonetheless, either in the collectors' minds and talk, or in the connoisseurs' colophons that Chinese collectors loved to attach to their prize paintings for many centuries, or in some other form.

In truth, it is only among the treasure gatherers of the higher sort and the more discriminating and imaginative patrons of art that the esthetic sense assumes the unique importance it is commonly believed to have for art collectors. Abbot Suger, for example, composed two splendid accounts of his contributions to the beauties of his abbey church and the splendors of the treasury of St.-Denis.[75] In neither is there a single mention of any of those best masters "from all over the kingdom" whom Suger summoned to St.-Denis to accomplish such wonders for him. Nor was this mainly the result of Suger's vanity, although he had plenty of that, too. What mattered to him was the beauty of the thing made, rather than the identity of the maker. And since he alone was responsible for its being made at all, by ordering it and finding the money to pay for it, he was entirely justified, by his lights, in claiming the entire credit.

In all these ways, the general definition of art collecting in itself is enough to show that true art collecting has been strictly confined to the five rare art traditions. To give just one illustration of how the general definition produces this result, you have only to ask yourself whether the assemblage of precious jades found in the tomb within a pyramid really make Pacal the Great of Palenque into an art collector.

Pacal reigned over Palenque about as long as Louis XIV reigned over France or the Emperor Kang Xi over China—in fact, for sixty-eight years in the seventh century A.D.[76] He brought his city to its pinnacle of might and glory; he left beautifully sculptured steles commemorating his achievements; and in other ways, too, he was a splendid patron of the arts as well as a major treasure-gatherer, as indicated by the jades buried with him. Certainly Pacal sought the best jade workers, stone carvers, architects, and stucco workers available in seventh-century Palenque; but did he give a moment's thought to the identities and special styles of artists of the past, as collectors always do? Would he have been extra-delighted by jades

which were "certainly pieces of Olmec date," in the unvarying way of collectors? Did he even label the treasures and other great works of his time as "by X" or "by Y," as collectors always do, too? In short, did any of the points that always mean so much to collectors—either collectors' categories, or collectors' rarities (except for the rarity of jade itself), or the "authenticity" of any work of art—mean anything whatever to Pacal the Great?

The answer to all these questions is surely a resounding negative. And they are not trivial questions, either, for the negative answer means Pacal the Great's way of thinking about works of art was totally different from the way of thinking in this era of omni-collecting. Furthermore, common sense and modest historical knowledge will dictate the same negative answer to similar questions about the Khmer emperors who built Angkor Wat, Angkor Thom, and all the other monuments; about Tutankhamen and his ancestors and successors; about the steppe chieftains entombed in the kurgans at Pazyryk; about the dynasts of Mycenae and the warlike rulers of the Hittites, and so on ad infinitum.

In sum, if you take the trouble to consider what art collecting really is and what laws govern all collecting, you cannot help but conclude that art collecting has been historically rare, and therefore of far-reaching significance whenever and wherever it has appeared.

IV

THE LITMUS TESTS

The present chapter is an addendum to its predecessor, aimed to provide simple litmus tests which will permit any commonsensible person to tell when true art collecting occurred and who was a true art collector in the long past of art. No such supplement would be needed, to be sure, if the situation of the visual arts in the later twentieth century were not so grossly abnormal by all past standards.

Yet when patrons of the arts have all but disappeared, it is not easy to grasp what the normal past's innumerable patrons actually did, how they related to the artists who received their commissions, and how the artists in turn related to these people who provided their livelihood and thus shared in some degree (as will be shown) in the creative process. Similarly, when almost our only treasures are the kind of pieces classified as "highly important" (meaning "expected to bring a staggering price") in the catalogues of the great modern jewel auctions, it is again exceedingly hard to perceive that in the past, Abbot Suger's Eagle and Archbishop Angilbertus II's *paliotto* were treasures first of all, and only secondarily great works of art. Then, too, when the mark of the human hand is all but unseen except by those who can afford to furnish their daily lives with the products of the past, it is almost impossible to comprehend the kinship between a $250 French crystal champagne glass and the Metropolitan's Euphronius crater—although one is, and the other was, a luxury product made for the contemporary luxury market.

In sum, the modern situation of the arts has left most people, including a good many scholars, with little understanding of the former uses and circumstances of production of the vast majority of works of art we most admire today. Not surprisingly, this kind of lack of knowledge, where the lack exists, leaves all sorts of gray areas in the history of art collecting. The litmus tests to be proposed hereafter are first of all required to provide

a simple way of removing these gray areas. There is another reason, how-
ever, for proposing the litmus tests. Most conspicuously in the classical
art tradition that was born in Greece, and in our own Western tradition
born of the Renaissance, what may be called mixed situations always con-
tinued to be common after true art collecting first appeared.

What I have called the gray areas mainly arise from the widespread
modern belief that art collectors have a monopoly of the kind of refined
yet bold esthetic sense which is so dramatically manifest in Abbot Suger's
Eagle. This is why Suger is so widely though mistakenly supposed to
have been an art collector.

This modern belief is still another result of the abnormal modern situa-
tion of the arts; for this is a time when governments and great corporations,
whether public or private, are almost the only remaining sources of major
old-style patrons' commissions to architects and other artists. Plain dreari-
ness is a common mark of this kind of patronage, perhaps because commit-
tees so commonly decide who will get the commissions. Hence it is only
natural for most people to assume that a well-developed esthetic sense is
hardly ever to be found except among serious art collectors and their
connoisseur-allies. Historically, however, nothing could be further from
the truth. The overwhelming majority of modern art collectors' highest
prizes were instead commissioned by the past's many inspired patrons of
the arts.

As for the mixed situations, these have usually arisen because most
of the past's great art collectors were also great patrons, and often great
treasure gatherers, too. The treasure gathering of Jean, Duc de Berry, has
already been touched upon. In addition, he was one of the most lavish
and successful patrons of the arts in the history of Western Europe. His
fairyland castles are shown in the *Très Riches Heures*[1] that the Limbourg
brothers painted for him, but they have all disappeared or ceased to be
recognizable. Nonetheless, the single commission to the Limbourg brothers
for the *Très Riches Heures* is as famous, by now, as any act of patronage
of the Duc de Berry's era.

The Duke was also a notable art collector, however. In particular, he
gathered a remarkable collection of books illuminated by Jean Pucelle,[2]
who was dead and somewhat out of fashion in the Duke's day but still
much admired by the Duke.[3] He also acquired at least one illuminated
book described in his inventory as *"ancien et romain"*;[4] and he was an
eager collector of classical and pastiche-classical carved gems and medals.[5]
Only a little later, too, Cosimo de' Medici Pater Patriae was one of the
greatest patrons of the arts the Western world has ever seen, but he was
almost equally notable as a pace-setting art collector who showed the way
to the other Italian magnates of the fifteenth century.[6]

A rather more difficult problem is presented by the true art collectors

among whose prizes the works of their contemporaries and near-contemporaries have figured conspicuously. In the post-Renaissance centuries in the West, such collectors have been common. Ironically, the impetus for this kind of art collecting in part came from the practical problem inevitably resulting from slow communications and slow and often risky means of transport. It was not much easier for an aspiring patron of the arts in the fifteenth and sixteenth centuries to send a commission from Italy to an artist in the Low Countries, or vice versa, than it had been for an Etruscan nobleman to send a commission from Tarquinia to a potter in Athens.

Tommaso Portinari, who disastrously headed the Medici branch bank in Bruges,[7] obviously acted as a patron of the arts when he commissioned the great altarpiece still bearing his name from Hugo van der Goes. Again, several Italian patrons commissioned works from Rogier van der Weyden when he was visiting Italy. But what of the fairly numerous works by Jan van Eyck and other early masters of the Low Countries which we know were in Italy before the fifteenth century ended—and not as a result of patrons' commissions? Van Eyck was especially admired in Genoa and Naples, and the Neapolitan Bartolomeo Fazio classed him with the greatest artists of the time;[8] but there were also Van Eycks, or supposed Van Eycks, in Urbino,[9] Florence,[10] Venice,[11] and other centers. Despite Fazio, moreover, I am personally inclined to think that the works of Van Eyck and the other masters of the Low Countries were mainly wanted as exotic luxuries by most of the Italian magnates of the fifteenth century who acquired such pictures, in much the same way those magnates who could afford the very much higher prices imported tapestries from Bruges and other Northern centers.

But this is no more than a personal judgment, although it has some basis in Michelangelo's later scornful dismissal of the Northerners.[12] It is beyond dispute, however, that the ideas and tastes of the Italian Renaissance finally crossed the Alps into the rest of Europe, although the normal role of patron of the arts was much too difficult for many Northern grandees who wanted works by the most famous Italian masters. A later chapter will show that the first portent of modern-style art-dealing on a large scale was a purchasing agent sent to Florence by King François I of France, to acquire for the French crown works by High Renaissance masters;[13] and this was certainly art collecting by proxy.

Then, too, Philip II of Spain not only most eagerly collected works by Hieronymus Bosch:[14] his dealings with Titian were also at least three-quarters of the way to art collecting. In other words, Titian was certainly given to understand that besides religious subjects, Philip II had a great liking for classical *poesie* with ample areas of nude female flesh;[15] yet above all, Philip II plainly wanted paintings by Titian's magical brush,

no matter what their subjects or dimensions. Again, Poussin's French pa-
trons, like Fréart de Chantelou, usually indicated what subjects they
wanted him to paint;[16] and on one occasion, when Fréart confessed disap-
pointment with the version of the Seven Sacraments Poussin had painted
for him, Poussin answered that the requirements of Fréart's own commis-
sion had caused the disappointment.[17] Yet there was also an element of
true art collecting in the way Poussin's French patrons so often secured
works from the master in Rome.

All this may sound niggling, but these are the real precedents for the
far, far rarer patron-collector mixed situation which persists today. David
Rockefeller considers himself much more an art collector than a patron;[18]
yet he ventured successfully into patronage of the arts when he commis-
sioned Group of Four Trees from Jean Dubuffet, to provide a sculptural
centerpiece for Chase Manhattan Plaza.[19] Then, too, Dr. Albert C. Barnes
was perhaps the greatest single American art collector of the twentieth
century; yet he acted as a patron when he boldly if unconsciously borrowed
tactics once used by Alcibiades,[20] all but kidnapping Matisse and keeping
him sequestered until he promised to paint decorations for the main gallery
of the Barnes collection in Merion, Pennsylvania.[21]

The First Litmus Test

Such mixed situations and gray areas, as I have called them, have
appeared in different guises in the later histories of all five rare art tradi-
tions. Hence the need for the litmus tests to be proposed hereafter. To
be sure, anyone having enough data on what constituted treasures in differ-
ent regions and periods can then spot treasure gathering whenever and
wherever it occurred, if he can just forget our modern way of seeing most
of the past's treasures solely as great works of art. With enough data,
again, any sensible person can see that persons buying the past's luxuries
for daily use were not art collectors. After all, it is surely easy to understand
that acquiring a Tang spittoon was not art collecting in Tang times, even
though such spittoons and almost all other luxuries of the past have today
become collectors' prizes. In consequence, my litmus tests are solely in-
tended to distinguish art collecting from patronage of the arts.

The first litmus test arises from the last chapter's contrast between
art-for-use-plus-beauty, the theme of the normal or patron's way of thinking
about works of art, and the theme of the collector's way of thinking,
which is art-as-an-end-in-itself. The truth is that the normal way of thinking
first of all has highly important effects on the artists themselves; and
these need to be explored further.

In a simplistic way, the difference made by the theme of art-for-use-
plus-beauty is neatly illustrated by the story of Matisse's decorations for

Dr. Barnes's main gallery. The chief glory of this amazing chamber is one of the greatest of Cézanne's paintings, the large final version of the Card Players. For Dr. Barnes, this masterpiece was an end in itself.[22] In other words, he wanted the Card Players solely because the painting delighted his eye and stirred his mind and soul, as it would the eye, mind, and soul of any perceptive man wherever it might hang. But Dr. Barnes wanted his decorations from Matisse for a use—in fact, the main gallery's architectural enrichment.

The use in turn both affected Matisse and shaped the work he did. As Matisse himself complained, it was not easy to devise architectural decorations suitable for a room already solidly hung with great works of art by other masters;[23] yet that was what he had to aim for. Furthermore, Matisse had to paint his decorations to fit the exceptionally confining architectural spaces Dr. Barnes offered him. He failed to achieve a fit on the first round.[24] Thus, because of the intended use, two sets of decorations were successively painted,[25] of which the earlier set that failed to fit may now be seen in Paris.[26]

If we forget that a huge majority of the most admired works of art of the past were made for a specific use (excepting Chinese paintings and calligraphy), we risk misunderstanding the works of art themselves. We cannot fully understand Matisse's decorations for Dr. Barnes without knowing their intended use. The Emperor Shōmu's kimono stand is one of the most perfect objects in the Shōsōin, but it does not appear to be a rationally shaped object if you do not know that it once sustained kimonos. The faldstool called the Throne of King Dagobert was expensively and finely made of bronze[27] because faldstools in the Dark and Middle Ages were signs of rank, forbidden to all but princes, high ecclesiastics, and the like,[28] but they also had to support those who sat upon faldstools. And all these facts must be known, once again, to anyone who now wishes to judge the so-called Throne of King Dagobert as a specimen of very early French artistry in bronze with additions by Abbot Suger.[29]

One could go on like this, object by object, through any of the world's enormous museum-repositories of the art of the ages, but this would surely seem tiresomely eccentric in our own odd time. The real point is, meanwhile, that even when a major artist accepts a patron's commission nowadays, the theme of use is always there, and always affects the artist's work. Dubuffet is a notoriously prickly artist, yet when he agreed to undertake Group of Four Trees, David Rockefeller persuaded him to spend two days studying Chase Manhattan Plaza in different lights and weather conditions, so that the piece of sculpture would be well adapted to its setting.[30] And according to report, Dubuffet admitted that this influenced his conception.

In our abnormal times, however, patrons dare not go very far with

the commissions they offer the artists they select. Only imagine the earth-shaking row, for instance, if David Rockefeller had asked for a large painting instead of a piece of sculpture, and had then commanded Dubuffet to paint the Glorification of the first John D. Rockefeller's Reign over Standard Oil, complete with symbolic Rockefeller dimes to enrich the composition! Such a patron's commission is unimaginable today, but it was by no means unimaginable in the quite recent past.

In seventeenth-century Rome, and particularly under Pope Urban VIII, papal nephewdom was splendidly profitable; and the Palazzo Barberini was an enormous first-fruit of papal nephewdom.[31] When the palazzo was largely finished, Cardinal Barberini commissioned Pietro da Cortona to decorate the ceiling of the *gran salone*.[32] The painter was thus required to cover a space nearly the size of a football field. In addition, he was told to paint the Glorification of the Reign of Pope Urban VIII, complete with Barberini bees as big as human infants, all following the extremely detailed program drawn up by the third-rate Barberini court poet, Francesco Bracciolini.[33] Yet he did not flinch. He did not hanker to paint something more relevant—that awful word—such as an ironic commentary on the financial advantages of having an uncle on the throne of St. Peter.[34] Instead, Pietro da Cortona cheerfully proceeded to produce one of the most marvelous, if somewhat special, decorative works of art of the seventeenth century.

Most modern theorists will conclude that Pietro da Cortona was shamefully eager to meet his patrons' wishes; but they will be wrong—unless they wish to tar with the same brush countless other great figures in our art tradition's earlier history. Ghirlandaio's contract for the Tornabuoni Chapel in Santa Maria Novella shows that the painter was not only required to submit sketches for each panel of his frescoes for the approval of Giovanni Tornabuoni;[35] in addition, he agreed to include in the frescoes a long series of portraits of members of the Tornabuoni family selected by his patron.[36] The portraits were to be there because one of the main uses of the chapel was to exhibit the family's grandeur and pious generosity. In just the same way, at least if Vasari is right,[37] Piero della Francesca included portraits of the Bacci family in his glorious frescoes of the Legend of the True Cross at Arezzo, which were commissioned by Luigi Bacci. Furthermore, even when family pride did not enter in so crassly, the greatest painters thought it was only proper to provide decorations carefully suited to the spaces assigned them. And suitable decoration is also a use.

Here consider Titian once again. Whenever a patron told him how and where his paintings were to be placed, that knowledge always governed his mind and hand. In the case of the Presentation of the Virgin in the Temple for the Scuola della Carità in Venice, he made the composition of the whole enormous picture hinge directly on the peculiarities of the

difficult space it was to fill; and in the blue and gold of the gown and nimbus of the Virgin, the central and climactic figure of the huge composition, he artfully echoed the colors of the coffered ceiling above.[38]

Titian went still further at Ferrara. Alfonso d'Este, Duke of Ferrara, first called on him in 1518 to complete the decoration of the ducal study, the *camerino d'alabastro*.[39] The paintings of course had to fit the spaces provided and suit the room as well. In addition, without argument so far as we know, Titian successively accepted two subjects which Duke Alfonso selected from a late classic work, the *Imagines* of the first and second Philostratus. On these subjects which another man had chosen, Titian painted two of the finest of his early *poesie*, the Andrians and the Venus Worship.[40] The source of the Bacchus and Ariadne is less certain,[41] but it seems likely the subject was again suggested by Duke Alfonso. Nor was that all. The Feast of the Gods, as Giovanni Bellini had left it, did not accord at all well with the new pictures Titian was introducing. Hence he repainted it extensively, to make a perfect decorative ensemble of such unparalleled character that one can hardly imagine its impact when in place.[42]

Please note that if Duke Alfonso had wanted another kind of decorative ensemble, a fresco cycle, we should instantly write this down as patronage of the arts. And note, too, that the ensemble Titian actually contrived for Duke Alfonso, though not in fresco, was really conceived like a fresco cycle. Art collecting stalked in on the heels of the troops, however, when Pope Clement VIII grabbed Ferrara in 1598, and the current papal nephew, Cardinal Aldobrandini, grabbed the Titians.[43]

Something must be said, too, of the significant fact that the use of a work of art was formerly its justification in the eyes of the patron who commissioned it and in the eyes of other people as well. This was even true when the work of art took the form of a treasure. Here, for the last time, consider Abbot Suger, who was as proud of the treasures he added to the stores of St.-Denis as he was of his aggrandizement of the abbey church itself.[44] Because of his fondness for treasures, Abbot Suger felt he had to defend himself against his puritanical contemporary, St. Bernard of Clairvaux.

"What doeth this gold in the sanctuary?" St. Bernard angrily demanded in a well-known letter to William of St.-Thierry. And he added grimly, "The Church is resplendent in her walls and beggarly in her poor, she clothes her stones in gold, and leaves her sons naked."[45]

Suger replied at length that "golden vessels, whatever is most valued among all created things" ought properly to be "laid out, with continual reverence and full devotion, for the reception of the blood of Christ . . . A saintly mind and a pure heart, with faithful intention . . . principally

matter. But we profess that we must do homage also through the outward ornaments of sacred vessels."[46]

Note first that Abbot Suger wrote "golden vessels" and not "works of art." Above all, note that Abbot Suger wrote of a *use*—the appropriate worship of God and His Son. To see how much this means, then consider Benedict Biscop, the learned and holy man who founded the monasteries of Wearmouth and Jarrow in the seventh century.[47] The Venerable Bede recorded that after completing his church, Benedict made a laborious journey to Rome to bring back to England five missing essentials for the new foundation: first, a large library; second, a rich collection of holy relics; third, the precentor of St. Peter's to teach the monks the "rites of solemn worship"; fourth, a papal charter giving the foundation immunity from taxes and episcopal interference; and finally, a considerable number of holy pictures for the church—no doubt because good painters were not then to be found in England. Concerning the pictures, Bede added: "By this . . . magnificent exhibition of so many religious subjects, the whole interior of the sacred edifice presents to the eye one continuous *scene of pious instruction*, accommodated to the capacities of all who enter, even of the humble and unlettered multitude."[48] (Italics added.) In short, both Bede and Abbot Suger ringingly sounded the theme of all normal patrons' thinking about art, which is, I repeat, art-for-use-plus-beauty. But this is not the way art collectors think about works of art, so the first litmus test for art collectors is as follows:

The potential usefulness of a work of art is never a serious consideration for a true art collector, as compared to the work's inherent qualities as art.

The Second Litmus Test

Some may object to this first test because certain art collectors boast, "I never buy anything I cannot use." Such collectors may indeed sit on their French eighteenth-century royal *mobiliers*. But in the first place, other ways of furnishing a living room are known which are both vastly cheaper and rather more cozy than buying royal *mobiliers* attributed to Jacob or Sené. In the second place, you have only to tell a collector of French eighteenth-century furniture that his or her most cherished *mobilier* is really a careful copy of an old one, made by one of the Paris copy-specialists of the nineteenth century. Then you will soon learn the real priorities.

There is a much more serious objection, however, to the unimportance to art collectors of mere use. The objection is that art collecting often

resembles private patronage of the arts in that it adds splendor, or at least prestige, to the collectors' surroundings and way of life. Surroundings enhanced with collected works of art are now a major source of personal prestige, and conferring prestige must have been the purpose of William Randolph Hearst, when he somewhat eccentrically gave an Italian primitive devotional picture to his mistress of many years, Marion Davies. The picture provoked Dorothy Parker's quatrain:

> Upon my honor, I saw a Madonna
> Hanging within a niche,
> Above the door of the private whore
> Of the world's worst son of a bitch.[49]

The quatrain suggests another minor but basic difference between private patronage and art collecting, which has already been brought out in the previous chapter's quotation from Burckhardt. Works of art specifically made to add splendor to the daily life of a private patron can never clash too grossly with the way of life in question—for the patron himself commissions them.[50] Yet this was certainly not true of Marion Davies's Madonna, and it is not true of many other collected works of art one now sees in hardly less surprising surroundings.

It is far more important, however, to note a rather different point. In brief, the patron always *shares*, at least in some degree, in the artist's act of creation. The patron's share may go no further than setting the outside price of his commission, and thus determining whether the artist's work will be large or small, ambitious or the reverse. In the past, however, the patron's share has usually gone much further. When Alfonso d'Este directed Titian to take the iconography straight out of Philostratus for two of his pictures for the *camerino d'alabastro*, he quite largely dictated Titian's resulting compositions. If you did not know the dates, you might almost think Titian's Andrians and Venus Worship were actually being described in *Imagines* I.6 and I.25.[51]

Other examples of the same sort multiply interminably, and when we come to what happened early in the High Renaissance, that high-toned lady Isabella d'Este, Marchioness of Mantua, will be seen enlarging the patron's share so greatly that she most seriously hampered the work of her chosen artists.[52] And in the ways already traced, both Dr. Barnes and David Rockefeller had their share in the works they commissioned, even in the confining circumstances of the twentieth century, when artists have to be begged to take commissions from patrons and will brook no patron's conditions about themes, color, composition, or anything else except the place to be enhanced.

The patron's share really amounts to a degree of direct responsibility for the work of art which the chosen master executes for him. The responsi-

bility may be carried very far indeed, as with the Barberini commission to Pietro da Cortona, or it may be almost timidly limited, as with David Rockefeller's commission to Dubuffet for Group of Four Trees. But it is always there. A good many years ago, the English critic John Steegman had the astuteness to perceive the importance of this fact. Thus the second litmus test that divides art collectors from all patrons of the arts is no more than a direct adaptation of a dictum of Steegman's,[53] as follows:

An art collector is concerned only with buying something for the production of which he has been in no way responsible, even if he buys the work of his contemporaries.

The Third Litmus Test

To be universally effective, this second litmus test must of course be combined with the first test, concerning the unimportance of usefulness in art collectors' eyes. For example, the second test may seem to make collectors of the pious persons who unquestionably bought devotional pictures at second hand in the fourteenth, fifteenth, and later centuries. Such purchasers at second hand had no share in the artists' acts of creation. But the devotional pictures served them as religious chromos serve today; and it is not art collecting to buy religious chromos for religious purposes. This is a trifling matter, however, and it is time to go forward to the third litmus test, which has to do with the nature of art collecting, rather than the nature of patronage of the arts.

The key fact is that because of the powerful role of collectors' categories in all collecting, successful art collectors need equipment that successful patrons do not have the least need for. Bess of Hardwick, for example, was one of the toughest and most ambitious women of Elizabethan England, and she was the founding mother of great ducal houses. Yet there is nothing to show that she was an immensely cultivated woman.[54] Nonetheless, she scored a memorable triumph as a patron of the arts when she got a design from Robert Smythson,[55] added her own notions of what a great house ought to be,[56] and proceeded to build perhaps the most original, and in my opinion one of the most beautiful, of England's many rural palaces, "Hardwick Hall more glass than wall."

In an enterprise like Bess of Hardwick's last great building project, there is no danger of such a misfortune as the Cleveland Museum had with its fake Grünewald. But Western art collectors have had to find their way around this kind of danger for several centuries, as you can plainly see from the works of two Italian seventeenth-century writers.

Marco Boschini wrote his *Carta del navegar pitoresco* toward the middle of the seventeenth century.[57] It is a satirical poem in Venetian dialect

on the ways of the art world in the city; and Boschini conspicuously included an emphatic warning to incautious collectors, to look twice at "old, smoked" paintings,[58] which were of course smoke-treated to make them look old. According to Boschini, the fakers further made the fraudulent paintings look like works of the cherished great masters by putting them in handsome and expensive frames.[59] Thus it is plain that art faking was prevalent in Venice, and it is just as plain that fakes were not wanted by the collectors Boschini put on their guard. There was so much faking in Venice, furthermore, precisely because Venice was one of the two chief centers of the Italian seventeenth-century art market.

Rome was the other chief center of the Italian art market in the seventeenth century, and the state of affairs in Rome near the opening of the century was usefully portrayed by Giulio Mancini. He was a papal physician and a collector on the side; he was not above discreetly turning a profit on pictures he owned when the opportunity offered;[60] and he wrote a manual for art collectors, *Considerazioni sulla pittura.*[61] His description of the methods of the Roman art fakers is similar to Boschini's description of the methods used in Venice, but it is somewhat more detailed. Besides "antiquing" their fakes with smoke, the fakers in Rome regularly secured "old panels" on which to work, so that the reverse sides of their fakes would look convincing.[62] Mancini, further, gave outstandingly interesting advice about the best way to tell the true works of great masters, not just from fakes, but also from studio products, from copies, and from works by the great masters' lesser contemporaries with similar styles.

Each leading master, Mancini said, had his own "handwriting" in his paintings,[63] which could be discerned by studying each leading master's way of painting such features as the eyes and "the curling of the hair."[64] If Mancini's work had been contemporaneously published instead of remaining in manuscript until only a few years ago, he would now be remembered as the first Morellian; for he invented the essentials of the Morellian system of testing authenticity over two and a half centuries before Giovanni Morelli-Lermolieff, whose system, in turn, was largely taken over by Bernard Berenson.

Nowadays, of course, the methods of art fakers and crooked dealers are far more sophisticated; but assaying authenticity is still easier said than done, even though something like the status of an exact science is now frequently claimed for art-historical connoisseurship. To give one more case to match Cleveland's fake Grünewald, there is the sad story of the Boston Museum's alleged Raphael.

The museum's leaders wanted to be able to boast of "our Raphael" to celebrate the hundredth anniversary of the museum's founding. A little portrait said to be by the young Raphael was on offer by a dealer in

Genoa. The portrait was unwisely bought for $600,000,[65] and just as unwisely brought into the U.S. without being declared at customs, which made the Boston Museum liable to pay a heavy fine according to the letter of the law.[66] The first result was a dreadful international rumpus about the dire loss to Italy's national heritage of a painting almost no Italians had ever seen or heard of. Since the picture had not been properly declared, the political rumpus stimulated a movement to collect a U.S. customs fine of $600,000—for the law set the fine as the market value of the picture.[67]

This was bad enough. Far worse for the museum, however, was another immediate sequel. Dr. John Shearman had authenticated the little picture as being by Raphael,[68] but as soon as the museum's acquisition was announced, just about every other Raphael expert in the world joined in saying that the attribution to Raphael was downright ridiculous.[69] Sydney Freedberg of Harvard, for instance, wrote an opinion that the picture was "of the period," but attributed it to the young Raphael's dimmest associate in the studio of Perugino, an incomparably obscure artist with the wonderful name of Sinibaldo Ibi. "I wanted to help," Professor Freedberg demurely explained,[70] pointing out that the market value of an Ibi, and therefore the proper customs fine, could hardly be more than $2,000. Even so, the Boston Museum was not helped. The Freedberg opinion was like telling Cardinal Albrecht of Brandenburg that a veritable hand of St. Ursula was "of the period" yet was really no more than the hand of the very last of St. Ursula's ill-fated troop of eleven thousand virgins. In the upshot, the discredited picture went back to Italy; the museum lost $600,000 it could ill afford; and the museum's director lost a job much loved.[71]

Such stories do not always end so sadly, but the fact remains that when the authenticity of any work of art of the past is successfully challenged, or seems to be so challenged, the work goes straight to the museum's reserves or the cupboard where the collector hides his mistakes—even if it has been cherished and admired for a very long time. This has happened in both the Metropolitan Museum and the Louvre.[72]

A question remains, however, as to how the key role of categories operates when art collectors concentrate on works of their own times. Here, fortunately, the answer was given me by no less a personage than Dr. Albert C. Barnes. By shameless flattery and sheer persistence, I gained admission to the Barnes collection when I was only nineteen,[73] in the period when outsiders almost never saw the Barnes pictures. Dr. Barnes opened the door for me, alarming even in carpet slippers. He gestured me onward to the galleries with a tremendous parting injunction: "Just remember, young man, these pictures you're going to see are the old masters of the future, *the old masters of the future!*"

Dr. Barnes's use of the phrase "old master" needs brief comment, because it had a meaning for him, and still has for us, which the phrase only fully acquired in the nineteenth century. In the posthumous inventory made for the dispersal of Rubens's pictures,[74] for example, the works from Italy, although well over a century old, were described as "good masters" or "Italian masters." Meanwhile, Rubens's only "old masters" were the Northern painters from Van Eyck through Bruegel, even including Albrecht Dürer, whose works seemed old-fashioned in Rubens's time. The same usage also appears in the correspondence of the great seventeenth-century collector of drawings, Cardinal Leopoldo de' Medici. When the Cardinal already had portfolios bulging with drawings by the giants of the High Renaissance and later painters, he ordered his agents to begin looking for "old masters"—meaning drawings from periods prior to the High Renaissance.[75] His first "old master" was a drawing by Vivarini.[76]

As used by Dr. Barnes, however, "old masters" plainly meant something quite different—in fact, those masters of the past of such great, even bullying stature that their works must be taken into account by all masters coming after them. The phrase will be used with this meaning in this essay, since it conveys a potent concept, as is shown by the impact of the Barnes collection.

The chief painters whose works Dr. Barnes collected—Cézanne, Renoir, Degas, Matisse, Picasso, and several more—have indeed become old masters. All art lovers now bitterly remember, too, how almost everyone else in Dr. Barnes's time, and earlier, too, missed the chances he seized upon to acquire works by these painters almost in carload lots.[77] Everyone today, therefore, fears missing good bets on our own era's old masters of the future. Memories of Dr. Barnes and a few other pioneer collectors of his type are in fact the main cause of the perfect frenzy of open-mindedness among the art collectors and museum curators of the later twentieth century.

As to the other side of the coin, the verdict of time has not altogether confirmed Dr. Barnes's claim for *all* his choices. He bought fifty Pascins,[78] for example, and the Pascins in the Barnes collection still hang quite as prominently as Dr. Barnes's Matisses. If his resources had been more limited, and he had concentrated exclusively on Pascin, Dr. Barnes would have little or no place in the art history of the twentieth century.

All this simply means that the successful art collector needs a depth of knowledge of a particular kind plus a knack for intensity of scrutiny, such as no patron like Bess of Hardwick has ever needed. These qualities enable the collector to tell what is "right" in the art of the past, and to make shrewd bets on old masters of the future. These are also the qualities that make a connoisseur. Thus the third litmus test for distinguishing art collecting from patronage of the arts is as follows:

To be successful, an art collector must be a connoisseur, or must hire connoisseurship.

The Last Litmus Test

But there is also a final litmus test, to my mind not the least important. In brief, art collecting affects the works of art themselves in a way that patronage of the arts cannot possibly do. It is enough to give a single, very simple example: an enamel-on-gilt-copper *armilla* made in the twelfth century, perhaps by the great Mosan goldsmith Godefroid de Clair.[79] Germany's Nuremberg Museum recently bought the *armilla* for $2,034,450 at the posthumous sale of the Robert von Hirsch collection.[80] In Nuremberg, the *armilla* looks like what it has become—a tremendous collectors' prize of the utmost rarity. But neither to the eye nor in almost any other way does the *armilla* look in the museum as it formerly looked, when it served as an epauletlike ornament of the hieratically grand ceremonial robes of Frederick Barbarossa[81]—the purpose the *armilla* was originally made to serve.

To see how this sea-change is wrought, we may begin with two quotations from Sir E. H. Gombrich. In the course of a discussion of a group of pictures, Professor Gombrich wrote a bit sadly some years ago: "Nearly all the objects in our collections were once intended to serve a social purpose from which they were alienated by collectors."[82]

On the upper arm of Frederick Barbarossa, the *armilla* obviously had the kind of social purpose Professor Gombrich had in mind here. In Nuremberg in its museum case, it does not. But there is more to this matter, too. Of the Greco-Roman copies like the Apollo Belvedere, Professor Gombrich has also remarked: "The most astounding consequence of the Greek miracle [was] the fact that copies were made to be displayed in the houses and gardens of the educated. For this industry of making reproductions for sale implies a function of the image of which the pre-Greek world knew nothing. The image was pried loose from the practical context for which it was conceived and [was] admired and enjoyed for its beauty and fame, that is, quite simply within the context of art."[83]

One may note in passing that so far as one can tell, no copies of works of art were ever made beyond the limits of the five rare art traditions—of course barring studio copies of such works as royal portraits and devotional pictures, plus such things as the cheap ex votos and souvenirs of temples already mentioned, which sometimes copied the cult images. In the Greek world, the kind of copies Professor Gombrich was speaking of—in fact, copies of works of art *qua* art—began to be made when documented collecting began, with the Pergamene dynasts of the third century B.C.[84] The chronology of copying has also been basically similar

in all the other rare art traditions. But this is far less significant than the main point.

The main point is that whether or no the second quotation concerns copies does not really matter. *Both* quotations from Professor Gombrich are totally applicable to every branch of art collecting, wherever and whenever art collecting has appeared in the world history of art, except when the collected works of art were made for a collectors' market in the first instance.[85] Nor is Professor Gombrich the sole witness on this point, for there is also testimony from the late Martin Wackernagel. He was a student of patronage of the arts in Florence during the Renaissance,[86] and he greatly preferred his beloved fruits of patronage to remain intact. On the dispersal of the panels and other painted decorations supplied by Andrea del Sarto, Granacci, Pontormo, and others for a grand Florentine room in the Palazzo Borgherini,[87] Wackernagel therefore remarked with asperity:

"The paintings, like so many others of the fifteenth and early sixteenth centuries, were [thus] separated from their original setting and function. They were uprooted and consigned to a purposeless museum existence, isolated in neutral surroundings, [whereas] at one time they had formed part of a well ordered whole. . . . [This is] a self-evident example, among many others, of what was portended as a consequence of art collecting and the greed for acquisition stimulated by the trade in works of art."[88]

I repeat, these data that provide the fourth litmus test exclude the modern works of art produced for a collectors' market in the first instance. What is produced for a collectors' market, or in the manner of the Chinese painters and calligraphers who took no patrons' commissions, is intended from the outset to be "admired and enjoyed . . . quite simply within the context of art." But this exception does not extend to works of art made for the luxury market, like the Metropolitan Museum's Euphronius crater. All such luxury products were originally designed to add splendor to particular ways of life, and these ways of life provided both context and social purpose. All this being understood, we get the fourth litmus test for distinguishing art collecting from patronage of the arts, as follows:

In the cases of all works of art made for functional contexts and known purposes, art collecting invariably pries loose whatever is collected from its former functional context, and deprives it of significant social purpose.

Farewell to Hairsplitting

So there you have the proofs that before the abnormal present, true art collecting has never appeared except in the five rare art traditions. Some of these proofs may strike readers as hairsplitting. Others may seem

to belabor the obvious. Hence I can only hope the reader will remember that proving a negative is never easy, and always requires prolonged, detailed examination of everything that may seem to make a contrary case.

In the present instance, the negative being proved has never been forthrightly stated anywhere in the scholarly literature, although there have been partial statements and vague hints.[89] Furthermore, this negative that has had to be proved at such length has high if unsuspected importance for art history. For if the five rare art traditions have art collecting in common, and art collecting has also been unknown in all other art traditions, logical conclusions then have to be drawn which are decidedly startling, even unsettling. One must conclude, first, that the five rare art traditions' wide differences from one another conceal some inner feature or features common to all five. For how else can art collecting have appeared in all five? And one must conclude, second, that the five rare traditions are set apart from the vast majority of art traditions by this same inner feature or features that the rare art traditions have in common. For how else is one to explain art collecting's historical rarity?

Later, these deep problems must be inquired into. For the present, only use the definitions previously proposed, and recall the general laws, and, in all doubtful cases, apply the four litmus tests. You will thus discover, I feel confident, that anything resembling art collecting in any but the five rare art traditions has now been ruled out of consideration. We can therefore say farewell to hairsplitting and may now proceed to the relationships between art collecting and the other by-products of art—which are also significant elements of the subject of this essay.

INTERCHAPTER $\mathcal{2}$

THE BLUEPRINT

Hard as it may be to believe, the U.S. has a good many serious collectors of Coca-Cola bottles, who reportedly once included President Carter.[1] Cecil Munsey's *Illustrated Guide to the Collectibles of Coca-Cola*[2] is the manual that pinpoints the most historically desirable Coca-Cola bottles for the collectors. And there is a brisk collectors' market, served by specialized dealers.

Again, it may be even more difficult to credit, but there is a somewhat narrower sect of other Americans, mainly in Texas, who collect early barbed wire.[3] The history they depend upon is *The Wire That Fenced the West*, by Henry D. and Frances T. McCallum.[4] The collectors further support a barbed-wire journal; and one of the main topics of *The Barbarian*[5] is of course the best way of locating the rarer barbed wires on a market as yet ill-organized.

Some may think that such unlikely data are out of place in a study of art collecting and the other by-products of art; but those who hold this view are sadly mistaken. Not only do art collectors obey the same general laws which govern all forms of mature collecting, however strange. In addition, art collecting resembles all other forms of mature collecting in that it is never more than one element, albeit the basic element, in a considerably larger system. No form of mature collecting, including art collecting, has ever existed in isolation. Wherever there is mature collecting, in fact, and whether the things collected are Coca-Cola bottles, or early barbed wire, or great works of art, you are certain to find the same triad: the form of collecting in question, *plus* some sort of history of the things collected, *plus* a collectors' market in some stage of development. This is why art collecting, art history, and the art market are the primary by-products of art.

The invariable presence of a history of the things collected is easy to

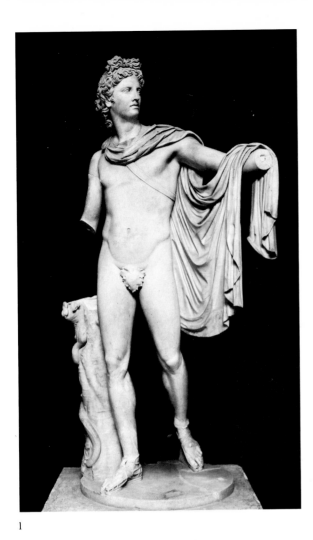

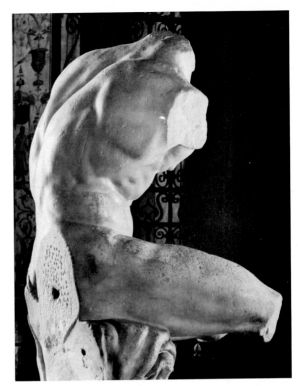

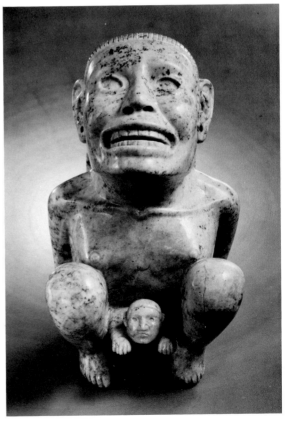

1. Apollo Belvedere, *Rome, Vatican Museum*

2. *Apollonios:* The Belvedere Torso,
 Rome, Vatican Museum

3. The Goddess Tlazoteotl, *Washington, D.C.,
 Dumbarton Oaks*

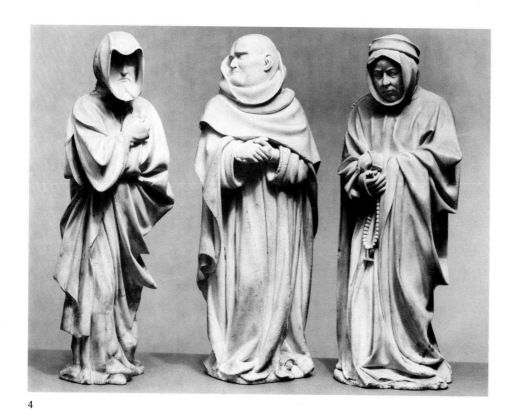

4

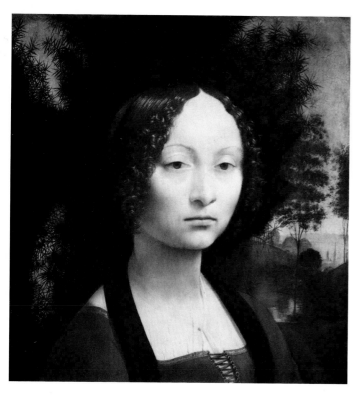

5

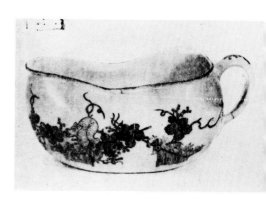

6

4. *Claus Sluter and Claus de Werve:* Three Mourners from the Tomb of Philip the Bold, *The Cleveland Museum of Art, Purchase from the J. H. Wade Fund; Bequest of Leonard C. Hanna, Jr.*

5. *Leonardo da Vinci:* Ginevra de Benci, *Washington, D.C., National Gallery of Art, Ailsa Mellon Bruce Fund*

6. Bourdalou from Chantilly, *London, Sotheby Parke Bernet & Co.*

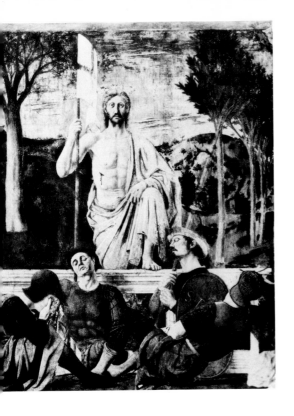

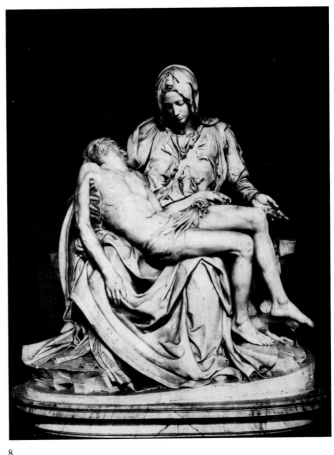

8

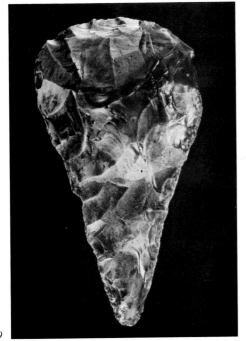

9

7. *Piero della Francesca:* The Resurrection,
 Borgo San Sepolcro, Picture Gallery

8. *Michelangelo:* Pietà, *Rome, St. Peter's*

9. Acheulian Hand Axe, *University of Chicago*

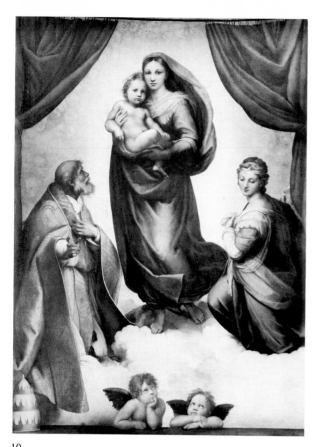

10

11

10. *Raphael:* The Sistine Madonna, *Dresden, Gemaldegale*

11. *Hendrik Staben:* Albert and Isabella in Rubens'
 Studio, *Brussels, Royal Museum*

12. The Wilton Diptych, *London, National Gallery*

12

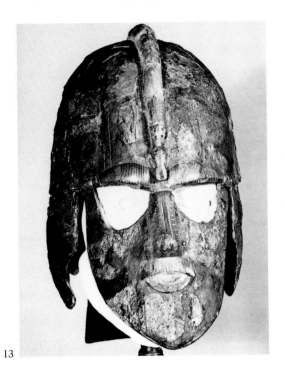

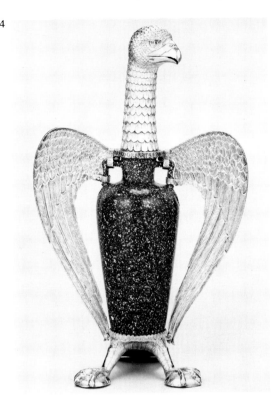

13. Sutton Hoo Helmet, *London, British Museum*

14. Eagle Vase of Abbot Suger, *Paris, Louvre*

15. *Robert Rauschenberg:* Monogram 1955–59, *Stockholm, Moderna Museet*

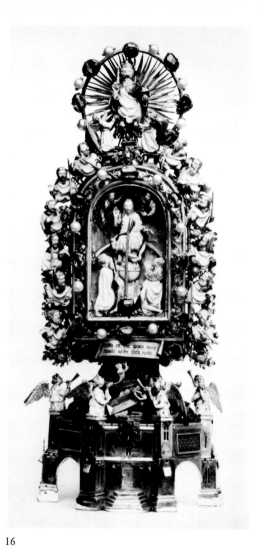

16

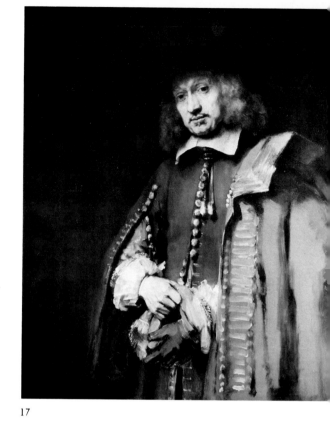

17

16. The Thorn Reliquary, *London,
 British Museum*

17. *Rembrandt:* Jan Six, *Amsterdam,
 The Six Collection*

18. *Shōsōin:* Emperor's Kimono Stand, *Kyoto*

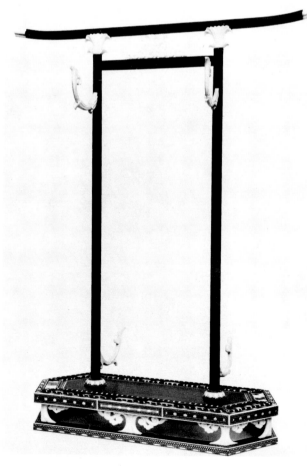

18

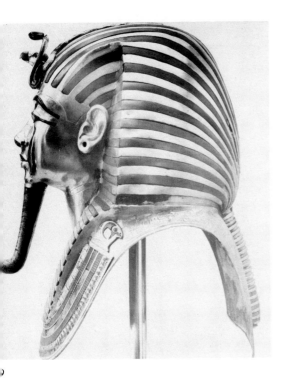

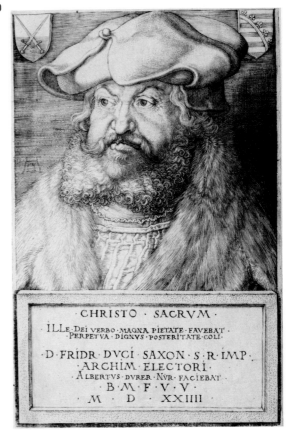

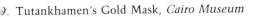

9. Tutankhamen's Gold Mask, *Cairo Museum*

0. *Dürer:* Frederick the Wise Elector of Saxony,
 Washington, D.C., National Gallery of Art

1. *Frederic Edwin Church:* The Icebergs, *Dallas Museum of Fine Arts, Anonymous Gift*

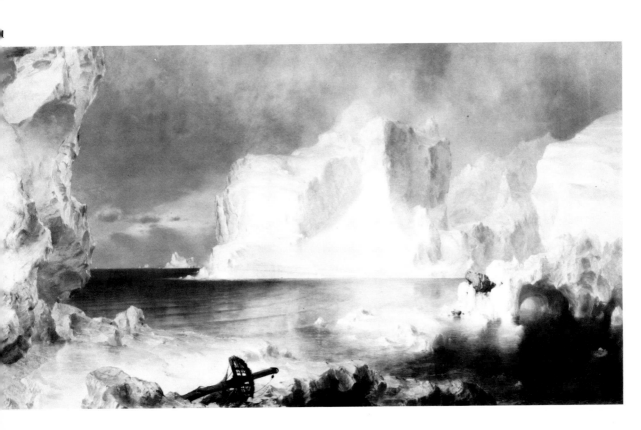

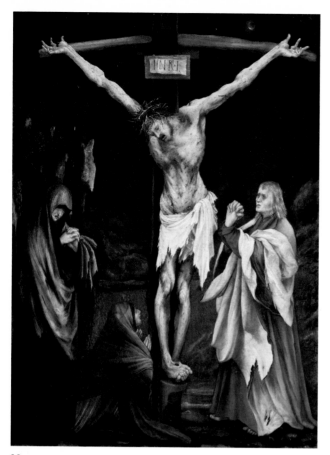

22

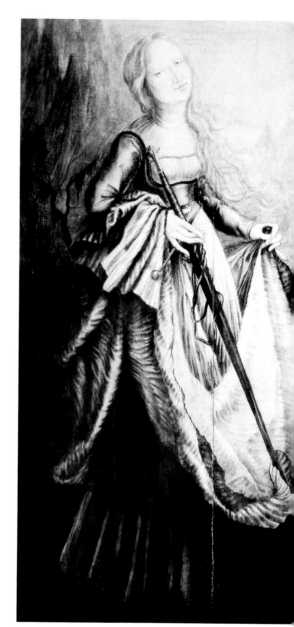

23

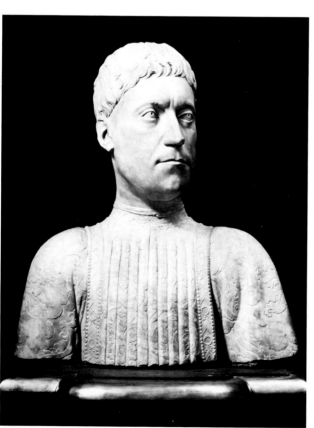

24

22. *Matthias Grünewald:* The Small Crucifixion,
 Washington, D.C., National Gallery of Art, Sam
 H. Kress Collection

23. St. Catherine. Modern Forgery in the Grünewald
 Cleveland Museum of Art, Study Collection 74.7

24. *Mino da Fiesole:* Piero de' Medici,
 Florence, Bargello

explain.[6] In some cases, the history has actually generated the collectors' category. *The Wire That Fenced the West,* for instance, recounts a story of considerable importance: no less than the transformation of huge areas of American landscape by the invention of wire cheap enough and strong enough to permit cattle ranching on a large scale. This was never possible before primitive types of barbed wire began to be made in this country in the last half of the nineteenth century, simply because all the earlier forms of fencing were far too costly or inefficient to be used for enclosing the enormous pastures needed for thousands of animals. In the cattle country of the Southwest, it was therefore only natural for some people to be deeply interested by the McCallums' history of early barbed wire; and this interest led to barbed-wire collecting.

In other cases, the collectors' category has generated the history. Thus the collecting impulse somewhat unexpectedly began to find a vent in Coca-Cola bottles a good many years ago. At first, the collectors had no guides beyond their own hunches and whatever traditional information was available to them. But when the collectors grew numerous and collecting became competitive, the need for surer guidance was naturally felt; and Cecil Munsey met the need with his authoritative work.

In one or other of these two ways, a history of the things collected has always come into being; and the history, in turn, has always played a crucial role in the collectors' division of the things they sought into one of the usual collectors' hierarchies. For collectors of Coca-Cola bottles, the summum bonum of their dreams is a "Hutchinson bottle," the earliest container ever used for the precious fluid. Because Hutchinson bottles are hard to find yet highly desirable in the eyes of Coca-Cola bottle collectors, no less than $1,000 was reportedly paid[7] for the last such bottle to change hands as these words are written. And with this fairly bizarre fact, we have come to the collectors' market, the third of the collecting phenomena which constitute the ever-present triad.

The collectors' hierarchies, it may be remembered, divide the things being collected into broad groups: ultra-desirable, desirable, worth having, and not worth having; and the collectors' market operates accordingly. Thus no collectors' market is ever a generalized market for all objects in the collectors' category in question. The results would be nightmarish if this were not the case. Imagine Coca-Cola bottle collectors aiming for maximum numbers of Coca-Cola bottles of no matter what sort, or barbed-wire collectors with the simple aim of piling up mountains of wire! No matter what the collectors' category, in fact, the collectors from the outset always seek only those things with the minimum hierarchical classification of "worth having"—in other words, things that have the special qualities of Cecil Munsey's "collectibles." The collectors' category plus the history interact to determine what is "collectible" and what is not. Collectors'

competition for the "collectibles" also produces a strong demand. In accordance with the law of supply and demand, a specialized market to supply the demand is the automatic result. And this is why a collectors' market is the third element in the triad.

The relationship between Coca-Cola bottle collecting, and Cecil Munsey's *Guide,* and the market on which Hutchinson bottles sell for $1,000, is therefore exactly analogous to the relationship between art collecting, and art history, and the art market. Nor is this the end of the matter. Whenever there is mature collecting, these three primary by-products of art are not merely found together in close interaction; in addition, all forms of mature collecting strongly tend to generate secondary phenomena closely akin to the secondary by-products of art listed in Chapter I. In the Coca-Cola Company's Atlanta headquarters, there is even a display for visitors which can be, and often is, described as a "Coca-Cola museum."[8]

In this respect, however, there is also a significant difference between art collecting and other forms of mature collecting. No doubt the difference is to be explained because the esthetic sense makes art collecting more rational than most other collecting. Whenever art collecting has appeared, at any rate, there has always been an extra-strong tendency for the secondary phenomena to appear, too.

These other by-products of art have further tended to develop in conspicuously important ways. For instance, there are many other obscure museums in the modern world approximately similar to the "Coca-Cola museum." But our major art museums are enormous institutions. Art museums of one sort or another are now so numerous, moreover, that they have made this the Museum Age, and in our art museums, the curatorial occupation has grown to be a recognized and respected profession.

As a cultural-behavioral system, art collecting and its associated phenomena have other aspects that deserve noting. In each of the five rare art traditions, to begin with, the art collectors have sought different works of art; the art historians have recounted different stories with different artist-heroes; and the works of art traded on the respective art markets have differed accordingly. But the patterns of collecting, the patterns of art history (at least in its early form), and the patterns of the art market have been much the same in all five art traditions. And the secondary phenomena, insofar as they have appeared at all, have again been schematically identical in all five traditions.

This does not mean, of course, that there have been no cultural divergences. Western collectors, both in antiquity and since the Renaissance, have always tended to display their paintings and sculpture, whereas Far Eastern collectors have tended to show their paintings and calligraphy only on special occasions, if at all. The reason for this also goes well beyond the relative fragility of paintings and calligraphy on paper or silk.

In China, for many centuries, painters' and calligraphers' works intended for interior decoration have been classed differently from similar works of art of higher intentions. Collected works of art were to be enjoyed by the collector in private, as one reads a book of poetry, or at most to be enjoyed with other knowledgeable collectors.[9] Japanese practice has therefore differed a bit from Chinese practice. Since the architectural feature known as the tokonoma came into use in Japan nearly six hundred years ago,[10] collectors have shown their greatest prizes in the tokonomas of their reception rooms or their tea rooms, but only on days when particularly honored guests were expected. In other words, the display has always been uncommon and highly temporary, but it has occurred and still does. In the Islamic world, too, collectors' practice has again differed. The later Islamic art collections largely took the form of bound albums of fine painting and calligraphy; and the albums were kept with the collectors' other books.

But all these divergences are essentially superficial. Furthermore, the other cultural divergences are not immensely more significant. In Japan, for instance, the rhythm at which the by-products of art developed was markedly different from the rhythm of development in China, in the Greek world, and in the West from the Renaissance onward. Japanese art history, particularly, made a strikingly late appearance.[11] But this was obviously because the basic phenomenon, art collecting, was one of Japan's innumerable cultural imports from China; and in consequence, even the development of art collecting in Japan was distinctly irregular and slow before the art-intoxicated era of the Ashikaga Shogunate in the fourteenth and early fifteenth centuries. In the later Islamic world, too, neither art collecting nor art history ever reached the advanced stage which these phenomena so conspicuously reached in all the other rare art traditions. And cultural differences also account for the fact that before worldwide cultural homogenization began, public art museums were unheard of beyond the limits of the two rare art traditions of the West.

None of the foregoing, however, can possibly detract from the historical significance of the really central facts. The first fact is, of course, that art collecting and the other by-products of art were unknown in the overwhelming majority of art traditions. The second fact is that whenever art collecting and any of the other by-products of art appeared in one of the five rare traditions, the underlying patterns of these phenomena were always the same. And the third fact is that without regard to the level of development of the by-products of art in each of the five rare traditions, the resulting integrated system again showed the same underlying patterns of relationships and interactions.

I have in fact called this interchapter "The Blueprint" because a blueprint gives one the best image of the immensely puzzling appearances of

art collecting and the other by-products of art in the world history of art. It is as though a master blueprint had been stored somewhere in the great warehouse of innumerable possible forms of human behavior. The blueprint's elements were, first, a special way of thinking about works of art; second, art collecting, art history, and an art market; and third, the secondary by-products of art. Something in the blueprint—unquestionably the special way of thinking about works of art—prevented any part of the design in the blueprint from being realized by all but five of the tens of thousands of cultures the world has known. In these five cultures, however, the blueprint was followed with extreme fidelity, at least as far as the internal circumstances permitted, and despite the obvious fact that these five cultures' arts, religions, histories, economic and social organizations, and other basic characteristics could hardly have differed more widely.

This is why it is now necessary to go forward from the examination of art collecting, in order to examine the various other by-products of art and their relationships to art collecting and one another. By far the most important relationship is that between art collecting and art history, and this will come next.

V

THE SIAMESE TWINS

Just as all five of the rare art traditions have produced art collectors, so all five have produced art historians. Nor is this all. Just as works of art were never truly collected beyond the limits of the rare art traditions, so true art history was never written. These, surely, are facts of some importance. At a minimum, they strongly underline the conclusion imposed by the rare art traditions' monopoly of art collecting—that these five traditions have had special ways of thinking about art which were theirs alone.

If you merely consider any sort of writing about art, of course, it has certainly not been restricted to the five rare traditions. Nowadays, in the first place, peoples only a few score years from illiteracy study their own art history, as they collect their own art and build their own art museums. But these are recent results of worldwide cultural homogenization and can therefore be ignored. Certain other kinds of writing about art cannot be ignored, however.

To begin with, patrons of the arts have liked to commemorate their own achievements, or to have their achievements commemorated for them, in many different human societies. Abbot Suger wrote about all that he had done at St.-Denis twice over, in much detail, and with endearing pride.[1] For the Emperor Justinian, the historian Procopius composed *De Aedificiis*,[2] describing the Emperor's great works all over the later Roman Empire. At the other end of the spectrum, there is a Yoruba praise chant paying tribute to the discriminating patronage of the Chieftain Ogunwale.[3] Each of these documents and many others like them have provided invaluable data for art historians; and so have inscriptions on buildings recording the names of the builders,[4] the frequent indications of the high ecclesiastics and other important persons who commissioned illuminated manuscripts,[5] the historical records on ancient Chinese bronzes,[6] inscriptions on reliquar-

ies naming those who gave the reliquaries,[7] and so on and on and on. But providing data for art historians is not the same thing as writing art history.

Abbot Suger, for instance, did not trouble to identify any of the artist-craftsmen he summoned from "all over the kingdom," and not one of their names has even been doubtfully learned from other sources.[8] Procopius, again, recorded that Anthemius of Tralles and Isidorus of Miletus were the architects of Hagia Sophia, primarily because their engineering feats on the great cathedral were considered close to miraculous;[9] but all the rest of the many structures listed in *De Aedificiis* were presented as though Justinian had issued an order and they had risen of themselves, in humble obedience to the imperial command. In short, commemorations of the achievements of patrons must be regarded as belonging to the history of patronage, no matter how useful these commemorations may have proved to art historians who came later.

On the same rule, craftsmen's handbooks belong to the history of arts' technology and patronage of art, and they are not art history, although again useful to art historians. I myself suspect that how-to books for artist-craftsmen were composed in just about every literate society that nourished a reasonably complex and long-enduring art tradition, even though few such how-to books survive today. We have none from Egypt, for instance, yet it would be downright surprising if there had been no Egyptian handbooks to set forth the method of applying the Egyptian canon of human proportions[10] and the other rules Egyptian artists had to follow. Even if handbooks could not be used by many of the artists because they were not trained as scribes, the position would have been altogether different for the higher officials of the Egyptian equivalent of the Ministry of Works. This was an important department of the ancient Egyptian government for millennia on end, and its higher officials were unquestionably literate, since at least two of them rose to head the entire government bureaucracy.[11] In their normal jobs as supervisory architect-engineers, they would have found craftsmen's handbooks invaluable for ready reference.

In India, meanwhile, the accidents of time have permitted the survival of a substantial group of the handbooks for artists called *silpasastras*; and one of them, the *Vishnudharmottara*,[12] further dates from as early as the seventh century A.D.[13] and also contains undoubted borrowings from still earlier works of the same type. It has been persuasively suggested, too, that Khmer artists got their iconographic and other guidance from Indian *silpasastras* imported by the Brahmins, who were the culture-bringers of Southeast Asia.[14] The medieval European handbooks, like Villard de Honnecourt's famous *Sketchbook*, are too well known to need enumeration at this juncture;[15] and the ghost of a late Byzantine handbook can

also be discerned in the Greek Orthodox *Painter's Manual* of Dionysius of Fourna.[16]

Yet there is fodder for art historians, but no art history, in the *Vishnudharmottara*'s instructions to painters to give women slenderer waists and wider hips than men,[17] and male gods the faces and forms of "youths of sixteen."[18] Nor is there any art history in the *Vishnudharmottara*'s enormous section on the wildly complicated iconography of the Indian Pantheon.[19] If you examine all the other surviving craftsmen's handbooks, moreover, you will get the same result: much fodder for art historians, but not one word of art history as properly defined.

Properly defined, art history is what the elder Pliny wrote in his chapters on the arts in the *Naturalis Historia*,[20] and what Zhang Yanyuan wrote in his *Li dai ming hua ji*,[21] and what Giorgio Vasari wrote in his *Lives*; and what the authors of the *Kundaikan*,[22] and later the painter Kano Ikkei, wrote in Japan;[23] and what Qādī Aḥmad[24] wrote in Persia. And here I have named only the first to write art history in each of the five rare art traditions, except in the case of the elder Pliny, who echoed Greek art histories that are now lost, and perhaps Zhang Yanyuan, whose ninth-century work is the earliest consecutive history of Chinese painting which we have today, but may have been preceded by other histories which have perished.

To this I must add, finally, that the phrase "art history" has no adjectives concealed within it. The truth is, I have heard more than one young art historian of the higher, dryer sort haughtily dismissing his profession's founder in the West as "not a real art historian"; and of course Vasari was not a scientific art historian in the modern style. Art history may in fact be written sloppily or carefully, scientifically or romantically, with much or little emphasis on stylistic analysis and iconography, with many anecdotes, or a plethora of theory, or a wealth of dreary but invaluable documentation—in short, according to the capacities and inclinations of the individual art historian. Good, bad, or indifferent, it is still art history. As such, as indicated by the names cited above, it is a phenomenon common to all five rare art traditions. And if anyone can name a true art historian before the era of worldwide cultural homogenization and beyond the rare art traditions' limits, I shall be immensely surprised—and I shall stand corrected, too.

These being the facts, it is justifiable to regard art collecting and art history almost as Siamese twins, and certainly as having a Siamese twin-like relationship. The two phenomena have not been chronologically born together in all five of the rare art traditions. Yet, once born, they have always been closely linked together in all five traditions, and in the manner of Siamese twins, they have always had a shared bloodstream of ideas

and critical viewpoints. Like Siamese twins, too, they have even died to-
gether on one occasion—in Europe after the fall of the Roman Empire
in the West.

The Vasarian Canon

This Siamese-twin relationship between art collecting and art history
has further had immense importance. Wherever the two phenomena have
coexisted, the resulting interactions have not merely gone far to determine
the general way of seeing. More important, artists' ideas and aspirations
have also been profoundly affected. It is odd, then, that the relationship
has never been carefully studied; and it is time to remedy this omission.
Another volume would be required, however, to cover this single aspect
of the histories of Greek, Chinese, Japanese, and later Islamic art. Hence
this chapter will concentrate on the Siamese-twin relationship in our own
art tradition, which is the best documented.

The first problem needing examination is how Western art collecting
and Western art history interacted to produce what may be called the
Vasarian, or Renaissance, canon of art. This is no trivial problem, either,
since the Vasarian canon demonstrably shaped the creative thinking of
just about all major artists, and set a standard of art for just about all
educated Europeans, for a period of nearly three centuries. It can be co-
gently argued, in fact, that the formulation of this canon was the most
significant single development in the early history of post-Renaissance
art in the West.

To understand what happened, it is necessary to begin at the beginning;
but this beginning will be covered in detail in later chapters, so a summary
will suffice. In the course of the fourteenth century in Italy, in brief,
art collecting rather slowly reappeared as an established social habit for
the first time in over eight hundred years.[25] The prizes the new Italian
collectors sought, however, were classical works of art exclusively; and
the great Italian fifteenth-century collectors (as opposed to patrons of the
arts) formed highly important and very famous classical art collections.
For these reasons—and for other reasons, too, which need not be entered
into at this juncture—the art lovers of the Renaissance universally accorded
canonical status to the great masters of antique art.[26] As canonical artists,
the "ancients" thus became our Western art tradition's first old masters—
in Dr. Barnes's sense of masters of the past whose formidable examples
cannot be safely ignored by any aspiring artist of the present.

In the twilight of the High Renaissance, in the sixteenth century's
second decade or thereabouts, the repertory of the Italian art collectors
then began to be significantly expanded. For the first time, works of art
belonging to our own Western art tradition began to be truly collected.

In this early stage, however, the prizes the collectors sought were decidedly miscellaneous. In the art collections described by Marcantonio Michiel[27] and by Rafaello Borghini in his *Il Riposo*,[28] and referred to in passing by Giorgio Vasari, you therefore find fair numbers of works by Italian masters of the later fifteenth century, some by the early painters of the Low Countries, and even a few Italian primitives from before the time the true Renaissance began. For instance, one can pinpoint two Giottos, one probable Giotto, and even a Cimabue and an alleged Cimabue.[29] But such works as these were the exceptions. The standard in almost all early sixteenth-century Italian art collections was a mixture of as many classical works of art as the collector could afford and a miscellany of later Renaissance works plus occasional paintings from the Low Countries.

Such was the intellectual and art-collecting climate in which Giorgio Vasari began the enormous labor of research that preceded the first edition of his *Lives* in 1550. The *Lives*, mainly in the revised edition published in 1568, established what I have called the Vasarian canon; and the Vasarian canon then quickly ended the rather random approach to art collecting that had prevailed before the *Lives* began to circulate.

The canon first of all ruthlessly excluded all works of art produced in Europe throughout the Dark and Middle Ages, with an extremely minor exception for Italian Romanesque architecture. This exception was made, in turn, because Vasari devoutly believed that the "ancients" were the necessary models for all art; and buildings like the Cathedral of Pisa passed muster because they were regarded by Vasari as near enough to the works of the "ancients."[30] It can be seen, then, that Vasari's viewpoint strongly confirmed the canonical status of the great artists of antiquity.

Neither this emphatic inclusion of the "ancients" nor the all but total exclusion of most of the European artists of the Dark and Middle Ages was Vasari's own contribution to the new canon of art. His opinion of the great classical artists was the same that had been held by Ghiberti, Donatello and Leon Battista Alberti, and even by earlier art lovers before the true Renaissance began. And when Vasari roundly called Gothic architecture "barbarous,"[31] he was actually using the same adjective that had been used by Filarete a century earlier.[32] Vasari's real contribution to the new Vasarian canon was, rather, his analysis of the development of art in Italy, beginning with what he saw as art's "rebirth" in the time of Cimabue, Giotto, Nicola Pisano, and other masters of the late thirteenth and early fourteenth centuries.

From this beginning, Vasari conceived the story of Italian art in the fourteenth and fifteenth centuries as a majestic but difficult progression, consisting of a long series of triumphant solutions of technical problems mainly concerning the accurate, but also the graceful and harmonious, representation of the thing seen.[33] Within this majestic progression, the

masters of the late thirteenth and early fourteenth centuries were warmly praised for their roles in art's "rebirth," but in Vasari's eyes, they were sadly imperfect artists.[34] The great Renaissance masters of most of the fifteenth century were then applauded for coming much nearer to perfection—near enough to be termed "excellent" artists, though still faulty in several respects.[35] Vasari held, however, that true "perfection" was only reached when Leonardo da Vinci showed how Perugino could be much improved upon; and Western art's first canonical masters were therefore Leonardo, Raphael, Michelangelo, Titian, and the other giants of the High Renaissance.[36] Thus the Vasarian canon comprised the great artists of antiquity on the one hand, and on the other hand, the High Renaissance giants who were held to have equaled and even surpassed the "ancients" for the first time in history. It followed logically from the Vasarian canon, moreover, that all the masters of the fourteenth, and even fifteenth century before Leonardo's glorious advent, had been no more than historically important precursors—and therefore not collectors' prizes or models for later artists.

The Canon's Impact

It is far from easy for us today to imagine either the general way of seeing or the artists' way of thinking that inevitably resulted from acceptance of such a restrictive canon of art. We cannot, nowadays, quite take seriously Horace Walpole, who played a major role in the Gothic Revival, yet wrote that "all the qualities of a perfect painter never met" except in Raphael, Guido Reni, and Annibale Carracci—which was the narrowest possible interpretation of the canon in its eighteenth-century phase. Consequently, the very existence of such an accepted canon has sometimes been doubted—and of course it was a canon with considerable fluidity over time. But its character and its existence can both be learned from the first attempt on record to protect a "national heritage" of Western art. This attempt was made in 1601, when the Grand Duke Ferdinando I de' Medici issued an edict forbidding export from Florence of the works of eighteen listed masters.[37]

The idea behind the Grand Duke's edict was not new, for Pope Sixtus IV had forbidden export from Rome of any classical work of art at a far earlier date. A bit later, a letter from Isabella d'Este cheerily explained to one of her Roman agents that the papal edict could be easily circumvented by borrowing a friendly cardinal's mules,[38] presumably because cardinals' mules passed the papal custom houses without challenge. As one might expect, the edict of the Grand Duke Ferdinando was also circumvented by many a clever device.[39] Indeed, the first such edict ever to be successfully enforced was the ukase of Peter the Great forbidding export

from Russia of Scythian antiquities, which the Tsar promulgated after his Governor of Siberia, Prince M. P. Gagarin, had delighted him with a gift of Scythian gold work.[40] But that is beside the point. The real point of the Grand Duke Ferdinando's edict is the accompanying list of artists whose works were forbidden to be exported.

This list was drawn up by a committee of twelve painters belonging to the Florentine Accademia del Disegno,[41] whose members were also charged with issuing export permits in special cases.[42] Perugino, at first forgotten, was added to the list a little later;[43] but the original list in the original order began with Michelangelo and Raphael, and then went on to Andrea del Sarto, Domenico Beccafumi,[44] Rosso Fiorentino, Leonardo, Franciabigio, Perino del Vaga, Pontormo, Titian, Francesco Salviati, Bronzino, Daniele da Volterra, Fra Bartolomeo,[45] Sebastiano del Piombo,[46] Filippino Lippi, Correggio, and Parmigianino.[47]

Thus all the names that made the glory of Florentine art, from Cimabue and Giotto to Ghirlandaio and Botticelli, were blithely passed over until the Florentine list makers at last came to Filippino Lippi. One suspects, too, that Filippino was listed only because of Vasari's outspoken admiration for the classical decorative apparatus of his later work,[48] especially in the Strozzi Chapel in Santa Maria Novella, just as Beccafumi was probably listed because Vasari detested Sodoma[49] and sought to put him down by touting his pupil and rival.[50] The list's core figures, beyond argument, were the High Renaissance giants, conspicuously including the non-Florentines, Raphael, Titian, and Correggio. In short, this was not a list intended to vaunt the historical splendor of Florence. Instead it was a list of artists whose works' mere presence in Florence was regarded by the Grand Duke and his list makers as a significant "ornament" which the state should not dispense with.

Nothing could more dramatically underline the Europe-wide truth of Frits Lugt's remark, in the more limited context of seventeenth-century Amsterdam, that the High Renaissance had "drowned" all that preceded it, so that no earlier artists "counted" at all, with minor exceptions for Mantegna and Giovanni Bellini. For although Filippino Lippi was on the grand-ducal list, I should be much surprised by evidence that an export permit was ever requested for any of his works, in the whole long period when Florence was still ruled by Medici grand dukes.

For that matter, significant exports of the lesser listed artists, like Beccafumi, would also be mildly surprising, for the verdict of time did not confirm the full canonical standing of *all* the painters chosen by the special committee of the Florentine Academy. Among Italian masters of the later sixteenth century, time's judgment instead conspicuously conferred canonical status on the Venetians, Veronese and Tintoretto. In each generation thereafter, the canon was also expanded to accommodate further leading

masters, like the Carracci and Guido Reni, Rubens and Poussin. The Vasa-
rian canon, as thus expanded, in turn set the limits of all European art
collecting for a very long period. From Cimabue and Giotto to Ghirlandaio
and Botticelli, the uncanonical earlier masters were passed over as not
worth having.

There were leads and lags, as usual, before the limits imposed by the
Vasarian canon were all but universally accepted. A picture by Botticelli
turns up in one of the collections described in *Il Riposo,* and his paintings
plainly retained a certain appeal rather longer than those of most other
fifteenth-century masters in the period when the Vasarian canon began
to have its strong effects. One suspects this was because he was a great
charmer in paint. Careful reading of Herbert H. Horne's masterly mono-
graph will provide the evidence. Yet Horne ended his monograph with
the somewhat melancholy final statement that "all Botticelli's work had
been 'assigned . . . to oblivion'" within a "century of his death." Of
course, the more omnivorous collectors might, and often did, augment
their holdings with works by masters held to be inferior to those admitted
to the canon, but the canon still set the limits; for the lesser masters
the collectors selected almost always belonged to the same periods and
worked in more or less the same styles as those who had been canonized—
with only three exceptions.

A minor exception is required for "curious" artists like Arcimboldo.[51]
A major exception is required for the early painters of the Low Countries,
who constituted a special case. They were very far from being ranked
where we rank Jan van Eyck today. Their works commanded extremely
modest prices; and above all, they were every bit as uncanonical as their
Italian contemporaries. Yet collectors never wholly rejected the earlier
Northerners. In the sixteenth century, the powerful Regent-aunt of the
Emperor Charles V, Margaret of Austria, owned the Arnolfini Wedding;[52]
and in the seventeenth century, the posthumous inventory of Rubens's
pictures showed two paintings attributed to Van Eyck.[53] Alas, however,
one suspects the early Northerners were not entirely ignored by most of
the collectors in question for the very reasons given by Michelangelo when
he scornfully dismissed them as mere traffickers in eye-catching realistic
detail, fit only to please "women and Priests."[54]

Finally, another significant exception is required for collectors of draw-
ings, who always tended to be a race apart. Here, too, Vasari showed the
way, but in a different manner—as a collecting pioneer. His famous *Libro
de' disegni* was planned to illustrate Italian art history from its rebirth
(as Vasari saw it), with supposed Cimabues at the beginning.[55] Thereafter,
some other drawing collectors, like the Cavaliere Gaddi, who acquired
Vasari's *Libro,*[56] and later Cardinal Leopoldo de' Medici, also aimed for
art-historical completeness. Whereas this was never the aim of a single

general art collection in the whole of Europe until an epoch-making change in the way of seeing obscurely began in the eighteenth century.

The Canon Breaks Down

Meanwhile, because paintings by the early Italian masters "did not count," their many surviving works in Italy were not seldom deposed from the altars of old churches and the walls of ancient houses, to make way for something more fashionably up to date. In the end, many fourteenth- and fifteenth-century masterpieces thus came into the hands of *rigattieri*—the omnipresent Italian dealers in old clothes and other junk and near-junk. By definition, what no one wants or has a use for except poor buyers from *rigattieri* has temporarily become junk or near-junk. So bluntly stated, this may be hard-sounding when applied to works by Giotto; but the truth is often hard.

Thus the situation was created in which our art tradition's archetypal junk collector was able to form what was probably our art tradition's single greatest innovating collection. The place was Venice, the start was perhaps made in the eighteenth century's third decade. Fra Carlo Lodoli was a Venetian of good family, born in 1690, who joined a religious order, the Osservanti Minori, against his father's wishes.[57] He was also a highly intelligent and original man, and despite his faithfully kept vow of poverty, he made a considerable place for himself as a leading Venetian intellectual.

He founded a school for sons of the Venetian nobility with a curriculum distinctly advanced for the period.[58] He belonged to the circle of the famous English consul in Venice, Joseph Smith, the patron and picture-collector whose first and most important collection was finally bought by King George III.[59] Lodoli also corresponded with both Scipione Maffei and Montesquieu.[60] He had a passion for art and architecture, and was sufficiently independent-minded to be a functionalist in the time of the highest Rococo.[61] (He held, for instance, that Venetian gondolas were beautiful, though so severely unadorned, because form and function were so perfectly married.[62]) He has a place in this essay, however, only because of his lonely, brilliant, and entirely novel junk collecting. This was explained by Fra Carlo Lodoli's disciple and biographer, Andrea Memmo, as follows:

"Poor friar as he was, he could not have undertaken the acquisition of a series of paintings from the most celebrated masters, since they are out of reach of all but the very wealthiest people. . . . He therefore thought of forming a collection very different from others, and perhaps more useful, wanting to show the step-by-step progression of art from its rebirth in Italy up to Titian, Raphael, Correggio, Buonarotti, and [Veronese]."[63]

Art history—and of course chiefly Vasari's own listing of Italian art's early masters—was therefore Fra Carlo Lodoli's guide when he decided

to make a collection "very different from others." Perhaps he got the notion from the drawing collectors. Cardinal Leopoldo de' Medici, that great drawing collector, also seems to have been the only important European art collector in the whole seventeenth century who troubled to acquire paintings by Italian masters earlier than the High Renaissance—barring Lugt's two special cases, Mantegna and Bellini.[64] One must suppose the Cardinal's early drawings opened his eyes to the beauty of Botticelli's Madonna of the Pomegranate and Piero di Cosimo's Immaculate Conception.[65] Before Lodoli settled for good in Venice in 1720, he traveled in Italy and spent some time in Rome.[66] Given his interest in art, it is likely that he managed to see Cardinal Leopoldo's portfolios of drawings in Florence. And it is again likely that in Rome he met the collector-dealer Padre Sebastiano Resta, who regularly included drawings by the earlier masters in the volumes of mounted drawings from his own collection which he put together to sell to other collectors.[67]

At any rate, wherever Fra Carlo Lodoli may have got his plan for a "new kind" of art collection, he bought paintings by masters of the fourteenth and fifteenth centuries in great numbers but always cheaply. To make his finds, he searched the stocks of "ragpickers and Jews who dealt in anything which had been discarded by others."[68] Eventually, the finds became so numerous that the collection took over his whole life. The pictures were stacked, many deep, along the walls of his humble rooms. "There was nowhere to sit" except on "a pile of books or on his narrow cot, which had become his best sofa."[69] Yet what would one not give nowadays for a trip in a time machine to see old Lodoli among his stacks of pictures!

His Venetian section began with "some leftover paintings by a Greek painter, not difficult to find in Venice, which, before the re-establishment of art in Italy, was the one and only place to have the best that Greece [meaning Constantinople] had to offer—whether it be wives, dresses, or beautiful things which were fashionable."[70] After these Byzantine works— quite possibly from the time of the glorious decoration of the Kariye Djami![71]—there came pictures by the earliest Venetians who had "learned to paint from the Greeks"[72]—so many that Andrea Memmo confessed he could not remember any of their names except for Andrea da Murano and Jacobello del Fiore.[73] Gentile da Fabriano (considered Venetian because of his many connections with Venice and regarded by Memmo as the true founder of the mature Venetian school) was only represented by a small picture; but following this were works by "the two Vivarini da Murano," Carpaccio, Donato Veneziano,[74] Basaiti, all three Bellini, Catena, and others; and all these were then topped off, as it were, by some "little things" by Giorgione and the early Titian.[75] "The Florentine School" was also represented by "many pieces," beginning with Cimabue and Giotto.[76]

"The Lombard School" was covered, too, beginning with a Squarcione; and there were even a "few" pictures from the "Roman, Bolognese, German and Flemish schools."[77] If only half of Lodoli's attributions were correct, this was a collection that the richest museum curators would now commit unmentionable crimes to secure. Although Lodoli must often have gone wrong about his early Florentines and many of his other non-Venetians— for he had almost no comparative material to study—even this part of his collection would surely be deeply exciting today. Furthermore, Lodoli is likely to have been right in many cases with his Venetian attributions, at least from the time of Gentile da Fabriano.

In the upshot, Fra Carlo Lodoli fell in love with the early masters whose works he had begun to collect because he could not afford the great prizes of his day. When his rooms were robbed in his last years, he did not dare go through his stacks of pictures to see what his losses were.[78] It would give him too much pain, he said. Alas, however, Lodoli's prizes were still junk in the eyes of his fellow Venetians when he died in 1761. "People did not realize their worth," so the whole huge collection was somehow lost after Lodoli's death.[79] Pretty certainly, the pictures went back to the ragpickers who had supplied them.

By that date, nonetheless, the Abate Facciolati had also formed a collection similar in plan to Lodoli's. This professor of history at the University of Padua was a friend of Consul Smith's, like Fra Carlo Lodoli,[80] and it is probable that the two pioneering collectors were at least aware they were striking out a new line together. For all one knows, the Abate Facciolati may even have started before Lodoli, but the only data on the Facciolati collection known to me are the few lines devoted to it by P.-J. Grosley. In 1754, Facciolati's early pictures struck this French visitor as sadly crude but still historically instructive[81]—already a more open-minded view than Président de Brosses's opinion of the Rucellai Madonna.

In Florence, too, the Anglo-Italian art dealer Ignazio Enrico Hugford was interested in fourteenth- and fifteenth-century works, and he was not alone.[82] Hugford was notable in another way, as well—as the painter of the very first of Italy's countless fake primitives, which he provided to replace the ancient Madonna of Impruneta in 1758. A replacement was required because a traveling grandee had asked to see the wonder-working portrait of the Madonna supposedly painted by St. Luke himself; and when the immemorial wrappings were removed from the panel before the grandee's arrival, the whole former paint surface was seen to have crumbled to dust.[83] In this instance, the need was for a convincing icon rather than a work of art. However, Hugford was also the man who sold the Uffizi a supposed Self-Portrait of Masaccio, which was all but certainly acquired for the Medici gallery of artists' self-portraits.[84] With the advance of art history, this picture then became a Self-Portrait of Filippino Lippi;

but Ulrich Middeldorf recently and most convincingly put two and two together and reclassified the picture as another Hugford fake.[85] Professor Middeldorf's arguments have an importance going well beyond the problem of the correct attribution, for whenever any class of works of art begins to be faked, a turning point has always been reached.

The Museum Age Dawns

The mention of Hugford and the Uffizi brings the focus to Florence. In the latter half of the eighteenth century, Florence in truth became a center of the new development that most probably started in Venice with Lodoli. In particular, there were further dramatic results at the Uffizi that have never before been studied. In 1743, the Uffizi had been converted from a princely art gallery into the first of Europe's truly major public art museums by the death of the last of the Medici, Anna Maria Luisa, Princess Palatine. She bequeathed all the incomparable Medici collections to the city of Florence "as an ornament of the State, for the utility of the public and to attract the curiosity of foreigners";[86] and she made the new Hapsburg-Lorraine grand dukes of Tuscany the trustees of her bequest.[87] But this historic bequest apparently led to no important outward changes at the Uffizi[88] before Grand Duke Pietro Leopoldo assumed the rule of Tuscany in 1765.

The new Grand Duke was a reformer by nature, in this resembling his older brother, the Emperor Josef II of Austria, from whom he inherited the Austrian Empire in 1790. In the realm of the arts, the brothers' activities further deserve attention they have never received; for they were the un-doubted fathers of the modern Museum Age. The Emperor transformed the Hapsburg family collection into a great, proto-modern public art mu-seum. In the course of this enterprise, the man the Emperor chose for the job, Christian von Mechel,[89] a disciple of Winckelmann's, also removed the additions and put back as many as possible of the missing bits of many masterpieces that had been cut down or enlarged in the old way, in order to ensure symmetrical hanging in the original imperial art gallery in the Stallburg.[90] Yet the achievement of the Grand Duke was still more remarkable.

When Pietro Leopoldo reached Florence in 1765, the glorious Medici heritage of works of art was intact but in chaos. In the Uffizi, specimens of natural history, rich armor, quantities of porcelain, and treasures and curios of all sorts competed for each inch of space with the pictures and sculpture.[91] The Uffizi was independently administered, while the grand-ducal Guardaroba controlled the vast numbers of works of art in the Palazzo Pitti, in the public offices of Florence, and in the former Medici villas. The chances of the past had already caused a handful of paintings by

early Florentine masters to come to rest in the Uffizi. Two Fra Angelicos and a Botticelli—in a room jammed with crucifixes, amber cups, wax figures, and other pictures—were recorded in the gallery in 1761–62.[92] Meanwhile, however, most of the early masterpieces in the Medici inheritance were all but invisible in the domains of the Guardaroba. A good many were in the Pitti Palace, for example, gathering dust in an out-of-the-way room where they had allegedly been placed two centuries before at the suggestion of Giorgio Vasari.[93]

Such was the situation that the new Grand Duke then revolutionized. In Pietro Leopoldo's own eyes, the most important measure he took was almost certainly purging the Uffizi of the porcelain, armor, natural-history specimens, and the like, and the gallery's subsequent reorganization as a true public art museum.[94] As early as 1769, however, he also ordered a general comb-out in the domains of the Guardaroba, with the aim of bringing into the Uffizi everything worthy of display there. As a result, Fra Angelico's Linaiuoli Tabernacle, with its original frame by Lorenzo Ghiberti, came into the Uffizi from one of the public offices,[95] and it was followed by Piero della Francesca's Diptych of the Duke and Duchess of Urbino, which was transferred from the villa of Poggio Imperiale in 1773.[96] By the standards of that period, the exhumation (for that was what it amounted to) of these two great masterpieces was an extraordinary event; but it was only a beginning. The decisive step was taken in 1775, when the Grand Duke named Giuseppe Bencivenni Pelli to the directorship of the Uffizi and attached to him Abate Luigi Lanzi as assistant antiquarian.[97]

Bencivenni Pelli had already proclaimed his faith in a published essay on Masaccio. For him, as for Vasari, "perfection" was reached only in the High Renaissance; but he declared one could not "know the difficult secrets of the fine arts" without appreciating the early masters and studying all the stages of development of the arts.[98]

As for Luigi Lanzi, he was a learned ex-Jesuit—the order had just been suppressed—and Etruscan antiquities were his long suit in 1775.[99] Yet he must have begun already to formulate the ideas which later made him write the first "systematic" history of Italian art,[100] and thereby become the second founder of Italian art history. With these two men in charge, the new tide at the Uffizi naturally flowed more swiftly. Exhumations from the Guardaroba continued and increased, and early works of art now began to be acquired on the open market.[101] Thus the Uffizi had been enriched, as well as purged and rearranged, when Bencivenni Pelli wrote his proud account of the gallery in 1779.[102] At about the same time, however, the Grand Duke Pietro Leopoldo visited his brother in Vienna,[103] and in the course of this visit he probably learned of the Emperor's decision to have the reorganized Hapsburg collection shown art-historically, by schools and periods.[104] At any rate, this further advance was

made at the Uffizi between 1779 and 1782, when Luigi Lanzi published a guide to the newly rearranged gallery.[105]

By any standards, 1781–82 were epoch-making years in the premodern history of art in the West. The Uffizi and the Emperor Josef's new museum in the Belvedere Palace,[106] opened in 1781, in truth provided the models that were followed everywhere[107] throughout the Museum Age's immense ensuing development. There were some local stops and starts. By the influence of Jean-Marie Roland, French Minister of the Interior in 1792–93, for example, art-historical hanging was flatly rejected as too unesthetic in the forerunner of the Louvre established in the early stages of the French Revolution.[108]

This matter of the way collected works of art were formerly displayed is an interesting subject in itself. The truth is that for centuries after Western art collecting reached maturity, most collectors sought to display their prizes in ways that suggested they were really the results of patronage of the arts instead of art collecting. You can see this tendency strongly at work in the correspondence between the first Marquess of Lansdowne and his buying agent in Rome, the artist-dealer Gavin Hamilton.[109] The Marquess was careful to let Hamilton know his architectural plans for Lansdowne House; and Hamilton, in turn, went to great pains to find pieces of antique sculpture that would appear to have been specially designed for the niches the Marquess had waiting for them.[110] The aim was the kind of effect that must have been made by a major room in a Roman magnate's villa, for which Greco-Roman copies of architecturally suitable dimensions, postures, and character had been specially ordered from Athens.

The collectors of paintings sought to solve the same problem (which we can hardly understand as a real problem today) in two quite different ways. The more conservative solution was covering whole walls of the collector's picture gallery with painstakingly arranged mosaics of paintings, hung so that frame touched frame and almost no wall surface showed.[111] The penalty of this solution was the frequent need to make grossly incongruous juxtapositions—hanging a Van Eyck,[112] for instance, next to pictures startlingly different in style and date. The other solution imposed a graver penalty, however. This solution was to make rather rigidly symmetrical arrangements of pictures, large ones below, small ones above, and all in balance with one another. The desired symmetry was only achieved by "formatizing" great masterpieces; and this was why Christian von Mechel had to remove additions to pictures and remedy losses when the Hapsburg paintings were moved from the Stallburg to the new museum in the Belvedere Palace.[113] The Emperor Josef II's new public museum, with all the pictures restored to their pre-"formatized" condition where possible and shown art-historically without regard to architectural effect, thus placed

a novel, much stronger emphasis on art collecting's theme of the work-of-art-as-an-end-in-itself. And overall, the novel examples set by the Emperor and the Grand Duke Pietro Leopoldo in Vienna and Florence had a long-range impact which is too obvious to need further elaboration.

In the Uffizi, moreover, the collecting idea first adopted by Fra Carlo Lodoli was now made official, as it were, by the Quarto Gabinetto. Even today, the Baron Vivant Denon's Salles des Écoles Primitives, opened in the Louvre in 1814,[114] are still widely supposed to have been the first museum rooms to show early Italian paintings. From these rooms we get our modern usage of "primitive," but in reality, the future Ludwig I of Bavaria had agents in Italy buying early Italian masters for Munich considerably before Vivant Denon's rooms were opened in Paris.[115] More important, the Uffizi's Quarto Gabinetto preceded Vivant Denon's supposed innovation by over three decades. In his description of the Quarto Gabinetto,[116] Lanzi listed paintings by Cimabue, Giotto, Taddeo and Agnolo Gaddi, Orcagna, Uccello, Fra Filippo Lippi, Andrea del Castagno, Fra Angelico, the Pollaiuolo brothers, and Botticelli.[117] Later, a good many of Lanzi's attributions were corrected by the immense scholarly industry which Lanzi himself helped to refound.[118] Yet the errors in attribution matter little, compared to the public inclusion of the formerly excluded.

Two further points are also made by the Uffizi's Quarto Gabinetto. First of all, the inclusion of the formerly excluded must certainly not be taken as proof that the Vasarian canon had already broken down for good. The motive, instead, was to illustrate art history. For example, the Uccello *battaglia* on Lanzi's list was the panel of the Rout of San Romano that is still one of the glories of the Uffizi.[119] But of course this was only one of three panels originally painted for Cosimo de' Medici.[120] At about the time when the Uffizi panel was exhumed from the Guardaroba, Uccello's two companion panels were evidently disposed of in one of the Guardaroba's occasional sales of Medici[121] leftovers, and this is how these two finally came to London and Paris by devious roads. One can only conclude that Lanzi and Bencivenni Pelli did not admit all three panels to the Uffizi, and did nothing to stop the sale of the remaining two, because both felt one large panorama of horses' rumps was quite enough to illustrate Uccello's *prospettiva*. Secondly, however, the Quarto Gabinetto clearly proves that when Fra Carlo Lodoli was first inspired by art history to search the stocks of the Venetian ragpickers, he was merely responding with extra promptness and sensibility to a novel but rather widespread impulse that was somehow in the air of Italy in the eighteenth century.

Why this impulse first made itself felt in Italy alone may seem to pose a difficult question. No such impulse can be detected in the rest of Europe until the eighteenth century's end;[122] so one wonders why Lodoli

and all the others who early took the same course were Italians themselves, or else foreigners who formed their collections while living in Italy. Reflection soon provides the obvious answer, however. In Italy alone works of the great Italian masters of the fourteenth and fifteenth centuries were easy to come by—as well as cheap. The cheapness mattered a lot to the collectors, too, as the easy availability of the Guardaroba's stores obviously meant a lot to Lanzi and Bencivenni Pelli. Toward the eighteenth century's close, the eccentric Earl-Bishop of Bristol and Derry announced, grandly, that he was adding to his large collection "all that old pedantry of ancient painting"[123]—mainly meaning works by Cimabue and Giotto!—but the Earl-Bishop was the first rich man in the field.[124] All the other pioneers had an economic motive for their choices, just like Lodoli.[125]

The economic motive was frankly admitted by the French Chevalier Artaud de Montor, who formed his collection while serving in Rome in a minor diplomatic post in the late eighteenth and early nineteenth centuries. In the preface to the catalogue he subsequently published in France, he explained that he had decided to illustrate art history by gathering the early masters solely because "no private man" could any longer hope to secure works by "Raphael, Correggio, Giulio Romano, Andrea del Sarto, the Carracci, Guido and Domenichino."[126] It must be added that the economic motive was evidently reinforced by the freedom with which the best-known early names were then attached to sufficiently ancient-looking paintings. Artaud de Montor believed he owned seven Cimabues, four Giottos, and much more on almost the same level.[127] One can see how wrong he was by visiting the dim recesses of the New-York Historical Society;[128] for this was the final resting place of the "Museum of Christian Art" formed in the first half of the nineteenth century by the eccentric Thomas Jefferson Bryan, one of America's earliest true art collectors.[129] Bryan's mass purchases abroad included much of Artaud de Montor's collection.[130]

The Early Masters' Rise

All this may seem mere anecdotage. In reality, however, the facts so briefly related show the real origins of a truly crucial episode in the premodern history of Western art and taste—the radical revaluation of the early masters which has now placed Giotto on a par with Raphael himself.[131] In this vast change in the Western way of seeing, art historians had their own role, alongside the art collectors, as is shown by Luigi Lanzi's share in the ground-breaking changes at the Uffizi. Nor should one forget J.-B. Seroux d'Agincourt, who settled in Rome in 1778 to compose his monumental, again ground-breaking *Histoire de l'art par les monuments depuis sa décadence au IVe siècle jusqu'à son renouvellement au XVe.*[132] Further-

more, Seroux d'Agincourt's personal influence was pretty surely more important than his belatedly published book,[133] for the list of those close to him in Rome is not far from being a roster of the collecting pioneers of the generation that straddled the eighteenth and nineteenth centuries.

Among these friends of Seroux d'Agincourt was Artaud de Montor,[134] as was his diplomatic chief in Rome, François Cacault, whose collection included important early pictures.[135] In the same group were the Englishman William Young Ottley, who both collected and wrote about the early Italians,[136] and the Baron Vivant Denon's later subordinate at the Musée Napoléon, Léon Dufourny.[137] While in Italy, Vivant Denon himself must surely have met Seroux d'Agincourt, for he had a way of meeting everybody. Yet one suspects it was Dufourny who suggested the plan for the Salles des Écoles Primitives when great numbers of important primitives were thrown onto the market by the Napoleonic suppression of the Italian monasteries and convents.[138] Then there are others who should be mentioned, if comprehensiveness were the aim here, like the Florence-based English artist and caricaturist Thomas Patch, who engraved and published the Masaccio–Masolino–Filippo Lippi frescoes in the Brancacci Chapel in 1770.[139] This set the precedent for the books of engravings of early Italian works which helped to inspire, first those German pre-Raphaelites the Nazarene painters,[140] and later the English pre-Raphaelites as well.[141]

Enough data have been accumulated, however, to show that in Italy in the last two thirds of the eighteenth century, a crucial reappraisal began which influenced the way men saw the great art of the European past quite as importantly as the Gothic Revival itself. It was far from happening all at once. For example, the commissioners from Tuscany could have carried home again the entire contents of the Louvre's Salles des Écoles Primitives after Waterloo, when Napoleon's looted works of art were being returned to their countries of origin.[142] But the commissioners thought such pictures were hardly worth the cost of packing and shipping;[143] and in any case, they preferred some richly inlaid stone-topped tables which were then in the Tuileries.[144] To this choice by the Tuscan commissioners, the Louvre today owes many of its finest Italian primitive paintings.

During the dawn of the nineteenth century, nonetheless, men with more ample means for the first time began to acquire the early masters' works, not solely for art-historical reasons or in the patronizing way of the Earl-Bishop of Bristol and Derry, but because they truly wanted them, even though they continued to make obeisance to the Vasarian canon.[145] When this stage opened, the leading figures were people like the English banker William Roscoe, who translated Lanzi's *Storia pittorica dell'Italia* and eagerly collected the early Italians until he got into financial difficulties;[146] the Boisserée brothers in Cologne, who concentrated on the early art of northern Europe;[147] and the Berlin-based English dealer

in Baltic timber, Edward Solly,[148] who secured great numbers of major early Italian works during the Napoleonic Wars,[149] and also bought the side panels of the Van Eyck Adoration of the Lamb.[150] Some of Solly's Italian altarpieces were huge, like the Starnina triptych,[151] which was one of the few such very large works to survive the destruction of part of the Berlin collection in the famous bombing of the Berlin flak tower in the Second World War. Because of the sheer size of so many of the paintings Solly managed to bring out of Italy, I myself have always suspected that he got the pictures through the strict Napoleonic border control, and thus to Berlin, with the help of a connection on the side with the British Secret Service. Even if he had such a connection, however, he was also adroit enough to use the Secret Service networks with remarkable effect.

In any case, these were all turning-point collections, destined to become the prides of great modern art museums.[152] When financial reverses forced Solly to sell his three thousand pictures in 1821, the way of seeing had already changed enough to persuade King Friedrich Wilhelm II and his Prussian government to pay the really enormous sum of £630,000[153]— and this for a collection that was in large part almost as foreign to the Vasarian canon as the lost collection of Lodoli! Many, as I have said, were later lost when the Berlin flak tower was destroyed by bombing. But the truly symbolic end of the Solly story was when the Treaty of Versailles specifically ordered the return of Solly's side panels of the Adoration of the Lamb from Berlin to the Cathedral of St. Bavo in Ghent, as part of Belgium's war reparations.[154] The mighty Van Eyck altarpiece was thus reunited at last;[155] and the rise of the early masters to the highest rank of art was grandiosely confirmed. When Giotto and Duccio di Buoninsegna were ascending to canonical status, in fact, Van Eyck and Rogier van der Weyden ascended alongside them.

If you want an example of the basic process of the early Italians' rise, which was fairly slow, there is the matter of the exquisite little Crucifixion attributed to Duccio. In 1863, it was bought at auction by the 25th Earl of Crawford and 8th of Balcarres for 250 guineas, or $1,313 of those days;[156] and not long ago it was sold by the 29th Earl for £1,000,000, or $1,780,000 in then-current money.[157] It should be noted, too, that long before the 25th Earl acquired his Duccio, he published one of the pioneering studies in English of the Italian primitive painters.[158] It is a mortally boring book; but it is still significant that its author, then Lord Lindsay, was the first to say that Piero della Francesca's frescoes at Arezzo were "masterly in every way," indeed comparable to the Elgin marbles, albeit "totally unknown and unappreciated."[159] Nonetheless, Fra Carlo Lodoli began to collect well over a century before Lord Lindsay and a friend visited Arezzo; he was actively collecting much more than two generations before Solly

and the Boisserée brothers; and Lodoli probably started visiting his ragpick-
ers a decade before Luigi Lanzi was born in 1732.

The Dame de Volupté

The tremendous episodes in the story of Western art which have just
been recounted—the establishment of the Vasarian canon of art and the
beginning of the canon's ultimate collapse—were both at bottom cases
of art history's shaping the way of seeing. The West's first art historian
established the Vasarian canon. Two centuries later, the canon then began
to be undermined by art-historically motivated collecting, directly inspired
by the data provided by Vasari and his successors. It goes without saying,
too, that each of these great changes in the way of seeing ended by pro-
foundly affecting artists' ways of working.

Nonetheless, we have by no means exhausted the matter of the art
collecting-art history interaction, always resulting from the shared blood-
stream of ideas and viewpoints. Art history not only can and does affect
art collecting in all sorts of far-reaching and sometimes unexpected ways.
Art collectors' innovations can also affect art historians, again in all sorts
of ways. To illustrate this kind of interaction, it will be useful to take
the most important early case of art history's being all but rewritten by
art collecting—the drastic revaluation of the seventeenth-century "cabi-
net" or genre painters of the Low Countries. The art-historical before-
and-after contrast produced by this rather specialized revaluation was ex-
ceptionally dramatic. To see the "after," you need only glance at any
art-historical compendium of leading artists of the past that was written
outside Germany and the Low Countries, from about the date of Mariette's
Abecedario[160] in the mid-eighteenth century until our own time. To see
the "before," it is enough to examine Roger de Piles's curious Balance
des peintres, published in 1708.[161] This shows in what a limited way
time had by then expanded the Vasarian canon, as it also shows that
great masters remained canonical even if rather disliked, as De Piles plainly
disliked Michelangelo.

The real revelation of the Balance, meanwhile, is the way the tremen-
dous seventeenth-century flowering of painting in the Netherlands, and
much of the allied development in the Spanish province, had been all
but ignored in the rest of Europe. Rembrandt was included by Roger de
Piles, with a medium rating; and so was Teniers, with a slightly lower
rating.[162] Among the seventeenth-century artists of the Low Countries,
Rubens was of course de Piles's great hero, and those linked to Rubens
in some way were also noticed. But that was that. Already, however, an-
other revolution in the Western way of seeing was being organized by

the astonishing lady who called herself the Dame de Volupté.

She started life as one of the fourteen children of the Duc de Luynes. With so many to provide for, the Duke had to marry his daughters where he could, and at the age of thirteen the future Dame de Volupté was married off to a youth at the court of Savoy, the Comte de Verue.[163] She seems to have much enjoyed her sixteen-year-old husband; but she almost immediately enchanted the Duke of Savoy, and was all but pushed into his bed by her ambitious and/or negligent seniors.[164] For considerably more than a decade thereafter, she was a classic bird in a gilded cage, loaded with jewels and other rewards but all but held in confinement by her ruler-lover.[165] In 1700 she managed to escape clandestinely to Paris, and before long set herself up in great luxury with her gains.[166] The character of her new life is indicated by the epitaph she composed for herself, as follows:

> Çi-git, dans une paix profonde,
> Cette Dame de Volupté,
> Qui, pour plus grande sureté,
> Fit son paradis dans ce monde.[167]

Saint-Simon, so often disapproving, tartly records that despite the Comtesse de Verue's sadly improper past, she became what is now called a "taste-maker" in the Paris of her time;[168] and this is important because of the way she furnished her paradise in this world. Her very large art collection in fact centered on the seventeenth-century painters of the Low Countries, but the genre or "cabinet" painters rather than Rubens. She owned no fewer than seventeen Teniers by the end of her life, for instance.[169] Thus began the tremendous Europe-wide interest in these painters, rather like the modern fashion for the French Impressionists, which was reflected in just about every Paris art collection and art auction for more than a century after the Dame de Volupté's own posthumous dispersal of 1737;[170] and also in many English art collections, like those of George IV and Sir Robert Peel.[171]

One thing was still missing, however. While Gerard Dou and Nicholas Berchem were at the top of the collectors' wanted-lists,[172] Vermeer remained all but unknown until the omission was belatedly remedied, in this case by art history.[173] The French art-historian, critic, and theorist Théophile Thoré-Bürger spotted Vermeer's greatness when he saw the View of Delft in the Hague;[174] and much later, he published his three articles on "Van der Meer de Delft" in the *Gazette des Beaux-Arts* of 1866, which soon made Vermeers collectors' prizes.[175]

Overall, it must also be noted that the main effect of the art collecting-art history interaction in the last two hundred years has always been to extend men's range of experienced delight. Without this continuous inter-

action, indeed, we should know no more today of Bruegel,[176] Georges de la Tour,[177] most of the great Spanish masters,[178] and God knows how many more, than was known of Vermeer before Thoré-Bürger had his revelation in the Mauritshuis.

It was quite inevitable, too, that all these extensions of the range of experienced delight should cause the final subversion of the Vasarian canon. As already mentioned, the Gothic Revival was pioneered by people like Horace Walpole. Yet by the early nineteenth century, serious art historians were studying Gothic art in most of Western Europe; and in the next stage, the great collections of Gothic art began to be formed,[179] and half of Europe began to be covered with more and more learnedly pseudo-Gothic edifices. In the case of the revaluation of classical art, the art historian Winckelmann laid the groundwork, and the collector Elgin inaugurated the next phase. The return to our tradition's early masters needs no further comment. And the combined result of these three great processes of revaluation was not only the collapse of the Vasarian canon. By the continued operation of the art collecting-art history interaction, the range of experienced delight was still more vastly extended thereafter, to embrace the arts of all the peoples in the world that are still known to us. Thus arose the modern way of seeing.

So a question that is perhaps wicked suggests itself. Both old Carlo Lodoli and the Comtesse de Verue, in their very different ways, were among the earliest important subverters of the Vasarian canon. But would they have enjoyed the end results of the canon's final collapse if they could see them today? What would they think, for instance, of galleries full of the fairly bloodstained art of New Guinea? Could they, indeed, have faced these end results with equanimity?

The Response to Art

Enough evidence has now been offered—from a great store of it—to show the effects of the Siamese twin–like shared bloodstream of ideas and viewpoints which always flows back and forth between art collecting and art history. But why and how, one asks, does this Siamese-twin relationship between the two phenomena ever come into existence? In other words, what is the root cause?

To track down the answer to these questions, it is best to return to the junk collectors. Modern junk collectors have no such opportunities as Fra Carlo Lodoli, for every flea market the world over has been scoured by earlier junk collectors and by the lower order of art dealers. Yet the most tragically poverty-stricken men and women still succumb to the collecting impulse. Even if all but uneducated, furthermore, they will always say to you in tones of pitiful hope that their seediest found objects "just

could turn out to be genuine antiques," or that their most appalling daubs "just might be really good pictures." In such cases, you can always read "genuine antiques" and "really good pictures" as meaning "art-historically identifiable." This insistence on the power of art-historical identification implies a complex response, quite different from the response of one who says, of this chance-found sea shell, or that piece of sea-gnarled driftwood, or of a deep-hued lump of amber, "Isn't it lovely?"

To pinpoint this crucial difference of response, you need only put another ending to the story of one of the more dramatic rescues in Western art history. The two Michelangelo Slaves in the Louvre have a story that is not merely dramatic, but also tragic and even bloodstained. Because of the "tragedy" of the tomb of Pope Julius II—as Michelangelo himself called that tangled drama[180]—the Slaves were surplus, and two came into the French royal collection.[181] For great services, toward the middle of the sixteenth century, King Henri II gave them to the Connétable de Montmorency.[182] Early in the seventeenth century, that voracious collector Cardinal Richelieu decided he must have the Slaves, but the Slaves had by then been built into the entrance of the Montmorency château, Écouen.[183] Unwisely, however, the Duc de Montmorency entangled himself in the rising of Louis XIII's treacherous and frivolous brother, Gaston d' Orléans. When apprehended, the Duke offered the two Michelangelos as a gift, presumably to save his skin;[184] and the Cardinal coolly accepted the gift and had the last head of the senior house of Montmorency executed all the same.[185] From the Cardinal, in turn, the Slaves descended to the Duc de Richelieu of the time of the French Revolution; and the Slaves were being used as pieces of garden sculpture when the Hôtel Richelieu in Paris was attacked and sacked by a Revolutionary mob.[186]

Whereupon, by great good fortune, Alexandre Lenoir somehow heard that the Hôtel Richelieu was in danger, and hastened to the scene to rescue its garden sculpture, which included Greco-Roman copies[187] as well as the Slaves. Like an aged but efficient firehorse, this singular man charged off to every possible scene of desolation throughout the Revolution, in order to save threatened works of art for his Musée des Monuments de l'Art Français.[188] Lenoir's Musée must have been a very odd institution— it even had an "Elysian" garden where one could picnic, sentimentally, among the rescued tombs of eminent French dead[189]—but it provided a safe haven for the two Michelangelos. They came to the Louvre in the end because Lenoir's beloved Musée was dispersed, thereby half breaking his heart.[190]

Only suppose, however, that the old firehorse had not been in time, or that Lenoir had been otherwise engaged at St.-Denis,[191] or Anet,[192] or another of his many rescue places. In that event, the Duc de Richelieu's garden figures, if not smashed to rubble by the mob, would surely have

been snapped up by one of the sordid secondhand dealers who battened on the French Revolution's destructions and dispersals. Most probably, the Slaves would then have been sold for garden sculpture once again and would have found a new home in Neuilly or somewhere similar. Invaded by lichen, gathering dust among the dusty laurels, losing now a nose and now part of an arm to the accidents of all garden sculpture, the Slaves would not have been *seen* as Michelangelos, perhaps for many decades, perhaps to this very day. Those with good eyes might have admired them. But it is a hundred-to-one bet that in the quite possible circumstances here envisioned, an enormous interval would have elapsed before these two masterpieces of High Renaissance sculpture finally evoked an assured Michelangelo response—whereupon collectors' competition would have richly profited the garden owner or, more likely, the person who spotted the true identity of the two lichen-covered statues.

This new ending to the story of Alexandre Lenoir's heroic rescue is of course imaginary; but both the Michelangelo response and its extreme importance are the opposite of imaginary. Nowadays it may be a Modigliani response, or a Shang bronze response, or a Mochica pottery response. At any rate, this kind of response, which is essentially art-historical, runs through all art collecting from start to finish. Even in the cases of collectors of contemporary art, the guiding star is still art history, because they are always betting that a favorite new painter or an admired new sculptor will eventually call forth something like a Matisse response or a David Smith response.

Art as Relic

To see the full significance of this peculiar response to art, you have only to consider, first, the curious story of the earliest recorded effort to fake a major masterpiece of Western art. Federigo II of Mantua was not only a great patron of the arts; he was also one of the earliest true collectors of Renaissance works of art; and he wanted a major Raphael—the usual collectors' desire—for Mantua. As Captain General of the Holy See, Federigo II was a man the second Medici Pope wished to please; so he hit upon the very great Raphael, painted as a Medici family portrait, of the first Medici Pope and his two nephews. In 1524, he asked Clement VII to get the portrait for him from its then owner, Don Ottaviano de' Medici.[193] Instead, Ottaviano de' Medici called in Andrea del Sarto to make an exact copy of the Raphael.[194] When the copy was finished, it was sent to Mantua, where Federigo II was "delighted"; and his court painter, Giulio Romano, fresh from being Raphael's chief pupil and studio assistant, "did not suspect the truth."[195]

Much later, when Federigo was dead, Giorgio Vasari explained to Giulio

Romano what had really happened. Giulio, who claimed to have worked on the original in Raphael's studio, protested that he "recognized his own handiwork" in parts of the picture, and at first refused to believe Vasari.[196] The story's point mainly lies, however, in the much later sequels, when the two pictures had finally come to rest, the real Raphael in the Uffizi and the Andrea del Sarto copy in Naples. On the one hand, art historians still argue about which two square inches of the Uffizi's picture were the contribution of Giulio Romano, and therefore should not evoke a Raphael response.[197] On the other hand, for decades in the nineteenth century, Italy resounded with the discord between pro-Naples and Florence-leaning art historians.[198] Each group claimed that *their* picture was the real thing, and therefore uniquely worthy of the Raphael response rather than the somewhat inferior response suitable to an Andrea del Sarto!

It is easy to laugh at these nineteenth-century Italian art historians for thinking and feeling this way about two marvelous, closely similar pictures, both by great, nearly contemporary masters, and known to have been literally indistinguishable when the second picture was painted. In fact, however, this is a way of thinking and feeling that is universal among art collectors as well as art historians.

The question therefore arises whether our art historians and art collectors are not a good deal less logical than old Guibert de Nogent. In the eleventh century, Guibert wrote *De Pignoribus Sanctorum*,[199] a powerful attack on the fakers of holy relics who were so common in his time. He was moved to take pen in hand by the claim of the monks of St.-Médard to possess a veritable tooth of Jesus Christ,[200] when all knew that the Savior had ascended to Heaven intact after His Resurrection.

Guibert considered that properly documented relics were perfectly acceptable,[201] and he had nothing to say against the large pilgrimage revenues that genuine relics brought to any ecclesiastical institution that owned famous ones. He was fairly charitable about the mistake of an overeager bishop, who had been tricked into believing that the bones of St. Exuperius were contained in the tomb of quite another Exuperius.[202] But he was extremely acid about his time's numerous traffickers in false relics, and about the pilgrim-hungry ecclesiastics who conferred false sainthood on mere "boys" buried in their graveyards.[203] He deplored the ease with which a saintly origin might be claimed for any "common" human bone.[204] Since this kind of relic was so particularly easy to fake, he further recommended a firm rule against multiplication of relics by dismemberment of saints whose tombs might have to be opened, even if the saints in question were well attested.[205] Nor was all this in the least odd or eccentric—although we may think it so. Being a man of his time, Guibert de Nogent fully believed in the intercession of the saints, and in the beneficial powers of true relics of the saints.

On one condition, Guibert de Nogent was in fact more logical by a

long chalk than our art historians and art collectors of today. If you truly believe that genuine holy relics—but only genuine ones, of course—can cure all sorts of human ailments, it is entirely rational to want relics to be genuine. And if you truly believe that the esthetic response is the *sole* important response to works of art, then it is *not* rational to care enormously about the true origin of a fake Raphael painted by another major master and good enough to deceive Raphael's leading pupil and studio assistant for a period of many years. But this only makes Guibert de Nogent more logical than our leading art historians on the all-important condition that the sole significant power of works of art is the power to evoke an esthetic response. In reality, however, the esthetic response is by no means our sole response to works of art, although most people wrongly think it is the sole response that matters.

The plain truth is that the esthetic qualities of works of art, although so immensely important, are by no means the only qualities which people of the rare art traditions have seen and responded to. At a minimum, all educated men of the rare art traditions have seen and responded to art *historically* as well as *esthetically*. Among our Western collectors, curators, and art historians, this double esthetic-plus-historical response is merely extra strong. Few are so forthright about it as the eminent student of Chinese art who has written that "right understanding" of any work of art can never be achieved without "right understanding of the work as a historical monument."[206] Yet all, without exception, feel the need for a correct attribution of every work of art, and all share the desire to know a work's historical context which any attribution inevitably carries with it.

That being so, the most deceptively exact Dasson copy of a Riesener desk, and the most brilliant modern pastiche of a Byzantine or late Roman consular diptych, and even an Aert de Gelder or a Govaert Flinck fine enough to have been accepted as a Rembrandt by the wisest critics of the previous two centuries—all these are still totally unacceptable because of the double response, historical as well as esthetic. Some of us may want such pictures and objects for decorative purposes. Art collectors and art historians may even rather like them. But art collectors and art historians and museum curators must nonetheless condemn them—and always do so.

The reason for the unvarying condemnation is the double response to art; and this leads to one of the more important and least suspected aspects of the by-products of art. In brief, art collecting and its associated phenomena invisibly but significantly transmute art in more ways than one. Art collecting makes ends in themselves of works of art produced for use plus beauty. The historical response to art that always goes with art collecting then causes all works of art, of whatever sort, to be considered as historical documents as well as things of beauty.

False historical documents, naturally, are never acceptable. Thus the deceptive Dasson copy, the skillful pastiche of a fifth-century ivory, the pleasing Aert de Gelder masquerading as a Rembrandt, must be rejected because they are all false documents. In such cases, *this historical response to the work of art actually overwhelms the esthetic response.* If proved to be a false document, the work of art must go to the collector's cupboard or the museum's cellars, not because it is any less pleasing esthetically, but solely because it is a false document. It is as simple as that. Thus the seemingly insoluble esthetic problem of authenticity is nothing of the sort. It is easily soluble because it is a historical problem, directly derived from the all-powerful role of collectors' categories in all collecting.

Defining the Historical Response

At this point, what is meant by the historical response plainly needs definition. On the lowest level, people respond to art historically whenever they attach importance to the history of the pictures, pieces of sculpture, or whatever as *works* of art. Thus it is not an important historical response to art *qua* art to call a church treasure *"l'écrin de Charlemagne"* because Charlemagne is wrongly supposed to have been the donor, or to remember that the biggest of the innumerable projects of the Emperor Justinian, that passionate builder, was the Cathedral of Hagia Sophia. Great patrons of the arts have been recorded and commemorated in many art traditions which had no art collecting, as has been pointed out; but despite patrons' inevitable share in the act of creation, they do not do the real work. On the other hand, it is a distinctly historical response to art to look at Hagia Sophia and praise Anthemius of Tralles and Isidorus of Miletus,[207] for they did the work. It is also an historical response to say of the Stanze, "These were Raphael's greatest conceptions," or even to say of any work of art, "This is a Claes Oldenburg," or "a classic Maya stele," or "an Amlash pot"—and so on and on.

Any kind of identification of a work of art is necessarily historical, so it is again a historical response to say, "These works are of that period, whereas those others are of this period," or to classify works of art by styles, or places of origin that imply stylistic traits, or schools of art marked by their own peculiarities. In short, *the historical response to art always— and only—occurs whenever and wherever people somehow situate in history artists and their works.*

Remembered Masters

The origins of this peculiar but important historical response to art have always been simple enough. The people of a given culture have

cared enough about their art to start remembering the leading masters of each generation. Significantly, all five of the rare art traditions have had many *remembered masters*—the label I shall use hereafter. And just as significantly, the cultural practice of remembering great masters of the past has never developed anywhere or at any time in the world history of art beyond the rare art traditions' limits.

Please note the phrase "cultural practice," however. In medieval Europe, for instance, even the greatest masters were never truly remembered; but as we go forward, we shall find a few borderline cases in the Middle Ages.[208] Again, the Yoruba praise chant for Ogunwale also praises the artist Ogunwale patronized, Lagbayi, nicknamed Arukumoda, who "carved wooden posts as images along the king's veranda" and "with intuitive measurement" could "change a piece of wood . . . into a human shape."[209] If a computer could somehow be fed all the artists' names in all the literatures of all the cultures that have left surviving documents of one sort or another, no doubt the right computer program would spew out a few more unexpectedly remembered masters. But this kind of highly exceptional preservation of an artist's memory, though interesting and striking, is far from being proof of an established cultural practice. In the overwhelming majority of art traditions, the normal cultural practice was simply to consign dead artists to oblivion along with every other sort of artisan.

In the first three millennia and more of Indian art history, for example, there is only one case of artists' names being recorded to parallel the praise for Lagbayi the Yoruba wood carver; and there is nothing to show that the Indian ivory carvers converted to sculptors in stone, who worked at Sanchi in the Andhra period, were ever generally remembered, although their names were inscribed on the great gate of the stupa which they decorated.[210] Instead, the first undoubtedly remembered Indian masters belong to the late period when Mogul art was in reality a province of later Islamic art.

Again, only survey the whole world history of art before something very wonderful and different began to happen in Greece in the seventh century B.C. You will find precisely five names of artists, or probable artists, who were demonstrably remembered by one or another of the early higher civilizations. Three are plainly mythical Old Testament figures: Tubal Cain,[211] the first artificer, and Bezaleel and Aholiab,[212] who were personally commanded by Jehovah to make the Ark of the Covenant for Moses. Then there is a historical Egyptian sculptor-architect-engineer who was remembered because he became a god after his death,[213] and there is another Egyptian deity whose occupation in his lifetime was just possibly architecture.[214] And there you have the entire worldwide list.

Two steps are needed, to be sure, before the full import of the foregoing facts can be easily grasped. First, you must cross off the list all masters

like the Egyptian sculptor-architect-engineer who was posthumously dei-
fied, and was therefore remembered as a god rather than an artist. In
the Middle Ages, St. Eloy (or Eligius) and St. Bernward of Hildesheim
were both artists but were remembered as saints;[215] and other cases of
the same sort might also be cited. Then, too, you must make the considera-
ble effort to look backwards in time, to the period *before* large numbers
of artists' names were added to the record by modern art history and
modern archeology. Artists whose names have been found in royal building
accounts, or in church records, or even in monastic chronicles unread
for many centuries, are not what I mean by remembered masters.[216] Nor
are the Egyptian artists whose names the archeologists have found in
tombs.[217]

What I mean by a remembered master, in fact, is an artist permanently
enshrined in the general cultural memory, as Giotto and Cimabue were
immediately enshrined as famous painters in our own art tradition, as
Phidias and Polyclitus were immediately enshrined as famous sculptors
in the classical art tradition, and as the two Wangs were immediately
enshrined as famous calligraphers in the Chinese art tradition. None but
the rare art traditions have regularly enshrined artists in their cultural
memories in this manner. And almost none but the rare art traditions
have even told tales or anecdotes or legends about artists, as can be learned
by careful analysis of *Legend, Myth, and Magic in the Image of the Artist*
by Ernst Kris and Otto Kurz.[218]

In each of the five rare art traditions, a considerable phase when masters
were remembered further preceded the second phase, when the tradition's
works of art began to be collected and its art history began to be written.
In our own Western tradition, to begin with, each generation's leading
masters unquestionably began to be remembered at the opening of the
fourteenth century, and by that century's end, lists of eminent Italian
artists also began to be compiled. The first list maker was Filippo Villani,[219]
the third of the Villani chroniclers of Florence. Several further list makers
followed;[220] and the last one, whose list was much used by Giorgio Vasari
himself, was the unidentified author of the sixteenth-century work known
as the *Anonimo magliabechiano.*[221]

The Greeks, again, remembered their own masters from the very early
Archaic stage of Greek art; and the Chinese tale of remembered masters
similarly reached back to the beginning of the second phase of Chinese
art. In Japan, one remembered master, the very early painter Kanaoka,[222]
somewhat unexpectedly crops up in one of the world's greatest histories
of warriors, their ambitions, their stratagems, and their tragedies, the *Heike
Monogatari*, which describes Japan's military-political upheaval in the
twelfth century; and there is no doubt that the more important Japanese
artists began to be remembered at a much earlier date.[223] In Islamic culture,

calligraphy was always a great art in itself, as it became in China near the beginning of Chinese art's second phase; and the first Islamic calligraphers to be truly remembered worked in the ninth century,[224] while the first painters on the later Islamic remembered list date from the fourteenth century.[225]

All these facts mean, quite simply, that in the cultures that nourished the five rare art traditions, people began to respond to art historically soon after each of these art traditions began to take recognizable form. Here, moreover, is the most probable explanation of the unvarying Siamese-twin relationship of art collecting and art history. I believe, in fact, that the two phenomena have this relationship because they really are like Siamese twins, in the sense that both come from the same egg—the egg being the historical response to art.

Anyone can perceive that the historical response to art is the egg that art history comes from; and a little thought will show you that the historical response is also the egg that art collecting comes from. As a first example, consider Federigo II of Mantua's pressure on the Pope to secure a Medici family portrait by Raphael. This pressure was applied not long after Raphael had died, too soon, and in the earliest period when works of our own art tradition began to be truly collected in Italy. Federigo of Mantua could very easily have given a commission to Andrea del Sarto to paint a far more appropriate Gonzaga family portrait; and he could also have told Andrea that he wanted his Gonzaga portrait to be modeled on the Raphael portrait. Instead, he was determined to have the Raphael, because Raphael was already seen as a great figure in history, whereas Andrea del Sarto was not yet seen in this way; and if he had learned that he had been fobbed off with an Andrea del Sarto, he would surely have been deeply angered.

By the same token, the Japanese envoys to the Tang court at Chang An wanted specimens of the brushwork of the two Wangs because this father and son were again seen as great figures in history; and the Japanese envoys would surely have been outraged if they had learned that they had been fobbed off with copies. In just this fashion, and in every art collection the world over since art collecting began, the two very different responses to art, historical and esthetic, have always interacted; and they still interact in every art collection today.

It is no wonder, then, that art history and art collecting have always been linked together in a Siamese-twin relationship; nor is it surprising that this link has never been severed. Consequently, there is a simple remedy if the splendor of any ancient society's remains should tempt you to say, "But these people really must have been art collectors! What nonsense to imagine art collecting has been limited to so few art traditions!" Just ask yourself whether there can have been an E. H. Gombrich or a

Meyer Schapiro in Ur of the Chaldees in the time of Abraham, or a Lanzi in Minoan Crete or Mycenaean Greece, or a Vasari among Herodotus' gold-loving Royal Scythians. Such questions answer themselves automatically, everywhere beyond the rare art traditions' limits. If there were no art historians, moreover, there can have been no true art collecting. So we come back to the five rare traditions' separateness.

Yet the Siamese-twin relationship between art collecting and art history is no more than one element in the more elaborate behavioral system constituted by all the by-products of art. The system as a whole still further emphasizes the rare art traditions' separateness. And the next step is to investigate the rest of this behavioral system, beginning with the art market.

VI

THE OTHER BY-PRODUCTS OF ART

The date was May 25, 1977; and the scene was Mentmore, the vast country house commissioned in the mid-nineteenth century from Joseph Paxton by Baron Mayer Amschel de Rothschild.[1] In a minor way, the occasion was historic—no less than the dispersal at auction of the first fully typical collection ever put together by a member of the Rothschild family, the only modern collecting dynasty to persist on a grand scale for five generations.

Rothschild collecting was undoubtedly rooted in the profitable dealings in numismatic collectors' prizes by the eighteenth-century founder of the Rothschild house.[2] Along the way, too, there were notable early episodes, such as the acquistion of the ancient "Treasure of the Two Sicilies,"[3] which was probably taken in pawn by the Naples branch of the Rothschild house. Then, too, the founder of the French house, Baron James de Rothschild, early purchased Rembrandt's splendid Standard Bearer from the Marchioness of Conyngham, the last publicly acknowledged mistress of an English king before the brief reign of Wallis Warfield Simpson. Lady Conyngham began to feel the pinch after the death of George IV. With the King in his grave, her normal source of supply had failed; and so she sold the Rembrandt,[4] which George IV is thought to have given her along with her ropes of enormous pearls (which were then far more famous than the Rembrandt).

When Baron Mayer Amschel de Rothschild built Mentmore, however, he had an entire, enormous Jacobean–early Victorian palace to furnish. He filled the new palace with an astonishing array of French eighteenth-century furniture and works of art of every imaginable kind,[5] and thus he really opened the more characteristic chapters of the Rothschild collecting saga. In a considerable measure, this was the house and collection which set what the French call *le style Rothschild*—the style that once

caused Henry James to admit, ruefully, that he could "stand a lot of gold."

Baron Mayer Amschel de Rothschild furthermore began to gather his enormous collection at a date when it was—or he said it was—more expensive to get modern washstands from a leading London supplier than to round up good Louis XV and Louis XVI commodes,[6] cut holes in the marble tops, slice off the sides and gut the interiors for plumbing, and place these ornate, unlikely confections in the corners of his guest rooms! Of course he chose the economical second alternative.[7] It can be seen, then, why the crowd was huge and the excitement intense when the entire contents of Mentmore were being sold at auction by Baron Mayer Amschel's great-grandson, the 6th Earl of Rosebery.

All the same, there was not much interest when No. 2422 was presented on the rostrum by Sotheby's auctioneer. Sotheby's had catalogued the picture as "Charles André (Carle) Van Loo, The Toilet of Venus."[8] It had been obscurely hanging in a Mentmore corridor for over a hundred years. It was dark with dirt and old varnish. Van Loo, a pleasing decorative painter of the mid-eighteenth century, is not much sought after today.[9] Hence the London dealer David Carritt secured No. 2422 for the Brussels-based "art investment fund" Artemis for the mere trifle (by modern standards) of £8,000 or $13,600 at the then-prevailing exchange rate.[10]

The dealer had suspected something interesting under the dirt and varnish, and had remembered a lost but recorded painting of Fragonard's youth, The Toilet of Psyche.[11] That picture had been completed while Fragonard was still working at King Louis XV's École des Élèves Protégés, as a set piece to be shown to the King at Versailles.[12] If Carritt was correct, this meant the addition to the canon of a major Fragonard—for the picture is more than five feet by six and little damaged despite the years. When the heavy film of dirt and varnish had been removed by cleaning, the result fully confirmed the dealer's astute guess. The story of David Carritt's success seeped out, and the new value of the new major Fragonard was given as no less than $1,000,000. The *Times* of London commented, with an almost audible sniff: "It is [now] art history rather than esthetics that dictates art market prices."[13]

In the upshot, there was no further price to report; for the picture was presented by David Carritt and Artemis to London's National Gallery,[14] at an unannounced but unquestionably high valuation which was probably less important to the dealer and his firm than the good will that will help them when they have art-export problems in England in the future. But the real point of the story is the *Times'* comment. This was innocent establishment twaddle.

Art market prices are *not* dictated by art history alone. At no time since art collecting began, furthermore, have prices ever been dictated

by esthetics—except in the sense that great artists and great periods of art have usually been preferred by collectors. Instead, prices on the art market are dictated, and always have been, by the interaction between art collecting and art history, with some of the other associated phenomena also playing roles that have greatly increased nowadays.

In the case of the rediscovered Fragonard, the twentieth-century revaluation of the French eighteenth-century masters was a significant factor. In the resulting collector's hierarchy for that period, Watteau, Fragonard, and Chardin are the highest prizes. Just prior to the Mentmore auction, the Louvre had therefore paid the equivalent of $1,000,000 for Fragonard's Le Verrou,[15] and this was cited when the *Times* reporter speculated on the rediscovered picture's revised price.[16] Again, more and more Fragonards have received museum entombment, and the resulting market scarcity has strongly affected prices. Yet again, super-prices for works of art have become such a conspicuous phenomenon since the Second World War that the rule today is beginning to be super-prices-for-almost-anything— or at least for almost anything of any quality that can be art historically labeled.

Yet the art collecting–art history interaction has been the fundamental one in every art market the world has ever seen. Few societies have had true art markets, to be sure. No society *can* have a true art market which does not have art collecting and art history; for just as the historical response to art engenders the two basic phenomena, so art collecting and art history in turn engender an art market by Siamese-twin incest. Because of the law of supply and demand, as already noted, an art market must automatically be organized as soon as enough art collectors begin to compete for the same works of art. Art history enters in most powerfully because an art market is no mere market in expensive luxuries.

Luxury markets have existed since the Paleolithic. A Syrian of Neolithic times bartering for the highly valued obsidian from mines in Turkey;[17] the Etruscan nobleman who bought the Euphronius crater; Abbot Suger importing "sapphire" glass from Byzantium because the secret of making fine blue stained glass had not yet been learned in early-twelfth-century France;[18] and a donor offering the great Austrian monastery of Melk a fine chasuble of opus Anglicanum at the beginning of the fourteenth century[19]—all these were operating on the luxury markets of their respective times. On a true art market, individually labeled works of art are instead traded at individual prices established by the individual place of each work of art in the prevailing art collectors' hierarchy. Art history has the essential role of supplying the labels by attribution, establishing the hierarchy, and authenticating what is offered on the market. But first, collectors create the market which dealers then spring up to supply.

The resulting historical rarity of true art markets is hard to perceive

nowadays, as usual because we see the past through the distorting glass of the abnormal present. We not only tend to mistake for art collectors all patrons of the past who commissioned works that are now tremendous art collectors' prizes. In the same fashion, we also assume that all works of art that are now tremendous collectors' prizes were always sought after by art collectors. Nothing could be further from the truth. Because of intrinsic value, treasures have always constituted special cases—not because of their qualities as works of art. Other special cases are works of art that can be economically reused in new contexts for their old purposes.[20] Otherwise, as has been shown, the rule from the beginning of history has been, as already noted, that works of art automatically became things of little worth as soon as they had lost the functional contexts and social purposes for which the original patrons commissioned them. This rule has been broken exclusively in the five rare art traditions, which have alone seen works of art as ends in themselves. But rather than mere assertion, a convincing case study will far better illustrate how this historical rule actually works.

Consider, therefore, the story of what is probably the rarest important work of art to come upon the market anywhere in the world in recent years. This is an original Greek bronze of exceptional quality from the later fourth century B.C.—a just under life-sized portrayal of a young victor in the games, displaying his laurels or his palm frond with easy grace. The bronze is intact, except that the palm frond or laurels are missing and the youth's legs have been brutally broken off above the ankles. The Getty Museum in Malibu, California, has now acquired the statue, and a new subchapter will shortly be added to the history of Greek art when the bronze youth becomes available for widespread expert study. The truth is that nothing quite like this has been seen for a great many centuries— perhaps since the last clearly identified pieces of sculpture by Lysippus were lost in a fire that consumed a famous palace in Constantinople, the Lauseum, in the late fifth century A.D.[21]

Alexander the Great's court sculptor, Lysippus, was always regarded in classical times as the culminating giant among all the many sculptors of the most creative centuries of Greek art;[22] and he is so regarded by art historians today.[23] Thus far, however, Western students of Greek art have had nothing to tell them what Lysippus' works really looked like, beyond second- and third-rate Greco-Roman copies,[24] and descriptions in the elder Pliny,[25] Quintilian,[26] Cicero,[27] and other classical writers.[28] Nonetheless, one of the few owners of trained eyes who were permitted to inspect the bronze youth before the statue was sold thereupon pronounced it "very possibly an original by Lysippus himself."[29] Another verdict was "not by Lysippus, but almost certainly a Greek original by one of Lysippus' greatest contemporaries."[30] For what little that may be worth, when I,

too, was allowed to see the statue, I found myself thinking that I now understood for the first time the emphasis on the "rendering of the hair" in the elder Pliny's summary of Lysippus' sculptural innovations.[31]

No doubt some will dispute the foregoing opinions when the statue has been publicly shown for a while, and the great debate about it therefore begins; for there is always an art-historical debate in such cases.[32] Yet no one, surely—even those who do not much like the softness of Greek fourth-century sculptural forms—will fail to agree that the bronze youth is a dazzling discovery, almost more remarkable than finding the lost Sleeping Cupid by Michelangelo himself. The Cupid is long-lost,[33] but we have the nearly contemporary Bacchus to give an idea of what it must have been like,[34] whereas the bronze youth is the first original that gives a visually persuasive idea, at a minimum, of what Lysippus' sculpture may have been like.[35] The statue was the unlikely catch of Italian fishermen, who brought it up from the floor of the Adriatic. It was murkily sold abroad, murkily appeared in Latin America, and then went murkily to Munich.[36] In Munich the murk ended, for here the bronze youth was acquired for the reported sum of $1,000,000[37] by Artemis, the "art investment fund" in which David Carritt is a partner. The fund, founded by Baron Léon Lambert of the Banque Lambert in Brussels, is the most successful enterprise of this sort.

Artemis held the bronze youth for some years, in fact until the oil billionaire J. Paul Getty left his museum an endowment that will bring in around $40,000,000 a year.[38] At once the inner circles of the art market began to buzz with rumors about the price Artemis would get for the bronze youth. The buzz was to be expected, since the Getty Museum's new endowment transformed the entire market's higher reaches. It could not help but do so, since this small museum now has an annual income approximately equal to all the freely available purchasing funds of all the world's other art museums put together.[39] In addition, the Getty Museum was originally designed to display classical works of art to best advantage.[40] Hence the bronze youth was a logical first purchase for the museum to make with its just-inherited hundreds of millions of dollars. In the upshot, the art market's rumors proved about right. The museum bought the bronze youth for $3,900,000,[41] and thus at a profit to Artemis of close to $3,000,000.

Although a good deal of the foregoing is reasonably dramatic, none of it should surprise anyone who knows the art market of the later twentieth century. What is surprising and puzzling, rather, is the sharp contrast between the condition of the bronze youth, with feet and ankles missing and jagged break-lines in the lower legs, and the condition of the other, fairly numerous Greek original bronzes that have been rediscovered by now.[42]

A little detective effort is needed here, which must begin with the ways these other rediscovered Greek original bronzes were actually saved for posterity. The Delphic Charioteer is a special case, for the Charioteer was buried by a landslip that brought down the whole monument.[43] With the Charioteer hidden until archeologists came along, his chariot and horses were probably melted down forthwith for the value of the bronze. A few other significant bronzes have also been exhumed by the archeologists' spades; but most of the major Greek originals in bronze are instead owed to the hazards of the classical art market.

The wonderful late Archaic Piraeus Apollo was found by roadworkers digging up a street in the port of Athens, along with a miscellaneous stock of other sculpture of different periods.[44] This was clearly a dealer's stock that had been waiting in a portside warehouse at the Piraeus, all but surely for shipment to Rome, when the warehouse was burned and the statues lost in the ashes after the Roman dictator Sulla condemned the Piraeus to flames in 86 B.C. A good many of the rediscovered Greek original bronzes have been fished up at sea, however, in just the way the bronze youth was fished up. The Poseidon-Zeus attributed to Calamis, the Anti-Cythera Boy, the enchanting little Hellenistic Jockey and His Horse (if it was his horse), and the Tunis Youth from Bardo—these are no more than a short representative list. As one can tell from the other things also fished up with these bronzes, all came from art dealers' shipments made in classical times,[45] when ships were still extremely vulnerable to the sea's dangers.

All the listed sea-found Greek original bronzes were fished up intact, or at least had plainly been shipped intact, as even the Jockey and Horse were.[46] Many, of course, had been corroded by the sea beyond repair, and others had been shattered in different ways when they went to the bottom. But not one had been shipped together with its heavy base, which would have been wasteful. Examine the Getty Museum's bronze youth, however. You see that the feet and lower legs were literally torn off the statue by main force, leaving the rest of the figure in beautifully intact condition. Yet one cannot imagine any kind of accident at sea that would literally have torn off the bronze youth's lower legs and feet while leaving all else intact—unless the youth had been shipped complete with its base. In that unprecedented case, but only in that case, the great weight of the base might have provided the needed shearing force during a bad storm.

So there is an enigma here which cries out for a solution. One must first note that unwanted bronze sculpture sometimes seems to have been broken up and sent overseas as scrap bronze even in classical times—as indicated by a shipment of fragments recently found on the sea bottom

off the western Italian coast—and assuming the fragments were sent to sea as fragments.[47]

One may then turn to the Colossus of Barletta, a heroic Byzantine bronze of an unidentified emperor (perhaps Heraclius, the ultimately frustrated restorer of the empire in the seventh century A.D.).[48] This huge object was brought up from the harbor of Barletta at some date before June 9, 1309, when Charles of Anjou, King of Naples, granted the "preaching friars in Manfredonia" permission to hack off as much of the bronze as they needed for their own purposes.[49] The statue's resulting losses were clumsily replaced in the fifteenth century, and the Colossus was set up in Barletta. A local author then celebrated the event with a poem on the statue, stating that it had been taken by the Venetians after the horrible Crusaders' sack of Constantinople in 1204, and had gone to the bottom of Barletta Harbor when a Venetian ship foundered there.[50]

This tradition in Barletta seems persuasive. What seems utterly unpersuasive, however, is the notion that the Venetians can have wanted the Colossus as a work of art. As will later be shown, art collecting was effectively unknown in Europe in the thirteenth century, and Byzantine works of art, barring treasures, were never sought by art collectors before the nineteenth century.[51] The motive of the Venetians must in fact have been the motive of the friars of Manfredonia when they removed the arms and lower legs of the Colossus for use as bell-metal. The perpetual bronze-hunger of the Venetian Arsenal, the greatest industrial establishment in medieval Europe,[52] will thus have been the true explanation of the presence of the Colossus in the cargo of the Venetian ship lost in Barletta Harbor.

One more item of evidence of high importance is the true story of Venice's glorious Horses of St. Mark. These had been ornaments of Constantinople's Hippodrome, and they were unquestionably part of the businesslike Venetians' share of the loot after the Crusaders' sack in 1204.[53] Significantly, the Horses were consigned directly to the Venetian Arsenal when shipped to Venice aboard a galley commanded by Domenico Morosini.[54] One of the earlier sources records that they were only saved from the Arsenal's furnaces in the first instance because the furnaces were not then large enough to receive an object as big as one of the Horses.[55] Waiting to be chopped down to size, the Horses therefore stood for a long while on one of the quays of the Arsenal, where they began to attract attention. Another source says that the scales of decision were luckily tilted the right way by unnamed Florentine ambassadors, who praised the Horses warmly.[56] Yet in a recent study, Professor Otto Demus has shown that the decision to place the Horses where they now are,[57] on pedestals before the upper facade of San Marco, was finally taken because they were ideal trophies of the shameful victory at Constantinople, of

which the Venetians were unashamedly proud. So the Horses were not placed where we now know them so well primarily because they were, and are, beautiful works of art.[58]

Two last items of evidence are needed, and then the enigma of the curious condition of the Getty Museum's bronze youth will cease to seem enigmatic. One of the Horses of St. Mark lost a foot and part of a leg before they reached Venice, and this fragment was taken by Domenico Morosini and put up as a trophy on the façade of the Casa Morosini, later the Casa Contarini.[59] The loss is most likely to have occurred when the Horses were being removed from their pedestals in the Hippodrome. In classical times, bronze statues were strongly fixed to their bases with molten lead. If they were to be removed from the bases without damage, the lead consequently had to be chiseled away with care.[60] If bronzes were simply dragged off their bases by main force, with ropes or in some other manner, the statues always tended to break off at their weakest point, in the lower leg or just above the foot.

For obvious reasons, main force was used by the postclassical bronze seekers who destroyed the huge majority of classical bronzes to get the raw material, caring nothing for the statues as works of art. This is why one of the statue bases at Olympia was found with a bronze foot still adhering to it.[61] Thus it seems an odds-on bet that the Getty Museum's bronze youth was separated from its base by medieval bronze seekers using main force in some way. The odds are high, too, that the bronze seekers in question were again the Venetians, after the sack of Constantinople. This explains the youth's being fished up in the Adriatic; for the already mutilated statue will then have been part of a shipment of scrap bronze destined for the Arsenal's furnaces. And the statue went to the bottom when the heavy-laden ship sank in one of the Adriatic's sudden furious storms.

For the sake of those particularly prone to seeing the past distortedly, the bronze youth's whole reconstructed story is now worth repeating. This is certainly a victor statue, commissioned by a patron to commemorate a young man's success in one of the Greek games in some temple precinct or on a rich family's tomb. It was thus originally akin to the bronze of Samuel Gompers, in the same way as the Delphic Charioteer. Very possibly, if then attributed to Lysippus, it became a collectors' prize in Hellenistic or Roman Imperial times. If it came from Constantinople, as here suggested, it must have been among the many Greek statues taken to ornament the new capital of the new Rome, either by Constantine the Great or one of his immediate successors.[62] As part of the loot of the Venetians, it was valued only as scrap bronze but was lost at sea. But by being fished up again in the later twentieth century, it automatically became a collec-

tors' *nonpareil* and art-market record breaker, worth no less than $3,-900,000 for museum entombment.

The story of the bronze youth makes another useful point, too. In brief, the art market is like the other primary by-products of art because it, too, transmutes works of art in its own sordid way. To recapitulate, collecting makes works of art into ends in themselves. Art history, by a more complex process, makes works of art into historical documents. As for the equally radical transmutation effected by the art market, this is best indicated by an experience of my own.

In the long course of the research done for this essay, I once visited a dealer in primitive art who must be nameless for reasons that will soon be obvious. He was opulently lodged in a handsome apartment, but the apartment was anonymous and an introduction was needed, since objects questionably extracted from their countries of origin often passed through the dealer's plump, well-tended hands. Mayan tomb pottery and Olmec jades,[63] African masks,[64] a Maori chieftain's war club, all succeeded each other on the artfully lighted display table. The dealer, sleekly tailored as well as highly manicured, brought these objects from his storage cupboards with the air of a hierophant disclosing ancient mysteries, and over each object he intoned a hierophant's litany. The slender yet powerful form; the enriching carving's high quality and near-abstract pattern; the glowing patination of the ancient wood—these were the main points of the litany for the "very rare" Maori chieftain's war club "of the *taiaha* type."[65]

Yet just what was this war club, before it became an art dealer's exhibit and a future collectors' prize? It was first a mark of rank in a warlike tribal society and, second, it was a grim, much-used weapon in fierce and frequent intertribal battles. Maori victors celebrated by eating the vanquished, so the war club was also an instrument to supplement the tribal diet.[66] If the war club's chieftain-owner could ever have glimpsed its dealer-owner, so toothsomely well nourished, a memorable feast would surely have ensued. From such ironic contrasts, daily observable in the modern world of the arts, it is easy to see how the art market transmutes works of art.

This transmutation is of course invisible, like the two other transmutations, since the works of art themselves are not outwardly altered. Yet the transmutation by the art market goes very far, nonetheless, since so much else is changed. The war club, for example, was once a fine if bloodstained weapon, but has become an object valued for its formal beauty— but also valued for a very large sum of money, because the dealer in question is a shrewd fellow; because revaluation has made people understand the formal beauty of such former curios; because the war club had

been art-historically authenticated; and because a good many rich men now compete for important examples of the arts of Pacific Oceania.⁶⁷ The plain if unpalatable truth is that the art market makes works of art into something very like growth stocks—indeed, something better than growth stocks in the eyes of "art investors."

Should We Lament?

It is customary either to look the other way or to deplore this transmutation. In the twelfth century in China, the Song critic and theorist Cai Tao lamented that "the love and appreciation [of art] is practiced everywhere, and the world treats it as merchandise and bribes; this is indeed a fault of our age."⁶⁸ No doubt similarly minded Greeks sounded the same note in the second century B.C. In our own time, when the transmutation has become so much more crass, the lamentations are much louder. Speaking for myself, I yield to no one in my low opinion of the customary ways of the art market, but it strikes me that the moralistic lamentations are both unrealistic and tinged with more than a little hypocrisy.

For example, Théophile Thoré-Bürger, whom we have already met as the rediscoverer of Vermeer, was a courageous member of the French left-wing of his time who was already in trouble with the authorities when he fell in love with the View of Delft in the Hague in 1842. It was after he went into revolutionary exile in 1849, moreover, that he began the work of identifying Vermeer's real oeuvre.⁶⁹ This had been so obscured by more fashionable attributions that the greatest of all Vermeers, The Artist in His Studio, in Vienna, had been transferred to Pieter de Hooch.⁷⁰ When Thoré-Bürger published the results of his researches in the *Gazette des Beaux-Arts* in 1866,⁷¹ he made Vermeers into collectors' prizes. Before this, however, he had been careful to secure as many Vermeers for his own collection as he could pry loose for modest sums. The two Vermeers in London's National Gallery⁷² and the lovely Concert in the Gardner collection in Boston⁷³ all came from Thoré-Bürger's collection, which was sold by his heirs in 1892. Again, anyone familiar with the New York "art scene" can identify the highly influential critic, another leading left-wing figure, who has helped make the current reputations of a good many painters of the American avant-garde. The painters thus benefited, the chief Abstract Expressionists, deserved every word of praise the critic accorded them. But while promoting them, the critic also made a substantial fortune by regularly insisting on being "given" major works by the artists whose market value his criticism was vastly augmenting.

In another way, the same rules apply to collectors who are totally disinterested financially, like Balzac's Cousin Pons.⁷⁴ Old Pons was the type-case of the obsessive collector, who makes up for want of means by

untiring ferreting, by a wonderful eye for quality, and by boldness in gathering prizes of high quality without regard to current fashions. Rather in the tone of Cai Tao, he lamented on one occasion that desks made by the great Riesener had begun to sell for prices he could no longer afford[75] (for this was the period when French eighteenth-century furniture was just coming back into favor in nineteenth-century Paris). But anyone who has read *Le Cousin Pons* will agree that the old man was also exceedingly proud of having beaten the game, so to say. He further had a lively awareness of the immense value of the works of art he had assembled for trifling amounts, and he was even fearful of the grim fate that finally overtook the collection and himself, precisely because of this immense money value.

The truth is that it would be inhumanly high-minded for any art collector to be less than gratified by a steep increase in the market value of his works of art, as it would be inhuman for art historians to take no account of the rise of new classes of collectors' prizes. Anyone familiar with the literature is aware that spates of art-historical writing always ensue whenever any class of works of art returns to favor, or when art collecting's empire is extended to include new provinces. By the same token, it would be mealy-mouthed to deny that transmutation by the art market does give works of art the characteristics of growth stocks. Here a single case in point will suffice.

The disreputable Fabrizio Valguarnera has already been seen laundering his ill-got gains in Rome by buying a painting out of Poussin's studio.[76] After this, the Plague of Ashdod passed through several hands in Rome, and finally the picture went to France, to the Duc de Richelieu of the mid-seventeenth century, who paid no less than ten times what Poussin had been paid by Valguarnera.[77] This was the same Duc de Richelieu who lost most of Cardinal Richelieu's fine collection of paintings, plus others he had acquired himself, on a bet he made with Louis XIV on a game of court tennis.[78] The Duke was happily able to console himself by gathering a large group of works by Rubens, which Roger de Piles helped him to secure.[79] De Piles was greatly assisted in his task by the devastations wrought by Louis XIV's campaigns in the Low Countries. The misfortunes of others are always the good fortune of art collectors.

In those days, it was far easier than it is today to form a memorable art collection; yet the theme of art-as-investment was already being heard, not just among dealers, but among very ordinary, rather simple people. Thus the Marquise de Sévigné's cousin, Philippe-Emmanuel de Coulanges, Maître des Requêtes, was obviously the sort of decent, genial, but unoriginal man who often parrots the opinions of other decent men of his time. In one of Mme de Sévigné's letters to her daughter,[80] there is an enthusiastic postscript by Coulanges urging the Comtesse de Grignan to approve her

husband's buying as many pictures as he wished, since they were like *"de l'or en barre."* Coulanges even promised Mme. de Grignan that she could always count on selling paintings at "double" their first cost[81]— thereby proving that decent men's opinions are not always wise.

The Art Dealers

The growth-stock effect, as I have called it, has now been adequately investigated; but this is no more than the primary effect of the art market's transmutation of works of art. Something will be said later about the history of the more important true art markets that the world has seen. But in this analysis of the art market as one of the by-products of art, all the effects of the transmutation of art by the market must at least be briefly examined. The effects on artists are not inconsiderable. For instance, who does not know abstract painters today who have been strongly discouraged from figurative experiments, because their dealers have told them their abstracts were already well-established market commodities?[82] Yet the first additional effect which requires serious documentation is that upon the art market's own leaders. This tends to be pretty lurid, as just two case studies will show all too plainly.

In the first decades of the seventeenth century, a man of mysterious origins (probably from the French-speaking part of the Low Countries)[83] established himself in Venice as Europe's leading art dealer of the grander sort. One knows Daniel Nys was in a large way of business simply because he had his Venetian headquarters in a very grand house.[84] Until Nys's time, in the early seventeenth century, England had done no more than import the ideas of the Renaissance, but during the reign of King James I, the art of the Renaissance also began to be imported almost *en bloc.* Daniel Nys had a role from the outset, perhaps aided here by a connection with the English ambassador to Venice already met with, Sir Dudley Carleton.

Thus Nys was the dealer called upon[85] when an up-to-date art collection was desired from Carleton by one of James I's several beautiful male favorites in England, Robert Carr,[86] Earl of Somerset, with his reddish-gold "Sycambrian locks" (in which King James liked to dry his hands after using the seventeenth-century equivalent of a finger bowl at the end of his dinner!). The pictures Nys assembled for Somerset, including five Tintorettos and three Veroneses, were priced at 800 ducats. The larger quantity of sculpture, almost all Greco-Roman, was priced at 2,000 ducats.[87] The first installment of these works of art (if not all of it) actually arrived in England, but by then Lord Somerset was unfortunately in the Tower for his complicity in the murder of his sponsor at court, Sir Thomas Overbury.[88] Nys seems to have lost nothing, however. Carleton was left with the sculpture on his hands, which he later traded to Rubens, and

the pictures, being in England, were divided between the Lord Chamberlain, the Earl of Pembroke, and the "Father of Vertu in England,"[89] the proud Earl of Arundel. These transactions took place in the seventeenth century's second decade. In the 1620s, Nys then began to play his decisive part in the greatest single collectors' coup in modern European history, the purchase by King Charles I of all the accumulated treasures of the Gonzaga rulers of Mantua.

Behind this coup there was a complicated story with a good many actors, which someday deserves to be told both fully and accurately.[90] It is enough, however, to say here that King Charles got the Mantua collection in two bites, as it were. For the first bite, Nys was the art dealer concerned, but he worked in tandem with Nicholas Lanier, the Master of the King's Music,[91] who had been sent back to Italy for this purpose after spying out the ground at Mantua a year or so before with the help of Nys.[92] The last Gonzaga Duke of Mantua had already pawned many of his jewels[93] and was still in fearful financial trouble. When he was therefore driven to sell a large part of his family's enormous and varied art collection, there was also fearful political trouble, for the people of Mantua had early national-heritage sentiments about the innumerable works of art in the various ducal palaces.[94] But sell the Duke did, in 1627,[95] and Nys duly reported this triumph to King Charles's court in London.[96] He gave the price to be paid the Duke as 68,000 scudi,[97] or £15,000.[98] This was enough to force the English government banker Sir Philip Burlamachi to skimp financial support of the Duke of Buckingham's ill-fated attempt to relieve Protestant La Rochelle from Cardinal Richelieu's besieging force.[99] The evidence is rather strong, however, that the amount actually paid to the Duke of Mantua was 50,000 ducats[100] all-in; and this was a good deal less than 68,000 scudi. Hence one must suppose that Daniel Nys silently pocketed the substantial difference.

Shortly thereafter the Duke of Mantua died and, as the Italian line of his family ended with him, he bequeathed Mantua to his French relative the Duc de Nevers.[101] The new Gonzaga-Nevers Duke of Mantua was far worse off than his predecessor, for the treasury was emptier than ever and the succession was also disputed.[102] Nys promptly saw the opportunity and struck again, obtaining all the sculpture, the Mantegna cycle of the Triumph of Caesar, and many other things withheld by the last Gonzaga Duke.[103] As proudly reported by Nys to London, the second bite cost £10,500;[104] and one does not know Nys's intended percentage. At any rate, there was immediate trouble, because Nys had acted without real authorization for the second bite, and Burlamachi was more despairing than ever. Nys pretended all the while that he had been fully authorized to buy, writing off to London about the wonderful new bargain he had made for the King—but also quietly trying to sell his entire second purchase

to the Queen of France.[105] In the end, Charles I yielded to the new temptation, but the money was slow in reaching Venice, and before Nys was paid in full, he had difficulties. He described these in a letter of 1631 to Thomas Cary, groom of King Charles's bedchamber, who was one of those helping to handle these enormous transactions at the London end. Nys wrote:

> In answer to your very agreeable letter, dated Greenwich, 13 May, st. vet. I wrote a week ago to Mons. Rowlandson, that being assailed by my creditors, who thought to bring me to the ground, I had suddenly opened my coffers and my house to them, and had said, Pay yourselves all, even to the last farthing, which they did. In this general removal and turn out, my people, in a back place, came upon paintings and statues belonging to the King my most gracious Master, at which I was greatly astonished and also rejoiced. I immediately advised Mons. Rowlandson and Mons. Burlamachi.
>
> The pictures are:
> Magdelen [sic], half length. *Titian.*
> Lucretia, naked. *Titian.*
> Three heads in one picture. *Titian.*
> Portrait of a female in a green dress. *Raffaelle.*
> Statues: —
> A large figure in antique copper, very rare.
> Figure of a woman sitting in marble; some say *Venus delli Ely,* others *Helen of Troy.* It is the finest statue of all and estimated at 6000 *escus.*
> A child, by *Michelangelo Buonarrotti.*
> A child, by *Sansovino.*
> A child, by *Praxiteles.*
>
> These three children are above price, and are the rarest things which the Duke possessed. I will send the whole by the first English ships.[106]

One wonders whether Thomas Cary or anyone else was even momentarily deceived by Nys's oily lies. Certainly no one with experience in such matters can believe for an instant that an art dealer of Nys's standing had somehow forgotten the very existence of such pre-eminent "pictures and statues belonging to the King [his] most gracious Master," or was in the least "astonished" by their presence in "a back place" in his fine house. What we have here, in reality, is a transparently self-serving account of a frustrated "hold-out." From highest to lowest in the trade, art dealers are always tempted to hold out a few of the best things when they handle a huge, poorly inventoried collection for a client; and from highest to lowest, they often seize the opportunity to steal on the sly—which is what a hold-out amounts to.

Unfortunately for Nys, Thomas Rowlandson, one of the Englishmen charged with supervising the transfer to England of the fruits of King

Charles's great collectors' coup, had evidently suspected the dealer of holding out. Probably Rowlandson had passed on his suspicions to the English court—Nys's later letter to Cary certainly points that way—and this would have given Burlamachi a fatally good excuse for further delaying payment to Nys. If so, this would explain why Rowlandson and Burlamachi were the first to be notified of Nys's alleged discovery in "a back place." And either in this way, or because Nys merely feared such measures by Rowlandson and was of course much worried, too, by having to wait for his money, he undoubtedly disgorged the greatest single hold-out any art dealer has ever attempted since the Western art market began, solely because he was frightened into doing so.

Case Study I speaks for itself. Case Study II is perhaps more interesting, simply because the central figure was a much more admirable man than the Nyses and Lord Duveens of art-market history. If P.-J. Mariette had been born with means, one suspects he would have been content with a career as a collector, connoisseur, and art historian, all of which he was. His *Abecedario* is a most interesting compendium of the state of expert knowledge in the mid-eighteenth century of the great artists of the European past.[107] His collector's mark on an old-master drawing has such prestige that it favorably affects the selling price, even today.[108] But Mariette was also an art dealer, in fact the dominant dealer in Paris in the first half of the eighteenth century; and as a dealer, he knew and exploited the art market's little ways, as one can see from his handling of the magnificent collection of old master drawings made by one of the Crozat brothers.[109]

These two vastly rich financiers, both great collectors, were ironically known as "Crozat le Riche" and "Crozat le Pauvre" because Antoine Crozat was thought to be the wealthiest man in Paris, which made Pierre Crozat no more than the second wealthiest. Mariette was charged with selling the drawing collection of Pierre Crozat, whose will ordered that the sale be held after his death, with the proceeds to go to the poor of Paris. It was a splendid chance for an astute dealer-collector and Mariette therefore rigged the outcome of this huge sale in 1741 by dividing the Crozat drawings into lots in which the "most valuable" were "swallowed up," drawings by Raphael were sold "undescribed," drawings by Michelangelo were sold almost *en bloc*, and the rest on the same system.[110] As a result, Mariette acquired for his own collection fifteen drawings by Leonardo da Vinci in the first lot for 9 livres;[111] twenty drawings by Michelangelo from the second lot for a total of 62 livres;[112] and so on and on to the end of the sale.

At least Mariette's motive was different from that of the Marlborough Gallery's far more complex and ugly attempt to take over the enormous number of paintings left by the late Mark Rothko, to pay no more than

peanut prices to the Rothko estate, and to sell the Rothkos for the Marlborough Gallery's benefit for the hundreds of thousands of dollars apiece which fine Rothkos now command.[113] Mariette merely wanted great drawings at cheap prices, chiefly for his own collection. Whereas it is reported that the founder of the Marlborough Gallery, Frank Lloyd, once boasted, "I collect money, not art."[114] In the upshot, the Marlborough Gallery was taken to court and, after a long and costly lawsuit, was forced to yield up the Rothkos that had been taken and was fined $9,000,000 in addition.[115] But if the attempt by the Marlborough Gallery had not failed, the result would have been similar, albeit on the money scale of the twentieth century, to the result of Mariette's operation in his own favor. On this last result, the French nineteenth-century scholar Charles Blanc made the dry comment that the poor of Paris "did not receive one twentieth"[116] of the real value of their legacy from "Crozat le Pauvre."

The Art Historians and Collectors

Enough has now been said to indicate the peculiar natural effects of the art market on its own leaders and chief manipulators. This moderately grisly account of the total phenomenon will still be incomplete, however, without brief notice of the effects of the art market on art historians and art collectors. Art historians of the generations who are at work today have materially higher standards than prevailed in the fairly recent past. Yet even today one can think of a few who are not wholly immune to the kind of art-market influence appearing in my files in a photocopy of a letter from Berlin to the leading New York art dealing firm, Knoedler's.

As background to this letter, it must first be noted that Josef Stalin decided to raise foreign currency by selling masterpieces from the Hermitage when he was launching his brutal drive to collectivize Soviet agriculture and industrialize Soviet society. The oil magnate Calouste Gulbenkian had an inside track with the Soviets because he had helped them importantly with sales of Baku oil, and he was given first choice.[117] The curators of the Hermitage, then still learned men of prerevolutionary vintage, were horrified by the Stalin-ordered sales[118] and dared to warn their masters in the party apparatus that Gulbenkian was stealing the Soviet state blind. There was much truth in this. Gulbenkian made four separate consummated deals with the Soviet authorities. By these he secured: first, a very large quantity of French eighteenth-century silver of the grandest possible sort; second, Houdon's Diana; and third, two magical Hubert Roberts plus Dieric Bouts' haunting Annunciation plus the superb Rubens portrait of Helena Fourment in a feathered hat, plus two really great Rembrandts—the portrait of his son Titus in a rich helmet impersonating Pallas Athena or the young Alexander the Great and an exceptional portrait of an old

man—plus four other pictures. The total cost to Gulbenkian was £379,000, but he got back a little more than £100,000 by reselling the four extra pictures to Wildenstein. Much of the silver was on the level of the Juste-Aurèle Meissonier tureen which lately sold for above $1 million. And Gulbenkian furthermore bid another £150,000 for an additional lot of gold and silver which he did not obtain. So you can see that he made a superb bargain.[119] Sensing this, the party officials in charge of the Hermitage paid enough attention to the curators' warning to call in M. Zatzenstein, of the Galerie Matthiesen, a Berlin firm that already had Soviet connections of some sort.[120]

The cat was out of the bag as soon as Zatzenstein heard what was afoot and was asked for valuations of the more important Hermitage pictures. The inadequately capitalized Galerie Matthiesen thereupon brought Calouste Gulbenkian close to apoplexy[121] by becoming the decidedly junior partner of the New York firm of Knoedler's—this firm being chosen because the chief client of Knoedler's in those days was Andrew W. Mellon, who was even better able to pay for masterpieces than Gulbenkian and much less inclined to haggle, too. To the immense good fortune of the United States, the ultimate consequence was the transfer to this country of a whole series of glorious works of art from the Hermitage. These Andrew Mellon bought and placed in the National Gallery, which he also paid for and presented to the nation.

Returning to the letter already mentioned, it was written from Berlin on February 9, 1931, by Zatzenstein to Knoedler's in New York, and it covers a whole series of fascinating problems having to do with the sales from the Hermitage.[122] By far the most notable passage deals with a picture attributed by the Hermitage to Van Dyck's imitator, Adrien Hannemann, and considered a portrait of the Prince of Orange as a boy. Zatzenstein pointed out delicately that the picture had formerly been regarded as a genuine Van Dyck. With this introduction, he cheerily explained he had just paid 20,000 marks to two eminent art historians of that period, Drs. Gustav Glück in Vienna[123] and Ludwig Burchard in Berlin,[124] in order to get the portrait profitably turned into a Van Dyck again. Gustav Glück's new attribution to Van Dyck duly appeared in the *Klassiker der Kunst* series.[125] The desired decision to buy the portrait then followed in America, and the portrait hung in the National Gallery with a Van Dyck attribution until just the other day. A member of the National Gallery staff, Arthur Wheelock, then showed that the portrait did not represent the Prince of Orange and also correctly returned the attribution to Adrien Hannemann.[126]

Another art-market effect, involving both a major art historian and a major American art collector, is revealed by the story of the little painting of Christ Carrying the Cross, for which the Gardner collection still provides

a daily offering in the form of a fresh bunch of violets placed before the picture. This was first thought a Giorgione, then went through uncounted other attributions,[127] and has again become the earliest known Giorgione in the latest monograph on the painter by Dr. Terisio Pignatti.[128] In the period when Bernard Berenson was establishing himself as an art historian and earning his bread as a dealer-connoisseur, he bought the picture as a Giorgione from an impoverished Italian noble family for £6,000,[129] or $30,000 in the money of those days, after promising that a copy would be discreetly supplied, as was common,[130] to fill the picture's place in the family palazzo.[131] The purchase was made on behalf of Mrs. Jack Gardner. As there had already been some local excitement about whether the family of Zileri dal Verme really had a right to sell their Giorgione,[132] getting it out of Italy was plainly going to present some problems.

In May 1897, Berenson therefore wrote to Mrs. Gardner, "It would be much easier for you in your vast trunks to get the picture out of Italy without risk of discovery than for me in my modest—a man's trunk is always modest—box."[133] Mrs. Gardner refused, but she knew this merely meant Berenson would arrange the smuggling for her. This he then did, by giving it to some friends who slipped it across the Italian border "swaddled like a baby in a blanket."[134]

This episode in Berenson's career is more than matched by another, slightly later episode revealed by a letter to Mrs. Gardner dated March 19, 1900. The letter indicated that Berenson had acquired Mrs. Gardner's Simone Martini altarpiece straight off the walls of a public art gallery where it had long been exhibited on loan. Mrs. Gardner was charged £500, or $2,500 of those days; and she evidently complained bitterly about the price. Berenson explained that to get the Simone altarpiece, he had been forced to take three other, quite uninteresting pictures. (One can envision the clandestine haggling with the family that owned the Simone.) What with packing, repacking, and careful restoration, plus the cost of these other pictures, Berenson told Mrs. Gardner she had got a major bargain—as indeed she had, for hers is the only complete Simone Martini altarpiece which has ever left Italy.[135]

In those days, Berenson was by no means the only art historian who was a strong believer in free trade in works of art. And the collectors of the period, like Mrs. Gardner, generally thought nothing of acquiring smuggled works of art, provided the original owner had been properly paid. Unlike Mrs. Gardner, P. A. B. Widener cheerfully did the smuggling himself. His wonderful Van Dyck of the Genoese period, the portrait of the Marchesa Cattaneo with her parasol-carrying black page,[136] is an enormous painting on canvas. An alert was on, too, for Italian art lovers were already worrying about the picture being sold abroad. According to reliable report, the large and splendid Widener touring car was therefore ingeniously im-

proved by the addition of an extra-large, extra-sporty-looking exhaust pipe; and the Marchesa Cattaneo crossed the Italian border rolled up in the false exhaust pipe.[137]

One cannot resist adding another well-authenticated Widener story, which began with his unwise clandestine purchase in Italy of a statuette attributed to Michelangelo. The mere name Michelangelo demanded extreme measures; so Widener had the statuette encased in a massive, incomparably awful plaster bust of himself by a minor contemporary sculptor. The bust was sent quite safely to the Duveen branch in Paris. There Widener smashed open his own bust with his own hands—only to be told that his statuette was an obvious fake.[138]

Nor have the effects of art's transmutation by the art market grown any more attractive today, except in two respects. One is the much higher standard prevailing among art historians, already noted. The other is the willingness of some American collectors to return illegally smuggled works of art to their sources, if the works happen to be important enough for the smuggling to cause a clamor in the newspapers. Norton Simon did this with his superb Chola bronze of Shiva, Lord of Dance, made in Southern India in the tenth century, brought to this country clandestinely and reportedly bought by Simon for $1,000,000.[139] The bronze is now due to return to India,[140] but one hopes not to the temple it came from, whose priests seem to have had a major role in its clandestine abstraction.

On the other hand, a good many collectors today must go much further than willingly acquiring smuggled works of art. In fact, you have to conclude that many art collectors as well as dealers have now become conscious receivers of stolen goods; for all the blame can hardly be placed on the art dealers when the rate of art thieving in France alone has reportedly risen to forty thousand thefts per annum.[141] As for the art market in general, anyone who knows its present character in New York and other major capitals must feel a strong nostalgia for the comparative purity of Daniel Nys and P.-J. Mariette.

In sum, it is no use pretending that when large sums of money are at stake, the by-products of art do not have a singularly seamy side. All those who touch the market in any way are therefore in danger of corruption. But it must also be noted that without the trade in works of art, everyone would still have to go to Italy to study the first great efflorescence of the Western art tradition. In the United States and many other countries as well, most of the greatest art of the West, indeed most of the greatest art of the entire world-past, would be altogether hidden from men's eyes if there had been no art market. In such matters there is always a trade-off, and only pious hypocrites pretend the trade-off does not exist, or that it is somehow possible to have great museums filled with great works of art without an art market to pry loose the paintings, sculpture, and

all the rest from their places of origin. You may say that the art market is to art as whorehouses are to sex—except that on this rule today, most people would enjoy precious little sex in areas without whorehouses.

So much, then, for the third in the primary triad among the eight by-products of art. To recapitulate again, just as art collecting and art history are Siamese twins because both are born of the historical response to art, so these two must always engender an art market. The law of supply and demand, I repeat, unavoidably requires that result. Hence, if you still doubt the singularity of the five rare art traditions, then ask yourself whether there can have been a Marlborough Gallery in Assyria wolfish for conquest (where one must admit Frank Lloyd would have found many a soul brother), or a Wildenstein in Memphis of the Old Kingdom, or a Sotheby's in fifteenth-century Benin, or a Nys or Mariette in Cuzco in the time of the unfortunate Atahualpa. Again, these questions answer themselves.

The Art Fakers

All five secondary by-products of art are engendered by the primary triad, though not completely in all five rare art traditions. About one of these other phenomena, art faking, I confess I have even considered whether to give it primary status. I did not do so, at least in part, because works of art have not seldom been faked for reasons having nothing to do with art collecting or art history or the art market. There are counterfeit heirlooms, for example. Japan's imperial regalia—the Mirror, the Seal, and the Sword—are thought to have been lost forever in the time of troubles caused by the ambitious Emperor Go-Daigo in the fourteenth century.[142] The existing Mirror, Seal, and Sword, all sacred objects, are therefore suspected of being fourteenth-century replacements.[143] No one can be absolutely sure, however, since the imperial regalia are still too sacrosanct for expert inspection. The truth is, counterfeit heirlooms and curios, like counterfeit relics, have been common enough in many times and places. One of the Fatimid caliphs of Egypt was the proud possessor of the alleged "saddle of Alexander the Great."[144]

To give one more example, again from Japan, after the Meiji Restoration the millennially old custom of presenting "imperial treasures" to all distinguished visitors was maintained until the death of the Emperor Meiji. Distinguished visitors were now far more numerous, however. Hence officials of the Japanese imperial household quietly bought up a stock of early copies of paintings by famous masters and had the copies placed in mounts reassuringly marked with the imperial chrysanthemum crest. In this manner, the distinguished visitors got their traditional due without sacrifice of any genuine imperial treasures. Later, "Meiji fakes" thus became

a discreetly whispered category on the Japanese art market,[145] but these, like counterfeit heirlooms, are nonetheless accidents of history. Meanwhile, the central point is that large-scale faking of works of art promptly begins whenever and wherever a brisk art market has been organized and substantial prices start to be paid. Indeed, one of the earliest documents directly concerning faked works of art comes from China and dates from about fifteen hundred years ago.

In the fifth century A.D., Yu He in effect served as curator of the imperial collection of the Liu Song dynasty, one of the lesser ruling houses in the divided China of that era. At the time in question, the Emperor Xiao Wu had recently died, and this led Yu He to present a memorial to the throne[146] saying, in summary, that the imperial collection of calligraphy was a sad morass of arrant fakes because of the credulity of the late Emperor and another member of the imperial house, who had also contributed largely to the collection. It is curious that this should have been the case, since the fifth century was only a hundred years after the moment when China's art of arts reached its first great apogee. Hence it should have been relatively easy to secure the genuine calligraphy of great masters, and there was some of this, too, in the imperial collection.[147] Yet the memorial's description of the fakes is plain.

"Marquis Hui of Xin yu always loved [calligraphy]. He offered rewards and summoned people in order to buy [from them], taking no account of the price. But base fellows carefully made copies and imitations: they changed the color of the paper by soaking it in the dirty water which drips from thatched roofs, and made it at the same time worn and stained, so that it looked like the [paper of] ancient writings. Genuine works and fakes were mingled, and nobody could distinguish between them. . . .

"Emperor Xiao Wu also collected excellent calligraphy. Gentlemen of the capital and provinces often presented [examples] to him; genuine and fake were mixed together in confusion."[148]

The classical art tradition has left no document to match this Chinese one, but as will be shown later, the evidence of faking is unmistakable. As for our own tradition, the first recorded major fake was made to retain a great painting despite political pressure to give it up;[149] but that was no more than the beginning of a story that soon became crassly, continuously commercial. Toward the close of the sixteenth century, as has been shown already, the papal physician-collector-dealer Giulio Mancini actually developed the methods of what is now called Morellian connoisseurship, precisely because faked paintings by the great masters of the High Renaissance were already so common in Rome.

Mancini also tells the story of Terenzio, a late-sixteenth-century painter from Pesaro who managed to become court artist, as it were, to the wealthy

Cardinal Montalto.[150] Instead of being satisfied with the Cardinal's patronage, Terenzio produced a fake Raphael. A later source says that he took the design from a "good drawing," presumably by Raphael, and painted it over an old picture in a finely carved frame.[151] This was close to the method of the Grünewald faker, who borrowed a gesture here, a pose there, and a color harmony elsewhere, all from genuine works by Grünewald.[152] Just as this man fooled the Cleveland Museum, the system used by Terenzio fooled Cardinal Montalto, and the Cardinal evidently paid a real Raphael price for the fake.[153]

Unfortunately, the fake Raphael sold to Cardinal Montalto was soon exposed, because the Cardinal started proudly inviting the Roman connoisseurs to see "my Raphael." When the Cardinal had been duly undeceived, Terenzio lost his valuable patronage. It was said of Terenzio, "In such a manner, men, through greed, lose in life all the good they might have accomplished."[154]

It would be tedious and is needless to call the roll of the great Western fakers of later periods, like Bastianini, Dossena, and Van Meegeren. Concerning the era before art history became a quasi-scientific discipline, however, it should be noted that the fakers were so numerous, and false attributions were such a routine art-dealers' trick, that the successful deceptions were really beyond counting. For instance, the owner of a single, not particularly famous English collection, the Earl of Wemyss, had actually been taught to believe he owned five works by Leonardo da Vinci, whose genuine surviving paintings can almost be counted on the fingers of two hands. Unfortunately, Lord Wemyss admitted Bernard Berenson to inspect his pictures. When told he was really the owner of zero Leonardos, the Earl was so angry that he ordered the art historian to leave the house at once—although the place was remote, there was no transport easily available, and Berenson had to trudge miles to the nearest station.[155]

Finally, it is irresistible to take note of the most remarkable faker anywhere in the world as these words are written, who must be nameless since he has not been formally exposed. The man is also one of the last serious practitioners of traditional Chinese painting, and he knows the lore of Chinese art as well as any art historian specialized in that subject. He is the most remarkable of all fakers because he has successfully faked works as remote in date as the Tang dynasty,[156] although he specializes in Dao Ji and other seventeenth-century painters. His one inescapable requirement is that his large collection of old silks and papers should contain the particular kind of silk or paper Chinese painters used at the dates of the paintings being faked, including Tang times over a thousand years ago. He has been so successful, too, that there is hardly a museum collection of Chinese art that does not contain at least one specimen of his handiwork; and this has helped him to support into old age a genially

epicurean way of life—for he is also a world-famous connoisseur of grand Chinese cookery. He is remarkable in another way, too, because his fakes do not automatically begin to look like daubs the moment they are shown to be fakes, as most faked pictures do. Indeed, they are beginning to be sought after for themselves. So one has to say: Good luck to him!

Revaluation, Antiques, Super-Prices

The way revaluation is engendered is less obvious than the way art faking begins as soon as there is a brisk market. Yet it is at least plain that no revaluation would ever be possible without art collections and an art market to provide examples for comparative study, and without art history to establish the collectors' hierarchy which the revaluers then alter. The art market has another role, too, for individual revaluations of artists and schools have often begun because collectors like old Carlo Lodoli have had to look for works of art that were cheaper and easier to come by than the great collectors' prizes. A good case in point is the sudden rise in interest in American artists of the nineteenth century, like Cole, Inness, Church, Moran, and Bierstadt. Most of the pioneers of this new field of collecting would all but certainly have preferred to gather French Impressionist paintings if Monet and Manet prices had not reached such astronomical levels. There is much more than this to the problem of revaluation, to be sure; but the deeper aspects of the problem would require a long independent essay.

Two more of the secondary by-products of art, antique collecting and super-prices, can also be dealt with so briefly that they may be taken out of order. Antique collecting in the modern sense of the phrase is an obvious outgrowth of art collecting. It only deserves a place as a separate by-product of art because it introduces the theme of old-for-old's-sake, and because even in those of the rare art traditions which have had antique collectors, a long time has characteristically passed after the development of art collecting before other people's old furniture has begun to be preferred to new furniture. The evidence concerning the other rare traditions will be presented in due course. In our own Western art tradition, old furniture was never collected before the eighteenth century.

One strand of modern antique collecting derives from eighteenth-century England. Horace Walpole and one or two other English pioneers of the Gothic Revival sought out "old oak" pieces under the usually mistaken impression that these were Elizabethan or even earlier.[157] The aim was always to give a touch of antiquarian romance, in Walpole's case to his Holbein Chamber at Strawberry Hill.[158] The other strand of antique collecting derives from eighteenth-century Paris, where Louis XIV's great cabinet-maker, André-Charles Boulle, was given the status of an old master among

ébénistes soon after his death, along with his younger but equally grand Régence–early Louis XV contemporary, Charles Cressent. Thus the strikingly rich products of the Boulle atelier became *"bon vieux Boulle"* in the Paris auction catalogues[159] and sold for heavy premiums in Paris right through the eighteenth century, until the French Revolution. Under Louis XVI, remarkably deceptive work in the style of Boulle was also done by first-class Paris *ébénistes* like Montigny, and fine style-of-Boulle pieces continued to be turned out by cabinetmakers catering to the luxury trade in early-nineteenth-century England.

The French Revolution made Boulle furniture temporarily unsalable to French people. For a good many decades after the Revolution, the French followed the rule laid down by the Emperor Napoleon when he rejected the incomparable jewel cabinet of Louis XVI's sister-in-law, the Comtesse de Provence, now in the English royal collection. This was offered to him as a suitable jewel cabinet for the future Empress Marie-Louise, but the Emperor rather crossly said he wished to "make new, not buy old."[160] Yet the Revolution meanwhile strongly promoted antique collecting in Europe in a fairly unexpected way. Great quantities of former royal furniture and fine pieces from the houses of émigré noblemen were sold at auction,[161] or even exported to get money and supplies for the revolutionary armies, in the precise way that the Soviet Antikvariat sent enormous shipments of fine furnishings from the houses of the Russian rich to be auctioned in Berlin.[162]

Colonel James Swan, the American supply agent of the Revolutionary Commission des Subsistences, dispatched to France over a hundred ships laden with leather, wheat, and the like, and to pay for all this, he brought shiploads of French luxuries, including grand furniture and porcelain, for auction in the American ports.[163] This was the first furniture of this sort ever seen in America, except for personal imports by Gouverneur Morris, Thomas Jefferson, and one or two others, and the American response to the Swan-imported furniture was tepid.

As for the response of Europe to the opportunities created by the Revolution, this can be judged from the former furnishings of the great Potocki country palace in Poland, Lançut, which was full of magnificent French eighteenth-century furniture. The French pieces were mostly inherited from an ancestress who sent an agent all the way from Poland to Paris to take advantage of the bargains at the interminable revolutionary auction of the entire contents of the Palace of Versailles.[164] Incidentally, the Lançut furniture is back in circulation among Western dealers and collectors. In 1945, with Marshal Zhukov's armies almost at the palace gates, Countess Betka Potocka managed to get a special train from one of Hitler's generals. The train carried the Countess, her son Count Alfred Potocki, her jewels, and the contents of Lançut (including trunks full of the liveries of the

innumerable Lançut footmen) all the way across Hitler's crumbling empire, to refuge in the tiny state of Countess Betka's cousin, Prince Liechtenstein.[165]

But I am falling into anecdotage. More seriously, the English response to the French Revolution's opportunities was particularly notable. For example, George IV, while Regent, sometimes used as agents his French hairdresser and chef, Weltje and Benois,[166] sending them to buy in the French ports across the Channel where the finest eighteenth-century furniture was sold by the *"charrette"*—the cartload.[167] At least one of the English royal collection's beautiful Louis XVI pieces of the type called *"meubles à l'hauteur d'appui"*—in other words, sideboards made for displaying other objects—is in fact a conflation of two former pieces of this type. There are signs, too, that the conflation was made by putting together the undamaged parts of two such sideboards which had evidently been knocked about during a Channnel crossing in bad weather.[168] But the real point here is that England in the early nineteenth century was the chief center of the collectors' enthusiasm for French eighteenth-century furniture which is now all but universal and has never waned.[169]

With this development recorded, and with the note of old-for-old's-sake already struck by Horace Walpole and others, the history of Western antique collecting need not concern us further, except for one significant point. *All* old furniture was not ardently collected as early as the products of Boulle, Cressent, Oeben, Riesener, Sené, and Jacob, which were sought from the French Revolution onward, though at first only outside France.

In the case of English furniture, for instance, the founder of the still-existing firm of Moss Harris Ltd. got his start as a "chairbreaker" in London in the early 1890s. Chairbreakers, a trade straight out of Mayhew's *London*, took chairs considered to be too far gone to be worth repairing and broke them up for the value of the wood, stuffing, upholstery nails, etc. The original Moss Harris was shrewd enough to pay a premium of a few pennies apiece for chairs of English eighteenth-century date, mainly Chippendale, and to put these aside until he had a stock. He further gathered the cash to have the chairs in his stock repaired, and he then set up in business as an antique dealer.[170] Furthermore, the historical study of French eighteenth-century furniture began as you might expect, in the nineteenth century; but the first serious study of English eighteenth-century furniture appeared as late as 1904, the date of publication of the first of Percy Maquoid's massive four volumes.[171] With this art-historical certification suddenly provided, prices of fine English pieces climbed correspondingly.[172]

The twentieth-century collectors' enthusiasm for all old furniture, of whatever description or origin, also strikes me as particularly significant for a special reason. It is perhaps the best illustration of the way the mere mark of the human hand has come to be more and more cherished,

in direct ratio to this mark's increasing rarity on any normal product of a contemporary factory or workshop.

Super-Prices

As for super-prices, there is no escape from them in any art market, as soon as large numbers of sufficiently well heeled collectors begin to compete ferociously for a limited number of prizes. I have again wondered, as with antique collecting, whether super-prices ought to be classified as an independent by-product of art. There are two reasons, however, for giving super-prices this ranking. On the one hand, the seamy side of the by-products of art has always been detectable, wherever and whenever an art market has been organized; but this seamy side can only attain its ultimate distastefulness when super-prices begin to prevail very widely. On the other hand, the real era of super-prices for works of art opened surprisingly late in our Western art tradition.

The lateness of this beginning did not mean, to be sure, that uncommonly important works of art did not command important prices from an early date. In the England of James I and Charles I, for example, £2,000 was quite literally a noble yearly income, at least for any nobleman who chose not to hang about the court for the rich pickings to be got there. And £2,000 was the exact amount of the first famous super-price, which was paid in 1650 at the tragic dispersal of the greatest single assemblage of Western works of art the world has ever seen, the Commonwealth's sale of King Charles I's incomparable collection.[173]

The other monarchs of Europe had been profoundly shocked by the King of England's execution in Whitehall; but this did not prevent Philip IV of Spain, the Hapsburg Archduke Leopold Wilhelm, then Regent of the Netherlands, Cardinal Mazarin, the real ruler of France, and other pious upholders of monarchical principles from sending their representatives to swarm like vultures around the dead King's artistic remains. King Philip of Spain was one of the more successful buyers at the long dispersal, and he paid £2,000[174] for the picture he christened "La Perla" when he saw it unpacked.[175] This Holy Family is now universally attributed to Giulio Romano, no doubt correctly.[176] Yet the modern attribution still seems a bit odd, since La Perla has one of the best-attested provenances of any picture of its date, and it was just as universally regarded as one of Raphael's very greatest works in the time of Charles I and Philip IV.[177] It came to England from Mantua, and Daniel Nys boasted of it as "one of the finest pictures in the world."[178] Instead of trusting it on board a ship from Venice, Nys further had Nicholas Lanier accompany the picture across the Alps and France for safe delivery in London.[179]

Yet if you examine the record of the Commonwealth's dispersal, you

soon find that the price of La Perla was altogether exceptional. Half the greatest museums in the world take pride in superb paintings from Charles I's collection, which were sold by the Commonwealth for immeasurably less than £2,000. For example, the Louvre's wonderful Giorgionesque Titian, the Concert Champêtre, may just conceivably be the "Picture of Musick. Done by Georgon" which was bought by the former Master of the King's Music, Lanier, for £100 plus a premium of £10.[180] The identification is not certain, but it is possible.

The truth is that famous works by Raphael alone commanded the more celebrated super-prices until almost the end of the nineteenth century. In the eighteenth century, as we have seen, Augustus III of Saxony and Poland paid the monks of San Sisto 17,000 gold ducats for the Sistine Madonna.[181] This was the equivalent of about £8,500 of that period,[182] and it meant King Augustus had paid for one picture close to a tenth of the launching cost of a major mid-eighteenth-century battleship, Nelson's Victory, which was still good enough to lead the line at Trafalgar.

Again, in the last half of the nineteenth century, London's National Gallery made a great stir by paying £70,000 to the Duke of Marlborough for Raphael's Ansidei Madonna.[183] In 1899, in contrast, Mrs. Jack Gardner was able to secure what many think the finest painting in the United States, Titian's Rape of Europa, for no more than $100,000;[184] and, at that, she saved money by wiring her consent to buy to Bernard Berenson in a single word, YEUP, which meant "Yes Europa."[185] In short, the modern era of super-prices for almost any work by a significant master of the past opened only in the first decade of the twentieth century. This was when a whole series of Americans far, far richer than Mrs. Gardner priced her right out of the market for great masterpieces. And only since the end of the Second World War has the art market reached the present phase of super-prices-for-almost-anything.

The Museum Story

So much for super-prices, the most attention-getting and by far the least interesting of the eight by-products of art. That leaves for examination only one last phenomenon, public art museums. Since we now live in the Museum Age, the museum story deserves to be told in some detail.

To begin with, museums need to be defined. The word comes, of course, from the Mouseion, the superb library the first Ptolemy built in Alexandria and dedicated to the Muses. Ever since the word came into use in Western Europe, all sorts of private collections, from the most artless Wunderkammern to the greatest princely art collections, have been called "museums." At the risk of being arbitrary, however, a public art museum will be used in this essay to mean just that—a permanently established assemblage

of works of art to which the public has a permanent right of entry. So defined, art museums are a strictly Western phenomenon; for they were established only in the regions sharing the classical art tradition, and then in the regions of our own art tradition—at least until cultural homogenization caused national museums to be established all over the world. In the other rare art traditions, splendid shows were for the masses, but the more refined pleasures to be got from studying individual works of art were for the classes.

Something will be said later of the museum story in the classical art tradition.[186] In our own Western art tradition, Rome's Museo Capitolino should probably be regarded as the first public art museum. In the Museo Capitolino's fairly primitive first form, Pope Sixtus IV brought together most of the city of Rome's more famous remnants of classical sculpture in 1471.[187] Yet municipal pride was really the theme here, as was also true of the statues of Florence's Loggia de' Signori, now the Loggia de' Lanzi, and the other sculpture early assembled in and around what is now the Palazzo Vecchio.[188]

Thus the first public art museum of one of the three main types known today, with art collecting as the central theme, was the Statuario Pubblico in Venice. In 1591,[189] construction of the Statuario Pubblico began for the sole purpose of displaying the classical sculpture collected by Giovanni Grimani, Patriarch of Aquileia,[190] plus what was left of the earlier collection of classical sculpture formed by the Cardinal Domenico Grimani.[191] The Cardinal had bequeathed all his collections to the Republic of Venice in 1523,[192] but because only one room was provided in the Doge's palace for showing selected sculpture,[193] there was no settled place to show the paintings and the other statues. Many precious things had therefore been lost.[194]

Presumably this was why the Patriarch, when his turn came, insisted that he would only give his sculpture to Venice if a place to show his own collection, together with Cardinal Grimani's remaining sculpture, could first be arranged in Sansovino's Biblioteca Marciana.[195] Vincenzo Scamozzi designed the Statuario Pubblico as a grand new entrance to the library.[196] It is a tragedy that this early monument of Western culture was effectively destroyed when the Grimani sculpture was transferred to Venice's Museo Archeologico.

In every century thereafter, the example set by the Patriarch Grimani has been followed elsewhere by other private collectors who have wanted to keep together after they were dead what they had gathered in life.[197] The first public art museum in France, for example, was opened on July 7, 1696, at Besançon, of all places, under the will of Monsignor J.-P. Boisot. This abbot of the Benedictine monastery of St. Vincent de Besançon[198] left his pictures, sculpture, medals, and library to his monastery with

the condition that they be made regularly accessible to the townspeople.[199] The little museum that resulted set another precedent by the idiosyncratic inconvenience of the hours when it was open, which were from 8:00 to 10:00 A.M. and 2:00 to 4:00 P.M. on Wednesdays and Saturdays.[200]

By now, of course, the exercise in self-commemoration inaugurated by Monsignor Boisot and the Patriarch Grimani has been imitated all over the world. The Nezu Museum in Tokyo, the Frick in New York, the Gardner in Boston, the Wallace in London, the Jacquemart-André in Paris—these are no more than a few examples from a long, long list.

Nonetheless, the true roots of the modern Museum Age are instead to be found in the princely collections of Europe. If mere *Wunderkammern* are excluded—and they should be—the Renaissance was the time when princely art collecting started in earnest; and the sixteenth century was the period when an art collection started to become a standard item of equipment for any European ruler with pretensions to culture, whether his domain was a great empire or something far more humble. In the sixteenth century, too, princely collections began to be shown in museum-like galleries specially planned for the display of works of art. Most of the more famous pictures in the French royal collection were assembled at Fontainebleau in a new *cabinet des peintures* in a pavilion built for that purpose in 1565,[201] and this was probably why Vincenzo Scamozzi thought the art galleries of great Italian houses and palaces were partly inspired from France.[202] Only a little later, much of Vasari's Uffizi was done over by Bernardo Buontalenti, to provide the Grand Duke Francesco I de' Medici with an art gallery which he also used as a *Wunderkammer*.[203]

The princely art collections of the sixteenth, seventeenth, and eighteenth centuries were museumlike in the sense that to varying degrees they were accessible to the public, or at least to the respectable part of the public. In most cases, tickets of admission had to be applied for, and there might even be an admission charge beyond the means of any visitor who was not fairly well off. At Dresden in 1764, Boswell admired the art gallery—the same one Goethe later called a "temple of art" and somewhat oddly praised for its beautifully waxed floors.[204] But Boswell was also made indignant by the substantial charge for admission.[205] In some other cases, however, admission was easy and there was no charge. Any man wearing a hat and sword (and therefore a *gentilhomme*) had free access to Versailles;[206] and there he could not only watch the King eat his dinner;[207] he could also inspect the royal works of art shown in the state rooms.

Yet the princely art collections were not really public art museums and were not so regarded in the period in question, for reasons that are particularly apparent in the history of King François I's art collection at Fontainebleau. One of the King's favorite places of relaxation in his favorite

château was a luxurious Turkish bath–like suite of rooms, l'Appartement des Bains.[208] Here, rather oddly, the King further hung the best of his pictures,[209] or, rather, fixed most of them to the walls with ornamental stucco surrounds.[210] As Cassiano del Pozzo noted when he visited France,[211] many of the pictures were half destroyed by the humidity constantly attacking them, and this was most probably why Leonardo's Leda and the Swan was finally lost to the world.[212] The mere possibility that a Leonardo was kept in a royal Turkish bath is enough to show that museum ideas did not control princely art collections. In these collections, in fact, the reigning prince could put any great work of art out of sight of his highest courtiers, or for that matter, he could sell the whole lot, as happened at Mantua.

The dawn of the Museum Age dimly began because of the three events already described in a previous chapter—the conversion of the Uffizi into a true public art museum by the will of the last of the Medici line in 1743; the further organization of the Uffizi as a true art museum by the Grand Duke Pietro Leopoldo; and the establishment of the forerunner of Vienna's Kunsthistorisches Museum in the Belvedere Palace by the Emperor Josef II. Just about every great public art museum in Europe today is basically a converted princely art collection. The last major conversion occurred in Russia in 1852, when Tsar Nicholas I opened the Hermitage after Leo von Klenze had added the New Hermitage to the Winter Palace.[213] The royal collection in England and the Liechtenstein collection in the vaults of Vaduz Castle are now the last princely collections of the old type.

In England, however, although the past is recalled by the magnificent art collection that in theory still remains the private property of Queen Elizabeth II, the third main type of modern art museum had appeared as early as the mid-eighteenth century. The British Museum (not originally an art museum but soon to become one) was established by act of Parliament in 1753,[214] and is the earliest Western art museum ever founded de novo with public revenues. The Napoleonic local museums,[215] mostly loot-aided,[216] then followed; and another act of Parliament set up London's National Gallery and provided funds to buy the foundation collection made by the founder of Lloyds, Sir John Julius Angerstein.[217] This completed the fundamental design of the Museum Age; for all the countless art museums of the modern West may be broadly divided into those founded to keep private art collections permanently intact, like the Statuario Pubblico; plus princely art collections converted into national or municipal collections, like the Uffizi, the Prado, the Hermitage, and many more in Europe; plus museums publicly founded at public expense, like the British Museum; plus mixtures of these three.[218]

Perhaps, too, one should add as a subtype the American museums

like the Metropolitan in New York,[219] founded by private enterprise in 1870, directed by a board of rich private supporters, but also municipally and state-aided. Even today, in any case, when art museums are almost as common public conveniences throughout the Western world as sewage and water systems, the roots of the vast majority are still in private or princely art collecting, or both; and all our art museums are ruled by art history.

This chapter has now completed the badly needed analysis of all eight by-products of art and of the relations of these peculiar phenomena to one another. At the chapter's opening, and here and there after that, a good deal of stress has had to be placed on the seamy side of art collecting and the associated phenomena. But if the reader wants my choice for the best illustration of the bright side, I suggest a Sunday visit to the Metropolitan in New York or the National Gallery in Washington, the Louvre in Paris or the National Gallery in London.

It is easy to object to museum entombment of works of art for the reasons sketched by Martin Wackernagel. Of Sunday visits to museums, it is of course customary to say, "You can't see the pictures for the crowd"; and there is something to that. But how moving a spectacle the crowd itself makes: the young fathers carrying babies on their backs to ease the young wives' burdens; the old people and the schoolchildren swarming through; in short the simplest of the simple taking much trouble to enjoy great works of art which were once for the private enjoyment of the richest of the rich!

In Conclusion

This much being said, the present chapter still requires a short conclusion. In brief, I have already pointed out that art collecting and the other by-products of art together constitute no more nor less than an integrated behavioral system, in which all the elements are linked to and interact with all the other elements. Now that the entire system has been described with illustrations of the way it works, it is worth calling attention to this system's intensely idiosyncratic character and extreme complexity. In the history of human culture, it is very hard to think of any other behavioral system of comparable elaboration, and no apparent practical utility, that has ever developed even once. But here we have a system that has been repeated, as though from a blueprint, and more or less completely, in no fewer than five different cultures. And this, surely, is sufficient reason for continuing the inquiry.

THE PROOF—AND THE QUESTION

Thus far, I hope, this essay has attained its essential preliminary objects. The importance of art collecting and its linked phenomena has been brought out, and the resulting system, which I have called the by-products of art, has been shown to be a significant feature of certain cultures. The phenomena with excessively vague outlines have been defined, and art collecting has been defined at considerable length for good practical reasons. And the reasons have also been shown for concluding that the by-products of art have been historically restricted to the five art traditions which I have ventured to call rare.

The causes of the rare art traditions' rarity are the heart of the matter. If the by-products of art had been everyday developments in the history of culture, they would have no great interest except for cultural anthropologists. Indeed, if art collecting and the linked phenomena had merely been common developments in higher civilizations, one might dismiss them as natural secondary results of the production of a storable surplus—and thus of wealth—which has been the key characteristic of every higher civilization since the dawn of history. Instead, however, the whole record as far as we know it shows that art collecting and the other elements of the total system have never appeared in the great majority of higher civilizations.

To sum up, ad interim, five art traditions have had in common certain ways of thinking about, responding to, and behaving about works of art, despite the immense differences in the arts of these five traditions, and in their historical-cultural backgrounds, too. And these ways of thinking, responding, and behaving have also been unknown in the thousands of other art traditions the world has known since art began, including major traditions which have been conspicuously and grandly creative over long

periods of time. Thus the truly central question still confronts us. The question is:

Why should only five art traditions have developed art collecting and some or all of the other by-products of art, when this intricate and curious behavioral system did *not* develop in the thousands of other art traditions the world has seen?

This question cannot be ducked or dodged. There is an unvarying law of science that significant differences of result imply significant differences of process. The differences of process may be internal and invisible, but they are always there. The same rule of science covers the five art traditions which have produced art collecting and some or all of its linked phenomena, and the vast majority which have not done so. Thus the immediate problem boils down to finding the peculiarities in these five art traditions' inner processes which have caused the appearance of the by-products of art.

Bold as this enterprise may be, it really must be attempted if this essay is to go beyond relating the mere surface history of the by-products of art. Progress toward a solution of the problem will be made, moreover, if the five art traditions can also be shown to share certain similar yet distinctive behavioral traits despite the great dissimilarities in their art. Showing this, admittedly, will only move the whole problem back one square, as it were. On this new square, the new question will be just why these behavioral traits were shared by the five rare art traditions, but were absent in the vast majority. All the same, if special behavioral traits can indeed be located in the rare art traditions, it will then be reasonable to assume that the by-products of art grew out of the special traits which these few traditions all shared.

Hence much more ambitious case studies must now be attempted. We must see how Greek art in the great centuries developed certain distinctive behavioral traits which had never been seen before in the whole course of the world history of art, and how the appearances of these peculiar traits then led on to the first appearances in all of art history of art collecting and the linked phenomena. We must have a look at the way the same pattern was then strangely repeated in China, half a world away. And we must have a much more summary look at what happened in Japan, and much later, in the Middle East when Islamic art collecting began.

Finally, it is also important to see how the behavioral traits in question more or less completely disappeared from European art, along with art collecting and all the other by-products of art. This happened, as you might guess, in the long interval between the final decay of the classical art tradition and the first symptoms of the onset of the Renaissance. Investigating these large matters is now the next order of business.

VII

"THE GREEK MIRACLE"

In theory, the inquiry now to be attempted should cover the whole world history of art. A prime purpose, after all, is to identify special cultural-behavioral traits shared by the five rare art traditions, yet absent from any of the countless other art traditions the world has known. But it is already a grandiose program to try to find traits which have been shared by the arts of Greece, the China of the Empire, Japan and later Islam, and the West beginning with the onset of the Renaissance. It is a downright impossible program to show that these same traits were also effectively unknown in any other branch of art, from the time when hand axes were first made with art by late Acheulian stoneworkers to the time of the Southeastern Nuba body painters of today. Hence the only course is to restrict the inquiry to the art traditions that may be classed as major, because they were strong enough to endure for long periods and sufficiently ambitious to leave behind them impressive works of art still available for study today.

Even so, an immense span of time is necessarily involved before one comes to the origin of the first of the five rare art traditions in the little states of Greece in the seventh century B.C. No fewer than thirty-two thousand years, or thereabouts, have in fact elapsed since the obscure beginning of the earliest major art tradition the archeologists have discovered.[1] This is unquestionably the great, all but incredibly long-lasting tradition which culminated in the wonderful works of art of the Upper Paleolithic painted caves of southern France and northern Spain. This continued and developed for about twenty millennia,[2] until close to the end of the Old Stone Age. Thereafter, too, came the Mesolithic, and the Neolithic, and then the Age of Bronze!

During the Neolithic Age, it seems not unlikely that we should now know of several major art traditions—if only the remains had been more

durable. Here, one thinks of the first known proto-city, Çatal Hüyük in Anatolia, built and rebuilt over close to a thousand years in the later seventh and early sixth millennia B.C.,[3] and especially of Çatal Hüyük's macabre temples. The finer temples had a great, unknowable, still mutely menacing deity in bas-relief as a focus on one wall;[4] the walls were additionally enriched with painted decorations and sometimes frescoed scenes;[5] and the décor also included the constantly recurring Çatal Hüyük motifs of pairs or long rows of huge horn cores of *Bos primigenius*,[6] and further pairs or rows of ample female breasts built up in mud plaster around the jaws of wild boars or carnivores[7]—with the fangs showing, moreover, through the enlarged nipples of these alarmingly symbolic bosoms. Such temples must have been true places of power, in fact magical power expressed through art. But the chief raw material at Çatal Hüyük was mud plaster: and James Mellaart, the excavator of this extraordinary site, could not retrieve more than the ghosts of most of what had been there, even by the advanced archeological methods he used.[8]

Durable remains were almost always left, however, by the more complex human societies we choose to call higher civilizations. After the rise of the first of these in the Chalcolithic–Early Bronze Age, a major independent art tradition was usually engendered by each reasonably self-contained higher civilization. Ancient Sumer and several of its successor-cultures in Mesopotamia and Iran, Anatolia and Syria-Palestine; Egypt, of course, from Predynastic times onward; the early Indian culture of Mohenjo-Daro and Harappa in the Indus Valley; Minoan Crete and its conqueror-inheritor, Mycenaean Greece; the China of the Shang and Zhou dynasties, of which the earliest bronze remains are now pre-Shang dating from about 2300 B.C.;[9] the Olmec culture of Central America, which developed around 1200 B.C.[10] and was the forerunner of so many wonderful pre-Columbian cultures—these compose the short list of higher civilizations that nourished major independent art traditions in the very long first phase of art's known story on our planet.

Throughout all these millennia, no art tradition of any higher civilization showed any sign at all of any of the by-products of art, as far as we know today. It may be, of course, that we do not know enough. Yet if any of these higher civilizations had adopted art collecting as a social habit, at least one assemblage fairly easily readable as indicating an art collection should have been discovered by now, in just the way the archeologists found the magpie-like collection of *objets trouvés* in a habitation-shelter of people who probably in part originated the Paleolithic tradition of the painted caves.[11] No such sign of true art collecting has ever been found.[12] Thus one can fairly safely assume art collecting was always unknown before the Greeks became collectors; and one can then assume, further, that through all these millennia all the other by-products of art

were also unknown, as were the special cultural traits that seem to produce these phenomena.

The Counterfeits

This being said, certain reservations are in order. On the one hand, some major art traditions plainly contained within themselves, in greater or lesser degree, what may be called the seeds of art collecting—of which more later. On the other hand, some of the major early art traditions, and some great later traditions outside the rare group as well, produced counterfeits which can be easily mistaken for one or another of the by-products of art, even including museums.

For example, if Fray Bernardino de Sahagun had written in the twentieth century instead of the sixteenth, he would probably have called the temple of Coacalco "Montezuma's art museum." Here "dwelt the gods of cities which, in all places which the Mexicans overran, they took captive. They then carried them back and shut them in here. And here they were guarded at Coacalco."[13] But of course the Aztecs did not carry these gods of other cities to the temple of Coacalco for the reasons Napoleon's art looters carried off the Apollo Belvedere in triumph to the Musée Napoléon.[14] They were carried off, shut in, and guarded because, if left among their subjugated peoples, they might have been dangerous, even vindictive.

Carrying off the gods of defeated enemies was a common enough practice in antiquity,[15] although the final solution of smashing the gods' images on the spot was often adopted, too.[16] Furthermore, trophy taking has always been a common practice among victors, as it still is and probably will always be. London's Victoria and Albert Museum formerly contained the entire regalia of the Burmese kingdom, taken in the conquest of Mandalay in 1885; but the ornate, ruby-encrusted objects forming the regalia were returned to newly independent Burma after the Second World War. On the eve of the retreat from Moscow, Napoleon wasted time deciding what trophy to drag home.[17] Hitler took trophies as well as looting works of art on an enormous scale. For just the same reasons, the celebrated stele of the laws of Hammurabi was found by the French excavators of the ancient Elamite capital of Susa in Iran. It had been brought home as a trophy when the Elamites briefly conquered Babylon in 1160 B.C.[18]

Then, too, antiquarianism has not seldom arisen in societies conscious of their own long past. This is the real explanation of "the museum of Belshazzar's sister," which was found and christened by the great excavator of Ur, Sir Leonard Woolley.[19]

The Biblical Belshazzar and his sister were members of the final generation of the Neo-Babylonian dynasty. The dynasty had been founded by Nabupolassar on the ruins of the second Assyrian Empire; and except in

the time of the Biblical Nebuchadnezzar, who was a great conqueror himself, these last native rulers of Babylon were always surrounded by foreign menaces. The terrible hand of God writing on the wall at Belshazzar's feast, "Mene, Mene, Tekel Upharsin,"[20] accurately predicted the Achaemenid conquest of Babylon by Cyrus the Great in 538 B.C.

Antiquarianism, stressing nativeness and continuity, often helps to rally a nation in the presence of foreign occupiers or external threats. The appeal of the Mesopotamian past was all the greater, no doubt, because Babylon had suffered from the brutal Assyrian occupiers almost until Nabupolassar's Scythian allies besieged and took the Assyrian imperial capital, Nineveh.[21] Thus his neo-Babylonian dynasty was strongly antiquarian. "The museum of Belshazzar's sister" was really a small antiquarian assemblage of ancient Sumerian texts, plus crude copies,[22] kept in a little room in Bel-shalti-Nannar's palace at Ur, where she served as priestess of the Moon God. In the same way, in the "Hauptburg" of Nebuchadnezzar's magnificently rebuilt Babylon, the King gathered much earlier images of Mesopotamian gods and kings,[23] partly for antiquarian reasons, but no doubt partly, too, because he was an exceptionally superstitious ruler who must have hoped for aid from these still-numinous presences.

The Seeds

So much for what I have called the counterfeits. As for the seeds of art collecting, their most obvious source is the intense interest in the arts that has marked certain cultures in certain periods. For instance, Minoan Crete in the period of the Second Palaces was rather obviously and quite intensely art-loving. Whereas the grim sanctuary of Yazilikaya hardly suggests that there were many great art lovers among the rulers of the Hittite Empire, whose supreme shrine was in this hidden cleft among the mountain rocks.

But there is another element as well that is to be found here and there in history, namely a strong interest in and respect for the art of the past, which can also lead, not always to antiquarianism, but to archaizing art. The early tribes inhabiting the coastal area of Peru were distinctly primitive, but among them the past was ever-present. The reason was practical: the intensely dry climate tended to preserve all past burials forever intact with all their pots and other grave goods. Thus thousand-year-old Ica pottery is now considered to contain archaizing echoes of pottery of much older horizons.[24]

In Egypt, particularly, both sources of the seeds of collecting were strong and conspicuous from early dates. The intensity of Egyptian interest in the arts is best exemplified by the moving pride in beautiful craftsmanship of the artists themselves, as shown in the tomb inscription of Irtysen,[25]

obviously a very great artist who served King Mentuhotep II of the XIth dynasty. Another sign is the artists' pride in their own major works, as shown by the personal memorial left by the court sculptors of the later XVIIIth dynasty, the father and son Men and Bak.[26] Egyptian tourism is documented, too, by the graffiti the tourists often left in places they visited; and some of these graffiti show that the tourism was art-oriented as well as religious in nature. For example, a certain Ahmose visited King Zoser's great IIIrd-dynasty tomb-temple and pyramid complex at Saqqara,[27] and was moved to leave this graffito: "The Scribe Ahmose, Son of Iptah, came to see the temple of Zoser. He found it as though Heaven were within it, Re rising in it."

Then, too, admiration and respect for the art of the past are both proved by the superb tomb-temple of Queen Hatshepsut of the XVIIIth dynasty. The design of Queen Hatshepsut's temple was actually developed from the design of the tomb-temple of Irtysen's master, King Mentuhotep II, seven dynasties before.[28] When Hatshepsut's temple was built, access was also carefully provided to the temple of Mentuhotep's Queen, Neferu,[29] on a lower level in the cliff at Deir El-Bahri.

Egyptian antiquarianism is again well attested, for instance by a fragmentary palette of the predynastic period in the Brooklyn Museum, which has an inscription added by Queen Tyi on the occasion of the Sed festival of her aged husband, Amenhotep III of the XVIIIth dynasty.[30] Yet again, Rameses II of the XIXth dynasty caused royal statues of much earlier dynasties, "mainly of granite," to be brought to Tanis to adorn the forecourts of his new temples there.[31] Furthermore, this Pharaoh's son, Prince Chaemwese, was Egypt's great antiquarian, restoring, for example, early pyramids, and adding inscriptions naming the monarchs of the Old Kingdom for whom these pyramids were built.[32] Finally, artists were even remembered in Egypt after a fashion, as indicated by a rock-cut inscription left by Khnum-Ibre in the early fifth century B.C.[33]

Take a second look, however, and you will find Khnum-Ibre was an architect-engineer who reached high official rank in the equivalent of the Ministry of Works while Egypt was under Persian rule; and the earlier masters listed in his inscription were also architect-engineers, who were remembered because they had reached comparable or even higher ranks in the bureaucracy, and were further claimed by Khnum-Ibre as his ancestors. Look once more, and you find Rameses II wanted royal images from more ancient temples for his new temples' forecourts because crowding royal dedications conferred prestige on the temples that boasted them.[34] But when overcrowding occurred, as at the great Temple of Amun at Karnak, the surplus sculpture was briskly buried—which is hardly the act of an art collector or museum curator.[35]

To sum up, I myself believe that during the millennia under discussion, the seeds of art collecting were both stronger and came closer to germination in Egypt than anywhere else with the possible exception of later Minoan Crete.[36] I further believe that there may well have been a few Egyptian art collectors and perhaps some sort of primitive Egyptian art history, especially in the Saite period. Near the end of independent Egypt's story, people looked back nostalgically to the glory of the Old Kingdom, and Egyptian art was also strongly, sometimes servilely, backward-looking.[37] For instance, the XXVIth-dynasty tomb of a certain Iby was actually copied from the tomb of another Iby who had lived many dynasties before.[38] While this kind of mood prevailed, it would be surprising if a few Egyptians did not take to collecting products of the early periods which they so much admired.

Yet only consider how the art and history of Egypt have by now been subject to intensive exploration for much more than a century. Remember, too, the sheer volume of material that has already been discovered. Thus far, nonetheless, the explorers have found no trace of any Egyptian art collection meeting the definition proposed in this essay, and obviously they have found no trace of any Egyptian art collecting, either—although they have gathered mountains of evidence for the modern reconstruction of the history of ancient Egypt and its art. Thus it seems clear that even if Egypt produced a few true art collectors in the course of over two and a half millennia, art collecting never remotely approached becoming an established Egyptian social habit. And this is the real test.

The "Miracle"

The millennia and the art traditions that have now been superficially examined represent just under nine-tenths of the known history of art since the first major art tradition began to take form early in the Upper Paleolithic. So much of the story had already been told before the glorious and mysterious creative mutation that occurred in Greece in the seventh century B.C. Out of this mutation came the great art of ancient Greece, plus the entire classical art tradition. It has been wisely called the "Greek miracle,"[39] and it was not miraculous solely because of Greek art's originality and grandeur.

Generations of great art historians and theorists, in classical times and in our own time, have studied and written about the "Greek miracle" in all its many aspects. To date, however, no scholarly stress has been placed on the sheer novelty of certain cultural-behavioral traits, all but one of which first appeared on earth in the great centuries of Greek art. More important, the meaning of these traits, in combination, has not been

seriously explored. Unless I am mistaken, in fact, it has never been suggested that these four special behavioral traits of Greek art combine to explain the other Greek "firsts" that chiefly concern us: namely, the first appearances on earth of true art collecting, art history, and the other linked phenomena. Not art collecting alone, but *all* the by-products of art seem to have originated in the Greek world,[40] and none of them had ever been seen before.

I must add that I have no easy explanation for any of Greek art's four special behavioral traits. It is bewildering, in itself, that a precedent-breaking creative mutation took place in the seventh century B.C. in the quarrelsome little states of Greece.[41] Moreover, there was nothing unprecedented in any of the accepted indicators now used to pinpoint this mutation. Among these indicators, for example, a key place is usually accorded to the earliest Greek monumental stone sculpture, which probably dates from about 650 B.C.[42] Yet the first Greek sculptors in stone were Johnnies-come-lately.

Huge boulders roughly shaped into semihuman form have been found, rather surprisingly, at a small site in Yugoslavia dating from eight thousand years ago; and these are the earliest known pieces of monumental stone sculpture.[43] The Greeks got their inspiration too, from the stone sculpture of Egypt. Indeed, about the finest and one of the earliest Greek *kouros* statues that survives intact, the marble youth in the Metropolitan Museum in New York,[44] still rather faithfully follows a system of human proportions imported from Egypt.[45] The stance and much of the treatment of the hair come from the same source. In large measure, this was a borrowed image. There were also other borrowings from the Phoenicians, from metal-rich Urartu in the Caucasus,[46] and elsewhere. Yet what the Greeks then did with what they borrowed was wholly new under the sun; for the Greek artists of the great centuries were the first in the world history of art to innovate both rapidly and unceasingly.

This compulsive innovation was in truth the first of the Greek art tradition's novel behavioral traits. Nowadays, of course, its novelty is far from easy to grasp. In the twentieth century, each new creative generation's inescapable need to innovate is taken as an immutable fact of the life of art. All our beginning artists fear above all the verdict on their work: "It's been done before." Since the past is so invariably seen through the distorting glass of the present, it is also commonly assumed that all artists of all earlier art traditions have felt the same compulsion to be original which is felt so strongly by the artists of our own time. Yet in reality this was far from the way of it. So far as the existing evidence goes and is known to me—and of course the evidence may not go far enough, or I may not have searched enough—the true compulsion to be original appears to be limited in art history to the five rare art traditions.

On Change in Art

Here, however, "compulsion" is the key word to note. For example, a recent study of the art of Polynesia before the intrusion of the West asserts that the Polynesian culture was one of the fairly large number in which artistic innovation was positively forbidden.[47] In other words, the artists of the Polynesian islands were required to repeat, over and over again, the forms hallowed by religion and ancient custom; and any artist doing what had been done before with uncommon verve was merely held to be aided by mana—that is, by an immanent power external to the artist himself.[48] Even if this study's conclusions are entirely correct, however, one may also be certain that Polynesian art was far from eternally changeless. Instead, if the earliest works of art of the Polynesian islands survived for study today, a nuanced sequence of stylistic periods could surely be deciphered. And the sequence would surely extend from the first adventurous settlements of the various islands by little parties guiding their frail, overladen double canoes by the stars, the sea signs, and the bird signs over thousands of miles of unknown ocean.

Again, in the eighth century A.D., after the fearful crisis of Byzantine iconoclasm, the second Council of Nicaea laid down the rule: "The making of icons is not the invention of painters. . . . What is ancient is worthy of respect, saith St. Basil. . . ." And the rule continued, in effect, that the conception of images belonged to the Church Fathers, only painting—execution—to the painters.[49] Yet an image of the Paleologan art of the time of the Kariye Djami differs greatly from an image of the period of the Macedonian Renaissance; and both differ even more greatly from the all but incredible image of the Savior, the sixth-century icon of Jesus Christ probably given to the Monastery of St. Catherine in Sinai by the Emperor Justinian, which was so wonderfully rediscovered a few years ago by Professor Kurt Weitzmann and his team of scholars.[50] In sum, artists may be restrained from innovation by the most rigid hieratic rules; yet some degree of change must still occur in every epoch of every art tradition, simply because no period in the history of any culture can ever precisely resemble any other period. At least to this extent, the reality of Alois Riegl's *Kunstwollen* is beyond argument.

Nor is this all. Every independent art tradition the world has ever known necessarily began with an initial period of active innovation, when the tradition was developing its own vocabulary of styles and forms. For various reasons, too, most long-lasting traditions—even those which were rule-bound—have further experienced secondary innovating periods, when forms altered and new styles evolved. This plainly happened in France in the twelfth century, when Gothic art was born of Abbot Suger's work

at St.-Denis.[51] And it happened in Egypt around 2700 B.C. at Saqqara, where the step pyramid the scribe Ahmose visited was the first in the awe-inspiring Egyptian series to be encased in dressed stone.[52]

Finally, in considering this central problem of change in art, room must be allowed for the great masters whom every major art tradition can be expected to produce on fortunate occasions—such artists as those the Polynesians considered to be aided by mana. All serious artists have always wished to excel, and all great artists have always wished to excel greatly. You can even come close to seeing great artists striving to excel if you study the remains of the arts of the past with reasonable care. Take, for instance, the seated portrait of the last successful Khmer Emperor, Jayavarman VII, that great conqueror, in the Pnomh Penh Museum,[53] and the little head of Amenemhat III in the Gulbenkian Museum.[54] In general form the statue of the Khmer Emperor is formulaic, and one may be sure the total figure of the Egyptian Pharaoh was also formulaic before most of it was lost. Yet what power, what expressiveness were achieved within the limits of the formulae! By the magic of their art, the sculptors made their images come close to announcing audibly, "I am Ozymandias, King of Kings." And because of this, these images altogether surpass contemporary works by lesser Khmer and Egyptian sculptors.[55]

By the same token Irtysen, for instance, would undoubtedly have been delighted to find new, more pleasing, or even more economical ways of working the ebony and ivory and gold in which he seems to have specialized.[56] He would have been proud, too, if he could have offered King Mentuhotep II a luxury object of a novel elegance that would charm "the Good God," as Egyptians called their rulers. He was a sculptor as well, and the way he boasted in his tomb inscription of his knack of making each of his statues lifelike[57] can only mean that he approached each commission as a problem to be solved in its own terms. All great artists throughout the whole history of art have always approached all major works as problems to be solved in their own terms.

Yet the fact remains that both Irtysen and the unknown sculptor of the Gulbenkian head of Amenemhat III were both required to follow,[58] and all but certainly did follow, a system of human proportions that was probably already in use in the late predynastic period, as indicated by the two figures of the ruler on the Palette of King Narmer.[59] This system became canonical rather early in the Old Kingdom, and was standardized by the IVth dynasty.[60] The canonical system thereafter controlled virtually all Egyptian sculpture of the human figure for about nineteen hundred years.[61] Furthermore, this canon of proportions was only one of a series of fairly rigid conventions which Egyptian artists went on obeying, century after century, for millennia on end. Moreover, even in most other art traditions which were not so convention-ridden, the terror of doing what

had been done before that is felt today was actually quite unknown. In truth, when compulsive innovation is under consideration, as in the Greek case, I repeat that the key point is the compulsion rather than the innovation. On this point, it is also useful to consider another observation by Professor Gombrich:

"Our modern notion that an artist must be 'original' was by no means shared by most peoples of the past. An Egyptian . . . or a Byzantine master would have been greatly puzzled by such a demand. Nor would a medieval artist of Western Europe have understood why he should invent new ways of planning a church, or of designing a chalice, or of representing the sacred story where the old ones served their purpose so well. The pious donor who wanted to dedicate a new shrine for a holy relic of his patron saint, not only tried to procure the most precious material he could afford, he would also seek to provide the master with an old and venerable example of how the legend of the saint should be correctly represented. Nor would the artist feel hampered by this type of commission. There remained enough scope for him to show whether he was a master or a bungler."[62]

What the Greeks Did

For contrast, then, consider what happened in Greece to the way of sculpting a naked male figure that the Greeks largely learned from Egypt. The Egyptian canon of human proportions was at last altered in the XXVIth dynasty to produce somewhat more elongated figures.[63] These were the proportions one finds repeated in the Metropolitan Museum's marble youth and in certain other very early Greek *kouroi* as well.[64] But although the initial Greek borrowing was so complete in some cases, the sculptured image imported from Egypt evolved so swiftly in Greece that the Greek Archaic statues of naked youths can be dated within a decade or so, just by the anatomical innovations the statues exhibit or lack. The innovations were so incessant, too, that they really must be interpreted as somehow compulsive.[65]

To give just one example, the backs of the marble youths made between 590 and 570 B.C. still have "spinal furrows . . . indicated by grooves,"[66] whereas the spinal furrows are already plastically "modelled" on the backs of youths dating from 570 to 550 B.C.[67] Whether or no more and more naturalistic representation of the naked human body was therefore a *conscious* aim has been much debated in recent years.[68] It is a little difficult to see how conscious aims of sculptors can be deciphered with certainty at this distance in time, and in the absence of documentation. But the problem of the aim of the Greek Archaic sculpture is beside the point here being discussed. None of those engaged in the debate in question has denied that Greek sculptural innovation was incessant and rapid in

the period under consideration. Nor can one think of any evidence for such swift and continuous evolution in the sculpture of any of the earlier art traditions now known to us. Hence it can be cogently argued (and I would argue) that Greek artists were the first in the world who ever feared the verdict, "It's been done before."

Or perhaps one should say that the more talented Greek artists were the first who positively felt compelled to be original, in the sense of adding something new and previously unseen to what their predecessors had done. It might be no more than another of the newly correct renderings of this muscle or that part of the human body that plainly interested the Archaic sculptors; but still, it had not been done before. Innovations were by no means limited, however, to the technical problems of lifelike representation. Over time, theoretical problems of harmony, of sound bodily proportions and the like, became even deeper preoccupations of the more talented Greek artists. Of the evolution of systems of bodily proportions in the fifth century B.C., J. J. Pollitt has written, "One gets the impression that each generation of sculptors *felt driven* to make improvements or at least variations upon the systems of earlier generations" (Italics added).[69] Furthermore, innovation never flagged throughout the centuries of the Greek creative surge, from about 650 B.C. until the surge started to lose momentum around 325 B.C. Lysippus, of course, was the last great sculptor before the surge subsided; and he, too, was a great innovator—in fact the inventor of yet another system of proportions, which made his figures appear as beautiful human beings instead of merely *being* like them (as he claimed himself), as well as the new, more "vivid rendering of the hair" which Pliny stressed.[70]

Lysippus and his fourth-century predecessor-contemporary Praxiteles were also considered "supreme as regards faithfulness to nature."[71] To be sure, mere "faithfulness to nature" was by no means the sole preoccupation of the Greek artists of the great centuries. As has been pointed out, highly sophisticated explorations of symmetry, of balance, of systems of proportions, and of harmonious ways of relating all the parts to the whole work of art, seem to have been made by the leading Greek artists throughout the great centuries.[72] Inevitably, these incessant explorations also produced successive innovations, generation after generation, like Lysippus' new system of human proportions at the end of this period.

Yet it can hardly be denied that the Greek artists' innovations in the great centuries were also much concerned, albeit perhaps at first not consciously or directly concerned,[73] with accurate representation of reality—and mainly the reality of the human body, whether static or later in action, whether alone or later in groups. This creates a grave difficulty nowadays, when the representation of reality strikes most people as a trivial trick. In consequence, it is tempting to dismiss the Greek artists'

continuous representational innovations, at least as against the theoretical innovations, as a trivial and minor theme in the story of Greek art. This was certainly not quite the Greeks' view, however—if we may read backwards from the way the Greek art historians later dealt with this subject.[74]

On Signing

Another, comparable difficulty also confronts anyone in the twentieth-century West who seeks to assess the second novel behavioral trait of the Greek art tradition. Representation in art is thought trivial today because of the stage our own art tradition has now reached; but signatures on works of art have come to seem far more trivial, simply because the sorriest manufacturers of motel-bedroom art now sign their products without fail. In the larger context of the world history of art, nonetheless, a signature on a work of art must be seen as a deeply symbolic act. By signing, the artist says, in effect, ''I made this and I have a right to put my name on it, because what I make is a bit different from what others have made or will make.'' In the entire course of the world history of art, this right to sign has most rarely been claimed by any artists beyond the limits of the five rare art traditions[75]—at least before the present, when worldwide cultural homogenization by what is called ''progress'' has led to artists' signing everywhere.

Before the Greeks, in fact, no artists' signatures are known from any art tradition except the Egyptian. In earliest times, the names of the makers of the costly art stone vessels and their pharaoh-owners were often recorded in ink on the vessels—but almost certainly by the storekeepers. From Egyptian tombs and memorials from all periods, we also have a considerable number of artists' names;[76] but art history's first known *signature*, meaning ''I made this,'' is on a statue base in the wonderful complex at Saqqara.[77] This bears the name of Imhotep, the artist-architect-engineer of the whole complex, and the man who rose to the equivalent rank of grand vizier and was later deified. It is pleasing to see an actual artist's signature by one long among the gods.

An instructive pendant to the case of Imhotep is that of Senenmut, another artist-architect-engineer who attained a rank equal to that of grand vizier. He was the genius who built the tomb-temple of Queen Hatshepsut; and in his mistress's tomb-temple, he repeatedly left his own image and his own name. The images were humbly small, and both images and signatures were invariably placed in notably inconspicuous locations—for instance, behind doors.[78] Later the images and signatures were defaced, and some have suggested this was done on Queen Hatshepsut's order to punish Senenmut's presumptuous intrusion in a royal sacred place.[79] A more likely view, however, is that the order came from Hatshepsut's stepson and suc-

cessor, Tuthmosis III, a vigorous and warlike ruler who evidently detested his predecessor on the throne. He erased Hatshepsut's cartouches wherever he found them; and he further condemned Senenmut to *damnatio memoriae* and all but destroyed the fine tomb the ex–grand vizier had built for himself.[80]

Yet the real point of this account is that Senenmut, like Imhotep, was an artist who reached the highest possible rank in Egypt short of ascending the throne itself. Just about every other Egyptian artist who left a true signature—that is, one meaning "I made this"—was also a man of high rank; and it seems fairly clear that mere authorship of works of art did not give Egyptian artists the right to sign. Instead, it appears that high rank or high favor gave the right to sign to a few most exceptional artists—about one every three centuries plus on average. Otherwise, as I have said, no artist anywhere on earth is known to have put his name on any work of art before the Greek creative mutation in the seventh century B.C.; and the Greek art tradition was also the first in which it was perfectly *usual* for artists to sign.

The oldest Greek sculptor's signature now surviving is that of Euthycartides, from a monument in Delos with an inscription stating that this otherwise unknown man both made and dedicated it.[81] The date is commonly believed to be in the latter half of the seventh century B.C.—and thus close to the time when Greek monumental sculpture first began. The oldest Athenian potter's signature is that of Sophilus, who worked in the early sixth century B.C.,[82] but there seem to have been still earlier ones elsewhere. Thereafter, there was nothing in the least unexpected in any Greek artist's putting his name on his work, if he felt like it.

This does not mean, of course, that signing was a universal practice.[83] Among the Greek potters and pottery painters of both black- and red-figure periods, a considerable majority left their works anonymous; and this majority included some of the finest masters, like the Berlin Painter.[84] Overall, one should probably picture a situation in Greece like that in Italy during the High Renaissance, when no one was surprised if artists signed, but no one was surprised, either, when Raphael chose to sign only a very few of his paintings, and Michelangelo signed only one piece of his sculpture, the Pietà—and in a fit of temper, at that, because it began to be said that he was not the sculptor.[85] Yet the fact that Greek works of art were not invariably signed does not in the least diminish the significance of the Greek artists' signatures. These, once again, were something new under the sun.

To say that these features of Greek artists' behavior were new under the sun does not automatically mean that they were important novelties, in and of themselves. One cannot doubt that among the results of the Greek artists' compulsive innovations was more and more accurate repre-

sentation of the human body. Yet anyone can see that the magic of Greek art does not lie in accurate representation. Here it is enough to compare the Critian Boy, from early in the fifth century, with the far more softly natural—but much less magical—late-fourth-century bronze youth in the Getty Museum. Again, the Greek artists' signatures plainly mean that the situation of craftsmen in Greece was higher, or at least more free than it had been in Egypt, or in any other previous culture for that matter;[86] but this social development was not necessarily significant from the standpoint of art. Instead, both the artists' signatures and their compulsion to do something that had not been done before are important, indeed deeply important, because of what they *imply*. They clearly imply that the Greek artists had a wholly new kind of self-image and goal.

Every Greek artist of consequence, in fact, seems to have wished to put his own individual stamp on his work in the most emphatic manner.[87] To us, the artist's hankering to assert his individuality is a matter of course. But it was far from a matter of course when this drive first manifested itself in Greece. Above all, when artists seek to put emphatic personal stamps on their works, as they first did in Greece, this amounts to a claim, whether conscious or unconscious, to have some sort of place in history. When artists claim places of their own in history—even quite modest places—this means, in turn, that something like a historical response to art is already dimly taking shape. And as I have tried to show, the historical response to art is the egg, so to say, from which art collecting is born, as it is obviously the egg from which art history is born.

Art Theory

Certainly a historical response to art is quite plainly revealed by Greek art's two other wholly novel behavioral traits. The first was the large volume of theoretical writing about art, mostly by the artists themselves. To many, it may seem astonishing that theoretical writing about art first began in Greece, and that this kind of writing about art has been as severely limited to the five rare art traditions as art history itself. In the Western world, on the one hand, art theory has been around for such a long time that we take it for granted. Filarete angrily denouncing Gothic architecture in his fifteenth-century treatise on an ideal city[88] sounds almost comically like Le Corbusier or one of the Bauhaus propagandists giving stick to the Beaux-Arts nearly five hundred years later.[89] On the other hand, a considerable volume of nontheoretical writing about art survives from art traditions quite outside the rare group. I have previously discussed the frequent commemorations of their own achievements by patrons of the arts like Abbot Suger, and the craftsman's handbooks like the Indian *Vishnudhar-mottara* and the *Sketchbook* of Villard de Honnecourt.[90]

Yet craftsman's handbooks merely tell *how* to do it, without argument. They are about the "now" of art, whereas theoretical works on art are about art's past, present, and future. The mere instruction, "This way, and not that dreary old way, for the following reasons," in fact reveals a strong sense of art as a continuing historical process. So far as is known today, no one had ever written theoretically about art when Greek artists took to producing works of this sort.

In the sixth century B.C., treatises on their work were written by the architects of the Temple of Hera on Samos, Theodorus and Rhoecus, and of the Temple of Artemis at Ephesus, Chersiphron and Metagenes;[91] and these must have been among the earliest prose works in Greek.[92] These were probably technical rather than theoretical, but still constituted an important beginning. In the fifth century, there was a work on perspective by the painter Agatharchus,[93] and the most famous of all Greek contributions to art theory was also of fifth-century date. This was a work on ideal human proportions, *The Canon*, by Phidias' great sculptor-contemporary Polyclitus,[94] who, further, made a statue called the Canon to illustrate his theory.[95] Polyclitus' theory was strongly mathematical, expressing the human proportions that would best combine beauty and truth to nature in a complex system of ratios between the measurements of different parts of the body. A good many scholars have sought to work out just what the ratios were,[96] but in the absence of anything but rather poor copies of pieces of sculpture by Polyclitus, none of these attempts has been generally accepted as fully successful.

After Polyclitus, several other Greek sculptors and painters produced what are presumed to have been theoretical works on their arts.[97] In the great centuries, the last of these was perhaps that by Lysippus' great painter-contemporary Apelles.[98] Barring echoes of *The Canon* in Galen and the discussion of Polyclitus' theory in Vitruvius,[99] all these Greek works are lost. Nonetheless, their former existence is certain; and when these works were written, they were, yet again, something altogether new under the sun.

The First Remembered Masters

As for the Greek art tradition's fourth novel behavioral trait, it is even more important for our purposes than the other three but somewhat different; for it has to do with the Greeks' feelings about their artists and their art. The evidence is clear that throughout the great centuries of Greek art, each generation's leading artists found a warm welcome which such innovators could never have received in Egypt, for example, except in the brief, abnormal time of the heretic Akhenaton. The welcome in Greece was not universal, to be sure. Both Plato and Aristotle wrote about

art, and so did the atomist philosopher Democritus of Abdera.[100] These were in fact the first major thinkers in human history who are known to have done this unless you count Confucius' views on music.[101] What Democritus had to say is lost, but in what Plato and Aristotle wrote, both betrayed decided conservatism.[102] Plato even praised Egyptian art because, he said, all innovation was forbidden;[103] and there must have been a good many other Greeks who wished their artists would stick to the old ways. Yet the mere fact that innovating artists never lacked patrons is enough to prove that the conservatives were a minority. Furthermore, the Greeks' response to their artists went much further than mere welcome. In brief, the leading masters of each generation found just the places in history they so evidently hankered for, since they were always *remembered.*

Nowadays, once again, this habit of remembering masters of the past, already touched upon, may superficially seem a very trifling matter. Educated men now have memories stocked with the names of scores, or even hundreds, of the past's great artists, along with something of their achievements. But when artists began to be remembered in Greece, this was still another thing quite new under the sun. There is not a shred of evidence that any artist anywhere had ever before been treated as a historical personage, with the sole exception of Imhotep, who became a god; another deified Egyptian whose case is arguable;[104] and the Old Testament's presumably mythical trio already described.

As any commonsensible person can see, the Egyptian case (or cases) of the artist–grand vizier turned deity, and the Hebrew cases of the artists allegedly obeying the spoken commands of God Himself, could hardly be farther from Xenophon's stories of Socrates' conversations with the painter Parrhasius and the sculptor Cliton in the *Memorabilia,*[105] or Aristotle's comparison of Polygnotus, the morally elevating painter of earlier times, the painter Dionysius, who was morally neutral, and Pauson, the potentially corrupting painter of his own time.[106] In the *Nicomachean Ethics,* too, Aristotle used the names of Phidias and Polyclitus to make a point about the nature of great skill;[107] and in the *Poetics* he compared Polygnotus as a painter of human character with Zeuxis, whom he regarded as uninterested in character.[108] Plato, too, used Zeuxis to make a point, and made the painter Apollodorus a character in one of his Socratic dialogues.[109] Such Greek mentions of artists and their art in philosophical and other writing, and the later but very similar Roman uses of artists' names,[110] are in fact decisive indicators. They convey the same message as the innumerable mentions of art and artists in Western literature of every kind from the early fourteenth century to our own time. As indicators, they are in truth the tests I had in mind when I earlier defined remembered masters as those leading artists of each culture who were fully incorporated in the general cultural memory.

It is also worth pausing here to make a brief comparison with the practices of great cultures beyond the limits of the rare art traditions. From the time of the early Vedic texts down to the era just prior to the Mogul conquest, there is an enormous volume of Indian religious, poetic, philosophical, political, and other writing—without one mention of an artist. From the fifteen-hundred-year-long period of the Shang and Zhou dynasties, the period of Chinese art's first phase, there are considerable numbers of poetic, historical, philosophical, and other texts, preserved and partly preserved—without one mention of an artist. From the region of the Mesopotamian higher civilizations, the preserved cuneiform tablets are so immensely numerous that scholars have many decades, perhaps centuries, of work before them if they are ever to learn the full contents of the royal library of the Assyrian kings, the archives of Mari and Ebla, the great numbers of tablets in ancient Sumerian, the tablets from Kul Tepe and Boghaz Koy, and so on and on—but so far as is known today, no tablet mentions an artist.

More texts from more higher civilizations are being continually discovered and forms of writing formerly incomprehensible are being slowly deciphered, as in the case of the Mayas. So one must be prepared for surprises at any time. At this point, one can only say that in all the vast volume of writing from all the cultures I have named already, and from many more cultures besides, there is nothing to suggest the existence of just one remembered master as I have defined that term.

To be sure, there are probably other special cases besides that Yoruba praise chant I ran across, half by accident. There are the medieval borderline cases I touched upon previously; and I suspect the archeologists may later find additional monumental inscriptions concerning artists, like the one about those Indian ivory-workers-turned-sculptors at Sanchi. Yet the contrast is still dramatic, and, I am certain, will always remain dramatic, with the way leading artists were always remembered and articulately commemorated by the peoples of the Greek, the later Chinese, the later Japanese, the later Islamic, and the modern Western art traditions. And in this matter, as in so many others, the Greeks of the great centuries showed the way.

Nor is this all. The Greeks may well have done much more than just remember their leading masters. The odds are good, in fact, that they finally recorded their most famous artists in chronological lists, similar to the Italian lists repeatedly made in the period from about 1400 to about 1530. No such Greek lists of artists now survive, but there is a clear analogy with the list of Olympic victors which later provided the chronological framework of Greek history according to Olympiads. There were other kinds of Greek list makers, too. Plato called them "archeologists."[111] So lost lists of artists are not at all improbable. In addi-

tion, the period of the earlier Renaissance lists of artists coincided almost exactly with the period of theoretical writing about art by Renaissance artists like Leon Battista Alberti and Leonardo da Vinci;[112] and the Italian list making also directly preceded the work of Giorgio Vasari. So one suspects the Greek case was similar, in the double sense that the Greek lists were being compiled in the time when Greek art theory was being developed and thus directly preceded the earliest Greek art history.

Art History Begins

The truth is that lists of artists almost have to be *assumed* in fourth-century Greece, merely because of what came next. For what came next was Greek art history, unless Greek art collecting very obscurely preceded its Siamese twin, as I myself suspect strongly. In later twentieth-century eyes, for the usual reasons, it may not seem really significant that the Greeks were the first to record the histories of the visual arts. Yet one can think of few more remarkable cultural developments having to do with the arts; for the appearance of art history meant that art and artists were suddenly being treated, at least in some measure, as on a par with war and war leaders, statesmen and affairs of state, religion and the gods, and the other topics and personages always thought worthy of recording since records began to be kept. You could have no clearer proof that the Greek creative mutation, as I have called it, was a true mutation in the symbolic sense of the word. No culture, after all, can be expected to produce historians of the arts unless the arts have been accorded a special place and role far greater, even far higher, than the place and role accorded to the arts by the innumerable cultures whose artists, however great, however rich their rewards in life, have had no hope of being remembered in death.

The world's two first art historians not only contrasted sharply with one another; they also seem to have represented the two contrasting strains of Greek thinking about the visual arts. Duris of Samos was a many-sided man—at one moment he was even tyrant of his native island, and at another moment an Olympic victor—and as an art historian, he was evidently gossipy, anecdotal, and far from reliable. Even Plutarch, despite his way of taking good stories where he could find them, noted that Duris did not always get his facts right.[113] From Duris, nonetheless, Pliny is now thought to have got his anecdotes about the curtain painted by Parrhasius which Zeuxis mistook for a real curtain; the grapes painted by Zeuxis which birds pecked at, and other artistic feats of the same sort.[114] It is clear, then, that the Duridian approach to art was what some have called the "popular" Greek approach. In other words, the accurate representation of reality, and, if possible, representation of reality so technically dazzling

that the beholder was bewildered and deceived, was a main sign of an artist's genius in the eyes of Duris.

Xenocrates[115] was quite another sort of art historian, however. He was an artist himself, in fact a sculptor, who was probably trained in Sicyon and particularly admired the Sicyonian school,[116] to which both Lysippus and Apelles also belonged by training and sympathy. He was far from ignoring the representation of reality, for no Greek did so; but he is thought to have placed a far stronger emphasis on the elaborate Greek artistic theories of symmetry, of proportions, of harmonious relationships, which are so inordinately difficult to reconstruct today, yet undoubtedly played so important a role during much of the greatest era of Greek art. In addition, Xenocrates cared far less about anecdotes and far more about what may be called connected art history; for he began with "rude antiquity," and went on from there, stage by stage, until he reached the time of Lysippus and Apelles, which he saw as the grand climax of the story he had to tell.

Like so much else one would like to have from Greece, the actual texts of Duris and Xenocrates have not survived to our day. Their chronological relationship to one another is not at all clear, either,[117] although it seems reasonably certain that Xenocrates wrote in the second quarter of the third century B.C. Nonetheless, the arcane methods invented by the classical scholars were long ago used to identify Duridian anecdotes in more than one surviving classical text,[118] and, even more important, to reconstruct the broad outlines of the lost art history of Xenocrates from known echoes, particularly in the chapters on the arts in the elder Pliny's *Naturalis Historia*. If one can depend on the reconstruction of Xenocrates by E. Sellers and K. Jex-Blake, as somewhat revised by Bernhard Schweitzer[119]—and this reconstruction has not yet been challenged[120]— it is most interesting to see how often this thoughtful Greek art historian of the third century B.C. anticipated our own tradition's first art historian, Giorgio Vasari, some nineteen hundred years later.

The anticipation is not surprising, to be sure, since Vasari was well aware of the classical model and partly took from it his own schema of the art history of the Renaissance. All the same, it is most remarkable that the classical model should have been considered entirely applicable to Italian Renaissance art, and not by Vasari alone, either. As Vasari was to do, at any rate, Xenocrates interpreted the story he was telling in terms of a grand progression from imperfection to perfection—perfection being achieved by a continuous surge of inspired innovations, partly theoretical and partly in the representation of reality. As Vasari was to do, again, Xenocrates credited each innovation to a leading artist—once getting his progression wrong with Myron, too, for much the same sort of reason Vasari did with Masaccio.[121] Xenocrates further held that the Greek pro-

gression attained its final culmination in the later fourth century, with Lysippus as the greatest sculptor and Apelles as the greatest painter. *"Cessavit deinde ars"*—"Art then stopped"— Pliny the Elder wrote of what happened just after the opening of the third century B.C.,[122] and this is again thought to reflect Xenocrates.[123]

Inevitably, this has seemed a daunting statement to many scholars. To begin with, Pliny contradicted himself almost in the next breath, for he gave ample space to the Pergamene and other artists of the first Hellenistic centuries. The clue has probably been found, however, in the odd second half of Pliny's sentence, *"ac rursus Olympiade CLVI revixit,"* which means that art revived again toward the middle of the second century B.C. This was in fact the moment when the school of Hellenistic art called neoclassic or neo-Attic began to develop. As the labels imply, the artists of this school looked backward to the style of Phidias and his contemporaries.

This suggests, in turn, that the art which "then stopped" was the particular kind of art approved by Xenocrates—for there seems to be little doubt, as noted, that Pliny in his first statement was echoing Xenocrates once again. The art approved by Xenocrates was evidently the Greek art of the great centuries, with its strong emphasis on "formal artistic problems—above all problems of proportions and composition—and only secondarily . . . on problems of naturalistic representation."[124] This kind of art really did stop, too, since the Pergamene and other Hellenistic artistic innovators paid far less attention to theories of proportion, symmetry, and so on, than they paid to the exploration of new subjects, new ways of expressing strong emotion, and new modes of art like extreme realism. This does not alter the fact, however, that if the bleak sentiment quoted above was in fact borrowed by Pliny from Xenocrates, then one must suppose that Xenocrates really did believe that art had reached some sort of final climax in the generation after Lysippus and Apelles. In just the same way, Vasari held that Italian art had reached a final climax with Leonardo, Raphael, Michelangelo, and the other giants of the High Renaissance. The Italian art historian did not go so far as the Greek's "Art then stopped," but he frankly doubted whether artists to equal the High Rennaissance giants would ever be seen again.[125]

Albeit in varying degrees, in short, both Xenocrates and Vasari believed that a sad ending of sorts had already occurred when they set to work on their art histories after looking backward over the preceding centuries. Surely it was no accident, moreover, that this sense of a prior ending was in the air when other Greeks also looked backward, and set out to collect works by the great masters of the same centuries that interested Xenocrates.

Greek Art Collecting

It goes without saying that in Greece in art's great centuries, public patronage of the arts was both lavish and inspired. Yet not only is there no trace of Greek art collecting in these centuries; in addition, it is clear that private patronage of artists was strikingly sparse. Pericles, the grand organizer of the Athenian public patronage whose lovely ruins still adorn the Acropolis, nonetheless lived privately in a famously modest way.[126] His nephew, Alcibiades, made himself the talk of the town on one of many occasions by kidnapping the painter Agatharchus and keeping him locked up until he had provided decorations for Alcibiades' house,[127] thus long anticipating Dr. Barnes with Matisse. Presumably, the town talked and Agatharchus' promise had to be extorted for the same reason: because getting a leading painter to provide decorations for a private house was all but unheard of. One scholar has even observed that in Greece before Hellenistic times, there was "no domestic architecture or domestic sculpture of artistic merit."[128]

In reality, rich Greek tyrants and rulers were often exceptions to this scholar's rule. In the sixth century B.C., Polycrates of Samos had a famous palace.[129] In the fifth century, Alexander the Great's forebear King Archelaus of Macedon built another famous palace at Pella.[130] Moreover, as soon as Alexander's conquests poured the gold of Persia into Greece, private patronage of the arts must have become very lavish indeed. But the question is, when did true art collecting begin?

If we could hope for the eventual appearance of much new evidence concerning the period, the evidence would then quite probably show that true art collecting began in an obscure, rather miscellaneous way in the Greek world in the last half of the fourth century B.C. In the rare art traditions, the logical sequence is, first, remembered masters leading on, second, to art collecting of a somewhat disorganized sort, with both then leading on, third, to written art history. Art history then organizes the view of the past of their own art held by the people of the rare art tradition in question, and this in turn produces a more organized style of art collecting, which endures until revaluation alters the earlier view of the artistic past. Very roughly speaking, this was what happened in the second phase of Chinese art, and in our own art tradition originating in the Renaissance, at least with respect to our own art tradition's products.[131] Yet such speculation, however logical, is not historical proof. Hence I once put a question about the beginning of proven art collecting in the Greek world to the founder of the study of Hellenistic art, Margarete Bieber. She answered without hesitation that King Attalus I of Pergamum was "the first big art collector."[132] And although Professor Bieber may have been too sweep-

ing—I myself suspect the early Ptolemies preceded Attalus as major collectors—Attalus I of Pergamum was unquestionably the first art collector to be solidly attested in the whole world history of art.

Like the stories of the other Hellenistic monarchies, the story of Pergamum is far from edifying, and Attalus I, so far as one can tell, was far from being a morally admirable man. The story of Pergamum (now Bergama, in modern Turkey) began with a treacherous embezzlement from one of Alexander's generals, Lysimachus. In the vicious Wars of the Successors after Alexander's death, Lysimachus decided to deposit his treasure of 9,000 talents in this obscure but strongly placed little hilltop town on the southern Anatolian coast. Whereupon Lysimachus' eunuch-treasurer, Philetaerus, locked the town's gates, changed his allegiance, and carved out a state for himself with the help of his master's gold.[133] He left the state to his nephew, Eumenes; and the third ruler of Pergamum was Attalus I, who inherited in 241 B.C.,[134] made the state into an important kingdom by craft and valor, and assumed the style of king.

The valor was needed to inflict a decisive defeat on the people of the eastern wing of the Gauls' third-century folk-wandering.[135] (They had settled in the Anatolian mountains and were menaces to their neighbors for a long time before they became the peaceful persons we know as St. Paul's Galatians.) Attalus' craft was shown when he accepted the role of principal collaborator in the Greek world of the new giant power, Rome.[136] For our purposes, meanwhile, Attalus I is so interesting because he sought to make provincial Pergamum into a major center of Greek culture.

With this end in view, he built and endowed a famous library and brought scholars to work and teach in it, here imitating the first Ptolemy's great library in Alexandria.[137] He was an ambitious patron of the arts, employing contemporary architects and sculptors in large numbers. The original of the Dying Gaul was made for his grand victory monument,[138] and the masters who worked for him and for his eldest son, Eumenes II, who built the even more ambitious Altar of Zeus,[139] were the founders of the Pergamene school, perhaps the most creative of all the diverse Hellenistic schools. In addition, Attalus I sought to enrich Pergamum with as many masterpieces from the great centuries of Greek art as he could get his hands on, and it was this that made him the first documented art collector.

Here, however, the record is confused by the fact that Attalus I was also history's earliest documented founder of an art-collecting dynasty, like the Medici or the Rothschilds. After Eumenes II, the dynasty included a second and a third Attalus. The story ends, in fact, with Attalus III, who bequeathed his unhappy kingdom to the Roman Senate and the Roman tax gatherers in 133 B.C. Furthermore, the classical texts do not fully

indicate which parts of the Pergamene art collection were owed to which King Attalus.

There are two fairly well-fixed points, to be sure. Attalus I acquired Aegina by purchase from the Aetolian League,[140] and, somewhat later, he joined in the successful Roman siege of the Euboean town of Oreus.[141] From Aegina, he then carried off a number of works of art, including a large bronze statue of Apollo by Onatus of Aegina, a master of the Severe Style of the early fifth century; another statue by the third-century sculptor Theron; and a bronze of a horse with no surviving atribution.[142] His most notable loot from Oreus was a group of undescribed works by the fourth-century master Silanion of Athens.[143] Eumenes II, in his turn, brought to Pergamum (or else set up there) the lost pieces of sculpture commemorated by inscriptions on a long marble base displaying attributions to Myron, Praxiteles, and the art historian Xenocrates in his guise as a sculptor trained in the tradition of Lysippus;[144] but it is not clear whether these lost statues were originals or among the copies ordered by the Pergamene dynasts. Other works of art in the Pergamene collection were a "celebrated group" by the son of Praxiteles, Cephisodotus, "in which the fingers seemed to press on flesh rather than marble,"[145] a painting of Ajax struck by lightning by Apollodorus of Athens;[146] and the Archaic group of the Graces by the late-sixth-century sculptor Bupalus, which Pausanias saw "in the bedroom of King Attalus."[147]

In the circumstances, it is an interesting exercise to set on one side the known acquisitions by loot, and then to guess which of the other works in the Pergamene collection were acquired in a more peaceable manner by Attalus I and which by his successors. I myself would guess that Attalus I's preferences were represented, above all, by the group by Cephisodotus, and that he was much more pleased with his works by Silanion from Oreus than with his big bronze in the Severe Style from Aegina. I would further guess that the painting by Apollodorus and other non-looted Pergamene sculpture in the Severe Style should be credited to Eumenes II or Attalus II, while I would name King Attalus III as the man who chose Bupalus' Graces to decorate his bedroom.

These guesses, though no more than guesses, are based on what we know today of the chronology and results of the phenomenon of revaluation in the Greek world—of which more must be said later. At any rate, if Greek art lovers followed Xenocrates as Italian and other European art lovers were to follow Vasari so many centuries later, the works of the fourth and early third centuries, which Xenocrates saw as the grand and final climax of Greek art's development, must at first have been admired and sought after more enthusiastically than works dating from substantially earlier in the Xenocratean progression of Greek art. Perhaps this did not go so far as to create a neat cut-off point for Greek art collectors, in the

way that European art collectors had an effective cut-off point at a date toward the beginning of the High Renaissance for a long time after Vasari's *Lives* set the accepted standard.[148] But an early preference for fourth-century art is at least suggested by the additional evidence provided by the bribes of Aratus of Sicyon.

In the mid-third century, Aratus became the leader of the Achaean League, lately refounded to defend the Peloponnese against the new great powers of that age. He wanted help for the league from Attalus I's near-contemporary, the third Ptolemy to rule in Egypt. Plutarch tells us Aratus was "not without good taste," and was "constantly collecting works which were of high artistic skill, and great refinement."[149] So Aratus sweetened Ptolemy III Euergetes—the "Benefactor"—with paintings by the fourth-century masters of the Sicyonian school, Pamphilus and Melanthius;[150] for in this period, painting in Sicyon was so important that Apelles himself studied under Pamphilus,[151] while Melanthius was one of Apelles' most famous contemporaries and was acknowledged by him to be his superior in composing groups of figures.[152] Ptolemy III Euergetes was probably delighted with Aratus' bribes, too, for he was a cultivated man. It was he who bought from the city of Athens for the Alexandrian library the official texts of Aeschylus', Sophocles', and Euripides' plays.[153]

Sicyon continued as a center of art into the third century, and the Sicyonian school actually experienced a revival. This is in fact the reason one cannot be certain whether the first Ptolemies preceded Attalus I of Pergamum as major art collectors. My own suspicion, as I have said, is that Greek art collecting really began in a small way in the later fourth century B.C., just as Renaissance works of art began to be truly collected in Italy in a small way during the later High Renaissance. If so, however, the Greek evidence is lost.

As to the early Ptolemies, the founder of the dynasty, Ptolemy I Soter, was one of Alexander the Great's closest companions and leading generals. He shrewdly took Egypt for his portion in the division of Alexander's vast empire, after the conqueror's death in Babylon. One source ascribes to him a bid of 30 talents[154]—a considerable sum—for a work by Nicias, the painter always employed by Praxiteles to color his marble sculpture;[155] but another source, which credits the bid to Attalus I and thus dates it later, seems more likely to be correct.[156]

When the tough first Ptolemy died in 284 B.C., he was succeeded by his son, Ptolemy II Philadelphus, a man quite different in character from his battle-scarred father. Learning was one of the second Ptolemy's prime interests, and he vastly aggrandized the great Alexandrian library dedicated to the Muses, from the name of which, *Mouseion,* we get our word "museum." He also appointed the poet Callimachus to a post in the library; and Callimachus' catalogue of the library's holdings then became the foun-

dation of the history of Greek literature.[157] Another interest of the second Ptolemy was courtly entertaining on a scale that made the Ptolemies' feasts famous throughout the Greek world; and we have a record of one of Ptolemy II's feasts held in a specially built pavilion containing a hundred golden tables. The pavilion was hung with rich patterned stuffs, and was further adorned with "100 marble statues by artists of the first rank" and "panels by painters of the Sicyonian school."[158] But since this school continued through the whole life of Ptolemy II, and sculptors also multiplied in third-century Greece, there is nothing to show whether the second Ptolemy was a true collector or merely a lavish patron, given to sending to Sicyon and Athens mass orders for paintings and sculpture. In any case, it is certain the Ptolemies never had the special reputation for art collecting which the Pergamene dynasts always had from the time of Attalus I.

So much, then, for the origins of art collecting and art history in the Greek world. Uncounted art collectors followed in the footsteps of Attalus I, Aratus of Sicyon and Ptolemy III Euergetes throughout the seven centuries of the classical art tradition's subsequent duration. A considerable number of Greek and Roman art historians continued the work of Xenocrates—although classical art history never entered the scientific phase we know today. Here, incidentally, Pergamum also played a role, for the first man known to have written art history after Xenocrates was Antigonus of Carystus, who came to Pergamum as one of Attalus I's sculptors and turned art historian in the Pergamene library.[159] Furthermore, as soon as these primary by-products of art had appeared in the Greek world, all the other linked phenomena also appeared in rapid succession. With the possible exception of antique collecting, all the by-products of art are in fact Hellenistic Greek inventions.

The Art Market

Inevitably, an art market was organized with particular promptness. As indicated by the bid of 30 talents for a painting by Nicias, substantial prices prevailed on the market at least as early as the time of Attalus I —another reason for believing that a good many undocumented art collectors preceded the Pergamene King. Real super-prices soon began to be paid for important works of art, too, as is clear from the story of Attalus II's high bid at the auction in Corinth. Here some background is needed. In brief, the second Attalus resumed the Pergamene dynasts' role as Rome's collaborators in the Greek world; so Attalus II could not have opposed the Romans' dreadful siege and sack of Corinth in 146 B.C., even if he had wished to do so. Instead, he dispatched a Pergamene contingent to aid the Romans.[160] When Corinth fell, the entire population was sent to

the slave markets; and the beautiful and ancient city was so totally destroyed that the Corinth of Roman times was a later foundation, made by Julius Caesar.

There was the usual post-sack auction of loot, and many bids were evidently placed on behalf of Attalus II, for Pausanias commented on the "spoils from Corinth" at Pergamum about three hundred years later.[161] The famous high bid was no less than 100 talents for a painting of Dionysus by Aristides.[162] The picture was one of those by Greek old masters that the Roman soldiers had used as dice tables,[163] and the high bid so astonished the Roman General Lucius Mummius (later named Achaicus in honor of his fearful victory) that he withdrew the painting by Aristides from the sale and included it among his dedications in the temples of Rome.[164]

Mummius was one of the *novi homines*, "new men," as Romans called the few who managed to shoulder their way into the closed ranks of the old senatorial aristocracy by attaining the consulship. (There were under twenty of them in the entire course of the Roman Republic.) He was also so untinged by Greek culture that when he sent his dedications of great Greek works of art back to Rome, he warned the shipmaster that identical replacements would have to be provided in case of any damage[165]—which was exactly like warning that identical replacements of Raphaels and Leonardos would be demanded in case of damage when arranging air shipment of these pictures from Italy to the U.S. for one of the big museum shows.

To become a "new man" culture was not required, but shrewdness and alertness were just as much needed as toughness. However uncultured, such a man would certainly have heard of the staggering price paid for this by Senator X, and Senator Y's triumph in securing that, if art collecting already flourished among the Roman upper class (for one may be sure gossip was as common among Roman senators as among American ones). Thus Mummius' complacency while his troops made dice tables of great panel pictures, and his astonishment at the high bid for a painting by Aristides, are both important pieces of evidence that art collecting was not as yet a Roman social habit in 146 B.C.

The chances are high, in fact, that the start of collecting in Rome was linked to the impact on the city of the other loot from Corinth, which must have flooded in along with Mummius' temple dedications.[166] It did not take long, moreover, for the Roman art market to develop to the point of producing a Roman version of Lord Duveen. Just as Duveen was an Englishman peddling English and European old masters to American multimillionaires, so Damasippus was a Greek peddling Greek old masters to Roman multimillionaires of the first century B.C. He turns up in a slightly peevish letter from Cicero to his friend M. Fabius Gallus,[167] in which Avianius Evander, a sculptor who may have been a dealer on the

side, is also mentioned. Perhaps because Cicero did not trust his own taste, he had a way of asking friends to buy works of art for him. He did this on a large scale with Atticus,[168] and he also did it with Fabius Gallus, when he himself was in the country and his friend was in Rome. Fabius Gallus had chosen three Bacchantes, apparently from Damasippus' stock; and Cicero did not consider these statues suitable to what is now horribly called his "image." He would have preferred Muses.[169] At any rate, he wanted Fabius Gallus to get Damasippus to take back the Bacchantes and refund their price. Damasippus went bankrupt in the end, but in the Rome of that time he was evidently a considerable personage, so well known that after his death Horace made him the central figure of a satire.[170]

From the later first century A.D., moreover, we have an epigram by Martial[171] depicting a characteristic scene in the Saepta Julia, which was used in Martial's time as a bazaarlike center for Rome's dealers in luxury goods, conspicuously including works of art and antiquities.[172] Mamurra, the epigram's antihero, plays the role of a rich connoisseur, going from object to object, pricing some, making offers for others, grandly criticizing sculpture attributed to Polyclitus, patronizingly taking in every aspect of the whole rich scene from jeweled tankards to antique silver. But when he is tired at last, he pays a penny for two trifling cups and carries them away himself—which of course meant to Martial's audience that Mamurra was too poor to own a single slave, and much, much too poor to pay for any of the costly things he had been pretending he might buy. Similar scenes are enacted daily in our own time, in the dealers' establishments in Paris, London, New York, and every other major center.

The prevalence of fakery on such a market was only to be expected. One of the younger Pliny's letters to his friend Annius Severus,[173] for example, reports his purchase of what must have been—or have been alleged by the dealer to be—a bronze figurine of an old man or woman in the style of extreme Hellenistic realism typified by the splendid Drunken Woman in Munich.[174] The bronze cost a large sum, for Pliny used a legacy to pay for it. He was delighted with it, too, describing it in loving detail. Near the letter's opening, however, is Pliny's obviously worried confession to "extremely defective" judgment in such matters. At another point, he says the bronze "appears to be a genuine antique" (the key word being "appears"); and at the close, he admits he is a "mere novice," induced to buy by others' praise of his bronze.

Who has not heard this kind of apprehensive language today from persons with untrained eyes who have spent a substantial sum on an antique or work of art? And who has not seen the apprehension justified in all too many cases? Nor is mere inference from the younger Pliny's rather touching letter the only evidence for faking. In Phaedrus' free Latin

version of Aesop's *Fables*, one odd addition to Aesop is a crisp passage
about art fakers who get high prices for falsely aged marbles falsely signed
"Praxiteles"; falsely worn silver statuettes with the imitated signature of
Myron; and strictly modern paintings with the signature of Zeuxis
added.[175] As Phaedrus wrote in the time of the Emperor Augustus, this
means that Greco-Roman fakers were then manufacturing "old masters"
which, if genuine, would have been four or five hundred years old—the
story of the Grünewald faker all over again.

Art Museums

By the end of the first century B.C., to be sure, the reverence for the
old masters of Greek art was of centuries-long standing; and from this
reverence, undoubtedly, the world's first art museums originated. Beyond
doubt, too, the models for the first art museums of the classical world
were the Greek temple accumulations of all sorts of works of art dedicated
by patrons, sometimes over many hundreds of years, as gifts to the gods.
These were shown in a museumlike way, with paintings and intrinsically
precious objects indoors, and statues (except the cult images) in the tem-
ple's *temenos* or sacred enclosure, which was thus turned into a haphazard
kind of sculpture garden.[176] The more important temples had curatorlike
officials, who accepted responsibility for the temples' inventories of ex
votos when taking office and handed on responsibility to their successors
in the same fashion.[177] Temples rich in important dedications were visited,
too, in the precise way art museums are visited today, as is shown by an
Alexandrian comic sketch of the mid-third century, Mime IV of Herodas.[178]

The scene of Mime IV is the Temple of Asclepius on Cos, and the
visitors are Coccale and Cynno, two women of modest means, as is indicated
by their inexpensive offering of a single cock. Coccale is the enthusiastic
one, Cynno the knowing one, who points out dryly that statues Coccale
admires extravagantly are the work of the "sons of Praxiteles";[179] who
explains condescendingly that one can always rely on "the hands of
Apelles" to be "true in all his paintings" when Coccale positively bubbles
over about a picture in the temple of an ox being led to sacrifice;[180] and
so on and on throughout the Mime. The esthetic viewpoint of Coccale
and Cynno is that of the old museum guides who used to urge one to
circle the room in order to see how "the eyes of the portrait are always
looking at you." But more significant is their documentation of a key
point, that the greatest masters of the past were not just remembered by
the learned and the privileged, but also popularly remembered as they
are nowadays.

Even before Herodas wrote his fourth Mime, a true public art gallery
of the sort we know today was established in Sicyon,[181] one must suppose

because of the pride of the Sicyonians in the famous artists of the Sicyonian school. Sometimes I darkly wonder whether Aratus took his bribes for Ptolemy III Euergetes straight out of the public gallery. In 56 B.C., moreover, "all the pictures of Sicyon were sold to liquidate the public debt, and were brought to Rome."[182] One other Greek case also needs to be mentioned, the Pinacotheca in the Propylaea of the Athenian Acropolis, which was certainly a picture gallery by the second century A.D., when Pausanias visited it.[183] Yet there is nothing to show that the Pinacotheca was originally planned as an art-oriented gallery in the museum style, and this kind of plan for it in the fifth century B.C. would have been strangely out of rhythm with the development of art collecting and the linked phenomena in Greece. There is much that is persuasive in the view that the gallery in question began as a public dining room.[184] As such, at first it probably contained pictures of particularly proud moments in the story of Athens, in the manner of the Painted Stoa; and it was then converted to its final use at a considerably later date. The conversion may even have been inspired by Sicyon's example.

Rome and the cities of Italy were the places, nonetheless, where the museum concept developed most richly and on nearly modern lines. The idea now so common in the West, that important works of art ought to be accessible to all, was first formulated in Rome, so far as the record shows. Cicero put it forward in passing in one of his Verrine orations,[185] and the Emperor Augustus' Chief Minister, Marcus Vipsanius Agrippa, forthrightly held that great pictures and statues should become public property instead of being hidden in the country houses of the rich.[186] The Baths of Agrippa, which this remarkable man built for the people of Rome, were planned to double in brass as an art gallery, and were therefore enriched with many famous works of art by Lysippus and others.[187]

Again, the Augustan historian Asinius Pollio restored the Atrium Libertatis, where the censors' records were kept; he attached to it a public library; and he enriched the complex with his important sculpture collection.[188] Caesar's companion in arms, the historian Sallust, purchased a great tract of land in Rome, extended the gardens already there, and embellished them with the loot he had gathered during his tenure as Governor of Numidia. These gardens, with Sallust's sculpture collection, soon came into the emperors' control, and for centuries thereafter they were open to privileged visitors, if not to the general public. The gardens thus constituted an outdoor sculpture museum as well as a place of refreshment. Because the Ludovisi Throne was found in this area of Rome in the course of a nineteenth-century real-estate development, it is generally thought to have been on view in the gardens and to have come from Sallust's collection.[189]

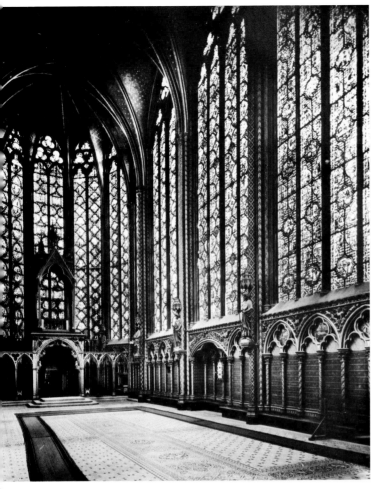

25

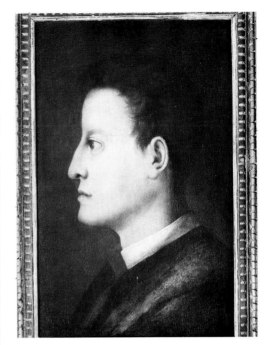

26

25. Sainte-Chapelle Interior, *Paris*

26. *Pontormo:* Cosimo de' Medici *Florence, Uffizi*

27. The Temple of the Inscriptions, *Palenque*

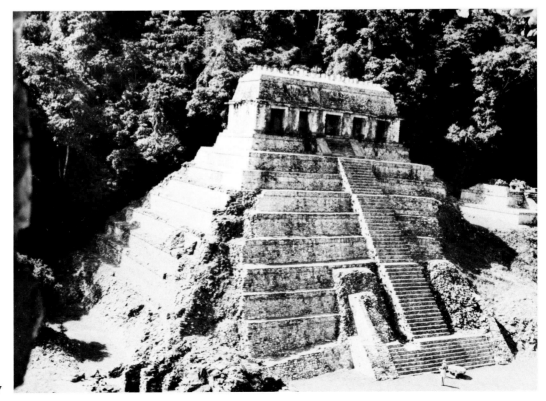

27

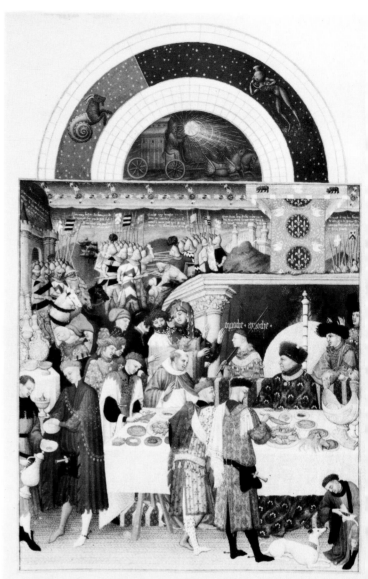

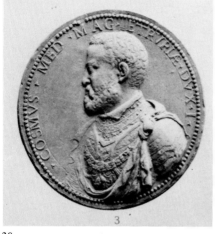

28

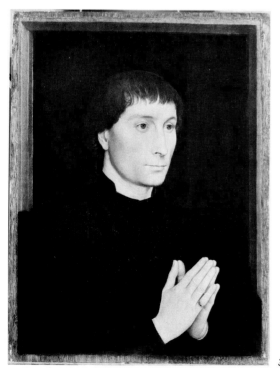

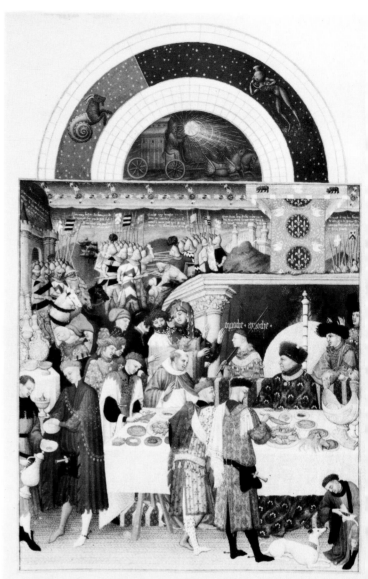

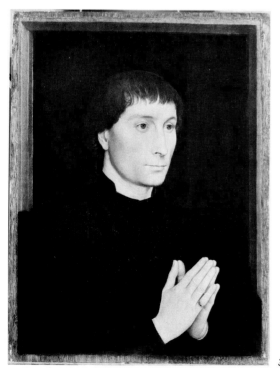

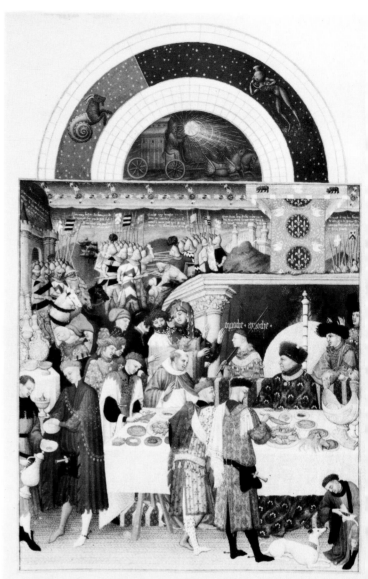

29

30

28. Profile of Cosimo de' Medici, Plate XVI, *from Medals of the Renaissance by G. F. Hall. Copyright 1920 by G. F. Hall, Oxford, Clarendon Press*

29. *Pol de Limbourg:* January, from the Très Riches Heures du Duc de Berry, *Chantilly, Musée Condé*

30. *Hans Memling:* Tommaso Portinari, *New York, Metropolita Museum of Art, Bequest of Benjamin Altman, 1913*

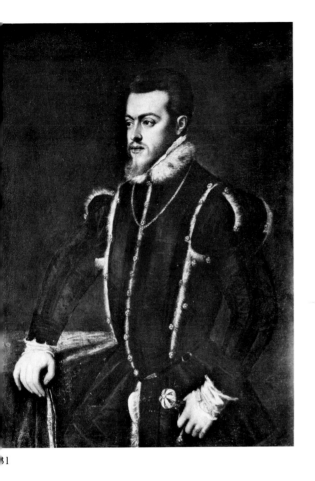

31

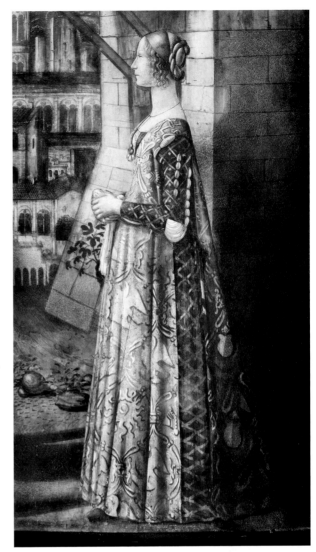

32

31. *Titian:* Philip II of Spain, *Madrid, Prado*

32. *Ghirlandaio:* Portrait of Giovanna Tornabuoni, *Florence, Santa Maria Novella*

33. *Matisse:* La Danse, 1933, *Merion Station, Pa., Barnes Foundation*

33

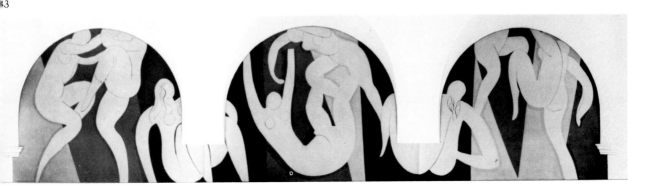

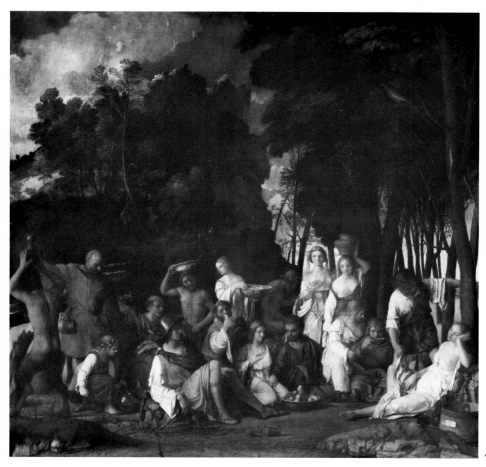

34

34. *Giovanni Bellini:* The Feast of the Gods, *Washingto D.C., National Gallery of Art, Widener Collection*

35

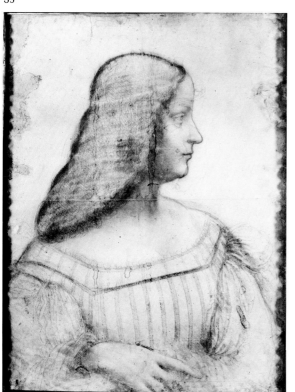

35. *Leonardo da Vinci:* Isabella d'Este, *Paris, Louvre*

36. Armilla of Frederick I Barbarossa, *Nuremberg, National Museum*

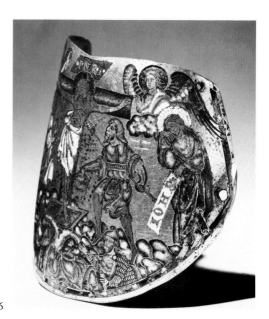

36

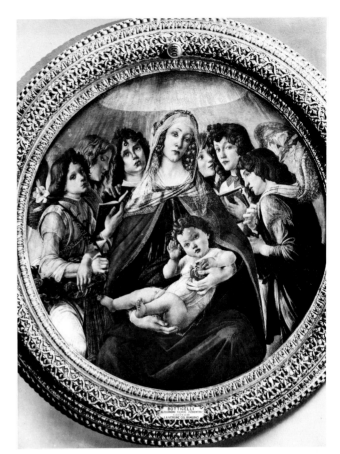

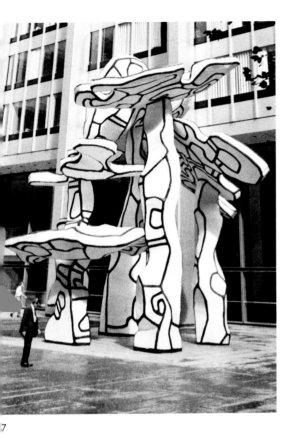

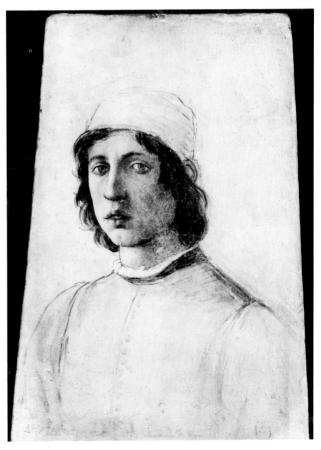

38

37. *Jean Dubuffet:* Group of Four Trees, 1971,
New York, Museum of Modern Art

38. *Botticelli:* Madonna of the Pomegranate,
Florence, Uffizi

39. *Filippino Lippi:* Self-Portrait, *Florence, Uffizi*

39

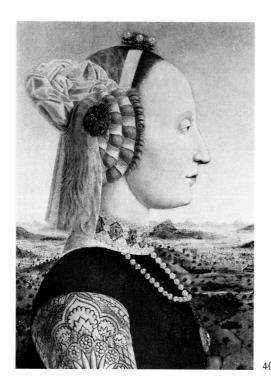

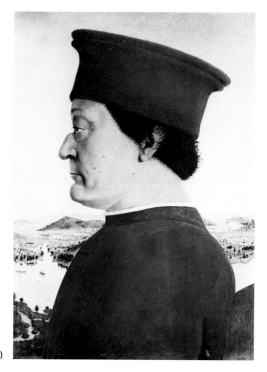

40

41

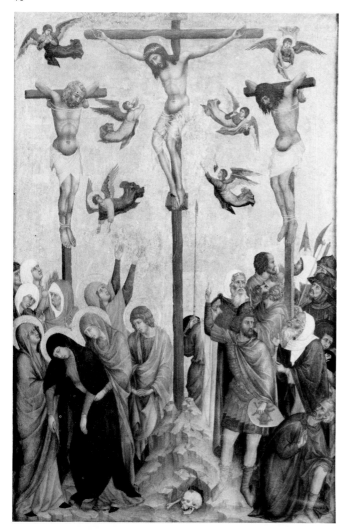

40. *Piero della Francesca:* Duke and Duchess of Urbino, *Florence, Uffizi*

41. *Duccio:* Crucifixion

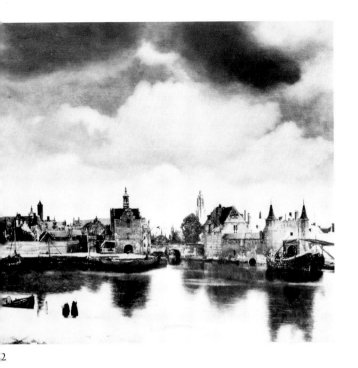

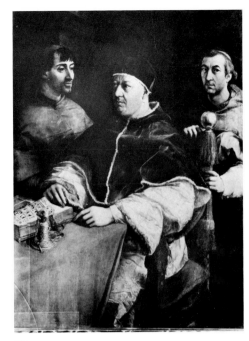

42

43

42. *Vermeer:* View of Delft, *The Hague, Mauritshuis*

43. *Raphael:* Pope Leo X with His Nephews, *Florence, Pitti Palace*

44. *Jean-Honoré Fragonard:* Psyche Showing Her Sisters Her Gifts from Cupid, *London, National Gallery*

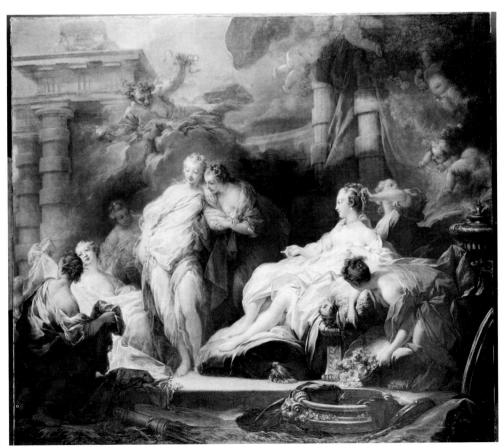

44

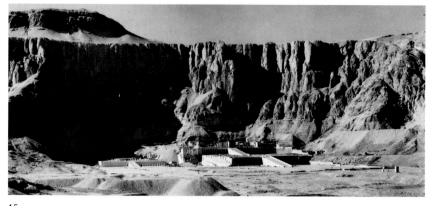

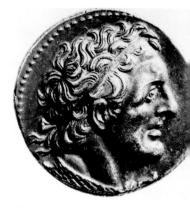

45

46

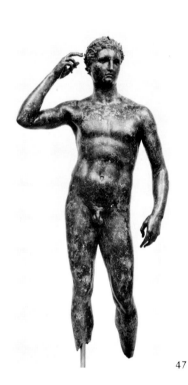

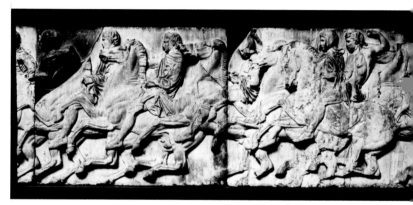

48

47

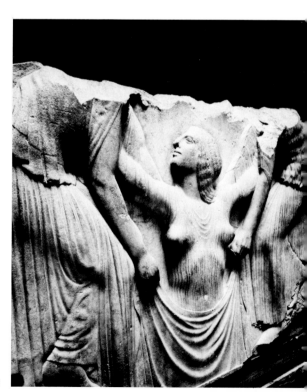

45. Tomb of Hatshepsut, *Deir-el-Bahri*

46. Head of Ptolemy I Soter, *Boston, Museum of Fine Arts*

47. *Lysippos:* The Getty Bronze, *Malibu, CA., The J. Paul Getty Museum*

48. Parthenon Relief-Cavalry, *London, British Museum*

49. Ludovisi Throne: Birth of Venus, *Rome, National Museum of the Baths of Diocletian*

49

Yet again, the Porticus Octaviae began as the portico surrounding Rome's first marble temples, of Jupiter Stator and Juno Regina.[190] The temples and original portico were built by M. Caecilius Metellus Macedonicus with his spoils from Macedon in the war in which he had the northern command, while the southern commander was the destroyer of Corinth, Mummius. In the space between his temples and his portico, Metellus dedicated Lysippus' equestrian statues of Alexander and the twenty-five members of the Companion Cavalry who fell in the Battle of the Granicus.[191] These had been commissioned by Alexander himself and placed in the holy city of Dium on the flanks of Mount Olympus, and Metellus carried home all these pieces of sculpture to serve as trophies of his victories.

Later, Metellus' portico surrounding his temples was improved and renamed the Porticus Octaviae,[192] and the new portico was provided with much sculpture and many paintings by the leading Greek old masters in its "schools," council chamber, and colonnades. One can hardly imagine, nowadays, such richness in works by the greatest geniuses of Greek art in a single center. Nor was Rome alone in having major works of art of the past on public view. In the *Satyricon* of Petronius, the hero, Encolpius, meets the old fustian poet Eumolpus in a picture gallery;[193] and this public gallery in a small Italian provincial town is described as containing works by Apelles, Protogenes, and Zeuxis. If the paintings were not copies and this passage of the *Satyricon* can be trusted as representing a nonfictional reality, it describes a municipal gallery comparable to an Italian provincial museum boasting paintings by Raphael, Giovanni Bellini, and Piero.

This was not the end of the story, either. In the classical world, individual works of art enjoyed the same fame that the most famous prizes of our modern art museums do today. It would be tedious to rehearse the numerous epigrams in the Greek anthology on the subjects, particularly, of a famously lifelike bronze cow by the sculptor Myron,[194] and the famously godlike gold-and-ivory Zeus that Phidias made for Olympia.[195] It would be equally tedious to rehearse the other mentions of the Phidian Zeus in the literature. They extend over a period of many centuries,[196] and all are effusively reverential except for those of Lucian and Strabo. Lucian ironically suggested that the majestic statue's gold-and-ivory exterior, being hollow, must conceal colonies of rats and mice inside it.[197] Strabo, a down-to-earth fellow, pointed out that the forty-foot-high seated Zeus was so large that if the God were ever to stand up, he would go straight through the temple's roof.[198]

Finally, and most telling of all, there is the episode of the Emperor Tiberius' infatuation with Lysippus' *Apoxyomenos*, a bronze of a beautiful youth scraping himself down after exercise. In his infatuation, the Emperor removed the statue from its place before the Baths of Agrippa to his own

bedroom. But the people of Rome made the kind of row the people of Paris would make if ex-President Giscard d'Estaing had coolly taken Correggio's erotic Jupiter and Antiope from the Louvre to his private apartments in the Élysée. Although so much more powerful than Giscard d'Estaing, Tiberius finally returned the *Apoxyomenos* to the Baths of Agrippa to quiet the clamor.[199]

Revaluation

The mere names of artists and descriptions of individual works of art in the foregoing paragraphs are enough to suggest how far revaluation went in the classical art tradition. Phidias, whose Olympian Zeus was the most admired single work of art in the known world for well over seven hundred years, had apparently been treated by Xenocrates in much the way Vasari treated the great masters of the fifteenth century before Leonardo. In other words, he was placed at the beginning of the final progression toward perfection[200]—meaning, of course, that he had not attained perfection himself. Indeed, as stated above, Xenocrates got Myron's date wrong, placing him after Phidias and Polyclitus, primarily because the Discobolus portrayed an athlete in motion, and he wrongly regarded this as a later advance toward the perfection finally attained in the fourth century.[201] As for the Ludovisi Throne, so likely to have been the gem of Sallust's collection, this is a work of the Severe Style, like the Delphic Charioteer and the Critian Boy; and the artists of the Severe Style, who carried on where the Archaic masters left off, were of course still farther from Xenocratean perfection than the mid- and later-fifth-century masters like Phidias. In sum, revaluation in the classical art tradition took the form of a fairly radical reordering of the hierarchy established by Xenocrates.

The Xenocratean hierarchy of artists, like the Vasarian one, was based on the equation "Later equals better," in Xenocrates' case until the culmination with Lysippus and Apelles, in Vasari's case with the culminating giants of the High Renaissance. Like our own Western art tradition's revaluation, the classical tradition's revaluation did not degrade the culminating masters from their high places. Instead, the earlier masters were moved up, so to say, in just the way Giotto and Piero della Francesca have been moved up to rank with Raphael himself in our own tradition. There was another similarity, too. Just as many people in the twentieth-century West find Raphael a "difficult" artist yet acknowledge his immense stature,[202] while Piero is now the natural hero of anyone with a good eye, so a good many people in classical times even began to place the summit of art with Phidias and Polyclitus, while still regarding Lysippus as a towering genius.[203]

There were two important differences between classical revaluation and our own, however. On the one hand, revaluation in classical times never extended beyond the limits of the classical art tradition, or indeed beyond the limits of Greek art in the great centuries and the Hellenistic era. There was a cut-off in time, so that Roman art is only rarely mentioned in the sources that tell us so much about Roman collections of Greek old masters; and there was a cultural cut-off, too, so that the arts of other peoples were never appraised, with a minor exception for the monumental art of Egypt. On the other hand, the Xenocratean canon also remained unchallenged for a considerably shorter period of time than the Vasarian canon.

The crucial episode is usually supposed to have been the call to Olympia of the sculptor Damophon to repair the Phidian Zeus.[204] The call to Damophon came toward the beginning of the second quarter of the second century B.C., and the repairs were apparently completed by 168 B.C. In the course of the repairs, Damophon was so deeply impressed by the sheer grandeur of Phidias' masterpiece that he took to working in the already mentioned neoclassic or neo-Attic style.[205] This style must have been seen at the time as a most radical departure from the styles of the fourth century and the various Hellenistic schools rooted in the third century. Both the new style and the revaluation of the great masters of the fifth century promptly won wide acceptance, too.

Furthermore, this change in the way of seeing was either followed or accompanied by an even more radical change. Men also began to see in a quite new way the masters of the Severe Style and even the Archaic Period; and these, too, began to be much admired. This development's timing is indicated by the works in the Archaic and Severe Styles at Pergamum,[206] where collecting presumably ceased when the state passed into the clutches of Rome in 133 B.C. As might be expected, this further change in the way of seeing also had important stylistic repercussions. These took the form of many works in the neoclassic style, which Romans particularly admired, and also of strongly archaizing works which were turned out in quantity in the first century B.C. and for a while thereafter[207]— some, one may be sure, to be sold in Rome as genuine articles, just as certain nineteenth-century pastiches by Bastianini were successfully passed off for a while as real fifteenth-century sculpture.[208]

This happened, moreover, although Xenocrates' original concept—of a continuous progression toward more and more harmonious representation of the human body at rest or in action—was never really abandoned in Roman times. You can find this concept of an artistic progression being echoed in Roman texts, like the passage in Cicero's *Brutus*[209] in which he compared the styles of art and the styles of rhetoric. Echoes of early Greek art history of a sort, but more and more the ''popular'' history

that began with Duris, continued right down to the last quasi-art-historical work of the classical world, the late-third-century *Descriptiones* of Callistratus, with its decidedly repellent account of a statue of a boy by Praxiteles: "It was a boy tender and young, and art had softened the bronze to express softness and youth; moreover it abounded in daintiness and desire."[210] This is the same sort of appreciation as that already quoted in respect of the work in the Pergamene collection by Praxiteles' son, Cephisodotus, the group in which the hands seemed to press on flesh rather than marble.

The Roman *locus classicus* of thoughtful art criticism is the second comparison between the styles of art and rhetoric, following Cicero's, in Quintilian's *Institutio Oratoria*. Quintilian was an enormously successful orator, scholar, and teacher who reached the consulship and then died in the later first century A.D. His treatment of Greek art history is again based on the concept of an artistic progression and is extensive and exact, so it is tempting to quote him at length. Yet the first essential point is that Quintilian positively preferred Polyclitus and Phidias to Lysippus. Polyclitus was "faultless" and would be "the greatest of sculptors," except that his works were "lacking in grandeur." Phidias "possessed . . . the qualities lacking in [Polyclitus]," and the beauty of his Olympian Zeus was such that "it is said to have added something even to the awe with which the god was already regarded."[211] Whereas Quintilian was the critic previously quoted, who described Lysippus and Praxiteles as "supreme as regards faithfulness to nature"[212]—which is plainly not such high praise as he gave the earlier sculptors he most admired.

Secondly, however, while giving due credit to the earlier Greek masters, including masters of the Severe Style, Quintilian considered that the Romans of his time who put the very early artists first in the hierarchy were cultural show-offs. Of the "enthusiastic admirers" of the "almost primitive works" of the painters Polygnotus and Aglaophon, he remarked crisply that "their motive" struck him as being "an ostentatious desire to seem persons of superior taste."[213] We, too, should surely suspect cultural exhibitionism in anyone who announced grandly, "After Masaccio, there's not much for me in Renaissance painting." And this is not a bad parallel.

Roman Collecting

So much, then, for the stories of the principal by-products of art in the classical art tradition. Yet the story of Roman art collecting, including antique collecting, still remains to be recounted; and this cannot be omitted, if only because the collecting climate of Rome in the era of booming imperial prosperity was so reminiscent of the climate in New York and other Western centers today. We have already seen the evidence, or rather

part of it, that art collecting was an unknown social habit in Rome at the time of Mummius' siege and sack of Corinth in 146 B.C. But this must not be taken to mean that great numbers of non-Roman works of art were not known in the city by the mid-second century. Mummius was following a long-established precedent when he dedicated a large share of the artistic loot of Corinth in the temples of Rome.[214]

If Livy is correct, the loot of Veii, Rome's first conquered Etruscan city, comprised the first works of art to be brought to Rome by victory in war.[215] Many further Etruscan and a few Greek works of art were won by subsequent victories in the course of Rome's steady expansion in Italy. Yet it would appear that even by the later third century B.C., the Romans were not altogether prepared for the wholesale looting of all the works of art in Syracuse. In the Second Punic War, M. Claudius Marcellus took Syracuse in 212 B.C. despite the engineering genius of Archimedes; and when the city fell, Marcellus made close to a clean sweep of the major works of art in the richest city in Sicily. Consequently, he brought back to Rome cartload after cartload of cult images, temple dedications, and all sorts of other beautiful things.[216] Plutarch's description of this episode, which partly follows Livy,[217] is worth quoting in full:

"Prior to this," says Plutarch, "Rome neither had nor even knew of these exquisite and refined things, nor was there in the city any love of what was charming and elegant; rather it was full of barbaric weapons and bloody spoils; and though it was garlanded with memorials and trophies of triumphs, there was no sight which was joyful or even unfearful to gentle and [cultivated] spectators. . . . One might apply Pindar's phrase, 'the war-deep precinct of Ares,' to the Rome of that day. For this reason . . . Fabius Maximus was more respected by the older Romans. . . . The elders blamed Marcellus first of all because he made the city an object of envy, not only by men but also by the gods [whose images] he had led into the city like slaves in his triumphal procession, and second because he filled the Roman people . . . with a taste of leisure and idle talk, affecting urbane opinions about art and artists, even to the point of wasting the better part of a day on such things."[218]

The Fabius Maximus mentioned by Plutarch was Fabius Maximus Verrucosus, who besieged and captured the Greek-Italian city of Tarentum in 209 B.C. He took enormous spoils of slaves, gold, and all sorts of rich things; but of Tarentum's images of the gods and heroes, he only brought back to Rome as his chief trophy the colossal Hercules by Lysippus. He said of the rest that these "angry gods" could be left to the remaining Tarentines.[219] The key point to note, meanwhile, is that like Fabius Maximus' great trophy, and like the painting by Aristides which Mummius snatched from Attalus II in Corinth, Claudius Marcellus' spoils of Syracuse became public dedications. For a long time, marvelous Greek works of

art flooded into Rome, but always to be publicly dedicated, so far as we know today. And this was far from being true art collecting.

The classical authorities give various dates for the beginning of art collecting in Rome, but the most likely date, named by Pliny[220] among other dates, (for Pliny never minded contradicting himself), is the period following Mummius' sack of Corinth. As Cicero tells us, the loot Mummius sent home himself was all dedicated in temples,[221] but one cannot be sure this was also true of the more cultivated northern commander in the same war. Furthermore, what Mummius sent home from Corinth cannot have been more than a small share of the total stock of works of art of one of the oldest, wealthiest, and most luxury-loving Greek cities. Much else that was beautiful must also have flowed into Rome, already the richest city in the classical world; and by then, too, Roman interest in Greek works of art had already been awakened.

There were two other factors as well. The Roman patrician and senatorial families had always lived austerely; but austerity is never an easy style to maintain when conquests are bringing in new wealth on an enormous scale. In addition, a fair number of the greatest Roman patricians were already succumbing to the temptation of Greek culture before the sack of Corinth. For instance, the second son of L. Aemilius Paulus, who became, by adoption, the third Scipio Africanus,[222] made a friend and mentor of the Greek historian Polybius. This happened a good many years before the sack of Corinth—in fact, when Polybius was one of the thousand hostages demanded by the Senate from the Achaean League after the Third Macedonian War.[223] Old-fashioned people like Marcus Porcius Cato could protest as much as they liked. He denounced Marcellus, for instance, for corrupting the public taste with Syracuse's works of art.[224] But the real portent of the future was the orator Lucius Crassus, who lived in the second half of the second century and the early first century—in other words, the period immediately following the sack of Corinth.

Crassus "first had columns of foreign marble in his house on the Palatine."[225] There were only six columns, of the far from showy marble of Hymettus, but the innovation caused Crassus' contemporary, Marcus Brutus, to give Crassus the nickname "the Palatine Venus."[226] In addition, Crassus paid a very large sum for two cups by Mentor, the most famous of the Greek silversmiths of the great centuries, but he was shamefaced about his purchase and did not show his cups on his sideboard.[227] In the story of true art collecting and in the special Roman circumstances, Lucius Crassus was exactly the kind of transitional figure one would expect to find in Rome in the later second and early first centuries B.C.

Once begun, however, the transition was enormously rapid. It is a nine-to-one bet that the large dealer's shipment in which the Piraeus Apollo was included had been destined for the Roman market before it was buried

in the ashes in 86 B.C., when Sulla put the Piraeus to the torch and did much damage in Athens itself. It was not long after this, too, when a political hanger-on of Sulla's made his debut as the single most predatory art collector—and this is an extreme distinction—in the whole record of Western art collecting.

Gaius Verres was not only the type case of the rapacious collector; he further came close to being the type case of the obsessive collector. In 80 B.C., on his way to service as quaestor in Cilicia under a notoriously corrupt Roman provincial governor, Verres stopped to scoop up works of art from Samos, Chios, and Tenedos.[228] His thefts from the ancient Temple of Hera at Samos have already been noted. By then, sad experience had taught every provincial that it was fruitless and dangerous to resist a Roman with serious political influence. But it was in 74 B.C. that Verres' real career of systematic rapine began, after he had managed to secure the governorship of Sicily, which was the richest province in the empire at that time.

It would take long, and it is needless, to list the works of art Verres managed to extort from the unfortunate Sicilians. Cicero's Verrine orations contain all the evidence. Temple collections were no more immune from Verres than private collections. For example, the Temple of Asclepius at Agrigentum yielded a dedication "by Publius Scipio . . . a beautiful statue of Apollo, on the upper leg of which the name of Myron was inscribed in small silver letters,"[229] while a rich Sicilian, a certain Heius, lost to Verres statues by Praxiteles, Myron, and Polyclitus for a token payment of 6,500 sesterces[230]—or a tiny fraction of these three statues' real market value at that time. Verres, further, took grand old Greek silver,[231] the gold-colored Corinthian bronzes that were the equivalent in those days of the finest French eighteenth-century gilt bronze today, and any other kinds of works of art that his agents[232] sniffed out for him. In addition, he levied taxes in such a way, without regard to works of art, that the formerly rich province was reduced to the sort of poverty Sicily had known during the worst ravages of the Second Punic War.

In despair, the provincials were finally driven to the normally hopeless expedient of bringing a suit against their governor in Rome. Cicero accepted the assignment of prosecuting him, and Verres employed the other most famous orator of the day, Hortensius. The judge, for once in a way, was honest.[233] When Cicero had made the first part of his case, Hortensius was forced to advise his client to flee Rome to refuge in Marseilles;[234] and Verres took his advice, carrying with him, however, all the works of art he had extorted from subject peoples. Later, when Mark Antony became dictator after the murder of Julius Caesar, Verres achieved another unique distinction among art collectors. Mark Antony asked Verres to surrender to him Corinthian bronzes which Verres loved, and the old

man refused flatly. Mark Antony thereupon proscribed him; and so Gaius Verres became the only art collector who is known to have died for his collection.[235]

When Julius Caesar reformed the administration of the provinces, and particularly after the Emperor Augustus defeated Antony in the final bitter contest for power, Roman art collecting began to resemble modern Western collecting far more closely. For one thing, as soon as high Roman officials were no longer free to steal nearly anything they took a fancy to, super-prices almost on the modern level prevailed for the great prizes. The elder Pliny, who was sensibly interested in the value of works of art, recorded a long series of these super-prices.[236] So far as one can judge, the price level for major Greek old masters in the times of Julius Caesar and Augustus was several times higher than the already high level reached in the time of Attalus II of Pergamum—whereas one suspects prices were actually lower on the Roman market while Verres-style pillage of helpless provincials was still common.

Art collecting was a conspicuous social phenomenon, too. One piece of evidence to this effect is that Vitruvius matter-of-factly recommended northern exposures for picture galleries—[237] which suggests that collections of paintings were normally found in grand houses of Vitruvius' time. The conspicuousness of Roman art collecting is even more clearly suggested, however, by the many references to it in Roman literature. A surprisingly long series of leading Roman writers—Varro[238] as well as Pliny; Cicero and Quintilian as already mentioned; not only Horace, but also Martial, Seneca, Statius, Juvenal,[239] and others as well—had something to say about collecting or collectors.

Some of what was said is fairly horrifying. Seneca, for instance, tells a story of a young slave who broke a precious crystal cup at a dinner Vedius Pollio was giving for Augustus.[240] Vedius angrily ordered the slave to be thrown into his tank full of huge lampreys (a great delicacy in Rome), where of course the youth would literally have been eaten alive.[241] The Emperor, disgusted, promptly pardoned the slave, ordered all Vedius' other antique and costly dinnerware to be smashed, too, and had the lamprey tank filled up. Some of the references are also decidedly funny, for Martial, particularly, was a great one for making fun of pompous collectors. One of his epigrams concerns a boring host, on whose table everything was ancient and good except the wine.[242]

On the whole, Martial seems to have judged his art-collector friends chiefly by their cooks and their cellars. Novius Vindex was evidently super-satisfactory on these two heads, and the praise of him in Statius' *Silvae* sounds like an uncommonly effusive bread and butter letter.[243] Martial, too, was warmly complimentary. Moreover, the data on Vindex as a collector make some other points worth noting. By his time, for one

thing, connoisseurship was a recognized talent in Rome, and he was therefore applauded for his ability to tell "even at a distance" the "line" that "reveals the hand of Apelles."[244] For another thing, the great prize of the Vindex collection was a table bronze—a small Hercules by Lysippus alleged to have belonged successively to Alexander the Great, to Hannibal, and to Sulla.[245] This glamorous provenance is one that would cause a wise modern collector to demand documentation; but the fact that it was given shows a proto-modern interest in provenances.

Then there is the further fact that a mere table bronze by Lysippus could cause much excitement in the late first century A.D., whereas less than 250 years earlier, it seems to have been taken almost as a matter of course that Caecilius Metellus Macedonicus should carry off from Dium an entire group by the great Lysippus of large equestrian bronzes of the highest historical interest. As collectors' competition increases and continues, the stock of works of art to be competed for always diminishes, and what would once have been lesser prizes always become prime prizes.

Roman antique collecting has already been touched upon in passing, but note should be taken of another mocking epigram by Martial, on a man whose friends and possessions were alike in all being "genuine antiques."[246] It is stated elsewhere that certain types of old silver were particularly valued if the pieces showed strong signs of age.[247] Collecting old silver, in fact, must have been as common in Rome as it is nowadays, as one can tell from the sheer number of Martial's epigrams about silver collectors.[248] The chief prizes were pieces by famous silversmiths of the great centuries in Greece, or else pieces having medallions or motifs chiseled by the famous Greek sculptors of the great centuries. Verres actually set up a workshop of his own in Sicily, to transfer these chiseled motifs to richer mountings, including gold ones.[249] Silver was apparently faked, too, for Martial records vessels attributed to the maker of Lucius Crassus' costly cups, Mentor,[250] whereas Pliny says flatly that the last known pieces by Mentor were lost much earlier, when the ancient Temple of Jupiter Optimus Maximus on the Capitoline went up in flames in the troubles of the "Year of the Four Emperors."[251]

On the whole, finally, Roman antique collecting seems to have centered on intrinsically precious objects like old silverware. "Corinthian" bronzes, made of an alloy that was no longer understood with certainty in Roman imperial times;[252] and two classes of objects whose precious raw materials are not clearly understood today, "murrhine" vases and "citronwood" tables[253]—these were the sorts of things the collectors wanted above all.

It seems fairly certain that silver collecting in a near-modern manner began in the Greek world. Otherwise, where would the earliest Roman art collectors like Lucius Crassus have learned that names like Mentor were so important? But "antique" collecting in our sense—in short, collect-

ing old furniture—is a far more doubtful subject, although there is at least a shred of evidence going beyond those citronwood tables, which were both antiques and treasures, too. In Cicero's letter to Fabius Gallus complaining about the Bacchantes Gallus had chosen for him, there is a rather mean final paragraph in which Cicero says he really would like to have what seems to have been a wrought-bronze table support that Gallus wanted for himself.[254] If the piece was contemporary, the problem could easily have been solved by asking Gallus to order an additional table support. Hence it is a good guess that the piece belonged to one of the more ornate furniture types that Greeks began to make and admire in Hellenistic times.[255]

The Story's End

No more is left to record but the end of the story. On the one hand, it seems evident that after the end of the first long period of imperial invincibility and rarely troubled prosperity, art collecting had a less conspicuous role in the life of the Roman upper class. So much must be deduced from the far more infrequent mentions of collecting in the later classical texts. On the other hand, collecting continued without remission until the fifth century A.D., and, in a more ghostly way, into the sixth century. For the later second century, when Rome's time of troubles really began, we have the always dubious testimony of the *Historia Augusta*. The *Historia* states that the Emperor Marcus Aurelius financed the long, bitter, and costly Marcomannic Wars without raising taxes, by offering all the imperial collections of works of art, of jewels, and of ceremonial robes in an enormous auction in the Forum of Trajan which continued for many days and brought in the necessary sums.[256] Although often liars, the authors of the *Historia* at least wished to be believed, as all liars do; so something approximately like this auction may be assumed to have happened, in order to make the story believable.

Then, for the third century, we have the evidence of the *Imagines* of the two Philostrati, a work much admired by Goethe[257] but all but unreadable today. What amounts to the introduction is the description of a handsome picture gallery,[258] after which come the highly rhetorical descriptions of the individual pictures that were drawn upon for the iconography of two of the Titians in the *camerino d'alabastro* at Ferrara. No picture is attributed to an individual artist—in itself a sign that art collecting was waning—and there is a modern scholarly argument about whether the gallery sketched at the outset was real or imaginary.[259] In any case, such a word picture of an art gallery implies the existence of at least a few important art collections in the later third century.

But there is no need to continue to pile detail on detail. Of the fourth

century, it is enough to say that Constantine the Great considered it essential to bring sculpture from all over the Eastern Empire to ornament his new capital, Constantinople.[260] Famous works were freely taken from places hallowed by history. The bronze serpent-tripod dedicated by the Greek cities that had joined to inflict the final defeat on the Persians at Plataea was moved from Delphi to the Hippodrome of the new capital.[261] Phidias' huge Athena Promachus, whose bright spear tip glistening high above the Acropolis had guided mariners to the Piraeus for eight hundred years, was carried off to stand before Constantine's new Senate House.[262] There was far more of the same sort. The pious Eusebius was shocked by the attention given to pagan works of art, but being a court ecclesiastic, he smoothly (and ridiculously) explained that the Emperor's motive was to make the old gods into figures of fun.[263] The real truth was obviously that even in the fourth century A.D., no one could conceive of a capital city without a splendid endowment of sculpture.

What happened in the sixth century will be treated in another chapter, but the present one cannot be suitably closed without some mention of the final twilight of classical art collecting in the fifth century A.D. The thickening dusk is easily discernible in the letters of Sidonius Apollinaris, a great territorial nobleman of Gaul and Bishop of Clermont-Ferrand— although married to the daugher of one of the last Western emperors. His loving description of his huge country house near Clermont-Ferrand makes the place sound exactly like one of the larger rural palaces of eighteenth-century England, except that the bathing arrangements were vastly superior.[264] As a bishop, he piously boasts that he has no statues of naked athletes[265]—which strongly suggests that in other great country houses of Gaul works of this sort were still common enough—and he dwells lovingly on the grand display of silver on his sideboard in a way that at a minimum suggests silver collecting of a sort.[266] The silver is likely to have been lost soon thereafter, when the Visigoths overran Sidonius' part of Gaul, although King Euric allowed Sidonius to keep his bishopric.

If the sources can be trusted, however, the last truly major[267] classical art collection was formed in the fifth century by the *praepositus sacri cubiculi* of the Emperors Arcadius and Theodosius II, the eunuch Lausus.[268] As Overseer of the Sacred Bedchamber, Lausus was a powerful insider at the court in Constantinople; and one may be sure he had advance warning of Theodosius II's edict suppressing the pagan places of worship.[269] Theodosius the Great, of course, had already suppressed the pagan cults;[270] but the more beloved temples of the old gods lingered. Wherever the edict of Theodosius II was obeyed, however—it was not at Athens, in the case of the Parthenon—the temples themselves were allowed to fall into ruin, or, at a minimum, they were denatured by the removal of their cult images. This gave Lausus a classic insider's opportunity, and one imag-

ines him seizing the happy chance to send his agents racing out to key places in Greece, Asia Minor, and the Aegean Islands, in order to secure at modest prices famous cult statues that had survived both the rapacity of Roman conquerors and the temptations later offered the Greek priesthoods by Roman art collectors.

The result for Lausus was clearly a most remarkable art collection—again, if the sources can be trusted. There are three sticking points, admittedly. The main source, to begin with, is the fairly late Byzantine writer Cedrenus; but it is pretty certain that he echoes earlier accounts of the collection of Lausus. Furthermore, the account by Cedrenus has the two best marks of authenticity in sets of facts reported at a later time: extreme precision and the inclusion of something genuine but otherwise unknown. This latter was a cult statue of Athena from Lindos. It must have been a strange work of art, for it was attributed to the ultra-Archaic masters Dipoenus and Scyllis;[271] and the raw material was said to be emerald,[272] but was probably some other green stone of considerable rarity like the stone of the "Emerald Buddha" in Bangkok.

The second sticking point is Cedrenus' inclusion in Lausus' collection of the Phidian Zeus from Olympia, which raises doubts because the statue was both large and of ivory with gold applied over a wooden armature, except for the rich throne. Transport to Constantinople of such a big, ancient, and fragile work of art cannot have been easy; but, again, the feat was quite imaginable in view of the resources available to Lausus. Then, too, we have the testimony of the sophist Themistius that the Zeus was still to be seen at Olympia until rather late in the fourth century;[273] so it was almost certainly still there for acquisition by the agents of Lausus. As for the third sticking point, it is the contention of the current excavator of Cnidus, Miss Iris Love, that Praxiteles' naked Aphrodite somehow survived *in situ*, and may well be represented by a foot fragment she has found and a much-damaged head in the British Museum's reserves.[274] But Miss Love's views on these matters have found no support at all among other archeologists.

Thus one is justified in tentatively picturing Lausus' palace in Constantinople, the Lauseum, as containing the Athena Lindia; the Praxitelean Aphrodite from Cnidus that made "Cnidus illustrious"; the Phidian Zeus; the new cult image which Lysippus supplied for the Temple of Hera on Samos; another particularly famous work Lysippus reputedly did for his own pleasure, depicting *Kairos* or Opportunity; and a long series of other works of art as well. Unhappily, the entire contents of the Lauseum perished in the great fire of the late fifth century which also destroyed the library of Constantinople and large areas of the city.[275] Despite this sad ending, I confess I like to think of Lausus and his Greek masterpieces that lingered on in the Lauseum, enjoying their last mead of love and

admiration at least for a little while. Yet when I think of Lausus, I have to confess further that I find myself pondering some deeply melancholy questions.

In the 1984-like world government of the future which the age of the H-bomb can too easily bring forth, will some culturally backward-looking high bureaucrat make comparable rescues from the ruins of the West? Will Piero's Risen Christ, and Leonardo's smiling lady, and eight or nine more of our art tradition's most sacred masterpieces, then serve as objects of such a man's private enjoyment, until time's cruelties at length write *finis* to the story? It is a fearsome vision, but not an impossible one.

VIII

THE PATTERN REPEATS

In the third century B.C., the Greeks and Chinese still lived, in effect, in separate worlds, as unable to communicate as Europe and the Americas before Columbus sailed the Atlantic. A thin trickle of trade, mainly in silk,[1] very probably went from the Far East to the West through all sorts of intermediaries, as certainly happened a bit later; but there was no serious East-West exchange of goods and no exchange whatever of ideas or knowledge for much more than a millennium after the third century.[2] Hence the Greek example can have had no role at all in China, when Chinese art started to be transformed into one of the rare art traditions.

These are the facts that now bring us face to face with the central mystery of the worldwide story of the by-products of art. In brief, a strikingly complex cultural pattern, though historically most exceptional, has been several times repeated in radically different cultures. Except in the Japanese case, furthermore, none of the repetitions of this distinctive pattern of the rare art traditions can be explained by normal cultural diffusion. Yet each repetition has almost seemed to follow the same invisible blueprint, as I remarked earlier.

In the previous chapter, the pattern was traced in its entirety for the first time. Briefly recapitulating, a glorious creative mutation produced a new Greek art tradition marked by decidedly new ways of thinking about the visual arts. The new ways of thinking in turn gave rise to a series of wholly novel cultural-behavioral traits. Thus the Greek artists were world art's first compulsive innovators; the first who often signed their works; the first to devise sophisticated theories of the visual arts; and above all, the first artists who gained permanent niches in the general cultural memory of their society and its inheritors. All these novelties then led on to the development in the Greek world of art collecting, art history, and all the other by-products of art for the first time in the long history of art.

The total pattern, if you think about it, is deeply mysterious in itself. It is ten times more mysterious, however, that this pattern first seen in the Greek world should then have been almost completely reproduced in China, at the opposite end of the gigantic Asian land mass. Nonetheless, this is precisely what began to happen in China in the late third century. This happened, however, at least in part, as a result of a vast and decisive political convulsion. Hence the political-historical background must first be sketched.

The Proto-Stalinist Roots

So far as our knowledge goes today, in brief, the earliest Chinese bronze finds of fragmentary blades were recently made in Gansu (Kansu) Province[3] and are thought to date from 2300–2000 B.C.; and China had fully entered the Bronze Age a couple of hundred years before the opening of the historical Shang dynasty[4] just after 1800 B.C.[5] The line of Shang kings extended to about 1050 B.C., when the Zhou (Chou) people conquered the Shang. The Western and Eastern Zhou dynasties, taken together, further endured for just over eight centuries. What may be called ancient China therefore lasted for considerably more than fifteen hundred years. A most special higher civilization; a great art worthy of a higher civilization; and, after the Zhou conquest, a political organization based on an intricate network of local feudal fiefs—these were the main features of ancient China.

The beginning of the end of ancient China occurred in the Eastern Zhou centuries, after the ruling dynasty had been gravely weakened. The Eastern Zhou period, starting in 770 B.C., was a rich time of dynamic change. China entered the Iron Age; first Confucianism and then all the other main schools of Chinese political and philosophic thought were founded;[6] and other major advances were made. Yet this was also a dreadful time, when the numerous feudal fiefs were coagulated by force and intrigue into a few large states, and these states promptly began to fight one another to the death. The climax was reached in the blood-drenched period of the Warring States, when the more and more ghostly Eastern Zhou dynasty disappeared at last.[7]

In the dire elimination contest among the Warring States, the victory finally went to the large, highly militarized, but culturally peripheral northwestern state of Qin (Ch'in). In 221 B.C., King Zheng (Cheng) of Qin therefore proclaimed a new dynasty, the Qin, and took a title never before used by any historical Chinese ruler,[8] Qin Shihuangdi (Ch'in Shih Huang Ti), or "First Universal Qin Emperor." Thus the Chinese Empire was founded, to endure through many another dynasty and many kinds of peril and upheaval until the empire came to an end over twenty-one centuries later—in 1911, and thus in the lifetimes of many still aboveground.

The new empire's foundation further caused Chinese art to begin to

take a quite new direction, with effects schematically comparable to the effects of the creative mutation in Greece in the seventh century B.C.—although these effects in China were more slow to emerge. There were also many continuities between ancient China and imperial China. Yet, with reservations to be noted later, it is still reasonable to speak of a first era of Chinese art before the foundation of the Chinese Empire, and a second era of art thereafter. To the second era of Chinese art, in particular, belong all the masterpieces of painting and triumphs of calligraphy, the superb architecture, the subtle and beautiful porcelains, and nearly everything else that made Chinese art the grand fount of inspiration for all the other peoples of the Far East for whom China was the culture-bringer.

In view of this great art's roots in the newly founded Chinese Empire, it would be pleasant to be able to record that the empire's founders were wholly admirable men. Alas, however, the state of Qin ultimately owed its victory to a radical reorganization carried out in the last half of the fourth century B.C. by the founder of the Legalist School of Chinese political thought, who is usually known as Lord Shang.[9] In the final contest for power, in the third century, King Zheng of Qin faithfully followed Lord Shang's Legalist principles, and his main strategist was Li Si (Ssu), the third century's ablest Legalist thinker. When King Zheng became Qin Shihuangdi and Li Si was named the new empire's chief minister, they also organized the Chinese Empire on sternly Legalist lines.

Hence Li Si proposed, and the first Emperor ordered, the empire-wide bonfire of all the books in China except those on practically useful subjects, such as agriculture; and on another occasion the Emperor reportedly had more than 460 dissident Confucianists buried alive.[10] The truth is that the new Chinese Empire of Qin Shihuangdi and Li Si can be best understood as an enormous proto-Stalinist state, promoting all the Stalinist aims and purposes and employing all the Stalinist methods which were applicable in a preindustrial society. The first inspirer of the new empire's design, Lord Shang, must also be seen as the world's earliest proto-Stalinist. His priorities, which the first Emperor and Li Si inherited, can be judged by a single excerpt from *The Book of Lord Shang*:

> If in a country there are the following ten evils: rites, music, odes, history, virtue, moral culture, filial piety, brotherly duty, integrity and sophistry, the ruler cannot make the people fight and dismemberment is inevitable, and this brings extinction in its train. If the country has not these ten things and the ruler can make the people fight, he will be so prosperous that he will attain supremacy.[11]

The Change in Art

Not quite all these grim precepts were obeyed by Qin Shihuangdi and his chief minister. For example, a pre-imperial memorial to the throne

by Li Si praised the state of Qin for having imported precisely the kind of Chinese traditional music which Lord Shang thought so pernicious. Before this step was taken, Li Si wrote, the "music of Qin" was no more than "beating on earthen jugs, knocking on jars, plucking the cheng (ch'eng) and striking the thigh bones, while singing and crying 'Wu Wu' "[12]—so it can be seen why the Chinese of the ancient cultural core area had earlier regarded the people of Qin as semibarbarian.

Li Si's memorial to the throne is also one of the bits of evidence that music should probably have pride of place in the before-and-after contrast between the first and second eras of Chinese art. Later on, lute music became important, and there is a large literature concerning it. But the music Li Si admired and Lord Shang disapproved of was entirely different in character, requiring a well-trained orchestra, singers, and, almost always, numerous dancers very grandly costumed.

This kind of music is the only art form that figures prominently in the ancient texts. The *Analects* or *Lun yu* (yü) report that Confucius confessed he did not "know the taste of flesh" for three months after hearing "the music of Shao in Qi (Ch'i)."[13] Confucius had a good deal more to say about music,[14] and one of his chief later disciples, Xun Zi (Hsun Tzu) wrote an extensive "Discussion of Music."[15] The *Book of Rites* has an entire musical section,[16] too, not itself early by Chinese standards but thought to be based on an early text.[17] The section includes a violent denunciation of the allegedly barbarous, evidently erotic "new music,"[18] which sounds comically like one of the late Nikita S. Khrushchev's fulminations against Western jazz. Yet the thrust of the whole argument is that proper music is an essential component of civilization itself.

Probably this was because the kind of music Confucius and his followers found so stirring—as opposed to the "new music"—was a key element in the hereditary rituals of the Zhou royal house and the great Chinese feudal lineages. Quite probably, too, this was one of the reasons so many anti-Confucians like Lord Shang condemned the early music. Barring the apolitical Taoists, all the major anti-Confucian thinkers of ancient China aimed to subvert the traditional feudal order in one way or another. If the early texts are a sufficient guide, in any case, one must conclude that this kind of music was ancient China's central art.

In the purely visual arts, meanwhile, the summits were the superb bronze vessels made for the feudal lords' sacrifices and feasts; the carved jades and other costly stones, again carved, which ornamented the feudal lords' persons and were placed in their tombs; the lacquers,[19] bronze fittings,[20] and other ornaments of their palaces; and the fine weapons[21] and rich chariot fittings they used in war.[22] Nor is this list based merely on what has survived archeologically. In the exchanges between feudal lords recorded in the early annals such as the *Zuo zhuan (Tso Chuan)* the

only works of art used as gifts were jades, and much more rarely bronzes,[23] although chariots, supplies of sacrificial animals, and other things also figured.

If you search the early texts, you find that mentions of the visual arts and their products are all but entirely absent, except in connection with the gift exchanges. Yet to those familiar with the Chinese art of the last two millennia, the visual arts' near-total absence from the early texts is bound to be less striking than an absence of another sort. In Chinese art itself, certain most important features were conspicuously absent in the first era.

The first absentee was fine calligraphy; for calligraphy in ancient China was no more an art than writing is with us—except insofar as some inscriptions on ritual bronzes were designed, like the legends on fine Greek coins, to record significant facts but also to be pleasing to the eye. Painting, too, was at best an extremely minor art[24] except perhaps in the Yangzi (Yangtze) Valley state of Chu (Ch'u).[25] The representation of reality was still another absentee; for the Chinese art of the first era was "hieratic"[26] and an art of "ornamental design."[27] And although the ancient Chinese were certainly eager treasure gatherers—for the works of art the feudal lords prized most highly were really treasures—neither the old texts nor the results of archeology reveal a trace of ancient Chinese art collecting or the other by-products of art, at any rate as these phenomena are defined in this essay.

For many Westerners, including some Western art historians, the sharpness of the contrast between the first and second eras of Chinese art may remain difficult to perceive, even after the foregoing summary of the main aspects of the first era. For those who have this difficulty, however, it is only necessary to run over once again the features absent from Chinese art's first era; for these were in fact the most prominent features of art's second era in China. Thus the reality of the before-and-after contrast can be easily judged from the following short list of the main distinguishing marks of the new direction Chinese art began to take after the empire was founded.

First, calligraphy rose from being a non-art to its special place as China's art of arts—the place calligraphy has now occupied in China for approximately two thousand years.

Second, painting, also so unimportant for so long, somewhat more slowly rose to its historic place as China's other major art.

Third, instead of remaining "hieratic," Chinese art became vividly representational, and the accurate representation of reality remained a significant goal of art for approximately fifteen centuries, or until near the close of the Southern Song (Sung) dynasty.

Fourth and finally, new ways of thinking about art also developed;

and these rather soon conferred on Chinese art much the same special cultural-behavioral traits that first appeared in Greek art, and then led on, as in the Greek world, to Chinese art collecting, art history, and most of the other by-products of art.

Why Two Eras

I must forthrightly confess I can cite no higher authority for the foregoing division of Chinese art history into two different eras, with a break-over point when the Chinese Empire was founded in the late third century B.C. It must be clearly understood, moreover, that the division into a first era and a second is *not* intended to suggest a sharp and instantaneous change in Chinese art.

No such sharp and instantaneous change has ever occurred in the whole of art history, so far as one can discover—except perhaps when a tribal art tradition was in effect exterminated because the tribe that nourished the tradition was exterminated or enslaved. Instead, there are always simultaneous leads and lags in all great changes in art. Or perhaps the best comparison is with the kind of enormously expensive French dress that used to be called *"une robe aux tons dégradés,"* meaning specially dyed so that it would begin pure white at the neck and shade downward rapidly but quite imperceptibly into deep crimson or some other strong color at the hem.

In the Chinese case, to illustrate, the first clear evidence of calligraphy being recognized as a true and serious art only appears well over two hundred years after the Chinese Empire's foundation. Yet some sort of transitional process, all but imperceptibly causing calligraphy to rise toward this wholly new status as an art, must be logically inferred in the interval; and as will be shown, certain developments connected with the foundation of the Chinese Empire rather clearly led to the transitional process in question.

With such reservations and qualifications constantly in mind, it seems to me the division of Chinese art into two eras can be accepted as legitimate, simply because I further believe a correct analysis of recorded Chinese history and the results of recent archeology both support the reign of Qin Shihuangdi as the moment when the second era of art obscurely, rather strangely, yet demonstrably originated. The first historically attested episode to consider is a measure that the first Emperor ordered and his chief minister carried out.

When the empire was established, the ways of writing the Chinese characters varied widely among the vanquished regional states of ancient China. Anyone can grasp the inconvenience of having several ways of writing the same word in a unitary, tightly controlled, and proto-Stalinist

empire. Hence Qin Shihuangdi commanded his chief minister to oversee the standardization and simplification of all the characters in written Chinese. Li Si did his work so well that his system survived essentially intact until Mao Zedong (Tse-tung) ordered further simplification of the Chinese characters in his time of power. It should be obvious, too, that Li Si's standardization and simplification contributed enormously to calligraphy's subsequent ascent to its new place as China's art of arts. Without a standard basic form for each character, in fact, the subsequent development would have been impossible. If only because of the difficulties of communicating clearly, calligraphy as communication was bound to hold the floor against calligraphy as art as long as there were different forms of many words, according to the region you came from.

The strongest archeological reason for dating the new direction of Chinese art from the foundation of the Chinese Empire is a sensational discovery made in 1974.[28] Previously, Max Loehr of Harvard and William Watson of London University had independently suggested that the Chinese adopted the representation of reality as a new goal of art a century or more before the time of Christ.[29] These suggestions by Professors Loehr and Watson have now been confirmed, and a better date for the change of goal has been provided, by the Chinese Communist archeologists' extraordinary find near the site of China's first imperial capital, Xianyang (Hsien-yang), not far from modern Xian (Sian). Here the first Emperor built his grandiose tomb. On the eastern approach to Qin Shihuangdi's tomb, a protecting army of tomb figures was buried in trenchlike underground chambers, and this is the great new find.[30] The army is composed of close to seventy-five hundred life-size, individually modeled terra-cotta soldiers,[31] complete with attendant horses and chariots, all in battle array. The pottery army's soldiers, along with a few smaller, nonmilitary figures, also from the tomb's approaches,[32] are the first fully naturalistic representations of human beings in the entire story of Chinese art, like nothing the art of China had ever produced before.

Representation had not, of course, been beyond the capacities of ancient Chinese artists and craftsmen. From as early as the Shang dynasty, there is the formal but strongly representational rhinoceros in the Brundage collection.[33] Yet Professor Loehr once invented an imaginary dialogue on the subject between two Shang bronze artists. One was imagined saying that the Brundage piece looked "remarkably like a rhinoceros." The other was made to reply that the resemblance was indeed remarkable, and then to add, "But is this art?"[34] The rhinoceros was markedly atypical, in short.

In truth, Qin Shihuangdi's buried pottery army can only be called dumbfounding, because the vividly lifelike soldiers constitute such a radical departure from anything previously known from China. Perhaps Qin Shihuangdi's own wishes had a role in this new departure. In the Shang

dynasty, great numbers of persons had been sacrificed at the funerals of rulers, to be placed in the royal tombs and to accompany the rulers into the life after death. Later, pottery tomb figures had been substituted for human sacrifices, but the first Emperor, who was much given to magic, may well have believed that the more exactly each tomb figure resembled a real human being, the more useful the substitute would be.

I venture to suggest, however, that such magical considerations, even if they existed, were really less important than certain practical factors. In particular, Qin Shihuangdi was a megalomaniac builder, and one of his major projects was building in his new capital exact replicas of all the lost palaces of all the conquered rulers of the Warring States.[35] Another was melting down all the bronze weapons of all the conquered regional states, to make colossal bronze figures[36] which one may guess stylistically foretold the buried pottery army.

When these great projects were put in hand in the new capital, Chinese art had been in ferment for some time. Experiments in proto-representation—the "hunting bronzes," for instance—were already being made in the time of the Warring States;[37] and there was also a great diversity of regional styles of this period. The rich former state of Chu in the Yangzi Valley, for instance, not only gave unusual emphasis to painting; in addition, there were strongly marked Chu styles of poetry,[38] lacquer, and sculpture in wood.[39] Thus the first Emperor's palace-building projects must not only have required an enormous ingathering of the best craftsmen from all over China. In addition, the ingathering at Xianyang must have made this Qin capital a perfect bubbling cauldron of stylistic interchanges among the local cultures of different regions. If the same sort of ingathering produced Gothic art at St.-Denis, the infinitely greater ingathering at the Qin capital may well have led to representational art in China.

Here, once again, reservations are in order. One cannot say that accurate representation immediately became a conscious goal of Chinese artists, or indeed a conscious preference of Chinese art lovers, because goals need to be stated in order to be known. The first recorded, still-preserved Chinese statements indicating representation as a goal of Chinese painting date from a much later period; and it was much later still before there was any Chinese writing about any arts except painting and calligraphy. Then, too, even the final changeover to mainly representational art must certainly have required a considerable period. If you survey the wonderful things found in the Mancheng (Man Ch'eng) tomb made for a Han prince and princess in the late second century B.C., for instance, you still get a mixed result. The marvelous gilt-bronze lamp already shows remarkable mastery of representation of a clothed human figure in a difficult pose, in the kneeling girl holding the working part of the lamp.[40] Whereas the two parcel-gilt-bronze figures of leopards inlaid with silver and garnets are dis-

tinctly stylized, for all their vigor and power.[41] In short, the leads and lags were there as usual. Yet the fact remains that the soldiers of Qin Shihuangdi's buried army, despite their stiffly posed bodies, stiffly encased in uniforms and armor, constitute something startlingly new and indicative for the future.

On Scholar-Officials

One must return to recorded history, however, to find what strikes me as the first Chinese Emperor's single most important, albeit wholly institutional contribution to the new direction of Chinese art. This was, quite simply, the actual foundation of the Chinese Empire. The reasons for this suggestion are simple enough, and are easy to deduce from hard-headed consideration of Chinese art history as well as Chinese political history. On the one hand, as will be later shown, the summits of Chinese art in the second era always belonged to the scholar-official class. On the other hand, the foundation of the Chinese Empire in itself created the conditions that made the scholar-official class so immensely important throughout all subsequent Chinese history—or at least until the Communists' triumph in 1949. No other outcome was really possible, because of the inescapable administrative demands of a huge and unitary empire, which made a literate bureaucracy a prime necessity.

In the end, in fact, the scholar-officials became China's permanent ruling class, in the way that has been most cogently described by Étienne Balazs.[42] Obviously, therefore, the relationships between the arts and the prevailing class system being what they always are—no doubt deplorably—the scholar-officials also became the Chinese art lovers whose tastes and decisions chiefly counted. But there was much more to it than that. In the second era of Chinese art, as I have remarked above, calligraphy rose to be China's art of arts, and painting became China's only other major art. And these two arts belonged to the ruling class, the scholar-officials, in a way and to a degree which have no complete parallels beyond China's borders.[43]

Because of the immense importance of this aspect of the Chinese art of the last two millennia, additional political-historical background needs to be provided at this juncture. Beginning at the beginning, the scholar-official class seems to have started to take form in the sixth century B.C.,[44] long before the empire's foundation. Confucius, born in the mid-sixth century in a lesser gentry family of the state of Lu, was an early scholar-official—for to belong to the class, it was not necessary to hold office, merely to be eligible as an officeholder. Education and tradition were the keys, and Confucius was the greatest teacher of the emergent new class. By the mid-third century, scholar-officials had gained major roles in the

governments of most of the Warring States, although the ancient lineages of the feudal lords still constituted the main ruling group. When the empire was founded, however, most of the feudal lineages came to an end or vanished into obscurity, and, above all, the old feudal China ended forever. China never again had a long-enduring, nationwide, and dominant class of warrior-aristocrats.

Even when the central government was strongest, moreover, as in the Qin dynasty, the emperors and their courts never constituted a true class. The imperial court instead comprised an ever-shifting group of persons who happened to have their hands on the levers of power for the moment; while the permanent administrators of the empire—and thus the effective rulers, over time—were the members of the scholar-official class. Even in the Qin years, great numbers of scholar-officials from the former states must have been employed in the new imperial government, if only because small armies of literate bureaucrats must have been needed to perform such feats as mustering a million men to work on forming the first Great Wall from existing walls built by the Warring States.

Other scholar-officials were plainly antigovernment, as indicated by the burial of the 460 unfortunate Confucianists; but intellectual dissidence seems to have played no real role in the abrupt fall of the Qin dynasty, which occurred in 207 B.C., shortly after the first Emperor's death. The spark was no more than a rebellion in a gang of a hundred conscripts called for military service,[45] yet the result was like an instantaneous and universal forest fire in tinder-dry weather. The truth is that the Chinese people have never put up for long with all-transforming, reuniting, but cruelly exacting regimes. They have had three of them in the last twenty-two centuries: first, the regime of Qin Shihuangdi and Li Si; second, the Sui dynasty, which completely reunited China in 589 A.D.[46] and fell in 618; and third, the regime of Mao Zedong, which has apparently ended with the defeat of the Gang of Four. To complete the first Emperor's story, he became the most execrated villain in Chinese history soon after his dynasty's fall; and so he remained until the triumph of Mao Zedong, who took the first Emperor as his personal model and inaugurated what amounted to a nationwide cult in his honor.[47] And now the first Emperor's cult, like the cult of Mao himself, appears to be in rapid decline.

That is by the way, however. After a short period of conflict, the Qin dynasty was succeeded by the Han, one of the most successful China has ever had; and during the Han dynasty, the scholar-official class made further progress toward its final place and form as China's ruling class for two thousand years. Under the Han, significantly, the Confucianists soon raised their heads again; the books that Qin Shihuangdi had burned were laboriously reconstituted; and in the later second century B.C., the great Emperor Han Wu Di (Ti) took the final step of making Confucianism

the official ideology of the empire. Han Wu Di, in fact, completed China's permanent imperial compromise: retaining almost intact the new structure of state power devised by the first Emperor and Li Si; lightening somewhat the brutal burdens imposed in Qin times; and throwing a seemly cloak of humanitarian Confucianism over all.

Thus all the elements were in place that were to matter so much for art's future in China. At no time, it should be understood, did the scholar-officials, narrowly defined, have anything like a monopoly of rule. Throughout the early period and at recurrent intervals thereafter, high birth played an important role in access to high office. The fortunes of the scholar-official class also rose and fell as the composition of the imperial court shifted and changed. At one moment, the court eunuchs, with whom the scholar-officials were always in conflict, would be the people in control; at other moments, dominance passed to the families of empresses, or to powerful regional clans. But the scholar-officials, as a class, had a permanent advantage possessed by no other group. They were always needed to carry on the government. Over time, the scholar-officials thus became the all but universally accepted models for all ambitious Chinese, of whatever origin.[48] Chinese culture and scholar-official culture came close to being interchangeable terms. And in its higher reaches, Chinese art also came close to being scholar-official art.

This complex social-political background has had to be sketched for quite practical reasons. To begin with, there is the simple question: why and how did calligraphy become China's art of arts? The answer, surely, is that skilled calligraphy was an essential ticket of admission to the scholar-official class; and the scholar-officials then made their basic skill into an art *by treating it as an art.* By extension, this also explains how painting became China's only other major art. The scholar-officials' sole tool, the Chinese writing brush, until recently was always the Chinese painters' sole tool. So it was both easy and natural for scholar-officials with a bent that way to begin using their skill with the writing brush to create paintings; and when this happened, painting ceased to be mere artisans' work and became a major art. These are other aspects of Chinese art which are also without exact parallels in the rest of art history.

Yet the story did not end there, by any means. Confucianism's role needs to be examined, too. It must be understood at once that by no means all scholar-officials were Confucianists. When Buddhism flourished in China, many were Buddhists. Among the great calligraphers and especially the great painters, many were Taoists. Yet the whole scholar-official class was nonetheless permeated with the Confucian value system; and since this also had effects on the second era of Chinese art, this value system needs brief investigation. In shorthand terms, political Confucianism may be defined as strongly humanitarian but equally strongly conserva-

tive, with the educated gentleman dedicated to public service as the ideal figure. To this, two points need to be added. Education, if it could be obtained, could make any man a gentleman; but a rigid hierarchy of classes was also part of the Confucian value system. First came the gentlemen—mainly the scholar-officials. Next came farmers, for the peasants were China's prime producers. Below them came craftsmen and artisans; and lowest of all were merchants and traders.

The effects on art of this value system were far-reaching. To begin with, it greatly reinforced the peculiar places of calligraphy and painting as the sole major arts. On the one hand, only a gentleman's education could produce greatness of mind and spirit under the Confucian value system. This led to the rule that since great works of art required greatness of mind and spirit, only gentlemen could produce great works of art.[49] Even in the cases of calligraphy and painting, therefore, true masterpieces could only come from scholar-officials;[50] and thus such things as artisan-painted Chinese ancestor portraits, so much liked in the West, were as much scorned in China as artisan-made calligraphic shop signs. In the end (and the end was over six hundred years ago) any work of art smelling too much of technical training, including technically skillful painting, tended to be looked down upon by many Chinese art theorists[51] as being too close to artisan's work.

On the other hand, a proper Confucian gentleman could not conceivably work with his hands—except to use a writing brush, of course. Thus the incredible fertility of the second era of Chinese art was simultaneously enjoyed and disdained by serious Chinese art lovers for many hundreds of years on end. The marvelous porcelains, the magnificent lacquers, the wonderful metalwork in gold, silver, and bronze, even the incomparable architecture and the vigorous sculpture—all these were thought unworthy of discussion by the numerous Chinese writers on art until a very late date,[52] with a minor exception for Buddhist sculpture during the centuries of Buddhism's religious predominance.[53] In consequence, after true art collecting began in China, the works of famous calligraphers and painters were the sole collectors' prizes for close to a thousand years.

The Snobbery Problem

In addition, the Confucian value system made what may be called the snobbery problem ultra-acute in Chinese art; and this is an important matter in itself, since the snobbery problem never seems to have appeared in the world history of art except in the more complex rare art traditions. There are practical reasons for this, too. In the countless art traditions of the majority, artists have always "known their place." They might rank as craftsmen like any others. Or their crafts might give them special

standing, as with lapidaries and feather workers among the Aztecs,[54] or metalworkers in pre-Christian Northern Europe.[55] Or their skills might somehow open the way to bureaucratic promotion, as with the Egyptian architect-engineers who became grand viziers.[56] But whatever place was allotted to artists in the society in question, the position was the one celebrated in the dreadful English hymn about "the rich man in his castle, the poor man at his gate."[57]

In the rare art traditions which generated the by-products of art, in contrast, artists did not "know their place." Instead, they claimed places in history simply as artists, in the sense of seeking to be remembered by posterity. More than once—as we shall find in the early history of the Western art tradition[58]—such artists' claims even caused complaints, on the ground that places in history ought to be reserved for rulers and noblemen, warriors and scholars. And behind this, in turn, was always the view, so strongly held in so many different societies, that no gentleman can work with his hands—as is obviously necessary for practitioners of the visual arts.

Many may think that all this talk of "gentlemen" and "places" is now downright archaic; yet the evidence for the snobbery problem in the rare art traditions is massive, once you look for it. In Greek art's story you find one side of the coin, for example, in Plutarch's observation that even the greatest admirer of Phidias and Polyclitus could not possibly want his son to *be* another Phidias or Polyclitus.[59] The other side of the coin is illustrated by the Greek stories of Alexander the Great's dealings with Lysippus[60] and Apelles,[61] which exactly parallel the Italian stories about the Emperor Charles V's dealings with Titian.[62] The Greek and Italian stories, though so far separated in time, in fact make exactly the same point: that the great ruler treated the great artist as a near-equal.

For the same basic reasons, Leonardo da Vinci took immense pains to prove that painting was every bit as good as the indisputably gentlemanly art of poetry, and maybe a bit better.[63] This also explains why Renaissance writers on art were so fond of borrowing, also from Plutarch, the saying he attributed to the Greek poet of the sixth and early fifth centuries B.C., Simonides, that painting was "silent poetry" and poetry "speaking painting,"[64] and of quoting the tag from Horace to the same effect.[65] Had they but known it, the Renaissance writers might also have quoted Su Dongpo (Tung-p'o), a Chinese poet of the eleventh century A.D. who wrote of two of the Tang (T'ang) dynasty's great poets and painters, Du Fu (Tu Fu) and Han Gan (Han Kan):

> Du Fu's poems are figureless paintings,
> Han Gan's paintings are wordless poems.[66]

The snobbery problem plus the Confucian value system in turn explain the bewildering aspect of the second era of Chinese art which has already

been touched upon. Not only was anything like sculpture or porcelain, which required the creator to work hard with his hands, by definition artisan's work and therefore not serious art. In addition, even in the realms of the accepted major arts, calligraphy and painting, it was important for artists to avoid the smallest appearance of artisan status. This was why so many painters and calligraphers refused patrons' commissions. This was also why they tended to be looked down upon, in the later centuries, if they accepted direct cash payments for their works. What seems so astonishing to us in the West, in fact, was entirely understandable in the light of the pre-Maoist value system of most Chinese.

Calligraphy into Art

Inescapably, it has taken some time to set the stage for the grand drama of Chinese art's transformation into one of the rare art traditions. But the stage setting has now been completed, and the next task must therefore be documenting how calligraphy and painting became the two major arts. The earliest evidence of the ascent of calligraphy is to be found in Ban Gu's (Pan Ku's) *Annals of the Former Han*.[67] It should be understood that the Former or Western Han dynasty continued for a little more than two centuries. An interregnum of disorder followed, and the usurping Emperor Wang Mang reigned from 9 to 23 A.D. A descendant of the Han house then reconquered the empire, and the Later or Eastern Han dynasty reigned until disorder triumphed again in 220 A.D.

Ban Gu's account of the Western Han, written in the second period, contains a series of biographies of the "Wandering Knights," and one of these was the aggressively bohemian scholar-official Chen Zun (Ch'en Tsun), who lived in the last years of the Western Han and served under the usurper Wang Mang.[68] His biography remarks that Chen Zun was "by nature . . . good at calligraphy. When he wrote letters to people, the recipients always put them away as something of great value."[69]

It is therefore clear that Chen Zun's letters were chiefly prized because of his calligraphy, although he had notable literary gifts, too.[70] This implies that calligraphy was already well on the way to being regarded as a true art by the beginning of the first century A.D. By the second century A.D., the fairly vertiginous ascent of calligraphy was then completed. Ironically enough, the best evidence comes from a decidedly backward-looking scholar-official who thought his contemporaries' love of calligraphy was nonsensical, on the philistine ground that treating calligraphy as an art would butter no parsnips for an official who wanted to get ahead.[71] Zhao Yi (Chao I) was not only backward-looking in his views; in addition, his *Polemic Against the Cursive Script* or *Fei cao shu (Fei ts'ao shu)*[72] requires a few words of explanation.

In brief, the Chinese characters retained the same basic forms (radicals,

numbers of strokes, etc.) from Li Si's simplification and standardization until Mao Zedong's further simplification; but in those twenty-two centuries—and before the standardization, too—great numbers of scripts, or styles of writing the characters, were devised, fell out of use, were revived with variations, and so on and on almost ad infinitum. The first script was the one that is found on the Shang-dynasty oracle bones.[73] The second, mainly found on the Zhou ritual bronzes, was the "great seal."[74] Li Si's own script was the "lesser seal," which remained the official script for public use until well after the fall of the Han.[75] But very early on—Zhao Yi says it was in the last years of the Qin dynasty—officials in a hurry had begun to use the "clerical script," which could be written much more rapidly.

"Now the rise of the cursive script took place in recent antiquity," wrote Zhao Yi. "Above, it is not that which was conferred by the signs of Heaven: below, it is not that which was given forth by the Yellow River or the Luo (Lo): in the middle, it is not that which was fashioned by the Sages. It was merely that, at the end of the dynasty, when punishments were severe and the nets were close-meshed, the official script was troublesome and laborious. Battles and incursions arose on all sides, military messages were exchanged at a gallop, feathered dispatches flew thick and fast, therefore they made the clerk's cursive, aiming at rapidity and nothing more. This script shows merely an intent to abridge and render easy, and it is not the creation of the Sages."[76]

The subsequent development of the "clerical" script was called "cursive" by Zhao Yi, who telescoped what happened. In reality, the "cursive" or "grass" script eventually grew out of the "clerical" script, thus giving the calligraphers who adopted it much greater opportunities for expressiveness by its far greater fluidity and variety of form. As the foregoing shows, it was this much more free, much less formal script against which Zhao Yi felt called upon to protest so vigorously in his *Polemic.* Zhao Yi's plaints leave no doubt, however, about calligraphy's standing as an art in the eyes of his contemporaries in the later second century A.D. He wrote, for example:

"Among the gentry of my commandery were two men called Liang Kongda (K'ung-ta) and Jiang Mengying (Chiang Meng-ying) both of whom were among the accomplished and intellectual men of the time. However, in their emulation of the cursive script of Master Zhang (Chang) [Zhi (Chih)] they more than rivalled that of Yan (Yen) [Hui, the Chinese "Beloved Disciple"] for Confucius. Kongda would copy out (manu-)scripts and take them to show to Mengying and together they would recite the texts and recopy them without ever growing weary. And after this, later scholars began to vie with one another in emulating these two brilliant men. If anyone obtained a scroll by those Prefects and Sub-prefects he would regard it as a secret treasure.

"But I personally fear this disregard of what is classic and cultivation of what is vulgar. This (script) is not a thing whereby one can cause the Tao to prevail and uplift the world."[77]

Somewhat crossly, Zhao Yi thus recorded an exciting but fairly early stage in a powerful, continuous, almost directed creative surge in China, which seems to have been broadly comparable to the Greek creative surge in the seventh through fourth centuries B.C. For almost all Westerners, it is nearly impossible to imagine a creative surge centering on fine calligraphy. Furthermore, even the greatest Chinese connoisseurs and savants cannot any longer speak with certainty about the detailed course of the creative surge—for reasons to be examined later.[78] Yet the reality of the creative surge itself is indisputable, at least on the basis of the data available today.

One mark of the swiftness of the surge of Chinese calligraphy's development as an art—and silly as this may seem, it *is* a mark—is the date of the first recorded appearance of an important practical effect of the snobbery problem in Chinese art. A great third-century calligrapher, Wei Tan (T'an), was commissioned to provide a suitable inscription for a new tower of the imperial palace, a hundred feet above the ground. This inscription had to be written on a precarious platform, in public, and with a huge brush. Wei Tan was enraged because he felt this made him appear no better than an artisan. Hence he laid down a Wei family rule to practice only the cursive script, which was not then used for public inscriptions.[79]

The earliest parallel story about a painter concerns the Tang artist, Yan Liban (Yen Li-pen), who was also publicly humiliated by being treated like a hireling by an emperor of the seventh century.[80] Thus it appears that the snobbery problem first put limits on the artist-patron relationship for calligraphers, and these limits only later bled over, so to say, into the story of Chinese painting.

For a long time, to be sure, there were certainly Chinese masters who did not see the matter as Wei Tan and Yan Liban did. The Chinese Michelangelo, the titanic Tang master Wu Daozi (Tao-tzu) painted many of his finest works on the walls of temples, monasteries, and palaces;[81] so most of these must have been done on commission. For more than half a millennium before the present, nonetheless, most of the chief Chinese painters and calligraphers usually worked only to please themselves—unless they were close to starvation.[82] A major turning point occurred with the Yuan (Yüan) dynasty, when many leading painters and calligraphers refused to become collaborators by working for the Mongol court. Nor is this all. In the later centuries of the Chinese tradition, the Chinese calligraphers and painters were also most unlike all Western artists from the beginning, in that their gentlemanly status further forbade them to take money for their works, as I have noted earlier. There were often more discreet rewards, such as extensive hospitality,[83] but these can hardly have compensated a master of established reputation for whose works

collectors were already fighting one another with large sums of money at the ready.

But the foregoing is a digression, although a useful one. If the snobbery problem influenced Wei Tan as early as the third century, this can only mean that in the third century calligraphy was fully established as an art apart, and recognized masters of calligraphy already felt entitled to claim a high place. The deduction concerning calligraphy's rapid innovative development is confirmed by the fact that the calligraphic creative surge, according to every Chinese account, reached its culminating climax as early as the fourth century A.D. This may seem surprising, since the Eastern Han dynasty collapsed ignominiously in 220 A.D., and for the next 360 years, China was afflicted by invasions by the steppe peoples of the North, divisions everywhere, and rapid and bewildering dynastic changes. If surging creativeness in the midst of turmoil strikes you as puzzling, however, then recall the events in Greece, beginning with the Persian invasions which led to the surviving structures of the Acropolis being built in Athens as replacements, and ending with the conquests of Alexander the Great, the man whom Lysippus and Apelles served.

There is no doubt, either, that the creative surge of Chinese calligraphy reached its climax under the short-lived Jin (Chin) dynasty in the fourth century. The culminating masters were Wang Xizhi (Hsi-chih) and Wang Xianzhi (Hsien-chih),[84] the father and son already mentioned in connection with the Shōsōin, who have been recognized from their own time to the present as the greatest calligraphers China has ever had.

Painting's Rise

So much for calligraphy's ascent to its now ancient place as China's art of arts. As for the parallel ascent of painting to become the second major art, it began later but was rapidly completed. In the first two centuries B.C., paintings plainly figured prominently in the palaces of the Western Han emperors. One of the palaces had a Hall of Paintings adjacent to the Throne Room itself. The paintings were portraits of famous rulers of the past,[85] and it appears that the paintings in such rooms of the Western Han palaces always had a moral as well as a decorative intent,[86] as one can tell from the story of Lady Ban (Pan). This lady reached the rank of "Beautiful Companion" late in the Western Han dynasty; and the infatuated Emperor Cheng (Ch'eng) even invited her to ride with him in his carriage. She refused, saying, "In the paintings of ancient times one always sees the sage rulers with eminent ministers by their side; only the last rulers of the Three Dynasties, the men who brought destruction to their lines, have their women favorites beside them."[87]

We have, too, the story of another palace lady of Western Han times

who was so high-minded that she refused to pay what was apparently a customary bribe to the ring of palace painters. In consequence, when it came time to present her likeness for the Emperor's consideration, the painters of the ring took businesslike revenge by making her portrait far from flattering, so she did not receive the imperial summons.[88] The story had a bad ending for the painters,[89] who were detected and executed; but this does not matter as compared with the fact that this is a typical Chinese story about the misdeeds of lower-class persons. The view that the painters had yet to emerge fully from the ruck of palace artisans, like the bronze and lacquer workers, is in turn confirmed by the few names of Western Han painters preserved in Chinese art history. All lacked official titles.[90] From the Eastern Han again, only a few painters' names are preserved, but all were men with fairly high official titles.[91] Hence this must have been when painting began to become an art for the scholar-official class.

From what happened in the next phase, however, it would appear that painting in the Eastern Han dynasty still had a fairly subordinate place. No Han painter is listed or classified in the first Chinese text on painting that deals with individual masters, Xie He's (Hsieh Ho's) *Old Record of the Classifications of Painters* or *Gu hua pin lu (Ku Hua P'in Lu)*.[92] The earliest painter dealt with by Xie He, a fifth-century painter himself, was a master of the third century.[93] Most of the other painters he covered were fourth- and early-fifth-century masters, including Gu Kai-zhi (Ku K'ai-chih)[94] and the slightly later Lu Tanwei (T'an-wei),[95] whom all subsequent Chinese historians, critics, and theorists of art always regarded and still regard, in effect, as we regard Giotto and Duccio di Buoninsegna. More generally, the fourth and early fifth centuries were always remembered as the first great age of Chinese painting.

The new start in Chinese art has now been defined and placed in context, and the rises of calligraphy and painting to their special places as the sole major arts have now been summarized. Even so, a final short digression is required before the main task of tracing the rest of the amazingly complete Chinese repeat of the complex pattern already traced in Greece. Common honesty demands a full confession of the peculiar character of the Chinese evidence. Consider, for example, the case of the British Museum's famous scroll, the Admonitions of the Instructress to the Ladies in the Palace.[96]

All That Is Lost

It bears the signature of Gu Kaizhi. This is an obvious later addition, but the scroll was acquired with an attribution to this fourth-century master mentioned by Xie He, and the attribution to Gu Kaizhi was long

accepted.[97] Some scholars are now beginning to suspect, too, that newly found archeological evidence will force higher respect for this old attribution.[98] To see the scroll's resulting significance, imagine a disaster sweeping away the world's entire stock of fourteenth-century Italian paintings except, say, for Duccio's Rucellai Madonna. In that horrendous event, the great Duccio would be the only original by a major painter from the rich preliminary stage of modern Western art before the true Renaissance began. In the same manner, if really by Gu Kaizhi, the London scroll is the only surviving original by any of the leading masters of the great first age of Chinese painting covered by Xie He.

Some time ago, to be sure, Osvald Sirén rejected the old attribution, arguing that the scroll was a fine and careful copy of a fourth-century original made three or four centuries later, in the Tang dynasty.[99] Under the normal rules, this should have caused the scroll's immediate relegation to the British Museum's reserves, but the rules do not work in the field of Chinese painting. The years of the Tang dynasty, from the early seventh to the early tenth centuries, were not only one of the most successful periods in Chinese political history; the Tang years are also universally remembered as the golden age of Chinese art.[100] Even if a mere Tang copy of a much earlier work, moreover, the British Museum's scroll is then the single Tang painting of highest quality that now survives anywhere!

As a pendant, it is also worth considering the case of the most famous calligrapher's masterpiece in the whole story of Chinese art. After a long and jolly party with like-minded friends in a hall called the Orchid Pavilion, Wang Xizhi took brush in hand and wrote his Orchid Pavilion Preface or Lan Ting Xu (Lan T'ing Hsu).[101] This was instantly recognized as the single supreme triumph of the first of the two greatest calligraphers China has ever produced. Wang Xizhi saw that he had surpassed himself; he tried to duplicate his feat; and he finally had to confess that he could not recapture the former flow of spontaneous inspiration.[102] By the fourth-century A.D., too, fine calligraphy was being generally and ardently collected. Hence Wang Xizhi's Orchid Pavilion Preface was treasured from the outset as a matchless collectors' prize, and still was treasured when it came by inheritance to a Buddhist monk connected with the Wang family, Zhiyong (Chih-yung), who left it to his disciple, Biancai (Pien-ts'ai).[103]

The fame of the Orchid Pavilion Preface caused Biancai to be prudently secretive. He even denied possession of the masterpiece when word of what he owned reached the Emperor Tang Tai Zong (T'ang T'ai-tsung), a passionate calligraphy enthusiast.[104] The Emperor then sent an emissary to Biancai who tricked the unhappy man into admitting he did own the great prize after all[105]—whereupon the Orchid Pavilion Preface inevitably

passed into the Tang imperial collection.[106] The Emperor at once ordered eminent calligraphers at the Tang court to make ten ultra-perfect, ultra-exact copies.[107] The imperially ordered copies were then copied and re-copied—and this was just as well, for the original of the Orchid Pavilion Preface went to the grave with Tang Tai Zong to be placed on the Emperor's chest in his tomb by the Emperor's own request.[108]

This singular story is enough, in itself, to suggest that originals from the brushes of Wang Xizhi and Wang Xianzhi were already impossible for ordinary persons to come by in the Tang dynasty. (This is why one can be so certain the Japanese envoys were deceived into taking home copies or plain fakes of the calligraphy of the two Wangs, which were then deposited in the Shōsōin.[109]) A little later, in the Song dynasty, it was already sadly said of the two Wangs, "No stroke of their brush can be seen any longer,"[110] and today, of course, there is no way of knowing at first hand the two greatest masters of China's art of arts. Furthermore, the types of evidence now used—early copies and engravings of calligraphy on steles[111]—have been attacked by the politically servile but learned Guo Moruo (Kuo Mo-jo) on the basis of recent archeological evidence. The generally treasured early copies, Guo Moruo argued, may give one an idea of the fine calligraphy of the Tang dynasty, but no dependable notion of the styles of the two Wangs.[112]

The period of the Song dynasty, from the late tenth to the later thirteenth centuries, is in fact the first from which fair though still tragically limited numbers of originals by great Chinese painters and calligraphers have come down to us.[113] Thus the history of style in the first twelve hundred years of the second era of Chinese art is now a reconstruction, all but exclusively based on copies, works in the style of early masters, provincial artisans' work like the paintings from Dunhuang (Tun Huang), engravings of calligraphy on stone steles,[114] and above all the enormous corpus of Chinese writing on art history and art theory.

The reconstruction may be challenged, and Chinese art history may thus be considerably revised, by the controlled archeological excavation that is now going on so widely in mainland China. Any day, further new results as unsettling and transforming as the first Emperor's buried army may well be reported. These results may then send the authors of the existing reconstruction back to their drawing boards.

Style per se, however, has very little to do with art collecting; for over the centuries, art collectors have gathered works of art in every imaginable style, as anyone can see who compares the prizes of contemporary art collectors with comparable Western collectors' prizes of four hundred years ago. Despite all the deficiencies in the evidence, there is enough of it to show how the new start of art in China led on, first, to the appearances of behavioral traits in Chinese art comparable to the new

traits found in Greek art, and then to the successive Chinese appearances of the by-products of art. Just when this or that first happened in China may be doubtful, but what happened is not easy to doubt.

Compulsive Innovation

The attentive reader may recall that the artists' strong compulsion to innovate was the first behavioral trait to be covered in tracing the Greek pattern. It deserves the place of honor in the Chinese pattern too—the compulsion being the key point in China as in Greece, rather than the innovations themselves. Of course, there could be no real resemblance between the Chinese innovations and the Greek innovations, because the arts were so different. Instead of sculpture and painting,[115] the Chinese had calligraphy and painting, and Chinese calligraphy had no room at all for the kind of cumulative representational innovations that went side by side in Greek art with innovations in theory until Lysippus was "supreme as regards faithfulness to nature."

To be sure, Chinese painting aimed for the representation of reality for many hundreds of years—in fact, until nearly the end of the Song dynasty in the later thirteenth century. Even so, however, there was limited room for technical innovations in representation. The "bone energy" conferred by the calligraphic line was always held to be just as important as "likeness of form,"[116] and this ruled out much of the representational repertory of Western painting.[117]

To illustrate, there is the conversation between a "clever painter" and the ninth-century connoisseur and art historian Zhang Yanyuan (Chang Yen-yuan) on the subject of painting the vapors of clouds. Zhang admitted that moistening the silk and then blowing the colors on produced a subtle result, but denied that it could be called painting, since no brush strokes could be seen. "It is like the ink splashing of [some] landscape painters which is also not called painting . . ." said Zhang.[118] Furthermore, all that survives of early Chinese painting and calligraphy affords nothing remotely like the chronological series of Archaic *kouros* statues on which Gisela M. A. Richter mainly based her comparative study of technical innovation in Greek Archaic sculpture.[119]

Nonetheless, there can be no doubt about the main point. In the second period of Chinese art, at least from the moments when calligraphy and painting gained their first and second places as the two major arts, leading Chinese calligraphers and painters strongly felt the same need to be original that was not felt at all, as Professor Gombrich has pointed out, in the great majority of art traditions. All students of Chinese art will surely agree on the importance and the persistence of this felt need during Chinese art's second era.[120]

Besides the larger changes of script style which have already been mentioned, the problems facing the calligraphers of each generation were to find ways to make their own calligraphy expressive, and to make their expression personal as well as powerful, or graceful, or beautifully balanced, or whatever the individual taste might be. Each calligrapher, in fact, strove for a personal and original style[121] which would set his work apart from all the rest in a much grander way, and on a much higher plane, than the differences in handwriting that permit forged wills to be spotted in the West. Unhappily, those able to see and feel the full impact of Chinese calligraphy are a narrow sect outside the Far East. To anyone outside this sect—like myself, alas—little help is given by the expert analyses of why one calligrapher was weak and another strong, and of the special virtues giving originality to each great calligrapher in the long Chinese succession.[122] So the problem of innovation in calligraphy will be taken no further, except to make one obvious factual point.

Brilliant calligraphic innovation in the second century A.D. was plainly the source of the excitement of Zhao Yi's contemporaries, whose enthusiasm he deplored. Innovation from the first century onward is also implicit in Zhao Yi's description of how the most admired masters of his own time were going on from where Zhang Zhi had left off, for Zhang Zhi was a master of the "cursive" script of the first century.[123] Innovation in the first century A.D. is again implicit in the way Zhao Yi further denounced Zhang Zhi for praising two other first-century masters of the "cursive" script, while criticizing "Luo and Zhao,"[124] evidently users of the "seal" script whom Zhao Yi defended warmly. Furthermore, although the first creative surge of Chinese calligraphy is held to have reached a grand climax as early as the fourth century, with the two Wangs, the originality of every succeeding major master of Chinese calligraphy is the point emphasized by the many writers on the subject who followed Zhao, from the second century A.D. to the present, when calligraphy appears to be a dying art on the Chinese mainland.[125]

Innovation in Painting

Compulsive innovation is easier to trace in the story of Chinese painting, because of the extra goal of representation of reality. Hence a short preliminary digression is needed, simply because most Westerners without Chinese experience cannot believe that much of Chinese painting really was representational, at least until toward the end of the thirteenth century. For a first corrective, it is only necessary to go through the more important Chinese texts on art. In the ninth century A.D., a great Chinese authority laid down the rule, "To paint is to cause to resemble."[126] The Chinese literature further shows a whole series of anecdotes about triumphs

of deceptive realism, exactly like the kindred anecdotes in the literature on art of the classical and Western art traditions—the Chinese painter who transformed an accidental inkspot into a fly so perfect people tried to brush it off the scroll,[127] the other painter whose birds attracted living birds,[128] the painter whose flowers attracted bees,[129] and so on. In the Song dynasty, moreover, stress was even placed on the importance of historical accuracy of costume in paintings of historical figures, and the already mentioned Tang master Yan Liban was criticized for falling short in this respect.[130] One thinks immediately of the immense pains taken by the nineteenth-century English and French academic painters of historical scenes to use correct "period" costumes and accessories.[131]

If all this strikes the skeptical reader as trivial and unconvincing, then I should advise traveling in China. For anyone who has not seen China with his own eyes, it is all but impossible to imagine the more magical Chinese landscapes—precisely the ones the Chinese landscape painters usually chose to represent. For anyone like myself who has lived fairly long in China, however, such a Song painting as Fan Kuan's (K'uan's) majestic Travelers amongst Mountains and Streams,[132] in Taipei, is obviously representational. The great cliff with its waterfall, the enchanting lower landscape with its swift little mountain stream, cause instant echoes in the mind of one vividly recalled expedition or another. Fan Kuan did not go to nature brush in hand, for Chinese landscape painters never did this except briefly and later in the Song dynasty; but the scene Fan Kuan painted is still such a real landscape as one may often come upon with surprised enchantment in mountainous parts of China, when the trail circles a mountain's flank and opens a new view before the eyes. Representation was not only a goal of art in China; it was also a goal toward which Chinese painters worked closer and closer, until they had reached the uttermost limits permitted by the calligraphic means the painters always used—whereupon other goals replaced representation, as will be shown.

Nonetheless, the progression that undoubtedly took place in Chinese painting cannot possibly be traced in simple terms of which master solved this representational problem and which that. In the first place, the comparative material is lacking until the Song dynasty—the end of the progression. In the second place, representation, although a significant goal of painting for centuries on end, was not the real test of a Chinese painter's quality. "Spirit resonance" was the test,[133] and this was just as much achieved by "bone energy"—in other words, a strong calligraphic line—as by "causing to resemble." Finally, a potted history of Chinese art would be wildly inappropriate in this essay.

Two points are enough, however, to demonstrate that there really was a creative progression of a peculiarly Chinese kind in the story of Chinese

painting down through the end of the Song dynasty in the early thirteenth century. To begin with, despite the absence of comparative material like Gisela Richter's series of *kouroi*, scholars who have given decades to the study of Chinese painting have even sought to divide the time of the progression—approximately third century A.D. down through the Tang and Song dynasties—into periods comparable to the early periods of Italian painting, Primitive, Renaissance, and High Renaissance.[134] These attempts have been based, too, on good evidence that in these centuries, continuous advances in calligraphic style and representational techniques constituted a true progression,[135] causing the Chinese to see the past of their painting (while originals still existed) in somewhat the way Italians of Vasari's time and the Greeks of the Hellenistic Age saw the past of Italian and Greek art.

Then, too, although the nature of this progression in Chinese painting can no longer be precisely defined, the fact of the progression is plainly implied by what actually happened. Chinese painting did not have just one climactic period, like the fourth century in Greece and the High Renaissance in Italy. Instead, there were two climaxes, in the Tang and Song dynasties.

It will again surprise many Westerners, but figure painting was the chief preoccupation of leading Chinese masters from the time of the painters Xie He studied through the Tang dynasty—or at least until the end of the eighth century A.D.[136] In these centuries, there were clearly all sorts of innovations in brushwork as well as the technique of representation. For instance, religious painting is normally much more conservative and repetitious than any other kind; yet there is even a record of an early Buddhist painter and sculptor, Dai Kui (Tai K'uei), whose reputation, together with the reputations of his sons, in later times rested on "their new patterns at every turn"[137]—in short, on bold advances. In brushwork, the key innovation was the abandonment of the "wire line" of Xie He's listed painters, in favor of a much freer calligraphic attack.[138] The first climax then came with the great late-seventh- and early-eighth-century figure painter, Wu Daozi.

We cannot visualize Wu Daozi's works today, primarily for the reason mentioned earlier, that the near-miraculous energy of his brush usually found its outlets on palace, temple, and monastery walls.[139] The palaces, monasteries, and temples of the Tang capital, Chang (Ch'ang) An, were all but completely destroyed in the recurrent rebellions and invasions from the North which first weakened the immensely successful Tang dynasty and then caused its end.[140] Today, not so much as a single reliable copy of a single work by Wu Daozi is known to survive. One can see why, since even in the next significant dynasty, the Song, the great painter, calligrapher, critic, and super-connoisseur Mi Fu believed that almost no

originals by Wu Daozi were still extant[141]—although Mi Fu undoubtedly knew there were over fifty works claimed for the master in the imperial collection of his day, partly inherited but greatly augmented by the painter-Emperor and super-collector Hui Zong (Tsung).

Yet climactic Wu Daozi certainly was. In the history of Chinese art, Wu Daozi has always been remembered as the master who surpassed all his predecessors and brought Chinese figure painting to its ultimate height of greatness.[142] He was climactic in another way, too, for the Chinese painters after Wu Daozi's time seemingly concluded that just about everything had been done by him that could be done.[143] Perhaps this played a part in another major shift of direction. At any rate, whatever the reason, figure painting ceased to be a central preoccupation of the leading masters fairly soon after Wu Daozi, and eventually it even came to be seen as a decidedly secondary and rather disreputable branch of art.[144] In consequence, landscape painting became central.

Before landscape painting became central, it had a long prior history. In the British Museum scroll there is a landscape scene, discordantly primitive as compared with the other scenes.[145] Wu Daozi occasionally painted landscapes;[146] and in the Tang dynasty, the highly decorative "blue-green" style of Chinese landscape painting also seems to have reached a first apogee.[147] But it was clearly in the early Song dynasty that all the technical problems of representing landscapes with brush and ink were rather suddenly solved, and Song landscape painting was the second grand climax in the story of painting in China. Within the history of Song landscape painting, a progression is again clearly discernible;[148] but what matters for this essay is the simple fact that the climax was seen as climactic by those who came after.[149] The Song masters were felt, in other words, to have done everything there was to do in landscape painting with a representational aim. Perhaps for this reason and in the immediately succeeding Mongol or Yuan dynasty, dating from the later thirteenth century, representation was therefore consciously abandoned as a serious goal of art.[150]

The great Yuan landscapists like Ni Zan (Tsan) instead painted landscapes of the mind, scenes no one could ever expect to come across on a journey, yet scenes which are strongly conceptual and can be described as "the writing of ideas."[151] The phrase was actually coined in the Yuan dynasty, and it is a good one, because Chinese painters not only abandoned representation as a goal; in addition, they gave still greater importance to pure brushwork effects.

From the Yuan dynasty onward, technically skillful representations of reality in painting further tended to be treated with more and more scorn—as they have been in the West today for a much shorter period. In the ensuing centuries, Chinese painters also took a whole series of new directions—for mere repetition was never acceptable—but only one aspect of

later Chinese art needs to be mentioned here. This was "painted art history," to borrow the admirable phrase of Professor Loehr.[152]

To make this understandable, one must begin by noting that Chinese painting and calligraphy were never immune to the respect for the past so strongly instilled by Confucius himself. In the fourth century, Wang Xizhi stressed the importance of learning from earlier masters of calligraphy.[153] But for centuries on end, what was learned was no more than Masaccio learned from Giotto, or Raphael from Masaccio. The first direct revival of an earlier style of calligraphy was made in the Tang dynasty by the calligrapher Li Yangbing (Yang-ping),[154] who brought back the "seal" script; and the first comparable revival in painting was made by the Song master Li Gonglin (Kung-lin),[155] who brought the fourth- and fifth-century masters' "wire line" into use again. From the Yuan dynasty onward, "painted art history" involved all sorts of other revivals of past styles; but the innumerable later Chinese masters who made these experiments were by no means immune to the fear of doing what had been done before that is peculiar to the artists of the rare art traditions. Works in this style or that were partly judged by the skill and historical knowledge shown; but if they looked like simple copies of old masterpieces, they called forth little admiration.

Indeed, the fear of doing what had been done before is implicit in the whole Chinese story of art, from the moments when calligraphy and painting were successively accepted as major arts. Just about every student of Chinese art for centuries has stressed the importance of originality (usually defined as individuality of style) as the ultimate test of a master's greatness. Furthermore, the second era of Chinese art displays precisely the phases that are to be expected in a "problem-solving" art tradition, as defined by E. H. Gombrich.[156] The most conspicuous departure from the Greek pattern was the ultimate Chinese abandonment of the representation of reality as a main goal of art, closely paralleling the Western abandonment of this goal in the later nineteenth and early twentieth centuries. Yet despite other wide differences, the Chinese echoes of what happened in Greece were strong indeed, although the Greek pattern was completed relatively rapidly, while the same pattern in China took long to complete and was also divergent in detail.

Artists' Signing

One of the divergences in detail is encountered when you have a look at how and when Chinese artists signed their works; for artists' signing was of course the second novel behavioral trait of Greek art. The reasons for this particular divergence, I believe, were the unusual practice in this respect of Chinese artisans at a very early date, plus the unusual importance

of the snobbery problem in Chinese art. For example, there are those who believe potters' marks are to be found among the undeciphered marks on Neolithic pottery.[157] This opinion is just that; but it is not a matter of opinion that potters' marks are attested in at least one region of China in the late period of the Warring States.[158] Qin Shihuangdi's buried armies were evidently produced in a highly organized workshop, too, and the workshop left its own marks on its products.[159] These have not yet been surely interpreted,[160] but one interpretation is that some of the characters forming the marks are the names of the workshop teams responsible for each pottery soldier.[161] This looks superficially persuasive, since team signatures were common in the imperial lacquer and bronze workshops of the Han dynasty.[162] I would suggest, therefore, that this workshop practice caused signing to be regarded as a thing for artisans to do in the early centuries of Chinese art's second era; and this in turn restricted signing by calligraphers and delayed signing by painters.

Some of the earliest-recorded fine calligraphy took the form of letters, like Chen Zun's; and these were almost necessarily signed or had a seal affixed.[163] But in painting, the received view is that signing may have begun as late as the Tang dynasty,[164] the time of a signed wall painting in one of the imperial tombs just opened by the archeologists.[165] Even in the Song dynasty, signatures still tended to be most inconspicuous,[166] although they were evidently far from unusual by then. In fact, you almost need a magnifying glass to find the artist's signature on the great Fan Kuan in Taipei.[167] It was in the Southern Song dynasty that putting a signature or seal on a painting became a common practice;[168] and the signed comments or poems on paintings then followed in the Yuan dynasty.[169] But signing, one must add, was perhaps the least significant of the four behavioral traits that first appeared in Greek art; so it is needless to go further.

Art Theory

As for the third behavioral trait that first appeared in Greek art, artists' writing theoretically about their art began very early in the second era of Chinese art. Although an odd specimen of the genre, Zhao Yi's second-century *Polemic* is a critical-theoretical work. On the other hand, Xie He's work, in the fifth century, is a classic theoretical product by the hand of an established artist—he was a portrait painter—and it is far more than an invaluable record of the artists of Chinese painting's first high point. In fact, the artists are chiefly recorded in order to be classified according to the "Six Principles" of painting which Xie He began by propounding;[170] and Xie He's Six Principles have figured in Chinese art theory and criticism from his day to the present.[171] Some believe Xie

He's theories reflect those of still earlier men,[172] and a much briefer theoretical work attributed to Gu Kaizhi,[173] and thus composed just before Xie He's time, also survives from that era. In addition, there are two short, theoretical texts on landscape painting composed by near-contemporaries of Xie He.[174] Over all, theoretical writing about art has gone on in China, sporadically but unceasingly, for well over one and a half millennia by now. In due course, connoisseurs and art historians began to contribute to the corpus, too; and the total corpus of Chinese art theory is now far more massive than the similar Greek corpus ever seems to have been, and exceeds all our own art tradition's accumulated theorizing before the late-nineteenth- and twentieth-century explosion of writing about art.

Remembered Masters

The Chinese repetition of the last and most important of Greek art's four novel behavioral traits can again be dealt with briefly. In Chinese art's second era, the historical response to art was stronger by far than the same response in the classical art tradition or in our own tradition. Thus Chinese masters of the past have been remembered longer, and the memory has been more tenacious, than in any other continuous art tradition the world has ever seen. The proofs of this memory in calligraphy begin with Zhao Yi. In the second century A.D., Zhao Yi's remembered masters were calligraphers of the previous century, but so far as we know did not include Chen Zun, who was remembered by Ban Gu. Yet the almost interminable line of remembered masters of Chinese calligraphy extends still further back, to Li Si, because his simplification and standardization of the characters were never forgotten.[175] The line of remembered masters of calligraphy has thus been extending, century after century, for well over two millennia by now.

The same rules apply to the remembered masters of Chinese painting, except that, as previously noted, Xie He's memory went no further back than the third century A.D. It seems possible, therefore, that research of some sort added to the record the names of the Chinese painters of the Han dynasty who now head the chronological list of Chinese painters;[176] but if this is so, the research was done over a thousand years ago, in the ninth century,[177] or perhaps even earlier. Once Chinese painters had begun to be remembered, again, painting's tale of remembered masters increased to accommodate the leading painters of just about every subsequent generation.

As to the tenacity of the Chinese cultural memory of artists of the past, it is all but incomprehensible to anyone who does not share Chinese culture. The point here is that great artists have gone on being remembered, century after century, when all their works were long lost, and often

when there was nothing visual such as an early copy to give a concrete hint of their styles. Instead, the descriptions of these artists' styles by art historians and theorists and critics early enough to have known the artists' works at first hand, have been conned carefully and over and over again by those who have never seen any of the artists' works. Throughout the whole long period of "painted art history," and in both calligraphy and painting, later artists were in fact quite often experimenting with mere *ideas* of past styles which they could only form by reading the literature on art.

To say this tenacity of the Chinese cultural memory is astonishing is to put it mildly. It is specifically Chinese, too; and it is probably still another result of Confucianism's influence on Chinese art. The continuous Chinese sanctification of antiquity, down to Chairman Mao's time, in fact quite largely stems from Confucius' use of "the former kings" as his exemplars, to show how China's troubles in his time might be cured by reviving the ways of these "former kings."[178]

Chinese Art Collecting

The ground has now been cleared, at long last, for the story of the by-products of art in China, where art collecting has flourished more luxuriantly for a longer period of time than in any of the other rare art traditions. At the outset, one encounters another of the divergences that set apart the Chinese pattern from the Greek pattern, despite the strong schematic similarities. Whereas Greek art collecting probably began just before the first creative surge in Greek art started to subside and is first documented shortly thereafter, Chinese art collecting evidently began when calligraphy's first creative surge was still in progress and painting was no more than starting to be regarded as a major art. A probable explanation is easy to find, however.

Partly because of the large numbers of characters, boys learning to write in China have usually worked from models; and this practice may well date from the Shang dynasty. Thus stocks of calligraphic models have long been kept in places tending to have a fair number of learners, such as the households of rich families. One may guess that Chen Zun's letters were at first primarily valued as particularly excellent models for learners. Yet the mere act of discrimination between an excellent model and a routine one already implies acknowledgment of gradings of quality in calligraphy. When calligraphy began to have the standing of a major art, moreover, it must have been only natural for the better stocks of models to begin to be thought about as true art collections. One may guess this was already happening by the time of Zhao Yi in the second century, when those who acquired calligraphy by the contemporary masters

of the "cursive" script treated their acquisitions as "secret treasures." It is a matter of record, too, that the first Chinese imperial collection, supposedly comprising both calligraphy and painting, was formed by the Eastern Han emperors.[179]

Between the fall of the Eastern Han dynasty in the early third century A.D. and the lifetimes of the two Wangs in the fourth century, collecting fine calligraphy evidently reached the usual terminal stage of all art collecting. "Old masters" gained importance, to the point where Wang Xianzhi is recorded as comparing the styles of two first-century calligraphers, the same Zhang Zhi condemned by Zhao Yi two hundred years earlier, and a contemporary of his, Cui Duan (Ts'ui Tuan).[180] Then, too, the calligraphy of the two Wangs was widely imitated in their own times, and both Wang Xizhi and Wang Xianzhi were reputedly taken in for a while by imitations of their own productions.[181] Furthermore, calligraphy collecting was now competitive enough to make it profitable to produce fakes for the market. Kang Xin (K'ang Hsin), a talented man of low origin, joined with an unnamed "Taoist from Nanzhou" in making imitations of Wang Xianzhi's calligraphy and selling them.[182] Probably to gain possession of a well-known original, this man even switched his own work for an inscription by Wang Xianzhi, and thus temporarily deceived the master himself.

Only a little later came the time of Yu He (Yü Ho), whose sad memorial to the throne concerning the fakes in the imperial collection of calligraphy of the brief Liu Song dynasty has been quoted *in extenso* in an earlier chapter.[183] Yu He's explanation of the way the fakers made their productions look old, by exposing them to the rainwater runoff from thatched roofs, exactly parallels the explanations of the methods of art fakers by Phaedrus in the time of the Emperor Augustus,[184] and by Mancini and Boschini in seventeenth-century Italy.[185]

For the stages by which paintings became collectors' prizes on a par with the works of famous calligraphers, the available information is less exact. Paintings were reportedly included in the Eastern Han imperial collection;[186] and if this is correct, they must have begun to be collected as early as the second century A.D. But the evidence for the makeup of this earliest imperial collection is considerably later in date;[187] so one wonders whether two facts were not mistakenly conflated. The decoration of the Han palaces certainly included many paintings. Just as certainly, there was an imperial collection. This kind of conflation has in fact been common throughout the history of the by-products of art, leading some people nowadays, for instance, to see as a kind of art museum what was in fact the Byzantine imperial accumulation of treasures, which were put on show occasionally to impress important visitors with the Emperor's grandeur.[188]

Yet it is not enormously important to know exactly when the range

of Chinese collectors' prizes extended to painting as well as calligraphy. It happened early, and collectors of paintings were soon just as feverish in the pursuit of their prizes as collectors of calligraphy. Rather over a thousand years ago, when Greek and Roman art collecting had receded into the past and there was not a single true art collection remaining in Europe, the fever of China's painting collectors was vividly recorded by Zhang Yanyuan in a chapter significantly entitled "On Grading by Name and Price."[189] As an art historian Zhang Yanyuan must be considered later, but it is irresistible to anticipate in this special case. Zhang Yanyuan began by explaining his chapter's aim:

"A certain person said to me, 'of old Zhang Huaihuan wrote his *Calligraphy Dealer (Shu gu)*, in which he discusses the [different] grades with the utmost detail. Why do you not arrange in order of their rank [all] famous painters since ancient times and make a *Painting Dealer (Hua gu)?'* " Zhang Yanyuan commented on this question: "Calligraphy and painting are different Ways [tao] which should not be studied indiscriminately. In [a work of] calligraphy one has but to take the characters as a standard in order to settle upon its value, but in a painting there are no such [well-defined] limits by which to determine its merit. Not only that but the famous works of the Han and Wei dynasties and of the Three Kingdoms have long since vanished from the world, and people today while highly regarding the ear despise the eye and are seldom capable of thorough criticism."[190]

Having thus condemned the proneness to secondhand opinion which can hardly be avoided when there are few or no originals to judge by, Zhang Yanyuan went on: "Where the traditions concerning their provenance are not in doubt and the things themselves are still in existence, then these [early masterpieces of painting] become important treasures of rulers of countries. . . . Gu (Kaizhi) of the Jin dynasty [late fourth century], Lu (Tanwei) of the (Liu) Song dynasty [early fifth] and Zhang (Sengyou) of the Liang dynasty [late fifth and early sixth] were perfect from beginning to end, and were treasures rare in any age. Where any of these men is concerned one cannot speak of price at all. If one should chance to acquire [even so little as] a square inch [of their work] one ought to keep it sealed in a box."[191]

He then proceeded to give his listing of the pre-eminent painters of High, Middle, and Late Antiquity—his division of Chinese art history before the great days of the Tang dynasty. His High Antiquity reached back to the Eastern Han dynasty, and four Eastern Han masters head the list.[192] It is needless, however, to go into further detail about these temporal divisions or about the names on the accompanying list. The greatest prizes were clearly labeled, as follows:

"As a general rule the people who make collections feel that *they*

must [ital. added] possess well known scrolls by Gu (Kaizhi), Lu (Tanwei), Chang (Sengyou) and Wu (Daozi) before they can say that they own any paintings. If a man says that he has some books, how can he be without the Nine Classics and the Three Histories? . . . It is an inner necessity for collectors to feel scrolls in their hands and determine their value by discussion, and not to be stingy [in buying them] but to regard keeping of them in their chests and boxes as the only important thing."[193]

As for the impossibility of stinginess, not only were the early masters like Gu Kaizhi and Lu Tanwei altogether beyond price in the ninth century in China; in addition, the major masters of Zhang Yanyuan's "Recent Antiquity"—the later sixth and early seventh centuries—and the great Tang painters were only within the reach of collectors with deep pockets and the willingness to disregard cost. The prices of these fairly recent major masters were staggering in Zhang Yanyuan's time, for he wrote:

"A single standing screen by Dong Boren (Tung Po-jen), Zhan Zeqian (Chan Tze-ch'ien), Zhen Fashi (Cheng Fa-shih), Yang Zehua (Tze-hua), Sun Shangze, Yan Liban, or Wu Daozi is worth twenty thousand [ounces] of gold, and . . . a slightly inferior specimen will sell for fifteen thousand . . . As for such [men] as Yang Qidan (Ch'i-tan), Tiang Sengliang (T'ien Seng-liang), Cheng Falun (Ch'eng Fa-lun), Youchi (Yu-ch'ih) I-seng, or Yen Lite (Li-teh), a single screen will be worth ten thousand ounces of gold. Here I have just mentioned men whose names are well known (even) among common people. If one speaks by analogy from these one can see [for oneself] how to classify the more unimportant men."[194]

Art Collecting's Consequences

By the ninth century A.D., in short, art collecting in China had reached a stage of development that recalls the state of Western art collecting today—and this although the second era of Chinese art had another ten centuries ahead of it before the upheavals of our own age! Collectors not only pursued their prizes with passion, and paid the enormous sums for them which Zhang Yanyuan recorded. Inevitably, collectors' demand had also generated an art market on which super-prices prevailed. The sums named by Zhang Yanyuan were obviously as near as he could come to market quotations. Inevitably, too, there were dealers; and elsewhere Zhang Yanyuan mentioned several dealer-connoisseurs, whom he credited with excellent judgment while deploring their trade in the usual way.[195]

One might suppose, therefore, that there could be nothing more to add to the history of Chinese art collecting, beyond the unending additions of leading masters of calligraphy and painting to the list of art collectors' prizes, century after century, and the simultaneous contraction of the

list of available prizes by time's constant ravages of the total stock of originals by early masters. Yet there are still three points that need making. The first is simple enough. In no other art tradition has art collecting stimulated art faking on so astonishing a scale.

The advance of faking in the Tang dynasty is admirably illustrated by the feat of Zheng Yizhi (Cheng I-chih), the Chinese collector who best compared to Gaius Verres in total lack of scruple.[196] This man was the favorite of the brilliant and terrible Empress Wu, the widow of the Emperor Tang Gao Zong (Kao-tsung), who began as regent of the empire and continued to rule China as of right until death at last removed her from the scene.[197] This homicidal but efficient woman cared about power, not art, whereas her rapacious favorite was an art lover.

Seeing his chance, Zheng Yizhi persuaded the Empress that the Tang imperial collection badly needed more careful conservation; and when the collection was confided to him, he then blatantly removed all the original works and returned to the palace fakes in the old mounts.[198] The whole world history of art collecting records nothing quite like this feat of wholesale faking. But the history of Chinese collecting bristles with other feats of the same nature, though not on the same scale. One could even put together a fairly long list of the famous artist-connoisseurs like Mi Fu in the Song dynasty, who have been charged with accepting old paintings and specimens of calligraphy for study and expert appraisal, promptly making clever copies, embezzling the originals, and giving back the copies to the unsuspecting owners in the old mounts, together with handsome appreciations, of course.[199]

If anything, faking was encouraged by the Chinese practice that originated in the Tang dynasty of putting collectors' seals on important works of painting and calligraphy,[200] and adding colophons of expert opinion or appreciation.[201] The original intent was to forestall fakers,[202] but the reverse happened. In a good many collectors' eyes, the seals and colophons became as significant as the works of art themselves.[203] So seals were also faked, to add a look of authenticity to fakes;[204] old colophons were removed from genuine works, to add glamour and a seeming guarantee to fakes;[205] and these practices were a frequent source of deception.[206]

Finally, a little needs to be said about the cardinal role of Chinese art collecting in the progressive, ultimately all but total loss of the earlier masterpieces of the second era of Chinese art. The usual forces of destruction—war, revolution, and invasion, the upheavals attendant on dynastic changes, the wear and tear of time itself—were more than usually powerful in China, if only because both Chinese painting and calligraphy on paper or silk are more than usually vulnerable. Yet in China more than elsewhere, art collecting had an effect of its own, to which far too little attention has been paid in the West.

Art collections, in truth, automatically bring together unnaturally large numbers of works of art, and thus all become vulnerable to a single local catastrophe. In the museum at Herakleion, for instance, all the more important remains of the lovely art of the Minoans are now gathered; yet that region of Crete normally has a major earthquake every fifty years. In Herakleion, in fact, a major earthquake is actually overdue today, and the charming museum is not reliably earthquake-proof. So almost all of Minoan art that we have today could conceivably be destroyed from one night to the next, whereas most of the same Minoan remains would have been perfectly safe in the silent earth that guarded them so long before yielding them to the archeologists' spades.

The whole history of Chinese collecting is studded with the stories of entire collections lost by one catastrophe or another. None is more moving than the great Song poetess Li Qingzhao's (Ch'ing-chao's) melancholy account of the collection she and her husband lovingly assembled with much knowledge and self-denial,[207] which she then lost in the troubles arising from the Jurchen Tartar invasion.[208] This was the invasion that drove the Song dynasty to take refuge in the south, at Hangzhou (Hang-chou); and accounts also survive of people going north into the Tartar-conquered territory at considerable risk, to get back ancient bronzes from the superb collection of the painter-Emperor Hui Zong (Tsung).[209] But while bronzes naturally survived unless they were melted down for their metal, the same could not be said of Hui Zong's enormous but fragile array of works by great painters and calligraphers.

The heart of the whole story of loss of works of art in China is in fact the grim tale of loss of imperial collection after imperial collection. The tale begins with the almost total loss of the Eastern Han imperial collection in the troubles that preceded the dynasty's fall.[210] What was probably the worst loss of all also occurred fairly early, but here a little background is again needed.

In brief, in the turbulent centuries after the end of the Han, most of North China was occupied by steppe peoples, who were then gradually Sinified. (Both the dynastic families of the Sui, who reunified the Chinese Empire in 589 A.D., and of the Tang, who succeeded the Sui, were at best half-Chinese in blood.) In the face of the first invasions of the North, many of the greatest Chinese families of the old core area in the Yellow River Valley therefore sought refuge in the South, taking with them their more precious belongings, and making the South the new core area of Chinese culture until the Sui reunification.[211] There were other factors at work, too. An imperial collection was seen as a legitimizing symbol.[212] Hence just about every Southern dynasty—and there were a series—assembled a collection in this period, as did every dynasty from the Sui down to the empire's end. Furthermore, it was a form of *lèse-majesté* to possess

a really important work of art and *not* to contribute it to the collection of the ruling dynasty.[213]

With all these factors at work together, it is clear that an enormous majority of surviving masterpieces of the first centuries of the second era of Chinese art had been gathered into the greatest single Southern imperial collection before the final Sui reunification in 589 A.D. This was the imperial collection of the Liang dynasty. The extent of the collection can be judged from the fact that one account asserts it contained nearly 250,000 works of painting and calligraphy.[214] When the Liang dynasty was about to fall, the Emperor Yuan Di (Ti), himself an artist,[215] first sought to make a bonfire of the entire collection and to use the bonfire as his own pyre.[216] This *Götterdämmerung* plan largely miscarried, but the entire collection was nonetheless lost in the end, before it could be got to safety.[217] This sort of horror was endlessly repeated, moreover. Lovers of Chinese art should in fact give thanks that the last of the long line of Chinese imperial collections can still be seen, in the main, in Taipei; for the Qing (Ch'ing) imperial collection escaped, though only barely, from the many dangers of the revolution of 1911 and its violent sequels, the Japanese invasion and the subsequent Communist revolution.[218]

Chinese Art History

It only remains to record the appearance of art history and the other by-products of art in China, and the story of the bewildering Chinese repetition of the Greek pattern will be completed. Next in importance after Chinese art collecting came Chinese art history, of course; but it is not easy to know just when to date the origin of art history in China. Xie He's fifth-century work, for instance, was primarily theoretical and classificatory. Yet art historian after art historian to our own day has used Xie He's list of classified painters for strictly historical purposes. Protests from later art historians against the relatively low place (Third Class) Xie He gave to Gu Kaizhi became a commonplace, in fact, with Zhang Yanyuan in the ninth century among the more vehement protestors.[219] Thus Xie He went much further toward connected art history in the fifth century than the list makers of the Italian Renaissance,[220] who recorded leading artists chronologically, usually beginning with Cimabue, in the century and a half before Giorgio Vasari.

In addition, a very large part of early Chinese writing about art has been long lost. In the Song dynasty, Guo Ruoxu (Kuo Jo-hsu) included in his work a bibliography of the more important earlier works on painting.[221] Twenty-nine titles are given, yet of so many, no more than seven now exist in fairly complete form.[222] Furthermore, the Chinese way-wardness with book titles makes it impossible to tell whether connected art histories earlier than the Tang dynasty are, or are not, concealed by

some of the titles of lost works given by Guo Ruoxu. As of today, at any rate, the Chinese equivalent of Giorgio Vasari is the same Zhang Yanyuan who wrote the ninth-century work containing the previously quoted chapter "On Grading by Name and Price."

Like Vasari's *Lives*, Zhang Yanyuan's *Record of Famous Painters of All the Dynasties*, or *Li dai ming hua ji*, is a compendious account of China's leading artists; but it covers a far longer period, for the first painters briefly dealt with lived in Western and Eastern Han times. Like Vasari, again, Zhang Yanyuan saw a discernible progression in Chinese painting, from High, to Middle, to Late Antiquity, and, finally, to the grand climax of painting with Wu Daozi. He was also the man who laid down the rule (attributed to an earlier authority but quoted with approval) that "to paint is to cause to resemble"; but unlike Vasari, Zhang Yanyuan's progression has to do with style rather than the technique of representation. On the other hand, Zhang Yanyuan's tone of reverence and awe in speaking about Wu Daozi is strongly reminiscent of Vasari's tone in speaking of his supreme hero, Michelangelo; and this passage is therefore worth quoting in part:

> Wu Daozi of the present dynasty stands alone for all time. Compared to him [the two early painters most highly praised] Gu (Kaizhi) and Lu (Tanwei) who preceded him are not worth a single glance, and after him there have been no successors. He learnt his brush-methods from [the calligrapher] Zhang Xu (Chang Hsu), which shows yet again that the use of the brush in calligraphy and painting is identical. . . . Wu may well be called the Sage of Painting. For since spirits lent to him the creative powers of Heaven his painting was inexhaustible.[223]
>
> . . . Only when we gaze upon [his] works . . . may we say that all Six Elements have been brought to like perfection; that he could not fail to exhaust the ten thousand phenomena; that some god must have borrowed his hand; and that he fathomed Creation to the utmost. And therefore such was the virile manifestation of spirit-resonance that it could scarcely be contained upon painted silk; such was the rugged freedom of his brush work that he had to give free expression to his ideas on the partitions and walls of buildings.[224]

It can be seen, then, that the first Chinese art historian believed the equal of the great late-seventh- and early-eighth-century master would never be seen again, just as Vasari did with Michelangelo. Vasari's view that the giants of the High Renaissance had reached heights that could hardly be scaled a second time was also paralleled, indeed exceeded, by Zhang Yanyuan's view that the masters of his own time, the ninth century, were a decadent lot unworthy of attention.[225] The late eighth and early ninth centuries were the period of the "untrammeled" painter who poured ink in his hair and used his head as a brush, and of Master Gu's action paintings assisted by alcohol. But the information on these Tang eccentrics

mainly comes from elsewhere,[226] for Zhang Yanyuan did not mention them, except perhaps by indirection.[227] Moreover, Zhang Yanyuan, in the ninth century, did not foresee the glorious development of landscape painting in the next dynasty, any more than Vasari, in Mannerist Florence in 1550, foresaw the Carracci, let alone Rubens, Rembrandt, and all the rest who came later.

It must be emphasized strongly that the foregoing comparison of Vasari and Zhang Yanyuan is *not* intended to suggest that the works of the Italian and Chinese art historians were truly the same, any more than in the cases of Vasari and Xenocrates. The differences of dimension and detail are in fact very great, and greater still are the differences between the arts of which Vasari and Zhang Yanyuan wrote the first connected histories, as well as the critical standards they respectively brought to these arts. The similarities, as far as they go, are wholly restricted to the proposed historical schema of each of the two art historians. Yet these strictly schematic similarities are surely curious and significant enough to be worth noting. Furthermore, just as the Vasarian schema of the art history of the Renaissance was never seriously challenged until a new kind of Western art history began to be written in the nineteenth century, so Zhang Yanyuan's schema of the early centuries of the history of Chinese art's second era was never seriously challenged until recent times. Indeed, it has not been really directly attacked by the modern scientific historians of Chinese art, if only because they have no originals on which a challenge can be based.

As to those who came after, the number of Chinese art historians before scientific art history invaded the Chinese field considerably exceeds the comparable number of Western art historians. Indeed, those who wrote after the Vasari-figure of Chinese art history are too numerous to describe. Only two points need noting. When Chinese art ceased to aim for representation in the Yuan dynasty, the art historians wrote about this development, provided justification for it, and adjusted their theories accordingly.[228] And it is worth recording that the total accumulated volume of Chinese art-historical writing, including art-historical data in theoretical works, connoisseurs' manuals, collectors' catalogues, anecdotal miscellanies, and other sources besides the formal art histories, enormously exceeds the total for any other art tradition—with the usual exception for the modern era.

Faking, Antiques, Revaluation

Of super-prices, art faking, and the art market in China, almost enough has been said already for this essay's purposes. On the technical lore and anecdotes of art faking alone, an entire volume might easily be collected,

and some of the stories are all but irresistible. Who, for instance, can resist the story of the Emperor Qian Long (Ch'ien Lung), the last of the really great imperial collectors, and his fake and genuine versions of the famous late Yuan landscape scroll, Dwelling in the Fu Chun (Fu-ch'un) Mountains? Qian Long knew no restraint when it came to stamping his large red imperial seal, no matter where, on favorite prizes, and he was equally unrestrained in scattering over his prizes poems and comments in his own hand.[229] Fortunately, he first acquired a clever fake of Dwelling in the Fu Chun Mountains. It was the fake, therefore, which the Emperor thoroughly defaced with proofs of his admiration;[230] whereas he left the original work of Huang Gongwang (Kung-wang) all but untouched when it, too, came into his possession, because he refused to believe, let alone admit, that he had been mistaken about the fake![231] As to the art market, the Song lament about works of art becoming "merchandise and bribes"[232] held true in the more tranquil periods of every Chinese dynasty from the Tang onward, and probably long before the Tang dynasty, too. It was characteristically in the recurring periods of upheaval that good calligraphy and painting ceased to be adequately guarded, and great losses of irreplaceable works of art therefore occurred.

Of Chinese antique collecting, it is almost enough to say that antiques in astonishing variety were pursued as prizes by Chinese collectors during many centuries before Mao Zedong's revolution. Ancient bronzes had been taken from earliest times by tomb robbers for the value of their metal; but they began to be sought in another way—in fact, by antique collectors—in the Song dynasty.[233] A mention has already been made of the Emperor Hui Zong's lost bronze collection, but there were many other Song bronze collectors, too, and the Song dynasty further produced a substantial body of antiquarian writing on the subject of the ancient bronzes.[234] At this period, ancient jades also began to be collected,[235] although more obscurely than bronzes; and the inkstones used by everyone who writes the Chinese characters in the old way or paints in the traditional Chinese manner became minor prizes. Mi Fu wrote a concise and interesting little book about the lore of inkstones and inkstone collecting,[236] from which it appears that "association pieces" were particularly valued. He made special mention of the inkstone of the great Wang Xizhi, which would have been over seven hundred years old in Mi Fu's time.[237]

Yet it was only in the Ming dynasty that category after new category of antique collectors' prizes began to be recognized.[238] The new stage entered in the early Ming dynasty is fully indicated by the fourteenth-century connoisseurs' manual, the Ge gu yao lun (Ko Ku Yao Lun), of which the original version was composed by a certain Cao Zhao (Ts'ao Chao).[239] The note of old-for-old's-sake is clearly heard in this miscellaneous compilation of many sorts of prizes and accompanying practical tips concerning

each category for dealers and collectors. In the Ming dynasty, things like the "fish" pendants awarded at court as honorific badges in Song times were already being sought after.[240] In short, Chinese antique collecting came to resemble modern Western antique collecting very closely indeed, except that old furniture was never an important category, and certain things, like tomb figures, were disdained.

Tomb figures were all but invariably of cheap pottery. At best glazed, they were also made in many copies in molds from the Han dynasty onward;[241] and being from tombs, they were regarded as ill-omened. This viewpoint was only abandoned, even among art dealers, when countrywide Chinese railway construction began in the late nineteenth and early twentieth centuries. This caused many tombs to be accidentally opened when rail enbankments were being constructed. Some Westerners in charge of railway construction were charmed by the tomb figures, and so these began to be collected in the West.[242] As the Western prices rose toward the present high levels,[243] tombs then began to be pillaged just for the tomb figures, and previously pillaged tombs were reopened to get the figures the thieves had formerly left behind.

As a phenomenon, revaluation existed in China but was always peculiarly Chinese. No wonder, for if we had no more firsthand evidence on Giotto than Boccaccio's praise for his miraculous and deceptive realism, we might easily suppose that the frescoes in the Arena Chapel resembled a religious version of Frith's Derby Day. But revaluation there certainly was. Southern Song painting, to begin with, fell out of favor with most Chinese collectors after the end of the Song dynasty.[244] Before modern times, Japanese painters, connoisseurs, and collectors were in fact the chief admirers of the Southern Song masters.[245] Yet Chinese revaluation mainly took the form of "painted art history," whose innumerable practitioners in the later centuries tended to read into the past whatever had come to be most valued in their particular period—in fact, their own present.

Summation

Public art museums, finally, were the only one of the eight by-products of art that failed to develop in China in one way or another.[246] The Chinese scholar-officials, and indeed the privileged persons in the other rare art traditions of Asia, never seem to have imagined that illiterate and unprivileged people would understand or be benefited, if given the opportunity to see large numbers of great works of art. Yet the enormous Chinese imperial collections, closed though they were to all but the most fortunate members of the imperial entourage,[247] were clearly the Chinese response to the same stimuli that produced art museums in the West. This is proved by the series of catalogues of imperial collections, beginning with the

Emperor Hui Zong's *Suan he hua bu (Hsuan-ho hua-pu)* in the eleventh century,[248] and ending with the gigantic catalogue of the Emperor Qian Long in the eighteenth century, the *Shi qu baoji (Shih-ch'u pao-chi)*.[249] Everything was done to make the imperial catalogues complete and scholarly—except that the susceptibilities of the imperial collectors had to be considered in the delicate matter of attributions. Even so, any one of the imperial catalogues will be found to compare favorably with the catalogues as yet available in many great Western art museums!

If you now look back over the pattern traced in this chapter, you will find that the repeat of the Greek pattern in China was astonishingly complete. With all the minor divergences of detail and despite the near-total dissimilarity of Greek art and Chinese art, every main feature of the Greek pattern is to be found in the Chinese pattern. One need only make a count to see how amazing this is: new direction taken by art leading to a second era in Chinese art quite sharply set apart from the first, to match the Greek mutation that produced the Greek art of the great centuries and the entire classical art tradition; behavioral traits in the second era of Chinese art that were altogether new in Asia, yet much the same as the novel behavioral traits that appeared in Greek art for the first time in history; and finally, the by-products of art, again previously unheard of in Asia, just as these same cultural phenomena had never been heard of before in the world history of art when they appeared in Greece. In sum, seeing the mystery at the center of the history of the by-products of art as anything less than mysterious can only result from a failure to see the facts in proportion. It is in truth without any exact parallel in the world history of culture. If you like, it is a mystery of cultural history rather than art history—although, in honesty, I must confess I think it is both at once.

The Japanese Pattern

The mystery will not be made less puzzling, or even usefully underlined, by retracing much the same pattern in comparable detail, and all over again, in the Japanese and later Islamic art traditions. Cultural diffusion is the inescapable explanation for the export of art collecting and the linked phenomena from China to Japan, and, indeed, for the export of certain of these phenomena to Korea and, in lesser measure, Vietnam. These three societies' responses to Chinese influence were neatly graduated. Vietnam essentially remained a minor cultural province of China until the French conquest; and long thereafter, the higher mandarins of the Annamese imperial court at Hué were required to take their degrees at the Chinese imperial Han Lin Academy, or Forest of Brushes, in Beijing.[250] The Koreans, in contrast, had a far more richly developed art

of their own[251] when the invasion by Chinese influence started shortly before the Christian era; and there is still much that is specifically Korean in some of the early monuments—for example, the frescoed tombs.[252] In addition, they developed their own specialties over the centuries, especially in the field of ceramics. Yet Chinese cultural dominance was so strong that government documents and serious literature were both written in Chinese until the Japanese conquest; and developments in Korean painting regularly echoed Chinese developments. The first Korean writing about art concerned Chinese art exclusively,[253] and until very late in the game, Chinese works of art were the prime prizes, though not the only prizes, sought by Korean collectors. It should be added that in the early period, Korea, then divided into three kingdoms, played a most important role as the conduit through which Chinese culture and Buddhist faith initially began to penetrate Japan. Yet it has seemed justifiable to exclude Korean art from the list of the rare art traditions for the reason already given, because it was a branch, albeit a fruitful and semi-independent branch, of Chinese art.

In Japan, in contrast, Chinese art was imported almost *en bloc*, so to say, and along with it came the first art collection in Japan, the previously described specimens of great calligraphy in the Shōsōin. Initially, the Japanese both invited and delighted in the transformation of their own culture by Chinese culture. Mention has been made already of the way the early-ninth-century Emperor Saga even required his court poets to write in Chinese. Thus Chinese styles were still dominant in the time of Kose no Kanaoka, the ninth-century painter who founded the Kose school.[254] Over time, however, *Yamato-e*—painting of Japanese subjects in a more Japanese style—came more and more to the fore; and a main part of the drama of the competition between the lady painting collectors in the *Tale of Genji* was the contrast between the old-fashioned paintings in the Chinese style, *Kara-e*, and the newer and more popular *Yamato-e*.[255] As fashion was close to a be-all and end-all of the Heian court, being old-fashioned was appalling. Hence the competition might have ended painfully if Prince Genji's unfailing tact had not turned it into something like the caucus race in *Alice*, in which everyone got a prize.

The role of *Yamato-e* in this little episode suggests why Japan belongs among the five rare art traditions, whereas Korea and Vietnam do not. The truth is that in their usual way with their major cultural importations over the millennia, the Japanese went on to absorb and Japonify—if that is the right word—all that had been imported from China. Even art collecting underwent Japonification, so that Japanese art collecting ended by being quite unlike Chinese art collecting. Chinese art lovers are just as unable as Western art lovers to grasp the standards of Japanese tea-ceremony collecting, just as most Chinese connoisseurs still dislike the kind of South-

ern Song painting typified by Mu Qi's (Ch'i's) famous Persimmons, which most Japanese connoisseurs would list among the half-dozen most enviable works of art in Japan.[256]

As might be expected with this kind of cultural importation, moreover, art collecting and the other linked phenomena developed in Japan in a more irregular manner than had been the case in either Greece or China. There can be no doubt that the first Japanese art collection formed part of the great Shōsōin dedication. There can be no doubt, either, that a light-hearted, rather specialized kind of art collecting flourished in Heian Kyoto; for there is other evidence besides the testimony of Lady Murasaki. Yet the great era of Japanese art collecting began considerably later, in the Muromachi period, when the Shogun Ashikaga Yoshimitsu set an example of extravagance, splendor, and esthetic refinement, all combined. Art history and the other associated phenomena similarly developed in Japan in a sequence that has none of the inner logic of the Greek and Chinese sequences. Yet the key facts remain: first, that the Japanese art tradition was undeniably independent, despite its total transformation by Chinese influence; and second, that all the special behavioral traits, from compulsive innovation and artists' signatures down to remembered masters,[257] appeared in this transformed Japanese art tradition, along with all the by-products of art which had been developed in China. As in China, too, the only missing phenomenon was public art museums; but as has been noted, Japan was the first independent Asian nation to import the idea of public art museums from the West. The forerunner of the present National Museum in Tokyo was established in 1871 in a rock-cut temple in the city.[258]

The Later Islamic Pattern

As for the development of the by-products of art in the later Islamic tradition, it was vestigial at best; but what happened in the Islamic world is far less familiar than what happened in Japan, so a slightly more complete sketch is perhaps in order. In the Islamic world, as in China, calligraphy was the art of arts, to the extent that in the sixteenth century, at the Ottoman court in Istanbul, the court calligraphers' stipends were considerably greater than the stipends of the court painters.[259] As in the case of the Chinese characters, too, the way Arabic was written underwent important stylistic changes over the centuries;[260] but the key moment for the early history of art collecting appears to have come when a great ninth- and tenth-century calligrapher, Abū 'Alī Muḥammad ibn 'Alī ibn Muqla, devised the Khaṭṭ al-mansūb, or proportioned script, and his tenth-early eleventh-century continuator, Ibn al-Bawwāb, went on to perfect it.[261] This freer and more elegant script then largely supplanted the splendidly monu-

mental Kufic script. When the treasuries of the Fatimid caliphs of Egypt were plundered by their guards hired from Central Asia in the later eleventh century, copies of the Qur'an written by both ibn Muqla and al-Bawwāb in gold letters on azure were among the guards' prizes,[262] meaning that these were then so precious that they were stored with more normal treasures and bullion. The *Fihrist* of al-Nadīm, a work on bibliography of the late tenth century, also makes it plain that the works of famous named calligraphers like these were already much sought after and highly valued.[263] In short, calligraphy collecting preceded all other forms of collecting in the Islamic world, again as happened in China.

A major change then came over the scene after Genghis Khan's grandson, Hūlāgū Khan, conquered most of the Middle East and established the Mongol Ilkhanate of Persia in the thirteenth century. For the inhabitants, the results were horrifying. It is estimated, for instance, that 60,000 of the population of Baghdad perished in the conquest and the ensuing massacre. The results for Islamic art were very lovely, nonetheless. Evidently Hūlāgū Khan brought Chinese artists in his train, or at a minimum brought Chinese paintings; for the earliest "Persian" miniatures that now survive show exceedingly obvious Chinese influence, most strongly in the handling of the landscapes but in other ways as well.[264] Perhaps, too, the Chinese officials usually employed at Mongol courts had something to do with broadening the range of Islamic art collecting.

At any rate, the earliest Islamic painter to be mentioned in a collecting context—he was highly praised by two much later Islamic art historians, who claimed to know his work at first hand[265]—was a certain Khwājah 'Abd al-Hayy. Nothing from his brush survives today, but the British Museum owns a book of poetry with calligraphy by Mīr 'Alī of Tabriz and illuminations usually attributed to Ustād Junayd of Baghdad,[266] a fifteenth-century miniaturist who learned his art from the same master as 'Abd al-Hayy. Nonetheless, Kamāl al-Dīn Bihzād, who probably died just after the first third of the sixteenth century, was the first great master-miniaturist whose remains are now ample enough to permit comparative study. His delicately charming style can be judged from works in the Freer Museum in Washington,[267] in the National Library in Cairo, and in some other museums as well.[268]

By Bihzād's time, too, art collecting had gone well beyond merely collecting the works of famous calligraphers—in origin in Islam pretty close to the kind of book collecting that centers on fine editions—and had become a well-established social habit, albeit a narrowly based one mainly confined to the courts of the various Islamic princes. The usual collectors' practice was to put together albums comprising both miniature paintings and specimens of calligraphy, such as the ones that still survive intact in the Topkapı Sarayı in Istanbul.

Some of the collections were enormous. In the sixteenth century, a minor prince of the Safavid dynasty of Persia, Sultān Ibrahīm Mīrzā the "Glorious," nephew of the great Shah Tahmāsp, was both a lavish patron of the arts and so eager a collector that he owned no fewer than three thousand volumes of fine calligraphy and miniature painting.[269] His case also suggests why collecting and the accompanying phenomena of art never developed really luxuriantly in the Islamic world. Prince Ibrahīm Mīrzā was killed in the time of troubles after the death of Shah Tahmāsp in 1576. His widow, Gauhar Sultān Khānum, was either more devout than her husband, or more fearful of the Islamic prejudice against representational art. Hence she caused one of her late husband's most famous albums, with miniatures by Bihzād and others, to be "washed out . . . with water" to remove the pictures.[270]

By then super-prices clearly prevailed, since it is also recorded concerning this single album that "its price was tantamount" to the land taxes of a large region.[271] The man who is quoted here was Qādī Ahmad, who wrote one of the three early histories of Islamic painting and calligraphy,[272] with Prince Ibrahīm Mīrzā as its patron-collector hero. A second early art historian was Dūst Muhammad, another man of the sixteenth century whose work is preserved in one of the great albums in the Topkapı Sarayı collection.[273] And the third early art historian was Mīrzā Muhammad Haydar, a learned cousin of the Mogul conqueror of India, the great Babur.[274] The conquest of India also introduces another theme, for art collecting seems to have been carried to India by the Moguls, and the earliest Indian remembered masters date from early Mogul times, as do the earliest Indian masters who signed their works. The Moguls, in fact, completed the process of making much of India a province of the later Islamic art tradition.

But enough has now been said to show that the three primary by-products of art—collecting, art history, and an art market—developed far enough in later Islamic art to deserve recording here, and, indeed, to deserve much longer and more careful study than has yet been given to this aspect of the story of Islamic art. It is always rewarding to investigate the transition from an almost wholly anonymous though very great art to an art with many remembered masters[275]—and not all these masters were calligraphers and painters, of course[276]—with a historical approach to art, and with art collectors competing with one another for great prizes at great prices. And this transition also occurred in Islamic art, although surprisingly late and in a relatively limited way.

As to how and when and with what results the mutation occurred in the West which made ours another art tradition of the rare type, this part of the story will be covered in the last half of this essay. To Westerners, it is the most interesting part of the story, and it is by far the best documented, too; so considerable space will be needed. It is enough to say

here, however, that the Western repeat of the pattern seen in Greece and China was closely comparable if analyzed schematically—for of course the similarities were strictly limited, as usual, to the behavioral traits and the by-products of art.

Before this final major task is undertaken, meanwhile, it will be useful to trace a totally different kind of development which is again linked to the mystery at the center of the history of the by-products of art. This development is the effective disappearance from Europe, not only of art collecting as a social habit, but also of the historical response to art and thus of art history, together with the rest of the by-products of art. All these cultural phenomena disappeared in the twilight of the classical art tradition and only reappeared eight centuries later, when the first preliminary tremors foretelling the Renaissance were being felt in Italy. Difficult though it is to prove such a large negative as the effective absence of art collecting for many centuries in Western Europe, this must be the subject of the next chapter.

IX

THE PATTERN VANISHES
—AND RETURNS

The last known classical art collection was found not long ago in the Athenian Agora by the excavators of the American School of Classical Studies.[1] The find spot was the well of a fine house that almost certainly belonged to the head of one of the Athenian philosophic schools.[2] These last pagan centers of learning were suppressed by the pious Emperor Justinian in 529 A.D.,[3] and the owner of the house may well have been one of the obstinately pagan thinkers who then sought refuge for a while in the Sassanian Empire[4] beyond Justinian's reach. At any rate, the house passed into Christian hands at about that date in the sixth century;[5] and before this happened, the sculpture which the house had formerly contained was lowered into the well, piece by piece and with great care.

The collection was far from resembling the assemblage of famous Greek masterpieces destroyed a little earlier, when the Lauseum went up in flames in Constantinople.[6] It amounted to no more than a few Roman imperial portrait busts and some fairly late Greco-Roman statuary.[7] Yet the collection's owner had evidently loved his prizes and wished to save them in hope of better times to come; and because he was so careful and the well was deep, the statues and busts were found almost undamaged nearly a millennium and a half later.

It is a sad little story, and it betokens the end of the art collectors' approach to works of art which had continued, albeit more and more feebly, as long as the classical art tradition still had some life in it. The origins of this ending are plain to see for anyone who can read signs, and not only in Western Europe, where the levers of power came into the hands of invaders from the north, but even in the Eastern Empire, where the claim was so loudly made to continue the grandeur of old Rome.[8] Only what happened in Western Europe will be covered in this chapter, however, since that is enough to demonstrate that the ending was no illusion.

One cause of this remarkable ending was the Church Fathers' suspicion that all classical art was somehow demon-tainted.[9] Another cause was the progressive collapse of the old Roman imperial order, with all the resulting economic disruption, military instability, and political decay. Yet what happened went too deep to be so simply accounted for. The entire pattern of social habits, the whole complex behavioral system traced in the last two chapters, vanished from the West, where it had been so strong and so conspicuous in the centuries of Hellenistic wealth and during the long era of Roman imperial prosperity. Thus one must conclude that the root of the matter was an actual change in ways of thinking. Just such a change is fairly starkly revealed, moreover, by Cassiodorus' valiant but doomed rear-guard action to protect Rome's wealth in art in the early sixth century.

Cassiodorus' Testimony

Cassiodorus was a learned member of an Italian landed family of Syrian origin, who served the first Ostrogothic King of Italy, Theodoric, and Theodoric's son-in-law and successor, Theodahad, rising through various posts to become Master of the Offices—in fact, head of the civil service.[10] His *Variae* comprise the letters, "formulae" for public appointments, and other documents he composed for his two Ostrogothic masters. These he made into a book in the hope that his successors in the Ostrogothic chancery would not use "unpolished and hasty forms."[11] As that phrase suggests, Cassiodorus clung to the style and viewpoint of cultivated men of earlier times, and that style of course called for a love of classical art. Hence several of the documents preserved in the *Variae* have to do with art, and all these show that in the early sixth century, enormous numbers of classical works of art were still to be seen in Italy, but were already in grave danger. One of the sources of the danger is indicated in a letter concerning the large bronze elephants which then stood on Rome's Via Sacra.[12] The topic gave Cassiodorus a pretext for a splendid display of his accumulated elephant lore, including the well-known power of an elephant's sneeze to cure headaches.[13] But the guts of the letter was a firm order to the Prefect Honorius to repair the elephants on the Via Sacra by seeing that "their gaping limbs be strengthened by iron hooks, and that their drooping bellies be fortified by masonry placed underneath them."

Time's ravages of works of art are a familiar process. War's almost equally familiar ravages were added, too, by the time Cassiodorus' *Variae* had been completed in 537 A.D. By then the troops of the Emperor Justinian had already invaded Italy with the mission of destroying the Ostrogothic kingdom and restoring the peninsula to the empire. The Emperor's great

general, Belisarius, was besieged in Rome by the counterattacking Ostrogoths in 537. During the siege, Belisarius' soldiers used as a fort the superb mausoleum of the Emperor Hadrian, the future Castel Sant'Angelo; and they smashed Hadrian's magnificent ornamental sculpture to get rocks to hurl down upon their attackers.[14] Yet neither war nor time had anything to do with the case that caused Cassiodorus to draft for King Theodoric a stern letter to a certain Tancila,[15] a senator of Ostrogothic origin, saying he was "much displeased at hearing that a brazen statue has been stolen from the city of Como." The King authorized torture in the investigation of the theft, and offered a large reward for the statue's return.

Just as telling is the appointment formula for the "architect of the city of Rome," in which Cassiodorus really let himself go on the glories of classical art.[16] He was a man who liked letting himself go in this way, chiefly to display his learning, yet he also seems to have expected the new architect to know little or nothing about this art of the past, in itself a sign of the times. At any rate, the architect was warned that if he did not do his best to defend and preserve Rome's innumerable pieces of sculpture, he would be deemed "the man of stone, and the statues about him the true living men."[17] Most telling of all, however, is the parallel passage in the appointment formula for the Count of Rome:

". . . The streets and open spaces of Rome require protection. I refer to that most abundant population of statues, to that mighty herd of horses . . . which adorn our city. . . . If there were any reverence in human nature, it, and not the watchmen, ought to be the sufficient guardian of the city of Rome. But what shall we say of the marbles, precious both by materials and workmanship, which many a hand longs, if it has opportunity, to pick out of their settings? . . . Watch for such evil-doers as we have described. Rightly does the public grief punish those who mar the beauty of the ancients with amputation of limbs, . . . [making] our monuments to suffer. Do you and your staff and the soldiers at your disposal watch especially by night. . . ."[18]

It is eerie to think of this Rome of Cassiodorus' time, with its human population already dwindling down toward its sculptured population, where men stole through the night streets to hack off a leg or arm of a bronze or marble statue for subsequent sale to the bronze founders and lime burners. Century after century, the demands for raw materials from the bronze founders, the lime burners, and even the builders, who used rubble of broken classical sculpture in walls and foundations,[19] were in fact the chief threats to the countless classical works of art that had survived the Western Roman Empire's fall.

If you consider the problem, moreover, you will see at once that this required a profound change in ways of thinking about art that would naturally rule out art collecting. For it goes without saying that mere

demands for raw materials could never have been so threatening as long as the ways of thinking about art endured that made Lysippus' *Apoxyomenos* the cherished possession of the whole Roman people, and thus caused the frustration of the infatuated Emperor Tiberius.[20] And it goes without saying, too, that as soon as the bronze itself had become the most valued component of Lysippus' masterpiece, art collecting had altogether vanished as a social habit.

There is a chance that Lysippus' beautiful bronze youth was still intact and on view in Cassiodorus' time. Procopius records that there were still works attributed to Lysippus and Phidias in Rome in the time of Belisarius' defense of the city,[21] and he adds, in a tone of some surprise, that the Romans—here plainly meaning the richer and more educated citizens Procopius will have talked to—were extremely proud of their city's richness in art.[22] But in the seventh century, Constans II paid the last visit to Rome of any Byzantine emperor.[23] His pompous show was only equaled by his squalid rapacity. Before saying farewell, he seized a series of famous pieces of bronze sculpture, evidently for their metal.[24] One can safely deduce the motive, because his largest theft was the entire roof of gilt-bronze tiles from the Pantheon,[25] although the Pantheon had already been consecrated as a church. It is not a bad bet, therefore, that the *Apoxyomenos* fell victim at last to Constans II.

The Story's Other Side

The utter disappearance of the social habit of art collecting is the key fact, in any case. It must not be supposed, however, that the appeal of classical art altogether ceased to be felt in the Dark and Middle Ages just because art collecting had vanished as a social habit. On the contrary, in the late eighth and ninth centuries, late classical art inspired the Carolingian Renascence.[26] In this instance, to be sure, one suspects that Charlemagne's advisers in such matters, Alcuin and Einhard, felt that their master's claim to revive the Roman Empire also called for revival of art in the Roman imperial style; and the same feeling is the most probable explanation of Charlemagne's importation from Italy of actual works of art. The Palatine Chapel at Aachen was not only supplied with imported columns;[27] in addition, a bronze wolf and pine cone were carried across the Alps for display there;[28] and an equestrian bronze of Theodoric, brought from Ravenna, also stood before Charlemagne's palace in Aachen.[29]

There is later testimony, however, of admiration for classical art unalloyed by any political consideration. The same eleventh-century thinker, Guibert de Nogent, who attacked false relics, wrote on another occasion: "We praise beauty in an idol which is justly proportioned, and although . . . an idol is a thing of naught . . . nor could anything be imagined

more profane, yet the true modelling of its members is not unreasonably commended."[30]

Other medieval judgments like Guibert's might be cited, and there is also the charming story of the English cleric Magister Gregorius, who went to Rome, probably in the twelfth century, and was promptly bewitched by a Venus statue then still to be seen there.[31] He confessed that he walked for miles several times, in order to have another look at his sculptured enchantress; and he also described at some length other sculpture that was still in Rome in those days.[32] Yet Magister Gregorius had the same mixed feelings as Guibert. The early medieval saint's biographies of Pope Gregory the Great admiringly but erroneously credited the Pope with defacing or destroying most of the classical sculpture still remaining in Rome in the late sixth and early seventh centuries.[33] Gregory I's English namesake mentioned what the sanctified Pope had supposedly done as a true act of piety, without regret—and in the same passage described his own admiration for the Venus statue.[34]

Nor was this all. By sheer force of numbers, a few classical works of art always survived aboveground despite the constant demands of the bronze founders and lime burners.[35] These survivors tended to have legends attached to them over time. Thus the equestrian bronze of Marcus Aurelius was long protected by the belief that it was a portrait of the first Christian Emperor, Constantine the Great;[36] and in Florence, the luck of the city somehow came to be associated with a statue of Mars that stood on the Ponte Vecchio in the time of Dante.[37] More important, classical works of art were repeatedly reused in the Dark and Middle Ages whenever a use could be found for them, and were even positively preferred to contemporary productions in some striking cases.[38]

That astonishing reliquary, the Majesté de Ste. Foy of Conques, has been found to have a head made in late Roman times,[39] probably as a golden parade helmet for an emperor or rich military dandy of the Western Empire's final period;[40] and the jewels that enrich the costume of the Majesté further include a large number of classical gems.[41] For centuries, in fact, antique carved gems were reused in this way on reliquaries, costly crosses, book covers, and other treasures, quite indiscriminately with other jewels, besides being set in rings.[42] Roman sarcophagi were also reused for important entombments. Charlemagne was provided with one;[43] so were several popes;[44] and excavations of a sort were even undertaken to get a suitable coffin for the blessed Aethelthryth.

This lady miraculously preserved her virginity while Queen of Northumbria, and then laid down her crown to retire to a nunnery, eventually founding one of her own. The Venerable Bede states that when the foundress died, the nuns searched for a coffin in the ruins of an "abandoned city,"[45] and there found one "beautifully wrought" of white marble. The

city was what remained of Roman Grantchester, and Aethelthryth's coffin was obviously a Roman sarcophagus.

The Solitary Real Collector

Finally, classical works of art were the sole prizes of the only art collector and near–art collector one can find in the entire record of the Dark and Middle Ages before the thirteenth century, when another change in the ways of thinking about art almost imperceptibly began in the West. In Rome, it was standard practice for popes, cardinals, and powerful families to take needed building materials from the temples and other monuments.[46] The more important noble families even made fortified redoubts for themselves in major Roman monuments.[47] The magnificent Palazzo Colonna of today, for example, replaces the ancient Colonna stronghold established in the former Temple of Serapis.[48] But a member of the noble family of the Crescenzi chose a slightly different approach. He was, in fact, remembered as having gathered many handsome classical bits and pieces to build into the walls of his house,[49] thus making one think of the similar use of fine fragments from the past by Isabella Stewart Gardner at Fenway Court. Was it this man to whom the Crescenzi owed the bronze bull reported to have been installed above the façade of their fortress-palace?[50] One does not know, but it seems to me the fragment gathering was halfway to art collecting.

Henry of Blois was a far more interesting case, however. He was the brother of King Stephen of England and Bishop of Winchester in the twelfth century; and he went to Rome to get himself named Archbishop of Western England.[51] He made no headway with the Pope or the Curia with his proposal for a third English archbishopric; and as consolation for his disappointment, he acquired a large collection of classical sculpture while in Rome.[52] This was so eccentric a thing to do at that period that a wit of the Papal Curia quoted against him a tag from the previously mentioned satire of Horace, "Damasippus has gone mad buying ancient statues."[53] Whereupon Henry of Blois crisply replied that the people of Christian Rome were a lot less admirable than their pagan predecessors,[54] and went off to England in a huff, taking along his sculpture—of which no further trace seems to exist.[55]

Just one real art collection in six centuries—or two, if you count Charlemagne's importations—cannot be regarded as evidence for a social habit of collecting. Yet the record shows no more. Of course it is possible that there were a few other obscure collectors who were not recorded. The stonecutters and mosaic workers known as the Cosmati regularly mined the ruins of Imperial Rome for the white and colored marbles and porphyry they used in their work; and on occasion they also sold antique statues

that turned up in the course of their mining operations.[56] If the statues were not dressed up as Christian images, or simply acquired as souvenirs of Rome, purchasing such a statue was art collecting of a sort. All the same, Henry of Blois must still be seen as a singularly isolated and atypical figure, predicting what was to come, but the very opposite of representative of his own time.

At this juncture, the reader must be impatiently wondering why a chapter concerned with the Dark and Middle Ages has devoted so much space to the ways of treating and regarding classical works of art after the Western Roman Empire's end. The answer is simple enough.

To begin with, it hardly needs to be pointed out that from a relatively early date, the Europe of the Dark and Middle Ages was wonderfully rich in great artists of many kinds. In times of comparative peace, patronage of the arts, both public and private, was lavish and often discriminating. Treasure gathering was widespread, too. Nor was there any weakening of the esthetic response throughout this long period. On the contrary, despite (or can it be because of?) the absence of courses in "art appreciation," the surviving documents offer ample evidence that people had the most lively sense of the beauty of the works of art[57] which enhanced their surroundings or, more often, gave splendor to their religion. But unless this essay's reasoning is fundamentally erroneous, evidence for a strong and persistent esthetic response is *not* evidence for art collecting.

The most laborious exploration of the record has failed to disclose a single man or woman throughout the whole period who actually collected the works of art of the Dark and Middle Ages, whether products of earlier times or of contemporary artists. Nor was the search confined to the written record. Inquiries generously answered by great medievalists have also failed to turn up any figure in the Dark and Middle Ages who really met this essay's definition of an art collector, barring the one collector of classical works of art already described. The truth is that with this lonely exception, the people of these centuries in Europe did not perceive works of art as things to be desired without regard to setting or function—unless they were also treasures, of course.

An Illustration

In order to get a more concrete notion of this difference between medieval ways of thinking about art and the ways of thinking we now take for granted as normal, it is only necessary to imagine Chartres Cathedral succumbing to some such disaster as a great fire. If that should happen nowadays—and pray God it does not!—collectors, dealers, museum curators, and large numbers of plain citizens would be swarming 'round the ruins like piranhas 'round a blood streak in the Amazon. Noseless, crown-

less heads from Chartres's royal portal; battered half-bodies still conveying something of the early Gothic sculptural power; the smallest semi-intact fragments of the incomparable Chartres windows; any bit or piece of the fabric much above the level of a mere shard or chunk of rubble—all these would instantly be at an enormous premium. The French government's Service des Monuments Historiques would have to order a heavy day-and-night guard on the ruins, to prevent their being pillaged. And if the guards performed their task successfully and the ruins were really beyond hope of repair, every salvageable bit and piece would eventually be displayed, with appropriate tickets, in a specially constructed Musée de Notre Dame de Chartres.

Then consider what actually happened after the great fire of 1194, which largely destroyed the Romanesque cathedral except for the crypt and newly rebuilt west front.[58] Chartres's holiest relic was the *Sancta Camisia*, the very shift worn by the Virgin Mary when she gave birth to Our Lord,[59] and Chartres was believed to be under the Virgin's special protection.[60] The fire at first convinced everyone that the Virgin had abandoned Chartres, and all gave way to despair. The source of the despair, moreover, was far less the loss of the cathedral itself than the loss of the *Sancta Camisia*. People felt "that it was unworthy to restore the structures of the city or the church, if it had lost such a precious treasure . . . the glory of the whole city."[61]

Luckily, Cardinal Melior of Pisa was in Chartres on a political errand.[62] He first called together the unnerved bishop and chapter,[63] and persuaded them to agree to devote three years of their enormous revenues[64] to building a new cathedral. He then summoned the townsfolk to a meeting, at which the people of Chartres were soon overjoyed to see Bishop Renaud de Mouçon and the clergy of the chapter appearing in procession, carrying the *Sancta Camisia*, which they had just found (or was it an opportune replacement?) miraculously preserved in the fire-blackened ruins.[65] After this, the exhortations of the Cardinal of Pisa were hardly needed to obtain eager support from the people of Chartres for the decision to rebuild.[66] So the great task was promptly undertaken that produced most of the cathedral that the world reveres today, with further help from magnates from all over France and even from England.[67]

The west front and the crypt of the burned cathedral were not much touched by the fire of 1194, and were built into the new one.[68] *Remplois*, as the French architectural scholars would say, were common enough in the Middle Ages, and besides salvageable parts of older structures, the things reused could include individual works of art, such as the twelfth-century sculpture on Notre Dame's thirteenth-century portal of St. Anne.[69] Before their cathedral was rebuilt, too, the less well disposed citizens of Chartres perhaps searched the ruins clandestinely, in the hope of finding

remnants of precious metal from the cathedral's burned treasures. But there is no evidence for any fragments of the old cathedral's works of art being preserved for their own sake, and one may be sure this did not happen in the later twelfth century.

The contrast between then and now is striking. It results from the simple fact, already noted, that the people of the Dark and Middle Ages did not collect the products of their own arts. They wanted the products of the arts, not just to serve their purposes, but to be beautiful as well. Similarly the rich and the churches eagerly gathered anything that was also a treasure, just as they collected holy relics; but they further preferred treasures made lovely by the hands of leading masters. Nonetheless, the theme in the Dark and Middle Ages was always art-for-use-plus-beauty, and no one saw art as an end-in-itself.

In this respect, moreover, the place of art in the Europe of the Dark and Middle Ages exactly resembled art's place in uncounted other regions and periods which were also rich in art, yet were beyond the limits of the five rare art traditions. In particular, the rare traditions are above all those which have generated art collecting; and it is entirely clear that in the Dark and Middle Ages, however many obscure special cases may later be unearthed, art collecting never remotely approached the status of an established social habit, even among a tiny, uncommonly art-loving minority in this area or that.

Art History's Absence

A measure of historical deformation must no doubt be allowed for in anyone who has come to really prolonged exploration of medieval art history as the result of an interest in the topic of this essay. To have a topic of one's own is to see the past through a diffracting medium, and diffraction inevitably deforms. Yet all that was *not* there in the Dark and Middle Ages, at any rate so far as we know today, really is so striking that it appears to deserve greater emphasis than has been placed upon it to date. In particular, art history, the other most important and indicative by-product of art, was as totally absent in this long period as anything resembling true art collecting in its only significant guise, as a recognizable social habit.

One or two eminent art historians have been troubled by the conspicuous gap in the record of the Dark and Middle Ages left because no one has found any medieval text or fragment of a text that can possibly be called an art history. More than once, therefore, it has been pointed out as compensation that the better-informed, more widely experienced men and women of medieval Western Europe could nonetheless recognize the origins of styles of art and of works belonging to each stylistic group.

And of course it is true, for example, that when the Gothic style spread from France into Germany, a fair number of Germans knew where the new style had come from.[70] Of course, too, those who were educated could often recognize classical works of art for what they were. Guibert de Nogent's remarks about "idols" are proof enough of that. Of course, finally, a few scholars were familiar with what had been written about art by Cicero, or Quintilian, or the elder Pliny, or other Roman authors; and the learned sometimes used the names of Phidias and Apelles, particularly, to denote high accomplishment in sculpture and painting. Only consider, however, the character of the historical information about the monuments of ancient Rome supplied to readers by the most popular and long-used of all the many guides to Rome, the twelfth-century *Mirabilia Urbis Romae*.[71]

In the *Mirabilia*, first of all, you find a bewildering, wholly imaginary reconstruction of the temple of "Jupiter and Moneta" on the Roman Capitol, as a gem-studded golden palace containing a remarkable military early-warning system. The early-warning system was said to have been composed of statues of all the provinces of the empire and other nations of the world. One wonders if this was not partly a mythologized memory of the cella of the temple of the deified Hadrian, which is now thought to have had a finely conceived décor based on statues of all the Roman Empire's provinces in Hadrian's time.[72] As to the actual temple of "Jupiter and Moneta," this was undoubtedly a mythologized memory of the Temple of Jupiter Optimus Maximus, pagan Rome's chief official shrine. According to the *Mirabilia*, at any rate, each statue of a province comprised in the mythical early-warning system was equipped with a bell; "as soon as the bell sounded, they knew that the country was rebellious"; and so the Roman Senate was always warned when and where to send the legions.[73]

It did not end there, either. The Dioscuri, or Horse Tamers, were among the few pieces of sculpture that always survived aboveground in medieval Rome. Here, therefore, the anonymous author of the *Mirabilia* was presumably writing about what he had actually seen, and he had even observed the names of Phidias and Praxiteles on the bases of the two groups. In consequence, the statues are fantastically explained in the *Mirabilia* as memorials to "two philosophers"—in fact Phidias and Praxiteles—who "came to Rome . . . in the time of the Emperor Tiberius." And the nakedness of the two horse tamers is further explained as symbolizing that all things were "naked and open" to these two "young philosophers" because of their wisdom![74] It is usual to contrast the anonymous author of the *Mirabilia* with the English lover of a Venus statue, Master Gregorius. The Englishman was certainly less inclined to be nonsensical, yet he, too, believed in the Roman Capitol's early-warning system.[75]

At first it is bewildering to read these twelfth-century documents, and

then to remember that in the twelfth century, and indeed long before the twelfth century, there were always a few learned Western Europeans who were well aware that both Praxiteles and Phidias had been sculptors rather than philosophers, and must also have realized that both of them flourished long before the time of Tiberius Claudius Caesar. Yet the bewilderment largely vanishes if you recall that art collecting, art history, and the other linked phenomena[76] were not alone in their disappearance after the fall of the Western Roman Empire. In addition, and in the wake of the same great historical transformation, all four of the peculiar behavioral traits which first appeared on earth in the classical art tradition when it was born in Greece were either greatly weakened or else vanished altogether. And above all, anything dimly recognizable as a truly historical response to art disappeared from Western Europe along with the behavioral traits that seem first to intimate, even to prepare the mature appearance of this special historical response which always parallels the esthetic response in the rare art traditions.

The First Two Traits

The reader may recall that the first of these four peculiar traits of the rare art traditions is held in this essay to be compulsive innovation, while the second is artists' signing their works as a quite normal thing to do. Of these two traits in the Dark and Middle Ages not much will be said, partly because eminent medievalists still disagree about many of the problems involved, and partly because it would be overbold to venture into specialists' territory where the historical outlines are still unclear. Concerning compulsive innovation in medieval art, only two points need to be made.

To begin with, change in art, and therefore innovation, was fairly frequent throughout the centuries between the fall of the Western Roman Empire and the dim emergence of new ways of thinking about art in fourteenth-century Italy. Throughout this whole period, for one thing, all the normal causes of change in art were of course at work. The inevitable shifts in the way of doing things from generation to generation; the happy inspirations of individual genius, which were then imitated; the special situations promoting change, like Abbot Suger's program at St.-Denis, curiously similar in its pattern of repercussions to King Zoser's program for a particularly memorable tomb-temple complex for himself: all these factors had their effects, either throughout the Dark and Middle Ages or at different times.

In addition, the whole period was affected by other sorts of factors promoting change, including change in art. The political organization of most parts of Western Europe was repeatedly altered in one way or another,

and when powerful new rulers thus emerged in this region or that, architects, artists, and craftsmen were usually called upon to serve each new ruler's needs. There were also all sorts of interchanges of cultural influences, between the unconverted North and the Christian zone in the early phase, between Byzantium and Western Europe,[77] between the medieval present and the Roman past, between various Western European regions, and between the Muslim lands and the Christians of the West, especially after the Crusades began. In short, it would have been astonishing if the long period separating the collapse of the Western Roman Empire and the early fourteenth century in Italy had not seen decidedly more changes in art than usually occur where artists do not feel the actual compulsion to innovate.

As has been stressed already, however, the compulsion rather than the innovation is the key feature of this trait of the rare art traditions. Thus the question to ask with regard to medieval artists is *not* whether they were sometimes innovators. The question to ask, rather, is whether leading medieval artists felt the compelling need to be in some degree original in the excellence they aimed for. The strongest factual argument that no such compelling need was felt is to be deduced from the character of the medieval craftsmen's handbooks, which will be discussed later. Among the authorities, meanwhile, G. G. Coulton wrote long ago of "the power of tradition, the comparative infrequency of innovation, in medieval art."[78] This is extra-impressive in its context; for Coulton was actually arguing that Émile Mâle had gone rather too far regarding the Church's omnipresent role in guiding and controlling individual artists, and thus inhibiting innovation. One can see what Coulton was getting at, for instance, in the first chapter of Mâle's most famous work.[79] Yet so far as I can discover, the problem of compulsive innovation has never been addressed by any of the great specialized medievalists, at any rate in the terms here proposed, with all the emphasis on the compulsion rather than the innovation.

Hence it will be enough to remind the reader once again of the important observations of Professor Gombrich, already quoted. He holds that "Our modern notion that an artist must be 'original' was by no means shared by most peoples of the past." Among the areas where he considers this "notion" was absent, medieval Western Europe is emphatically included. Medieval artists, he argues further, did not even "feel hampered" by commissions from patrons who enjoined them to follow this or that "old and venerable example of how the legend of the saint should be correctly represented." Even so, there still "remained enough scope for [the artist] to show whether he was a master or a bungler."[80]

So much, then, for the first of the peculiar behavioral traits of the rare art traditions. As for trait two, artists' signing their works in the

Dark and Middle Ages, I have to confess I feel even more at a loss. Medieval artists' signatures constitute a most complex subject, which has even given rise to sharp controversy in the past. Early in the present century, a French medievalist published an entire volume overtly aimed to force his colleagues to eat their words, because they held that illuminators of medieval manuscripts were persons too humble to have been permitted to inscribe their names on the manuscripts they so gloriously enriched.[81] Certainly there is no truth at all in the rather widespread nineteenth-century belief that medieval manuscripts and other works of art were always or almost always anonymous.

Yet to put the matter in proportion, it is also well to note that we have the names of many of the patrons who gave windows and other parts of the fabric to Chartres,[82] but we do not have the signature of a single one of the memorably talented workers in stained glass who provided one of the chief glories of the rebuilt cathedral. Again, we have the signature of only one Chartres sculptor of the most important years, a certain Rogerus, who scratched his name, perhaps clandestinely, on the invisible back of one of the statues of the great Royal Portal.[83] And, finally, we have no name at all for the towering architectural genius mainly responsible for the rebuilt cathedral. Perhaps his name was recorded on the fabric or in a labyrinth design in the pavement, but the record has now been lost. Otto von Simson holds this view[84] but has still been driven to christen this great architect and master mason "the Master of Chartres Cathedral."[85] In these circumstances, and in view of the further fact that no serious medievalist has ever expressed surprise or shock that the vast majority of the artist-contributors to the marvel that is Chartres are unknown from signatures or in any other way, it seems reasonable to say it was by no means normal for medieval artists to sign their works.

Furthermore, the record of the medieval signatures as known today has no rhyme or reason to it, as far as one can tell. For example, Spanish manuscript illuminators of the tenth and eleventh centuries put their signatures on their works with considerable regularity[86] in the same early period when medieval illuminators' signatures were distinctly rare north of the Pyrenees; and in the same way, there are few or no French Gothic sculptors' signatures, while contemporary Italian sculptors often signed, and one or two even signed pretty boastfully.[87] Moreover, in the twelfth and thirteenth centuries, the Roman Cosmati, in their triple role as architects, architectural sculptors and mosaicists, signed their works with surprising regularity.[88] In sum, what is needed, and is now entirely missing, is a comprehensive and authoritative treatment of the entire subject of medieval artists' signatures. The need for such a study is particularly urgent because of the first of the further points which it seems useful to make.

The Signature Puzzle

The first point is simple enough. The puzzling pattern of the medieval artists' signatures, and the fact that, overall, signing was rare enough to be far from normal, are in reality far less mysterious than the simple fact that we now know the names of a fair number of medieval artists from their signatures. This is mysterious, in turn, because of a point stressed earlier, that signing has been all but unheard of throughout art history beyond the limits of the rare art traditions—and Western European medieval art must rather plainly be placed beyond those limits. There have been remarkably few exceptional cases. Some of these—the tiny number of true signatures from Egypt and those ivory-workers-turned-sculptors at Sanchi—have been covered in previous chapters. No doubt there are further exceptional cases which have not been unearthed. Indeed I found a most exceptional case within a fortnight of writing the previous sentence;[89] and today, of course, worldwide cultural homogenization has led to artists' signing their works in many parts of the world. Yet the general rule still remains: normal signing in the rare art traditions, versus no signing at all in the other traditions. Because of this general rule, the medieval artists' signatures from Western Europe, though uncommon enough to cause a learned stir when a new one is discovered, are also numerous enough to stand out as significant anomalies.

These medieval artists' signatures can hardly have been yet another post-Roman echo of the art of the Greek and Roman past. Barring a tiny number of signatures like that of Glycon on the Farnese Hercules and the products of the quasi-industrial Aphrodisias sculpture workshops, where signing was common for an unknown cause,[90] later Roman art was even more effectively anonymous than medieval art. Nor is that all. In the Roman Empire, the cultivated public evidently rather soon lost interest in the identity of any artists except the famous masters of Greek art. Thus contemporary artists are no longer named in later Roman texts, and remarkably few Roman artists are named anywhere at all, even by Pliny. Callistratus only attributed works he described to their makers if these belonged to the great centuries of Greek art,[91] leaving all the rest entirely unattributed, while Philostratus and his son did not trouble to attribute to a named master a single work among the many they sought to picture in words. These are presumably the reasons we can only speculate today on the identity of such a major original genius as the designer and/or master sculptor of the Column of Trajan.[92] These are also the most likely reasons the Horse Tamers have labels ascribing them to Phidias and Praxiteles instead of the man or men who made them in Roman imperial times. More particularly, these are the reasons the artists' habit of signing

cannot have slopped over—to put it inelegantly—from late Rome into the Dark and Middle Ages.

Furthermore, the idea of artists' signing most certainly cannot have been borrowed from the few classical artists' signatures that were actually known in medieval times. It has been seen what nonsense was made of the names of Phidias and Praxiteles on the bases of the Dioscuri. Nor can anyone of that period have grasped the import of the name of the Greek gem cutter Euodos inscribed on the gem portraying the Emperor Titus' daughter Julia, which formed the terminal enrichment of the *"écrin de Charlemagne."*[93] So the question arises, where did the idea of signing come from? A practice that is all but unheard of does not, after all, normally arise spontaneously.

Naturally, there was no single cause for the appearance of the artists' practice of signing their works in medieval Western Europe. In the early period of manuscript production, the scribe and sometimes the illuminator named themselves—albeit fairly rarely outside Spain—because one or both dedicated his work to God or to the saints. Piety was thus the cause here. Yet one wonders whether it may not be helpful in searching for the first inspiration to look northward, to pre-Christian Europe beyond Imperial Rome's frontier.[94] In pre-Christian Germanic society, metalworkers were persons of high standing.[95] We also have a significant record of two remarkable and very grand pre-Christian objects of the fifth century A.D., the Golden Horns of Gallehus.[96] These were found in Denmark in early modern times, but were later stolen and melted down for their gold. Fortunately, the old drawings are accurate enough to show that the horns were made, and one was also signed, by the rune master Hlewagastir.[97]

In the period from the barbarian invasions through the great era of Charlemagne's empire and its aftermath, moreover, a notably high proportion of the European artists' names preserved by signatures are in fact the names of metalworkers. Even signed swords are known.[98] Nor should this surprise anyone, for goldsmith's work, particularly, had the status and character of a true major art throughout the Dark Ages and in the Middle Ages, too.[99]

To illustrate, the famous sanctified goldsmith, St. Eligius, or Eloy, was also a Merovingian mint master, and he is usually held to have stamped his name on his coins.[100] It has been argued that St. Eligius and the coin signer were not the same man, but in any case, a good many coins of this period give the names of the moneyers. This is worth noting because Imperial Roman mints were recorded on the coins they produced, while the mint masters did not sign. But perhaps the difference in practice should be attributed to the strange organization of coin production in Merovingian times, when mints were not necessarily officially established.

Much more striking, therefore, is the fairly high percentage of gold-

smiths' signatures on Dark Age and Carolingian jewelry and the like. For example, the name of the goldsmith, Uffila, can be seen with the names of the donor and recipient, Wigerig and Witegifil, on the late-seventh-century Lombard brooch in Munich;[101] and the eighth-century casket of Teuderigus, in the treasury of the Swiss Abbey of St.-Maurice d'Agaune, was made by the goldsmiths Undiho and Ello, who further recorded how their work was commissioned and by whom.[102]

"Wuolvinius Phaber" is still to be seen on the back of the marvelous golden *paliotto* in Milan, offering his magnificent handiwork to St. Ambrose,[103] as has been pointed out earlier. But note, too, that Wuolvinius thus placed himself almost on a par with the *paliotto's* donor, Archbishop Angilbertus II.[104] In the ninth century, at Lobbes, Abbot Hartburt also had a famous bell made, and the bell founder, Paternus, placed his name on it with that of the patron.[105] Both patrons' and goldsmiths' names were similarly recorded on a golden chalice ordered for St.-Benoît-sur-Loire from one Arnardus by Abbot Gauzlin.[106]

Yet the suggestion that the Western European artists' signatures partly reflected influence from the pre-Christian North is of course entirely speculative. Furthermore, an enormous amount of further scholarly work needs to be done before this problem of signing in the Dark and Middle Ages can be rationally discussed.

Trait Three

As to the third behavioral trait peculiar to the rare art traditions, one is almost tempted to say that theoretical writing about art was entirely unknown in Europe in the Dark and Middle Ages. But in the first place, there was a good deal of theoretical writing of a special sort, about art's place in religion. Charlemagne officially sponsored a work on this subject;[107] and the subject repeatedly generated discussion after his time,[108] and indeed from the very beginning of the iconoclastic controversy in Constantinople.[109]

It should be easy to see that theories about art's role in religion and true artistic theory are not of the same family. It is less easy, however, to differentiate what may be called practical theory from the kind of artistic theory the rare art traditions generated. At least from the moment when men began to construct their own shelters, practical theory has always been a necessary part of the equipment of any builder. You cannot put up a usable log cabin, or an Indian tepee, or a Mongolian yurt, without a considerable measure of practical theory—in addition to other skills, tools, and raw materials. On a far grander scale, the same rule of course applied in Europe in the Dark and Middle Ages.

No one could conceivably design and construct edifices like the great

Romanesque and Gothic cathedrals and abbey churches without rules of proportion and safe construction to guide the work. The design of the rebuilt Chartres was not hit-or-miss. Yet in the degree that theory existed, it was practical theory—in other words, an accretion from the practical experience of generations, traditionally handed down from master to master, and differing somewhat from region to region, as was only natural, because regional practices and preferences were unavoidably involved.

A conflict of the practical theories of different regions in fact gave rise to the fourteenth-century debate between the imported Northern experts like Heinrich Parler and the Lombard master masons about the right way to complete Milan Cathedral.[110] And just because the debate happened to be recorded for the Milan Cathedral archives, this hardly constitutes theoretical writing about art.[111]

The absence of theoretical writing about art of course did not mean there was no writing about art of any kind. In fact, three important texts survive: the knowledgeable *De Diversis Artibus* by "Theophilus,"[112] in which the twelfth-century author, probably Roger of Helmershausen, expatiates so touchingly on the artist's satisfaction in serving religion;[113] the earlier *De Coloribus et Artibus Romanorum*, by the unidentified "Heraclius,"[114] with its oddities like the plan for softening semiprecious stones for carving in a fearsome concentration of virgin billy-goat's urine;[115] and, finally, the famous thirteenth-century *Sketchbook*, or *Lodgebook*, of Villard de Honnecourt.[116]

But to begin with, it must be emphasized again that these are all craftsmen's handbooks—how-to books of artists' recipes, or in the case of Villard de Honnecourt, recipes and drawings of good models to follow. They have much to teach us, as one might expect. Especially Villard de Honnecourt and Roger of Helmershausen—if he really was "Theophilus"—show once again that the men of the Middle Ages had the lively capacity for careful esthetic discrimination which Professor Meyer Schapiro has so strongly insisted upon. When Villard de Honnecourt saw an architectural design he thought unusually pleasing or uncommon, he made a record of it,[117] just as Theophilus was given to saying that a particular way of doing a difficult job would produce a particularly fine effect or would lead to efficiency.[118] Yet craftsmen's handbooks are still what these works are.

All this being noted, it must also be noted that even this kind of writing about art was so uncommon in the Middle Ages that, since the rediscovery of Villard de Honnecourt's work fairly early in the nineteenth century,[119] the slender *Sketchbook* alone has generated far more books and articles about it than the book itself has pages.[120] It staggers the mind to calculate the response of the art historians if a genuinely theoretical medieval work on art ever chances to be discovered. So far as is known, however, the Dark and Middle Ages in Europe produced no single theoreti-

cal work that can begin to stand comparison with the surviving echoes of Polyclitus' *Canon*, from Greece in the fifth century B.C., let alone Xie He's *Six Principles* from the fifth century A.D. in China or the works of Leon Battista Alberti on painting, sculpture, and architecture from the Italy of the early Renaissance.

To my way of thinking, finally, the main lessons to be drawn from the three medieval craftsmen's handbooks (at any rate for this essay's purposes) are rather different from any suggested heretofore. Any recipe book, after all, is based and always has been based on the underlying assumption that there is a right way and a wrong way to do whatever is in hand. Even the little work of Villard de Honnecourt, written at a time when really profound changes in European art were not far ahead, is pervaded by the belief that there is at least a best way, which he has drawn from his own wide experience. Meanwhile, beyond stating his own preferences, Villard offers no explanation of the reasons—and reasons of this sort are necessarily theoretical—that his way really is the best rather than some other way. Practice and his eye, in other words, were the guides of Villard de Honnecourt. Thus even the *Sketchbook* strongly underlines the absence of the kind of body of art theory that artists of the rare art traditions have always had to take into account after an early stage of these traditions' development—whether by accepting the guidance of this body of theory, or choosing from its offered alternatives as one chooses dishes from a buffet table, or rebelling against what has been hitherto accepted.

Yet this is not the real heart of the matter. When any man sets out to write a recipe book, whether a master chef like Escoffier or a master craftsman like Roger of Helmershausen–"Theophilus," his motive can only be to instruct the next generation to get precisely the same results he has got by doing precisely the same things he did. Of course, Escoffier would have been horrified by a dish faithfully reproducing the recipes of the earliest European cookbooks, just as Roger of Helmershausen would have been horrified by faithful reproductions of works of art from the European Dark Ages. Equally, if both had lived longer, both would have seen far-reaching changes in cookery and art. But this is because change is the single unvarying constant of history in all history's innumerable aspects, including cookery and art.

The fact remains that the compulsion to innovate is most unlikely to have been felt by the artists of any period of any art tradition in which serious writing exclusively concerned with art was limited to craftsmen's handbooks, as in Western Europe in the Middle Ages. Innovations, as always, occurred repeatedly despite the injunctions to "do it just this way" in the handbooks, but the point, as has been stressed before, is the presence or absence of the compulsion; and the handbooks reveal an

absence of any compulsion. Thus the nature of the surviving European writing about art of the Dark and Middle Ages is not only a proof that the marvelous artists of this period were not guided by theory, except for what has here been called practical theory. In addition, the three medieval craftsmen's handbooks are the strongest single proof of the observations of Professor Gombrich, the importance of which has already been repeatedly underlined.

The Most Telling Behavioral Trait

So we come to the key behavioral trait of the rare art traditions, namely, these traditions' uniform habit of remembering their own masters. This is the key trait, of course, because the historical response to art is so plainly the root of both art collecting and art history; and this special response has always been first revealed by "remembered masters"—as I have called the artists thus incorporated in the general cultural memory. Once again, one is tempted to cut short the discussion by saying that European art in the Dark and Middle Ages produced no single remembered master, thus differing from the art of Byzantium, which had three;[121] and then to leave it at that. But one cannot possibly leave it at that, for a whole series of reasons.

To begin with, such a statement, neither adorned nor explained, will severely shock too many people, partly because the history of European art in the Dark and Middle Ages has become curiously deceptive. It is deceptive, of course, because such a wealth of evidence has been accumulated that we now have an impressively complete history of medieval Western European art, and much is even known about the artists. It is easy therefore (and even easy for great scholars) to forget that all this knowledge has been the result of rather recent research. The history of medieval art was a near-blank before the research began; and no medieval artist's name was known Europe-wide for any significant period after his death. Indeed, no medieval artist's name was inscribed in any European national memory; and if a few were locally remembered for three or four generations, the memory hardly extended beyond the walls of the institutions the artists served by adorning them.

To gain perspective, it will be well to trace the before and after briefly. Since the opening of the second stage of the Gothic Revival in the early nineteenth century, the vast labor of research has continuously gathered momentum, generation after generation. Archives of all sorts, whether public or private, ecclesiastical or princely, have been minutely dredged again and again. Funerary monuments have been examined. Cathedral fabrics and floors have been scrutinized. Monastic chronicles have been read for the first time in many hundreds of years. Scholars have dutifully

perused the depressing rhetorical exercises describing buildings and the like that are now called *ekphrases,* like Ermoldus Nigellus' versified description of Charlemagne's palace at Ingelheim in the time of Louis the Pious. And all these possible sources of data, and others besides, so totally ignored for centuries on end, have been consulted with the sole object of rediscovering the detailed history of European art in the centuries from the Western Roman Empire's fall to the first stirrings of the Renaissance in Italy, and with the further object of rescuing this huge, rich segment of European art history from its former condition of effective anonymity and oblivion.

Appropriately enough, the immense task of rediscovery was begun in a small way long before the nineteenth century, and by none other than Giorgio Vasari. He identified the eleventh-century architect of the Cathedral of Pisa as "Buschetto, a Greek from Dulichium," from the inscriptions on his tomb, and he noted that one of the epitaphs was a piece of Latin doggerel claiming for Buschetto the power to enable a few girls to move what could hardly be moved by a thousand oxen.[122] Evidently Buschetto's engineering skills were near-legendary; for there is also a fourteenth-century letter about the Vatican obelisk in Rome, which Buschetto was credited with raising after it had fallen. The same girls/oxen claim made in Pisa was still to be seen in Rome in the fourteenth century, inscribed on the Vatican obelisk or its base.[123]

In the seventeenth century, too, J. F. Félibien, nephew of André, inspected France's Gothic cathedrals and churches and inserted architectural data in his uncle's earlier book.[124] On the floor of Amiens Cathedral, Félibien found the names of the successive masters of the work inscribed in one of the labyrinth designs in which architect–master masons of Gothic times sometimes left a record of what they had achieved. Thus Robert de Luzarches and Thomas and Renault de Cormont were all added to the history of architecture in France.[125] At Reims, Félibien also discovered the tomb of Hugues Libergier, the architect and master mason of the now lost Church of St.-Niçaise;[126] and by similar methods, Félibien rescued a few others from oblivion.[127] Incidentally, Félibien is interesting in another way as well, because he did not altogether share Vasari's low opinion of Gothic architecture. He admired the "beauty and excellence of the work" at Amiens and was impressed by the cathedral's size, although he complained of the "too great" height of the nave in proportion to its width.[128]

In the eighteenth century, again, Horace Walpole thought of writing "a history of our architecture . . . especially of the beautiful Gothic."[129] He chose as his architect-partner James Essex, the designer of Strawberry Hill's Beauclerck Tower.[130] The plan was soon dropped, but not before Essex had assembled a considerable body of material by digging in monastic

chronicles and even in ancient archives.[131] It was only in the nineteenth century, however, that the enormous task of exhumation—for this is really the right word—was undertaken in earnest and on a broad front.

The Real Work Begins

England's prime founder of the scientific study of medieval architecture was Robert Willis, a clergyman and Cambridge don of the first half of the nineteenth century whose chief love was Gothic building.[132] He began by making significant theoretical contributions, as in his essay "On the Construction of Vaults in the Middle Ages."[133] In addition, Willis wrote a series of papers on the histories of individual English Gothic structures, and these necessarily led him to art-historical exhumation. For his study of Canterbury Cathedral,[134] for example, he drew upon the charming local record made by the monk Gervase,[135] who had also drawn upon another, earlier Canterbury ecclesiastic, Eadmer.[136] James Essex had previously made notes from Gervase,[137] but Essex's notebooks remain unpublished to this day; and it was therefore Willis who first enshrined in architectural history the names of the successive masters-of-the-work of Canterbury's choir, William of Sens and William the Englishman.[138]

Willis went no further than records like that made by Gervase, however, for he was not an archive dredger. Thus he was stumped by the identity of the designer of Canterbury's somewhat later nave. He wrote, gloomily, "the monastic writers usually enumerate the building or repair of a church . . . among the good works of their ecclesiastics, and from such disjointed hints . . . we must be content to heap together our architectural histories."[139] A bit later, others were not content. They dived straight into the unusually ample archives of the English crown, and there they found two eminent architect–master masons of the later fourteenth century, Henry Yevele[140] and Stephen Lote.[141] To these two Canterbury's nave is now confidently attributed.[142]

Ironically, this process of art-historical exhumation, as I have called it, has now gone so far that the exhumers no longer demand surviving works of art to paste their newfound names on. If we limit ourselves to the vineyard that Robert Willis was one of the first to till, there is King Henry III of England's fascination for art historians, partly because he was a major patron of the arts—he largely built Westminster Abbey as it now exists[143]—but, above all, because his court's records have come down to us with unusual fullness.

Thus it is known today that the "famous painter-monk, William of Winchester," was the author "of a certain picture at Westminster, in the wardrobe where the King was wont to wash his head, of the King who

was rescued by his dogs from . . . sedition."[144] But this interesting composition does not survive, of course; and neither does the endlessly discussed painted chamber at Westminster, rediscovered and then destroyed by fire in the early nineteenth century.[145] By now, too, the whole of Henry III's building accounts have been published[146] (and most interesting sociocultural documents they are). Thus we also know that the painter-monk William had at least one rival from abroad, "Master Peter of Spain the painter,"[147] as well as considerable domestic competition; but of Master Peter's work, yet again, no trace remains. All this is art-historical exhumation carried to its ultimate extreme. But the process, nowadays, is also carried to an extreme in the reverse direction—by the creation of artificial labels that gradually take on the guise of flesh-and-blood creators of anonymous works of art that can still be seen and studied.

One such artificial label has already been cited, Otto von Simson's "Master of Chartres Cathedral." A great many other medieval masters, late and early, like the "Master of the Bouçicaut Hours," "the Ebbo Master," and "the Egbert Master," have been rescued from anonymity by this same system. In his own time, the "Master of the Registrum Gregorii" was a creative personality of great importance,[148] but the degree to which he was remembered is revealed by the label devised for him.

Since the whole process of reconstituting centuries of art history is both significant and fascinating, it is irresistible to cite two further cases of truly triumphant art-historical exhumation. The first, being a case of archeological exhumation, belongs to a rare type. In 1837, in brief, a certain Abbé Devoucoux cleaned the plaster off the majestic Romanesque tympanum of the Cathedral of Autun. (It had been covered over, as really too hideous, about a century before the Abbé's time, and the cathedral's ancient interior had also been faced with marble.)[149] With the plaster removed from the tympanum, the Abbé Devoucoux found the inscription GISLEBERTUS HOC FECIT under the feet of the wonderful Christ within His mandorla, and just above the somber scenes of the Last Judgment.[150] Thus one of the true titans of Romanesque sculpture was locally resurrected, as it were.

His fame was then consecrated when one of the French pioneers of medieval art history, A. du Sommerard, announced the name and work of Gislebertus to a much wider audience.[151] In the next stage, in 1939, the Service des Monuments Historiques made further clean-ups and removals at Autun, including taking off the cathedral interior's eighteenth-century marble facing.[152] This disclosed the astonishing plastic power of the Romanesque column-capitals, and this disclosure raised Gislebertus even higher; for it is now generally agreed that he executed or supervised the entire sculptural program at Autun.[153] Hence he can now be referred to, in an offhand way and in a work meant for general readership, as "one

of the most famous" Romanesque sculptors.[154] Nowadays this is not unjustified, either, for a large literature is growing up about Gislebertus, so long forgotten.[155]

The Lessons of Sluter

As to the second case of exhumation, it has been chosen for three reasons: because the forgotten creator in question was so late—in fact, still alive long after the ever-remembered Donatello and Ghiberti were born in Italy; because his case also has other lessons for us; and, finally, because the creator's exhumer must hold something like a world's exhumation record to this day. In the nineteenth century in France, Comte Léon de Laborde had the advantage of countless archives never before dredged. By publishing the household accounts of the luxurious and extravagant court of the dukes of Burgundy,[156] the Comte de Laborde brought to light again a whole series of artists whose names had been lost to history; and he scored heavily in the same way with his work on artists who were employed by the French royal court.[157] All three Clouets, for example, had been conflated into "Janet," and had therefore been regarded as one artist for close on three hundred years when the Comte de Laborde went back to the original documents.[158] Yet the Comte de Laborde's most spectacular exhumation was Claus Sluter, surely one of the major European sculptors of all time.[159]

The Mourners Sluter made for the tomb of Duke Philip the Bold of Burgundy, in the Chartreuse de Champmol at Dijon, are relatively small in scale. In the much larger tomb design (started by Jean de Marville, who was first aided by Sluter in 1385),[160] the encircling mourners' procession was only one element. Yet among all the sculpture in all our American museum collections, no three pieces are more envied than Cleveland's three Sluter Mourners, which were originally lost to Dijon in the storm of the French Revolution.[161]

The case of Sluter has much to tell us. To begin with, he had considerable fame in his own day; for it must be clearly understood that just because leading masters were not posthumously *remembered*, no one should suppose that they were not contemporaneously *recognized*. On the contrary, the many records of medieval artists' journeyings, like that implied by Henry III's "Master Peter of Spain," or by the employment of William of Sens at Canterbury, indicate clearly that in both Romanesque and Gothic Europe, the best masters of each generation were widely known and often widely sought after by their contemporaries.

William of Sens, for instance, was surely called to work across the Channel, after Canterbury Cathedral had suffered a dreadful fire, because his prior work on Sens Cathedral had made such an impression;[162] and

when William of Sens fell from his scaffolding and became a hopeless invalid, William the Englishman must have been chosen to succeed him because he had already made a reputation in England.[163] And, as we know from Villard de Honnecourt's *Sketchbook*, this French thirteenth-century master-of-the-work had enough fame to be summoned to show his skill as far away as Hungary.[164] In sum, it is as wholly wrong to suppose that leading artists were anonymous and unknown figures *in their own times* in the Dark and Middle Ages as it is entirely erroneous to picture men of the Dark and Middle Ages as incapable of seeing much difference between the work of good and bad artists. The monastic chroniclers alone are enough to prove the contrary. The more prominent signatures, of course, tell the same story as the monastic chroniclers. Architect–master masons would not have been commemorated in those floor labyrinths, and Jean de Chelles's contribution to the structure of Notre Dame[165] would not have been commemorated, either, if the cathedral chapters concerned had not been proud to employ such notable masters.

To return to Claus Sluter, he was unquestionably admired in his own time in the same fashion as his highly reputed but later forgotten predecessors cited above. Sluter's sculpture not only set a style for a generation or so, to the point where the fourth Cleveland Mourner, from the later tomb of Duke John the Fearless by Antoine le Moiturier,[166] so closely resembles the three Mourners by Sluter that specialists' eyes are needed to spot the difference. In addition, Sluter enjoyed what may be called a craft remembrance which lasted at least a hundred years after his death in 1405 or 1406. About a century later another French sculptor, Michel Colombe, is found telling a patron that he wished to use the same stone that "maistre Claux" had used.[167] This is an important point to note; for although there is little surviving evidence, one cannot doubt that all the greater masters like Sluter and, indeed, Gislebertus, were regularly remembered for two or three generations, or even a bit more, within the limits of their crafts.

In his masons' lodge, for instance, Villard de Honnecourt was certainly remembered for a while, if only because his *Sketchbook* was made for his lodge brothers.[168] The *Sketchbook* was certainly used, too, for it contains additions by two masters later than Villard de Honnecourt.[169] A little later, the Parlers, and especially Peter Parler, enjoyed a long craft memory in Bohemia;[170] and of course Peter Parler was also self-commemorated by the bust of himself he included in the sculptural décor of Prague Cathedral. The question remains, however, whether such a man as Gislebertus was also more widely remembered beyond the limits of his craft because he left his signature on his great tympanum, whereas oblivion eventually engulfed Sluter because he never signed his works.

The General Cultural Memory

For this question, the answer can only be sought in literature. To see why literature aimed at general readers constitutes the real test, it is enough to perform a simple exercise. Think of the surprise it would now cause for a presumably educated man to ask, "Who the devil was Giotto?" The surprise would be comparable if the same question were asked about hundreds of other Western masters down to our own time. Or think of the surprise in the classical world if an educated man inquired, "Just who was Phidias?" and of the surprise that would still be caused in China, again among educated men, by a similar inquiry about Wu Daozi. It is from literature aimed at general readers, moreover, rather than from specialized reading of anything like art history, that most educated men of the rare art traditions have always got their memories of great masters of the past. This is why being enshrined in the general cultural memory is the true test of a remembered master.

Thus when searching for early remembered masters, one must first exclude the archives and other non- and quasi-literature that the art-historical exhumers have made their special province. Being mentioned in a set of building accounts is not being remembered. One must exclude, too, the "monkish chronicles" like that of Gervase of Canterbury, for these were solely intended for local consumption, chiefly within the foundations that were their prime subjects, and their main emphasis, almost invariably, was on the "good works of their ecclesiastics," as Robert Willis lamented. Artists and craftsmen employed by these ecclesiastics were only mentioned in passing, if often with admiration, by the monastic chroniclers. Matthew Paris, in his chronicle of his Abbey of St. Albans, was really alone in giving artists equal prominence with the patrons;[171] and Matthew Paris was an artist himself.

Yet the main reason for excluding the monastic chroniclers is that they did not, indeed could not, have the effect of adding the names of any artists they happened to mention to the general cultural memory of succeeding generations beyond the walls of the foundations their chronicles were written for. The same holds true for the great artists remembered strictly locally as the makers of works that were the prides of the institutions they belonged to. We should know nothing about Godefroid de Huy, if it were not for a century-later enlargement of the Necrology of the Monastery of Neufmoutiers,[172] in which Godefroid is described as a goldsmith "second to no one in his time."[173] It was this, mainly, that permitted modern scholars to identify Godefroid with a certain "G," with whom Abbot Wibald of Stavelot exchanged letters.[174] There is also the

case of Nicholas of Verdun. His "altar" at Klosterneuberg was originally a remarkably rich ambo, and when it was converted for use on the altar, this fact was recorded in the thirteenth century—with a record of the further facts that the maker was Nicholas of Verdun and the man who commissioned this great work was Gwernharus, in short Prior Wernher.[175]

Borderline Cases

If one turns to works written for a general audience, however, the silence about individual artists becomes almost total. There are the artist-saints, of course, like St. Eligius and St. Bernward, who were always remembered—but as saints. There are one or two artists whose names were associated with miracles, like Tuotilo of St.-Gall. He was a famous craftsman of his day; his services were in wide contemporary demand; and he was long remembered in the great Monastery of St.-Gall—yet one wonders whether his memory would have lasted so long if he had not achieved a kind of local sainthood by sharing in a supposed miracle[176] performed by the Virgin Mary. Moreover, Tuotilo certainly had no permanent fame beyond the confines of St.-Gall's narrow canton, for all that is known of him is to be found in the chronicle written by the fourth Ekkehard of St.-Gall.[177]

There are one or two more borderline cases, like the artist John, an Italian employed by the Emperor Otto III. He was mentioned in an obscure life of an Italian bishop[178] and just may have been the same man now known as the "Master of the Registrum Gregorii."[179] And, finally, there are the two architect–master masons mentioned in the twelfth-century guidebook compiled for the pilgrims wishing to visit the famous shrine of Santiago de Compostela in northern Spain. They turn up almost as afterthoughts, when due attention has been given to a perfect swarm of magnate-patrons; but there they are. The men "who first labored at the building of the basilica of the Blessed James were named Bernard the elder, a builder of genius, and Robert, who, with about fifty other masons, worked assiduously at it under the very faithful administration of Lord Wicartus, the Canon Lord Seferedus, and the Abbot Lord Gundesindus in the reign of Alfonso, King of Spain. . . ."[180]

Hard as it may seem to believe, this guidebook mention of Bernard and Robert comes closer than anything else in the record of the Dark and Middle Ages to the countless commemorations of great and remembered masters of art in the literature of classical antiquity, of the second era of Chinese art, and of the West beginning in Italy in the fourteenth century.

Taken all in all, the laborious reconstitution of the art history of Europe in the centuries in question has been an epoch-making feat. The work

has gone so far that the names of about thirteen hundred medieval architectural craftsmen are now known for England alone,[181] and for France, more than two hundred master masons.[182] Add all that has been learned about architectural craftsmen in other regions of Europe. Add, too, goldsmiths and other metalworkers, painters and illuminators, and craftsmen of other types, and you now have an impressively long honor roll of medieval artists' names. Furthermore, the names on the honor roll are the framework on which much of this vital segment of reconstituted art history hangs today. Yet the reconstitution is curiously deceptive, as already suggested; for it leads anyone in the least unsuspecting to assume that the people of medieval Europe remembered their own masters as we do, and also thought about art and artists much as we do. In fact, however, artists were not remembered, at any rate in the special sense that is important to this essay; and it cannot be too strongly underlined that in reality, medieval ways of thinking about and responding to art and artists were quite different from our ways.

A Reminder, a Last Problem

To the foregoing, it is only necessary to add a reminder, plus the suggested solution of one last troubling but minor problem, and the ground will be cleared to go forward. The reminder is simple. It must be repeated again that just because there is no evidence that medieval Europeans long remembered their own masters of earlier generations or responded to art historically, this must *not* be taken as implying anything invidious. The presence or absence of the historical response to art has no bearing on the strength or weakness of the esthetic response or the power to create great works of art. In the Athens of Pericles, Greek masters of the past were already remembered, as Italian masters certainly were in Florence in the fifteenth century; while in Chartres, when the marvelous new cathedral went up, the memories of great masters were held so unimportant, or at least so beside the point, that it is impossible today to identify the greatest of all the medieval architect–master masons, who must therefore be referred to as "the Master of Chartres Cathedral." Yet who is fool enough, nowadays, to argue that the Parthenon and Chartres are anything but two incomparable triumphs of human genius, between which comparisons of excellence are entirely fruitless?

Nor is this the end of the matter. A few art traditions have been classed together as "rare" in this essay, because they have a series of significant similarities despite their wide differences, and because just these similarities set the rare art traditions apart from all the many other traditions the world has known since art began. But this is not intended to imply, and must not be taken to imply, a claim that the rare art traditions have

been more fruitful in masterpieces of art than many other major art tradi-
tions of the past. As subjects of study, the rare art traditions are perhaps
extra-interesting because their development has extra dimensions of com-
plexity—but complexity is no proof of superiority. Not the least pleasing
aspect of the strange situation of the arts in the later twentieth century
is the way all of us are now offered the products of so many great arts
of the past to choose from, in a way that was unknown in the earlier
history of art. And this choice today is not only wonderfully wide; it is
also an entirely free choice.

With the record set straight by the reminder just offered, the last
troublesome problem arising from the absence of truly remembered medi-
eval masters may also be tackled. The problem arises because there was
a borderline period in European art, when some great masters were always
remembered, and other, nearly contemporary masters were consigned to
oblivion. Claus Sluter's lifetime overlapped extensively with that of Jan
van Eyck, ever-remembered, and furthermore Sluter was much later in
date than Giotto, also ever-remembered. It is not quite enough to say,
either, that Sluter did not enter the general cultural memory because he
received no early mention in European literature aimed for the general
reader. Another master north of the Alps, later than those already covered,
the French court-painter André Beauneveu, was honored by mentions in
a far more important work than any of the earliest northern works which
mention Van Eyck.[183] Beauneveu was praised at some length in Froissart's
Chronicles,[184] and he was described as being in the service of Jean, Duc
de Berry.[185] Yet Beauneveu did not enter what has been called the general
cultural memory, either of France or of Europe, any more than Claus
Sluter did, whereas Van Eyck unquestionably did so.

The logical way out of this dilemma probably lies in the fact that
Van Eyck was known and admired in Italy from a date within his own
working lifetime, whereas Sluter and Beauneveu were not so known. The
same rule perhaps explains the cases of still later artists north of the Alps,
like the Clouets, who were also more or less forgotten as individual creators.
By the Clouets' time, some Italians were no doubt familiar with their
work; yet the Clouets had become "Janet" rather than being separately
remembered; Italians were the principal keepers of the modern Western
art tradition's list of remembered masters throughout the Renaissance and
for a while thereafter.[186]

At this point, sharp-minded readers may well be murmuring about
overly selective use of the word "remembered." After all, why should
one not class as "remembered" Tuotilo, reverently remembered at St.-
Gall; or the artists of St. Albans who were so much admired by Matthew
Paris; or Beauneveu, mentioned in Froissart; or even the Emperor Otto's
painter John? I repeat, therefore, that truly remembered masters have al-

ready been defined as the leading masters of each generation who are permanently fixed in the general cultural memory. You can see what is meant by the general cultural memory if you simply repeat the test already proposed, of asking yourself about the resulting degree of surprise if a presumably educated man asked, "Who the devil was Giotto?" Even today, only specialists are likely to be able to say anything with accuracy about the work of André Beauneveu, whereas any person with much pretense to education can recite on Cimabue and Giotto, and indeed on scores or even hundreds of other Italian and other Western artists from Giotto's time onward.

This problem of remembered masters in truth creates one of the first sharp breaks between European art from the beginning of the Dark Ages until near the end of the thirteenth century, and the subsequent art of Europe, beginning in Italy. If style is the only test, there is no doubt that the Renaissance only began toward the opening of the fifteenth century. But if the tests are the rebirth of the lost habit of remembering the masters of the past, plus certain other striking symptoms of new ways of thinking about art, then the onset of the Renaissance occurred toward the opening of the fourteenth century. This is venturesome to say nowadays, yet only consider the evidence, which is first provided by no less a genius than Dante, and in no less a work than the *Divina Commedia*.

The First Remembered Masters

In all of Western European writing before Dante, there is nothing that even vaguely resembles the passage in the *Purgatorio* magnificently proclaiming—at least by implication—that great artists were now to be enshrined in the general cultural memory on a par with great rulers and great sinners, great saints, great statesmen, and great warriors. The passage concerns the sin of pride, and Dante's speaker is Oderisi of Gubbio, an Italian illuminator famous in his day, but less famous and successful than his rival, Franco da Bologna. In the course of his visit to Purgatory, Dante encounters and addresses Oderisi:

> "Aren't you Od'risi?" I said. "He who was known
> as the honor of Agobbio, and of that art
> Parisians call *illumination?*"

> "Brother," he said, "what pages truly shine
> are Franco Bolognese's. The real honor
> is all his now, and only partly mine.

> "While I was living, I know very well
> I never would have granted him first place,
> so great was my heart's yearning to excel.

"Here pride is paid for. Nor would I have been
among these souls,[187] had I not turned to God
while I still had in me the power to sin.

"O gifted men, vainglorious for first place,
how short a time the laurel crown stays green
unless the age that follows lacks all grace!

"Once Cimabue thought to hold the field
in painting, and now Giotto has the cry
so that the other's fame, grown dim, must yield."[188]

The Fourteenth-Century Change

Thus Cimabue and Giotto, precisely the masters credited by Giorgio Vasari with Italian painting's rebirth, also became the first truly remembered masters of Western Europe. Dante's break with past practices and precedents was so dramatic that Roberto Longhi has described his hero, perhaps a mite extravagantly, as founding, "with this sentence, and in the very center of his poem, our critique of art"; and he has further saluted Dante's "supremely authoritative entrance into the *Musée Imaginaire* of art criticism."[189]

Significantly, Dante's commemoration of mere painters was such a noticeable new departure that it caused discernible disquiet in his own time. The reason was quite plainly the one touched upon in the previous chapter, that commemorating artists amounted to treating them as historical personages, and artists were not held to be important enough to figure in history (and therefore in serious poetry), since history was the proper preserve of the great, the rich, the warlike, the noble, the saintly, and, at least in a measure, the learned. These more conservative ideas can be read between the lines in the *Ottimo commento*, and are all but overtly stated in the other principal fourteenth-century commentary on Dante by Benvenuto Rambaldi da Imola.

In the section of the *Purgatorio* devoted to pride, Dante deals first with the great and noble who had sinned by pride. The unknown author of the *Ottimo commento* therefore remarked that by Dante's decision to include artists as well as these noble persons, "he shows how pride does not proceed in mortals only from ancient blood and brave deeds in war, and elegant manners, but also from excellence in the mechanic arts. . . . Do not be surprised, O reader, if the author places these artisans of the mechanic arts in the spheres of honor and fame."[190] The commentator then excused Dante by reaching far back in time for a precedent, which he found in the Latin writer of the early empire Valerius Maximus. As for Benvenuto da Imola, he was still more specific and still more obviously doubtful whether mere painters had a proper place in great poetry.

But Dante was his hero and had to be defended, as follows:

"Do not marvel here if Dante names persons who are not of noble birth, since pride is felt in the lowest classes, and especially in the artists' class, more so than among the noble and high born: painters and sculptors are a proof of this, and almost all write or engrave or sculpt their names on their works."[191]

In short, Benvenuto da Imola even regarded artists' signatures on their works as proofs of sinful pride. What he has to say about this is interesting in itself, because of the plain hint that artists' signing, the second trait peculiar to the rare art traditions, was considerably more common in four-teenth-century Italy than is now supposed. In that century, Italian illuminators unquestionably took to signing their works with much greater regularity.[192] But this is a thorny problem, needing expert exploration.

In any case, the main point is that the new ways of thinking about art and artists implied by the quoted passage in the *Purgatorio* had come to stay in Italy. Old-fashioned persons might "marvel" and demand the explanations supplied by Dante's commentators, but from Dante's time onward, artists figured regularly in the works of Italian poets, other writers, and even historians of the fourteenth century. Giotto naturally figured particularly prominently, and was almost treated as an old master before he died, just as Picasso was. The minor poet Cecco d'Ascoli gave some lines to him in *L'acerba,* around 1330, or a few years before Giotto's death, in 1337.[193] Boccaccio's posthumous eulogy of Giotto has already been touched upon, but at this point may be worth quoting in full:

> . . . Giotto was a man of such outstanding genius that there was nothing in the whole of creation that he could not depict with his stylus, pen, or brush. And so faithful did he remain to Nature (who is the mother and the motive force of all created things, via the constant rotation of the heavens), that whatever he depicted had the appearance, not of a repro-duction, but of the thing itself, so that one very often finds, with the works of Giotto, that people's eyes are deceived and they mistake the picture for the real thing.
>
> Hence, by virtue of the fact that he brought back to light an art which had been buried for centuries beneath the blunders of those who, in their paintings, aimed to bring visual delight to the ignorant rather than intellec-tual satisfaction to the wise, his work may justly be regarded as a shining monument to the glory of Florence. And all the more so, inasmuch as he set an example to others by wearing his celebrity with the utmost modesty. . . .[194]

There is much of interest in this passage, such as the elitist approach to art behind the scornful reference to the "ignorant," and the feeling that some sort of revival of classical art was already in progress in the mid-fourteenth century, so plainly revealed by the reference to the "art

that had lain buried for centuries." Modern theorists find it hard to believe that Giotto's near-contemporaries saw his painting as a return to the lost art of the classical past. Vasari himself, four hundred years ago, must have found it hard to believe that a man like Boccaccio could have regarded works by Giotto as miraculously accurate representations of reality. But one must still take Boccaccio's word for it that these were the views held by intelligent people of his own time.

A few words are in order, too, about the division between those who know and those who know nothing behind that phrase, "the ignorant." You find it again in Petrarch, as already briefly noted. When he was making a will, Petrarch felt he had to leave something to his last patron, Francesco da Carrara, which meant solving the familiar problem of what to give someone who has everything already. Hence Petrarch included in his will a clause full of meanings:

"To my magnificent Lord of Padua, since he by God's grace lacks nothing, and I have nothing worthy of him, I pass on my picture or icon of the Blessed Virgin Mary, a work of the eminent painter Giotto, which was sent to me by my friend Michele di Vanni of Florence, the beauty of which the ignorant do not understand. I leave this image to the same Magnificent Lord. . . ."[195]

None can fail to be struck by the recurrence of that term, "the ignorant." The truth is that still another peculiarity of the rare art traditions seems to be a split in the way of seeing between those who know and those who know nothing. This elite-versus-philistine split is glaringly apparent today. But so far as one can see, it has always been there, at least in some degree, in all of the rare art traditions; whereas one can find no evidence for such a split beyond the rare art traditions' limits. The Palatine Chapel, for example, must have been regarded as an astonishing novelty by most people of the region of Aachen who saw the chapel in Charlemagne's time. Yet instead of being shocked by the Palatine Chapel's novelty, one may be sure all were delighted by its richness, splendor, and grandeur. Any work outstanding for any one of these qualities seems to have been automatically admired in any of the art traditions of the majority group—the richness, the splendor, or the grandeur, as the case might be, always being comparative with what was known already, of course. What is called "taste," meanwhile, seems to be yet another peculiar feature of the rare art traditions, no doubt because "taste" is necessarily always comparative and therefore demands some degree of historical response to art.

Artists' New Standing

The main point to note, meanwhile, is that Boccaccio conspicuously regarded Giotto, not merely as a great artist, but as a great man in his

own right, with no nonsense about "the lowest classes." Nor was this view of great artists' worth by any means limited to Boccaccio. Giotto's appointment as overlord of all the work on Florence's Duomo, made three years before the master died, was prominently noticed by Giovanni Villani in the first of the three Villani chronicles of Florence.[196] Nor was Villani the only historian to give Giotto the standing of a significant historical figure. Riccobaldo Ferrarese wrote his chronicle of the early fourteenth century when Giotto had nearly two decades of life ahead of him. And in this chronicle, the master is described as *"pictor eximius Florentinus,"* and his frescoes at Assisi, Rimini, and Padua are recorded.[197]

Other artists were not overlooked, either. Petrarch had made friends with Simone Martini in his Avignon days, and wrote three sonnets in which Simone is a key figure,[198] besides getting him to do a miniature for the first page of his favorite copy of Virgil.[199] For an eminent and learned man of letters to call a mere artist *"il mio Simon"* in his published writings, as Petrarch did, would have been unthinkable a hundred years earlier. Then, too, one of the *Novelle* of Franco Sacchetti turns on a question he put in the mouth of the painter Orcagna. Besides Giotto, the question is, who was the greatest master of painting? Was he Cimabue, or Stefano, or Bernardo, or Buffalmacco, or some other, such as Taddeo Gaddi? Orcagna's question starts a debate among the artists present. The sculptor Alberto di Arnoldo is tentatively suggested, but the debate ends in laughing agreement that the greatest masters of art are the ladies of Florence, because they paint their faces and thus improve upon the handiwork of God Himself.[200] Yet the mere fact of such a question being posed and debated among known artists in such a work as Sacchetti's would again have been unheard of in the Middle Ages.

There is evidence, as well, that these and other mentions of artists by Italian fourteenth-century authors, including Sacchetti—for the list is too long to be given exhaustively here—betoken something even more symptomatic and equally unrecorded in earlier centuries: in fact the same kind of enduring *popular* remembrance of great artists in fourteenth-century Italy as is indicated in Mime IV of Herodas in the Greek world of the third century B.C. Toward the end of the fourteenth century we find the Prato merchant Francesco di Marco Datini, certainly not a richly cultivated man, grumbling crossly that "even Giotto" would not have cost him so much as the contemporary painters he had commissioned to decorate the main rooms of his house.[201] In the same fashion but a few years later, a cautious, narrow-minded Florentine merchant, Giovanni di Pagolo Morelli, boasted in his *Ricordi* that his sister Mea's hands were so "well made" that they seemed to have been "painted by Giotto himself."[202] In other words, Giotto was a common byword for artistic excellence for generations after his death.

Nor was the habit of remembering leading masters the sole indication of a revived historical response to art in fourteenth-century Italy. In the next stage, in fact, art history was directly prefigured, and again in a way previously unknown in post-Roman Europe. In the late fourteenth century, Cennino Cennini composed his *Libro dell'arte*, a particularly comprehensive and instructive craftsmen's handbook for painters.[203] Much has been written about Cennino's work; but far from enough emphasis has been placed on the sheer newness of concept inherent in the author's own artistic genealogy in the preface, which Cennino began with Giotto, continued through Taddeo and Agnolo Gaddi, and ended with his own training under Agnolo.[204] In the late fourteenth century, too, Filippo Villani included in the last of the Villani family's writings about Florence a chronological list of Florentine masters beginning with Cimabue and Giotto.[205] As Michael Baxandall has pointed out, Filippo Villani's treatment of art's development in Florence throughout the fourteenth century was not marked by much originality of thought.[206] Yet what he wrote was still remarkably original in quite another way, as the earliest attempt to offer a connected account of this kind of artistic development in any European historical work since classical times.

The account is extremely summary, indeed sketchy. Yet the introduction is of great interest, because it so clearly implies that some people still held the old view that mere artists had no right to a place in history. And the discussions of Giotto and Cimabue are of even greater interest, for their proof that Vasari's opinion about art's "rebirth" in Italy was held by intelligent Italians long, long before the first Western art historian's time. Thus a good deal is worth quoting:

> The ancients, who wrote admirable records of events, included in their books the best painters and sculptors of images and statues along with other famous men. . . . These most wise men thought, so I infer, that imitators of nature who endeavoured to fashion likenesses of men from stone and bronze could not be unendowed with noble talent and exceptional memory, and with much delightful skill of hand. For this reason, along with the other distinguished men in their annals they put Zeuxis . . . Phidias, Praxiteles, Myron, Apelles of Cos . . . and others distinguished in this sort of skill. So let it be proper for me, *with the mockers' leave* [italics added], to introduce here the excellent Florentine painters, men who have rekindled an art that was pale and almost extinguished.
>
> First among whom John, whose surname was Cimabue, summoned back with skill and talent the decayed art of painting, wantonly straying far from the likeness of nature as this was, since for many centuries previously Greek and Latin[207] painting had been subject to the ministrations of but clumsy skills, as the figures and images we see decorating the churches of the Saints, both on panels and on walls, clearly show.
>
> After John, the road to new things now lying open, Giotto—who is

not only by virtue of his great fame to be compared with the ancient painters, but is even to be preferred to them for skill and talent—restored painting to its former worth and great reputation. For images formed by his brush agree so well with the lineaments of nature as to seem to the beholder to live and breathe; and his pictures appear to perform actions and movements so exactly as to seem from a little way off actually speaking, weeping, rejoicing, and doing other things, not without pleasure for him who beholds and praises the talent and skill of the artist. Many people judge—and not foolishly indeed—that painters are of a talent no lower than those whom the liberal arts have rendered *magistri*, since these latter may learn by means of study and instruction written rules of their arts while the painters derive such rules as they find in their art only from a profound natural talent and a tenacious memory. Yet Giotto was a man of great understanding even apart from the art of painting, and one who had experience in many things. Besides having a full knowledge of history, he showed himself so far a rival of poetry that keen judges consider he painted what most poets represent in words.[208] He was also, as was proper to a most prudent man, anxious for fame rather than gain. Thus, with the desire of making his name widely known, he painted something in prominent places in almost every famous city in Italy, and at Rome particularly in the atrium of the Basilica of St. Peter, where he represented most skillfully in mosaic the Apostles in peril in the boat, so as to make a public demonstration of his skill and power to the whole world that flocks to the city. . . .

As from a most copious and pure spring glittering brooklets of painting flowed from this admirable man and brought about an art of painting that was once more a zealous imitator of nature, splendid and pleasing.[209]

This passage in Filippo Villani's work is as far removed from anything written about art in any historical work of the Dark and Middle Ages as the passage in Dante is removed from any previous mention of individual artists in European literature. The before-and-after contrast with the past is downright dramatic, in truth.

The contrast means that a way of thinking about art and artists had begun to appear that was entirely different from the earlier way of medieval Western Europe. Interestingly enough, the impulse toward this new way of thinking seems to have been felt, not just in fourteenth-century Italy, but also in Europe beyond the Alps, although here it was plainly a pretty dim and abortive impulse. One indicator of such a change of impulse beyond the Alps was the already mentioned notice of André Beauneveu in Froissart. Another indicator is the fact that the master illuminator of Paris, Jean Pucelle, was both remembered after his death as a great artist and sought after by at least one French fourteenth-century collector—both unheard-of departures from medieval European practice.[210] Yet the fact remains that the impulse toward new ways of thinking about art

was immensely stronger in Italy and produced its real results in the Italian peninsula, where the fourteenth-century contrast with the medieval past was evident in other ways that have not yet been covered.

Meanwhile, one asks, why this contrast? One asks, too, why a most complex, wholly novel behavioral system having to do with art developed mysteriously in Greece, and why a schematically identical system later developed in China. These are questions which cannot be answered with assurance, but a possible answer will be offered with due tentativeness.

THE DEVELOPED HISTORICAL SENSE

A personal confession is now in order. It has taken nearly twenty years[1] to assemble, analyze, and set down in rational order the facts presented thus far in this essay and those to be presented hereafter. Yet the main factual outlines have been clear in my mind for nearly half a decade, and ever since then I have been puzzling over the central mystery which the facts so obviously make it desirable to solve.

There are certain questions, of course, which it is positively desirable to forget about, for the excellent reason that they can never be finally answered. Surely, for example, it is fruitless to ask for the deep causes of either the creative mutation in Greece in the seventh century B.C., or of the first predictive stirrings of the Renaissance in Italy in the fourteenth century. Any sensible man or woman knows something big began to happen in both cases. Why it began to happen is also a problem that has engaged a great many intelligent and learned persons. Yet no fully satisfactory explanation has ever been offered.

For a long time, I believed that the question I am about to tackle was in the same unanswerable category as: "Why was there a Renaissance?" Now I am not so sure that this is true, but, equally, I am far from sure that I have got the right answer to the question. In any case, the extreme tentativeness of the proposed answer must be plainly advertised—the real motive for being so personal—before anything further is said on the subject. As to the question, it is the one about the rare art traditions that a fair number of readers must have much on their minds by now:

"Why these five art traditions, and not all those countless others?"

Nothing, after all, could be more bewildering than the developments already described. First, a wholly unprecedented, highly complex behavioral system appeared in the classical art tradition that was born in Greece. Next, and again without precedent, the same thing happened in the second

era of Chinese art—despite the countless dissimilarities of Greek and Chinese art and culture. Nor is this all. How the pattern was exported from China to Japan is not hard to understand, but one cannot forget the pattern's partial recurrence in later Islamic art, or its full recurrence in Western Europe beginning in the proto-Renaissance in Italy.

Yet this series of schematically identical developments in dramatically diverse cultures is far from the only source of bewilderment. There is the way this behavioral system effectively vanished from Western Europe for hundreds of years after being long established and well known there in Roman times; and there is the further fact that no trace of the system can be found in a long series of other great art traditions, all richly creative, all capable of grandeur, and all nourished by higher civilizations which flourished for long periods. In sum, the question "Why these five art traditions, and not all those countless others?" is both insistent and goes deep.

The only possible approach to a solution—or at least the only approach I can think of—is to examine the nourishing cultures of all five rare art traditions. Begin by looking for elements that were common to the classical culture that originated in Greece, the culture of China after the foundation of the empire, the culture of Japan beginning in the seventh century A.D., later Islamic culture, and Western culture beginning in Italy in the proto-Renaissance. Despite their immense diversity, these five cultures had several common elements. An emphasis on literacy is one; a tendency to imperialism is another. However, the need is for an element that was common to all five cultures which nourished the rare art traditions, yet was conspicuously absent from all other higher civilizations the world has known. Surprisingly enough, there *is* one such element. The nourishing cultures of the five rare art traditions have alone shown evidence of what may be called *a developed historical sense*, for want of a better phrase.

The crucial word is "developed." Most human societies above the subsistence level have manifestly possessed some sort of historical sense. Ancestor lists have been recited or written down. Legends of the past have been preserved and passed on. The Incas, who were preliterate, nonetheless kept fairly elaborate annals. Some believe they were somehow aided by the *quipus*, a mnemonic device made of differently knotted, differently colored strings, which was more normally used for recording counts of various kinds, such as tallies of tribute. Written annals have been kept by almost all literate cultures, all over the world; and so far as one can tell, all higher civilizations have also accumulated archives of one sort or another. In the majority of higher civilizations, too, chroniclers have gone beyond the annalists, to give a richer and more human life to their chronicles. Yet none of these productions evince what is meant by a developed historical sense.

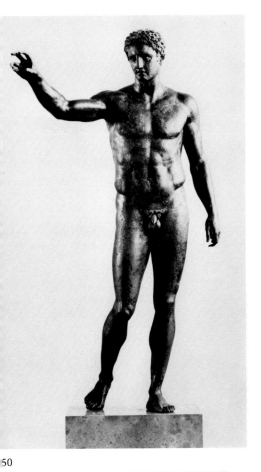

50

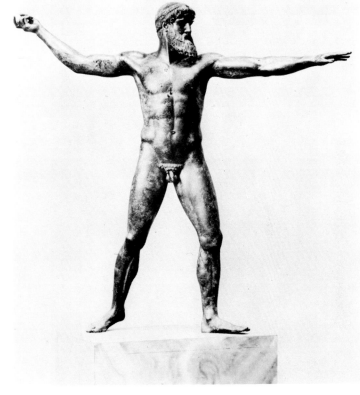

51

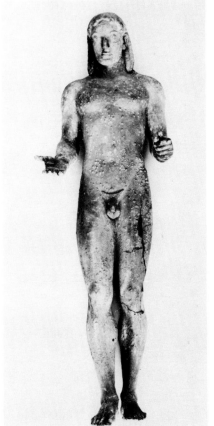

52

50. The Anticythera Youth, *Athens, National Archaeological Museum*

51. *Calamis:* Poseidon/Zeus, *Athens, National Archaeological Museum*

52. *Piraeus:* Apollo, *Athens, National Archaeological Museum*

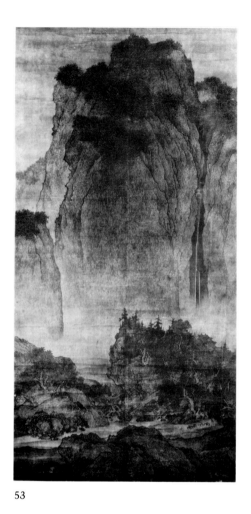

53

54

53. *Fan K'uan:* Traveling Among Streams and Mountains,
Taichung, National Palace Museum Collection

54. *Ku K'ai-Chih:* A Lady and Her Husband,
London, British Museum

55. *Ni Tsan:* Woods and Valleys of Yü-Shan, 1372,
*Gift of the Metropolitan Museum of Art, New York,
Dillon Fund, 1973*

55

56. *Kaigetsudo Ando:* Figure of a Courtesan, *Washington, D.C.,
Freer Gallery of Art, Smithsonian Institution*

57. Emperor Shah Jahan, Album Leaf, *Baltimore,
Walters Art Gallery*

58. Fang Ding, 16th-14th century B.C., *Beijing, Cultural Relics
Publishing House*

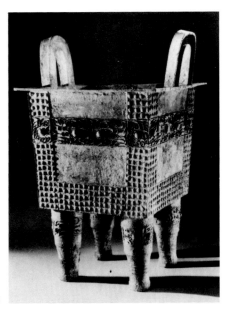

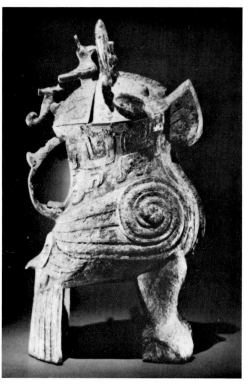

59

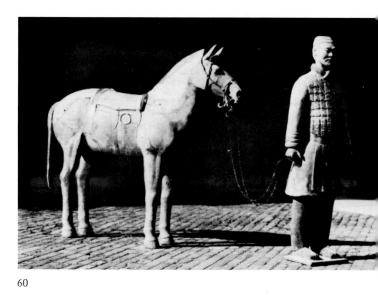

60

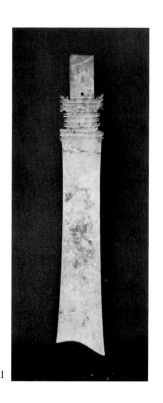

61

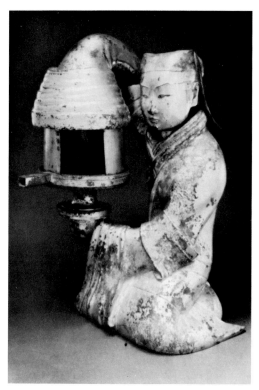

62

59. Bird-shaped Zun, 13th-11th century, B.C., *Beijing, Cultural Relics Publishing House*

60. Cavalryman & Saddle Horse, 220–206 B.C., *Beijing, Cultural Relics Publishing House*

61. Nineteen-inch Jade Blade, 2000–1500 B.C., *Cultural Office of Henan Yanshi Xian*

62. Gilt Bronze Lamp, 1st half 2nd century B.C., *Beijing, Cultural Relics Publishing House*

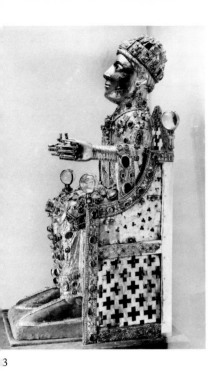

3

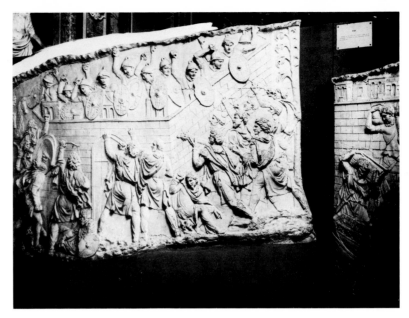

64

63. Majesté de Ste. Foy, *Conques, Cathedral Treasury*

64. Trajan's Column—Detail, *Rome*

65. Tympanum, *Autun Cathedral*

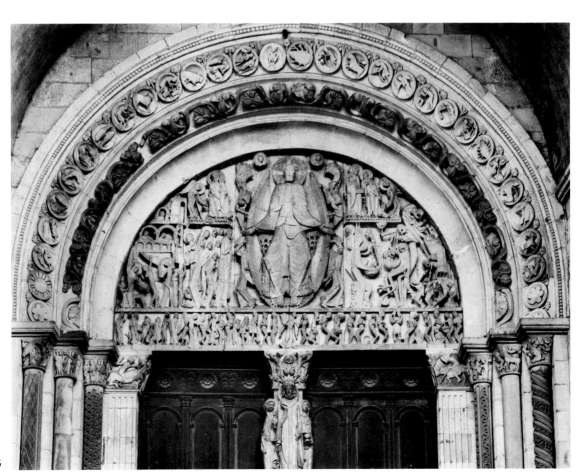

65

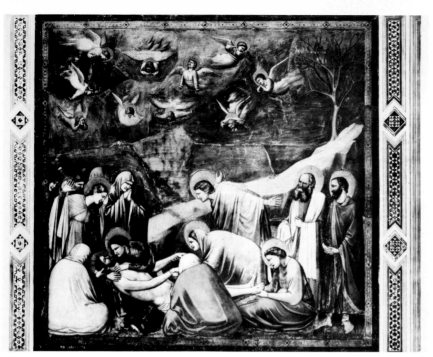

66

66. *Giotto di Bondone:* The Lamentation,
 Padua, Arena Chapel

67. Chartres Cathedral, West Portal,
 Jamb Figures

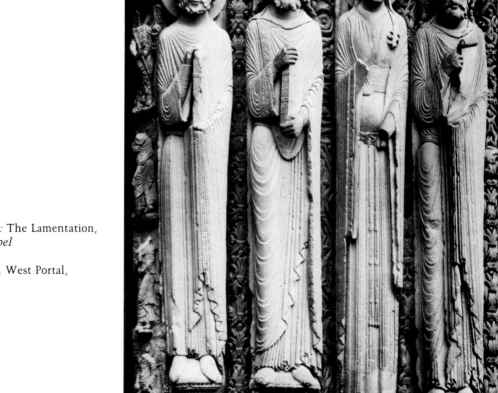

67

68. Porta della Mandorla,
 Florence, Cathedral

69. *Ghiberti:* The Sacrifice of Isaac,
 Rome, National Museum

70. *Ghiberti:* Self-Portrait,
 Florence, Baptistery

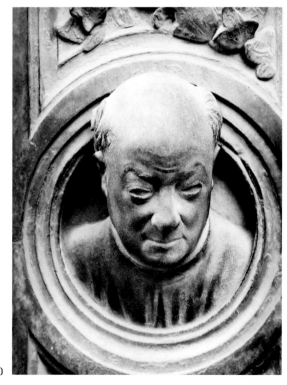

69 70

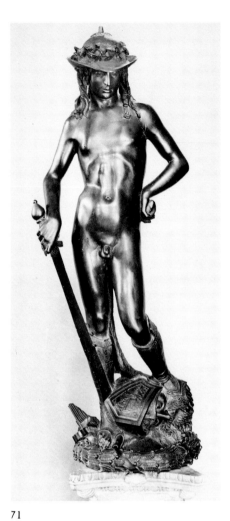

71

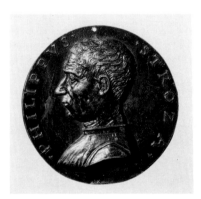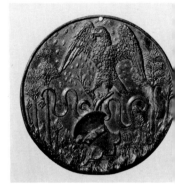

72

71. *Donatello:* David, *Florence, National Museum*

72. *Manner of Fiorentino:* Filippo Strozzi, *Washington, D.C., Natior Gallery of Art, Samuel H. Kress Collection*

73. *Filippino Lippi:* Strozzi Chapel, St. Philip Exorcising the Demon, *Florence, S. M. Novella*

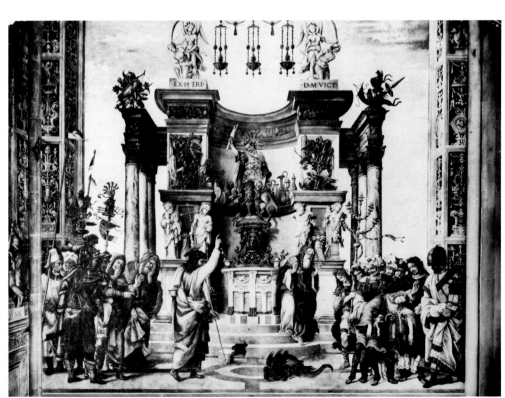

73

To see what that phrase means, it is best to turn to the work of the real founder of modern historiography, Eduard Fueter. In his *Geschichte der neueren Historiographie*, Fueter named the Italian humanists of the fourteenth and fifteenth centuries as the true founders of Western historical writing.[2] Petrarch and those who came after him struck Fueter as different in an absolute sense from the medieval annalists and chroniclers;[3] and he held that they prepared the way for Machiavelli and Guicciardini in the sixteenth century. These two, and especially Guicciardini, were in effect saluted by Fueter as the first full-fledged proto-modern historians.[4]

Perhaps this is too black-on-white. Perhaps what may be called narrative history should be given an intermediate place between annals and chronicles, on the one hand, and on the other, the kind of analytic history that began in Europe in the sixteenth century according to Fueter. For the Venerable Bede God was omnipresent, to be sure, and Fueter objected strongly to the appearance of the Divine Will as a force in history. Yet it would be foolish to deny that the Venerable Bede wrote narrative history of a high order. Again, Snorri Sturluson was a believing Christian, yet he sensibly regarded skillful leadership, military might and the ability to gather and hold together superior armed forces as the really controlling factors in the history of his part of the world. When the events in Norway that Snorri recounts emerge from the murk of legend, furthermore, the *Heimskringla* becomes a most memorable historical narrative. As straight historical narrative, indeed, the account of the stormy reign of St. Olaf is unsurpassed anywhere. Yet even Snorri and the Venerable Bede do not meet the tests laid down by Fueter.

It is needless to summarize all the tests which Fueter laid down, such as a secular approach to historical writing, consultation of sources, and so on. It is simplest to say (although this is putting words in Fueter's mouth) that even if no fabulous or legendary materials are included, annals and chronicles are about who did what, when and where, as is purely narrative history, while developed history is concerned with the how and the why, the circumstances and the ultimate consequences of events. As Fueter remarked in his discussion of Machiavelli, the true historian must recognize "great historical connections," and fit "individual facts into larger developments."[5] Putting it another way, merely recording events and telling stories, as is the habit of annalists and chroniclers, is inherently different from studying and writing about history as process.

If you survey the total of historical works from all the societies of the past that have come down to our own time, you find that those undeniably concerned with history as process are surprisingly and most significantly restricted. There are the great Greek historians, Herodotus, Thucydides, and Polybius, and the great Latins, Livy, Sallust, Tacitus, and Ammianus Marcellinus, with another Greek, Procopius, at the end of the line. There are the great Chinese, beginning with Sima Qian in the second

century B.C.[6] There are those Japanese who followed Chinese models. Scholars hold that Japanese analysis of history as process began with the untranslated thirteenth-century *Gukanshō* by the Buddhist Abbot Jien;[7] and it further seems to me there is even much astute historical analysis in the interstices between the tales of warriors in that amazing work, also somewhat tenuously connected with the Abbot Jien, the *Heike Monogatari*.[8] This, in fact, is a suprisingly perceptive and intelligible account of a tremendous political change in Japan, the final loss of real power by the Kyoto aristocracy. In later Islam, there is Ibn Khaldūn, with his marvelous *Muqaddimah*,[9] and there are the many Western writers covered by Fueter, beginning with the Italian humanists of the fourteenth century. Yet beyond the limits of the five cultures that produced the writers just listed, you cannot easily name any surviving work written anywhere on earth which was seriously concerned with history as process. Or at least you could find none before worldwide cultural homogenization; for many societies have true historians today.

Assume (at least for the sake of argument) that this summary and its underlying distinctions are correct and sound. Inevitably, then, it follows that the five nourishing cultures of the five rare art traditions had in common the developed historical sense, whereas this somewhat intangible but important element was either absent or markedly weak in all other cultures, however complex and successful.

Here, or so I believe, is the possible, although far from certain, answer to the question asked a little earlier. Remember, first, that all the art traditions which have produced art collecting and some or all of the other by-products of art have had the peculiarity of responding to art historically as well as esthetically. Remember, second, that this double response to art, historical as well as esthetic, cannot be found in any other art tradition beyond the limits of the rare group, unless in a form so diluted as to have little meaning.

More and more, therefore, the historical response to art appears to be the key that unlocks the mystery and solves the problem, at any rate in some measure. For it can hardly be an accident that this historical response to art has been restricted to just five art traditions, each of which was nourished, in turn, by one of the five cultures that alone showed real evidence of a developed historical sense.

I must emphasize again that this answer to the central question is strictly tentative; and I must confess, too, that it seems to me lamentably misty—if that is the right word. It is easy to demonstrate that the five rare art traditions were distinguished by their historical response to art. All remembered their own masters. All had the habit of attributing works of art of the past to this master or that. All produced some sort of art history. And all have valued particularly highly works of art by the famous

early masters who came to be considered canonical. Nor are these features
to be found in any other art traditions, except in a most ghostly way as
in medieval Europe.

Again, the "developed historical sense" may be an entirely arbitrary
phrase, but it refers to a demonstrable fact. The Venerable Bede, for in-
stance, was a giant in his time; but no commonsense person will deny
that Bede's historical writing, for all its value, really does differ in kind
from the European historical writing which had its roots in the work of
the fourteenth-century Italian humanists, then reached its first maturity
with Guicciardini and Machiavelli; and was developed thereafter by so
many great Western historians. The same difference in kind is to be found
between the *Spring and Autumn Annals* and the *Zuo zhuan* of China's
Eastern Zhou era, and the *Shi ji*, the massive masterwork of Sima Qian.
Again, the same difference in kind is to be found between the various
sets of annals and king lists surviving from the pre-Greek Mediterranean
societies and Mesopotamia, and the works of Herodotus and his successors.
In sum, the proof of the pudding is the eating. Yet what caused a far
more ambitious, far more analytic kind of history to be written at some
times and in some cultures, but not at other times and in other cultures?
This is a question no one has ever answered.

Furthermore, it is far from clear just why cultures possessing a devel-
oped historical sense have also exhibited the historical response to art.
There does not appear to be any logical reason why these two cultural
elements should always go hand in hand, and never be found separately.
But this is what has happened. Once more, one cannot dismiss as a mere
coincidence the simple fact that the same cultures that produced true
history by Fueter's definition were also alone in producing the art histories
which we have from all five rare art traditions.

So there is the best I can do with the central problem posed by this
essay, and a pretty poor best I fear it is. All the same, it can hardly be
mere coincidence, once again, that art collecting, the historical response
to art, and the developed historical sense all began to revive in the West
at about the same time and in the same place. The revival of the historical
response to art in Italy in the fourteenth century was sketched at the
close of the last chapter. If Fueter was correct, the fourteenth-century
Italian humanists were the first who showed the symptoms of the devel-
oped historical sense that is so conspicuous in the Western world today.
And modern-style art collecting's beginning in the fourteenth century
in Italy will be described in the next chapter.

X

ART COLLECTING REVIVES

The first recognizably modern Western art collector now known from the surviving evidence is a decidedly puzzling figure. Oliviero Forzetta was a highly successful moneylender in Treviso, a town in the Veneto to the north of Venice.[1] He was born in 1300 and died in 1373;[2] so his lifespan extended through the whole first period of the revival of classical learning in Italy. Yet somehow one does not expect a provincial moneylender, however prosperous, to form a major, pioneering art collection, or to gather a pioneering private library rivaling the classical libraries of Petrarch and Boccaccio. Oliviero Forzetta did both.

He was not merely a moneylender himself; he was also the son and grandson of moneylenders. His parents' overly open and profitable indulgence in the sin of usury, indeed, gave rise to the single most curious scene in the scanty records concerning Forzetta. In 1322, his mother, Aquilia, was on her deathbed. When she asked the clergy for the last rites, she was answered with a demand for a full confession of her earnings as a usurer. As though haggling with God Almighty, she named a trifling sum. This time she was answered with a roar: *"Usuraria prava et manifesta!"* In fear of Hell, the dying woman finally repented and promised the Bishop of Treviso a free hand with all she left behind. The Bishop took 200 lire, or nearly ten times the amount named by the wretched Aquilia, plus unspecified goods from her estate.[3]

Warned by this episode, Oliviero Forzetta's father, Nicolò, left another 200 lire to expiate his own sin of usury when he died a few years after Aquilia.[4] Even so, Forzetta's troubles with the Church, always arising from the same sin of usury, continued for a considerable period after both his father and mother had gone to their graves. He was even briefly excommunicated in 1330, the year after his father died.[5] Although he evidently made far more money than his parents, and was sufficiently respected

in Treviso to be given important municipal appointments,[6] we know little about Forzetta's life except that he married five times. His first marriage, at age twelve, was annulled.[7] His four later wives, significantly, all had some sort of connection with the local nobility. One, who brought Forzetta a considerable dowry, was the daughter of the Count of Gorizia,[8] one of the chief grandees of the region. These marriages, ambitious for a money-lender, were no doubt a tribute to Forzetta's wealth. Overall, then, one must picture Oliviero Forzetta as a very rich man of an Italian town in the early fourteenth century.

The puzzle Forzetta presents does not really result from his position in the world, however. Fairly grubby men of money have often suffered from the collector's itch. Yet if Forzetta had a bad case of this not uncommon itch, why did he not follow the perfectly conventional path taken by his near-contemporary and great man of that part of the world, Niccolò di Lussemburgo, Patriarch of Aquileia? The Patriarch's inventory shows that he was an insatiable treasure gatherer in pure medieval style.[9] In those days, this would have been a normal course to follow for a moneylender suffering from the itch, and certainly a far less surprising course than the one Forzetta chose.[10]

To begin with, Forzetta wrote bad Latin, yet he began to gather texts of the great thinkers and poets of the classical past not long after Petrarch started to assemble his famous library. As early as 1335, Forzetta was trying to find texts of Ovid, Sallust, Cicero, Livy, Seneca, and Orosius, along with Averroes, St. Gregory, and St. Thomas Aquinas.[11] A few years after Forzetta's death, an inventory was then taken of the books he willed the Eremitani of Santa Margherita. These were only part of his library, for other books of his went to the Frati Minori of San Francesco.[12] Yet the Eremitani inventory of 1378 is enough to prove that except for Livy, Forzetta ended by owning works of all the classical authors he was searching for in 1335, plus Aristotle, Quintilian, Euclid, Plato, Virgil, Horace, Juvenal, Lucan, and Persius.[13] To us, such a library may not seem impressive. In reality, however, Forzetta undoubtedly owned one of the better private libraries of classical authors in Italy in his time.[14]

What Forzetta Collected

For Forzetta's equally surprising art collection, unfortunately, our main evidence comes entirely from a single note or memorandum in his own hand which was transcribed and published in the eighteenth century but is now lost.[15] This note is dated 1335 and concerns things he currently wished to buy in Venice, including the first list of classical authors given above. The note begins with a series of entries on *"testae"* which Forzetta wanted to purchase or to order. One or two of these were probably antique

cameos; for in fourteenth-century Italy a *"testa"* in this kind of context was often a cameo, although in that era the word was used for almost any sort of head, painted or sculpted.[16] A bronze figure is also mentioned, again probably antique.[17] After two or three more entries, including one about a coat of arms to be painted for himself, Forzetta's note proceeds to "fifty medals," surely antique coins, which had been promised to him by a certain Magister Simon.[18] Next come the items having to do with books as well as items covering drawings by a Venetian artist already dead, Perenzolo, who may have come from Treviso.[19]

Then follow the main entries on classical and conjecturally classical works of art. There is no need for conjecture, to begin with, about two marble reliefs showing four putti, later wildly attributed to Praxiteles.[20] These neo-Attic reliefs had been in the Church of San Vitale in Ravenna for many centuries.[21] The best guess is that Forzetta secured the reliefs of putti, but that within a century they were built into house façades in the Piazza San Marco. In the sixteenth century they further came to the Church of Santa Maria dei Miracoli, whence, in 1811, they entered the collection of the archeological museum in Venice.[22]

One may be pretty sure, too, that a particularly large classical cameo or another relief is referred to in a difficult entry concerning a special *testa*, that seems to have depicted a figure with a head bound with a fillet and garlanded with roses. This belonged to "Anna sister of the late Gioacchino," who was perhaps the brother of Perenzolo.[23] Then there is a *"puer,"* pretty certainly another classical putto figure, to be obtained from Guglielmo Zapparini, along with more drawings by Perenzolo in the possession of the latter's widow.[24] Finally, although the difficulties of translation are again considerable, one guess is that the "lions, horses, bulls, naked men and hunts [?] of men and beasts"[25] belonging to a certain Marinus de Gallera were antique marbles or bronzes of one sort or another. It has been more recently (and less persuasively) suggested that these were surprisingly early classicizing drawings by contemporary artists. Yet this seems even more improbable.[26]

Overall, at any rate, "medals and coins, bronzes, marble sculptures, engraved gems, manuscripts of classical authors, all bulk so large [in Forzetta's note] that one might think oneself in the middle of the 15th century."[27] The quotation is from Eugène Müntz. Roberto Weiss also wrote that "the activity of Oliviero Forzetta is really the earliest known instance of a systematic chase after ancient objects, not because their shapes were unusual or their materials were uncommon, but simply because they were old."[28]

As for my belief that Forzetta finally assembled a major art collection, this rests upon his last testament.[29] As a usurer on a large scale, he felt compelled to be uncommonly generous to the church and the poor, not

only for the salvation of his own soul, but also, one suspects, to avoid the kind of row with the ecclesiastical authorities that his mother had gone through on her deathbed. For those days, too, he had a colossal fortune to leave—above 80,000 ducats in cash and more in real estate, without counting his collections.[30]

As has been seen, he divided his books between Treviso's monasteries of the Eremitani of Santa Margherita and the Frati Minori of San Francesco. After generous dowries for Forzetta's daughters and other bequests, the lion's share of Forzetta's fortune became the endowment to the Trevisan Ospedale de' Battuti, to aid the poor of the town. He also ordered his art collection to be sold after his death, to provide a fund for dowries for impoverished and deserving young women.[31] This was a popular charitable purpose of that era, later served by the will of Francesco di Marco Datini of Prato.[32] Note, therefore, that one must assume Forzetta had gathered large numbers of works of art in his favored classical categories by the time he made his will in 1368,[33] if he then believed the sale of his collection would pay for a charity of this type.

How, then, is one to read the great Treviso moneylender-collector as a sign of his times? I suggest, to begin with, that Forzetta's origin in the Veneto was not without meaning. In the fourteenth century, Venice was the mistress of a large empire in the Eastern Mediterranean, and carried on a busy trade with all the ports of Greece and the Middle East. From time to time, chance-found antiquities must thus have drifted into Venice from these fruitful sources, and in this way reached the hands of Venetians like those named as prospective suppliers in Forzetta's note on things to purchase.

The inventory of the Doge Marino Falier,[34] executed for high treason to the Venetian Republic in 1355, includes two cupboards in his *"camera rubea"* stuffed with all sorts of objects, including fifty antique coins and three inscriptions on marble "found at Treviso." The Doge's "two heads of barbarians brought from Africa by the sailor Jacobellus"[35] are also easiest to explain as fragments of the statues of blacks so often produced in Alexandria by Hellenistic sculptors. At any rate, they cannot have been contemporary products (unless they were dried human heads); for sculpture in the round representing human beings was certainly unknown in the Islamic Maghreb. But there were many other things as well, such as two ancient swords, one of bronze and therefore probably a survival from the dawn-time of Italian history[36] and one with inscriptions and thus probably of Lombard origin.[37] A whole series of objects had been obtained, too, from the Doge's neighbor Marco Polo, including a ring inscribed, "Kublai Khan to Marco Polo"! And there were more precious things "which the aforesaid Marco had from the king of the barbarians."[38] The mixture in fact suggests that the ill-fated Doge regarded the contents of these cupboards primarily

as curios—unless they were treasures like his gold and alabaster candelabra and Kublai Khan's gold and silver gifts.[39]

Early Portents

It seems to me, however, that the real clues to Oliviero Forzetta's pioneering art collection are to be sought outside Venice. To begin with, a slight but perceptible change had begun to come over the European scene as long as a hundred years before Forzetta's time. In the early decades of the thirteenth century, that most unmedieval figure the Emperor Frederick II Hohenstaufen assembled a classical art collection that was evidently far more ambitious than the collection of Henry of Blois in the twelfth century. Or, rather, this is evident from the somewhat speculative reconstruction of Frederick II's activities in the realm of the arts by H. Wentzel, the principal modern authority on carved gems in the Middle Ages.[40] Besides classical sculpture for his castles in Apulia,[41] it seems certain on this basis that the Emperor gathered both antique coins and, more particularly, antique carved gems.[42]

Modest coin and important gem collections have to be deduced from the pastiches the Emperor demanded from his craftsmen. His own coins, the famous Augustales,[43] somewhat crudely follow Imperial Roman models, which the Emperor must have provided. The products of his gem-carving atelier, as defined by Wentzel, even more strongly imply the existence of a substantial collection of antique carved gems. Really successful pastiches cannot be made, after all, without an ample supply of models of high quality to inspire and guide the pasticheurs. The success of the Wentzel-defined Hohenstaufen pastiches is best indicated by the large gem listed as "l'Archa"[44]—"the Ark"—and given one of the highest valuations in the inventory of Lorenzo de' Medici's possessions after "the Magnificent's" death in 1492.[45] The male nudes on this gem are so deceptively classical that until quite recently, some scholars maintained the gem was carved in Imperial Roman times, despite the obviously Biblical subject, which is Noah's Ark with the animals going in two by two.

One may be sure that the chief reason Frederick II Hohenstaufen collected classical works of art, and required his craftsmen and also the sculptors he employed to work in a pseudo-classical style, was the same desire to underline his claim to revive the ancient Roman Empire that partly explains the Carolingian Renascence. He even built himself a pseudo-triumphal arch in Capua.[46] As a collector, moreover, the Emperor was apparently as isolated in his own time as Henry of Blois had been in the twelfth century.

Rather wider significance therefore attaches to another thirteenth century development. Around 1210, or almost simultaneously with Frederick

II Hohenstaufen's proclamation as Holy Roman Emperor, the central portal of Notre Dame de Paris was given a series of medallion reliefs carved with Virtues and Vices. The vice of Idolatry is represented by a figure adoring a pagan statue—here a bust. Strangely enough, however, the bust is enclosed in an oval frame suspended from a ring. Wentzel has shown that what the idolater is really adoring is an antique carved gem in a setting. And he has shown, too, that this surprising medallion on Notre Dame's portal must be connected with a strong and distinctly changed fashion for antique gems.[47]

Portrait gems were now rather strongly preferred. If the gems were sought for their subjects, in turn, this meant that works of art of this sort were beginning to be seen, at least in a very primitive way, as ends in themselves. Seeking gems for the portraits was, after all, quite different from cherishing the gems as jewels like any others (even if indecent and for church use[48]), or preserving them as quasi-magical objects,[49] or reading Christian meanings into them that were never there.[50] These had been the usual medieval responses.

In addition, at the end of the thirteenth century, Ristoro d'Arezzo recorded that rediscovered bits and pieces of the Aretine pottery of Roman times were much admired and highly valued in that area.[51] If the period were better documented, in truth, other very early Western art collectors besides Oliviero Forzetta might well be known to us today.

It may be, for instance, that the artist Perenzolo had collected classical fragments in a casual, unmethodical way before he died. Forzetta's note of 1335 indicates a connection between the late Perenzolo and the marbles and/or bronzes to be obtained from Marinus de Gallera. The latter also owned desirable *"aves"*[52]—drawings of birds?—by Perenzolo. Thus one wonders whether both the drawings and at least some of the sculpture had been purchased from the dead artist's estate. Or, if what has previously been read as sculpture was instead a series of drawings, then such drawings of classical subjects point to an assemblage of models. Classical fragments must still have been dirt cheap in Perenzolo's lifetime; and if he was indeed a collector, he probably regarded his prizes as curiosities that he also thought attractive.

The Main Clue

For what it may be worth, at any rate, my own belief is that true art collecting of a limited and preliminary sort had indeed begun in the West, albeit most obscurely, shortly before Forzetta's time. Nonetheless, it seems to me that the main clue to the puzzle of Forzetta's art collecting is to be found in his ambitious and equally pioneering book collecting. We shall probably never know why a Treviso moneylender who wrote bad

Latin should have joined so actively in the revival of classical learning, even if only by gathering impressive numbers of classical texts; but this is not of great consequence. What is consequential, rather, is the evidence that the revival of classical learning went hand in hand with a new admiration for classical works of art among a good many people. Furthermore, this new way of seeing classical art was really different in kind from the sneaking admiration one finds expressed here and there in the record of the Middle Ages—for example, by Guibert de Nogent. The difference in kind, of course, arises from Guibert's open abhorrence of "idols," however admirably formed.[53]

The difference is documented by Lorenzo Ghiberti's story of the Venus statue discovered in the mid-fourteenth century in Siena, which he knew from a contemporary drawing by Ambrogio Lorenzetti.[54] The Venus (with a base bearing the name of Lysippus) was discovered when a house foundation was being dug; and "all the expert and learned in art and sculpture ran to see this statue, made with such beautiful and marvelous artistic skill."[55] The Sienese made a public feast in honor of the discovery and gave the Venus a proud place atop the Fonte Gaia. Yet, as Ghiberti tells the story in his *Commentarii*, trouble came soon when one of the more old-fashioned Sienese spoke up at a city meeting:

"Fellow citizens, having come to the conclusion that since we have discovered this statue we have had naught but bad luck and considering how idolatry is abhorrent to our faith, we must conclude that God is sending us all grief for our errors. Consider too how since we have been honoring this statue, things have gone from bad to worse, and we are going to continue to have bad luck. I am of the opinion of those who recommend that it be broken and smashed and the pieces sent to be buried in [the lands of] Florence."[56]

The statue's rubble was to be buried across the Florentine border, of course, because Siena and Florence were almost continuously at war, and the war had produced the bad luck here complained about. The city meeting voted to take this citizen's advice, too, so the curious exercise in the transfer of bad luck by sympathetic magic was actually performed.[57] The real point of the story lies, however, in the before-and-after contrast between two ways of seeing. The contrast, indeed, is what makes this oft-told tale worth retelling; for what may be called the political-cultural implications have not been explored before.

The initial reception of the Venus statue leaves no room for doubt that Ghiberti's "expert and learned in art and sculpture" included many, indeed most, of Siena's upper-class leaders. Given the status of craftsmen in those days, mere artists like Ambrogio Lorenzetti can hardly have managed to organize a public feast, and, single-handed, they certainly cannot have contrived the installation of the Venus statue as the most conspicuous

decoration of the most conspicuous fountain in the city. The city's leaders really must have played the chief roles in this first stage. Nor was their decision wholly unprecedented. A bit earlier, another female statue had been found at Verona, and Cansignorio della Scala, then ruler of the city, had placed it prominently on one of Verona's chief fountains.[58] The people of Verona in those days were not given to arguing with the Della Scala, and they named the classical image "Madonna Verona" and decided they could be proud of her.

It was different at the Siena city meeting, however; and what happened is extremely revealing. The revulsion against the Venus statue and the decision to smash it show that a large majority of the Sienese still saw classical works of art almost exactly as Guibert de Nogent had seen them three centuries earlier—as fine enough in their own way, perhaps, but still demon-tainted and "abhorrent" to good Christians.[59] Thus you have to conclude that the new, unqualified admiration for works of art like the Venus statue, so manifest in the statue's initial reception, was still an elite taste in 1357. It cannot have been a taste restricted to the more progressive painters and sculptors, for they did not have the leverage to produce Siena's original response to the Venus statue's discovery. The elite in question plainly included a good many of the craftsmen's wealthy patrons. Nor is it surprising that the new taste was conspicuously *not* shared by the large majority of Sienese. If the "ignorant" in the fourteenth century did not properly appreciate Giotto, as Boccaccio and Petrarch both remarked, the same "ignorant" were even less likely to appreciate classical sculpture, with all its overtones of paganism and idolatry.

It goes without saying that the "ignorant" did not include the four-teenth-century Italian humanists. Petrarch placed the beginning of the Dark Ages at the moment when "the name of Christ was celebrated in Rome and adored by the Roman Emperors"[60]—in short, the moment of the conversion of Constantine, which had been remembered for many centuries as the time of the triumph of light and truth. In his *Africa*, too, Petrarch predicted, "This sleep of forgetfulness will not last forever. When the darkness has been dispersed, our descendants can come again in the former pure radiance."[61] Antiquity was the radiant epoch in ques-tion; and the very concept of the Dark Ages was originated by Petrarch.[62] It must be added that Petrarch believed that the darkness of the Dark Ages was primarily political. As Fueter remarked, he used the past to console himself for the present.[63]

Looking to the Past

Petrarch's own feelings about art in general appear to have been ambiva-lent. What he had to say in his will about Giotto and his friendship

and admiration for Simone Martini have already been mentioned. He never seems to have studied classical art with real interest, however, except insofar as it illustrated history, of which he also wrote: "What else, then, is all history if not praise of Rome?"[64] Despite his fascinated wanderings among Rome's ruins with his friends the brothers Stephano and Fra Giovanni Colonna,[65] he was still prone to accept myths about the artistic aspects of this past he loved that were near to the nonsense of the author of the *Mirabilia Urbis Romae*.[66] Roberto Weiss held that he still half believed the classical gods were demons,[67] in the old way; and the physical sites of great events of the past were what particularly interested Petrarch in Rome.

In his *De Remediis*, furthermore, he argued back and forth but finally reached the judgment that works of art dealing with secular subjects were best avoided.[68] Here, however, he evidently made a silent exception for morally elevating depictions of great men and heroes. The exception is implied by the Sala Virorum Illustrium—the grand room which Petrarch's patron, Francesco da Carrara, had frescoed with famous men of history, choosing the subjects from Petrarch's own *De Viris Illustribus*.[69] Nonetheless, the impact on art of Petrarch's new interpretation of history can hardly be overestimated. The key fact is that once people accepted his opinion of the conversion of Constantine as the moment when the Dark Ages began, many of the same people were sure to forget the medieval view of classical works of art as demon-tainted idols. The secular approach to history was bound to go hand in hand with a secular judgment of art. And nostalgia for Rome's imperial grandeur was bound to turn the eyes of some to classical art.

It is easy to show that Petrarch's concept of the Dark Ages had its own large influence on the way people thought about the art of the "radiant" classical past, and on art's subsequent development, too. Boccaccio has already been seen praising Giotto for bringing back "the art which had lain buried."[70] Ghiberti went a great deal further in the fifteenth century. This was much, much later, of course, but it is still highly significant because the link is so undeniable between Petrarch's view that the Dark Ages began with Constantine's conversion and Ghiberti's opinion of the consequences of Constantine's conversion for the arts. Ghiberti wrote that in the time of Constantine (here unjustly blaming the first Christian Emperor for the destructions that began in the time of Theodosius I[71]), "Idolatry suffered great persecutions so that all paintings and statues were destroyed and despoiled of all nobility and of their ancient and perfect dignity, and along with the statues and paintings, the volumes and commentaries and rules which taught such wondrous and pleasing art. . . . In this manner ended sculpture and painting and any theories dealing with them."[72]

Ghiberti even believed that a Venus statue found in Florence in the

foundations of the Brunelleschi houses in the late fourteenth century had been buried with extra care in late Roman times, and solely in order to protect this beautiful yet pagan work from vengeful damage by the triumphant Christians.[73] His belief is likely to have reflected what he heard from his elders, who had first-hand knowledge of the Venus statue's discovery. It must be added, too, that although protective burial of a pagan work of art may seem superficially improbable, Ghiberti's belief in this has now been strongly supported by the odd way the last known classical art collection was concealed in that well in Athens,[74] and by other, more recent evidence as well.[75] Altogether, in any case, it is no wonder that Theodor E. Mommsen wrote of the Renaissance, paraphrasing and carrying further ideas put forward by Benedetto Croce:[76]

"The whole idea of the Italian *rinascita* is inseparably connected with the notion of the preceding era as an age of obscurity. The people living in that 'renascence' thought of it as a time of revolution. They wanted to break away from the medieval past and all its traditions, and they were convinced they had effected such a break. They believed that in their time, to use the words of Petrarch, 'the darkness had been dispersed' Their model was Antiquity."[77]

To return to the fourteenth century, the revival of classical learning not only went hand in hand with the new way of seeing classical works of art which must be inferred from Oliviero Forzetta's collecting and Siena's first response to the Venus statue found there. In addition, the new way of seeing and the new enthusiasm for antiquity caused the path taken by Forzetta to be followed by other men—although few of them can now be identified, and the moneylender-collector may well have been hardly known outside Treviso and Venice. Petrarch himself collected antique coins and medals, and in 1354 he gave part or all of his collection to the Emperor Charles IV.[78] No doubt he made this kind of collection because medals and coins provided the depictions of famous men that he approved of. He certainly made his gift to the Holy Roman Emperor as a kind of history lesson on the lost grandeur of the pagan Roman Empire.[79]

Petrarch's closest friend, Lombardo della Seta, was a different sort of collector, however. He sought classical works of art as ends-in-themselves, with no reference to the past's greatness, if one can judge by the single surviving piece of evidence. When the beautiful Venus statue was found in Florence in the new foundations of the Brunelleschi houses, Della Seta purchased the piece of sculpture and brought it back to Padua.[80]

Collecting by 1375

Yet the most significant testimony concerning the standing of classical art in Italy in the later fourteenth century comes from another friend of Petrarch's, who never seems to have made such an acquisition as Della

Seta did. Besides a few minor treasures and a rare text of Vitruvius, medical books are the most important items listed in the surviving inventory of the possessions of Giovanni Dondi dall'Orologio.[81] Nor is this surprising, since he was an eminent physician.

Dondi acquired his odd extra name, "Of the Clock" (still borne by the same Dondi family), from a famous clock he designed and built which became a showpiece of the Visconti Palace at Pavia.[82] According to Petrarch, he had enough talent "to have reached the stars," if only "medicine had not held him down."[83] He was a man of wide interests, and his interests included classical antiquities, which he studied on a trip to Rome in 1375. Dondi's letters about his visit to Rome are the best evidence still existing of the way classical art was then coming to be thought about.[84] The most revealing and important was one addressed to Dondi's theologian friend Fra Guglielmo da Cremona.

"Though few of the products of ancient genius survive," wrote Dondi, "yet those that are still in existence here and there are avidly sought for and gazed at by those who have perception in these matters, and great prices are paid for them:[85] and if you compare the products of today with those of a former time you cannot escape the conclusion that those who made them were naturally endowed with a more powerful talent and were more skilled in mastery of the art. I am speaking of ancient buildings and statues and sculptures together with other things of this kind: when contemporary artists carefully examine certain of these ancient works of art they are overwhelmed by amazement."[86]

To illustrate what he meant here, Dondi went on to describe an unnamed but eminent sculptor whose identity, needless to say, has been much debated. "More than once," wrote Dondi, "I heard him discuss the statues and sculptures he had seen in Rome with such admiration and veneration that in his discourse he seemed to be all but beyond himself, so full of wonder was the subject." The sculptor, Dondi added, had once been almost literally paralyzed with excitement when he and some friends, walking together, came upon a place where "some such images were to be seen." The statues kept him rooted to the ground until he was half a mile behind his companions. And Dondi ended by citing the same sculptor's opinion "that if such sculptures had only the breath of life, they would be better than nature."[87]

This well-known letter is worth quoting at some length because of the diverse interpretations which have been put on it—none of them really down-to-earth, as I believe. There is no question, to be sure, that Dondi was less interested in the remains of sculpture then surviving in Rome than in the remains of architecture, their surviving inscriptions and their historical associations. It was he who copied the already mentioned doggerel about Buschetto's engineering skill, which he found when he visited the Vatican obelisk.[88] He expatiated at length, too, on the value of the

antique monuments as memorials of Rome's great men and Rome's imperial grandeur. In another letter to Fra Guglielmo da Cremona, he wrote of Rome's monuments as "the testimonies of great men";[89] and the earlier-quoted letter is in fact the only one Dondi wrote from Rome that discusses classical art *qua* art.

Yet the foregoing surely does not justify the interpretation that Dondi's sole interest in the remains of classical sculpture and architecture was historical and literary. In the letter quoted, one cannot find any indication of "the sense of superiority to the visual aspects of [antique] art" which has been attributed to Dondi by one authority.[90] On the contrary, Dondi was plainly voicing his own opinion when he wrote that the masters of classical times were "naturally endowed with a more powerful talent and were more skilled in mastery of the art" than the masters of his own time. The enthusiasm of the unnamed sculptor was then described to support Dondi's further statement that contemporary artists were "overwhelmed by amazement" when they saw the works of their classical predecessors. Thus it would appear that Dondi's views about the superiority of classical art actually coincided with the views of "those who have perception in these matters"—even though he made no claim to connoisseurship himself, and was not an art collector. Meanwhile, for anyone who has given much study to the history of art collecting and its attendant phenomena, the Dondi letter has only one possible meaning—and a most important meaning not before suggested, at that.

This new interpretation of the letter is unavoidable because of the normal stages every collecting category always goes through. In brief, every new collecting category—whether Chinese tomb figures, or post-Impressionist paintings, or, one may be sure, classical works of art in fourteenth- and fifteenth-century Italy—invariably goes through at least three easily recognizable stages.

In stage one, a tiny group of pioneers, perhaps no more than one or two, begin to collect things in the category in question, paying the trifling prices always paid for the unwanted. In stage two, the category becomes an elite enthusiasm; limited collectors' competition sets in; and prices are thus pushed up to a level which always surprises outsiders. Anyone who is old enough will surely remember this second stage of post-Impressionist collecting in the 1920s and 1930s, when prices for Matisses and Picassos were still absurdly low by present-day standards, yet seemed shockingly high to the noncollectors of the time.[91] As for stage three, interest in the collecting category, whatever it is, at length ceases to be a mark of elite taste. Instead, large numbers of persons begin to hanker for Tang horses,[92] or Picassos and Matisses, or classical works of art, as the case may be. Whereupon collectors' competition intensifies enormously, and true super-prices therefore start to be paid.[93]

In the case of classical art collecting in Italy—the first true art collecting

in the West—stage one of the foregoing progression is represented by Oliviero Forzetta's note of 1335. Stage three will be seen when the fifteenth century is reached in this essay. Giovanni Dondi was writing about what happened in between, in fact stage two, when classical works of art—it is worth repeating—were already "avidly sought for" and commanded prices that seemed "great" to Dondi. Who else, indeed, but collectors could these avid seekers have been? How else can the prices have reached such notable levels except as a result of collectors' competition? In the absence of competing buyers, neither works of art nor any other commodity can ever fetch much money.

Such is the framework that will at once enable anyone to see the real meaning of Dondi's key statement. The statement can only mean, quite simply, that Italy's classical art collectors were still a narrow group by the end of the fourteenth century's third quarter, but there were already at least enough of them to cause competition, and thus to drive up prices of classical works of art to levels that surprised noncollectors like Dondi.

The surprise caused among those like Dondi must have been increased, too, because this really was true art collecting's first appearance in the West as an established, recognizable social habit—albeit still an elite habit. Thus art collecting, in itself, must have been a major surprise to the majority. Putting this aspect of the matter in its lowest terms, people in the fourteenth and fifteenth centuries usually expected to get a discount if they purchased pieces of sculpture or painting at second hand, for reuse in a church, chapel, or elsewhere.[94] Yet here were people paying large premiums for classical sculpture which had no discernible practical use at all! The great transition from art-for-use-plus-beauty to art-as-an-end-in-itself was in fact taking place. And since this transition necessarily involves a wholly novel way of seeing, it has always caused some initial bewilderment whenever it has occurred.

There are also other fragments of evidence to confirm the foregoing interpretation of Dondi's letter about classical art. One may begin with Oliviero Forzetta's death in 1373, or just two years before Dondi went to Rome. Since Forzetta's will required his art collection to be sold, this was presumably done shortly after his death; and the proceeds were apparently sufficient for the charity Forzetta had planned. This has to mean that by the time Giovanni Dondi went to Rome, there were enough other people with Forzetta's tastes to make a market for the classical works of art Forzetta had mainly collected. There is also a casual note by Benvenuto da Imola concerning yet another beautiful Venus statue he saw in a house in Florence in 1390.[95] From this it must be deduced that at least a few people already regarded classical works of art as suitable ornaments of their immediate surroundings.

Then, too, there are only two reasonable ways to reconstruct the practical background of Della Seta's purchase of the Florentine Venus statue

which he brought to Padua. Either Della Seta heard about the statue's discovery in Padua on a primitive collectors' grapevine—in itself indicative—or he was in Florence and heard of the statue there because its discovery had caused a considerable stir in the city. If there was such a stir, this is again indicative. There is other evidence for Florentine excitement about the new discovery, especially the vividness of Ghiberti's later-written account of the way the statue was found. Furthermore, it would have been highly anomalous for the Florentines to respond phlegmatically to such a find shortly after the excited response of their Sienese enemies and neighbors.

Later-Fourteenth-Century Collecting

By the last decades of the fourteenth century, there is the further evidence of the new appetite for classical carved gems, coins, and medals among some of the French princes of that time, above all Jean, Duc de Berry,[96] whose taste was much affected by contemporary trends in Italy.[97] Then add, finally, that after the Milanese invaders were driven out of Padua in 1390, the family of Petrarch's former patron, the Carrara, were restored to their rule of the city, and celebrated by striking medals imitated from classical coins.[98] For the reasons already given, the Carrara pastiches imply the prior existence of a collection of genuine classical medals and coins, most probably in the possession of the Carrara themselves, who may have got their inspiration from Petrarch's collection. In Venice in 1394, two craftsmen of the mint, Lorenzo and Marco Sesto, also designed and struck medals of the Emperor Galba and Alexander the Great,[99] which undoubtedly followed classical prototypes. This, of course, indicates medal and coin collecting. The Sesto brothers perhaps got their models from the Carrara, whose commemorative medals were ordered from Venice.[100] Hence one suspects originals were sent to Venice from Padua to show what sort of thing was wanted. Yet the brothers would hardly have produced pseudo-classical works of art on their own hook except in the context of an established Venetian taste.

In short, the evidence for classical collecting in fourteenth-century Italy is certainly fragmentary. Certainly, too, it is hard to have to depend so much on so few chief fragments: what we know of Oliviero Forzetta, especially his note of 1335 and his will; what happened in Siena in 1357; and Dondi's letters from Rome in 1375. Yet there are many other, lesser fragments, too, if you search for them. Indeed, the total number of fragments is surprising, given the obvious fact that the story of the arts in Italy in the fourteenth century is only about one ten-thousandth as well documented as, for example, the story of the arts in Paris in the short period before the First World War.

One could write a massive, detail-packed volume on art collecting in

Paris in this decade and a half, when Gertrude and Leo Stein[101] and the Russians I. A. Morozov and S. Shchukin[102] pioneered post-Impressionist collecting; and Dr. Albert C. Barnes, rich with the revenues of Argyrol's adoption as the standard antivenereal preventive of the French army,[103] began the collecting career that produced the superb assemblage of the Barnes Foundation. No such volume can be written, however, concerning Italian art collecting in the fourteenth century. One can only gather the bits of data, press out each bit's necessary meaning in accordance with the laws that rather strangely govern all art collecting, and then arrange the bits in a logical pattern. When this is done, it is impressive and significant that all the chance-preserved data point to the same conclusion. The data are also sufficient to give this conclusion a high degree of certainty. To recapitulate, the data indicate that by the last quarter of the fourteenth century, classical art collecting was an established though still elite social habit in the more prosperous and more humanist-oriented centers of Italy.

I would go still further, too; for it is easier to understand what was happening in Italy in the later fourteenth century if the early classical collectors are thought about as a small number of persons sharing an avant-garde taste. This is simplistic and exaggerated, of course. Yet to see why this is not altogether unreasonable, it is worth making a short digression on the larger problem of avant-gardes in thought and art.

In art, particularly, one must begin with the obvious fact that great innovators are *not* necessarily avant-garde artists. Masaccio, Raphael, Rubens, and all the other towering masters of the established, continuing Western art tradition were conspicuous innovators in different ways. Yet no one would class them as avant-garde artists, precisely because they made their innovations within the limits of the art tradition they belonged to. True avant-gardes instead appear—and only appear—when a major break with the past is coming and a great turning point in art is therefore at hand. At these rare junctures, avant-gardes in art have the task of every military advance guard (the source of the image). This task is to test and partly clear a new and untried road that the main army will take a little later. Political-social rebelliousness is not essential to make an avant-garde, though this is often claimed nowadays;[104] instead artistic avant-gardes are made by bold and successful choices of wholly new roads in art.

Such wholly new roads in art furthermore imply the end, or approaching end, of the old, accustomed roads which have been traveled before, and they are linked to novel but not necessarily socially rebellious views of the world and society. In China in the first centuries of the present era, for instance, the scholar-official class was completing its rise to the place it occupied thereafter until 1911—as the class with a near-monopoly on the day-to-day management of the Chinese Empire. This major social

change was in turn linked to a profound change in Chinese art, namely
the consecration as China's art of arts of calligraphy, the scholar-officials'
most necessary skill as already discussed in a previous chapter. As has
also been shown, in this transformation of calligraphy from a means of
communication into a conscious art, not even the most ingenious modern
deformers of history can possibly find any whisper of social protest. And
it would again be a deformation of history to read social protest into the
new view of the classical past adopted by Petrarch and the other fourteenth-
century humanists, or the connected view of classical art which is the
subject of this chapter.

There are in fact two practical tests of avant-gardes in art. In the first
place, the kind of art an avant-garde produces or favors is at first seen
by the majority as disruptive and even dangerous, whether or no it bespeaks
political protest. In the Chinese case, we have seen how Zhao Yi denounced
the new cursive script of the artist-calligraphers of the second century
A.D. for essentially moral reasons. As the reader may recall, he declared
that the applause for the artist-calligraphers who used the cursive script
amounted to "disregard of what is classic and cultivation of what is vulgar,"
and could never "cause the Tao to prevail and uplift the world."[105] The
fourteenth-century response of the devout majority of Sienese to their
newly glorified Venus statue was on all fours with this moral response
of Zhao Yi, but considerably more energetic. On all fours, too, were the
successive majority responses in the West to the Impressionists, to Cé-
zanne, and above all to the post-Impressionists. Students of the subject
may be left to decide how much real social protest was involved in the
great change in art beginning in the nineteenth century. What matters,
in any case, is that if New York in 1913 had been a city like Siena in
1357, a good many of the works of art in the Armory Show might well
have been burned by majority vote, and, again, largely on moral grounds.[106]

As for the second test of avant-gardes in art, it is both simpler and
far more important than the angry initial response of the majority. By
definition, successful avant-gardes predict the new course that art will
take. In this respect, to be sure, the fourteenth century was a peculiar
case. More normally—so far as one can judge from the slight historical
evidence from the past—the artists themselves are to be found among
the leaders of the avant-garde. If Giovanni Dondi's unnamed sculptor is
accurately portrayed, moreover, Italian artists must have begun hankering
to test the brand-new road of the Renaissance considerably before the
first visible signs of the true Renaissance appeared toward the end of the
fourteenth century. Instead, however, the classical art collectors and those
who shared their view of classical art were the people who provoked the
fourteenth-century Italians' only recorded majority response to the new
avant-garde taste—at Siena, obviously. And even before the artists—at

least so far as we know now—Italian art collectors were also the first to predict the glorious new direction art would take in Italy, which then set the direction of Western art for centuries thereafter.

The Fundamental Question

This predictive aspect of fourteenth-century Italian art collecting raises a fundamental question. I have to admit that it is a question I have long hesitated to tackle. I hope I have made myself into a reasonably dependable historian of art collecting and its linked phenomena, despite the lack of much equipment it would be desirable to have. It has taken many years, and much generous help from others. Yet the alert reader may have noticed that thus far, in all strictly art-historical matters covered in this essay, I have tried to follow the leading students of art history in our time. I shall do so again hereafter. At this juncture, however, there is no way of ducking or dodging the question above-mentioned, although it requires a new look from a new angle at the most crucial and most studied turning point in the early history of our Western art tradition. The question is:

What was the role of fourteenth-century Italian art collecting in the origins of the true Renaissance in Italy?

To begin with, the possibility that the role was considerable has to be carefully weighed, if only because art collecting, wherever it has arisen, has not seldom affected the subsequent development of art itself. In recent years, leading historians of the subject have repeatedly noted that the developments of both calligraphy and painting throughout much of Chinese art's second era were powerfully affected by Chinese art collecting.[107] In contrast, this approach has not been common among students of the Western art tradition, because the effects of art collecting on Western art have usually been much less direct and obvious. Yet who can imagine Picasso painting that seminal picture, the Demoiselles d'Avignon, without the prior influence of the earliest collections of African art then being formed in Paris?[108] Nor can one see any valid obstacle to a comparable influence having been exerted by the early Italian collections of classical art in the years when the true Renaissance was in gestation. So one is really forced to ask whether a role should not be allotted to the classical art collecting which appeared on the Italian scene before the true Renaissance began, and foretold the Renaissance artists' return to antiquity.

The question of the role of this new phenomenon in Italy confronts you automatically, so long as you accept the account given here of the beginnings and progress of Italy's ground-breaking early art collecting. To avoid impossible diffuseness of citation in discussion of the question, it will be best to base the discussion on a single recent and authoritative

study covering the key years in detail. The years that chiefly matter are the decade-plus from around 1390 until just after the beginning of the fifteenth century—in fact, the decade-plus when the first clear portents of the coming of the Renaissance in art could be seen in Florence. And as a basis for discussion, I have chosen what seems to me the most elegant and persuasive study of a single master whose ideas took form and creative activity began in Florence in these key years. This study is *Lorenzo Ghiberti*, by Richard Krautheimer in collaboration with Trude Krautheimer-Hess.[109]

To summarize crudely, Professor Krautheimer concentrates his analysis of this early stage in Ghiberti's career on the two great developments which most loudly announced the coming of the true Renaissance. The first of these portents of art's new direction was the design, construction, and decoration of the Porta della Mandorla of Florence's Duomo.[110] The new work was begun in 1391 and largely completed a few years later. The overall design of the Porta della Mandorla is still Gothic; but elements of the decoration, especially the figures sculptured in relief on the pilasters, are conspicuously classical in inspiration. Among these figures in turn, special notice has long been paid to the figures of Abundantia and the youthful Hercules. Professor Krautheimer also attributes another surviving work to the Hercules Master, the unidentified but obviously talented and innovating sculptor responsible for the Hercules figure. This is a Virgin Annunciate with a strongly classicizing head.[111]

As for the second and much greater development portending art's new direction, it was the announcement and outcome of a competition for a new pair of bronze doors for the Florentine Baptistery, to match the doors made long since by Andrea Pisano. Leading artists were invited in 1400 to submit model reliefs for the new doors by a committee of the Calimala,[112] the important merchants' guild, which had the responsibility for the Baptistery in the same way that the Arte della Lana, the Wool Guild, had responsibility for the Duomo. Two of the competition reliefs survive, by Brunelleschi and Ghiberti.[113] Although Ghiberti was primarily a goldsmith and still a young member of his father's shop at that time, his relief won the competition, and he therefore got the commission for the new pair of doors in 1402/03.[114] Brunelleschi was the runner-up.[115]

Both Brunelleschi's and Ghiberti's competition reliefs reflect close study of the remains of classical art, although in different ways, as Professor Krautheimer shows at some length.[116] Hence Professor Krautheimer convincingly suggests that the actual terms of the Calimala's competition, as announced in 1400, directly specified that the competition reliefs should be *"all'antica."*[117] He further speaks repeatedly of the "vogue for *all'antica* art,"[118] or "the fashion for the antique,"[119] that prevailed in Florence in the last decade of the fourteenth century. Besides holding that the terms

of the great competition for the Baptistery doors were quite largely dictated by this fashion for the antique, he further holds that the same fashion was earlier reflected in the figures in relief on the pilasters of the Porta della Mandorla, and, most importantly, in the Abundantia and the youthful Hercules.[120] In other words, the proposed equation for the true Renaissance's immediate origins is: fashion for the antique, *plus* quite unprecedented works following this fashion, *equaled* the current that in the end produced the Renaissance itself. In this otherwise convincing equation of the Renaissance's final gestation, however, there is an obvious missing factor, which can be summed up in a second insistent question.

The Second Question

Just how did this fashion for the antique arise in Florence, probably around 1390, and just who were the fashion setters?

One must begin consideration of this second question by pointing out that the Florentine fashion for the antique was a coin with two sides. On one side were the artists' ground-breaking *all'antica* works. But on the other side were the patrons. The patrons' role must be deduced, but this is not difficult. If any leaders of the Wool Guild still believed that classical works of art were demon-tainted pagan idols, they would surely have objected strongly to the brilliantly exact representation of one of these idols in the Hercules figure on the frame of a new door for the most important religious edifice in Florence.

The case of the new pair of doors for the Baptistery is even more instructive. No sooner had Ghiberti won the competition than he adopted the International Style in most of his work on the doors themselves.[121] The doors, therefore, are only intermittently classicizing,[122] whereas the competition relief which got Ghiberti the commission is emphatically *all'antica*.[123] This is strong additional evidence for Professor Krautheimer's view that Ghiberti made his competition relief in this way because the patrons, the leaders of the Calimala, had told all the competitors they wanted to choose from reliefs in a classicizing style. In short, the data indicate that the fashion for the antique in Florence in the fourteenth century's last decade involved a fairly radical change of taste among leading men in the city. Given the nature of the artist-patron relationship at the close of the fourteenth century, no other conclusion completely fits the facts.

The usual supposition is that those who caused this crucial change in taste were the late-fourteenth-century Florentine humanists, led by the great Chancellor of Florence of that time, Coluccio Salutati.[124] There can be no question about the importance of Salutati's position and influence

in the city. It was Salutati, for example, who urged upon Palla di Nofri Strozzi the need for someone to teach Greek in Florence.[125] Palla Strozzi, already a very rich man, responded by paying the largest part of the considerable bill for importing Emmanuel Chrysoloras from Constantinople and also for his salary in Florence.[126] A disciple of Salutati's, Jacopo da Scarperia, carried the Florentines' invitation to Chrysoloras in Constantinople in 1395, and Chrysoloras came to Florence in 1397.[127] This was a truly major event, too; for except in the Greek-speaking patches of southern Italy, no Italian scholar had known Greek for centuries. Boccaccio tried to learn from a Greek-speaker from Calabria, but with small success.[128] For years, Petrarch searched eagerly for a codex of Homer in Greek; but after he got his longed-for codex, he could never read a line of it.[129] When Chrysoloras reached Florence, however, his lectures attracted a whole series of younger humanists like Leonardo Bruni and Guarino da Verona; and so Greek studies in Italy began again, as a result of Salutati's initiative.[130]

It should also be noted that Palla Strozzi attended Chrysoloras' lectures along with Bruni and Guarino. One of the great features of intellectual life in Florence in the Renaissance, at least until the death of Lorenzo de' Medici in 1492, was the strong interest in classical studies and the high place given to humanist scholars by many political and financial leaders of the city. This remarkable aspect of fifteenth-century Florence must be traced back to the late fourteenth century, however, and more specifically to the humanist intellectual climate Salutati and his disciples managed to generate. The best symbol of this new intellectual climate is Palla Strozzi, basically a rich businessman, humbly, earnestly going to school with the Greek teacher he had taken the lead in bringing to Florence at Salutati's behest.

Yet there is no evidence that Salutati himself took an active interest in the visual arts.[131] Furthermore, generating a new intellectual climate is altogether different from setting a highly specific and fairly radical new fashion in art, such as the fashion for the antique. Is one to suppose, for instance, that the intellectual climate, alone and unaided, caused a good many Florentines to take an entirely new look at the long-familiar four sarcophagi[132] then in the piazza before the Duomo? It is not easy to picture leaders of Florence suddenly starting to say to themselves around 1390, "Dear me, I never really looked at those sarcophagi before; but now that I look at them, I see they're remarkably fine."

Most will agree that the Florentine fashion for the antique can hardly have arisen in this simple, almost self-starting way. The fashion itself necessarily involved the transformation of what had been an avant-garde taste into an establishment taste shared by many of the magnates. For such a change to have occurred at all, the new intellectual climate Salutati did so much to create was certainly the most important requirement. Hu-

manism had to clear the way for a new way of seeing classical art, before a fashion for the antique in art could possibly arise. Yet no class of works of art has ever begun to be seen in an entirely novel way solely because men like Coluccio Salutati have taken thought and then taken pen in hand.

To see why this rule is sound, the ways Europeans have seen Chinese art in the last three centuries teaches a useful lesson. In the later seventeenth century, an impulse emanating from the Jesuits at the court of the Emperor Kang Xi led Europeans to form a highly favorable, indeed much too optimistic picture of China as a beneficent empire ruled by philosophy. Yet in the realm of the arts, the sole results were an even wider market for China's commercialized export art, and the strong eighteenth-century fashion for Chinoiserie. In the later nineteenth century, however, a few Westerners in China and Japan[133] began to look carefully at great Chinese paintings, at the powerful early bronzes and at the marvelous Tang, Song, Yuan, and early Ming porcelains and pottery. The superlative qualities that these men first perceived were soon perceived by many others, with results that are now conspicuous in many countries of the West. In sum, the intellectual impulse to think anew about China only led—*could* only lead, in fact—to a new way of seeing Chinese art with the help of a strong secondary stimulus. And this stimulus came only when people began to *look* at truly fine Chinese works of art, and thus to see anew the works of art themselves.

In the case under discussion, the intellectual impulse to think anew about the classical past, its history, and its literature emanated from the pioneer humanists of the fourteenth century. But I venture to suggest that the secondary stimulus needed to produce the ensuing fashion for the antique in Florence must surely have come from pioneer classical art collectors and the works of art they made available for study. Without this kind of secondary stimulus to educate the eyes of the magnates of the Calimala, one really cannot imagine the Calimala's committee asking artists, in 1400, to submit emphatically *all'antica* competition reliefs for the new doors for the baptistery. And it seems to me downright illogical to look elsewhere for the crucial secondary stimulus, if classical art collecting was already established as an elite social habit in Italy as early as 1375—which I further believe may be taken as certain.

The Third Question

I know well that for many people, it will seem a dizzying leap from the fairly lowly subject of the Italian origins of Western art collecting to the enormous subject of the origins of the Renaissance in Italy—and thus to the birth of the whole Western art tradition. I know well, too,

that readers must now be asking: "Then who the devil were the Florentine collectors who played the role you describe?" I have a tentative and partial answer, but it must be deferred until another, closely related aspect of the origins of the Renaissance has been re-examined from the special angle of the history of art collecting.

Generations of art historians have searched for the classical models or prototypes used by a long line of innovating Italian masters, starting with Nicola Pisano in the thirteenth century.[134] The search has been needful, for the excellent reason that the artists' creative innovations can only be explained by inspirations drawn from classical models. Beginning with Nicola Pisano's borrowings from the sarcophagi he saw in the Campo Santo in Pisa, the search for the models used by artists has often met with success, too.[135]

The main obstacle to the art historians' search, however, has been the restricted number of classical works of art that were publicly accessible to artists in the thirteenth, fourteenth, and early fifteenth centuries. The most numerous group on the short list was in fact composed of sarcophagi. Just about every city in Italy had some Roman sarcophagi, often reused for the same purpose they were made for; and certain cities had large numbers of them. Because they were so numerous and accessible, the sarcophagi were naturally much drawn upon by artists of the early Renaissance, in just the way Nicola Pisano had used those in Pisa long before.

To illustrate, Professor Krautheimer and his partner-collaborator have of course searched for Ghiberti's classical models. They have found only a limited number of classical echoes in the first pair of doors for the Baptistery, in which the influence of the International Style was so strong.[136] But Ghiberti had evolved a classicizing style of his own by the time he designed his second pair of doors, the Gates of Paradise. And Professor Krautheimer shows that Ghiberti repeatedly borrowed motifs for the Gates of Paradise from sarcophagi he knew, often combining and recombining his borrowings with great boldness and ingenuity.[137]

After the sarcophagi, however, the short list of classical models publicly accessible to artists in the late fourteenth and early fifteenth centuries rather swiftly tails off. There were of course a few pieces of sculpture that had more or less escaped time's ravages and were still aboveground. Even in the Middle Ages, artists sometimes borrowed for their own works the image of the Spinario in Rome.[138] Rome, of course, had several more pieces of sculpture, too, such as the Horse Tamers and the equestrian Marcus Aurelius; and a few other Italian cities could show one or two Roman statues, such as the late classical equestrian bronze called the Regisol in Pavia.[139] Then there were also broken fragments of sculpture still lying about in Rome;[140] and there were the ruined monuments. But there the short list really ends, unless you suppose artists got access to ecclesiasti-

cal treasuries, and there borrowed motifs from the antique carved gems so often used to enrich medieval treasures.

Because the foregoing list is so short, in turn, Professor Krautheimer's search for prototypes has met with most incomplete success in just the cases where one would most like to hear of success. These cases are, of course, the works that first directly portended the new direction of Italian art—in fact, the Abundantia and Hercules figures of the Porta della Mandorla; the Madonna with a classicizing head attributed to the Hercules Master; and above all the competition relief which won Ghiberti the commission for the first pair of new Baptistery doors. Of the Abundantia, Professor Krautheimer says the figure "is derived from a Roman coin."[141] Of the Hercules, he says the figure reproduces "a rare type known in only two Roman bronze statuettes."[142] And he adds that the Hercules Master's Virgin Annunciate also "carries upon fine shoulders the head of a young Greek athlete."[143]

The treatment of Ghiberti's competition relief is still more interesting. Here Professor Krautheimer concentrates particularly on the exquisitely modeled nude figure of the youthful Isaac kneeling on the mountaintop, waiting for the cruel knife of Abraham made ready in humble obedience to Jehovah, and just before the knife will be averted from the sacrifice by the messenger-angel of the Lord.[144] In the appendix to Professor Krautheimer's book, Trude Krautheimer-Hess contributes what amounts to a short independent essay on possible prototypes for the Isaac figure alone.[145] All previously suggested prototypes are dismissed as unsatisfactory, since not one of those reviewed shows the delicate muscular modulation and "silky" skin of the Isaac figure's young body.[146] Hence Professor Krautheimer is driven to conclude, quite simply, that Ghiberti must here be suspected of "copying directly the modeling of a Lysippan or Scopasian torso."[147] This therefore makes it necessary to ask a third important question:

Just where can Ghiberti have found the Lysippan or Scopasian torso which he probably "copied" in his Isaac figure; just where was that Roman coin of uncommonly high quality behind the Abundantia; and just how did the Hercules Master run across the bronze statuette and the Greek athlete's head which he borrowed from so directly?

If you think about it, knowing where artists like Ghiberti and the Hercules Master can have found their obviously missing prototypes is just as important, at least in a practical, down-to-earth way, as knowing just which classical prototypes the artists used. The streets of Florence were certainly not littered with fine classical torsos, or antique coins of high quality, or Greek heads, or small Roman bronzes. Nor can artists have found prototypes in museums or art dealers' establishments: there

were none. If the discovery of a piece of classical sculpture was then regarded as a considerable event in the city, as seems to have been the case in Florence as well as Siena, one must also conclude that publicly accessible classical works of art were very few and far between—barring the things on the short list already covered. And if convincing artists' prototypes cannot be located on the short list, then the question asked above becomes central and unavoidable.

Without hesitation, I would answer this question as I did the previous one. The people who provided the missing prototypes must have been the early Italian collectors of classical art. Indeed, their collections are really the only possible sources one can think of for missing prototypes of the types Professor Krautheimer describes.

This does not mean, of course, that one can point to this or that fourteenth-century art collection in Italy as the source of the prototype for this or that work of art of the early Renaissance. The evidence merely indicates there were such art collections, and extends no further. Indeed, the bas-reliefs of four putti from Ravenna are the unique surviving classical works of art that can now be securely linked to a fourteenth-century art collector. They can be seen today in Venice's Museo Archeologico,[148] and these are certainly the putti Oliviero Forzetta wished to secure in 1335. But despite the immense gaps in the data, there are sound positive as well as negative reasons for believing that Italian artists of the great turning point really must have used art collections as sources of prototypes.

The negative reason is the one already given—that one can think of no other places where the unlocated prototypes can have been found. The positive reason is the vacuum-cleaner effect of all art collecting, which soon causes the particular kind of thing being collected to disappear from general circulation. This is an automatic effect, and no wonder. Pieces of Yuan porcelain are after all unlikely to go on being used as umbrella stands after an ex–umbrella stand has turned out to be worth more than half a million dollars.[149] In the fourteenth century in Italy, one can already see the methodical, vacuum-cleaner approach of all serious art collectors in Forzetta's note to himself about things to acquire in Venice. Of the four rare cases of newfound classical works of art described in the old texts,[150] two are actually seen in art collections—the others being those found in Siena and Verona. The truth is that if classical works of art were already being "avidly sought for" and commanded "great" prices in 1375, then the seekers, the art collectors, must have secured just about all the classical works of art that were newly unearthed in Italy, or were brought into Italy from the Eastern Mediterranean. There was of course no organized trade in classical works of art to supply the fourteenth-century collectors; but that is not a sufficient reason for supposing that demand did not affect supply in the usual way.

As to whether the early collections provided the kind of artists' proto-
types that are needed, a strongly affirmative answer will emerge when
we turn to the art collections of the early fifteenth century.[151] And as
to the question of classical art collecting by Florentines, it seems to me
hardly worth asking. By the closing decades of the fourteenth century,
Florence had become the flourishing center of Italian intellectual life. In
no other city in Italy of that time was interest in art greater or more
fruitful. Again, only assume that collecting classical works of art was an
established though elite social habit in Italy as early as 1375. Then it
would have been downright astonishing if there were no classical collectors
in Florence in good time to stimulate the crucial fashion for the antique
and also to provide prototypes for the artists influenced by this fashion.

Here, therefore, it is worth pausing very briefly to take note of a rule
of probability analysis. Two quite different kinds of probability have
emerged from the inquiry into early Italian art collecting's role in the
origins of the Renaissance. The first is the probability that classical art
collecting contributed importantly to the rise in Florence of Professor Kraut-
heimer's crucial fashion for the antique. The second is the probability
that most of the inadequately identified prototypes of the earliest artists'
works portending the Renaissance were in fact found in Florentine art
collections of the period. The rule of the analysts is that when two different
kinds of probability are mutually confirmatory, each kind gains enough
confirmation from the other to provide the basis of a sound working hy-
pothesis. Nor is this all.

At least one Florentine collection, whether large or small, is firmly
attested by Benvenuto da Imola's mention of a Venus statue in a rich
house there. Furthermore, it is now time for me to offer my own provisional
identification of one of the leading Florentine art collectors in the extraordi-
nary years when the Renaissance originated. I have only a single Florentine
candidate, but it is certain that he was his period's leading collector of
classical art; and there is at least a good probability, once again, that he
played a significant part in promoting the Florentine fashion for the antique
which then led on to the new art.

On Niccolò Niccoli

Niccolò Niccoli was a younger member of the humanist circle of Coluc-
cio Salutati.[152] As a humanist, he was also an extremist; for he had no
patience with anything that was *not* antique.[153] He was a man of considera-
ble position in the city, and he had relations with the more important
city leaders—in fact the potential patrons whose conversion to the fashion
for the antique was obviously necessary if the fashion was to lead to much
larger results.[154] In short, Niccoli had all the qualifications for the role I

believe he played. Nonetheless, my nomination of Niccolò Niccoli is some-
what hazardous because of the time frame.

The key years of the fashion for the antique, it must be remembered,
were roughly from 1390, when the members of the Wool Guild probably
began to consider providing the Duomo with something like the Porta
della Mandorla, until 1402/03, when Ghiberti got his commission for
the Baptistery's new doors. These were the key years, too, when Professor
Krautheimer's Lysippan or Scopasian torso and other missing prototypes
were needed by the Hercules Master and Ghiberti. Yet the main sources
for Niccolò Niccoli date well after these key years. Indeed, they chiefly
show him after 1420, when he was already a comparatively old man for
that period.

But let us ignore this problem of the time frame and first examine
the richly detailed portrait of Niccoli in his older years which all the
sources combine to paint. If we then work backward to the less complete
evidence for the years 1390–1402/03, it will be found that the detailed
portrait and the earlier evidence make a remarkably good fit.

Niccoli is frequently mentioned, sometimes with admiration, some-
times with angry hostility, in the correspondence and surviving writings
of the men of his time. For example, he was not only the target of a
series of invectives, of which more later; in addition, he appears as an
important figure in a series of dialogues on various subjects, of the sort
the humanists evidently enjoyed writing. Three are by Poggio Bracciolini,[155]
including *De Nobilitate,* written after Niccoli's death in 1437. Two more
dialogues are by Lorenzo Valla and Giovanni Aretino Medico;[156] but by
far the most is to be learned from the dialogue and sequel that opened
the series, by Niccoli's close friend of that time, Leonardo Bruni. The
first part of the dialogue is usually dated around 1400, the sequel only
a little later.

In Bruni's *Dialogi ad Petrum Paulum Histrum,*[157] the central figure
is Coluccio Salutati. Niccoli is cast as the simon-pure and fiery humanist
extremist, who carries his scorn for all but antiquity to the point of denigrat-
ing Dante, Petrarch, and Boccaccio for writing so much in the vulgar tongue
instead of Latin.[158] Dante is further denounced on the ground that his
letters showed he could not even write good Latin if he wanted to.[159]
Salutati, a lover of many years of the great fourteenth-century Italian
writers, is much shocked and pained by this outburst;[160] but is later con-
soled, since Niccoli, in the sequel or second part of the dialogue, partially
retracts his attack on Dante and the others.[161]

In the exchanges between Niccoli and Salutati another important point
is made, too. How, Niccoli asks in effect, can one talk about antiquity
when so many of the greater writers of antiquity have become mere empty
names, for want of texts of their works?[162] And he goes on to poke fun

at the Aristotelians of his own time and the Middle Ages, for going on and on about Aristotle on the basis of grossly imperfect and misleading versions of Aristotle's works.[163] The point of this exchange, of course, is that it clearly announces the greatest single aim of Niccoli's long life, which was nothing less than reconstituting the complete corpus of the literature of antiquity, as far as that could be done.

The main sources for the portrait of Niccolò Niccoli are a bit different, however. He turns up here and there, and sometimes fairly often, in just about all the surviving correspondences of the early-fifteenth-century humanists. But the two humanists who were closest to him and always remained his friends and supporters were the learned General of the Camaldolese Order, Ambrogio Traversari,[164] and the papal secretary and subsequent humanist Chancellor of Florence, Poggio Bracciolini.[165] The correspondences of these special friends are the first two main sources concerning Niccoli.[166] Poggio was a considerably younger man than Niccoli, who further aided Poggio to rise from relative poverty and obscurity to the success he conspicuously attained; and for Poggio, Niccoli was close to a father figure. Hence Poggio delivered a funeral oration on his lost friend after Niccolò Niccoli died in 1437.[167] This oration is the third main source for Niccoli's portrait, and the fourth and fifth ones are the engagingly vivid account of Niccoli in Vespasiano da Bisticci's *Vite di uomini illustri*[168] and the short biography of Niccoli by Antonio Manetti.[169]

It is remarkable that the sources concerning Niccoli are so numerous and ample. He had a modest fortune inherited from a prosperous father. But during most of his life he earned no money, and by the standards of the Medici, the Strozzi, and other Florentine plutocrats of that era, he was already getting perilously close to being a poor man by 1420. Furthermore, although he was a friend of Cosimo de' Medici Pater Patriae and also held office in Florence from time to time,[170] he played no political role worth mentioning. Thus he had neither of the most common qualifications for fame in the Florence of that day.

To begin with, however, he was evidently the kind of picturesque fellow who always attracts notice in a smallish, closely integrated community such as Florence then was—as long as the picturesque fellow is also taken seriously. For one thing, he was a decided dandy as long as he lived, given to wearing elegant long rose-red robes.[171] There are even two letters from Ambrogio Traversari to Niccoli, when the latter was out of the city, in which assurances that Niccoli's wardrobe was being well looked after are oddly mingled with news of old books and old friends.[172] Vespasiano da Bisticci also gives a charming picture of Niccoli, always the dandy, sitting down to eat his dinner and drink his wine from "beautiful old dishes" and crystal or other precious vessels from his art collection—all

on beautiful white napery. Watching these ceremonious and refined re-
pasts, says Vespasiano, was "a noble sight," like encountering "a figure
from the ancient world."[173]

Then, too, Niccoli was peppery and touchy in the kind of way that
interests others, yet provokes many people, too; and his intellectual posture
was also decidedly provocative. As has been seen, he downgraded the
great fourteenth-century Italian writers because his preferences were so
exclusively classical, which was provocative enough. But in addition, his
interest in classical literature was provocative in itself. His grand aim was
the recovery of lost classical texts, and a secondary aim was the restoration
to the correct form of all the classical texts he knew. He was openly
scornful of all incorrect readings. He was even aggressive about the right
way to spell Latin. His way has been judged the proper one; but this
did not console other learned men who were told that even the texts
they were using and their Latin spelling were sadly incorrect. The touchi-
ness, the pepperiness, and above all the scorn for the ingrained scholarly
habits of that period in turn explain the series of contemporary invectives
against Niccoli—by Cino Rinuccini,[174] Guarino da Verona,[175] Lorenzo di
Marco Benvenuti,[176] and, after a great falling out, Leonardo Bruni of
Arezzo,[177] plus nonstop attacks by Francesco Filelfo.[178]

The invectives tend to be repetitious, since all have two main thrusts:
first, that Niccoli showed a shocking lack of respect for great writers and
thinkers of the more recent past, in the way indicated in the Bruni dialogue;
and second, that Niccoli was a mere pedant, solely concerned with textual
correctness, with too much emphasis on grammar and spelling, and no
interest in the thought behind his beloved texts. One additional point
of great interest is made by Guarino da Verona, however. He mocks Niccoli
for boring everyone with his endless details about the great monuments
of antiquity, their measurements, their proportions, the systems of orna-
ment used, and so on.[179] Since the Guarino invective is dated 1413, this
shows Niccoli making what amounts to active propaganda for the kind
of new architecture inaugurated by Brunelleschi, but a good many years
before Brunelleschi began to embody his ideas in stone.

Another important point is made by both the invectives and the dia-
logues in which Niccoli figures. The dialogue writers of that period did
not borrow people's names for their works unless the people in question
were likely to be known to their readers. By the same token, fairly impor-
tant people—and four of the five invective writers were more than fairly
important—do not trouble to compose and circulate vigorous attacks on
other persons having no importance of their own. Hence both the dialogues
and the invectives clearly imply that Niccolò Niccoli was one of the more
notable personages in the Florence of his day.

Nor is this the end of this aspect of Niccoli's personality. The reactions

to these quarrels of Niccoli's special friends, Ambrogio Traversari and Poggio Bracciolini, also have their meaning. In some of the quarrels, they are not known to have intervened. The unpleasant Filelfo, for instance, was treated as a bad lot and a hopeless case. But it was different with Leonardo Bruni, whom Traversari and Poggio valued rather highly. Hence both Poggio and Traversari made the most laborious efforts to patch things up between Bruni and Niccoli when the two squabbled in 1417.[180] Poggio wrote Bruni that Niccoli was "tender and sensitive . . . [as if] made of glass."[181] The patching up succeeded. Traversari rejoiced.[182] And this time Poggio wrote Niccoli to urge him to go as far as "a renewal of love" with Bruni,[183] who had always been another of Niccoli's good friends until the squabble.

Niccoli's dandified and oversensitive exterior in fact concealed a man with an enormous knack for friendship, whose intellect was much respected, too, at any rate among the many who were fond of him. He had nothing material to offer either Traversari or Poggio, yet both, in effect, followed his direction in enterprises that meant much to them,[184] and their affection for him was such that they were always willing to take endless trouble on his behalf—as the data on his friends' concern with Niccoli's wardrobe and his quarrels are enough to show.

Another bit of evidence is a characteristic letter, from Traversari in Venice to his brother Jerome in Florence,[185] announcing, first, that he was sending home "a bundle of pens, not the best, but some that were given to me as a gift. You will give them to my friend Niccolò to choose from. . . ." To which the extremely busy leader of the Camaldolese Order added that he further hoped to send for Niccoli "those Greek volumes, the gift of my friend, [the Venetian humanist, Francesco] Barbaro, and two little vials, one of the best treacle . . . along with a bundle of cinnamon." Nothing could better convey the odd but pleasing character of Niccoli's intimacy with Poggio and Traversari than Traversari's splendidly indiscriminate mixture of Greek codices, quill pens, cinnamon, and treacle. All were calculated to please Niccoli, one may be sure.

Niccoli as Fashion Setter

Besides a talent for making close friends of extremely able men who then cared deeply about him through thick and thin, Niccoli had other significant advantages. He was evidently a delightful companion, to the point where Cosimo de' Medici paid all expenses to have Niccoli with him on more than one of his trips out of Florence—for example, when Cosimo fled the plague to Verona and another of the Florentine humanist circle, Carlo Marsuppini, was also included in the party.[186] Probably toward the end of Niccoli's life, and because his modest fortune was finally ex-

hausted, Cosimo further gave him an open drawing account at the Medici bank to use as long as he lived.[187]

Then, too, Niccoli had the additional knack of attracting the young. To be sure, his own attraction was reinforced by the attraction of his art collection—of which more later—and of his library. This must have been the largest private library in the West of those days. By the end of his life, to be precise, Niccoli owned over eight hundred codices,[188] in many of which, after the practice of the time, works by several different authors were bound together. Whereas the entire library of the University of Oxford numbered not much above a hundred volumes before Duke Humfrey of Gloucester's memorable gift of 1439.[189] Nonetheless, all too few older men, however well stocked their libraries and however fine their collections, are ever likely to rival Niccoli in "always [having] his house full of distinguished men and the leading youths of the city."[190] Almost daily, "ten or twelve young gentlemen" would come to read books in Niccoli's library, after which Niccoli would propose a scholarly topic for discussion.[191]

Finally, Niccoli had none of the snobbish view of artists that is suggested by Leonardo Bruni's decidedly patronizing program for Ghiberti's second pair of doors for the Baptistery.[192] On the contrary, Niccoli "especially favored" artists: not only the young Luca della Robbia, but also the very men who chiefly forged a new art out of the fashion for the antique, Brunelleschi, Ghiberti, and Donatello.[193]

In the foregoing summary of Niccoli's personal traits and relationships, anyone can observe the necessary ingredients of the kind of man who is able to influence those around him, and to start new trends of thought if he has any to propose. Even so a question still remains. Niccoli was no great writer himself, presumably because he cared so much about good Latin style,[194] and he left almost nothing of his own behind except for an unimportant letter or two, plus a debt of 500 ducats to the Medici bank and his library and art collection. Thus some may well still ask why Vespasiano da Bisticci, writing considerably later, included Niccoli among the important Florentines of the early fifteenth century.

The answer seems to be that in his own queer way, Niccoli really was among the more important Florentines. He was the active leader of the early-fifteenth-century humanists' great effort to rescue from mold, dust, and decay a considerable part of the classical literature we know today. Without this humanist effort, and, one must add, the much earlier but comparable effort in Constantinople of the Patriarch Photius and his continuator, Arethas, it is chilling to think how much diminished our knowledge of the Greek and Roman past would be today.[195] Second, Niccoli accumulated the largest private library of his time; and not a few of his volumes resulted from his diligent copying and collation of classical texts[196]

found by himself when young, or later brought home by his wider-ranging friends.[197] In the course of this work, too, he rather rapidly abandoned the crabbed medieval script and began to use a modified version of the beautiful Carolingian minuscule,[198] thereby contributing largely to the fine script used in the Renaissance and thus to the present italic form of the modern alphabet.[199] Third, he had no match among the art collectors of that time. And fourth, he was not only the kind of man who is capable of influencing others; he also used his capacity to the full. As E. H. Gombrich has written, he was a catalyst.[200]

Of the humanist effort to rediscover lost classical texts, not much needs to be said in this chapter except to show Niccoli's own role. In the funeral oration, Poggio Bracciolini specifically recorded his own indebtedness to Niccoli for financial assistance in the great task, and for his generosity in making available to the rest of the scholarly world the lately found texts of Greek and Latin works which Niccoli had tirelessly copied in his usual way.[201] Poggio then went on—I fear not without a touch of irony—concerning Niccoli's methods with his juniors: "In this matter, I can truly say that it was through the persuasion, pressure applied, urging and almost the browbeating of Niccolò that practically all the books that were recently discovered, both by others and myself . . . were restored to Latin literature."[202] And on this topic, finally, Poggio warmly praised his lost friend for bequeathing his library for public use, whereas the libraries of both Petrarch and Coluccio Salutati had been dispersed when they died.[203] As a result of Niccoli's testament, he still has his tangible memorial today in those of his books which finally came to the great Laurentian Library, Florence's Central National Library, and some other, more scattered libraries where Niccoli's codices have strayed.[204]

As for Niccoli's art collecting, the evidence of the largeness and importance of his classical collection is ample and unequivocal. Vespasiano da Bisticci described Niccoli emphatically as having "wide judgment, not only in letters, but also in painting and sculpture, and he had in his house a number of medals, in bronze, silver and gold; also many antique figures in copper and heads in marble,"[205] and as further owning "a vast number of vessels"[206]—which here means vessels in crystal and other hard stones, just as those "antique figures in copper" were in fact classical bronzes.

In the funeral oration, Poggio Bracciolini went much further. Niccoli, he declared, "took much delight in pictures and statues and various collections of objects fashioned in the manner of men of old. For almost alone, he had a greater number of these things, and more choice ones, than practically anyone else. . . . [In his house] could be seen statues and pictures, likenesses of men of old, and coins dating back to that earlier age when bronze first began to be struck and coined money first began

to be stamped."[207] In the early 1430s,[208] finally, Florence was visited by
that tireless traveler, recorder of classical works of art (including an intact
pediment of the Parthenon), collection viewer, and general picker-up of
anything having to do with the Greek or Roman past, Ciriaco d'Ancona.
The notes on Ciriaco's visit have much to tell us about the range of Floren-
tine classical collecting at the time of his visit.[209] What matters here,
however, is that the high point of the visit was a meeting with Niccoli,
which Ciriaco "especially eagerly" recalled. He talked with Niccoli for
hours about classical remains in the Eastern Mediterranean area. Above
all, he compared Niccoli as a collector to Ptolemy II Philadelphus[210]—
here undoubtedly referring to Athenaeus' account of the second Ptol-
emy's grand feast in a pavilion decorated with a hundred statues by the
best Greek masters and numerous panels by painters of the Sicyonian
school.[211]

Overall, therefore, it is unchallengeable on the evidence that Niccoli
was the leading collector of classical works of art in his own time. Poggio
Bracciolini said so specifically. Ciriaco d'Ancona implied that Niccoli had
that position. Whenever Ambrogio Traversari saw a classical work any-
where in Italy, he wrote to Niccoli about it at uncommon length.[212] It
is just as significant, too, that Niccolò Niccoli repeatedly used his collection
and his influence to indoctrinate others with his own taste for classical
art.

On this head, Ambrogio Traversari is the least precise. In a letter to
Francesco Barbaro mildly lamenting his dear friend's touchiness, Traversari
added that Niccoli was a "good man with much integrity," to whom "all
youth . . . should give thanks for his encouragement of learning."[213] In
the funeral oration, however, Poggio Bracciolini dotted the iii's and crossed
the ttt's. Of Niccoli's works of art, he said, "Many people were drawn
to seeing [them] . . . so that you could say that they were placed and
displayed not in some private place, but [publicly]."[214] In other words,
Niccoli made his house and art collection into the nearest thing Florence
then had to a public art museum.

There is good evidence, too (although one would like much more),
that Niccoli's artist friends carefully studied the objects in his collection.
On this head, we have the testimony of Lorenzo Ghiberti that among
Niccoli's "other antiques," there was "a chalcedony" that was a "marvel-
ous thing" which Ghiberti considered "more perfect" than anything else
he had ever examined.[215] A good deal more of this carved gem will be
heard in this chapter and the next ones; for it had a dramatic history
and was so celebrated in the fifteenth century that it was known as *il
calcedonio*—"the chalcedony."[216]

So there you have the facts concerning Niccoli in his older years.
Even taken by themselves, the facts already set down plainly suggest that

in the art history of the early Renaissance, Niccoli had an importance that has been too little taken into account.

Niccoli's Dates

The great question remains, however, whether Niccoli was far enough advanced on the career he later followed to have had a significant share in setting Professor Krautheimer's fashion for the antique in Florence from 1390 onward. Equally important is the question whether he can have had the kind of collection as early as 1390 in which the Hercules Master and Lorenzo Ghiberti would have found the prototypes Professor Krautheimer believes they must have followed.

Concerning the second question, it may be well to start by noting that when we can inspect Niccoli's collection, so to say, through the fifteenth-century descriptions of it,[217] there can be little doubt that possible prototypes were there. Think of that Lysippan or Scopasian torso which is so badly needed to explain the quality of Ghiberti's Isaac figure, and then think of those copper, really bronze, classical statues mentioned by Vespasiano da Bisticci. Or think of the Hercules Master's Virgin Annunciate, with its "Greek athlete's" head. Then think of Niccoli's marble antique heads, any one of which may so easily have come from a neo-Attic figure of the type so many Romans particularly admired.

But what of Niccoli's collection in 1390, and what of his potential as a shaper of artistic opinion at that relatively early date in his life? One may begin the attack on this central question with Niccoli's birth in 1364.[218] He chose a propitious moment to enter the world, for Florence was already beginning to recover from the heavy double blow of the Bardi and Peruzzi bankruptcies and the Black Death. The grave crisis of the Ciompi revolt also ended while Niccoli was still a boy. His father was a rich man—not enormously rich, perhaps, but a comfortable member of the upper business group in the city.[219] The son got a thorough classical education, fell in love with antiquity and early joined the circle of Coluccio Salutati. But while his father lived, he had to work in the parental business.[220] The elder Niccoli died, however, when the son was still a young man; whereupon Niccolò Niccoli left his brothers to carry on, lived on his own share of the family fortune, and retired from business forever.[221] He then devoted the rest of his life to the learned and artistic pursuits which so completely absorbed him.

By 1390, Niccoli was twenty-six and thus near the threshold of middle age by the harsher standards of that era, when middle age began at thirty. There is good evidence, too, that even as early as the 1390s, Niccoli was already something of a figure in Florence. The funeral oration by Poggio Bracciolini fairly shamelessly gave Salutati and Niccoli[222] the sole credit

for bringing Emmanuel Chrysoloras from Constantinople to teach Greek to the Florentines who longed to know the language of Plato, Aristotle, and Homer. This was shameless because Palla Strozzi had actually paid much of the bill for importing Chrysoloras, in the way that has been noted; but Poggio's elimination of Strozzi is understandable, too, since Cosimo de' Medici was supreme and Strozzi was in political exile when Poggio's oration was delivered. There was some truth in Poggio's claim, however, for although most of the bill for importing Chrysoloras and providing a salaried place for him was in fact paid by Strozzi, Niccoli was also active in promoting Chrysoloras' journey to Italy.[223]

This has two important meanings for our purposes. Niccolò Niccoli acted, in effect, as Strozzi's junior partner in a major enterprise, and thus he clearly knew Strozzi pretty well. He cannot have been close to Strozzi without having friendly access to other men in Florence's leadership group. To act with Strozzi in this way, moreover, is the sort of thing younger men never get the opening to do, even in a relatively small city such as Florence then was, and even by paying, unless they have already become personages in their own right.

As for the other pieces of direct evidence on Niccoli's standing in Florence in the earlier years here under discussion, the most telling is the previously described dialogue written by Leonardo Bruni. As the dialogue dates from around 1401 and describes or pretends to describe a nearly contemporary event, the sketch of Niccoli in the dialogue portrays him toward the end of these earlier years.[224] One must assume, too, that Bruni was accurate in portraying Niccoli as simon-pure, aggressive, and exclusive in his love for antiquity. The invective writers, it must be remembered, repeatedly made the same point about Niccoli in a different way. One must assume, further, that Niccoli was already well known in Florence for his new, extreme humanism, which had probably shocked other Florentines as it does Salutati in the dialogue. And one must assume, finally, that in this way and in others, too, Niccoli had already become a fairly conspicuous figure in the city. In fact, the way Niccoli is cast in Bruni's dialogue can be confidently interpreted as meaning that he already had a city-wide reputation as an extremist in his admiration for antiquity, which in turn made a splendid insiders' joke of his denigration of Dante, Petrarch, and Boccaccio, as described by Bruni.

It must be added that if Niccoli could early deplore Dante's choice of Italian for the fourteenth century's greatest masterpiece, the same viewpoint must surely have carried over into his opinions about art. Given all we know about Niccoli, and not least about his art collecting, Niccoli's conviction of the superiority of classical art must have been much more aggressive and absolute than the view expressed by Giovanni Dondi. Furthermore, he can be counted on to have expressed this opinion as soon

as he had formed it. In 1413 he was ridiculed by Guarino da Verona for, in effect, advocating an architectural return to antiquity before Florence possessed a single Renaissance building.[225] How likely, then, that Niccoli was one of the more active promoters of the fashion for the antique in Florence in the time of Bruni's dialogue! Yet it is still to be shown whether Niccoli is also likely to have formed his classical art collection early enough to provide Professor Krautheimer's required classical prototypes at the right time.

Here one must begin with a peculiarity of all collectors, and not least of art collectors. In brief, the more compulsive the collector, the younger he is pretty sure to be when he starts to collect. Robert von Hirsch, for instance, was the last great European collector in the dazzling nineteenth-century style. Besides the *armilla* of Frederick Barbarossa,[226] he owned so many other wonderful things that after he died at over ninety, his works of art sold for a little more than $34,000,000—a record for a single collection. And Robert von Hirsch started collecting when he was barely twenty.[227] Many other art collectors who started as young, or even a bit younger, might easily be mentioned. So it is not at all improbable that Niccoli started collecting in 1380, when he was no more than seventeen or a bit less. By then, his formal education was undoubtedly over, for young men in Florence did not go to school into their twenties, in the way they go to universities today.[228] In fourteenth-century Italy, in fact, most sons of prosperous men went to work at thirteen or fourteen, and the children of the poor did so at nine or ten.[229] Thus seventeen was a far greater age in Florence in Niccoli's time than twenty was when Baron von Hirsch began his remarkable career as an art collector.

The second piece of evidence to consider is that, at least by 1420, when our more detailed knowledge of Niccoli begins, he already had the great collection the sources describe. This must be inferred since he had evidently all but ceased art collecting by then and was primarily preoccupied by the recovery and reproduction of lost classical texts. This necessarily requires an early date for the formation of his collection. To be sure, there are two minor pieces of contrary evidence. A letter from Ambrogio Traversari in Venice reports hearing that "Francesco Pistorio"—really Fra Francesco da Pistoia, an interesting character we shall encounter later—was in Syria with a commission from Niccoli to look for classical texts and/or works of art.[230] A letter from Leonardo Bruni, before his quarrel with Niccoli in 1417, also indicates Bruni had managed to secure a gem carved with a figure of Narcissus for Niccoli's collection.[231] But there is no hint that anything came of the rumored commission to Fra Francesco da Pistoia, and I suspect that the gem carved with a figure of Narcissus was possibly the last addition to Niccoli's art collection. I have good reasons, too.

In brief, there certainly should be some hint of what was happening, if Niccolò Niccoli had gone on acquiring large numbers of classical works of art in his later years, from Fra Francesco da Pistoia or anyone else. This is because the humanist correspondence of the '20s and '30s of the fifteenth century contains recurring reports about classical gems and coins and sculpture, which the writers had seen in other people's collections, or had regrettably missed seeing, or had heard that someone or other had just got his hands on.[232] Poggio Bracciolini's letters to Niccoli also offer occasional descriptions of other pieces of classical sculpture which were in Poggio's own collection, or had just been picked up by him, or that he hoped to pick up.[233] Hence if Niccoli had still been actively collecting in his later years, one may be close to dead certain that his collecting would have been rather more abundantly reflected in his friends' letters of that period. And there is no such reflection.

The third piece of evidence bearing on the dating of Niccolò Niccoli's art collection is the modesty of his fortune—no more than one brother's share of what his father left. To understand why this is significant, it must be understood, too, that classical collecting in Italy rather plainly entered stage three of the collecting cycle fairly early in the fifteenth century. The evidence is fragmentary, as so often, but it still seems probable that the 1420s were the decade when the really rich in Italy finally began to join the collectors' competition for classical works of art.[234]

In short, the data indicate that the fifteenth-century humanist correspondence reflects so little art collecting by Niccoli precisely because Niccoli had been priced out of the market, most likely by the end of the fifteenth century's second decade. Even the Narcissus gem found by Bruni was added to Niccoli's collection before that date. Collectors being priced out of the market are common enough in collecting history, after all. It happened to Mrs. Jack Gardner, for instance, in the first decade of the twentieth century, when J. P. Morgan, Henry Clay Frick, the Rembrandt enthusiast Altman, and other American "squillionaires" (as Bernard Berenson called the people who paid for I Tatti) started to offer prices Mrs. Gardner could not hope to pay for the old masters she chiefly wanted.[235] A Vermeer at $6,000, which was the sum Mrs. Gardner paid for hers at the Thoré-Bürger sale,[236] looks remarkably different from a Vermeer at ten, or twenty, or even a hundred or more times that price. So must have an antique carved gem or classical bronze when the same sort of rise in prices began to take place in Niccoli's later life.

This is no mere speculation, either. Vespasiano da Bisticci specifically notes that in Niccoli's later life, people evidently wondered how a man of his limited means could possibly have acquired so many hard-stone vessels, particularly, since these had become very precious. Vespasiano's significant explanation was that Niccoli formed his collection when "things

of this sort were not so highly prized."[237] And then there is the further explanation, just as significant, that in the years when Niccoli's collection was assembled, "those who wished to please him would send him either marble statues, or antique vases, or sculpture, or marble inscriptions."[238]

In the first appearance of serious art collecting in the West, one can well imagine Niccoli's friends trying to please him by giving him classical works of art as presents before the fourteenth century ended. Since art collecting was so novel a social phenomenon, the "great prices" that Giovanni Dondi recorded were probably not so very great, though high enough to surprise noncollectors. But in the subsequent transition from art collecting's stage two to stage three, intensifying collectors' competition necessarily caused a further price rise. After that, the presents to Niccoli recorded by Vespasiano da Bisticci are really unimaginable. People do not give away works of art as though they were Christmas cards when the works have begun to become really valuable. In sum, there are good reasons to believe that as a collector, Niccoli got in on the ground floor—which again means he started to collect early in his life.

Remember Occam's Razor

Yet I have kept to the last the most telling and specific of all the pieces of evidence concerning the early date for the beginning of Niccoli's art collecting. It is the story of the *calcedonio* in Niccoli's collection, which Lorenzo Ghiberti thought "more perfect" than anything he had ever seen. In brief, Niccoli spotted this gem, which was carved with Diomedes' theft of the Palladium, hanging on a string around a child's neck on a street in Florence. Niccoli promptly located the child's father, bought the gem for 5 florins and, once he owned it, decided it must be the work of Polyclitus.[239] (Such attributions were common at this stage in Western art collecting's story: witness Ghiberti's *"letto di Policleto,"*[240] a small, still-surviving bas-relief of Eros and Psyche, the like of which Polyclitus can never have seen.[241])

Once acquired, Niccoli's gem off a child's neck became over time one of the most celebrated pieces in his collection. This one must infer from what happened when Luigi Scarampi Mezzarota came to Florence in the early 1430s in the train of Pope Eugenius IV. Scarampi was an important man at the Papal Court and was later named Patriarch of Aquileia and a cardinal.[242] He badgered Niccoli until the collector loaned him the great prize. Having got *il calcedonio* into his hands, Scarampi then nagged Niccoli, probably also making difficulties about giving the prize back to its owner, until Niccoli agreed to sell at last. This time, the gem's price was no less than 200 florins, a really enormous sum in those days.[243]

In the later twentieth century, everyone is an art collector, and vertigi-

nous price rises are common on the art market. Yet an increase in value of any collector's prize by a factor of forty times is still considered, even today, what the French dealers would enviously call a *"très bon bénéfice de collectioneur."* In the fifteenth century, such a collectors' profit must have been downright astonishing; and this, no doubt, was why Vespasiano da Bisticci included the story in his account of Niccoli. Even in the twentieth century, large, rapid price rises are still unknown except when a lost work of art of great established value has been rediscovered. Hence *il calcedonio* must surely have needed a long time to rise forty times in value at this very early stage in the development of Western art collecting. It is conservative, therefore, to estimate that about fifty years elapsed between Niccoli's original purchase and the sale to Luigi Scarampi Mezzarota.[244]

Thus it is again conservative to suggest a date in the very early 1380s for Niccoli's acquisition of the gem that later became so famous. This, in turn, strongly buttresses my first suggestion that the beginning date of Niccoli's art collecting was around 1380. And if Niccoli began collecting so early, and at a time, too, when an antique gem of highest quality could still be picked up for 5 florins, then he could easily have had an important collection of classical works of art before the fashion for the antique began to take hold in Florence, around 1390. Thus all the facts are now in place that support my nomination of Niccolò Niccoli for the role I have suggested for him—the role of one of the Florentine collectors, if not the chief Florentine collector, who provided the needed secondary stimulus for the new fashion for the antique that led on to such tremendous results in art. With these facts in place at last, moreover, the main argument of this chapter is also complete.

Yet a little more must be said before this chapter closes, if only because it deals with art collecting's role in the history of art in a way that will not be attempted again in this essay. For one thing, my nomination of Niccolò Niccoli for the role I have suggested is not essential to my main hypothesis. It seems to me persuasive, and I hope it may persuade others. Yet if Niccoli did not in reality play this role, it still strikes me as profoundly improbable that there were no other pioneer Florentine collectors to fill the resulting gap. No one could be surprised, for instance, by new documents showing that an important early collection of classical art was made by Palla Strozzi, with his great wealth, his intense interest in humanist studies, and the interest in art that caused him to be chosen as one of the Calimala's three-man committee surpervising the execution of Ghiberti's first pair of Baptistery doors.[245] The truth is that my hypothesis concerning art collecting's share in the Renaissance's origins has only two indispensable parts: first, that classical art collecting was an established though elite social habit in Italy a decade or more before the first obvious

signs that the Renaissance was on the way; and second, that it is therefore only logical to assume a connection between the new social habit and the new direction taken shortly thereafter by the art and artists of Italy.

I am well aware that all specialists tend to exaggerate the importance of their specialties. I believe, and I think the evidence demonstrates, that classical art collecting in Italy had its own share in the origins of the Renaissance; but I do *not* believe that this contribution was more than one element in a large and very complex pattern. Other elements in the pattern were as important or more important; and certain important elements are still missing, too, and probably always will be. For instance, it is particularly troubling that so little is known about the mood and aims of the artists themselves (perhaps repressed by patrons?) in the considerable time gap between Dondi's unnamed sculptor's confession of fervent veneration for classical sculpture, and the Hercules Master's first forthright reflection of the fashion for the antique in the decoration of the Porta della Mandorla.

Yet Occam's Razor must never be forgotten. This is the cardinal rule of science, that the simplest hypothesis explaining a set of facts deserves to be tentatively accepted, unless the correctness of a more complicated hypothesis can be solidly proven. The rule clearly applies to my hypothesis that the crucial fashion for the antique in Florence was largely set by the classical art collectors, who also supplied what I have called the missing prototypes. That much I dare to claim for art collecting's share in the origins of the Renaissance; and I claim no more.

XI

THE ROLE OF COSIMO

Which works of art were sought after by collectors? Which works were sought by patrons of the arts alone? What interested no one except junk dealers? In every period, these questions demand answers by the historian of art collecting. Finding the answers is always rewarding, too, since one can always expect surprising ones. And nowhere is the surprise greater than in the fifteenth century in Italy.

Dependable answers about this period in art collecting's history require wide-ranging investigation. Whereas the evidence from the fourteenth century is so sadly sparse, the fifteenth-century evidence is extensive and, further, comes from all the major Italian centers of that time. In truth, setting forth all the evidence would fill an entire volume, which would be tediously repetitious. Consequently, selection is unavoidable; and the method of selection will be to treat Florence as a microcosm, where both art and art collecting developed in representative ways.

Or perhaps the word "representative" is ill-chosen. The truth is that in both spheres which bear on the theme of this chapter, the Florentine story was much richer than the story in the other Italian cities. Of the story's first phase, Leon Battista Alberti wrote most movingly of his own long-awaited homecoming from political exile:

"I was both astonished and grieved at the loss of so many outstanding and excellent arts and sciences from our flourishing antique past. We know how widespread they were from the works that are left to us and through references to them. Painters, sculptors, architects, musicians, geometricians, theoreticians, seers and similiar noble and outstanding intellects are very rare today and there are few to praise them. So I believed, as many have already stated, that Nature, the mistress of [all] things had grown old and tired. She no longer produced either the geniuses or

giants which in her more youthful and glorious days she had so marvel-
lously and abundantly produced.

"Since then I have returned to Florence from the long exile in which
we Alberti have grown old, to this city of ours, adorned above all others.
I have come to understand how in many men there is a genius for accom-
plishing many praiseworthy things and especially in you Filippo [Brunelles-
chi] and in our good friend Donato [Donatello], the sculptor, and others
like Nencio [Ghiberti], Luca [della Robbia], and Masaccio."[1]

Alberti's point may not be immediately obvious today. We no longer
have the old notion that the decay of arts and sciences must be explained
by the decay of nature's power, nor can we imagine explaining the darkness
of the Dark Ages in Europe by a failure of nature's vigor at the time of
the classical world's twilight. Yet the germ of this idea is already to be
found in the complete version of Giovanni Dondi's previously quoted
letter about classical art in the later fourteenth century, and two centuries
after Alberti's time, the idea's ghost walks again, as it were, in Rubens's
odd suggestion that classical sculpture was more beautiful than what came
later because human bodies were finer in classical times. For us, meanwhile,
the point is the list of great artists whom Alberti thus saluted. These
were the men who made Florence the nursery of the arts in Italy in the
fifteenth century's first decades. And Florence remained central to Italian
art until a new scene opened with the fall of Medici power in the city
in 1494.

By that time, Medici rule over Florence had lasted without interruption
for no less than sixty years. The chief founder of the family's greatness,
Cosimo de' Medici, was also the first of the long line of rich and powerful
Italians who became ardent collectors of classical works of art—or, at any
rate, he was the first anything is known about today.[2] When Cosimo
died in 1464, the grateful Florentines gave him his posthumous title, *Pater
Patriae*, "Father of the Country," and the succession passed to his eldest
son, Piero the Gouty, so named from the affliction that crippled him.

As a classical collector, Piero de' Medici was quite as ardent as his
father had been;[3] but when he died in 1469, the next heir of Medici
power, Lorenzo de' Medici, soon surpassed both his father and his
grandfather.[4] Before he died in 1492, Lorenzo the Magnificent, as all men
called him, had in truth become the most famous art collector Europe
had seen since the decay of the Roman Empire in the West. And even
in 1494, when Lorenzo the Magnificent's feckless son and heir was driven
from Florence by the combined pressures of Savonarola and the invading
French, the only objects the fleeing Piero de' Medici snatched up and
carried away from the superb palace of his forebears were three antique
carved gems from his father's collection.[5]

In any history of art collecting, the Medici therefore have their special

place as the first Western collecting dynasty to compare with the Attalids of Pergamum. But the fifteenth-century Medici have a special place in another way, too, because their art collecting was the model, at least in some degree, for the magnates' art collecting which became almost universal in Italy before the next century opened. Quite demonstrably, too, this Italian magnates' art collecting, for which the fifteenth-century Medici partly set the example, then exercised an influence on Western art itself which lasted for another three hundred years.

Nor is this all. Cosimo de' Medici Pater Patriae was not only the first magnate-collector we now know much about; he was also an inspired patron of the arts, and as a patron, he was probably more lavish with his own purse than any of his successors in the long and grandiose line of Italian magnate-patrons.[6] Piero and Lorenzo de' Medici both followed Cosimo in this respect, too, as they did in art collecting. Thus Medici commissions showered upon the extraordinary company of Florence's leading artists, from the time of Brunelleschi, Donatello, Ghiberti, and Masaccio until the time when the youthful Michelangelo lived and got a considerable share of his esthetic education under the roof of Lorenzo the Magnificent. And again quite demonstrably, the scope and innovative character of the private patronage of the Medici fed back indirectly but importantly into the development of art collecting after the fifteenth century.

Yet throughout the entire century, Medici art collecting and Medici patronage of the arts went forward in parallel, as two distinct and separate activities. As art collectors, the fifteenth-century Medici sought classical works of art exclusively; and no works by any of the great Italian masters they patronized were ever truly collected by them. Nor did this strange rule apply to the Medici alone. In the fifteenth century, the single city of Florence produced more than a score of artists whose least works collectors and museum curators would now fight furiously to obtain, and one cannot forget the towering masters who were not Florentines, like Piero della Francesca. Yet all these artists, everywhere in Italy, had dealings only with patrons.[7] And although art collectors multiplied all over Italy, the sole collectors' prizes remained the products of antiquity until the fifteenth century ended.[8] Here is the great surprise of the fifteenth-century story.

Unless the surprise is understood, what really happened in this extraordinary century cannot be fully understood. Much that happened later will also remain more than a little blurred. But understanding the surprise requires long and careful analysis of artist-patron relationships and of art collecting's development in the light of the definitions previously offered in this essay. The present chapter will therefore lay the groundwork, carrying the story through the lifetime of Cosimo Pater Patriae, and examining the considerable long-range consequences of his activities in the sphere

of the arts. The ensuing chapter will then cover the period when Florence was successively ruled by Piero the Gouty and Lorenzo the Magnificent. It is then that the surprise, as I have called it, is easiest to demonstrate.

The Early Climate

Such is the necessary preface to a long task of exploration. Before tackling the main task, however, some note must also be taken of certain special cases. Not unnaturally, our proposed microcosm, Florence, was not exactly like the other cities of Italy, and not only because it was the center of the arts. Naples differed in the Neapolitans' special esteem for works of art imported from the Low Countries.[9] The cities of northern Italy differed in their relative slowness to absorb the Renaissance. Rome differed, because occasional discoveries of classical sculpture[10] were a natural consequence of the construction works consequent on the papacy's return from Avignon in 1387.

Then, too, a special case of sorts probably existed at the opening of the fifteenth-century story. I myself would guess, at any rate, that the collectors of the fourteenth and even the very early fifteenth centuries did not leave Italian art entirely to the patrons, in the way that became general soon thereafter. It must be remembered, to begin with, that Oliviero Forzetta's note of 1335 not only mentions contemporary Venetian artists[11] to whom he intended to give commissions—a part of the Forzetta note earlier passed over because this was routine patronage. In addition, the note shows Forzetta planning to acquire works of art left behind by two dead artists, Perenzolo and Gioacchino, the sons of a Magister Angiolo, if a recent scholar is correct.[12]

A quite different set of facts is more telling, however. Something has already been said about all art collectors' automatic electrical response to any artist who already has, or even promises to have, the standing of an old master—as that phrase is used in this essay. Furthermore Giotto, particularly, had something fairly close to this kind of standing for a great many years after his death in 1337. Petrarch was given his Giotto Madonna by a friend in Florence[13] considerably after Giotto was in his grave, and he wrote his will assigning the Madonna to Francesco da Carrara when Giotto had already been dead for about a generation.[14] In the generation after Petrarch, too, we have the oddly assorted testimony of Francesco di Marco Datini, Giovanni di Pagolo Morelli, Cennino Cennini, and Filippo Villani[15] that Giotto was regarded until the close of the fourteenth century and for a while thereafter, not just as the historical refounder of Italian art in the later way, but as the still pre-eminent painter, the best and most talented, among all those Italy had produced. Later still, Masaccio went to Giotto for inspiration in order to start painting on a new course.[16]

Against this background, it seems quite probable that there were a couple of Giottos among the otherwise unidentified "pictures" which are recorded in both the principal descriptions of Niccolò Niccoli's collection. A number of these paintings, I would boldly guess, were among his depictions of "famous men of old" mentioned by Poggio Bracciolini, perhaps with features derived from Niccoli's even more cherished images of "men of old" on antique coins, medals, or portrait gems. It would have been natural for Niccoli to commission such pictures to enhance his collector's grand ensemble; and it may be no accident that the first ambitious fresco cycle in any Florentine private interior that has been recorded was in a house where Niccoli was a familiar, and had as its subject great men of history.[17] But in view of the characteristic collecting mentality, and also of Giotto's special standing in Niccoli's young manhood, it would also have been natural for Niccoli to mingle a Giotto or two with his classical works of art. And there is another reason for this surmise which will be given later.

Yet the surmise is no more than that, and it is high time to embark upon this chapter's main theme. It may be well to set the stage with the best existing thumbnail sketch of the ideas about classical art and the kind of response to it that prevailed in Florence in the early fifteenth century. Curiously enough, this comes from the Greek from Constantinople, Emmanuel Chrysoloras, and is to be found in a letter from him. During his visit to Rome in 1411, he wrote his brother Demetrius:

> Can you believe of me that I am wandering about this city of Rome, swivelling my eyes this way and that like some boorish gallant, clambering up palace walls, even up to their windows, on the chance of seeing something of the beauties inside? I never used to do this sort of thing when I was young, as you know, and had a poor opinion of those who did. Yet here I am, getting on in years, and I scarcely know how I have been brought to this point. Am I reading you a riddle? Hear, then, its answer.
>
> I am doing all this in the hope of finding in these places beauty not in living bodies but in stones, marbles, and images. You might say that this is even more ridiculous than the other. And it has often occurred to me to wonder about this: how it is that when we see an ordinary living horse or dog or lion we are not moved to admiration, [and] do not take them for something so very beautiful. . . . Yet when we see a representation of a horse, or ox, plant, bird, human being . . . we are much impressed and, when we see their representations, make much of them. Though they are not, I suppose, any more meticulously formed than the living objects, the representations are praised in proportion to the degree in which they seem to resemble their originals. . . . We do not concern ourselves with whether the beak of a live bird or the hoof of a live horse is properly curved or not, but we do with whether the mane of a bronze lion spreads beautifully . . . or whether the sinews and veins are shown in the stone

leg of a statue. These are the things that men take pleasure in.

Many people would willingly have given many living and faultless horses to have one stone horse by Phidias or Praxiteles, even if this happened to be broken or mutilated. And the beauties of statues and paintings are not an unworthy thing to behold; rather do they indicate a certain nobility in the intellect that admires them. It is looking at the beauties of women that is licentious and base.

What is the reason for this? It is that we admire not so much the beauties of the bodies in statues and paintings as the beauty of the mind of their maker. . . . The artist's mind, though it is not itself disposed particularly to laughter or pleasure, anger or sorrow—and may indeed be disposed to their contraries—yet impresses these passions on the materials. This is what we admire in these representations.[18]

This remarkable letter is deservedly well known, but the full import of the ideas expressed and the letter's rather widespread interconnections have not been much pondered. The letter plainly means, for instance, that there was a good deal more surviving or newfound classical sculpture in Roman palaces of the early fifteenth century than we now know about, although there was no early-fifteenth-century Aldovrandi to provide a detailed record of the contents of the palaces. Then, too, the interesting passage about a mutilated horse by Phidias or Praxiteles obviously refers back to the Dioscuri, with their false labels; for these pieces of sculpture were in a much damaged state when Chrysoloras saw them. But the same passage also refers forward, unknowingly, to Leon Battista Alberti's argument that a work of art's raw materials are of no real consequence, even if intrinsically costly, since any work by one of the great masters of antiquity would still be beyond price, even if made of the poorest metal, lead.[19] These near-parallel statements by Chrysoloras and Alberti are in truth the first overt Western formulations of the underlying theme of all art collecting, the theme of the work of art as an end in itself.

Note above all, however, that Chrysoloras' ideas about classical art, sophisticated and thoroughly thought out for those days, really cannot have been formed except in Italy, most probably soon after he reached Florence from the East. For one thing, he not only expected his brother in Constantinople to be astonished that he was pursuing classical works of art like a "boorish gallant" in pursuit of women; he further expected Demetrius Chrysoloras to be so unfamiliar with the ideas he expressed that he explained them at great length. For another thing, it was hardly possible in Constantinople in Chrysoloras' day to form the kind of ideas about classical art which he set down in Rome.

The Eastern capital's originally massive heritage of classical sculpture partly dated from the time of Constantine the Great's pillage of many older cities[20] to adorn his new center of empire with those pagan images

which so upset the pious Eusebius.[21] More was added later, and much of this heritage endured until 1203, when the ruthless marauders of the Fourth Crusade appeared before the walls. For example, Phidias' great bronze Athena Promachus, whose gilded spear tip was once, as we have seen, the seamark used by mariners to guide them to the Piraeus, had been brought from the Acropolis to stand before the Senate House. But in 1203, the Constantinople mob somehow became convinced that the Athena's upraised arm was magically beckoning the Western barbarians into their city, and the mob therefore pulled down and smashed this last masterpiece of Phidias to survive[22]—except, of course, for the elements of the Parthenon sculpture he may have worked on himself. Then came Constantinople's cruel sack by the Crusaders, with all the dreadful losses described by Nicetas Choniates.[23] There were further losses, too, so that by the fourteenth century, virtually no classical works of art could any longer be seen in the Eastern capital, as Chrysoloras himself lamented in another context.[24] Nor can one find any hint of true art collecting of any kind in the later centuries of Constantinople's history before the coming of the Ottomans.[25]

This did not keep a good many educated persons in the tottering Byzantine Empire from looking back with extreme nostalgia to the better days of their remote ancestors. The ruins of Pergamum, for instance, inspired the Emperor Theodore II Lascaris to a well-known melancholy comparison of the poverty of his own time and the achievements of antiquity.[26] But it is still a practical fact that no one can form fairly exact ideas about any kind of art without specific works of art to persuade and educate the eyes. Here, remember again that if a few Westerners working in China and Japan in the later nineteenth century had not begun to be attracted by the paintings, bronzes, and early porcelains which display the true greatness of Chinese art, all of us today would still have the earlier notion that Chinese art was no more than Chinoiserie.

The Humanists

When Chrysoloras left Constantinople, he cannot have had much more than a Chinoiserie notion of what classical art was really like. In Florence, however, Chrysoloras must at first have seen much of Niccolò Niccoli, who had helped to promote his coming to the city and then attended his lectures. If the previous chapter is correct about the dating of Niccoli's collection, this must also have been among the first assemblages of the art of antiquity, and almost certainly the very first large assemblage, that Chrysoloras ever had a chance to study. Of course, a coolness arose between the two men in the end, as happened so often with Niccoli.[27] Yet it is still only logical to suppose the ideas expressed by Chrysoloras about classi-

cal art were the ideas of Niccoli and his circle. There is also a solid reason for this deduction, to be given later.[28]

So we come back to Niccolò Niccoli and the generation of Italian humanists after Coluccio Salutati. The present tendency of scholarship is to concentrate on the intellectual aspect of these men's lives; and this aspect was certainly immensely important. The humanists' intellectual aim was high—nothing less than the recapture of both the history and the arts and sciences of the classical past. Surely, however, the practical contributions of these men have left more enduring marks on the world we live in than their purely intellectual contributions like, for instance, the "civic humanism" of Leonardo Bruni as defined by Hans Baron.[29] Niccoli's probable contribution to the new direction taken by Western art has already been outlined. Again, the great surge forward of Western mathematics in the sixteenth century was based upon the fifteenth-century humanists' success in "assembling in Italy an almost complete corpus of Greek mathematical writings."[30]

To give just one more illustration, both modern archeology and modern epigraphical studies must honor Poggio Bracciolini as a founder. Arguably, the study of epigraphy began with the grossly tendentious and inaccurate compilation of Cola di Rienzi,[31] but the first proto-modern epigraphists were Poggio and Ciriaco d'Ancona;[32] and because of the archeological chapter on Rome in his *De Varietate Fortunae*,[33] Poggio is also remembered as one of the first proto-modern archeologists, although he was here surpassed by Flavio Biondo.[34] It is enough to add that for the last two centuries, a scholar's reputation has been automatically made if he restored to our libraries just one obscure lost text or a single archive of real significance, such as the historically fascinating, though often dry as dust, contents of the Cairo Geniza, which S. D. Goitein has been justifiably proud to make a lifework.[35] Yet to Poggio Bracciolini alone our libraries owe most of the text of Ammianus Marcellinus that we now have, several orations of Cicero, the existing texts of Quintilian, Lucretius and Columella, Vitruvius complete, Manilius, Probus, and what we now have of several lesser writers and thinkers of antiquity.[36]

If only for this essay's special purposes, meanwhile, the most significant contribution of the humanists of the early fifteenth century was somewhat different. The humanists, and especially Niccolò Niccoli and the humanists closest to him, in fact set the example and provided the inspiration for much richer and more powerful Italians, like Cosimo de' Medici, who then followed in their footsteps as students and collectors of classical art.[37]

But this part of the story must wait upon the immediate need, which is to review the situation in the first decades of the fifteenth century. There are few hints of the rich-men's collecting of the near future in

the humanist correspondence of these decades, which is the principal source of the evidence. Instead the correspondence strikes three main notes that are relevant: love of the long-lost codices and classical works of art the humanists hunted for, delight in the hunt itself, and rejoicing when the hunt was successful.

The intensity of this rejoicing is the best proof of how epoch-making people then found results which we have now all but forgotten. When Poggio unearthed his text of the *Institutio Oratoria*, Leonardo Bruni promptly wrote him a near-delirious letter of congratulation on this "liberation" of the great Quintilian from "the iron dungeon of the barbarians."[38] The "barbarians" in question were the men of the northern monasteries Poggio was then raiding, either taking copies of texts he wanted, or, more simply, abstracting the originals. In his capacity as papal secretary, Poggio had been sent to the Council of Constance;[39] but instead of listening to the eloquence of the Church Fathers, he went off codex-hunting at Einsiedeln, Reichenau, and other great but decaying monastic establishments of Switzerland, South Germany, and eastern France.[40] At St.-Gall, for example, learning had once flourished, and it was here that Poggio's Quintilian was discovered. Yet he found much of the library of St.-Gall in a sort of lumber room at the bottom of the church tower, where the precious codices had been heaped up and were thick with dust and suffering from mold.[41] This is worth noting, for it means that many of the texts which the humanists rescued were saved in the nick of time. Their rescues often seem to have been unique surviving copies, and the Quintilian could well have been lost in another generation in the conditions at St.-Gall.

The Humanist Networks

The codex hunt was linked to the hunt for classical works of art in the simplest possible way. There were, in fact, two main networks, covering most of Italy and capable of reaching into Europe beyond the Alps and into the Eastern Mediterranean as well;[42] and the codex hunters' network and the art collectors'-connoisseurs' network overlapped at several points. Poggio Bracciolini and Ambrogio Traversari, particularly, were leading figures in both networks; and at the center of both networks sat Niccolò Niccoli in Florence.

In his younger years, Niccoli rescued a few texts himself,[43] and his dominant role in the codex hunt was succinctly described in the passage from Poggio's funeral oration already quoted. Here, it must be added, one must allow for an aspect of the problem that Poggio's oration passed over in silence, Niccoli's quarrels with so many of the other humanists. He cannot have continued to inspire the long series of humanists he eventually quarreled with. Furthermore, the codex hunt was carried on intensively

throughout the entire fifteenth century, and thus long after Niccoli's death. For example, the great search for books for the Vatican Library only began in earnest in 1447, when Tommaso da Sarzana ascended the throne of St. Peter as Pope Nicholas V.[44] Again, in the later fifteenth century, Lorenzo de' Medici the Magnificent employed the Greek John Lascaris[45] to find all possible manuscripts in the Eastern Mediterranean.

Overall, nonetheless, it seems only right to interpret what Poggio said in the funeral oration about Niccolò Niccoli's key role in the codex hunt as meaning, at a minimum, that it was mainly Niccoli who first really organized the hunt as well as continuing to guide those hunters who remained his friends. Credit for starting the hunt must certainly be given to Petrarch and Coluccio Salutati.[46] But as Leonardo Bruni's previously cited dialogue indicates, Niccoli was far more preoccupied than Coluccio Salutati with the incompleteness and poor character of so many of the classical texts as they existed in his younger years,[47] and above all, with the enormous known gaps in the then-existing array of such texts.[48] With his collector's mentality, Niccoli would also have called for a much more systematic approach to these problems preoccupying him than had been made by Coluccio or anyone else before Niccoli.

To this may also be added two specific illustrations of the way Niccoli operated from the center of the codex hunter's network. One is a letter written from England by Poggio Bracciolini.[49] Before Poggio set off about 1419 for a sojourn among the English (whom he detested), he had evidently been instructed by Niccoli to be sure to find a codex of Origen said to be owned by Salisbury Cathedral. In the letter from England, Poggio apologetically announces failure to Niccoli but insists he has made an adequate search. Indirectly, the letter thus confirms the statement in Poggio's funeral oration that Niccoli tended to "browbeat" codex hunters who failed to bring home the bacon without a good excuse.

Then there is also an ironic letter from Ambrogio Traversari,[50] assuring Niccoli that, as they had both planned, he had made every effort to persuade an important papal mission to France and Germany to carry on the codex hunt in this territory rich in prizes. The leaders of the mission, Cardinals Albergati and Cesarini, had already been told what to look for and where to look by the *Commentarium* supplied to them by Niccoli himself.[51] Not content with this, however, Niccoli had evidently mobilized Traversari to use his own persuasive powers to urge the Cardinals on. But Traversari was skeptical and added to his letter to Niccoli a reminder of all cardinals' deplorable way of being distracted by worldly concerns from the noble requirements of learning.

As for Niccoli's role in the collectors'-connoisseurs' network, several of Traversari's letters make this abundantly plain. In the same letter from Venice to his brother in Florence that promised quill pens, treacle, and

"Greek volumes" for Niccoli, Traversari added this instruction to Jerome Traversari:

"Tell my friend Niccolò that I saw the medal of Queen Berenice, weighing an ounce and a half, and I shall presently send a cast from it in lead; but I was unable to see the rock crystal portrait of Alexander."[52]

Obviously, Niccoli had heard of these two objects on the collectors' grapevine, and had told Traversari that he must not miss seeing them in Venice. Traversari explained that the portrait of Alexander had been taken out of the city, and we even have a clue as to how this happened in a fragment of a letter from Ciriaco d'Ancona dated 1445,[53] concerning his sea encounter off Crete with Giovanni Delfin. Ciriaco's letter is of course much later than Traversari's; but it would seem that Delfin, an important Venetian naval commander, had a regular habit of carrying his best-loved classical treasures to sea with him. Thus Delfin showed Ciriaco what was obviously the same gem Traversari wrote about, "a noble seal of crystal, of the size of one's thumb, engraved in very deep relief by the wonderful skill of the artist Eutyches with the portrait of Alexander of Macedon, helmeted, as far down as the breast." This, by the way, is one of these ancient collectors' prizes that have been fairly surely identified by a modern art historian.[54]

Returning to the lifetime of Niccolò Niccoli, we have another letter from Ambrogio Traversari, happily describing to Niccoli a meeting with Ciriaco d'Ancona in Venice in 1432.[55] Ciriaco showed Traversari "likenesses"—surely coins or medals, cameos or intaglios—of Lysimachus, Philip, and Alexander and another "likeness in onyx of the younger Scipio . . . of the utmost elegance." There is a further report in this letter that Traversari had run across a physician coin-collector who owned a particularly fine "likeness" of Alexander the Great, which he had "never seen anything to match." And there is a report by Traversari to Niccoli about how Poggio Bracciolini, then in Rome, was organizing a "diligent search" in faraway Rhodes for the house of "a certain monk who had [recently] died, within the walls of whose dwelling a thousand statues of ancient workmanship, some stone, some marble, had been laid away."[56] Traversari thought the story of the monk's hoard sounded a bit fishy.

Concerning the highly significant birth of what can only be called connoisseurship in both antique works of art and ancient texts, there is also good evidence. Of Niccoli's role as a connoisseur of classical art, one can judge only by the shared concepts and atmosphere of judgment implied by his friends' letters; but there is hard evidence that he became a good judge of the quality and dates of classical texts in the course of his unending labor of collation and reproduction. He was openly dissatisfied, for instance, with his copy of the elder Cato's work on Roman farming. He therefore tried to get a text of *De Re Rustica* in the ancient Lombard

script for purposes of collation,[57] presumably on the rule which still holds, that a manuscript's reliability is usually proportional to the earliness of its place in the line of transmission. In a sense, indeed, Niccoli was one of the first proto-modern scholars, with all a modern scholar's concern for the integrity and reliability of every text of importance for his work.

Far more interesting, however, are the traces of true art connoisseurship, the first directly recorded in the West so far as one can discover, in some of Traversari's letters. Another letter to Niccoli from Venice describes the enthusiasm of the Venetian patricians for antique-coin collecting, and mentions "gold coins, very broad and weighing one and a half ounces," newly found at Constance in Switzerland. These were of "Constantine and Constans, very beautiful but not at all on the artistic level of the earlier ones."[58] Here, in short, was Traversari admiring the celebrated Constantinian gold *solidi,* yet comparing them unfavorably with earlier, more purely classical issues of the Imperial Roman mints.

Traversari was therefore a beginning connoisseur of coin styles and was knowing about coin dating. Like Niccoli, too, he was interested in the dates of manuscripts. Another letter to Niccoli greatly praises a Greek codex from Constantinople containing seven plays of Sophocles among other splendors. Of this codex, which was destined for Niccolò Niccoli's library, Traversari remarks, "as for its age, I judge it to be before the six hundredth year,"[59] evidently meaning before the seventh century—which was certainly not correct but still interesting as evidence that dates of codices were already being studied. Still another Traversari letter gives Niccolò an enchanting description of the beauties of Ravenna;[60] but he pokes patronizing fun in this letter at the ignorance of the monks of Santa Maria in Porta, who claimed that an antique porphyry vessel in their church's treasury was one of the jars in which our Lord turned water into wine at the marriage feast in Cana. It is a trifle, but a wonderfully unmedieval trifle; and the implication is that men like Traversari and Niccoli, though both deeply pious, nonetheless almost ostentatiously refused to be taken in by legendary ecclesiastical nonsense concerning remains of classical art.

Poggio's Collecting

Classical works are also a recurring topic in the letters of Poggio Bracciolini. Poggio's treatment of the topic is a bit different from Traversari's treatment, however, simply because Poggio was a collector himself, and therefore wrote fairly often about his own collection. He was a man of modest origins, still much worried about money even in his middle years, as we find in a letter to Niccoli from London about the demands made on him by his family.[61] His humanist learning made his fortune, first in

the papal chancery and, in his old age, when he was Chancellor of Florence. Since he had limited means and did not really get in on the ground floor as a collector, it is natural that we do not find him trying to gather the ultra-expensive things, like Niccoli's carved gems and precious ancient vessels. Throughout the fifteenth century, as will later be shown, there was a considerable spillover, even into classical art collecting, from the treasure-standard of value that prevailed in the Middle Ages.[62] Poggio's avoidance of the semitreasures of antiquity, like gems, is in fact another indication of a strong price rise for the kind of classical works of art that Niccoli had gathered earlier, when "such things were not so greatly valued."[63]

Poggio therefore collected antique sculpture, using his years in Rome to form most of his collection and to acquire the exact knowledge of Rome's antiquities he displayed in *De Varietate Fortunae*. No doubt sculpture remained considerably cheaper than gems and the like all through the fifteenth century, not just because of the spillover from the treasure standard, but also because the supply of sculpture was constantly replenished. At first the replenishment resulted from the previously noted digging for the foundations of new structures in Rome. Later, what amounted to mining operations for classical sculpture were also carried on in Rome.[64]

In the prize-hunting manner of all early Western archeologists, Poggio searched for ancient works of art, not only in Rome itself, but also at Grottaferrata, Ferentino, Alba, and other promising sites. In the letter that mainly recounts these visits to Niccoli,[65] there are descriptions to make a modern archeologist desperately envious, of "splendid villas"; "pools"; "lakes to draw water from"; "aqueducts, some of them arched, some of them underground, so that almost any villa . . . could have its own" water; "still standing . . . vaulted arches and shell-work and underground passages"; huge crypts, where Poggio coolly speculates the Roman villa owners must have locked up their slaves after work at night; and "porticoes . . . still intact, and . . . constructed in a most beautiful manner." One great villa in the Alban hills, Poggio suggests, might have belonged to Clodius Pulcher, another to Cicero himself. He further speaks of the shore of "the Alban lake" being "filled with buildings and some statues . . ."

Another letter to Niccolò Niccoli tells how Poggio was lucky enough to watch the discovery of a female classical bust in foundations that were being dug at Monte Cassino; how he purchased the bust on the spot for his collection; and how he visited the monastery's decaying library and there discovered and abstracted a copy of the Roman treatise on aqueducts by Frontinus.[66] Still another letter remarks of one of his sculpture finds, "Donatello saw it and praised it highly."[67] To Niccoli, yet again, he wrote humorously about his room "filled with marble heads," among which

one was "elegant and intact," while the others, though battered about the nose, would still "please."[68] The same letter, dated 1427, indicates Poggio was already thinking of settling down in Florence with his collection around him. From what he says, he already looked forward to installing his sculpture in a villa on Florence's outskirts; and in anticipation, this was already named his "Academy of the Valdarno."

Thoughout Poggio's correspondence, in fact, classical sculpture is a repeated theme. We find him urging Fra Francesco da Pistoia, the Minorite friar already encountered as "Francesco Pistorio," to get him as many pieces of sculpture as could be found in Greece and the Aegean in the course of Fra Francesco's recurrent voyages. In this letter,[69] Poggio explains that, quite aside from the historical associations, he takes "immeasurable" delight in classical sculpture, "to the extent I can be said to be an enthusiast . . . The skill of the artist moves me, since I see Nature herself being represented in marble. . . . You can do nothing more welcome to me, Francesco, than if you return to me laden with [such] sculptures. . . . Many men labor under various diseases: this one holds me especially, that I admire these works in marble sculptured by outstanding artists perhaps too much, and beyond the degree that should suffice for a learned man. . . . I am compelled to wonder at the art of any man who so molds a living being in lifeless marble that often nothing but the breath of life seems to be absent. . . ." You could have no clearer expression of the collectors' passion than this letter written by Poggio to Fra Francesco da Pistoia in 1431. The parallel between Poggio's explanation of his passion and Chrysoloras' letter of 1411 is also obvious, and supports the attribution of Chrysoloras' ideas to Niccolò Niccoli and his circle. These ideas were in fact the common property of a substantial group of men, all more or less linked in one way or another.[70]

In the same connection, too, we find Poggio displaying those common collectors' quirks that help to make collecting history entertaining as well as instructive. One such quirk is plain bargain hunting, sometimes of a not very honorable kind. Fra Francesco da Pistoia was the man who told Poggio the tall tale about the repository in Rhodes with a thousand statues. Poggio then passed the great news to Traversari, who rightly did not believe it. But Fra Francesco had also given Poggio more reliable news of a Rhodian merchant named Suffretus—as Poggio spelled his name, explaining he was a Greek.[71] This man had gathered a large number of antiquities of the sort that Poggio so much desired. One may be certain the friar hoped for a commission-producing authorization to make purchases from Suffretus on Poggio's behalf. Whereupon, no doubt relying on his considerable fame as a scholar and official, Poggio wrote directly to Suffretus, bypassing Fra Francesco. The letter is a model of the oiliness and greed for acquisition

that art collectors often display when great prizes may be inexpensively within their grasp.

It begins: "I think you will perhaps be surprised that one who like myself is unknown to you and living at a great distance from you, should dare to ask you for something." Poggio then describes how he has heard of Suffretus' collection, and how a friend has urged him to "write to you at once, and ask for something—you were, he said, a most learned and cultured man, and would not refuse my request." Obviously hankering to get what he wants on the cheap, Poggio adds that "statues of this kind are not held valuable except by men of outstanding talent and refined learning." But with minimal grace, he closes by saying that he will take the statues, with Suffretus' consent, "either in answer to my prayers or for a price."[72]

Another collectors' quirk, suspicion of all attributions and of the honesty of most people, was illustrated by the sequels to the foregoing letter. Suffretus seems to have responded to Poggio's letter with a promise of three busts, of Hera, Athena, and Dionysus, which were attributed to Polyclitus and Praxiteles.[73] The acquisition of the busts was announced to Poggio by Fra Francesco da Pistoia.[74] Poggio, from Rome, in turn announced the coming of the busts to Niccoli in Florence, in tones of real triumph—although he was pretty patronizing about "Graeculi" who had a way of using names like Praxiteles and Polyclitus with too little justification in order to "sell statues . . . at a higher price."[75] Fra Francesco finally delivered the three busts to Poggio; but apparently a standing figure was also expected in the shipment.[76] It did not arrive, and Fra Francesco explained that it had been seized at sea by Catalan pirates.[77] Poggio at once concluded that the standing figure had been stolen instead, and by the very man he had asked to be his purchasing agent in the Eastern Mediterranean.[78]

Worse was to follow, however. Suffretus had shown or otherwise communicated Poggio's letter to another Eastern Mediterranean classical collector, the Genoese Governor of Chios, Andreolo Giustiniani, and this led to a further promise of classical sculpture for Poggio.[79] Once again, the transmitting agent for Giustiniani's consignment was Fra Francesco. The shrewd friar instead sold (or gave, in hope of a rich return gift) the best part of the consignment to Cosimo de' Medici, whereupon Poggio exploded in a perfect frenzy of rage in a letter of complaint to Giustiniani.[80] "He told Cosimo, who is here," wrote the all but apoplectic Poggio, "that he thanked Cosimo for deigning to accept. . . . At the same time, he told him that he would make an effort so that the [gem] of the head of Trajan, with which you sealed your letters, should be brought to him. And so you see how great the deceit of this man is; how great is his talent for

using words like snow; and how great his . . . lies." By now, the knowing collector who is beaten to the post by a much richer collector has become a stock figure in the sometimes singular drama of Western art collecting, but so far as I can discover, Poggio Bracciolini was the first to appear in this role.

Other Portents

There is good cause, too, for the prolonged attention here given to the frequently shady doings of Fra Francesco da Pistoia. When art dealers, even semispecialized, at length appear, and a market, however obscure, begins to be organized, it always means that any form of art collecting has reached its first maturity. The growing demands of art collectors in truth beget the dealers and the market, by the law of supply and demand. For this reason, Fra Francesco da Pistoia is a highly significant figure, if a somewhat mysterious one.

He was almost certainly the same "Fra Francesco" whom Vespasiano da Bisticci mentions as close to Niccolò Niccoli, and as much liked by Cosimo de' Medici for his gifts as a fortuneteller;[81] but there is not even any way of being dead sure about this. Nor is there any way of knowing just why the friar was so given to traveling in the Eastern Mediterranean. Probably he traded in several commodities from that area which had high value without much bulk, and he was at least considered as an emissary from the Pope to the Ottoman Sultan;[82] but the main references to Fra Francesco in the humanist correspondence indicate that one of his regular sidelines was a trade in classical works of art of Eastern Mediterranean origin. If he had not been known for this sideline, Poggio would hardly have given him the open-ended commission to buy antique sculpture which began the relationship that ended in such recriminations. This trade in classical works in turn made the friar from Pistoia the first art dealer specialized in supplying collectors to be found in the Western record, nearly a hundred years before the first such dealer in Western works of art.[83] And if Fra Francesco was a dealer of doubtful honesty, he merely set a precedent that was to be followed much more often than not from that day to this.

Significantly, too, Ciriaco d'Ancona all but certainly had the same sideline as Fra Francesco. It would have been easy for this great traveler and antiquarian to trade in antiquities, and there is evidence he did so.[84] Ciriaco, however, was a far more interesting figure than the friar—a self-taught Latinist and Grecianist,[85] the maker of an enormous collection of antique inscriptions still valued by modern epigraphers for the inscriptions that have been lost in the interval;[86] a student of every aspect of antiquity including Greek and Roman architecture;[87] a man of limitless curiosity;

and very likely a spy for the papacy in the troubled Eastern Mediterranean regions he endlessly traversed.[88]

As to the view that he also had a sideline as a dealer in antiquities, you have to fit the bits of evidence together to see why this is likely. The gems Ciriaco showed Traversari in Venice look very much like a small stock formed to be sold to the Venetians, who clearly had a particular liking for the smaller, richer objects from the classical past. Then, too, in the 1440s Ciriaco's letters to his friend Andreolo Giustiniani,[89] the Genoese Governor of Chios just encountered, show that Ciriaco was using the island ruled by Giustiniani as a place of deposit for newly acquired pieces of classical sculpture. Ciriaco's shipments of such pieces to Chios at least once reached the dimensions of a shipload (probably a large caique-load);[90] and a deposit on this scale can only have been the kind of preliminary assemblage that roving dealers often make before shipping what they have gathered to the market. Finally, Francesco Filelfo, for once friendly and honestly enthusiastic, warmly praised Ciriaco for pouring into Italy so many *"monumenta"* of the classical past.[91] In this letter, Filelfo chiefly had in mind Ciriaco's collections of inscriptions. But he also remarked that Ciriaco had made a lot of money in this way, and since there was no cash market for copies of inscriptions, Filelfo really must have meant that Ciriaco had also shipped to Italy many antique works of art, and had profited largely thereby.

Nonetheless, the account of one of Ciriaco's visits to Florence is more significant. He made at least two such visits in the 1430s—in 1432, when he also stopped in Siena,[92] and in 1438–39, to attend the abortive council meant to unify the Orthodox and Catholic churches, when he is thought to have served the Emperor John VIII Paleologus as interpreter.[93] It was certainly in the course of the 1432 visit, however, that Ciriaco made his survey of all the more important collections of classical works of art that could then be seen in Florence. The account of the visit in Scalamonti's biography of his friend[94] was written long after 1432, but students of Ciriaco believe the account was squarely based on notes taken at the time by Ciriaco himself.[95] The date is doubly fixed—by the fact that among the leaders of Florence whom Ciriaco saw, one of those singled out for mention is Palla Strozzi, soon to be exiled after the triumph of Cosimo de' Medici in 1434, and by the further fact that the glowing passage on Ciriaco's long hours with Niccolò Niccoli is solidly incorporated in the same account, whereas Niccoli was already dead by 1438.

In Florence in 1432, Ciriaco was received as a distinguished visitor, for whom all doors were open. He was shown the Duomo by Brunelleschi himself. He was welcomed in their houses by leaders of the city: not only Palla Strozzi, but also Niccolò da Uzzano, Cosimo de' Medici, and others of the rich and great. He was taken by Leonardo Bruni to see the

Signoria's complete *Pandects* of Justinian, looted from Pisa[96] and thought so uniquely important that the codices were kept in the Palazzo de' Priori and were finally enshrined in a special box made for the purpose by Neri di Bicci.[97] Yet the high point of Ciriaco's time in Florence still seems to have been a round of visits to the city's collections and collectors of classical works of art. First and foremost on the list was Niccolò Niccoli, whose long hours with Ciriaco and the deep impression he and his collection made on the visitor have already been described. The round of visits went further, however:

"Meanwhile, after Ciriaco had accompanied Carlo Aretino [Marsuppini] to see his outstanding library along with ancient coins and images, together with a remarkable gem of nicolo [bluish onyx] carved by the famous Pyrgoteles with a figure of a Lupercalian priest,[98] and a bronze statue of ankle-winged Mercury, *they also saw many very valuable fine things of the same sort belonging to Cosimo* [*de' Medici*], *that richest of men*. And at the houses of Donatello and Nencio [Ghiberti], famous sculptors, he saw many ancient statues, and new ones produced by them from bronze and marble."[99] (Italics added.)

There are several interesting points about this passage. It is the only record of Donatello's classical art collection, surely formed for studio purposes as Ghiberti's collection was. The two sculptors' classical collections must also have been reasonably well advanced by 1432, in order to offer "many" pieces of antique sculpture for Ciriaco's inspection. Then, too, the passage usefully places Carlo Marsuppini among the humanist collectors of Florence of that time, when Poggio was still in Rome. But of the greatest interest is the reference to Cosimo de' Medici, which I have ventured to italicize.

Here one must begin by noting that according to the usual wisdom, Cosimo's classical art collecting began in earnest considerably later than 1432—probably as much as a decade or more later.[100] Yet the passage from Scalamonti turns out to be strong evidence to the contrary, if carefully studied and if the experts are right about Scalamonti basing this account on Ciriaco's own contemporary notes. What happened is clear enough. Marsuppini took Ciriaco in hand at some time after his long hours spent with Niccoli, first showed the visitor his own library and art collection, and then took him to see the collection of Cosimo de' Medici. Both episodes of this collection viewing with Marsuppini are recounted in a single sentence, and the short description of the visit to Cosimo de' Medici's collection comes immediately after the mention of the Marsuppini's two chief prizes, the gem carved by Pyrgoteles and the bronze statue of Mercury. Thus the reference back to Marsuppini's prizes is unmistakable when Cosimo is then stated to own "many very valuable fine things of the same

sort." In short, Ciriaco's testimony plainly indicates that Cosimo de' Medici owned notable classical works of art by 1432.[101]

Medici Collecting Begins

It will be well to add to the foregoing the other pieces of evidence bearing on the date when Cosimo de' Medici began to collect classical works of art. Historically, this is an important date; or so it seems to me, since I further believe the founder of Medici power and rule in Florence was the man who chiefly showed the way to the other rich and powerful Italians who soon entered the collectors' competition. This development ended by affecting the course of Western art for several centuries, in ways to be shown. Hence a special effort is in order to find out just when and how the development probably began. Despite the received wisdom, furthermore, all the other surviving pieces of evidence point to the same conclusion as the account of Ciriaco's visit to Florence.

One must start with the other near-certain piece of evidence. If Cosimo de' Medici could be pleased by a pseudo-gift of classical works of art, and all but certainly paid generously in return, then he was already an eager collector in the early 1430s, the date of Poggio's angry letter about Fra Francesco da Pistoia's diversion to Cosimo of the shipment from Chios. Next comes Lorenzo Ghiberti's description, in his *Commentarii*, of how he mounted as a ring one of the most famous antique gems of the fifteenth century in Italy.[102] This was a large carnelian carved (Ghiberti to the contrary) with the flaying of Marsyas by Apollo in the presence of Olympus.[103] It was known for no very good reason as "the seal of Nero."[104] As introduction, it should be noted that the period Ghiberti is here writing about is fixed by his immediately preceding mention of other works of his, undertaken in the 1420s. The enumeration ends with the St. Matthew commissioned by the Arte del Cambio for Orsanmichele, for which Ghiberti received the handsome fee of 650 florins in 1422.[105]

"In that time, *(in detto tempo),*" Ghiberti continues, "I also mounted a carnelian of the size of a nut: with the perfect hand of an ancient master, it was carved with three figures. As a mounting, I added a dragon with wings slightly spread, and with head bent aside; the curve of the back is in the middle, and the wings provide a grip. The dragon, or as we might say, the winged serpent, was amongst ivy leaves, and with my own hand and in antique letters, I engraved an inscription around the figures [of the gem] in the name of Nero. . . . The three figures symbolized the three ages of life. They were certainly from the hands of Pyrgoteles or Polyclitus. I have never seen finer work."[106]

There is little doubt, then, that this gem, one of the prides of Lorenzo

de' Medici's collection in the later fifteenth century,[107] received its setting from Ghiberti during the 1420s, and quite possibly as early as 1425. A question remains, however, about the identity of the owner of the gem who commissioned the setting from Ghiberti. One thinks first of the humanist collectors, and more especially of Niccolò Niccoli. Despite their limited means, they cannot be absolutely excluded; for Ambrogio Traversari acquired an antique gem in the 1430s, apparently for use as a seal, and he then asked the advice of Cosimo de' Medici's brother, the first Lorenzo, about where to get a ring setting.[108] Yet the fact remains that the gem set by Ghiberti unquestionably ended in the Medici collection, and was already in Medici possession in the 1450s.[109] On the whole, therefore, it seems much more likely that the luxurious and costly setting described by Ghiberti was commissioned by Cosimo de' Medici himself, in celebration of what may well have been his first venture as a true art collector.

The next piece of evidence to consider is Donatello's marvelous David with the head of Goliath, which Vasari says was commissioned by Cosimo de' Medici.[110] Most still agree with Vasari, but the date of the commission has, as usual, been a much-argued problem.[111] However, H. W. Janson, in his major monograph on Donatello, confidently comes down on the side of a date "about 1430."[112] Other contemporary authorities, who originally preferred a later date, now lean strongly to Professor Janson's opinion.[113] For the art historians, the date is so important because of the light it sheds on Donatello's development, but it is also important for this essay's special purposes.

This is because of the triumphal scene of putti on the visor of Goliath's helmet. The scene is a "free variant of the same composition on an antique sardonyx"[114] from the Medici collection—a gem whose design was later more exactly reproduced in one of the roundels decorating the courtyard of the great new palazzo built by Cosimo de' Medici on the Via Larga.[115] Again, therefore, it seems most likely that Donatello borrowed this motif for Goliath's helmet from a gem already in Cosimo's possession by 1430;[116] and this fits neatly with the probabilities concerning the supposed "seal of Nero," for which Ghiberti provided the setting, not to mention the evidence of Ciriaco d'Ancona and Poggio Bracciolini.

Finally, there is the important matter of Luigi Scarampi Mezzarota's[117] purchase of Niccolò Niccoli's *calcedonio*, for 200 florins. This must have occurred in 1434 or a little later, for Scarampi had come to Florence in the train of Pope Eugenius IV, who took refuge there from the insurgency in Rome in that year.[118] Many decades earlier, as has been noted, Niccoli had paid 5 florins for his gem; and this was far from being a nothing-price in those days—in fact, about one-third of the entire sum later given Uccello for painting the large memorial of Sir John Hawkwood in the

Duomo.[119] But the sum that secured the gem for Luigi Scarampi was really staggering—the annual income Poggio Bracciolini believed would allow him to live comfortably as an independent scholar,[120] and approximately two-fifths of the capital contribution expected of a non-Medici manager of one of the Medici branch banks.[121]

To explain such a price so early in the collecting story, one is forced to picture a situation like that of the Metropolitan Museum, when the Euphronius crater was acquired for a cool million dollars. The Metropolitan was spurred on by the vulturelike hovering of several immensely rich collectors of fine Attic pottery, who had recently entered the market in Germany, Switzerland, and this country. Luigi Scarampi must have been similarly spurred, since he paid so great a sum for a gem originally picked up by Niccoli for 5 florins. But who were these hovering competitors in 1434? Yet again, Cosimo de' Medici is much the most likely answer. In this case, in truth, one can think of no other possible answer except the sole plutocrat in Florence with a classical collection thought worthy of a visit by Ciriaco d'Ancona.

Cosimo as Collector

Since all the foregoing evidence has the same thrust, one may venture to picture Cosimo de' Medici becoming a classical art collector in a small way in the 1420s, starting with carved gems and perhaps coins and medals; and one must suppose his collection had attained a certain importance by the time Ciriaco was taken to see it in 1432. With the "when" thus disposed of, it is also necessary to ask *how* Cosimo came to collecting. Donatello is given credit by Vasari for persuading Cosimo de' Medici to become a classical collector,[122] and there may well be something to this. Cosimo was immensely fond of the sculptor, giving him a series of other important commissions besides the David,[123] perhaps even tolerantly and discreetly assisting him to track down a runaway studio-boy whom Donatello loved,[124] and on one occasion vainly seeking to reform Donatello's habitual shabbiness by presenting him with handsome new clothes.[125] By 1432, as has been seen, Donatello had his own classical collection; his judgment on classical works of art was much valued by others;[126] and his services were also called for to restore pieces of classical sculpture for his patron, when Cosimo added this branch of classical collecting.[127] Yet a review of all the data impellingly suggests that Donatello was far from alone in the role Vasari attributed to him.

By the 1420s, if you think about it, the humanist circle around Niccolò Niccoli must have been regarded by most people as the inventors of classical art collecting. Niccoli, particularly, undoubtedly had the kind of prestige that is usually accorded to an enormously successful pioneer in any field

which is beginning to attract the interest of more and more people. Some developments of the fourteenth century were still remembered in the fifteenth century, such as Lombardo della Seta's acquisition of his Venus statue.[128] Yet what had happened earlier must have seemed pretty remote, whereas Niccoli's classical collection even served as a kind of public art museum.[129]

As has been seen, too, Niccoli himself was a close friend of Cosimo de' Medici. Besides taking Niccoli to Verona to escape the plague, Cosimo took him along to Rome on another trip, in 1424,[130] but Niccoli was unhappy in Rome because the monuments of his beloved antiquity were so cruelly ruined. The other humanists close to Niccoli were also close to Cosimo, as indicated by the warm messages for the great man with which both Poggio and Ambrogio Traversari often end letters to Florence.[131] When Cosimo was in Rome on one occasion, too, Poggio served as his guide to the antiquities, accompanying him as far as Ostia to see what remained of the port of Rome's great days.[132] In the humanist correspondence, to be sure, Cosimo's classical art collecting is only once referred to, in Poggio's angry letter about Fra Francesco da Pistoia. Yet given all the facts, it is really impossible to believe that the humanists, and especially Niccoli, did not have a major share in passing on to Cosimo that collectors' passion which unquestionably infected him in the end.

Nor is this all. Nearly a hundred years ago, Eugène Müntz, the first man to publish much of the data on Medici art collecting in the fifteenth century, was also the first to suggest that the sculpture collection of Poggio Bracciolini and the much greater and more varied classical collection of Niccolò Niccoli both went to augment Cosimo de' Medici's collection when these men died.[133] Both suggestions are most persuasive, too. Just as he planned, Poggio had brought his sculpture collection to Florence, and he had acquired the villa with fine gardens he looked forward to in Rome as his "Academy of the Valdarno."[134] When he died in 1459, he left a young wife from a fairly grand family, whom he had married in old age.[135] Even by then, there were no other rich Florentines except Cosimo and his two sons now known to have been in the market for classical sculpture. Thus there were probably no other buyers easily available if Poggio's widow wished to sell, as she may well have done, with children to support and with Poggio's income from benefices and salary as Chancellor of Florence cut off by his death.

As for Niccolò Niccoli, he named Cosimo as his chief executor in a large committee of executors when he made his last will before he died in 1437;[136] and perhaps because Niccoli's estate was worse than embarrassed, the other members of the committee let Cosimo do pretty much what he pleased.[137] Niccoli had not merely exhausted his entire fortune; his debt to the Medici bank alone was 500 ducats by 1437,[138] and his

library, which must have been extremely valuable, was tied up by the
clause in his will destining his books for public use. Great numbers of
the books had been loaned out by Niccoli, who was habitually generous
to other scholars, and a good many of these were apparently beyond reach.
But Cosimo duly deposited four hundred codices in the library of the
Convent of San Marco, where they remained until the Laurentian Library
was founded.[139]

That therefore left only Niccoli's works of art to cover outstanding
debts and to constitute some sort of inheritance for his heirs, his niece
and his maidservant-mistress.[140] In these circumstances, it would be down-
right surprising if the works of art were not acquired by Cosimo, who
must by then have been envying Niccoli's treasures for a good many years.
In sum, both Müntz's long-ago suggestions still appear somewhat specula-
tive, but they also look highly logical, particularly in view of the fact
that throughout the fifteenth century, the Medici collection distinctly
resembled a great whale's maw constantly ingesting other fish.

Concerning Cosimo de' Medici's activities as a true art collector, as
opposed to his patronage of the arts, there is not much more to add,
alas. Unlike the Medici of the next two generations, he left no inventory,
or at least none that has survived. Perhaps the reason was that by the
time Cosimo died, in 1464, his favorite son, Giovanni, had preceded him
to the grave. Thus no inventory for division of goods was needed, since
the sole heir was Cosimo's gout-crippled elder son, Piero *"Il Gottoso."*

At any rate, only two other sets of facts about Cosimo's collecting
are sufficiently well attested to be worth setting down. At some point
in his collecting career (and I would guess rather early) Cosimo began
adding classical sculpture to his collection. How much sculpture he se-
cured, overall, cannot be exactly determined, but it is certain that he
owned one of the fifteenth century's more famous classical statues, the
Medici "white" Marsyas, so called to distinguish it from the equally famous
"red" Marsyas purchased by Cosimo's grandson, Lorenzo the Magnificent,
partly to make a pair with the white one. Donatello was then called in
by Cosimo to repair and perhaps complete the "white" Marsyas,[141] just
as Verrocchio was much later called in by Lorenzo to perform the same
service for the "red" Marsyas.[142] In addition, Donatello was called in by
Cosimo to restore a series of ancient busts,[143] which probably included
among them the busts of Roman emperors used to decorate the rear or
garden façade of the new palazzo.[144]

Finally, one can also read between the lines of two inventories of the
possessions of Piero Il Gottoso taken in 1456 and in 1465.[145] The last
supplementary inventory clearly reflects the recent death of Cosimo and
his son's resulting inheritance; and the reflection reveals that Cosimo's
collections of antique coins, carved gems, and vessels carved in hard stones

had become decidedly important by the time he died. In brief, as compared with the inventory taken nine years earlier, Piero's gold "medals" (the term used at that period for classical coins as well as true medals) had increased from 53 to 100; the silver "medals" had risen from 300 to 503; and the tally of antique carved gems and hard-stone vessels had also been proportionally augmented.

With the data all set forth, it will also be well to close this part of the present chapter with the remarks of the first man to take note of the significance and the sheer novelty of the development that occurred when Cosimo de' Medici Pater Patriae became the first magnate–art collector in the Western record. "The gradual emergence of the collector-type," wrote Martin Wackernagel, ". . . must be considered an important and new phenomenon. The collector, *unlike the patron*, is interested in the work of art as such for the sake of its special artistic quality or individuality. . . . As a collector, he [also] endeavors to bring together many objects of a particular category. . . . Cosimo, as well as the humanists senior to him, already had this kind of collector's interest. . . ."[146] (Italics added.) This is of course another way of saying that the theme of Cosimo's classical collecting, like that of the humanists who preceded him, was the work of art as an end-in-itself. Whereas the theme of Cosimo's patronage of the arts was of course art-for-use-plus-beauty.

Florentine Patronage

It is now time, so to say, to enter quite another part of the wood, in fact the patronage of art in Florence in the fifteenth century; for this also has a bearing on the subject of this essay in a way to be shown later. In surveying the story of patronage in Florence, one must begin with the fact that public patronage, all but exclusively religious in purpose, had been a recognized social duty of every highly placed Florentine family long before 1400. Throughout the fifteenth century, too, the most common way of performing this duty was to give a family chapel to one of the churches. In itself, the *jus patronatus* over such a chapel was a recognized property right of a special kind. By 1486, the rich Strozzi had produced another major leviathan of wealth in the person of a younger relation of the exiled Palla, Filippo Strozzi. In that year, he therefore acquired a *jus patronatus* as part of "a real estate deal between the Boni [the former owners], the convent [of the Church of Santa Maria Novella], and Strozzi" himself.[147] This gave Filippo Strozzi the right to redecorate the chapel, for which Filippino Lippi did the frescoes Vasari was to admire so much,[148] while Benedetto da Maiano supplied the sculpture.[149]

It should be added that the *jus patronatus* carried with it the right to show the patron's arms in the chapel, and even to show suits of armor

and other family souvenirs.[150] The truth is that providing churches with richly adorned chapels showing the family arms was a form of competitive display as well as a proper display of piety. In the mid-fourteenth century, the brothers Tano and Gherardo Baroncelli are known to have been responsible, over time, for no fewer than three chapels, although only one, frescoed by Taddeo Gaddi, survives today in the Church of Santa Croce.[151] Furthermore, despite the severe blow of the Peruzzi bankruptcy and the family connection with the Peruzzi bank, the son of Tano Baroncelli, Martino, then followed with still another chapel in Santa Croce; and the design for this one, made for the patron's approval, may well be "the earliest extant scale drawing."[152]

Public patronage aside, however, private patronage of the arts in Florence was far from ostentatious for a very long period. This was partly because life in Florence so long tended to be fairly hazardous. Thus all the subfamilies of every major family tended to cluster together in a quarter of their own, which then had something of the character of a family fortress;[153] and the larger houses were near to fortresses in themselves. The Palazzo Davanzati, for example, is a restored edifice of the later fourteenth century;[154] and here one may still see four original *"piombatoi"*—apertures in the floor of the main room on the *piano nobile* which could be opened to pour down molten lead on unfriendly persons at ground level.[155]

Though fortresslike in plan and purpose, the Palazzo Davanzati had some interiors with wall paintings, including a pleasant "parrot room." Francesco di Marco Datini also had his house in Prato rather less imaginatively decorated with paintings by Agnolo Gaddi and Niccolò di Piero Gerini, and was then angered by the painters' modest charges.[156] Yet as far as is known, the earliest wall paintings were far from ambitious in character, and were probably ordered as inexpensive substitutes for the wall hangings of more extravagant rich men.[157] In fact, the already mentioned first cycle of wall paintings of an important character recorded in any Florentine house was the cycle of pictures of famous men of history which Cosimo de' Medici's shrewd and prudent father, Giovanni di Bicci de' Medici, commissioned from Bicci di Lorenzo.[158]

Furthermore, the fortress influence on rich men's houses continued for over four decades in the fifteenth century, although several major palazzi went up in Florence during these years.[159] To name one, the Palazzo Uzzano was constructed fairly early in the century, and it still had a severely plain and almost fortresslike exterior. As for the interior, an inventory of the entire palazzo was taken in 1425, after Niccolò da Uzzano's brother died; and this reveals a dwelling of functional bleakness, with no works of art anywhere except a few devotional pictures and a piece of devotional sculpture in cheap *"terra ornata."*[160] Of course, some of

the rooms in the palazzo may have been frescoed, for frescoes, being irremovable, were never inventoried; but if frescoes were there, nothing is known of them now.

Pieces of plate, which must be counted as treasures, were of course different from the works of art of which the Uzzano family had so few. For instance, in the thirteenth century, the famous Florentine magnate of that time, Niccolò Acciaiuolo, built the Certosa, or Charterhouse, near Florence. A letter from him survives—another important document on Florentine public patronage—describing his own intense delight in this very important project.[161] When the foundation was complete, Niccolò Acciaiuolo's wife, Madonna Margherita, and other members of the family gave the Certosa many pieces of plate, evidently from their own stocks, along with some other gifts. The monastery's documents concerning all this plate[162] suggest that the richer and more ostentatious Florentine families from an early date owned important numbers of pieces of plate— which was of course a convenient way of storing capital as well as a way of making a fine display on grand occasions.

Overall, however, before Cosimo de' Medici gained control of the levers of power in 1434, the great men of Florence appear to have been rather uniformly self-denying in their surroundings, even if not in the sheer size of their palazzi, in their wives' dress, in the plate for their buffets, and in their celebrations of family weddings and funerals. Initially, Cosimo and his brother Lorenzo seem to have been very nearly as lonely as private patrons of the arts as they were in collecting classical works of art[163]—if Lorenzo was indeed a collector as well as a patron, as I suspect from the references to him in the humanist correspondence and elsewhere. But we have no record of the first Lorenzo's activities in the field of the arts besides his contribution to building the Church of San Lorenzo[164] and a sadly general description of the splendor of his possessions at the time of his death in 1440.[165]

Cosimo as Patron

It is different with Cosimo. To be sure, a large part of the record of his private patronage comes from the much later inventory of the Palazzo Medici taken after the death, in 1492, of Cosimo's grandson Lorenzo the Magnificent;[166] yet this is sufficient. The works of art commissioned from contemporary artists by the senior branch of the Medici were in fact allowed to accumulate for three generations, without any weeding when many of the works in question became distinctly old-fashioned.

It is therefore possible to pick out, among the works in the inventory attributed to named artists, the ones that can be reasonably supposed to have been commissioned by Cosimo in his early years as a private patron.

These are works possibly or probably produced before Cosimo built his new palazzo, and, more decisively, works by artists who were no longer alive when Cosimo's sons, Piero and Giovanni, reached the age when they were at all likely to give artists commissions on their own hooks.

Besides considering age, I have also taken into account the fact that neither Piero nor Giovanni de' Medici ever left their father's roof for a house of his own and that both therefore needed space for useful patronage of the arts. The space was provided when Cosimo built the huge new palazzo on the Via Larga, which both of his sons then actively helped to adorn and enrich in Cosimo's later years. Work on the palazzo foundations began in 1444,[167] when Piero was only twenty-six, and I have therefore taken 1444 as my cut-off date, before which all works in the palazzo in Lorenzo de' Medici's time must have been commissioned by Cosimo in what may be called his novitiate in private patronage.

Using this cut-off date, you find that Cosimo brought to the palazzo three works by Masaccio,[168] an indeterminate but impressive number of Fra Angelicos,[169] perhaps two Uccellos and a Pesellino,[170] probably two or three other Donatellos besides the David[171] (which was not inventoried, for reasons to be shown later), and two Giottos.[172] Or, rather, I should say that I now incline to think Cosimo already owned the two Giottos in 1444.

These last pictures are among the most nagging puzzles of the posthumous inventory of Lorenzo the Magnificent's possessions. They were astonishing acquisitions for a later-fifteenth-century collector, and nothing quite like them is to be found, either, in any major inventory that now survives from the ensuing centuries. It is of course remotely possible that the two Giottos were bought as devotional pictures by a Medici of Giotto's time.[173] It is also possible, too, that Lorenzo himself bought the Giottos as a suitable gesture when he put up the memorial to Giotto in the Duomo, with its inscription composed by Poliziano.[174] Yet it is also easy to imagine Cosimo getting the Giottos as part of the package when (and if) he acquired the art collection of Niccolò Niccoli, from which of course some of Cosimo's other early pictures may also have come.

It must be added that the Italian works of art owned by Cosimo de' Medici in his pre-palazzo period make a short list compared with the massed results of private patronage by three generations of the Medici in the fifteenth century. Yet the contrast is startling when this seeming short list is instead compared with the painted terra-cotta Madonna in a chest, four paintings of the Madonna and two more of saints, probably all of the most routine devotional type, which were the only significant works of art in the Palazzo Uzzano inventory of 1425.[175]

The story of Medici patronage would be sadly distorted, moreover, if Cosimo's public patronage of the arts were omitted; for, as suggested al-

ready, he was probably the greatest of all the numerous and lavish public patrons in the grandiose Italian record. Whereas other rich families had their own family chapels, the Medici in effect had a family church, Brunelleschi's Church of San Lorenzo. This was started by Giovanni di Bicci de' Medici, carried on by the first Lorenzo after his father's death, and largely completed by Cosimo after the death of his brother.[176] In addition, Cosimo built the Badia of Fiesole and expensively stocked its library with two hundred specially ordered codices.[177] He built the Convent of San Marco, too, with its monks' cells frescoed by Fra Angelico and his atelier, and its special cell for Cosimo's religious retreats with an appropriate picture of the Magi bringing their rich gifts to the newborn Lord.[178] Nor was this by any means the entire list of Cosimo's projects in Florence—and he also played the patron's role in Venice,[179] Jerusalem,[180] and several other places.

The truth is that the chosen private pleasures of this astute and ruthless banker and crafty, tough political leader were, first, putting up superb buildings and gathering works of art, and, second, the pursuits of learned men and their conversation. During the church unification council in Florence, Cosimo met Gemistus Plethon and was interested by him in Platonism.[181] He therefore provided the funds that enabled Marsilio Ficino to complete his education and to go on to make his well-known translation of Plato's works into Latin.[182] Cosimo further gave Ficino the small house on the lands of his villa, Careggi, which was known as the "Accademiola" because of its associations with the body known as the Platonic Academy.[183] And he died while listening to one of the Platonic dialogues being read aloud.[184] Before death took Cosimo, he remarked a little sourly of the building he so enjoyed that he was glad he had done so much of it because he could not hope to be remembered in Florence for another fifty years except for what he had built.[185]

As for the costs, they were so enormous that shortly after his grandson Lorenzo became head of the Medici bank, curiosity drove him to have the bank's payment accounts searched to get an overall total. The result was the often quoted *ricordo* by Lorenzo de' Medici, meant for his descendants, that Medici spending on building, on alms for the poor, and on municipal taxes, just in the years from 1434 to 1471, amounted to "an incredible sum of money which adds up to 663,755 florins."[186] Of this gigantic outlay, equal overall to perhaps $150,000,000 in the inflated dollars of today,[187] the lion's share was certainly Cosimo's own outlay. His grandson went on to say in his *ricordo:* "Although many judged we ought to have left more in our purse, I consider [this sum] better spent for the good of the State."[188]

Lorenzo de' Medici's *ricordo* thus introduces a theme of considerable importance. Religion was undoubtedly one motive of Cosimo's expendi-

tures on public patronage with a strongly religious emphasis. As a banker, he was necessarily a usurer; usury was a mortal sin; and mortal sins had to be expiated by those who wished to save their souls. But another motive of Cosimo's expenditures was just as unquestionably political. In the late sixth century B.C., Pericles' forebears, the rich Alcmaeonids, paid for the marble of the second temple at Delphi after the first one burned down, mainly to show that they could not be counted out of the political game because Pisistratus had exiled them from Athens.[189] By the same token, splendor in public patronage of the arts was much admired by the Florentines; and among most of his fellow citizens, Cosimo unquestionably gained standing and thus strengthened his position by his splendid embellishments of the city.[190]

One may be sure, however, that different emotions were felt by members of some of the other rich Florentine families. These people, accustomed to be proud of their family chapels and their contributions to such guild enterprises as the Calimala's adornments of the Baptistery, inevitably felt sadly outclassed by Cosimo's immeasurably more glorious undertakings. Even the public patronage was evidently criticized by many as excessive and showy. This is indirectly indicated by Lorenzo's *ricordo* and quite directly by the answer to Cosimo's critics written by Timoteo Maffei, the abbot of the Badia. The answer is a Latin dialogue forthrightly entitled *In Magnificentiae Cosmi Medicei Detractores*.[191]

By then, however, Cosimo had built the new palazzo on the Via Larga at the enormous cost of 60,000 florins,[192] and this naturally added fuel to the indignation of the "detractors" of Cosimo's "magnificence." Concerning the palazzo, Abbot Maffei explained that "in this house he has not thought about what Cosimo wanted but what was consistent with such a great city as Florence."[193] In the palazzo's story, moreover, political considerations clearly had a major role. It was a major political decision in itself just to build such an immensely grand house, the first Florentine departure from the former style of rich men's big but severely plain houses with rather bleakly functional interiors, and the first palazzo, too, which was forthrightly designed on the new Renaissance principles.[194]

The Palazzo Medici

In all other ways, and throughout all his thirty years of rule over Florence, Cosimo was careful to appear as a plain citizen like any other, affable to all fellow citizens, never arrogant, and making not the least outward show in his own appearance or his attendance.[195] With his vast wealth and his love of building and art, Cosimo probably wanted to build a grand new palazzo for years before he took the project in hand, but hesitated until he felt firmly and permanently fixed in the saddle of

power.[196] The kind of house he wanted would hardly be suitable for a plain citizen.

Moreover, even after Cosimo decided to make the move at last, the first design, submitted by Brunelleschi, was, significantly, rejected as much too obviously grand.[197] Hence Michelozzo got the commission for the new Palazzo Medici (now Medici-Riccardi);[198] work on the foundation began in 1444; and the end result was certainly more than grand enough. How grand, one can see from the impression made on Galeazzo Sforza, son and eventual heir of the Medici ally Francesco Sforza, Duke of Milan.

Young Sforza made a state visit to Florence in 1459, and he and his party sent home excited accounts of "the studies, chapels, salons, chambers and garden, all of which are constructed and decorated with admirable mastery, decorated on every side with gold [meaning gilding] and fine marbles, with pictures and inlays done in perspective by the most accomplished and perfect of masters down to the very benches and floors of the house [undoubtedly meaning that the benches along the walls of the main rooms, and probably the doors, too, were ornamented with the pictorial wooden inlays of the intarsia workers, while the floors had patterned parquets or inlays of varicolored marbles]; tapestries and household ornaments of gold and silk; silverware and bookcases that are endless without number; then the vaults or rather ceilings of the chambers and salons, which are for the most part done in fine gold [here meaning parcel-gilding] with diverse and various forms."[199]

The foregoing account was sent to Milan by one of the older men who accompanied young Sforza—as his bear-leaders, one suspects, since he was then only fifteen. Another letter, this time from the boy to his father, adds enthusiastic praise for the palazzo garden to the retainer's account; and also, significantly, speaks glowingly of the Medici's "sculpture." These letters are invaluable, for they are not dubious exercises in Medici propaganda, like Avogadro's wholly undependable efforts. Instead, they were meant solely for the eyes of the Duke of Milan, and since young Sforza and the other letter writers in his party were describing what was before their eyes and recording their own impressions, their descriptions must be taken quite literally. The letters are in fact unique records of the way the palazzo interiors were decorated.

The new palazzo, then, was altogether dazzling in itself, even without the dazzling array of works of art gradually accumulated in it. About these latter, there seem to have been some of the same initial hesitancies as there were about the decision to build the palazzo, which in turn caused Cosimo to reject Brunelleschi's first design. In the foregoing account of the role of politics in Cosimo's patronage of the arts, I have crudely followed E. H. Gombrich; and he also suggests, in the same article, that even Donatello's David was kept "in the background"[200] when first brought to the palazzo.

One can even make a stab at the year when the David was placed where it stood thereafter for over four decades, on a column in the center of the palazzo courtyard. The logical moment for this was when the courtyard was additionally adorned with its Donatellesque roundels in the 1450s.[201] All but one of the roundels, with the Medici arms, showed classical designs. One was from a sarcophagus,[202] another was taken from the famous *calcedonio* found by Niccolò Niccoli so long ago—or, rather, from a gesso or lead cast of the *calcedonio*, which was still in Rome when the courtyard received its new ornaments.[203] The other designs were all from carved gems in the Medici collection, including the alleged "seal of Nero."[204] The conspicuous enrichment of this semipublic part of the palazzo had its own meaning; and so did the roundels showing the finest Medici gems. These latter meant, in fact, that Cosimo and his sons were now rather more than ardent collectors of classical works of art. They were also eager to have the rest of the world know about and admire their collection's importance.

Nor was this the end of the story during Cosimo's lifetime. A long series of memorable works were commissioned from great artists to add to the palazzo's glories: Uccello's three great panels of the Rout of San Romano, for which the commission probably came from Cosimo himself in the mid-1450s;[205] Donatello's Judith with the Head of Holofernes,[206] placed in the palazzo garden;[207] the three lost Pollaiuolo panels of the Labors of Hercules, each just under twelve feet square, for the Sala Grande;[208] Benozzo Gozzoli's frescoes for the chapel, which were the affair of Piero the Gouty;[209] the sets of tapestries which Giovanni de' Medici ordered from the Medici agents in the Low Countries;[210] the ceiling ornaments and floor tiles by Luca della Robbia, which must have made Piero de' Medici's study-workroom[211] the most enchanting banker's lair the world has ever seen; and so on and on. And to the contemporary works of art Cosimo and his sons commissioned, one must add their quantities of gold and silver plate, their rich stuffs, the amazing array of jewels one finds in Piero de' Medici's last inventory (including thousands of loose pearls);[212] the rarities like Piero's unicorn horn;[213] and above all, the ever-increasing classical art collection and the large and constantly augmented library of superb books, mostly classical texts.[214]

With their new palazzo, in sum, the Medici largely set an example of a new way of living. Splendor there had been before in the surroundings of the rich and powerful, and in most parts of Europe that had experienced prosperity and a measure of good order from the fall of the Western Roman Empire until the Palazzo Medici first opened its doors. But in the first place, there was nothing in the least medieval in the splendor of the fifteenth-century Medici from Cosimo's time onward. Gilding was everywhere in Cosimo's new house, but guards and armed retainers were nowhere to be seen.[215] Nor was there any high table for the Medici and

their equals, with lesser persons eating "below the salt." The fifteenth-century Medici were famously hospitable; but even in the days of Lorenzo the Magnificent, when Medici rule in Florence was already regarded as hereditary, there was no precedence except on days when state guests were being entertained.[216] Indeed, the teen-age Michelangelo, if he came to the meal promptly, might find himself receiving the Magnificent's instructions about connoisseurship of antique coins and carved gems, which Condivi recorded,[217] while older guests, far more important than any youth, simply took their places as they entered.

As for the palazzo itself, it is not easy to picture in its heyday. The great windows generously poured in light on rich surfaces of every kind. Tapestries, pieces of plate, small sculptures, paintings large and small were everywhere in all the rooms of any importance.[218] Even the books in their ornamented cases had bindings of great cost,[219] and gilded moldings framed some of the pictures.[220] Nothing could have been more unlike the interiors of the Palazzo Uzzano. But that was by no means all. The new palazzo was not only the first forthrightly Renaissance great house in Florence; it was also the first Renaissance great house to make a wide impression anywhere in Italy, and therefore in the world. So when I try to imagine the effect on the Florentines of their first exposure to the palazzo on the Via Larga, I find myself recalling the impression made by the grand opening of Mrs. Jack Gardner's palace on the Boston Fenway, to which Mrs. Gardner admitted no one before this curious event. I once heard about this from an old Boston lady who had been there as a girl of eighteen.[221]

"To this day," she told me, "I've never got over it. After forty years, I still feel the delight, I feel the surprise, and I shall feel them until the Lord takes me. The beautiful things everywhere—the flowers, the superb flowers everywhere—the warmth, the luxury! I'd seen no European great houses, nor even any in New York; and in those days, nobody in Boston had a house full of beautiful things, or a house full of flowers, or even a house that was comfortably warm!"

The Palazzo's Influence

If you think about it, this Bostonian response to Mrs. Gardner's splendors must have been exceeded by the Florentine response to the splendors of the new-built Palazzo Medici. Or at least this must have been true of the response of the Florentines who saw the palazzo's interiors;[222] for the exterior still had a prudent measure of the customary severity, despite the novelty of its developed Renaissance style in a private dwelling. Furthermore, if one may judge by the impression made on young Galeazzo Sforza,

a great many other Italians also responded with delighted astonishment to the new Medici way of living among a bewildering variety of great works of art and all sorts of other rich things. Given the dates, for instance, one can make an excellent case that the lavish use of intarsia enrichment in the new palazzo, "down to the very benches . . . of the house," which so impressed young Sforza and his party in 1459, was in reality the inspiration of the famous later but still-surviving intarsia decorations of the palazzo at Urbino—although not, of course, the model for the astonishing ducal study there. In short, it is reasonable to suppose the innovations of the Palazzo Medici had a good deal to do with the spread of the new, wholly unmedieval style of life, not necessarily more splendid than some styles of life that had gone before, but much more splendid in a proto-modern manner.

The subject deserves far more intensive study. Extensive comparisons are needed of magnates' inventories of different periods. Other lines should be pursued, too, such as determining how fine things were used. Which, for instance, were made to be carried about in the medieval way from great house to great house, like the stores of tapestries and grand plate of Jean, Duc de Berry, and other, much earlier grandees? And which fine things were planned for relative permanence in a near-modern way, like the superb paintings so lavishly commissioned by the fifteenth-century Medici, and their tapestries, which were also made to fit the rooms[223] and therefore as permanent elements of the décor? Yet whatever results such a study may produce, Cosimo de' Medici and his immediate successors will surely be allotted a significant role in the decline of medieval ways and the rise of a proto-modern way of living among the rich and powerful men of Italy in the Renaissance.

Because of this, in turn, the Medicean private patronage of the arts, mainly inaugurated by Cosimo Pater Patriae, also had its important after-effects on the history of art collecting. Here it should first be noted that the Medici collection of classical works of art made no great contribution to the dazzling effect of the Palazzo Medici's interiors. Indeed, the art collection was not so much as mentioned by young Sforza, probably because the large sculpture was shown exclusively in the garden and on the Palazzo's rear façade;[224] while the coins, medals and carved gems seem to have been kept in drawers and cupboards, to be brought out for inspection by interested persons. In other words, the fruits of private patronage were what mainly gave such splendor to the interiors of the Palazzo Medici. But as soon as it became usual for magnates to make their interiors splendid with the fruits of a private patronage, the next phase was only a step away. This phase came in the early sixteenth century, when magnates ceased to achieve splendor solely by accumulating large numbers of works of art by the slow processes of patronage. Instead, they bought splendor

ready-made, by becoming true collectors of great works of the Renaissance.[225]

Collecting's Influence on Art

Such was the effect on the history of art collecting of the private patronage of the fifteenth-century Medici, beginning with Cosimo Pater Patriae, as mentioned early in this chapter. It was not a direct effect; it can only be inferred without being proved; and it was not so important an effect as the reverse case. This reverse case, also mentioned in the introduction to this chapter, was of course the effect on the future history of Western art itself of the art collecting of the fifteenth-century Medici, again beginning with Cosimo.

A good deal was said in previous chapters about the Vasarian canon of art, and its power over art and taste until the canon at length broke down for good in the nineteenth century. The reader may remember that the establishment of the canon made the giants of the High Renaissance the canonical old masters of the Western art tradition, while the great masters of the classical past were the primordial old masters, quite on a par with the High Renaissance giants. But who, then, gave the classical masters this remarkable standing, and when was it given to them? The answer comes in two parts. The "ancients," as they were so often called, had undoubtedly become fully canonical by the end of the fifteenth century. And the Italian magnate-collectors of the fifteenth century, led by the Medici, had an enormous role in the canonization of the "ancients," although the artists had a large role, too.

Here again, one must be careful to avoid exaggeration of the Medici share in what happened. For example, the owners of those Roman palaces that Emmanuel Chrysoloras tried to penetrate unquestionably owned pieces of classical sculpture before any Medici thought of doing so. Yet in view of the small impression these rich men of Rome left behind them, one suspects that they took advantage of the occasional sculpture discoveries being made in Rome in something of the spirit of old-fashioned American farmers, who so often used to bring in Indian arrowheads from the fields to place on the mantelpiece of the best parlor.[226] Several of the grand Roman families claimed descent from great names of antiquity, as the Porcari did from Marcus Porcius Cato. For such families, displaying classical works of art was a way of underlining their ancient origins. Stefano Porcari, executed for conspiracy by Pope Nicholas V, was in fact a classical collector, at least in a small way;[227] and one may guess he set the example for later Porcari, who always hastened to acquire any classical work showing a pig, or pigs,[228] because the emblem of the ancient Porcii was held to have been a pig. Rome was not the only center, either, where classical

sculpture could be seen before Cosimo de' Medici became a classical collector. The Venus statue Lombardo della Seta acquired in Florence was in turn acquired from Della Seta's son by the Marquis of Ferrara;[229] but this is the only classical work of art known to have been in the collection of the Este in Ferrara at a date before Medici collecting started.

Then, too, it must be emphasized again that Cosimo de' Medici was inspired to become an active collector of classical works of art by the examples of the humanist collectors and artist-collectors, who were his friends and preceded him. All this being remembered, however, I still believe it is correct to describe Cosimo Pater Patriae as the first magnate-collector of classical art on a really large scale now known from the Italian record.

Certainly no magnate before Cosimo is known to have collected for so long or so consistently, or to have passed on the collecting passion to the next generations in the way Cosimo did. Furthermore, I also believe that want of detailed information has led to underestimation of the extent of Cosimo's art collection by the time he died. To be specific, it is quite certain that Cosimo collected classical sculpture along with coins, gems, medals, and the like. So much has been shown. In the next chapter, it will again be shown that before the fall of the Medici in 1492, the garden of the Palazzo Medici displayed a large number of pieces of classical sculpture.

It is a long leap, but I should therefore bet that in the original design presented to Cosimo, the garden of the palazzo was planned from the first as a place to display large pieces of sculpture, mainly classical, thus taking maximum advantage of the always effective contrast between bronze and marble sculptural surfaces and green, growing things. Donatello's Judith with the Head of Holofernes, a Medici commission of Cosimo's later lifetime, was unquestionably displayed in the garden until the great palazzo was looted and emptied in 1494;[230] and it cannot be rationally excluded that Cosimo was also the man who placed in the garden a considerable share of its classical sculpture, especially in view of the impression made by the sculpture on young Sforza in 1459. To make such an impression, there must have been a good deal of it by that date.

In his later life, it must be added, Cosimo was by no means the greatest classical art collector in Italy. That distinction by then belonged to Pope Paul II,[231] and even while still Cardinal of St. Mark, Pietro Barbo had a classical collection far stronger than the Medici collection in antique gems, medals, small sculpture, and other pieces which were little but costly. But a good many of the most notable objects in Paul II's collection ended in the Medici collection, as will later be shown. There can be no doubt, either, that by the death of Lorenzo the Magnificent in 1492, the Medici collection of classical works of art which was begun by Cosimo had become

the most famous and most envied in all Italy.[232] By the fifteenth century's end, too, Italian-magnate collections of classical art were so numerous and so much taken for granted that any local ruler, or Venetian patrician of the richest inner circle, or cardinal with the good fortune to be profitably close to the all-giving Throne of St. Peter, must have felt half naked without a few pieces of Greco-Roman sculpture to show his visitors.[233]

In Italy in the fifteenth century, in sum, the process reached its first maturity, which would dot all Europe with echoing galleries of Greco-Roman marbles, from Naples to Berlin, and from London to St. Petersburg, before the great change in the way of seeing in the nineteenth century. Furthermore, to be the pioneer magnate-collector who mainly started this remarkable trend, as Cosimo de' Medici did, was to play a major role in the history of Western art.

In the first place, all theorists of art for centuries partly formed their ideas in the sculpture galleries. And secondly, the artists also formed their taste in the same way. In the seventeenth century, Poussin was even warmly praised for the way his figures revealed long study of antique sculpture.[234] In truth, it would have been hard to find any leading artist in the centuries before the great change in the way of seeing who did not believe learning from "the ancients" was essential for anyone aspiring to enter the higher realms of art[235]—at any rate until the way of seeing changed so radically. And I repeat, it seems clear that the near-sanctification of the ancients received much impetus from the crucial example Cosimo de' Medici set as a magnate-collector.

But we have yet to tackle squarely the great surprise of the fifteenth-century story. This will be done in the next chapter.

XII

THE LESSON OF LORENZO

A description of the recreations of Piero de' Medici, who ruled Florence from 1464 to 1469, is one of the more curious and significant documents in the history of art and taste in Italy in the fifteenth century. Filarete heard it from an eyewitness, Nicodemus, "a worthy man,"[1] who was in fact the Milanese ambassador to Florence.[2] Fortunately, Filarete was a garrulous and discursive writer; so he inserted what Nicodemus had told him in his book on an ideal city, the *Trattato dell'architettura.*[3] He meant his insertion as a kind of lesson in good taste for rulers and great men like Francesco Sforza, for whom he named his ideal city "Sforzinda."

It should be added that the Florentines did not call Piero de' Medici "Il Gottoso" for nothing. At the end of his life, his gout killed him[4]; and even at the time Filarete wrote about, shortly before the death of Cosimo Pater Patriae in 1464, Piero was already in agonizing pain much of the time and often could not walk. But he was also a man of stoical courage, as he proved on the death of his father. He then needed a litter because he could not mount a horse, yet he had himself carried into Florence, avoiding assassins waiting to intercept him; and there he briskly put down a conspiracy against Medici rule by Luca Pitti and others who had thought the heir too crippled to fight. If you know this background, the same defiance of daily pain again shows through Filarete's report:

> He takes pleasure and finds a pastime in the following. He has himself carried into [his] studio. . . . When he arrives here, he looks at his books. They seem like nothing but solid pieces of gold. They are most noble both within and without; in Latin and in the vulgar [tongue] to suit man's delight and pleasure. Sometimes he reads one or the other or has them read. He has so many different kinds that not one day but more than a month would be required to see and understand their dignity. Let us leave aside the reading and the authors of these books. It is not necessary to

list them, because he has them in every discipline, whether in Latin, Greek, or Italian, so long as they are worthy. He has honored them, as you have understood, with fine script, miniatures, and ornaments of gold and silk, as a man who recognizes the dignity of their authors and through love of them has wished to honor their works in this manner. Then on another day he runs over all these volumes with his eye for his pleasure, to pass the time and to give recreation to his sight.

The following day, according to what I was told: he has effigies and portraits of all the emperors and noble men who have ever lived made in gold, silver, bronze, jewels, marble, or other materials. They are marvelous things to see. Their dignity is such that only looking at these portraits [wrought] in bronze—excluding those in gold, silver, and in other noble stones—fills his soul with delight and pleasure in their excellence. These give pleasure in two ways to anyone who understands and enjoys them as he does: first for the excellence of the image represented; secondly for the noble mastery of those ancient angelic spirits who with their sublime intellects [have] made such [ordinary] things as bronze, marble, and such materials acquire such great price. Valuable things such as gold and silver have become even greater through their mastery, for, as it is noted, there is nothing, from gems on, that is worth more than gold. They have made it worth more than gold by means of their skill. . . .

He takes pleasure first from one and then from another. In one he praises the dignity of this image because it was done [by the] hand of man; and then in another that was more skillfully done, he states that it seems to have been done by nature rather than by man. When we see something made by the hand of Phidias or Praxiteles, we say that it does not seem by their hand. It appears to have come from heaven rather than to have been made by man. He takes the greatest pleasure and delight in these things. Another day he looks at his jewels and precious stones. He has a marvelous quantity of them of great value cut in different ways. He takes pleasure and delight in looking at them and in talking about the virtue and value of those he has. Another day [he looks] at vases of gold, silver, and other materials made nobly and at great expense and brought from different places. He delights greatly in these, praising their dignity and the mastery of their fabricators. . . .

In short, worthy and magnificent man that he is . . . he delights in every worthy and strange thing and does not note the expense.[5]

Here was a man who had lived his whole life amid the first magnificent flowering of the Renaissance in Italy[6]—the very years when Florence became the nursery of the arts. The public patronage of the Medici had notably increased the beauty of the city. The palazzo Piero and his father inhabited was the first such structure put up for private use in the new style pioneered by Brunelleschi; and his and his father's patronage had filled its rich rooms with works by all the greatest artists of the time. But did he have himself carried to the Sala Grande, to see the now lost

paintings of the Labors of Hercules, the most ambitious ever attempted by Antonio Pollaiuolo?[7] Did he direct his litter bearers to Donatello's Judith and Holofernes in the garden, or to the David in the courtyard, or to the rooms holding other, smaller bronzes by the master?[8] Or did he pay another visit to the chapel frescoed by Benozzo Gozzoli under his own direction?[9] Apparently not. Instead, this man in constant pain made his free hours more bearable by asking his attendants to pass in review before him the books, the classical works of art, and the jewels and plate he and his father had brought together in the palazzo.

Even those books have a lesson. If you examine the inventory of the library of the Palazzo Medici[10] in Piero de' Medici's later years, you find a striking disproportion. From Dante onward, the great Italians were there, of course. So were enough works by the Church Fathers to make a respectable showing—but only barely enough. The great majority of the books Piero de' Medici loved so much were instead works from the classical past, with special emphasis on the Roman historians and poets, orators and thinkers.[11] The contrast is dramatic, even with so recent a library as that of Jean, Duc de Berry, with its magnificent array of superlatively illuminated books of hours, its other devotional and religious works, its many romances, and its rather sparse collection of the classical writers.[12] The difference between the two libraries is in fact the difference between two stages of cultural history, late medieval and proto-modern.

Then there is another lesson to be learned from the Filarete-Nicodemus emphasis on precious things. To grasp the full meaning of this lesson, to be sure, the kinds of precious things being mentioned must first be understood. As his inventories show,[13] Piero de' Medici owned great numbers of diamonds, rubies, pearls, and other jewels, and quantities of the plate that so much struck young Galeazzo Sforza when he visited the Palazzo Medici in 1459. But a good many of those jewels he looked at in his leisure hours were surely from his or his father's large collection of antique carved gems. By the same token, those gold and silver images of emperors and worthies were surely from their combined collections, again large, of antique coins and medals of precious metal, just as the images in "noble stones" were portrait gems.

Thus this part of the Filarete-Nicodemus description introduces a theme already briefly touched upon, the spillover from the medieval treasure standard of value in fifteenth-century art collecting. The spillover did not mean for one moment that nontreasures of classical origin were not much valued and ardently collected, too. As has been seen, Piero's father sought classical sculpture. So did the younger brother who predeceased Piero, Giovanni;[14] and Piero was probably not far behind Giovanni. Nonetheless, it is clear that carved gems, antique and pseudo-antique vessels in hard stones, and classical medals and coins of silver and gold held a

higher place in the collectors' hierarchy of the fifteenth century than they were to hold later on, when pieces of sculpture like the Apollo Belvedere, the Laocoön, and the Medici Venus became the most famous and admired classical works of art.

The Fifteenth-Century Surprise

Yet the foregoing lessons are not the most important to be learned from the account of the consolations which Piero de' Medici sought when he could get away from his daily business. The most important lesson concerns the sharp line which always divided art collecting and patronage of the arts throughout the fifteenth century. The second of the Medici rulers of Florence was both a collector and a patron, like his father before him and his son after him. Like his father, again, he was also a straight treasure gatherer on a large scale. But classical works of art were what he truly collected, just as classical texts were what he chiefly wanted for his library. And if the account of Piero de' Medici's private pleasures is not misleading, the great Renaissance works he and his father had commissioned from the supreme artists of Florence in this gloriously creative half century somehow had a distinctly different standing in Piero's eyes. At any rate, the classical works and mainly classical books from their collections, plus their treasures, were the elements in the astonishing contents of the Palazzo Medici that Piero de' Medici wished to see and study again and again when he was immobilized by pain.

So we come back to what was called, in the last chapter, the great surprise of the fifteenth-century story. To recapitulate, in this century so fruitful in artists of inspired genius, in lavish patrons, and in eager art collectors of enormous wealth, the collectors sought classical works of art exclusively until the century's end. There were borderline cases, of course. Works by the great early masters of the Low Countries, Jan van Eyck, Rogier van der Weyden, and others, were rather often imported and acquired by rich Italians. By the fifteenth century's end, the Medici owned a Van Eyck,[15] a Petrus Christus,[16] and possibly a major Rogier van der Weyden.[17] Strictly interpreted, my definition would make these imported works of art collectors' prizes. I myself believe, however, that the extreme minuteness of realistic detail in the works of Van Eyck and his successors constituted their attraction;[18] and I further think that the importation of these pictures, in some sense as foreign exotica, must be partly equated with the simultaneous importation of tapestries[19] from the Low Countries, by Giovanni de' Medici among others, because the skill of the Low Countries weavers made the tapestries much-desired foreign luxuries. Another, really more significant borderline case was constituted by the pastiche-classical small bronzes, carved gems, and hard-stone vessels

which the collectors of the fifteenth century, again including the Medici, freely mingled with their truly classical works of art. But the key to these objects' desirability was their pastiche-classical character. The main point is, meanwhile, that with the exception of these classical pastiches, the Italian Renaissance works of art the patrons commissioned were never collectors' prizes—although modern art collectors would undoubtedly come close to homicide to get just one of them.

"Never" is a big word, to be sure. The documentation from the fifteenth century is extensive, but it is far from complete. If it were anything like the documentation from the nineteenth century, for instance, it might well reveal some collector somewhere or other in Italy—almost certainly a man of limited means—who turned aside from the costly competition for antique gems, medals, and coins and classical sculpture, and instead sought works by leading masters of the Renaissance which happened to become available at second hand. It stands to reason such works sometimes came on the market when the people of this or that fine house met with misfortune. People with fine houses habitually gave their commissions directly to their favored artists. There were as yet no real art dealers, unless you count obscure traders in classical works and traffickers in devotional objects. Hence when misfortune caused dispersal of the contents of fine houses, all of these except for the treasures and rich stuffs would have gone to the *rigattieri*, the omnipresent secondhand dealers. Among the *rigattieri*, therefore, a collector farsighted enough to want major Renaissance works of art instead of classical or pastiche-classical objects and sculpture might have made a splendid harvest over time.

Yet I have searched widely and have followed every lead I found to a potential fifteenth-century art collector of the type above-defined, and the search has always led nowhere. For example, the most promising-looking lead of this sort that I found in the literature was Attilio Schiaparelli's description of Andrea Minerbetti's approach to works of art.[20] Minerbetti was a member of the Florentine upper class of the later fifteenth century, who lived on into the sixteenth century long enough to have the contents of his palazzo inventoried for the last time in 1546. The Palazzo Minerbetti in Santa Trínita was large and already handsomely furnished, with special emphasis on pieces of furniture decorated with intarsia, at the time of the first inventory by Andrea Minerbetti in 1493.[21] This inventory shows that the furnishings then included ten paintings, of which four were devotional pictures, and eleven pieces of sculpture in terra cotta, gilt copper, wax, and wood, of which one was a wooden crucifix and five more had sacred subjects. By 1500, a large gesso Madonna in relief and a clay (presumably terra-cotta) head of Christ, two more paintings, and a tondo of the Madonna from the Della Robbia shop[22] had been added to the palazzo's ornaments.

Andrea Minerbetti's entire *Ricordanze* in the Laurentian Library have also been examined, to see whether the impression left by the foregoing relatively meager fifteenth-century data would be much changed by Minerbetti's sixteenth-century dealings in works of art. These later documents left by Andrea Minerbetti show him endlessly buying and selling all sorts of things such as mattresses and textiles, but including works of art. The *Ricordanze* also show that the number of works of art in the palazzo had considerably increased by the time of the 1546 inventory.[23] Minerbetti further made gifts of furniture and pictures to his children,[24] and sometimes he swapped with members of his family, as when he let his brother Francesco have an antique bronze head (the only classical work of art ever mentioned) in exchange for a painting from the Low Countries, two more pictures, and some furniture.[25]

To sum up, the *Ricordanze* certainly prove that Andrea Minerbetti liked to have paintings and pieces of sculpture in his house, which was well decorated in other ways also; but there is no indication that he ever paid a great deal for his sculpture and paintings—with the possible exception of the antique bronze head that had such a substantial exchange value. Throughout the *Ricordanze*, again, there is no discoverable support for Schiaparelli's belief that Andrea Minerbetti was a "typical representative of the collector [whose] taste [was] oriented at first towards Filippo Lippi, Ghirlandaio, Donatello and Verrocchio."[26] The Della Robbia tondo is the sole attributed work of art from beginning to end of these documents.

The conservative interpretation of the Minerbetti *Ricordanze* is in truth that they prove the force of the example set by Cosimo de' Medici, who first showed rich men that they ought to furnish their interiors more grandly, with works of art other than devotional pictures in addition to such late medieval luxuries as expensive hangings and plate. The *Ricordanze* further suggest (but do not prove) that Andrea Minerbetti inclined to do this on the cheap, buying what look suspiciously like routine workshop pictures wherever he could find them, instead of giving commissions to the best masters of the time in the manner of most of his contemporaries. There is really nothing to indicate he was an art collector of any significance, although his son Bernardetto, a close friend of Giorgio Vasari, was a serious art lover and connoisseur as well as a collector and patron of the arts.[27]

On Giovanni Rucellai

The right man to consider in connection with the problem now being explored is instead Giovanni Rucellai, the contemporary and friend of Cosimo de' Medici, whose son, Bernardo, married Cosimo's daughter, Nannina. Unlike Minerbetti, Rucellai spent money with an open hand as

long as he had it—for he had bad financial luck at the end of his life. Leon Battista Alberti designed the new façade provided by Rucellai for Santa Maria Novella,[28] on which his generosity is still commemorated in letters close to a yard high. His public patronage had already embraced another major project;[29] and when Cosimo Pater Patriae showed the way with his Palazzo Medici, Giovanni Rucellai followed with his own palazzo of conspicuous grandeur.[30] For this second of the Florentine palazzi in a forthright Renaissance style, Rucellai again used Alberti as his architect. Every student of the period also knows almost by heart two passages from Rucellai's *Zibaldone*,[31] a kind of daybook he kept for his descendants' benefit. One of these is particularly pleasing, because of the insight it gives into Rucellai's character and proclivities:

"I also thank God for the good fortune I have had in my business, since I was able to increase and multiply what little I inherited, and I now find myself with a good deal of wealth, esteem and good credit. And not only has He granted me His Divine Grace in earning money, but also in letting me spend it well, which is no lesser virtue than earning it. I believe more honour came to me in how I spent my money than in how I earned it and [it gave] greater contentment for my soul."[32]

For present purposes, another passage in the *Zibaldone* has more importance, however. Rucellai was obviously extremely pleased by the grand way he furnished his new palazzo, once he had built it. So he wrote: "Memoria we have in our house more works of sculpture and painting and tarsia [pictorial mosaic in woodwork] and *commessi* [pictorial inlays of colored marbles] from the hand of the best masters to have worked for a good many years back, not only in Florence but in Italy."[33] The masters listed by Rucellai, as represented in his palazzo, are Filippo Lippi, Antonio Pollaiuolo, Andrea del Castagno, and Paolo Uccello, the sculptor-painter Andrea Verrocchio, Domenico Veneziano, the two sculptors Desiderio da Settignano and Giovanni Bertini, the "carver" Ghiberti's son Vittorio, the goldsmith Maso da Finiguerra, and the intarsia worker Giuliano da Maiano, who was also an architect, of course.[34]

Concerning this passage in the *Zibaldone*, Rudolf and Margot Wittkower once wrote that Rucellai "seemed less concerned with assembling anonymous works of art for his palace, than collecting works of famous masters."[35] This is unchallengeable, but the question still remains, whether Rucellai's boast really does imply that he was a true collector of contemporary works of art, or whether he was merely proud of having ordered numerous handsome ornaments for his palazzo from the very best suppliers.

People nowadays forget how much it formerly meant to use the best suppliers, and how well recognized, even standardized, the best suppliers formerly were. But in what may be called the Edith Wharton world of

the Northeastern United States before the Great Depression, the suppliers from whom this little world's denizens got their suits and shoes,[36] their sweaters, shirts, handkerchiefs, and neckties,[37] their firearms if they liked killing small birds,[38] their fishing tackle if that was their preference,[39] their marmalade for breakfast, and the Virginia ham for their dinners, were all plainly indicated by the same iron laws that prescribed the schools and colleges where their offspring could be suitably educated. Other choices might be made, of course. Some might have American orange marmalade (deplorably made with sweet oranges rather than "Seville" or bitter oranges) instead of Dundee or Cooper's Oxford. But such things were known by all that world to be second-best choices; and going to none but the best suppliers was a matter of course for all heads of well-regulated households who could pay the bills.

In Florence in Giovanni Rucellai's time, no doubt, the iron laws of suitability in all things were not developed in the strange way they had developed in the Northeastern United States in the last decades of the nineteenth and first decades of the twentieth centuries. But in his time the Florentines were strongly conscious that their city really was the nursery of the arts, and very proud of it, too. Rucellai, moreover, was obviously just the kind of man to share this consciousness and pride; and if he had not done so, his chosen architect, Alberti, would soon have enlightened him. Alberti, after all, was the man who wrote that the arts had seemed to die after the great epoch of antiquity, but many centuries later had been miraculously reborn in Florence because of Brunelleschi and Ghiberti, Donatello, Masaccio, and Luca della Robbia.[40] And if these best masters of the first phase of the Renaissance could not receive Giovanni Rucellai's commissions, there were those he patronized, already listed.

This latter point is important in itself, for the easy availability of great masters in fifteenth-century Florence is another natural source of distortion of our historical vision by seeing the past through the misleading glass of the present. Imagine an American Rucellai of the early 1930s who wanted to enhance one of his grand rooms with wall paintings. Such a rich American's most likely choice of artist would have been José-Maria Sert, or if he had led a rather more English-leaning life, he might have tried to tempt young Rex Whistler to come from London and decorate the room with his charming and exceedingly clever eighteenth-century pastiches. If our imaginary Rucellai figure of the early 1930s had chosen either of these two artists, he would not now be remembered by art historians for his perceptiveness in the way that Dr. Barnes is of course remembered for his choice of Matisse to do the decorations for the main gallery at Merion. But Dr. Barnes chose Matisse precisely because he was an astute collector of what was then avant-garde art, whereas Sert or Rex Whistler would have been conventional artists for a rich American of the early

1930s to go to—and the rich man and his friends would also have been pleased by the results, and would have boasted about them, too.

The danger of distorted vision thus arises because it is too easy to forget that in fifteenth-century Florence, Giovanni Rucellai ran little risk of such an erroneous choice as that just outlined. The leading positions of the artists he was proud of patronizing were quite as well recognized in Florence as the superiority of Peel, Maxwell, or Lobb shoes from London used to be recognized by every prosperous man in New York and Boston in my own remote youth. Rucellai might have done even better, to be sure, if he had sought out Piero della Francesca, but that would have amounted to importing from abroad—which fifteenth-century Florentines seldom did,[41] except occasionally from the Low Countries, whereas well-brought-up, well-heeled Americans of the early twentieth century did it with great regularity. In any case, the key point to note is simple. In Florence, particularly, the fifteenth century was a truly golden time for anyone with the means and inclination to be a generous patron of the arts. For it was then so difficult for a Florentine patron of the arts to go really wrong that almost any large-scale private patron was sure to *look*, to later generations, like an art collector of great boldness and the most refined discrimination.

The Litmus Tests Again

In considering the resulting problem of private patronage of the arts in fifteenth-century Florence, the first requirement is to recall the definition of art collecting and the litmus tests for distinguishing collecting from patronage, which were offered in early chapters of this essay. One of these tests is that the collector gathers works of art for which he has no responsibility, even if they are works by his contemporaries. This test alone all but certainly placed Giovanni Rucellai's commissions for paintings and sculpture for his palazzo entirely outside the realm of true art collecting.

In Florence in the fifteenth century, there were undoubtedly ready-made paintings for sale, mainly routine devotional pictures. The *Ricordi* of Neri di Bicci plainly indicate that he had more than one kind of completed work of art on offer in his shop, although he frequently took special orders, too, like the Signory's commission for a fine case for the Florentine copy of the *Pandects*.[42] But there is no evidence that artists of the standing of those listed by Giovanni Rucellai ever undertook major work except on commission.[43] At the end of his life, Uccello was an old man whose work had gone out of fashion; and so he was in need.[44] But this was somewhat after the period when Rucellai arranged his interiors with such splendor.

The one real gray area, in fact, is the reproduction of pieces of sculpture for the market, as happened in the Della Robbia shop and also in Neri di Bicci's shop. Donatello actually designed the relief of the Madonna and Child which he made as a gift to his doctor, so that it could be reproduced from a mold provided on the back of the relief.[45] Whether and how many leading sculptors themselves also trafficked in such reproductions of their works is far from entirely clear. But it is quite clear there were no regular dealers in Renaissance works of art in Florence, with the possible exception of a few minor merchants who traded in devotional works of stock patterns as one might trade in any other commodity. The betting is thus much more than nine to one that Giovanni Rucellai went straight to the artists he favored with his commissions, in the immemorial way of private patrons of the arts.

It is also an odds-on bet that Giovanni Rucellai's share of responsibility for the works of art in his palazzo usually went a good deal further than commissioning them and paying the bill. The chances are high, in fact, that he told his chosen painters and sculptors what subjects he wished them to treat, and in a good many cases, even indicated the dimensions of the resulting works. No inventory of the Palazzo Rucellai survives, alas, but the great posthumous inventory of the possessions of Lorenzo de' Medici the Magnificent shows that some of the most important Medici pictures of Rucellai's period were built into the structure of the palazzo after they were completed.

The three great Uccellos of the Rout of San Romano, with two more paintings by the same master and a Pesellino, appear to have formed a kind of frieze around the upper wall of Lorenzo's bedchamber, probably filling the entire space between the upper edge of the paneling and the ceiling cornice. Here they were divided, and thus attached to the wall, by gilded pilasters.[46] They must have made much the same effect as actual frescoes. So must Pollaiuolo's huge paintings of the Labors of Hercules in the Sala Grande; for these, too, were both framed and attached to the wall by gilded moldings of some sort.[47]

Then, too, before deciding that such men as Giovanni Rucellai were really major art collectors in another guise, it is useful to have a look at the proportion between their probable expenditure on their works of art, as compared with other kinds of expenditure on their houses. To get this matter into correct perspective, one must first note that Rucellai was more than a little smug about having provided his five daughters with dowries totalling 10,000 florins, and of having married his son Bernardo to a Medici bride who had a dowry of 3,700 florins.[48] One must remember, too, that 8,000 florins sufficed for the entire working capital of the Medici branch bank in Venice,[49] and that the resident managing partner, Lotto di Tanino Bozzi, had to contribute no more than 500 florins to the capital

of the enterprise he directed at a fine profit to himself.[50]

These figures need to be borne constantly in mind, because it is too easy, nowadays, to suppose that Fra Angelico, for instance, worked for the most trifling prices. Whereas the 190 florins he received for the Linaiuoli artarpiece[51] was in reality a very large sum of money, much greater, in fact, than the entire sum paid under the *catasto* by any Florentine family but a tiny number of the luckiest. In the *catasto* of 1427, the Medici, one of the three richest families in the city, were assessed at only 384 florins.[52] They led the list, along with the Strozzi and the two Panciatichi brothers.[53] Moreover, the figures for 1457 indicate that the great majority of families, even among the upper classes, paid less than 10 florins![54] Thus commissioning a painting, even for as little as 10 florins, was a substantial self-indulgence in the eyes of all but the very rich.

All the same, the enormous new palazzi that began to go up in Florence after Cosimo de' Medici had made a great house a near-necessity for any family with a claim to lead were not only expensive in themselves.[55] What went into the houses was also enormously expensive—and the pictures and sculpture, if any, were a minor part of the expense. Here again, the best guide is the posthumous inventory of Lorenzo the Magnificent. This crucial document will later have to be examined at length, and one does not want to anticipate too much. But a few details may be noted which bear on the problem of private patronage in the fifteenth century.

One may begin with the fact that Antonio Pollaiuolo's three large paintings for the Sala Grande were valued at only 20 florins apiece, although each covered close to 130 square feet.[56] Because of the pictures' size, the low valuations suggest that Pollaiuolo did these pictures of the Labors of Hercules on the spot, thus avoiding any difficulties about getting them into the Sala Grande when completed. I suggest, further, that Pollaiuolo's Medici patrons must therefore have provided him and his assistants with the food and wine they consumed during the entire period he was at work on these pictures, and that the price was also lowered by the fact that the Medici paid in addition for all paints and other raw materials.[57] I make these suggestions because I also believe, for reasons to be shown later, that the men who made Lorenzo the Magnificent's posthumous inventory took their valuations straight from the voluminous Medici records. These records may also have distorted the real cost of the Pollaiuolos in other ways.

Even after allowing for many such distortions, however, it still seems clear that the outlay on the three great Pollaiuolos was a trifling part of the total outlay on the decoration of the Sala Grande. Here consider Botticelli's Madonna with the two Sts. John, painted for the Bardi chapel in Santo Spirito and now in Berlin. Botticelli's fee for this picture was 35

florins, with 2 florins extra allowed for ultramarine made from lapis lazuli. Meanwhile, Giuliano da Sangallo got 24 florins for carving the frame, and gilding cost no less than 38 florins.[58] These price differences indicate that the three Medici Pollaiuolos in the Sala Grande, whatever their true price, must have cost far less than the parcel gilding of the Sala Grande's ceiling, for which much pure gold leaf was surely needed, or the intarsia and other inlay works which so delighted Galeazzo Sforza. It may even be that the Pollaiuolos cost a bit less than the mere making and gilding of the moldings containing the three pictures. After all, Botticelli's painting in Berlin also cost far less than the total for making its frame and the necessary gilding.

To this, one more significant detail may be added. If you study Lorenzo the Magnificent's posthumous inventory in its complete form, in the copy that fortunately exists in the Warburg Institute in London,[59] you find that at the time of Lorenzo's death in 1492, the Palazzo Medici contained staggering numbers of other things besides the works of art that almost alone appear in Eugène Müntz's printed edition. There were a great many beds, mattresses, and pillows, for instance, and they were evidently far from cheap. Just one featherbed and two pillows had the exact value, 15 florins,[60] of a small but richly framed relief by Donatello[61] or a lesser Fra Angelico.[62] Ordinary clothing was, again, far from cheap, at least of the sort worn by the Medici. The inventory's valuations of the clothing listed (including the "old, sad gown"—possibly a baby dress—of Lorenzo's son Piero and the corsets and petticoats of Piero's wet-nurse) altogether add up to almost 3,700 florins.[63] And this, as we shall see, was considerably more than the total for all the palazzo's paintings and pieces of sculpture specifically attributed to artists of the Italian Renaissance.

To sum up, Giovanni Rucellai was unquestionably proud that the Renaissance works of art in his palazzo had been provided by leading artists, and any surviving works by the artists he patronized are unquestionably tremendous collectors' prizes today. But it does not seem to me correct to see Giovanni Rucellai as a true art collector, in the real sense of that phrase. To begin with, because of the curious cost relationships, you really have to see Rucellai's Renaissance paintings and sculpture as no more than elements—conspicuous elements perhaps, but representing a much smaller investment than other elements, all the same—in the total array required in those days for splendidly furnishing the life of a Florentine magnate.

For good or ill, splendidly furnishing the daily lives of magnates and pseudo magnates has been, and is, the all but unvarying aim of all private patronage of the arts. To add to the splendor of these furnishings was the function, or social purpose, of the works of art in Florentine interiors like those of the Palazzo Rucellai; and they did not, indeed could not,

become ends in themselves until they later passed into the hands of art collectors—unless their fate was to perish somehow, like the three big Medici Pollaiuolos.[64] Thus all the tests for true art collecting yield negative results in the case of Giovanni Rucellai.

Lorenzo de' Medici

If the reader has not been convinced by the foregoing, conviction will surely arise from close analysis of Lorenzo de' Medici the Magnificent as a figure in art history. In some sense, the third of the Medici rulers of Florence in the fifteenth century is the hero of the present chapter, so I should perhaps begin with a confession of interest, even of prejudice. On the whole, the single historical figure I should choose to know well—if that choice were open—is Lorenzo the Magnificent. He was no Alexander the Great or Caesar, or even a Richelieu or a Bismarck; yet what good company he must have been!

He was an athlete until the family gout began to attack him. He wrote poetry of much freshness and charm. He loved all country things. He was not merely the supporter, but also the close friend of the leading humanists of his time, notably Marsilio Ficino, Angelo Poliziano, and Pico della Mirandola. He was a man of genuine learning, widely read, with a passion for books, and entirely able to talk with his intellectual friends on equal terms. He was a man of remarkable personal courage, albeit the very opposite of warlike.[65] And he was so astute a leader of Florence that the great historian Francesco Guicciardini described his death as "bitter for his country, which had flourished marvelously in riches and all those benefits and arts in human affairs which are the usual concomitants of long-lasting peace, all resulting from Lorenzo's reputation and wisdom and talent for all manner of honorable and excellent undertakings."[66] In short, his fellow citizens had good reasons for calling Lorenzo de' Medici "Il Magnifico." All the Medici from Cosimo onward were addressed by the honorific title of "magnificent," but in Lorenzo's case the title came to resemble a personal name.

Like all men, Lorenzo the Magnificent had his faults and weaknesses, of course. In particular, he was an inept banker, and from time to time, when the need finally arose, he was not above treating the treasury of Florence as his own privy purse.[67] As the political leader of Florence, too, he could be coldly ruthless with his opponents.[68] Yet I dare to argue that there is little justification for the current fashion of denigrating Lorenzo as a luxurious dilettante whose taste centered wholly on costly things,[69] and as a deficient and unimaginative patron of the arts.

As a patron, Lorenzo the Magnificent could not, of course, compare with his formidable grandfather. It is hard to think of any patron in Western

art history who has ever outdone the patronage of Cosimo Pater Patriae, at least among those who paid the bills out of their own purses instead of out of tax revenues in the manner of popes and princes. Yet Lorenzo was no mean patron of the arts himself.

Verrocchio was his preferred sculptor for larger works like the Boy with a Dolphin, made for Careggi.[70] One must also add the Verrocchio David and the things listed in 1495 by Verrocchio's brother as having been made in response to Medici commissions but still not paid for.[71] Donatello's pupil Bertoldo di Giovanni further came close to being a house sculptor—for example, making a decorative bronze relief which Lorenzo used as a chimney frieze, and also (one suspects) some of the small bronzes that were scattered about the palace and the villas.[72] Lorenzo also built Poggio a Caiano;[73] and his preferred architect was this great villa's designer, Giuliano da Sangallo.[74] Among the painters, too, Lorenzo gave his largest private commissions to Filippino Lippi for frescoes at Poggio a Caiano,[75] and to Ghirlandaio, Botticelli, Perugino, and once again Filippino Lippi, for another fresco cycle of antique subjects at his villa near Volterra, Lo Spedaletto.[76]

The real reason Lorenzo the Magnificent's patronage is now so often pooh-poohed is that so many of his more important commissions to great artists have disappeared, or have been damaged beyond recognition, or were not finished. Yet the foregoing is not even a complete list of his private commissions; and he also gave public commissions on a scale suitable to his position.

He has lately been identified with more certainty, for example, as the chief patron of the charming Church of Santa Maria del Sasso at Bibbiena, for which we now know that Giuliano da Maiano was the architect.[77] He has been thought to have helped along Benozzo Gozzoli's fresco cycle in the Campo Santo at Pisa, although this claim is undocumented;[78] and he further commissioned two Ghirlandaio altarpieces for the Abbey of San Giusto at Volterra.[79] Toward the end of his life, he even built an entire monastery and church for the Augustinians in Florence, in the grand manner of his grandfather.[80] But this large structure, another design by Giuliano da Sangallo, was already destroyed in 1529.

The truth is, I think, that Lorenzo de' Medici's reputation as a patron of the arts has suffered unduly, partly because of the many losses, partly by comparison with his grandfather, and partly because of the natural reaction against Giorgio Vasari's exaggerations of all Medici patronage—which Vasari undoubtedly put on paper with one eye on Grand Duke Cosimo I's natural fondness for pro-Medici propaganda. If Lorenzo were now being judged solely on his own performance, he would surely be regarded as one of the major patrons of the arts of the later fifteenth century. A leading modern puncturer of the Lorenzo legend has even

remarked, quite rightly, that Poggio a Caiano was a brilliant and advanced conception, uniquely foretelling the great Palladian villas of the next century.[81] For a patron with any other name, Poggio a Caiano alone would have earned Lorenzo an eminent place in the story of patronage in our art tradition.

Lorenzo as Arbiter

Lorenzo was also treated as the perfect talent spotter by almost all the other powerful men of his time. He perhaps recommended Leonardo da Vinci to Ludovico Sforza.[82] He had a role in sending Giuliano da Maiano to Recanati to build the palace of Cardinal Venier.[83] He also sent Giuliano da Maiano to the Duke of Calabria, later the King of Naples.[84] He did the same for Filippino Lippi with Cardinal Olivieri Caraffa.[85] In 1488, he also sent Giuliano da Sangallo to Naples with a design for a palace[86]— although Giuliano was then occupied with Lorenzo's own commissions. He helped to place Andrea Sansovino with the King of Portugal.[87] The list explains why Lorenzo the Magnificent has even been accused of "impoverishing" Florentine art, because he was so generous in urging upon other grandees the services of artists from Florence.[88]

If you look at these facts more realistically, however, they mainly mean that other grandees of his own time vastly respected Lorenzo's judgment in artistic matters. Nor are the foregoing facts the sole proof that Lorenzo was widely regarded as an arbiter of taste, and was therefore appealed to when difficult choices had to be made in matters involving the arts. Here it will be sufficient to cite the single case of the petty row that broke out in Pistoia over a monument to Pistoia's benefactor, Cardinal Niccolò Forteguerri. As to the details of the row, it is enough to say that the heart and center was a vast committee, composed of six men named by the city council, *plus* the Operai of the Cathedral of San Jacopo, *plus* the officials of the school the Cardinal had endowed, the Sapienza.[89] When any kind of enterprise is confided to a committee of this size, there is always trouble; and trouble duly arose.

One cause of the trouble was the commonest of all, money. Andrea Verrocchio's design had at first been chosen; but it was due to cost a bit more than the established limit of 300 florins.[90] The other cause of trouble was the almost equally common one, vanity. A cheaper design by Piero Pollaiuolo had later been generally approved, apparently as more economical, and this decision put those who made it on their mettle to defend their judgment. Riven by the kind of difference that money and vanity so frequently produce in combination, the Pistoians used Lorenzo as a court of appeal in a letter[91] dated March 11, 1477.

The models by Verrocchio and by Pollaiuolo were sent to Florence,

and the Pistoians' letter declared that in such matters, Lorenzo was "gifted with great intelligence and understanding."[92] A second letter more humbly begged Lorenzo for help on the stated ground that the Pistoians had to decide on "something [of] which we do not have much experience."[93] Presumably as a result, Verrocchio received the final contract, although he did not live to complete the work. Finally, the peculiar position occupied by Lorenzo is again underlined by the freedom artists felt to write him begging letters or other requests for aid, like the letter from Mantegna pleading for financial assistance with his house in Mantua[94]—although assisting Mantegna in Mantua would seem an odd responsibility to have asked the leader of Florence to shoulder, even in part.

As leader of Florence, furthermore, this brilliant politician-poet-intellectual was demonstrably proud of Florence's great artists, and he clearly shared the general consciousness, so strongly articulated by Alberti and others before and after Alberti, that something enormously important had happened to the arts in Italy in general, and in Florence in particular. Lorenzo not only helped to put up the memorial to Giotto in Florence's Duomo, with its epitaph composed by Poliziano.[95] He further paid for the tomb for Filippo Lippi, erected in Spoleto Cathedral two decades after Fra Filippo's death, again with an epitaph by Poliziano.[96]

To be sure, one can fault Lorenzo the Magnificent as a talent spotter in a way that his contemporaries never did, because he did not offer commissions to the two greatest artists of his time. Certainly, he gave no commissions to Piero della Francesca or to Leonardo da Vinci, so far as is known today. Yet even as a discoverer of new talent, Lorenzo played a major role in the history of our art tradition, because of the crucial part he had in the early career of Michelangelo. The Lorenzo-Michelangelo story necessarily raises the vexed question of the Casino Mediceo, which Lorenzo arranged for his wife, Clarice Orsini, as a kind of urban *villeggiatura* quite separate from the Palazzo Medici.[97] The casino's main feature was a garden full of classical sculpture, and Vasari recorded that when Clarice de' Medici died in 1488, Lorenzo turned the place into an "academy" where young Florentine artists could get training under the supervision of Lorenzo's house sculptor, Bertoldo.[98] Some time ago, Vasari's whole story of this "academy," with its improbable list of artists trained there, was dismissed as another Vasarian exercise in Medici puffery, in this case motivated by a desire to see a new Florentine Academy established by his grand-ducal patron, with himself at the head.[99] And this is now an accepted opinion.

It certainly seems unlikely that there was any such formally organized academy as Vasari claimed. Yet the evidence of Michelangelo's authorized biographer, Ascanio Condivi, cannot be altogether dismissed, if only because he wrote under the Master's own eye. The evidence of Condivi is

that Lorenzo de' Medici first saw Michelangelo as a boy, copying classical sculpture in a Medici garden, where Michelangelo had been introduced by his older artist-friend Granacci. According to Condivi, Michelangelo actually abandoned his training in the Ghirlandaio shop because he had obtained the right of admission to this Medici garden full of classical sculpture.[100]

The garden in question, to which one must infer artists were regularly admitted, is certain to have been the casino garden rather than the garden of the palazzo itself, because it was "at San Marco" and was also being used, when Michelangelo began to frequent it, as something like a builders' yard since cut stonework was stored there for another structure[101]—which can hardly have happened in the palazzo garden. It does not seem at all far-fetched, either, to suppose Bertoldo was charged with authorizing artists to use the casino garden. After all, the gates cannot have been thrown open to anyone and everyone who cared to enter. If this was the way of it, furthermore, even this much more realistic reconstruction of the role of the casino does much credit to Lorenzo the Magnificent as a man, and further proves his constant and enlightened interest in art and artists.

Be that as it may, Condivi's story, undoubtedly based on the aged Michelangelo's memory of a major turning point in his boyhood, is that Lorenzo found the boy in the garden copying, and even improving on, a damaged antique statue of a faun. He was impressed by the boy's talent but pointed out that since the faun was old, it was unlifelike to show him with all his teeth. Michelangelo quickly made the faun gap-toothed. When Lorenzo came to visit the garden again, he was pleased by what the boy had done and decided to take him into his own house and provide him with a place at his famous table, where all men of talent were welcome without precedence of age or rank.[102]

This was such a turning point in Michelangelo's career in part because the Buonarroti were gentlefolk grown poor; and Michelangelo's shabby-genteel father had therefore been snobbishly objecting to a member of the family following a "mechanical" career.[103] The father's conversion was rapid, however, when the Magnificent in person intervened to defend Michelangelo's desire to be a sculptor and announced his wish to have the youth live in the Palazzo Medici.[104] Until the end of his long life the Master evidently remained deeply proud of the way he had been distinguished by Lorenzo, for all the foregoing details are lovingly dwelt upon by Condivi, including the fact, previously noted, that by being prompt for meals, the sixteen-year-old Michelangelo would often manage to sit next to the Magnificent himself.

In addition, Condivi recorded that Lorenzo liked to discuss things in his collection with his protégé—"jewels, carnelians, medals and other things of great price like to them."[105] It makes a moving picture—the

all-powerful leader of Florence and greatest art collector of the age taking pleasure in passing on his knowledge of antiquities to the boy destined to become one of the two or three truly titanic geniuses of Western art! And it is moving, too, that the aging titan remembered all of it in such affectionate detail.

Lorenzo as Collector

So we come at last to the central theme, Lorenzo de' Medici as an art collector. I would wager a large sum that if the needed evidence ever turns up, it will show Lorenzo was already collecting classical works of art before he was out of his teens. He was still in his very early twenties, although already the real ruler of Florence, at the time of his single greatest collector's coup. This happened immediately after the death of Pope Paul II in July 1471, when Lorenzo went to Rome as chief of the Florentine embassy to congratulate Paul II's successor, Pope Sixtus IV.[106]

Since this coup by Lorenzo the Magnificent was the acquisition of part of the dead Pope's art collection, the collection itself must first be introduced. In brief, we do not know just how or when Paul II began to collect classical works of art.[107] But the Pope built what is now the Palazzo Venezia when he was still a cardinal, and even then he already had what was quite certainly the largest collection of classical art anywhere in the world.[108] He was a Venetian, born Pietro Barbo; his uncle was Pope Eugenius IV; and after his uncle's death, he was the favorite of Pope Calixtus III. These useful connections obviously permitted him to build his huge palazzo and to amass his even huger collection. The surviving inventory of the collection was begun in 1457,[109] approximately seven years before Paul II was elevated to the Throne of St. Peter; yet the lists of small antique bronzes, carved gems, and the like already go on for page after page after page.

No larger sculpture is listed, perhaps for the same reason that no larger classical sculpture is listed in the Medici inventories—a question to be tackled later. But there are innumerable other rich things in the 1457 inventory, most notably great numbers of tapestries, embroideries, and grand hangings,[110] and many of the Byzantine miniature mosaics in costly settings,[111] which are most rare today but were probably easy to come by after the fall of Constantinople to the relentless armies of Mehmet the Conqueror.[112] In contrast, the paintings listed in the inventory are few and far between, with a minimum of identifiable works by Renaissance masters;[113] while the lists of jewels and jewelry are downright staggering. No wonder that when Paul II died, the people of Rome murmured that a demon he had exorcised from one of his countless rings had strangled him;[114] while the humanist Platina more reasonably held that he died of

74

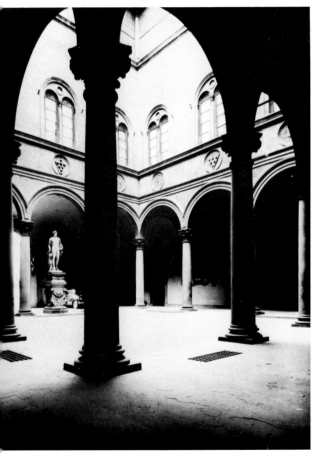

75

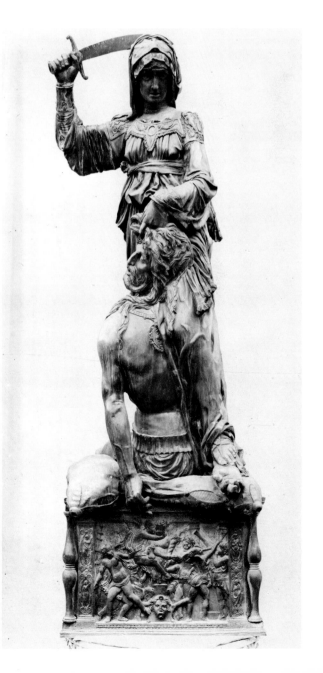

74. *Manner of Fiorentino:* Marsilio Ficino,
 Washington, D.C., National Gallery of Art,
 Samuel H. Kress Collection

75. Courtyard of the Palazzo Medici-Riccardi, *Florence*

76. *Donatello:* Judith and Holofernes, *Florence,*
 Palazzo Vecchio

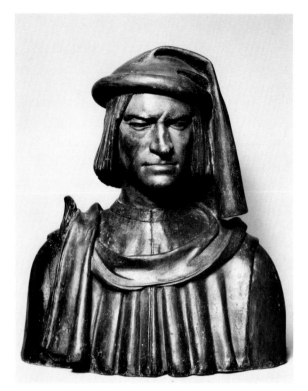

77

79

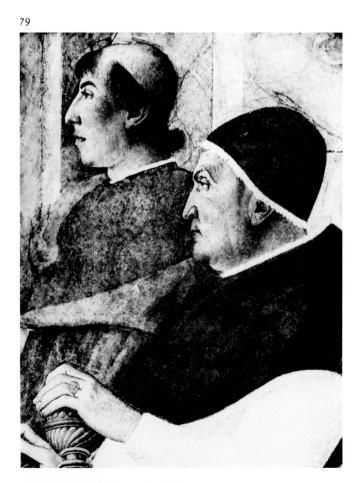

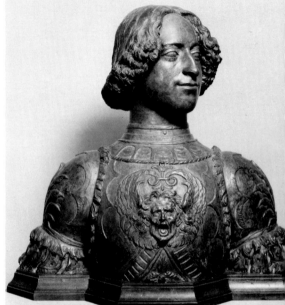

78

77. *Andrea del Verrocchio:* Lorenzo de' Medici,
Washington, D.C., National Gallery of Art,
Samuel H. Kress Collection

78. *Andrea del Verrocchio:* Giuliano de' Medici,
Washington, D.C., National Gallery of Art,
Samuel H. Kress Collection

79. *Melozza da Forli:* Head of Sixtus IV,
Rome, Vatican

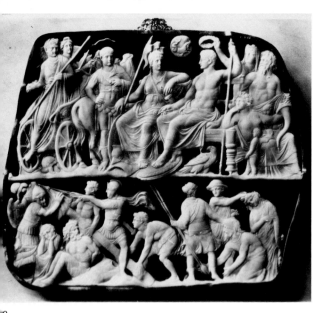

80. Gemma Augustea, *Vienna, Kunsthistorisches Museum*

81. *Fra Angelico and Fra Filippo Lippi:* The Adoration of the Magi, *Washington, D.C., National Gallery of Art, Samuel H. Kress Collection*

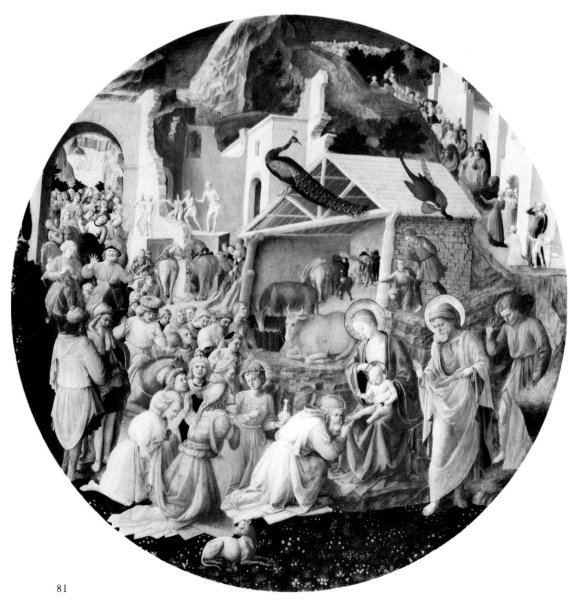

81

82

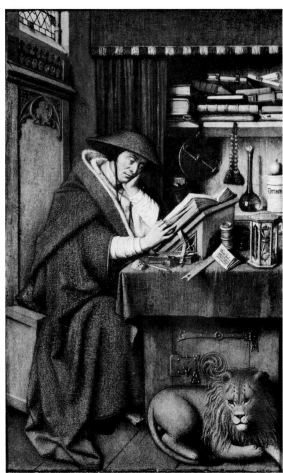

82. *Masaccio:* Birth Salver, the Confinement Room of
a Florentine Lady, *West Berlin, Staatliche Museum*

83. *Jan van Eyck:* St. Jerome in His Study, *City of
Detroit Appropriation, Detroit Institute of Arts*

83

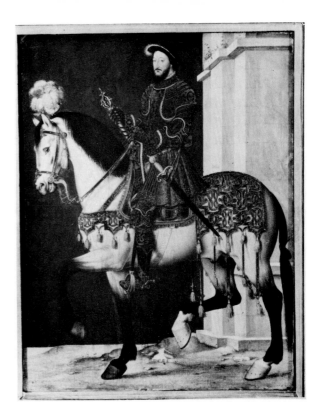

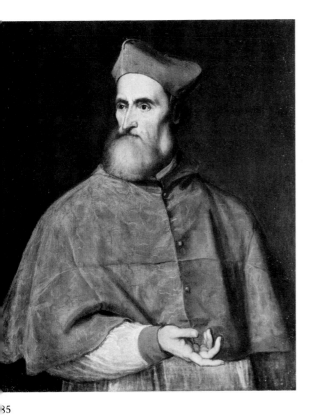

84. *Jean Clouet:* Francis I, *Paris, Louvre*

85. *Titian:* Cardinal Pietro Bembo, *Washington, D.C.,*
National Gallery of Art, Samuel H. Kress Collection

86. *Leone Leoni:* Emperor Charles V, *Washington, D.C.,*
National Gallery of Art, Samuel H. Kress Collection

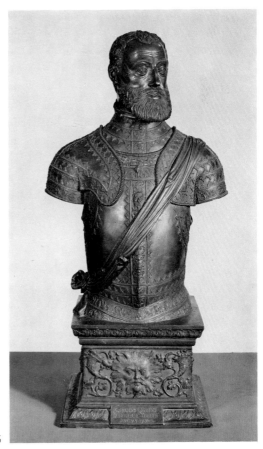

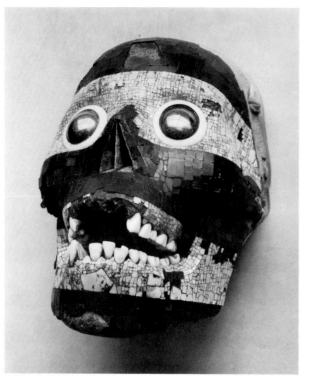

87

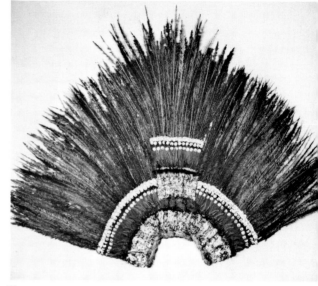

88

87. Aztec Mask, *London, British Museum*

88. Aztec Feather Crown, *Vienna, Museum of Ethnology*

89. *Raphael:* Pope Julius II, *London, National Gallery*

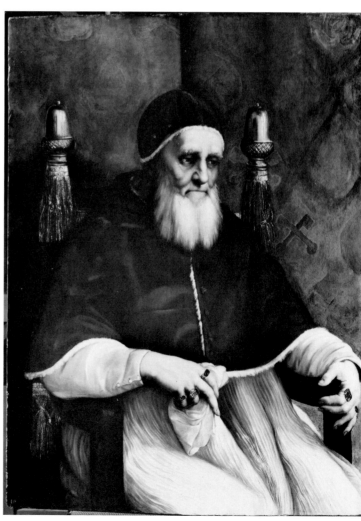

89

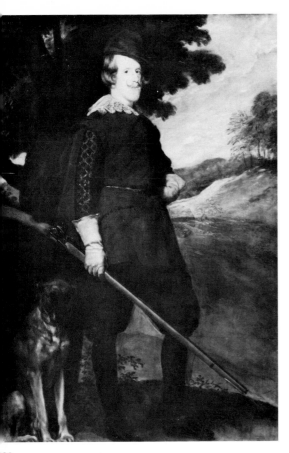

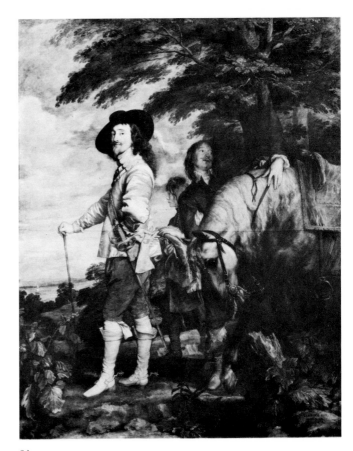

90 91

90. *Velázquez:* Philip IV in Hunting Costume, *Madrid, Prado*

91. *Van Dyck:* Charles I, *Paris, Louvre*

92. *Rembrandt:* Portrait of Baldassare Castiglione, *Vienna, Graphische Sammlung Albertina*

92

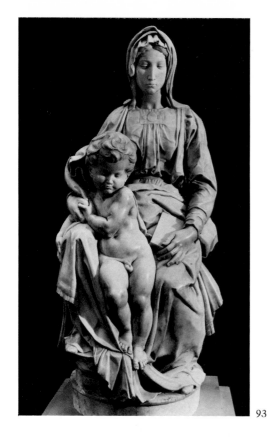
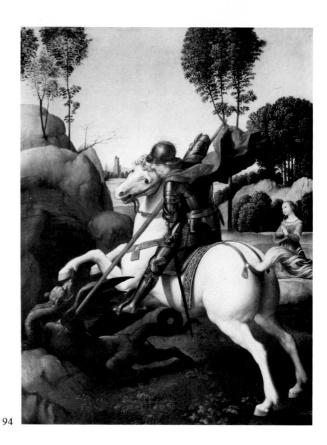

93 94

93. *Michelangelo:* The Bruges Madonna, *Bruges, Notre Dame*

94. *Raphael:* Saint George and the Dragon, *Washington, D.C, National Gallery of Art, Andrew W. Mellon Collection*

95. *Mantegna:* The Dead Christ, *Milan, Brera Museum*

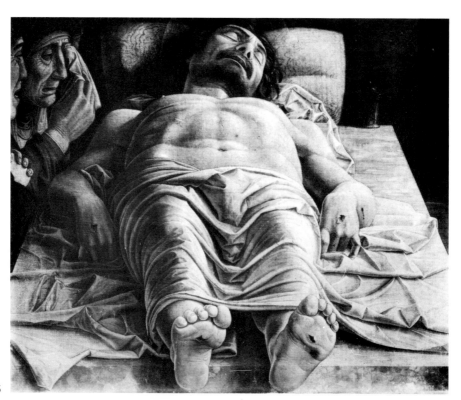

95

apoplexy brought on by the weight of gold and jewels in his papal tiara,[115] which was variously estimated as worth anything from 120,000 to 200,000 ducats.[116]

Even so, the 1457 inventory can hardly give more than a most incomplete idea of the possessions of this ecclesiastical collector at the time of his death, after he had controlled the revenues of the papacy for nearly seven years. In particular, no mention is made in the 1457 inventory of what were to be Paul II's two most celebrated possessions, our old friend Niccolò Niccoli's *calcedonio* and the really enormous Hellenistic double-sided cameo now known as the Tazza Farnese. The finest carved gem in Niccoli's collection was seen, in Chapter X, passing into the possession of the papal official Luigi Scarampi Mezzarota, later a cardinal. There is an old story that Cardinal Scarampi died of a seizure brought on by the choice of Cardinal Barbo to receive the tiara;[117] that Cardinal Scarampi's nephews and heirs tried to hurry his classical collection and other valuables secretly out of Rome; and that the new Pope pounced in time to take what he wanted.[118] But all this sounds very fishy. At any rate whether by act of power or by purchase, Paul II acquired the gem Niccoli had first discovered at some time after his collection was inventoried in 1457.

The history of the Tazza Farnese is even more curious. It is a very large piece of sardonyx, carved on one side with the mask of Medusa, and on the other side with a royal-mythological scene in a Nile setting. The work was most probably done in Alexandria in Ptolemaic times;[119] and one may guess that the big gem was lost and then dug up many centuries later in Egypt, perhaps under the Fatimids, and eventually went eastward in trade or as a present between rulers.

At any rate, it is pinpointed in the treasury of Timur the Lame or his heir by a miniature of it by Mohammed al-Khayyam,[120] which is too careful and accurate a depiction to leave any room for doubt. The date of this miniature is thought to be the early fifteenth century. How the gem then got to Rome is again open to speculation. It may have been presented as a state gift to a Western diplomat, like the Spaniard Ruy González de Clavijo.[121] Several Western envoys visited Timur and his heirs at their successive capitals, Samarkand and Herat. Or it may have been purchased from the Timurid treasury by one of the Italian merchants traveling the Middle East who knew Paul II was willing to pay almost any price for things of this sort and quality. In any case, it was in the papal collection when Paul II died at last, after spending so extravagantly on his jewels and his collectors' prizes that the papal cupboard was almost bare.

The new Pope, Sixtus IV, later sponsored the Pazzi conspiracy, which led to the assassination of Lorenzo de' Medici's younger brother, Giuliano,

and came close to costing Lorenzo his life as well.[122] But at this first meeting, in 1471, His homicidal Holiness evidently took to the young Florentine leader whom he later tried so hard to destroy. He not only restored the Medici bank to the important function of Depository General to the Holy See, which Paul II had given to a fellow Venetian;[123] he also used the bank to sell Paul II's immense stores of jewels in order to replenish the papal treasury—reportedly at a wonderful profit to the Medici.[124]

In addition, the new Pope let Lorenzo the Magnificent have what he wanted from Paul II's collection. Large acquisitions from the collection were also seemingly made by Cardinal Francesco Gonzaga, who had such a passion for carved gems that he had come to own about six hundred classical cameos and intaglios at the time of his death.[125] But Lorenzo was so pleased with his own acquisitions that his *ricordo* of his visit to Rome is solely concerned with the works of art which he brought back. The first to be mentioned were busts of the Emperor Augustus and his great minister, Agrippa. Next comes *"la Scudella nostra,"* in fact the Tazza Farnese, and oddly called a dish by Lorenzo, as it was later called a *tazza*, because of its size. Finally, Lorenzo noted that he had "bought" this great prize "along with a great many other cameos and medals,"[126] and above all *"il calcedonio."*

One can gauge the collecting climate in Italy in 1471 from the simple fact that the young leader of Florence and the Cardinal from Mantua were both so eager for substantial shares of the spoils of the dead Pope's collection. Later, Cardinal Gonzaga was to write to his father, the current ruler of Mantua, asking for a loan of Mantegna, another classical art collector, so that he might have the benefit of the painter's opinion on some of his recent acquisitions.[127] But it must be clearly noted that by 1471, the collecting climate revealed by the magnates' contest over the spoils of the just-dead Pope had already existed for a long time in Italy.

For example, Filarete wrote his treatise on an ideal city before the death of Cosimo Pater Patriae, and another remarkable passage in the treatise is an excited description of the Gemma Augustea.[128] Filarete wrongly believed that this great Imperial Roman gem came from the collection of Jean, Duc de Berry, most probably because this was the one French collection with a certain fame in Italy. Filarete only knew the Gemma Augustea at second hand, from a gesso mold; yet he praised it as "one of the finest things" he had ever seen "for the great skill shown in the figures engraved in it." Thus by the mid-fifteenth century, this gem still beyond the Alps in France had something of the kind of standing in Italy that a world-famous painting or piece of sculpture has today. Of course the fame of the Gemma Augustea did not extend beyond an Italian in-group; but such in-groups tell much about the movements of taste and changes in social habits.

As might be expected, collectors' competition for classical works of art also became fierce at least as early as the mid-fifteenth century. The best evidence is from a letter written to Florence from Rome by Cosimo de' Medici's illegitimate son, Carlo.[129] The letter first reports success in sending off statues—quite certainly antique—that had been gathered for Giovanni de' Medici by a certain Messer Bernardo. Then follows the surprising story of Pisanello's choice collection of medals, which Carlo de' Medici had managed to buy or get a promise of.

Unluckily, the Cardinal of St. Mark—in other words, the future Pope Paul II—was hot on the same trail; and he learned of Carlo's success with the medals. The Cardinal therefore intercepted Carlo de' Medici on the street; he positively dragged him into his own house; and he all but held him to ransom. "I could not get away," wrote Carlo de' Medici, "and . . . he took from me what I had in my purse, and between rings and seals he took the worth of 20 florins and refused to give it back." A more perfect example of collectors' frenzy than this overt pocket-picking by a future pope is hardly to be found in the records of collecting in the West. And Carlo de' Medici's letters from Rome also describe other classical finds such as two "almost undamaged" marble heads, and contain another bitter reference to the Cardinal of St. Mark's "greed" for "antique coins."[130]

The competition for classical works of art seems to have grown even more hot, too, during the years of Lorenzo the Magnificent's rule in Florence; but it was hardly collectors' competition of the modern sort, in auction rooms and art dealers' lairs. As already suggested, I think there continued to be dealers in classical works of art of the type of Poggio Bracciolini's shady correspondent, Fra Francesco da Pistoia—in fact, people who had a sideline of importing such things from the Eastern Mediterranean and the Middle East, to sell to Italian collectors like Pope Paul II. We know of no such traveling dealers in the later fifteenth century, nor do we know anything about how Paul II amassed his collection, but it is difficult to see how he could have gathered such amazing numbers of the kinds of objects he loved without the aid of people of this sort. The loot of Constantinople in his collection also tends to confirm this suspicion—but it is still only a suspicion. I have no doubt, too, that Rome in the fifteenth century had its low-level snappers-up of newly found coins, gems, and even pieces of sculpture, who would then resell for a quick profit in the way that was first solidly documented in the early sixteenth century.[131] But there were certainly no fifteenth-century dealers in a large way of business, nor were there art auctions of the type all too familiar today.

Probably no dealers of any importance developed so early because all the leading collectors of the last half of the fifteenth century were magnates of one sort or another, and the magnates had their own agents to serve

them. As has been seen, the Greek scholar John Lascaris got his living partly by searching for Greek and other classical codices for Lorenzo the Magnificent in the Eastern Mediterranean. It seems probable, however, that most of Lorenzo's agents were connected with the branches of the Medici bank. The whole staff of every branch of the bank must have known that nothing could delight the Magnificent more than a report of yet another classical work of art secured for his collection. Two such reports survive, both revealing ferocious competition between Lorenzo and other collectors. Perhaps the most striking was written in Rome in February 1488 by Luigi d'Andrea Lotti di Barberino:[132]

"It having come to the attention of S. Pietro ad Vincula [the Cardinal of the church of that name, Giuliano della Rovere, future Pope Julius II], that some beautiful things had been discovered in a monastery, he went there and ordered they should be given to no one and that they should stop digging, for he wanted what had been found, and he would take care of the digging. Nevertheless our Giovanni with a friend, worked things out in such a way that at night time he would have them dig; and he has found three beautiful little fauns on a marble base, all three encircled by a snake, all of which I found very beautiful, so true to life that they seemed to be shouting and defending themselves with wondrous gestures, and the one in the middle seemed to be on the point of falling and dying. These we have been promised and will cost 50 ducats; and the reason for the price is that he [Giovanni, no doubt] has to pay off his friend, so that he will not talk about it. When you shall see them you will not think the money ill spent. . . ."

Or, yet again, consider the almost equally feverish tone of the news from Ostia, sent to Lorenzo by Giovanni Antonio on August 1, 1488.[133] Antonio first announced that he had seen "many beautiful things, many marble statues and ancient tombs and in old buildings works done with small stones in the form of mosaic, and since those small bricks must have come from different soil and earth, they had different colors . . . some redder than others, also black and yellow and almost white so that the work turned out well and [was] very different and unusual." To this was added news of the archeologically fascinating discovery "in the foundation of the wall of the canal of Ostia" of a "ship nailed all over with copper nails." Antonio promised to send some of the nails along with "the head of a child" rounded up by the staff of the bank. And so he reached his grand climax, which was the further promise to send still another head to Lorenzo, "complete with nose and ears [that] I was personally able to *steal from the clutches* of Archbishop Niccolini." (Italics added.)

In view of the foregoing, it is not at all surprising that prices of classical works of art also rose steeply throughout the fifteenth century. Little is

known, unhappily, about prices paid for pieces of classical sculpture, at
least until the very end of the fifteenth century and the beginning of
the sixteenth. Logically, one must suppose that competition pressed prices
upward, while they were simultaneously depressed by the numbers of
finds being made. But it must be noted that a version of the fauns attacked
by a serpent survives and has been identified,[134] so it is certain Lorenzo's
clandestinely excavated prize from Rome was hardly more than a piece
of table sculpture in marble. For such a piece of small sculpture, the 50
florins paid to "our Giovanni" and his co-conspirator was no small sum;
and to this must be added the considerable cost of transporting so fragile
an object to Florence, plus any solatium offered to the monastery. This
was surely needed to console the monastery for having its garden treated
as a sculpture mine.

In the case of carved gems, meanwhile, the evidence for a steep price
rise is dramatic. It may be recalled that Niccolò Niccoli's *calcedonio* was
bought by him for 5 florins and sold to the future Cardinal Scarampo
for 200 florins. What price Paul II paid the Cardinal or his heirs—if he
did pay—is not known, nor is the price paid by Lorenzo the Magnificent
when he acquired it. But in the posthumous inventory of Lorenzo's posses-
sions, the *calcedonio* is down for 1,500 florins![135] Hence this gem was
now worth three hundred times what Niccoli had paid for it, and seven
and a half times what Cardinal Scarampo had paid Niccoli. These astonish-
ing facts are also partly paralleled by the rise in value of a cameo carved
with Daedalus and Icarus, from 100 ducats in one of Piero de' Medici's
inventories[136] to 400 florins in Lorenzo's posthumous inventory.[137]

The Great Inventory

With this crass discussion of the usual effects of fierce competition
on the collector's market, and the still more crass mentions of actual
prices, we are now approaching the heart of the matter. Once art collecting
has begun, deplorable as this may seem, current prices always tell the
story of the current state of taste. So the reader must be prepared for
the fact that price differentials among different kinds of works of art offer
the truly decisive proof of what I have called the great surprise of the
fifteenth century.

Nor is this all. The price differentials in question are of a character
that may profoundly shock the reader, as they have been shocking count-
less art historians since they first became known to scholarship. So a re-
minder is in order, that the history of taste always demands the sternest
neutrality. No one on earth can define good taste or bad taste in a way
that will be valid and durable, even for so short a period as two generations.
There is only the good taste of a particular time and place, which may

be described as the taste of those men with the best minds and eyes who have cared much about art in that time and place. It must be faced squarely, too, that you would have found no one in the fifteenth century, from the young Michelangelo to the humanist intellectuals who frequented the Palazzo Medici, from Cardinal Caraffa in Rome and Naples to the tough Ludovico Sforza in Milan, to deny that the taste of Lorenzo the Magnificent was the very grandest expression of the high taste of his own time.

Savonarola would probably have given a different verdict, but then he heartily disliked and loudly denounced the whole art of the Renaissance, at any rate in its secular and more aggressively classicizing aspects. So it is necessary to choose in advance between Savonarola and the rest, in order to prepare for detailed examination of the great inventory of the contents of Lorenzo the Magnificent's town palace and country villas.

This inventory was painstakingly made after Lorenzo died in his early forties, and it incorporates far more detail than is found in any other surviving fifteenth-century inventory. It is the most important single document bearing on the character of Florentine high taste in the later fifteenth century; so it is worth spending some time on its character and peculiarities before coming to the key point the inventory makes. I have given long study to this large document of many pages, first in the edited form published by Eugène Müntz, and then in the complete transcription possessed by the Warburg Institute[138] (of which another example is in the Kunsthistorisches Institut in Florence). For what little my opinion may be worth, I have thus reached some conclusions about how the inventory was made; and although I have no proof except from the inventory itself, I shall first set these conclusions down.

To begin with, a notary must have been involved somehow, for at that time estate inventories were made by notaries. But it stands to reason that the notary chosen was one closely linked to the Medici bank, which must have needed notarial services frequently. Furthermore, the massive inventory itself, astonishingly complete and detailed for that period, strongly suggests that the detailed donkeywork needed for the inventory was done by members of the bank's staff, no doubt under the direction of the notary chosen for the purpose. The fullness and clerical precision of detail; the care of measurement where measurement was desirable; the systematic way the Palazzo Medici was covered, room by room and from floor to ceiling, including many things that were contained in cupboards, drawers, and chests—all these features bespeak trained members of the bank's staff rather than a notary working without this sort of special assistance. Members of the bank's staff will have had no trouble, either, putting valuations on the great numbers of barrels of wine and casks of olive oil, and the supplies of other commodities that were stored in the palazzo

and the villas; nor will they have been puzzled about how to value jewels and plate, or clothes and linen, or other things with a well-established market value.

For the classical works of art, I suspect they had notes made by Lorenzo himself, of the kind that collectors so often make about their prizes. For the Renaissance works of art, I am also pretty sure the inventory makers lifted their valuations straight from the payment records of the Medici bank. This conviction of mine, already voiced, admittedly cannot be proved. For art historians, my conviction also creates certain difficulties. For instance, most critics believe that it was Fra Filippo Lippi who was mainly responsible for the tondo of the Adoration of the Magi, now in our National Gallery.[139] Yet the inventory makers gave the painting to Fra Angelico alone. Perhaps the original contract was signed with Fra Angelico at the end of his life, who then left Fra Filippo to finish almost the entire job, and the inventory makers, with the contract before them, went no further than this evidence. At any rate, use of the Medici bank's records by the inventory makers is the only solution I can think of which fits with two peculiar features of the great inventory in need of some explanation: the relative comprehensiveness of the valuations, and the large numbers of Renaissance works of art specifically attributed to named masters. Use of the bank's payment records would explain both features, which are most exceptional in inventories of that time.

To this I must add that the bank's payment records may sometimes have misled the inventory makers, and this just possibly helps to explain certain anomalies, like the attribution to Fra Angelico mentioned above. To be specific, one source of confusion to the inventory makers may have been the activities of Bartolomeo di Paolo Serragli, whose enlightening personal papers were discovered by Gino Corti and published by him and Frederick Hartt.[140] Serragli was not an art dealer in our sense of the phrase, but he was a busy commission agent often dealing with artists for wealthy patrons. In that capacity, he was much employed by the Medici of the generation of Piero the Gouty. The Medici used him to transact business with their chosen artists—including making interim payments to them— and also to hunt down classical works of art for their collections.

Besides the Messer Bernardo who sought classical sculpture in Rome for Piero the Gouty's brother, Giovanni, Bartolomeo Serragli for a time carried on the same Roman hunt for statues for Giovanni.[141] For Giovanni's study, too, Serragli seems to have arranged for a set of marble reliefs, probably of the twelve Caesars, which were to be taken from antique coins; and one of these is thought to exist today—the relief of Julius Caesar by Desiderio da Settignano, now in the Louvre.[142] Then Serragli also paid the large sum of 100 florins to Donatello in October 1456. Professors Hartt and Corti argue cogently that this payment was to meet the

cost of the bronze in some major piece of sculpture, and they show further that the piece of sculpture in question may be identified, by the date and the weight of the metal, with the Judith with the Head of Holofernes which Donatello made for the Medici.[143]

All Serragli's transactions with artists are of the greatest interest; but the reason for bringing in Serragli in connection with Lorenzo the Magnificent's inventory is simply that payments to Serragli may so easily have appeared in the Medici bank's payment records without any supporting data. Thus the inventory makers may not have known they needed to add payments to Serragli to the amounts paid directly to Desiderio, Donatello, and the other artists he dealt with on behalf of the Medici. After all, Serragli had been active over a generation before the death of Lorenzo the Magnificent; so it would be only natural for the inventory makers, even if members of the staff of the bank using the bank's records, to have no memory or understanding of the commission agent's real role. Antonio Pollaiuolo is not recorded as having had dealings with Serragli. Yet some comparable quirks in the records of Medici purchases and commissions of nearly forty years earlier may also have misled the inventory makers about the right value to put on the huge Pollaiuolos in the Sala Grande.

Some Facets of the Inventory

The foregoing is all speculative, although I believe the speculations are not ill-founded. There is nothing speculative, in contrast, about the striking omissions from the inventory. By far the most important omission is large sculpture. Neither in the Palazzo Medici nor in the country villas is there any mention of any piece of sculpture beyond the level of table sculpture, reliefs used as overdoors, and suchlike.[144] There is no doubt, moreover, that Lorenzo the Magnificent owned much large sculpture when he died. The presence of Donatello's Judith in the garden of the Palazzo and the David in the courtyard is plainly documented at the time of the expulsion of the Medici from Florence in 1494.[145]

There is documentation, too, for the fact that in 1499 the post-Medicean Signory of Florence sent classical sculpture from the Medici collection as a goodwill present to one of the more dangerous French military leaders by then infesting unhappy Italy.[146] We have seen the ample evidence that Lorenzo, his uncle Giovanni, if not his father Piero, and his grandfather Cosimo, were all ardent collectors of classical sculpture. There is also a letter from Lorenzo to his son, the younger Piero, instructing him to show an important visitor the "anticaglie" in the garden as well as the palazzo.[147] Antiques in the garden can only have been pieces of sculpture. Indeed, I believe that Lorenzo had another motive for arranging the casino and its garden for Clarice de' Medici besides the wish to make his wife happy.

I fear he chiefly wanted another convenient and suitable garden in which to show the Medici collection of classical sculpture, which had probably grown much too big to be shown *in toto* and to advantage in the palazzo garden. It is the nature of all collectors often to please themselves under the guise of pleasing others, including wives.

There is nothing surprising in the omission from the great inventory of all frescoes, wherever they might be, including Benozzo Gozzoli's splendid decoration of the palazzo chapel. Frescoes, after all, were irremovable in the fifteenth century, and so were never inventoried, as already noted. Sculpture, on the other hand, is entirely removable, even if large. By the time Lorenzo the Magnificent died, the better-known and more intact pieces in the Medici collection of classical sculpture must also have been worth substantial amounts of money. The sculpture was not shown indoors, however, as one can tell from the posthumous inventory. This includes only a few pieces of identifiably ancient sculpture in all the object-jammed rooms, such as a small bronze Hercules "missing a leg,"[148] and an overdoor relief in marble with "antique figures."[149]

Thus the only solution I can see to this puzzle is, quite simply, that the inventory makers never put a foot outdoors with their lists and their pens. This way of confining inventories to the actual contents of dwellings would also explain the omission of any classical sculpture from the 1457 inventory of Pope Paul II's possessions—an omission that greatly troubled Eugène Müntz.[150] And it would again explain the omission of classical sculpture from the two inventories of Piero de' Medici the Gouty, who must have owned much classical sculpture after the deaths of his brother and his father, even if he did not himself share his father's and brother's liking for ancient statues—which seems improbable in any case.

Finally, note must be taken of another omission from the great inventory that is quite different in character. In brief, Piero de' Medici the Gouty's last inventory shows that shortly before his death in 1469, he owned jeweled collars, brooches, unset pearls, rings set with precious stones, and even earrings, to a value of 17,689 florins.[151] The pearls alone, thousands of them apparently loose, were worth 3,412 florins;[152] the grandest jewel was a *"fermaglio da spalla"* or shoulder brooch of gold set with rubies and pearls, at 5,000 florins;[153] and the total worth of all this jewelry was enough to make any Florentine a notably rich man overnight. As has been noted, Piero the Gouty also owned a hundred gold "medals" and 503 silver "medals" just before he died; and all of the jewels and medals must have come into the possession of Lorenzo the Magnificent, either by inheritance from his father or from his brother, Giuliano, who had no legitimate heirs when he was murdered. The contrast is therefore striking between the last inventory to Piero the Gouty and the posthumous inventory of his son Lorenzo.

The posthumous inventory shows that Lorenzo still had two pieces

of jewelry of the sort called "important" in modern auction catalogues. One was a pendant set with a diamond and a single, perfectly colored, pear-shaped pearl of thirty-eight carats weight, valued at 3,000 florins, and the other was a large brooch centering on a big balas ruby, with two grand pearls and a diamond in the setting, put down for 2,200 florins.[154] His other jewels brought the total for jewelry up to 13,125½ florins.[155] But in those days, men in important positions wore much jewelry on state occasions; and this was hardly more than would have permitted the leader of Florence to make a respectably grand appearance when show was called for. So what had happened to the rest of the Medici jewels which Lorenzo is likely to have augmented when he was still a young man? Again, Lorenzo had indisputably much increased his father's collection of medals and coins in precious metals during the early years of his life. "Medals" are specified among his spoils from the collection of Pope Paul II, and it would have been against nature for Lorenzo the Magnificent to ignore such established collectors' categories as long as he could afford anything he liked. Yet when he died, only one gold medal, bearing the image of Cosimo, was listed in the inventory.[156] So what, once again, had happened to so many gold coins and medals?

The answer, beyond serious doubt, is to be found in Raymond de Roover's study of the rise and decline of the Medici bank. The somber times that had begun with the death of Cosimo in 1464 took a sharp turn for the worse with the Pazzi conspiracy of 1478, after which the fury of Pope Sixtus IV—he seems to have blamed Lorenzo the Magnificent bitterly for *not* having been assassinated—placed both Lorenzo and the bank almost under siege,[157] while Florence was in constant danger of armed attack by large armies. Furthermore, when Lorenzo almost literally put his head in the lion's mouth by going alone and unarmed to Naples to persuade the ferocious Ferrante of Aragon to make peace in 1481, the bank's troubles were not over. One of Lorenzo's weaknesses as a banker was inadequate supervision of the men in charge of the bank's important branches; and heavy losses were thus incurred, especially by the bad judgment and dubious practices of Tommaso Portinari, the donor of the great Portinari altarpiece, who was head of the Bruges branch. According to Raymond de Roover, the Medici bank supplied the Bruges branch with advances and commodities worth in all over the years no less than 88,024 ducats, and got back only wool with the value of 12,500 ducats.[158]

"These," remarked Lorenzo in a memorandum written when he belatedly realized what had been going on, "are the great profits which are accruing to us through the management of Tommaso Portinari."[159]

In Lorenzo the Magnificent's last years, the affairs of the bank had fallen into such a sorry state that two and one-half years after his death, when the Medici were expelled from Florence, it was "on the brink of

bankruptcy."[160] The bank's perilous situation, as I believe, explains Lorenzo's inability to get his hands on the enormous collection of carved gems left by Cardinal Francesco Gonzaga, which had been pawned with the Medici bank's Roman branch after the Cardinal died with debts amounting to 14,000 ducats.[161] The Roman manager, Giovanni Tornabuoni, was not on the best of terms with Lorenzo; yet the bank's weakness must have been the excuse he offered for not sending the gems to Florence as Lorenzo desired. For the same reason, I suggest that a great many jewels, all the gold coins, and many silver coins and medals in the palazzo collections were either pledged to the bank, to shore up its liquidity, or else just sold for what they would bring to restore the bank's capital position.[162]

So we come at last to the extraordinary price differentials in the great inventory here under study, which are the final proof that only classical works of art were truly collected in the fifteenth century, while Renaissance works of art were never collectors' prizes in that period. The first man to study the Medici inventories closely was Eugène Müntz, any one of whose publications of new documents would make a modern scholar's reputation. Normally, Müntz was a perceptive man as well as an almost incredibly industrious researcher. Yet as final introduction to the main point of this chapter, I must record my opinion that Müntz had no grounds for dismissing the makers of the posthumous inventory as a set of blockheads.[163]

On the contrary, the inventory makers were not only remarkably painstaking, eager to omit no possible detail, and exceptionally complete as to attributions and valuations. In addition, they had the good sense to invent no attribution if they did not know of one, so that many works of art in the inventory are unattributed; and they were again careful to put down no valuation that was beyond their competence. Thus Lorenzo the Magnificent, while sacrificing all but one of his gold coins and medals and most of his silver ones, had kept the antique coins in bronze because these had a low money value and were of interest only to students and connoisseurs like himself. In consequence, the quantity of bronze coins and medals presented a grave problem to the inventory makers. They counted them carefully—all 1,844 of them. But they could not estimate the worth of these things, so they just wrote *"1844 medaglie di bronzo,"* without giving an estimate of value.[164]

The Price Contrasts

With this last comment on the work of the inventory makers out of the way, we may now get down to the price differentials. The country villas contained few works of art except pieces of sculpture like Verrocchio's Boy with a Dolphin at Careggi;[165] but we do not know how the

Boy with a Dolphin was valued because it was large and therefore out of doors. Frescoes, too, were never inventoried. The only really notable panel painting in a villa was an Entombment, which could well have been done by Rogier van der Weyden, in the chapel at Careggi. This was not estimated.[166] Hence we shall consider hereafter only the fabulous—for once the tired old adjective is literally justified—contents of the Medici palazzo on the Via Larga.

First, it may be well to lump the innumerable things the palazzo contained into categories, and to show the relationships between the categories. I shall omit the large stores of commodities like wine and oil, and begin with all the attributed Renaissance works of art with valuations. These add up to a total of 968 florins[167]—but this sum is then almost doubled when unattributed works of art are included. These, in general, are put down for low prices if valued at all, but there are a good many of them. As indicated previously, the articles of clothing of many kinds add up to almost 3,700 florins. The household furniture, table and other linen, and the tapestries come to more than 10,500 florins altogether. Then the palazzo's countless contemporary treasures of plate and the like, the many rich pieces of armor, and the nonclassical collectors' prizes not of Renaissance origin, such as the Byzantine miniature mosaics that Lorenzo probably secured from Pope Paul II's collection, have an overall valuation of close to 20,000 florins, including what was left of the Medici jewels. Finally, the single class of classical collectors' prizes, mainly carved gems and classical and pastiche-classical vessels and the like in hard stones, have a total value of no less than 36,422 florins.

In sum, the contrasts of value between the different categories of the contents of the Palazzo Medici are fairly eye-opening. Here was a great house literally stuffed with the products of the private patronage of three generations of the richest and most active patrons of the arts in fifteenth-century Florence. Yet the Renaissance works by identified masters, numerous and conspicuous as they were throughout the palazzo, constitute the category with by far the lowest total value in the inventory. It is still more eye-opening, however, to turn to the valuations of individual works of art, Renaissance and classical, and thus to see the price differentials in more detail.

Taking some examples at random, two Masaccio panels of St. Peter and St. Paul are jointly valued at 12 florins;[168] and a *desco da parto* or birth salver painted by Masaccio is down for only 2 florins.[169] The two Giottos previously mentioned are inventoried as a small Crucifixion, at 6 florins, and a Deposition, at 10 florins.[170] The most highly valued Donatello is a marble bas-relief of St. John the Baptist (evidently a scenic relief, for it is carefully listed as having many figures and "with perspective") at 30 florins.[171] (Note that this most highly valued Donatello was worth

only 60 percent of the cost of the Fauns and Serpents Lorenzo got from home.) Another Donatello, a Virgin and Child in gilt bronze, is down for 25 florins.[172] Among the works of named masters, a marble head by Desiderio da Settignano takes bottom place after Masaccio's *desco da parto*, at 3 florins.[173] A portrait by Pollaiuolo of "Duca Ghaleazo" (surely Sforza) is estimated at 10 florins.[174] An Andrea del Castagno ("Andreino") of St. John, used as an overdoor decoration, is valued—with its gilt framing— at 15 florins.[175] A value of 10 florins is given to one of the two Botticellis listed with an attribution,[176] and the other, used to ornament a bed, is listed without a valuation.[177] But considerable numbers of pictures are left anonymous, and these may perhaps have included other Botticellis.

The Fra Angelicos, of which Lorenzo owned six,[178] range upward from 5 florins[179] to 100 florins[180] (the highest listed price for any fifteenth-century painting) for our National Gallery's big tondo of the Adoration of the Magi, with its many figures and its problem of attribution already discussed. Even the paintings from the Low Countries, then exotic imports into Florence, were valued in the same way. This is especially interesting, since some of these Low Country pictures, instead of being displayed like pictures, appear to have been stored among the gems and other treasures— no doubt because they were small in size as well as minutely painted, and would therefore be brought out for special inspection, as the carved gems surely were. Thus we find Lorenzo de' Medici's Van Eyck;[181] a *"tavoletta"* by Petrus Christus of a "French lady";[182] and another *"tavoletta"* depicting Judith and Holofernes by Mantegna's teacher, Squarcione,[183] in the middle of a bewildering list of jewels, costly rosaries, Byzantine mosaics, precious vessels of small size, ivories of various types, and also medals, all in the *"schrittoio"* of Lorenzo. The Van Eyck even had *"una guaina"*—some sort of slipcover—so that it can only have been shown when uncovered for that purpose.

The Squarcione is given a valuation of 25 florins; the "Pietro Cresti da Bruggia" is valued at 40 florins. And a valuation of 30 florins is put down for the *"tavoletta"* by "Giovanni di Bruggia," as Van Eyck was then known in Italy.[184] Uccello's three great panels of the Rout of San Romano, together with two other Uccellos and an undescribed work by Pesellino, already noted, are all put down together in one lot, no doubt because they all decorated the same room, at 300 florins for the six.[185] The three Pollaiuolos in the Sala Grande, at 20 florins apiece, have been discussed already.

Thus the majority of the Renaissance pictures and pieces of sculpture are valued for far less, individually, than the best of the tapestries and embroidered hangings, of which Lorenzo de' Medici owned large numbers. By way of comparison, a large tapestry showing "a hunt of the Duke of Burgundy" is estimated at 100 florins,[186] on a par with the Fra Angelico

tondo; and a smaller tapestry "with figures in a tournament" is valued at 50 florins,[187] on a par with one of the Uccello panels of the Rout of San Romano. A set of hangings on the theme of Petrarch's Triumphs, of large area to be sure (and pretty surely the same set Giovanni de' Medici ordered in Bruges in the late 1450s)[188] is also valued at 220 florins, or only 80 florins less than a Pesellino and five Uccellos, including Uccello's San Romano panels, and although these paintings with their framing pilasters must have covered a space that measured, longitudinally, close to eighty feet.[189]

Furthermore, the prime prizes of Lorenzo's collection were not the wonderful works of art that Florence was then producing in such incomparable profusion. They were instead objects that evidently seemed to Lorenzo far more rich or rare—unless, to be sure, he was cruelly misrepresented by his inventory makers. The outstanding rarity is a richly mounted unicorn's horn (almost certainly a narwhal's tusk), which was valued at 6,000 florins.[190] Meanwhile, as the lists of values by categories indicate, the largest part of the inventory's summary of Lorenzo's collecting-investment was represented by things of the kind we have already found Cosimo and Piero collecting—many scores of gems, mainly antique; the depleted coins and medals, again mainly antique; and large numbers of the costly vessels and objects in hard stones, both antique and pseudo-antique, most often provided with mountings in precious metal, and sometimes with added gems. The prices of these things, where given, contrast quite staggeringly with the 12-florin Masaccios and the 10-florin Botticelli.

The larger gold or silver or silver-gilt mounted vessels of hard stones range from 500 to 2,000 florins apiece.[191] The "seal of Nero" which Ghiberti mounted as a ring and another "carnelian mounted in gold" showing Phaëthon in his chariot are down for 1,000 florins each.[192] A sardonyx wine jug, mounted in silver gilt, is down for 2,000 florins;[193] so is a jasper "rinfreschatoio," also mounted in vermeil;[194] and so, too, is another old friend from an earlier chapter, the Hohenstaufen pastiche which the Medici inventory makers called "l'Archa."[195] Finally, there is the Tazza Farnese, that very large and medium-hideous antique cameo of sardonyx, already discussed, which is valued at no less than 10,000 florins![196] It is wrongly inventoried as being composed of agate and chalcedony as well as sardonyx—understandable in view of the strongly contrasting colors of the stone—but the identification is sure, since the inventory describes the head of Medusa carved on one side of the Tazza.

Some Conclusions

Now that the price-differential cat is out of the bag, so to say, there are several further things that need saying. In justice to Lorenzo the Magnif-

icent, to begin with, it must be remarked that the inventory of the Palazzo Medici on the Via Larga markedly distorts the picture of Lorenzo's patronage of the arts, because so many of the Renaissance paintings and pieces of sculpture date from before his time. As proved by his already described commissions for frescoes at Poggio a Caiano and Lo Spedaletto, Lorenzo was the patron of the very best painters of his own time—with the two rather glaring exceptions of Piero della Francesca and Leonardo da Vinci. But in reality, his patronage of contemporary painters only had free rein in the country villas; for the town palace was already so crammed with the fruits of the patronage of his father Piero, his uncle Giovanni, and his grandfather Cosimo, that there was no space in the palazzo for major new paintings by contemporary artists. Imagine trying to fit a couple of large new Botticellis into the Sala Grande with its three Pollaiuolos, each covering nearly 130 square feet! If Lorenzo had commissioned Botticelli's Primavera and Birth of Venus, this fact alone would have caused him to be remembered as a most lavish and discriminating patron. But of course he did nothing of the sort, for he had nowhere to put such pictures.[197]

The truth is that Lorenzo could not possibly have attempted such new introductions in the Palazzo Medici without putting into store works of art his father and grandfather had commissioned. He is known to have revered them both, and he quite clearly respected too greatly what they had chosen to remove their choices from the sight of all. The result was the previously touched-on accumulation, without weeding, of the fruits of three generations of Medici patronage.

Secondly, it is worth noting that this most superb of all the palaces in Italy in the fifteenth century would have put any modern decorator to bed with severe indigestion. To be sure, the seating and tables were sparse, even Spartan, by modern standards of comfort. In the reception rooms, most seating was apparently on built-in benches along the walls. Tables for meals are likely to have been trestle tables, brought from storage as needed when meals were being prepared, and those at table probably sat on stools, with few exceptions. The beds were the main touches of what would now be called luxury and comfort in furniture. Nonetheless, the greater rooms must have been rich in themselves, with their parcel-guilded ceilings, their inlaid or finely tiled floors, and their woodwork and benches all decorated with intarsia. Furthermore, the eye of the visitor to the Palazzo Medici would have been assaulted by a multitude of beautiful, wonderful, and costly things of every variety, either in cases or hanging on the walls. As one scholar rather sadly pointed out, the inventory shows that the rooms of the palazzo were not arranged like "modern galleries"[198] although everything it contained of a nonutilitarian nature and many of its more utilitarian contents as well would now be given museum entombment without an instant's delay, and amid many scholars' and art lovers'

prayers of thanksgiving for their rediscovery. Instead, the arrangement, while rich, was rather homely in a certain way.

The two Masaccio panels of Sts. Peter and Paul hung over the fireplace in the "chamber" of the big room above the loggia, probably where Cosimo had first put them many decades earlier. The main painted decorations of Lorenzo the Magnificent's bedroom had also been contrived by his grandfather, and Lorenzo may well have told himself tales about Uccello's fantastically costumed cavaliers on their ramping horses when he was uncomfortably wakeful as a boy. The Botticelli inventoried without a valuation is described without comment as the *"sopracielo"* of the bed of Lorenzo's son, the arrogant and ill-judging Piero.[199] (Hence this Botticelli does not appear in Müntz's *Collections des Médicis au XVe siècle;* for Müntz left all furniture out of his published inventories. Perhaps for that reason, the picture has never been discussed by any scholar, as far as I can discover, except for Herbert Horne and, recently, R. W. Lightbown.[200]) But it is needless to go further, except to sum up by saying that the great inventory gives an extraordinary picture of life in the Palazzo Medici in Lorenzo's time, with the oil and wine and cheese and the like coming in from the farms every year to fill the cellars and storerooms, with splendor unimaginable shining everywhere in the grand rooms, and with Lorenzo and his humanist and other friends amid all this splendor, living the easy yet far from soft, genial yet politically and intellectually serious kind of life that is so well documented.

Meanwhile, the main point is that the enormous contrasts of value in the great inventory leave no room for further doubt that Renaissance works of art were never collected in the fifteenth century, whereas classical works of art were eagerly and competitively collected. The true story is always told, alas, by prevailing values, and where the values speak, one cannot argue. As I have said, I am convinced myself that the valuations of the attributed fifteenth-century works of art in the inventory were lifted straight out of the payment records of the Medici bank, and in this sense, they were real values. Yet I even question whether these works had quite this much real value, in the sense of resale value on the open market at the time the inventory makers went to work.

As far as one can tell from the imperfect record, rich people did not yet go in for buying Renaissance paintings and pieces of sculpture at second hand, except perhaps when they could be reused for devotional purposes. Although patrons abounded in the fifteenth century, moreover, the competition for leading artists' services had not yet really begun to drive up artists' fees, in the way that began to happen rather early in the sixteenth century. Meanwhile, just about every Italian magnate with pretensions to high taste—and that meant most of them—was a more or less eager collector of classical works of art by the end of the fifteenth century.

Competition among collectors was fierce, as has been shown. The values had risen enormously because of this competition, as has also been shown. And so you find the contrasts of value in the great inventory here analyzed that have upset generations of art historians, who would cheerfully give a series of objects like the Tazza Farnese for just one of the large Medici Pollaiuolos or, indeed, just one of the 12-florin Masaccios.

This interpretation of the inventory of the possessions of Lorenzo the Magnificent is confirmed by much evidence. To begin with, there are Lorenzo's letters to his two sons. When he wrote young Piero about doing the honors of the palazzo for an important visitor who turned up in his own absence, he did not urge his son to show the visitors the fruits of Medici patronage for three generations—although these were very wonderful. As already noted, the *"anticaglie"* in the palazzo and the garden were what he instructed Piero to show.[201] Again, when his son Giovanni was going off to Rome as a Cardinal at only fifteen, he wrote the boy an enchanting letter of advice.[202] Most of it is about the conduct suitable to a boy-cardinal—about being pleasant and approachable rather than haughty and grand, about remembering his age instead of his rank when he addressed others, about avoiding excessive luxury and display, and so on. But when it came to art, Lorenzo said nothing about commissioning contemporary works of art, which one supposes he rightly took for granted his son would do. Instead, he urged the boy to begin collecting antique works of art, on the ground that this was a desirable thing to do and would make a good impression.

There is ample documentation, too, for the fact that although Lorenzo the Magnificent was a major patron of the arts, whose advice on art and artists was always in wide demand, he was primarily seen by his contemporaries as a great classical collector. Galeazzo Sforza remarked, humbly and (one suspects) just a mite enviously, that Lorenzo had amassed "the most noble objects from the entire universe."[203] That last phrase plainly means Sforza was not thinking, here, about the wealth of Italian paintings and sculpture that Lorenzo possessed. Those who had to give presents to Lorenzo frequently chose an antique, which they could be sure would please him.[204] Then, too, a Greek manuscript purchased for Lorenzo by John Lascaris, now in the British Museum, has an appended verse epigram which is quite specific: "Whatever is carved in silver or in tawny gold we have seen, Lorenzo, in your palace. Whatever the skilled hands of Praxiteles, Phoenix, Aristo and Myron could represent; whatever Cunachus, or Mentor, Mythias, both the Polycles, Lysippus and Callimachus gave [to mankind] you collected, with admirable love of *virtù*."[205]

The same strong emphasis on classical works of art appears in an account of the pillage of the Medici Palace two years after Lorenzo' death, when the hellfire preaching of Savonarola, and the dread invasion of Italy by

the French army of Charles VIII, had combined to cause the first expulsion
of the Medici from Florence. This great turnabout in human affairs, in
1494, caused to be "put up for sale . . . besides the house furnishings
. . . statues of ancient workmanship, chased metal, gems and various stones
distinguished by remarkable carving from the hands of ancient workmen,
murrhine vases, coins in gold, bronze and silver on which the likenesses
of famous commanders were to be seen—all collected by long and learned
study, in years of peace."[206] This is another reason it seems clear that
Galeazzo Sforza chiefly had in mind the classical art collection when he
said Lorenzo had amassed "the most noble objects from the entire uni-
verse."

Finally, if any further proof is needed that a contemporary reality is
reflected by the contrasting values in Lorenzo's posthumous inventory,
then that proof is easily available in the story of the youthful Michelange-
lo's fake antique. By the time Michelangelo made this statue of a Sleeping
Cupid or putto, he was a beginning sculptor just setting up on his own.
His first patron, Lorenzo the Magnificent, was dead some years, and the
Medici of the line of Cosimo had been barred from Florence. Lorenzo di
Pierfrancesco de' Medici was still in the city, however, loudly professing
his allegiance to the new popular government, and Michelangelo showed
him his Sleeping Cupid, which he had all but certainly undertaken to
prove to potential patrons what he could do. Over time, it became usual
to say about Michelangelo that he had finally and decisively surpassed
"the ancients"—the greatest compliment a Renaissance artist could receive.
The Cupid was certainly in a near-antique style, probably like the style
of the Bacchus that Michelangelo made only a little later. So Lorenzo di
Pierfrancesco de' Medici gave Michelangelo the following sage, if not very
scrupulous, advice: "If you were to treat it so that it seemed to have
been buried in the earth, I would send it to Rome and pass it for an
antique, and you would sell it *at a far better price.*" (Italics added.)[207]

Michelangelo did not hesitate. As Condivi boasted in the course of
telling this story, Michelangelo was a man "to whom no mode of skill
was unknown," including making an entirely new-made statue appear
"to have been made many ages ago."[208] The "antiqued" statue was confided
to a certain Baldassare del Milanese, another of the dubious traffickers
who are so numerous in the history of the art market, and the first un-
doubted dealer to turn up by name in the record after Fra Francesco da
Pistoia. Baldassare del Milanese promptly offered the statue to Cardinal
Riario,[209] a man who approached the remains of the classical past with a
two-edged sword.

To build what is now the Palazzo della Cancelleria, the Cardinal got
a kind of mining concession to take marble and other building materials
from Rome's surviving monuments,[210] and he even had a special marble

workshop for preparing the pillage of antiquity for modern reuse.[211] On the other hand, he was a classical art collector on a considerable scale.[212] Although the Cardinal therefore had experience of genuine antiquities, Michelangelo's fake antique completely deceived him, and he paid 200 ducats for it. Unfortunately, Baldassare del Milanese remitted only a small part of this large sum to Michelangelo, who thereupon made a resounding row. The repercussions reached Cardinal Riario, who promptly returned the statue to Baldassare del Milanese and asked for his money back.[213] The subsequent story of the statue is remarkable, and will be traced in later chapters.

This first episode in the story had a good ending for Michelangelo, however. He went to Rome, apparently to offer to Cardinal Riario the services of the sculptor whose work had taken him in, and there he did the Bacchus and began his real career.[214] But the lesson of the episode of the fake antique, at any rate for our purposes, is rather different and quite clear. The lesson is, first, that classical works of art then sold for substantially higher prices than comparable contemporary works, precisely because they were collectors' prizes, and, second, that by the end of the fifteenth century, collectors' competition was already beginning to cause prices for antique sculpture to start catching up with the prices of such things as carved gems.

The Palazzo's End

With Lorenzo the Magnificent gone to his forefathers and Michelangelo gone to Rome, this chapter is now drawing to a close. Yet something must still be said about Lorenzo's son Piero, who inherited the rule of Florence with no whisper of opposition because of his father's immense accumulated prestige. Piero must probably be credited with another collector's coup on the scale of Lorenzo's coup in Rome in 1471—but if this is true, it was a wholly unintentional coup. When the Medici bank was liquidated, Cardinal Francesco Gonzaga's carved gems were still pawned with the Roman branch, and thus they seem to have come into Piero's possession after the liquidation, although they remained in Rome. At any rate, after Piero had been expelled from Florence, the Gonzaga gems were available for Piero to pawn in his turn, in order to raise money from the new leviathan of wealth, the Roman banker from Siena, Agostino Chigi.[215]

In addition, the remarkable fact has recently been discovered that the second Piero de' Medici acquired a Cimabue from a monastery, a most astonishing step to take.[216] One can have little doubt that he believed he was acting in the spirit of his father; and this acquisiton by Piero is the strongest argument that the Medici Giottos were acquired by Lorenzo, rather than by Cosimo in the way previously suggested. In any case, the

place in the Palazzo Medici given to the Giottos in Lorenzo's time, and his son's acquisition of this Cimabue, are both significant pointers. They point to a dawning historical response to Italian art, in parallel with the historical response to classical art which had prevailed since the early fourteenth century.

I fear, however, that Piero's approach to culture is better indicated by his special pride in the extraordinary turn for speed of his Spanish running footman,[217] and by his sole commission to Michelangelo. Piero invited Michelangelo to be his guest in the Palazzo Medici, just as his father had done. But Michelangelo's talents as a sculptor were used only once—to make a famous snowman in the courtyard or the garden of the palazzo, when one day Florence had experienced the heaviest snowfall remembered by anyone then alive![218]

The second Piero de' Medici ruled Florence for only two years. In 1494, his response to the threat to Florence of the French invasion was pusillanimous and foolish. Savonarola's preaching had been undermining the Medici position for some time, as had Piero's arrogance and lack of wisdom. The uprising against the Medici followed, and Piero de' Medici had to fly for his life. He escaped Florence only in the nick of time. Thus in that great house glorious from the patronage and bulging with the collections of three generations of his forebears, Piero was only able to snatch up and take with him three easily portable objects of great value. One suspects the Tazza Farnese was too securely locked away to be promptly accessible to a man in great fear and a great hurry. Furthermore, Lorenzo the Magnificent's posthumous inventory strongly suggests that the Ghiberti-mounted "seal of Nero," the gem of equal value carved with Phaëthon in his chariot, and the famous *calcedonio* first discovered by Niccolò Niccoli were all stored in the same place in the *schrittoio* of Lorenzo the Magnificent.[219]

One may thus imagine Piero clawing at a drawer in desperate haste, seizing the gems, and rushing out of the palazzo. At any rate, these three gems were all he took with him when he left Florence forever.[220] Perhaps, too, Niccolò Niccoli's great prize was somehow dropped during Piero's flight to Rome, for the original gem was never seen again, although many copies of it exist. Meanwhile, the two other gems went to Naples by winding roads of marriage and inheritance, as did the Tazza Farnese, which got its modern name as a result of a Medici-Farnese marriage;[221] and all three have long since received museum entombment. Hence they now commemorate Medici art collecting in the fifteenth century in the same city where Lorenzo de' Medici risked his life to bring peace to his city by walking, alone and unguarded, straight into the dangerous clutches of Ferrante of Aragon.

ON PROGRESSION IN ART

This essay has now reached another of those points at which new questions arise and demand answers. Consider the implications of the posthumous inventory of Lorenzo de' Medici, so self-evident yet so bewildering to us. Then consider that only a few decades after the inventory was taken, collectors began to compete for works by great masters of Renaissance art every bit as eagerly as they had long competed for classical works of art. Why did this striking transition occur?

The inherent problem is not trivial, for the changeover from patronage to collecting quite clearly involves a deep change in ways of thinking about and responding to art. So why do people become art collectors, instead of, in the immemorial role of patrons, approaching the contemporary masters who please them most?

This is the first question which must now be tackled. The basic answer, I incline to think, lies in a rather simple rule. *Art collecting automatically starts when the rare art traditions' remembered masters begin to have the standing of old masters,* as these phrases are used in this essay. This does not mean, of course, that *all* remembered masters acquire old master standing, as one can easily see by comparing the cases of Bouguereau and Cézanne.

Bouguereau is still remembered as one of the slickest of the French nineteenth-century Academicians; but no one, surely, would now call Bouguereau an old master. To be sure, Bouguereau's works, after long sojourns in many a dusty attic, are beginning to find a market of sorts in this age of omni-collecting; but if Bouguereau could hear how he is critically judged today, he would bitterly lament his own failure. In his lifetime, nonetheless, Bouguereau achieved glittering success. Accepted for the Salon in 1849; Grand Prix de Rome in 1850; painting purchased for the Luxembourg as early as 1855; Academician in 1859; enormous,

never failing financial rewards thereafter; the ribbon of the Légion d'Honneur in 1859, Commander in 1885, and Grand Officer in 1903: these were the splendid steps along his road.[1]

In contrast, Cézanne, only a little younger than Bouguereau, hankered greatly for much the same sort of success Bouguereau enjoyed, vainly sending a picture to the Salon every year for many years.[2] Yet the pictures were always coldly rejected; and in the upshot, Cézanne's most significant reward was the awed admiration of future generations—for whatever that may be worth in the silence of the grave. Cézanne, in fact, is the preeminent old master of the modern age, whose impact on art itself can hardly be overestimated. As for his impact on serious art collectors and eminent museum curators, this grows more dramatic with each new decade.

Thus no mere shade of difference, no barely perceptible distinction, divides masters merely remembered from those with the standing of old masters. Some may ask, "How can you say old masters are collected, remembered masters are not? Think of all those who collect contemporary works of art. And think of the countless lesser masters whose works are now much sought after, and the countless categories of totally anonymous works of art which are also expensively collected."

To begin with, however, it must be remembered that in Rome in the time of Novius Vindex, a table bronze attributed to Lysippus seems to have been almost as much admired and envied as an entire heroic group of life-size bronzes by the same master had been about two hundred and fifty years earlier. In China, even more conspicuously, lesser works of art were automatically promoted, as it were, as soon as works by the great early masters ceased to be obtainable. In our time, of course, this promotion of what is minor by the scarcity of what is major has been carried further than it was ever carried before. Yet the very nature of the promotion of the minor amounts to conferment of a kind of factitious old master standing.

The case of the American nineteenth-century painters like Bierstadt and Church has already been covered.[3] Perhaps the same sort of promotion also awaits Bouguereau himself, although those who make the market for Bouguereau's works at present are either the kind of people who consider "It's so amusing!" as high praise for a work of art, or else shrewd dealers stocking up for a potential rise. As for the anonymous works of art which are now so eagerly collected, these chiefly come from the innumerable art traditions which had no remembered masters; and the finer objects, like the rather recently discovered Mayan tomb pottery of astonishing quality,[4] richly deserve their acquired old master standing.

Nor are those who collect contemporary works of art exceptions to my rule about old masters versus remembered masters. Whenever art collecting becomes a well-established, widespread social habit, some people

always take to speculating on what Dr. Barnes called "old masters of the future."[5] One can smell the beginning of this kind of speculation as early as the seventeenth century, in Philippe de Coulanges' promise to Mme. de Sévigné's daughter that pictures were like gold bars, and could be counted on to double in value.[6] Meanwhile, it is even more important that the old master rule explains the most marked peculiarity in the history of art collecting in our own art tradition.

Our Tradition's Unique Feature

The Western tradition is alone among the rare art traditions in that there were undoubted art collectors before the stylistic crystallization of the tradition itself. I myself believe that our tradition originated before the beginning of the true Renaissance around 1400—for I also believe the Renaissance was already in unseen gestation by about 1300. I believe this because a new start of sorts was so obviously indicated by the changed ways of thinking about art and artists first announced by Dante, which then interacted with the changed way of thinking about history first announced by Petrarch. But this is a matter of opinion, whereas it is not a matter of opinion that the Western art tradition is the only one of the rare traditions in which we have evidence for active art collecting considerably before the first moment when the tradition itself assumed stylistically recognizable form.

My rule nonetheless covers and also explains this special case simply because in Italy soon after 1300 "the ancients" started to acquire the standing of old masters, and were already fully recognized as art's primordial old masters by the Florentine masters who originated the new art in the glorious dawntime of the visible opening of the true Renaissance. The importance of this fact tends to be underrated nowadays. The truth is that we find it hard to understand the close-to-indiscriminate reverence of the men of the early Renaissance for classical works of art, because our way of seeing is not theirs.

For example, if you go to see the Louvre's slumbering, bottom-displaying, ithyphallic Hermaphrodite, the statue is highly likely to strike you as close to whorehouse art. The effect is not diminished, either, by the elaborately buttoned marble mattress added by Bernini.[7] Yet the Hermaphrodite Lorenzo Ghiberti saw being excavated in Rome was evidently fairly similar to the Louvre Hermaphrodite;[8] and this piece of sculpture moved Ghiberti to ecstasies of admiration. Its "perfection," he said, could not be expressed in words, and he added that the statue's subtleties of surface were such that they could not be fully appreciated except by touch. He also wrote of the "most perfect" beauty of the Venus statue acquired from Florence by Lombardo della Seta, which he saw at Ferrara.[9] Again,

he remarked that the eyes alone could not comprehend this statue's "sweet-ness," even in a strong light; so he recommended passing the hand over it for full appreciation.[10] This reverence amounting to awe can also be found in Leon Battista Alberti's praise-lament for Rome's remains of classi-cal architecture, which he studied in order to learn from them "with tears in his eyes" because they were "decaying and crumbling away."[11]

Much other closely comparable testimony might be easily cited. Hence no one should be surprised that classical works of art were the great prizes of the Italian art collectors of the fifteenth century. In the view of men like the sculptor-collector, Ghiberti, and the magnate-collector, Lorenzo de' Medici, the "ancients" were the supreme, indeed the sole old masters. Moreover, only compare what happened in our own art tradition with what happened in the classical art tradition. You then find there is nothing so enormously bewildering, after all, in what I have called the great surprise of the fifteenth century: the fifteenth-century neglect of Italian Renais-sance works of art by art collectors as opposed to patrons of the arts.

Progressions' Effects

The Greek tale of remembered masters began soon after the miraculous Greek creative mutation, with artists of the seventh century B.C. like Dipoe-nus and Scyllis. The first Italian remembered masters were artists of the late thirteenth and early fourteenth centuries, most notably Nicola Pisano, Cimabue, and Giotto. Yet almost until the end of the great centuries in Greece, leading masters dealt only with patrons of the arts; and true art collecting did not begin in the Greek world before late in the fourth century B.C. at the very earliest. In the same fashion, leading Italian masters dealt only with patrons until the early twilight of the High Renaissance; and Italian Renaissance works of art did not begin to be fairly widely and truly collected before the second decade of the sixteenth century. In both Greece and Italy, in sum, the first phases were the marvelous creative surges in which the two art traditions originated; and the resulting works of art only began to be collected when these first creative surges were at length subsiding.

How, then, is one to explain this remarkable parallel between two art traditions so widely separated in time? This is another question which now calls for an answer. Logically, the answer must be sought in another striking parallel between the two traditions—in fact, the rather similar way the first historians of Greek and Italian art analyzed the stories they recounted.

The schematic similarity of the historical analyses of Xenocrates of Sicyon in the third century B.C. and Giorgio Vasari in the mid-sixteenth century A.D. has already been briefly noticed in Chapter VII. The Xenocra-

tean and Vasarian progressions in art proceeded from imperfection to perfection, so that in both cases, these progressions inescapably consigned all the earlier masters to an inferior rank, as being less than "perfect." Yet what is more telling is the way the two pioneers of art history judged the creative situations in their own times.

For Xenocrates, as has been seen, the culminating geniuses of the great centuries of Greek art were the late fourth-century sculptor and painter, Lysippus and Apelles. As has been seen, too, Xenocrates further believed that "art then stopped" about a generation after the deaths of these two masters[12]—which was when he wrote his history of Greek art. Vasari, in rather the same way, published the first edition of his *Lives* about a generation after the death of Raphael, and when Michelangelo and Titian, though still at work, were already very old men. Surveying the state of art in the mid-sixteenth century, the Italian was a little less pessimistic than the Greek had been in the early third century B.C.—but only a little less. Vasari in fact held that with the great masters of the High Renaissance, "art reached the height of what a true imitator of nature is capable of achieving." Art, he went on, had therefore "climbed so high that [we are] rather to fear a fall to a lower height than to reach higher summits."[13] On this same problem it is also worth quoting another of Professor Gombrich's insights, this time concerning the situation just before the death of Raphael:

"Round about 1520 all lovers of art in the Italian cities seemed to agree that painting had reached the peak of perfection. Men such as Michelangelo and Raphael, Titian and Leonardo had actually done everything that former generations had tried to do. No problem of draughtsmanship seemed too difficult for them, no subject matter too complicated. They had shown how to combine beauty and harmony with correctness, and had even surpassed—so it was said—the most renowned Greek and Roman statues in their mastery of detail. For a boy who wanted to become a great painter himself, this general opinion was perhaps not altogether pleasant to listen to. However much he may have admired the wonderful works of the great living masters, he must have wondered whether it was true that nothing remained to be done because everything art could possibly do had been achieved."[14]

Of course Greek art had not "stopped" in Xenocrates' time. Hellenistic art in all its variety was yet to come, and the classical art tradition continued to be impressively creative in one way or another for well over four centuries after the Greek world was entirely subjugated by Rome. Of course, Western art in Vasari's time had not reached the only "height" it was "capable of achieving." Instead, post-Renaissance art in all its variety had only just begun. Of course, too, Professor Gombrich's imaginary young man around about 1520 could well have been Bronzino, for instance,

who would then have been seventeen. But all this is beside the point. The real point is that the three art historians, Xenocrates in the third century B.C., Vasari in the sixteenth century and Professor Gombrich in the twentieth century, all agree that when the great creative surges finally began to subside, people of those times somehow *felt* that something very big was coming to an end. And Xenocrates and Vasari, furthermore, emphatically shared this feeling themselves.

Before and After

In this sense of an ending, however wrong-headed, in this belief, however ill-founded, that a splendid climax had already been reached and art's road thereafter might well be downward, I suggest we have the basic solution of the problems now under discussion. To see why this is so, consider first how a fifteenth-century patron and art collector like Lorenzo de' Medici must have thought about his own activities in the realm of the arts. For Lorenzo, beyond doubt, the "ancients" were the grand founts of art, who would never come again. It was therefore logical for him to collect classical works of art with great eagerness and at great expense.

When it came to Renaissance works of art, however, the logic worked just the other way. Of course Lorenzo the Magnificent had no knowledge of the astonishing notebooks kept by his near-contemporary, Leonardo da Vinci. Yet Lorenzo would all but certainly have agreed with Leonardo's observation in one of the *Notebooks* that only "a wretched pupil does not surpass his master."[15] As long as the leading artists of each new generation were expected to outdo their teachers of the previous generation, it did not make sense for Lorenzo to add to his family's accumulations of Pollaiuolos, Uccellos, Fra Angelicos and Masaccios by collecting the works of these earlier masters. Instead, when Lorenzo wanted Renaissance paintings, it made sense to give commissions to Botticelli and Ghirlandaio, Filippino Lippi and Perugino—and these were precisely the artists whom he commissioned to decorate his villa, Lo Spedaletto.[16]

A different prospect opened, however, before Federigo II of Mantua in the third decade of the sixteenth century. Like Lorenzo de' Medici, the Marquis, later first Duke of Mantua,[17] was both art collector and patron of the arts; and as a patron, he was also more ambitious than the leader of Florence had been a generation earlier. Giulio Romano, freed by Raphael's death, was his artist-in-residence, carrying through great projects for Federigo like the Palazzo del Te.[18] Of the surviving giants of the High Renaissance, both Titian and Correggio accepted major commissions from him. As an art collector, too, Federigo II of Mantua mainly took the same road Lorenzo de' Medici had taken; for he added largely to the Gonzaga stores of classical works of art.

Yet there was no really important[19] Raphael in the Gonzaga collection, and there was no confidence any longer in the continuous progression of the arts implied by Leonardo's rule about talented pupils always surpassing their masters. Giulio Romano was in fact Raphael's most distinguished pupil; and he was much admired and richly rewarded at Mantua. Yet that certainly did not mean Giulio Romano was held to equal, much less to surpass Raphael. After his death Raphael almost instantly became the nonpareil who would not come again, just as "the ancients" would not come again. So the application to the Pope was made for the Raphael of Leo X and his two attendant cardinals; and the chain of events began that produced Andrea del Sarto's fake Raphael, now in Naples.

There are several things to say about this hypothesis concerning the way Renaissance works of art first began to be truly collected—for an hypothesis is all it is. To begin with, there is other evidence to cite which indicates the road of art was expected to be downward when the giants of the High Renaissance were successively vanishing from the scene. The contrast is dramatically sharp, for instance, between Leonardo's rule about pupils and masters, and the curious passage in Ascanio Condivi's life of Michelangelo on the subject of the uttermost limits of art.[20] The passage asserts, first, that art has limits like everything else; second, that Michelangelo had reached art's limits; and third, therefore, that those who came after could have nothing more to do except to ape Michelangelo as best they could. In short, Condivi, here probably echoing Michelangelo as so often, pessimistically foresaw that art's glory would be dimmed—whereas Leonardo's rule implies art's continuous upward movement to greater and greater glories.

Yet despite the ample proofs that the sense of an ending was widespread in the twilight of the High Renaissance, no hypothesis concerning developments hundreds of years ago can ever be more than tentative. We have much evidence of Federigo II of Mantua's efforts to obtain from Pope Clement VII the Raphael he wanted,[21] but we can only guess at his motives for wanting the picture. It seems likely that Federigo's motives were those here suggested, for this fits the other data neatly. Yet it is never feasible to read the minds of the dead with certainty.

Finally, the limitations of my hypothesis need to be strongly stressed. Collecting itself does not originate because people begin to say, "We shan't see anything quite like that any more," as they undoubtedly did say about Raphael's works after he had died, too young. Art collecting is instead rooted, as I hope has been shown, in the historical response to art; and this was why classical works of art were collected in Italy for over two hundred years before collectors began to seek Renaissance works of art. The question here being tackled is subtly different from the actual origins of art collecting. It has to do exclusively with a matter of timing—in

fact with why our own art tradition in the time of Federigo II of Mantua began to turn in upon itself, as it were. Put another way, the question is why Renaissance works of art rather abruptly became collectors' prizes, along with classical works, at just this moment rather than some earlier or later moment.

For good or ill, I can think of no better solution of this problem of timing than the hypothesis I have put forward. I believe, too, the same hypothesis adequately explains how art collecting began in the Greek world at the moment when the Greek creative surge was subsiding.

In each of the other rare art traditions, to be sure, other factors made the pattern less neat. In the second era of Chinese art, for example, the enormous role of calligraphy caused a variation. All but certainly, the very early start of Chinese collecting was primarily for the reason already given,[22] because the Chinese had always assembled specimens of calligraphy as examples for boys learning to write. In the Japanese art tradition, again, since art collecting was a cultural import along with so much else, the whole development of the by-products of art followed a somewhat haphazard course, as has been said. In later Islamic art, finally, collecting really arose when books produced by certain famously innovating and skillful calligraphers began to have what the dealers call a large plus-value as works of art; so the first Islamic art collectors were halfway between art collecting and collecting fine books.

The plain fact remains, however, that in all five rare art traditions, the major art collectors' prizes have been the works of long-recognized old masters, or works of lesser artists promoted to old master standing by the rarity of higher prizes, or works by artists believed likely to be the "old masters of the future," as Dr. Barnes put it. And these rules still hold for Western, Far Eastern and Islamic art collecting as these words are written.

XIII

THE CLIMAX IN THE WEST

Perhaps mercifully, this essay is at last nearing its end; for it remains only to show how Western art collecting reached maturity. The right place to begin is with the transition that occurred during the next half-century-plus after Lorenzo de' Medici died in 1492. To show the before-and-after contrast, a little recapitulation is in order. Lorenzo the Magnificent either inherited his Italian works of art or patronized his preferred contemporary masters. As an art collector, however, he sought classical or pastiche-classical works of art almost exclusively, in the way that was usual throughout the fifteenth century.

Rather soon after Lorenzo died, however, a few people for the first time became true collectors of Italian art. Meanwhile, the pursuit of the long-established Italian art collectors' specialties—classical gems, coins, medals, and pieces of sculpture—also grew even more competitive and widespread. These were the two main features of the transition in question. It must be regarded as a transition for two reasons: because the Renaissance paintings and pieces of sculpture acquired by collectors during the period of transition constituted a somewhat mixed bag by later collecting standards, and this, in turn, was because the Vasarian canon of art, as I have called it, was yet to be outlined and accepted.

The nature of the transition is best illustrated in the *Ricordi* of Fra Sabba da Castiglione, first published in Bologna in 1549, but seemingly written over a considerable period before that date.[1] As this is still a rare book by an obscure man, both need a few words of introduction.

Fra Sabba da Castiglione was a Milanese of gentle birth but small fortune who entered the order of the Knights of St. John of Jerusalem in the very early sixteenth century, when he would have been approximately twenty years old. He was evidently an agreeable young fellow with considerable culture, and he made important friends before he left for Rhodes

to serve in the Knights' great commandery there in 1505.[2] Isabella d'Este, Marchioness of Mantua, was one of these friends, as his correspondence with her from Rhodes attests.[3] The correspondence further reveals that Fra Sabba went to Rhodes with a ready-formed admiration for classical sculpture, and this was one of the reasons he was unhappy there. The knights from north of the Alps struck him as half barbarous, partly because so many of them, including the Grand Master of the order, a French nobleman, still regarded pieces of classical sculpture as pagan idols and further held that admiring idols was a sin.[4]

Perhaps for this reason, Fra Sabba transferred from the Rhodes commandery to his order's other headquarters, in Rome, after only three years, and held a post of some authority there until 1516. Unfortunately, in some way not specified—was it in a duel?—he was unfitted to be a fighting knight by a severe injury to his right or sword hand, and whether because of this injury or its cause, he lost his post in Rome in 1516. In 1518, however, he was named to head one of the very minor commanderies of the Knights of St. John, La Magione, at Faenza. La Magione had been left a near-ruin in one of Cesare Borgia's Italian wars, and Fra Sabba's chief preoccupations for the rest of his life were putting the commandery in order, renovating the church and redecorating it with frescoes and in other ways, and restoring the half-abandoned garden with his own hands. Otherwise he passed his time in learned pursuits and in constant charities to the poor of Faenza. Altogether, he seems to have been a genuinely good man as well as a pleasant and cultivated one. He died in 1554.[5]

As to his *Ricordi*, the little work was intended as a kind of vademecum or guide in life for his nephew Bartolomeo da Castiglione, who also became a Knight of St. John.[6] The book covers many topics, which Fra Sabba apparently took in hand almost at random, just as ideas came to him over the years before the Bologna edition of 1549. The passage of real interest for this essay's purpose is *Ricordo* 109, on the subject of suitable decoration of grand interiors.[7]

At the outset, Fra Sabba specified that he was talking of the way "lords and great gentlemen, rich, noble and grand, not to say swelled up with wind, like to decorate their palaces, their houses, and above all their rooms public and private." Some of the rich and grand, Fra Sabba began by remarking, liked rooms decorated with musical instruments of many kinds. In the sixteenth century, this was a long-established though probably uncommon practice. The earliest record of the practice is in fact in Guillebert de Metz's fifteenth-century work on the Paris of his period, which contains a detailed description of the *Wunderkammer*-house of Jacques Duchié, locally famous in its time. This included a room entirely devoted to displaying musical instruments.[8]

In Fra Sabba's time, too, fine musical instruments were luxury objects

made by acknowledged masters like Lorenzo da Pavia, who practiced in Venice and was patronized by Isabella d'Este, among many others.[9] Fra Sabba pointed out the talents of Lorenzo da Pavia, and also gave his blessing to displays of fine instruments, on the grounds that the instruments were both "pleasing to the eye" and could be used when wanted to "charm the ear." The indications of what I have called the transition only begin in the next passage, however, and this is worth quoting at some length.

"Others [meaning other grandees of the type defined at the outset] make their rooms fine with antiques such as heads, torsoes, busts and complete ancient statues of marble or bronze. But since beautiful antiques are rare and cannot be obtained without the greatest difficulty and expense, others choose works by Donato [Donatello] who can be compared with any sculptor of antiquity in sculptural design and workmanship . . . as is shown by his divine and excellent works in Florence in Orsanmichele and by his Gattemalata at Padua.

"Still others have chosen the works of Michel Angelo, the glory of our century in both painting and sculpture. . . ."

After further remarks on Michelangelo's supreme genius, Fra Sabba went on to name several lesser sixteenth-century sculptors as possible choices, beginning with Gian Cristoforo Romano, another friend of Isabella d'Este's, and including Alfonso Lombardo, a Ferrara man and friend of Fra Sabba's. But he ended this passage by naming pieces of sculpture by Verrocchio and Pollaiuolo.[10] As to the next passage, it concerns coins, medals, and carved gems; and the antiques again come first, and then the products of a series of recent masters, gem carvers as well as goldsmiths.[11] So Fra Sabba at last reached painting; and again, part of this passage is worth quoting:

"Still others get pleasure from ornamenting their fine rooms with pictures, panels, histories and portraits painted by Fra Filippo [Lippi] Carmelite, by Mantegna, and by Giovanni Bellino, masters famous in their days and with beautiful powers of invention—or from the hand of Leonardo da Vinci, a man of the very greatest talents, most excellent and very famous as a painter, a pupil of Verrocchio, as one can tell from the sweetness of expression, and the first to imagine large figures shown in lamplight. Except for the Last Supper . . . at Milan (a work assuredly divine and famous throughout the world) one finds few works from his hand."[12] At this point, Fra Sabba inserted a long, regretful excursus on the reasons for the extreme rarity of paintings by Leonardo, after which he evidently felt it was high time to get back to his main business. Hence he seems to have set down, pell-mell and just as they occurred to him, the other painters whose works he thought suitable for use in fine rooms. Those on the list, in the order given, are Filippino Lippi, Perugino, Raphael, Giulio Romano, Girolamo da Trevigi, Francesco Menzocchi, Piero della

Francesca and Melozzo da Forlì. Girolamo (whom Fra Sabba called "Travisio") and Menzocchi were included because both were friends, and Fra Sabba further employed both to do frescoes in his commandery's church.[13] But it is still a surprising list.

There is only a little more worth noting. Briefly, Fra Sabba further considered that specimens of the deceptive pictorial intarsia of the sixteenth century were fitting decorations, as were prints for the more private rooms of a house. He approved of prints by Lucas van Leyden and particularly those of Dürer, which he called "divine."[14] (He also owned at least one.[15]) Finally, he dealt with tapestries and painted hangings, some of which were highly recommended.[16]

He then added that although he was "only a poor knight," he had managed to find a few prizes to decorate his own study. The chief among these was a head of St. John the Baptist at the age of fourteen which he believed to be by Donatello and considered of such high quality that if Donatello's "other works had disappeared, this one alone would be enough to make him immortal." (Edmond Bonnaffé believed that this St. John survived at Faenza, but the head has either disappeared or Bonnaffé was wrong, according to Professor Horst W. Janson.)[17] Then there was a St. Jerome in terra cotta painted and patinated to imitate bronze, about one-third life-size, by Alfonso Lombardo, above mentioned; plus one of the panels of pictorial intarsia Fra Sabba so greatly liked; plus an antique urn in veined Oriental alabaster, plus a "lot of other little things."[18]

On the Decorating Factor

Such, then, were the outlines of Italian art collecting in what I have called the period of transition, as traced by Fra Sabba da Castiglione. There are two main reasons for starting this chapter with Fra Sabba's imaginary picture of grand houses inhabited by the kind of people who then gathered Italian works of art of the past. In the first place, Fra Sabba puts particular emphasis on a factor in Western art collecting which is too often forgotten, in fact the desire for elegant interior decoration. For lesser collectors of the early sixteenth century, who could not obtain or afford major Raphaels, Titians and the like, the decorating factor was obviously strong.

It must be emphasized again that the decorating factor is *not* an unvarying element in all art collecting. It is and perhaps always has been entirely absent in serious Chinese art collecting, and it is worth recapitulating and expanding what has been said already on this subject.[19] In brief, no Chinese collector with the least pretensions to high culture is known to have used his really good pictures or pieces of calligraphy to decorate his interiors during a period now probably much longer than a millennium. Collections were for the collectors' own delight, or to be shown to other

connoisseurs,[20] and they were carefully stored unless specially brought out.[21] Paintings were certainly used for decoration in China, as were large specimens of calligraphy. But such paintings were acquired with decoration in mind, and except in the imperial palaces and the houses of the ultra-grand, the paintings were seldom by those recognized in their lifetimes as leading artists, thus causing their works to become contemporary collectors' prizes. Similarly, the regularly exhibited specimens of calligraphy were usually gifts from friendly scholars, and were likely to be put away beyond harm's reach by serious collectors if the scholar-calligrapher in question then began to be regarded as a pre-eminent talent.

In Japan it was a bit different. The previously mentioned work by Kanaoka in the *Heike Monogatari* was a painted screen used as a permanent ornament in an empress's rooms in the twelfth century.[22] This kind of display of a work by an early master would have been most unlikely after the Ashikaga Shogunate opened a new era for art, but it was surprisingly late in the Japanese story when suites of rooms in houses on the scale of palaces ceased to be largely or entirely decorated with screens and panels, but now painted as ensembles by the most admired contemporary masters. A series of the marvelous palace rooms of the last great warlord-tyrant of the sixteenth century, Hideyoshi Toyotomi, are still preserved to dazzle visitors in the Nishi-Honganji temple in Kyoto; and the Kyoto palace of the Tokugawa Shoguns, the Nijo-in, can still be seen, too, and in décor this palace almost equals Hideyoshi's rooms. Yet at least from the time of the Ashikaga Shogunate and probably earlier, the Japanese were very nearly as averse as the Chinese to public display of their true art collections,[23] except on great occasions when important families would bring out their finest old screens[24] and leading collectors would show their highest prizes in the tokonomas of their chief reception rooms or their tea rooms.

In the later Islamic art tradition, again, the two classes of grand prizes of all art collectors, the works of famous calligraphers and painters, were usually done originally to glorify the superb books Islamic princes liked to commission; and before miniature painting began to be important, the greatest calligraphers chiefly worked on Qur'ans. When detached specimens of fine calligraphy and miniature painting were assembled by collectors, moreover, they were then bound in booklike albums. To be sure, it is known that great painters sometimes received commissions to paint whole rooms in palaces, as great calligraphers no doubt got commissions for models for important permanent inscriptions in public places. But none of the painted rooms has survived which can be attributed to a major master, and on the whole, the later Islamic art collectors, with their books and albums, came much closer to the Chinese collectors than to Western collectors.

In the West alone, in fact, since true art collecting first originated in the Greek world in the later fourth or the third century B.C., and whenever collecting has been an established social habit straight down to the present, art collections have regularly been shown in the collectors' houses or palaces, or in institutions they sponsored like the Pergamene Library; and interior or even garden decoration has often been a factor in this kind of art collecting. Interior decoration further seems to have been a particularly strong factor, as I have said, in the sixteenth-century period of transition here under discussion, as indicated by Fra Sabba da Castiglione.

Nor should the long power of this decorating factor ever be forgotten. It explains the way collections of pictures were shown in Europe until the opening of the modern Museum Age, and why the pictures were sometimes brutally adapted for display in order to make the effect more architectural, as in the Stallburg in Vienna.[25] It also explains much else, such as the way English eighteenth-century collectors of Greco-Roman sculpture sometimes chose their statues to fit their niches instead of the other way around, and even sought to achieve an architectural effect in their special sculpture galleries by roughly symmetrical arrangement of the many pieces shown.[26] But enough has been said earlier about these aspects of past Western art collecting. All reasonably worldly and knowledgeable persons today can also judge how much weight to give to the decorating factor, how much to the factor of status, and how much to give to what may be called the true collecting factor in just about any modern art collection they happen to see.

On the Priorities

As to the other reason for choosing Fra Sabba da Castiglione as this chapter's first witness, it is the obvious, emphatic pride of place he accords to classical works of art in the collecting categories within which classical works were obtainable in the sixteenth century. Nowadays, one can hardly imagine putting Greco-Roman sculpture first; putting second, as prizes to be sought after if good classical pieces were too expensive or altogether unobtainable, works by both Donatello and Michelangelo; and then following with the rest of the sculptors on Fra Sabba's list, ending with Verrocchio and Pollaiuolo. But that is what Fra Sabba did nonetheless, and in the realms of coins, medals, and carved gems as well as sculpture.

Furthermore, these priorities, to us so incomprehensible, were by no means limited to Sabba da Castiglione. The years 1506–07 produced two famous finds in Rome, the Laocoön and the statue of the Emperor Commodus as Hercules; and if one may judge by the ample papal pensions awarded to the lucky persons on whose lands these pieces of sculpture were accidentally unearthed,[27] this first decade of the sixteenth century was a period

when collectors' competition caused a further steep rise in prices for first-rate classical sculpture in fairly intact condition. Only a little later, King François I asked Andrea del Sarto to bring him back from Italy some paintings and sculpture, but Andrea never returned to France and, according to Vasari, embezzled the King's money.[28] It was Primaticcio who carried out the King's commission, to get molds of the most famous pieces of Greco-Roman sculpture in Rome.[29] Benvenuto Cellini, consumed with rage as so often, recorded Primaticcio's commission, and also recorded how the bronzes made from the molds were then unveiled, along with his own statue of Jupiter, in the Grande Galerie at Fontainebleau.[30]

The competition for lesser antiquities, such as fine Roman coins, further intensified greatly, as can be learned from a letter in Isabella d'Este's voluminous correspondence. In this letter, one of the Marchesa's numerous collecting agents, the Greek scholar Giorgio di Negroponte, lamented the impossibility of finding antiquities in Rome at reasonable prices, and cited as an example a coin of Nero for which a petty trafficker had given 6 ducats when it was unearthed, and, after it was cleaned, had named a new price of 25 ducats.[31] The latter sum—and for a newfound coin!—was one-quarter of the top price Isabella d'Este is known to have paid for a painting by a major Renaissance master, as will emerge later. The price of the coin is also worth comparing with Mantegna's annual salary at Mantua, which was 180 ducats a year plus rations and some other perquisites.[32]

The impression one gets from the near-feverish speculation in antiquities in early-sixteenth-century Rome is further confirmed by another kind of evidence: the beginning-compilation and publication of a whole series of descriptions of famous galleries and garden collections of antique sculpture, really amounting to catalogues and guides for visitors to Rome. The first seems to have been Francesco Albertini's Latin *Opusculum*, published in 1510.[33] Ulisse Aldovrandi's work on antique sculpture to be seen in private collections in Rome is probably the most studied today, although it was originally published in 1556 as an appendix to a larger work by Lucio Mauro.[34] Such works in other European languages as well as Italian went on being produced at intervals for a long period.[35]

Finally, some notice should be taken of the best direct evidence we have on the composition of actual rather than imagined art collections in the period when Fra Sabba da Castiglione probably began to compose his *Ricordi*. This is the little manuscript published as *L'anonimo* when first rediscovered, and now solidly attributed to Marcantonio Michiel.[36] The collections covered are some in Venice and the more important ones in Padua and other cities of northern Italy. In the collections Michiel described, the antiquities and pastiche-antiquities are given special emphasis, and almost no private collector of much consequence can be found

in the book who did not have at least a few pieces of ancient sculpture or some other antiques.

For example, one of the collections described at greatest length was that of Pietro Bembo, in the house at Padua that he occupied in retirement before he became a cardinal. Bembo owned no fewer than seventeen pieces of classical sculpture of varying dimensions, as well as unidentified marble heads, "earthen vases," gold, silver, and bronze "medals," plus "precious stones, carved and set in rings," all of which were described as "antique."[37] Furthermore, Michiel passed over, or Bembo had not yet acquired, the best-known antiquity now held to come from his collection, the Egyptian bronze tablet representing the Mysteries of Isis, now in the Egyptian Museum in Turin.[38] In short, antiquities formed the largest single element in the Bembo collection, and antiquities also appear repeatedly in other collections covered by Michiel.

If detailed comprehensiveness were an aim of this essay, in fact, one or more entire chapters would have to be devoted to the continuous development, throughout the sixteenth century and long thereafter, of this single department of European art collecting. But it is enough to say that the sixteenth was the decisive century when antique sculpture galleries first began to multiply and spread outward to Europe north of the Alps, leading on to the late-eighteenth-century climax, when no capital from St. Petersburg westward could be found in any part of Europe which did not boast at least one such gallery among its chief ornaments. The larger European capitals, of course, often had several galleries, and they could be found, too, in great country houses, as so often in England.

Corrections

We come at last to the warnings and correction required because this chapter opens with Fra Sabba da Castiglione. In brief, Fra Sabba was highly personal in his choice of artists whose works he regarded as collectors' prizes, and named on his lists far from famous artist-contemporaries whom he had patronized in one way or another. He put so much emphasis on Donatello because he thought he owned a work by Donatello himself. Despite the persisting admiration for Donatello by Michelangelo and others,[39] in the sixteenth century Donatello's sculpture was never sought after with such ardor as works by the giants of the High Renaissance. H. W. Janson cites a series of incidences of Donatellos in Florentine palaces in the first half of the sixteenth century; and he believes these had been acquired in the collectors manner rather than being inheritances. Ugolino Martelli even had himself painted by Bronzino in 1540 with the unfinished David. Donatello faded into the shadows from the collectors standpoint after 1600, just as Botticelli did.[40]

As the other warning about Fra Sabba, it must always be remembered in reading him that he was a compulsive list maker, who enjoyed showing off his knowledge so far as that knowledge went. The part of *Ricordo* 109 devoted to musical instruments contains a list of eighteen musical instruments of Fra Sabba's time.[41] Except that this comprehensive list (including bagpipes) underlines Fra Sabba's acquaintance with the subject, it is almost entirely superfluous. In the same fashion, it must be suspected that in the *ricordo*'s section on paintings, Fra Sabba again became a compulsive but rather hasty list maker after he had dealt with Fra Filippo Lippi, Giovanni Bellini, Mantegna, and above all Leonardo. Hence the culminating, larger list of painters is surprising, first of all for the earlier-fifteenth-century masters who are included. Meanwhile, it is also clear from this painters' list that Fra Sabba's knowledge sometimes did not go far enough. This is shown by the striking omissions from the list: such giants of the High Renaissance as Titian, Giorgione, and Correggio, and also the early painters of the Low Countries, whose works could still be found in prominent places in a good many sixteenth-century collections.

Michiel's description of the Bembo collection actually begins with two Memlings;[42] and Van Eycks (or supposed Van Eycks);[43] and works by Rogier van der Weyden,[44] as well as more Memlings[45] and other Northern paintings appear in other collections described by Michiel. Of the earlier Florentines listed at such length by Fra Sabba, virtually none appear in Michiel, no doubt because he was describing collections in Venice and the cities of the North, mostly under Venetian influence; but there was a supposed Cimabue in Padua,[46] highly doubtful because it came from an old church there, and there is nothing to show Cimabue ever worked in Padua. Even if near in date to Cimabue, moreover, the picture must have been acquired for purely historical reasons, since anything else like a primitive painting, or even any Italian painting (beyond the odd family legacy) by a fifteenth-century painter as early as Fra Filippo Lippi, is conspicuously absent in the Michiel-described collections. The most numerously represented Italian painters from before the High Renaissance were, not surprisingly, the later Bellini, and among the giants of the High Renaissance, Giorgione was in the lead in these collections; but Pietro Bembo owned a Raphael portrait of his two friends, the Venetian writers Navagiero and Beazzano,[47] and a good many more special cases might be mentioned.

It can be seen, then, what is meant by the statement that the first real collections of Italian art in the first half or more of the sixteenth century were fairly mixed bags by the standards that later prevailed in all major collections for close to two hundred and fifty years—in fact, from the last decade or so of the sixteenth century to the early nineteenth century. The same lesson is to be drawn from the Botticellis Herbert Horne

managed to locate that were to be seen in various places in the later six-
teenth century and also from the larger of the two collections described
by Rafaello Borghini in *Il Riposo*.[48] This was composed or at least published
after the second edition of Vasari's *Lives;* but in both collections covered
in *Il Riposo* the emphasis is primarily Florentine, in just the way the
emphasis was primarily Venetian in the collections described by Michiel.
The collectors in question, who were also participants in *Il Riposo's* ram-
bling dialogue, were Bernardo Vecchietti and Ridolfo Sirigatti; and presum-
ably Borghini was writing about real rather than imagined collections just
as Michiel did, since Sirigatti was one of his friends and Borghini also
seems to have known Vecchietti's villa fairly well.

The scene of a large part of *Il Riposo* is in fact this villa outside Florence,
where the company is shown through Vecchietti's collection. This was
evidently a remarkable and most enviable assemblage, for it contained
two Michelangelo cartoons, one for his lost Leda, and one for "the wars
of Pisa," a Leonardo da Vinci drawing of the head of a dead man, a drawing
by Benvenuto Cellini, two more by Bronzino, "many" figures by Giovanni
Bologna in clay and wax, some landscapes by Flemish painters, and, finally,
a "beautiful painting" by Botticelli plus a painting of "two heads" by
Antonello da Messina. Add another whole room full of small *modelli*
by Giovanni Bologna and paintings by unnamed masters, great numbers
of small collectors' objects and *Wunderkammer* prizes such as small
bronzes, silver and gold vases, some porcelain (presumably Chinese), pieces
of rock crystal, and all sorts of other things like knives and scimitars
from the Middle and perhaps Far East.[49] As for the Sirigatti collection,
which *Il Riposo's* company also inspects, it contained works by Andrea
del Sarto, Pontormo, Perino del Vaga, Ridolfo Ghirlandaio, Bronzino, Gio-
vanni Bologna, and Federigo Zuccaro, plus more Flemish landscapes; and
this collection compensated for Vecchietti's apparent neglect of antiquity
by containing no fewer than a thousand heads, torsos, and arms, which
must obviously have been antique.[50]

The Vasarian Canon

Even allowing for the innumerable variations that human nature, in-
cluding collectors' nature, is always given to, the contrast is still fairly
marked between these relatively miscellaneous collections of the transi-
tional period above-described and the later collections more narrowly based
upon what I have ventured to call the Vasarian canon. As may be recalled,
the canon had only three main elements: the great masters of antiquity,
chiefly as represented by Greco-Roman sculpture; plus the giants of the
High Renaissance, Giorgio Vasari's first era of "perfection" in art; plus
the leading masters of successive generations who were admitted to the

canon. As may also be recalled, Gothic works of art and works by almost all masters preceding the High Renaissance were excluded from the canon.

The first turning point from transitional art collecting to collecting guided by the Vasarian canon may also be approximately dated if Luigi Lanzi can be trusted—or, rather, if one can trust those Lanzi got his key facts from, most probably the staff of the Pitti Palace in the later eighteenth century, with their traditional memory of the Medicean past. As has been noted in an earlier chapter, the contents of the Quarto Gabinetto of the Uffizi, as described by Lanzi in his contemporary guide to the reorganized gallery, extended in time from works attributed to Giotto and Cimabue through works of fifteenth-century painters as late as Botticelli. As was also noted, Lanzi stated that a good many of these early pictures had been found in a room of the Pitti Palace where they had been placed by the suggestion of Giorgio Vasari himself, but Lanzi did not indicate what masters' names were then attached to these pictures.[51]

Vasari died in 1571; so one must suppose the relegation of early pictures to this Pitti Palace room occurred in the later period of Vasari's life, when he served and advised Grand Duke Cosimo I de' Medici. The room was plainly rather out of the way, for the whole tone of Lanzi's brief account indicates a happy rediscovery. Hence one must further suppose that Vasari did not urge Grand Duke Cosimo I to arrange these paintings by fourteenth- and fifteenth-century masters for actual display to visitors of the Palazzo Pitti. One may even guess that the Grand Duke was thinking of disposing of or even destroying such old-fashioned paintings until Vasari pleaded that the paintings in question be put in semi-storage, as having real art-historical interest albeit so far from Vasarian "perfection."

To be sure, all the foregoing rests on Lanzi's sole testimony, or, rather, the testimony of his informants about Vasari's past role, for I have been unable to discover any way of checking this part of Lanzi's *Real Galleria di Firenze.* Yet Lanzi's account strikes me as probably at least approximately correct, for two quite different reasons. On the one hand, the pictures in question were certainly in a room in the Pitti Palace before Lanzi or Bencivenni Pelli or both of them learned of their whereabouts and transferred them to the Uffizi, for here Lanzi spoke from experience.

On the other hand, even as early as the later lifetime of the first Medici Grand Duke, the relegation of pictures remote from the current fashion to something like storage would be a natural step along the road toward Grand Duke Ferdinando I's list of painters whose works were forbidden to be exported from Florence. Evidently Botticellis were still considered worthy of being shown to visitors in the later decades of the sixteenth century. The "beautiful" Botticelli in *Il Riposo*, the Botticellis mentioned by Horne which were still on view then, plus some exhibits in the 1980 Medici exposition in Florence[52] indicate that in the later sixteenth century,

Botticelli had not yet, so to say, vanished into the shadows in which he remained until the Uffizi's Quarto Gabinetto was arranged for display in the later eighteenth century. One suspects the latest paintings in the Lanzi-noticed room in the Palazzo Pitti were Uccellos, Fra Angelicos, and works by their contemporaries.

A different tale is told, however, by the forbidden list of Grand Duke Ferdinando I, first issued in 1601. This list reveals quite clearly that, by then, serious art was in effect believed to begin with the High Renaissance.[53] This of course continued to be the general view until the previously described, all-but-subterranean changes in eighteenth-century Italy began to have a wider influence on Western thought about Western art toward the opening of the nineteenth century.

Before what I have called the transition, in other words, even the greatest Italian collectors, as summed up and typified by Lorenzo the Magnificent, were active patrons of Renaissance artists, but did not truly collect Renaissance works of art. After the transition ended with general acceptance of the Vasarian canon, moreover, only a single major collector with the means to seek the highest prizes—in fact Cardinal Leopoldo de' Medici—is known to have bothered to *acquire*[54] a Botticelli throughout the whole of the seventeenth and eighteenth centuries, while important works of the High Renaissance giants and later masters admitted to the Vasarian canon were sought just as eagerly as important classical works of art. So how and why did Western art collecting move forward from the stage found at the end of the fifteenth century to the quite different stage found only about a century later?

On Isabella d'Este

The answer to this question comes in several parts, but one can begin with Isabella d'Este, by far the best-documented Italian art collector of the transitional period. Although it is now risky to be unflattering about any leading lady in the long drama of the past, I have to confess that I have never found the celebrated Marchioness of Mantua really likable. Her humanist culture, although famous in her own day, gives the impression of having been more for show than use. She could be remarkably cold-blooded in getting what she wanted, not least in her art collecting, as will be shown. Her priorities were also just a mite odd for a serious art collector. She cannot have paid less than 600 ducats, for instance, for the sable muff and cloak made of eighty sable skins and lined with crimson satin which she ordered for the wedding in Milan of her sister Beatrice d'Este and Ludovico Sforza;[55] and this contrasts sharply with the sums she was ready to pay great artists for fairly major paintings. But the facts of Isabella's career matter more than her character.

In brief, she was born in 1474, the daughter of Ercole I d'Este, Duke of Ferrara, and at barely sixteen she was married to Francesco Gonzaga, Marquis of Mantua. Since cash resources are the sinews of all collecting as they are of war, it may be noted that her income at the time of her early marriage appears to have been 6,000 ducats a year, rising to perhaps twice that at the time of her death in Mantua in 1539.[56] But during her husband's lifetime, she repeatedly had to pawn her jewels to help him over bad financial patches or to pay debts of her own; and she had nothing like the resources of the contemporary popes, or King François I, or even the great Sienese banker in Rome, Agostino Chigi, who could afford to have Raphael decorate his villa and his chapel in Santa Maria della Pace as well as his funerary chapel at Santa Maria del Popolo.[57]

Isabella d'Este's closeness with money (which I suspect was part natural as well as part necessary) was in some degree compensated, however, by her skill in organizing an impressive network of collecting agents, comprising all the Mantuan representatives in such cities as Rome, Florence, and Venice, plus friends in several Italian centers. Her friends were of all sorts and from high to fairly low degree. She never bought from a professional art dealer herself, so far as can be discovered, although her collecting agents dealt with traffickers in classical works of art, particularly in Rome;[58] and she either corresponded directly with artists from whom she commissioned or wished to commission work, or else she dealt with them through the agent network.

Finally, Isabella d'Este is the best art collector through whose views, successes, and failures one can study the nature of the period of transition in Italy, for three main reasons. First of all, her correspondence and other sources constitute an unmatched archive of documentation, and there is also an inventory of her collection, or, rather, of her last suite of apartments in Mantua, which was taken very soon after her death.[59] This inventory can be considered to give a reliable picture of the last state of her collection, too, since she always seems to have kept her own works of art in her own rooms, and thus separate from the possessions of her husband and, later, her son Federigo, who became the first Duke of Mantua. Second, and just as important, her collecting was both backward-looking in one way and forward-looking in another, and thus it was truly transitional in character. Third, and most important of all, her dealings with her preferred contemporary artists show an excessively exacting patron of the arts being turned into a collector, or at least being forced to try to become a true collector; and this is really the most interesting aspect of Isabella d'Este's art collecting.

The forward-looking character of Isabella d'Este's collecting activities may be dealt with first, since it can be briefly described. Even in her role as patron of the arts rather than true art collector, she looked forward

to the seventeenth century, as revealed by Grand Duke Ferdinando's 1601 list of artists whose works were forbidden for export, and by Frits Lugt's previously quoted remarks about the art market in the seventeenth century in Amsterdam. In her younger years at Mantua, she could easily have given commissions to Botticelli and Piero di Cosimo. On one occasion she was even urged to do so, but she ignored the suggestion.[60] She might also have secured one or more of Piero della Francesca's works at Urbino after Cesare Borgia's temporary expulsion of her unfortunate sister-in-law and close friend, Elisabetta Gonzaga, Duchess of Urbino, and her husband, the second Montefeltro Duke, Guidobaldo. Yet she did not lift a finger to get a Piero.[61] The sole early painter known to have interested her was "Giovanni di Bruggia"—almost certainly the name she used for Jan van Eyck[62]—but then Van Eycks are also recorded in more than one seventeenth-century collection. She owned two important Mantegnas and a Giovanni Bellini, but these two were named by Frits Lugt as the only exceptional, slightly earlier masters not altogether "drowned" by the High Renaissance.[63] As will be shown, she was well aware of the immense importance of the High Renaissance giants and sought works by several of them, albeit usually in vain. In gathering paintings, she also quite plainly had a cut-off point, beyond which she did not reach back in time (except for the Van Eyck). This point was the moment when Vasari credited Perugino with giving art "a new and more lifelike beauty."[64] And Perugino, of course, was on Grand Duke Ferdinando's list, even though he was added after the original list was promulgated.

It is this cut-off point of Isabella's, in turn, which makes her more predictive of the future of Western art collecting than most of the collectors described by Marcantonio Michiel or Bernardo Vecchietti in *Il Riposo*. What makes her a bit backward-looking, meanwhile, is the abundant evidence that she approached classical works of art in much the same way as Lorenzo the Magnificent, particularly sharing Lorenzo's bias in favor of classical and classicizing treasures at a time when first place was already beginning to be accorded to classical sculptures like the Apollo Belvedere. In 1502, she even sought to become one of the heirs of Lorenzo's collection. When she learned that some of his precious hard-stone vessels were on the Florentine market, she sent a letter to the Mantuan agent in Florence, Francesco Malatesta, asking him to have the pieces inspected by "Leonardo the painter, who . . . is a friend of ours."[65]

Malatesta complied, and reported to Isabella that "he praises all of them, but especially the crystal vase, which is all of one piece and very fine, and has a silver-gilt stand and cover; and Leonardo says that he never saw a finer thing. The agate one also pleases him, because it is a rare thing . . . but it is cracked. . . . That of amethyst, or as Leonardo calls it, jasper, is transparent and of variegated colors, and has a massive gold

stand [studded with] many pearls and rubies. . . . This greatly pleased Leonardo, as being something quite new, and exquisite in color. All four have Lorenzo Medici's name engraved in Roman letters on the body of the vase."[66] Malatesta also sent her colored drawings and gave prices: 350 ducats, 200 ducats, and 240 ducats, respectively, for those above-described, and 150 ducats for the fourth one, a "jasper vase, on a plain silver stand."[67]

It is doubtful whether Isabella bought any of the pieces Leonardo recommended. She was then going through one of her recurrent periods of financial stringency; and they cannot be identified in the inventory of 1542. But the inventory reveals that by the end of her life, she had accumulated more than seventy vessels of the sort Leonardo da Vinci inspected on her behalf.

Isabella evidently laid out large sums for such things, too, at any rate by her standards. Thus, in 1505, her friend the sculptor Gian Cristoforo Romano wrote her from Milan to recommend paying 400 ducats for a large rock-crystal, enameled-silver, and silver-gilt wine cooler which was being offered for sale by the famous Milanese goldsmith Caradosso.[68] This was the same man, incidentally, whom Ludovico "Il Moro" had sent off to Florence after the expulsion of the Medici, to negotiate with the Signory for things he wanted from the Medici collection;[69] and this is an indication that goldsmiths sometimes doubled in brass as dealers in costly objects. Quite possibly, a Florentine goldsmith was the seller of the pieces from the Medici collection that Isabella tried to get later.

At any rate, Isabella refused Caradosso's wine cooler, after taking it on approval;[70] but she had a look at "the most perfectly beautiful inkstand of this age or any other," as Gian Cristoforo Romano described it. For this inkstand, Caradosso was asking no less than 1,000 ducats. Isabella, who was a great haggler, probably beat down Caradosso. Yet it was certainly not an economical inkstand; and we can be sure it was neither of the two inkstands described in the 1542 inventory.[71]

Isabella d'Este's particular fondness for objects made of costly raw materials should not be regarded, however, as having dulled her enthusiasm for the other kinds of classical antiquities that Lorenzo de' Medici also collected, whether medals, coins, or carved gems, or, above all, pieces of sculpture. The intact garden-courtyard of her last suite of rooms at Mantua has a great number of niches[72]—empty since the sale of the Mantua collection of sculpture to King Charles I of England.[73] The niches alone are enough to indicate that she owned many major pieces of classical sculpture. In addition, there were Michelangelo's Sleeping Cupid and the marble Cupid lying on a lion's skin, generally regarded as a work by Praxiteles, but the inventories show these were small enough to be shown indoors.[74]

As I said earlier, one of her friends was Sabba da Castiglione; and most of his correspondence with Isabella from Rhodes concerns classical

sculpture. He managed to send to Mantua from Rhodes several marbles he acquired while serving there.[75] To get the antique sculpture then lying about disregarded in the garden of the Grand Master at Rhodes, Fra Sabba slyly advised that Isabella approach the Grand Master's nephew, the French Viceroy of Milan; but he begged her not to mention his own name, lest he be "handed over as a pagan and a heretic to the Inquisition."[76] This indirect approach apparently worked, too. Fra Sabba also suggested that he might manage to remove, pack up, and ship to Isabella quantities of sculpture from the remains of the Mausoleum of Halicarnassus;[77] for the Turkish town of Bodrum, just across the water from Rhodes, was of course built on, and partly out of, the ruins of Halicarnassus. But this ambitious plan fell through.

Furthermore, the previously cited letter from Giorgio di Negroponte is not the only indication in Isabella d'Este's correspondence of the fever of speculation in classical antiquities that gripped Rome in the early sixteenth century. In 1505, Gian Cristoforo Romano went from Milan to Rome, whence he wrote her: "So many fine things have been discovered since I was here last. . . . [But] many people take interest in these matters, so that it has become very difficult to get the best things, unless you are the first to see them and ready to pay well, as they soon fetch large prices. . . . I will keep my eyes open, and have already told the excavators to let me know, before anyone else, if they find a really good antique."[78] The mention of the "excavators" interestingly implies that there were now specialists in Rome who partly made their livings by mining for antiquities. Romano concluded that he would serve no one but his dear lady of Mantua in this manner, since he had always hated to see Rome "stripped of its treasures." When he was very young, he added, he had even done his best "to prevent such things going" to Lorenzo de' Medici.

On Collectors' Opportunities

What seems to me Isabella d'Este's cold-bloodedness also showed up fairly dramatically in her classical collecting. All serious collectors, to be sure, tend to have a cold-blooded strain. Deathbed watching is a standard collector's habit, for instance; and Jean, Duc de Berry,[79] King Charles I of England (or at least his overseas agents),[80] and a good many modern collectors I have known[81] were all eager deathbed watchers. So was Isabella. For instance, her close Venetian friend Michele Vianello, a major collector, was the original owner of Isabella's "Giovanni di Bruggia," a picture of the pursuit of Moses and the Red Sea overwhelming the host of Pharaoh. Evidently Isabella had always coveted it, and Vianello had barely breathed his last when she wrote off to Venice without a hint of regret to request that the picture be secured for her.[82] She had to bid hard for it against

another Venetian collector, Andrea Loredano, but she got what she wanted in the end, albeit for her top price for a picture, 115 ducats.[83] By the same token—although this really belongs with the data on Isabella's partial transformation into a true collector of Renaissance works of art—she shot off another letter to Venice as soon as she learned of the death of Giorgione, requesting the Venetian banker she usually went to for loans, Taddeo Albano, who was also a member of her agent network, to buy for her a "picture of Notte, very beautiful and original." This she believed to be in the dead master's studio,[84] but Albano had to reply that her belief had no foundation.[85]

The disasters of states, whether great or small, have always helped art collectors, too, in just the way collectors have been helped by deaths, bankruptcies, and other misfortunes among those with enviable possessions; and nothing evoked displays of Isabella d'Este's chilly single-mindedness like political disasters which might put pieces of classical sculpture and other works of art within her reach. In 1506, when Pope Julius II drove out the tyrant of Bologna, Giovanni Bentivoglio, she promptly sought to obtain antique marbles from the Bentivoglio collection.[86] (The Pope's victory also opened the way for Lorenzo Costa to come from Bologna to Mantua, to replace the dead Mantegna.) But the most remarkable display of Isabella d'Este's lack of remorse in her dealings occurred still earlier, in 1502, when Cesare Borgia drove the Duke and Duchess of Urbino out of their state by a treacherous surprise attack.

As the Duchess was both her sister-in-law and her intimate, Isabella was happy to make the refugees welcome at Mantua. But meanwhile she wrote to Rome, to her brother, Cardinal Ippolito d'Este, to point out that "the Lord Duke of Urbino, my brother-in-law, had in his house a small Venus of antique marble, and also a Cupid, which were given him some time ago by His Excellency the Duke of Romagna [one of Cesare Borgia's earlier titles]. I feel certain that these things must have fallen into the said Duke's hands. . . . I desire exceedingly to possess these statues, which does not seem to me impossible, since I hear that His Excellency has little taste for antiquities, and would accordingly be the more ready to oblige others."[87] She went on to ask for Cardinal d'Este's good offices with Cesare Borgia, authorizing the Cardinal to use her name, and to explain that she was so eager that she had sent an express courier with her letter. But no word was written about the Urbino Pieros, as I have said.

Just a little later, there is a letter to her husband in Milan, mainly concerned with the recovery of the dowry of his unfortunate sister, the Duchess of Urbino. Yet this letter also exults over the arrival of the Urbino statues; and the postscript returns to the subject with evident delight: "I do not write of the beauty of the Venus, because I believe Your Excel-

lency has seen it, but for a modern thing the Cupid has no equal."[88] According to Condivi, who ought to have known, the Cupid was in fact the very early Michelangelo that had been palmed off on Cardinal Riario as an antique.[89] Following its rejection by Cardinal Riario, it had evidently come into Cesare Borgia's hands, and was then passed on during the early period when the Borgias sought good relations with the Duke of Urbino.

Later still, when Cesare Borgia lost his power after the death of the Borgia Pope and the Montefeltro regained Urbino, the restored Duke and Duchess tried to get their possessions back from Isabella. She would have none of it, however, reminding her brother- and sister-in-law that she had requested their permission to secure the two pieces of sculpture from Urbino's conqueror.[90] To this the English scholar Andrew Martindale added dryly that since the Duke and Duchess of Urbino were in "refuge in Mantua at the time, the answer to her request [of them] must have been a foregone conclusion."[91]

We have now placed in Isabella d'Este's elaborately arranged apartments at Mantua both the pieces of sculpture, the classical Cupid attributed to Praxiteles and Michelangelo's fake antique, which Daniel Nys later classed as two of the three "rarest things" the Gonzagas owned. Nys has already been seen trying vainly to hold out for himself these two works when he acted for King Charles I in the purchase of the Gonzaga collections, and then giving up in alarm and sending them to England.[92] Later in this essay, the Michelangelo will be met with again for the last time. Meanwhile, it is high time to tackle what is really the most revealing feature of Isabella's activities having to do with art—in fact, what I have called her partial and forcible transformation from patron of the arts into a true, albeit far from successful, collector of Renaissance works.

A Forced Transformation

The whole weight of the evidence of Isabella's correspondence indicates that as long as she was acquiring works of art, she vastly preferred the role of patron in dealing with contemporary masters, and furthermore liked to carry to absurd lengths the unavoidable share of all patrons in shaping the works of art they commission. She was not only fussy and exacting about the arrangement of her own apartments, and wished every contemporary work of art to fit exactly into its envisioned place and also to "go" with the other works in place already. In addition, she had a passion for imposing on artists she patronized her own pictorial programs, always pointing morals and often calling for inordinate numbers of figures in each painting—such programs, in fact, as were all but certain to prevent any artist from doing his best.

The last two major paintings she acquired were the Allegories of Virtue

and Vice by Correggio, who seems to have been a pliable fellow. Behind these two pictures, one cannot doubt, were two of Isabella's characteristically complex and flossy programs, obviously intended to exhibit her borrowed plumes of learning.[93] At any rate, the contrast is dramatic between the two Allegories and the other, far more impressive pictures Correggio did for Isabella's son Federigo, the Jupiter and Antiope,[94] also in the Louvre, the School of Love,[95] in London, and the series of the Loves of Jupiter, one now in Berlin, one in Rome, and two in Vienna.[96] One almost suspects that Federigo, who did not always get on well with Isabella, wished to show his mother what a great artist could achieve when he was given room to do so, as it were.

Isabella's contrasting impulse to give her preferred artists a minimum of room for creative choice is apparent from very nearly the start of her career. The first pictures to ornament her apartments at Mantua were Mantegna's Parnassus, or Triumph of Love, and its companion piece, the Triumph of Virtue. The programs behind these paintings do not survive, no doubt because Mantegna was already resident in Mantua and did not need to be instructed by letters; but no one can examine Mantegna's two paintings for his new mistress without concluding that he had to follow externally provided programs—although he solved the problem reasonably successfully. It was different, however, when Isabella decided she wanted a companion piece to the Mantegnas from Perugino. Her instructions to the Florentine agent already met with, Francesco Malatesta, were extremely explicit. The artist was to be persuaded "to accept the task of painting a picture on a *storia* or invention which we will give him, with small-sized figures, such as those which you have seen in our *Camerino*"[97] —meaning the two Mantegnas.

Perugino was at first hard for Malatesta to reach, and it was Malatesta who therefore suggested going to the more easily accessible Botticelli or Piero di Cosimo—with no result whatever.[98] But Perugino was also a businesslike fellow, and he soon agreed to do the desired picture, once Malatesta got hold of him, and at the offered price, which was 100 ducats. He promised to finish the task in a few months, accepting a down payment of 20 ducats.[99] Isabella d'Este then sent him her program for the picture: "My poetic invention, which I wish to see you paint, is the Battle of Love and Chastity—that is to say, Pallas and Diana fighting against Venus and Love. Pallas must appear to have almost vanquished Love. After breaking his golden arrow and silver bow, and flinging them at her feet, she holds the blindfold boy with one hand"—and so on, and on, and on, through a whole series of other gods and goddesses and mythological figures and "thousands of little loves."[100]

It is not surprising, then, that poor Perugino, with his propensity for plenty of space in his compositions compared to relatively few, large figures,

seems to have been floored by the job he had promised to do. This was probably why he endlessly put off the work. Yet the program provided by Isabella should not absolutely surprise us, either; for it merely amounts to a rather pompous and detailed transcription into the terms of the more superficial sort of late Renaissance humanism, of the iconographic programs for religious pictures that patrons sometimes specified down to the time of the High Renaissance and even thereafter. Isabella was helped with the program by her humanist friend Paride da Ceresara.[101] In any case, Perugino signed his contract with Isabella in 1502, but had done nothing at all by 1504. He at length explained that he did not understand the size he ought to give the personages in the foreground of his proposed picture.[102] Whereupon Isabella wrote him, in January 1504: "The enclosed paper, with the thread wound around it, gives the length of the biggest figure on M. Andrea Mantegna's pictures, close to which your own will hang. The other figures behind can be of any size that you like."[103]

Even so, a whole series of agents and friends had to be used to put pressure on Perugino, and, at one moment, Isabella even threatened to bring suit for return of her down payment,[104] before the picture was finally finished and delivered to Mantua in the late spring of 1505. To complete the story of this Perugino, it did not absolutely please Isabella (and one can see why).[105] Yet it remained in her rooms along with the two Mantegnas and two related paintings by Lorenzo Costa that were added later, with the two Correggios eventually completing the pictorial décor of the last apartments Isabella occupied.[106]

The point of this whole story, meanwhile, is that both the Mantegnas and the Perugino were carefully, indeed overcarefully, planned as part of a unified scheme of decoration of a known setting; and like the five Uccellos and Pesellino in Lorenzo de' Medici's bedroom, they were incorporated into the actual architecture of their intended setting by their pedestals and frames. Perugino himself quite understood this. Thus he chose his want of knowledge of the dimensions of Mantegna's foreground figures as the best excuse for his own delays; and Isabella herself, though so impatient, accepted the excuse without argument and sent him the paper and thread to ensure decorative unity. Isabella was obviously not indifferent to the fact that both Mantegna and Perugino were famous masters of the slightly older generation, but when she gave them her commissions, she most emphatically did not cross the border between art collecting and art patronage.

In other words, in the age-old way, she still thought first of the setting to be enhanced, and then of the work of art that was to enhance it, instead of thinking (and coveting) only the individual work of art as an end in itself, without regard to setting or context, and as a collector's prize comparable to, though different from, Lorenzo de' Medici's Tazza.

In her dealings with other great masters, however, Isabella d'Este was undoubtedly driven to cross this highly significant yet not easily definable border between patronage and true collecting.

Giving In

All this is adequately proved by the data on Isabella's dealings with other masters less easy to bully than Perugino. We may begin with the revealing story of her commission to Giovanni Bellini. She first tackled the great but already aged Venetian through his fellow citizen Michele Vianello. Evidently Vianello, who had been visiting the Mantuan court, had there been provided with Isabella's proposed pictorial program, or *storia*. He reported from Venice that Bellini was sadly overworked but would undertake the commission, "both for your sake and for love of me." He warned that Isabella would have to wait a year and a half, and concluded: "As to the price, he asks 150 ducats, but may reduce it to 100. This is all I can do."[107] On those terms, Isabella closed the bargain, and rather belatedly sent 25 ducats to Vianello, to give Bellini as a down payment. Before long, however, Bellini was grumbling that Isabella's *storia* would not permit him to "do his best,"[108] and this produced a breakthrough of sorts.

Isabella wrote Vianello that she was "content to leave the subject to [Bellini's] judgment, as long as he paints a story or fable . . . representing something antique."[109] She added that she would send measurements of the picture's desired size—for she was still preoccupied with the way it would fit into its intended setting. Over a year passed, however, with no result from Bellini, whereupon Isabella lost patience altogether and wrote to Vianello abandoning her first project. She then asked him to offer Bellini the choice between returning the 25-ducat down payment, or being sued for its return, or giving her a "Nativity [which] should contain the Madonna and Our Lord God and St. Joseph, together with a St. John Baptist and the usual animals."[110] To this Bellini agreed; but there was a further hitch. Isabella insisted upon reducing the price of her Bellini to 50 ducats, since his picture would be smaller than the originally proposed painting, and would also have to hang in a bedroom (that context, again!) because of its religious subject.[111] Bellini, after balking a bit, accepted the reduction to 50 ducats. Yet there had to be another threat of a lawsuit, before the picture was finally delivered to Mantua in the summer of 1504.[112]

Nothing daunted, Isabella returned to the attack upon Bellini only a year later, this time persuading Pietro Bembo to bring really extreme pressure on the old man to do her a picture of a classical subject. On August 27, 1505, Bembo was able to report that he had joined with a special

friend of Bellini's, Messer Paolo Zoppo, to give "him such a battle that I think the castle will surrender."[113] By November, Bellini had agreed to do the painting,[114] and in January 1506, Bembo wrote Isabella from Venice that Bellini "was only awaiting the measurements of the canvas," although he warned her that the *"invenzione"* would have to be left entirely to the artist, since Bellini had "his own ideas."[115] In the end, however, the castle did not surrender. Bellini was to die years later, never having done the painting of a classical subject that Isabella had always wanted from him.

As for the giants of the mature High Renaissance, Leonardo da Vinci did a portrait drawing of Isabella while visiting Mantua.[116] She also had an active role in the commission to Raphael to paint a portrait of her son Federigo while the latter was in Rome as a boy.[117] But one suspects the master only accepted the commission because Federigo had become a great favorite with Pope Julius II.[118] After Pope Julius died, the portrait was probably finished by one of Raphael's studio assistants, and furthermore passed into the possession of a member of a cardinal's household, from whom Federigo much later obtained it with the help of political pressure.[119] Correggio was in fact the only leading painter of the mature High Renaissance really importantly represented in the Marchesa's own collection.

This was not for want of trying on Isabella's part, however. Even before approaching Perugino for the painting intended to match the two Mantegnas, she began a determined assault on Leonardo da Vinci. Her first approach was made through the Carmelite Vicar General, Pietro da Novellara, in March 1501. Isabella evidently realized from the outset that dealing with Leonardo was by no means like dealing with masters of the order of Perugino or even Giovanni Bellini. If Leonardo agreed to paint a picture for her studio (where her paintings were then shown), she announced she would leave the subject entirely to him, but if he proved unwilling to undertake anything on a significant scale, she said she would be glad to have a small Madonna.[120]

The Vicar General did his best with Leonardo, but got nowhere.[121] Isabella then made another attempt, sending a letter of her own to Leonardo through the envoy of Ferrara in Florence. But the new intermediary got no more than a promise of an eventual answer to Isabella.[122] Still another flattering letter was then sent to Leonardo himself, through a third intermediary, saying that Leonardo could name his own price, and this time suggesting a figure of Jesus Christ at twelve years old, when he disputed with the Doctors in the Temple.[123] There was still no result; nor was there any result in 1506, when the Marchesa made her last vain effort to get what she wanted from Leonardo, this time mobilizing his own uncle, Alessandro Amadori.[124] And so that chapter ended when Leonardo left Florence again.

The same rules governed Isabella's somewhat later dealings with Raphael. No prices mentioned; a good deal of blarney to please the great man; no hint of another complicated program; and the mobilization of the most influential intermediaries available—such were the rules. In Raphael's case, it would appear that the Marchesa made the first approach in person when she met the master during a visit to Rome; but all she got was plenty of politeness and empty promises.[125] The main intermediary thereupon employed was one likely to produce results if anyone could, Baldassare Castiglione, who was Raphael's close friend. Castiglione first wrote Raphael from Urbino, and then went after him face to face in Rome with apparent success;[126] whereupon Isabella allowed her hopes to rise to the point of sending a canvas of the size she wanted to Castiglione, as Raphael had encouragingly requested.[127] Later, in 1519, she had a report from Rome that Raphael had actually begun work on the desired picture, but the author of the report, the Ferrarese envoy in Rome, had learned from Castiglione himself that Raphael was in reality only making a show of working when Castiglione was almost literally standing over him during visits to his studio.[128]

There is nothing in Isabella's surviving correspondence, either, to show that she ever got the Raphael she longed for. She would certainly have crowed over it in her letters if she had ended by securing a work by Raphael for herself. All the same, the successive assaults on Leonardo and Raphael have been worth describing at some length because they show so clearly how such factors as the new social standing of the greater artists of her time forced Isabella d'Este to experiment, one may be sure most reluctantly and also unsuccessfully, with the role of a true collector of contemporary works of art. She would surely have much preferred the situation prevailing in the fifteenth century, when Ghirlandaio was apparently happy to accept the kind of contract he signed with Giovanni Tornabuoni, despite all its detailed conditions and instructions and because the price was right.[129]

It cannot be too often underlined that the key feature of the role of all patronage of the arts is what I have called the patron's share in the works of art they commission. Isabella d'Este's obvious preference was for enlarging this share very nearly to the point of guiding the painter's brush and the sculptor's chisel in person. Yet she was a shrewd and worldly woman. She must have known that a far more humble approach was essential to get a painting from Leonardo da Vinci, who painted so rarely, was so easily diverted by other interests, and already had a reputation in his lifetime as a mysterious universal genius. (When Isabella's siege of Leonardo began, one of her intermediaries offhandedly explained that getting a picture from the master was likely to be impossible, because his sole current preoccupation was mathematics.)[130]

As for Raphael and Michelangelo, they were not mages in the way

Leonardo came close to being; but they were clearly the Western art tradition's first recognized princes of art. They were besieged with commissions from patrons who could afford to be much freer with their money (or the money of the public treasuries they controlled) than Isabella d'Este could ever think of being. Michelangelo's earnings were so great that he single-handedly restored his decayed family to a high place in Florence. Raphael, who lived far more splendidly than Michelangelo, even had his own palazzo in Rome. Both were courted by popes and princes, and both had intimate friends close to the highest levels of the Italian world of their time.[131] In sum, these two, with Titian, announced the new place that leading artists have been able to claim in the Western world ever since their time—at any rate, as soon as their preeminence as artists has been widely accepted. The before-and-after differences implied by this new social development deserve more detailed and comprehensive study some day.

In contrast to his mother, finally, Federigo Gonzaga, first Duke of Mantua, was ready to play either the collector's or the patron's role with equal enthusiasm if the inducement was strong enough, and he was also a very great patron of the arts, with a fine eye and a decent sense of limits. In his dealings with Titian and Giulio Romano as well as Correggio, he was in fact almost uniformly and brilliantly successful. Correggio's paintings done for Federigo have already been mentioned. Titian also undertook to paint a whole series of Roman emperors, very famous at the time.[132] Titian in fact delivered eleven emperors, but the authorities disagree as to whether this was the entire set, or whether one emperor was missing and had to be supplied by another hand. In any case, this was emphatically a patron's commission, for the imaginary portraits had to fit prepared spaces in the room they were to decorate. (This series of paintings constituted one of King Charles I's proudest acquisitions from Mantua. After his execution, the emperors were bought at the dispersal of the King's collection by Philip IV of Spain, but were, unhappily, lost in a fire in Madrid in the eighteenth century.)[133]

In addition, Federigo of Mantua also acquired other works by Titian. Their correspondence about the Magdalen which Titian painted for the Duke indicates that although Federigo could possibly have chosen the subject, the master was left an almost entirely free hand to paint as he liked according to his own "great concepts."[134] Furthermore, Federigo freely made the transition from patron to true collector, as is shown by what happened when he decided he must have a major Raphael for Mantua after the master's death.[135] It did not alter the case, either, that he was fobbed off with a copy by Andrea del Sarto; for a collector can hardly be blamed for being fooled by a splendid copy which also deceived Raphael's chief studio assistant.

Federigo was also quite astute enough to understand that any attempt to resume the patron's role would be inappropriate when he further decided that he wanted for Mantua a work by the mature Michelangelo, to supplement his mother's Sleeping Cupid in the master's earliest style. Instead of offering Michelangelo a commission, Federigo merely begged for the Pope's help in persuading Michelangelo to send to Mantua anything at all the master chose for the purpose.[136] Once again, Federigo was thus acting as a true collector. Even so, he met with no success.

The Art Market's Origin

As might be expected by any worldly reader who has got so far, something resembling the modern art market also began to come into being because of the many factors at work in the transitional period in the first half of the sixteenth century. An additional factor hardly yet covered supplied the first stimulus for the organization of a proto-modern art market: the dissemination beyond the Alps of the art and taste in art of the Italian Renaissance.

This did not happen all at once. Lorenzo de' Medici, for instance, corresponded with King Louis XI of France, but Louis XI did *not* ask Lorenzo for works by the great Florentine masters of that time. Instead, the French King particularly wanted a holy relic with a high reputation for curative powers.[137] After the French expedition which was the beginning of the end of Renaissance Italy, King Charles VIII brought home painters—but they appear in the same contemporary list as Italian gardeners and cooks.[138] Certain of the French King's higher officers, however, sought classical sculpture in Florence,[139] and, in 1501, one of them demanded a bronze David, which was furnished by Michelangelo.[140] Such was the first intimation of what was to come.

The intervening developments, which were complex, need not be covered. What came next in 1527, after the second expulsion of the Medici from Florence, was the unscrupulous member of the Florentine upper class whom Martin Wackernagel dubbed "the first art dealer."[141] He was sent back to Florence from France by King François I to secure Italian works of art for the French royal collection.

He was not really the first art dealer, one must add, for there had been major dealers in the classical world, and we have the names of several Chinese dealers from as early as the Tang dynasty. As has been seen, furthermore, there had been Western traffickers in classical works of art at least as early as the opening decades of the fifteenth century—the time of Fra Francesco da Pistoia and Ciriaco d'Ancona—and by the early sixteenth century, the trade in classical works must have been brisk in Rome, although we have the names of only two of the traders, the earliest being

Baldassare del Milanese, the man used by Michelangelo to sell his fake-antique Sleeping Cupid in Rome.[142] In the fifteenth century, in addition, there were also minor merchants in the Low Countries who were at least semispecialized in selling paintings;[143] and someone besides the artists must have profited from the fairly numerous paintings exported from the Low Countries to Italy. But all that is by the way, for Wackernagel's "first art dealer" was nonetheless a significant portent for the future.

Giovanni Battista della Palla was a minor member of the anti-Medici faction who had been expelled from Florence after the first return of the Medici. He sought refuge in France, and he made many friends there as a fashionable specimen of Florentine gilded youth. In 1527, when the second expulsion of the Medici occurred, Della Palla hastened back to Florence with his commission from King François I;[144] and he did a big business for several years thereafter. His opportunity chiefly arose, of course, for the practical reason that the still-normal artist-patron relationship was difficult to sustain over long distances and with bad communications.

Some things Della Palla had made for special purposes, like the fountain sculptures by Tribolo he supplied for Fontainebleau, and copies by Ridolfo Ghirlandaio of Pollaiuolo's Hercules paintings, which had been moved by this time from the Palazzo Medici to the Palazzo Vecchio.[145] Some things he simply commissioned as good market speculations, like Andrea del Sarto's Sacrifice of Isaac, now in Dresden, and a Charity by the same artist.[146] Some things, too, he got at second hand, like the Fra Bartolomeo of St. Sebastian, from the Chapter House of San Marco. This was a picture that had been removed from public view because certain pious ladies confessed that the sight of the beautiful naked youth had moved them to wrong thoughts.[147] As an art dealer, moreover, it is clear that Della Palla was characteristically capable of extreme toughness when he saw a chance to turn a profit, as is indicated by Vasari's account of his attempted raid on the Palazzo Borgherini to get the painted decorations whose subsequent dispersal was so deplored by Wackernagel in a passage quoted earlier.[148]

The wealthy Pier Francesco Borgherini was in political exile in Lucca when Della Palla persuaded the Florentine Signory that the decorations of the room in the Palazzo Borgherini which Wackernagel later wrote about would make a most acceptable present to King François I. The room had been decorated with panels painted by Jacopo Pontormo with scenes of the life of Joseph; and Vasari considered that the finest work Pontormo ever did was the scene of Joseph in his wealth and power in Egypt, receiving his father Jacob and his brothers who had once betrayed him.[149] Other masters were represented, too, and the room further contained an Andrea del Sarto Madonna.[150] Although Della Palla had the Florentine Signory behind him, however, he reckoned without Madonna Margherita, the wife

of the exiled Borgherini, who had been left behind in Florence.

She repelled Della Palla's attack on her house with a torrent of invective that would have caused the brassiest, greediest modern art dealer to go cringing down the stairs again.[151] As to Della Palla's end, he was jailed by the Medici after their second and final return in 1530 and executed in 1532 by order of Pope Clement VII.[152] As to the end of the room decorations that Madonna Margherita so spiritedly saved, they lasted Vasari's time; but not long thereafter this great decorative ensemble was broken up and its elements were sold. Parts of it are still to be seen in Florence, Rome, and London.[153]

Giovanni Battista della Palla undoubtedly made his own speculations on works of art to be exported from Florence to France. It would be astonishing if he had not done so. Yet just as undoubtedly, he was primarily an agent buying on commission for the French King and doing so at François I's behest. This was why he was no more than a portent, as remarked earlier. Throughout the sixteenth century and much of the seventeenth as well, moreover, no great artist I have been able to discover produced paintings directly for an art dealer in the modern manner. Although the dealings of Philip II of Spain with Titian rather plainly make the Spanish King not just a patron, but also a collector of works by a great contemporary master (for he evidently let Titian have his head in a way at least one remove from ordinary patronage), Titian mainly dealt with patrons of the arts like the Emperor Charles V; above all, if he occasionally sold paintings on the market—which is disputable, although I think he did— he handled the sales himself.[154] Titian's example was followed for a long time by the leading masters who came after him.[155] As noted in an earlier chapter,[156] Salvator Rosa in his maturity was furthermore the first significant master to insist upon painting almost all his major works without any patron's intervention, for subsequent disposal to the seventeenth century's growing number of collectors.

These conditions left a prospective art dealer no room except for the traffic in classical works of art, in treasures and quasi-treasures of different kinds, and in works by major Renaissance masters which might come on the market because of the misfortunes of the powerful families that had owned them. Even so, this was enough to permit the emergence in the mid-sixteenth century of the earliest great art dealer in the Western record to operate in a style fully resembling the Duveens and Wildensteins of the twentieth century.

This man was Jacopo Strada. Born at Mantua in 1507, by 1549 a citizen of Nuremberg, residing in Vienna by 1556, Strada yet did much of his business in Venice for a long period of time.[157] This was a natural base for Strada to have chosen. On the one hand, most of the great Florentines and Florence-trained masters of the High Renaissance had chiefly worked

in maturity outside the city, or in Florence for non-Florentine patrons, as Michelangelo did for a series of popes; and the later fifteenth-century Florentine masters already had little interest for international collectors. On the other hand, the great sixteenth-century Venetian masters were in strong demand, and Venice was conveniently full of collections belonging to grand families suffering from want of funds.

Strada served as court antiquary to the Hapsburg Holy Roman Emperors Ferdinand I and Maximilian II, as well as the Emperor Rudolph II, with whom his relations must have been assisted by the fact that Strada's daughter, Katharina, was the Emperor's mistress.[158] But he had other rich and powerful customers, too. This was the period when Duke Albrecht V of Bavaria acquired most of the strange array of antiquities and fake antiquities covering a large part of the walls of that even stranger chamber, like a Mannerist wedding cake turned inside out, the Antiquarium in Munich.[159] Strada eventually transferred to Munich to serve the Duke.

In some respects, Crowe and Cavalcaselle's nineteenth-century life of Titian has no doubt been superseded by later research, yet this book's last chapter still remains the best study of the circumstances favoring Strada's conspicuous success.[160] Not just the Emperor Rudolph and Duke Albrecht, but a good many princes north of the Alps were now beginning to feel that an art collection was a necessary ornament among the possessions of a European ruling house; and magnates like the Fuggers were buying as well. Meanwhile, too, Venice was not the only Italian city in which the loss of the former Italian commercial pre-eminence was loosening the market. Works of art were not too hard to come by, in other words, because "impoverished descendants of great houses . . . parted secretly with heirlooms to fill their purses."[161]

Isabella d'Este's friend Cardinal Pietro Bembo had made special arrangements, for example, to have his considerable collection kept permanently together; but his son and heir, Torquato, "secretly disposed of the best pieces from time to time," parting with "some of his treasures to Strada . . . before 1567," and in the end getting rid of "almost all."[162] In the same period, famous Venetian families like that of Isabella's collecting competitor, Andrea Loredano, were starting to do the same sort of thing as Torquato Bembo, and the heirs of Giulio Romano were briskly selling off his classical marbles.[163] In this traffic, Strada collaborated with several lesser men like Niccolò Stoppio. In his turn, Stoppio also had fairly acrimonious dealings with Titian himself, concerning the sale of a costly crystal casket to Duke Albrecht of Bavaria, for Titian loved money and was not above turning an extra ducat by selling fine things for other people on commission.[164] Titian painted a portrait of Strada,[165] and he may have given it to him in return for promises of German princely commissions, just as he gave away other pictures to Pietro Aretino[166] and to the Farnese for promotional purposes.[167]

The court antiquary was an interesting figure in other ways, as well. He was an ardent collector of drawings, for example. Part of his collection seems to have originally belonged to Sebastiano Serlio;[168] and from Serlio he acquired the manuscript of his *Seventh Book of Architecture,* which Strada published, with an introduction, in Frankfurt in 1575.[169] In addition, he secured all the Raphael drawings belonging to Giulio Romano from the heirs of Raphael's principal studio assistant.[170] He was also a numismatist, and one may be sure he supplied his princely clients with antique coins and medals as well as sculpture.

As the bric-a-brac in Titian's portrait of Strada reveals, classical antiquities were evidently more important to Strada than Renaissance works of art. The same point is made by the character of the collection of Albrecht V of Bavaria, already noted. The really intense hunt for Renaissance old masters only began in the late sixteenth and early seventeenth centuries. Someday, one hopes, a comprehensive study will be made of this whole curious, often sordid but significant commercial process of the modern art market's first organization, but that is not the task of this essay.

The Later Sixteenth Century

So far as the sixteenth century is concerned, in fact, this essay's task has been almost completed. Enough has been said already about how Western art history began with Giorgio Vasari's *Lives*—for this is still a great and pioneering work if considered in the context of its time, despite the fact that correcting Vasari's many inevitable errors later became a minor scholarly industry. Only a few more pages are therefore needed, first to suggest the somewhat mixed state of art collecting which still persisted at the close of the sixteenth century, and then to show how the future was nonetheless plainly predictable before the year 1600.

The Austrian Archduke Ferdinand II of Hapsburg, who ruled the Tyrol, all but certainly thought of himself as an art collector. Yet by any rational test, his Ambrasianum, the huge collection the Archduke assembled in his Schloss Ambras, was no more than a giant *Wunderkammer.* To be sure, the Archduke owned a few great art collectors' prizes by any standard, such as his Dürer sketchbook, now in the Albertina in Vienna. He also owned a fair number of paintings and pieces of sculpture, very seldom of first quality, in the classes that conventionally appeared in the true art collections of his time. But above all, he owned vast numbers of *Wunderkammer* objects—in fact, curiosities that were undoubtedly thought desirable for ethnographic-historical reasons; or because of their exotic origins, like his extremely early Japanese export lacquer;[171] or because of their exotic raw materials, such as his immense assemblages of things made of amber, rhinoceros horn, and the like.[172] And this is a most incomplete list.

A fair number of the Archduke's *Wunderkammer* objects, to be sure, have come to seem extremely beautiful in our eyes because of the great changes in the Western way of seeing which so obscurely began in the eighteenth century. My own favorite is the feather crown, with its waving quetzal plumes worth far more to the Aztecs than their weight in pure gold, which Montezuma included in his first great propitiatory gift to Cortez.[173] This gift to Cortez was seen by Albrecht Dürer in Brussels, for the feather crown was among the Aztec things of all sorts which made Dürer marvel at the *Ingenia* of foreign peoples.[174] From this treasure, the feather crown and other featherwork from Cortez' spoils were given by the young Emperor Charles V to his brother, Ferdinand of Austria; and from Ferdinand I the featherwork was then inherited by his son, Archduke Ferdinand II of the Tyrol,[175] the man who mainly built up the Schloss Ambras collection. This was how these marvels of Aztec featherwork luckily escaped the final fate of most of Cortez' gift, when the loot from Mexico was either melted down for the gold and silver, or sold for what it would bring, or simply discarded if there were no offers.

How such things were then thought about is suggested by the fact that the feather crown given Cortez by Montezuma, after being embezzled from Schloss Ambras by the reigning Hapsburgs after Archduke Ferdinand's death,[176] is now to be seen in the Museum für Völkerkunde in Vienna.[177] But being treated as an ethnographical exhibit does not make it less lovely. It fully equals such things in the Hapsburg *Schatzkammer* itself as the coronation cloak added to the sanctified regalia of the Holy Roman Empire by Frederick II Hohenstaufen, with its inscription, inwoven in the border by Palermo's Muslim weavers, who made the cloak for Roger II d'Hauteville, somewhat ironically begging Allah in Arabic script to protect the ruler's health and grandeur.[178]

But that is by the way. The Schloss Ambras collection has been touched upon primarily to indicate the varied character retained by much European collecting, even as late as the sixteenth century's closing decades. Meanwhile, the road that really grand European collecting would take for another two centuries and more was much better revealed by a remarkable incident of late-sixteenth-century art collecting in Rome, which has just been rediscovered with fairly dramatic results. The story is worth retelling briefly, and will make a good end to this chapter.

In brief, the foundation collection of the London National Gallery was formed by the founder of Lloyd's, Sir John Julius Angerstein; and it contained a portrait of Pope Julius II attributed to Raphael. The picture's quality was concealed by heavy coats of varnish, and it was soon placed in the National Gallery's reserves as a mere copy. Only a few years ago, the sharp eye of Konrad Oberhuber, now of Harvard, discerned an exceptionally fine painting through the obscuring varnish. This happened while

Professor Oberhuber was visiting the National Gallery's reserves.[179] In consequence, the National Gallery had the picture cleaned, revealing a real Raphael of great power and beauty.

A difficulty existed, however, since the Uffizi owned another portrait of Pope Julius which had long been held to be the original by Raphael.[180] X-rays nonetheless showed that the National Gallery's portrait had the *pentimenti* which are a characteristic feature of original pictures, since even the greatest masters, in fact the greatest masters above all, are given to trying different effects before completing a work. At this point, therefore, Cecil Gould, then assistant keeper of the National Gallery, took over where Oberhuber, the cleaners, and the X-ray technicians had left off, and happily discovered the significance of what appeared to be an inventory number on the back of the picture.[181]

This was the necessary clue leading back to the later-sixteenth-century story above-mentioned. The story's hero, or villain, was Cardinal Sfondrati, nephew of the Sfondrati Pope, Gregory XIV. Before Gregory XIV ascended the Throne of St. Peter in 1590, his nephew had apparently started collecting pictures already, but his collection largely consisted of what the French dealers call *croûtes*. With all the advantages of a papal nephew to assist him, however, Cardinal Sfondrati boldly stole—one can hardly use any other word—two Raphaels from the Church of Santa Maria del Popolo, a Madonna and the portrait of Pope Julius which the Pope had given his family church as a personal memorial. Unhappily, Pope Gregory XIV then died almost immediately, in 1591.

Cardinal Sfondrati thus found himself with his main source of supply abruptly cut off. Hence he began trying to peddle his collection to various Italian and European grandees, using the two Raphaels as the grand attractions. He found no takers at first since he insisted on selling the collection *en bloc*, with all the bad pictures along with the Raphaels.[182] Cardinal Sfondrati was finally rescued, however, by the advent of one of the heaviest spenders in the long line of papal nephews, Cardinal Scipione Borghese, who made the block purchase in order to get the Raphaels.

Fortunately for Cecil Gould, too, the Borghese collection was inventoried at an early date, and inventory numbers were placed on the backs of the pictures. Gould looked up the inventory, found the Raphael portrait with its number, and then joyfully saw that the Borghese inventory number was the same one still discernible on the National Gallery's portrait of Pope Julius.[183] This feat of scholarly detective work, plus the presence of *pentimenti*, plus the obvious quality of the portrait after its cleaning, then forced general agreement that this was Raphael's original after all.[184]

To complete the story, the Raphael Madonna which Cardinal Sfondrati also stole from Santa Maria del Popolo has now been identified, in much the same way, in a painting long thought to be a copy of the so-called

Madonna of Loreto. This Raphael is in the Musée Condé at Chantilly.[185] Cleaning, discovery of the right Borghese inventory number on the back of the picture, the presence of conspicuous *pentimenti*, the quality revealed by the cleaning—all the same proofs are there. So this picture has now been transferred from Raphael's studio assistant, Penni, to the great master himself.[186] The two mottoes of the twin stories are: Now-you-see-it-now-you-don't is a common rule in the history of art collecting; and quality often wins in the end, at any rate with the aid of modern scholarship.

But the twin stories are also important for the history of Western art collecting, because Cardinal Sfondrati's use of his stolen Raphaels as drawing cards suggests the beginning-triumph of the Vasarian canon—which ironically included the triumph of Raphael as the greatest painter of all time, although Vasari undoubtedly admired Michelangelo much more.

And now there is no more left to get through except brief final remarks on the main features of seventeenth-century art collecting—which completely prefigures modern art collecting—plus short reflections on the meaning of the odd facts in this essay.

XIV

THE SEVENTEENTH CENTURY

A few significant loose ends still need to be tied up. A little space will still be needed for brief reflections on some of this essay's larger implications. A halt will then be called, although it is tempting to go onward.

Going onward is tempting because the history of Western art collecting from its beginning in the fourteenth century to about 1700 is so much less spectacular than the ever-more-extravagant history of collecting from the end of the seventeenth century to the present. Yet illuminating hitherto obscure origins is certainly more useful than recounting oft-told tales; and this is the practice I have followed in this essay. Art collecting in the West unquestionably reached its first maturity in the seventeenth century, and there are obvious practical reasons for ending this overlong essay forthwith.

This is not to say, of course, that the history of art collecting and the other by-products of art in the West was in the least sterile after 1700. Not only did collecting develop continuously, to attain a positively bizarre luxuriance; just as significantly, the other linked phenomena also developed and gained importance continuously. The history of public art museums in the nineteenth and twentieth centuries is a whole subject in itself, as is the historiography of art from the eighteenth century onward. In addition, the system comprising the by-products of art was rounded out, by revaluation for instance, and further acquired certain striking and novel features. Art exhibitions, to name one, have their roots in the seventeenth century; but they have grown more numerous and gained influence almost unceasingly down to the present, when exhibitions of several sorts play the major role familiar to all. Yet the period from 1700 to our own strange era is nonetheless set apart historically from the period from 1300 to 1700, precisely because, by 1700, the basic system comprising all the primary by-products of art was already in existence and was exercising

many discernible side-effects. Being set apart in this manner, the later centuries deserve separate, perhaps even more detailed treatment. And meanwhile there are those loose ends still needing to be tied up.

The loose ends that need tying up were in fact consequences of Western art collecting's seventeenth-century maturity and also the plainest signs that maturity had then been reached. The first one requiring notice is the unseen yet unceasing eddy of great works of art from center to center, from nation to nation, and nowadays from continent to continent. This eddy always begins whenever and wherever art collecting begins. It has now become a world eddy; and it will presumably continue as long as collecting makes great works of art into major ends in themselves, fit to serve as "ornaments" of powerful states;[1] as trophies of conquest; as ancient families' proofs of grandeur; as ancient grandeur's substitutes for new plutocracies; and, since the Museum Age began, as triple-starred attractions of famous art museums.

The pulse of history controls the world eddy. In other words, after art collecting has become an established social habit, most great works of art soon appear to be permanently unattainable—while history's pulse is slow. This is because they have been gathered into the palaces of rulers, or the dwellings of the impregnably rich, or public institutions supposedly established for eternity—or, more recently, the works of art have been fixed in place by laws strictly enforced by states that seem to be immune to subversion. In the long run, however, fortune's wheel always turns once again, proving once again the cruel nearness of permanence to impermanence even for the most powerful rulers, and the most vastly rich, and the states most confident of stability. This was how Andrew W. Mellon was able to provide his new National Gallery with Raphaels and other famous pictures sold from the Hermitage itself by order of Josef Stalin. This is why today collectors of Khmer art are said to be acquiring sculpture from Angkor Wat and other Khmer monuments, so safe for so long; for bits of sculpture are reportedly being hacked off by starving Cambodians freed by chaos and driven by despair to serve dealers across the border in Thailand.

In sum, whenever true art collecting prevails, works of art long beyond reach eventually move into the world eddy in places where power declines, or money grows short, or order dissolves into disorder; and the eddy then carries its burdens until they are deposited where power is great, and money is plentiful, and order reigns. The first obscure Western movements of the eddy can be detected when art collecting first reappeared in Italy. The classical works of art sought by Oliviero Forzetta can only have been available in Venice because someone had brought them there from somewhere else. The way Renaissance works of art finally entered the eddy, too, not just as luxuries or images to pray before, but as prizes for art

collectors, has also been described in the previous chapter. But I have reserved this diagram of the ever-moving eddy for the present chapter because it was in the seventeenth century that the movements of the eddy quickened to a proto-modern rate, and a really large burden of works of art was first carried by the eddy from nation to nation.

This was partly because the seventeenth century was the time when art collecting on a princely scale became a common pursuit, not just for rulers of major states, but among a good many persons with princely revenues in France and Spain, England, the Spanish Netherlands, the free Netherlands, and the more prosperous centers of Germany and the Austrian Empire. But the eddy also swelled and quickened because the seventeenth century was a time of comparative Italian decline, although Medici collecting never ceased, and major new collections continued to be formed by papal nephews and others who were fortunately placed. Hence the century's central theme was a series of massive movements of High Renaissance and later masterpieces from the Italian palaces and villas where they had first been lodged to new homes in other European countries. Among the leading seventeenth-century collectors who seized the new opportunities in Italy the roster includes Philip IV of Spain, Cardinal Richelieu and Cardinal Mazarin, the Archduke Leopold Wilhelm of Hapsburg, and many more on almost the same level; but among them all, absolute pre-eminence must certainly be accorded to Charles I of England.

The English King's years of art collecting extended only from his late adolescence—he was just sixteen when he was made Prince of Wales in 1616—until hardly more than twenty years later, when he discovered, in 1640, that he could not govern without a Parliament. This was when the troubles began that ended his collecting and, rather more important, finally brought him to the scaffold where he "nothing common did or mean."[2] Only a little while after the King was publicly beheaded in Whitehall in 1648, the Commonwealth then began the tragic dispersal of Charles I's art collection and almost all his other personal and hereditary possessions. But although the art collection endured so briefly in its entirety, it was certainly the most enviable large assemblage of works of art ever made in the West, just as the Commonwealth's dispersal was, and will surely remain forever, the most remarkable sale of works of art ever seen since Western art collecting began.

In addition, the West's greatest single movement of the international eddy of works of art was King Charles I's acquisition of the accumulated collections of the Gonzaga of Mantua. Daniel Nys, the leading art dealer based in Venice, has already been seen promoting and profiting from this still-unparalleled collector's coup. But there are micro-movements of the eddy as well as macro-movements. The eddy is in fact basically composed of innumerable random individual transfers of individual works of art;

and what strikes me as the most fascinating series of these individual transfers also reached its seeming-term as an ultimate result of the King's amazing purchase at Mantua.

The Michelangelo Story

In previous chapters, the long, complex Italian journey of Michelangelo's Sleeping Cupid has already been followed: how Lorenzo di Pierfrancesco de' Medici told the youthful sculptor he could get a far better price by selling his new statue in Rome as an ancient work; how Michelangelo cleverly "antiqued" the marble; how Cardinal Riario was first deceived and then undeceived—these episodes have been related.[3] The next stages have been described, too—how Cesare Borgia apparently sent the Cupid to the Duke of Urbino as a diplomatic gift; how he got it back again by his treacherous surprise attack on the duchy; how Isabella d'Este slyly secured the Michelangelo while she was harboring at Mantua her brother-in-law, the Duke of Urbino, and her husband's sister and own best friend, the Duchess; and how the Duke and Duchess vainly sought the return of their piece of sculpture after their restoration at Urbino.[4] Finally, it has been seen how the Michelangelo was among the works of art from Mantua that Daniel Nys sought to "hold out" after King Charles's tremendous collector's coup; and how Nys then took fright, for fear the hold-out would prevent him from getting his money for the second part of the Mantua purchase; and how he promised he would send to England on the next available ship the Raphael, the Titians, and all the choice pieces of sculpture he had secreted in "the back part" of his big house in Venice, of course including the Sleeping Cupid.[5]

There is no evidence to pinpoint the statue's reaching London. But there would surely be evidence if it had not done so, for the large surviving correspondence would surely give some indication of the loss, if there had been a loss, after the King had been notified by Nys's letter that a Michelangelo was being shipped to him. The astonishingly rich representation of the giants of the High Renaissance was the chief factor making the King's art collection the most enviable the West has ever seen. For example, at the time of its dispersal the collection included thirty works by the King's chief court painter, Van Dyck, but there were fifty-five paintings attributed to Titian—an astonishing old-master-versus-contemporary balance![6] King Charles plainly wanted every one of the High Renaissance giants to be represented in his collection, too. Then as now, any painting by Leonardo seemed almost wholly unobtainable, but by special efforts the King got at least one unchallenged work by the master, the Young St. John, from the French royal collection.[7] As Michelangelos were already just as hard to find as Leonardos, the King was highly unlikely

to overlook the nonfulfillment of Nys's promise of a Michelangelo. And since there is nothing in the correspondence or the archives to suggest Nys's shipment did *not* reach England, it may be safely assumed the Sleeping Cupid arrived in London in due time and was then incorporated in the royal collection.

There are also other reasons logic must be used instead of documentation to show this early Michelangelo actually arrived in England. To begin with, Charles I owned close to four hundred pieces of sculpture by the end of his life—in addition to nearly fourteen hundred pictures![8] Classical works constituted the overwhelming majority of the sculpture collection, too, and for the untrained and uninformed, the Michelangelo must have been exceedingly easy to lose, as it were, in the great mass of antique works. The Sleeping Cupid was in a strongly classicizing style, after all, and had actually been sold as antique in Rome. Furthermore, very little of the King's sculpture was covered in the relatively knowledgeable inventory by Abraham van der Doort;[9] and obviously uninformed and untrained persons inventoried and valued the sculpture for the victorious Commonwealth's dispersal of the King's possessions. This latter inventory's entries on the sculpture are strikingly brief and bare of serious information except for an occasional note on a statue's region of origin; identifications of the subjects portrayed are intermittent as well as dubious;[10] and the estimates of value given—which were the minimum prices the Commonwealth officials were prepared to accept—were no doubt often off the mark of the market values of that period.[11]

Nonetheless, there are five entries concerned with Cupids described as sleeping, ranging in estimated value from £6 to £30,[12] along with three more entries describing a "Cupid big as ye life. whole. figure" at £80,[13] a "Cupid. leining on his arme. a hole. figure" at £20,[14] and "an other Cupid lyeing on the ground" at £6.[15] All of these were sold in October 1651. The eight statues were divided between four purchasing syndicates headed respectively by Ralph Grynder, an upholsterer, Major Edward Bass, a merchant, and two men, George Greene and Robert Stone, who were probably creditors of the beheaded King as were Grynder and Bass.[16] The syndicates acquiring the King's possessions were mainly speculating on the resale value. Quite often works of art were immediately resold to the foreigners hungrily hanging about in London on the fringes of this greatest single sale of works of art in the whole history of the Western art tradition. There were a good many of these, such as the Paris-based banker-collector-art dealer Evrard Jabach and the buying agents appointed by leading foreign collectors like Philip IV of Spain and Cardinal Mazarin; and they reaped a rich harvest from the Commonwealth's dispersal.

The King's works of art wanted by European collectors appear, however, to have been primarily paintings from Charles I's never-matched assemblage

of famous pictures by the giants of the High Renaissance. Indeed, I know of no record of any of the King's sculpture being received into one of the leading European collections of that day—although the sculpture must have gone somewhere, since the pieces generally fetched the prices the Commonwealth was asking. England must be almost ruled out, too, for England under Oliver Cromwell cannot have been a good market for sculpture. Thus it seems entirely likely that some or all of the pieces of sculpture tentatively identifiable with Michelangelo's Sleeping Cupid were shipped by the purchasing syndicates to Amsterdam, for final disposal in what was by then the center of the European art market. Given the dates, this would have meant the Michelangelo was sold again in Amsterdam, most probably in one of the big Amsterdam art auctions, in the period when Rembrandt was still spending money freely in the way that caused his bankruptcy in 1656.

Among other purposes, Rembrandt obviously spent rather heavily on his art collection, which then had to be offered at his bankruptcy sale along with everything else he possessed. His frequentation of the Amsterdam auctions is amply attested, too, for instance by his quick sketch of Raphael's magical portrait of Baldassare Castiglione, now in the Louvre, with a note that the picture had sold for 3,500 guilders.[17] One wonders, indeed, whether Rembrandt learned the final price of the Raphael by going to bid on the picture at the sale of the collection chiefly made in Venice by the art dealer and merchant Lucas van Uffelen.[18] He may even have been the underbidder, but if so he was beaten by the Spanish-Jewish jewel-and-armaments dealer doing business in Paris, Antonio Lopez, who later sold the Raphael to Cardinal Mazarin.[19]

Above all, however, one wonders whether King Charles's Michelangelo was not acquired in Amsterdam by Rembrandt at another of the big art auctions, and was therefore the *"kindeke van Michael Angelo Bonalotti"* listed among the contents of Rembrandt's own studio in the inventory taken prior to the bankruptcy sale of 1656.[20] The *"kindeke"* is usually supposed to have been a cast or copy of the figure of the Child in Michelangelo's Bruges Madonna and Child. But in the first place, the Bruges Child would not have been easy to transform into an independent piece of sculpture. In the second place, the attribution of the *"kindeke"* to "Michael Angelo Bonalotti" in the list of Rembrandt's goods made for the bankruptcy sale is unusually firm and exact for an inventory of that date, suggesting that Rembrandt himself believed he owned a genuine work by Michelangelo. And he can hardly have been mistaken about a copy or cast of the Bruges Child.

Of course, this is all speculation, and perhaps it is overbold speculation; yet it is somehow pleasant to think of Rembrandt's studio as the last known stage on the long road traveled by the youthful Michelangelo's

fake antique. Even if the speculation is correct, however, no one can tell today what happened to the Sleeping Cupid at the heartbreaking sale of Rembrandt's goods or thereafter. It is not uncommon, in truth, for master-pieces to disappear from view, either forever or for very long periods, once they have entered the great eddy of works of art from center to center and nation to nation.

The First Curators

So much, then, for this peculiar eddy that is always set in motion by art collecting. As to the next loose end needing tying up, Abraham van der Doort, already mentioned, was a significant loose end in his own right. He was a minor artist from the Netherlands,[21] whom Charles I named, in effect, the first curator of his collection. He was far from comparing with the learned scholar-curators we know today. His way of explaining that a list was on a piece of paper which was left on the table was to write that it was "in a pis paper Wij Was lefft opan da tabel."[22] But he was fairly knowing, carefully distinguishing in his inventory between studio pieces, works "of the school of," straight-out copies, and undoubted originals by major masters; and he repeatedly noted when pictures had been "diffast," meaning damaged, or (and this was already sadly often) "over-washed" or "scoured," meaning overcleaned.[23]

He was also industrious and careful, recording in his inventory all provenances he could learn about including the frequent courtiers' gifts to the King and the King's own numerous swaps, and further listing what had been given by the King for the various pictures he acquired by swapping. The Wilton diptych, for instance, almost certainly wanted by the King for his series of English royal portraits, was secured from an English noble family in exchange for a portrait of Charles I, "werontu de king had sit in tu liffens."[24] The Leonardo was also obtained from France by a deal arranged through the French ambassador in London. This swap transferred to the French royal collection a Holbein portrait of Erasmus and a Titian of the Virgin and Child with St. John.[25] The Titian, as Van der Doort recorded, had been "given heeretofore to yo'r Ma'tie by—my lord of Carlile who had it of Docto'r Dunn"—the last-named presumably the great divine and even greater poet, John Donne, which makes this a particularly striking provenance.

Overall, Van der Doort's methods portended curatorial methods which have persisted down to the present. More important, he was a portent himself. A little later in the seventeenth century, Filippo Baldinucci served Cardinal Leopoldo de' Medici as curator of his huge drawing collection, and when he had finished cataloguing the marvels in the Cardinal's scores of portfolios, he turned to art-historical writing.[26] So all the countless

curators of private and public art collections today must look back to old Abraham van der Doort as their profession's real founder, while the fairly numerous curators who also continue to work as art historians must similarly look back to Baldinucci.

England Conquered

To my mind, however, King Charles I's epochal collection retains its chief importance in our own day as a major cultural symptom. It was in fact decisively symptomatic of the onward march of the empire of Renaissance art and taste, which continued until the Americas and Russia were conquered and the empire thus extended to the outermost limits of the Western world. The first and most important stage of this empire's expansion was fairly protracted, and Renaissance art conquered England surprisingly late. Italian luxuries, Italian Renaissance ideas and written works, even much-distorted third-hand echoes of Renaissance architecture, all reached England from the late fifteenth through the early seventeenth centuries; but throughout this whole period, it is doubtful whether all of England boasted more than a single work by a major Italian Renaissance artist.

Until the early seventeenth century, in fact, the most direct influences on the visual arts in England came from Northern Europe; and the greatest master to work for long in England was a Northerner. Hans Holbein the Younger was of course Henry VIII's court painter. In the later sixteenth century, too, the artist above the journeyman level who did the most work in England was the portraitist Hans Eworth.[27]

To be sure, lesser Italians and Italian-trained artists also came to England from time to time. The turbulent sculptor Torrigiano was employed on the tomb of King Henry VII after he got into hot water in Florence for such misdeeds as breaking the young Michelangelo's nose. Later in the period, the Mannerist Federigo Zuccaro worked in England for a while, and Anthonis Mor, an Italian-trained Fleming, also did some work there. But if you look for works of Italian masters of the first order, Titian made only two sixteenth-century appearances as a visitor, so to say. When poor Queen Mary was about to marry Philip II of Spain, the Titian portrait of King Philip was sent to the Queen on loan, so that she would have some notion of what her future husband looked like. Significantly, the English Queen had to be instructed, in the letter announcing the picture's advent, that in order to *see* the Titian properly, she must stand well away from it.[28] This Titian was returned after ten days.[29] In the same way, the Titian Venus and Adonis was sent to England for King Philip's enjoyment there at the time of his marriage to Queen Mary, but was in all probability rather meanly taken back to Spain the moment the

Spanish King left his wife and returned home.[30]

Thus the one undoubted case of a great High Renaissance painting actually owned in England was the little Raphael of St. George and the Dragon, now in our National Gallery.[31] This small picture was painted by order of Duke Guidobaldo of Urbino when he got the Order of the Garter from King Henry VII; it was suited to the occasion by the Garter insignia; and it was carried to England by Baldassare Castiglione, the Courtier himself serving as his Duke's envoy. At the time, however, the Raphael cannot have made a strong impression, for it evidently strayed from the English royal collection before long. It is certainly quite unlike any of the several anonymous paintings of St. George described in the surviving royal inventories of 1547 and 1549–50.[32] In fact, the whereabouts of England's unique treasure by one of the already consecrated old masters cannot even be located during the long interval before the picture turned up again in the seventeenth century in the possession of the Earl of Pembroke, who swapped it with Charles I for a portfolio of Holbein drawings.[33]

There were various preliminary stirrings, but the truth is that the impact of Renaissance art was only fully felt in England in the seventeenth century. The first culture bringer seems to have been the great architect and masque designer, Inigo Jones. When Jones returned from his Italian studies, he made his English debut with the radically novel scenery and costumes for Ben Jonson's *Mask of Blacknesse* in 1605.[34] The effect on all with eyes to see must have been truly electric. In 1610, when James I's eldest son, Prince Henry, was made Prince of Wales and also given an independent household, he soon named Jones his Surveyor.[35]

By this date—although the Prince was only sixteen in 1610—he must already have embarked on his short career as England's first art collector of the modern type. As early as 1611, there is a Venetian report[36] on his "gallery of very fine pictures, ancient and modern, the larger part brought out of Venice"; and the imported pictures in the "gallery" could hardly have reached England by 1611 unless they had been ordered before 1610. The Prince's premature death, in 1612, not only made the future Charles I the heir to the throne; he was also the heir to his brother's collection and example. From Prince Henry, too, Charles inherited old Van der Doort. But before Charles was old enough to begin collecting on a serious scale, the new fashion was already well established at the English court. Thus Robert Carr, Earl of Somerset, he of the reddish-gold "Sycambrian locks," sent to Venice for both pictures and sculpture in the way, and with the results, already described in another chapter.[37]

The ultimate buyer of several of the pictures in the consignment to Somerset, the proud Earl of Arundel, "Father of Vertu" in England, was one of the truly great collectors of the seventeenth century, given to sending his agents all over Europe and even the Levant to secure prizes for

his collection. Arundel House, particularly famous for its classical marbles, soon became a required place to visit for all foreigners interested in the arts who came to England.[38] A vicious collectors' rivalry grew up between Arundel and the Duke of Buckingham, the chief of James I's beautiful male favorites, whom Arundel, with his ancient name, regarded as an upstart. The Duke was also the favorite of Charles I in the first years of the latter's reign, and with a favorite's huge rewards to spend, Buckingham filled his great mansion, York House, with all sorts of splendid pictures and pieces of sculpture. His large purchase from Rubens has already been mentioned in passing.[39] And the third of the English collecting triumvirate from the King's circle was the Earl of Pembroke, also mentioned already.

These three, with the King, were enough to make England in the prosperous years of King Charles's reign a magnet for great works of art in much the way the United States became a magnet when the era of major American millionaire collecting opened, around 1900. There was already a strong collecting ambience in London, too, some years before Charles I came to the throne in 1625. As Prince of Wales after his brother, Charles himself began to buy important works of art on his impulsive trip to Spain to try to marry the Infanta;[40] and once he was King, he quite obviously sought to make his England, at long last, into an overflowing treasure house of everything the Renaissance had to offer. To make a decisive break with the provincial styles favored by his predecessors, King Charles commissioned Rubens to paint the ceiling of the Banqueting House in Whitehall;[41] he used Inigo Jones as his architect; and he persuaded Van Dyck to become his principal artist in residence. But for this essay's purposes, the King's art collecting is still central, and not least because of his collection's overall character.[42]

Charles I's Collection

It must be noted as preface that in King Charles's time, the balance of value between household goods and great works of art was much nearer to what it had been in the times of Lorenzo the Magnificent and Isabella d'Este than to the balance between these categories in the houses of major twentieth-century collectors. Some of the King's goods designed for state occasions were sold for prices equaling or exceeding the prices of his most famous pictures. For example, a saddle and foot cloth of crimson velvet, with bridle, crupper, and other horse trappings to match, all embroidered "with pearle," went for £2,000,[43] or the same price as the supposed Raphael later christened "La Perla" by Philip IV of Spain, the King's most highly valued painting. At the other end of the spectrum, too, a close stool covered in brown velvet went for £10,[44] which was one-quarter of the price fetched at the Commonwealth dispersal by the Titian portrait of Doge Andrea

Gritti, now in our National Gallery.[45] Again, it is too easy to forget that suites of tapestry were far and away the most costly things in the King's palaces. "Tenn. peeces. of Arras. Hangings of ye storye of Abraham" were put down for £8,260 by the Commonwealth's appraisers, and £5,019 was the valuation of "Tenn. peeces. of Rich Arras. of ye history of Julius Caeasar."[46]

In both these ways, one is reminded of earlier periods by the documents concerning the dispersal of the King's art collection and all his other goods. Yet as an art collector, Charles I predicted the future rather better than most of his contemporaries. He owned works by Bruegel, Bosch, and other Northern masters outside the mainstream of Renaissance painting, including three Rembrandts (none of which sold for more than £5),[47] but his assemblage of pictures of these types was far smaller than that of the Archduke Leopold Wilhelm of Hapsburg, whose most famous present-day memorial is the incomparable Bruegel room in the Kunsthistorisches Museum in Vienna. Again, King Charles may have had large resources invested in tapestries, but Cardinal Mazarin spent far more heavily on tapestries;[48] and whereas the Cardinal was quite as much a treasure gatherer as a true art collector—although he was a great art collector, beyond doubt—King Charles shone as an art collector above all. The inventories clearly show that his assemblage of luxury furniture and treasures, even including his own crown and his crown jewels, was far less important than his collections of paintings and sculpture.

The sculpture collection's large size and mode of assemblage were at once modern by seventeenth-century standards[49] and also predictive of the future. What was predicted, of course, was the long series of galleries of classical marbles which dotted the map of Europe from end to end by the opening of the nineteenth century. The galleries outside Italy were also assembled precisely as King Charles's collection mainly was, chiefly by importations from Italy. Among the Italian importations, inevitably, the acquisition of the Mantua sculpture was by far the most significant. But the King also used agents going farther afield, as did Lord Arundel. Lord Arundel's agent, William Petty, ranged as far as Constantinople.[50] One of King Charles's suppliers, Sir Kenelm Digby, made what amounted to a pirate voyage in the Mediterranean and, among other exploits, brought back sculpture and inscriptions on marble from Delos.[51] On this topic, it must finally be remarked that King Charles's sculpture evidently seemed to many early-seventeenth-century Englishmen more worthy of remark than his countless other prizes. The sculpture was singled out, for instance, by Baldassare Castiglione's belated and homespun English imitator, Henry Peacham. In the work he tried to make into another *Courtier* for his own time, Peacham wrote:

". . . I cannot but with much reverence, mention the every way Right

honourable Thomas Howard Lord high Marshall of England, as great for
his noble Patronage of Arts and ancient learning, as for his birth and
place. To whose liberall charges and magnificence this angle of the world
oweth the first sight of Greeke and Romane Statues, with whose admired
presence he began to honour the Gardens and Galleries of Arundel-House
about twentie yeeres agoe, and hath ever since continued to transplant
old Greece into England. King Charles also ever since his comming to
the Crowne, hath amply testified a Royall liking of ancient statues, by
causing a whole army of old forraine Emperours, Captaines, and Senators
all at once to land on his coasts, to come and doe him homage, and attend
him in his palaces of St. James, and Somerset house. . . ."[52]

The King's Pictures

The paintings, however, were what made Charles I's collection so out-
standing a milestone in the history of Western art collecting. Despite
the multiplicity of marvelous and rare things the King gathered together,
fine pictures far outweighed all the rest, and within the mass of paintings
of all sorts, including a good many copies, original works by the masters
who would be great collectors' prizes forever after also far outweighed
the rest of the collection.

Of really early pictures, there were few or none of importance except
the Wilton diptych. Even of fifteenth-century Italian masters, there were
still very few, in fact no more than a single Antonello da Messina[53] and
a couple of works by Giovanni Bellini,[54] plus the Triumph of Caesar and
the other paintings by Mantegna from Mantua, including the strongly
foreshortened Dead Christ[55] the master always refused to part with during
his lifetime. The prides of the King's collection were the Raphaels and
Titians, the Correggios and the Giorgiones, for all four masters were numer-
ously represented. But also richly represented were the leading Italian
masters of every generation after the High Renaissance, notably including
Annibale Carracci and Caravaggio. The Northern masters were not ne-
glected, either. The groups of Holbeins and Dürers were in fact remarkable,
and Charles I plainly admired both very highly. Thus Lord Arundel sought
to please the King by quite ruthlessly pressuring the City Fathers of Nurem-
berg to make a state gift to Charles of Dürer's marvelous portrait of himself
as a young man with long golden curls in a black and white leather cap.
And from Nuremberg, Lord Arundel also extorted a portrait of the artist's
father.[56]

Yet even so, the Northerners were perceptibly subordinated to the
Italians, and the King's chief bets on the old masters of the future were
astutely placed on Rubens and Van Dyck, for they were in the Italianate
mainstream of post-Renaissance art, whereas Rembrandt was only sparsely

represented and his works were humbly valued because he was not in this mainstream. It is hard to remember, but it must always be borne in mind, nonetheless, that for long after his death, Rembrandt was not admired as he is today, as one of the West's very greatest masters with no ifs or buts added to the judgment. It was revaluation which opened the way for reappraisal of Rembrandt in the nineteenth century.

The Great Dispersal

Taken all together, Charles I's was the archetypal Western art collection of its time, both summing up and considerably surpassing the highest aspirations of all leading collectors of the long period before revaluation redirected attention to the Italians of the era before the High Renaissance, made Gothic art respectable again, and downgraded the Greco-Roman marbles. So far as one can judge, moreover, Charles I's art collection fetched a total price that probably still stands as the record sum ever paid for an entire collection—if you take real purchasing power as the test of a price. On this head it must be added, there has been much confusion. Long ago, Horace Walpole cited £118,080/10/2 as the total sum,[57] but Walpole's statement has been endlessly misread and then repeated as the total price paid for all the King's works of art, without mention of the rest.[58] Walpole, or rather his main source, the antiquarian George Vertue, must have recorded incorrectly the figure £118,280/7/½, which is given at the end of a rather complete version of the inventories, of which I have obtained a photocopy.[59] Or perhaps he used a slightly different manuscript; or the difference is to be accounted for by Vertue having done his own addition. In any event, a glance at the copy I have obtained will show that this was the figure for everything that was disposed of, from close stools to Titians, from copper pans from the King's kitchens to his Raphaels and Correggios.

Furthermore, the central document giving this total is only one of a series of related documents, some of which supplement the central document. In his Walpole Society publication of the great dispersal, Sir Oliver Millar has therefore offered a conflation. Given these facts, months of careful study and the use of a computer would be needed to give the exact sums obtained for all the King's paintings and sculpture, as opposed to all the other things that were disposed of, which even included Charles I's coronation robes and remnants of the wardrobe of Henry VIII. Hence I have made no more than a very rough computation, omitting all things sold except paintings and sculpture, and allowing for the fact that the Raphael cartoons and the Mantegna cycle of the Triumph of Caesar, like the more costly tapestries and some other things, were retained by the Commonwealth or did not find buyers. The computation's result cannot

be regarded as even approaching precise accuracy, but it can at least serve as a crude measurement.

Using this crude approximation, the Commonwealth apparently obtained about £36,000 for the King's pictures and around £18,000 for his sculpture. These sums may not seem enormous when compared with the "record" art prices of today, but in reality, these modern "records" might almost as well be quoted in oak leaves instead of dollars or pounds sterling. If you remember the gold value of the English pound in the time of the Commonwealth, and if you further recall the enormously greater purchasing power of money in that period, the total sum obtained for the art collection of King Charles I is seen to have been genuinely enormous, even though there is no way to quote a precise modern equivalent.

Beyond doubt—to sum up—the formation and the dispersal of Charles I's art collection were the two greatest events in the history of seventeenth-century art collecting. Such a collection had never been formed before and would never be formed again—although ruler after ruler, and, as soon as the Museum Age began, museum after great museum, sought to outdo King Charles. For a few brief years, to be sure, a high percentage of the most famous works of art in Europe could be seen in Paris in the Musée Napoléon; and if Adolf Hitler and his Germany had not been defeated, the same sort of display would certainly have been repeated in the vast museum Hitler planned in Berlin. But most of these two massive accumulations of looted art had to go back, before long, to the places that had been looted; so they hardly count.

In contrast, the King's collection was gathered by peaceful means, in the hope of permanence. Instead, however, the sequel was the Commonwealth's grand dispersal, so the fruits of this dispersal are now the pride of just about every art museum in the Western world. Sometimes these marvels made no more than a single journey, like the pictures brought by ship to Spain and then carried in a great mule train over the mountains to the rejoicing Philip IV.[60] Sometimes there were many journeys, like those of the little Raphael St. George, which first passed from hand to hand in France, was then acquired by Catherine the Great, and was finally sold to Andrew Mellon by Stalin's grim command.[61] But in one way or another, and in most leading countries of the West, there are still superb memorials to King Charles's discrimination and love of art.

The King may therefore stand as a sufficient symbol of what may be called the grand collecting that was so prevalent in the seventeenth century, when the supply of the highest prizes had not yet been enormously diminished by the cruel accidents of time, or war, or internal upheaval, or the careless ignorance that so often impairs fine collections when they pass from art collectors to their heirs.

Yet the seventeenth century was not merely notable for the spread

over much of Western Europe and into England of art collecting of the grander sort.

Universal Collecting

In the more prosperous parts of Europe, notably France and the Low Countries, but perhaps including Spain, art collecting became, not just an established social habit, but a common habit among persons living above a certain level of comfort and privilege. In the case of France, the evidence is voluminous and takes the incontestable form of a series of manuscripts and published volumes intended to serve as guides to the important collections of one sort or other, either in the whole country or in particular localities. Toward the seventeenth century's beginning, two Germans, Just Zinzerling and Abraham Gölnitz, successively published the *Itinerarium Galliae* and the *Ulysses Belgico-Gallicus*, with special emphasis on picture and medal collections and significant libraries.[62]

These were followed by a fair number of other such works in French. In English, too, the accounts of their travels by John Evelyn[63] and the physician and naturalist Martin Lister[64] are clear evidence of the frequency of collecting as well as the strong seventeenth-century fashion for collection-visiting, which is obviously attested by the other travelers' guides, too. Some of these works are very odd indeed. For example, in 1649, a certain Pierre Borel published his *Antiquitez de Castries*—not, after all, an immensely important center—and to this he appended a list of the principal *"cabinets curieux et autres choses remarquables"* which one could see in the major cities of Europe. Lists of collections were again included in Jacob Spon's *Recherches des antiquités et curiosités de Lyon;* and toward the end of the century, the Abbé de Marolles (of whom more later) published his useful but comically wooden versified account of the collectors of Paris.[65]

The list might be extended further but fortunately need not be. As to the Low Countries, a whole series of paintings of interiors survive, always helpful to the art historians but almost never inspiring, which show proud art collectors surrounded by their collections and often in the act of receiving distinguished collection visitors.[66] From Spain, the evidence is more accidental in the main; but there is plenty of it, in the reports to King Charles I of his ambassadors in Madrid, who also served as his collecting agents,[67] in the correspondence of Lord Arundel with the diplomats and others he, too, was using as collecting agents,[68] and no doubt in many Spanish sources as well. Some of the data from this correspondence can be surprising and valuable. For example, the Leonardo notebook recently rediscovered in the great library in Madrid, after being

lost for centuries, was apparently internationally known in the seventeenth century. In the first half of the century, it belonged to a Spanish-Jewish *converso*, Don Juan de Espina. King Charles probably sought to buy the notebook from him,[69] and Lord Arundel, who was harder to discourage than his King, made two determined attempts at different times, and was extremely pettish about De Espina's reluctance to sell.[70]

Moreover, art collecting not only became so widespread in the seventeenth century that important and well-known private collections could then be found in French provincial towns where you would be unlikely to find any today. In addition, collecting diversified enormously, and specialized narrowly, too. The Maréchal de Grammont delighted Louis XIV with an account of how he ran into the current "Monsieur de Paris," Sanson, first of the family line of public executioners of Paris that ended with the Sanson who was "Monsieur de Paris" in the dire days of the French Revolution's Terror. The Sanson of the seventeenth century was encountered at an art dealer's shop, looking over pictures of various tortures, which, he explained, he collected because he found them delightful and most helpful in his métier as well.[71] Or consider the power of the collector's itch that impelled the Abbé de Marolles. In 1655, when he was fifty years old, he had already accumulated no fewer than seventy thousand of the prints that were his specialty. Eleven years later, when he published a catalogue, his total of prints had reached 123,400, by more than six thousand different engravers. He then sold the lot to the King, and the Marolles collection thus became the foundation of the Cabinet des Estampes. Even so, the Abbé had hardly parted with his first collection before he began again, finally gathering a new total of 111,424 examples, including over ten thousand original drawings, before he died at last.[72]

In addition, the Abbé de Marolles was one of the seventeenth-century collectors—there were several—whom La Bruyère took as his model for Diognète and Démocède, the collector figures among his *Caractères*.[73] Diognète is a collector of coins and medals, and La Bruyère mocks his intense preoccupation with the trifling differences of condition that so profoundly affect such things' desirability—and price—in the eyes of numismatic enthusiasts. Démocède is a print collector, immensely proud of one of his least attractive examples solely because of its extreme rarity, but bitterly discouraged because his enormous series of the prints of Jacques Callot is still incomplete—for want of the least successful print Callot ever made. In sum, the stamp collectors' approach to art collecting, as it may be called, existed long before postage stamps came into use. Yet the real point is, of course, the fact that La Bruyère thought collectors should be included in his gallery of human types; for this is another strong proof that by La Bruyère's time art collecting was a well-organized and common pursuit with many branches.

In an earlier chapter, too, the evidence has been seen—in the *Lettres* of Mme de Sévigné, of all places—that collecting for investment was already common practice.[74] Hence it can be understood why Western art collecting must be regarded as having reached complete maturity before 1700, at any rate as a social habit and cultural phenomenon. An account of what happened until our own day, rich and strange as this has often been, would still be no more than a chronicle of collecting fashions, price changes, family and natural disasters and other causes for dispersal of famous collections, and so on and on. The origins and early development of all the later-appearing by-products of art have also been covered previously, so the historical part of this historical essay has reached its term. Yet there is still a little more to say.

On Historical Determinism

The history that has now been traced in its main outlines concerns a cultural-behavioral pattern of fairly extreme complexity which has been repeated more or less completely and in schematically identical forms in five quite different cultures. Three of these great cultures, the classical culture that was born in Greece, the second phase of Chinese culture which opened with the establishment of the Chinese Empire, and the later Islamic culture centering in the Middle East, diverged very widely from one another. One more, the Japanese culture, was powerfully influenced by the culture of imperial China. And the last, the form of Western culture that originated in the Renaissance, was historically linked to classical culture, but only rather tenuously linked across the gulf of long intervening centuries. In four of these five cultures, therefore, the cultural pattern under study appears to have developed either entirely spontaneously, or very nearly spontaneously.

To make matters worse, this repeating pattern of art collecting and other by-products of art is a cultural-behavioral system offering no practical reward to the culture in which it has appeared. In mature form, the pattern instead absorbs heavy investments of time, and money, and intellectual capital, as I have already pointed out. Yet there is no visible return on the required investments of the sort offered by so many other cultural patterns that have been repeated throughout history, such as the development of the same more advanced agricultural methods in quite different periods and in wholly separated regions of the globe.

One reason for this brief addendum to the present chapter is in fact the suspicion automatically aroused among serious scholars of the later twentieth century by any search for historically repeating cultural patterns. The mere search for such recurrent patterns and the assertion that they exist are often enough to give rise to dark hints of historical determinism.

So I must hasten to say that I distrust determinism as much as anyone; that I have never been convinced by any of the important determinist works I have felt compelled to read; and that I have indeed found all of them repellent in one way or another, with the sole exception of Ibn Khaldūn.[75] Yet there is a wide space for maneuver, so to say, between stern rejection of determinism and the common view nowadays that any attempt to examine repeating historical patterns is somehow tainted.

Schematically identical repeating patterns can in fact be found in history, but *not* because of any deep laws or rules determining the rise and the decline of societies and cultures. Patterns instead recur simply because all sorts of recurring factors—if the factors are powerful and the recurrences are fairly similar—are then highly likely to produce schematically repetitious results. You can even find this kind of result under one or another pompous label more than once in Arnold Toynbee's own work.[76]

"Challenge and Response" is high-sounding and portentous. But if you simply say that any society faced with a novel life-and-death problem must either risk extinction or find a way to solve the problem in question, then no sane man can argue with this generalization. Nor is it in the least surprising that the strains and adjustments inevitably needed for societies to find solutions for unfamiliar life-and-death problems have sometimes strengthened the societies in question. This is a sequence that has recurred in history rather more often, and from the tribal level upward, than Toynbee suggested. The foregoing may be a banal example of historical recurrence as compared with art collecting, art history, and the other linked phenomena. Yet it seems to me blinkered to deny that the byproducts of art constitute a well-defined cultural-behavioral pattern, or to ignore the ample evidence that this pattern has been repeated in five different cultures, or to dispute the significance of the further fact that the pattern cannot be found in any other culture of the past, however successful.

The Recurring Factor

As to the recurring factor causing the improbable similarities of the five rare art traditions, the secret is simple enough if I am correct. The secret is that the five cultures nourishing the rare art traditions were also the five cultures which somehow took to writing true history, as defined by Fueter,[77] instead of being content with annals and chronicles to tell them of their pasts. I have no notion at all why just five major cultures have had this most significant developed historical sense, as I have called it, or why this sense was effectively absent in so many other cultures belonging to higher civilizations. Divine Providence, or the laws of economics, or some other higher force whose workings have never been exactly

comprehensible, can only be held ultimately responsible in our present state of knowledge. But the fact remains that a long series of rich and complex cultures before the present period of worldwide homogenization have not produced a single historical work that would pass the Fueter tests. Whereas just this has unquestionably been done, whether on a large scale or in a limited way, by the five cultures in which you find art collecting and the other by-products of art.

By the same token, I have no notion at all why the developed historical sense—if that label is accepted—should also have bled over in these five cultures, thus producing an essentially historical response to art supplementing the normal and universal esthetic response. This does not seem to me at all inevitable or even entirely understandable. Why on earth, one wonders, should all the cultures marked off by the particularly complex and sophisticated way of thinking about past events which we call history have had the further odd habit of remembering each generation's leading masters of the visual arts? And why should these five then have begun to write art history? The fact remains that these five cultures and no others have ultimately taken to writing art history, at least of a primitive sort, and most often an exceedingly thoughtful and elaborate sort; and art history, sensibly defined, has not been written in any other cultures, at least before our own abnormal era.

As to the vital link between the historical response to art and the appearance of the by-products of art in each of the art traditions of the five cultures in question, I hope this link has been persuasively demonstrated, bit by bit, in this essay's ten opening chapters and the relevant interchapters. In short, I believe the curious cultural-behavioral pattern that is this essay's true theme must be seen as still another of the repeating historical patterns caused by discernible recurring factors. Here, think once again of the simple example earlier suggested, of a potentially fertile but wholly arid lowland region immediately adjacent to a well-watered mountain region. Where geography is arranged in this manner, the factors are obviously present to lead to the invention of an irrigation system fed by reservoirs in the mountains. This invention has been repeated more than once in history, in wholly separate and otherwise different situations as in early Ceylon and Inca Peru, despite the large manpower costs of building and maintaining the reservoirs and building and keeping clean the channels leading the water from the mountains to the plains. Yet no one has been mystified by these repetitions.

For the same reasons, no one should be mystified because the peculiar way of thinking about the visual arts which derives from the historical response to art should have generated art collecting and some or all of the by-products of art in each of the five cultures that have had this historical response in common. The plain truth is that the mystery does

not lie in the visible effects, which are the by-products of art and the ways of thinking about art that are behind these phenomena. The mystery lies in the root causes, the developed historical sense and the odd way a developed historical sense leads on to a historical response to art. Explain these first causes, and I believe you will then explain their special effects examined in this essay. But, alas, I cannot explain the first causes except in terms of some great, unknowable force capable of giving rise to the first causes.

The foregoing brief recapitulation has seemed desirable because it also seems desirable to distinguish clearly between the determinist approach to historical repetition and the entirely pragmatic approach adopted in this essay. It must be added that this essay has been purposely limited in an important way. No more than the bare outlines have been traced of the minimum hypothesis needed to explain the rarity and the recurrences of art collecting, art history, and the other by-products of art. If the hypothesis meets the stringent tests that will surely be applied to it, and if it is then held to be worth exploring further, there will be far more to explore. For example, the behavioral traits of the rare art traditions, which seem to give rise to art collecting and the linked phenomena, in themselves rather obviously constitute a major subject. Consider, here, just one of these behavioral traits, compulsive innovation—in fact the artists' distaste for doing just what has been done before because of each artist's drive to be in some degree original. This behavioral trait is particularly conspicuous and significant in the situation of the arts in the later twentieth century. Hence artists' fear of voices mumbling, "It's been done before," is now taken for granted as normal and natural in a way that is historically quite unjustified.[78] Yet simple logic suggests that there are not only rich rewards but there is also a penalty for the rare art traditions because they share this trait of compulsive innovation.

Rewards and Penalties

Anyone reasonably familiar with the histories of the rare art traditions can perceive the rewards: great surges of confident creativeness and, over time, a glorious fertility in creative variation. Who but someone with a Western-conditioned mind and eye could imaginably perceive any link whatever between, say, Poussin and Cézanne? Yet Poussin and Cézanne not only achieved major creative variations; in addition, Poussin's achievement helped to inspire Cézanne's achievement.

As to the penalty above-mentioned, one must begin with the fact that every art tradition, whether short-lived or long enduring, simple and tribal or complex and grandiose, necessarily has its own unspoken limits, which cannot be transcended by an artist wishing to work *within* the tradition

in question. An easy example is the late Scythian gold work, treating Scythian subjects yet wholly Greek in style and treatment. Study, for instance, the finest of all these pieces, the superb gold collar or gorget found in the Tolstoya Mogila kurgan in Southern Russia.[79] The gorget's lower register shows scenes from the wild steppe, centering on horses being attacked by pairs of gryphons. Vivid and down-to-earth scenes of Scythian life enrich the upper register. So far as I know, no one has ever suggested that this unparalleled triumph of vigorous design and delicate craftsmanship was made by anyone but a Greek goldsmith; yet I have always wondered about this, and still do.

Those terrible gryphons attacking the horses in the lower register are a Greek motif imported from Mesopotamia and first known in the Greek world in Minoan-Mycenaean times. But the transformation of Greek gryphons into the mythical enemies of the enormous, steppe-wandering horse herds of the rich Scythian chieftains was a case of a Greek motif being adapted to embody nightmares straight out of the Scythian consciousness; for no true Greek can possibly have imagined herds of hundreds or thousands of horses being left almost free to chance the dangers of the open steppe in the Scythian way. By the same token, the gryphons tearing at the horses are no more than another version of one of the most ancient motifs of the animal art of the steppe peoples, the so-called felid attacking a bovid—in fact a carnivore attacking a large grass-eater—and the same motif is again seen at either end of the golden gorget's lower register, in the lion and lioness attacking a wild boar and in the other lion-couple attacking a stag. No normal Greek can have thus betokened the perils of the limitless open grasslands; and, for the same reasons, no normal Greek can have given such vivid life and truth to the scenes of the upper register, of Scythian life in camp on the steppe among the wagons. Yet the golden gorget is the greatest single surviving masterpiece of Greek fourth-century gold work, quite unsurpassed (at any rate in my opinion) both in the amazing quality of its workmanship and in the energy and extreme elegance of the overall design.

Is one, then, to suppose that one of the very greatest masters of Greek fourth-century gold work, from Athens or some other metropolitan center, abandoned all of metropolitan life's usual delights for the much narrower but perhaps more profitable life in a Greek Black Sea colony like Olbia? Was it in fact a Greek who thus gained the minute knowledge of Scythian life and legendary lore that was so obviously needed to make the golden gorget for the Scythian chieftain who must have commissioned it? Or is it not more likely that the gorget was made by a Scythian born and bred, who had been trained in an Athens workshop—perhaps starting as a young slave—and had then come home as a finished goldsmith? After all, it has long been known that men of foreign origin often worked in the

grander craft workshops in Athens.[80] Scythians, furthermore, had a long native tradition of skilled metalworking, as is amply attested by many wonderful purely Scythian products of the ancient animal art of the steppe peoples.

The foregoing may seem a long digression. Instead it offers a particularly neat illustration of the kind of limits that characterize all art traditions—and are indeed essential to make a coherent tradition. The point is, of course, that it does not matter a particle whether the maker of the golden gorget was a native Greek or a talented Scythian trained from youth in a first-rate Greek workshop. Either way, and despite its Scythian motifs and scenes, the golden gorget is a transcendent Greek work of art, having no real stylistic link with the Scythians' native art tradition.[81] The art is Greek, in other words, although much of what the art depicts and even some of the motifs used are Scythian. No one in his senses would argue otherwise except perhaps a Scythian, if there were any nowadays—and even then only a Scythian intoxicated by the racial or national pride that has sometimes been known to deform art historians' judgments!

All this is to the point, in turn, because certain conclusions so evidently flow from the fact that all coherent art traditions really do have limits—never traceable limits, to be sure, but still limits which cannot be ignored by artists wishing to work within their own traditions. These limits are the real explanation, as I believe, of the penalty the rare art traditions seem to have to pay if they last long enough—a penalty which has already been mentioned as being natural in these traditions, along with their rich possibilities of reward. The nature and causes of the penalty can be simply spelled out, too.

If all art traditions have their own limits, in brief, then the number of variations and innovations any tradition can contain within these limits is necessarily finite, even if this number is never possible to compute with precision. Yet the rare art traditions have compulsive innovation as a continuing behavioral trait. Again necessarily, therefore, each rare art tradition's finite number of containable innovations must be exhausted in the end. Nothing new is then left to do that is really worth doing, yet the artists of the rare traditions still continue to fear the verdict "It's been done before." At this point, the penalty has to be paid in one of two ways. In the Chinese tradition, the penalty for painters took the form of the dessicated dreariness and sad sterility of the last centuries before the recent vast upheaval in Chinese society (and unless you are deeply moved by the famous sacred icon of Mao Zedong Coming 'Round the Mountain,[82] you cannot much admire the Communist victory's purely artistic consequences up to the present). In the case of the classical art tradition, in contrast, the penalty was the slow death of the tradition itself, which occurred in the twilight of the Western Roman Empire. But

in this case, the old tradition had an afterlife in its successor traditions, postclassical Western European art and Byzantine art, in somewhat the way Greek mythology tells us Narcissus and Hyacinthus had afterlives in the flowers that sprang up from their graves.

On Being Seventy-Plus

As to just where our Western art tradition may be on the penalty curve, this is a question no man over seventy should even try to answer. If you are seventy or over, you remember what looked to be a new dawn of rich Western creativeness in the 1920s and 1930s. So you ask yourself what has come of the rebirth of architecture, and where are the painters carrying on from Picasso and Matisse and Braque, and who are the writers now to match Proust and Joyce, Eliot and the young Auden. You wonder, therefore, whether what looked like a new dawn was not instead a splendid sunset. But those over seventy should always refrain from judgments of the present or the future, and not least the present or the future of the arts; for they can never remember that time and time again the arts have found new sources of life and vigor when the old springs have all but dried up. Nor is it easy for the old to be consoled by recalling that even if art traditions wither and die, art is undying. The truth is, the old love what they knew in youth, yet what they knew in youth cannot come again.

ENVOI

At long last, the end of this essay's long road has finally been reached. As envoi, it is appropriate to offer the *locus classicus* among descriptions of the passion which afflicts all art collectors. The *locus classicus* in question belongs, not inappropriately, to the century when the Western art tradition reached maturity, and it appears in the *Mémoires* of the second Loménie de Brienne. The second Loménie was a minor and eccentric seventeenth-century figure, most unlike his serious-minded father, who also wrote *Mémoires;* but he was still the chosen *homme de confiance* of Cardinal Mazarin in the Cardinal's last years. The scene described took place at the very end of the Cardinal's life, when Mazarin was already a dying man. I quote my own translation of the second Loménie's work. Loménie speaks:

"I was strolling through the new rooms [of the Mazarin palace in Paris]. I was in the little gallery where there was the [suite of tapestries] on the theme of Scipio. The Cardinal had none more beautiful. I heard [the Cardinal] coming by the noise of his slippers, in which he was shuffling along as a man does who is still greatly weakened by serious illness. I hid behind the tapestry,[1] and I heard him exclaiming, 'I must leave all this!' At each step he would halt, for he had no strength, he would glance this way or that, studying this object or that, and from the heart itself, he would cry out: 'I must leave all this!' And turning again, he would add: 'And that, too! How much trouble I've taken to collect all these things! How can I say farewell to them without sadness? . . . [Yet] I shall not see them again where I am going!' I could not contain a heavy sigh, and he heard me. 'Who's there?' he said. 'Who's there?' 'It is I, Monseigneur,' [I answered]. . . . 'Come near, come near,' he said in a very weak voice. He was naked in his woolen dressing gown trimmed with gray fur, and he was wearing his nightcap. He said to me, 'Give

me your hand, I'm very weak, I can't go on for very long. . . . And going back to his former thought: 'Look well, old friend, at that beautiful Correggio, and that Titian Venus, and that incomparable Deluge by Annibale Carracci; for I know you like pictures and understand them. Ah! my poor friend, I must leave all this! Good-bye, dear pictures that I have loved so much, which have cost me so dear!' "[2]

NOTES

I. THE ALTERED APOLLO

1. Apollo: Walther Amelung, *Die Skulpturen des Vatikanischen Museums*, II (Berlin, 1908): no. 92, pl. 12; Wolfgang Helbig, *Führer durch die öffentlichen Sammlungen klassischer Altertümer in Rom*, ed. Hermine Speier, 4th ed; I (Tübingen, 1963): no. 226; George M. A. Hanfmann, *Classical Sculpture* (London, 1967), pp. 320–21. Leochares: Gisela M. A. Richter, *The Sculpture and Sculptors of the Greeks*, 4th rev. ed., (New Haven, 1970), pp. 220–22; Georg Lippold, "Die griechische Plastik," in *Handbuch der Archäologie*, ed. Walter Otto and Reinhard Herbig, no. 5 [III,1], (Munich, 1950), pp. 268–72.

2. Richter, *Sculpture and Sculptors*, pp. 220–22.

3. Georg Lippold, *Kopien und Umbildungen griechischer Statuen* (Munich, 1923); Lippold, "Copie e copisti," in *Enciclopedia dell'arte antica*, II (Rome, 1959): 804–10; Margarete Bieber, *Copies: A Contribution to the History of Greek and Roman Art* (New York, 1977). See also Bieber, *The Sculpture of the Hellenistic Age*, rev. ed. (New York, 1961), pp. 177–82; Gisela M. A. Richter, *Three Critical Periods in Greek Sculpture* (Oxford, 1951), pp. 42 ff.; Paul Zanker, *Klassizistische Statuen* (Mainz, 1974).

 Unless the copies were in bronze, which was rare, they were made by the pointing process. Great sculptors who have not worked their own marble, like Canova, have commonly used this process. But the Greco-Roman copies plainly began with a cast from the original. This was the first stage, which was then reproduced by pointing, the second stage. For evidence of molds for such a cast being taken from a famous work, see Lucian, *Iuppiter Tragoedus*, 33; and Pliny, *Naturalis Historia* XXXV. 45. See also Martin Robertson, *A History of Greek Art*, 2 vols. (London, 1975), I: 562; Donald Strong, *Roman Art*, Penguin ed. (Harmondsworth, 1976), pp. 28–30.

4. Richter, *Sculpture and Sculptors*, pp. 226–27, fig. 801; Bieber, *Sculpture of the Hellenistic Age*, p. 37; Robertson, *A History of Greek Art*, I:467. But even Glycon very loosely followed a Greek original, a Heracles by Lysippus.

5. Even a temporary theater was reportedly adorned with three thousand statues by the aedile Marcus Scaurus in 58 B.C.; see Edmond Bonnaffé, *Les Collectionneurs de l' ancienne Rome* (Paris, 1867), p. 29. It must be added that the Romans here were following the Greeks, for Pliny reports that seventy-three thousand statues were still

to be seen in Rhodes in his own time! (*Naturalis Historia* XXXIV. 36; though some of the manuscripts report only three thousand statues.) And no fewer than ninety pieces of sculpture were found in a single large private house, the Villa of the Papyri in Herculaneum; see Michael Grant, *Cities of Vesuvius: Pompeii and Herculaneum* (London, 1971), p. 137. For additional collections, see also Bonnaffé, *Les Collectionneurs*, pp. 9–47, 49–55; "La collezione nell'antichità," in *Lorenzo Ghiberti*, exhibition catalogue, Museo dell'Accademia and Museo di San Marco (Florence, 1978–79), pp. 554–59.

6. Cornelius C. Vermeule, "Graeco-Roman Statues: Purpose and Settings, I," *Burlington Magazine* 110 (1968): 545–58. See also Brunilde Sismondo Ridgway, "The Aphrodite of Arles," *American Journal of Archaeology* 80, no. 2 (Spring 1976): 153.

7. Giorgio Vasari, *Le opere*, ed. Gaetano Milanesi ("Vasari-Milanesi") (1903; Florence, 1973), II: 245; cf. Richard Krautheimer, *Lorenzo Ghiberti*, 2nd ed. (Princeton, 1970), I: 305 n. 51. Trude Krautheimer-Hess ("More Ghibertiana," *Art Bulletin* 46 [1964]: 316–17) argues that Vasari knew firsthand the part of Ghiberti's collection that remained in the hands of his heirs in the sixteenth century. If no part of the collection had been sold by then, he had also seen the bronze leg. See "La collezione di Lorenzo Ghiberti," in the exhibition catalogue *Lorenzo Ghiberti*, pp. 559–67, for Ghiberti's collection of antiques. See also Julius von Schlosser, "Der Sammler und Liebhaber der Antike," in his *Leben und Meinungen des Florentinischen Bildners Lorenzo Ghiberti* (Basel, 1941), pp. 123–64.

8. Helbig, *Führer*, I: 170; Roberto Weiss, *The Renaissance Discovery of Classical Antiquity* (Oxford, 1969), pp. 102–03. The Apollo was drawn twice while in the Roman collection of Cardinal Giuliano della Rovere before he became Pope Julius II (Hermann Egger, *Codex Escurialensis: Ein Skizzenbuch aus der Werkstatt Domenico Ghirlandaios* [Vienna, 1906], pls. 53, 64). A later report that the statue was found at Anzio during the papacy of Alexander VI is still sometimes credited (Hans von Hülsen, *Römische Funde*, 2nd rev. ed. [Darmstadt, 1966], pp. 206–08, 253).

9. Hans Henrick Brummer, *The Statue Court in the Vatican Belvedere* (Stockholm, 1970), pp. 44–71, esp. p. 47.

10. Kenneth Clark, *Civilisation: A Personal View* (New York, 1969), p. 2.

11. Margarete Bieber, *Laocoön: The Influence of the Group Since Its Rediscovery*, rev. enl. ed. (Detroit, 1967), pp. 12–13.

12. Michelangelo's early presence at the site is recorded in a letter of Francesco da Sangallo of 28 February 1567 reprinted in Brummer, *The Statue Court*, p. 75; cf. Giovanni Bottari and Stefano Ticozzi, *Raccolta di lettere sulla pittura, scultura ed architettura*, III (Milan, 1822): 475–76.

Among the many dicta by the master that have been repeated, this one is supported by a bit more evidence than usual. No comment by Michelangelo was recorded by Sangallo (see above), but a version of the famous phrase was fathered on Michelangelo rather early (see Janus Jacobus Boissard, *Romanae Urbis Topographiae et Antiquitatum* I [Frankfurt, 1597]: 135: "*miraculum artis singulare*"). It is fairly certain, too, that Michelangelo joined with those who identified the newly found statue, as most modern scholars do, with the Laocoön in the palace of the Emperor Titus, recorded and described by Pliny (*Naturalis Historia* XXXVI. 37). He would then have been repeating the verdict of Pliny. Pliny, incidentally, claimed incorrectly that the Laocoön had been carved from a single block of marble; and this supposed feat was one reason for his verdict.

For Michelangelo's artistic reliance on the Laocoön: Arnold von Salis, *Antike und Renaissance* (Zurich, 1947), pp. 257–58; Gerhard Kleiner, *Die Begegnungen Michelangelos mit der Antike* (Berlin, 1950), pp. 27–28; Herbert von Einem, "Michel-

angelo und die Antike," in *Stil und Überlieferung: Aufsätze zur Kunstgeschichte des Abendlandes* (Düsseldorf, 1971), pp. 154–57.

13. Paul Fréart de Chantelou, *Journal du voyage du Cavalier Bernin en France,* ed. Ludovic Lalanne (Paris, 1885), p. 26 (8 June 1665); Domenico Bernini, *Vita del Cavalier Gio. Lorenzo Bernino* (Rome, 1713), p. 13 (note the re-evaluation of the documentary value of this *Vita* by Cesare D'Onofrio, "Priorità della biografia di Domenico Bernini su quella del Baldinucci," *Palatino* 9 [1966]: 201–08); Filippo Baldinucci, *Vita di Gian Lorenzo Bernini,* ed. Sergio Samek Ludovici (1682; Milan, 1948), p. 146.

14. Charles de Tolnay, *Michelangelo,* 2nd ed., V (Princeton, 1971): 37, 113; cf. 47; I (1969): 71, 186–87 (an early drawing). Further: Einem, "Michelangelo, und die Antike," pp. 153–54; Kleiner, *Begegnungen,* p. 43, figs. 20–21 (cf. Tolnay, *Michelangelo,* V: 41).

15. Rudolf Wittkower, *Gian Lorenzo Bernini,* 2nd ed. (London, 1966), p. 5; cat. 18, pls. 14, 26; Wittkower, "The Role of Classical Models in Bernini's and Poussin's Preparatory Work," in *Studies in Western Art: Acts of the Twentieth International Congress of the History of Art* (Princeton, 1963), III: 47; see also D. Bernini, *Vita,* p. 13. For a clear instance of Bernini's use of the Laocoön in the developing of his statue of Daniel (Santa Maria del Popolo, Rome) through a series of drawings, see Rudolf Wittkower, "Classical Models," pp. 47–48; Heinrich Brauer and Rudolf Wittkower, *Die Zeichnungen des Gianlorenzo Bernini* (Berlin, 1931), pp. 57–58, pls. 42–47.

16. See, for instance, Heinz Ladendorf, *Antikenstudium und Antikenkopie* (Berlin, 1953), pp. 47–48, 68, 71, 73; Cornelius Vermeule, *European Art and the Classical Past* (Cambridge, Mass., 1964), *passim.*

17. Johann Wolfgang von Goethe, *Italian Journey,* trans. W. H. Auden and Elizabeth Mayer, Penguin ed. (Harmondsworth, 1962), p. 136; cf. p. 148 (9 Nov. and 3 Dec. 1786).

18. *Goethe's Autobiography: Poetry and Truth from My Life,* trans. R. O. Moon (1932; Washington, D.C., 1949), p. 440.

19. See Ferdinand Boyer, "Les Responsabilités de Napoléon dans le transfert à Paris des oeuvres d'art de l'étranger," *Revue d'Histoire Moderne et Contemporaine* 11 (October–December 1964): 242. For the quotation see Paul Wescher, "Vivant Denon and the Musée Napoléon," *Apollo* 80 (September 1964): 180. The quatrain makes the common assumption of the period, that the Apollo and the others were Greek originals. See also Charles Saunier, *Les Conquêtes artistiques de la révolution et de l'empire* (Paris, 1902), p. 35; Fernand Beaucamp, *Jean-Baptiste Wicar (1762–1834): son oeuvre et son temps* (Lille, 1939), I: 248–52; Cecil Gould, *Trophy of Conquest: The Musée Napoléon and the Creation of the Louvre* (London, 1965), p. 41 *et passim;* Boyer, "Napoléon et les collections d'antiques en Italie," *Information Historique* 21 (January–February 1959): 22–25.

20. Olga Raggio, "Canova's Triumphant 'Perseus,'" *Connoisseur* 172 (November 1969): 204–12, esp. p. 209.

21. The Apollo may have been among the statues restored by the sixteenth-century sculptor Montorsoli (Vasari-Milanesi, VI: 632–33). The additions were recently removed (Helbig, *Führer,* I: 170), but the change is minor.

22. The prevailing taste of course reflects the prevailing value system—and the value system in turn indicates what is "good taste" and "bad taste"—but *only* where and when that particular value system happens to be accepted.

23. *Gertrude Stein on Picasso,* ed. Edward Burns (New York, 1970), pp. 17–18. I first heard the phrase when Gertrude Stein and Alice B. Toklas made their American tour in the 1930s.

24. Giovanni Boccaccio, *Decameron*, trans. G. H. McWilliam, Penguin ed. (Harmondsworth, 1972), p. 494 (VI. 5). See also Chapter IX below.

25. *Le vite de' più eccellenti pittori, scultori ed architettori*, 1st ed., Florence, 1550; 2nd, ed., Florence, 1568 (Vasari-Milanesi, 9 vols., Florence, 1878–85).

26. Vasari-Milanesi, II: 97, 99, 102–3. For the importance Vasari attached to representation, see, for instance, his remarks on Francia, Perugino, and Leonardo (IV: 11).

27. Boccaccio, *Decameron*, p. 494 (VI.5). Specifically, Boccaccio separates Giotto from his predecessors who painted "to bring visual delight to the ignorant, rather than intellectual satisfaction to the wise." (cf. Michael Baxandall, *Giotto and the Orators* [Oxford, 1971], p. 60).

28. See Petrarch's will of 1370, reprinted and translated in *Petrarch's Testament*, ed. Theodor E. Mommsen (Ithaca, N.Y., 1957), pp. 78–80; also Roberto Salvini, *Giotto bibliografia*, (Rome, 1938), p. 5, no. 11 (cf. Baxandall, *Giotto and the Orators*, p. 60).

29. Giovanni Gaye, *Carteggio inedito d'artisti dei secoli XIV, XV, XVI*, I (Florence, 1839): 481–82; Walter Paatz, "Die Gestalt Giottos im Spiegel einer zeitgenössischen Urkunde," in *Festschrift Carl Georg Heise*, ed. Erich Meyer (Berlin, 1950), pp. 85–102.

30. "Dominant" is intended to take care of educational and class differences.

31. Edmond Bonnaffé, *Dictionnaire des amateurs français au XVIIe siècle* (Paris, 1884), pp. 51, 55, 85, 121, 181, 219, 298.

32. A short account of the row is to be found in Léon Mirot, *Roger de Piles* (Paris, 1924), pp. 37–47. For further detail, see Bernard Teyssèdre, *Roger de Piles et les débats sur le coloris au siècle de Louis XIV* (Paris, 1957). See also Victor H. Miesel, "Rubens, Ancient Art and the Critics," *Criticism* 5 (1963): 214 ff.; James Henry Rubin, "Roger de Piles and Antiquity," *Journal of Aesthetics and Art Criticism* 34 (1975): 157–63.

33. Marcel Proust, *À la recherche du temps perdu*, Pléiade ed., (Paris, 1954), III: 583.

34. In a remarkable and passionately admiring appreciation, the French eighteenth-century connoisseur-dealer-auctioneer Quentin de Lorangère nevertheless found Rembrandt's nudes "*insupportables et d'une nature à faire horreur, elles font assez apercevoir qu'il n'a jamais connu les beautés et les agréments des figures antiques.*" (Charles Blanc, *Le Trésor de la curiosité*, I [Paris, 1857]: lxiii.)

35. *The Letters of Philip Dormer Stanhope, 4th Earl of Chesterfield*, ed. Bonamy Dobree, IV (London, 1923): 1727 (10 May O.S., 1751).

36. The things Dürer saw—especially the sun of gold and the moon of silver—correspond exactly with the inventory taken on arrival in Spain of the appeasing presents that Montezuma sent to Cortez when he landed on the Vera Cruz coast. See L. Torres de Mendoza, *Colección de documentos ineditos relativos al descubrimento, conquista y organización de las antiguas posesiones españolas*, XII (Madrid, 1869): 318 ff.; also Marshall H. Saville, *The Goldsmith's Art in Ancient Mexico* (New York, 1920), pp. 21–36, 56 ff. For the transfer from Spain to Brussels of the treasures Dürer saw, see *Albrecht Dürers niederländische Reise*, ed. J. P. Veth and Samuel Müller (Berlin, 1918), II: 100 ff.

37. Quoted from *Northern Renaissance Art, 1400–1600: Sources and Documents*, ed. Wolfgang Stechow (Englewood Cliffs, N.J., 1966), pp. 100–01; also in Stechow, *Dürer and America* (Washington, D.C., 1971), pp. i–ii. The original text is in *Dürer schriftlicher Nachlass*, ed. Hans Rupprich, I (Berlin, 1956): 155 ("Tagebuch der Reise in die Niederlande," 27 Aug. 1520), 184, n. 194; cf. III (1969): 441.

38. *Handbook of the Robert Woods Bliss Collection of Pre-Columbian Art*, Dumbarton Oaks (Washington, D.C., 1963), no. 109.

39. Saville, *The Goldsmith's Art in Ancient Mexico*, pp. 102–04.

40. See Detlef Heikamp, *Mexico and the Medici* (Florence, 1972), *passim.* Also Lorenzo Pignoria, *Le vere et nove imagini dei indiani* (1st ed. 1614/1615), in Vincenzo Cartari, *Imagini delli dei degl'antichi* (1647; Graz, 1963), pp. 361–70 (cf. Ronald W. Lightbown, "Oriental Art and the Orient in Late Renaissance and Baroque Italy," *Journal of the Warburg and Courtauld Institutes* 32 [1969]: 242). An instance of a pre-Columbian object treasured as a precious curiosity is a Mexican green stone mask set in an elaborate eighteenth-century mounting, now in the Treasury of the Munich Residenz (Heikamp, "Mexikanische Altertümer aus süddeutschen Kunstkammern," *Pantheon,* 28 [May–June, 1970], cover photograph). The Bolognese artist-collector Pelagio Pelagi (1775–1860) acquired thirty-eight pre-Columbian ceremonial vases, perhaps in the late 1820s, for his collection of works of art (Comune di Bologna, *Pelagio Palagi artista e collezionista,* exhibition catalogue [Bologna, 1976], pp. 405–12). See also Chapter XIII below on the Aztec featherwork in the Schloss Ambras collection.

41. I saw this happening when I went to Harvard in 1929. At that time, the great Mayan Maize God and two other fine Mayan heads had just been transferred, on loan, from the obscurity of the Peabody Museum to the Fogg Art Museum—and this was thought to be a most avant-garde act at that time! Two of the three Mayan heads have now been sold on the art market by the Peabody Museum. For the Maize God head in the collection of the Peabody Museum, see Gordon R. Willey, "The Maize God: Maya Sculptured Stone Head," in *Masterpieces of the Peabody Museum,* exhibition catalogue, Harvard University (Cambridge, Mass., 1978), pp. 86–87.

42. Note "effectively." The sculpture of the Parthenon, for instance, was known to specialists through eyewitness reports and later through the drawings made by a Frenchman, probably Jacques Carrey of Troyes, in the second half of the seventeenth century (Martin Robertson, *The Parthenon Frieze* [London, 1975], p. 15). But it had no impact on the art world before the Elgin marbles reached London.

43. Richter, *Three Critical Periods,* pp. 48–49. This date has lately been attacked; see Robertson, *A History of Greek Art,* I: 541–43.

44. The Idolino in Florence is another Hellenistic Greek original, but it enjoyed no comparable celebrity (see Walther Amelung, *Führer durch die Antiken in Florenz* [Munich, 1897], no. 268; Ulrich Middeldorf, "Girolamo, Aurelio and Ludovico Lombardi and the Base of the 'Idolino,'" *Burlington Magazine* 73 [1938]: 251–57). The Horses of St. Mark, in Venice, were celebrated from a very early date, but the argument about whether they are Greek originals or Roman copies is not settled to this day. Bruna Forlati Tamaro has reviewed many contributions to this still-open question in her "Nuova ipotesi sui cavalli di S. Marco," *Rendiconti degli atti della Pontificia Accademia Romana di Archeologia,* ser. III, 37 (1964–65): 83–104; see also Ottavio Vittori and Anna Mestitz, "Artistic Purpose of Some Features of Corrosion on the Golden Horses of Venice," *Burlington Magazine* 117 (March 1975): 132–39. One could go on, but it is needless.

45. Within Europe as a whole, Venice was something of an exception to this rule, since sculpture continued to come to Venice from the Eastern Mediterranean for a good while after 1453. This inflow included a few Greek originals—although none of these attained an Apollo-like reputation. See Marilyn Perry, "A Greek Bronze in Renaissance Venice," *Burlington Magazine* 117 (March 1975): 204–11. Interest in the art of Greece, awakened by literary texts, was never completely dormant. Raphael, it seems, retained draftsmen in Greece to copy antiquities (Vasari-Milanesi, IV: 361; cf. Ekaterini Samaltanou-Tsiakma, "A Renaissance Problem of Archeology," *Gazette des Beaux-Arts* 78 (1971): 225–32. Over the years there were other isolated incursions

into the lands east of Italy. For Ciriaco d' Ancona's recording of the antiquities of Greece during his travels there, a century earlier than Raphael, see Bernard Ashmole, "Cyriac of Ancona," *Proceedings of the British Academy* 45 (1959): 25–41; and Edward W. Bodnar, *Cyriacus of Ancona and Athens* (Brussels-Berchem, 1960).

46. John Thomas Smith, *Nollekens and His Times*, 2 vols. (London, 1828), I: 11–12, 183–84, 250–51.

47. Adolf Furtwängler, *Masterpieces of Greek Sculpture* (Chicago, 1964), pp. 343–45, fig. 148; Bieber, *Sculpture of the Hellenistic Age*, p. 19; Robertson, *A History of Greek Art*, I: 393.

48. Vasari-Milanesi, VII: 407–08; Benvenuto Cellini, *La vita*, ed. Paolo d'Ancona (Milan, n.d.), bk. II, ch. xxxvii, p. 369, ch. xli, pp. 374–75. *La Collection de François Ier*, ed. Janet Cox-Rearick, Musée du Louvre, Les Dossiers du Département des Peintures, 5 (Paris, 1972), pp. 44–48.

49. For example, a major, very early stage of English art collecting effectively began with the visits to Italy of Thomas Howard, Earl of Arundel, in 1612 and in 1613, when he took Inigo Jones as a companion. On the second visit he bought newly discovered classical sculpture in Rome. Mary F. S. Hervey, *The Life, Correspondence and Collections of Thomas Howard, Earl of Arundel* (Cambridge, 1921), pp. 66 ff., 84–85, n. 3; cf. Henry Peacham, *The Compleat Gentleman* (1622; Oxford, 1906), p. 107. The history of travel to Italy in the seventeenth and eighteenth centuries is most fully treated in Ludwig Schudt, *Italienreisen im 17. und 18. Jahrhundert* (Vienna, 1959). For serious students of the "antique," see Erna Mandowsky and Charles Mitchell, *Pirro Ligorio's Roman Antiquities* (London, 1963), pp. 19–28.

50. André Malraux, *Le Musée imaginaire* (Geneva, 1947), p. 17.

51. Erwin Panofsky, "Dürer and Classical Antiquity," in his *Meaning and the Visual Arts* (Garden City, N.Y., 1955), pp. 249–55.

52. Winckelmann's *Gedanken über die Nachahmung der griechischen Werke in der Malerei und Bildhauerkunst* (trans. in *Winckelmann: Writings on Art*, ed. David Irwin [London, 1972], pp. 61–85) was first published in fifty copies at Dresden in 1755. Winckelmann did not arrive in Rome until November 18 of that year (Carl Justi, *Winckelmann und seine Zeitgenossen*, 5th ed. [Cologne, 1956], I: 439 ff.; II: 19; see further Ludwig Curtius in *Johann Joachim Winckelmann 1768/1968* [Bad Godesberg, 1968], pp. 8–10, 13–15).

53. Mirot, *Roger de Piles*, pp. 37 ff.

54. Roger de Piles, *Abrégé de la vie des peintres* (Paris, 1699), "L'École allemande et flamande: Réflexions sur les ouvrages de Rubens" (here quoted as trans. in Wolfgang Stechow, *Rubens and the Classical Tradition* [Cambridge, Mass.], 1968, p. 27).

55. Rubens, *De Imitatione Antiquarum Statuarum*, first published by Roger de Piles in his *Cours de peinture par principes* (1st ed. Paris, 1708; reprinted in Piles, *Oeuvres diverses* [Paris, 1767], I: 127–33). A full translation appears in *Artists on Art from the XIV to the XX Century*, ed. Robert Goldwater and Marco Treves, 3rd ed. (New York, 1958), p. 148. But here, in tribute to a lost friend, I again quote from Stechow, *Rubens and the Classical Tradition*, p. 27.

56. Michael Jaffé, *Rubens and Italy* (Oxford, 1977), p. 7. See also Julius S. Held, *Rubens: Selected Drawings* (London, 1959), I: 49–53, which treats Rubens's drawings of classical sculpture, including no fewer than twelve of the Laocoön and twelve of the Trajan column reliefs, as well as many of the other famous antiquities of Rome, like the Apollo Belvedere. See further Justus Müller Hofstede, "Beiträge zum zeichnerischen Werk von Rubens," *Wallraf-Richartz-Jahrbuch* 27 (1965): 281–96; and Victor H. Miesel, "Rubens' Study Drawings After Ancient Sculpture," *Gazette des Beaux-Arts* 61 (1963): 311–26.

57. Nancy T. de Grummond, "A Seventeenth-Century Book on Classical Gems," *Archeology* 30 (January 1977): 14–25. Marjon van der Meulen, *Petrus Paulus Rubens Antiquarius: Collector and Copyist of Antique Gems*, dissertation, Utrecht, 1975 (Alphen aan den Rijn, 1975). For the best short account of this project, see Christopher Norris, "Rubens and the Great Cameo," *Phoenix, Maandschrift voor Beeldende Kunst* 3 (Amsterdam, 1948): 179–88.

58. Details of this transaction can be found in Rubens's correspondence, the standard edition of which is the *Codex Diplomaticus Rubenianus*, published as *Correspondance de Rubens et documents épistolaires*, ed. Charles Ruelens and Max Rooses, 6 vols. (Antwerp, 1887–1909). Mention can be found as early as 1 November 1617, but the details emerge clearly from their exchange of letters extending from 17 March 1618 to 28 May 1619 (II: 130–218); see esp. 28 April–26 May 1618 (II: 135–74). See also *The Letters of Peter Paul Rubens*, trans. and ed. Ruth S. Magurn, 2nd ed. (Cambridge, Mass., 1955).

59. Rubens, *De Imitatione*, in Piles, *Cours de peinture*, p. 131 (cf. *Artists on Art*, p. 149). Again, this translation is from Stechow, *Rubens*, p. 27.

60. Stechow, *Rubens*, p. 50, figs. 36, 37.

61. William R. Valentiner and Paul Wescher, *The J. Paul Getty Museum Guidebook*, 2nd ed. (Los Angeles, 1956), *passim*.

62. Richard Payne Knight placed the finest works in the Elgin collection "in the second rank" but put the Apollo, along with the Laocoön, "in the first class of art." See Great Britain, Parliament, House of Commons, *Report from the Select Committee of the House of Commons on the Earl of Elgin's Collection of Sculptured Marbles* (London, 1816), p. 92.

63. Payne Knight included the Lansdowne Hercules in a list of "important articles" then in English collections, each of them "worth more than any two articles in Lord Elgin's collection" (*Report from the Select Committee*, pp. 95–99). See further Adolf Michaelis, *Ancient Marbles in Great Britain*, trans. C. A. M. Fennell (Cambridge, 1882), pp. 103–06, 451–52, no. 61; and *Lansdowne House, London: A Catalogue of the Ancient Marbles Based on the Work of Adolf Michaelis*, ed. A. H. Smith (London, 1889), p. 11, and cat. 61, pp. 26 ff.

64. Canova arrived in London in November 1815 (Michaelis, *Ancient Marbles*, p. 145). Canova's famous letter to Elgin in praise of the marbles (10 November 1815) is found in *Report from the Select Committee*, appendix pp. xxi–xxii. See also Michaelis, *Ancient Marbles*, p. 146, n. 381; A.-C. Quatremère de Quincy, *Canova et ses ouvrages*, 2nd ed. (Paris, 1836), pp. 288–89 (for Canova's letter of 9 December 1815); and William Richard Hamilton, *Second Letter to the Earl of Elgin on the Propriety of Adopting the Greek Style of Architecture in the New Houses of Parliament* (London, 1836), p. 25.

65. Lord Elgin was paid £35,000, whereas his expenses, both capital outlay and interest, totaled about £75,000 (Michaelis, *Ancient Marbles*, p. 149). For the entire affair, see Michaelis, *Ancient Marbles*, pp. 132–51, and William St. Clair, *Lord Elgin and the Marbles* (London, 1967).

66. At the Lansdowne sale at Christie's, the Hercules was bought in at £4,830 and then resold to J. Paul Getty for £6,000. Gerald Reitlinger, *The Economics of Taste*, II (London, 1963): 246–47, 360.

67. Thomas Jenkins bought the Attic relief, one of a pair, at Naples in 1771 for £10 the pair (Reitlinger, *Economics*, II: 246).

68. In a recent monograph, the statue was given to Onatus, but this is a minority opinion (José Dörig, *Onatas of Aegina*, Monumenta Graeca et Romana 1 [Leyden, 1977], pp. 7–8).

69. Goethe was able to see full-scale drawings of the marbles made by Benjamin Robert Haydon, which were sent to Germany (St. Clair, *Lord Elgin*, pp. 263–64).

70. G.-B. Piranesi, *Della magnificenza ed architettura de' Romani* (Rome, 1761); Piranesi, *Parere su l'architettura* (Rome, 1765). See also Rudolf Wittkower, "Piranesi's 'Parere su l'architettura,' " *Journal of the Warburg Institute* 2 (1938–39): 147–59.

71. See the astonished reactions in the academic theorist A.-C. Quatremère de Quincy's *Lettres sur l'enlèvement des ouvrages de l'art antique à Athènes et à Rome, écrites les unes au célèbre Canova les autres au Général Miranda* (Paris, 1836), pp. 28–29.

72. Vasari-Milanesi, I: 137 (cf. Paul Frankl, *The Gothic: Literary Sources and Interpretations* [Princeton, 1960], pp. 255–57, 290–95); Antonio Averlino Filarete, *Filarete's Treatise on Architecture*, ed. John R. Spencer (New Haven, 1965), I: xxx–xxxi (cf. Filarete, *Trattato di architettura*, ed. Anna Maria Finoli and Liliana Grassi [Milan, 1972], pp. 227–30, 382, 481–82).

73. Louis Réau, *Les Monuments détruits de l'art français*, 2 vols. (Paris, 1959), I: 133.

74. Réau, *Les Monuments détruits*, I: 129.

75. Réau, *Les Monuments détruits*, I: 119.

76. See René Lanson, *Le Goût du moyen âge en France au XVIIIe siècle* (Paris and Brussels, 1926), p. 6.

77. Lanson, *Le Goût*, p. 38, pls. XI, XII, XIII.

78. See the full discussion of Milan Cathedral in Rudolf Wittkower, *Gothic Versus Classic: Architectural Projects in Seventeenth Century Italy* (London, 1974), pp. 17–64.

79. See John Summerson, *Architecture in Britain 1530 to 1830*, 4th rev. ed., Penguin ed. (Harmondsworth, 1963), pp. 236–37.

80. Réau, *Les Monuments détruits*, I: 321.

81. Charles Oursel, "Les 'Pleurants' disparus des tombeaux des ducs de Bourgogne au Musée de Dijon," *Bulletin Archéologique du Comité des Travaux Historiques et Scientifiques* (Paris, 1909), pp. 14–17; William D. Wixom, *Treasures from Medieval France*, exhibition catalogue (Cleveland, 1967), no. VI 21, pp. 256, 377.

82. Charles Rohault de Fleury, *Mémoire sur les instruments de la passion de N-S. J-C.* (Paris, 1870), p. 205.

83. Réau, *Les Monuments détruits*, II: 34–36.

84. Augustus Welby Pugin, *The True Principles of Pointed or Christian Architecture* (London, 1853), p. 39.

85. Frits Lugt, "Italiaansche kunstwerken in Nederlandsche verzamelingen van vroeger tijden," *Oud Holland* 53 (1936): 104.

86. Charles de Brosses, *Lettres familières sur l'Italie* I: (Paris, 1869), 256.

87. Personal communication from Professor Ulrich Middeldorf.

88. Brosses, *Lettres*, I: 144.

89. Brosses, *Lettres*, I: 256.

90. Brosses, *Lettres*, I: 249. This is the famous passage in which he says, *"ce n'est pas la seule sottise qu'on lui* [Michelangelo] *fasse dire,"* as a dismissal of Michelangelo's supposed description of Ghiberti's second pair of doors as "the Gates of Paradise."

91. John Burnet, ed., *The Discourses of Sir Joshua Reynolds* (London, 1842), pp. 212–13.

92. See the chronology of ethnographical museums and exhibitions of primitive art— as art—in Robert J. Goldwater, *Primitivism in Modern Painting* (New York, 1938), pp. 8–9.

93. For example, a Benin flute player sold at Sotheby's in London, on July 8, 1974, for £185,000. (Compare the price of the Lansdowne Hercules.)

94. Kenneth Clark, *The Gothic Revival* (London, 1928; rev. enl. ed., London, 1950).

95. Francis Haskell, *Rediscoveries in Art: Some Aspects of Taste, Fashion and Collecting in England and France* (Ithaca, 1976).

96. Note the recent 14th Council of Europe exhibition, *The Age of Neoclassicism*, The Arts Council of Great Britain (London, 1972). Canova (cat. nos. 300–31) was in some sense the star of the show, and a critical comeback for Canova should logically lead to a critical comeback for the Apollo Belvedere.

97. *Report from the Select Committee*, p. 93; this is based on an erroneous statement in James Stuart and Nicholas Revett, *The Antiquities of Athens*, 3 vols. (1762; reprint New York, 1968), I: 5.

98. Michaelis, *Ancient Marbles*, p. 149.

99. For the style of art dealing stimulated by the high tide of enthusiasm for Greco-Roman marbles, see Brinsley Ford, "Thomas Jenkins: Banker, Dealer and Unofficial English Agent," *Apollo* 99 (June 1974): 416–25; and Smith, *Nollekens and His Times*, I: 251, on Jenkins's dishonesty.

100. The final price was never published, and an informed estimate is given here. The Prince of Liechtenstein's first asking price was, however, no less than $10,000,000, according to an unpublished lecture by John Walker, Director of the National Gallery of Art at the time the purchase was made ("Onward and Upward with the Arts: Reflections on the Museum Profession," a manuscript kindly put at my disposition by its author). See also John Walker, *Self-portrait with Donors* (Boston, 1974), p. 50. It is now being said this price has been exceeded by the $6,400,000 paid for J. M. W. Turner's Juliet and Her Nurse at Sotheby Parke Bernet. See Rita Reif, "A Turner Sells for Record $6.4 Million," *New York Times* (May 30, 1980), p. C19. In reality, allowing for intervening inflation, the price paid for the Turner in 1980 was substantially below the price paid for the Velázquez ten years earlier. Just as it is doubtful whether the price paid for Leonardo's Ginevra de' Benci exceeded the £310,000 in five-dollar gold pounds with which Tsar Nicholas II secured Leonardo's Benois Madonna just before the First World War—again because of intervening inflation. Reportedly this latter price was the benchmark which set Prince Liechtenstein's price for the Ginevra.

101. £2,310,000 paid by Wildenstein to Christie, Manson & Woods Ltd. in London, November 27, 1970.

102. Christie, Manson & Woods Ltd., Geneva, November 8, 1977. The price paid was £612,500.

103. Nicholas Gage, "Met Finds Vase Purchase 'Legal,'" *New York Times* (March 7, 1974) p. 50, col. 4; Paul Hofmann, "Team of Italians to Examine Vase," *New York Times* (March 12, 1974) p. 34, col. 3.

104. Sotheby Parke Bernet & Co., London, April 2, 1974.

105. Christie, Manson & Woods Ltd., London, June 5, 1972.

106. I am indebted to Mr. Michael Tree, formerly of Christie's, for this information.

107. Geraldine Norman, "Record £30,000 for Clichy Convolvulus Paperweight," *Times* (July 5, 1977), p. 16.

108. Stewart Alsop, "America's New Big Rich," *Saturday Evening Post* (July 17, 1965), pp. 23–28, 36–39, 42–46.

109. The antimuseum theme later echoed by so many Dadaists was first announced by the Futurists. F. T. Marinetti, "Manifesto del Futurismo," in *Archivi del Futurismo*, ed. Maria Drudi Gambillo and Tersa Fiori (Rome, 1958), I: 17–19; trans. in Joshua C. Taylor, *Futurism* (New York, 1961), pp. 124–25.

110. The twenty-one works in the Louise and Walter Arensberg Collection at the Philadel-

phia Museum of Art (Anne d'Harnoncourt and Kynaston McShine, *Marcel Duchamp* [New York, 1973]).

111. Shimada Shujiro, "Concerning the I-p'in Style of Painting, I," trans. James Cahill, *Oriental Art*, n.s. 7, no. 2 (1961): 66 ff.

112. Shimada, "I-p'in Style," p. 69.

113. Shimada, "I-p'in Style," p. 68. Alexander C. Soper, "Shih K'o and the I-p'in," *Archives of Asian Art*, no. 29 (1975–76), pp. 14–17. For an argument that the Yi-Pin painters did not produce anti-art, see also Soper, "The Relationship of Early Chinese Painting to Its Own Past," in *Artists and Traditions*, ed. Christian F. Murck (Princeton, 1977), pp. 21–47. But this argument does not cover artists who poured ink into their hair.

114. Critics, indeed, think nothing of revising artists' intentions, as when Clement Greenberg physically altered the great works included in the estate of the sculptor David Smith, of which he is a trustee. Hilton Kramer, "Altering of Smith's Work Stirs Dispute," *New York Times* (September 13, 1974); and Kramer, "Questions Raised by Art Alteration," *New York Times* (September 14, 1974).

115. Johann Wolfgang von Goethe, "Der Sammler und die Seinigen," in *Schriften zur Kunst*, ed. Ernst Bentler (Zurich, 1954); trans. Samuel Gray Ward in Goethe, *Essays on Art* (Boston, 1845), p. 62.

116. Israel Shenker, "A Pollock Sold for $2-Million, Record for American Painting," *New York Times* (September 22, 1973), pp. 1, 19.

117. Elizabeth Stevens, "Indian Art, Out of Context," *Wall Street Journal* (December 23, 1971), p. 8.

118. Frank Davis, "The Sign of the White Horse," *Country Life* (June 10, 1971), p. 1456.

119. For example, a large late-eighteenth-century wooden hay rake in the David Rockefeller collection.

120. Sherman E. Lee, *Tea Taste in Japanese Art* (New York, 1963), pp. 28–35.

121. Lee, *Tea Taste in Japanese Art*, p. 31; *Seizansō seishō: Illustrated Catalogue of the Nezu Collection*, 10 vols., V (Tokyo, 1939–43): pl. 9.

122. *Seizansō seishō:* V: pl. 9.

123. The exhibition of *bourdalous* was held October 3–13, 1958, l'Hôpital de la Salpêtrière.

124. Harold Newman, "Bourdalous Part 2: Some Continental Examples," *Connoisseur* 177, no. 711 (May, 1971): 22–31.

125. Besides the paintings, calligraphy and ancient bronzes there were literally scores of collectors' categories by the end of the Ming dynasty, including such things as "fish bags" (ornaments of court dress) of the Song dynasty, ancient tallies of several kinds and so on and on (*Chinese Connoisseurship: The Ko Ku Yao Lun, The Essential Criteria of Antiquities*, trans. and ed. Sir Percival David [London, 1971], pp. 249, 262).

126. The Emperor Qian Lung was greatly interested in the work of the Jesuit painter Castiglione in the mid-eighteenth century (Cécile and Michel Beurdeley, *Castiglione, peintre jésuite à la cour de Chine* [Paris, 1871], p. 7). And in the early centuries of Chinese Buddhism, too, both paintings and sculpture were imported from early Buddhist centers mainly in India. I used to own (now stolen) a Tang-dynasty votive tile from the temple in the first Tang capital, Chang An. The front showed the temple's cult image, "the great Indian buddha," as indicated by an inscription on the back of the tile. But this cult image, plainly large, was almost certainly "Indian" because it followed an Indian model, or because the sculptor was an Indian immigrant artist.

INTERCHAPTER 1. THE RARE ART TRADITIONS

1. For example, the Colosseum was given to Cardinal Pietro Barbo, later Pope Paul II, as a government might grant a mining or quarrying concession, to provide marble and other stone for the Cardinal's new palace, now the Palazzo Venezia (Michela di Macco, *Il Colosseo: funzione simbolica, storica, urbana* [Roma, 1972], pp. 51–52).

2. Cicero, *Actio Secunda in C. Verrem*, I. 49–51, 61.

3. "Valuable" is a word that has to be interpreted for tombs in widely varying ways, according to the tomb robbers' habits of life. In the case of the Pazyryk kurgans (see below, notes 16–29), the sedentary people who heaped up and robbed the kurgans had a way of life that appears to have differed radically from that of the nomadic steppe chieftains who were buried in these barrows. Presumably this was why such things as the ceremonial horse trappings held no interest for the tomb robbers. In Egypt, again, tombs were apparently robbed wholesale in periods of internal disorder, when the tomb guardians either conspired with the robbers or themselves became the main robbers. Thus anything of practical use was likely to be taken, although pieces of sculpture, bas-reliefs and the like were always disregarded, except perhaps when wooden sculpture could be used for fuel.

4. Alison Frantz, "From Paganism to Christianity in the Temples of Athens," *Dumbarton Oaks Papers* 19 (1965): 205.

5. Frantz, "From Paganism to Christianity," p. 200.

6. I do not list the great destructions of works of art, sometimes in abandoned monuments, more often in monuments still in use, such as the image-smashing by the Puritans of the British Commonwealth or the destructions and abandonments of the French Revolution. These campaigns were started for reasons of religion or ideology and are therefore not relevant to the argument.

7. The pagan sculpture of the Pantheon was most likely removed before the Pantheon became a church. See Rodolfo Lanciani, *The Destruction of Ancient Rome* (New York, 1889), p. 111.

8. Lawrence Palmer Briggs, *The Ancient Khmer Empire*, published as *Transactions of the American Philosophical Society*, 41 (Philadelphia, 1951): 257–61; George Coedès, *The Indianized States of Southeast Asia*, ed. Walter F. Vella, trans. Susan Brown Cowing (Honolulu, 1964), pp. 236–37.

9. George Coedès, "La Stèle de Ta-Prohm," *Bulletin de l'École Française d'Extrême-Orient* 6 (1906): 77; Coedès, "La Stèle du Práh Khǎn d'Aṅkor," *Bulletin de l'École Française d'Extrême-Orient* 41 (1941): 294, 298, 299.

10. Personal communication from Chea Thay Seng, Conservateur du Musée National, during my visit to Phnom Penh in 1970.

11. Reginald Le May, *The Culture of South-East Asia: The Heritage of India* (London, 1954), p. 134.

12. Bernard Groslier and Jacques Arthaud, *Angkor Art and Civilization*, rev. ed. (1957; New York, Washington, 1966), p. 199; Louis Finot, *Le Temple d'Angkor Vat. P'tie Ie*, École Française d'Extrême-Orient, Mémoires Archéologiques 2 (Paris, 1929) pp. 13–15.

13. "Nearby, one can see another small building like a palace. It is the replica of Ankor [*sic*] Wat. King Rama IV ordered it built in memory of its part in the past history of the Kingdom of Thailand." See Thong-in Soonsawad, *Panorama of Thailand: A Guide to the Wonders and Highlights of Thailand*, 2nd rev. ed. (1965; Wichita, Kan., 1966), p. 41; see also Helen Bruce, *Nine Temples of Bangkok* (Bangkok, 1960), p. 40.

14. Finot, *Le Temple d'Angkor Vat*, p. 23.

15. André Malraux, *La Voie royale* (Paris, 1951).

16. L. L. Barkova, "The Frozen Tombs of the Altai," in *Frozen Tombs: The Culture and Art of the Ancient Tribes of Siberia*, exhibition catalogue, British Museum (London, 1978), p. 24; Sergei I. Rudenko, *Frozen Tombs of Siberia*, trans. with preface by M. W. Thompson (Berkeley and Los Angeles, 1970), pp. xxvi–xxix, xxxvi, 293–309.

17. Rudenko, *Frozen Tombs*, p. 9.

18. Rudenko, *Frozen Tombs*, pp. xxii–xxiii, 9–12.

19. Boris Piotrovsky, "Early Cultures of the Lands of the Scythians," in *From the Lands of the Scythians: Ancient Treasure from the Museums of the U.S.S.R. 3000 B.C.–100 B.C.*, exhibition catalogue, Metropolitan Museum of Art, Los Angeles County Museum of Art (New York, 1975), p. 22.

20. Rudenko, *Frozen Tombs*, pp. 42–44, 138–93; Karl Jettmar, *Art of the Steppes: The Eurasian Animal Style* (London, 1967), pp. 108, 110, 114, 116. The ceremonial nature of the saddlery is discussed by both Rudenko (pp. 138–39) and Jettmar (p. 110).

21. Rudenko, *Frozen Tombs*, pp. 32–33, 174, 199–200, 202–6, 296–97, 305–6.

22. Rudenko, *Frozen Tombs*, pp. 30–31, 72–80, 85–87, 89, 91–93, 144–49, 166, 174, 182–84, 201, 229–37, 242–43.

23. Rudenko, *Frozen Tombs*, pp. 108, 239–42, 250, 259.

24. Rudenko, *Frozen Tombs*, p. 285.

25. Rudenko, *Frozen Tombs*, p. 33.

26. Excavation actually began in the nineteenth century, but Rudenko and Gryaznov were still the discoverers of the great majority of surviving objects from the Altai kurgans. *Frozen Tombs* (British Museum), pp. 27–77, nos. 11–74, 78–100.

27. M. P. Zavitukhina, "The Siberian Collection of Peter the Great," in *Frozen Tombs* (British Museum), pp. 13–4; Rudenko, *Frozen Tombs*, p. xxxiii.

28. *Frozen Tombs* (British Museum), pp. 35 (pl. 31), 47 (no. 31).

29. Barkova, "The Frozen Tombs of the Altai," pp. 25–26; Rudenko, *Frozen Tombs*, pp. 110–14; Jettmar, *Art of the Steppes*, p. 106.

30. See, for example, the story of the temple façade from Calalemul, now reassembled in the National Museum of Anthropology in Mexico City, told in Karl E. Meyer, *The Plundered Past* (New York, 1973), pp. 22–26.

31. See Chapter VII.

32. For Greek art collecting and its sequels, again see Chapter VII.

33. For the development of Chinese, Japanese, and Islamic art collecting, see Chapter VIII.

34. For all other problems here discussed, see Chapters VII, VIII, and IX.

35. James C. Faris, *Nuba Personal Art* (London, 1972).

36. Faris, *Nuba Personal Art*, pp. 30–32, 38–70.

37. Alois Riegl, *Stilfragen*, 2nd ed. (Berlin, 1923), p. 22; F. Adama van Scheltema, *Die altnordische Kunst*, 2nd ed. (Berlin, 1924), pp. 21–31.

38. Faris, *Nuba Personal Art*, pp. 73–113.

39. Faris, *Nuba Personal Art*, pp. 84–88, pls. 10, 11, 14, 18, 27, 31, 35, 36, 42.

40. Faris, *Nuba Personal Art*, pp. 66–67.

41. Faris, *Nuba Personal Art*, p. 6 *et passim*; Victoria Ebin, *The Body Decorated* (London, 1979), pp. 74, 82.

42. Faris, *Nuba Personal Art*, p. 11

43. For example, artifacts, masks, and the like acquired from the small mountain tribes of New Guinea are still entering the art market.

II. ART FOR USE

1. *Summa Theologica* (Rome, 1923), I–II, Q. 27, art. I; I.Q.5, art. 4.
2. Josephus Gredt, *Elementa Philosophiae.* II, *Metaphysica* (Barcelona, 1946), p. 29.
3. Precise estimates vary, so this is an approximate date.
4. J. Desmond Clark, "African Origins of Man the Toolmaker," in *Human Origins,* ed. Glynn Ll. Isaac and Elizabeth R. McCown, Perspectives of Human Evolution 3 (Menlo Park, Cal., 1970), pp. 36–38; Clark, "Africa in Prehistory: Peripheral or Paramount," *Man,* n.s. 10 (1975): 185–86, 190; Charles Singer and E. J. Holmyard, eds., *A History of Technology,* I (Oxford, 1955): 27–30.
5. This date has steadily been pushed back in recent years. "A million and a half years ago" seems to reflect the current majority view of paleo-anthropologists. See Clark, "Africa in Prehistory," p. 185.
6. There are also some late Acheulian cleavers as finely made as the hand axes (personal communication from Professor J. Desmond Clark). In the Mousterian-Acheulian layers of the cave Pech de l'Azé, François Bordes discovered the oldest engraved bone thus far known. The engraving takes the form of seemingly aimless scribbling, yet Bordes's discovery is nonetheless highly significant. François Bordes, *A Tale of Two Caves* (New York, 1972), pp. 61 fig. 17, 62.
7. Clark, "African Origins," p. 37. Significantly, it was around this time that late Acheulian man began to use ochre as a pigment. See Stephen W. Edwards, "Non-utilitarian Activities in the Lower Paleolithic: A Look at Two Kinds of Evidence," *Current Anthropology* 19 (1978): 135–38.
8. Clark, "African Origins," p. 37; Clark, "Africa in Prehistory," p. 190; Singer and Holmyard, *History of Technology,* I: 28.
9. This should not be understood to mean anything more than that they pleased Acheulian eyes. See discussion below this passage, and earlier.
10. For example, "Your first and proper standing is not as church-wardens and parish overseers, in an English country, but as members of the great Christian community of Europe. And as members of that community (in which alone, observe, pure and precious ancient art exists, for there is none in America, none in Asia, none in Africa) . . . ," quoted in John Ruskin, *The Lamp of Beauty,* ed. Joan Evans (Garden City, N.Y., 1959), p. 311, excerpted from *A Joy for Ever: The Political Economy of Art* (1857). A search through Ruskin's complete works would undoubtedly disclose repetitions of this opinion, as well as some variations from it.
11. Yrjo Hirn, in *The Origins of Art* (1900; New York, 1971), pp. 7–8, was one of the first European esthetic theorists to challenge the view of Immanuel Kant. Worth quoting is Hirn's opening gun: "Metaphysicians as well as psychologists, Hegelians as well as Darwinians, all agree that a work, or performance, which can be proved to serve any utilitarian, non-esthetic purpose must not be considered as a genuine work of art. True art has its one end in itself, and rejects every extraneous purpose." Hirn cites Kant's *Kritik der Urtheilskraft* (Leipzig, 1880), p. 147. The critical Kant passage actually comprises the third part of section 43 and section 44, on pp. 145–47.

The first section sternly distinguishes between true art and handicraft. In the second section Kant argues that a true work of art can only be made with no other purpose primarily in mind. The phrase "end in itself" is Hirn's description of the thrust of Kant's argument in these two sections; but it would seem to be a sound summary, although other passages in this same work by Kant somewhat dilute the effect of this statement. The dilution is unimportant, because the position taken in these two sections is the one that dominated so much of nineteenth-century discussion

of esthetic theory. The distinction between "fine art" and "craftsmanship" was all but universally made, and attention was almost never paid to the practical purposes for which most of the greatest works of art were actually made.

Besides the reference to Kant already given, Hirn cites Friedrich Schiller, *Über die ästhetische Erziehung des Menschen, passim,* (see for example the Wolfart Henckmann edition [Munich, 1967]); Herbert Spencer, *The Principles of Psychology,* 2 vols., 3rd ed. (London, 1890), II, 628, 632; Émile Hennequin, *La Critique scientifique* (Paris, 1888), pp. 26–28; Ernst Grosse, *Die Anfänge der Kunst* (Freiburg, i.B., 1894); and Grant Allen, *Physiological Aesthetics* (London, 1877), pp. 32, 33.

12. Or perhaps it should be said that these views are only logically tenable if you are prepared to maintain that half or more of the most treasured exhibits in modern comprehensive art museums ought not to be there, because they are not works of art.

13. When the Pietà was undertaken, Jacopo Galli significantly predicted that it would be ". . . the most beautiful work in marble that Rome has ever seen and no other master would today make it better." Charles de Tolnay, *Michelangelo,* 2nd. ed., I (Princeton, 1969): 91.

14. See the discussion in Chapter III.

15. The history of the Sistine Madonna as given here is taken from Dussler, who is paralleled in general by Sir John Pope-Hennessey. The numerous earlier reconstructions of the Madonna's history are listed in Dussler. See Luitpold Dussler, *Raphael: A Critical Catalogue of His Pictures, Wall-Paintings and Tapestries,* trans. Sebastian Cruft (London and New York, 1971), pp. 36–38; Sir John Pope-Hennessey, *Raphael* (New York, 1970), pp. 17, 209–12.

16. Dussler, *Raphael: A Critical Catalogue,* p. 37.

17. Dussler, *Raphael: A Critical Catalogue,* p. 37.

18. The entire story is quoted by Joachim Menzhausen, Director of the Green Vaults, in "Five Centuries of Art Collecting in Dresden," in *The Splendour of Dresden: Five Centuries of Art Collecting,* exhibition catalogue, State Art Collections of Dresden, German Democratic Republic (New York, 1978), p. 23. For a more probable version see J.-D. Passavant, *Raphael D'Urbin,* rev. and annot. Paul Lacroix (Paris, 1860), I: 257–58.

19. Kant in this context was only thinking about what used to be called "high art"— painting and sculpture. In Kant's time, all the rest of the products of the visual arts, with the sole exception of architecture, were in a different class as artisans' work.

20. See Chapter VI. Note the word "major." Also see Chapter VI for the minor public art museums which preceded the Uffizi and the Kunsthistorisches Museum.

21. Goethe, *Dichtung und Wahrheit,* trans. as *Goethe's Autobiography: Poetry and Truth from My Life,* by R. O. Moon (1932; Washington, D.C., 1949), p. 278.

22. This statement does not apply to the great majority of paintings and pieces of sculpture from the last two centuries, but even among the surviving works of Chardin, many are thought to have been painted as overdoor decorations. Pierre Rosenberg, *Chardin 1699–1779,* exhibition catalogue, The Museum of Art (Cleveland, 1979), pp. 145, 146, nos. 27, 28; 149, nos. 29, 30; 337, 339, no. 123; 340, 342, 341, 343–44, no. 124; 347, no. 126; 348, 350, no. 127; 351.

23. Sheila L. Weiner, *Ajanta: Its Place in Buddhist Art* (Berkeley, 1977), pp. 32, 120.

24. Weiner, *Ajanta,* pp. 108–17; Roy C. Craven, *A Concise History of Indian Art* (London, 1976), p. 121.

25. Weiner, *Ajanta,* p. 1; Craven, *Concise History,* p. 121.

26. John L. Stephens, *Incidents of Travel in Yucatan*, 2 vols. (1843; reprint New York, 1963), I: 258–59; II: 14, 29–30, 40, 79–80, 169, 306–07.

27. A. V. Kidder, "Division of Historical Research," *Annual Report of the Chairman of the Division of Historical Research, Carnegie Institution of Washington. Year Book No. 46* (1946–47), pp. 173–79.

28. Alberto Ruz Lhuillier, *El Templo de las Inscripciones Palenque*, Colección Científica Arqueología, 7 (Mexico, 1973), pp. 151 ff.

29. Karl E. Meyer, *The Plundered Past* (New York, 1973), pp. 3–43.

30. For example, the Japanese Imperial regalia.

31. For example, the candlesticks from the Temple in Jerusalem brought to Rome by the Emperor Titus and finally lost, probably in the sack of Rome by Alaric in 410 A.D.

32. For example, the Roman palladium.

33. See Chapter IX.

34. *Oriental Ceramics: The World's Great Collections.* X, The Freer Gallery of Art (Tokyo, 1975), monochrome pl. 24.

35. *Kan-Ko-Chō* [Mirror of Antiquity], Collection of Reproductions from Treasures of the Shōsōin Catalogue issued at Takashima (Osaka, 1928), unpaginated; see plate of ivory and sandalwood kimono stand.

36. Gisela M. A. Richter, *The Sculpture and Sculptors of the Greeks*, 4th rev. ed. (New Haven, 1970), pp. 169 n. 20, 170, 171–72. See also J. J. Pollitt, *The Ancient View of Greek Art* (New Haven and London, 1974), p. 53.

37. Plutarch, *Pericles*, 31.

38. This began very early in the development of the modern Western art tradition. For example, it is known that the figures shown in Francesco da Carrara's Sala Virorum Illustrium were taken from Petrarch's *De Viris Illustribus*.

39. Meyer Schapiro, "Diderot and the Artist and Society," *Diderot Studies* 5 (1964): 6.

40. Meyer Schapiro, "On the Relation of Patron and Artist: Comments on a Proposed Model for the Scientist," *American Journal of Sociology* 70 (1964): 363. See also John Larner, *Culture and Society in Italy 1290–1420* (London, 1971), p. 328.

41. William M. Evan, "Role Strain and the Norm of Reciprocity in Research Organizations," *American Journal of Sociology* 68 (1962): 346–54, esp. 351 ff.

42. For the documentation, see Chapter VIII.

43. In the ninth century A.D. Chinese art collectors already kept their prizes "in their chests and boxes." See Chapter VIII, p. 243.

44. See Chapter VIII.

45. Sometimes, though rarely, the human female figure had been portrayed in the nude, as in the figure on one of the side panels of the Ludovisi Throne and on many of the more erotically painted pieces of Greek pottery.

46. Pliny, *Naturalis Historia* XXXVI. 20.

47. See note 47 to Chapter I.

48. Pliny, *Naturalis Historia* XXXVI. 20.

49. The naked Aphrodite is mentioned in a whole series of other classical writers besides Pliny. It is the centerpiece, for instance, in Lucian's *Amores*, XIII–XIV.

50. See Chapter VII.

51. The young Caesar went to Bithynia as an envoy in 81–80 B.C., where, in the widespread belief of his contemporaries, he was seduced by the King.

52. Pliny does not specify that the offer to Cnidus was made by the IVth Nicomedes (c. 94–75/4 B.C.). The offer may perhaps have come from Nicomedes III (c. 127–94 B.C.), called Euergetes, the Benefactor, because of his gifts to the Greek cities;

but the rhythm of art collecting's development in the Greek world makes it more probable that such an offer came from a foreign ruler in the first century B.C.

53. Pliny, *Naturalis Historia* XXXVI. 21.

54. See discussion of this in Chapter VII.

55. Schapiro, "On the Relation of Patron and Artist," p. 363.

56. John Boardman, *Greek Sculpture: The Archaic Period* (London, 1978), pp. 9–10.

57. David M. Robinson and Edward J. Fluck, *A Study of the Greek Love-Names* (Baltimore, 1937), pp. 1–14.

58. J. D. Beazley, *Attic Red-Figure Vase Painters*, 3 vols., 2nd ed. (Oxford, 1963), I: 14 no. 2; Beazley, *Paralipomena: Additions to Attic Black-Figure Vase Painters and to Attic Red-Figure Vase-Painters*, 2nd ed. (Oxford, 1971), p. 322.

59. J. D. Beazley, *Attic Black-Figure Vase-Painters* (Oxford, 1956), p. 143 no. 1; Beazley, *Paralipomena*, p. 59.

60. James R. Mellow, "A New (6th Century B.C.) Greek Vase for New York," *New York Times Magazine* (November 12, 1972), pp. 42–43, 114, 116, 120.

61. John Boardman, *Athenian Red-Figure Vases: The Archaic Period* (London, 1975), p. 88.

62. In 1979, a dozen champagne glasses of the best quality sold for $3,000 (information supplied by Baccarat's New York branch).

63. E. Sabbe, "L'Importation des tissus orientaux en Europe occidentale au haut moyen âge (IXe et Xe siècles), Partie le," *Revue Belge Philologie et d'Histoire* 14, no. 3 (July–September 1935): 836.

64. J. Lestoquoy, "Le Commerce des oeuvres d'art au moyen âge," *Annales d'Histoire Sociale* 3 (1943): 19–26.

65. Larner, *Culture and Society in Italy 1290–1420*, pp. 285–86, 310 ff.

66. Jacob Burckhardt, *Die Sammler*, in *Beiträge zur Kunstgeschichte von Italien*, Gesamtausgabe 12 (Stuttgart, Berlin, and Leipzig, 1930), p. 300.

67. The fact that this devotional painting centers on King Richard II makes it 99-percent certain that it was a special commission (Francis Wormald, "The Wilton Diptych," *Journal of the Warburg and Courtauld Institutes* 17 [1954]: 191 ff.).

68. See Franco Sacchetti on Mino da Siena in Larner, *Culture and Society*, pp. 286, 311.

69. Gino Corti, "Sul commercio dei quadri a Firenze verso la fine del secolo XIV," *Commentari* 22 (January-March 1971): 84–88.

70. Robert Brun, "Notes sur le commerce des objets d'art en France et principalement à Avignon à la fin du XIVe siècle," *Bibliothèque de L'École des Chartes* 45 (1934): 327–46. The accounts of the Datini firm, according to Brun, show exports of thirty-five paintings over the years 1371–90.

71. At least once, however, a picture of better quality was requested by the firm's Avignon branch, obviously because of a special order (Iris Origo, *The Merchant of Prato: Francesco di Marco Datini 1335–1410* [London, 1957], pp. 41–42; Brun, "Notes sur le commerce," p. 331).

72. Johannes Wilde, *Venetian Art from Bellini to Titian* (Oxford, 1974), p. 11.

73. Bruno Santi, ed., *Neri di Bicci: Le ricordanze* (Pisa, 1976).

74. Santi, *Neri di Bicci*, pp. 15–16. The count given here, and the reconstruction of the way the reliefs were produced, were made by Professor Ulrich Middeldorf, review of *Neri di Bicci* in *Renaissance Quarterly* 31 (Summer 1978): 218–21.

75. Lorne Campbell, "The Art Market in the Southern Netherlands in the Fifteenth Century," *Burlington Magazine* 118 (April, 1976): 188–98.

76. Campbell, "The Art Market," pp. 196–97.

77. Gino Corti and Frederick Hartt, "New Documents Concerning Donatello, Luca and

Andrea della Robbia, Desiderio, Mino, Uccello, Pollaiuolo, Filippo Lippi, Baldovinetti, and Others," *Art Bulletin* 44 (June 1962): 155–67.

78. Campbell, "The Art Market," p. 191.
79. Campbell, "The Art Market," pp. 194–95.
80. Campbell, "The Art Market," pp. 192, 195, 196.
81. Raymond de Roover, *The Rise and Decline of the Medici Bank, 1397–1494* (Cambridge, Mass., 1963), p. 144.
82. Larner, *Culture and Society*, p. 328.
83. Campbell, "The Art Market," p. 196; Max J. Friedländer, *Early Netherlandish Painting*. III, *Dieric Bouts and Joos van Ghent*, trans. Heinz Norden (Leyden, 1968), pp. 11–25.
84. Friedländer, *Early Netherlandish Painting*, III: 18–19.
85. Friedländer, *Early Netherlandish Painting*, III: 18.
86. Friedländer, *Early Netherlandish Painting*, III: 18.
87. Friedländer, *Early Netherlandish Painting*, III: 11, 21.
88. See Chapter XI.
89. See Chapter XIII.
90. See Chapter X.
91. Felton Gibbons, "Practices in Giovanni Bellini's Workshop," *Pantheon* 23 (1965), pp. 146–55.
92. J. A. Crowe and G. B. Cavalcaselle, *Titian: His Life and Times*, 2 vols. (London, 1877), II: 82 ff., 142 ff., 374 ff.; Georg Gronau, *Titian*, trans. Alice M. Todd (London, 1904), pp. 133, 227.
93. Gronau, *Titian*, pp. 248–49.
94. Wolfgang Braunfels, "I quadri di Tiziano nello studio a Biri Grande (1530–1576)," in *Tiziano e Venezia*, Convegno Internazionale di Studi, Venezia, 1976 (Vicenza, 1980), pp. 407–10.
95. Crowe and Cavalcaselle, *Titian*, II: 155, 185, 197, 273.
96. Crowe and Cavalcaselle, *Titian*, II: 254–55.
97. Pietro Aretino, *Lettere sull'arte*, ed. E. Camesasca, II (Milan, 1957): 192–93.
98. Ilse Hecht, "The Infants Christ and St. John Embracing: Notes on a Composition by Joos van Cleve," *Apollo* 113 (April, 1981): 222–29.
99. Francis Haskell, *Patrons and Painters* (New York, 1963), p. 11.
100. Michael Mahoney, *The Drawings of Salvator Rosa*, (New York and London, 1977), pp. 96–101. *Salvator Rosa*, exhibition catalogue, Hayward Gallery London, intro. Michael Kitson (London, 1973), p. 14; Haskell, *Patrons and Painters*, p. 11.
101. Jane Costello, "The Twelve Pictures 'Ordered by Velasquez' and the Trial of Valguarnera," *Journal of the Warburg and Courtauld Institutes* 13 (1950): 254–55, 260–61, 263, 275; Anthony Blunt, *The Paintings of Poussin: A Critical Catalogue*, 2 vols. (London, 1966), I: 24–25.
102. Oliver Millar, *Rubens: The Whitehall Ceiling* (London, 1958); Oliver Millar, "The Whitehall Ceiling," *Burlington Magazine* 98 (August, 1956): 258–67.
103. Millar, *Rubens*, pp. 10 ff.
104. W. Noël Sainsbury, ed., *Original Unpublished Papers Illustrative of the Life of Sir Peter Paul Rubens as an Artist and a Diplomatist* (London, 1859), pp. 236–37, nos. 1–37, 241–43, nos. 175–281.
105. The inventory of Rubens's collection included ninety-four of his own original paintings. Sainsbury, *Original Unpublished Papers*, pp. 239–40, nos. 81–174.
106. Sainsbury, *Original Unpublished Papers*, pp. 31–32.
107. Sainsbury, *Original Unpublished Papers*, p. 53.
108. Sainsbury, *Original Unpublished Papers*, p. 31.

109. Sainsbury, *Original Unpublished Papers*, pp. 302–03.

110. *European Paintings: An Illustrated Summary Catalogue*, National Gallery of Art (Washington, D.C., 1975), p. 314, no. 1948.

111. The agreement was that Buckingham would pay 100,000 florins in all, but Rubens failed to deliver certain paintings of his own that had been included in the agreed price, and the sum received was therefore 84,000 florins. *Correspondance de Rubens et documents épistolaires*, ed. Charles Ruelens and Max Rooses, II (Antwerp, 1898): 192. The fullest account of the dealings between Rubens and the Duke of Buckingham is that of Dr. Jeffrey Muller, "Rubens's Museum of Antique Sculpture; An Introduction," *Art Bulletin* 59 (December 1977): 575, together with some additional details provided in Dr. Muller's forthcoming book, to be entitled *Rubens's Museum*. The pictures by other hands which Rubens sold Buckingham included one Titian, a version of his Diana and Actaeon, but the identities of the rest are unknown.

112. J. Denucé, *Art Export in the 17th Century in Antwerp: The Firm Forchoudt* (Antwerp, 1931).

113. Denucé, *Art Export*, p. 14.

114. Denucé, *Art Export*, p. 17.

115. This had begun with the painters of devotional pictures like the Venetian *"Madonnieri."*

116. *The Diary of John Evelyn*, ed. E. S. de Beer (London, 1959), pp. 23–24.

117. Thomas Sidney Cooper, *My Life*, 2 vols. (London, 1890).

118. Cooper, *My Life*, I: 24.

119. Calvin Tomkins, "The Art World: Rocks," *New Yorker* (March 24, 1980), pp. 76, 78, 80, 82.

120. Hilton Kramer, "Art: De Kooning of East Hampton," *New York Times* (February 10, 1978); Robert Hughes, "Softer De Koonings," *Time* (March 6, 1978), pp. 78–79.

121. This rule does not hold for Renaissance jewelry, in which the stones rarely have high modern values, and for more recent jewelers like Lalique, who again used relatively inexpensive stones and put enormous extra emphasis on the design of his pieces.

122. James Mellaart, "Excavations at Çatal Hüyük, 1963: Third Preliminary Report," *Anatolian Studies* 14 (1964): 39–119; Mellaart, *Çatal Hüyük: A Neolithic Town in Anatolia* (London, 1967), pp. 16, 20, 22, 213–14; Colin Renfrew, J. E. Dixon, and J. R. Cann, "Obsidian and Early Cultural Contact in the Near East," *Proceedings of the Prehistoric Society* 32 (1966): 38, 52, 59, table 7.

123. Bernal Díaz del Castillo, *The Discovery and Conquest of Mexico*, trans. A. P. Maudslay, ed. Irving A. Leonard (New York, 1956), p. 248. See also, for an account of the uses and ways of working jade in Mesoamerica, William F. Foshag, "Mineralogical Studies of Guatemalan Jade," *Smithsonian Miscellaneous Collections* 135 (December 3, 1957): 5 *et passim*.

124. Díaz del Castillo, *Discovery and Conquest of Mexico*, pp. 317, 321.

125. Bernal Díaz del Castillo was assisted to escape by his rejection of gold and his choice of four fine jades (*Discovery and Conquest of Mexico*, p. 313).

126. There is some evidence that flint of special colors was particularly highly valued in the Old Stone Age. The value attached to obsidian in the Neolithic Era has already been mentioned. Some semiprecious stones, like lapis lazuli, also began to be exported over long distances at very early dates.

127. Bernice Grohskopf, *The Treasure of Sutton Hoo* (New York, 1970), p. 34.

128. Rupert Bruce-Mitford, *The Sutton Hoo Ship-Burial*, I, *Excavations, Background, the*

Ship, Dating and Inventory (London, 1975), pp. 690–98, 712–15; Rupert Bruce-Mitford, *The Sutton Hoo Ship-Burial*, 2nd ed. (London, 1972), pp. 56, 60–64.

129. Bruce-Mitford, *The Sutton Hoo Ship-Burial*, I (1975): 201–02; Bruce-Mitford, *The Sutton Hoo Ship-Burial* (1972), pp. 30–31, pl. 17.

130. Bruce-Mitford, *The Sutton Hoo Ship-Burial*, I (1975): 202; Bruce-Mitford, *The Sutton Hoo Ship-Burial* (1972), pp. 30–31.

131. Bruce-Mitford, *The Sutton Hoo Ship-Burial* (1972), pp. 70–72, 73–74.

132. Colin H. Kraay and Max Hirmer, *Greek Coins* (London, 1966), pp. 13, 288, nos. 122, 123, pls. 44, 45. The *Demareteion* was commemorative in purpose when first issued, but Syracuse continued issuing decadrachms with the Arethusa design for a considerable period.

133. Kraay and Hirmer, *Greek Coins*, p. 288.

134. Richard Duncan-Jones, *The Economy of the Roman Empire* (Cambridge, 1974), p. 126.

135. Duncan-Jones, *Economy of Roman Empire*, p. 126.

136. Richard Krautheimer with Trude Krautheimer-Hess, *Lorenzo Ghiberti*, 2nd ed., 2 vols. (Princeton, 1970), I: 106, 107.

137. Krautheimer, *Lorenzo Ghiberti*, I: 112.

138. Krautheimer, *Lorenzo Ghiberti*, I: 105.

139. Personal communication from Leo Castelli, Rauschenberg's dealer.

140. Personal communication from Leo Castelli.

141. Lorenzo Ghiberti, *I commentarii*, in Julius von Schlosser, ed., *Lorenzo Ghibertis Denkwürdigkeiten* ("Ghiberti-Schlosser"), 2 vols. (Berlin, 1912), I: 44 *"trentotto migliaia di fiorini"*; also Vasari-Milanesi, II: 236; *"trentamila ducati d'oro"*; Schlosser, *Leben und Meinungen des Florentinischen Bildners. Lorenzo Ghiberti* (Basel, 1941), pp. 44, 213.

142. Helmut Buschhausen, "The Klosterneuberg Altar of Nicholas of Verdun: Art, Theology, and Politics," *Journal of the Warburg and Courtauld Institutes* 37 (1974): 1; Otto Demus's forthcoming book contains additional information on the Klosterneuberg Altar, but until then the standard work is Floridus Röhrig, *Der Verduner Altar*, 3rd ed. (Vienna, 1964). See also Peter Lasko, *Ars Sacra: 800–1200*, Penguin ed. (Harmondsworth, 1972), pp. 240–52; Otto Demus, "Neue Funde an den Emails des Nikolaus von Verdun in Klosterneuberg," *Österreichische Zeitschrift für Kunst und Denkmalpflege* 5 (1951): 13–22.

143. See Chapter IX.

144. See Chapter IX.

145. Erwin Panofsky, ed., *Abbot Suger on the Abbey Church of St.-Denis and Its Art Treasures* (Princeton, 1946).

146. Blaise de Montesquiou-Fezensac with Danielle Gaborit-Chopin, *Le Trésor de Saint-Denis: Inventaire de 1634* (Paris, 1973); Simon Germain Millet, *Le Trésor sacré, ou Inventaire des sainctes reliques et autres précieux ioyaux qui se voyent en l'église & au trésor de l'abaye royale de S. Denis en France*, 2nd ed. (Paris, 1938); W. Martin Conway, "The Abbey Church of Saint-Denis and Its Ancient Treasures," *Archaeologia* 66, 2nd ser. 16 (1914–15): 103–58. For an early description of the treasury, see *The Diary of John Evelyn*, 4 vols. (London, 1906) I: 66–68 (November 12, 1643).

147. Montesquiou-Fezensac, *Le Trésor de Saint-Denis, Inventaire de 1634*, pp. 42–43; Panofsky, *Abbot Suger*, pp. 36, 78–79, 206; Joan Evans, "Die Adlervase des Sugerius," *Pantheon* 10 (1932): 221–23, 53; H. Swarzenski, *Monuments of Romanesque Art* (London, 1954) p. 65, no. 152.

148. Montesquiou-Fezensac, *Le Trésor de Saint-Denis, Inventaire de 1634*, p. 150.

149. Montesquiou-Fezensac, *Le Trésor de Saint-Denis, Inventaire de 1634*, pp. 7–8, 10–11, 30–31, 33, 45, 62, 290.

150. Conway, "The Abbey Church of Saint-Denis," pp. 128–30, pl. X; J. Hubert, J. Porcher, W. F. Volbach, *The Carolingian Renaissance* (New York, 1970), pp. 254, no. 234; 256, 291, no. 323; 356, no. 234; 361, no. 323.

151. Conway, "The Abbey Church of Saint-Denis," p. 128, pl. X; Hubert et al., *The Carolingian Renaissance*, pp. 254–56, 291, no. 323; 356, no. 234; 361, no. 323.

152. For a king selling treasures see Matthew Paris's *English History*, trans. J. A. Giles (London, 1853), II: 267. See also David Herlihy, "Treasure Hoards in the Italian Economy 960–1139," *Economic History Review*, 2nd ser., 10, no. 1 (1957): 1–14.

153. Anna Somers Cocks, "The Myth of 'Burgundian' Goldsmithing," *Connoisseur* 194 (March 1977): 180–86.

154. Hermann Fillitz, *Katalog der weltlichen und der geistlichen Schatzkammer*, Führer durch das Kunsthistorische Museum, no. 2, 3rd rev. ed. (Vienna, 1961), p. 1.

155. Joachim Menzhausen, *The Green Vaults* (Leipzig, 1970), p. 43. Note that the dukes of Saxony were also Electors of the Empire and became kings of Poland for a while in the eighteenth century. The kingship of Saxony proper was originally a creation of the Emperor Napoleon.

156. Menzhausen, *The Green Vaults*, p. 43; Millard Meiss, *French Painting in the Time of Jean de Berry: The Late XIV Century and the Patronage of The Duke*, 2 vols. (London, 1967), I: 45.

157. Meiss, *French Painting: The Late XIV Century*, I: 45.

158. Ghiberti–Schlosser, I: 43–44.

159. Eugène Müntz, *Les Arts à la cour des papes pendant le XVe et le XVIe siècle*, 3 vols., I (Paris, 1878–82): 190–91.

160. Ghiberti–Schlosser, I: 43.

161. Richard Krautheimer, "Ghiberti and Master Gusmin," *Art Bulletin* 29 (1947): 30.

162. Ghiberti–Schlosser, I: 44.

163. Meiss, *French Painting: The Late XIV Century*. I: 45; Otto Cartellieri, *The Court of Burgundy* (New York, 1925), p. 16.

164. Louis Raynal, *L'Histoire du Berry depuis les temps les plus anciens jusqu'en 1789* 4 vols., II (Bourges, 1844–47): 453. The first to deplete the treasures of the Ste.-Chapelle was the same Duke who had donated them. For the Protestant pillage, see note on same page.

165. Paul Gauchery, "Le Palais du Duc Jean et la Sainte-Chapelle de Bourges: nouveaux documents sur leur état primitif, leur mutilation ou leur destruction," *Mémoires de la Société des Antiquaires du Centre*, 39 (1919–20): 47.

166. Charles Rohault de Fleury, *Mémoire sur les instruments de la Passion de N.-S. J.-C.* (Paris, 1870), pp. 205 ff.; *Exuviae Sacrae Constantinopolitanae*, ed. P. Riant, II (Paris, 1879): 277–79.

167. London, British Museum, Waddesdon Room Catalogue, no. 67. See Charles Hercules Read, *The Waddesdon Bequest: Catalogue of Works of Art Bequeathed to the British Museum by Baron Ferdinand Rothschild, M.P. 1898* (London, 1902), pp. 31–33.

168. Philipp Maria Halm and Rudolph Berliner, *Das Hallesche Heiltum* (Berlin, 1931); Paul Redlich, *Cardinal Albrecht von Brandenburg und das Neue Stift zu Halle 1520–1541* (Mainz, 1900), p. 228; U. Steinmann, "Der Bilderschmuck der Stiftskirche zu Halle," *Staatliche Museen zu Berlin: Forschungen und Berichte* 2 (1968): 69–104.

169. Redlich, *Cardinal Albrecht*, pp. 259, 278.

170. Marcel Aubert, *Figures monastiques: Suger* (Abbaye Saint-Wandrille, 1950), p. 38.

For only 31 of the Abbey's 169 domains, he augmented the cash revenue by 1,324 pounds of silver, with some increases in kind as well.

171. Panofsky, *Abbot Suger*, p. 27.

172. Panofsky, *Abbot Suger*, p. 36.

173. The two heads, catalogue numbers 27.21 and 27.22, were acquired by the Walters Art Gallery in 1911. See Marvin Chauncey Ross, "Monumental Sculptures from St.-Denis: An Identification of Fragments from the Portal," *Journal of the Walters Art Gallery* 3 (1940): 90–107; William D. Wixom, *Treasures from Medieval France*, exhibition catalogue, Cleveland Museum of Art (Cleveland, 1967), pp. 72, no. III-14; 73–74, 354.

174. Conway, "The Abbey Church of Saint-Denis," pp. 143 ff., pl. XVI; Seymour de Ricci, "Un Chalice du trésor de St.-Denis," *Académie des Inscriptions et Belles Lettres, Comptes-Rendus* (1923), pp. 335 ff.; M. Rosenberg, "Ein wiedergefundener Kelch," *Festschrift zum sechzigsten Geburtstag von Paul Clemen* (Bonn, 1926), pp. 208–17. More recently: Wixom, *Treasures from Medieval France*, pp. 70, no. III-13; 353–54; Hermann Fillitz, *Das Mittelalter*, I, Propyläen Kunstgeschichte 5 (Berlin, 1979), p. 256, no. 341.

175. Panofsky, *Abbot Suger*, p. 1, so describes him without qualification.

176. Otto von Simson, *The Gothic Cathedral* (New York, 1956), pp. 96–98.

177. Panofsky, *Abbot Suger*, p. 27; Paul Frankl, *Gothic Architecture*, Penguin ed. (Harmondsworth, 1962), pp. 27–30, 34–36.

178. Panofsky, *Abbot Suger*, pp. 18–20; Peter Hirschfeld, *Mäzene: Die Rolle des Auftraggebers in der Kunst* (Berlin, 1968), pp. 48–59; Paul Frankl, *The Gothic: Literary Sources and Interpretations* (Princeton, 1960), pp. 23–24.

179. Panofsky, *Abbot Suger*, p. 36.

180. Pliny, *Naturalis Historia*, XXXV, 57, 59; Pausanias, *Descriptio Graecae*, V. xi. 6.

181. F. Lanier Graham, *Hector Guimard*, exhibition catalogue, Museum of Modern Art (New York, 1970), pp. 4, 14; Gillian Naylor, "Hector Guimard—Romantic Rationalist?" in *Hector Guimard*, Architectural Monographs 2 (London, 1978), p. 86.

182. R. E. Wycherley, "The Athenian Agora III," *Literary and Epigraphical Testimonia*, American School of Classical Studies at Athens (Princeton, 1957), p. 44. Wycherley very tentatively suggests that the "proconsul" was an imperial agent enforcing the edict of Theodosius I against the pagan cults. But Polygnotus' pictures had historical rather than religious subjects. Consequently Alison Frantz, in a soon-to-be-published book, more sensibly suggests that the "proconsul" was the famously rapacious Antiochus, proconsul of Achaea in 395–96.

183. Adolf Michaelis, *Ancient Marbles in Great Britain*, trans. C. A. M. Fennell (Cambridge, 1882); William St. Clair, *Lord Elgin and the Marbles* (London, 1967).

184. Graham, *Hector Guimard*, p. 4. See also Lynne Thornton, "Guimard & the Metro," *Connoisseur* 204 (August, 1980): 252–53.

185. Adrienne L. Kaeppler, *"Artificial Curiosities": Being an Exposition of Native Manufactures Collected on the Three Pacific Voyages of Captain James Cook, R.N.*, Bishop Museum Special Publication 65 (Honolulu, 1978), pp. 60, 62.

186. Roland W. and Maryanne Force, *Art and Artifacts of the 18th Century* (Honolulu, 1968), pp. 14–15, 17; for illustrations of capes see pp. 41–61; of helmets, pp. 31–37. See also Kaeppler, *"Artificial Curiosities,"* pp. 52–53, 58, 60–69, 71–73; William Howells, "Hawaiian Feather Cape," "Hawaiian Crested Helmet," in *Masterpieces of the Peabody Museum*, exhibition catalogue, Harvard University (Cambridge, Mass., 1978), pp. 46–47, 48–49.

187. Mark Girouard, *Life in the English Country House* (New Haven and London, 1978), pp. 2–3.

188. The club has wisely kept intact almost the entire extraordinary mansion.

189. Arsène Houssaye, *Un Hôtel célèbre sous le Second Empire: L'Hôtel Paiva, ses merveilles précédé de l'ancien hôtel de la Marquise de Paiva* (Paris, n.d.), pp. 33, 36.

190. Francis Henry Taylor, *The Taste of Angels* (Boston, 1948), p. 5.

191. Taylor, *The Taste of Angels*, p. 5. Taylor, curiously enough, quotes a statement by Howard Carter on this point; and yet the inventories that refute this statement are also Carter's.

192. Howard Carter, *The Tomb of Tutankhamen*, 3 vols. (London, 1923–33), I: 144–45.

193. Carter, *The Tomb*, I: 94; II: 144–46; Howard Carter, *The Tomb*, rev. ed. (abridged into 1 vol., London, 1972), pp. 215–17; *Treasures of Tutankhamen*, exhibition catalogue, The British Museum (London, 1972), p. 42.

194. Carter, *The Tomb*, III: 87; Carter, *The Tomb*, rev. ed., p. 187.

195. Carter, *The Tomb*, I: 93; III: 146; Carter, *The Tomb*, rev. ed., pp. 24, 216; Edward F. Wente, "Tutankhamun and His World," in *Treasures of Tutankhamun*, exhibition catalogue, National Gallery of Art, et al. (New York, 1976), p. 27.

196. A likely future exception is the tomb of Emperor Tang Gaozung and his consort, the Empress Wu, not far from modern Sian. This was tunneled into a stone mountain several hundred feet high. The entrance passage was repeatedly blocked by huge slabs of marble reinforced in various ingenious ways. Consequently, the tomb has never been robbed. So much has already been discovered by the preliminary sounding of the People's Republic of China. Despite intense pressure from Guo Moruo to open the tomb before he died, the leaders of the Archeological Service courageously decided to wait to open this great tomb until they felt confident they had perfected the techniques to preserve all the tomb's contents. It may well be that the contents, when at last revealed, will surpass the combined contents of the Shōsōin and the tomb of Tutankhamen.

197. Shōsōin Jimushō, *Shōsōin Hōmotsu: Hokusō* [Treasures of the Shōsōin: The North Section] (Tokyo, 1962), English text, p. VI; Ishida Mosaku and Wada Gunichi, *The Shōsōin*, English résumé by Harada Jiro (Tokyo, Osaka & Moji, 1954), p. 2.

198. See Chapter VIII.

199. See Chapter VIII.

200. See Chapter VIII.

201. Providing gifts for foreign missions was standard practice throughout the history of the Chinese empire, so far as is known today. The members of foreign missions were considered to be tribute bearers, and the imperial gifts were, in theory, rewards of the loyalty of those who sent the "tribute."

202. For the extraordinary development of art faking in the Tang period, see chapter VIII. The Tang instance cited concerns faking for a private purpose. But when faking was developed to such a stage, that implies dealers who are always the chief first buyers, as all knowedgeable persons will agree.

203. George B. Sansom, *Japan: A Short Cultural History*, rev. ed. (New York, 1943), pp. 82 ff., 150–57.

204. Okada Jō, "History of the Collections," in *National Museum, Tokyo*, Great Museums of the World (New York, 1968), p. 162.

205. Noguchi Yone, *Emperor Shōmu and the Shōsōin* (Tokyo, 1941), pp. 15–17; Kobayashi Taichiro, "Shōsōin no Kigen" [On the Origin of the Shōsōin], *Kokka* 659 (1947): 97–101.

206. The initial dedication recorded in *Tōdaiji Kenmotsuchō* [Record of Gifts Dedicated to Tōdaiji] comprises five groups of objects. The large group of Emperor Shōmu's personal belongings was donated on the twenty-first day of the sixth month of the

eighth year of Tempyō-Shōhō (756) and is catalogued in the *Kokka Chimpochō* [Record of National Treasures]. For a brief summary in English of all the dedications, see Shōsōin Jimusho, *Shōsōin Hōmotsu: Hokusō* [Treasures of the Shōsōin: The North Section], English text, pp. V–VI. For an English translation of the preamble to the *Kokka Chimpochō* and the dedicatory prayer to the Record of the Various Medicines, see Sir Percival David, "The Shōsōin," *Transactions and Proceedings of the Japan Society* 28 (London, 1932), reprinted in Harada Jiro, *English Catalogue of Treasures in the Imperial Repository Shōsōin* (Tokyo, 1932), pp. 154–55. For the entire *Tōdaiji Kenmotsuchō*, see Fujita Tsuneo, *Kōkan Bijutsu Shiryō: Jiin Hen* [Printed Historical Records of Japanese Art: Temples] (Tokyo, 1975), II: 193–232.

207. Shōsōin Jimusho, *Shōsōin Hōmotsu: Hokusō*, English text, p. VI.

208. Shōsōin Jimusho, *Shōsōin Hōmotsu: Hokusō*, English text, p. VI, item 9; Ishida and Wada, *The Shōsōin*, English résumé, p. 3.

209. Two copies of the alleged brushwork of the two Wangs survive in the Japanese Imperial Collection and may have come originally from the Shōsōin. (Lothar Ledderose, *Mi Fu and the Classical Tradition of Chinese Calligraphy* [Princeton, 1979], p. 13). Calligraphy by the Emperor Shōmu and the Empress Kōmyō also survives in the Shōsōin, as do great quantities of archives and other early calligraphic specimens. Kanda Kiichiro, *Shōsō-in no Shoseki* [On the Calligraphies Conserved in the Shōsōin], ed., Shōsōin Jimusho [Tokyo, 1964], English résumé).

210. Shōsōin Jimusho, *Shōsōin Hōmotsu: Hokusō*, English text, p. VI, item 4; Harada, "Chronological Reference Table," in *English Catalogue of Treasures*, pp. 167–181.

211. In his "Chronological Reference Table," Harada records most of the known removals as well as the donations. For extracts from the more important primary sources of the eighth and ninth centuries, see Harada's supplement to Fujita Tsuneo's *Tōdaiji Kenmotusuchō*, "Shussō Kiroku" [Record of Removals from the Repository], *Kōkan Bijutsu Shiryō: Jiin Hen*, II: 235–42; see also Ishida and Wada, *Shōsōin*, English résumé, p. 4.

212. Harada, "Chronological Reference Table," p. 170.

213. Louisa McDonald Read, "The Masculine and Feminine Modes of Heian Secular Painting and Their Relationship to Chinese Painting—A Redefinition of Yamato-e," dissertation, Stanford University (1975), pp. 157–73.

214. Harada, "Chronological Reference Table"; Horiike Haruo, "Shōsōin no Nusubito" [Shōsōin Robbers], *Rekishi Hyōron*, no. 109 (September 1959): 86–88.

215. Murasaki Shikibu, *The Tale of Genji*, 2 vols., trans. with intro. by Edward G. Seidensticker (New York, 1977), II: 739–40.

216. For Yoshimasa's Buddhist ordination at Tōdaiji's Kaidanin, see Wada Gunichi, "Shōsōin no Chokufū" [Imperial Sealing of the Shōsōin Repository], *Yamato Bunka* 11 (September 1953): 36–37.

217. Hayashiya Tatsusaburō, *Tenka Ittō* [Unifying Everything Under Heaven], Nihon no Rekishi [History of Japan] 12 (Tokyo, 1974): 169–71.

218. Harada, "Chronological Reference Table," pp. 178, 179; Wada, "Shōsōin no Chokufū," p. 37.

219. Wada, "Shōsōin no Chokufū," p. 41. It was under Fujiwara Michinaga that the Fujiwara clan reached their peak of wealth and power in the Heian period. He was the father of three empresses, placed members of his family in most of the Imperial ministries and was given a rank equivalent to an empress's when he accepted the tonsure. See *Ōkagami, The Great Mirror: Fujiwara Michinaga (966–1027) and His Times*, trans. Helen Craig McCullough (Princeton, 1980), p. 191.

220. Harada, "Chronological Reference Table," Ishida and Wada, *Shōsōin*, English resumé, pp. 3–4; Noguchi, *Emperor Shōmu and the Shōsōin*, pp. 27–28; see also Andō Kōsei,

Shōsōin Shōshi [Brief History of the Shōsōin] (Tokyo, 1947), pp. 9–13, 131–58.

221. Okada, "History of the Collections," p. 162.

222. *Eiga Monogatari*, ed. Matsumura Hakushi, Nihon Koten Zensho 58 (Tokyo, 1962), p. 268.

223. Murasaki Shikibu, *The Tale of Genji*, trans. Arthur Waley (London, 1957), I: x–xi.

224. Murasaki, *The Tale of Genji*, trans. Seidensticker, I: 305–17 (chap. 17, "A Picture Contest"); other collecting, I: 291.

225. Nagaya Kenzō, *Shōsōin Gakki no Kenkyū* [Study of Musical Instruments in the Shōsōin] (Tokyo, 1964).

226. The desirability of these foreign luxuries can be judged from the Tang tomb figures of foreign entertainers and merchants and from other evidence such as the Tang silver- and goldsmiths' work imitating Sassanian silver.

227. A white glass ewer; Shōsōin Jimusho, *Shōsōin Hōmotsu: Chūsō* [Treasures of the Shōsōin: The Middle Section], pl. 2.

228. A cut-glass bowl and a cobalt-blue glass goblet with a design of lozenges applied are probably from Byzantium (Shōsōin Jimusho, *Shōsōin Hōmotsu: Chūsō*, pls. 1, 3).

229. For a study of the medicines in the Shōsōin—most of which were imported from China, although others came to Japan from Arabia, Persia, and India—see Doi Keizo, "Shōsōin Yakushu no Shiteki Ronsatsu" [Medicines in Ancient Japan: Study of Some Drugs Preserved in the Imperial Treasure House at Nara], *Neiraku (Nara)* 15 (1932): English translation, pp. 113–32; Japanese text and illustrations, pp. 133–48.

230. For household furnishings in the Shōsōin, see Shōsōin Jimusho, *Shōsōin Hōmotsu* volumes. Examples in the *Hokusō* volume include a red lacquer cabinet (pl. 24), numerous mirrors (pls. 63–70), folding screens (pls. 72–88), arm rests (pls. 90–94), rugs (pls. 102–14), and incense burners (pls. 32, 83). Furnishings of a liturgical nature are included in the *Nanso* [South Section] volume. Ishida and Wada discuss furniture as well as clothing (see note 166) and tableware (see note 204) in their chapter on daily life ("Seikatsu Bunka") in *Shōsōin*, pp. 85–91; see also pls. 32, 81, 88, 120.

231. Examples of clothing can be seen in Ishida Mosaku, *Shōsōin to Tōdaiji* (Tokyo, 1962), figs. 223–37. See also Shōsōin Jimusho, *Shōsōin Hōmotsu: Hokusō*, pls. 17, 20, 115, for *kesa* (priests' robes) and embroidered shoes; and Shōsōin Jimusho, *Shōsōin Hōmotsu: Chūsō*, pls. 8, 33–37, for a belt decorated with lapis lazuli and silk sashes.

232. For an array of writing material from the scriptorium, see Shōsōin Jimusho, *Shōsōin Hōmotsu: Chūsō*, pls. 14–32.

233. For glassware, see Shōsōin Jimusho, *Shōsōin Hōmotsu: Chūsō*, pls. 1–7; for trays, a dish and bowl, several ceramic objects, see Shōsōin Jimusho, *Shōsōin Hōmotsu: Nansō*, pls. 29–48, 71–77, 76, 77. For a study of ceramics, see Shōsōin Jimusho, *Shōsōin no Tōki* [Ceramic Objects in the Shōsōin] (Tokyo, 1971).

234. For the various parts necessary for a game of *suguroku* as well as the famous *go* board of *shitan* wood decorated with marquetry, see Shōsōin Jimusho, *Shōsōin Hōmotsu: Hokusō*, pls. 49–51, 53–56. For another *go* set and a dart-throwing game, see Shōsōin Jimusho, *Shōsōin Hōmotsu: Chūsō*, pls. 84–86, 87–88.

235. Ishida and Wada, *Shōsōin*, figs. 282–97; Shōsōin Jimusho, *Shōsōin Hōmotsu: Hokusō*, pls. 57–62; *Shōsōin Hōmotsu: Chūsō*, pls. 121–25.

236. Many of the items related to religious ceremonies of a Buddhist nature are shown in Shōsōin Jimusho, *Shōsōin Hōmotsu: Nansō*. An overview of the scope of objects related to both secular and religious ceremonies can be found in Ishida, *Shōsōin to Tōdaiji*, figs. 130–84, 179–89 (Buddhist fittings and priests' items), 199–222 (masks),

259–69 (annual festivals). For three of several studies centering on the masks preserved in the Shōsōin, see Kanamori Jun, "Shōsōin Gigakumen ni tsuite" [On the Ancient Dance Masks in the Collection of the Shōsōin Imperial Repository], *Kokka* 552 and 553 (November and December, 1936); Ishida Mosaku, *Shōsōin Gigakumen no Kenkyū* [Studies of Gigaku Masks in the Shōsōin] (Tokyo, 1955).

237. Ishida and Wada, *Shōsōin*, fig. 118.

238. A representative sample of some of the studies of these paintings includes articles on the landscape paintings: Matsumoto Eiichi, "Shōsōin Sansui zu no Kenkyū" [On the Landscape Paintings in the Shōsōin Repository], *Kokka* 596, 597, 598, 602, 604, 605, 606, 608 (1941); on the painted *biwa*: Yonezawa Yoshio, "Tōchō Kaiga ni okeru Keijishugi to Kizō Kogaku zu no Gafū" [Mimesis in Tang Painting and the Style of "A Lute Player on a Camel's Back"], *Kokka* 658 (January 1947); on the ink painting of a bodhisattva: Kameda Tsutomu, "Mafu Sumi-e Bosatzu Zō to Nin-nō-e" [An Image of Bosatsu in the Shōsōin and the Ninnō-e Rite], *Kokka* 659 and 660 (1947); on the screen painting of "ladies under a tree": Iijima Isamu, "Torige Ritsujo Byōbu no Mondai Ten" [Some Problems Concerning the Screen "Figures of Ladies Decorated with Birds' Feathers"], *Museum* 105 (December 1959): 2–6; Iijima, "Torige Ritsujo Byōbu Sairon" [Again on the Screen "Figures of Ladies Decorated with Birds' Feathers" in the Shōsōin], *Museum* 106 (January 1960): 7–11; Iijima, "Torige Ritsujo Byōbu ni Atarashitaru Shiron o Kuwaete" [Again on the Screen "Figures of Ladies Decorated with Birds' Feathers"], *Museum* 113 (August, 1960): 2–6.

239. See note 225 above.

240. Read, "The Masculine and Feminine Modes of Heian Secular Painting," p. 157, no. 3. On the quality of painting in the Shōsōin, see also Alexander Soper, "The Rise of Yamato-e," *Art Bulletin* 24 (December 1942): 352.

241. Richter, *Sculpture and Sculptors*, p. 253; Brunilde Sismondo Ridgway, *The Severe Style of Greek Sculpture* (Princeton, 1970), p. 34; Karl Schefold, *Die Griechen und ihre Nachbarn*, Propyläen Kunstgeschichte 1 (Berlin, 1967), p. 176, pl. 57.

242. Richter, *Sculpture and Sculptors*, pp. 8, 253; Ridgway, *The Severe Style*, p. 34; Schefold, *Die Griechen*, p. 176, pl. 57.

243. James M. Goode, *The Outdoor Sculpture of Washington, D.C.: A Comprehensive Historical Guide* (Washington, D.C., 1974) p. 276.

244. Horst Gerson, *Rembrandt Paintings*, trans. Heinz Norden (Amsterdam, 1968), p. 386.

245. Clifford Irving, *Fake!* (New York, 1969), p. 170.

246. Irving, *Fake!* pp. 8, 170.

247. Irving, *Fake!* pp. 170–71.

248. Irving, *Fake!* p. 170.

III. ART COLLECTING

1. *Great Private Collections*, ed. Douglas Cooper, intro. Kenneth Clark (New York, 1963); Niels von Holst, *Creators, Collectors and Connoisseurs*, intro. Herbert Read (New York, 1967); *The Collector in America*, compiled by Jean Lipman and the editors of *Art in America*, intro. Alan Pryce-Jones (1961; London, 1971); Peter Mitchell, *An Introduction to Picture Collecting* (London, 1968); Pierre Cabanne, *The Great Collectors* (London, 1963); Frank Herrmann, ed., *The English as Collectors* (London, 1972).

2. Adolph Donath, "Psychologie des Kunstsammelns," *Bibliothek für Kunst und Anti-quätensammler* 9 (1911): 11–18; Hubert Wilm, *Kunstsammler und Kunstmarkt*

(Munich, 1930); Alois Riegl, "Über antike und moderne Kunstfreunde," *Gesammelte Aufsätze* (Vienna, 1929), pp. 194–206. Jacob Burckhardt, *Die Sammler*, in *Beiträge zur Kunstgeschichte von Italien*, Gesamtausgabe 12 (Stuttgart, Berlin, and Leipzig, 1930), pp. 295–496; Lothar Brieger, *Das Kunstsammeln*, 3rd ed. (Munich, 1920); Hannelore Sachs, *Sammler und Mäzene* (Leipzig, n.d.); Julius von Schlosser, "Zur 'Philosophie' des Kunstsammelns," *Präludien* (Berlin, 1927); Johann Wolfgang von Goethe, "Der Sammler und die Seinigen," in *Schriften zur Kunst*, ed. Ernest Beutler (Zurich, 1954), pp. 259–320, with an introduction, pp. 1138–41; and translated as "The Collector and His Friends," in Goethe, *Essays on Art*, trans. and ed. Samuel Gray Ward (Boston, 1845), pp. 42–117.

3. See, for example, Sir Francis J. B. Watson, "French Furniture in the Salerooms, the Early Period 1660–1830," in *Art at Auction: The Year at Sotheby Parke Bernet 1972–73* (New York, 1974), pp. 329–444.

4. See Chapter VI.

5. For example, Francis J. B. Watson, *The Wrightsman Collection*, 5 vols., Metropolitan Museum of Art (Greenwich, Conn., 1966); Watson, *Furniture*, Wallace Collection Catalogues (London, 1956); and the series of studies on the James A. de Rothschild Collection at Waddesdon Manor, of which one is Geoffrey de Bellaigue's *Furniture, Clocks and Gilt Bronzes*, 2 vols. (Fribourg, 1974).

6. The important early publications are: Eugène Müntz, *Les Collections des Médicis au XVe siècle* (Paris, 1888); and Müntz, *Les Arts à la cour des papes pendant le XVe et le XVIe siècle*, 3 vols. (Paris, 1878–82); Alessandro Luzio, *La galleria dei Gonzaga venduta all'Inghilterra nel 1627–28* (Milan, 1913); Henri Duc d'Aumale, ed., *Inventaire de tous les meubles du cardinal Mazarin dressé en 1653* (London, 1861).

7. Charles Blanc, *Le Trésor de la curiosité*, 2 vols. (Paris, 1857–58); Fritz Lugt, *Répertoire des catalogues de ventes publiques: première période, vers 1600–1825* (The Hague, 1938).

8. Sir Herbert Read, "Pioneering in Art Collecting," in *Pioneering in Art Collecting*, ed. D. D. Galloway (Buffalo, 1962), pp. 7–11; Maurice Rheims, *Art on the Market*, trans. David Pryce-Jones (1959; London, 1961), pp. 17–49; Lord Eccles, *On Collecting* (London, 1968); see also note 2 above.

9. Robert Wraight, *The Art Game* (London, 1965); Geraldine Keen, *The Sale of Works of Art: A Study Based on the Times-Sotheby Index* (London, 1971); Charles Platten Woodhouse, *Investment in Antiques and Art: What, Where and How to Buy* (London, 1969).

10. Here I have in mind Vasari above all, but the other art-historical works that have influenced art collecting are too numerous to list.

11. Louisine W. Havemeyer, *Sixteen to Sixty: Memoirs of a Collector*, privately printed for the family of Mrs. H. O. Havemeyer and The Metropolitan Museum of Art (New York, 1961); Marjorie Phillips, *Duncan Phillips and His Collection*, foreword by Laughlin Phillips (Boston–Toronto, 1970); Louise Hall Tharp, *Mrs. Jack* (Boston, 1965); José de Azeredo Perdigão, *Calouste Gulbenkian* (Lisbon, 1969); Aline B. Saarinen, *The Proud Possessors* (New York, 1958); Wilmarth Sheldon Lewis, *See for Yourself* (New York, 1971).

12. For example, books by or about art dealers: Julien Levy, *Memoir of an Art Gallery* (New York, 1977); Edward Fowles, *Memories of Duveen Brothers*, intro. Sir Ellis Waterhouse (New York, 1976); René Gimpel, *Diary of an Art Dealer*, trans. John Rosenberg, intro. Sir Herbert Read (London, 1963); Germain Seligman, *Merchants of Art: 1880–1960, Eighty Years of Collecting* (New York, 1961).

13. Riegl, "Über Kunstfreunde," pp. 194–206.

14. Riegl, "Über Kunstfreunde," pp. 198–202.

15. Riegl, "Über Kunstfreunde," pp. 203 ff.

16. Riegl, "Über Kunstfreunde," pp. 195–96.

17. Burckhardt, *Die Sammler*, pp. 295–496.

18. Burckhardt, *Die Sammler*, p. 324.

19. *The Shorter Oxford English Dictionary* has the following under "collection" as its third definition: "A group of things collected or gathered together, e.g. of literary materials 1460; of specimens, works of art, etc. 1651; . . ." In the context of this essay I venture to think my version defines what we now mean by "art collecting" or "stamp collecting" somewhat more precisely, because of the great importance of the categories in all collecting of this sort. See *The Shorter Oxford English Dictionary*, prepared by William Little, H. W. Fowler, J. Coulson, rev. and ed. C. T. Onions, 2 vols. (Oxford, 1936), I: 341.

20. See discussion of these birds below.

21. Robert Wraight, *The Art Game*, pp. 46–49.

22. For the notable case of G. B. Sommariva, see Francis Haskell, *An Italian Patron of French Neoclassical Art* (Oxford, 1972).

23. To keep collectors from claiming excessive exemptions for works of art donated to museums, the Internal Revenue Service has been driven to establish an expert board of review.

24. Here consider the Coca-Cola bottle and barbed-wire collectors to be discussed in Interchapter 2.

25. Several men are reportedly required to heft the finer specimens of the "stone money" of the Pacific island of Yap, which had to be imported, too.

26. Victorian birds'-egg collecting, for instance, took a regular toll of adolescent lives.

27. André Leroi-Gourhan, *Treasures of Prehistoric Art*, trans. Norbert Guterman (New York, 1967), p. 39.

28. Leroi-Gourhan, *Treasures of Prehistoric Art*, p. 39.

29. P. Riant, *Des Dépouilles religieuses enlevées à Constantinople au XIIIe siècle par les Latins, et des documents historiques nés de leur transport en Occident*, Mémoires de la Société Nationale des Antiquaires de France 36 (Paris, 1875): pp. 7–8.

30. *Exuviae Sacrae Constantinopolitanae*, ed. P. Riant and F. de Mély (Paris, 1904), III: 269–70; Riant, *Des Dépouilles religieuses*, p. 8.

31. *Exuviae Sacrae Constantinopolitanae* III: 269; Riant, *Des Dépouilles religieuses*, p. 8.

32. Charles Rohault de Fleury, *Mémoire sur les instruments de la passion de N.-S. J.-C.* (Paris, 1870), p. 203.

33. Rohault de Fleury, *Mémoire sur les instruments*, p. 205.

34. Richard Friedenthal, *Luther: His Life and Times*, trans. John Nowell (New York, 1970), p. 69.

35. Julius von Schlosser, *Die Kunst- und Wunderkammern der Spätrenaissance* (Leipzig, 1908), p. 16.

36. See Peter Dance, *Shell Collecting* (Berkeley and Los Angeles, 1966), pp. 227–31, for the "precious wentletrap"; pp. 238–58 for the "glory of the sea."

37. Blanc, *Trésor de la curiosité*, I: 51.

38. L. N. and M. Williams, *Stamps of Fame* (London, 1949), pp. 96–97.

39. Narbeth and Lyon, *Successful Investing in Stamps and Bank-Notes* (London, 1975), p. 15.

40. Nolan Zavoral, "Beer-Can Barter," *Washington Post* (September 26, 1978), pp. C1–C2.

41. This record price, plus $40,000 auctioneer's commission (!), was paid for a 1936

Mercedes roadster at Christie's Los Angeles on February 25, 1979. No doubt it will be exceeded soon, but since the text has already been altered three times for new records for vintage cars, it seems fruitless to go on trying to keep up with this buoyant collector's market.

42. "Quick Grab Shovel, Collectors Pay Lots for Ancient Bottles," *Wall Street Journal* (January 9, 1970).

43. A signature of Paul Revere on a receipt for expenses to the Boston Committee of Correspondence adding up to £14.02 was sold on April 26, 1978, at Sotheby Parke Bernet for $70,000. The expenses were for Revere's ride to carry the news of the Boston Tea Party to New York.

44. A jacket worn by Napoleon at the battle of Waterloo, 1815, sold for $38,452 in 1976. See *Art at Auction: The Year at Sotheby Parke Bernet 1976–77* (London, 1977), pp. 308–10.

45. For the foregoing information on "first day" and other covers, I have to thank the philatelic columnist of *The New York Times*, Samuel Tower.

46. David C. Huntington, "Church and Luminism: Light for America's Elect," in *American Light: The Luminist Movement 1850–1875*, ed. John Wilmerding et al., exhibition catalogue, National Gallery of Art (Washington, 1980), pp. 155–90, 195, pl. 19.

47. James Miller, "American Paintings in Europe," in *Art at Auction: The Year at Sotheby Parke Bernet 1979–1980* (London, 1980), p. 147.

48. Sotheby Parke Bernet, *American 19th and 20th Century Paintings, Drawings, Watercolors & Sculpture*, Sale 4290 (October 25, 1979, New York), no. 34.

49. See Chapters X and XI.

50. The fakery is proved by the sheer number of identical Instruments of the Passion which were owned by various European churches and cathedrals by the end of the Middle Ages.

51. Sotheby Parke Bernet, "Focus on Postage Stamps," *Burlington Magazine* 121, no. 912 (March 1979): i–iii.

52. National Gallery of Art, *European Paintings: An Illustrated Summary Catalogue* (Washington, 1975), p. 166, cat. no. 1379.

53. Diana Tittle, "The Agony and the Ecstasy of Sherman E. Lee," *Cleveland Magazine* (January 1979), pp. 56, 134–36.

54. Helen Cullinan, "Museum's Prize Termed a Fake," *Cleveland Plain-Dealer* (October 28, 1977), p. 6–A; Chris Jensen, "Fake!," *Cleveland Plain-Dealer*, Sunday Magazine (March 5, 1978), p. 7.

55. "Cleveland Museum Says Its Grünewald Is a Fake," *New York Times* (October 28, 1977); Cullinan, "Museum's Prize Termed a Fake," p. 6–A; Jensen, "Fake!," pp. 6 ff.

56. Tittle, "The Agony and the Ecstasy," p. 136; Cullinan, "Museum's Prize Termed a Fake," p. 1; Jensen, "Fake!," p. 6.

57. *"Pichonnerie"* is common French dealer's jargon but is not in Larousse, although Baron Pichon has his small niche.

58. For what was probably the first such collection and its fate, see the account of Fra Carlo Lodoli in Chapter V.

59. A. J. Marshall, "Bower Birds," *Scientific American* 194 (June, 1956): 50.

60. Marshall, "Bower Birds," p. 49; E. Thomas Gilliard, *Birds of Paradise and Bower Birds* (London, 1969), p. 348.

61. Gilliard, *Birds of Paradise*, pp. 281–93.

62. Gilliard, *Birds of Paradise*, pp. 294–99.

63. Marshall, "Bower Birds," pp. 51–52; Gilliard, *Birds of Paradise*, pp. 350–51.

64. The story of the Gardener bower birds was told to me by Dr. Ripley, but it appears in part in Dillon Ripley, *The Trail of the Money Bird* (New York, 1942), pp. 260, 266–67.

65. Norman Chaffer, "Bower Building and Display of the Satin Bower-bird," *The Australian Zoologist* 12 (1959): 297; A. J. Marshall, *Bower-birds: Their Display and Breeding Cycles* (Oxford, 1954), pp. 37–38; Gilliard, *Birds of Paradise*, p. 348; T. Iredale, *Birds of Paradise and Bower Birds* (Melbourne, 1950), pp. 209–10; Marshall, "Bower Birds," p. 49.

66. Marshall, *Bower-birds: Their Display and Breeding Cycles*, pp. 37–38; G. E. Hutchinson, "Marginalia," *American Scientist* 40 (1952): 151.

67. Marshall, "Bower Birds," pp. 50–52; Gilliard, *Birds of Paradise*, p. 348; Iredale, *Birds of Paradise*, p. 211.

68. All the data on the waxbills and the whydahs were obtained by me from Dr. Konrad Z. Lorenz at the Max Planck Institute of Behavioral Physiology. See Joseph Alsop, "Profiles: A Condition of Enormous Improbability," *The New Yorker* (March 8, 1969), pp. 39–42, 44, 47, 48–50, 53–54, 56–58, 63–66, 68, 71–74, 77–82, 84–93. For those who wish to consult the underlying paper by Dr. Jürgen Nicolai, see "Der Brutparasytismus der Viduinae als ethologisches Problem," *Zeitschrift für Tierpsychologie* 21 (1964): 129–204.

69. Chaffer, "Bower Building and Display," p. 296.

70. The most important of these is my friend Dr. Li Chi of the Academia Sinica, who superintended the rescue of all the results of the Academia's great pioneer dig at Anyang, all now safe in Taiwan. In Chongqing he could do virtually no scholarly work, and the conservation of these invaluable Shang oracle bones, magnificent bronzes, and other irreplaceable finds in their damp air-raid shelter-caves was a full-time job for Dr. Li and the few members of his staff.

71. Müntz, *Les Collections*, p. 33; Marco Spallanzani, *Ceramiche orientali a Firenze nel Rinascimento* (Florence, 1978), pp. 55 ff.

72. S. Ducret, *German Porcelain and Faience* (London, 1962), p. 62, no. 7.

73. Ernest F. Fenollosa, *Epochs of Chinese and Japanese Art* (1912; rev. ed. New York–London, 1921), I: xiv–xv.

74. Fenollosa, *Epochs of Chinese and Japanese Art*, I: viii–x.

75. See Chapter II.

76. Robert L. Rands, "The Rise of Classic Maya Civilization in the Northwestern Zone: Isolation and Integration," in *The Origins of Maya Civilization*, ed. Richard E. W. Adams (Albuquerque, 1977), p. 178.

IV. THE LITMUS TESTS

1. Millard Meiss, *French Painting in the Time of Jean de Berry: The Limbourgs and Their Contemporaries*, 2 vols. (New York, 1974), II: pls. 539–49.

2. Millard Meiss, *French Painting in the Time of Jean de Berry: The Late XIV Century and the Patronage of the Duke*, 2 vols. (London, 1967), I: 169, 300–301.

3. Meiss, *French Painting: The Late XIV Century*, I: 169, 300–301.

4. Meiss, *French Painting: The Late XIV Century*, I: 43. In fact the manuscript is eleventh century and English, although it must have seemed hopelessly out of fashion by the Duke's time.

5. Meiss, *French Painting: The Late XIV Century*, I: 52–58.

6. Cosimo de' Medici is here specified because there is no evidence that the pioneer collectors of classical art in the fourteenth and very early fifteenth centuries were also notable patrons. A possible exception, wever, is the first Italian classical collec-

tor in the fourteenth-century record, the Trevisan moneylender Oliviero Forzetta (see Chapter X). On Cosimo de' Medici's double role see Eugène Müntz, *Les Collections des Médicis au XVe siècle* (Paris, 1888), pp. 3-10. See André Chastel, *Art et humanisme à Florence au temps de Laurent le Magnifique*, 2nd ed. (Paris, 1961), pp. 31, 34-35, for his role as a collector. For his role as a patron see Vespasiano da Bisticci, *Le vite*, ed. Aulo Greco, 2 vols., II (Florence, 1970-76): 167-211; E. H. Gombrich, "The Early Medici as Patrons of Art," in *Italian Renaissance Studies: A Tribute to the late Cecilia M. Ady* (London, 1960), pp. 279-311 (reprinted in Gombrich's *Norm and Form* [London, 1966], pp. 35-57); A. D. Fraser Jenkins, "Cosimo de' Medici's Patronage of Architecture and the Theory of Magnificence," *Journal of the Warburg and Courtauld Institutes* 33 (1970): 162-70.

7. Raymond de Roover, *The Rise and Decline of the Medici Bank, 1397-1494* (Cambridge, Mass., 1963), pp. 348-51.

8. The passage from Fazio's *De Viris Illustribus* is translated by Michael Baxandall in *Giotto and the Orators* (Oxford, 1971), pp. 99, n. 109, 106-7.

9. Baxandall, *Giotto and the Orators*, p. 107, n. 142.

10. See Chapter XII.

11. Marcantonio Michiel, *Der Anonimo Morelliano*, in Albert Ilg, ed., *Quellenschriften für Kunstgeschichte und Kunsttechnik des Mittelalters und der Neuzeit*, n.s. 1 (Vienna, 1888): 98 ff.

12. Le Comte A. Raczynski, *Les Arts en Portugal* (Paris, 1846), p. 14.

13. See Chapter XIII.

14. Charles de Tolnay, *Hieronymus Bosch*, rev. ed. (London, 1966), pp. 48, 337 ff.

15. Harold Wethey, *The Paintings of Titian*. 3 vols. (London, 1969-75), III: 78-84.

16. Anthony Blunt, *Nicolas Poussin*, 2 vols. (New York, 1967), I: 213-14, 216.

17. Blunt, *Nicolas Poussin*, I: 225, 367-70.

18. Personal communication from David Rockefeller.

19. Personal communication from David Rockefeller.

20. See Chapter VII.

21. Personal communication from Pierre Matisse. Anne d'Harnoncourt of the Philadelphia Museum of Art, whom I have also consulted, tells me that there is no family recollection of the episode, and Pierre Matisse's recollection is somewhat hazy. But the story was also current at the time—as I well remember, since I myself, as a young newspaper man in New York, covered Matisse's visit to the U.S. in the early 1930s.

22. The place of honor Dr. Barnes accorded the great Cézanne, in the center of the end wall of the main gallery, announces his conviction that securing the Card Players was a major triumph.

23. Alfred Barr, *Matisse: His Art and His Public* (New York, 1951), p. 220.

24. Barr, *Matisse*, p. 220. This was also confirmed in a letter dated October 19, 1976, from Miss Violette de Mazia of The Barnes Foundation.

25. Barr, *Matisse*, p. 220.

26. The first set is in the collection of the Paris Musée Municipal de l'Art Moderne and is reportedly about to be suitably exhibited.

27. Henry Havard, *Dictionnaire de l'ameublement et de la décoration depuis le XIIIe siècle jusqu'à nos jours*, 4 vols. (Paris, 1887-90), I: 723, fig. 512. See also Jean Hubert, *Arts et vie sociale de la fin du monde antique au moyen âge*, Mémoires de Documents Publiés par la Société de l'École de Chartes 24 (Geneva, 1977) pp. 485-93.

28. Havard, *Dictionnaire de l'ameublement*, I: 718-23; Hubert, *Arts et vie sociale*, p. 485.

29. Erwin Panofsky, ed., *Abbot Suger on the Abbey Church of St.-Denis and Its Art Treasures* (Princeton, 1946), pp. 73, 92.

30. Personal communication from David Rockefeller.

31. Giuliano Briganti, *Pietro da Cortona* (Florence, 1962), p. 195.

32. Briganti, *Pietro da Cortona*, pp. 139, 197–200.

33. Briganti, *Pietro da Cortona*, pp. 197, 200–2.

34. Compare the Barberini commission to Diego Rivera's commission to provide a fresco for Rockefeller Center in 1933. Rivera felt he had to be "relevant," so he made Lenin one of the heroes of his fresco. Consequently it was covered with a politically irrelevant work by José Maria Sert. ("Rockefeller Center Ousts Rivera Over Painting of Lenin," *New York Herald Tribune* [May 10, 1933], pp. 1, 3; Bertram D. Wolfe, *The Fabulous Life of Diego Rivera* [New York, 1963], p. 333).

35. Hannelore Glasser, *Artists' Contracts of the Early Renaissance* (New York and London, 1977), p. 141.

36. Glasser, *Artists' Contracts*, pp. 141–45; Francis William Kent, *Household and Lineage in Renaissance Florence* (Princeton, 1977), pp. 251–52.

37. Vasari-Milanesi, II: 495.

38. Johannes Wilde, *Venetian Art from Bellini to Titian* (Oxford, 1974), p. 160. See also David Rosand, "Titian's Presentation of the Virgin in the Temple and the Scuola della Carità," *Art Bulletin* 58 (1976): 55–84; Rosand, "Titian's Light as Form and Symbol," *Art Bulletin* 57 (1975): 58–64; Rosand, "Titian in the Frari," *Art Bulletin* 53 (1971): 196–213.

39. Wethey, *The Paintings of Titian*, III: 29–30, 146–47.

40. Wethey, *The Paintings of Titian*, III: 34–35, 37–41, 146, no. 13; 151, no. 15.

41. For a discussion of the sources see Wethey, *The Paintings of Titian*, III: 148–49.

42. Wethey, *The Paintings of Titian*, III: 33, 144–45; see also John Walker, *Bellini and Titian at Ferrara* (London, 1956).

43. Wethey, *The Paintings of Titian*, III: 30, n. 172, 31.

44. See Panofsky's *Abbot Suger*.

45. J.-P. Migne, ed., *Patrologia Latina*, vol. CLXXXII, cols. 914–15; V. Mortet, ed., *Recueil de textes relatifs à l'histoire de l'architecture et la condition des architectes en France au moyen âge*, I (Paris, 1911): 367–68. See also, for the translation of St. Bernard's letter to William of St.-Thierry, G. G. Coulton, *Art and the Reformation* (1928; reprint Hamden, Conn., 1969), Appendix 26, pp. 572–74. For a discussion of the way St. Bernard carried out these ideas within his own order, see Marcel Aubert, *L'Architecture cistercienne en France*, I (Paris, 1943): 138 ff.

46. Panofsky, *Abbot Suger*, pp. 64–67.

47. The Venerable Bede, *The Lives of the Abbots of Wearmouth* (1818; reprint Newcastle-upon-Tyne, n.d.), p. 1.

48. Bede, *The Lives of the Abbots of Wearmouth*, p. 14.

49. According to Miss Lillian Hellman, a close friend, Dorothy Parker went twice to parties at Marion Davies's. The text of the quatrain comes from Marshall Best, senior editor on the staff of Viking Press, which still publishes the work of Dorothy Parker, but the quatrain is not in her official collected works.

50. It should perhaps be noted that a patron-commissioned work of art may later turn out to be grossly incongruous with the way of life of the heir or heirs of the original patrons. But no one becomes a true art collector by inheritance, of course.

51. See also Wethey, *The Paintings of Titian*, III: 146, 151.

52. See Chapter XIII.

53. John Steegman, *The Rule of Taste from George I to George IV*, intro. James Laver (1936; reprint London, 1968), p. 96.

54. David N. Durant, *Bess of Hardwick* (London, 1977).
55. Mark Girouard, *Robert Smythson* (London, 1966), pp. 121–23; Durant, *Bess of Hardwick*, p. 157; Durant, "The Men Who Built Hardwick," *National Trust*, no. 29 (Spring 1978), p. 10.
56. Girouard, *Smythson*, p. 129.
57. Marco Boschini, *La carta del navegar pitoresco*, ed. Anna Pallacchini (1660; Rome, 1966).
58. Boschini, *La carta del navegar pitoresco*, p. 176.
59. Boschini, *La carta del navegar pitoresco*, p. 176.
60. Francis Haskell, *Patrons and Painters* (New York, 1963), pp. 123–24.
61. Giulio Mancini, *Considerazioni sulla pittura*, ed. A. Marucchi, Accademia Nazionale dei Lincei: Fonti e documenti inediti per la storia dell'arte, 2 vols. (Rome, 1956).
62. Mancini, *Considerazioni sulla pittura*, I: 134.
63. Mancini, *Considerazioni sulla pittura*, I: 134.
64. Mancini, *Considerazioni sulla pittura*, I: 134.
65. "2 Museum Officials Testify on 'Raphael,' " *Boston Globe PM* (February 11, 1971), p. 3.
66. "2 Museum Officials Testify," pp. 1, 3.
67. Alan M. Kriegsman, "Boston's Raphael Smuggled?," *Washington Post* (January 8, 1971), pp. B1, B10; Stephen Kurkjian, "Italy Probes Boston Painting," *Boston Globe AM* (January 23, 1970), p. 11; "Italian Dealer Accused of Smuggling Hub's Raphael," *Boston Globe AM* (February 28, 1970), p. 3; "The Maltese Falcon Revisited," *Boston Globe PM* (February 12, 1971), p. 14.
68. Bernard Weintraub, "A Raphael in Boston Arouses Skepticism," *New York Times* (April 29, 1970), p. 47; Kriegsman, "Boston's Raphael Smuggled?," p. B10.
69. Edgar J. Driscoll, Jr., "Raphael's Eleonora Awaits Italy's Move," *Boston Globe* (Sunday, March 28, 1971), pp. A-41, A-42; Weintraub, "A Raphael in Boston," p. 47.
70. Personal communication from Professor Sydney J. Freedberg, Fogg Art Museum, Harvard University.
71. Gregory Mcdonald, "Rathbone Quits as Director of Art Museum," *Boston Globe AM* (December 18, 1971), pp. 1, 17; Grace Glueck, "Boston Aide Quits in Dispute," *New York Times* (December 18, 1971); Robert Taylor, "Rathbone gets N.Y. Position," *Boston Globe AM* (April 21, 1973), p. 10.
72. Pierre Verlet, *Le Mobilier royal français: meubles de la couronne conservés en France* (Paris, 1945), I: 61–65, pls. XXX, XXXI; Francis J. B. Watson, "French Tapestry Chair Coverings: A Popular Fallacy Re-examined," *Connoisseur* 148 (October, 1961): 168–69. By the time Pierre Verlet showed that over half the pieces in the Mobilier des Dieux were nineteenth-century additions, the whole group had been revered as the finest Louis XV *mobilier* in Paris for over a hundred years, and had been exhibited in the Louvre for decades. The pieces condemned by Verlet are still in the reserves of the Louvre, whereas those shown to be "right" have been transferred to Versailles. The Metropolitan Museum's case was the saga of the late Archaic bronze horse challenged as a fake by an administrative officer who knew something about bronze technique, but almost nothing about Greek art history. The horse was removed from view for a long period but is now being exhibited again, albeit with a much later date than formerly.
73. This was in 1929, while I was a student at Harvard.
74. W. Noël Sainsbury, ed., *Original Unpublished Papers Illustrative of the Life of Sir Peter Paul Rubens as an Artist and a Diplomatist* (London, 1859), pp. 236–37, 241–43.
75. Archivio di Stato di Firenze, "Carteggio d'artisti," IX: 7, folio 143. Letter from Leo-

poldo de' Medici to Bernardino della Penna, 1662: ". . . or old masters, I do not have or I have very few; I want therefore to get some before I close the books." I owe this reference to the kindness of Dr. Konrad Oberhuber, who made his own notes available to me. For the full text of Leopoldo de' Medici's letter see Gloria Chiarini De Anna, "Leopoldo de'Medici e la sua raccolta di disegni nel Carteggio d'Artisti dell' Archivio di Stato di Firenze," *Paragone* 307 (1975): 42.

76. Archivio di Stato di Firenze, "Carteggio d'artisti," VI, folio 440. Letter from Paolo del Sera to Leopoldo de' Medici, September 24, 1667: "I have bought the drawing by the hand of Bartolommeo Vivarini. . . . There is no doubt that it is in the old manner. . . ." I also owe this reference to the kindness of Dr. Konrad Oberhuber.

77. Dr. Barnes acquired fifty Cézannes and over a hundred Renoirs.

78. Personal communication from Miss Violette de Mazia, The Barnes Collection.

79. Sotheby Parke Bernet, *Masterpieces from the Robert von Hirsch Sale at Sotheby's,* with an article on the Branchini Madonna by Sir John Pope Hennessy (Westerham, Kent, 1978), p. 64.

80. R. W. Apple, Jr., "Record $13.4 Million Session Held in London Art Auction," *New York Times* (June 23, 1978), p. C20; Sotheby Parke Bernet, *Masterpieces from the Robert von Hirsch Sale,* p. 67.

81. Marie-Madeleine Gautier, *Émaux du moyen âge occidental* (Fribourg, 1972), pp. 173–74, 367–68, ill. 119; H. Swarzenski, *Monuments of Romanesque Art* (London, 1954), p. 72, pl. 181; Rainer Kahsnitz, "Barbarossa's *Armilla,*" *Connoisseur* 199 (November, 1978): 164–65; Sotheby Parke Bernet, *Art at Auction: The Year at Sotheby Parke Bernet 1977–1978* (London, 1978), pp. 225–27.

82. E. H. Gombrich, "Art Transplant," *New York Review of Books* 12 (June 19, 1969): 8.

83. E. H. Gombrich, *Art and Illusion* (London, 1968), p. 120.

84. Arnold W. Lawrence, *Greek and Roman Sculpture,* rev. ed. (London, 1972), p. 211. See also Chapter VII.

85. See Chapter II.

86. This is the subject of Wackernagel's chief work, *Der Lebensraum des Künstlers in der Florentinischen Renaissance* (Leipzig, 1938).

87. The first, albeit unsuccessful, attack on the decoration of this room was made by the first art dealer who concerned himself with Renaissance works of art. (Martin Wackernagel, "Giovanni della Palla, der erste Kunsthändler," *Die Kunst* 73 (1936): 270–71, 276; Vasari-Milanesi, II: 243.)

88. Wackernagel, "Giovanni della Palla," p. 271.

89. For a partial statement made as an *obiter dictum* see George Kubler, *The Shape of Time* (New Haven, 1962), p. 44.

INTERCHAPTER 2. THE BLUEPRINT

1. Personal communication from Dr. C. Steven Gurr, who is perhaps the leading collector in the field.

2. Cecil Munsey, *The Illustrated Guide to Collectibles of Coca-Cola* (New York, 1972).

3. "Sharp-Eyed Collectors Searching for Barbed Wire," *New York Times* (May 5, 1974).

4. Henry D. and Frances T. McCallum, *The Wire That Fenced the West* (Norman, Okla., 1965).

5. Personal communication from Sidney A. Brintle, Past President, Texas Barbed Wire Collectors Association.

6. In this age of omni-collecting, when collectors' categories proliferate constantly, Vasaris proliferate, too. The year 1980 was memorable for the publication of Udo Becher's *Early Tin Plate Model Railways* (New York); and *American Antique Toys* by Bernard

Barenholtz and Inez McClintock (New York) (see Rita Reif, "Books to Bring Joy to Toy Collectors," *New York Times*, Sunday, December 21, 1980, Arts and Leisure section). Both of these expensive publications can only be aimed at pre-existing collectors' markets.

7. Personal communication from Philip Mooney, Archivist of the Coca-Cola Company.

8. The museum is in the Visitors Center of the headquarters of the offices of the Coca-Cola Company in Atlanta, Georgia, and displays a great quantity of "Coca-Cola Collectibles."

9. Lu Shihua, *Scrapbook for Chinese Collectors: Shu Hua Shuo Ling*, trans. Robert H. van Gulik (Beirut, 1958), pp. 65, 67–68.

10. Yoshida Tetsuro, *The Japanese House and Garden*, trans. Marcus G. Sims (London, 1963), pp. 88–90, 98.

11. For the *Kundaikan* and the slightly later work by Kano Ikkei, see Chapter V, notes 22 and 23.

V. THE SIAMESE TWINS

1. Abbot Suger, *De Rebus in Administratione Sua Gestis* and *De Consecratione Ecclesiae Sancti Dionysii* in Erwin Panofsky, ed., *Abbot Suger on the Abbey Church of St.-Denis and Its Art Treasures* (Princeton, 1946), pp. 40–81, 82–121.

2. Procopius, *De Aedificiis*, ed. J. Haury, in *Procopii Caesariensis Opera* (Leipzig, 1913), vol. III, no. 2.

3. S. A. Babalqla, *The Content and Form of Yoruba Life* (Oxford, 1966), pp. 196–99.

4. For one such inscription, see the discussion of the monastery of St. Catherine on Mount Sinai in Chapter IX, note 121.

5. Giving this kind of indication was a common though intermittent practice, for example followed in the Dioscurides herbal of Juliana Anicia in Vienna, a sixth-century manuscript (see Kurt Weitzmann, *Studies in Classical and Byzantine Manuscript Illumination* [Chicago and London, 1971], p. 186). In the Dark Ages in Western Europe, the practice all but died out, but it resumed in Carolingian times. Obvious cases are Archbishop Ebbo's Gospel Book and Archbishop Drogo's Sacramentary. See Carl Nordenfalk, *Book Illumination*, in Nordenfalk and André Grabar, *Early Medieval Painting*, trans. Stuart Gilbert, 2 vols. in one (London, 1957), p. 186.

6. The practice of inscribing bronzes began in a relatively small way during the Shang dynasty. See, for instance, *The Great Bronze Age of China: An Exhibition from the People's Republic of China*, ed. Wen Fong, Metropolitan Museum of Art (New York, 1980), p. 183, no. 28. Under the Western Zhou dynasty, the inscriptions then became much longer; see pp. 203–4, nos. 41, 42.

7. The Casket of Teuderigus (or Teudericus), a Merovingian cloisonné reliquary, goes far beyond naming the donor. An inscription records that it was ordered by the priest Teuderigus, that Nordolaus and Rihlindis had it made, and that the makers were the goldsmiths Undiho and Ello. See Walter de Sager, "Treasures of the Abbey of St.-Maurice d'Agaune," *Connoisseur* 175 (October 1970): p. 80.

8. Panofsky, *Abbot Suger*, p. 162. Airardus, certainly a craftsman and perhaps even "*operarius*" of St.-Denis, was portrayed on a lost pair of doors. But these were the doors of the Carolingian abbey church, merely transferred by Suger to the North Portal.

9. Procopius, VII, *De Aedificiis*, I. i. 24, 50, 70; II. iii. 7. The near-miraculous character of the structure is repeatedly emphasized.

10. See Chapter VII.

11. These were Imhotep, who served King Zoser in the IIId dynasty, and Senenmut,

who served Queen Hatshepsut in the XVIIIth dynasty. Again, see Chapter VII.

12. Stella Kramrisch, *The Vishnudharmottara (Part III). A Treatise on Indian Painting and Image-Making,* 2nd rev. ed. (Calcutta, 1928).

13. Kramrisch, *The Vishnudharmottara,* p. 5.

14. Ananda K. Coomaraswamy, *History of Indian and Indonesian Art* (1927, reprint New York, 1965), p. 126.

15. *Facsimile of the Sketch-Book of Wilars De Honecort, an Architect of the Thirteenth Century,* with commentaries and descriptions by M. J. B. A. Lassus, and by M. J. Quicherat, ed. Robert Willis (London, 1859).

16. Dionysius of Fourna, *Le Guide de la peinture* in M. Didron, ed., *Manuel d'iconographie chrétienne grecque et latine,* trans. Paul Durand (Paris, 1845; reprint New York, 1963).

17. Kramrisch, *The Vishnudharmottara,* p. 39.

18. Kramrisch, *The Vishnudharmottara,* p. 41.

19. Kramrisch, *The Vishnudharmottara.*

20. See *The Elder Pliny's Chapters on the History of Art,* trans. K. Jex-Blake, commentary by E. Sellers (Chicago, 1968).

21. See *Li tai ming hua chi* in *Some T'ang and Pre-T'ang Texts on Chinese Painting,* trans. and annot. William Reynolds Beal Acker, Sinica Leidensia 8, vol. I (Leyden, 1954). See also Chapter VIII.

22. *Kundaikan Sayu Choki* is a fifteenth-century handbook of Chinese art which circulated in manuscript until the early nineteenth century. See *Japanese Ink Paintings,* ed. Shimizu Yoshiaki and Carolyn Wheelwright (Princeton, 1976), p. 223.

23. *Tansei Jakubokushū,* compiled by Kano Ikkei, c. 1650, covers 140 Japanese painters of the fourteenth through seventeenth centuries. See *Japanese Ink Paintings,* p. 204, n. 4.

24. Qādī Aḥmad, *Calligraphers and Painters,* trans. V. Minorsky, Freer Gallery of Art Occasional Papers 3, no. 2 (Washington, D.C., 1959).

25. See Chapter X.

26. See Chapter XI.

27. Marcantonio Michiel in *Notizia d'opere di disegno,* ed. Jacopo Morelli (Bassano, 1800).

28. Raffaello Borghini, *Il Riposo* (Florence, 1584).

29. Vasari-Milanesi, I: 386, 395–96. Two Giottos also appear in the posthumous inventory of the possessions of Lorenzo the Magnificent (Eugène Müntz, *Les Collections des Médicis au XVe siècle* [Paris, 1888], pp. 64, 77). It had been my belief that these were inheritances from a much earlier generation of Medici until the recent discovery that Lorenzo de' Medici's son Piero actually acquired a Cimabue (see Chapter XII). For another possibility having to do with Nicolo Niccoli and Cosimo de' Medici see Chapter XI.

30. Vasari-Milanesi, I: 237–38.

31. Vasari-Milanesi, I: 236.

32. Antonio Averlino Filarete, *Filarete's Treatise on Architecture,* ed. John R. Spencer, 2 vols. (New Haven, 1965), I: xxx.

33. Vasari-Milanesi, IV: 7–15.

34. Vasari-Milanesi, II: 95.

35. Vasari-Milanesi, II: 95–96, repeated with rather more severity in IV: 9–11.

36. Vasari-Milanesi, IV: 11–15.

37. Mary Ann Jack Ward, "The 'Accademia del Disegno' in Sixteenth Century Florence: A Study of an Artists' Institution," dissertation, University of Chicago (1972), pp. 267 ff.

38. A. Bertolotti, *Figuli, fonditori e scultori in relazione con la corte di Mantova* (Milan, 1890), p. 73.

39. Ward, "The 'Accademia del Disegno,'" p. 272.

40. M. P. Zavitukhina, "The Siberian Collection of Peter the Great," in *Frozen Tombs: The Culture and Art of the Ancient Tribes of Siberia*, exhibition catalogue, The British Museum (London, 1978), pp. 13–14.

41. Ward, "The 'Accademia del Disegno,'" pp. 271–72.

42. Ward, "The 'Accademia del Disegno,'" pp. 268, 271.

43. Ward, "The 'Accademia del Disegno,'" p. 269, n. 2.

44. See Ward, "The 'Accademia del Disegno,'" p. 269: "Michelangelo Buonarroti, Raffaello da Urbino, Andrea del Sarto, Mederino, . . ." "Mederino" is clearly a slight misspelling of "Mecherino," a name commonly given to Beccafumi.

45. "Il Rosso (Giovanni Battista di Jacopo), Leonardo da Vinci, Franciabigio, Perino del Vaga, Jacopo Pontormo, Titian, Francesco Salviati, Agnolo Bronzino, Daniello da Volterra, Francesco Bartolommeo di S. Marco . . ." The last name undoubtedly refers to Fra Bartolomeo.

46. ". . . Francesco Bartolomeo del Piombo, Filippino Lippi, Antonio Corregio, and Parmigianino." The first name should certainly be "Sebastiano del Piombo."

47. Ward, "The 'Accademia del Disegno,'" p. 269.

48. Vasari-Milanesi, III: 461–77.

49. Vasari-Milanesi, VI: 379–99.

50. Vasari-Milanesi, V: 633–54.

51. Hugh Trevor-Roper, *Princes and Artists: Patronage and Ideology at Four Hapsburg Courts 1517–1633* (New York, 1976), p. 104; R. J. W. Evans, *Rudolf II and His World: A Study in Intellectual History 1576–1612* (Oxford, 1973), pp. 163, 165–66; Thomas DaCosta Kaufmann, *Variations on the Imperial Theme in the Age of Maximilian II and Rudolf II* (New York, 1978); Benno Geiger, *I dipinti ghiribizzosi di Giuseppe Arcimboldi* (Florence, 1954), pp. 27, 29; Legrand and Sluys, *Arcimboldo et les arcimboldesques* (Paris, 1955), pp. 35–37.

52. Max J. Friedländer, *Early Netherlandish Painting*, I: *The Van Eycks–Petrus Christus*, trans. Heinz Norden (Leyden, 1967), pp. 40–41.

53. W. Noël Sainsbury, ed., *Original Unpublished Papers Illustrative of the Life of Sir Peter Paul Rubens as an Artist and a Diplomatist* (London, 1859), p. 241: "179. 180. Two pictures of a Man and a Woman; by John van Eyck."

54. Francisco de Hollanda, *Four Dialogues on Painting*, trans. Aubrey F. G. Bell (London, 1928), pp. 15–18.

55. Licia Collobi Ragghianti, *Il libro de' disegni del Vasari*, 2 vols. (Florence, 1974), I: 26; Erwin Panofsky, "The First Page of Giorgio Vasari's 'Libro,'" in *Meaning in the Visual Arts* (Garden City, N.Y., 1955), pp. 169–225.

56. Ragghianti, *Il libro*, I: 13.

57. Andrea Memmo, *Elementi d'architettura lodoliana ossia l'arte del fabbricare con solidità scientifica e con eleganza non capricciosa*, 2 vols. (Rome, 1786; rev. 2nd ed., Zara, 1833–34; reprint Milan, 1973) I: 40–42.

58. Memmo, *Elementi*, I: 50–58.

59. Gianfranco Torcellan, *Una figura della Venezia settecentesca: Andrea Memmo* (Venice-Rome, 1963), pp. 38–39; Francis Haskell, "Consul Smith and His Patronage," *Apollo* 82 (August, 1965): 98, 103; Haskell, *Patrons and Painters* (New York, 1963), pp. 320, 322; for the extent of Consul Smith's collection acquired by George III, see K. T. Parker, *The Drawings of Antonio Canaletto in the Collection of His Majesty the King at Windsor Castle* (Oxford & London, 1948), pp. 9, 29–58, nos. 1–143.

60. Memmo, *Elementi*, I: 44–45, 49–50,75.

61. Massimo Petrocchi, *Razionalismo architettonico e razionalismo storiografico* (Rome, 1947), pp. 19–23.

62. *Enciclopedia italiana di scienze, lettere ed arti*, XXI (Rome, 1934): 380.

63. Memmo, *Elementi*, I: 78–79. The relevant passages of Memmo's *Elementi* were kindly translated for me by Professor Anna Modigliani Lynch.

64. The large price (see Chapter XIV) paid by King Charles V for Mantegna's Triumph of Caesar led to false Mantegna signatures on other, unfashionably early paintings. There is—or was—one on the Metropolitan Museum's Carpaccio (personal communication from the late Theodore Rousseau).

65. *Uffizi, Florence*, Great Museums of the World (New York, 1968), pp. 66, 89.

66. Memmo, *Elementi*, I: 43.

67. A. E. Popham, "Sebastiano Resta and his Collections," *Old Master Drawings* 11 (June, 1936): 1–19, pls. 1–18.

68. Memmo, *Elementi*, I: 82.

69. Memmo, *Elementi*, I: 81.

70. Memmo, *Elementi*, I: 79.

71. Paul A. Underwood, *The Kariye Djami*. I, *Historical Introduction and Description of the Mosaics and Frescoes*, (New York, 1966), p. 15.

72. Memmo, *Elementi*, I: 79.

73. Memmo, *Elementi*, I: 79.

74. This obscure artist is identified in Antonio Maria Zanetti, *Della pittura veneziana*, 2 vols. (Venice, 1797), II: 190.

75. Memmo, *Elementi*, I: 79–80.

76. Memmo, *Elementi*, I: 81.

77. Memmo, *Elementi*, I: 81.

78. Memmo, *Elementi*, I: 81–82.

79. Memmo, *Elementi* (Rome, 1786), I: 59. It was omitted from the revised, enlarged, 3-vol. edition of 1834. See Torcellan, *Una figura della Venezia settecentesca: Andrea Memmo*, pp. 30, n. 2; 192, n. 2, for the publication history of Memmo's work.

80. Haskell, "Consul Smith and His Patronage," pp. 98–99; Haskell, *Patrons and Painters*, p. 320; for a summary of Abate Facciolati's contribution as a scholar see Giulio Natali, *Storia letteraria d'Italia: il Settecento* (Milan, 1929), I: 518–19. See also Giovanni Previtali, *La fortuna dei primitivi* (Turin, 1964), pp. 219–20.

81. Pierre-Jean Grosley, *Nouveaux Mémoires, ou Observations sur l'Italie, et sur les Italiens*, II (London, 1764): 142–43.

82. John Fleming, "The Hugfords of Florence, Part II, with a Provisional Catalogue of the Collection of Ignazio Enrico Hugford," *Connoisseur* 136 (November 1955): 199, 206.

83. Fleming, "The Hugfords of Florence, Part II," pp. 200, 203.

84. Fleming, "The Hugfords of Florence, Part II," p. 206.

85. Bruce Cole and Ulrich Middeldorf, "Masaccio, Lippi, or Hugford?" *Burlington Magazine* 113 (September 1971): 503–4, 507.

86. Luisa Becherucci, "Introduction," in *Uffizi, Florence*, p. 13.

87. Becherucci, "Introduction," p. 13.

88. Before Pietro Leopoldo reached Florence, however, the pictures in the Palazzo Pitti were rehung. The new arrangement depended "upon the freshness of the gilding of the frames, and then upon the position of the figures of each picture not to turn its back to the throne." See *Horace Walpole's Correspondence*, ed. Wilmarth S. Lewis, XXII (New Haven, 1960): 246.

89. See Gustav Glück, *The Picture Gallery of the Vienna Art Museum* (Vienna, 1931), pp. xvii–xviii; Alfons Lhotsky, *Festschrift des Kunsthistorischen Museums zur Feier*

des fünfzigjährigen Bestandes (Vienna, 1941–45), Part II, *Die Geschichte der Sammlungen*, pp. 445–49, 464.

90. Glück, *The Picture Gallery of the Vienna Art Museum*, pp. xii–xiv; Lhotsky, *Festschrift des Kunsthistorischen Museums*, Part II, pp. 434–35, pls. XXXVIII–XXXIX; Alfred Stix, "Die Aufstellung der ehedem Kaiserlichen Gemäldegalerie in Wien im 18. Jahrhundert," in *Museion* (Vienna, Prague, Leipzig, 1922), pp. 11–16.

91. Aurelio Gotti, *Le gallerie e i musei di Firenze* 2nd ed. (Florence, 1875), p. 176.

92. Abbé Jérôme Richard, *Déscription historique et critique de l'Italie, ou Nouveaux Mémoires sur l'état actuel de son gouvernement, des sciences, des arts, du commerce de la population et de l'histoire naturelle*, III (Dijon-Paris, 1766): 185–86.

93. Luigi Lanzi, *La Real Galleria di Firenze accresciuta, e riordinata per comando di S.A.R. l'Arciduca Granduca di Toscana* (Florence, 1782), p. 69.

94. Lanzi, *La Real Galleria*, pp. 6–10.

95. Gotti, *Le gallerie e i musei di Firenze*, pp. 169–70; Giuseppe Bencivenni Pelli, *Saggio istorico sulla Reale Galleria di Firenze*, 2 vols. (Florence, 1779), II: 236–37.

96. Alessandro Conti, "Francesco Petrarca e Madonna Laura: uno strano ritratto," *Prospettiva* 5 (April 1976): pp. 58, 61, n. 7.

97. Ugo Segrè, *Luigi Lanzi e le sue opere* (Assisi, 1904), p. 5; Onofrio Boni, *Elogio dell'Abate Don Luigi Lanzi* (Florence, 1814), p. 14.

98. *Serie di ritratti d'uomini illustri toscani con gli elogi*, ed. Giuseppe Allegrini, 4 vols. (Florence, 1766–73), II: 55.

99. Luigi Lanzi, *Saggio di lingua etrusca e di altre antiche d'Italia* (Rome, 1789); Giusta Nicco Fasola, "Luigi Lanzi, C. Giuseppe Ratti e la pittura genovese," *Miscellanea di storia ligure in onore di Giorgio Falco* (Milan, 1962), pp. 357–58; Segrè, *Luigi Lanzi*, pp. 8–9.

100. *Storia pittorica dell'Italia inferiore* (Florence, 1792), vol. I, was the first vol. of Lanzi's projected 2-vol. study of Italian painting, which remained incomplete until a 2nd edition was published in 3 vols. as *Storia pittorica dell'Italia* (Bassano, 1795–96). "Systematic" is the word in Lanzi's introduction, which sternly criticizes earlier Italian art historians.

101. Fleming, "The Hugfords of Florence, Part II," pp. 199, 204–06.

102. See note 95, above.

103. Grand Duke Pietro Leopoldo visited Vienna from August 1778 to March 1779.

104. See notes 89 and 90, above.

105. See note 93.

106. See notes 89 and 90, above.

107. For example, the establishment of London's National Gallery in 1824, and the semi-public opening of the Hermitage in 1852. Most other European princely collections also became public art museums, and art-historical hanging became the rule as well.

108. Cecil Gould, *Trophy of Conquest* (London, 1965), pp. 24–27.

109. *Lansdowne House, London: A Catalogue of the Ancient Marbles Based on the Work of Adolf Michaelis*, ed. A. H. Smith (London, 1889), pp. 7–12.

110. *Lansdowne House*, pp. 54–55, 56–57 ff.

111. S. Speth-Holterhoff, *Les Peintres flamands de cabinets d'amateurs au XVIIe siècle* (Brussels, 1957). The numerous illustrations show the method of hanging, which was not confined to the Low Countries.

112. On "Le Cabinet d'Amateur de Corneille Van der Geest," see Speth-Holterhoff, *Les Peintres flamands*, pp. 101–03. Cornelius van der Geest's Van Eyck appears in a picture by Willem van Haecht.

113. See notes 89 and 90, above.

114. *Notice des tableaux des écoles primitives de l'Italie, de l'Allemagne, et de plusieurs autres tableaux de différentes écoles, exposés dans le grand salon du Musée Royal* (Paris, 1815); Gould, *Trophy of Conquest*, pp. 112–15; Jean Chatelain, *Dominique Vivant Denon* (Paris, 1973), pp. 182–85, 209–10, 222.

115. Wolf-Dieter Dube, "Introduction," in *Pinakothek, Munich*, Great Museums of the World (New York, 1969), p. 14.

116. Lanzi, *La Real Galleria*, pp. 67–72.

117. Lanzi, *La Real Galleria*, pp. 70–72.

118. Luigi Lanzi's *Storia pittorica dell'Italia* (see note 100) was undoubtedly the precursor and in some degree the inspiration of the early scientific art-historians of the nineteenth century.

119. Lanzi, *La Real Galleria*, p. 71; Galleria degli Uffizi, *Catalogo dei dipinti* (Florence, 1948), cat. no. 479, pp. 16–17.

120. John Pope-Hennessy, *The Complete Work of Paolo Uccello* (London, 1950), pp. 150–52.

121. *Horace Walpole's Correspondence*, XXV (1971): 230. Mann here discusses sales of other things than pictures. But the catalogue of the London National Gallery makes it clear that the London Uccello must have been sold out of the Medici collections, and thus came on the market.

122. See the discussion of Roscoe, the Boisserée brothers, and Solly, below, and in notes 146, 147 and 148.

123. "The pictures are chiefly Cimabué, Giotto, Guido da Siena, Marco di Siena, & all that old pedantry of painting which seemed to show the progress of art at its resurrection. . . ." From a letter to Sir William Hamilton of 26 January, 1798, in William S. Childe-Pemberton, *The Earl Bishop: The Life of Frederick Hervey, Bishop of Derry, Earl of Bristol*, 2 vols. (London, 1924), II: 562. The Earl Bishop conceived the idea of forming a historical collection as early as 1792 (see Childe-Pemberton, *The Earl Bishop*, II: 436, for the letter of 20 March, 1792, to his daughter Mary, Countess of Erne). It may well be that he picked up the notion from Seroux d'Agincourt (see below) or a member of his circle in Rome, the center where he stored his acquisitions.

124. After the Earl-Bishop succeeded to the earldom, he enjoyed the combined income of the bishopric of Derry and the substantial Hervey property. Childe-Pemberton, *The Earl Bishop*, I: 250.

125. All were men of modest means at best. The richest was probably the nobleman Marchese Tommaso degli Obizzi. See Millard Meiss, "Italian Primitives at Konopiste," *Art Bulletin* 28, no. 1 (March 1946): 1–16.

126. M. le Chevalier A. F. Artaud de Montor, *Peintres primitifs: collection de tableaux rapportés d'Italie* (Paris, 1843), p. 14.

127. Artaud de Montor, *Peintres primitifs*, pp. 5, 21–49.

128. *Catalogue of the Gallery of Art of the New-York Historical Society* (New York, 1915), pp. 57–60.

129. Aline B. Saarinen, *The Proud Possessors* (New York, 1958), pp. xxi–xxii.

130. Some of the collection was sold by Sotheby Parke Bernet in 1971 (New-York Historical Society, *Catalogue*, pp. 60 B-22; 61 B-28, B-31; 66 B-59; 67 B-71; 71 B-115; 78 B-172; 82 B-204; 84 B-223; 87 B-249; 88 B-255; 90 B-277; 95 B-327, B-328; 96 B-339). The best of the remaining primitives have lately been transferred from the Historical Society to the Metropolitan Museum, on the initiative of Sir John Pope-Hennessy, so part of the statement in the text is out of date.

131. For the rise in Giotto's standing, see Albert C. Barnes, *The Art in Painting*, 3rd ed. (New York, 1937), pp. 112–14, 135–40. Barnes, indeed, placed Giotto far above Raphael.

132. J.-B. L.-G. Seroux d'Agincourt, *Histoire de l'art par les monuments depuis sa décadence au IVe siècle jusqu'à son renouvellement au XVe* (Paris, 1810–23), I: 11.

133. Previtali, *La fortuna*, pp. 165 ff.; M. Lamy, "La Découverte des primitifs italiens au XIXe siècle, Seroux d'Agincourt et son influence sur les collectionneurs, critiques et artistes français," *Revue de l'Art, Ancien et Moderne* 39 (March 1921): 169–81; 40 (September–October 1921): 182–90.

134. Previtali, *La fortuna*, pp. 185–87; Tancred Borenius, "The Rediscovery of the Primitives," *Quarterly Review* no. 475 (April 1923), pp. 264–66.

135. Previtali, *La fortuna*, pp. 230–32; Fernand Beaucamp, *Jean-Baptiste Wicar, le peintre lillois (1762–1834)*, 2 vols. (Lille, 1939), II: 368, n. 1, 369.

136. Previtali, *La fortuna*, pp. 229–30, n. 2; Borenius, "The Rediscovery," pp. 268–69.

137. Previtali, *La fortuna*, p. 333; Beaucamp, *Jean-Baptiste Wicar*, II: 344, n. 1; Gould, *Trophy of Conquest*, p. 86.

138. Gould, *Trophy of Conquest*, pp. 110–13.

139. Francis J. B. Watson, "Thomas Patch (1725–1782): Notes on His Life, Together with a Catalogue of His Known Works," *The Walpole Society*, 28 (1939–40): 27; Edward A. Maser, "Giotto, Masaccio, Ghiberti and Thomas Patch," *Festschrift Klaus Lankheit zum 20. Mai 1973* (Cologne, 1973), pp. 192–99.

140. Keith Andrews, *The Nazarenes* (Oxford, 1964), pp. 78–79.

141. Watson, "Thomas Patch," p. 27; Borenius, "The Rediscovery," p. 262; Andrews, *The Nazarenes*, p. 79.

142. Beaucamp, *Jean-Baptiste Wicar*, II: 474. For the extent of the paintings ceded by Italy to France see Marie-Louise Blumer, "Catalogue des peintures transportées d'Italie en France de 1796 à 1814," *Bulletin de la Société de l'Histoire de l'Art Français*, fasc. 2 (1936), pp. 245 ff.

143. Beaucamp, *Jean-Baptiste Wicar*, II: 475–76.

144. Beaucamp, *Jean-Baptiste Wicar*, II: 475.

145. Both William Roscoe and Edward Solly made obeisance to the old canon of art for the record, and Roscoe forthrightly stated his collection was aimed to illustrate art history in the eighteenth-century way. See Michael Compton, "William Roscoe and Early Collectors of Italian Primitives," *Liverpool Bulletin*, Walker Art Gallery, 9 (1960–61): 29. For Solly see note 148.

146. Although Roscoe stated specifically that illustrating art history was his aim, he bought Italian primitives on too large a scale, paying too high prices, not to have done it also because he liked these pictures. Reverses forced him to sell his collection in 1816. The pictures he bought were then acquired by the Walker Art Gallery (Compton, "William Roscoe," pp. 46–47).

147. E. Firmenich-Richartz, *Die Brüder Boisserée* (Jena, 1916).

148. Frank Herrmann, "Who Was Solly?," parts 1–5, *Connoisseur* 164 (April 1967): 229–34; 165 (May 1967): 13–18; 165 (July 1967): 153–61; 166 (September 1967): 10–18; 169 (September 1968): 12–17.

149. Herrmann, "Who Was Solly?," part 1, pp. 232–34; Herrmann, "Who Was Solly?," part 2, pp. 13–15, 17–18; Herrmann, "Who Was Solly?," part 3, pp. 153–59.

150. Herrmann, "Who Was Solly?," part 1, p. 233.

151. Herrmann, "Who Was Solly?," part 3, pl. 12.

152. The Boisserée collection of early German painting in Munich's Pinakothek; a good part of the Roscoe collection of early Italian painting in the Walker Art Gallery,

Liverpool; and what now remains of the Solly collection in Berlin's Gemäldegalerie, Staatliche Museen.

153. It should be noted that the price the Prussian government settled on was considerably less than what Solly thought his collection was worth. See Solly's letter of 13 October 1821 in Herrmann, "Who Was Solly?," part 4, pp. 14, 16. For the actual price paid, see Herrmann, "Who Was Solly?," part 5, p. 12.

154. Article 247. See the Treaty of Versailles in *Foreign Relations of the United States: Paris Peace Conference 1919*, Department of State (Washington, D.C., 1947), 13:524–25.

155. Herrmann, "Who Was Solly?," part 1, p. 234.

156. Christie, Manson & Woods Ltd., *Highly Important Old Master Pictures* (London, July 2, 1976), p. 99.

157. Christie, Manson & Woods Ltd., *Highly Important Old Master Pictures*, pp. 98–101.

158. Alexander William Crawford Lindsay, *Sketches of the History of Christian Art*, 3 vols. (London, 1847).

159. Lord Lindsay writing from Florence, March 28, 1842. See Francis Haskell, *Rediscoveries in Art: Some Aspects of Taste, Fashion and Collecting in England and France* (Ithaca, N.Y., 1976), p. 75, n. 25.

160. P.-J. Mariette, *Abecedario*, in *Archives de l'art français*. Vols. 2, 4, 6, 8, 10, 12 (Paris, 1851–1860). See vol. IV. The *Abecedario* is so interesting because it takes the form of a dictionary of artists of significance. Great numbers of Dutch and Flemish painters are included (but not Van Eyck!), which would certainly have not occurred much earlier.

161. Roger de Piles, *Cours de peinture par principes* (1708; reprinted Geneva, 1969).

162. Based on a system of a maximum of 72 points, Rembrandt is given a rating of 50, Teniers of 46 (Piles, *Cours de peinture*, pp. 493 ff. unpaginated). See also the "Balance des Peintres" as reproduced in Bernard Teyssèdre, *L'Histoire de l'art vue du grand siècle* (Paris, 1964), pp. 173–75.

163. Louis Duc de Saint-Simon, *Mémoires*, ed. Gonzague Truc, 7 vols. (Paris, 1947–61), I: 763–64.

164. Saint-Simon, *Mémoires*, I: 764.

165. Saint-Simon, *Mémoires*, I: 764.

166. Saint-Simon, *Mémoires*, I: 766.

167. Charles Blanc, *Le Trésor de la curiosité*, I (Paris, 1857): iii.

168. Saint-Simon, *Mémoires*, I: 766.

169. Blanc, *Trésor de la curiosité*, I: 1, 3–6, 8–15.

170. Blanc, *Trésor de la curiosité*, I:1–10.

171. *George IV and the Arts of France*, exhibition catalogue, The Queen's Gallery, Buckingham Palace (London, 1966), p. 6; Francis J. B. Watson, "George IV as an Art Collector," *Apollo* 83 (June 1966): 419; Mrs. Jameson, *Companion to the Most Celebrated Private Galleries of Art in London* (London, 1844), pp. 3–10, 341–80.

172. *Dutch Pictures from the Royal Collection: The Queen's Gallery Buckingham Palace*, intro. Oliver Millar (London, 1971), pp. 30–31; Gerald Reitlinger, *The Economics of Taste*, I (London, 1963): 12, 49.

173. Haskell, *Rediscoveries in Art*, pp. 88–90.

174. Haskell, *Rediscoveries in Art*, pp. 86–87; W. Bürger (Thoré-Bürger), "Van der Meer de Delft," *Gazette des Beaux-Arts* 21 (October, 1866): 298.

175. Bürger, "Van der Meer de Delft," *Gazette des Beaux-Arts* 21 (October, November, December, 1866): 297–303, 458–70, 542–75.

176. The 1911 edition of *The Encyclopedia Britannica*, 11th ed. (New York), IV: 503, dismisses Bruegel as inferior to Teniers. And Carel van Mander refers to him as "Pier den Droll" because "there are very few works from his hand the beholder can look at seriously, without laughing" (Carel van Mander, *Dutch and Flemish Painters*, translation of *Schilderboeck* by Constant van de Wall [New York, 1936], p. 153).

177. *Georges de la Tour*, exhibition catalogue, Orangerie des Tuileries, 2nd ed. (Paris, 1972), p. 27.

178. Ilse Hempel Lipschutz, *Spanish Painting and the French Romantics* (Cambridge, Mass., 1972), pp. 8–9, 16–17, 24–25, 30, 36–37, 46–49.

179. In France, for example, two very important collections—formed by Edmé-Antoine Durand, an art lover of independent means, and a painter, Pierre Révoil—both appear to have originated toward the end of the eighteenth century. Durand was then able to sell his collection to the Louvre for 480,000 gold francs in 1824, a very large sum in those days. *Le "Gothique" retrouvé avant Viollet-le-Duc*, exhibition catalogue, Hôtel de Sully, Caisse Nationale des Monuments Historiques et des Sites (Paris, 1979), p. 92.

180. Charles de Tolnay, *Michelangelo*, 2nd ed., IV (Princeton, 1970): 3–4.

181. Tolnay, *Michelangelo*, IV: 97. For a slightly different account see Paul Joannides, "Michelangelo's Lost Hercules," *Burlington Magazine* 119 (August 1977): 550.

182. Tolnay, *Michelangelo*, IV: 97.

183. Tolnay, *Michelangelo*, IV: 97.

184. Louis Courajod, *Alexandre Lenoir, son journal et le Musée des Monuments Français*, 3 vols. (Paris, 1878, 1886, 1887), II: 247; Edmond Bonnaffé, *Recherches sur les collections des Richelieu* (Paris, 1883), p. 33; Tolnay, *Michelangelo*, IV: 97.

185. M. Georges Huard, "Alexandre Lenoir et les 'Esclaves' de Michel-Ange," in *Mélanges en hommage à la mémoire de Fr. F. Martroye* (Paris, 1940), p. 374.

186. Courajod, *Alexandre Lenoir*, I: xviii–xix, 8, no. 73; II: 247, no. 98; 249, no. 101.

187. Courajod, *Alexandre Lenoir*, I: 8 no. 70.

188. Courajod, *Alexandre Lenoir*, I: clv; II: 2, 205–6; *Le "Gothique" retrouvé avant Viollet-le-Duc*, pp. 75, 77–78.

189. Alexandre Lenoir, *Description historique et chronologique des monuments de sculpture, réunis au Musée des Monuments Français*, 6th ed. (Paris, 1802), p. 17; Rev. William Shepherd, *Paris, in Eighteen Hundred and Two, and Eighteen Hundred and Fourteen* (London, 1814), pp. 84–85; *Le "Gothique" retrouvé avant Viollet-le-Duc*," p. 78.

190. Musée National du Louvre, *Catalogue sommaire des sculptures du moyen âge, de la Renaissance et des temps modernes* (Paris, 1897), p. 44; Huard, "Alexandre Lenoir," pp. 373, 385–86.

191. Courajod, *Lenoir*, I: lxxxvii–xciii.

192. Courajod, *Lenoir*, I: cxxix ff.

193. Vasari-Milanesi, V: 41; Sydney F. Freedberg, *Andrea del Sarto: Catalogue Raisonné* (Cambridge, Mass., 1963), pp. 130, 132; John Shearman, *Andrea del Sarto* (Oxford, 1965), II: 266.

194. Vasari-Milanesi, V: 41; Freedberg, *Andrea del Sarto*, pp. 131–33; Shearman, *Andrea del Sarto*, II: 266.

195. Vasari-Milanesi, V: 42; Freedberg, *Andrea del Sarto*, p. 132.

196. Vasari-Milanesi, V: 42; Freedberg, *Andrea del Sarto*, p. 133.

197. Luitpold Dussler, *Raphael: A Critical Catalogue of his Pictures, Wall-Paintings and Tapestries*, trans. Sebastian Cruft (London and New York, 1971), p. 46.

198. Freedberg, *Andrea del Sarto*, p. 133; Shearman, *Andrea del Sarto*, II: 266.

199. Guibert de Nogent, *De Pignoribus Sanctorum*, in *Patrologia Latina*, ed. J.-P. Migne, CLVI (Paris, 1880): cols. 608–80.

200. Guibert, *De Pignoribus*, col. 608.

201. Guibert, *De Pignoribus*, col. 615.

202. Guibert, *De Pignoribus*, col. 625.

203. Guibert, *De Pignoribus*, col. 620.

204. Guibert, *De Pignoribus*, col. 625.

205. Guibert, *De Pignoribus*, col. 626.

206. Max Loehr, "Some Fundamental Issues in the History of Chinese Painting," *Journal of Asian Studies* 23 (February 1964): 185.

207. Procopius, *De Aedificiis*, I. i. 24, 50, 70; II. iii. 7. Procopius' record of the architects of the Hagia Sophia is almost the only mention by name of any postclassical artist in all of Byzantine literature. The chief exception is a poetic epigram and other references to the twelfth-century painter Eulalius. On this topic see also Cyril Mango, "Antique Statuary and the Byzantine Beholder," *Dumbarton Oaks Papers* 17 (1963): 66, 67, n. 73.

208. See Chapter IX.

209. Babalqla, *The Content and Form of Yoruba Life*, p. 198.

210. Roy C. Craven, *A Concise History of Indian Art* (London, 1976), p. 70.

211. *Genesis* 4:22.

212. *Exodus* 31:1–11; 35:30–35; 36:2; 38:22–23.

213. See William Stevenson Smith's statement: "The legendary character of Imhotep, who was revered centuries after his death as a demi-god, the builder of the temple of Edfu, the wise chancellor, architect and physician of Djoser, has now acquired reality through the discovery of his name on a statue base of Netjerykhet [i.e., Djoser] in the excavations of the Step Pyramid." (*The Cambridge Ancient History*, 3rd ed., vol. I, part II, *Early History of the Middle East*, [Cambridge, 1971], p. 145.) For the discovery of Imhotep's inscribed name see C. M. Firth and J. E. Quibell, *Excavations at Saqqara. The Step Pyramid.* Service des Antiquités de l'Egypte (Cairo, 1935), p. 78.

214. Amenhotep, son of Hapu, was another beneficent grand-vizier equivalent who ended by being deified. Some believe he may have reached his high rank by the same avenue followed by Imhotep, starting in the Egyptian equivalent of the Ministry of Works. On these two demi-gods, see D. Wildung, *Imhotep und Amenhotep*, Münchner Aegyptologische Studien 36 (Berlin, 1977); and D. Wildung, *Egyptian Saints: Deification in Pharaonic Egypt* (New York, 1977).

215. For the life of St. Eloy, see *Vita Eligii Episcopi Noviomagensis*, ed. W. Krusch, in *Monumenta Germaniae Historica*, Scriptores Rerum Merovingicarum, IV (Hanover-Leipzig, 1902): 634–761 (X, 32); *Butler's Lives of Saints*, ed., rev. Herbert Thurston and Donald Attwater (New York, 1956), IV: 455–58. For the life of St. Bernward see Thangmar, *Vita Bernwardi Episcopi Hildesheimensis*, ed. H. G. Pertz, in *Monumenta Germaniae Historica*, Scriptores in Folio, IV (Hanover, 1841): 754–86; *Butler's Lives of Saints*, IV: 396–97; Francis J. Tschan, *Saint Bernward of Hildesheim*, 3 vols. (South Bend, Indiana, 1942–52).

216. See Chapter IX.

217. Edith Williams Ware, "Egyptian Artists' Signatures," *American Journal of Semitic Languages and Literatures* 43 (October 1926–July 1927): 185–207.

218. Ernst Kris and Otto Kurz, *Legend, Myth, and Magic in the Image of the Artist*, preface by E. H. Gombrich (New Haven and London, 1979), pp. 2–12.

219. Filippo Villani's text on painters in *De Origine Civitatis Florentiae Famosis Civibus* of 1381–82 is reproduced in Karl Frey, *Il libro di Antonio Billi* (Berlin, 1892), pp. 73–75.

220. In Naples, in *De Viris Illustribus* (see Michael Baxandall, *Giotto and the Orators* [Oxford, 1971], pp. 99–111) Bartolomeo Fazio offered a short list of artists like that of Villani, but he cast his net wider, so to say, by giving first prize to Jan van Eyck (see Baxandall, *Giotto and the Orators,* pp. 106–7, text XVI). Then in Florence, Cristoforo Landino inserted another list of Italian artists in the preface to his edition of Dante (see Ottavio Morisani, "Art Historians and Art Critics—III: Cristoforo Landino," *Burlington Magazine* 95 [1953]: 270, n. 6). Landino covered fifteen masters; more than forty masters were subsequently recorded in *Il libro di Antonio Billi*. The total of artists given comes from the more complete of the two codices preserving Billi's work. Both are reproduced by Frey in *Il libro di Antonio Billi,* pp. 1–53.

 Besides these important lists, lesser artist lists were printed: Antonio de Tuccio Manetti, *I XIV uomini singhulari in Firenze dal 1400 innanzi* (Florence, between 1494–97); Ugolino Verino, *De Illustratione Urbis Florentiae* (Florence, after 1502); Raffaele Volterrano, *Antropologia* (Rome, 1506); Camillo Leonardo, *Specchio delle pietre* (Venice, 1502); Michele Savonarola, *Libellus de Magnificis Ornamentis Regie Civitatis Padue* (c. 1446); Giovanni Santi, *Cronaca rimata delle imprese del duca Federigo d'Urbino* (Urbino, after 1482).

221. Karl Frey, *Il codice magliabechiano* (Berlin, 1892), pp. 47–120.

222. *Heike Monogatari: The Tale of the Heike,* trans. Hiroshi Kitagawa and Bruce T. Tsuchida (Japan, 1975), pp. 35–36.

223. Murasaki Shikibu, *The Tale of Genji,* trans. Edward G. Seidensticker, 2 vols. (New York, 1977), I: 237, 310–17, 517, 529.

224. See Chapter VIII.

225. See Chapter VIII.

VI. THE OTHER BY-PRODUCTS OF ART

1. G. F. Chadwick, *The Works of Sir Joseph Paxton* (London, 1961), pp. 188–92.

2. Count Egon Caesar Corti, *The Rise of the House of Rothschild 1770–1830,* trans. Brian and Beatrix Lunn (1928; New York, 1972), pp. 4–15.

3. A considerable share of the *Trésor des Deux Siciles* is owned by the Baron Élie de Rothschild, having come to the French house from the senior Rothschild house in Frankfurt (personal communication from the Baronne Élie de Rothschild).

4. Personal communication from the Baronne Élie de Rothschild.

5. Sotheby Parke Bernet & Co., *Mentmore,* 5 vols. (London, 1977), vol. I, *Catalogue of French and Continental Furniture, Tapestries and Clocks;* vol. II, *Catalogue of Works of Art and Silver;* vol. III, *Catalogue of Vincennes and Sèvres and Other Continental Porcelain and Italian Maiolica;* vol. IV, *Catalogue of Paintings, Prints and Drawings;* vol. V, *Catalogue of General Contents of the House.*

6. Sir Francis J. B. Watson, "Mentmore and Its Art Collections," in *Mentmore,* I: x (this essay is contained in each vol.).

7. Watson, "Mentmore and Its Art Collections," in *Mentmore,* I: x.

8. *Mentmore,* IV: 17, cat. no. 2422, illustration opposite p. 17.

9. He may be more sought after soon. See Francis Haskell, "Reinventing the Eighteenth Century," *New York Review of Books* 27 (October 9, 1980): 29.

10. Geraldine Norman, "£8,000 Mentmore Painting may be £600,000 Fragonard," *Times* (June 17, 1977), p. 1.

11. Personal communication from David Carritt.

12. David Carritt, "The Case for the Lost Psyche," *Times* (June 17, 1977).

13. Norman, "£8,000 Mentmore Painting," p. 2.

14. "Saving the Mentmore Fragonard," *Country Life* 163 (May 25, 1978): 1459.

15. Daniel Wildenstein, "Sur 'Le Verrou' de Fragonard," *Gazette des Beaux-Arts* ser. 6, 85 (January, 1975): supplement, 13–24.

16. Norman, "£8,000 Mentmore Painting," p. 1.

17. Colin Renfrew, J. E. Dixon, and J. R. Cann, "Obsidian and Early Cultural Contact in the Near East," *Proceedings of the Prehistoric Society* 32 (1966): 30–72.

18. Erwin Panofsky, ed., *Abbot Suger on the Abbey Church of St.-Denis and Its Art Treasures,* (Princeton, 1948), pp. 53, 77, 168, n. 58, 12.

19. Donald King, "Introduction," in *Opus Anglicanum: English Medieval Embroidery,* The Victoria and Albert Museum (London, 1963), pp. 5, 23, cat. no. 39; A. G. I. Christie, *English Medieval Embroidery* (London, 1938), no. 68.

20. Willibald Sauerländer, *Gothic Sculpture in France 1140–1270,* trans. Janet Sondheimer (London, 1972), pp. 404–06.

21. Georgius Cedrenus, *Compendium Historarum,* 2 vols. ed. Immanuel Bekker, *Corpus Scriptorum Historiae Byzantinae,* (Bonn, 1828–97), I: 564.

22. Pliny, *Naturalis Historia* XXXIV. 61–67.

23. Margarete Bieber, *The Sculpture of the Hellenistic Age,* rev. ed. (New York, 1961), pp. 30–57; Gisela M. A. Richter, *The Sculpture and Sculptors of the Greeks,* 4th rev. ed. (New Haven, 1970), pp. 224–38; Martin Robertson, *A History of Greek Art,* 2 vols. (London, 1975), I: 463–84; Ernest A. Gardner, *Six Greek Sculptors* (London, 1910), pp. 210–34.

24. Bieber, *Sculpture of the Hellenistic Age,* p. 31; Richter, *Sculpture and Sculptors,* p. 288; Gardner, *Six Greek Sculptors,* p. 210.

25. Pliny, *Naturalis Historia* XXXIV. 37, 40. See also note 31, below.

26. Quintilian, *Institutio Oratoria* 12. X. 9.

27. Cicero, *Brutus* LXXXVI. 296.

28. Strabo, *Geographia* VI. 278; Martial, *Epigrammata* IX. 44; Statius, *Silvae* IV. 6, lines 32–47; Plutarch, *De Alexandri Fortitudine seu Virtute* II. 2. 3; Plutarch, *De Iside et Osiride* 24; Arrian, *Anabasis* 1. 16. 4.

29. Personal communication from Dr. Cornelius C. Vermeule, Curator of Classical Art, Boston Museum of Fine Arts.

30. Personal communication from Dr. Dietrich von Bothmer, Curator of Greek and Roman Art, Metropolitan Museum of Art.

31. "His chief contributions to the art of sculpture are said to consist of his vivid rendering of the hair, in making the heads smaller than older artists had done, and the bodies slimmer and with less flesh, thus increasing the apparent height of his figures." *The Elder Pliny's Chapters on the History of Art,* trans. K. Jex-Blake, with commentary by by E. Sellers (Chicago, 1968), pp. 51, 53 (XXXIV. 65).

32. See, for example, the story of the Praxitelean Hermes at Olympia. Acclaimed when found as an original by the master himself, in fact the same statue that had been described *in situ* by Pausanias, the Hermes at Olympia is now held to be an exceptionally good copy probably made to replace the original when this was acquired by a Roman collector. See Robertson, *A History of Greek Art,* I: 386–87. For the dig report see E. Curtius, F. Adler, and G. Hirshfeld, *Die Ausgrabungen zu Olympia,* 4 vols. (Berlin, 1876–81); and for Pausanias' description see J. G. Frazer, *Pausanias's Description of Greece,* 6 vols. (London, 1898), I: 262 (V. xvii. 3); III: 595–99.

33. The Cupid figures in this chapter's discussion, below, of the Mantua sale to Charles I of England. For the rest of the Cupid's story, see Chapters XII, XIII and XIV.

34. The Bacchus was commissioned from Michelangelo either by Jacopo Galli (see Ascanio Condivi, *Michelangelo*, ed. Paolo d'Ancona [Milan, 1928], p. 66) or by Cardinal Riario (see Charles de Tolnay, *Michelangelo*, 2nd ed., I [Princeton, 1969]: 26–27, 145).

35. The Getty bronze is decidedly *un*like the Lysippan copies.

36. For a reconstruction of what happened in Italy, see Bryan Rostron, "Smuggled," *Saturday Review* (March 31, 1979), pp. 25–26, 28–30.

37. Private communication from a companion of Baron Léon Lambert on the journey to Munich, where he purchased the statue for Artemis. Earlier, lesser dealers must have financed the Italian fishermen's contest in the Italian courts and no doubt bought the statue from the fishermen for a much smaller sum. Rostron, on p. 29 of "Smuggled," cites $700,000 as the figure paid by Artemis, but this is certainly incorrect.

38. "The Getty Museum: A Magnificent Inheritance," *Washington Post* (June 21, 1976), p. B7; Joel Kotkin, "The Problems of Having $720 Million," *Washington Post* (February 6, 1977), pp. Fl, F3; Robert Lindsey, "Getty Museum Ponders How to Spend $800 Million," *New York Times* (January 9, 1978), pp. A1, A18.

39. Karl E. Meyer, *The Art Museum: Power, Money, Ethics*, A Twentieth Century Fund Report (New York, 1979), p. 59.

40. The main museum building is actually an attempted re-creation of a villa at Herculaneum.

41. Rostron, "Smuggled," p. 30.

42. For example, the Piombino Apollo in the Louvre, the Poseidon-Zeus attributed to Calamis and the Anticythera Boy now both in Athens. To the list must be added, too, the two glorious Greek heroic bronzes of warriors found at sea near Reggio, off the Calabrian coast, in 1972. No full scholarly publication on these remarkable pieces of sculpture has appeared as yet, but Professor Homer Thompson has kindly informed me they were first suspected of coming from the set of figures of eponymous heroes of the ten Athenian citizen tribes, done early in his career by Phidias himself, and dedicated by the Athenians at Delphi. A recent authoritative opinion is that of Professor Martin Robertson (personal communication); he considers the two statues Greek originals of the fifth century, with one perhaps a bit later than the other. A late date is given these bronzes, however, by Professor Brunilde Sismondo Ridgway (*Fifth Century Styles in Greek Sculpture*, Princeton, N.J., 1981). (A note on these two bronzes has recently appeared in *Apollo*: Neil Ritchie, "The Riace Bronzes: Masterpieces of Greek Art," *Apollo* 113, [1981]: 402–03.)

43. Robertson, *A History of Greek Art*, I: 188–89.

44. Robertson, *A History of Greek Art*, I: 182.

45. J. N. Svoronos, "Die Funde von Antikythera," *Das Athener National Museum* text vol. I (Athens, 1903): 1–85; Peter Cornelius Bol, "Die Skulpturen des Schiffsfundes von Antikythera," *Mitteilungen des Deutschen Archäologischen Instituts. Athenische Abteilung*, Beiheft 2 (Berlin, 1972); H. G. Beyen, *La Statue d'Artemision* (The Hague, 1930), pp. 51–52; Werner Fuchs, *Der Schiffsfund von Mahdia*, Bilderhefte des Deutschen Archäologischen Instituts Rom 2 (Tübingen, 1963). Besides the Eros or Youth, the Bardo find included a wide variety of bronzes large and small, marble sculpture in relief as well as in the round, some bronze furniture, and some elements of marble architectural sculpture.

46. Both were badly shattered when they went to the bottom, as they were bound to be because they were so thinly cast. But looking at them as now reconstituted in Athens, you cannot doubt that both were originally intact.

47. Giuseppe Foti, "Relitti di navi greche e romane nei mari della Calabria," *Calabria*

Turismo 18 (October-December 1973): 13. For another find of bronze statuary fragments which seem to have been intended for use as bronze scrap, this time on the island of Anticythera, see Earle R. Caley, "Chemical Composition of Greek and Roman Statuary Bronzes," in *Art and Technology: A Symposium on Classical Bronzes,* ed. Suzannah Doeringer, David Gordon Mitten, and Arthur Steinberg (Cambridge, Mass., 1970), p. 39.

48. Herbert Koch, "Bronzestatue in Barletta," *Antike Denkmäler* 3 (1912–13): 21; R. Delbrück, *Spätantike Kaiserporträts* (Berlin, 1933), p. 225.

49. Koch, "Bronzestatue in Barletta," p. 20.

50. Koch, "Bronzestatue in Barletta," p. 21; Kurt Kluge and Karl Lehmann-Hartleben, *Die antiken Grossbronzen,* vol. II: *Grossbronzen der römischen Kaiserzeit* (Berlin and Leipzig), pp. 67–68.

51. There is one exception to this rule. Such things as Byzantine mosaics were acquired in considerable numbers by Pope Paul II after the fall of Constantinople, and later by Lorenzo de' Medici the Magnificent. But these mosaics, like Byzantine ivories, were plainly regarded as treasures. See Chapter XII.

52. Frederic C. Lane, *Venice: A Maritime Republic* (Baltimore, 1973), pp. 14, 163–64, 362–64.

53. Francesco Sansovino, *Venezia: città nobilissima et singolare* (Venice, 1581), pp. 135v.–136v.; Marilyn Perry, "Saint Mark's Trophies: Legend, Superstition, and Archaeology in Renaissance Venice," *Journal of the Warburg and Courtauld Institutes* 40 (1977): 27.

54. Sansovino, *Venezia,* pp. 135v.–136v.; Perry, "Saint Mark's Trophies," p. 28.

55. Leopoldo Cicognara, *Dei quattro cavalli riposti sul pronao della basilica di S. Marco* (Venice, 1815), p. 27. All the sources are late by the usual standards. Yet what they record is by no means flattering to Venetian taste in the arts; and the marked absence of *campanilismo* suggests these sources reflect an accurate memory or lost records of what really happened.

56. Andrea Mustoxidi, *Lettera sui quattro cavalli della Basilica di S. Marco in Venezia* (Padua, 1816), p. 39.

57. Or perhaps one should say where the horses used to be: air pollution is forcing replacements to be installed.

58. Otto Demus, *The Church of San Marco in Venice: History, Architecture, Sculpture* (Washington, D.C., 1960), pp. 27, 113–14; see also Bruna Forlati Tamaro, "Nuova ipotesi sui cavalli di S. Marco," *Rendiconti degli atti della Pontificia Accademia Romana di Archeologia,* ser. III, 37 (1964–65): 83–104.

59. Cicognara, *Dei quattro cavalli,* p. 26; Marino Sanudo, *Vitae Ducum Venetorum Italice Scriptae ab Origine Urbis* (Milan, 1733), p. 534.

60. You can see how this was done in several illustrations in Bol, "Die Skulpturen des Schiffsfundes von Antikythera," esp. pl. 14.

61. *Olympia. Ergebenisse der von dem Deutschen Reich veranstalteten Ausgrabungen.* IV, *Die Bronzen,* ed. Adolf Furtwängler (Berlin, 1890), p. 11/3a, and pl. III.

62. Cyril Mango, "Antique Statuary and the Byzantine Beholder," *Dumbarton Oaks Papers* 17 (1963): 56–58 ff.

63. Some newspaper notices of this trade include Robert Reinhold, "Traffic in Looted Maya Art Is Diverse and Profitable," *New York Times* (March 29, 1973), pp. 1, 28; William M. Carley, "Some of the Looters of Archeological Sites Now Turn to Murder," *Wall Street Journal* (November 30, 1971), pp. 1, 26; Marlise Simons, "It Takes Expertise or a Gun (or a Bribe) to Plunder the Treasure of the Mayans, Toltecs (or Olmecs) in Oaxtepec or Cuernavaca," *Washington Post* (August 5, 1967), pp. C1, C6.

64. On the collecting of African art, see Eva L. R. Meyerowitz, "The Taste for African Art," *Apollo* 108 (March, 1978): 212–20.

65. For the type see Te Rangi Hiroa (Sir Peter Buck), *The Coming of the Maori* (Wellington, 1952), pp. 276–77.

66. Hiroa, *The Coming of the Maori*, pp. 102, 400–401.

67. For example, the 1978 Sotheby's auction of the George Ortiz Collection. See *Art at Auction: The Year at Sotheby Parke Bernet 1977–78* (London, 1978), pp. 306–12; Judith Nash, "Salesrooms: Primitive Art," *Connoisseur* 199 (September 1978): 66.

68. Cai Tao, *Tie wei shan cong tan*, in Bao Tingbo, compiler, *Zhi bu zu zhai cong shu*, Xing Zhong ed. (Taipei, 1964), ch. 67–68, 4:23b.

69. W. Bürger, "Van der Meer de Delft," *Gazette des Beaux-Arts* 21 (October 1866): 299; André Blum, *Vermeer et Thoré-Bürger* (Geneva, 1946), pp. 16–18, 22–27.

70. Kunsthistorisches Museum, Vienna, *Katalog der Gemäldegalerie* II: *Vlamen, Holländer, Deutsche, Franzosen* (Vienna, 1958), p. 141, no. 395.

71. Bürger, "Van der Meer de Delft," *Gazette des Beaux-Arts* 21 (October-December 1866): 297–303, 458–70, 542–75.

72. Neil Maclaren, *The Dutch School*, National Gallery Catalogue (London, 1960), pp. 436–38, no. 1383; 438–39, no. 2568.

73. Philip Hendy, *European and American Painting in the Isabella Stewart Gardner Museum* (Boston, 1974), pp. 282–83.

74. Honoré de Balzac, *Le Cousin Pons*, Flammarion (Paris, n.d.).

75. Balzac, *Le Cousin Pons*, p. 37.

76. Jane Costello, "The Twelve Pictures 'Ordered by Velasquez' and the Trial of Valguarnera," *Journal of the Warburg and Courtauld Institutes* 13 (1950): 260–61, 263.

77. Costello, "The Twelve Pictures 'Ordered by Velasquez' and the Trial of Valguarnera," p. 240, n. 1.

78. Edmond Bonnaffé, *Dictionnaire des amateurs français au XVIIe siècle* (Paris, 1884), pp. 274–75.

79. Bonnaffé, *Dictionnaire*, p. 275; Léon Mirot, *Roger de Piles* (Paris, 1924), pp. 40–41. Piles wrote his own memorials, publishing *Le Cabinet de Monseigneur le duc de Richelieu* in 1676, and following it with an augmented description of the collection in 1681, *Dissertation sur les ouvrages des plus fameux peintres, dédiée à Monseigneur le duc de Richelieu*.

80. Madame de Sévigné, *Lettres*, 3 vols. (Paris, 1953–57), I: 786–801 (329, À Madame de Grignan, 9e août [*1675*]).

81. Madame de Sévigné, *Lettres*, I: 800.

82. This happened to my Polish friend, Jan Lebenstein, whose Paris dealer did not even permit him to sell the mordant and brilliant figurative works he began to produce after he moved from Warsaw to Paris.

83. In Venice, Daniel Nys was known as a Fleming. See Vincenzo Scamozzi, *L'idea della architettura universale* (Venice, 1615), part I, bk. III, chap. XIX, p. 306. Frits Lugt also called him a Fleming; see "Italiaansche kunstwerken in Nederlandsche verzamelingen van vroeger tijden," *Oud Holland* 53 (1936): 113, n. 23. But it seems most likely that the family originated in the French-speaking part of the Low Countries, since Nys wrote French fluently and well. See W. Noël Sainsbury, ed. *Original Unpublished Papers Illustrative of the Life of Sir Peter Paul Rubens as an Artist and a Diplomatist* (London, 1859), pp. 279, n. 11; 331, 334, 336, 339.

84. Scamozzi, *L'idea della architettura universale*, part I, bk. III, chap. XIX, p. 306; Mary F. S. Hervey, *The Life, Correspondence & Collections of Thomas Howard, Earl of Arundel* (Cambridge, 1921), p. 410.

85. Hervey, *The Life, Correspondence & Collections*, pp. 100, 102, 297.

86. William McElwee, *The Murder of Sir Thomas Overbury* (London, 1952), pp. 24–30; Hervey, *The Life, Correspondence & Collections*, p. 100.

87. Sainsbury, *Original Unpublished Papers*, pp. 275–78.

88. McElwee, *The Murder of Sir Thomas Overbury*, p. 195; Hervey, *The Life, Correspondence & Collections*, pp. 82, n. 1, 96.

89. Hervey, *The Life, Correspondence & Collections*, pp. 100–102, 131; Sainsbury, *Original Unpublished Papers*, pp. 273–80. For the way Carleton unintentionally acquired the sculpture from Nys, and also for Carleton's trade with Rubens, and Carleton's interesting offer of his newly acquired Rubenses to the King of Denmark, see Jeffrey Muller, "Rubens's Museum of Antique Sculpture: An Introduction," *Art Bulletin* 59 (December 1977): 571–72.

90. For example, the price paid for the Mantua collection is incorrect in both Henry Francis Taylor, *The Taste of Angels* (Boston, 1948), pp. 212–15; and Germain Bazin, *The Museum Age*, trans. Jane van Nuis Cahill (New York, 1967), p. 83. The first accurate though incomplete account is in Hugh Trevor-Roper, *The Plunder of the Arts in the Seventeenth Century* (London, 1970), pp. 27–36.

91. Sainsbury, *Original Unpublished Papers*, pp. 320, 322, n. 50; Alessandro Luzio, *La galleria dei Gonzaga venduta all'Inghilterra nel 1627–28* (Milan, 1913), p. 137.

92. Sainsbury, *Original Unpublished Papers*, pp. 320–22; Luzio, *La galleria dei Gonzaga*, p. 139.

93. Sainsbury, *Original Unpublished Papers*, p. 325; Trevor-Roper, *The Plunder of the Arts*, pp. 28–29.

94. Sainsbury, *Original Unpublished Papers*, p. 325; Luzio, *La galleria dei Gonzaga*, pp. 143, 144, 145.

95. Only after protracted negotiations with the Duke and his agents did Nys secure the first part of the collection. Luzio, *La galleria dei Gonzaga*, pp. 138–42, 147–153.

96. Sainsbury, *Original Unpublished Papers*, pp. 324–26; Luzio, *La galleria dei Gonzaga*, pp. 154–55.

97. Sainsbury, *Original Unpublished Papers*, p. 327.

98. Sainsbury, *Original Unpublished Papers*, p. 323. This is obviously Philip Burlamachi's figure for the exchange value of the 68,000 scudi quoted by Nys.

99. Trevor-Roper, *The Plunder of the Arts*, p. 36.

100. See the letter of October 30 from the Mantuan official, Zavarelli, reporting home after a final bout of haggling with Nys, in Luzio, *La galleria dei Gonzaga*, p. 148.

101. Sainsbury, *Original Unpublished Papers*, p. 328.

102. King Charles was fortunate that Nys was able to acquire the Mantua collections before the climax of the Duke's troubles, which occurred in 1630, when Mantua was stormed and sacked.

103. Sainsbury, *Original Unpublished Papers*, pp. 326–29; Luzio, *La galleria dei Gonzaga*, pp. 153–61.

104. Sainsbury, *Original Unpublished Papers*, p. 328

105. Luzio, *La galleria dei Gonzaga*, pp. 164–65.

106. Sainsbury, *Original Unpublished Papers*, pp. 336–37. The original, written in French, is published in Luzio, *La galleria dei Gonzaga*, pp. 165–66.

107. P.-J. Mariette, *Abecedario*, in *Archives de l'Art Français*, vols. 2, 4, 6, 8, 10, 12 (Paris, 1851–60); recently reprinted as *Abecedario et autres notes inédites*, 6 vols. (Paris, 1964).

108. The mark is an *M* within a circle on the drawing. If the drawing retains Mariette's blue mat with his own note (usually in Latin) stating his attribution and giving

additional information about provenance, "the plus is even greater." Personal communication from Miss Beverly Schreiber, Old Master Drawing Expert, Sotheby Parke Bernet.

109. Charles Blanc, *Le Trésor de la curiosité*, I (Paris, 1857): xlv–xlvii; L. Clément de Ris, *Les Amateurs d'autrefois* (Paris, 1877), pp. 204–05.

110. Blanc, *Trésor de la curiosité*, I: 20–21, 265.

111. Blanc, *Trésor de la curiosité*, I: 20.

112. Blanc, *Trésor de la curiosité*, I: 20–21.

113. Lee Seldes, *The Legacy of Mark Rothko* (New York, 1978).

114. Seldes, *The Legacy of Mark Rothko*, p. 61.

115. Seldes, *The Legacy of Mark Rothko*, pp. 271–72.

116. Blanc, *Trésor de la curiosité*, I: 265.

117. John Walker, *Self-Portrait with Donors* (Boston-Toronto, 1974), p. 242.

118. When Roland Balaÿ still headed Knoedler's, I talked with this last surviving participant in the transactions in Moscow, in the early 1930s. He could not remember the name of the chief curator of the Hermitage at that period, and I have been unable to discover the name from Soviet sources. He did remember, however, that "The chief curator was a White Russian who was obviously deeply pained by the whole affair." It was Mr. Balaÿ who, immensely kindly, gave me permission to have copies of the entire correspondence concerning the sales in this country from the Hermitage. The correspondence shows that the officials who were really in charge were rigid party-liners from the Soviet Antikvariat. See also José de Azeredo Perdigão, *Calouste Gulbenkian* (Lisbon, 1969), pp. 101–22.

119. Perdigão, *Gulbenkian*, pp. 102–17; Horst Gerson, *Rembrandt Paintings*, trans. Heinz Norden (Amsterdam, 1968), pp. 377, no. 293; 500, no. 293. (The Gulbenkian Museum lists this as a painting of Pallas Athena; see Perdigão, *Gulbenkian*, pp. 109, 111).

120. He later changed his name to that of his gallery, Mattheisen (personal communication from John Walker).

121. Walker, *Self-Portrait with Donors*, pp. 242–43.

122. The text of this letter will eventually be available for examination in the Library of Congress, where my files, including the massive files accumulated in the course of preparing this essay, are due to be deposited.

123. Glück was Director of the Gemäldegalerie at the Kunsthistorisches Museum in Vienna.

124. Burchard contributed to Glück's book on Van Dyck (see below) and was praised lavishly in the acknowledgments.

125. Gustav Glück, *Van Dyck des Meisters Gemälde*, Klassiker der Kunst (Stuttgart, 1931), pp. 506, 507.

126. U.S. National Gallery of Art, *European Paintings*, p. 118, cat. no. 51. The detective work leading to the recent change of attribution was done by Dr. Arthur K. Wheelock, Jr., the National Gallery's Curator for Dutch and Flemish Painting. He also showed the subject of the portrait to be Henry, Duke of Gloucester, rather than the Prince of Orange.

127. By 1971, when Terisio Pignatti published his monograph on Giorgione, six art historians had previously attributed the painting to the "circle of Giorgione," and there were other attributions as well on the record; but when the picture was offered to Mrs. Gardner, Berenson described it as a Giorgione; and Pignatti now attributes it to Giorgione. Terisio Pignatti, *Giorgione*, trans. Clovis Whitfield (London, 1971), p. 94, no. 1. See also Berenson letters listed in note 130, below.

128. Although Pignatti ascribes the painting to Giorgione, the Gardner Museum's catalogue

lists it as being a work "After Giovanni Bellini" (Pignatti, *Giorgione*, pp. 46, 48, 94, cat. no. 1; Hendy, *European and American Painting in the Isabella Stewart Gardner Museum*, p. 20).

129. Ernest Samuels, *Bernard Berenson: The Making of A Connoisseur* (Cambridge, Mass. and London, 1979), p. 250.

130. Letters from Bernard Berenson to Mrs. Gardner, February 10, 1897; May 26, 1897; June 16, 1897. Copies of the Berenson-Gardner correspondence were provided through the kindness of Rollin van N. Hadley, Director of the Isabella Stewart Gardner Museum.

131. A copy-replacement was also supplied to the Inghirami family when Mrs. Gardner secured her Raphael portrait of Cardinal Inghirami. See Hendy, *European and American Painting in the Isabella Stewart Gardner Museum*, p. 196.

132. Letters from Bernard Berenson to Mrs. Gardner, June 16, 1897; December 11, 1897.

133. Letter from Bernard Berenson to Mrs. Gardner, May 26, 1897.

134. Letter from Bernard Berenson to Mrs. Gardner, January 9, 1898; see also letters from Bernard Berenson to Mrs. Gardner, December 12, 1897; December 16, 1897. There was a subsequent investigation, but an extremely cursory one. See Samuels, *Bernard Berenson*, p. 251.

135. Letters from Berenson to Mrs. Gardner; May 23, 1899; March 19, 1900.

136. U.S. National Gallery of Art, *European Paintings*, p. 120 cat. no. 688.

137. Aline B. Saarinen, *The Proud Possessors* (New York, 1958), pp. 80–81. The story is not quite completely told, but is otherwise well known in the older art world.

138. Edward Fowles, *Memories of Duveen Brothers* (London, 1976), pp. 50–51.

139. Fern Marja Eckman, "Stolen Statue of Shiva Bought by Simon," *New York Post* (May 11, 1973), pp. 2, 20; Martin Lerner, "Shiva, Lord of Dance," *Connoisseur* 193 (November 1976): 172–75.

140. Eckman, "Stolen Statue of Shiva," p. 20. Having been bought outright, the bronze is now officially on a ten-year loan from the government of India to the Norton Simon Foundation. See Lerner, "Shiva, Lord of Dance," p. 173.

141. Ronald Koven, "Broken: Art-Theft Pipeline," *Washington Post* (April 18, 1979), p. B5.

142. George Sansom, *A History of Japan 1334–1615* (London, 1961), pp. 9 & n. 3, 138. It is not clear why Sir George Sansom refers to "the Mirror, the Seal and the Sword," since the imperial regalia are usually described as "the Mirror, the Jewel, and the Sword."

143. Sansom, *A History of Japan 1334–1615*, pp. 55, 86, 118.

144. al-Qāḍī al Rashīd ibn al-Zubayr, *Kitāb al-dhakhā'ir wa-l-tuḥāf*, ed M. Hamidullah (Kuwait, 1959), p. 81, section 98.

145. A pair of screens bearing a false signature of Kano Eitoku was given by the Emperor Meiji to my grandmother, Mrs. Douglas Robinson, when she visited Japan in the years of Theodore Roosevelt's presidency. The screens were in fact fine late seventeenth-century copies which had been tinted with tea or some other mild coloring agent to "antique" them. When I inherited them and showed them to the late director of the Freer Gallery, Dr. Archibald G. Wenley, he all but broke my heart by exclaiming, "Ah, another pair of Meiji fakes!" These family treasures had long been exhibited on loan to the Metropolitan Museum in New York, in the early period when Western knowledge of Far Eastern art was more limited than it is today.

146. Yu He, *Lun shu biao* [Memorial on Calligraphy], in *Fa shu yao lu*, ca. 847 A.D., ed. Zhang Yanyuan, Yishu cong bian edition, 14a–18b.

147. Yu He, *Lun shu biao*, 14a–18b.

148. Yu He, *Lun shu biao*, 14a–18b.

149. See Chapter V.
150. Giulio Mancini, *Considerazioni sulla pittura*, ed. A. Marucchi, (Rome, 1956), I: 257; Giovanni Baglione, *Le vite de' pittori, scultori, architetti ed intagliatori* (Naples, 1733), p. 149.
151. Mancini, *Considerazioni sulla pittura*, I: 257; Baglione, *Le vite de' pittori*, p. 149.
152. See Chapter III.
153. Baglione, *Le vite de' pittori*, p. 149.
154. Baglione, *Le vite de' pittori*, p. 149. Translated by Professor Anna Modigliani Lynch.
155. Samuels, *Bernard Berenson*, p. 155; Sylvia Sprigge, *Berenson: A Biography* (Boston, 1960), p. 117.
156. Wen Fong, "The Problem of Forgeries in Chinese Painting: Part One," *Artibus Asiae* 22 (1965): 95–119. In this article the wise will note the name of the man from whose collection some of the pictures covered are said to have come, and will wonder about the identity of the unnamed "Shanghai collector" who sold still others. See especially p. 110.
157. Horace Walpole, *Description of Strawberry Hill* (Strawberry Hill, 1784), p. 80.
158. Walpole, *Description of Strawberry Hill*, p. 43.
159. At the Blondel de Gagny sale of 1776, *"Une Grande Commode, de Boulle"* sold for 2,000 livres—or one-third the price of one of Blondel de Gagny's two Rembrandts, see Blanc, *Trésor de la curiosité*, I: 335, 345.
160. Francis J. B. Watson, "The English as Collectors of French Furniture," *Connoisseur* 186 (June 1974): 80, 86.
161. Francis J. B. Watson, "Some Royal French Furniture in the English Royal Collections," in *The Connoisseur Coronation Book* (London, 1953), pp. 63–65; *George IV and the Arts of France*, Queen's Gallery, Buckingham Palace (London, 1966), p. 24 no. 45.
162. Germain Seligman, *Merchants of Art, 1880–1960* (New York, 1961), p. 174; René Gimpel, *Diary of an Art Dealer*, trans. John Rosenberg (New York, 1966), p. 413.
163. Howard C. Rice, "James Swan: Agent of the French Republic 1794–1796," *New England Quarterly* 10 (September 1937): 469–70, 471, 475–76.
164. The auctions are described in Watson, "Some Royal French Furniture," p. 61.
165. Personal communication from Count Alfred Potocki.
166. Watson, "Some Royal French Furniture," p. 62; Watson, "George IV as an Art Collector," *Apollo* 83 (June 1966): 412, 414; Geoffrey de Bellaigue, "George IV and French Furniture," *Connoisseur* 195 (June 1977): 118.
167. Watson, "Some Royal French Furniture," pp. 61–62.
168. I saw this piece in the course of being repaired in the Queen's furniture reparatory, through the kindness of Sir Francis Watson.
169. Watson, "The English as Collectors of French Furniture," p. 86; see also, for example, Watson, *The Wrightsman Collection*. I, *Furniture*, Metropolitan Museum of Art (Greenwich, Conn., 1966).
170. Personal communication from Mr. Norman McOstrich, long with Moss Harris & Sons, Ltd., and later furniture expert at Parke Bernet, New York, before the firm was acquired by Sotheby's.
171. Percy Macquoid, *A History of English Furniture*, 4 vols: *The Age of Oak* (London, 1904); *The Age of Walnut* (1905); *The Age of Mahogany* (1906); *The Age of Satinwood* (1908).
172. Gerald Reitlinger, *The Economics of Taste*, II (London, 1963): 154.
173. Oliver Millar, ed., *The Inventories and Valuations of the King's Goods 1649–1651*, published as *The Walpole Society* 43 (1970–72): xxii; Millar, *The Queen's Pictures* (London, 1970), pp. 57–59; W. L. F. Nuttall, "King Charles I's Pictures and the

Commonwealth Sale," *Apollo* 82 (October 1965): 303, 305–09; *The Nation's Pictures*, ed. Anthony Blunt and Margaret Whinney (London 1950), pp. 7–8.

174. Millar, *Inventories and Valuations*, p. 305, no. 113.

175. Frederick Hartt, *Giulio Romano*, 2 vols. (New Haven, 1958), I: 53.

176. Hartt, *Giulio Romano*, I: 53, n. 22.

177. Oliver Millar, ed., *Abraham van der Doort's Catalogue of the Collections of Charles I*, published as, *The Walpole Society* 37 (1958–60): 22, no. 11; Millar, *Inventories and Valuations*, p. 305, no. 113. Its reputation is indicated by the curious way the picture was recorded in the sales list as "The Madonna," as though Raphael had painted no other, and despite the fact that it is a Holy Family.

178. Sainsbury, *Original Unpublished Papers*, p. 325.

179. Sainsbury, *Original Unpublished Papers*, p. 327.

180. Millar, *Inventories and Valuations*, p. 312, no. 227. This picture has been identified by Cecil Gould as "A Concert by an imitator of Titian" (see Gould, *The Sixteenth Century Italian Schools*, National Gallery Catalogue (London, 1975) pp. 305–06), and by W. L. F. Nuttall as "The Concert attributed to Bellini" (see Nuttall, "King Charles I's Pictures and the Commonwealth Sale," p. 307), but surely the Concert Champêtre is a "Picture of Musick," and one can see nothing in the original document that excludes the Louvre picture, since all contemporary descriptions of known paintings are exceedingly summary and in some cases downright misleading, as is indicated by the description of La Perla. In addition, the price paid, £ 110, was in the range being paid at the dispersal for undoubted works by great masters. Finally, the Concert Champêtre entered the French Royal Collection from Evrard Jabach's collection, and he is known to have gone to London to buy at the Commonwealth dispersal (Louis Hautecoeur, *Catalogue des peintures exposées dans les galeries du Musée National du Louvre. II, École italienne et école espagnole* [Paris, 1926], p. 164; see also Millar, *The Queen's Pictures*, p. 59).

181. J.-D. Passavant, *Rafael von Urbino* (Leipzig, 1839), II: 340.

182. Reitlinger, *The Economics of Taste*, I (London, 1961): 115.

183. Reitlinger, *The Economics of Taste*, I: 112, 178; Luitpold Dussler, *Raphael: A Critical Catalogue*, trans. Sebastian Cruft (London and New York, 1971), pp. 13–14. How large a sum this was at that time may be judged from the fact that this was precisely the fortune that in effect ruined the life of Isabel Archer, the heroine of Henry James's *Portrait of a Lady*.

184. Letter from Bernard Berenson to Mrs. Gardner, May 10, 1896.

185. Letter from Bernard Berenson to Mrs. Gardner, May 10, 1896; Samuels, *Bernard Berenson*, p. 246.

186. See Chapter VII.

187. *A Catalogue of the Ancient Sculptures preserved in the Municipal Collections of Rome. The Sculptures of the Museo Capitolino*, ed. H. Stuart Jones, I (Oxford, 1912): 1; W. S. Heckscher, *Sixtus IIII Aeneas Insignes Statuas Romano Populo Restituendas Censuit* (The Hague, 1955), pp. 46–47.

188. See the splendid debate of the artists' committee named to choose the proper place to put Michelangelo's David (Giovanni Gaye, *Carteggio inedito d'artisti dei secoli XIV, XV, XVI*, II [Florence, 1840]: 454 ff.; see also Tolnay, *Michelangelo*, I: 96–98, 152–53).

189. Marilyn Perry, "The Statuario Pubblico of the Venetian Republic," *Saggi e memorie di storia dell'arte* 8 (1972): p. 8; Perry, "Cardinal Domenico Grimani's Legacy of Ancient Art to Venice," *Journal of the Warburg and Courtauld Institutes* 41 (1978): 228.

190. Perry, "The Statuario Pubblico," p. 79; Perry, "Cardinal Domenico Grimani's Legacy,"

pp. 226–28; Pio Paschini, "Il mecenatismo artistico del Patriarca Giovanni Grimani," *Studi in onore di Aristide Calderini e Roberto Paribeni, III: Studi di archeologia e di storia dell'arte antica* (Milan, 1956), pp. 851–62; Rodolfo Gallo, "Le donazioni alla serenissima di Domenico e Giovanni Grimani," *Archivio Veneto*, series 5, 82, nos. 85–86 (1953): 51–54. For more light on the Patriarch's sculpture collection and his improvements in the Grimani palazzo to display the collection better, see Marilyn Perry, "A Renaissance Showplace of Art: The Palazzo Grimani at Santa Maria Formosa, Venice," *Apollo* 113 (April 1981): 215–21.

191. Perry, "Cardinal Domenico Grimani's Legacy," pp. 227–28; Gallo, "Le donazioni," pp. 54–57.

192. Perry, "Cardinal Domenico Grimani's Legacy," pp. 217–20; Gallo, "Le donazioni," pp. 36–37.

193. Perry, "Cardinal Domenico Grimani's Legacy," pp. 215, 220–23.

194. Perry, "Cardinal Domenico Grimani's Legacy," p. 223; Bruna Forlati Tamaro, *L'origine della raccolta Grimani* (Venice, n.d.), p. 8.

195. Perry, "The Statuario Pubblico," pp. 79–80; Perry, "Cardinal Domenico Grimani's Legacy," pp. 226–27; Paschini, "Il mecenatismo artistico del Patriarca Giovanni Grimani," pp. 859–60; Gallo, "Le donazioni," pp. 51–54.

196. Scamozzi, *L'idea della architettura universale*, part I, bk. III, chap. XIX, p. 305; Perry, "The Statuario Pubblico," pp. 80–81.

197. The Frick, Gardner, Walters, Winterthur, and several other collections in America attest that this is a very common collector's instinct.

198. The name is spelled "Bloizot" in Germain Bazin's, *Le Temps des musées*, p. 142; but "Boisot" in Edmond Bonnaffé, *Dictionnaire des amateurs français au XVIIe siècle*, p. 28. To find out which was correct I consulted the former French Ambassador Charles Lucet, who most kindly obtained the underlying documents from the Archives du Doubs. These documents, L. 731 and L. 732, show that Boisot is undoubtedly correct. See also *Extrait du Testament* (1874), MSS. 1268, Bibliothèque de Besançon.

199. See *Extrait du Testament*. The collection was inventoried on January 5, 1695, and the inventory is attached to the testament in MSS. 1268 with a copy of the Bibliothèque de Besançon MSS. 1269.

200. On October 8, 1695, proceedings were begun to arrange a home for the Boisot collection in the Benedictine monastery of St.-Vincent. On July 4, 1696, the announcement was made that the collection would be open to the public during the hours named.

201. Pierre Dan, *Le Trésor des merveilles de la maison de Fontainebleau* (Paris, 1642), pp. 134 ff.

202. Scamozzi, *L'idea della architettura universale*, part I, bk. III, chap. XIX, p. 305.

203. Detlef Heikamp, "La Tribuna degli Uffizi come era nel Cinquecento," *Antichità viva*, no. 3 (1964), pp. 11–30; Luciano Berti, *The Uffizi* (Florence, 1971), pp. 8–9; *Mostra storica della Tribuna degli Uffizi*, preface by Luciano Berti, catalogue by Stella Rudolph and Anna Biancalani, Quaderni degli Uffizi 1 (Florence, 1970), pp. 4, 11–12, 14–16; Wolfram Prinz, *Die Entstehung der Galerie in Frankreich und Italien* (Berlin, 1970), p. 51; Luisa Becherucci, "Introduction," in *Uffizi, Florence*, Great Museums of the World (New York, 1968), pp. 11–12.

204. *Goethe's Autobiography: Poetry and Truth from My Life*, trans. R. O. Moon (1932; Washington, D.C., 1949), p. 278.

205. *Boswell on the Grand Tour: Germany and Switzerland 1764*, ed. Frederick A. Pottle (New York, 1953), p. 135.

206. Pierre Verlet, *Versailles* (Paris, 1961), p. 413.

207. Louis, Duc de Saint-Simon, *Mémoires*, ed. Gonzague Truc, 7 vols. (Paris, 1947–61), VI: 1074.

208. Dan, *Le Trésor des merveilles*, pp. 94–96; Félix Herbet, *Le Château de Fontainebleau* (Paris, 1937), p. 147; *La Collection de François Ier*, catalogue by Janet Cox-Rearick, preface by Sylvie Béguin, Musée du Louvre (Paris, 1972), pp. 10–11.

209. Herbet, *Le Château de Fontainebleau*, p. 148; *La Collection de François Ier*, p. 10; Abbé Pierre Guilbert, *Description historique des château, bourg, et forêt de Fontainebleau*, 2 vols. (Paris, 1731), I: 71–73.

210. *La Collection de François Ier*, p. 11.

211. Eugène Müntz and E. Molinier, "Le Château de Fontainebleau· au XVIIe siècle d'après des documents inédits," *Mémoires de la Société de l'Histoire de Paris et de l'Île-de-France* 12 (1885): 270.

212. *La Collection de François Ier*, pp. 18–19, no. 18.

213. Denys Sutton, "Treasures from Leningrad," *Master Paintings from the Hermitage and the State Russian Museum, Leningrad*, exhibition catalogue, National Gallery of Art, et al. (New York, 1975), p. 15.

214. J. Mordaunt Crook, *The British Museum* (London, 1972), p. 49.

215. Cecil Gould, *Trophy of Conquest* (London, 1965), pp. 75–76.

216. Gould, *Trophy of Conquest*, pp. 77–78; Franco Russoli, "Introduction," in *Brera, Milan*, Great Museums of the World (New York, 1970), pp. 11, 13–14.

217. Mrs. A. B. Jameson, *Handbook to the Public Galleries of Art in and near London*, (London, 1845), pp. 5–8; Michael Levey, "Introduction," in *National Gallery, London*, Great Museums of the World (New York, 1969), p. 9; Gregory Martin, "The Founding of the National Gallery in London. Part II," *Connoisseur* 186 (May 1974): 24, 27–31.

218. Mixtures mainly occur when converted princely museums go on purchasing works of art at public expense, as most of them have done.

219. Calvin Tomkins, *Merchants and Masterpieces: The Story of the Metropolitan Museum of Art* (London and Harlow, 1970).

VII. "THE GREEK MIRACLE"

1. Around 30,000 B.C. is the date usually given to the first objects hinting the beginning of the Upper Paleolithic art of the painted caves. But cave painting itself did not develop until considerably later. See note 2.

2. The estimate of twenty millennia assumes that the really major art of the painted caves began in the Aurignacian. André Leroi-Gourhan, *Treasures of Prehistoric Art*, trans. Norbert Guterman (New York, 1967), p. 494.

3. James Mellaart, *Çatal Hüyük: A Neolithic Town in Anatolia* (London, 1967), pp. 49–53.

4. Mellaart, *Çatal Hüyük*, pp. 85–130; Mellaart, *The Neolithic of the Near East* (New York, 1975), pp. 108–9, figs. 58b–c.

5. Perhaps the most remarkable paintings were those of the vulture shrine (Mellaart, *Çatal Hüyük* pp. 82–83, figs. 14–15, 45, 93, 95, pls. 48–49).

6. Mellaart, *Çatal Hüyük*, pp. 84–130.

7. Mellaart, *Çatal Hüyük*, pp. 101, 106–7, 111, 126.

8. The exhibit from Çatal Hüyük in the Archeological Museum in Ankara is therefore quite largely a reconstruction, although individual objects like the famous seated goddesses have, of course, survived approximately intact (Mellaart, *Çatal Hüyük*, p. 184, figs. 81, 83).

9. Small and primitive bronzes have now been found in China dating from as early as 2300 B.C. Then follow the Erlitou bronzes of which the most important seem to have been made of sheet bronze. The first mature bronze culture of China was that of

the Shang dynasty, beginning about 1800 B.C. See Ma Chengyuan, "The Splendor of Ancient Chinese Bronzes," in *The Great Bronze Age of China: An Exhibition from the People's Republic of China*, ed. Wen Fong, Metropolitan Museum of Art (New York, 1980), pp. 1–5.

10. Michael D. Coe, "Olmec and Maya: A Study in Relationships," in *The Origins of Maya Civilization*, ed. Richard E. W. Adams (Albuquerque, 1977), p. 192.

11. Leroi-Gourhan, *Treasures of Prehistoric Art*, p. 39.

12. To give one illustration, accumulations of Greek painted pottery with dates extending over as much as a hundred years have been found in Etruscan family tombs. These *look* like pottery collections. Turn, however, to Otto J. Brendel, *Etruscan Art*, Penguin ed. (Harmondsworth, 1978), p. 114. You find that the accumulations were merely the grave goods of "successive burials" over a considerable period.

13. Fray Bernardino de Sahagun, *Florentine Codex, General History of the Things of New Spain*, trans. Arthur J. O. Anderson and Charles E. Dibble (Santa Fe, New Mexico, 1951), p. 168.

14. See Chapter I.

15. André Parrot, *Mari: capitale fabuleuse* (Paris, 1974), p. 18.

16. Parrot, *Mari*, p. 33.

17. Général de Caulaincourt, Duc de Vicence, *Avec l'Empéreur de Moscou à Fontaine-bleau*, ed. Christian-Melchior Bonnet, notes by Jean Hanoteau (1933; rev. ed., 3 vols. in one, ed. Jean Hanoteau, 1968), p. 119.

18. J. A. Brinkman, *A Political History of Post-Kassite Babylonia 1158–722 B.C.*, Analecta Orientalia 43 (Rome, 1968), pp. 88, n. 459; Walther Hinz, *The Lost World of Elam*, trans. Jennifer Barnes (London, 1972), pp. 124–25; Georges Roux, *Ancient Iraq*, Penguin ed. (Harmondsworth, 1967), p. 238. (Note conflict of conquest-dates between Hinz and Roux.)

19. Sir Charles Leonard Woolley, *Excavations at Ur* (London, 1954), pp. 237–38; Woolley with contribution by M. E. L. Mallowan, *Ur Excavations*, IX, *The Neo-Babylonian and Persian Periods* (London, 1962), p. 18; C. J. Gadd, *History and Monuments of Ur* (London, 1929), pp. 238–39.

20. *Daniel* 5:1–31.

21. The occupation lasted from the time of Tiglath-pileser III of Assyria in the eighth century B.C. until just before the fall of Nineveh toward the end of the seventh century.

22. Woolley, *Excavations at Ur*, pp. 237–38; Gadd, *History and Monuments of Ur*, p. 239.

23. Robert Koldewey, *Das wiedererstehende Babylon: Die bisherigen Ergebnisse der deutschen Ausgrabungen* (Leipzig, 1913), pp. 153–67; Friedrich Wetzel, "Kriegstrophäen und anderer Schmuck des Palastes," *Königsburgen von Babylon*, vol. II, *Die Hauptburg und der Sommerpalast Nebukadnezars im Hügel Babil*, ed. Robert Koldewey and Friedrich Wetzel (Leipzig, 1932), pp. 19–24.

24. Dorothy Mengel, "Archaism on the South Coast of Peru," in *Selected Papers of the Fifth International Congress of Archeological and Ethnological Sciences*, ed. Anthony Wallace (Philadelphia, 1960), pp. 596–600. For another case, see Richard Burger, "The Moche Sources of Archaism in Chimu Ceramics," *Nawpa Pacha* 4 (Berkeley, 1976): 95–104.

25. Alexander Badawy, "The Stela of Irtysen," *Chronique d'Égypte* 36 (July 1961): 269–75. More recently, some Egyptologists have transliterated the hieroglyphics as "Iri-irusen." See W. Barta, *Das Selbstzeugnis eines altaegyptischen Künstlers*, Münchner Aegyptologische Studien 22 (Berlin, 1970), pp. 14 f., *et passim*.

26. Labib Habachi, "Varia from the Reign of King Akhenaten," *Mitteilungen des deut-*

schen Archäologischen Instituts Abteilung Kairo 20 (1965): 85–89; Donald B. Red-ford, *History and Chronology of the Eighteenth Dynasty of Egypt: Seven Studies* (Toronto, 1967), p. 99.

27. C. M. Firth and J. E. Quibell, *Excavations at Saqqara, The Step Pyramid,* Service des Antiquités de l'Égypte (Cairo, 1935), p. 78.

28. W. S. Smith, *The Art and Architecture of Ancient Egypt,* Penguin ed. (Baltimore, 1958), pp. 128–29.

29. H. E. Winlock, *Excavations at Deir el Bahri, 1911–1913* (New York, 1942), p. 103.

30. Bernard Von Bothmer, "A New Fragment of an Old Palette," *Journal of the American Research Center in Egypt* 8 (1969–70): 7.

31. H. Kees, *Ancient Egypt: A Cultural Topography* (London, 1961), p. 198. Kees's account has been amended more recently, but the essence of what happened is not altered by the amendment. See J. van Seters, *The Hyksos: A New Investigation* (New Haven and London, 1966), pp. 128–31.

32. Farouk Gomaà, *Chaemwese, Sohn Ramses' II: und Hoherpriester von Memphis,* Ägyptologische Abhandlungen 27 (Wiesbaden, 1973), pp. 61–71.

33. G. Posener, *La Première Domination perse en Égypte: recueil d'inscriptions hiéro-glyphiques,* Bibliothèque d'Etude 11 (Cairo, 1936): 98–105.

34. Kees, *Ancient Egypt,* p. 198.

35. P. Barguet, *Le Temple d'Amon-Rê à Karnak: essai d'exégèse,* Publications de l'Institut Français d'Archéologie Orientale du Caire, Recherches d'archéologie, de philologie et d'histoire 21 (Cairo, 1962) pp. 276–80.

36. However, the only remaining hint of Minoan art collecting takes the form of the early Egyptian hard-stone vessels which seem to have been handed down in the Minoan palaces for long periods of time; and this must, of course, be regarded as a kind of treasure gathering.

37. *Egyptian Sculpture of the Late Period: 700 B.C. to A.D. 100,* comp. Bernard Von Bothmer with Herman De Meulenaere and Hans Wolfgang Müller, ed. Elizabeth Riefstahl (New York, 1960), pp. xxxvii, 28, no. 24; I. Nagy, "Remarques sur le souçi d'archaïsme en Égypte à l'époque saïte," *Acta Antiqua Academiae Scientiarum Hungaricae* 21 (1973): 53–63.

38. N. de G. Davies, *The Rock Tombs of Deir el Gebrâwi,* Part I, Archeological Survey of Egypt, Eleventh Memoir, ed. F. Ll. Griffith (London, 1902), pp. 39–40; W. F. von Bissing, "Das Verhältnis des Ibi-Grabes in Theben zu dem Ibi-Grabe von Deir el Gebrâwi," *Archiv für Orientforschung* 3 (March–June 1926): 53–55.

39. E. H. Gombrich, *Art and Illusion* (London, 1968), p. 120.

40. Two of them, antique collecting and art faking, are not documented before Roman times, but the probability is strong that both are pre-Roman, and no one can say positively that these two phenomena did not first appear in the Hellenistic centuries.

41. Many explanations have been put forward. None seems wholly satisfactory, but the best would seem to be that offered by Martin Robertson, *A History of Greek Art,* 2 vols. (London, 1975), I: 22 ff.

42. Jean Charbonneaux, Roland Martin, and François Villard, *Archaic Greek Art 620–480 B.C.* (New York, 1971), p. 19.

43. J. A. S. Evans, "Redating Prehistory in Europe," *Archaeology* 30 (March 1977): 76–85; Dragoslav Srejović, "Lepenski Vir: Protoneolithic and Early Neolithic Settle-ments," *Archaeology* 22 (January 1969): 26–35.

44. Gisela M. A. Richter with Irma A. Richter, *Kouroi: Archaic Greek Youths* (London, 1960), pp. 2–3, 27–28, 30–31, 41–42; figs. 25–32, 60–62.

45. Kim Levin, "The Male Figure in Egyptian and Greek Sculpture of the Seventh and Sixth Centuries B.C.," *American Journal of Archaeology* 68 (1964): 13–28. Brunilde

Sismondo Ridgway, *The Archaic Style in Greek Sculpture* (Princeton, 1977), pp. 29 ff., confirms this view of the Metropolitan *kouros* and gives more interesting detail on the whole subject. Eleanor Guralnick, "Kouroi, Canon and Men: A Computer Study of Proportions," *Computer Studies in the Humanities and Verbal Behavior* 4 (1973): 77–80, found that the New York *kouros* was one of three, the others being the Tenea and Melos *kouroi*, which were "similar in proportions to the Egyptian Second Canon" up to 75 percent. There is at least one reference to the Canon in ancient Greek art criticism: Plato, *Laws* II. 656d–e.

46. Robertson, *History of Greek Art* I:23.

47. T. Barrow, *Art and Life in Polynesia* (London, 1971), p. 57. Barrow also points out, however, that although "probably never deliberate," slow changes in style undoubtedly occurred.

48. Barrow, *Art and Life in Polynesia*, p. 57.

49. Giovanni Domenico Mansi, *Sacrorum Conciliorum Nova et Amplissima Collectio*, (Florence and Venice, 1759–98), XIII: 252, as kindly translated by Professor Ihor Ševčenko of Dumbarton Oaks. See also Cyril Mango, *The Art of the Byzantine Empire, 315–1453: Sources and Documents* (Englewood Cliffs, N.J., 1972), pp. 172–73. See also André Grabar, *L'Iconoclasme byzantin* (Paris, 1957), pp. 259–61.

50. Kurt Weitzmann, *The Monastery of Saint Catherine at Mount Sinai: The Icons. I, From the Sixth to the First Century* (Princeton, 1976), pp. 13–15, cat. no. B.1. So far, the implications of this extraordinary work of art, so different in character from the contemporary Ravenna mosaics, for example, do not seem to have been adequately explored.

51. See Chapter II.

52. Jean-Philippe Lauer, *Saqqara* (London, 1976), pp. 2–3.

53. Madeleine Giteau, *Khmer Sculpture and the Angkor Civilization* (New York, 1965), p. 201, cat. no. 2.

54. José de Azeredo Perdigão, *Calouste Gulbenkian* (Lisbon, 1969), pp. 156–58.

55. It was natural for the portrait statue of Jayavarman VII to be strikingly higher in quality than the average sculpture of the Bayon. The vast temple he built at Angkor Thom must have required work by scores, perhaps even hundreds, of sculptors, but the very best master got the Emperor's own commission. The same rules no doubt applied to the Egyptian Pharaoh's small statue.

56. Badawy, "The Stela of Irtysen," p. 271.

57. Badawy, "The Stela of Irtysen," pp. 271, 274–75.

58. This assumes the correctness of those Egyptologists who hold that the standard system of proportions was universally used—a point that is disputed. I have followed the most recent study of the subject, Erik Iversen, *Canon and Proportions in Egyptian Art*, 2nd ed., rev. with Yoshiaki Shibata (Warminster, 1975). See also the testimony of Plato, *Laws* II. 656d–e.

59. Iversen, *Canon and Proportions*, pp. 60–66.

60. Iversen, *Canon and Proportions*, p. 60.

61. Iversen, *Canon and Proportions*, p. 75. Except figures of Semitic and other supposed barbarians.

62. E. H. Gombrich, *The Story of Art*, 3rd ed. (London, 1950), p. 114.

63. Iversen, *Canon and Proportions*, pp. 75–88.

64. Ridgway, *The Archaic Style*, pp. 29–30; see also Guralnick, "Kouroi, Canon and Men," pp. 77–80.

65. On the compulsive aspect of Greek Archaic sculptural innovation, see Ridgway, *The Archaic Style*, pp. 4, 11, 38. Ridgway in another passage denies that originality mat-

tered to the Greeks. But the originality here discussed was *not* the sort Professor Ridgway seems to have in mind—the sort wanted by Serge Diaghilev when he asked to be astonished. It was enough for the leading masters of each generation to innovate sufficiently to be seen as making an advance upon their predecessors' work, or merely to believe they were doing so.

66. Richter, *Kouroi*, p. 31.

67. Richter, *Kouroi*, p. 130. Ridgway, *The Archaic Style*, pp. 4–5, holds that the dating criteria cannot be used with this degree of precision, but considers them broadly applicable. John Boardman, *Greek Sculpture: The Archaic Period* (London, 1978), pp. 64–66, takes an intermediate position on the dating, while denying that realistic representation was a conscious goal.

68. Richter's *Kouroi* takes the aim of accurate representation for granted throughout. Ridgway, *The Archaic Style*, p. 11 and elsewhere, qualifies this opinion while not absolutely denying it, on the ground that the aim of representation was "not primary." Boardman, *Greek Sculpture*, p. 65, holds that the aim defined by Miss Richter was in fact reached, but denies it was a "goal" consciously recognized by Archaic sculptors at the time.

69. J. J. Pollitt, *The Ancient View of Greek Art: Criticism, History, and Terminology* (New Haven, 1974), p. 22.

70. Pliny, *Naturalis Historia* XXXIV. 65.

71. Quintilian, *Institutio Oratoria* XII. x. 9.

72. Pollitt, *The Ancient View of Greek Art*, pp. 22–23.

73. See note 67. The debate has also been joined by Pollitt, *The Ancient View of Greek Art*, p. 6. He applies the adjective "apparent" to the "progression towards naturalism" and states "idealism and naturalism" coexisted as concepts in Greek art. On "naturalism" as an objective result rather than an aim of the creative progression, see also Ridgway, *The Archaic Style*, p. 13.

74. Eugénie Sellers, "Introduction," in *The Elder Pliny's Chapters on the History of Art*, trans. K. Jex-Blake (Chicago, 1968), pp. xiii–xciv.

75. For a discussion of medieval artists' signatures, as well as other exceptional signatures, see Chapter IX.

76. Edith Williams Ware, "Egyptian Artists' Signatures," *American Journal of Semitic Languages and Literatures* 43 (October 1926–July 1927): 185–207.

77. J.-P. Lauer, *Saqqara*, London, 1976. Firth and Quibell, *Excavations at Saqqara: The Step Pyramid*, pl. 58.

78. William C. Hayer, "Varia from the Time of Hatshepsut," *Mitteilungen des deutschen Archäologischen Instituts Abteilung Kairo* 15 (1957): 80–84.

79. Alan R. Schulman, "Some Remarks on the Alleged 'Fall' of Senmūt," *Journal of the American Research Institute in Egypt* 8 (1969–70): 29, n.3, 30.

80. For a review of all the arguments in this complex question, see Schulman, "Some Remarks on the Alleged 'Fall' of Senmūt," pp. 31–46; for Schulman's own view, see pp. 47–48.

81. Robertson, *History of Greek Art*, I: 43.

82. John Boardman, *Athenian Black-Figure Vases* (New York, 1974), pp. 12, 18; Robertson, *History of Greek Art*, I:127.

83. For a summation of what is known about Archaic sculptors' signatures, with signers compared to nonsigners, see Ridgway, *The Archaic Style*, pp. 285–97.

84. John Boardman, *Athenian Red-Figure Vases: The Archaic Period* (London, 1975), pp. 91–92, 94–95, 103–11.

85. Carlo Pedretti, "The Sforza Sepulchre," *Gazette des Beaux-Arts* 89 (April 1977): 125, n. 23.

86. On this point and on signatures of artists, see Alison Burford, *Craftsmen in Greek and Roman Society* (Ithaca, N.Y., 1972), pp. 20–21 and elsewhere.

87. No other conclusion can reasonably be reached from the combination of compulsive innovation and fairly frequent signing.

88. Antonio Averlino Filarete, *Treatise on Architecture*, trans. with intro. and notes by John R. Spencer (New Haven and London, 1965), I: xxxi, n. 25, 176.

89. Ulric Conrads, *Programs and Manifestoes on XXth Century Architecture* (Cambridge, 1970), pp. 19 ff., 34 ff., and 55 ff.

90. See Chapters IV and IX.

91. Vitruvius, *De Architectura* 7. praef. 12. See also Pliny's *Naturalis Historia* XXXV. 152.

92. J. J. Coulton, *Greek Architects at Work* (London, 1977), p. 24, expresses this opinion, as does Dr. Bernard Knox, Director, Center for Hellenic Studies (personal communication).

93. Vitruvius, *De Architectura* 7. praef. 11.

94. Galen, *De Placitis Hippocratis et Platonis* V. 449; Vitruvius, *De Architectura* III. 1. 1–5.

95. Galen, *De Placitis* V. 449.

96. Pollitt, *The Ancient View of Greek Art*, pp. 89–90.

97. Pollitt, *The Ancient View of Greek Art*, p. 11.

98. Pliny, *Naturalis Historia* XXXV. 19–80.

99. See note 93.

100. Diogenes Laertius, *Lives of the Philosophers* IX. 48. Democritus was also one of the sources consulted by the elder Pliny (*Naturalis Historia* "Indices" XXXIV, XXXV).

101. Confucius, *Analects* VII. 17 and VIII. 8 are key passages. See also my Chapter VIII, notes 11–18.

102. Plato, (*The Sophist* 235e–236a) criticized the sculptors of his time for adjusting the proportions of their figures so that they would look natural when seen from below, on the ground that this was deception; and he attacked painters (*Republic* 602c–d) on the same grounds for their use of chiaroscuro. Aristotle (*Politics* 1340a 33–38) expressly preferred Polygnotus to later Greek painters on the ground that Polygnotus was a better moral teacher.

103. Plato, *Laws* II. 656d–e.

104. The man in question was Amenhotep son of Hapu. See note 214 to Chapter V.

105. Xenophon, *Memorabilia* III. 10. 1–8.

106. Aristotle, *Poetics* 1448a1–6.

107. Aristotle, *Nicomachean Ethics* 1141a9–12.

108. Aristotle, *Poetics*, 1450a24–29.

109. For Apollodorus, see Plato, *Symposium, passim*. For Zeuxis, see Plato, *Gorgias* 453c–d. For mentions of painters in the Greek comic poets, see also Walter Miller, *Daedalus and Thespis*, III (Columbia, Miss., 1932): 612 ff.

110. Complete citation on this point would be too voluminous. See, however, Cicero, *Brutus* LXXXVI. 296 as an example. The names of Lysippus and Polyclitus have here become conveniently evocative literary allusions.

111. Plato, *Hippias Major* 285d. See also Arnaldo Momigliano, "Ancient History and the Antiquarian," in *Contributo alla storia degli studi classici* (Rome, 1955), p. 70.

112. Julius Schlosser-Magnino, *La letteratura artistica*, trans. Filippo Rossi (Florence, 1956), pp. 106 ff.

113. Plutarch, *Pericles* 28. 3.

114. Sellers, *Pliny's Chapters*, p. lxi. See also Pollitt, *The Ancient View of Greek Art*, pp. 63–66.

115. Xenocrates is now thought to have been the same man as the Athenian sculptor of that name recorded by Pliny (*Naturalis Historia* XXXV. 65–66). See Bernhard Schweitzer, "Xenokrates von Athen," *Die Kunst der Antike* I (Tübingen, 1963): 105–27. He was formerly thought to have been a Sicyonian, although he was called an Athenian by H. Gallet de Santerre in his discussion of the elder Pliny's sources in the introduction to the Budé text (Pline l'Ancien, *Histoire Naturelle XXXIV* [Paris, 1953], pp. 49–57).

116. His admiration for this school was the chief argument that led Sellers to say Xenocrates was Sicyonian rather than Athenian (*Pliny's Chapters*, p. xx, n. 2).

117. Duris had reached middle age by the end of the fourth century, and it is not clear when his work on art was published. Pollitt suggests that it was in effect an answer to Xenocrates (*The Ancient View of Greek Art*, p. 65) and was therefore later.

118. Pollitt, *The Ancient View of Greek Art*, p. 65.

119. Sellers, *Pliny's Chapters*, pp. xvi–xxxvi. See also Schweitzer, "Xenokrates von Athen," pp. 105–64.

120. At present Schweitzer is accepted as the final authority.

121. Xenocrates apparently believed that portraying a figure in motion, like Myron's Discobolus, represented an advance on the more static sculpture of Phidias and Polyclitus, who were in fact distinctly younger (Pliny, *Naturalis Historia* XXXIV. 57–58). Vasari, similarly, gave Masaccio too late a date because he was seen as building on a foundation created by Uccello, Donatello, and Brunelleschi, whereas he died long before these three; see Vasari-Milanesi, II: 288–89.

122. Pliny, *Naturalis Historia* XXXIV. 52.

123. Sellers, *Pliny's Chapters*, p. xxi; Schweitzer, "Xenokrates von Athen," p. 155.

124. Pollitt, *The Ancient View of Greek Art*, p. 76.

125. Vasari-Milanesi, II: 96.

126. Plutarch, *Pericles* 7. 5.

127. Plutarch, *Alcibiades* 16. Pseudo-Andocides, *Contra Alcibiades* 17.

128. Margarete Bieber, *The Sculpture of the Hellenistic Age*, rev. ed. (New York, 1961), p. 5.

129. It was so famous that the Emperor Caligula for a while planned to rebuild the palace. See Suetonius, *Caligula* 21.

130. Aelian, *Varia Historia* XIV. 17.

131. For Chinese art and later Islamic art, see Chapter VIII. For the first collecting of Renaissance works of art, see Chapter XIII. The Japanese case was special, since, as previously stated, the whole cultural-behavioral system that produced art collecting came to Japan by diffusion from China.

132. Personal communication from Margarete Bieber. See also Esther V. Hansen, *The Attalids of Pergamon*, 2nd ed. (Ithaca, N.Y., & London, 1971), p. 316.

133. Hansen, *The Attalids*, pp. 14–16.

134. Édouard Will, *Histoire politique du monde hellénistique* (Nancy, 1966), I: 266–67.

135. Hansen, *The Attalids*, p. 31.

136. M. Cary, *A History of the Greek World: From 323 to 146 B.C.* (London, 1951), pp. 188–89. See also E. Badian, "Rome and Antiochus the Great," *Classical Philology* 54 (1959): 81–99.

137. Cary, *A History*, pp. 321–22. That the Alexandrian Museum was founded by the first and not the second Ptolemy may be indicated by Plutarch, *Moralia* 1095d. See

Pauly-Wissowa, *Real Encyclopädie der classischen Altertumswissenschaft*, XVI (Stuttgart, 1935): 801–04; P. M. Fraser, *Ptolemaic Alexandria* (Oxford, 1972), I: 305–35.

138. Gisela M. A. Richter, *The Sculpture and Sculptors of the Greeks*, 4th rev. ed. (New Haven, 1970) p. 234; Bieber, *Sculpture*, p. 108.

139. Richter, *Sculpture and Sculptors*, pp. 234–35; Robertson, *History of Greek Art*, I: 527–48.

140. Polybius, *Histories* XXXII. 8. 10. It was to be of military use to him later: Livy, *Ab Urbe Condita* XXVII. 30. 10, XXXI. 28. 6.

141. Livy, *Ab Urbe Condita* XXXI. 45. 1–47.3: for his trouble, he received Andros and Oreus.

142. *Die Inschriften von Pergamon*, ed. Max Fränkel (Berlin 1890–95), I: nos. 47–49. See Pausanias, *Descriptio Graecae* VI.xiv.11, VIII.xlii.7; *Anthologia Palatina* IX. 238. See also Hansen, *The Attalids*, p. 316; Arnold Schober, *Die Kunst von Pergamon* (Vienna 1951), pp. 39 ff.

143. *Die Inschriften von Pergamon*, I: no. 50. See Hansen, *The Attalids*, pp. 316–17.

144. *Die Inschriften von Pergamon*, I: nos. 135–41. See Pliny, *Naturalis Historia* XXXIV. 83. See also Hansen, *The Attalids*, p. 317.

145. Pliny, *Naturalis Historia* XXXVI. 24.

146. Pliny, *Naturalis Historia* XXXV. 60.

147. Pausanias, *Descriptio Graecae* IX. xxxv. 6. It is not clear why Hansen, *The Attalids*, p. 316, lists this among the works secured from Aegina by Attalus I. The inscription that she cites (*Die Inschriften von Pergamon*, I: no. 46) does not indicate where or by whom the work was acquired.

148. See Chapter V.

149. Plutarch, *Aratus* 12. 5.

150. Plutarch, *Aratus* 12. 5.

151. Plutarch, *Aratus* 12. 2. Pliny, *Naturalis Historia* XXXV. 75.

152. Pliny, *Naturalis Historia* XXXV. 80.

153. Galen, *Commentaria in Hippocratis Epidemia III* (XVIIa606–07). See Fraser, *Ptolemaic Alexandria*, I: 325; II: 480, n. 147.

154. Plutarch, *Moralia* 1093e.

155. Pliny, *Naturalis Historia* XXXV. 133.

156. Pliny, *Naturalis Historia* XXXV. 132. Pliny states that Nicias refused the offer of Attalus, but Nicias, being a contemporary of Praxiteles, lived in the fourth century, whereas Attalus I lived in the third and early second centuries; so the refusal must be an addition. Or else the offer really was made by Ptolemy I. H. Rackham (*Pliny's Natural History* [Cambridge, Mass., 1952], IX: p. 346, n.c.) thinks Plutarch is right.

157. Cary, *A History*, p. 322.

158. Athenaeus, *Deipnosophistae* V. 196e.

159. Pliny, *Naturalis Historia* XXXIV. 84. See also Sellers, *Pliny's Chapters*, pp. xxxvi–xlv.

160. Hansen, *The Attalids*, p. 139.

161. Pausanias, *Descriptio Graecae* VII. xvi. 8–9.

162. Pliny, *Naturalis Historia* VII. 126. Pliny elsewhere makes the bid 600,000 sesterces (*Naturalis Historia* XXXV. 24).

163. Polybius, *Histories* XXXIX. 2; Strabo, *Geographia* VIII. 6. 28.

164. Pliny, *Naturalis Historia* XXXV. 24.

165. Velleius Paterculus, *Historiae Romanae* I. xiii. 4.

166. Cicero, *Actio Secunda in C. Verrem* I. 21.

167. Cicero, *Epistulae ad Familiares* VII. 23.

168. Cicero, *Epistulae ad Atticum* I. 10.

169. Cicero, *Epistulae ad Familiares* VII. 23.

170. Horace, *Satires* II. 3.

171. Martial, *Epigrammata* IX. lix.

172. Samuel Ball Platner, *Topography and Monuments of Ancient Rome* (Boston and Chicago, 1904), pp. 364–65. Full references are given in H. Kiepert and Ch. Hueben, *Formae Urbis Romae Antiquae, Nomenclator Topographicus* (Berlin 1896), p. 126.

173. Pliny, *Epistulae* III. vi. 1–4.

174. Bieber, *Sculpture*, p. 81 and fig. 284.

175. Phaedrus, *Fabulae* Prologue to bk. V. 4–9.

176. Euripides, *Ion* 186–233; Herodas, *Mime* IV.

177. *A Selection of Greek Historical Inscriptions*, ed. Russell Meiggs and David Lewis (Oxford, 1975), no. 76; J. Pouilloux, *Choix d'inscriptions grecques* (Paris, 1960), nos. 36–37. See also Jacques Tréheux, "L'Inventaire des clérouques d'Imbros," *Bulletin de Correspondance Hellénique* 80 (1956): 462–79. These inventories list temple treasures. None makes any mention of paintings or statues.

178. Herodas, *Mime* IV.

179. Herodas, *Mime* IV. 23.

180. Herodas, *Mime* IV. 66–73.

181. Charles H. Skalet, *Ancient Sicyon* (Baltimore, 1948), p. 143.

182. Pliny, *Naturalis Historia* XXXV. 127.

183. Pausanias, *Descriptio Graecae* I. xxii. 6.

184. John Travlos, *Pictorial Dictionary of Ancient Athens* (London, 1971), p. 482. See also Vincent J. Bruno, *Form and Colour in Greek Painting* (London, 1977), Appendix, pp. 107–08.

185. Cicero, *Actio Secunda in C. Verrem* IV. 57. 126.

186. Pliny, *Naturalis Historia* XXXV. 26.

187. Again, Pliny, *Naturalis Historia* XXXV. 26.

188. Pliny, *Naturalis Historia* VII. 115, XXXVI. 23–24, 33–34; Suetonius, *Augustus* 29. 5. See also Ovid, *Tristia* III. 1. 72 and Donald Strong, *Roman Art*, Penguin ed. (Harmondsworth, 1976).

189. Samuel Ball Platner and Thomas Ashby, *A Topographical Dictionary of Ancient Rome* (Oxford, 1929), pp. 271–72, cite the ancient evidence on the gardens. These belonged to the Emperor by the time of Tiberius; Vespasian and Aurelian used them as a resort; and Nerva died there. Still in use in the fourth century, they were sacked by Alaric's Goths in 410. See also Pierre Grimal, *Les Jardins romains* (Paris, 1969), pp. 126–31. On the Ludovisi Throne, see Erika Simon, *Die Geburt der Aphrodite* (Berlin, 1969), pp. 97 ff.; Wolfgang Helbig, *Führer durch die öffentlichen Sammlungen klassischer Altertümer in Rom*, ed. Hermine Speier, 4th ed., III (Tübingen, 1969): 259–63; Mary V. Comstock and Cornelius C. Vermeule, *Sculpture in Stone: The Greek, Roman and Etruscan Collections in the Museum of Fine Arts* (Boston, 1976), pp. 81–82, 20–25, no. 30.

190. Velleius Paterculus, *Historiae Romanae* I. xi. 2–3.

191. Pliny, *Naturalis Historia* XXXIV. 64. See also Velleius Paterculus, *Historiae Romanae* I. xi. 2–3.

192. Platner and Ashby, *Topographical Dictionary*, p. 305.

193. Petronius, *Satyricon* 83.

194. *Anthologia Graeca* IX. 713–42, 793–98, all by Julian, Prefect of Egypt.

195. *Anthologia Graeca* XVI. 81.

196. As late as the third century A.D., the Zeus turns up importantly in Flavius Philostratus' *Life of Apollonius of Tyana* VI. 19 and in Plotinus' *Enneads* V. 8. 1. In the sixth

century, the statue appears as one of the wonders of the world in Cassiodorus, *Variae* 7. 15.

197. Lucian, *Iuppiter Tragoedus* 8. In Lucian's *Timon* 4, there is also a hint that thieves had managed to carry off gold snipped from the statue's hair.

198. Strabo, *Geographia* VIII. iii. 30.

199. Pliny, *Naturalis Historia* XXXIV. 62.

200. Sellers, *Pliny's Chapters*, pp. xvi–xxxvi; Schweitzer, "Xenokrates von Athen," pp. 105–64 (especially , 141–58).

201. Sellers, *Pliny's Chapters*, p. xx.

202. John Pope-Hennessy, *Raphael* (New York, 1970), p. 37.

203. Pollitt, *The Ancient View of Greek Art*, p. 63.

204. Bieber, *Sculpture*, p. 151. See also Bieber, "Pliny and Graeco-Roman Art," *Hommages à Joseph Bidez et Franz Cumont* (Brussels, 1949), pp. 39–42.

205. Pausanias, *Descriptio Graecae* IV. xxxi. 6. See Bieber, *Sculpture*, p. 158.

206. Again, an exception must be made for Pergamum's works of art acquired as loot.

207. Bieber, *Sculpture*, pp. 171–82.

208. John Pope-Hennessy, "The Forging of Italian Renaissance Sculpture," *Apollo* 99 (April 1974): 250 ff.

209. Cicero, *Brutus* LXX.

210. Callistratus, *Descriptiones* 11. See also 8. 1 for an all but miraculous realism.

211. Quintilian, *Institutio Oratoria* XII. x. 9.

212. Again, *Institutio Oratoria* XII. x. 9.

213. Quintilian, *Institutio Oratoria* XII. x. 3.

214. The Dionysus by Aristides went to the Temple of Ceres, for instance: Pliny, *Naturalis Historia* XXXV. 24.

215. Livy, *Ab Urbe Condita* V. 22.

216. Livy, *Ab Urbe Condita* XXV. 40. 1–3.

217. Livy, *Ab Urbe Condita* XXV. 40, XXVI. 21, XXXIV. 4.

218. Plutarch, *Marcellus* 21.

219. Plutarch, *Fabius* 22. 5. This is an expansion of Livy, *Ab Urbe Condita* XXVII. 16. 4–8, in which Lysippus' Hercules does not appear, however. Livy furthermore states that paintings were included in the loot taken by Fabius Maximus.

220. Pliny, *Naturalis Historia* XXXV. 24.

221. Cicero, *Actio Secunda in C. Verrem* I. 21, III. 4.

222. Polybius, *Histories* XXXI. 23. 1–25. 1.

223. Polybius, *Histories* XXX. 13, 32.

224. Livy, *Ab Urbe Condita* XXXIV. 4. 3–4. This was presumably the basis of Plutarch's account of the Senate's reaction to Marcellus' loot from Syracuse.

225. Pliny, *Naturalis Historia* XXXVI. 7.

226. Pliny, *Naturalis Historia* XXXVI. 7.

227. Pliny, *Naturalis Historia* XXIII. 147.

228. Cicero, *Actio Secunda in C. Verrem* I. 19.

229. Cicero, *Actio Secunda in C. Verrem* IV. 43. 93.

230. Cicero, *Actio Secunda in C. Verrem* IV. 6. 12.

231. Cicero, *Actio Secunda in C. Verrem* IV. 1. 1.

232. Cicero, *Actio Secunda in C. Verrem* IV. 13. 30–31.

233. The judge was Manlius Glabrio. (Cicero, *Actio Prima in C. Verrem* II. 4, X. 29, XIV. 41, XVI. 51; *Actio Secunda in C. Verrem* I. 11. 29–30.)

234. *Ciceronis Orationum Scholiastae*, ed. Thomas Stangl (Hildesheim, 1964), p. 223.

235. Pliny, *Naturalis Historia* XXXIV. 6; Lactantius, *Institutiones Divinae* II. iv. 33–37.

236. Pliny, *Naturalis Historia* VII. 126.

237. Vitruvius, *De Architectura* VI. 4. 2.

238. Pliny, *Naturalis Historia* XXXVI. 41.

239. Juvenal, *Satires* III. 212–22, VIII. 98–107, XI. 100–10. See also I. 75–76.

240. Seneca, *Dialogues* V. 40.

241. Lampreys are all-consuming carnivores, and get their nourishment by attaching sucker-like mouths to their victims and sucking out the flesh.

242. Martial, *Epigrammata* VIII. 6.

243. Statius, *Silvae* IV. vi.

244. Statius, *Silvae* IV. vi. 29.

245. Statius, *Silvae* IV. vi. 59–98; Martial, *Epigrammata* IX. 43.

246. Martial, *Epigrammata* XII. 69.

247. Pliny, *Naturalis Historia* XXXIII. 157.

248. For instance, Martial, *Epigrammata* VI. 92.

249. Cicero, *Actio Secunda in C. Verrem.* IV. 24. 54.

250. Martial, *Epigrammata* IV. 39.

251. Pliny, *Naturalis Historia* XXXIII. 154. See also Martial's allusion to the counterfeiting of antique silver: *Epigrammata* VIII. 34.

252. Pliny, *Naturalis Historia* XXXIV. 6; Pliny the Younger, *Epistulae* III. 6; Martial, *Epigrammata* IX. 59.

253. Pliny, *Naturalis Historia* XXXVII. 18–22, 30 (cf. XXXIII. 5); Martial XIV. 113, for murrhine; for citronwood tables, Pliny, *Naturalis Historia* XIII. 91–102 is the *locus classicus*. See also Cicero, *Actio Secunda in C. Verrem* IV. 17. 37; Martial, *Epigrammata* XIV. 85, 89; Petronius, *Satyricon* CXIX. 27; Dio Chrysostom, *Olympica* XII. 49.

254. Cicero, *Epistulae ad Familiares* VII. xxiii.

255. Gisela M. A. Richter, *The Furniture of the Greeks, Etruscans, and Romans* (London, 1966), pp. 13–84.

256. Scriptores Historiae Augustae, *Marcus Antoninus* XVII. 4.

257. See Johann Wolfgang von Goethe, "Philostrats Gemälde," in *Werke*, XXVI (Stuttgart, 1868): 276 ff. This originally appeared in *Über Kunst und Altertum* II, 1 (1818): 27 ff., 145 ff.

258. Philostratus, *Imagines* I. 295–96K (introduction).

259. Otto Schönberger summarizes the history of the dispute in his introduction to *Philostratus: Die Bilder* (Munich, 1968), pp. 26–37.

260. Eusebius, *Vita Constantini* III. 54, in *Die griechischen christlichen Schriftsleiter der ersten drei Jahrhunderte*, ed. Friedhelm Winckelmann, VII (Berlin, 1975): 101–02.

261. A remnant is still in Istanbul.

262. R. J. H. Jenkins, "The Bronze Athena at Byzantium," *Journal of Hellenic Studies* 67 (1947): 31–33, summarizes the reasons for identifying the Athena at Constantinople with this famous statue by Phidias.

263. Cyril Mango, "Antique Statuary and the Byzantine Beholder," *Dumbarton Oaks Papers* 17 (1963): 55–58, gives a partial list of the statues transported, and full references. See also St. Jerome, *Chronicon*, ed. J. K. Fotheringham (London, 1923), p. 314, who writes: "*Dedicator Constantinopolis omnium paene urbium nuditate.*"

264. Sidonius Apollinaris, *Epistulae* II. ii. 4–5.

265. Sidonius Apollinaris, *Epistulae* II. ii. 6.

266. Sidonius Apollinaris, *Epistulae* II. ii. 11.

267. By "major" I mean a collection containing undisputably major works of art.

268. Georgius Cedrenus, *Compendium Historiarum*, ed. Immanuel Bekker, 2 vols., *Corpus Scriptorum Historiae Byzantinae* (Bonn, 1828–97), I: 564. Cedrenus' account is more

briefly repeated by Johannes Zonaras, *Annales*, ed. M. Pinder, 3 vols., *Corpus Scriptorum Historiae Byzantinae* (Bonn, 1828–97), III: 130–31. This account is treated as dependable by Professor Mango, "Antique Statuary and the Byzantine Beholder," p. 58.

269. *The Theodosian Code*, trans. Clyde Pharr (Princeton, 1952), p. 476, no. 25.

270. *The Theodosian Code*, pp. 473–74, nos. 10–12.

271. Pliny (*Naturalis Historia* XXXVI. 9), calls these two "the first to win fame in the carving of marble," yet there are some who believe these Archaic sculptors made wooden statues, "*xoanoi*," exclusively.

272. "*Smaragdos*" is the word translated as emerald.

273. Themistius, *Orationes*, ed. Wilhelm Dindorf (Hildesheim, 1961), XXVII. 337b (p. 406), XXXIV. 40 (p. 455).

274. Iris Cornelia Love, "A Preliminary Report of the Excavations at Knidos, 1969," *American Journal of Archaeology* 74 (1970): 149–55.

275. Georgius Cedrenus, *Compendium Historiarum*, I: 616.

VIII. THE PATTERN REPEATS

1. The earliest possible mentions of silk in Greek texts date from the fourth century, but the earliest certain mentions are very considerably later. See Pauly-Wissowa, *Real Encyclopädie der classischen Altertumswissenschaft*, Zweite Reihe, II (Stuttgart, 1923): 1724–27; *Der Kleine Pauly* (Munich, 1975), V: 78; see also Gisela M. A. Richter, "Silk in Greece," *American Journal of Archaeology*, 2nd series, 33 (1929): 29–33. However, a little Chinese silk was found in the sixth-century Pazyryk barrows (see Sergei Ivanovich Rudenko, *Frozen Tombs of Siberia*, trans. with preface by M. W. Thompson [Berkeley and Los Angeles, 1970], pp. 305–06, pls. 134A, 178). Hence it seems likely that the Greeks in the settlements on the northern coast of the Black Sea, being in regular touch with the Scythians at the western end of the trans-steppe trade, must have seen this luxury material, at least on rare occasions.

2. Before Western exports began regularly reaching China in the premodern period, there were intermittent importations of many kinds. The first imports of much significance were the horses of Ferghana, much larger and more spirited than those available in the Far East. These were first secured by a military expedition sent by the Emperor Han Wu Di. The same expedition began the extension of the Chinese Empire to include much of modern Xinjiang Province, which made a kind of bridge to the West (see Herrlee G. Creel, "The Role of the Horse in Chinese History," in *What is Taoism? and Other Studies in Chinese Cultural History* [Chicago and London, 1970], pp. 170, 175–78). Homer H. Dubs also argues, with support from Sir William Tarn, that a few legionary captives taken by the Parthians from Crassus' army defeated at Carrhae may have escaped to take service with a Hun warlord, and then have been captured by the Chinese and settled in the Central Asian town of Li Jian, which thus became one of the early Chinese names for Rome (see Homer H. Dubs, *A Roman City in Ancient China* [London, 1957]). In addition, Greek merchants claiming to be envoys from the Emperor Marcus Aurelius turned up on the Southern Chinese border in 166 A.D. (see C. P. Fitzgerald, *China*, ed. C. G. Seligman [London, 1935], pp. 193–94). But these facts merely indicate the extreme slightness of contact and exchange.

3. Ma Chengyuan, "The Splendor of Ancient Chinese Bronzes," in *The Great Bronze Age of China: An Exhibition from the People's Republic of China*, ed. Wen Fong, Metropolitan Museum of Art (New York, 1980), p. 1.

4. K. C. Chang, "The Chinese Bronze Age: A Modern Synthesis," in *The Great Bronze Age of China*, p. 35.

5. Early Chinese dates are controversial almost without exception. I have followed the dating used by Alexander C. Soper in "Early, Middle, and Late Shang: A Note," *Artibus Asiae* 28 (1966): 5–38, except to make allowance for the finds referred to in notes 3 and 4, above.

6. Chinese scholars used to hold that the *Dao de jing*, the basic text of Taoism, was as early in date as any Confucian document, and that Lao Zi was a contemporary of Confucius and perhaps older than he; but I follow the more recent scholars who do not hold these views. Arthur Waley maintains, for instance, that the grammar of the *Dao de jing* is "typical of 3rd century B.C. philosophers." See Arthur Waley, *The Way and Its Power: A Study of the Tao Te Ching and Its Place in Chinese Thought* (1934; London, 1949), p. 127.

7. Derk Bodde, *China's First Unifier: A Study of the Ch'in Dynasty as Seen in the Life of Li Ssu (280?–208 B.C.)*, Sinica Leidensia 3 (Leiden, 1938), pp. 1–5.

8. The title was probably suggested by that of the strictly mythical "Yellow Emperor" (Bodde, *China's First Unifier*, pp. 5, 77–78, 124–28).

9. The best account in English of this remarkable man is to be found in the introduction of J. J. L. Duyvendak's translation, *The Book of Lord Shang: A Classic of the Chinese School of Law* (Chicago, 1963), originally in Probsthain's Oriental Series 17 (London, 1928); see also Sima Qian, *Shi ji*, (Beijing, 1959), chap. 68.

10. See Sima Qian, *Shi ji*, chap. 6, "Annals of Qin Shihuang," 212 B.C., p. 258, trans. Yang Hsien-yi and Gladys Yang, in *Selections from Records of the Historian* (Beijing, 1979), p. 181. The surface charge against the scholars was embezzlement, but the basic charge was "spreading various rumors" among the people of the empire.

11. Duyvendak, trans., *The Book of Lord Shang*, p. 199.

12. Bodde, *China's First Unifier*, p. 19.

13. Confucius, *Analects*, VIII. 13; trans. James Legge in *The Chinese Classics*, 5 vols. (Hong Kong, 1893–95, reprint 1960), vol. I, or in *The Four Books* (1930; New York, 1966).

14. Siu-Chi Huang, "Musical Art in Early Confucian Philosophy," *Philosophy East and West* 13 (April 1963): 49–60.

15. "A Discussion of Music," in *Hzun Tzu: Basic Writings*, trans. Burton Watson (New York, 1963), section 20, pp. 112–20.

16. *The Sacred Books of China: The Li Ki*, trans. James Legge (Oxford, 1885), vol. XXVIII, chap. XVII.

17. *The Sacred Books of China: The Li Ki*, chap. I, pp. 1–9; see also Bernhard Karlgren, "The Early History of the Chou Li and Tso Chuan Texts," *Bulletin of the Museum of Far Eastern Antiquities, Stockholm*, 1 (1929): 19–20, 56–57.

18. "Record of Music," in *The Sacred Books of China: The Li Ki*, chap. XVII, pp. 116–21.

19. For example, *Freer Gallery of Art*. I, *China* (Washington, D.C., 1972), p. 177, illust. nos. 112, 113.

20. For example, *Freer Gallery of Art*, I: 155, illust. nos. 21, 22, 24.

21. Max Loehr, *Chinese Bronze Age Weapons* (Ann Arbor, 1956).

22. For example, *Masterpieces of Chinese and Japanese Art*, Freer Gallery of Art Handbook (Washington, D.C., 1976), p. 19, no. 32.14; see also *Freer Gallery of Art*, I: 154, illust. no. 13.

23. Legge, *The Chinese Classics*, vol. 5, *The Ch'un Ts'ew with the Tso Chuan*, Duke Chwang XXII. 6, pp. 102, 104; Duke Min II. 7, pp. 126–29; Duke Seang XI. 8, p. 453; Duke Seang XIX. 6, pp. 525–26; Duke Ch'aou VII. 4, p. 617; Duke Ting IV. 4, p. 754. (Legge romanization.)

24. Alexander C. Soper, "The Relationship of Early Chinese Painting to Its Own Past," in *Artists and Traditions*, ed. Christian F. Murck (Princeton, 1976), pp. 21–22.

25. Michael Sullivan, *The Arts of China* (Berkeley, 1977), p. 60.

26. William Watson, *Style in the Arts of China* (London, 1974), pp. 16, 18, 25 ff.

27. Max Loehr, "Chinese Painting," in *Catalogue of the Exhibition of Chinese Calligraphy and Painting in the Collection of John M. Crawford, Jr.* ed. Laurence Sickman et al. (New York, 1962), p. 34; and Loehr, *Ritual Vessels of Bronze Age China* (New York, 1968), pp. 12–13. The question of the possible symbolic or religious content of ancient bronze décor continues to divide scholars (see the divergent views expressed in *The Great Bronze Age of China*). No one has argued, however, that the illusionistic representation of reality was a primary goal of art.

28. The first report of this discovery was a paragraph in the article "Brief Notes on the Relics Excavated During the Movement to Criticize Confucius and Lin Biao," *Wenwu,* no. 1 (1975), pp. 44–51.

29. Max Loehr, "The Question of Individualism in Chinese Art," *Journal of the History of Ideas* 22, no. 2 (April-June 1961): 148; Watson, *Style in the Arts of China,* p. 18. Professor Watson has told me he was unfamiliar with Professor Loehr's suggestion when he wrote his book.

30. The Archeological Team of the Qin Pit of Pottery Figures, "[Excavation of the Qin Dynasty Pit Containing Pottery Figures of Warriors and Horses at Lintong, Shaanxi Province]," *Wenwu,* no. 11 (1975), pp. 1–18. This article has been fully translated by Albert E. Dien, "First Report on the Exploratory Excavations of the Ch'in Pit of Pottery Figures at Lin-t'ung hsien," *Chinese Sociology and Anthropology* 10, no. 2 (Winter 1977–78): 3–50. An abstract of the same excavation report was prepared by Dien and Jeffrey K. Reigel, *Early China* 3 (1977): 99–100. The excavation report was followed by two supplementary articles: Qin Ming, "[Notes on the Arrangement of the Qin Dynasty Pottery Figures of Warriors and Horses from Lintong]," *Wenwu,* no. 11 (1975), pp. 19–23; and Wen Meiyan and Qin Zhongxing, "[The Sculptural Arts of the Qin Dynasty Pottery Figures]," *Wenwu,* no. 11 (1975), pp. 24–30. A further report appeared in *Kaogu,* no. 6 (1975), pp. 334–39. Two warriors and a chariot horse from this pit were exhibited in Japan in 1976. See *Chūka jimmin kyōwakoku kodai seidōki ten* [Exhibition of Ancient Bronzes of the People's Republic of China] (Tokyo, 1976), nos. 122–30. In May 1976, a second, smaller pit was discovered to the north of the first. For a report on Pit No. 2, see The Qin Dynasty Pit Archeological Team, "[Excavation of the Qin Dynasty Pit Containing Pottery Figures of Warriors and Horses at Lintong, Shaanxi Province]," *Wenwu,* no. 5 (1978), pp. 1–19. This excavation report has been fully translated by Dien, "Excavation of the Ch'in Dynasty Pit Containing Pottery Figures of Warriors and Horses at Lin-t'ung, Shensi Province," *Chinese Studies in Archaeology* 1 (Summer 1979): 8–55. Five warriors and two horses from Pit No. 2 and one warrior from Pit No. 1 have been exhibited in the United States. For a discussion of these figures and a general article in English on the find as a whole, see Maxwell K. Hearn, "The Terracotta Army of the First Emperor of Qin (221–206 B.C.)," in *The Great Bronze Age of China,* pp. 351–73, nos. 98–105.

31. Pit No. 1 is estimated to contain six thousand figures; Pit No. 2 is estimated to have slightly more than fourteen hundred figures. Pit No. 3 has only sixty-eight figures, probably representing a command unit, and a fourth pit was empty, suggesting that work on the army may never have been completed. See Hearn, "The Terracotta Army," pp. 361–67.

32. One of the smaller figures previously excavated at Lintong was shown in the United States in 1974–75 (see *The Chinese Exhibition: The Exhibition of Archaeological Finds of the People's Republic of China,* Nelson Gallery of Art–Atkins Museum [Kansas, City, 1975], cat. no. 139). For excavation reports on these finds, see *Kaogu,*

no. 8 (1962), pp. 407–11, 419; *Wenwu*, no. 9 (1964), pp. 55–56; and *Wenwu*, no. 5 (1973), pp. 66–67.

33. René-Yvon Lefebvre d'Argencé, *Bronze Vessels of Ancient China in the Avery Brundage Collection* (San Francisco, 1977), pl. 13. See also Archibald Wenley, "A Hsi Tsun in the Avery Brundage Collection," *Archives of the Chinese Art Society of America* 6 (1952): 41–43. A well-known descendant of this Shang piece is a late third-century B.C. rhinoceros excavated in 1963 in Shaanxi Province, now in the collection of the Historical Museum, Peking (see *The Great Bronze Age of China*, no. 93).

34. Personal communication from Professor James Cahill, who heard this lecture by Professor Loehr.

35. Bodde, *China's First Unifier*, pp. 79, 120, 178.

36. *Selections from Records of the Historian*, p. 168.

37. Alexander C. Soper, "Life-Motion and the Sense of Space in Early Chinese Representational Art," *Art Bulletin* 30 (1948): 170.

38. David Hawkes, *Ch'u Tz'u: The Songs of the South* (Oxford, 1959; reprint Boston, 1962), pp. 1–9.

39. See Jan Fontein and Tung Wu, *Unearthing China's Past*, Museum of Fine Arts, (Boston, 1973), pp. 66–74, 76–77.

40. For a detailed discussion of the Mancheng tombs and the gilt-bronze lamp, see Jenny F. So, "The Waning of the Bronze Age: The Western Han Period (206 B.C.–A.D. 8)," in *The Great Bronze Age of China*, pp. 323–28.

41. The parcel-gilded leopards traveled to the United States in 1974–75; see *The Chinese Exhibition*, cat. nos. 164–65. See also William Watson, *The Genius of China* (London, 1973), pp. 102–3.

42. Étienne Balazs, *Chinese Civilization and Bureaucracy*, trans. H. M. Wright, ed. Arthur F. Wright (1964; New Haven and London, 1968), pp. 6–7 *et passim*.

43. In all other art traditions except, to a lesser degree, the Japanese, the most admired artists have never, as far as I know, been drawn mainly from the upper classes. Metalworkers in pre-Christian Northern Europe may have constituted a second exception, however. (See Chapter IX.)

44. Balazs, *Chinese Civilization and Bureaucracy*, p. 18.

45. Sima Qian, *Shi ji* 48, "The Hereditary House of Ch'en She," trans. Burton Watson, *Records of the Grand Historian of China* (New York, 1961), I: 19–22.

46. The new dynasty was proclaimed in 581 A.D., but the defeat of the last opponents occurred in 589.

47. Time must tell, but at this writing the pragmatists led by Deng Xiaoping appear to be launching a new kind of Communist regime, as different from that of Mao as the Han dynasty from the Qin. As to the cult of Qin Shihuangdi, he was universally called the greatest man in Chinese history "before Chairman Mao" when I was in China in 1972. But his cult is pretty sure to go the same way as the cult of Mao (who proclaimed the first Emperor as his chief personal model in his poem "Snow"); and what is already happening to the Mao cult is dramatically conspicuous.

48. Ping-Ti Ho, "The Salt Merchants of Yang-Chou: A Study of Commercial Capitalism in Eighteenth Century China," *Harvard Journal of Asiatic Studies* 17 (1954): 165–66. This shows merchant families transforming themselves into scholar-official families at the first opportunity.

49. Lothar Ledderose, *Mi Fu and the Classical Tradition of Chinese Calligraphy* (Princeton, 1979), pp. 28–29.

50. Ledderose, *Mi Fu*, pp. 28–33.

51. See Susan Bush, *The Chinese Literati on Painting: Su Shih (1037–1101) to Tung*

Ch'i-ch'ang (1555–1636), Harvard–Yenching Institute Studies 27 (Cambridge, Mass., 1971), especially chap. 2, pp. 29–82.

52. The ancient bronzes, and to a lesser extent the ancient jades, began to be written about during the Song dynasty. And even then the greatest interest was in the archaic bronze inscriptions.

53. William R. B. Acker, *Some T'ang and Pre-T'ang Texts on Chinese Painting*, Sinica Leidensia 8 and 12 (Leyden, 1954–74), II: 100–01. This is a near comprehensive compilation of all the early texts in Chinese for those who can read the language and in translation for those who cannot.

54. Fray Bernardino de Sahagun, *The War of Conquest: How It Was Waged Here in Mexico*, trans. Arthur J. O. Anderson and Charles E. Dibble (Salt Lake City, 1978), p. xv.

55. R. Ewart Oakeshott, *The Archaeology of Weapons* (New York, 1960), p. 99.

56. *The Cambridge Ancient History*, 3rd ed., vol. I, part 2, *Early History of the Middle East*, ed. I. E. S. Edwards, C. J. Gadd, and N. G. L. Hammond, (Cambridge, 1971) p. 145.

57. I am informed that this hymn has been dropped from English hymnals, but it was still sung in the school chapel of an English friend of mine during the years between the world wars.

58. See Chapter IX.

59. Plutarch, *Pericles* 2.

60. Pliny, *Naturalis Historia* XXXIV. 63–65.

61. Pliny, *Naturalis Historia* XXXV. 85–87.

62. Hugh Trevor-Roper, *Princes and Artists* (New York, 1976), p. 26. The source of the Titian story is Italian long after Titian's time, and it is regarded as legendary.

63. Leonardo da Vinci, *Treatise on Painting*, trans. A. Philip McMahon (Princeton, 1956), I: 17, may be cited, among several possible choices.

64. Plutarch, *Moralia* 346 f.

65. Horace, *Ars Poetica* 1. 361.

66. Hans H. Frankel, "Poetry and Painting: Chinese and Western Views of Their Convertibility," *Comparative Literature* 9 (Fall 1957): 289.

67. Ban Gu, *History of the Former Han Dynasty*, trans. Homer H. Dubs, 3 vols. (Baltimore, 1938–55); see also Ban Gu, *Courtier and Commoner in Ancient China: Selections from the History of the Former Han*, trans. Burton Watson (New York and London, 1974).

68. Ban Gu, *Courtier and Commoner in Ancient China*, pp. 237–38.

69. Ban Gu, *Courtier and Commoner in Ancient China*, p. 237.

70. Ban Gu, *Courtier and Commoner in Ancient China*, p. 237.

71. Acker, *Some T'ang and Pre-T'ang Texts*, I: lvii.

72. In Acker this title is given as *Polemic Against the Grass Script*, but the character can also mean "cursive," and the latter is now the more common usage. Except for this substitution, the text used here is the translation provided by Acker, *Some T'ang and Pre-T'ang Texts*, I: liii–lix.

73. Bodde, *China's First Unifier*, pp. 152, 156–57; Lien-Sheng Yang, "Chinese Calligraphy," in *Catalogue of the Exhibition of Chinese Calligraphy and Painting in the Collection of John M. Crawford, Jr.*, p. 47.

74. Bodde, *China's First Unifier*, pp. 148–52, 157.

75. Bodde, *China's First Unifier*, pp. 147–50, 153–56; Shen C. Y. Fu with Marilyn W. Fu, Mary G. Neill, and Mary Jane Clark, *Traces of the Brush: Studies in Chinese Calligraphy* (New Haven, 1977), p. 43.

76. Acker, *Some T'ang and Pre-T'ang Texts*, I: lv.

77. Acker, *Some T'ang and Pre-T'ang Texts*, I: liv & n. 2, 3.

78. See pp. 229–32 in this chapter.

79. Yang Xin, *Gu lai neng shu ren ming* [Names of Skilled Calligraphers from Antiquity to the Present], in *Fa shu yao lu* [Essential Records of Calligraphy], ca. 847 A.D., ed. Zhang Yanyuan, Yishu cong bian edition, chap. 1, p. 6; see also Ledderose, *Mi Fu*, pp. 31–32.

80. Acker, *Some T'ang and Pre-T'ang Texts*, II: *Chang Yen-Yüan Li Tai Ming Hua Chi*, 214.

81. Osvald Sirén, *Chinese Painting: Leading Masters and Principles*, part I, *The First Millennium*, vol. I, *Early Chinese Painting* (London and Bradford, 1956), pp. 110–11, 119–25.

82. Susan Bush, *The Chinese Literati on Painting*, pp. 1, 7, 31.

83. *The Art of Wen Cheng-Ming 1470–1559*, exhibition catalogue by Richard Edwards, essay by Ann Clapp (New York, 1975), p. 7.

84. Ledderose, *Mi Fu*, pp. 12–15; Fu et al., *Traces of the Brush*, pp. 82–83.

85. Ban Gu, *Courtier and Commoner in Ancient China*, p. 127, n. 11.

86. Acker, *Some T'ang and Pre-T'ang Texts*, I: 112, n. 4; see also Sirén, *Chinese Painting: Leading Masters and Principles*, I: 2–3; Laurence Sickman and Alexander Soper, *The Art and Architecture of China*, 2nd ed. (Harmondsworth, 1960), p. 31.

87. Ban Gu, *Courtier and Commoner in Ancient China*, p. 261.

88. Acker, *Some T'ang and Pre-T'ang Texts*, II: 5.

89. Acker, *Some T'ang and Pre-T'ang Texts*, II: 5.

90. Acker, *Some T'ang and Pre-T'ang Texts*, II: 4–6.

91. Acker, *Some T'ang and Pre-T'ang Texts*, II: 6–14.

92. Xie He, *The Ku Hua P'in Lu*, or *Old Record of the Classifications of Painters*, in Acker, *Some T'ang and Pre-T'ang Texts*, I: 3–58.

93. Xie He, *Ku Hua P'in Lu*, pp. 7–8.

94. Xie He, *Ku Hua P'in Lu*, pp. 18–19.

95. Xie He, *Ku Hua P'in Lu*, pp. 6–7.

96. Basil Gray, *Admonitions of the Instructress to the Ladies in the Palace*, British Museum (London, 1966); Arthur Waley, *An Introduction to the Study of Chinese Painting* (1923; London, 1958), pp. 50–58.

97. Gray, *Admonitions of the Instructress*, p. 16. Laurence Binyon was the first Western scholar to proclaim the attribution in "A Chinese Painting of the Fourth Century," *Burlington Magazine* 4 (January 1904).

98. Thomas Lawton, *Freer Gallery of Art Fiftieth Anniversary Exhibition*, vol. II: *Chinese Figure Painting* (Washington, D.C., 1973), p. 4.

99. Sirén, *Chinese Painting: Leading Masters and Principles*, I: 33–34.

100. Sickman and Soper, *The Art and Architecture of China*, p. 117.

101. He Yanzhi, *Lan ting ji* [History of the Lan ting xu] (714 A.D.), Yishu cong bian edition, pp. 54–58; see also Han Chuang (John Hay), "Hsiao I Gets the Lan-t'ing Manuscript by a Confidence Trick," 2 parts, *National Palace Museum Bulletin* 5 (July/August 1970); 5 (January/February 1971).

102. Ledderose, *Mi Fu*, p. 19.

103. He Yanzhi, *Lan ting ji*, p. 55; Han Chuang, "Hsiao I Gets the Lan-t'ing Manuscript," p. 3.

104. Acker, *Some T'ang and Pre-T'ang Texts*, I: 127, 203–4; see also Lothar Ledderose, "Die kaiserliche Sammlung als Instrument der Kunstpolitik in China," in *Zeitschrift der deutschen morgenländischen Gesellschaft*, supplement III, 2, *XIX. deutscher Orientalistentag 1975*, off-print (Wiesbaden, 1977), pp. 1634–35; Arthur Waley, *An Introduction to the Study of Chinese Painting*, p. 70.

105. He Yanzhi, *Lan ting ji*, pp. 56–57; Han Chuang, "Hsiao I Gets the Lan-t'ing Manuscript," pp. 3–4; Waley, *An Introduction to the Study of Chinese Painting*, p. 70.

106. He Yanzhi, *Lan ting ji*, p. 57; Han Chuang, "Hsiao I Gets the Lan-t'ing Manuscript," p. 5; Waley, *An Introduction to the Study of Chinese Painting*, p. 70.

107. Wen Fong, "The Problem of Forgeries in Chinese Painting, Part One," *Artibus Asiae* 22 (1965): 95.

108. Sang Zhichang, *Lan ting kao*, preface 1208, Yishu cong bian edition, chap. 3, p. 18.

109. Ledderose, *Mi Fu*, p. 13; see also Chapter II above.

110. Zhao Xigu (c. 1250), *Dong tian qing lu ji*, Yishu cong bian edition, p. 268; see also E. Zürcher, "Imitation and Forgery in Ancient Chinese Painting and Calligraphy," *Oriental Art* n.s. 1 (1955): 141.

111. Ledderose, *Mi Fu*, pp. 13–15.

112. Guo Moruo, "You Wang Xie muzhi di chutu lun dao Lan ting xu di zhen wei," *Wenwu*, no. 176 (June 1965), pp. 1–25; Guo Moruo, "Xinjiang xin chu tu di Jin ren xieben San guo zhi can zhuan," *Wenwu*, no. 8 (August 1972), pp. 2–6. See also other articles in *Wenwu*, no. 176 (June 1965), no. 177 (July 1965), and nos. 179–82 (September-December 1965).

113. Max Loehr, "Some Fundamental Issues in the History of Chinese Painting," *Journal of Asian Studies* 23 (February 1964): 187.

114. Robert H. van Gulik, *Chinese Pictorial Art as Viewed by the Connoisseur*, Serie orientale Roma 19 (Rome, 1958), pp. 86–101.

115. But see the remarks on the few Chinese sculptors, all from the period of unchallenged Buddhist supremacy, in Zhang Yanyuan, in Acker, *Some T'ang and Pre-T'ang Texts*, II: 100–101.

116. Acker, *Some T'ang and Pre-T'ang Texts*, I: 148.

117. Acker, *Some T'ang and Pre-T'ang Texts*, I: 149 ff.; see also Loehr, "Some Fundamental Issues in the History of Chinese Painting," p. 191.

118. Acker, *Some T'ang and Pre-T'ang Texts*, I: 190. This appears to be Zhang Yanyuan's only reference to the "untrammeled" Tang painters like Master Gu.

119. See Chapter VII.

120. Loehr, "Some Fundamental Issues in the History of Chinese Painting," pp. 189–91; and Loehr, "Chinese Painting," p. 33.

121. Ledderose, *Mi Fu*, pp. 38–39.

122. Soper, "The Relationship of Early Chinese Painting to Its Own Past," pp. 23 ff.

123. Acker, *Some T'ang and Pre-T'ang Texts*, I: 177–78.

124. Acker, *Some T'ang and Pre-T'ang Texts*, I: liv–lv.

125. Calligraphy began to die many years ago, when the use of the fountain pen became widespread among educated Chinese.

126. Acker, *Some T'ang and Pre-T'ang Texts*, I: 67.

127. Acker, *Some T'ang and Pre-T'ang Texts*, II: 19.

128. *Kuo Jo-Hsu's Experiences in Painting (T'u-Hua Chien-Wen Chih)*, trans. Alexander C. Soper (Washington, D.C., 1951), pp. 103–04.

129. *Kuo Jo-Hsu's Experiences in Painting*, p. 104.

130. *Kuo Jo-Hsu's Experiences in Painting*, p. 14.

131. Roy Strong, *And When Did You Last See Your Father?, The Victorian Painter and British History* (London, 1978), pp. 49–60.

132. Sirén, *Chinese Painting: Leading Masters and Principles*, I: 202–04.

133. Acker, *Some T'ang and Pre-T'ang Texts*, I: xxix–xxxiii, xli–xlii, 3–5.

134. Alexander C. Soper, "Life-Motion and the Sense of Space," p. 168; see also George Rowley, *Principles of Chinese Painting* (Princeton, 1947), pp. 24–25.

135. Soper, "The Relationship of Early Chinese Painting to Its Own Past," pp. 21–47;

Loehr, "Some Fundamental Issues in the History of Chinese Painting," pp. 191–92; Wen Fong, "Archaism as a 'Primitive' Style," p. 91, in *Artists and Traditions*, ed. Christian F. Murck (Princeton, 1976), p. 91.

136. Fong, "Archaism as a 'Primitive' Style," p. 90.

137. Acker, *Some T'ang and Pre-T'ang Texts*, II: 101.

138. Acker, *Some T'ang and Pre-T'ang Texts*, I: 179–84.

139. Acker, *Some T'ang and Pre-T'ang Texts*, I: 257, 258, 259, 261, 263, 266, 268, 271, 272, 273, 275, 284, 285, 286, 288, 289, 302, 305, 306, 320, 361, 362, 375, 376; II: 235.

140. Acker, *Some T'ang and Pre-T'ang Texts*, I: 255, n. 3; II: 236.

141. Mi Fu, *Hua shi* [History of Painting], Yishu cong bian edition, p. 8, discusses major attributions.

142. Acker, *Some T'ang and Pre-T'ang Texts*, I: 151, 179; Sirén, *Chinese Painting: Leading Masters and Principles*, I: 115–19.

143. Acker, *Some T'ang and Pre-T'ang Texts*, I: 179.

144. James Cahill, *Hills Beyond a River: Chinese Painting of the Yüan Dynasty, 1279–1368* (New York and Tokyo, 1976), p. 133; Fong, "Archaism as a 'Primitive' Style," pp. 89–90.

145. Gray, *Admonitions of the Instructress to the Ladies in the Palace*, pp. 3–4; Sirén, *Chinese Painting: Leading Masters and Principles*, I: 31.

146. Acker, *Some T'ang and Pre-T'ang Texts*, I: 156.

147. Sirén, *Chinese Painting: Leading Masters and Principles*, I, pp. 103–08.

148. Loehr, "Some Fundamental Issues in the History of Chinese Painting," p. 192; see also Loehr, "Chinese Painting," pp. 38–42.

149. Max Loehr, "Chinese Painting after Sung," Ryerson Lecture, Yale University (March 1967), pp. 3 ff.

150. Cahill, *Hills Beyond a River*, pp. 163–66, 175–76, *et passim*.

151. Fong, "Archaism as a 'Primitive' Style," p. 90; see also Cahill, *Hills Beyond a River*, pp. 119–20.

152. Loehr, "Some Fundamental Issues in the History of Chinese Painting," p. 193.

153. Yu He, *Lun shu biao* [Memorial on Calligraphy], in *Fa shu yao lu*, 847 A.D., ed. Zhang Yanyuan, Yishu cong bian edition, ch. 1, p. 14; ch. 2, pp. 19, 23; Sun Guoting, *Shu pu*, 687 A.D., Yishu cong bian edition, p. 1.

154. Fu et al., *Traces of the Brush: Studies in Chinese Calligraphy*, p. 44.

155. Richard Barnhart, "Li Kung-Lin's Use of Past Styles," in *Artists and Traditions*, pp. 51–71.

156. E. H. Gombrich, "The Renaissance Concept of Artistic Progress and Its Consequences," in *Norm and Form* (London, 1966), pp. 1–10.

157. Ping-Ti Ho, *The Cradle of the East* (Hong Kong, 1977), pp. 224–25; K. C. Chang, "Pre-historic and Shang Pottery Inscriptions: An Aspect of the Early History of Writing and Calligraphy" (draft paper), pp. 3 ff.; Guo Moruo, "Gudai wenzi zhi bianzheng de fazhan" [A Demonstration of the Development of Ancient Writing], *Kaogu*, no. 3 (1972), p. 2.

158. The Archeological Team of Beijing City, "[Eastern Zhou and Han Tombs to the North of Huairou near Beijing]," *Kaogu*, no. 5 (1962), pp. 219–39; The Archeological Team of the Bureau of Culture, Tianjin City, "[The Second Excavation of a Warring States Tomb at Zhang gui zhuang in the Eastern Suburbs of Tianjin]," *Kaogu*, no. 2 (1965).

159. "[Excavation of the Qin Dynasty Pit Containing Pottery Figures of Warriors and Horses at Lintong, Shaanxi Province]," *Wenwu*, no. 11 (1975), pp. 6–7; trans. Dien, in *Chinese Sociology and Anthropology* 10 (Winter 1977–78): 27–28.

160. See note 159.

161. Worker's Theoretical Study Group, Beijing Automobile Plant and Department of Art History, Academy of Fine Art, Central May Seventh University, "[Artistic Achievements in the Age of Qin Shihuangdi]," *Kaogu*, no. 6 (1975), pp. 338–39.

162. Watson, *Style in the Arts of China*, pp. 115–16; William Willets, *Foundations of Chinese Art: From Neolithic Pottery to Modern Architecture* (London, 1965), p. 135.

163. In addition to letters, we begin to find calligraphers signing steles in the late second century A.D.: Zhu Deng, *Wei Weiqing Heng Fang bei*, A.D. 168, in *Shodō zenshū* (Tokyo, 1966–67), vol. 2, pl. 96–97; Qiu Jing, *Wu du tai shou Li Xi xixia song*, A.D. 171, in *Shodō zenshū*, vol. 2, pl. 102–03; Qiu Fu, *Li Xi xi li qiao fu ge song*, A.D. 172, in *Shodō zenshū*, vol. 2, pl. 104–05.

164. Laurence Sickman, "Introduction," in *Catalogue of the Exhibition of Chinese Calligraphy and Painting in the Collection of John M. Crawford, Jr.*, p. 26.

165. This is the tomb of Li Zhongrun, Crown Prince Yi De, painted by Yan Bian, who is believed to be identical with a painter mentioned in Zhang Yanyuan, although the Chinese characters are very slightly different. See Jan Fontein and Tung Wu, *Han and T'ang Murals Discovered in Tombs in the People's Republic of China and Copied by Contemporary Chinese Painters*, exhibition catalogue, Museum of Fine Arts, (Boston, 1976), pp. 104–05.

166. Fu et al., *Traces of the Brush*, p. 185.

167. Although Sirén believed Fan Kuan's Travelers Among Mountains and Streams to be without a signature (see *Chinese Painting: Leading Masters and Principles*, I: 204), it is indeed signed, but the signature is so discreet it seems hidden. See James Cahill, *Chinese Painting* (Lausanne and Paris, 1960), p. 32; Sullivan, *The Arts of China*, p. 166.

168. "By the Southern Sung Dynasty, the signing of paintings was a common practice, still in a relatively inconspicuous way. . . ." See Sickman, "Introduction," p. 26.

169. Fu et al., *Traces of the Brush*, pp. 183–84; Cahill, *Hills Beyond a River*, p. 19. Loehr, "The Question of Individualism in Chinese Art," p. 157.

170. Acker, *Some T'ang and Pre-T'ang Texts*, I: 3–5.

171. Alexander C. Soper, "The First Two Laws of Hsieh Ho," *The Far Eastern Quarterly* 8 (August 1949): 423; James Cahill, "The Six Laws and How to Read Them," *Ars Orientalis* 4 (1961): 372–81; Lui Shou Kwan, "The Six Canons of Hsieh Ho Re-examined by a Contemporary Chinese Painter," Parts I & II, *Oriental Art* 17, no. 2 (Summer 1971): 144–47; no. 3 (Autumn 1971): 252–55; see also Acker, *Some T'ang and Pre-T'ang Texts*, II: 157–62; Sirén, *Chinese Painting: Leading Masters and Principles*, I: 4–8.

172. Acker, *Some T'ang and Pre-T'ang Texts*, I: xxi, xliii–xlv; II: 126–27.

173. Acker, *Some T'ang and Pre-T'ang Texts*, II: 44, 58–73; Sirén, *Chinese Painting: Leading Masters and Principles*, I: 34.

174. Susan Bush, "Two Fifth-Century Texts on Landscape Painting and the 'Landscape Buddhism' of Mount Lu," paper written for an ACLS-sponsored conference on "Theories of the Arts in China," June 6–12, 1979.

175. Fu et al., *Traces of the Brush*, pp. 43–55.

176. Acker, *Some T'ang and Pre-T'ang Texts*, II: 4.

177. Acker, *Some T'ang and Pre-T'ang Texts*, I: xlvii. This is the date for Zhang Yanyuan, but he may have been drawing upon earlier scholars.

178. Herrlee G. Creel, *Confucius and the Chinese Way*, reprint of *Confucius: The Man and the Myth* (1949; reprint New York, 1960), pp. 143 ff.; Creel, *The Origins of Statecraft in China*, vol. I, *The Western Chou Empire* (Chicago, 1970): 42.

179. Acker, *Some T'ang and Pre-T'ang Texts*, I: 111–14.

180. Yang Xin, *Gu lai neng shu ren ming* [Names of Skilled Calligraphers from Antiquity to the Present], in *Fa shu yao lu* [Essential Records of Calligraphy], Yishu cong bian edition, chap. 1, p. 5.

181. Wang Sengqian, *Lun shu* [Discussing Calligraphy], in *Fa shu yao lu*, c. 847 A.D. chap. 1, p. 9.

182. Wang Sengqian, *Lun shu* [Discussing Calligraphy], chap. 1, p. 10.

183. See Chapter VI.

184. Phaedrus, *Fabulae*, Book V Prologue 1. 4 ff.

185. See Chapter IV.

186. See note 179.

187. The evidence is ninth-century, therefore half a millennium later than the collection of which Zhang Yanyuan records the destruction. See Acker, *Some T'ang and Pre-T'ang Texts*, I: 112–14.

188. The idea that there was something like a Byzantine art museum mainly derives from the *Book of Ceremonies (De Ceremoniis)*, which contains careful instructions for decorating the Magnaura and the Chrysotriklinos for the reception of important foreign ambassadors, with an infinity of silver chains and candelabra, enamels, and other treasures, many of which were apparently borrowed from church treasures to make the palace and state apartments even more impressive (see Constantinus Porphyrogenitus, *De Ceremoniis*, ed. J. J. Reiski, 2 vols., *Corpus Scriptorum Historiae Byzantinae* (Bonn, 1828–97), II: 570 ff.). The Emperor Manuel Comnenus made a great show of the palace treasures for King Amaury of Jerusalem when the latter passed through Constantinople in 1171 A.D. (see William of Tyre, xx.23 in *Recueil des historiens des Croisades*, I-2 [Paris, 1844]: 985). But you can see how far these displays really were from the "palace museum" one or two students have talked about, from the sad episode of the Emperor Leo VI and the Arab father of his minister Samonas. The Emperor decorated the Magnaura for the visitor and, further, let him see the treasures of St. Sophia. The greatest treasures were relics, and almost all were regarded as impregnated with sanctity; so there was much trouble and scandal because it was thought highly improper to make such a display for an infidel (see Theophanes, *Theophanes Continuatus*, ed. Immanuel Bekker, *Corpus Scriptorum Historiae Byzantinae* [Bonn, 1828–97], pp. 374–75).

189. Acker, *Some T'ang and Pre-T'ang Texts*, I: 194–202.

190. Acker, *Some T'ang and Pre-T'ang Texts*, I: 194–95.

191. Acker, *Some T'ang and Pre-T'ang Texts*, I: 195.

192. Acker, *Some T'ang and Pre-T'ang Texts*, I: 196.

193. Acker, *Some T'ang and Pre-T'ang Texts*, I: 199–200.

194. Acker, *Some T'ang and Pre-T'ang Texts*, I: 200.

195. Acker, *Some T'ang and Pre-T'ang Texts*, I: 205.

196. Acker, *Some T'ang and Pre-T'ang Texts*, I: 128, n. 3. For Gaius Verres see Chapter VII.

197. Acker, *Some T'ang and Pre-T'ang Texts*, I: 128, n. 2.

198. Acker, *Some T'ang and Pre-T'ang Texts*, I: 128.

199. Mi Fu (1052–1107), *Shu shi* [History of Calligraphy], Yishu cong bian edition, pp. 21b–22a; see also Ledderose, *Mi Fu*, pp. 69–91.

200. Xu Hao, *Gu ji ji* [Record of Ancient Works], in *Fa shu yao lu*, chap. 3, p. 52; Acker, *Some T'ang and Pre-T'ang Texts*, I: 216 ff., 231 ff.

201. Lu Shihua, *Scrapbook for Chinese Collectors: Shu Hua Shuo Ling*, trans. Robert H. van Gulik (Beirut, 1958), chap. X, pp. 44–45; chap. XIV, p. 52.

202. Max Loehr, "Chinese Paintings with Sung Dated Inscriptions," *Ars Orientalis* 4 (1961): 219–84.

203. Lu Shihua, *Scrapbook for Chinese Collectors*, chap. XXI, p. 62; see also Sickman,

"Introduction," pp. 26, 30; James Cahill, "Collecting Paintings in China," *Arts Magazine* 37 (April 1963), p. 68.

204. Cahill, "Collecting Paintings in China," p. 69; Wen Fong, "The Problem of Forgeries in Chinese Painting," p. 98.

205. Lu Shihua, *Scrapbook for Chinese Collectors*, chap. XI, pp. 46–47; see also Gulik, *Chinese Pictorial Art*, p. 192; Mi Fu, *Shu shi* [History of Calligraphy], Yishu cong bian edition, p. 56; Ledderose, *Mi Fu*, p. 109, trans. 30.

206. Lu Shihua, *Scrapbook for Chinese Collectors*, chap. XV, pp. 52–54; chap. XVI, pp. 54–55; chap. XVII, p. 56; chap XXIV, p. 66; see also Cahill, "Collecting Paintings in China," p. 70; Fong, "The Problem of Forgeries in Chinese Painting," pp. 97 ff.

207. Kai-Yu Hsu, "The Poems of Li Ch'ing Chao (1084–1141)," *Publications of the Modern Language Association* 77 (December 1962): 522.

208. Hsu, "The Poems of Li Ch'ing Chao (1084–1141)," p. 523.

209. R. C. Rudolph, "Preliminary Notes on Sung Archaeology," *Journal of Asian Studies* 22 (February 1963): 173–74.

210. Acker, *Some T'ang and Pre-T'ang Texts*, I: 114 & n. 1.

211. Arthur F. Wright, *The Sui Dynasty* (New York, 1978), pp. 24–28 ff.

212. Ledderose, "Die kaiserliche Sammlung als Instrument der Kunstpolitik in China," pp. 1633–34.

213. Much of Zhang Yanyuan's family collection disappeared into the imperial collection in this manner (Acker, *Some T'ang and Pre-T'ang Texts*, I: 136–42).

214. The size of the Liang dynasty collection varies according to the account consulted: Zhang Yanyuan lists "240,000 scrolls of famous paintings" (see Acker, *Some T'ang and Pre-T'ang Texts*, I: 122). This *must* be an error. Yet Ledderose also states "240,000 scrolls" in *Mi Fu*, p. 42; while "140,000 scrolls" is given by Zürcher, in "Imitation and Forgery," p. 143.

215. Acker, *Some T'ang and Pre-T'ang Texts*, II: 169–70.

216. Acker, *Some T'ang and Pre-T'ang Texts*, I: 122–23 & n. 2; Ledderose, *Mi Fu*, p. 42 & n. 152.

217. Acker, *Some T'ang and Pre-T'ang Texts*, I: 123–25.

218. Ledderose, "Die kaiserliche Sammlung als Instrument der Kunstpolitik in China," pp. 1632, 1636. When I was in China during the Second World War, the imperial collection and the entire collection of finds made by the Academia Sinica at Anyang were stored in boxes in caves in the Chongqing area.

219. Acker, *Some T'ang and Pre-T'ang Texts*, I: 36–37; cf. 18–19.

220. See Chapters IX and XI.

221. *Kuo Jo-Hsu's Experiences in Painting*, pp. 5–6.

222. *Kuo Jo-Hsu's Experiences in Painting*, pp. 113–14, nn. 25–49, gives a detailed discussion of each title. In addition to the seven extant titles, four others are known in fragments quoted by Zhang Yanyuan.

223. Acker, *Some T'ang and Pre-T'ang Texts*, I: 179.

224. Acker, *Some T'ang and Pre-T'ang Texts*, I: 151–52.

225. Acker, *Some T'ang and Pre-T'ang Texts*, I: 149.

226. Li Sizhen, *Shu hou pin*, in *Fa-shu yao lu*, chap. 3, and Zhu Jingxuan, *Tang chao ming hua lu*, both of the Tang dynasty, are sources cited by Shimada Shujiro in "Concerning the I-P'in Style of Painting-I," trans. J. Cahill, *Oriental Art*, n.s. 7 (Summer 1961): 66–74; see also Alexander C. Soper, "T'ang Ch'ao Ming Hua Lu (The Famous Painters of the T'ang Dynasty)," *Archives of the Chinese Art Society of America* 4 (1950): 5–25.

227. See note 118.

228. Susan Bush, *The Chinese Literati on Painting*, pp. 121–45, collects a series of texts from Yuan figures that exemplifies the new trend.

229. Cahill, *Hills Beyond a River*, p. 112; Cahill, "Collecting Paintings in China," p. 72.

230. Cahill, *Hills Beyond a River*, p. 112; Cahill, "Collecting Paintings in China," p. 72.

231. Cahill, *Hills Beyond a River*, p. 112; Cahill, "Collecting Paintings in China," p. 72.

232. See Chapter VI.

233. Rudolph, "Preliminary Notes on Sung Archaeology," pp. 173–75.

234. Rudolph, "Preliminary Notes on Sung Archaeology," pp. 169–77.

235. Margaret Medley, *The Chinese Potter* (New York, 1976), pp. 156, 158.

236. *Mi Fu on Ink-Stones*, trans. Robert H. van Gulik with intro. and notes (Beijing, 1938).

237. *Mi Fu on Ink-Stones*, p. 31.

238. Ming porcelain collecting has now been firmly dated by Chinese Communist archeologists' finds in Ming tombs. See J. M. Addis, *Chinese Ceramics from Datable Tombs and Some Other Dated Material: A Handbook* (London and New York, 1978), pp. 48 ff.

239. *Chinese Connoisseurship: The Ko-Ku Yao-Lun, The Essential Criteria of Antiquities*, trans. and ed. Sir Percival David, with a facsimile of the Chinese text of 1388 (London, 1971), p. xliii.

240. *Chinese Connoisseurship: The Ko-Ku Yao-Lun*, pp. 257–62.

241. The Han dynasty is the first period from which came a substantial number of essentially identical tomb figures, indicating that the figures were being made in molds.

242. Jan Fontein and Tung Wu, *Unearthing China's Past*, p. 15.

243. Frank Davis, "Horses from the Tomb," *Country Life* 164 (October 19, 1978): 1171.

244. Soper, "The Relationship of Early Chinese Painting to its Own Past," in *Artists and Traditions*, p. 43.

245. H. Paul Varley, "Ashikaga Yoshimitsu and the World of Kitayama: Social Change and Shogunal Patronage in Early Muromachi Japan," in *Japan in the Muromachi Age*, ed. John W. Hall and Toyada Takeshi (Berkeley, 1977), pp. 191–92.

246. The only possible exception is the Hall of the 100 Stelae in Xian, which comprises a whole series of stelae displaying different styles of calligraphy and periods in calligraphy's development (See Thomas Lawton, "An Introduction to the Sian Pei-Lin ['Forest of Stelae']," prepared for the Symposium on Chinese Calligraphy, Yale University [April 8–10, 1977]). My friend, Professor Wen Fong, considers that this assemblage had the character of a public art museum (personal communication from Professor Fong, Princeton University).

247. Ledderose, *Mi Fu*, pp. 43–44; Ledderose, "Die kaiserliche Sammlung als Instrument der Kunstpolitik in China," p. 1635; Acker, *Some T'ang and Pre-T'ang Texts*, I: 212–13.

248. *Xuan he hua pu*, Hua shi cong shu edition (Taipei, 1974), pp. 355–641.

249. The compilation of *Shi qu bao ji* was completed in 1745, and two supplements, *Shi qu bao ji xu bian* and *Shi qu bao ji san bian*, were commissioned in 1793 and 1817 respectively. But publication of the catalogue came somewhat later: *Shi qu bao ji* in 1918; *Shi qu bao ji xu bian*, 1948; and, in 1917, an index to *Shi qu bao ji san bian* was published. It was not until 1969 that the complete text of the catalogue was issued under the same titles by the National Palace Museum, Taipei.

250. I recall the unfortunate President Ngo Dinh Diem telling me that his father, a high mandarin at the Hué court, had been the last Vietnamese to take his degree before the Han Lin Academy was brought to an end at last by the Chinese Revolution of 1911.

251. See, for instance, the boldly shaped earthenware of the Old Silla dynasty (fifth and

sixth centuries A.D.), and the most un-Chinese Old Silla gold work (Kim Chewon and Kim Won-Yong, *The Arts of Korea* [London, 1966], pp. 38 ff. and 176 ff). The gold crowns, particularly, have loud echoes from steppe art.

252. Ikeuchi Hiroshi and Umehara Sueji, *T'ung-kou*, 2 vols. (Tokyo, Xinjing, 1938–40). This concerns the wall paintings found at Gao gou li.

253. Ahn Hwi Joon, "An Kwon and 'A Dream Visit to the Peach Blossom Land,'" *Oriental Art*, n.s. 26 (Spring 1980); Ahn, "Importation of Chin Painting into Korea During the Koryō and the Early Yi Dynasties," *Yamato Bunka*, no. 62 (July 1967). Professor Ahn has much to say about Chinese influence on Korean collecting and Korean painting styles. It may be added that Kim Hong-do, an eighteenth-century master, was in fact one of the first Korean painters to portray Korean rather than Chinese subjects (Kim and Kim, *Arts of Korea*, pp. 22–23).

254. Alexander C. Soper, "The Rise of Yamato-e," *Art Bulletin* 24 (December 1942): 363. This article is the most comprehensive and useful account I have discovered of the Japonification of painting in the centuries through the end of the Heian era.

255. Soper, "The Rise of Yamato-e," pp. 366–70. For those wanting to get the full flavor of Murasaki's painting-collectors' contest (*Tale of Genji*, trans. Seidensticker, pp. 305–17), Soper's commentary is required reading.

256. Sherman E. Lee, "Mu-ch'i," in *Encyclopedia of World Art*, X, (New York, 1965): cols. 371–74; Laurence Sickman, *The Art and Architecture of China*, pp. 140–41.

257. The signatures on the earliest pieces of sculpture in the Hōryū-ji (see Kurata Bunsaku, *Hōryū-ji: Temple of The Exalted Law*, trans. W. Chie Ishibashi, exhibition catalogue, Japan Society, New York, 1981, pp. 23–24 *et passim*) seem somewhat surprising, given their dates. But these may well be the results of two quite different factors: the peculiar organization of the very early Japanese in guild-like clans or clan-like guilds of hereditary specialists called "*be*"; and the high place accorded to the foreign sculptors who played so large a role at the beginning of the story of Buddhist sculpture in Japan. For remembered masters, see again *Tale of Genji*, trans. Seidensticker, pp. 305–17. It should be understood that Lady Murasaki's novel is supposed to describe events in an earlier generation. Hence the masters named in this chapter of her novel were somewhat earlier than her time, like Kimmoki and Tsunenori.

258. Okada Jō, "History of the Collections," in *National Museum, Tokyo*, Great Museums of the World (New York, 1968), p. 162.

259. Personal communication from Dr. Esin Atil, The Freer Gallery of Art.

260. Many useful surveys now exist for the stylistic development of Arabic writing. Among the more recent are: Martin Lings, *The Quranic Art of Calligraphy and Illumination* (London, 1976); Y. H. Safadi, *Islamic Calligraphy* (London, 1978); Annemarie Schimmel, *Islamic Calligraphy* (Leyden, 1970); Anthony Welch, *Calligraphy in the Arts of the Muslim World* (Austin and New York, 1979).

261. N. Abbot, "The Contribution of Ibn Muḳlah to the North Arabic Script," *American Journal of Semitic Languages and Literature* 56 (1939): 70–83; D. S. Rice, *The Unique Ibn al-Bawwāb Manuscript in the Chester Beatty Library* (Dublin, 1955). See also *Encyclopedia of Islam*, 2nd ed. (Leyden, 1960–), s.v. "Ibn Muḳla" and "Ibn al-Bawwāb."

262. Ibn al-Zubayr, *Kitāb al-dhakhā'ir wa-l-tuḥāf*, ed. M. Hamidullah (Kuwait, 1959), p. 255, ss. 382–83.

263. al-Nadim, *Kitāb al-Fihrist*, ed. Gustav Flügel, 2 vols. (Leipzig, 1871–72), and *The Fihrist of al-Nadim: A Tenth Century Survey of Muslim Culture*, ed. and trans. Bayard Dodge, 2 vols. (New York and London, 1970).

264. Eustache de Lorey, "L'École de Tabriz: l'Islam aux prises avec la Chine," *Revue des Arts Asiatiques* 9 (1935): 27–39; Ivan Stchoukine, *La Peinture iranienne sous*

les derniers Abbasides et les Ilkhans (Bruges, 1936); Eric Schroeder, "Ahmed Musa and Shams al-Dīn: A Review of 14th century Painting," *Ars Islamica* 6 (1939): 113–42; M. S. Ipşiroğlu, *Painting and Culture of the Mongols* (New York, 1966); Güner Inal, "Artistic Relationship Between the Far and the Near East as Reflected in the Miniatures of the Ğami' al-Tawārīḫ," *Kunst des Orients* 10 (1975): 108–43.

265. Thomas W. Arnold, "Mīrzā Muḥammad Ḥaydar Dughlāt on the Harāt School of Painters," *Bulletin of the School of Oriental Studies* 5 (1930): 672; "Dūst Muhammad's Account of Past and Present Painters," in L. Binyon, J. V. S. Wilkinson, and B. Gray, *Persian Miniature Painting* (London, 1933; New York, 1971), pp. 184–85. See also a translation of this text by D. E. Klimburg-Salter, "A Sufi Theme in Persian Painting," *Kunst des Orients* 11 (1976/77): 82.

266. Basil Gray, *Persian Painting* (Geneva, 1961; reprint New York, 1977), pp. 46–52.

267. Esin Atıl, *Exhibition of 2500 Years of Persian Art* (Washington, D.C., 1971), cat. no. 26.

268. *Encyclopedia of Islam*, 2nd ed. (Leyden, 1960–), s.v. "Bihzād"; Ivan Stchoukine, *Les Peintures des manuscrits tîmurîdes* (Paris, 1954), pp. 21–25 and 68–86; Gray, *Persian Painting*, chap. 6.

269. V. Minorsky, trans., *Calligraphers and Painters: A Treatise by Qāḍī Aḥmad, Son of Mīr-Munshī* (Washington, D.C., 1959), pp. 155–64, 183–84 (p. 158 refers to library of 3,000 volumes).

270. Minorsky, *Calligraphers and Painters*, p. 184. For more recent discussion of Sultān Ibrahīm Mīrzā's personality and patronage, see various publications by Stuart Cary Welch: *A King's Book of Kings* (New York, 1972), pp. 72–76; *Persian Painting* (New York, 1976), pp. 23–24; *Wonders of the Age: Masterpieces of Early Safavid Painting, 1501–1576* (Cambridge, Mass., 1979) pp. 27–31.

271. Minorsky, *Calligraphers and Painters*, p. 184.

272. Binyon, et al., *Persian Miniature Painting*, pp. 184–85.

273. See note 259, above.

274. Binyon, et al., *Persian Miniature Painting*, pp. 184–85.

275. Merely in the three later Islamic art historians, large numbers of artists are listed.

276. Leading architects were also remembered, for instance, albeit from a relatively late date. Sinan, the great Ottoman architect, is the most famous. Despite the splendor of many of the early Islamic buildings, their designers' names do not survive.

IX. THE PATTERN VANISHES—AND RETURNS

1. T. Leslie Shear, Jr., "The Athenian Agora: Excavations of 1970," *Hesperia* 40 (1971): 249–71.

2. Shear, "The Athenian Agora," p. 273.

3. Alison Frantz, "Pagan Philosophers in Christian Athens," *Proceedings of the American Philosophical Society* 119 (February 1975): 36–37.

4. J. B. Bury, *The History of the Later Roman Empire*, 2 vols. (London, 1923), II: 370.

5. Shear, "The Athenian Agora," pp. 267, 269.

6. See Chapter VII. See also Cyril Mango, "Antique Statuary and the Byzantine Beholder," *Dumbarton Oaks Papers* 17 (1963): 58.

7. Shear, "The Athenian Agora," p. 269.

8. The original plan for this chapter called for parallel treatment of what happened in Western and Eastern Europe in the period under discussion. Under the generous guidance of Professors Cyril Mango of Oxford, Ihor Ševčenko of Dumbarton Oaks and Kurt Weitzmann of Princeton, research was carried as far as language limitations

permitted. The ending in Byzantium proved to be even more complete, if anything, than it was in Western Europe.

There is not a single art collector in the Byzantine record to compare with Henry of Blois (see below, this chapter). The Byzantines never wrote anything approaching art history. Before the very late period, far fewer Byzantine artists are known by their signatures than Western medieval artists, and a surprisingly high percentage of the total number are the illuminators who worked together on a single book, the *Menologium* of the Emperor Basil in the Vatican Library. The theme of all Byzantine art was unquestionably art-for-use-plus-beauty, the uses being to make religion magnificent, to glorify the occupant of the imperial throne, and to give splendor to the lives of the privileged. As for the historical response to art, this can best be judged by careful reading of Professor Mango's illuminating paper, "Antique Statuary and the Byzantine Beholder" (see note 6 above). For the arguments which decided me, see also Professor Mango's *Byzantium: The Empire of New Rome* (New York, 1980), pp. 256–57, and the rest of his excellent chapter on Byzantine art and architecture.

None of this should be taken to mean, of course, that the esthetic sense was somehow dulled in Byzantium, or that the Byzantines did not nourish one of the greatest art traditions we now know about. The flat contrary is true, and Byzantine art also repeatedly influenced contemporary Western European art (see below, note 77). But it is also true that this art tradition eventually became something of a dead end, barring its aftermaths in Russia, Greece, and, perhaps one should add, Armenia, whereas the Western European art of the Dark and Middle Ages was instead a bridge of sorts between later classical art and the new art that was born in Italy after the fourteenth century. In addition, the original plan for this chapter proved to lead inexorably to the most tedious repetitions. So I changed the plan.

9. Among the examples of ancient statues considered demon-tainted, for the statue of Virgil, see Charles Yriarte, *Rimini* (Paris, 1882), pp. 61 ff., 378–79; G. Voigt, *Die Wiederbelebung des classischen Alterthums*, 4th ed., I (Berlin, 1960): 573–75; for the Trier Venus, see Chassot von Florencourt, "Der gesteinigte Venus-Torso zu St. Matthias bei Trier," *Jahrbuch des Vereins von Alterthumsfreunden im Rheinlande* 13 (1848): 128–40; L. Rademacher, "Venus in Ketten," *Westdeutsche Zeitschrift* 24 (1905): 219 ff. See also, Edmond Le Blant, "De quelques statues cachées par les anciens," *Mélanges d'Archéologie et d'Histoire* 10 (1890): 389–96; Mango, "Antique Statuary and the Byzantine Beholder," pp. 55 ff.; A. Esch, "Spolien. Zur Wiederverwendung antiker Baustücke und Skulpturen im mittelalterlichen Italien," *Archiv für Kulturgeschichte* 51 (1969): 45–46.

10. Arnaldo Momigliano, "Cassiodoro," in *Dizionario biografico degli italiani*, XXI (Rome, 1978): 494–504. See also Momigliano, "Cassiodorus and Italian Culture of His Time," *Proceedings of the British Academy* 41 (1955), pp. 207–45; Fedor Schneider, *Rom und Romgedanke im Mittelalter* (1925; reprint Cologne, 1959), pp. 82–96.

11. *The Letters of Cassiodorus, Being a Condensed Translation of the Variae Epistolae of Magnus Aurelius Cassiodorus Senator*, ed. Thomas Hodgkin (London, 1886), p. 138.

12. *The Letters of Cassiodorus*, pp. 442–43.

13. *The Letters of Cassiodorus*, p. 442.

14. Procopius, *History of the Wars* V. xxii. 22. Cf. Cesare Onofrio, *Castel S. Angelo* (Rome, 1971), p. 59. See also Pio Pagliucchi, *I castellani di Castel S. Angelo* (Rome, 1973), pp. 4–5; Mariano Borgatti, *Castel Sant'Angelo in Roma* (Rome, 1931), p. 78; F. Gregorovius, *Geschichte der Stadt Rom im Mittelalter vom V. bis XVI. Jahrhundert*, I–VI ed. W. Kampf, II (reprint Darmstadt, 1963): 178–79.

15. *The Letters of Cassiodorus*, p. 190.

16. *The Letters of Cassiodorus*, p. 331.

17. *The Letters of Cassiodorus*, p. 331.

18. *The Letters of Cassiodorus*, pp. 329–30.

19. Flaminio Vacca, *Memorie di varie antichità trovate in diversi luoghi della città di Roma* (Rome, 1594), p. 5, no. 13; Pietro Santi Bartoli, *Memorie di varie escavazioni fatte in Roma*, in Carlo Fea, *Miscellanea filogica critica e antiquaria* (Rome, 1790), I: CCXXVI, no. 17; CCXXXII, no. 42; Rodolfo Lanciani, *Storia degli scavi di Roma*, I (Rome, 1902): 22 ff. *et passim*; Arnold Esch, "Spolien. Zur Wiederverwendung antiker Baustücke und Skulpturen im mittelalterlichen Italien," pp. 1–14 *et passim*.

20. See Chapter VII.

21. Procopius, *History of the Wars* VIII. xxi. 12–13. Cf. Rodolfo Lanciani, *La distruzione di Roma antica* (Milan, 1971), pp. 13, 84.

22. Procopius, *History of the Wars* VIII. xxi. 5. Cf. Lanciani, *La distruzione di Roma antica*, p. 85.

23. Paul the Deacon, *History of the Langobards*, trans. William Dudley Foulke (Philadelphia, 1907), pp. 223–24 (V. xi).

24. Paul the Deacon, *History of the Langobards*, vol. V, xi, p. 224.

25. *Liber Pontificalis*, ed. L. Duchesne (Paris, 1955), p. 343 (78.3). See also Paul the Deacon, *History of the Langobards*, p. 224 (V. xi); Frank G. Moore, "The Gilt-Bronze Tiles of the Pantheon," *American Journal of Archeology* 3, ser. 2 (1899): 40–43.

26. Erwin Panofsky, *Renaissance and Renascences in Western Art* (Stockholm, 1960), pp. 42–54.

27. P. E. Schramm and F. Mütherich, *Denkmale der deutschen Könige und Kaiser* (Munich, 1962), p. 114, no. 2.

28. Schramm and Mütherich, *Denkmale der deutschen Könige und Kaiser*, p. 115, no. 5; E. G. Grimme, "Der Aachener Domschatz," *Aachener Kunstblätter* 42 (1973): 7, nos. 1, 2; W. Braunfels, "Karls des Grossen Bronzewerkstatt," in *Karl der Grosse*. III. *Karolingische Kunst* (Düsseldorf, 1965), 168 nos. 4, 5; 196; *Karl der Grosse*, exhibition catalogue (Aachen, 1965), p. 27, no. 3; Richard Krautheimer, "Carolingian Revival of Early Christian Architecture," *Art Bulletin* 24 (1942): 35.

29. Agnellus, *Liber Pontificalis Ecclesiae Ravennatis*, ed. O. Holder-Egger in *Monumenta Germaniae Historica*, Scriptores Rerum Langobardicum et Italicorum Saec. VI–IX (Hanover, 1878), p. 338 (94); Julius von Schlosser, ed., *Schriftquellen zur Geschichte der karolingischen Kunst*, Quellenschriften für Kuntsgeschichte, n. s. 4 (Vienna, 1892), p. 1140. See also Harmut Hoffman, "Die Aachner Theodorichstatue," *Das erste Jahrtausend*, ed. Victor H. Elbern, I (Düsseldorf, 1962): 318–35; Krautheimer, "Carolingian Revival of Early Christian Architecture," pp. 35–36; Gunter Bandmann, "Die Vorbilder der Aachener Pfalzkapelle," *Karl der Grosse*. III, *Karolingischen Kunst*, p. 439; Schlosser, *Quellenbuch zur Kunstgeschichte des abendländischen Mittelalters*, Quellenschriften für Kuntsgeschichte, n.s. 7 (Vienna, 1896) pp. 134–38.

30. *The Autobiography of Guibert: Abbot of Nogent-Sous-Coucy*, trans. C. C. Swinton Bland (London, 1926), p. 9.

31. Magister Gregorius, *Narracio de Mirabilibus Urbis Romae*, ed. R. B. C. Huygens (Leyden, 1970), pp. 20–21. See also James Bruce Ross, "A Study of Twelfth Century Interest in the Antiquities of Rome," *Medieval and Historiographical Essays in Honor of T. W. Thompson* (Chicago, 1938), pp. 316–20.

32. Magister Gregorius, *Narracio de Mirabilibus Urbis Romae*, pp. 9–10.

33. Tilmann Buddensieg, "Gregory the Great: The Destroyer of Pagan Idols," *Journal of the Warburg and Courtauld Institutes* 28 (1965): 44–65.

34. Magister Gregorius, *Narracio de Mirabilibus Urbis Romae*, p. 20.

35. Arnold Esch, "Spolien. Zur Wiederverwendung antiker Baustücke und Skulpturen im mittelalterlichen Italien," pp. 35 ff.

36. Magister Gregorius, *Narracio de Mirabilibus Urbis Romae*, p. 13; *A Description of Rome by Benjamin of Tudela* in trans. of *Mirabilia Urbis Romae* by Francis Morgan Nichols, *The Marvels of Rome* (London and Rome, 1889), p. 156. See also James S. Ackerman, "Marcus Aurelius on the Capitoline Hill," *Renaissance News* 10 (1957): 69–75; Arturo Graf, *Roma nella memoria e nelle immaginazioni del Medio Evo* (Turin, 1923), pp. 456–61.

37. Dante Alighieri, *La Commedia. 2. Inferno*, ed. G. Petrocchi (Milan, 1966), XIII. ll. 144–47; Alighieri, *La Commedia. 4. Paradiso*, ed. Petrocchi (Milan, 1967), XVI. ll. 145–47. See also Giovanni Villani, *Cronica*, ed. F. Gherardi Dragomanni, I (Florence, 1844): bk. III, chap. 1; bk. IV, chap. 7; bk. V, chap. 38; Werner Haftmann, *Das italienische Säulenmonument* (Leipzig, 1939), pp. 124–25.

38. Esch, "Spolien. Zur Wiederverwendung antiker Baustücke und Skulpturen im mittelalterlichen Italien," pp. 1–64, *passim*; R. Hamann-McLean, "Antikenstudium in der Kunst des Mittelalters," *Marburger Jahrbuch für Kunstwissenschaft* 15 (1949/50): 161–73.

39. Jean Taralon, "La Nouvelle Présentation du trésor de Conques," *Les Monuments historiques de la France* n.s. 1, no. 3 (1955); Taralon, "La Majesté d'Or de Sainte Foy du trésor de Conques," *Revue de l'Art*, nos. 40–41 (1978): 16; Marie-Madeleine Gautier, *Rouergue roman* (La Pierre-qui-Vive, 1963), p. 136; *Les Trésors des églises de France*, exhibition catalogue, Musée des Arts Décoratifs (Paris, 1965), pp. 289, no. 534, 292–93.

40. Taralon, "La Nouvelle Présentation du trésor de Conques"; Taralon, "La Majesté d'Or de Sainte Foy du trésor de Conques," p. 17. Gautier, *Rouergue roman*, p. 136; *Les Trésors des églises de France*, pp. 289 ff.

41. There are thirty-three early carved gems, all antique except one from the very late empire, one Byzantine, and one Carolingian (*Les Trésors des églises de France*, p. 289).

42. Hans Wentzel, "Mittelalter und Antike im Spiegel kleiner Kunstwerke des 13. Jahrhunderts," in *Studien tillägnade Henrik Cornell på 60 årsdagen* (1950), p. 79; G. A. S. Snijder, "Antique and Mediaeval Gems on Bookcovers at Utrecht," *Art Bulletin* 14 (1932): 5–52. W. S. Heckscher, "Relics of Pagan Antiquities in Medieval Settings," *Journal of the Warburg Institute* 1 (1937/38): 204–20.

43. Erwin Panofsky, *Tomb Sculpture* (New York, 1964), p. 48; Richard H. L. Hamann-McLean, "Antiken Studium," p. 163; *Karl der Grosse*, p. 30, no. 7; H. Beumann, "Grab und Thron Karls des Grossen zu Aachen," *Karl der Grosse. IV, Das Nachleben* (Düsseldorf, 1967), pp. 9–38; Grimme, "Der Aachener Domschatz," p. 8, no. 3.

44. R. Montini, *Le tombe dei papi* (Rome, 1957), pp. 142–43, 183–87, 197–99, 229–30.

45. Bede, *The Ecclesiastical History of the English People and Other Selections from the Writings of the Venerable Bede*, ed. James Campbell (New York, 1968), p. 216; see also Thomas Wright, "On Antiquarian Excavations and Researches in the Middle Ages," *Archaeologia* 30 (1844): 439.

46. Lanciani, *Storia degli scavi di Roma*, vol. I, *passim*; Lanciani, *La distruzione di Roma Antica*, pp. 180–97.

47. Federico Hermanin, *L'arte in Roma dal secolo VIII al XIV* (Bologna, 1945), pp. 107–23; Arnold Esch, *Bonifaz IX. und der Kirchenstaat* (Tübingen, 1969), pp. 212–13 *et passim*.

48. E. Nash, *Pictorial Dictionary of Ancient Rome* (London, 1962), II: 376 ff.; G. Lugli, *I monumenti antichi di Roma*, III (Rome, 1938): 275, 279.

49. Hermanin, *L'arte in Roma dal secolo VIII al XIV*, pp. 112–14; C. Cecchelli, *Studi e documenti sulla Roma Sacra*, I (Rome, 1938): 264; P. Fedele, "Il culto di Roma nel Medio Evo a la casa di Niccolò di Crescenzio," in *Il Centro di Studi di Storia dell'Architettura* (Rome, 1940), pp. 17–26; B. M. Apolloni, "La casa dei Crescenzi nell'architettura e nell'arte di Roma medioevale," in *Il Centro di Studi di Storia dell'Architettura*, pp. 27–37; Luigi Càllavi, *I palazzi di Roma* (1932; reprint Rome, 1968), pp. 87–90.

50. Magister Gregorius, *Narracio de Mirabilibus Urbis Romae*, p. 13.

51. John of Salisbury, *Historia Pontificalis*, ed. R. L. Poole (Oxford, 1927), pp. 81–82; John of Salisbury, *Memoirs of the Papal Court*, trans. Marjorie Chibnall (London, 1956), pp. 78–79. See also Horace Kinder Mann, *The Lives of the Popes in the Middle Ages* (London, 1925), IX: 81–82.

52. John of Salisbury, *Memoirs of the Papal Court*, p. 79, n. 1; see also E. F. Jacob, "Some Aspects of Classical Influence in Mediaeval England," *Vorträge der Bibliothek Warburg 1930/31* (Leipzig, 1932), pp. 14–15; cf. P. C. Claussen, "Antike und gotische Skulptur in Frankreich um 1200," *Wallraf-Richartz-Jahrbuch* 35 (1973): 84. George Parks, *The English Traveller to Italy*, (Rome, 1954), I: 106. See also Ross, "A Study of Twelfth Century Interest in the Antiquities of Rome," pp. 307–08.

53. Horace, *Satires* II. iii. 64.

54. John of Salisbury, *Memoirs of the Papal Court*, p. 80.

55. Jacob, "Some Aspects of Classical Influence in Mediaeval England," p. 15; W. Oakeshott, *Classical Inspiration in Medieval Art* (London, 1959), pp. 77–78; Parks, *The English Traveller to Italy*, I: 106, n. 7.

56. P. Fedele, "Sul commercio delle antichità in Roma nel XII secolo," *Archivio della Società Romana di Storia Patria* 32 (1909): 466; Esch, "Spolien. Zur Wiederverwendung antiker Baustücke und Skulpturen im mittelalterlichen Italien," pp. 26–27.

57. Meyer Schapiro, "On the Aesthetic Attitude in Romanesque Art," in *Romanesque Art* (New York, 1977), pp. 1–27.

58. V. Mortet and P. Deschamps, eds., *Recueil de textes sur l'histoire de l'architecture et la condition des architectes*, II (Paris, 1929): 167–70.

59. Otto von Simson, *The Gothic Cathedral*, rev. ed. (New York, 1962), p. 160.

60. Simson, *The Gothic Cathedral*, pp. 160, 161–62.

61. *The Miracles of the Virgin in Chartres Cathedral*, ed. Robert Branner (New York, 1969), p. 95.

62. Simson, *The Gothic Cathedral*, p. 162.

63. Simson, *The Gothic Cathedral*, p. 162.

64. Simson, *The Gothic Cathedral*, p. 162.

65. Simson, *The Gothic Cathedral*, p. 163.

66. Simson, *The Gothic Cathedral*, pp. 163–64.

67. Simson, *The Gothic Cathedral*, pp. 175–76, 178–82.

68. Simson, *The Gothic Cathedral*, pp. 186, 217.

69. Willibald Sauerländer, *Gothic Sculpture in France 1140–1270*, trans. Janet Sondheimer (London, 1972), p. 404.

70. Sauerländer, *Gothic Sculpture in France 1140–1270*, p. 11.

71. See note 36. See also L. Duchesne, "L'Auteur des Mirabilia," *Mélanges d'Archéologie et d'Histoire* 24 (1904): 479–89; R. van Marle, "Overzicht der voornaamste beschrijvingen von Rome uit den vroeg-christelijken tijd, middeleeuwen en renaissance," *Mededeelingen van het Nederlandsch Historisch Instituut te Rome* 3 (1923): 141 ff.; 4 (1924): 153 ff.; P. E. Schramm, *Kaiser Rom und Renovatio* II (Leipzig, 1929): 47–51; Schneider, *Rom und Romgedanke im Mittelalter*, pp. 174–78.

72. J. M. C. Toynbee, *The Hadrianic School* (Cambridge, 1934), pp. 152–59.

73. Nichols, *Mirabilia Urbis Romae*, pp. 46–47.

74. Nichols, *Mirabilia Urbis Romae*, pp. 39–40; see also Graf, *Roma nella memoria e nelle imaginazioni*, pp. 111–12.

75. Magister Gregorius, *Narracio de Mirabilibus Urbis Romae*, pp. 18–19.

76. It does not appear to be worthwhile to try to demonstrate the disappearance of *all* the by-products of art in the Dark and Middle Ages. The most important of these phenomena, without which I believe the rest cannot come into existence, are undoubtedly art collecting and art history, and these two have already been covered. What I have called counterfeits of some of the other phenomena existed in the period in question, but if the reader will bear in mind the definitions offered in this essay, the counterfeits should be easy to recognize for what they are. Besides luxuries and treasures, for example, certain works of art were also produced for the market (see J. Lestoquoy, "Le Commerce des oeuvres d'art au moyen âge," *Annales d'Histoire Sociale* 3 [1943]), but there was certainly no collectors' art market, on which works by this or that named master were offered for enormous premiums. Equally, some have seen the medieval church treasuries as primitive museums, just as the treasuries have been seen as art collections of a sort. The treasuries were undoubtedly visited by pilgrims who could gain access to them. Yet the real drawing cards were the reliquaries stored in the treasuries and the immense richness of the treasuries themselves. In addition, some ecclesiastical treasuries had a minor *Wunderkammer* side. This was probably how churches began to acquire ostrich eggs, like the one in Piero della Francesca's Madonna and Child with Saints and Angels adored by Federigo da Montefeltro. The first eggs were no doubt brought back as great curiosities by returning Crusaders. But *Wunderkammern* are not art museums. The truth is, anything in the period that looks like one of the by-products of art in fact turns out to be essentially different on close analysis.

77. Otto Demus, *Byzantine Art and the West* (New York, 1970); Ernst Kitzinger, "The Byzantine Contribution to Western Art of the Twelfth and Thirteenth Centuries," *Dumbarton Oaks Papers* 20 (1966): 25–47; reprinted in Kitzinger, *The Art of Byzantium and the Medieval West: Selected Studies* (Bloomington, Ind., 1976), pp. 358–78; Kurt Weitzmann, "Various Aspects of Byzantine Influence on the Latin Countries from the Sixth to the Twelfth Century," *Dumbarton Oaks Papers* 20 (1966): 1–24.

78. G. G. Coulton, *Art and the Reformation* (1928; reprint Hamden, Conn., 1969), p. 242.

79. Émile Mâle, *L'Art religieux du XIIIe siècle en France* (1898; Paris, 1958) I: 29–70.

80. E. H. Gombrich, *The Story of Art*, 3rd ed. (London, 1950), pp. 113–14.

81. F. de Mély, *Les Primitifs et leurs signatures: les miniaturistes* (Paris, 1913). His colleagues are attacked at length in the introduction.

82. Simson, *The Gothic Cathedral*, pp. 168, 180–81.

83. John Harvey, *The Gothic World: 1100–1600, A Survey of Architecture and Art* (London, 1950), p. 61; cf. Alan Priest, "The Masters of the West Façade of Chartres," *Art Studies* 1 (1923) 31 ff.

84. Simson, *The Gothic Cathedral*, p. 225.

85. Simson, *The Gothic Cathedral*, pp. 183–231.

86. C. R. Dodwell, *Painting in Europe 800–1200*, Penguin ed. (Harmondsworth, 1971), pp. 103–5.

87. On the French sculptors, see Sauerländer, *Gothic Sculpture in France*, p. 24. As for the Italians, eulogistic inscriptions are preserved on sculptures in Modena, Ferrara and Verona. For example, one sculptor in Modena left this inscription on his work at the Cathedral of S. Geminiano: "Amongst sculptors, how worthy of honour and fame thou art, thy sculptures now show, O Guglielmo." Another inscribed these

words on a series of reliefs in S. Zeno at Verona: "Thou canst see the skill of Nicolò from these examples of his work." See Arthur Kingsley Porter's *Lombard Architecture*, 3 vols. (1917; reprint New York, 1967), III: 15, 530. I should like to thank Professor Meyer Schapiro for the privilege of reading page 19 of the manuscript of his unpublished article entitled "Wolvinius Magister Phaber: The Crowning of an Artist in the Early Middle Ages," in which he discusses the matter of the Italian signatures. See also Antje Middeldorf Kosegarten, "The Origins of Artistic Competitions in Italy," *Lorenzo Ghiberti nel suo tempo*, Atti del Convegno 1978 (Florence, 1980), pp.170 ff.

88. Edward Hutton, *The Cosmati* (London, 1950), pp. 33 ff.

89. By chance, a work on Central Asian painting came to hand two weeks after the previous statement in the text was put on paper. Here was found Tita, whose signature is to be seen on the leg of an elephant in one of the Buddhist Jātaka frescoed scenes of the late third century A.D., from Miran, an extremely remote site on the Southern Silk Road. And here, too, was found a record of signed wooden votive tablets, painted approximately 300 to 400 years later than Tita's fresco. These are from Kuča, a site on the Northern Silk Road. See Mario Bussagli, *Central Asian Painting* (London, 1978), pp. 21 ff., 71.

90. George M. A. Hanfmann, *From Croesus to Constantine* (Ann Arbor, 1975), pp. 63–64; Martin Robertson, *A History of Greek Art*, 2 vols. (London, 1975), I: 608, 611.

91. The only sculptors named in this little book are Scopas, Praxiteles, and Lysippus. See Callistratus, *Descriptiones* 2–3, 6, 11.

92. Ranuccio Bianchi Bandinelli, *Rome, The Centre of Power: Roman Art to A.D. 200*, trans. Peter Green (London, 1970), pp. 229 ff.

93. W. Martin Conway, "The Abbey Church of Saint-Denis and its Ancient Treasures," *Archaeologia*, 66, ser. 2, no. 16 (1914–15): 128–30, pl. X; J. Hubert, J. Porcher, W. F. Volbach, *The Carolingian Renaissance*, (New York, 1970), pp. 254, no. 234; 256, 291, no. 323; 356, no. 234; 361, no. 323.

94. This includes almost all of Germany and the eastern Slav countries of Europe, plus the area of the three Scandinavian countries of today.

95. R. Ewart Oakeshott, *The Archaeology of Weapons* (New York, 1960), p. 99.

96. Willy Hartner, *Die Goldhörner von Gallehus* (Wiesbaden, 1969).

97. Hartner, *Die Goldhörner von Gallehus*, pp. 2, 25.

98. What appear to be smiths' marks are already to be seen, punched on some blades of the late Hallstatt period. Some of these marks are surprisingly elaborate. Actual signed swords were found in the great trove in the Nydam bog in Denmark (Oakeshott, *The Archaeology of Weapons*, pp. 60, 99). Signed swords were also imported to Scandinavia from the Rhineland during the Viking Age. See James Graham-Campbell and Dafydd Kidd, *The Vikings* (London and New York, 1980), p. 133.

99. Émile Lesne, *Histoire de la propriété ecclésiastique en France*, III (Lille, 1936): 185, n. 6.

100. *Vita Eligii Episcopi Noviomagensis*, ed. W. Krusch, in *Monumenta Germaniae Historica*, Scriptorum Rerum Merovingicarum, IV (Hanover and Leipzig, 1902): 634–761 (X. 32). See also *Dictionnaire d'archéologie chrétienne et de liturgie*, ed. F. Cabrol and H. Leclercq, IV: 2674–87; *Butler's Lives of the Saints*, 4 vols., ed. Herbert Thurston, S.J. and Donald Attwater (New York, 1956) IV: 456. Anatole de Barthélemy, "Liste des noms d'hommes gravés sur les monnaies de l'epoque mérovingienne," *Bibliothèque de l'École des Chartes* 42 (1881): 283–305. Barthélemy doubts that the Eligius who put his name on coins was the same Eligius who became a bishop and a saint, because the coinage from the time of Clovis II would imply that Eligius

had continued as a moneyer after becoming bishop. He further appends a long list of names on Merovingian coins and he argues that most of them were the names of moneyers because of the peculiar and very primitive organization of coin production in the period. The assumption that the moneyer Eligius was also the bishop and saint is more usual among students of the problem.

101. Ludwig Roselius, *Deutsche Kunst*, III (Bremen and Berlin, 1935): 12a.

102. Édouard Aubert, *Trésor de l'Abbaye de Saint-Maurice d'Agaune* (Paris, 1872), pp. 141–45. See also Lesne, *Histoire de la propriété ecclésiastique en France*, III: 202; P. Bouffard and J.-M. Theurillat, *Saint-Maurice d'Agaune: trésor de l'Abbaye* (Geneva, 1974).

103. Lesne, *Histoire de la propriété ecclésiastique en France*, III: 186; Hubert, et al., *The Carolingian Renaissance*, pp. 241–46, 355, nos. 220, 221. See also Oleg Zastron, *L'oreficeria in Lombardia* (Milan, 1978), fig. 89.

104. Lesne, *Histoire de la propriété ecclésiastique en France*, III: 194 n. 11. See also Roger Hinks, *Carolingian Art* (1934; reprint Ann Arbor, 1962), pp. 109, 191.

105. Lesne, *Histoire de la propriété ecclésiastique en France*, III: 116. Schlosser, *Schriftquellen zur Geschichte der karolingischen Kunst*, pp. 67, no. 236; 442, no. 15.

106. Lesne, *Histoire de la propriété ecclésiastique en France*, III: 223.

107. *Libri Carolini sive Caroli Magni Capitulare de Imaginibus*, ed. H. Bastgen, in *Monumenta Germaniae Historica. Legum. Sectio III. Concilia, Tomi II Supplementium* (Hanover and Leipzig, 1924) (I, 2; III, 13). See also Rosario Assunto, *La critica d'arte nel pensiero medioevale* (Milan, 1961), pp. 61–70.

108. Roger Hinks, *Carolingian Art*, pp. 98–99.

109. See the letter of Pope Gregory I to Bishop Serenus of Marseilles in *Sancti Gregorii Magni Epistolae*, bk. XI, letter 13, in *Patrologia Latina*, vol. 77 (Paris, 1849), cols. 1128–30; see also Assunto, *La critica d'arte nel pensiero medioevale*, pp. 55–59.

110. Rudolf Wittkower, *Gothic Versus Classic* (London, 1974). See also James Ackerman, " 'Ars sine scientia nihil est.' Gothic Theory of Architecture at the Cathedral of Milan," *Art Bulletin* 31 (June 1949): 84–111.

111. A. Nava, *Memorie e documenti storici intorno all'origine, alle vicende ed ai riti del Duomo di Milano* (Milan, 1854); *Annali della fabbrica del Duomo di Milano dall'origine fino al presente*, 8 vols. (Milan, 1877–85).

112. Two recent editions of *De Diversis Artibus* by Theophilus are *On Divers Arts*, trans., intro., and annot. J. G. Hawthorne and C. S. Smith (Chicago, 1963); and *The Various Arts*, trans., intro., and annot. C. R. Dodwell (London, 1961). See also the reprint of the nineteenth-century edition by Charles de l'Escapolier, *Théophile prêtre et moine. Essai sur divers arts*, intro. by J.-M. Guichard (1843; reprint Nogent-le-Roi, 1977).

113. Theophilus, *On Divers Arts*, pp. 11–13.

114. Heraclius, *De Coloribus et Artibus Romanorum*, ed. Albert Ilg in *Heraclius. Von den Farben und Künsten der Römer*, Quellenschriften für Kunstgeschichte 4 (Vienna, 1873): 2–146. See also the English and Italian editions: Mrs. Merrifield, *Manuscripts of Eraclius—De Coloribus et Artibus Romanorum*, Original Treatises on the Arts of Painting (London, 1849), I: 166–257; A. Pellizzari, "Heraclii Sapientissimi Viri. De Coloribus et Artibus Romanorum," *I trattati attorno le arti figurative*, I (Naples, 1915), 503–15.

115. Heraclius, *De Coloribus et Artibus Romanorum*, bk. I, chap. VI (Ilg ed., p. 61).

116. Hans R. Hahnloser, *Villard de Honnecourt*, 2nd rev. ed. (Graz, 1972). Some scholars have called it a lodgebook. See Paul Frankl, *The Gothic: Literary Sources and Interpretations* (Princeton, 1960), pp. 35–48; Coulton, *Art and the Reformation*, pp. 99–109.

117. For example, the drawing of the tower of the cathedral at Laon, with the sculptured bulls which still survive, must have been made to record something uncommon (folio 9 verso and 10 recto). The most lovely of all rose windows, at Chartres, also appears (folio 15 v.).

118. Including the right layout of the craft workshop (Theophilus, *The Various Arts*, pp. 64 ff.).

119. The *Sketchbook* was used as a source in an early-nineteenth-century work on medieval costume, but was first seriously brought to the attention of the learned world by Jules Quicherat; see "Notice sur l'album de Villard de Honnecourt," *Revue Archéologique* 6 (1849): 65–80, 164–88, 209–26. Following these articles, Quicherat published a facsimile of the *Sketchbook* with commentary by himself and M.J.B.A. Lassus. He also showed the *Sketchbook* to Robert Willis, who then produced *Facsimile of the Sketch-Book of Wilars De Honecort, an Architect of the Thirteenth Century; with Commentaries and Descriptions by M. J. B. A. Lassus and by M. J. Quicherat,* ed, Robert Willis (London, 1859). The real flood of learned writing followed thereafter.

120. See the bibliography in Hahnloser, *Villard de Honnecourt,* pp. 177–81, 280–81.

121. The Byzantine masters whose names had been discovered by scholarship by 1878 are listed and described by Friedrich Wilhelm Unger, *Quellenschriften der Byzantinischen Kunstgeschichte,* Quellenschriften für Kunstgeschichte 12 (Vienna, 1878; reprint Osnabrück, 1970), pp. 45–54. The list is extremely short; but it has been lengthened somewhat since the time of Unger, most notably by the discovery of the names of the donors of St. Catherine of Sinai, the Emperor Justinian and Empress Theodora, together with the name of the architect, Stephanus of Eilat, all painted on the roof beams of the church. This discovery was made by the historic Sinai expedition led by Professor Kurt Weitzmann of Princeton University; see George H. Forsyth and Kurt Weitzmann with Ihor Ševčenko and Fred Anderegg, *The Monastery of Saint Catherine of Mount Sinai: The Church and Fortress of Justinian,* Plates vol. (Ann Arbor, 1966), p. 8. Nonetheless, the Byzantine total is close to infinitesimal, compared with the very large total of names of medieval artists and draftsmen who have now been discovered by scholarship, even if you also include Byzantine artists known to have worked in the West, who are not usually taken into account by Byzantinists. See A. L. Frothingham, Jr., "Byzantine Artists in Italy from the Sixth to the Fifteenth Century," *American Journal of Archaeology* 9 (1894): 32–52.

 The truly remembered masters, whose incorporation into the general cultural memory is attested by references in the existing literature, are Anthemius of Thralles, Isidorus of Miletus, and Eulalius. For recognition of Anthemius of Thralles and Isidorus of Miletus, architects of Hagia Sophia, see Procopius, *De Aedificiis* I, i. 24, 50, 70; II, iii, 7. For the painter Eulalius, see Theodorus Prodromus, "Supplicatory Poem Addressed to Emperor Manuel I," verses 37 ff., in A. Maiuri, "Una nuova poesia di Teodoro Prodromo," *Byzantinische Zeitschrift* 23 (1920): 399 ff; Nicephorus Callistus' epigram in A. Papadopoulos-Kerameus, "Nikêphonos Kallistosxanthopoulos," *Byzantinische Zeitschrift* 11 (1902): 46, no. 14; Nikolas Mesarites, "Description of the Church of the Holy Apostles at Constantinople," ed. and trans. G. Downey, *Transactions of the American Philosophical Society* 47 (1957): 860, 884, n. 30.

122. Vasari-Milanesi, I: 237–38.

123. Vincenzo Bellemo, *Jacopo e Giovanni de Dondi* (Chioggia, 1894), pp. 134–38.

124. See also Roger de Gaignières' drawings of ancient tombs, in Jean Adhémar, "Les Tombeaux de la Collection Gaignières," *Gazette des Beaux-Arts* 84 (July-September 1974): 5–192; 88 (July-August 1976): 3–88; 88 (September 1976), 89–128; 90 (July-August 1977): 3–76.

125. J.-F. Félibien. *Receuil historique de la vie et des ouvrages des plus célèbres architectes*, in André Félibien, *Entretiens sur les vies et sur les ouvrages des plus excellents peintres anciens et modernes; avec la vie des architectes*, rev. ed. (Paris, 1725), V: 226. J.-F. Félibien's work, first published in 1687, was included in this later edition of his uncle André's *Entretiens*.

126. Félibien, *Entretiens sur les vies*, V: 227–28.

127. Félibien, *Entretiens sur les vies*, V: 228–31.

128. Félibien, *Entretiens sur les vies*, V: 227.

129. *Horace Walpole's Correspondence*, ed. Wilmarth S. Lewis, XVI (New Haven, 1951): 27.

130. Wilmarth S. Lewis, "The Genesis of Strawberry Hill," *Metropolitan Museum Studies* 5 (1934–36): 82; Donald R. Stewart, "James Essex," *Architectural Review* 108 (1950): 321.

131. Stewart, "James Essex," pp. 319–20, 321. See also Nikolaus Pevsner, *Some Architectural Writers of the Nineteenth Century* (Oxford, 1972), pp. 2 ff.

132. Willis was Jacksonian Professor of Natural and Experimental Philosophy at the University of Cambridge, 1837–75. See Pevsner, *Some Architectural Writers of the Nineteenth Century*, pp. 52–61.

133. Robert Willis, "On the Construction of Vaults in the Middle Ages," *Transactions of the Royal Institute of Architects* 1, pt. 2 (1842).

134. Robert Willis, *The Architectural History of Canterbury Cathedral* (London, 1845).

135. Gervase of Canterbury, *Tractatus de Combustione et Reparatione Cantuariensis Ecclesiae*, in *The Historical Works of Gervase of Canterbury*, ed. William Stubbs, I (London, 1879): 3–29. Willis translated the work in *The Architectural History of Canterbury Cathedral*, pp. 32–62.

136. Gervase of Canterbury, *Tractatus*, ed. Stubbs, I: 7–9; Willis, *The Architectural History*, p. 9, notes.

137. Pevsner, *Some Architectural Writers of the Nineteenth Century*, p. 7.

138. Willis, *The Architectural History*, pp. 35 ff., 51 ff.

139. Willis, *The Architectural History of Canterbury Cathedral*, p. xvi.

140. John Harvey, ed., *English Medieval Architects: A Biographical Dictionary Down to 1550* (London, 1954), pp. 171–73, 312–19; Harvey, *Henry Yevele* (London, 1944).

141. Harvey, *English Medieval Architects*, pp. 171, 314–16, 318–19; Arthur Oswald, "Canterbury Cathedral: The Nave and Its Designer," *Burlington Magazine* 75 (December 1939): 221–28; Harvey, *Henry Yevele*, pp. 49, 66, 71–2.

142. Harvey, *Henry Yevele*, pp. 51, 64–66, 71, 72. See also Harvey citations in notes 140 and 141.

143. Royal Commission on Ancient and Historical Monuments, *Inventory of Westminster Abbey* (London, 1924); W. R. Lethaby, *Westminster Abbey and the King's Craftsmen* (London, 1906); Lethaby, *Westminster Abbey Re-examined* (1925; reprint New York, 1972). Peter Brieger, *English Art 1216–1307* (Oxford, 1957), pp. 106–34. See also Otto Lehmann-Brockhaus, *Lateinische Schriftquellen zur Kunst in England, Wales und Schottland vom Jahre 901 bis zum Jahre 1307* II (Munich, 1956): 108, no. 2668; 109, no. 2669; 122–23, nos. 2725–29; 148–49, nos. 2754–55; 151–52, no. 2763; 154–55, nos. 2772–73; 155, no. 2778; 165, no. 2817; 165–66, nos. 2820–21; 168–69, nos. 2831–32.

144. Tancred Borenius, "The Cycle of Images in the Palaces and Castles of Henry III," *Journal of the Warburg and Courtauld Institutes* 6 (1943): 42. See also T. Hudson Turner, *Some Accounts of Domestic Architecture in England* (Oxford, 1851), p. 262.

145. W. R. Lethaby, "English Primitives: The Painted Chamber and the Early Masters of

the Westminster School," *Burlington Magazine* 7 (July 1905): 257–69; Lethaby, "The English Primitives—VIII," *Burlington Magazine* 33 (July 1918): 3–7.

146. *Building Accounts of King Henry III*, ed. H. M. Colvin (Oxford, 1971).

147. *Building Accounts of King Henry III*, p. 239.

148. Carl Nordenfalk, "Der Meister des Registrum Gregorii," *Münchner Jahrbuch der bildenden Kunst* 1 (1950): 61–77; Nordenfalk in André Grabar and Nordenfalk, *Early Medieval Painting*, trans. Stuart Gilbert (London, 1957), p. 203; Peter Lasko, *Ars Sacra 800–1200*, Penguin ed. (Harmondsworth, 1972), pp. 106–7, 214–15; D. H. Turner, " 'The Odalricus Peccator' Manuscript in the British Museum," *British Museum Quarterly* 25 (1962): 11–16; John Beckwith, *Early Medieval Art* (New York, 1964), pp. 97–103. So many citations are provided here to show what one can only call the power of the labels that create the personages.

149. D. Grivot and G. Zarnecki, *Gislebertus: Sculptor of Autun* (London, 1961), pp. 19, 25.

150. Grivot and Zarnecki, *Gislebertus*, pp. 13, 25, 28.

151. André du Sommerard, *Les Arts au moyen âge* (Paris, 1843), pp. 202, n. 2, 203, 205.

152. Grivot and Zarnecki, *Gislebertus*, p. 14.

153. Grivot and Zarnecki, *Gislebertus*, pp. 13 ff.

154. Kenneth Clark, *Civilisation* (New York, 1969), pp. 46–47.

155. This is a standard result when a new medieval master of some eminence has a name put to him. Connections with other masters, the possibility that the newly named master had a school of his own, and his later influence, are among the matters promptly explored.

156. Léon de Laborde, *Les Ducs de Bourgogne: études sur les lettres, les arts et l'industrie pendant le XVe siècle* (Paris, 1849), vol. I.

157. Léon de Laborde, *La Renaissance des arts à la cour de France: études sur le seizième siècle*, 2 vols. (1850–55; reprint New York, 1966).

158. Laborde, *La Renaissance des arts*, I: 1–150; II: 565–73. See also Peter Mellen, *Jean Clouet* (London, 1971), pp. 3–5.

159. Laborde, *Les Ducs de Bourgogne*, I: 575.

160. Henri David, *Claus Sluter* (Paris, 1951), pp. 108 ff. Georg Troeschev, *Claus Sluter* (Freiburg i.B., 1932), p. 15.

161. Charles Oursel, "Les 'Pleurants' disparus des tombeaux des ducs de Bourgogne du Musée de Dijon," *Bulletin Archéologique du Comité des Travaux Historiques et Scientifiques* (1909), pp. 14–17. See also William D. Wixom, *Treasures from Medieval France* (Cleveland, 1967), pp. 256, no. VI21, 377.

162. Willis, *The Architectural History of Canterbury Cathedral*, pp. 35 ff.; see Lehmann-Brockhaus, *Lateinische Schriftquellen*, I (Munich, 1955): 219, no. 802; also in Lehmann-Brockhaus see I: 225–26, no. 815; 226, no. 816.

163. Willis, *The Architectural History*, pp. 51 ff. See also Lehmann-Brockhaus, *Lateinische Schriftquellen*, I: 226, no. 816; 226–28, no. 817; 228, no. 819; 229–31, nos. 821–23.

164. *Facsimile of the Sketch-Book of Wilars De Honecourt*, p. 3, pl. xix. See also Hahnloser, *Villard de Honnecourt*, pp. 56, pl. 20b; 73–75, pl. 30a.

165. Robert Branner, *St. Louis and the Court Style in Gothic Architecture* (London, 1965), pp. 76–77.

166. Wixom, *Treasures from Medieval France*, p. 304, no. VII-G.

167. Paul Vitry, *Michel Colombe et la sculpture française de son temps* (Paris, 1901), p. 489.

168. Hahnloser, *Villard de Honnecourt*, p. 238.

169. Hahnloser, *Villard de Honnecourt*, pp. 194–99.

170. Harvey, *The Gothic World*, pp. 41, 52.

171. *Gesta Abbatum Monasterii Sancti Albani*, Cottonian MS. Claudius E.IV, British Museum, ed. Henry Thomas Riley (London, 1867), pp. 19, 37, 233, 242, 279, 314.

172. F. Ronig, "Godefridus von Huy in Verdun," *Aachener Kunstblätter* 32 (1966): 88–89; see also H. Swarzenski, *Monuments of Romanesque Art* (London, 1954), pp. 29, 67–68, pls. 163–64, 166–69.

173. Ronig, "Godefridus von Huy in Verdun," p. 89.

174. Letters C, "Wibaldi Abbatis Ad G. Aurificem," and CI, "G. Aurificis Ad Wibaldum Abbatem," in *Patrologia Latina*, ed. J.-P. Migne, vol. 189 (Paris, 1890), cols. 1193–94; *Rhin-Meuse: art et civilisation 800–1400*, exhibition catalogue (Cologne and Brussels, 1972), pp. 17, 79, illust. V10. See also Otto Lehmann-Brockhaus, *Schriftquellen zur Kunstgeschichte des 11. und 12. Jahrhunderts für Deutschland, Lothringen und Italien* (Berlin, 1938), p. 718, no. 3026.

175. Floridus Röhrig, *Der Verduner Altar* (Vienna, 1955), pp. 16–17.

176. Ekkehard IV, *Casus S. Galli*, c. 45, in Schlosser, *Quellenbuch zur Kunstgeschichte des abenländischen Mittelalters*, pp. 152–53.

177. Ekkehard IV, *Casus S. Galli* c. 34, 39, 22, 40, in Schlosser, *Quellenbuch zur Kunstgeschichte*, pp. 151–52.

178. John (anon.), *Vita Balderici*, c. 14–15, in Schlosser, *Quellenbuch zur Kunstgeschichte*, pp. 149–51.

179. Nordenfalk in *Early Medieval Painting*, p. 203.

180. *Le Guide du pèlerin à Saint-Jacques de Compostelle*, ed. Jeanne Vielliard, 4th ed. (Macon, 1969), p. 117.

181. Harvey, *English Medieval Architects*, p. 11.

182. Henri Stein, *Les Architectes des cathédrales gothiques* (Paris, 1909), pp. 122–24.

183. The first Northern mention of Van Eyck occurs in an obscure poem by Jean Lemaire, *La Couronne Margaritique*, written between 1504 and 1511. Interestingly, this was preceded by the first Italian celebrations of Van Eyck by Ciriaco d'Ancona, Bartolomeo Fazio, and Filarete. See Max J. Friedländer, *Early Netherlandish Painting*, trans. Heinz Norden, 10 vols. (Leyden 1967–73), I: 33–34.

184. *Oeuvres de Froissart*, Kervyn de Lettenhove ed. (Brussels, 1867–77), XX: 297–98.

185. *Oeuvres de Froissart*, I: 108; XIV: 197.

186. This suggestion was made by my regretted friend, the late Wolfgang Stechow, in the course of a long discussion of this problem. See also Max Friedländer's discussion of the way Hugo van der Goes was inscribed on the Italian list of remembered masters, all but exclusively on account of his Portinari altarpiece. Friedländer, *Early Netherlandish Painting*, IV: 11.

187. For the untheological: Purgatory was a painful way station to Heaven; if Oderisi had not repented, he would have been in Hell.

188. Dante Alighieri, *The Divine Comedy: The Purgatorio*, trans. John Ciardi (New York, 1961), p. 123 (XI, 79–96).

189. Roberto Longhi, "Proposte per una critica d'arte," *Paragone*, no. 1 (1950), p. 8. See also Assunto, *La critica d'arte nel pensiero medioevale*, pp. 259–84.

190. *L'ottimo commento della Divina Commedia, d'un contemporaneo di Dante*, ed. A. Torri (Pisa, 1828), II: 186–87.

191. Benvenuto Rambaldi da Imola, *Commento latino sulla Divina Commedia di Dante Alighieri* (Imola, 1856), p. 230.

192. Erardo Aeschlimann made a count of illuminators' names, but it is not clear from this text whether the names recorded are taken from signatures on the manuscript

or have been discovered by scholarship in some other way. So it would be misleading to give an exact total of the number of Italian fourteenth-century illuminators who actually signed; but it is clear from Aeschlimann that signing was much more frequent in the fourteenth century. See Aeschlimann, *Dictionnaire des miniaturistes du moyen âge et de la Renaissance dans les différentes contrées de l'Europe* (Milan, 1940).

193. Creighton Gilbert, "Cecco d'Ascoli e la pittura di Giotto," *Commentari* XXIV (January-June 1973): 19–25.

194. Giovanni Boccaccio, *The Decameron*, trans. G. H. McWilliam, Penguin ed. (1972; Harmondsworth, 1976), p. 494 (VI, 5).

195. Prince d'Essling and Eugène Müntz, *Pétrarque: ses études d'art, son influence sur les artistes* (Paris, 1902), p. 55, n. 6. See also *Petrarch's Testament*, ed. Theodor E. Mommsen (Ithaca, N.Y., 1957), pp. 21–25; 79, no. 12.

196. Villani, *Cronica*, bk. XI, chap. 12.

197. *Compilatio Cronologica* (Rome, 1474), folio 101 verso, in P. Murray, "Notes on Some Early Giotto Sources," *Journal of the Warburg and Courtauld Institutes* 16 (1953): 60, n. 1.

198. *Poesie di Petrarca*, ed. F. Neri, N. Sapegno, E. Bianchi, and G. Martellotti (Milan-Naples, 1951), sonnets xlix, l, lxxxvi. See also Essling and Müntz, *Pétrarque*, pp. 9–11; Schlosser, *Quellenbuch zur Kunstgeschichte des abendländischen Mittelalters*, pp. 351–52; Lionello Venturi, "La critica d'arte e Francesco Petrarca," *L'arte* 25 (1922): 243.

199. Essling and Müntz, *Pétrarque*, pp. 11–13; R. van Marle, *Simone Martini* (Strasbourg, 1920), pp. 68–70.

200. Franco Sacchetti, *Il Trecentonovelle*, ed. Emilio Faccioli (Turin, 1970), novella 136, pp. 352–55.

201. G. Livi, *Dall'archivio di Francesco Datini, mercante pratese* (Florence, 1910), p. 17 (1392 letter from Francesco Marco Datini to Domenico di Cambio). See also Iris Origo, *The Merchant of Prato* (London, 1960), p. 238; Bruce Cole, "The Interior Decoration of the Palazzo Datini in Prato," *Mitteilungen des Kunsthistorischen Institutes in Florenz* 13 (1967–68): 61–82.

202. Giovanni di Pagolo Morelli, *Ricordi*, ed. Vittore Branca, 2nd ed. (Florence, 1969), p. 178.

203. Coulton, *Art and the Reformation*, pp. 109–19.

204. Cennino d'Andrea Cennini, *Il libro dell'arte: The Craftsman's Handbook*, trans. Daniel V. Thompson, Jr. (New York, 1960), p. 2.

205. Filippo Villani, *Liber de Civitatis Florentiae Famosis Civibus*, ed. G. C. Galletti (Florence, 1847), pp. 35–36. A slightly different transcription from the same manuscript in the Biblioteca Laurenziana is given by Karl Frey, *Il libro di Antonio Billi* (Berlin, 1892), pp. 73–75; this transcription is also available in Schlosser, *Quellenbuch zur Kunstgeschichte des abendländischen Mittelalters*, 370–71. For the Italian transion see Filippo Villani, *Le vite d'uomini illustri fiorentini*, ed. G. Mazzuchelli (Florence, 1847), p. 47; for the English translation based on Vat. Barb. lat. 2610, see Michael Baxandall, *Giotto and the Orators* (Oxford, 1971), pp. 70–72. On Filippo Villani, see E. F. van der Grinten, *Elements of Art Historiography in Medieval Texts* (The Hague, 1969), pp. 36–37, 53.

206. Baxandall, *Giotto and the Orators*, p. 72.

207. In this context, "Greek" means Byzantine and "Latin" apparently means Italian.

208. This remark of Villani's is the first of many recalling Horace's *"Ut pictura poesis"* (*Ars Poetica* 361).

209. Baxandall, *Giotto and the Orators*, pp. 70–71.

210. François Avril, *Manuscript Painting at the Court of France* (New York, 1978), p. 14. The collector in question was of course Jean, Duc de Berry, already discussed.

INTERCHAPTER 4. THE DEVELOPED HISTORICAL SENSE

1. To be precise, I have been at work from 1964, the time of completion of an earlier book, *From the Silent Earth*, until the present, and full-time since my retirement from newspaper work over five years ago.
2. Eduard Fueter, *Geschichte der neueren Historiographie*, trans. as *Histoire de l'historiographie moderne* by Émile Jeanmarie (Paris, 1914). Petrarch is first pinpointed as the pioneer on pp. 5 ff.
3. Fueter, *Histoire*, pp. 14 ff.
4. Fueter, *Histoire*, pp. 66 ff.
5. Fueter, *Histoire*, p. 80.
6. Partly because of the work's majestic scope and resulting length, Sima Qian's complete *Shi ji* has never been fully translated into a European language. The first sections were translated into French at the end of the last century by the great Édouard Chavannes; and long ago I read this now rare book in several volumes with benefit. However, I have made direct use only (except where assisted by Dr. Christian and Alfreda Murck, who can of course consult the entire original text) of *Records of the Grand Historian of China, Translated from the Shih Chi of Ssu-Ma Ch'ien*, by Burton Watson, 2 vols. (New York and London, 1968), which is, again, a partial translation.
7. Kato Shuichi, *A History of Japanese Literature: The First Thousand Years*, trans. David Chibbett (New York and San Francisco, 1979), pp. 254 ff.
8. *Heike Monagatari: The Tale of the Heike*, trans. Hiroshi Kitagawa and Bruce T. Tsuchida (Tokyo, 1975).
9. Ibn Khaldūn, *The Muqaddimah: An Introduction to History*, trans. Franz Rosenthal, 3 vols. (New York, 1958).

X. ART COLLECTING REVIVES

1. Gerolamo Biscaro, *L'ospedale e i suoi benefattori* (Treviso, 1903), pp. 49–69; Augusto Serena, *La cultura umanistica a Treviso nel secolo decimoquinto* (Venice, 1912); Rambaldo degli Azzoni Avogaro, "Della zecca, e delle monete ch'ebbero corso in Trivigi" in Guid'Antonio Zanetti, *Nuova raccolta delle monete e zecche a'Italia*, vol. IV (Bologna, 1786): 151–52; Domenico Maria Federici, *Memorie trevigiane sulle opere di disegno* (Venice, 1803); Roberto Weiss, "Lineamenti per una storia degli studi antiquari in Italia," *Rinascimento* 9 (1958): 154; Luciano Gargan, "Oliviero Forzetta e la diffusione dei testi classici nel Veneto al tempo del Petrarca," in *Classical Influences on European Culture A.D. 500–1500* (Cambridge, 1971), pp. 73–80; Gargan, *Cultura e arte nel Veneto al tempo del Petrarca* (Padua, 1978); Gargan, "La cultura umanistica a Treviso nel Trecento," in *Tomaso da Modena e il suo tempo* (Treviso, 1980), pp. 145–56.
2. Biscaro, *L'ospedale*, pp. 51, 62.
3. Biscaro, *L'ospedale*, p. 52. Gargan writes that Aquilia died in 1323, not 1322; see *Cultura e arte nel Veneto*, pp. 7–8.
4. Biscaro, *L'ospedale*, p. 53.
5. Biscaro, *L'ospedale*, p. 54. It should be noted, however, that Gargan states that Forzetta was excommunicated in 1337; see *Cultura e arte nel Veneto*, p. 14.
6. Biscaro, *L'ospedale*, p. 56, n. 1; Gargan, *Cultura e arte nel Veneto*, pp. 14–15.

7. Biscaro, *L'ospedale*, pp. 56–57.

8. Luciano Gargan, "Cultura e arte a Treviso al tempo di Tomaso," in *Tomaso da Modena*, exhibition catalogue (Treviso, 1979), p. 30; Gargan, *Cultura e arte nel Veneto*, pp. 17–18.

9. Vincenzo Joppi, "Inventario delle cose preziose lasciate dal Patriarca d'Aquileia," *Archivio storico per Trieste: l'Istria e il Trentino* 1 (1881/1882): 96–105.

10. Gargan very tentatively suggests Forzetta may have been influenced by a backwash into Treviso of the early revival of classical studies in Padua. The Paduan grammarian Lovato Lovati actually lived in Treviso for a while. See Gargan, "La cultura umanistica a Treviso nel Trecento," pp. 146–48.

11. Avogaro, "Della zecca," p. 151; Gargan, "Oliviero Forzetta e la diffusione dei testi classici nel Veneto al tempo del Petrarca," p. 75; Gargan, *Cultura e arte nel Veneto*, pp. 38, 66 ff.

12. Biscaro, *L'ospedale*, pp. 66–67; Serena, *La cultura umanistica*, pp. 7, 14–15. Gargan, *Cultura e arte nel Veneto*, pp. 66 ff., 125ff.

13. Gargan, *Cultura e arte nel Veneto*, pp. 142–88. For a discussion of the classical texts see Gargan, "Oliviero Forzetta e la diffusione dei testi classici nel Veneto al tempo del Petrarca," pp. 73–80.

14. See also S. Connell, "Books and Their Owners in Venice 1345–1480," *Journal of the Warburg and Courtauld Institutes* 35 (1972): 163–86; U. Pasqui, "La biblioteca d'un notaio Aretino del secolo XIV," *Archivio storico italiano* 4 (1889): 250–55; L. Chiappelli, "Una notevole libreria Napoletana del Trecento," *Studi medievale:* n.s. 1 (1928): 456–70; A. Avena, "I libri del notaio Veronese Bartolomeo Squarceti da Cavajon (1420)," *Bibliofilia* 13 (1911): 241 ff.; B. Cecchetti, "Libri, scuole, maestri, sussidii allo studio in Venezia nei secoli XIV e XV," *Archivio veneto* 32 (1886): 329 ff.

15. Avogaro, "Della zecca," pp. 151–52; Serena, *La cultura umanistica*, pp. 321–22; Gargan, *Cultura e arte nel Veneto*, pp. 36 ff.

16. Avogaro, "Della zecca," p. 151; Federici, *Memorie trevigiane sulle opere di disegno*, pp. 178–79; Gargan, *Cultura e arte nel Veneto*, p. 37.

17. Avogaro, "Della zecca," p. 151; Gargan, *Cultura e arte nel Veneto*, p. 37.

18. "Item quod Damianus mihi promixit quatuor Pastas & Schacum Elephanti &c. Regis Artusii; & quod Magist. Symeon ejus barbanus dabit mihi quinquaginta Medayas." Avogaro, "Della zecca," p. 151. See also Federici, *Memorie trevigiane*, p. 184; Gargan, *Cultura e arte nel Veneto*, pp. 37–38.

19. "Item a Fr. Titiano Or. Predicatorum Conventus Veneti querere de libro Orosii. "Item querere a bidellis de majore Ovidio & omnibus aliis Ovidiis, Salustio, Marcotullio, Rethorica nova & antiqua Tullii, Servio, Titilivio, Valerio Maximo, Moralibus super Job Sancti Gregorii, Ystoriis romanis, Tullio opere completo. "Item queras exigere omnia designamenta, que cond. fuerunt Perenzoli filii Magr. Angeli.; pignorata penes Magistros Franciscum & Stephanum de Sancto Johanne novo, & quaternum suum: in quo sunt omnia animalia. & omnia pulcra, facta manu dicti Perenzoli, & omnes ejus taglos pariter & designamenta ubicumque pignorata & deposita &c." Avogaro, "Della zecca," p. 151. See also Federici, *Memorie trevigiane*, p. 179; Gargan, *Cultura e arte nel Veneto*, p. 38.

20. Avogaro, "Della zecca," p. 151; Federici, *Memorie trevigiane*, pp. 179–80; Gargan, *Cultura e arte nel Veneto*, pp. 41 ff. See also Giuseppe Valentinelli, *Marmi scolpiti del Museo Archeologico della Marciana di Venezia* (Prato, 1866), p. 126, n. 1.

21. Francesco Sansovino, *Venetia, città nobilissima et singolare* (Venice, 1581), p. 63 recto; Hans Dütschke, *Antike Bildwerke in Oberitalien*, V (Leipzig, 1882), no. 257, p. 96; cf. vol. IV (Leipzig, 1880), no. 850, pp. 369–70; Carlo Anti, *Il Regio Museo*

Archeologico nel Palazzo Reale di Venezia, Le guide dei musei italiani (Rome, 1930), p. 140, nos. 10, 13. Also, Gargan, "Cultura e arte a Treviso al tempo di Tomaso," p. 43.

22. Valentinelli, *Marmi scolpiti del Museo Archeologico della Marciana di Venezia,* nos. 193, 199, pp. 124–27; Gargan, *Cultura e arte nel Veneto,* pp. 43 ff.

23. *"Item de Testa, Leonibus, Anera, equis depictis, quos habet Anna soror cond. Joachini; que Testa, habet super caput gislandam de rosis cum una infula."* Avogaro, "Della zecca," p. 151; Gargan, *Cultura e arte nel Veneto,* p. 38. Gargan suggests that Perenzolo and Gioacchino were both sons of Magister Angelo in "Cultura e arte a Treviso al tempo di Tomaso," p. 42.

24. *"Item de puero condam Guillielmi Zaparini lapideo, & multis aliis designamentis Perenzoli, quas uxor condam ipsius habet &c."* Avogaro, "Della zecca," p. 151; Gargan, *Cultura e arte nel Veneto,* p. 38.

25. *"& nota quod Marinus de Gallera habet Leones, equos, Boves, nudos Homines, cechaturas hominum, & Bestiarum, & aves condam Perenzoli."* Avogaro, "Della zecca," p. 151. I owe my translation of this and the other passages from the Forzetta note to Dr. Bernard Knox of the Center for Hellenic Studies. "Hunts" for *"cechaturas"* is necessarily an extremely conjectural rendering, although possible in view of the peculiarities of Forzetta's Latin. *"Caelaturas,"* which is Gargan's proposed substitute (*Cultura e arte nel Veneto,* p. 38, n. 21), is essentially imagined, as the note has long ago disappeared. However, since the Latin, *"caelator,"* means a chiseler of bas-reliefs as well as an engraver on metal, it may be that sarcophagus reliefs, so often come by, are concealed in these *"cechaturas hominum & Bestiarum."* But I believe the wise course is to leave open the meaning of the troublesome last eight words, and to concentrate on the *"Leones, equos, Boves, nudos Homines."* The inclusion of *"nudos Homines"* makes this an enormously improbable list of subjects for any European artist of the late thirteenth and early fourteenth centuries. Meanwhile, classical fragments of these types can easily have been available in Venice, and the evidence of the rest of the Forzetta note indicates clearly that he was interested in classical works of art, including sculpture. The best course, therefore, is to follow Eugène Müntz, whose opinion is quoted in the text along with that of Roberto Weiss.

26. Gargan, "Cultura e arte a Treviso al tempo di Tomaso," pp. 31, 42; Gargan, *Cultura e arte nel Veneto,* p. 38, n. 21.

27. Eugène Müntz, *Les Arts à la cour des papes,* II (Paris, 1879): 164–65.

28. Roberto Weiss, *The Renaissance Discovery of Classical Antiquity* (Oxford, 1969), p. 28.

29. Biscaro, *L'ospedale,* p. 118; Gargan, *Cultura e arte nel Veneto,* pp. 223–29.

30. Biscaro, *L'ospedale,* pp. 49, n. 1; 62–63.

31. Biscaro, *L'ospedale,* p. 118; Gargan, *Cultura e arte nel Veneto,* p. 227.

32. Iris Origo, *The Merchant of Prato* (London, 1957), p. 337.

33. Biscaro, *L'ospedale,* pp. 60, 118.

34. Augusto Cesare Levi, *Le collezioni veneziane d'arte e d'antichità dal secolo XIV ai nostri giorni* (Venice, 1900), pp. xxxvi–xxxvii, n. 2; G. M. de Gheltof, *La collezione del doge Marino Falier e i tesori di Marco Polo* (Venice, 1881). Again, Dr. Knox has translated the relevant passages.

35. *"Item duo capita barbarorum quae duxit ex africa jacobellus nauta."* Levi, *Le collezioni,* p. xxxvii.

36. *"Item gladium aeneum padue inventum."* Levi, *Le collezioni,* p. xxxvii. Bronze swords are most unlikely to have been made after the end of the Bronze Age, when the technicians learned to temper iron to take a good edge.

37. *"Unum gladium mire antiquitatis cum inscriptionibus."* Levi, *Le collezioni,* p.

xxxvii. For the Lombard origin see the discussion of inscribed swords in Chapter IX.

38. *"Item alie capseleta cum zogiis auri et argenti inter quos unum anulum cum inscriptione que dicit Ciuble Can Marco Polo, et unum torques cum moltis animalibus tartarorum sculptis que res donum dedit predictus Marcus quidam Faletrorum. . . .*
 "Item duo capselete de corio albo cum variis rebus auri et argenti quae habuit praedicus Marcus a barbarorum rege."
 In addition, the inventory mentions:
 "Item unum ensem mirabilem qui habet tres enses simul quem habuit in suis itineribus praedictus Marcus. . . .
 "Item unam tenturam de pannis indicis quae habuit praedictus Marcus.
 "Item de itineribus Marci praedicti liber in corio albo cum multis figuris," and
 "Item aliud volumen quod uocatur de locis mirabilibus tartarorum scriptum manu praedicti marci." Levi, *Le collezioni*, pp. xxxvi–xxxvii.

39. *"Item duo candelabra pulcherrima cum alabastro et auro."* Levi, *Le collezioni*, p. xxxvi.

40. Hanz Wentzel, " 'Staatskameen' im Mittelalter," *Jahrbuch der Berliner Museen* 4 (1962): 42–47; Wentzel, "Der Augustalis Friedrichs II und die abendländische Glyptik des 13. Jahrhunderts," *Zeitschrift für Kunstgeschichte* 15 (1952): 183 ff.

41. Ernst Kantorowicz, *Frederick the Second 1194–1250*, trans. E. O. Lorimer, (1931; London, 1957), p. 322.

42. *Die Zeit der Staufer*, exhibition catalogue, Württembergisches Landemuseum, 5 vols. (Stuttgart, 1977), I: 675 *et passim*. See also Eugene Byrne, "Some Medieval Gems and Relative Values," *Speculum* 10 (1935): 181–83.

43. S. Ricci, "Gli 'Augustali' di Federico II," *Studi medievali*, n.s. 1 (1928): 59–73.

44. *Die Zeit der Staufer*, I: 692–93, no. 885.

45. Eugène Müntz, *Les Collections des Médicis au XVe siècle* (Paris, 1888), p. 68; Nicole Dacos, Antonio Giuliano and Ulrico Pannuti, eds., *Il tesoro di Lorenzo il Magnifico. I, Le gemme* (Florence, 1973), p. 64, no. 37.

46. Kantorowicz, *Frederick the Second*, pp. 530–33; C. A. Willemsen, *Kaiser Friedrichs II. Triumphtor zu Capua* (Wiesbaden, 1953).

47. Hanz Wentzel, " 'Portraits à l'Antique' on French Mediaeval Gems and Seals," *Journal of the Warburg and Courtauld Institutes* 16 (1953): 342–44.

48. G. Demay, *Des Pierres gravées employées dans les sceaux du moyen âge* (Paris, 1878), p. 6. See also Thomas Wright, "On Antiquarian Excavations and Researches," *Archaeologia* 30 (1844): 443 ff.

49. W. S. Heckscher, "Relics of Pagan Antiquities in Medieval Settings," *Journal of the Warburg Institute* 1 (1937/38): 204–20; G. A. S. Snijder, "Antique and Mediaeval Gems on Bookcovers at Utrecht," *Art Bulletin* 14 (1932): 14–17.

50. Heckscher, "Relics of Pagan Antiquities in Medieval Settings," pp. 217–20; Snijder, "Antique and Mediaeval Gems on Bookcovers at Utrecht," pp. 5–52, esp. 5–18.

51. Ristoro d'Arezzo, *Della composizione del mondo* (Milan, 1864), pp. 255–57.

52. Avogaro, "Della zecca," p. 151.

53. Guibert de Nogent, in *Patrologia Latina*, vol. 156 (Paris, 1880), col. 840 (I, 2); trans. in C. C. S. Bland, *The Autobiography of Guibert* (London, 1926), p. 9.

54. Ghiberti-Schlosser, I: 63; II: 31, 189–92; Schlosser, *Leben und Meinungen des Florentinischen Bildners Lorenzo Ghiberti* (Basel, 1941), pp. 152–58. See also Richard Krautheimer, with Trude Krautheimer-Hess, *Lorenzo Ghiberti*, 2 vols., 2nd ed. (Princeton, 1970) I: 287, n. 17. For the Siena Venus, as retold by Ghiberti, see also Schlosser, "Über einige Antiken Ghibertis," *Jahrbuch der Kunsthistorischen Sammlungen des Allerhöchsten Kaiserhauses*, 24 (1904): 143–50.

55. Ghiberti-Schlosser, I: 63.

56. Ghiberti-Schlosser, I: 63, as kindly translated by Professor Anna Modigliani Lynch.

57. Ghiberti-Schlosser, I: 63.

58. Luigi Simeoni, *Verona*, new ed. (Verona, 1953), pp. 50–51; *Verona e il suo territorio*, III.1 (Verona, 1975): 712.

59. On this subject, see Chapter IX, note 9.

60. I have used the English translation of Theodor E. Mommsen, "Petrarch's Conception of the 'Dark Ages,' " in *Medieval and Renaissance Studies* (Ithaca, 1959), p. 116. See also Francesco Petrarca, *Rerum Familiarum Libri* VI. 2 in Vittorio Rossi, ed.; *Le familiari* (Florence, 1934), II: 55–60; cf. R. Tatham, *Francesco Petrarca, the First Modern Man of Letters: His Life and Letters*, 2 vols. (London, 1926), I: 343–46.

61. Again the English translation is in Mommsen's "Petrarch's Conception of the 'Dark Ages,' " p. 127. See also Francesco Petrarca, *Africa* IX. 451–57 (ed. N. Festa [Florence, 1926], p. 278).

62. Mommsen, "Petrarch's Conception of the 'Dark Ages,' " pp. 106 ff.

63. Eduard Fueter, *Geschichte der neueren Historiographie*, 3rd ed. (1936; reprint New York, 1968), p. 2.

64. *"Quid est enim aliud omnis historia quam Romana laus?"* Francesco Petrarca, *Opera Omnia* (Basel, 1554; reprint Ridgewood, N.J., 1965), p. 1187 quoted in Mommsen, "Petrarch's Conception of the 'Dark Ages,' " p. 122, n. 164.

65. Petrarca, *Rerum Familiarum Libri* VI. 2; see also Giuseppe Billanovich, "Gli umanisti e le chronache medioevali," *Italia medioevale e umanistica* 1 (1958): 129; Prince d'Essling and Eugène Müntz, *Pétrarque: ses études d'art, son influence sur les artistes* (Paris, 1902), pp. 23 ff.

66. Petrarca, *Rerum Familiarum Libri* VI. 2; Roberto Weiss, "Petrarch the Antiquarian," *Classical, Medieval and Renaissance Studies in Honor of Berthold Louis Ullman*, II (Rome, 1964): 199–209. See also Chapter IX above.

67. Weiss reached this conclusion on the basis of a marginal annotation in Petrarch's Virgil, but Weiss's interpretation is disputed. Weiss, *Renaissance Discovery of Classical Antiquity*, p. 50.

68. Petrarca, *De Remediis Utriusque Fortunae* I. 51, in *Opera Omnia* I: 52.

69. Theodor E. Mommsen, "Petrarch and the Decoration of the Sala Virorum Illustrium in Padua," *Art Bulletin* 34 (1952): 95–116; reprinted in Mommsen, *Medieval and Renaissance Studies* (Ithaca, N.Y., 1955), pp. 130–74; Annegrit Schmitt, "Zur Wiederbelebung der Antike im Trecento," *Mitteilungen des Kunsthistorischen Institutes in Florenz* 18 (1974): 167–218.

70. Boccaccio, *Decameron* VI. 5; see also A. Solerti, *Le vite di Dante, Petrarca e Boccaccio* (Milan, 1904), pp. 671 ff.

71. See Chapter IX. Theodosius I's edict suppressing the pagan cults touched off the first round of Christian image bashing.

72. Ghiberti-Schlosser, I: 35; II: 108.

73. Ghiberti-Schlosser, I: 62; II: 188–89. See also Krautheimer, *Lorenzo Ghiberti*, I: 287, n. 17.

74. See Chapter IX.

75. Xenia Muratova, "Paris," *Burlington Magazine* 119 (October 1977): 725–26; "The Arts in Europe: The Royal Statues of Notre Dame Uncovered," *Connoisseur* 196 (November 1977): 236.

76. Benedetto Croce, *Theory and History of Historiography*, trans. Douglas Ainslie (London, 1921), pp. 201, 241.

77. Mommsen, "Petrarch's Conception of the 'Dark Ages,' " p. 129.

78. Weiss, "Petrarch the Antiquarian," p. 207. See also Alessandro Magnaguti, "Il Petrarca

numismatico," *Rivista Italiana di Numismatica* 20 (1907): 155–57; Schmitt, "Zur Wiederbelebung der Antike im Trecento," p. 167.

79. Petrarca, *Rerum Familiarum Libri* XIX. 3; Schmitt, "Zur Wiederbelebung der Antike im Trecento," p. 168.

80. Ghiberti-Schlosser, I: 62; II: 188–89. See also Giuseppina Ferrante, "Lombardo della Seta: umanistica padovano," *Atti del Reale Istituto Veneto di Scienze, Lettere ed Arti* 92, no. 2 (1933–34): 450–51.

81. Vittorio Lazzarini, "I libri, gli argenti, le vesti di Giovanni Dondi dall'Orologio," *Bolletino del Museo Civico di Padova* n.s. 1 (1925): 20–36; see also Neal W. Gilbert, "A Letter of Giovanni Dondi dall'Orologio to Fra Guglielmo Centueri: A Fourteenth Century Episode in the Quarrel of the Ancients and Moderns," *Viator* 8 (1977): 313–14.

82. A. Gloria, "I due orologi meravigliosi inventati da Jacopo e Giovanni Dondi," *Atti del Reale Istituto Veneto di Scienze, Lettere ed Arti* 54 (1895-96): 675–736; 55 (1896/97): 1000–17; Lynn Thorndike, *A History of Magic and Experimental Science* (New York, 1934), III: 386–88; Neal W. Gilbert, "A Letter of Giovanni Dondi," p. 299, n. 1.

83. Petrarca, *Epistolae* XVI. ep. 3.

84. Giacomo Morelli, *Di Giovanni Dondi dall'Orologio, medico di Padova, e dei monumenti antichi da lui esaminati a Roma, e di alcuni scritti inediti del medesimo* (Padua, 1850).

85. The actual language used by Dondi in this crucial passage is *"De artificiis ingeniorum veterum, quamquam pauca supersint, si qua tamen manent alicubi, ab his qui ea in re sentiunt cupide queruntur et videntur, magnique penduntur."* (Gilbert, "A Letter of Giovanni Dondi," p. 336). The translation here quoted was most kindly made for me by Dr. Knox. Neal W. Gilbert, the first to publish this much-quoted letter of Dondi's in full with a complete translation, has offered a slightly different version: "Of the artistic products of ancient genius, few survive. But those that do remain anywhere are eagerly sought and seen and highly prized by those who feel strongly about such things: . . ." ("A letter of Giovanni Dondi," p. 344). In the first place, the difference between "high prices" being paid for objects and the same objects being "highly prized" is obviously no more than six of one, half-dozen of the other. In the second place, Dr. Knox's translation more exactly expresses what was plainly Dondi's real meaning. Hence I have retained Dr. Knox's translation.

86. Gilbert, "A Letter of Giovanni Dondi," p. 344.

87. Gilbert, "A Letter of Giovanni Dondi," p. 345.

88. Vincenzo Bellemo, *Jacopo e Giovanni de' Dondi* (Chioggia, 1894), p. 135.

89. Giovanni Dondi's letter to Fra Guglielmo da Cremona (Venice, Marc. lat., fol. 56 ff.) in Jacopo Morelli, "De Joanne Dondio," *Operette* II (Padua, 1820): 303 ff.

90. Krautheimer, *Lorenzo Ghiberti*, I: 299.

91. *John Quinn 1870–1925: Collection of Paintings, Water Colors, Drawings and Sculpture* (Huntington, N.Y., 1926); Aline B. Saarinen, *The Proud Possessors* (New York, 1958), pp. 234–37. Although the prices reported seem downright ridiculous today, I can still remember educated and art-loving New Yorkers making jokes about the folly of those who paid such prices.

92. See Chapter VIII.

93. For example, the highest price paid for a Picasso (at the time of writing!) is $3 million at the Garbisch Collection auction on May 12, 1980. See Sotheby Parke Bernet Inc., *The Garbisch Collection, Volume One: Highly Important Impressionist and Modern Paintings, Drawings and Sculpture* (New York, 1980), no. 41. The

same picture would probably have sold for $30,000 in the 1930s, when post-Impressionist collecting was still in Stage II.

94. For instance, Krautheimer (*Lorenzo Ghiberti*, I:93–95) states that in 1428 the fourteenth-century statue of St. Stephen which adorned Orsanmichele was sold by the Wool Guild (Arte della Lana) to the Opera del Duomo for the sum of 175 florins, which was "unusually high for a second-hand marble statue." He explains this on the ground that the Wool Guild happened to control the Opera del Duomo, and wished to take money from the Opera to pay for the new Ghiberti bronze for Orsanmichele, with which the guild aimed to put the bronzes of the other guilds to shame. The old statue of St. Stephen, which is now lost, was then set up on the cathedral's façade, presumably, at least in part, to justify the Wool Guild's payment of a high price.

95. Ghiberti-Schlosser, II: 187 ff.; Schlosser, "Über einige Antiken Ghibertis," p. 143; Voigt, *Die Wiederbelebung des classischen Alterthums*, I: 377, n. 1; Eugène Müntz, *Les Précurseurs de la Renaissance* (Paris, 1882), p. 141, n. 3; Schlosser, *Leben und Meinungen*, p. 155.

96. Millard Meiss, *French Painting in the Time of Jean de Berry: The Late Fourteenth Century and the Patronage of the Duke* (London and New York, 1967), I: 52–58. *Inventaires de Jean Duc de Berry*, ed. Jules Giuffrey, 2 vols. (Paris, 1894–96), I: 41 *et passim*.

97. Meiss, *French Painting: The Late XIV Century*, I: 53 ff.

98. Schmitt, "Zur Wiederbelebung der Antike im Trecento," p. 168; G. F. Hill, *A Corpus of Italian Medals of the Renaissance* (London, 1930), I: 3; G. F. Hill and Graham Pollard, *Medals of the Renaissance*, rev. ed. (London, 1978), pp. 19–20; Julius von Schlosser, "Die ältesten Medaillen und die Antike," *Jahrbuch der Kunsthistorischen Sammlungen des Allerhöchsten Kaiserhauses* 18 (1897): 65–66; Franco Panvini Rosati, *Medaglie e placchette italiane dal Rinascimento al XVIII secolo*, exhibition catalogue (Rome, 1968), p. 17, nos. 1, 2.

99. Hill, *A Corpus of Italian Medals of the Renaissance*, p. 4, nos. 10, 11, 12; Hill and Pollard, *Medals of the Renaissance*, pp. 19–20; Schlosser, "Die ältesten Medaillen und die Antike," p. 70.

100. Schlosser, "Die ältesten Medaillen und die Antike," p. 75.

101. Saarinen, *The Proud Possessors*, pp. 174–205.

102. Sergius Yakobson, "Russian Art Collectors and Philanthropists: The Shchukins and the Morozovs of Moscow," *National Gallery of Art: 1974 Studies in the History of Art*, 6 (Washington, D.C., 1975): 156–73.

103. I have been unable to document this statement. But I remember being told by a junior member of the firm of Durand-Ruel that Dr. Barnes began buying pictures on a considerable scale because the French army's decision to use Argyrol for antivenereal purposes had greatly increased his company's revenues.

104. Renato Poggioli, "The Artist in the Modern World," *Graduate Journal* 6 (Winter 1964): 99 ff. In contrast see Francis Haskell, "Re-inventing the Eighteenth Century," *New York Review of Books* 27 (October 9, 1980): 31. Professor Haskell holds, "It is, indeed, doubtful whether any of the visual arts (with the exception of caricature) can have been explicitly conceived of as protest or social progress before the nineteenth century. . . ."

105. See Chapter VIII.

106. Meyer Schapiro, "Introduction of Modern Art in America: The Armory Show," in *Modern Art: 19th and 20th Centuries* (New York, 1978), pp. 135–78. It may be added here that the label "avant-garde" has actually been applied to the early fifteenth-century humanists, and the usual moral response to avant-gardes has been stressed

by George Holmes, in *The Florentine Enlightenment, 1400–50* (London, 1969), pp. 1–67. As an example of the moral response, he uses Cino Rinuccini's *Invettiva*, a work which was primarily aimed at Niccolò Niccoli. The fact is worth noting, even though Holmes has nothing significant to add on the avant-garde (for that period) character of Niccoli's artistic taste.

107. See Chapter VIII.

108. *Pablo Picasso: A Retrospective*, ed. William Rubin, exhibition catalogue, The Museum of Modern Art (New York, 1980), p. 87.

109. See note 54 above.

110. Krautheimer, *Lorenzo Ghiberti*, I: 52–53.

111. Krautheimer, *Lorenzo Ghiberti*, I: 53, n. 10.

112. Krautheimer, *Lorenzo Ghiberti*, I: 32–34, 37–41; see also A. Doren, *Studien aus der Florentiner Wirtschaftsgeschichte*, vol. I, *Die Florentiner Wollentuchindustrie* (Stuttgart, 1901); vol. II, *Das Florentiner Zunftwesen* (Stuttgart and Berlin, 1908); Martin Wackernagel, *Der Lebensraum des Künstlers in der Florentinischen Renaissance* (Leipzig, 1938).

113. Krautheimer, *Lorenzo Ghiberti*, I: 42–43; II: pl. 1, fig. 1.

114. Krautheimer, *Lorenzo Ghiberti*, I: 35–43.

115. Krautheimer, *Lorenzo Ghiberti*, I: 41–43.

116. Krautheimer, *Lorenzo Ghiberti*, I: 45, 49, 279, 281–82.

117. Krautheimer, *Lorenzo Ghiberti*, I: 281.

118. Krautheimer, *Lorenzo Ghiberti*, I: 299.

119. Krautheimer, *Lorenzo Ghiberti*, I: 279, 283.

120. Krautheimer, *Lorenzo Ghiberti*, I: 279–81.

121. Krautheimer, *Lorenzo Ghiberti*, I: 283.

122. Krautheimer, *Lorenzo Ghiberti*, I: 283, 286.

123. See note 116 above.

124. Krautheimer, *Lorenzo Ghiberti*, I: 279.

125. Vespasiano da Bisticci, *Le vite*, ed. Aulo Greco, 2 vols. (Florence, 1970–76), II: 140.

126. Vespasiano, *Le vite*, II: 140.

127. G. Cammelli, *I dotti bizantini e le origini dell'umanismo*. I, *Manuele Crisolara* (Florence, 1941), pp. 28–40; Roberto Weiss, "Jacopo Angeli da Scarperia (c. 1360–1410–11)," in *Medieval and Humanist Greek* (Padua, 1977), pp. 258–61.

128. Oskar Hecker, *Boccaccio-Funde* (Brunswick, 1902), pp. 137–57.

129. Pierre de Nolhac, *Pétrarque et l'humanisme* (Paris, 1892), pp. 339 ff. See also Roberto Weiss, "Petrarca e il mondo greco," in *Medieval and Humanist Greek* (Padua, 1977), pp. 166–92; Weiss, "Petrarch and Homer," in *Medieval and Humanist Greek*, pp. 150–65.

130. Remigio Sabbadini, *Le scoperte dei codici latini e greci ne' secoli XIV e XV*, 2 vols. (1905–14; reprint Florence, 1967), I: 43–71; Eugenio Garin, *La cultura del Rinascimento: profilo storico* (Bari, 1967), pp. 24–33; Cammelli, *I dotti bizantini e le origini dell'umanismo*. I, *Manuele Crisolara*.

131. Krautheimer, *Lorenzo Ghiberti*, I: 296. See also Alfred von Martin, *Mittelalterliche Welt- und Lebensanschauung im Spiegel der Schriften Coluccio Salutatis* (Munich, 1913), p. 8, n. 4.

132. Krautheimer, *Lorenzo Ghiberti*, I: 278.

133. The very earliest, as far as I can discover, were an Englishman and an American who were sent to Japan after the Meiji Restoration to teach subjects quite unconnected with art. The Englishman was Dr. William Anderson, whose *Japanese Wood Engravings* was published in 1895 (London). The American was Ernest F. Fenollosa, who wrote articles and conducted much fruitful activity in Japan, and whose *Epochs of*

Chinese and Japanese Art, 2 vols., was posthumously published in 1912. Anderson was chosen to catalogue the British Museum collection since this was then largely the collection he had made in Japan (see William Anderson, *Descriptive and Historical Catalogue of a Collection of Japanese and Chinese Paintings in the British Museum,* [London, 1886]), and Fenollosa's many and much finer acquisitions in Japan a little later became the foundation collection of Oriental art of the Boston Museum of Fine Arts. Other pioneers who should be mentioned are the Italo-Franco-Belgian Raphael Petrucci and the Englishman Laurence Binyon. Before these men set to work, of course, the enthusiasm for Japanese prints and the like had a strong effect, but these were the first to investigate and to write about the great earlier masters of China and Japan. For the relatively modest advance of Far Eastern art history in the West by the beginning of the present century, see, for instance, Laurence Binyon, "A Chinese Painting of the Fourth Century," *Burlington Magazine* 4 (January 1904): 39–44. Although Binyon was later to become a leading authority, this article would not pass muster today as a serious master's thesis.

134. John Pope-Hennessy, *Italian Gothic Sculpture,* 2nd ed. (London and New York, 1972), pp. 3–4.

135. See, for example, the discussion of Ghiberti's classical models in Krautheimer, *Lorenzo Ghiberti,* II: 337–57.

136. Krautheimer, *Lorenzo Ghiberti,* I: 66–67; see also Krautheimer, "Ghiberti and Master Gusmin," *Art Bulletin* 29 (March 1947): 25 ff.

137. Krautheimer, *Lorenzo Ghiberti,* I: 287–93; II: 343–51.

138. W. Heckscher, "Dornauszieher," *Reallexikon zur deutschen Kunstgeschichte,* IV (Stuttgart, 1958), cols. 289–99.

139. G. Bovini, "Le Vicende del 'Regisole' statua equestre ravennate," *Felix Ravenna,* ser. 3, fasc. 36 (1963), pp. 138–54.

140. Rodolfo Lanciani, *Storia degli scavi di Roma,* vol. I (Rome, 1902).

141. Krautheimer, *Lorenzo Ghiberti,* I: 280.

142. Krautheimer, *Lorenzo Ghiberti,* I: 280.

143. Krautheimer, *Lorenzo Ghiberti,* I: 281.

144. Krautheimer, *Lorenzo Ghiberti,* I: 46–49.

145. Krautheimer, *Lorenzo Ghiberti,* II: 339.

146. Krautheimer, *Lorenzo Ghiberti,* I, 283.

147. Krautheimer, *Lorenzo Ghiberti,* I, 282.

148. Valentinelli, *Marmi scolpiti del Museo Archeologico della Marciana di Venezia,* p. 126; Anti, *Il Regio Museo Archeologico nel Palazzo Reale di Venezia,* pp. 139–40, nos. 10, 13.

149. See Chapter II.

150. Ghiberti mentions the discovery of three newfound classical works of art: the Venus statue found in Siena and the one found in Florence, and a Hermaphrodite unearthed in Rome. See Ghiberti-Schlosser, I: 61–62; II: 187–88.

151. For the early fifteenth-century art collections of Niccolò Niccoli and Poggio Bracciolini see Müntz, *Les Collections,* pp. 6–10; William Roscoe, *The Life of Lorenzo de'Medici* (London, 1797) II: 196–98; W. Liebenwein, *Studiolo* (Berlin, 1977), pp. 65–66. For Poggio's collection in particular see also Ernst Walser, *Poggius Florentinus. Leben und Werke* (Leipzig, 1914), pp. 141. 146–48; William Shepherd, *Vita di Poggio Bracciolini,* trans. T. Tonelli, 2 vols. (Florence, 1825), I: 256–62. For fifteenth-century collectors in general, including Poggio, see Müntz, *Les Arts à la cour des papes,* I: 165–80.

152. Giuseppe Zippel, *Nicolò Niccoli* (Florence, 1890), pp. 11–12, 17, 24.

153. E. H. Gombrich, "From the Revival of Letters to the Reform of the Arts: Niccolò

Niccoli and Filippo Brunelleschi," reprinted in *The Heritage of Apelles* (Oxford, 1976), pp. 93–110; George Holmes, *The Florentine Enlightenment*, pp. 11 ff. *et passim.*

154. Müntz, *Les Précurseurs de la Renaissance*, pp. 112 ff.; Holmes, *The Florentine Enlightenment*, pp. 11–15 *et passim.*

155. Zippel, *Nicolò Niccoli*, p. 39, n. 4. Holmes, *The Florentine Enlightenment*, pp. 119, 147–50.

156. Zippel, *Nicolò Niccoli*, pp. 39, 49, 54; Holmes, *The Florentine Enlightenment*, pp. 127–31.

157. *Prosatori latini del Quattrocento*, ed. E. Garin (Milan, 1952), pp. 44–99; Hans Baron, *Humanistic and Political Literature in Florence and Venice* (Cambridge, Mass., 1955), pp. 126–65; Baron, *The Crisis of the Early Italian Renaissance* (Princeton, 1955), I: 38–40, 190–245; II: 395–400; Zippel, *Nicolò Niccoli*, pp. 14–15.

158. *Prosatori latini del Quattrocento*, pp. 68 ff.

159. *Prosatori latini del Quattrocento*, pp. 68 ff.

160. *Prosatori latini del Quattrocento*, p. 74.

161. *Prosatori latini del Quattrocento*, pp. 82 ff.

162. *Prosatori latini del Quattrocento*, pp. 52 ff.

163. *Prosatori latini del Quattrocento*, p. 58.

164. Zippel, *Nicolò Niccoli*, pp. 21–24.

165. Zippel, *Nicolò Niccoli*, p. 26.

166. Ambrogio Traversari, *Latinae Epistolae*, ed. Lorenzo Mehus, 2 vols. (Florence, 1711; reprint Bologna, 1968), vol. I, "Praefatio" and "Vita"; vol. II, "Epistolae"; Poggio Bracciolini, *Epistolae*, ed. T. Tonelli, 3 vols. (Florence, 1832–61).

167. Poggio Bracciolini, *Opera Omnia*, ed. R. Fubini, 4 vols. (Basel, 1538; reprint Turin, 1964–69), I: 270–77.

168. Vespasiano, *Le vite*, II: 225–42.

169. See Giannozzo Manetti, *Vita Nicolae* in Traversari, *Latinae Epistolae*, I: lxxvi–lxxviii; Baron, *The Crisis of the Early Italian Renaissance*, I: 290; II: 571–72, n. 60. See also Enea Silvio's biography of Niccoli in Baron, *The Crisis of the Early Italian Renaissance*, II: 550, n. 22.

170. Lauro Martines, *The Social World of the Florentine Humanists 1390–1460* (London, 1963), pp. 161–63.

171. Vespasiano, *Le vite*, II: 239; Manetti, *Vita Nicolae* in Traversari, *Latinae Epistolae* I: lxxvii.

172. Traversari, *Latinae Epistolae*, vol. II, bk. VIII, letter II, col. 354; letter VIII, col. 370; Zippel, *Nicolò Niccoli*, p. 27.

173. Vespasiano, *Le vite*, II: 239.

174. Giovanni da Prato, *Il paradiso degli Alberti*, ed. A. Wesselofsky (Bologna, 1867), vol. I, part 2, pp. 303–16.

175. *Epistolario di Guarino Veronese*, ed. R. Sabbadini (Venice, 1915), I: 33–46.

176. G. Zippel, "L'invettiva di Lorenzo di Marco Benvenuti contro Niccolò Niccoli," *Giornale storico della letteratura italiana* 24 (1894): 168–79; Baron, *The Crisis of the Early Renaissance*, vol. II, Appendix 5, pp. 409–16.

177. "Leonardo Bruni Oratio in Nebulaneum Maledicum," in Zippel, *Nicolò Niccoli*, pp. 75–91.

178. Traversari, *Latinae Epistolae*, I: lxi; "Orazione fatta al popolo fiorentino delle laude di Dante eccellentissimo Poeta e gravissimo Filosofo," in G. Benadduci, "Prose e poesie volgari di Francesco Filelfo," *Atti e Memorie della R. Deputazione di Storia Patria per le Province delle Marche* 5 (1901): 21–23; Baron, *The Crisis of the Early Renaissance*, II: 528–29, n. 18.

179. *Epistolario di Guarino Veronese*, I: 189.

180. Leonardo Bruni, *Epistolarum Libri, VIII*, ed. Lorenzo Mehus (Florence, 1741), bk. V, letter IV; G. Tiraboschi, *Storia della letteratura italiana*, VI (Milan, 1824): 192.

181. Bracciolini, *Epistolae*, vol. 1, bk. II, letter II, pp. 108–10.

182. Traversari, *Epistolae Latinae*, II, bk. 8, letter 16, col. 380.

183. Bracciolini, *Epistolae*, vol. 1, bk. III, letter V, pp. 192–95.

184. Walser, *Poggius Florentinus*, p. 203.

185. Traversari, *Epistolae Latinae*, vol. II, bk. II, letter 76, col. 566.

186. Zippel, *Nicolò Niccoli*, p. 54.

187. Vespasiano, *Le vite*, II: 230.

188. Bracciolini, *Opera Omnia*, p. 276; see also B. Ullman and P. Stadler, *The Public Library of Renaissance Florence* (Padua, 1972), pp. 59–104.

189. Anthony Hobson, *Great Libraries* (New York, 1970), p. 164. See also Berthold L. Ullman, *Studies in the Italian Renaissance*, 2nd ed. with additions and corrections (Rome, 1973), pp. 345 ff.

190. Vespasiano, *Le vite*, II: 234.

191. Vespasiano, *Le vite*, II: 234.

192. Krautheimer, *Lorenzo Ghiberti*, I: 159–62 ff., 169–72 ff., 302; II: 372 (doc. 52).

193. Vespasiano, *Le vite*, II: 237.

194. Vespasiano, *Le vite*, II: 235.

195. Paul Lemerle, *Le Premier Humanisme byzantin* (Paris, 1971), pp. 177–204, 205–241.

196. Vespasiano, *Le vite*, II: 228.

197. Ullman and Stadler, *The Public Library of Renaissance Florence*, pp. 89–104.

198. Dario Covi, "Lettering in Fifteenth Century Florentine Painting," *Art Bulletin* 45 (1963): 3. It should be added that the other source of the modern way of writing was the study of epigraphy, which aroused interest in the way capital letters had been written in Roman times.

199. Gombrich, "From the Revival of Letters to the Reform of the Arts" p. 102. It should be added that Niccoli's own writing was decidedly "cursive," according to Gombrich.

200. Gombrich, "From the Revival of Letters to the Reform of the Arts," p. 95.

201. Bracciolini, *Opera Omnia*, I: 271; Shepherd, *Vita di Poggio Bracciolini*, I: 290.

202. Bracciolini, *Opera Omnia*, I: 272; Shepherd, *Vita di Poggio Bracciolini*, I: 290.

203. Bracciolini, *Opera Omnia*, I: 276–77; Shepherd, *Vita di Poggio Bracciolini*, I: 291.

204. Ullman and Stadler, *The Public Library of Renaissance Florence*, pp. 62–73.

205. Vespasiano, *Le vite*, II: 232–33.

206. Vespasiano, *Le vite*, II: 239–40.

207. Bracciolini, *Opera Omnia*, I: 276.

208. Edward W. Bodnar, *Cyriacus of Ancona and Athens* (Brussels-Berchem, 1960), p. 18, n. 1.

209. See Francesco Scalamonti, *Commentario premesso alla vita di Ciriaco Anconitano*, in Giuseppe Colucci, *Antichità picene*, XV (Fermo, 1792): xcii.

210. Scalamonti, *Commentario*, p. xcii.

211. Scalamonti, *Commentario*, p. xcii.

212. Traversari, *Latinae Epistolae*, vol. II, bk. 8, letter 45, col. 412; bk. 8, letter 48, col. 417; bk. 8, letter 52, col. 421; bk. 9, letter 76, col. 566.

213. Traversari, *Latinae Epistolae*, vol. II, bk. VI, letter 2, col. 211.

214. Bracciolini, *Opera Omnia*, I: 276.

215. Ghiberti-Schlosser, I: 64; II: 192, n. 4.

216. See for instance, Lorenzo de Medici's *ricordo* in Antonio Francesco Gori, *La Toscana illustrata*, I (Leghorn, 1755): 191–94, reporting his acquisition of "Il Calcedonio."

217. See note 151.

218. Zippel, *Nicolò Niccoli*, p. 10 & n. 1.

219. Zippel, *Nicolò Niccoli*, p. 10; Martines, *The Social World of the Florentine Humanists*, p. 160.

220. Zippel, *Nicolò Niccoli*, p. 11.

221. Zippel, *Nicolò Niccoli*, p. 11.

222. Bracciolini, *Opera Omnia*, I: 272.

223. Vespasiano, *Le vite*, II: 236.

224. Zippel, *Nicolò Niccoli*, p. 14, n. 2; Baron, *Humanistic and Political Literature*, pp. 154–59.

225. *Epistolario di Guarino Veronese*, I: 39–40.

226. See Chapter IV.

227. J. G. W., "Robert von Hirsch 1883–1977," in *The Robert von Hirsch Collection*. I, *Old Master Drawings, Paintings and Medieval Miniatures*, Sotheby Parke Bernet (1978), p. ix.

228. Christian Bec, *Les Marchands écrivains* (Paris-The Hague, 1967), pp. 383 ff.; Michael Baxandall, *Painting and Experience in Fifteenth Century Italy* (Oxford, 1972), p. 86.

229. Bec, *Les Marchands écrivains*, pp. 383 ff.; Baxandall, *Painting and Experience*, p. 86.

230. Traversari, *Latinae Epistolae*, vol. II, bk. 8, letter 48, col. 417.

231. Bruni, *Epistolarum Libri VIII*, II: 189.

232. Traversari, *Latinae Epistolae*, vol. II, bk. 8, letter 38, col. 400.

233. Bracciolini, *Epistolae*, vol. I, bk. III, letter 15, pp. 213–14; vol. I, bk. III, letter 37, pp. 283–85; vol. I, bk. IV, letter 12, pp. 322–24; vol. I, bk. IV, letter 13, pp. 324–27.

234. See Chapter XI.

235. As one example of the competition of much richer collectors there is the case of two paintings bought by Duveen from the Hainauer Collection. The most attractive and important was the Andrea del Castagno portrait of a man, which Duveen did not offer to Mrs. Gardner because he believed he could get a much larger price from J. P. Morgan—as he did (see Rollin van N. Hadley, "What Might Have Been: Pictures Mrs. Gardner Did Not Acquire," *Fenway Court 1979* [Boston, 1980], p. 50, no. 61). Mrs. Gardner was offered and took a profile portrait of a woman by Piero del Pollaiuolo which would not have pleased the new millionaire buyers of that time because the subject was decidedly plain (Philip Hendy, *European and American Paintings in the Isabella Stewart Gardner Museum* [Boston, 1974], p. 187).

236. Louise Hall Tharp, *Mrs. Jack* (Boston, 1965), p. 166.

237. Vespasiano, *Le vite*, II: 239–40.

238. Vespasiano, *Le vite*, II: 240.

239. Vespasiano, *Le vite*, II, 233.

240. Schlosser, "Über einige Antiken Ghibertis," pp. 125–40; Schlosser, *Leben und Meinungen*, pp. 123–40.

241. See David Rosand, "Titian and the Bed of Polyclitus," *Burlington Magazine* 117 (April 1975): 243, no. 72.

242. *Enciclopedia italiana di scienze, lettere ed arti*, III (Rome, 1929): 808; XXXI (1936): 2–3; *The New Century Italian Renaissance Encyclopedia*, ed. Catherine B. Avery (New York, 1972), p. 852; Gaetano Moroni, *Dizionario di erudizione storico-ecclesiastica*, XLV (Venice, 1847): 12–14; Ludwig Pastor, *Geschichte der Päpste*, 3rd and 4th eds. (Freiburg i.B., 1901), I: 295–96. Hill, *Italian Medals of the Renaissance*, I: 197–98. Alfonso Chacón, *Vitae, et Res Gestae Pontificum Romanorum et S.R.E.*

Cardinalium, II (Rome, 1677): 919–23; L. Rizzoli, "Il Cardinale Lodovico Scarampo Mezzarota," *Atti e memorie della R. Accademia di Scienze, Lettere ed Arte in Padova,* n.s. 17 (1900): 83–92. "Scarampi" is the approved modern spelling but "Scarampo" is nakedly given by Vespasiano da Bisticci.

243. Vespasiano, *Le vite,* II: 233.

244. A wise scholar tells me that the foregoing argument has "no sound art-historical basis." But art history to date has passed over the ways of the art market. Any rise in prices by a factor of forty is unimaginable without a long period of holding the work of art to be sold, in order to permit market prices to rise. If any collector's prize has increased in value by a factor of forty in a period of under four decades, I have never heard of it. And allowing fifty years for the rise in price of Niccoli's gem is certainly most conservative, given the period under consideration.

245. Krautheimer, *Lorenzo Ghiberti,* I: 106.

XI. THE ROLE OF COSIMO

1. Leon Battista Alberti, *On Painting and On Sculpture,* ed. Cecil Grayson (London, 1972), p. 33.

2. Eugène Müntz, *Les Collections des Médicis au XVe siècle* (Paris, 1888), pp. 3–6; Müntz, *Les Précurseurs de la Renaissance* (Paris, 1882), pp. 136–46. The problem will be discussed further throughout this chapter.

3. Müntz, *Les Collections,* pp. 11 ff.; Müntz, *Les Précurseurs,* pp. 147–60.

4. Müntz, *Les Collections,* pp. 52 ff.; Müntz, *Les Précurseurs,* pp. 167 ff.; esp. 181 ff.

5. Müntz, *Les Précurseurs,* pp. 214–15.

6. E. H. Gombrich, "The Early Medici as Patrons of Art," in *Norm and Form* (London, 1966), pp. 35–37; A.D. Fraser Jenkins, "Cosimo de'Medici's Patronage of Architecture and the Theory of Magnificence," *Journal of the Warburg and Courtauld Institutes* 33 (1970): pp. 162–70.

7. See the distinction between patron-commissioned works of art and collected works of art in Chapters II, III, and IV.

8. With a minor and also arguable exception for Jan van Eyck and his successors in the Low Countries. See discussion in Chapter XII.

9. Bartolomeo Fazio, *De Viris Illustribus,* ed. Lorenzo Mehus (Florence, 1745), pp. 43–49; S. Bottari, *Antonello* (Turin, 1953), pp. 2 ff.; Jan Lauts, *Antonello da Messina* (Vienna, 1940), pp. 7–8; Roberto Weiss, "Jan Van Eyck and the Italians," *Italian Studies* 11 (1956): 1–15, esp. 9 ff., and 12 (1957): 7–21.

10. Rodolfo Lanciani, *Storia degli scavi di Roma* (Rome, 1902–13), vol. I, *passim.*

11. Rambaldo degli Azzoni Avogaro, "Della zecca, e delle monete ch'ebbero corso in Trivigi" in Guid'Antonio Zanetti, *Nuova raccolta delle monete e zecche a' Italia,* IV (Bologna, 1786): 151–52; Domenico Maria Federici, *Memorie trevigiane sulle opere di disegno* (Venice, 1803), pp. 184–85.

12. Luciano Gargan, "Cultura e arte a Treviso al tempo di Tomaso," in *Tomaso di Modena,* exhibition catalogue (Treviso, 1979), p. 42.

13. *Petrarch's Testament,* ed. Theodor E. Mommsen (Ithaca, 1957), pp. 22–23, 78–79.

14. *Petrarch's Testament,* pp. 78–81.

15. Datini: Iris Origo, *The Merchant of Prato* (London, 1957), p. 238. Morelli: Giovanni di Pagolo Morelli, *Ricordi,* ed. Vittore Branca, 2nd ed. (Florence, 1969), p. 178. Cennini: Cennino Cennini, *Il libro dell'arte,* chaps. I and LXVII, as cited in R. Salvini, *Giotto bibliographia,* I (Rome, 1938): 7. Villani: Filippo Villani, *De Origine Civitatis Florentiae et Eiusdem Famosis Civibus,* in Karl Frey, ed. *Il libro di Antonio Billi* (Berlin, 1892), p. 74.

16. Lùciano Berti, *Masaccio* (Milan, 1964), pp. 47 ff.

17. Vasari-Milanesi, II: 50.

18. The letter is translated by Michael Baxandall in *Giotto and the Orators* (Oxford, 1971), pp. 81–82.

19. Alberti, *On Painting*, bk. II, para. 25, pp. 60–61.

20. Jakob Burckhardt, *Die Zeit Constantins des Grossen* (Leipzig, 1880), pp. 419–20.

21. Eusebius, *Vita Constantini* III. 54, in *Die griechischen christlichen Schriftsleiter der ersten drei Jahrhunderte*, ed. Friedhelm Winckelmann (Berlin, 1975), VII: 101–02.

22. Perhaps this statement should be qualified in view of the possibility that scholars may decide to attribute to Phidias the two fifth-century bronzes which were discovered off the Calabrian coast in 1972. See the discussion in Chapter VI, note 42. On the Athena Promachus, see Friedrich Wilhelm Unger, ed. *Quellenschriften der Byzantinischen Kunstgeschichte*, Quellenschriften für Kunstgeschichte 12 (Vienna, 1878; reprint Osnabrück, 1970), pp. 147–48.

23. Unger, *Quellenschriften*, pp. 148–49.

24. Cyril Mango, "Antique Statuary and the Byzantine Beholder," *Dumbarton Oaks Papers* 17 (1963): 70.

25. The Ottoman rulers were collectors, as the Topkapî Sarayî attests, but their prizes were later Islamic calligraphy and illumination.

26. Mango, "Antique Statuary," p. 69.

27. Since Niccoli fought with so many humanists of his time except Poggio Bracciolini and Ambrogio Traversari, a list hardly needs to be appended.

28. See below, this chapter.

29. Hans Baron, *The Crisis of the Early Italian Renaissance* (Princeton, 1955), I: 303.

30. P. L. Rose, "Humanist Culture and Renaissance Mathematics: The Italian Libraries of the 'Quattrocento'," *Studies in the Renaissance* 20 (1973): 104; see also Rose, *The Italian Renaissance of Mathematics* (Geneva, 1975).

31. Giovanni Battista De Rossi, "Le prime raccolte d'antiche iscrizioni compilate in Roma tra il finir del secolo XIV, ed il cominciare del XV," *Giornale arcadico* 127 (April-June 1852): 254–355; Tiraboschi, *Storia della letteratura italiana*, V-2 (Milan, 1823): 586 ff.

32. Erich Ziebarth, "Cyriacus von Ancona als Begründer der Inschriftenforschung," *Neue Jahrbücher für das klassische Altertum* 9 (1902): 214–26; Edward W. Bodnar, *Cyriacus of Ancona and Athens* (Brussels-Berchem, 1960), pp. 19 ff.; Ernst Walser, *Poggius Florentinus* (Leipzig, 1914), p. 28.

33. Poggio Bracciolini, *De Varietate Fortunae*, ed. Domenico Georgio (1723; reprint Bologna, 1969), bk. I.

34. Roberto Weiss, *The Renaissance Discovery of Classical Antiquity* (Oxford, 1969), pp. 66–73.

35. See S. D. Goitein, *A Mediterranean Society: The Jewish Communities of the Arab World as Portrayed in the Documents of the Cairo Geniza*, 3 vols. (Berkeley, 1967–78).

36. Remigio Sabbadini, *Le scoperte dei codici latini e greci ne' secoli XIV e XV*, 2 vols. (1905–14; reprint Florence, 1967), II: 199 ff.

37. See discussion of collecting by the Medici, beginning in this chapter and throughout Chapter XII.

38. Phyllis W. G. Gordan, *Two Renaissance Book Hunters* (New York, 1974), pp. 191–92; Leonardo Bruni, *Epistolarum Libri VIII*, ed. Lorenzo Mehus (Florence, 1741), bk. VIII, part 1, pp. 111–13.

39. Poggio attended the council with anti-Pope John XXIII. Gibbon tells us how the

council dealt with John XXIII: ". . . the most scandalous charges [of heresy] were suppressed; the vicar of Christ was only accused of piracy, murder, rape, sodomy, and incest," (*The Decline and Fall of the Roman Empire*, Modern Library ed., 2 vols. [New York], II: 1428 [ch. LXX]). Since his man's case was a foregone conclusion, Poggio was presumably left with much free time to pursue his book hunt.

40. Sabbadini, *Le scoperte* I: 77 ff., II: 193; Tino Foffano, "Niccoli, Cosimo e le ricerche di Poggio nelle biblioteche francesi," *Italia medioevale e umanistica* 12 (1969): 113–28.

41. Walser, *Poggius Florentinus*, p. 52.

42. The history of book and antique collecting in the Eastern Mediterranean before modern times is a subject deserving more attention. In the fifteenth century the record begins with such figures as Ciriaco d'Ancona, Fra Francesco da Pistoia, and Andreolo Giustiniani, and extends through John Lascaris, the Greek who served Lorenzo de' Medici the Magnificent. But there is enough thirteenth- and fourteenth-century evidence to call for further exploration.

43. Sabbadini, *Le scoperte*, I: 74 ff.

44. Eugène Müntz and P. Fabre, *La Bibliothèque du Vatican au XVe siècle* (Paris, 1887), pp. 34–114.

45. A. Fabroni, *Laurentii Medicis Magnifici Vita*, 2 vols. (Pisa, 1784), I: 152.

46. Sabbadini, *Le scoperte*, I: 23–42.

47. *Prosatori latini del Quattrocento*, ed. Eugenio Garin (Milan, 1952), pp. 55 ff.

48. *Prosatori latini*, pp. 55 ff.

49. Gordan, *Two Renaissance Book Hunters*, p. 46; Poggio Bracciolini, *Epistolae*, ed. T. Tonelli, 3 vols. (Florence, 1832–61), vol. I, letter 10, pp. 42–44.

50. Ambrogio Traversari, *Latinae Epistolae*, ed. Lorenzo Mehus, 2 vols. (Florence, 1711; reprint Bologna, 1968), vol. II, bk. 8, letter 2, cols. 352–54.

51. Traversari, *Latinae Epistolae*, vol. II, bk. 8, letter 2, cols. 352–54.

52. Traversari, *Latinae Epistolae*, vol. II, bk. 9, letter 76, col. 566.

53. Bernard Ashmole, "Ciriac of Ancona," *Proceedings of the British Academy 1959* (London, 1960), pp. 38–39.

54. The rock-crystal gem was in Florence in the nineteenth century and, according to Bernard Ashmole, in the Berlin Museum before the Second World War (Ashmole, "Ciriac of Ancona," p. 38).

55. Traversari, *Latinae Epistolae*, vol. II, bk. 8, letter 45, col. 412.

56. Traversari, *Latinae Epistolae*, vol. II, bk. 8, letter 38, col. 400.

57. Traversari, *Latinae Epistolae*, vol. I, preface, p. 1.

58. Traversari, *Latinae Epistolae*, vol. II, bk. 8, letter 48, col. 417.

59. Traversari, *Latinae Epistolae*, vol. II, bk. 8, letter 8, col. 368.

60. Traversari, *Latinae Epistolae*, vol. II, bk. 8, letter 52, col. 421.

61. Bracciolini, *Epistolae*, vol. I, bk. I, letter 10, pp. 42–45.

62. Throughout the Middle Ages, of course, treasures, as defined in Chapter II, were the *only* works of art with serious independent value.

63. Vespasiano da Bisticci, *Le vite*, ed. Aulo Greco, 2 vols. (Florence, 1970–76), II: 239–40.

64. See Chapter XII.

65. Gordan, *Two Renaissance Book Hunters*, pp. 167–70; Bracciolini, *Epistolae*, vol. I, bk. IV, letter 13, pp. 324–27.

66. Bracciolini, *Epistolae*, vol. I, bk. III, letter 37, pp. 283–85.

67. Gordan, *Two Renaissance Book Hunters*, p. 167; Bracciolini, *Epistolae*, vol. I, bk. IV, letter 12, pp. 322–24.

68. Bracciolini, *Epistolae*, vol. I, bk. III, letter 15, pp. 213–14.

69. Bracciolini, *Epistolae*, vol. I, bk. IV, letter 15, pp. 330–33, translated by Dr. Bernard Knox.

70. See, for example, the extraordinary echoes of Chrysoloras on the beauty of classical art, of Leon Battista Alberti on the high value of a work by Phidias or Praxiteles even if made of lead, and of Poggio himself, which appear in the letter from Poggio's friend Cincius Romanus to the little-known Franciscus de Fiana. Cincius writes, concerning those who destroy the monuments of antiquity: "Truly I would prefer and pay more for a small marble figure by Phidias or Praxiteles than for a living and breathing image of the man who turns the statues of those glorious men into dust or gravel." Gordan, *Two Renaissance Book Hunters*, p. 190.

71. Bracciolini, *Epistolae*, vol. I, bk. IV, letter 21, pp. 347–49.

72. Bracciolini, *Epistolae*, vol. I, bk. IV, letter 21, pp. 347–49, translated by Dr. Knox.

73. Gordan, *Two Renaissance Book Hunters*, pp. 166–67; Bracciolini, *Epistolae*, vol. I, bk. IV, letter 12, pp. 322–24.

74. Gordan, *Two Renaissance Book Hunters*, pp. 166–67; Bracciolini, *Epistolae*, vol. I, bk. IV, letter 12, pp. 322–24.

75. Bracciolini, *Epistolae*, vol. I, bk. IV, letter 12, pp. 322–24.

76. Bracciolini, *Epistolae*, vol. II, bk. VI, letter 14, pp. 174–77.

77. Bracciolini, *Epistolae*, vol. II, bk. VI, letter 14, pp. 174–77.

78. Bracciolini, *Epistolae*, vol. II, bk. VI, letter 14, pp. 174–77.

79. Bracciolini, *Epistolae*, vol. II, bk. VI, letter 14, pp. 174–77.

80. Bracciolini, *Epistolae*, vol. II, bk. VI, letter 14, pp. 174–77, kindly translated by Dr. Knox.

81. Vespasiano, *Le vite*, II: 170–71.

82. Gordan, *Two Renaissance Book Hunters*, p. 151; Bracciolini, *Epistolae*, vol. I, bk. III, letter 40, pp. 290–91.

83. Martin Wackernagel, *Der Lebensraum des Künstlers in der Florentinischen Renaissance* (Leipzig, 1938), pp. 289–91.

84. See below.

85. Bodnar, *Cyriacus of Ancona and Athens*, p. 20.

86. *Cyriacus of Ancona's Journeys in the Propontis and the Northern Aegean 1444–1445*, eds. Edward W. Bodnar and Charles Mitchell (Philadelphia, 1976), p. 1.

87. Bodnar, *Cyriacus of Ancona and Athens, passim*; Bernard Ashmole, "Cyriac of Ancona and the Temple of Hadrian at Cyzicus," *Journal of the Warburg and Courtauld Institutes* 19 (1956): 179–91; P. W. Lehmann, "Cyriacus of Ancona's Visit to Samothrace," in *Samothracian Reflections* (Princeton, 1973), pp. 3–56.

88. F. Babinger, "Mehmed der Eroberer in östlicher und westlicher Beleuchtung," *Südost-Forschungen* 22 (1963): 17, n. 19.

89. G. Targioni-Tozzetti, *Relazioni d'alcuni viaggi fatti in diverse parti della Toscana*, 2nd ed., V (Florence, 1773): 66–69, 408–61.

90. Targioni-Tozzetti, *Relazioni*, V: 423–24.

91. Cyriaco d' Ancona, *Itinerarium*, ed. Lorenzo Mehus (Florence, 1742), p. XLIX.

92. Bodnar, *Cyriacus of Ancona and Athens*, p. 18, n. 1; G. B. De Rossi, *Inscriptiones Christianae Urbis Romae Septimo Saeculo Antiquiores*, II (Rome, 1888): 356–87.

93. Personal communication from Dr. Edward W. Bodnar, S. J., Georgetown University.

94. Francesco Scalamonti, *Commentario premesso alla vita di Ciriaco Anconitano*, in Giuseppe Colucci, *Delle antichità picene*, XV (Fermo, 1792): xlv–clv.

95. G. Voigt, *Die Wiederbelebung des classischen Alterthums*, 4th ed. (Berlin, 1960), I: 269, n. 1.

96. Scalamonti, *Commentario*, p. xcii; Filippo di Benedetto, "Learzio, Omero e le 'Pandette,'" *Italia medioevale e umanistica* 12 (1969): 53–112.

97. Bruno Santi, ed., *Neri di Bicci: Le ricordanze* (Pisa, 1976), p. 17.

98. This is a standard fifteenth-century muddle about subjects and attributions of classical works of art, similar to Ghiberti's interpretation of the seal of Nero (see below). Pyrgoteles was a Greek gem engraver of the time of Alexander the Great (Pliny, *Naturalis Historia* VII. 125, XXVII. 8); he would hardly have chosen a Roman Lupercalian priest as his subject.

99. Scalamonti, *Commentario*, p. xcii.

100. Richard Krautheimer, *Lorenzo Ghiberti*, 2 vols., 2nd ed. (Princeton, 1970), I: 278.

101. The translation of this passage was kindly made by Dr. Bernard Knox of the Center for Hellenic Studies; but I have taken the great liberty of altering Dr. Knox's rendering of the word *"suppellectilia,"* substituting "fine things." The dictionaries (e.g., *Medieval Latin Word List*, ed. J. H. Baxter and Charles Johnson [Oxford and London, 1934], s.v. *"superlectile")* give the normal definition of the word *"suppellectilia"* as "furniture," derived from the original meaning "coverlet." Dr. Knox followed the dictionaries, as was natural; but I do not see how "furniture" can be made to fit the entire phrase in Scalamonti, which is *"preciosa multa eiusdem generis suppellectilia."* The trouble is that *"eiusdem generis"* plainly refers back to the classical works of art seen in Marsuppini's collection. Furthermore, if you examine other fifteenth-century humanist texts you find *suppellectilia* was used to indicate household valuables of almost any sort. See, for example, the description of the possessions of Lorenzo de' Medici, Cosimo's brother, in the funeral oration by Pacinus, which may be found in the preface to the Mehus edition of Traversari, *Latinae Epistolae*, I: xvii–xix: *"Erat enim distissimus agri, distissimusque auri, atque pretiosae vestis, & universae supellectilis, signis, tabulis pictis, vasis caelatis, margaritis, libris mirum in modum affluit* &c." See also the letter of Ciriaco d'Ancona to Andreolo Giustiniani in Targioni-Tozzetti, *Relazioni*, V: 452–53. For another similar use of the word, this time as a transplant into Italian, see Sabba da Castiglione, *Ricordi di Monssignor Sabba da Castiglione* (Venice, 1560), *Ricordo* CIX: 59 recto, where it appears in its modern Italian form: *"suppellettile."*

102. Ghiberti-Schlosser, I: 47; II: 177–78, n. 11; Krautheimer, *Ghiberti*, I: 13.

103. Nicole Dacos, Antonio Giuliano, and Ulrico Pannuti, *Il tesoro di Lorenzo il Magnifico.* I: Le gemme (Florence, 1973), pp. 55–57.

104. Vasari-Milanesi, II: 235. See also E. Kris, *Meister und Meisterwerke der Steinschneidekunst* (Vienna, 1929), I: 25.

105. Krautheimer, *Ghiberti*, I: 87.

106. Ghiberti-Schlosser, I: 47, trans. by Professor Anna Modigliani Lynch.

107. Müntz, *Les Collections*, p. 69.

108. Traversari, *Latinae Epistolae*, vol. II, bk. VI, letter 16, cols. 344–45.

109. Müntz, *Les Collections*, p. 16. See also Vasari-Milanesi, II: 235–36.

110. Vasari-Milanesi, II: 406. See also Horst W. Janson, *The Sculpture of Donatello*, 2nd ed. (Princeton, 1963), p. 81.

111. Janson, *Donatello*, p. 81.

112. Janson, *Donatello*, pp. 83–84.

113. For example, Professor Ulrich Middeldorf tells me that he now agrees with Professor Janson, although he once supported the opposite view in his review of Kauffman's *Donatello* in *Art Bulletin* 18 (1936): 576.

114. Janson, *Donatello*, p. 84.

115. André Chastel, *Art et humanisme à Florence au temps de Laurent le Magnifique*, 2nd ed. (Paris, 1961), p. 47.

116. The motif on the helmet unquestionably comes from the gem, and it is hard to see where else Donatello could have gone to find this motif for a piece of sculpture

being made for Cosimo de' Medici, except to the latter's personal collection.

117. Antonio Averlino Filarete, *Treatise on Architecture*, ed. John R. Spencer (New Haven, 1965), I: 316; Vespasiano, *Le vite*, II: 233.

118. L. Pastor, *Geschichte der Päpste*, 3rd & 4th eds., I (Freiburg i.B., 1901): 296–97.

119. Hanna Lerner-Lehmkuhl, *Zur Struktur und Geschichte des Florentinischen Kunstmarktes im 15. Jahrhundert* (Wattenscheid, 1936), pl. 3.

120. Gordan, *Two Renaissance Book Hunters*, p. 67; Bracciolini, *Epistolae*, vol. I, bk. I, letter 17, p. 71.

121. Raymond de Roover, *The Rise and Decline of the Medici Bank* (Cambridge, Mass., 1963), p. 56.

122. Vasari-Milanesi, II: 419–20.

123. There are five Donatellos listed in the posthumous inventory of Lorenzo de' Medici (Müntz, *Les Collections*, pp. 63–64), all of which were probably acquired as a result of Cosimo's commissions, considering the dates and Donatello's relationship with Cosimo. In addition, there were the David and the Judith with the Head of Holophernes, which were not listed in the inventory; and Vasari records (Vasari-Milanesi, II: 407) that Cosimo had Donatello repair the so-called white Marsyas and various other pieces of classical sculpture.

124. Janson, *Donatello*, p. 85.

125. Vespasiano, *Le vite*, II: 194.

126. Janson, *Donatello*, p. 125.

127. Vasari-Milanesi, II: 407, 420.

128. Ghiberti-Schlosser, I: 62; II: 188–89.

129. Bracciolini, *Opera Omnia*, I: 276.

130. Vespasiano, *Le vite*, II: 230; Traversari, *Latinae Epistolae*, vol. II, bk. VIII, letter 8, cols. 366–67.

131. See, for example, Bracciolini, *Epistolae*, vol. I, bk. II, letter 37, pp. 283–85 and Traversari, *Latinae Epistolae*, vol. II, bk. VIII, letter 34, col. 392.

132. Gordan, *Two Renaissance Book Hunters*, pp. 114–15; Bracciolini, *Epistolae*, vol. I, bk. III, letter 12, pp. 209–10.

133. Müntz, *Les Précurseurs*, pp. 104 and 112 for Niccoli's collection, p. 124 for Poggio's.

134. The villa with the garden ornamented by Poggio's sculpture collection is described at the opening of his dialogue, *De Nobilitate*. See also Gordan, *Two Renaissance Book Hunters*, p. 118; Bracciolini, *Epistolae*, vol. I, bk. III, letter 15, p. 214.

135. Walser, *Poggius Florentinus*, p. 162.

136. Giuseppe Zippel, *Nicolò Niccoli* (Florence, 1890), pp. 96–100.

137. Zippel, *Nicolò Niccoli*, p. 68.

138. Vespasiano, *Le vite*, II: 200–201. The sum is given as 500 *"ducati"* on p. 200, and as 500 *"fiorini"* on p. 201. However, the values of the Venetian and Florentine currencies were not far apart.

139. Zippel, *Nicolò Niccoli*, p. 69; B. Ullman and P. Stadler, *The Public Library of Renaissance Florence* (Padua, 1972), pp. 15 ff., 47.

140. Zippel, *Nicolò Niccoli*, p. 98; Ullman and Stadler, *The Public Library*, p. 9.

141. Vasari-Milanesi, II: 407.

142. Vasari-Milanesi, III: 366–67.

143. Vasari-Milanesi, II: 407.

144. Vasari-Milanesi, IV: 219.

145. Müntz, *Les Collections*, pp. 11 ff., 35 ff.

146. Wackernagel, *Der Lebensraum*, p. 256.

147. Eve Borsook, "Documents for Filippo Strozzi's Chapel in Santa Maria Novella and Other Related Papers," *Burlington Magazine* 112 (1970): 801 (docs. 20, 21); Stefano

Orlandi, *Necrologia di Santa Maria Novella* (Florence, 1955), II: 513. For the Strozzi Chapel in general see Borsook, "Documents," pp. 737–45, 800–84; John R. Sale, "The Strozzi Chapel by Filippino Lippi in Santa Maria Novella," dissertation, University of Pennsylvania (1976), pp. 100–108; W. and E. Paatz, *Die Kirchen von Florenz*, III (Frankfurt a. M., 1952):708–09; G. Bini and P. Bigazzi, *Vita di Filippo Strozzi* (Florence, 1851), pp. 27, 42–43.

148. Vasari-Milanesi, III: 471–73.

149. Borsook, "Documents," pp. 742 ff.; Sale, "The Strozzi Chapel," pp. 118 ff.; Luitpold Dussler, *Benedetto da Maiano* (Munich, 1924), pp. 42–45.

150. Wackernagel, *Der Lebensraum*, pp. 248–50.

151. Paatz, *Die Kirchen von Florenz*, I: 556–59; Julian Gardner, "The Decoration of the Baroncelli Chapel in Santa Croce," *Zeitschrift für Kunstgeschichte* 34 (1971): 89–114.

152. Hannelore Glasser, *Artists' Contracts of the Early Renaissance* (New York, 1977), p. 121. See also Eve Borsook, "Notizie su due capelle in Santa Croce a Firenze," *Rivista d'arte* 36 (1961–62): 89–98; B. Degenhart and A. Schmitt, *Corpus der italienischen Zeichnungen 1300–1450* I-1 (Berlin, 1968): 88–89.

153. R. Goldthwaite, "The Florentine Palace as Domestic Architecture," *American Historical Review* 77 (October 1972): 980 ff.

154. Luciano Berti, *Il Museo di Palazzo Davanzati* (Florence, 1971); Maria Fossi Todorow, "Il Museo della Casa Fiorentina Antica in Palazzo Davanzati," *Atti della "Società Leonardo da Vinci"* (1973–74), pp. 359–65; Todorow, *Palazzo Davanzati*. Biblioteca de 'Lo Studiolo' 2. (Florence, 1979).

155. Berti, *Palazzo Davanzati*, p. 10; Todorow, "Il Museo," pp. 369, 371; Todorow, *Palazzo Davanzati*, pp. 13, 17.

156. R. Piattoli, "Un mercante del Trecento e gli artisti del tempo suo," *Rivista d'arte* 11 (1929): 550 ff.; see also Bruce Cole, "The Interior Decoration of the Palazzo Datini in Prato," *Mitteilungen des Kunsthistorischen Institutes in Florenz* 13 (1967): 61–82.

157. Part of the decoration in the grandest room in the Palazzo Davanzati and much of the decoration of the "parrot room" take the form of simulated wall hangings, implying that real ones were common in the houses of the upper class, but that it would have been much more expensive to hang an entire room with costly stuffs than to pay a painter a couple of florins a day, at the most, to have the room permanently decorated.

158. Vasari-Milanesi, II: 50; Wackernagel, *Der Lebensraum*, p. 154.

159. Goldthwaite, "The Florentine Palace," pp. 977–1012.

160. W. Bombe, *Nachlass-Inventare des Angelo da Uzzano und des Ludovico di Gino Capponi* (Leipzig, 1928), see nos. 10, 54, 80, 167, 203, 240, 323 ff.

161. Giovanni Gaye, *Carteggio inedito d'artisti dei secoli XIV, XV, XVI,* I (Florence 1839): 61–62.

162. Curzio Mazzi, *Argenti degli Acciaiuoli* (Siena, 1895).

163. Müntz, *Les Précurseurs*, pp. 136–47.

164. Domenico Moreni, *Continuazione delle memorie istoriche dell'Ambrosiana Imperiale Basilica di S. Lorenzo,* I (Florence, 1816): 41; Gombrich, "The Early Medici," p. 36; Vespasiano, *Le vite,* II: 181.

165. See the preface to Traversari, *Latinae Epistolae,* I: xvii–xix, and note 101 above.

166. Müntz, *Les Collections*, pp. 58 ff.

167. I. Hyman, "Notes and Speculations on S. Lorenzo, Palazzo Medici, and an Urban Project by Brunelleschi," *Journal of the Society of Architectural Historians* 34 (1975): 101.

168. Müntz, *Les Collections*, pp. 58, 86.

169. Müntz, *Les Collections*, pp. 64, 85, 86.

170. The two other Uccellos and the Pesellino were in the "Chamera di Lorenzo" de' Medici in the inventory of 1492 (Müntz, *Les Collections*, p. 60). John Pope-Hennessy, *Uccello* (London, 1950), pp. 20–23, has given a description of the room and a proposed date for the three great Uccellos of the Rout of San Romano. As the subjects of the three other pictures have nothing to do with the Rout cycle, it is probable (although by no means certain) that they were earlier commissions by Cosimo; the Rout cycle was then painted partly to complete the decoration of the room.

171. Müntz, *Les Collections*, pp. 63, 64. See also Janson, *The Sculpture of Donatello*, pp. 92–95.

172. Müntz, *Les Collections*, pp. 64, 77.

173. This would have been very early, however, for a devotional picture to be put to use in a bourgeois house.

174. Vasari-Milanesi, I: 408–9.

175. But, again, we must bear in mind that there may have been frescoes in the Palazzo Uzzano that were not inventoried, as was the practice.

176. See Moreni, *S. Lorenzo*, vol. I; Gombrich, "The Early Medici," *passim.*

177. F. Borsi et al., *La Badia Fiesolana* (Florence, 1976), pp. 68–103; U. Procacci, "Cosimo de'Medici e la Badia Fiesolana," *Commentari* 19 (1968): 80–97.

178. John Pope-Hennessy, *Fra Angelico*, 2nd ed. (London, 1974), pp. 19–24.

179. Jenkins, "Cosimo de'Medici's Patronage of Architecture," pp. 164–65.

180. Vespasiano, *Le vite*, II: 180–81; Vasari-Milanesi, II: 443.

181. Marsilio Ficino, *Opera Omnia*, 2nd ed. (1576; reprint Turin, 1959), IV: 1537. See also Arnaldo Della Torre, *Storia dell'Accademia Platonica di Firenze* (Florence, 1902), pp. 456 ff.

182. Della Torre, *Storia dell'Accademia*, pp. 541 ff.

183. Vespasiano, *Le vite*, II: 204; Della Torre, *Storia dell'Accademia*, p. 538; Paul Oskar Kristeller, "Lay Religious Traditions and Florentine Platonism," in *Studies in Renaissance Thought and Letters* (Rome, 1956), pp. 110 ff.; David Coffin, *The Villa in the Life of Renaissance Rome* (Princeton, 1979), pp. 12–13.

184. Ficino, *Opera Omnia*, II: 648–49.

185. Vespasiano, *Le vite*, II: 191–92.

186. See the *ricordo* published in William Roscoe, *The Life of Lorenzo de' Medici*, 3rd ed. (London, 1797), vol. I, Appendix XII, p. 29; and in "Ricordi del Magnifico Lorenzo di Piero di Cosimo de' Medici," in Antonio Francesco Gori, *La Toscana illustrata*, I (Leghorn, 1755): 194. See also Roover, *Rise and Decline*, p. 371.

187. Here I have merely doubled the sum produced by my former calculation, which was based on the gold content of the florin in Cosimo de' Medici's time and the former valuation of gold at $200 an ounce. Since that time, the gold price has risen vastly higher and then fallen a bit, but even at present the sum given is conservative. Of course, it may not be conservative later on, but if I knew what would happen to the price of gold, I could count on being a much richer man in the future. I owe my information on the gold content of the fifteenth-century florin to Ed Reiter, numismatics columnist for *The New York Times.*

188. Roscoe, *Lorenzo de'Medici*, vol. I, Appendix XII, p. 29.

189. Herodotus, *History* v. 62.

190. Gombrich, "The Early Medici," pp. 35–57; Jenkins, "Cosimo de'Medici's Patronage of Architecture," pp. 162–70.

191. Gombrich, "The Early Medici," pp. 39–40; Jenkins, "Cosimo de'Medici's Patronage of Architecture," pp. 165–66.

192. Vespasiano, *Le vite,* II: 189.

193. G. Lami, *Deliciae Eruditorum,* XII (Florence, 1742): 155; Gombrich, "The Early Medici," p. 39; I. Hyman, "Fifteenth Century Florentine Studies," dissertation, New York University (1968), pp. 207–8.

194. Wackernagel, *Der Lebensraum,* pp. 241 ff.; Hyman, "Notes and Speculations on S. Lorenzo," pp. 98–120; Karl Frey, *Michelagniolo Buonarotti: Quellen und Forschungen* (Berlin, 1907), I: 24 ff.; Wolfger Bulst, "Die ursprüngliche innere Aufteilung des Palazzo Medici in Florenz," *Mitteilungen des Kunsthistorischen Institutes in Florenz,* 14 (1970): 369–92; Vasari-Milanesi, II: 433.

195. Vespasiano, *Le vite,* II: 192.

196. For a recent discussion of this matter see Dale Kent, *The Rise of the Medici* (Oxford, 1978), pp. 69–70.

197. Karl Frey, ed., *Il codice magliabechiano* (Berlin, 1892), p. 68; Frey, ed., *Il libro di Antonio Billi* (Berlin, 1892), p. 34; Vasari-Milanesi, II: 371–72, 433.

198. Vasari-Milanesi, II: 433.

199. Rab Hatfield, "Some Unknown Descriptions of the Medici Palace in 1459," *Art Bulletin* 52 (1970): 233.

200. Gombrich, "The Early Medici," p. 41. The essay was originally published in the volume *Italian Renaissance Studies: A Tribute to the late Cecilia M. Ady* (London, 1960), pp. 279–311. In the earlier version Gombrich does not mention the possibility of Cosimo having kept the David "in the background."

201. U. Wester, "Die Reliefmedaillons im Hofe des Palazzo Medici zu Florenz," *Jahrbuch der Berliner Museen* 7 (1965): 28–29.

202. Wester, "Die Reliefmedaillons," pp. 27–28.

203. Presumably it was still in the possession of Cardinal Scarampo, who purchased it from Niccolò Niccoli, for it does not appear in the 1457 inventory of its next owner, Pope Paul II (Eugène Müntz, "Inventaire des camées antiques de la collection du Pape Paul II," *Revue archéologique* 36 [1878]: 155–71), indicating that the Pope acquired the gem after that date.

204. Chastel, *Art et humanisme à Florence,* pp. 45 ff.

205. John Pope-Hennessy, *Paolo Uccello,* 2nd ed. (London, 1969), p. 153.

206. Janson, *Donatello,* pp. 198–205.

207. Janson, *Donatello,* p. 198.

208. Leopold D. Ettlinger, *Antonio and Piero Pollaiuolo* (Oxford, 1978), pp. 164–65.

209. Gombrich, "The Early Medici," pp. 48–50.

210. Aby Warburg, "Flandrische Kunst und Florentinische Frührenaissance," *Gesammelte Schriften* (Leipzig, 1932), I: 187; S. Schneebalg-Perelman, "Le Rôle de la banque de Médicis dans la diffusion des tapisseries flamandes," *Revue Belge d'Archéologie et d'Histoire de l'Art* 38 (1969): 22; Müntz, *Les Précurseurs,* pp. 161–62.

211. John Pope-Hennessy, *Catalogue of Italian Sculpture in the Victoria and Albert Museum* (London, 1964), I: 104–8; Pope-Hennessy, *Luca della Robbia* (Oxford, 1980), pp. 240–42; Vasari-Milanesi, II: 174.

212. Müntz, *Les Collections,* pp. 35–37.

213. Müntz, *Les Collections,* p. 40.

214. Müntz, *Les Collections,* pp. 44–49.

215. All fifteenth-century accounts of the way the Medici lived emphasize the combination of splendor and simplicity. Guards only began to be employed in the sixteenth century, by the restored Medici.

216. Ascanio Condivi, *Michelangelo,* ed. Paolo d'Ancona (Milan, 1928), pp. 42–44.

217. Condivi, *Michelangelo,* pp. 42–44.

218. Hatfield, "Some Unknown Descriptions," p. 233.

219. Tammaro De Marinis, *La legatura artistica in Italia nei secoli XV e XVI* (Florence, 1960), I: 89.

220. Müntz, *Les Collections*, pp. 60, 62, 63, 64; Vasari-Milanesi, II: 149.

221. Mrs. William S. Patten, mother of my friend of the same name. She later became Mrs. Thomas F. Davies, and she was Miss Anne Van Rensselaer Thayer when she went to Mrs. Gardner's grand opening.

222. Hatfield, "Some Unknown Descriptions," p. 240.

223. Roover, *Rise and Decline*, p. 144.

224. It is clear from the posthumous inventory of Lorenzo that no large sculpture was shown inside the palazzo, although much sculpture was used in the interiors, such as bas-reliefs employed as overdoor panels, table bronzes and so forth. It is equally clear that during the late period there was much sculpture in the garden and in the rear façade of the palazzo (Vasari-Milanesi, IV: 218–19). There is no reason to suppose that the sculpture collection in the garden was not begun by Cosimo de' Medici, and the "white" Marsyas which he had Donatello repair constitutes positive evidence that Cosimo collected classical sculpture, as his son Giovanni also did.

225. See Chapter XIII.

226. Among the Yankees of my youth this practice of picking up arrowheads was so common that no fewer than three former neighbors in the Connecticut town where I grew up had the familiar arrangements of arrowheads on the mantelpieces of their best parlors.

227. Lanciani, *Storia degli scavi di Roma*, I: 115; Weiss, *Renaissance Discovery*, p. 186; Eugène Müntz, *Les Arts à la cour des papes*, II (Paris, 1879): 177.

228. Personal communication from Dr. Phyllis Bober.

229. Ghiberti-Schlosser, I: 62; II: 189.

230. Janson, *The Sculpture of Donatello*, p. 200.

231. Müntz, *Les Arts à la cour des papes* II: 128 ff.; Weiss, *Renaissance Discovery*, pp. 186–88; Weiss, *Un umanista veneziano: Papa Paolo II* (Venice-Rome, 1958), pp. 25–30. *Palazzo Venezia, Paolo II e le fabbriche di San Marco*, exhibition catalogue, Palazzo Venezia (Rome, 1980), pp. 40–49.

232. Weiss, *Renaissance Discovery*, p. 190.

233. Weiss, *Renaissance Discovery*, pp. 193–95. On Cardinal Domenico Grimani, for example, see Marilyn Perry, "Cardinal Domenico Grimani's Legacy of Ancient Art to Venice," *Journal of the Warburg and Courtauld Institutes* 41 (1978): 215–44.

234. Anthony Blunt, *Nicolas Poussin*, 2 vols. (New York, 1967), I: 227–35; Rudolf Wittkower, "The Role of Classical Models in Bernini's and Poussin's Preparatory Work," *Acts of the Twentieth International Congress of the History of Art*, III (Princeton, 1963): 47–48.

235. This is a change that is not easy to date, but certainly every serious Western artist had ceased to study the antique in the way practiced by Poussin and recommended by Rubens in *De Imitatione Antiquarum Statuarum* rather long before the close of the nineteenth century.

XII. THE LESSON OF LORENZO

1. Antonio Averlino Filarete, *Treatise on Architecture*, ed. John R. Spencer (New Haven, 1965), I: 319.

2. Filarete, *Treatise on Architecture*, I: 319, n. 5.

3. Filarete, *Treatise on Architecture*, I: 319 ff.

4. G. Pieraccini, *La stirpe de'Medici di Cafaggiolo*, I (Florence, 1924): 56.

5. Filarete, *Treatise on Architecture*, I: 320.

6. Piero de' Medici, 1416–1469.

7. Leopold D. Ettlinger, *Antonio and Piero Pollaiuolo* (Oxford, 1978), pp. 164–65.

8. Vasari-Milanesi, II: 405, 406, 407.

9. E. H. Gombrich, "The Early Medici as Patrons of Art," in *Norm and Form* (London, 1966), pp. 48–49.

10. Eugène Müntz, *Les Collections des Médicis au XVe siècle* (Paris, 1888), pp. 44 ff.

11. Müntz, *Les Collections*, pp. 45–47.

12. Millard Meiss, *French Painting in the Time of Jean de Berry: The Late XIV Century and the Patronage of the Duke*, 2 vols. (London, 1967), I: 287 ff. The inventory of the Duc de Berry's book collection can be consulted in Jules Guiffrey, *Inventaires de Jean Duc de Berry (1401–1416)*, I (Paris, 1894): 223–71; II (1896): 120–36, 242–43, 313–19, 337–39.

13. Müntz, *Les Collections*, pp. 11–51.

14. Eugène Müntz, *Les Précurseurs de la Renaissance* (Paris, 1882), p. 162. See also Gino Corti and Frederick Hartt, "New Documents Concerning Donatello, Luca and Andrea della Robbia, Desiderio, Mino, Uccello, Pollaiuolo, Filippo Lippi, Baldovinetti and Others," *Art Bulletin* 44 (1962): 157.

15. Müntz, *Les Collections*, p. 78. See also *Flanders in the Fifteenth Century: Art and Civilization*, exhibition catalogue (Detroit, 1960), pp. 69–72; Erwin Panofsky, *Early Netherlandish Painting* (Cambridge, 1953), I: 189.

16. Müntz, *Les Collections*, p. 79; Panofsky, *Early Netherlandish Painting*, I: 313, n. 7.

17. Müntz, *Les Collections*, p. 88; Panofsky, *Early Netherlandish Painting*, I: 273 & n. 4; M. Davies, *Rogier van der Weyden* (London, 1972), p. 212.

18. See Roberto Weiss, "Jan Van Eyck and the Italians," *Italian Studies* 11 (1956): 1–15, and 12 (1957): 7–21. These articles show that the first Van Eycks were imported by two Genoese merchants and one Lucchese merchant. The first center of interest in Van Eyck was Genoa, with Genoese merchants who had connections in Bruges in the lead. The next center was, of course, Naples, where Fazio gave Van Eyck a place at the very top of the hierarchy of art. Weiss further emphasizes the significant fact that Fazio was particularly struck by Van Eyck's attention to detail.

19. For tapestry imports, see Raymond de Roover, *The Rise and Decline of the Medici Bank* (Cambridge, Mass., 1963), pp. 144–45. Mercantile links with the Low Countries were apparently in the background of important orders for tapestries, just as the same links lay behind the importation of paintings from the Low Countries.

20. Attilio Schiaparelli, *La casa fiorentina e i suoi arredi nei secoli XIV e XV* (Florence, 1908), pp. 184–87.

21. Schiaparelli, *La casa fiorentina*, p. 184 & n.

22. Schiaparelli, *La casa fiorentina*, p. 186.

23. The 1493 inventory (Andrea Minerbetti, "Ricordanze," Florence, Biblioteca Laurenziana Ms. Aquisti e Doni 229, vol. 2, c. 7 recto–c. 8r.) reveals approximately 25 items which can be broadly classified as works of art, whereas the 1546 inventory (c. 168r.–c. 171 verso) reveals approximately 71.

24. For instance, there is an entry dated January 1, 1521 (Minerbetti, "Ricordanze," c. 110r.) to record a sizable gift from Andrea to his son Tommaso and his son's wife, which included paintings, sculptures, two wardrobes, a bed, a couch, and a terra-cotta portrait of Tommaso's mother. See also c. 7r., c. 43r., c. 76r., c. 76v., c. 77r., cc. 104v.–105r., and c. 156r.

25. Minerbetti, "Ricordanze," c. 51r.–c. 59v.

26. Schiapparelli, *La casa fiorentina*, p. 185.

27. Some of the many letters the younger Minerbetti and Vasari exchanged may be

found in Vasari-Milanesi, vol. VIII, and Karl Frey, *Il carteggio di Giorgio Vasari* (Arezzo, 1941).

28. Girolamo Mancini, *Vita di Leon Battista Alberti*, 2nd ed. (Florence, 1911), pp. 458–67; M. Dezzi Bardeschi, *La facciata di Santa Maria Novella a Firenze* (Pisa, 1970); A. Perosa, ed., *Giovanni Rucellai ed il suo Zibaldone* (London, 1960), pp. 25–26; Rudolf Wittkower, "Alberti's Approach to Antiquity in Architecture," *Journal of the Warburg and Courtauld Institutes* 4 (1940): 7–11.

29. On the Church of San Pancrazio, see Perosa, ed., *Giovanni Rucellai*, pp. 24–25; M. Dezzi Bardeschi, "Il complesso monumentale di S. Pancrazio a Firenze ed il suo restauro," *Quaderni dell'Istituto di Storia dell'Architettura*, ser. 13, fasc. 73–78 (1966), pp. 1–66; F. W. Kent, *Household and Lineage in Renaissance Florence* (Princeton, 1977), p. 287.

30. Mancini, *Vita di Leon Battista Alberti*, pp. 419–26; C. R. Mack, "The Rucellai Palace: Some New Proposals," *Art Bulletin* 56 (1974): 517–29.

31. Perosa, *Giovanni Rucellai*, pp. 23–24, 117–18.

32. Perosa, *Giovanni Rucellai*, pp. 117–18; kindly translated by Professor Anna Modigliani Lynch.

33. Perosa, *Giovanni Rucellai*, pp. 23–24. Translated by Professor Lynch.

34. Perosa, *Giovanni Rucellai*, pp. 23–24.

35. Rudolf and Margot Wittkower, *Born Under Saturn* (New York, 1963), p. 32.

36. English tailors for clothes and English shoemakers, especially Lobb, Peel, and Maxwell for shoes and boots.

37. London shops like Hilditch & Keys, but for the very rich, Sulka and Charvet.

38. Again London, preferably Purdy.

39. Here American suppliers were preferred. It should be understood that these notes apply only to men. For the better-heeled women, Paris was the only place for clothes, except for tweeds, riding clothes, and sweaters. The tweeds and riding clothes came from London women's tailors, the sweaters from London or Peck & Peck in New York. The less well heeled men and women went to the leading New York suppliers of that period, except in Boston, where excessively smart women's clothes were regarded with deep suspicion.

40. Leon Battista Alberti, *On Painting and on Sculpture*, ed. Cecil Grayson (London, 1972), p. 33.

41. Going abroad, in this context, is intended to mean principally offering commissions to non-Florentine artists. In fact, of the thirteen fifteenth-century secular interior commissions listed by André Chastel in his *Art et humanisme à Florence au temps de Laurent le Magnifique*, 2nd ed. (Paris, 1961), p. 169, and of the other major fifteenth-century secular interior paintings in Florence, namely the frescoes portraying great men of history by Bicci di Lorenzo painted for Giovanni di Bicci (Vasari-Milanesi, II: 50) and the Rout of San Romano cycle, the two other Uccellos, and the Pesellino in the bedroom of Lorenzo de' Medici all were done by Florentines.

42. Bruno Santi, ed., *Neri di Bicci, Le ricordanze* (Pisa, 1976), p. 17.

43. John Larner, *Culture and Society in Italy 1290–1420* (London, 1971), p. 328.

44. Vasari-Milanesi, II: 216–17.

45. John Pope-Hennessy, "The Madonna Reliefs of Donatello," *Apollo* 13 (1976): 178–82; reprint in Pope-Hennessy, *The Study and Criticism of Italian Sculpture* (New York, 1980), pp. 71–105. Reportedly, the relief was being used as an ashtray when it was discovered. The manufacturing and trade in reliefs from molds is an extremely murky subject as yet. But see the same article for Pope-Hennessy's discussion of the problem.

46. Müntz, *Les Collections*, p. 60; John Pope-Hennessy, *Paolo Uccello*, 2nd ed. (London,

1969), pp. 152–53; Herbert Horne, "The Battle Piece by Paolo Uccello in the National Gallery," *Monthly Review* 5 (1901): 125; W. Bulst, "Die ursprüngliche innere Aufteilung des Palazzo Medici," *Mitteilungen des Kunsthistorischen Institutes in Florenz* 14 (1970): 391.

47. Ettlinger, *Pollaiuolo*, pp. 164–65.

48. Perosa, *Giovanni Rucellai*, pp. 32, 121. The dowry consisted of 2500 florins in currency, together with 1200 florins worth of gifts.

49. Roover, *Rise and Decline*, pp. 242–43.

50. Roover, *Rise and Decline*, pp. 56, 247.

51. John Pope-Hennessy, *Fra Angelico*, 2nd ed. (London, 1974), p. 195.

52. Archivio di Stato di Firenze, catasto 49 of 1427, c. 1140, in I. Hyman, "Fifteenth Century Florentine Studies," dissertation, New York University (1968), p. 248. See also Roover, *Rise and Decline*, p. 28.

53. See Roover, *Rise and Decline*, p. 28. See also Lauro Martines, *The Social World of the Florentine Humanists* (London, 1963), Appendix II, Tables on Wealth, pp. 369, 372, where the figures for net capital declared by Florentine citizens for the catasto of 1427 are listed. Messer Palla di Nofri Strozzi had net capital of 101,422 florins; together, the Panciatichi brothers had net capital of 126,986 florins; and Giovanni di Bicci de' Medici declared net capital of 79,472 florins.

54. Roover, *Rise and Decline*, p. 30.

55. R. Goldthwaite, "The Florentine Palace as Domestic Architecture," *American Historical Review* 77 (1972): 977–1012.

56. Müntz, *Les Collections*, pp. 62–63. The inventory says the paintings were 6 *braccia* on each side. One Florentine *braccio* was equal to 0.58 meters, or 1.9 feet. The paintings, therefore, were 11.4 feet on each side, covering almost 130 square feet.

57. This was not an unusual practice. See Hanna Lerner-Lehmkuhl, *Zur Struktur und Geschichte des Florentinischen Kunstmarktes im 15. Jahrhundert* (Wattenscheid, 1936), pp. 26 ff.

58. Herbert Horne, *Botticelli* (London, 1908; Princeton, 1980), p. 136; Martin Wackernagel, *Der Lebensraum des Künstlers in der Florentinischen Renaissance* (Leipzig, 1938), p. 347; R. Lightbown, *Sandro Botticelli* (London, 1978), II: 56–57; Lerner-Lehmkuhl, *Zur Struktur und Geschichte*, Heft III, Table IV.

59. In response to a request made on my behalf by my regretted friend Mr. Theodore Rousseau of the Metropolitan Museum, the Warburg Institute most generously supplied me with the first copy of the complete inventory, as far as I know, to reach the United States.

60. "Inventario del palagio di Firenze et sua masseritie," [1512 copy of 1492 Medici inventory], typescript courtesy of the Warburg Institute, London, p. 116 (c. 42).

61. Müntz, *Les Collections*, p. 63.

62. Müntz, *Les Collections*, p. 64.

63. To obtain the totals given here and hereafter for different categories in the posthumous inventory of Lorenzo de' Medici's possessions, Professor Anna Modigliani Lynch most kindly undertook to color-code all the entries in a copy of the inventory, placing a small red, blue, brown, or whatever color mark next to each entry according to the category to which she had allotted it. With the help of a small computer, the sums of the different categories were separately added, resulting in the totals named in this chapter.

Later, the results were checked by my research assistant, William Connell, who arrived at the same figures. A more laborious analysis might well produce slightly different results; but the results here given are certainly accurate enough to show the balance between the categories of the innumerable objects in the Palazzo Medici.

It should be added that no attempt was made to compute total values for the large quantities of wine and other commodities which were stored in the cellar, since these were not really household goods but, rather, installments of the family income being held for ultimate use or sale. The gown is on p. 173 (c. 59ᵗ) of the Warburg copy. The nurses' underthings may be found on pp. 148–49 (c. 51–52). It was the evidence of such details here cited, plus the indications of revenue from each of Lorenzo's many properties in the *contado*, which led me to conclude that the members of the bank staff did the donkey-work on the great inventory.

64. Ettlinger, *Pollaiuolo*, pp. 164–65.

65. Pieraccini, *La stirpe de'Medici di Cafaggiolo*, I: 95–140. It is now known that Lorenzo's trip to Naples was secretly arranged in advance with the ruler of Naples, Ferrante of Aragon. But for Lorenzo to go alone to Naples, putting himself entirely in Ferrante's power, was still an enormous risk to take with a ruler hardly more scrupulous than Cesare Borgia.

66. Francesco Guicciardini, *Storia d'Italia*, ed. Silvana Seidel Menchi (Turin, 1971), I: 10. Translated by Sydney Alexander in Guicciardini, *The History of Italy* (New York, 1969), p. 9.

67. Roover, *Rise and Decline*, pp. 366–67.

68. See, for example, the events that followed the Pazzi conspiracy of 1478: Luca Landucci, *Diario fiorentino* (Florence, 1883), pp. 17–20; Niccolò Machiavelli, *Istorie fiorentine*, ed. F. Gaeta (Milan, 1962), pp. 518 ff.

69. Gombrich, "The Early Medici," p. 55; Wackernagel, *Der Lebensraum*, pp. 257–70; Chastel, *Art et humanisme*, pp. 13–27.

70. Charles Seymour, *Verrocchio* (London, 1971), pp. 55–57, 162.

71. Seymour, *Verrocchio*, pp. 53–55, 57, 161–63, 174–75.

72. For the chimney frieze, see Müntz, *Les Collections*, p. 84. Most of the small table pieces in the 1492 inventory were unattributed. One example that is documented as having been done by Bertoldo is the bronze centaur that was in Piero's room in the palace (Müntz, *Les Collections*, p. 86). See also Ulrich Middeldorf, "On the Dilettante Sculptor," *Apollo* 107 (1978): 314–16.

73. Philip Foster, "A Study of Lorenzo de'Medici's Villa at Poggio a Caiano," dissertation, Yale University (1976), *passim*.

74. G. Clausse, *Les San Gallo* (Paris, 1900), I: 142–48; G. Marchini, *Giuliano da Sangallo* (Florence, 1942), pp. 16–18, 85–86 *et passim*.

75. P. Halm, "Das unvollendete Fresko des Filippino Lippi in Poggio a Caiano," *Mitteilungen des Kunsthistorischen Institutes in Florenz* 7 (1931): 393–427; K. Neilson, *Filippino Lippi* (Cambridge, 1938), pp. 98–105; Vasari-Milanesi, III: 473–74.

76. Lightbown, *Sandro Botticelli*, I: 97–99; II: 218; Wackernagel, *Der Lebensraum*, p. 158; Vasari-Milanesi, III: 258.

77. Ludovico Borgo, "Giuliano da Maiano's Santa Maria del Sasso," *Burlington Magazine* 114 (1972): 448–52.

78. See Wackernagel, *Der Lebensraum*, p. 269.

79. Vasari-Milanesi, III: 273; P. E. Küppers, *Domenico Ghirlandaio* (Strasbourg, 1916), pp. 38–41.

80. C. von Fabriczy, "Giuliano da Sangallo," *Jahrbuch der Königlich Preussischen Kunstsammlungen* 23 (supplement, 1902): 4, 16–17; Marchini, *Giuliano da Sangallo*, pp. 32–33, 89.

81. Chastel, *Art et humanisme*, p. 154; P. G. Hamberg, "The Villa of Lorenzo il Magnifico at Poggio a Caiano and the Origin of Palladianism," in *Idea and Form* (Stockholm, 1959), pp. 76–87.

82. Karl Frey, ed., *Il codice magliabechiano* (Berlin, 1892), p. 110. See also Kenneth

Clark, *Leonardo da Vinci*, Penguin ed. (Harmondsworth, 1967), pp. 43–44; E. Barfucci, *Lorenzo de'Medici e la società artistica del suo tempo* (Florence, 1945), p. 221. As Leonardo carried a present from Lorenzo de'Medici to Ludovico Sforza, Lorenzo was plainly familiar with the arrangements for Leonardo's removal to Milan, and it seems likely that he was consulted by his fellow ruler about the summons to Milan.

83. C. von Fabriczy; "Giuliano da Maiano," *Jahrbuch der Königlich Preussischen Kunstsammlungen* 24 (supplement, 1903): 142, 171–72; G. Marchini, *Giuliano da Maiano* (Florence, 1958–59), pp. 51–52.

84. G. Hersey, *Alfonso II and the Artistic Renewal of Naples, 1485–1495* (New Haven, 1969), pp. 69–70; Hersey, "Poggioreale: Notes on a Reconstruction and an Early Replication," *Architectura* (1973), pp. 13–21; M. Martelli, "I pensieri architettonici del Magnifico," *Commentari* 17 (1966): 107–11. When Giuliano died, Lorenzo tried to find a replacement. He wrote Alfonso, the Duke of Calabria, to say, "having looked everywhere and carefully examined all the architects at present in this city of Florence, and having found none to be in the same class as Giuliano da Maiano, I have written to Mantua, where one can find a good Florentine architect, Luca Fancelli, should the Marquis of Mantua be able to spare him." Giovanni Gaye, *Carteggio inedito d'artisti dei secoli XIV, XV, XVI*, I (Florence, 1839): 300. Translated by Professor Lynch.

85. Eugène Müntz, "Nuovi documenti," *Archivio storico dell'arte* 2 (1889): 483–84; A. Scharf, *Filippino Lippi* (Vienna, 1950), pp. 25–30; Vasari-Milanesi, III: 467. I am informed that this great Neapolitan name is now spelled "Carafa."

86. Marchini, *Giuliano da Sangallo*, pp. 28–30, 85; H. Biermann, "Das Palastmodell Giuliano da Sangallos für Ferdinand I. König von Neapel," *Wiener Jahrbuch für Kunstgeschichte* 23 (1970): 154–95.

87. Vasari-Milanesi, IV: 513–14; G. M. Huntley, *Andrea Sansovino* (Cambridge, 1935), pp. 32–41; G. Battelli, *Andrea Sansovino e l'arte italiana della Rinascenza in Portogallo* (Florence, 1936).

88. Chastel, *Art et humanisme*, p. 15.

89. C. Kennedy, E. Wilder, and P. Bacci, *The Unfinished Monument by Andrea del Verrocchio to Cardinal Niccolò Forteguerri at Pistoia* (Northampton, Mass., 1932), pp. 11–12.

90. Kennedy et al., *The Unfinished Monument*, pp. 12–13.

91. Gaye, *Carteggio*, I: 256–57; see also Kennedy et al., *The Unfinished Monument*, pp. 13 (& doc. VI), 78.

92. Gaye, *Carteggio*, I: 256–57. Translated by Professor Lynch.

93. Gaye, *Carteggio*, I: 258. Translated by Professor Lynch.

94. J. A. Crowe and G. B. Cavalcaselle, *A History of Painting in North Italy*, 2nd ed. (London, 1912) II: 100. See also E. Rosenthal, "The House of Andrea Mantegna in Mantua," *Gazette des Beaux-Arts* 60 (1962): 341, 347, n. 25.

95. Vasari-Milanesi, III: 336–37; W. and E. Paatz, *Die Kirchen von Florenz*, III (Frankfurt a.M., 1952): 371, 501, n. 259.

96. Vasari-Milanesi, II: 630; III: 467–68.

97. Karl Frey, *Michelagniolo Buonarotti: Quellen und Forschungen zu seiner Geschichte und Kunst* (Berlin, 1907), I: 62–64; Barfucci, *Lorenzo de'Medici*, pp. 201–48.

98. Vasari-Milanesi, VII: 141; IV: 256 ff.

99. Chastel, *Art et humanisme*, pp. 19–25; Chastel, "Vasari et la légende Médicéenne: l'école du jardin de Saint-Marc," in *Studi Vasariani: Atti del convegno per il IV centenario della prima edizione della "Vite" del Vasari, 1950* (Florence, 1952), pp. 159–67.

100. Ascanio Condivi, *Michelangelo*, ed. Paolo d'Ancona (Milan, 1928), pp. 37–40.

101. Condivi, *Michelangelo*, p. 26.

102. Condivi, *Michelangelo*, pp. 42–44.

103. Condivi, *Michelangelo*, p. 42.

104. Condivi, *Michelangelo*, p. 42.

105. Condivi, *Michelangelo*, p. 44.

106. *Ricordi del Magnifico Lorenzo di Piero di Cosimo de' Medici*, in Antonio Francesco Gori, *La Toscana illustrata* (Leghorn, 1755), I: 194; Müntz, *Les Arts à la cour des papes*, II (Paris, 1879): 156, n. 2.

107. Müntz, *Les Arts*, II: 129 ff.

108. Müntz, *Les Arts*, II: 128, Roberto Weiss, *Un umanista veneziano: Papa Paolo II* (Venice-Rome, 1958), p. 25.

109. Müntz, *Les Arts*, II: 181–287.

110. Müntz, *Les Arts*, II: 144, 152, 159, 207–8, 279–87.

111. Müntz, *Les Arts*, II: 143, 203–5.

112. Almost all were of Christian subjects and were therefore unacceptable to the Turks, which must have caused many to be sold to Italian merchants.

113. Müntz, *Les Arts*, II: 144, 201–06, 202; Vasari-Milanesi, II: 619.

114. Ferdinand Gregorovius, *Geschichte der Stadt Rom* (reprint Darmstadt, 1963), XIII: 111.

115. Müntz, *Les Arts*, II: 151; Müntz, "La Tiare pontificale du VIIIe au XVIe siècle," *Mémoires de l'Académie des Inscriptions et Belles Lettres* 26 (1898): 296.

116. Müntz, *Les Arts*, II: 149, gives the lower valuation; Gregorovius, *Geschichte der Stadt Rom*, XIII: 104, gives the higher one.

117. Gaetano Moroni, *Dizionario di erudizione storico-ecclesiastica*, XLV (Venice, 1847): 13.

118. Gregorovius, *Geschichte der Stadt Rom*, XIII: 104; Moroni, *Dizionario*, XLV: 14.

119. Nicole Dacos, Antonio Giuliano, and Ulrico Pannuti, eds., *Il tesoro di Lorenzo il Magnifico*. I: *Le gemme* (Florence, 1973), p. 70.

120. Horst Blank, "Eine persische Pinselzeichung nach der Tazza Farnese," *Archäologischer Anzeiger* 79 (1962): 307–08.

121. Ruy González de Clavijo, *Embassy to Tamerlane*, trans. Guy le Strange (London, 1928). Clavijo's presents from Timur were rich (pp. 276–77), but included no collectors' objects like the Tazza Farnese.

122. Landucci, *Diario fiorentino*, pp. 17–20; Machiavelli, *Istorie fiorentine*, pp. 518 ff.

123. Roover, *Rise and Decline*, p. 198.

124. Müntz, *Les Arts*, II: 153–54.

125. Clifford M. Brown, "Cardinal Francesco Gonzaga's Collection of Antique Intagli and Cameos: Questions and Provenance, Identification and Dispersal," unpublished, p. 1. See also note 161 below.

126. Müntz, *Les Arts*, II: 156, n. 2; *Ricordi del Magnifico Lorenzo*, in Gori, *La Toscana illustrata*, I: 194.

127. I. Del Lungo, *Florentia* (Florence, 1897), p. 313.

128. Filarete, *Treatise on Architecture*, I: 317. See also R. Bauer et al., *Das Kunsthistorische Museum in Wien* (Vienna, 1978), p. 41.

129. Gaye, *Carteggio*, I: 163; Müntz, *Les Précurseurs*, p. 162; Weiss, *Un umanista veneziano: Papa Paolo II*, pp. 27–28; Weiss, *Renaissance Discovery of Classical Antiquity*, (Oxford, 1969), p. 171.

130. Gaye, *Carteggio*, I: 163–64.

131. See the story of Baldassare del Milanese and Michelangelo's Cupid below, this chapter.

132. Gaye, *Carteggio*, I: 285; Barfucci, *Lorenzo de'Medici*, p. 310; Weiss, *The Renaissance Discovery*, p. 188; Rodolfo Lanciani, *Storia degli scavi di Roma*, I (Rome, 1902): 86.

133. Gaye, *Carteggio*, I: 286; Lanciani, *Storia degli scavi*, I: 86; Müntz, *Les Collections*, p. 57.

134. Arnold Schaber, "Eine neue Satyrgruppe," *Mitteilungen des deutschen Archaeologischen Instituts, Römische Abteilung* 52 (1937): 83–93.

135. Müntz, *Les Collections*, p. 69; Dacos et al., *Il tesoro*, I: 57.

136. Müntz, *Les Collections*, p. 38; Dacos et al., *Il tesoro*, I: 40.

137. Müntz, *Les Collections*, p. 66; Dacos et al., *Il tesoro*, I: 40.

138. See note 63 above.

139. F. R. Shapley, *Paintings from the Samuel H. Kress Collection, Italian Schools XIII–XV Century* (London, 1966), pp. 95–97. See also Pope-Hennessy, *Fra Angelico*, pp. 38, 219, 238.

140. Corti and Hartt, "New Documents," pp. 155–67.

141. Corti and Hartt, "New Documents," p. 157.

142. Corti and Hartt, "New Documents," pp. 157–58. See also Ulrich Middeldorf, "Die Zwölf Caesaren von Desiderio da Settignano," *Mitteilungen des Kunsthistorischen Institutes in Florenz* 23 (1979): 297–312.

143. Corti and Hartt, "New Documents," pp. 158–59.

144. Müntz, *Les Collections*, pp. 58, 60, 63, 79, 84, 85, 86, 88, 92, 93, 94.

145. Horst W. Janson, *The Sculpture of Donatello*, 2nd ed. (Princeton, 1963), p. 198.

146. Gaye, *Carteggio*, II (1840): 52–53; J. Wilde, "The Hall of the Great Council of Florence," *Journal of the Warburg and Courtauld Institutes* 7 (1944): 76, n. 3.

147. Frey, *Michelagniolo Buonarotti: Quellen*, pp. 74–75.

148. Müntz, *Les Collections*, p. 79.

149. Müntz, *Les Collections*, p. 64. Perhaps the overdoor relief was *all'antica*, rather than genuinely antique. But this cannot apply to the legless Hercules, for a contemporary table bronze with such a defect would never have been acquired.

150. Müntz, *Les Arts à la cour des papes*, II: 135.

151. Müntz, *Les Collections*, pp. 35–37.

152. Müntz, *Les Collections*, p. 37. On p. 35, Müntz totaled the value of the pearls incorrectly. His figure, 3,512, is off by 100.

153. Müntz, *Les Collections*, p. 36.

154. Müntz, *Les Collections*, p. 80.

155. Lorenzo's jewels are listed in Müntz, *Les Collections*, pp. 72–73, 80–82. Cameos, belts, and reliquaries have not been included in the total here given, so as to facilitate comparison with the total arrived at above for the value of Piero's jewels. To each of these exceptions, furthermore, a function different from that of jewelry must be ascribed.

156. Müntz, *Les Collections*, p. 74.

157. Roover, *Rise and Decline*, pp. 221, 366.

158. Roover, *Rise and Decline*, p. 349.

159. Roover, *Rise and Decline*, p. 349, n. 179.

160. Roover, *Rise and Decline*, p. 370.

161. None of the Gonzaga gems were not included in the 1492 Medici inventory, a fact to be attributed not to some fault in the inventory, but, as Clifford Brown argues in a fine unpublished article entitled, "Cardinal Francesco Gonzaga's Collection of Antique Intagli and Cameos: Questions of Provenance, Identification and Dispersal," to the refusal of the Gonzaga family to follow the instructions of Cardinal Gonzaga's will and sell the gems to pay his debts. Rather, they pledged a portion of the gems at the Rome office of the Medici bank against future repayment. There they remained in the hands of Giovanni Tornabuoni, protected from Lorenzo's acquisitiveness both by Tornabuoni's animosity toward Lorenzo and by the terms of the agreement with

the Gonzaga. It was only after the expulsion of the Medici from Florence in 1494, when stopgap measures were being taken to keep the family solvent, that some of the Gonzaga gems were used as collateral by Piero de' Medici for a loan from Agostino Chigi.

162. In fact, the evidence seems to point decidedly toward the former possibility. Philippe de Commines wrote that three thousand gold and silver medals were confiscated from the palace when it was sacked (Müntz, *Les Précurseurs*, p. 213). We can readily imagine that Lorenzo in his early years had increased the family collection of coins and medals as indicated by Commines. If these were mostly pledged to the bank at the time of the 1492 inventory they would not have been listed; but it is entirely possible that although the coins had been pledged, they were still kept at the Medici palace for Lorenzo's pleasure, perhaps in some sort of strongbox bearing the bank's seal, which would hardly have been respected by the looters.

163. Müntz, *Les Collections*, pp. 54–55.

164. Müntz, *Les Collections*, p. 79.

165. Günter Passavant, *Verrocchio* (London, 1969), p. 174.

166. Müntz, *Les Collections*, p. 88; Panofsky, *Early Netherlandish Painting*, I: 273; Davies, *Rogier van der Weyden*, p. 212.

167. See note 63 above.

168. Müntz, *Les Collections*, p. 58.

169. Müntz, *Les Collections*, p. 86.

170. Müntz, *Les Collections*, pp. 64, 77.

171. Müntz, *Les Collections*, p. 64. This has been tentatively identified as the Relief of the Feast of Herod in the Musée Wicar in Lisle (H. W. Janson, *The Sculpture of Donatello*, Princeton, N.J., 1963, pp. 129–31). In addition the same source, pp. 86–88, again tentatively identifies the "Saw Madonna" in the Boston Museum of Fine Arts and the marble bas-relief of the Ascension of Jesus Christ in the Victoria and Albert Museum as two more of the Donatellos listed in the great inventory.

172. Müntz, *Les Collections*, p. 64.

173. Müntz, *Les Collections*, p. 85.

174. Müntz, *Les Collections*, p. 60.

175. Müntz, *Les Collections*, p. 62.

176. Müntz, *Les Collections*, p. 86.

177. "Inventario del palagio di Firenze," Warburg copy, p. 138 (c. 48t). See also Horne, *Botticelli*, pp. 157, 354 (doc. XXIX); Lightbown, *Sandro Botticelli*, I: 97; II: 219.

178. Müntz, *Les Collections*, pp. 60, 64, 85, 86, 87.

179. Müntz, *Les Collections*, p. 64.

180. Müntz, *Les Collections*, p. 60.

181. Müntz, *Les Collections*, p. 78.

182. Müntz, *Les Collections*, p. 79.

183. Müntz, *Les Collections*, p. 78.

184. This painting was probably the St. Jerome now in Detroit. Panofsky thought that it was begun by Van Eyck, but mainly painted by Petrus Christus; see *Early Netherlandish Painting*, I: 189. The painting has since (after its 1956 cleaning) been confirmed as a Van Eyck. See *Flanders in the Fifteenth Century*, exhibition catalogue (Detroit, 1960), pp. 69–72.

185. Müntz, *Les Collections*, p. 60.

186. Müntz, *Les Collections*, p. 59.

187. Müntz, *Les Collections*, p. 59.

188. Müntz, *Les Collections*, p. 59; A. Grunzweig, *Correspondance de la filiale de Bruges des Médicis*, ed. Maurice Lamartin (Brussels, 1931), pp. 26–27.

189. Müntz, *Les Collections*, p. 60. The paintings were 42 *braccia* long, i.e., 79.8 feet.

190. Müntz, *Les Collections*, p. 66.

191. See Müntz, *Les Collections*, pp. 64–66. Of the thirty or so hard stone vessels listed in the inventory, no less than ten were valued at more than 500 florins. And of those valued below 500 florins, some, for instance a goblet with a lid, made of jasper and amethyst, ornamented with gold, 30 rubies and 36 pearls, at 400 florins, and a heavy crystal goblet with a silver glaze of German or Gothic workmanship (*"alla tedesca"*) at 150 florins, must still have been quite impressive. The lowest value given for a hard stone vessel is 20 florins for an amethyst cup. Incidentally, the jasper and amethyst cup, richly mounted, at 400 florins, sounds very much like the second most expensive of Lorenzo de' Medici's vessels which Isabella d'Este later consulted Leonardo da Vinci about buying (see Chapter XIII). All the former Medici vessels considered for purchase by Isabella were said to be engraved with Lorenzo's "name." In fact, it was Lorenzo's usual practice to engrave his precious hard stone vessels simply with "·LAV·R·MED·."

192. For the "seal of Nero," see Müntz, *Les Collections*, p. 69; Dacos et al., *Il tesoro*, I: 55–57. And for the Phaëthon in his chariot, see Müntz, *Les Collections*, p. 69; Dacos et al., *Il tesoro*, I: 59–60.

193. Müntz, *Les Collections*, p. 65.

194. Müntz, *Les Collections*, p. 64.

195. Müntz, *Les Collections*, p. 68.

196. Müntz, *Les Collections*, p. 66.

197. E. H. Gombrich, "Botticelli's Mythologies: A Study in the Neoplatonic Symbolism of his Circle," *Journal of the Warburg and Courtauld Institutes* 8 (1945): 7–21, 54. Gombrich writes that the two paintings were commissioned by Lorenzo di Pierfrancesco de' Medici, although Ronald Lightbown (*Sandro Botticelli*, I: 85–86, 72 ff.; II: 51–53, 64) and John Shearman ("The Collections of the Younger Medici," *Burlington Magazine* 117 [1975]: 12–27), dispute this interpretation.

198. Müntz, *Les Collections*, p. 55.

199. "Inventario del palagio," p. 138 (c. 48ᵗ).

200. Horne, *Botticelli*, pp. 157, 354 (doc. XXIX); Lightbown, *Sandro Botticelli*, I: 97; II: 219.

201. Karl Frey, *Michelagniolo Buonarotti: Quellen*, I: 74–75.

202. Pieraccini, *La stirpe de'Medici de Cafaggiolo*, I: 118.

203. Chastel, *Art et humanisme*, p. 18. So far as I have been able to discover, only Chastel gives this quotation, and he mentions no source.

204. See, for example, Weiss, *The Renaissance Discovery*, p. 189.

205. Müntz, *Les Collections*, p. 56. Kindly translated by Dr. Bernard Knox.

206. Müntz, *Les Collections*, p. 99. Translated by Dr. Knox.

207. Condivi, *Michelangelo*, pp. 59–60. Translated by Herbert Horne in Condivi, *The Life of Michelagnolo Buonarotti* (New York, 1904), p. 16.

208. Condivi, *Michelangelo*, p. 60; trans. Horne, *The Life of Michelagnolo*, p. 16. See also Charles de Tolnay, *Michelangelo*, 2nd ed., I (Princeton, 1969): 25, 54 n. 88, 89, 202. Tolnay rejects part of the story, but after all, Condivi wrote with Michelangelo's knowledge.

209. Vasari-Milanesi, VII: 147–48.

210. Lanciani, *Storia degli scavi*, I: 11–12, 85.

211. Lanciani, *Storia degli scavi*, I: 11–12.

212. Lanciani, *Storia degli scavi*, I: 94.

213. Condivi, *Michelangelo*, p. 62; Vasari-Milanesi, VII: 147–48.

214. Condivi, *Michelangelo*, pp. 64–65.

215. Müntz, *Les Collections*, pp. 104–6.
216. Eugenio Battisti, *Cimabue* (University Park, Pa., 1967), p. 95.
217. Condivi, *Michelangelo*, p. 49.
218. Condivi, *Michelangelo*, pp. 47–48; Vasari-Milanesi, VII: 145; Tolnay, *Michelangelo*, I: 20.
219. Müntz, *Les Collections*, p. 69.
220. See the letter from Caradosso to Ludovico Sforza in E. Piot, *Le Cabinet de l'amateur* (Paris, 1863), p. 33.
221. Margaret of Austria's first husband was Duke Alessandro de' Medici, from whom she inherited the Tazza. Her second husband was Ottavio Farnese, Duke of Parma and Piacenza, and their son, Alessandro, inherited the Tazza Farnese upon her death (G. Pesce, "Gemme medicee del Museo Nazionale di Napoli," *Rivista del Reale Istituto d'Archeologia e Storia dell'Arte* 5 [1937]: 53).

INTERCHAPTER 5. ON PROGRESSION IN ART

1. *Dictionnaire de biographie française,* ed M. Prévost and Roman d'Amat, VI (Paris, 1954): cols. 1299–1300.
2. Jack Lindsay, *Cézanne: His Life and Art* (New York, 1969), p. 102.
3. See Chapter III.
4. Michael D. Coe, *Lords of the Underworld: Masterpieces of Classic Maya Ceramics,* exhibition catalogue (Princeton, 1978), *passim*.
5. See Chapter IV.
6. Madame de Sévigné, *Lettres 1644–1675,* 3 vols. (Paris, 1953). I: 786–801 (329–À Madame de Grignan, 9e aôut [1675]). See also Chapter VI above.
7. Originally, Bernini's mattress greatly added to the statue's fame. See Francis Haskell and Nicholas Penny, *Taste and the Antique* (New Haven and London, 1981), pp. 234–36.
8. Ghiberti-Schlosser, I: 61f.
9. Ghiberti-Schlosser, I: 62f.
10. Ghiberti-Schlosser, I: 62f.
11. Leon Battista Alberti, *De Architectura* in *L'architettura di L. B. Alberti tradotta in lingua fiorentina da Cosimo Bartoli* (Florence, 1550), p. 7.
12. See Chapter VII.
13. Vasari-Milanesi, II: 96. Translated by Professor Anna Modigliani Lynch.
14. E. H. Gombrich, *The Story of Art* (London, 1950), p. 265.
15. Leonardo's comment appears in the Forster Bequest Ms. III, London, Victoria and Albert Museum (1490–1493), p. 66 recto.
16. See Chapter XII.
17. The Mantua dukedom was created for Federigo II Gonzaga by Emperor Charles V in 1530.
18. Vasari-Milanesi, V: 535–44; Frederick Hartt, *Giulio Romano,* 2 vols. (New Haven, 1958), I: 91–160; Egon Verheyen, *The Palazzo del Te in Mantua* (Baltimore, 1977), *passim*.
19. One has to note, however, that a portrait of Federigo was begun by Raphael while Federigo was a boy being held hostage in Rome by Pope Julius II. Federigo's youthful portrait was left unfinished by Raphael after the death of Pope Julius. It was probably completed by one of the master's studio assistants, and came into the possession of one of the cardinals from whom Federigo finally acquired it. See Alessandro Luzio, "Federico Gonzaga ostaggio alla corte di Giulio II," *Archivio della Società di Storia Patria Romana* 9 (1886): 509–82; Julia Cartwright, *Isabella d'Este,* 2

vols. (London, 1903), II: 53–54, 73–74, 161; and the discussion in Chapter XIII.

20. Ascanio Condivi, *Michelangelo*, ed. Paolo d'Ancona (Milan, 1928), pp. 165 ff.

21. Sydney J. Freedberg, *Andrea del Sarto: Catalogue Raisonnée* (Cambridge, Mass., 1963), pp. 131–33.

22. See Chapter VIII.

XIII. THE CLIMAX IN THE WEST

1. Edmond Bonnaffé, "Sabba da Castiglione," *Gazette des Beaux-Arts* 30 (1884): 19–33, 145–54; Ignazio Massaroli, "Fra Sabba da Castiglione e i suoi ricordi," *Archivio storico lombardo*, ser. 2, 16 (1889): 357 ff.; Giovanni Zama, "I ricordi di Sabba Castiglione," *Studi romagnoli* 6 (1955): 359–92.

2. F. Petrucci, "Sabba da Castiglione," *Dizionario biografico degli italiani* 22 (Rome, 1979): 100–106.

3. Alessandro Luzio, "Lettere inedite di Fra Sabba da Castiglione," *Archivio storico lombardo*, ser. 2, 13 (1886): 91–112.

4. Luzio, "Lettere inedite," pp. 98–101.

5. Petrucci, "Sabba da Castiglione," pp. 100–106.

6. Fra Sabba in fact dedicated the book to his nephew Bartolomeo da Castiglione. See the "Proemio" to the *Ricordi di Monssignor Sabba da Castiglione* (Venice, 1560).

7. Castiglione, *Ricordi*, pp. 56 recto–60 verso; see also Bonnaffé, "Sabba da Castiglione," pp. 23 ff.

8. Edmond Bonnaffé, *Les Collectionneurs de l'ancienne France* (Paris, 1873), p. 11.

9. A. Bertolotti, *Musici alla corte dei Gonzaga in Mantova* (1890; reprint Bologna, 1969), pp. 17–18, 31.

10. Castiglione, *Ricordi*, p. 56r.; Bonnaffé, "Sabba da Castiglione," p. 24.

11. Castiglione, *Ricordi*, pp. 56v.–57r.

12. Castiglione, *Ricordi*, p. 57r.; Bonnaffé, "Sabba da Castiglione," p. 28.

13. Castiglione, *Ricordi*, p. 57r.; Bonnaffé, "Sabba da Castiglione," p. 145.

14. Castiglione, *Ricordi*, p. 57v.; Bonnaffé, "Sabba da Castiglione," p. 147.

15. Bonnaffé, "Sabba da Castiglione," p. 152.

16. Castiglione, *Ricordi*, p. 58v.

17. Castiglione, *Ricordi*, p. 58v.; Bonnaffé, "Sabba da Castiglione," p. 151; Horst W. Janson, *The Sculpture of Donatello*, 2nd ed. (Princeton, 1963), p. 249. See also A. Archi, *La Pinacoteca di Faenza* (Faenza, 1957), p. 24.

18. Castiglione, *Ricordi*, pp. 58v.–59r.; Bonnaffé, "Sabba da Castiglione," p. 151.

19. In Chapter VIII.

20. Lu Shihua, *Scrapbook for Chinese Collectors: Shu Hua Shuo Ling*, trans. Robert H. van Gulik (Beirut, 1958), pp. 66–67 (chap. XXV).

21. See Chapter VIII and the quotation from Zhang Yanyuan: "If one should chance to acquire (even so little as) a square inch (of the work of the great early masters) one ought to keep it sealed in a box," in William Reynolds Beal Acker, *Some T'ang and Pre-T'ang Texts on Chinese Painting* (Leyden, 1954), I: 195. His sentiments are echoed by Lu Shihua in the *Scrapbook for Chinese Collectors*, p. 65 (chap. XXIII); p. 67 (chap. XXVI).

22. *Heike Monogatari: The Tale of the Heike*, trans. Hiroshi Kitagawa and Bruce T. Tsuchida (Tokyo, 1975), p. 35.

23. Even in the Japanese palaces richly decorated with painting, supposedly fireproof storehouses were provided at some distance from the main structure; and here both family treasures and bullion were stored along with paintings, specimens of calligraphy and other prizes in the family art collection, which were only brought out of the storehouse for special display.

24. The great occasions calling for the finest prizes in the art collection to be shown were the Japanese New Year's Day and receptions for visitors of exceptionally high rank. But anyone organizing a particularly grand tea ceremony would also show the very best works of art in his collection in his tea room's tokonoma, in order to make the tea ceremony more memorable.

25. Gustav Glück, *The Picture Gallery of the Vienna Art Museum* (Vienna, 1931), pp. xiii–xiv.

26. A. H. Smith, ed., *Lansdowne House, London: A Catalogue of the Ancient Marbles Based on the Work of Adolf Michaelis* (London, 1889). See in particular the Appendix, which preserves the correspondence between Lord Shelburne (the future Marquess of Lansdowne) and Gavin Hamilton, the artist and art dealer commissioned by Lord Shelburne to gather a sculpture gallery for him. There are also the notes made by Shelburne concerning his collection. Hamilton tried to obtain in Italy the statuary needed to fit his specifications, and succeeded admirably, too. See the illustration of the Lansdowne House dining room, in Preston Remington, "The Galleries of European Decorative Arts and Period Rooms," *The Metropolitan Museum Bulletin*, 13 (November 1954): 107; Damie Stillman, *The Decorative Work of Robert Adam* (New York, 1966), p. 70, no. 31.

27. For the Laocoön, see Rodolfo Lanciani, *Storia degli scavi di Roma*, I (Rome, 1902): 139; F. Gregorovius, *Geschichte der Stadt Rom* (Darmstadt, 1963), XIV: 420–21; G. Bottari, *Raccolta di lettere*, III (Milan, 1882): 474–77. For the Hercules-Commodus, see Lanciani, *Storia degli scavi*, I: 144; Gregorovius, *Geschichte der Stadt Rom*, XIV: 422; Luzio, "Lettere inedite," pp. 93–94. The Hercules was identified as Commodus by Cardinal Tommaso Inghirami.

28. Vasari-Milanesi, V: 29–32. See also Sydney Freedberg, *Andrea del Sarto* (Cambridge, Mass., 1963), I: 47; John Shearman, *Andrea del Sarto* (Oxford, 1965) I: 4.

29. Vasari-Milanesi, VII: 407–8.

30. Benvenuto Cellini, *La vita*, ed. Paolo d'Ancona (Milan, n.d.), bk II, chap. XXXVII, p. 369; chap. XLI, pp. 374–75. See also L. Dimier, "Benvenuto Cellini à la cour de France," *Revue Archéologique*, 1 (1898): 241–80; Dimier, "Une Pièce inédite sur le séjour de Benvenuto Cellini à la cour de France," *Revue Archéologique*, 2 (1902): 85–95.

31. Luzio, "Lettere inedite," pp. 93–94; Julia Cartwright, *Isabella d'Este*, 2 vols. (London, 1903) II: 9.

32. Paul O. Kristeller, *Andrea Mantegna* (London, 1901), pp. 182, 467.

33. Francesco Albertini, *Opusculum de Mirabilibus Novae et Veteris Urbis Romae* (Rome, 1510).

34. Ulisse Aldovrandi, "Delle statue antiche," in Lucio Mauro, *Le antichità de la città di Roma* (Venice, 1556), pp. 115 ff.

35. Sets of prints appeared at this time as well. On the catalogues, guides and prints, see Francis Haskell and Nicholas Penny, *Taste and the Antique* (New Haven and London, 1981), pp. 17–22.

36. Marcantonio Michiel in *Notizia d'opere di disegno*, ed. Jacopo Morelli (Bassano, 1800). See also *Der Anonimo Morelliano* in *Quellenschriften für Kunstgeschichte und Kunsttechnik des Mittelalters und der Neuzeit*, ed. Albert Ilg, n. s. I (Vienna, 1888), and the translation by Paolo Mussi in Marcantonio Michiel, *The Anonimo* (1903; reprint New York, 1969). Regarding the authorship, see E. A. Cicogna, *Intorno la vita e le opere di Marcantonio Michiel* (Venice, 1861), pp. 12–13.

37. *Notizia d'opere di disegno*, pp. 20–21; Roberto Weiss, *The Renaissance Discovery of Classical Antiquity* (Oxford, 1969), pp. 200–202.

38. *Notizia d'opere di disegno*, pp. 140–42; Weiss, *Renaissance Discovery*, p. 201.

39. Ascanio Condivi, *Michelangelo*, ed. Paolo d'Ancona (Milan, 1928), pp. 77–78.

40. In this connection, it should be remembered that in 1501 Pierre de Rohan, Maréchal de Gié, requested the Florentine Signory to provide him with a copy of Donatello's bronze David. And it was Michelangelo who eventually supplied a David (Charles de Tolnay, *Michelangelo*, 2nd ed., I [Princeton, 1969]: 205). The request for a copy of the David in fact reflected the as yet unformed and provincial taste of the French. There is no other instance in the record of this period of a request for a copy of a work by a much earlier master.

 The references to works by Donatello in Florentine houses in the sixteenth century (see H. W. Janson, *The Sculpture of Donatello*, incorporating the notes and photographs of Jenŏ Lānyi, Princeton, N.J., 1963) begin on pp. 21–23 with the unfinished David in the Martelli collection but there are several more scattered throughout Janson's work. Professor Janson makes an excellent case that most or all of these Donatellos must be distinguished from those in the Medici inventory of 1492 because it is unlikely they were commissioned by the members of the relevant Florentine optimate families who were contemporary with Donatello, whereas the Donatellos in the Medici palazzo were most probably commissioned by the sculptor's warm friend and leading patron, Cosimo de' Medici Patriae.

41. Castiglione, *Ricordi*, p. 56r.–56v.
42. *Notizia d'opere di disegno*, p. 17.
43. *Notizia d'opere di disegno*, pp. 41, 45, 74.
44. *Notizia d'opere di disegno*, pp. 78, 81.
45. *Notizia d'opere di disegno*, pp. 74, 75, 76, 77.
46. *Notizia d'opere di disegno*, p. 17.
47. *Notizia d'opere di disegno*, p. 18.
48. Raffaello Borghini, *Il Riposo* (Florence, 1584), pp. 12–15, 19–22; Herbert Horne, *Botticelli: A Painter of Florence* (1908; Princeton, 1980), pp. x, 24, 127, 148, 256, 263–64, 282, 318–19, 320.
49. Borghini, *Il Riposo*, pp. 12–15.
50. Borghini, *Il Riposo*, pp. 19–20.
51. Luigi Lanzi, *La Real Galleria di Firenze accresciuta, e riordinata per comando di S.A.R. l'Arciduca Granduca di Toscana* (Florence, 1782), pp. 69–71.
52. *Palazzo Vecchio: committenza e collezionismo medicei*, exhibition catalogue (Florence, 1980), pp. 254–55; Horne, *Botticelli*, esp. his introduction, pp. xv–xvi, *et passim*.
53. Mary Ann Jack Ward, "The 'Accademia del Disegno' in Sixteenth Century Florence," dissertation, University of Chicago (1972), pp. 267 ff; A. Emiliani, *Leggi, bandi e provvedimenti per la tutela dei beni artistici e culturali negli antichi stati italiani 1571–1860* (Bologna, 1978), pp. 32–34.
54. The painting is the Madonna of the Pomegranate, done for the audience hall of the Magistrato dei Massai in the Palazzo della Signoria in Florence. It was probably still there when it entered Cardinal Leopoldo's collection in the seventeenth century. Leopoldo certainly can be said to have "acquired" it, since at a minimum he must have had to ask the reigning Grand Duke's permission in order to secure it. See Vasari-Milanesi, III: 322, n. 3; Horne, *Botticelli*, pp. 153–55; Ronald Lightbown, *Botticelli*, 2 vols. (Berkeley, 1978), II: 65–66; and *Uffizi, Florence*, Great Museums of the World (New York, 1968), p. 66. It must be understood, too, that the precise wording of the statement here annotated has been carefully considered. "Major collector" is the key phrase. In Florence particularly, but also in Rome in some measure, families claiming ancient origins always tended to pick up ancient pictures for a song, in order to emphasize the long duration of the family's grandeur. There is every reason to believe that this is why the Botticelli Adoration of the Magi, now

in our National Gallery, had found its way in the late eighteenth century to a Roman collection, whence it was secured by the Baron Vivant Denon for Czar Paul I in 1808. Vivant Denon is recorded as having said that this painting came from one of the "best" Roman collections, but he acquired it through the agency of an Italian engraver who brought it to Paris, and he did not name the original owner—both most suspicious circumstances. The active Roman collectors deserving to be called "major" were quite exceptionally few and far between in the late eighteenth century. See Lightbown, *Botticelli*, II: 46–47 and *Palazzo Vecchio: committenza e collezionismo medicei*, p. 254.

55. Isabella was willing to pay up to 10 ducats for one sable skin in order to make a muff. On that basis, the cloak of 80 skins could have cost 800 ducats, but a somewhat lower valuation for the cloak seems reasonable to me, since the skin for the muff was to be extra-fine. Hence a figure not less than 600 ducats. See Alessandro Luzio, "Il lusso d'Isabella d'Este," *Nuova antologia* 63 (Rome, 1896): 455 ff; Cartwright, *Isabella d'Este*, I: 54–55. It should be noted that Mrs. Ady (*née* Cartwright) is nowadays spoken of in haughty tones by scholars, but she has the great advantage of being comprehensive, albeit sentimental, about her heroine, and she cites her sources quite regularly. Her translations from the sources are also dependable and fluent, and, as will be observed, I have made much use of them.

56. Andrew Martindale, "The Patronage of Isabella d'Este at Mantua," *Apollo* 79 (1964): 184; Cartwright, *Isabella d'Este*, I: 226.

57. Luitpold Dussler, *Raphael: A Critical Catalogue*, trans. Sebastian Cruft (London and New York, 1971), pp. 93–100. See also John Shearman's "Die Loggia der Psyche in der Villa Farnesina und die Probleme der letzten Phase von Raffaels graphischem Stil," *Jahrbuch der Kunsthistorischen Sammlungen in Wien* 60 (1964): 59–100 and his "The Chigi Chapel in S. Maria del Popolo," *Journal of the Warburg and Courtauld Institutes* 24 (1961): 129–60.

58. See, for instance, the letter published in Luzio, "Lettere inedite," pp. 93–94. Also Cartwright, *Isabella d'Este*, II: 9. On Isabella's network of collecting agents see, most recently, Weiss, *Renaissance Discovery*, pp. 197–99; Clifford M. Brown, " 'Lo insaciabile desiderio nostro de cose antique': New Documents on Isabella d'Este's collection of Antiquities," in *Cultural Aspects of the Italian Renaissance* (Manchester, 1976), pp. 324–53, 497; and Brown, "The Grotta of Isabella d'Este," *Gazette des Beaux-Arts* 89 (1977): 155–71; 91 (1978): 72–82.

59. Published in Alessandro Luzio, "Isabella d'Este e il sacco di Roma," *Archivio storico lombardo* 9–10 (1908): 414–25.

60. Cartwright, *Isabella d'Este*, I: 330.

61. See below for the letter written by Isabella to her brother, Cardinal Ippolito d'Este, on June 30, 1502, in which she asks him to secure from Cesare Borgia only an antique Venus and a Cupid from the Urbino collection. Giovanni Gaye, *Carteggio inedito d'artisti dei secoli XIV, XV, XVI*, II (Florence, 1840): 53, 90–91; Edoardo Alvisi, *Cesare Borgia* (Imola, 1878), p. 537; Cartwright, *Isabella d'Este*, I: 230–31.

62. Gaye, *Carteggio*, II: 82; Cartwright, *Isabella d'Este*, I: 360 ff.

63. Frits Lugt, "Italiaansche kunstwerken in Nederlandsche verzamelingen van vroeger tijden," *Oud Holland* 53 (1936): 104.

64. Vasari-Milanesi, IV: 11.

65. For the passage see Alessandro Luzio, "Ancora Leonardo da Vinci e Isabella d'Este," *Archivio storico dell'arte* 1 (1888): 182, n. 2; trans. Cartwright, *Isabella d'Este* I: 322. See also Clifford M. Brown, "Little Known and Unpublished Documents Concerning Andrea Mantegna, Bernardino Parentino, Pietro Lombardo, Leonardo da Vinci and Filippo Benintendi," *L'arte* 7–8 (1969): 194–206.

66. Luzio, "Ancora Leonardo," p. 182; trans. Cartwright, *Isabella d'Este*, I: 323.

67. Luzio, "Ancora Leonardo," p. 182; trans. Cartwright, *Isabella d'Este*, I: 323.

68. A. Venturi, "Gian Cristoforo Romano," *Archivio storico dell'arte* 1 (1888): 112–13; Cartwright, *Isabella d'Este*, II: 2.

69. E. Piot, *Le Cabinet de l'amateur* (Paris, 1863), pp. 31 ff.

70. Venturi, "Gian Cristoforo Romano," pp. 112, 116; trans. Cartwright, *Isabella d'Este*, II: 2–4.

71. Luzio, "Isabella d'Este e il sacco di Roma," pp. 422, 424.

72. There is a picture of Isabella's *giardinetto* (as the garden-courtyard was called) with the empty niches in Martindale's "The Patronage of Isabella d'Este," p. 189.

73. Alessandro Luzio, *La galleria dei Gonzaga venduta all'Inghilterra nel 1627–28* (Milan, 1913), *passim*.

74. Luzio, "Isabella d'Este e il sacco di Roma," p. 424.

75. Luzio, "Lettere inedite," pp. 105–6; Cartwright, *Isabella d'Este*, II: 17.

76. Luzio, "Lettere inedite," p. 99; trans. Cartwright, *Isabella d'Este*, II: 15.

77. Luzio, "Lettere inedite," pp. 108–9; Cartwright, *Isabella d'Este*, II: 18.

78. Venturi, "Gian Cristoforo Romano," pp. 148–50; trans. Cartwright, *Isabella d'Este*, II: 7–8.

79. Millard Meiss, *French Painting in the Time of Jean de Berry: The Late XIV Century and the Patronage of the Duke*, 2 vols. (London, 1967), I: 300.

80. One notable instance of the vulture-like activity of the King's agents is recorded in a letter of September 11, 1631, from Sir Arthur Hopton in Spain to Lord Dorchester. Hopton wrote: "The Marques of Lleganes is sicke of a dangerous calentura, which importes this only in his Majesties service, that hee hath some good pictures, and Statues, which, if hee should miscary, may bee lookd out for, if his Majestie shall so ordaine." However, both the Marquess and his collection survived. Elizabeth du Gué Trapier, "Sir Arthur Hopton and the Interchange of Paintings Between Spain and England in the Seventeenth Century: Part 1," *Connoisseur* 164 (April 1967): 239.

81. On this subject of deathbed watching, I still remember the late Forsyth Wickes, whose French furniture and decorative objects are now in the Boston Museum of Fine Arts. He owned a particularly pretty table-garniture of three Sèvres vases. The two smaller ones had been purchased after the death of the first J. P. Morgan. The third and largest one was secured seventeen years later from an English collection. "And that," Mr. Wickes told me drily, "was one English Lord whose death I couldn't bring myself to regret."

82. Cartwright, *Isabella d'Este*, I: 360. See Bembo's response in Gaye, *Carteggio*, II: 82.

83. Gaye, *Carteggio*, II: 82; Cartwright, *Isabella d'Este*, I: 361.

84. Alessandro Luzio, "Isabella d'Este e due grandi quadri di Giorgione," *Archivio storico dell'arte* 1 (1888): 47; trans. Cartwright, *Isabella d'Este*, I: 389–90. See also Terisio Pignatti, *Giorgione*, trans. Clovis Whitfield (Venice, 1971), p. 158.

85. Luzio, "Isabella d'Este e due grandi quadri di Giorgione," p. 47; Cartwright, *Isabella d'Este*, I: 390–91; Pignatti, *Giorgione*, p. 158.

86. Carlo d'Arco, *Dell'arte e degli artefici di Mantova*, II (Rome, 1857): 73; Cartwright, *Isabella d'Este*, I: 292–93.

87. Gaye, *Carteggio*, II: 53; trans. Cartwright, *Isabella d'Este*, I: 230–31.

88. Alvisi, *Cesare Borgia*, p. 537; trans. Cartwright, *Isabella d'Este*, I: 232.

89. Condivi, *Michelangelo*, p. 62.

90. Martindale, "The Patronage of Isabella d'Este," p. 186; Cartwright, *Isabella d'Este*, I: 233.

91. Martindale, "The Patronage of Isabella d'Este," p. 186.

92. Luzio, *La galleria dei Gonzaga*, p. 77.

93. Cecil Gould, *Correggio* (London, 1976), pp. 127, 239–42.

94. Gould, *Correggio*, pp. 124–25, 238.

95. Gould, *Correggio*, pp. 124–25, 213–16.

96. Gould, *Correggio*, pp. 130 ff., 194–96, 270–71, 274–76; Egon Verheyen, "Correggio's *Amori di Giove*," *Journal of the Warburg and Courtauld Institutes* 29 (1966): 160–92.

97. Cartwright, *Isabella d'Este*, I: 329. A French translation appears in Charles Yriarte, "Isabelle d'Este et les artistes de son temps," *Gazette des Beaux-Arts* 14 (1895): 132.

98. Cartwright, *Isabella d'Este*, I: 330.

99. Yriarte, "Isabelle d'Este," p. 134; Cartwright, *Isabella d'Este*, I: 330.

100. Eugène Müntz gives the original letter in his *Histoire de l'art pendant la Renaissance* II (Paris, 1891): 62. Charles Yriarte gives a French translation in "Isabelle d'Este," pp. 135 ff. I have used the English version in Cartwright, *Isabella d'Este*, I: 331.

101. Egon Verheyen, *The Paintings in the Studiolo of Isabella d'Este at Mantua* (New York, 1971), pp. 23–27.

102. Cartwright, *Isabella d'Este*, I: 333.

103. Kristeller, *Andrea Mantegna*, p. 493, gives the complete letter; trans. Cartwright, *Isabella d'Este*, I: 333.

104. Cartwright, *Isabella d'Este*, I: 334.

105. Yriarte, "Isabelle d'Este," pp. 137–38; Cartwright, *Isabella d'Este*, I: 338–39.

106. Egon Verheyen, *The Paintings in the Studiolo, passim*.

107. W. Braghirolli, "Carteggio d'Isabella d'Este Gonzaga intorno ad un quadro di Giambellino," *Archivio veneto* 13 (1877): 370–83; trans. Cartwright, *Isabella d'Este*, I: 341–42. On Isabella and Bellini see also Giles Robertson, *Giovanni Bellini* (Oxford, 1968), pp. 134–40.

108. J. M. Fletcher, "Isabella d'Este and Giovanni Bellini's Presepio," *Burlington Magazine* 113, (December 1971): 703–12; Cartwright, *Isabella d'Este*, I: 343.

109. Fletcher, "Isabella d'Este and Bellini's Presepio," p. 704; trans. Cartwright, *Isabella d'Este*, I: 343.

110. Braghirolli, "Carteggio d'Isabella," p. 381; trans. Cartwright, *Isabella d'Este*, I: 346.

111. Fletcher, "Isabella d'Este and Bellini's Presepio," p. 708.

112. Braghirolli, "Carteggio d'Isabella," p. 381; Yriarte, "Isabelle d'Este," *Gazette des Beaux-Arts* 15 (1896): 221; Fletcher, "Isabella d'Este and Bellini's Presepio," pp. 709–10.

113. Gaye, *Carteggio*, II: 76; trans. Professor Anna Modigliani Lynch. See also Yriarte, "Isabelle d'Este," 15 (1896): 224.

114. Yriarte, "Isabelle d'Este," 15 (1896): 226.

115. Gaye, *Carteggio*, II: 71; trans. Cartwright, *Isabella d'Este*, I: 357–58. See also Robertson, *Bellini*, pp. 138–40.

116. Cartwright, *Isabella d'Este*, I: 171–172; Kenneth Clark, *Leonardo da Vinci*, Penguin ed. (Harmondsworth, 1967), pp. 100–101.

117. Cartwright, *Isabella d'Este*, II: 73–74; V. Golzio, *Raffaello* (Vatican City, 1936), pp. 26–28; J. A. Crowe and G. B. Cavalcaselle, *Raphael*, 2 vols. (London, 1885), II: 184–85. For the complete story of Federigo's forced sojourn in Rome see Alessandro Luzio, "Federico Gonzaga ostaggio alla corte di Giulio II," *Archivio della Società di Storia Patria Romana* 9 (1886): 509–82.

118. Cartwright, *Isabella d'Este*, II: 53–54.

119. Cartwright, *Isabella d'Este*, II: 161.

120. Venturi, "Nuovi documenti," p. 45; Cartwright, *Isabella d'Este*, I: 318–19.

121. Venturi, "Nuovi documenti," pp. 45–46; Cartwright, *Isabella d'Este*, I: 319–20.

122. Alessandro Luzio, "Ancora Leonardo da Vinci," pp. 181–82; Cartwright, *Isabella d'Este*, I: 321–22.

123. Luzio, "Ancora Leonardo da Vinci," pp. 182–83; Cartwright, *Isabella d'Este*, I: 323–25.

124. Luzio, "Ancora Leonardo da Vinci," p. 183; Cartwright, *Isabella d'Este*, I: 326–27.

125. Cartwright, *Isabella d'Este*, II: 112.

126. Golzio, *Raffaello*, p. 37; *Cartwright, Isabella d'Este*, II: 163.

127. Golzio, *Raffaello*, p. 37; Cartwright, *Isabella d'Este*, II: 163–64.

128. Golzio, *Raffaello*, pp. 37–38; Cartwright, *Isabella d'Este*, II: 164.

129. G. Milanesi, *Nuovi documenti per la storia dell'arte toscana* (Florence, 1901), pp. 134–36; G. S. Davies, *Ghirlandaio* (London, 1908), pp. 103–28, 170–72.

130. Venturi, "Nuovi documenti," p. 46; Cartwright, *Isabella d'Este*, I: 320–21.

131. Vasari-Milanesi, VII: 442; Harold Wethey, *The Paintings of Titian*, 3 vols. (London, 1969–75), III: 43–47, 235–40; J. A. Crowe and G. B. Cavalcaselle, *Titian: His Life and Times*, 2 vols. (London, 1877), I: 420, 458, 459; II: 21.

132. Although Vasari (VII: 442) records that Titian painted twelve emperors, the 1627 Mantua inventory refers to eleven paintings of emperors by Titian and one painted by Giulio Romano. However it was probably not Romano but Bernardino Campi who painted the twelfth emperor, since the latter is reported to have added a Domitian to the set no later than 1584. See Wethey, *The Paintings of Titian*. III: 43–44, 235–36. Wethey, however, does not believe that a twelfth emperor would have been able to fit in the Gabinetto dei Cesari of the Ducal Palace at Mantua, and suggests that the set was really complete at eleven. Hartt, on the other hand, suggests that one adorned "the center of the ceiling." See Hartt, *Giulio Romano*, I: 170.

133. Wethey, *The Paintings of Titian*. III: 236.

134. Gaye, *Carteggio*, II: 224–25.

135. Vasari-Milanesi, V: 41–43; Shearman, *Andrea del Sarto*, pp. 125–26, 265–67.

136. Gaye, *Carteggio*, II: 227; L. Pastor, *Geschichte der Päpste*, 1st–4th eds. (Freiburg i.B., 1907), IV-2: 760–61; Charles de Tolnay, *Michelangelo*, 2nd ed., III (Princeton, 1970): 15; Egon Verheyen, *The Palazzo del Te in Mantua* (Baltimore, 1977), pp. 15, 46.

137. B. Buser, *Die Beziehungen der Medici zu Frankreich* (Leipzig, 1879), pp. 230, 505; E. Barfucci, *Lorenzo de' Medici e la società artistica del suo tempo* (Florence, 1945), p. 310.

138. Anatole de Montaiglon, "État des gages des ouvriers italiens employés par Charles VIII," *Archives de l'Art Français*, 1 (Paris, 1851–52): 95 ff.

139. Gaye, *Carteggio*, II: 52–55.

140. Gaye, *Carteggio*, II: 52–55; Tolnay, *Michelangelo*, I (1969): 98–99, 205–09.

141. Martin Wackernagel, *Der Lebensraum des Künstlers in der Florentinischen Renaissance* (Leipzig, 1938), p. 289. See also his earlier article, "Giovanni della Palla, der erste Kunsthändler," *Die Kunst* 73 (Munich, 1936): 270–71, 276.

142. Condivi, *Michelangelo*, pp. 60, n. 54; 61, n. 55.

143. H. Floerke, *Studien zur niederländischen Kunst und Kulturgeschichte* (Munich, 1905), pp. 6 ff; Lorne Campbell, "The Art Market in the Southern Netherlands in the Fifteenth Century," *Burlington Magazine* 118 (1976): 188–98.

144. Wackernagel, *Der Lebensraum*, p. 289.

145. Vasari-Milanesi, VI: 540; Wackernagel, "Giovanni della Palla," p. 271.

146. For Andrea del Sarto's Sacrifice of Isaac see Vasari-Milanesi, V: 50; Shearman, *Andrea del Sarto*, pp. 280–81; for his Charity see Vasari-Milanesi, V: 51; Shearman, *Andrea del Sarto*, p. 278.

147. Vasari-Milanesi, IV: 188.

148. See Chapter VI.

149. Vasari-Milanesi, VI: 261 ff.

150. Vasari-Milanesi, V: 27.

151. Vasari-Milanesi, VI: 262–63.

152. A. Ademollo, *Marietta de'Ricci*, ed. L. Passerini, I (Florence, 1845): 180, n. 22.

153. See K. W. Forster, *Pontormo* (Munich, 1966), pp. 130–32.

154. See Chapter II.

155. Both Poussin and Rubens dealt directly with their customers, rather than use art dealers as intermediaries. See Chapter VI.

156. See Chapter II.

157. Crowe and Cavalcaselle, *Titian*, II: 365–71; J. F. Hayward, "Jacopo da Strada, XVI Century Antique Dealer," *Art at Auction 1971–72* (New York, 1973), pp. 68–74; U. Thieme and F. Becker, *Allgemeines Lexikon der bildenden Künstler*, XXXII (Leipzig, 1938): 145–47; O. Hartig, "Die Kunsttätigkeit in München unter Wilhelm IV. und Albrecht V. 1520–1579," *Münchner Jahrbuch*, n.s. 10 (1933): 216 ff.; E. Scheicher, *Die Kunst- und Wunderkammern der Habsburger* (Vienna, 1979), pp. 139–40.

158. For Strada as court antiquary see Hayward, "Jacopo da Strada," pp. 70–71. For Katharina as Rudolph's mistress (she bore him six children), see R. J. W. Evans, *Rudolf II and His World* (Oxford, 1973), pp. 49, 58, 129; and Hayward, "Jacopo da Strada," p. 73. Strada, however, seems to have had a falling out with Rudolph, for in 1579 he complained of his treatment and asked to be relieved of his court duties, and his son Ottavio succeeded him as the emperor's antiquary. See Hayward, "Jacopo da Strada," p. 73.

159. E. Hubala, "Ein Entwurf für das Antiquarium der Münchner Residenz 1568," *Münchner Jahrbuch*, s. 3, IX/X (1958/9): 128–46.

160. Crowe and Cavalcaselle, *Titian*, II: 365–71.

161. Crowe and Cavalcaselle, *Titian*, II: 366.

162. Crowe and Cavalcaselle, *Titian*, II: 367.

163. Crowe and Cavalcaselle, *Titian*, II: 367.

164. Crowe and Cavalcaselle, *Titian*, II: 368 ff.

165. Wethey, *The Paintings of Titian*. II: 48–49, 141–42.

166. Aretino was a great propagandist of Titian in court circles at the time. For example, he sent Federigo Gonzaga two Titians in 1527, one of them a portrait of himself by the master. See Crowe and Cavalcaselle, *Titian*, I: 318. Titian painted Aretino's portrait at least two other times (see *The Frick Collection: An Illustrated Catalogue*. II: *Paintings: French, Italian and Spanish*, text compiled by Bernice Davidson, with Edgar Munhall [New York, 1968], p. 258). He painted Aretino as Pontius Pilate in his great *Ecce Homo* now at Vienna (see Crowe and Cavalcaselle, *Titian*, II: 93–95), and he furthermore gave Aretino a copy of the *Ecce Homo* now at Madrid, as another present (see Crowe and Cavalcaselle, *Titian*, II: 160–61).

167. Titian did a number of paintings for the Cardinal Farnese in hopes of receiving a sinecure for himself, and later, in hopes of securing a benefice for his son. See Crowe and Cavalcaselle, *Titian*, II: 82 ff., 142 ff., 374 ff.

168. Myra Nan Rosenfeld, "Sebastiano Serlio's Drawings in the Nationalbibliothek in Vienna for his *Seventh Book of Architecture*," *Art Bulletin* 56 (1974): 400–409. See also Rosenfeld, *Sebastiano Serlio (1475–1555)*, exhibition catalogue, Low Memorial Library, Columbia University (New York, 1975), p. 2.

169. Rosenfeld, *Sebastiano Serlio (1475–1555)*, p. 13; Konrad Oberhuber, *Raphaels Zeichnungen*, Abteilung IX (Berlin, 1972): 19.

170. Luzio, *La galleria dei Gonzaga*, p. 241; Frederick Hartt, *Giulio Romano*, I: 255, 257; Oberhuber, *Raphaels Zeichnungen*, p. 19.

171. Beatrix von Ragué, *A History of Japanese Lacquerwork* (Toronto and Buffalo, 1976), p. 158.

172. Julius von Schlosser, *Die Kunst- und Wunderkammern der Spätrenaissance* (Leipzig, 1908), p. 50 *et passim*; E. Scheicher, *Die Kunst- und Wunderkammern*, pp. 123, 127 *et passim*.

173. It used to be described as "Montezuma's Crown," implying that he wore it himself, but although there is very little doubt that the feathered crown came from Montezuma's gift to Cortez, the scholars are now uncertain whether the crown was used originally by a living man or to adorn the statue of a god. It was restored in 1880, mainly by replacement of the many worn or destroyed quetzal plumes. Karl A. Nowotny, *Mexikanische Kostbarkeiten aus Kunstkammern der Renaissance im Museum für Völkerkunde Wien und in der Nationalbibliothek* (Vienna, 1960), pp. 42–53; Ferdinand Anders, "Der Federkasten der Ambraser Kunstkammer," *Jahrbuch der Kunsthistorischen Sammlungen in Wien* 61 (1965): 119–32.

174. See Chapter I for the Dürer passage.

175. Scheicher, *Die Kunst- und Wunderkammern*, pp. 30, 108. There are the usual scholarly complications, such as the absence of what seems to have been a golden bird mask in the description of the feather crown in an inventory made in 1519, immediately after the arrival of Cortez' treasure in Europe, the appearance of this *"Schnabel"* in the Schloss Ambras inventory of 1596, and its disappearance in the descriptions of the feather crown in later inventories of the contents of Schloss Ambras. Common sense and reasonable allowance for the fondness of collectors for "improving" their collections, for the fondness of unwatched guardians for bits of pure gold and the common accidents of time and history, all permit the fairly simple provenance here given. In addition, it should be noted that Ferdinand I left some of the Mexican objects descended from his father to his other son, Charles II. See Nowotny, *Mexikanische Kostbarkeiten*, p. 43; and Detlef Heikamp with Ferdinand Anders, "Mexikanische Altertümer aus süddeutschen Kunstkammern," *Pantheon* 28 (May-June 1970): 205.

176. He left the standard collector's will, stating that the collection was to remain intact at Schloss Ambras. His wishes, however, were defied by his Imperial relations who took the most precious things to Vienna. Recently, Schloss Ambras has begun to attract great attention again. The castle has now been restored by the government, and some of the collection has been brought together there once more, although the feather crown is still in Vienna as these words are written.

177. *Präkolumbische Kunst aus Mexiko und Mittelamerika*, exhibition catalogue, Museum für Völkerkunde (Vienna, 1959–60), pp. 77–78.

178. Hermann Fillitz, *Trésor sacré et profane de Vienne*, trans. André Espiau de la Maistre, 2nd rev. ed., Kunsthistorisches Museum (Vienna, 1963), pp. 39–40.

179. Konrad Oberhuber, "Raphael and the State Portrait–I: The Portrait of Julius II," *Burlington Magazine* 113 (1971): 124–30.

180. Oberhuber, "Raphael and the State Portrait," p. 124–27; Cecil Gould, *Raphael's "Portrait of Julius II"* (London, 1970), p. 5.

181. Gould, *Raphael's "Portrait of Julius II,"* pp. 4–5; Gould, "The Raphael Portrait of Julius II," *Apollo* 92 (1970): 188.

182. Gould, *Raphael's "Portrait of Julius II,"* pp. 1–3; Gould, "The Raphael Portrait," pp. 188–89.

183. Gould, *Raphael's "Portrait of Julius II,"* pp. 3–5.

184. Gould, *Raphael's "Portrait of Julius II,"* pp. 7 ff.

185. Sylvie Béguin, S. Bergeon, R. Cazelles, S. Delbourgo, *La Madone de Lorette* (Paris, 1979); B. Frederickson and A. Hladka, "New Information on Raphael's 'Madonna di Loreto'," *J. Paul Getty Museum Journal*, no. 3 (1976): 5–45; Cecil Gould, "Afterthoughts on Raphael's so-called Loreto Madonna," *Burlington Magazine* 122 (May 1980): 337–41.

186. Béguin, et al., *La Madone de Lorette, passim*; Gould, "Afterthoughts," pp. 337–41.

XIV. THE SEVENTEENTH CENTURY

1. In his 1602 decree limiting the export of works of art from Florence, Grand Duke Ferdinand de' Medici argued that preserving the *"ornamento"* of the city was of the greatest importance in preserving its reputation. Mary Ann Jack Ward, "The 'Accademia del Disegno' in Sixteenth Century Florence," dissertation, University of Chicago (1972), p. 268.

2. Andrew Marvell, "An Horatian Ode upon Cromwell's Return from Ireland," *The Oxford Book of English Verse*, ed. A. T. Quiller-Couch (London, 1905), p. 384.

3. See Chapter XII.

4. See Chapter XIII.

5. See Chapter VI.

6. Oliver Millar, ed., *The Inventories and Valuations of the King's Goods 1649–1651*, published as *The Walpole Society* 43 (1970–72). The Van Dycks are on pp. 67, 69(2), 70(2), 151, 198(2), 206(3), 217, 265, 267, 268, 269, 300, 306(2), 316(2), 317, 318(7), 319. The Titians are on pp. 64(2), 66, 70(4), 71(2), 190(4), 201, 206(3), 263, 267, 268(2), 269(2), 270(12), 271(3), 298(4), 299(2), 300(2), 304, 305, 306, 310, 313, 314, 315, 316, 320. The Titian entry on p. 263 ("Three. figures p'r Tytian at £100") could be read as an entry for three paintings, but I have taken it to refer to three figures within one painting. In addition, there is one picture which is described on p. 268 as either by Salviati or Titian. It has been left out of this count. It should also be noted that this list of paintings attributed to Titian includes the twelve emperors from Mantua (see Chapter XIII), one of which may have been painted by Bernardino Campi, while another of these twelve may have been the one painted by Van Dyck to replace Titian's badly damaged Vitellius. (See Oliver Millar, ed., *Abraham van der Doort's Catalogue of the Collections of Charles I*, published as *The Walpole Society*, 37, [1958–1960]: 234.)

7. Millar, *Abraham van der Doort's Catalogue*, p. 89. See below the discussion of the trade which brought the Leonardo to England.

8. G. Waagen, *Treasures of Art in Great Britain*, I (London, 1854): 9.

9. G. Waagen, *Treasures of Art*, I: 11. Most of the sculpture pieces in the Van der Doort inventory are on pp. 70–73, 92 ff., and 165–70 of Millar, *Abraham van der Doort's Catalogue*.

10. Most of the entries for sculpture in the dispersal inventory are on pp. 130–36, 138–50, and 155–56, 260–62, 272–73 of Millar, *The Inventories and Valuations of the King's Goods*.

11. The doubtfulness of the estimates of value of the pieces of sculpture is no more than a guess, however, based on the higher valuations normally placed on classical sculpture in the seventeenth century.

12. Millar, *The Inventories and Valuations*, pp. 140–41, 143, entries 11, 19, 20, 27, and 81.

13. Millar, *The Inventories and Valuations*, p. 140, entry 7.

14. Millar, *The Inventories and Valuations*, p. 140, entry 9.

15. Millar, *The Inventories and Valuations*, p. 141, entry 28. In addition, there is an

entry for "a little. Cupid sitting" at £10 (Millar, *The Inventories and Valuations*, p. 141, entry 33). This seems an unlikely candidate since Michelangelo's Cupid was almost certainly lying down.

16. Millar, *The Inventories and Valuations*, pp. 140–41, 143. The men are identified in Millar's index under their respective names on pp. 437, 439, and 442.

17. Kenneth Clark, *Rembrandt and the Italian Renaissance* (New York, 1966), pp. 124–27.

18. A. R. Peltzer, ed., *Joachim von Sandrart's Academie der Bau-, Bild-, und Mahlerey-Künste* (Munich, 1925), p. 417; see also Sabine Eiche, "The Return of Baldassare Castiglione," *Burlington Magazine* 123 (March 1981): 154–55.

19. Luitpold Dussler, *Raphael: A Critical Catalogue*, trans. Sebastian Cruft (London and New York, 1971), pp. 33–34.

20. C. Vosmaer, *Rembrandt, sa vie et ses oeuvres* (Paris, 1877), p. 444; Clark, *Rembrandt and the Italian Renaissance*, p. 208. Paul F. Norton's "The Lost Sleeping Cupid by Michelangelo," *Art Bulletin* 39 (1957): 251–57, traces the history of the Cupid, but makes no mention of Rembrandt's "*kindeke.*"

21. See Millar, *Abraham van der Doort's Catalogue*, pp. xiii ff.

22. Millar, *Abraham van der Doort's Catalogue*, p. 192.

23. Tragically enough, many of the "Mantua peeces" are described as "quite Spoyled by quicksilver." (See esp. Millar, *Abraham van der Doort's Catalogue*, pp. 173–75.) Scholars have put forward various views about how this can have happened. I should like to add the suggestion that perhaps one or more of the ships which carried the Mantua collection from Venice to England stopped in Spain to pick up flasks of mercury from the Almadén mines. The defacements so often noted by Van der Doort could then have happened very easily if some of the mercury flasks had been broken in a storm, and their contents had leaked down into the cases full of pictures, which would have been lower in the hold since they were loaded first.

24. Millar, *Abraham van der Doort's Catalogue*, p. 161.

25. Millar, *Abraham van der Doort's Catalogue*, p. 89; Seymour de Ricci, *Description raisonnée des peintures du Louvre*, (Paris, 1913), p. 166.

26. His book, the complete title of which is *Notizie de' Professori del disegno da Cimabue in qua, per le quali si dimonstra come e perche le bell'arti di Pittura, Scultura e Architettura, lasciata la rozzezza della maniere greca e gottica si siano in questi secoli ridatti all'antica loro perfezione* (Florence, 1681), was the most influential after Vasari of the early Italian art histories, with the exception of Bellori.

27. L. Cust, "The Painter H. E. ('Hans Eworth')," *The Walpole Society*, 2 (1912–13): 1–44; Roy Strong, *The English Icon: Elizabethan and Jacobean Portraiture* (London, 1969) pp. 9–10.

28. J. A. Crowe and G. B. Cavalcaselle, *Titian: His Life and Times*, 2 vols. (London, 1877), II: 209; Erna Auerbach, *Tudor Artists* (London, 1954), pp. 90–91; Harold Wethey, *The Paintings of Titian*, 3 vols. (London, 1969–75), II: 203.

29. Wethey, *The Paintings of Titian*, II: 203.

30. Wethey, *The Paintings of Titian*, III: 189–90.

31. Dussler, *Raphael: A Critical Catalogue*, p. 13. But there is also an argument that this was instead the Louvre's St. George and the Dragon. See James B. Lynch, Jr., "The History of Raphael's Saint George in the Louvre," *Gazette des Beaux-Arts* 59 (April 1962), pp. 203–12.

32. William Arthur Shaw, ed., *Three Inventories of the Years 1542, 1547 and 1549–50 of Pictures in the Collections of Henry VIII and Edward VI* (London, 1937).

33. Millar, *Abraham van der Doort's Catalogue*, pp. 79, 208.

34. Roy Strong, *Splendor at Court: Renaissance Spectacle and the Theater of Power*

(Boston, 1973), p. 213; Strong, *Festival Designs by Inigo Jones*, exhibition catalogue (Washington, D.C., 1967–68), pp. 2–3; John Harris, Stephen Orgel, and Roy Strong, *The King's Arcadia: Inigo Jones and the Stuart Court*, exhibition catalogue (London, 1973), pp. 35 ff.; Strong, *The English Icon*, p. 55.

35. Harris, Orgel, and Strong, *The King's Arcadia*, p. 55.

36. *Calendar of State Papers, Venetian*, XII (London, 1905): 106; Oliver Millar, *The Queen's Pictures* (London, 1977), p. 27.

37. See Chapter VI.

38. See, for example, Joachim Sandrart's descriptions of Arundel House as given by Mary F. S. Hervey, *The Life, Correspondence & Collections of Thomas Howard, Earl of Arundel* (Cambridge, 1921), pp. 255–57.

39. See Chapter VI.

40. Claude Phillips, "The Picture Gallery of Charles I," *The Portfolio* 25 (January 1896): 19–21.

41. Oliver Millar, *Rubens: The Whitehall Ceiling* (London, 1958), *passim*.

42. Most notably for the banqueting house in Whitehall which Rubens decorated, and also for the Queen's house in Greenwich.

43. Millar, *The Inventories*, p. 383.

44. Millar, *The Inventories*, p. 120.

45. Millar, *The Inventories*, p. 71; Wethey, *The Paintings of Titian*, II: 108–09.

46. Millar, *The Inventories*, p. 158.

47. Millar, *The Inventories*, pp. 198, 264, 265.

48. Mazarin's tapestries were valued at 632,000 livres after his death in 1661, with a single series, *"le Grand Scipion,"* assessed at 100,000 livres! See Edmond Bonnaffé, *Dictionnaire des amateurs français au XVIIe siècle* (Paris, 1884), p. 212.

49. "Modern" in the sense that in the King's time it was already normal for a magnate collector to have a gallery of marbles.

50. D. E. L. Haynes, *The Arundel Marbles* (Oxford, 1975), pp. 5–7; W. Noël Sainsbury, ed., *Original Unpublished Papers Illustrative of the Life of Sir Peter Paul Rubens as an Artist and a Diplomatist* (London, 1859), pp. 284–85.

51. Henry Peacham, *The Compleat Gentleman* (1st publ. 1622; Oxford, 1906), p. 107.

52. Peacham, *The Compleat Gentleman*, p. 107.

53. Millar, *The Inventories*, p. 187. I suspect that the Antonello da Messina, and probably also the Bellinis (see below), were included in the great bulk purchase from Mantua, for the Mantua collections were continuously gathered over a very long period.

54. Millar, *The Inventories*, pp. 191, 246.

55. The Triumph is on p. 186 of Millar's *Inventories*, the Dead Christ appears on p. 195, and the seven other Mantegna pictures are on pp. 64(2), 195(2), 266(2), 298.

56. Francis C. Springell, *Connoisseur & Diplomat: The Earl of Arundel's Embassy to Germany in 1636 as recounted in William Crowne's Diary, the Earl's Letters and Other Contemporary Sources* (London, 1963), pp. 129–31.

57. Horace Walpole, *Anecdotes of Painting in England*, ed. Ralph Wornum, 4 vols. (1876; reprint New York, 1969), I: 287.

58. For example, Francis Henry Taylor, *The Taste of Angels* (Boston, 1948), p. 236.

59. "Inventory of the Goods of Charles I," Commonwealth Sale Catalogue, PS 1846, Harleian 7352, British Museum, London, p. 327. I have to thank the British Public Record Office for kindly letting me have a photocopy of the document.

60. Phillips, "The Picture Gallery of Charles I," p. 50.

61. Dussler, *Raphael: A Critical Catalogue*, p. 13.

62. Bonnaffé, *Dictionnaire*, p. v.

63. *The Diary of John Evelyn*, ed. E. S. De Beer (London, 1959).

64. Martin Lister, *A Journey to Paris in 1698* (London, 1698; reprint New York, 1971).

65. Bonnaffé, *Dictionnaire*, p. vi.

66. See S. Speth-Holterhoff, *Les Peintres flamands de cabinets d'amateurs au XVIIe siècle* (Brussels, 1957).

67. Millar, *The Queen's Pictures*, p. 36.

68. Hervey, *The Life, Correspondence & Collections*, pp. 164, 299–301, 403; Sainsbury, *Original Unpublished Papers*, pp. 298–99.

69. Phillips, "The Picture Gallery of Charles I," p. 20.

70. Arundel's letter concerning the book, addressed to Lord Aston, the Ambassador at Madrid, is published in both Hervey, *The Life, Correspondence & Collections*, p. 403, and Sainsbury, *Original Unpublished Papers*, pp. 298–99. In the letter to Lord Aston, Arundel complains of Don Juan's "foolish humor."

71. Bonnaffé, *Dictionnaire*, p. 283.

72. Bonnaffé, *Dictionnaire*, pp. 203–5; L. Clément de Ris, *Les Amateurs d'autrefois* (Paris, 1877), pp. 104–23.

73. Jean de La Bruyère, *Les Caractères, ou Les Moeurs de ce siècle*, ed. Pierre Kuentz (Paris, 1969), pp. 193–94.

74. See Chapter VI.

75. Ibn Khaldūn's basic theory of history was that high civilizations or cultures were always doomed to be conquered by more hardy and warlike peoples from the fringes of the cultured areas; and that this was bound to be repeated over and over again because each group of conquerors ceased to be hardy and warlike once they had been exposed to the softening and corrupting influences of high culture. Thus he was an undoubted determinist, if a simplistic one; but he was also one of the most endearing historians I have ever read. See Ibn Khaldūn, *The Muqaddimah: An Introduction to History*, trans. Franz Rosenthal, 3 vols. (New York, 1958).

76. Arnold J. Toynbee, *A Study of History*, 11 vols. (London, 1934–59).

77. See Interchapter 4.

78. See the discussion of this problem in Chapter VII.

79. *From the Lands of the Scythians: Ancient Treasures from the Museums of the U.S.S.R., 3000 B.C. to 100 B.C.*, exhibition catalogue, Metropolitan and Los Angeles County Museums (New York, 1975), p. 31, pl. 31–33.

80. If you take only the Athenian potters and pottery painters, the list of probable foreigners is in fact very long and begins for this essay's purposes with Scythes, a painter of Scythian origin (see J. D. Beazley, *Attic Red-Figure Vase-Painters*, 3 vols., 2nd ed. [Oxford, 1968], pp. 82–85, 166, 1624; Beazley, *Paralipomena*, 2nd ed. [Oxford, 1971], p. 329). In addition, the other foreigners identified as such at one time or another by leading authorities are Amasis, or "The Amasis Painter," an Egyptian; Lydus, a Lydian; Colchus, presumably from Colchis; Thrax, no doubt a Thracian; Sicelus, who must have been a Sicel from Sicily; "The Brygus Painter," another probable Thracian; Sicanus, thought by some to be another Sicilian; Midas, who may have been a Phrygian; and Syriscus, a Syrian who has been identified with Pistoxenus by Professor Martin Robertson in "Beazley and After," *Münchner Jahrbuch der bildenden Kunst* 27 (1976): 42. It should also be remembered that Aristophanes indicates that there were Scythians in the Attic constabulary (see *Thesmophoriazusae*, 762–64, 854, 923–1225).

81. See, for example, in the catalogue of the 1975 Scythian exhibit at the Metropolitan and Los Angeles County Museums, *From the Lands of the Scythians*, the following objects: a golden stag (pl. 3); a mirror-back (pl. 4); a panther (pl. 5); another stag (pl. 15); a snake and some sort of predator (pl. 22); a felt swan (pl. 25); and a gilded silver horse (pl. 28).

82. This is the large landscape in a debased traditional Chinese style, with a rather more than life-size picture of the Great Helmsman appearing on a trail circling the mountain's flank. Reproductions were formerly to be seen in every airport waiting-room in mainland China, and may still be, for that matter.

ENVOI

1. It should be understood that tapestries were formerly hung loosely, like curtains, instead of being stretched flat on the wall in the way that is usual today. This explains the scene in *Hamlet* (III, iv) where Polonius hides "behind the arras."
2. *Mémoires inédits de Louis-Henri de Loménie, Comte de Brienne*, ed. F. Barrière, II (Paris, 1828): 114–17.

BIBLIOGRAPHY

When I realized what a monster this bibliography had become, I concluded that a short explanatory note was desirable. In brief, I have had to take my facts where I could find them, and I have often had to look in odd places, and hope for help from happy happenstance. The process of research has in fact too often been like placer mining in a poorish river, in which large quantities of dross must be panned to yield only a few grains of gold, and very occasionally a real nugget. As my research has also been continuous for nearly eighteen years, the cumulative result is massive. As to the languages inaccessible to me, see the Preface.

I have omitted some of the trivia used to prove minor points which are cited in the notes, but I have included in the bibliography all serious sources named in the notes, even if the sources contributed to no more than one or two sentences of text. I have also added a few general studies which gave me overall guidance but did not find their way into the notes. (Museum catalogues [without authors] are listed under their respective cities.) Finally, where translations have been used they are included here, except for the ever-useful Loeb translations of the Greek and Latin classics.

On balance, I decided that this approach would be more helpful to other researchers than would a severely pruned bibliography; and this is why this book's bibliography is a monster. If no one else later thinks these problems are worth looking into, it will also be a superfluous monster.

BOOKS

Aachen. *Karl der Grosse.* Exhibition catalogue. Aachen, 1965.

Acker, William R. B. (trans.). *Some T'ang and Pre-T'ang Texts on Chinese Painting.* Sinica Leidensia 8, 12. Leyden, 1954–74.

Addis, J. M. *Chinese Ceramics from Datable Tombs and Some Other Dated Material: A Handbook.* London and New York, 1978.

Ademollo, Agostino. *Marietta de' Ricci.* Ed. Luigi Passerini. Vol. I. Florence, 1845.

Aelian. *Varia Historia.*

Aeschlimann, E. *Dictionnaire des miniaturistes du Moyen Âge et de la Renaissance dans les différentes contrées de l'Europe.* Milan, 1940.

Agnellus of Ravenna. *Liber Pontificalis Ecclesiae Ravennatis.* In *Monumenta Germaniae Historica.* Scriptores Rerum Langobardicum et Italicorum Saec. VI–IX. Ed. O. Holder-Egger. Hanover, 1878.

Aḥmad, Qāḍī. *Calligraphers and Painters.* Trans. V. Minorsky. Freer Gallery of Art Occasional Papers, III, no. 2. Washington, D.C., 1959.

Alberti, Leon Battista. *De Architettura.* Ed. Cosimo Bartoli. Florence, 1550.

———. *On Painting and On Sculpture.* Ed. Cecil Grayson. London, 1972.

Albertini, Francesco. *Opusculum de Mirabilibus Novae et Veteris Urbis Romae.* Rome, 1510.

Aldovrandi, Ulisse. *Delle statue antiche* in Lucio Mauro, *Le antichità de la città di Roma.* Venice, 1556.

Alighieri, Dante. *Divina Commedia: la Commedia secondo l'antica vulgata.* 4 vols. Ed. G. Petrocchi. Milan, 1966–67.

———. *The Divine Comedy: Purgatorio.* Trans. John Ciardi. New York, 1961.

Allegrini, Giuseppe (ed.). *Serie di ritratti d'uomini illustri toscani con gli elogi.* 4 vols. Florence, 1766–73.

Allen, Grant. *Physiological Aesthetics.* London, 1877.

Alvisi, Edoardo. *Cesare Borgia.* Imola, 1878.

Amelung, Walther. *Führer durch die Antiken in Florenz.* Munich, 1897.

———. *Die Skulpturen des Vatikanischen Museums.* Vol. II. Berlin, 1908.

Anderson, William. *Descriptive and Historical Catalogue of a Collection of Japanese and Chinese Paintings in the British Museum.* London, 1886.

———. *Japanese Wood Engravings.* London, 1895.

Andō Kōsei. *Shōsōin Shōshi.* [A Brief History of the Shōsōin]. Tokyo, 1947.

Andrews, Keith. *The Nazarenes.* Oxford, 1964.

Annali della fabbrica del Duomo di Milano dall'origine fino al presente. 8 vols. Milan, 1877–85.

Anthologia Graeca.

Anti, Carlo. *Il Regio Museo Archaeologico nel Palazzo Reale di Venezia.* Rome, 1930.

Aretino, Pietro. *Lettere sull'arte.* Vol. II. Ed. E. Camesasca. Milan, 1957.

Aristophanes. *Thesmophoriazusae.*

Aristotle. *Nicomachean Ethics.*

———. *Poetics.*

———. *Politics.*

Arrian. *Anabasis.*

Artaud de Montor, A. F. *Peintres primitifs: Collection de tableaux rapportés d'Italie.* Paris, 1843.

Assunto, Rosario. *La critica d'arte nel pensiero medioevale.* Milan, 1961.

Athenaeus. *Deipnosophistae.*

Atıl, Esin. *Exhibition of 2500 Years of Persian Art.* Washington, D.C., 1971.

——— (ed.). *Turkish Art.* Washington, D.C., and New York, 1980.

Aubert, Édouard. *Trésor de l'Abbaye de Saint-Maurice d'Agaune.* Paris, 1872.

Aubert, Marcel. *L'Architecture cistercienne en France.* Vol. I. Paris, 1943.

———. *Figures monastiques Suger.* Abbaye Saint-Wandrille, 1950.

Auerbach, Erna. *Tudor Artists.* London, 1954.

Aumale, Henri, Duc d' (ed.). *Inventaire de tous les meubles du cardinal Mazarin dressé en 1653.* London, 1861.

Avery, Catherine B. (ed.). *The New Century Italian Renaissance Encyclopedia.* New York, 1972.

Avril, François. *Manuscript Painting at the Court of France.* New York, 1978.

Babalqla, S. A. *The Content and Form of Yoruba Life.* Oxford, 1966.

Babinger, Franz. *Mehmed the Conqueror and His Time.* Ed. W. C. Hickman. Trans. R. Mannheim. Princeton, 1978.

Baglione, Giovanni. *Le vite de' pittori, scultori, architetti ed intagliatori.* Naples, 1733.

Balazs, Étienne. *Chinese Civilization and Bureaucracy.* Ed. A. F. Wright. Trans. H. M. Wright. 1964. Reprint. New Haven and London, 1968.

Baldinucci, Filippo. *Notizie de' professori del disegno.* Florence, 1681.

————. *Vita di Gian Lorenzo Bernini.* Ed. Sergio Samek Ludovici. Milan, 1948.

Balzac, Honoré de. *Le Cousin Pons.* Flammarion ed. Paris, n.d.

Ban Gu. *Courtier and Commoner in Ancient China, Selections from the History of the Former Han.* Trans. Burton Watson. New York and London, 1974.

————. *History of the Former Han Dynasty.* 3 vols. Trans. Homer H. Dubs. Baltimore, 1938–55.

Barfucci, E. *Lorenzo de' Medici e la società artistica del suo tempo.* Florence, 1945.

Barguet, Paul. *Le Temple d'Amon-Rê à Karnak; essai d'exégèse.* Publications de l'Institut Français d'Archéologie Orientale du Caire. Recherches d'archéologie, de philologie et d'histoire, 21. Cairo, 1962.

Barnes, Albert C. *The Art in Painting.* 3rd. ed. New York, 1937.

Baron, Hans. *The Crisis of the Early Italian Renaissance.* 2 vols. Princeton, 1955. Rev. ed. (1 vol.) Princeton, 1966.

————. *Humanistic and Political Literature in Florence and Venice.* Cambridge, Mass., 1955.

Barr, Alfred. *Matisse: His Art and His Public.* New York, 1951.

Barrow, T. *Art and Life in Polynesia.* London, 1971.

Bartoli, Pietro Santi. *Memorie di varie escavazioni fatte in Roma* in Carlo Fea, *Miscellanea filologica critica e antiquaria.* Vol. I. Rome, 1790.

Bastgen, H. (ed.). *Libri Carolini sive Caroli Magni Capitulare de Imaginibus.* In *Monumenta Germaniae Historica.* Legum Sectio III. Concilia. Tomi II. Supplementum. Hanover and Leipzig, 1924.

Battelli, G. *Andrea Sansovino e l'arte italiana della Rinascenza in Portogallo.* Florence, 1936.

Battisti, Eugenio. *Cimabue.* University Park, Pa., 1967.

Bauer, R., et al. *Das Kunsthistorische Museum in Wien.* Vienna, 1978.

Baxandall, Michael. *Giotto and the Orators.* Oxford, 1971.

————. *Painting and Experience in Fifteenth Century Italy.* Oxford, 1972.

Baxter, J. H., and Johnson, Charles (eds.). *Medieval Latin Word List.* Oxford and London, 1934.

Bazin, Germain. *The Museum Age.* Trans. Jane van Nuis Cahill. New York, 1967.

————. *Le Temps des musées.* Brussels, 1967.

Beaucamp, Fernand. *Jean-Baptiste Wicar (1762–1834): son oeuvre et son temps.* 2 vols. Lille, 1939.

Beazley, J. D. *Attic Black-Figure Vase Painters.* Oxford, 1956.

————. *Attic Red-Figure Vase Painters.* 2nd ed. 3 vols. Oxford, 1963.

————. *Paralipomena: Additions to Attic Black-Figure Vase Painters and to Attic Red-Figure Vase Painters.* 2nd ed. Oxford, 1971.

Bec, Christian. *Les Marchands écrivains: affaires et humanisme à Florence, 1375–1434.* Paris and The Hague, 1967.

Becherucci, Luisa. (intro.). *Uffizi. Florence.* Great Museums of the World. New York, 1968.

Beckwith, John. *Early Medieval Art.* New York, 1964.

Bede. *The Ecclesiastical History of the English People and Other Selections from the Writings of the Venerable Bede.* Ed. James Campbell. New York, 1968.

————. *The Lives of the Abbots of Wearmouth.* 1818 ed. Reprint. Newcastle-upon-Tyne, n.d.

Béguin, S.; Bergeon, S.; Cazelles, R.; Delbourgo, S. *La Madone de Lorette.* Paris, 1979.

Bellaigue, Geoffrey de. *Furniture, Clocks and Gilt Bronzes.* James A. de Rothschild Collection, Waddesdon Manor, 2 vols. Fribourg, 1974.

Bellemo, Vincenzo. *Jacopo e Giovanni de' Dondi.* Chioggia, 1894.

Bernini, Domenico. *Vita del Cavalier Gio. Lorenzo Bernino.* Rome, 1713.

Berti, Luciano. *Masaccio.* Milan, 1964.

———. *Il Museo di Palazzo Davanzati.* Florence, 1971.

———; Rudolph, Stella; Biancalani, Anna. *Mostra storica della Tribuna degli Uffizi.* Florence, 1970.

Bertolotti, A. *Figuli, fonditori e scultori in relazione con la corte di Mantova.* Milan, 1890.

———. *Musici alla corte dei Gonzaga in Mantova.* 1890. Reprint. Bologna, 1969.

Beurdeley, Cécile and Michel. *Castiglione, peintre jésuite à la cour de Chine.* Paris, 1871.

Beyen, H. G. *La Statue d'Artemision.* The Hague, 1930.

Bianchi Bandinelli, Ranuccio. *Rome: The Centre of Power. Roman Art to A.D. 200.* Trans. Peter Green. London, 1970.

Bieber, Margarete. *Copies: A Contribution to the History of Greek and Roman Art.* New York, 1977.

———. *Laocoön: The Influence of the Group Since Its Rediscovery.* Rev. ed. Detroit, 1967.

———. *The Sculpture of the Hellenistic Age.* Rev. ed. New York, 1961.

Bini, G., and Bigazzi, P. (eds.). *La vita di Filippo Strozzi il Vecchio scritta da Lorenzo suo figlio.* Florence, 1851.

Binyon, L.; Wilkinson, J. V. S.; Gray, B. *Persian Miniature Painting.* London, 1933. Reprint. New York, 1971.

Biscaro, Girolamo. *L'ospedale e i suoi benefattori.* Treviso, 1903.

Blanc, Charles. *Le Trésor de la curiosité.* 2 vols. Paris, 1857–58.

Blum, André. *Vermeer et Thoré-Bürger.* Geneva, 1946.

Blunt, Anthony. *Nicolas Poussin.* 2 vols. New York, 1967.

———. *The Paintings of Poussin. A Critical Catalogue.* 2 vols. London, 1966.

———, and Whinney, Margaret (eds.). *The Nation's Pictures.* London, 1950.

Boardman, John. *Athenian Black-Figure Vases.* New York, 1974.

———. *Athenian Red-Figure Vases: The Archaic Period.* London, 1975.

———. *Greek Sculpture: The Archaic Period.* London, 1978.

Boccaccio, Giovanni. *The Decameron.* Trans. G. H. McWilliam. Penguin ed. Harmondsworth, 1972.

Bodde, Derk. *China's First Unifier: A Study of the Ch'in Dynasty as Seen in the Life of Li Ssu (280?–208 B.C.).* Sinica Leidensia. Leyden, 1938.

Bodnar, S.J., Edward W. *Cyriacus of Ancona and Athens.* Brussels, 1960.

———, and Mitchell, Charles (eds.). *Cyriacus of Ancona's Journeys in the Propontis and the Northern Aegean 1444–1445.* Philadelphia, 1976.

Boissard, Janus Jacobus. *Romanae Urbis Topographiae et Antiquitatum.* Vol. I. Frankfurt, 1597.

Bologna. *Pelagio Palagi artista e collezionista.* Exhibition catalogue. Bologna, 1976.

Bombe, W. *Nachlass-Inventare des Angelo da Uzzano und des Ludovico di Gino Capponi.* Leipzig, 1928.

Boni, Onofrio. *Elogio dell'Abate Don Luigi Lanzi.* Florence, 1814.

Bonnaffé, Edmond. *Les Collectionneurs de l'ancienne Rome.* Paris, 1867.

———. *Dictionnaire des amateurs français au XVIIe siècle.* Paris, 1884.

———. *Recherches sur les collections des Richelieu.* Paris, 1883.

Bordes, François. *A Tale of Two Caves.* New York, 1972.

Borgatti, Mariano. *Castel Sant'Angelo in Roma.* Rome, 1931.

Borghini, Raffaello. *Il Riposo*. Florence, 1584.

Borsi, F., et al. *La Badia Fiesolana*. Florence, 1976.

Boschini, Marco. *La carta del navegar pitoresco*. Ed. Anna Pallacchini. 1660. Reprint. Rome, 1966.

Bothmer, Bernard V.; De Meulenaere, Herman; Müller, Hans Wolfgang; Riefstahl, Elizabeth. *Egyptian Sculpture of the Late Period 700 B.C. to A.D. 100*. Brooklyn Museum. New York, 1960.

Bottari, Giovanni, and Ticozzi, Stefano. *Raccolta di lettere sulla pittura, scultura ed architettura*. Vol. III. Milan, 1822.

Bottari, S. *Antonello*. Turin, 1953.

Bouffard, P., and Theurillat, J.-M. *Saint-Maurice d'Agaune, trésor de l'abbaye*. Geneva, 1974.

Bracciolini, Poggio. *Epistolae*. 3 vols. Ed. T. Tonelli. Florence, 1832–61.

——. *Opera Omnia*. Vol. I. Ed. R. Fubini. Turin, 1964.

——. *De Varietate Fortunae*. Ed. Domenico Georgio. 1723. Reprint. Bologna, 1969.

Branner, Robert (ed.). *The Miracles of the Virgin in Chartres Cathedral*. New York, 1969.

——. *St. Louis and the Court Style in Gothic Architecture*. London, 1965.

Brauer, Heinrich and Wittkower, Rudolf. *Die Zeichnungen des Gianlorenzo Bernini*. Berlin, 1931.

Brendel, Otto. *Etruscan Art*. Penguin ed. Harmondsworth, 1978.

Brieger, Lothar. *Das Kunstsammeln*. 3rd. ed. Munich, 1920.

Brieger, Peter. *English Art 1216–1307*. Oxford, 1957.

Briganti, Giuliano. *Pietro da Cortona*. Florence, 1962.

Briggs, Lawrence Palmer. *The Ancient Khmer Empire*. Published as Vol. 41 of *Transactions of the American Philosophical Society*. Philadelphia, 1951.

Brinkman, J. A. *A Political History of Post-Kassite Babylonia 1158–722 B.C*. Analecta Orientalia 43. Rome, 1968.

Brosses, Charles de. *Lettres familières sur l'Italie*. Paris, 1869.

Bruce, Helen. *Nine Temples of Bangkok*, Bangkok, 1960.

Bruce-Mitford, Rupert. *The Sutton Hoo Ship-Burial*. 2nd ed. London, 1972.

——. *The Sutton Hoo Ship-Burial*. I, *Excavations, Background, the Ship, Dating and Inventory*. London, 1975.

Brummer, Hans Henrick. *The Statue Court in the Vatican Belvedere*. Stockholm, 1970.

Bruni, Leonardo. *Epistolarum Libri VIII*. Ed. L. Mehus. 2 vols. Florence, 1741.

Bruno, Vincent. *Form and Colour in Greek Painting*. London, 1977.

Burckhardt, J. *Die Sammler*. Beiträge zur Kunstgeschichte von Italien. Gesamtausgabe vol. XII. Stuttgart, Berlin, and Leipzig, 1930.

——. *Die Zeit Constantin's des Grossen*. Leipzig, 1880.

Burford, Alison. *Craftsmen in Greek and Roman Society*. Ithaca, N.Y., 1972.

Burns, Edward (ed.). *Gertrude Stein on Picasso*. New York, 1970.

Bury, J. B. *The History of the Later Roman Empire*. 2 vols. London, 1923.

Buser, B. *Die Beziehungen der Medici zu Frankreich*. Leipzig, 1879.

Bush, Susan. *The Chinese Literati on Painting: Su Shih (1037–1101) to Tung Ch'i-ch'ang (1555–1636)*. Harvard–Yenching Institute Studies 27. Cambridge, Mass., 1971.

Bussagli, Mario. *Central Asian Painting*. London, 1978.

Cabanne, Pierre. *The Great Collectors*. London, 1963.

Cabrol, F. and Leclerq, H. *Dictionnaire d'archéologie chrétienne et de liturgie*. Vol. IV. Paris, 1921.

Cahill, James. *Chinese Painting*. Lausanne and Paris, 1960.

——. *Hills Beyond a River: Chinese Painting of the Yüan Dynasty*. New York and Tokyo, 1976.

Cai Tao. *Tie wei shan cong tan* in Bao Tingbo, compiler, *Zhi bu zu Zhai cong shu,* Xing Zhong ed. Taipei, 1964.

Calendar of State Papers and Manuscripts Relating to English Affairs Existing in the Archives and Collections of Venice and in Other Libraries of Northern Italy. Vol. XII. London, 1905.

Càllavi, Luigi. *I palazzi di Roma.* 1932. Reprint. Rome, 1968.

Callistratus. *Descriptiones.*

Cammelli, G. *I dotti bizantini e le origini dell' umanesimo.* I, *Manuele Crisolara.* Florence, 1941.

Carmichael, Elizabeth. *Turquoise Mosaics from Mexico.* Exhibition catalogue. British Museum. London, 1970.

Cartari, Vincenzo. *Imagini delli dei degl' antichi.* 1647. Reprint. Graz, 1963.

Cartellieri, Otto. *The Court of Burgundy.* New York, 1925.

Carter, Howard. *The Tomb of Tutankhamen.* 3 vols. London, 1923–33.

———. *The Tomb of Tutankhamen.* Rev. ed., abridged. London, 1972.

Cartwright, Julia. *Isabella d'Este.* 2 vols. London, 1903.

Cary, M. *A History of the Greek World from 323 to 146* B.C. London, 1951.

Cassiodorus. *Variae Epistolae.* Trans. Thomas Hodgkin in *The Letters of Cassiodorus, Being a Condensed Translation of the Variae Epistolae of Magnus Aurelius Cassiodorus Senator.* London, 1886.

Castiglione, Sabba da. *Ricordi di Monssignor Sabba da Castiglione.* Venice, 1560.

Caulaincourt, Général A. de, Duc de Vicence. *Avec l'Empéreur de Moscou à Fontainebleau.* Rev. ed. 3 vols. Ed. Christian Melchior-Bonnet. Paris, 1968.

Cecchelli, C. *Studi e documenti sulla Roma sacra.* 2 vols. Rome, 1938–51.

Cedrenus, Georgius. *Compendium Historiarum.* 2 vols. Ed. Immanuel Bekker. *Corpus Scriptorum Historiae Byzantinae.* Bonn, 1828–97.

Cellini, Benvenuto. *La vita.* Ed. Paolo d'Ancona. Milan, n.d.

Cennini, Cennino d'Andrea. *Il libro dell'arte. The Craftsman's Handbook.* Trans. Daniel V. Thompson, Jr. New York, 1960.

Chacón, Alfonso. *Vitae et Res Gestae Pontificum Romanorum et S.R.E. Cardinalium.* 2 vols. Rome, 1677.

Chadwick, G. F. *The Works of Sir Joseph Paxton.* London, 1961.

Chantelou, Paul Fréart de. *Journal du voyage du Cavalier Bernin en France.* Ed. L. Lalanne. Paris, 1885.

Charbonneux, Jean; Martin, Roland; Villard, François. *Archaic Greek Art 620–480* B.C. New York, 1971.

Chastel, André. *Art et humanisme à Florence au temps de Laurent le Magnifique.* 2nd ed. Paris, 1961.

Chatelain, Jean. *Dominique Vivant Denon.* Paris, 1973.

Chesterfield, Earl of. *The Letters of Philip Dormer Stanhope, 4th Earl of Chesterfield.* Vol. IV. Ed. Bonamy Dobree. London, 1923.

Childe-Pemberton, William. *The Earl Bishop: The Life of Frederick Hervey, Bishop of Derry, Earl of Bristol.* 2 vols. London, 1924.

Christie, A. G. I. *English Medieval Embroidery.* London, 1938.

Christie, Manson and Woods, Ltd. *Highly Important Old Master Pictures.* London, 2 July 1976.

Cicero. *Actio Prima in C. Verrem.*

———. *Actio Secunda in C. Verrem.*

———. *Brutus.*

———. *Epistulae ad Atticum.*

———. *Epistulae ad Familiares.*

Cicogna, E. A. *Intorno la vita e le opere di Marcantonio Michiel.* Venice, 1861.

Cicognara, Leopoldo. *Dei quattro cavalli riposti sul pronao della basilica di S. Marco.* Venice, 1815.

Ciriaco d'Ancona. *Itinerarium.* Ed. L. Mehus. Florence, 1742.

Clark, Kenneth. *Civilisation: A Personal View.* New York, 1969.

————. *The Gothic Revival.* Rev. enl. ed. London, 1950.

————. *Leonardo da Vinci.* Penguin ed. Harmondsworth, 1967.

————. *Rembrandt and the Italian Renaissance.* New York, 1966.

Clausse, G. *Les San Gallo.* Paris, 1900.

Clément de Ris, L. *Les Amateurs d'autrefois.* Paris, 1877.

Coe, Michael. *Lords of the Underworld: Masterpieces of Classic Maya Ceramics.* Exhibition catalogue. Princeton, 1978.

Coedès, George. *The Indianized States of Southeast Asia.* Ed. W. F. Vella. Trans. Susan Brown Cowing. Honolulu, 1964.

Coffin, David. *The Villa in the Life of Renaissance Rome.* Princeton, 1979.

Cologne–Brussels. *Rhin-Meuse: Art et civilisation 800–1400.* Exhibition catalogue. Cologne and Brussels, 1972.

Colvin, H. M. (ed.). *Building Accounts of King Henry III.* Oxford, 1971.

Comstock, Mary, and Vermeule, Cornelius. *Sculpture in Stone, the Greek, Roman and Etruscan Collections in the Museum of Fine Arts.* Boston, 1976.

Condivi, Ascanio. *The Life of Michelagnolo Buonarotti.* Trans. Herbert Horne. New York, 1904.

————. *Michelangelo.* Ed. Paolo d'Ancona. Milan, 1928.

Constantinus Porphyrogenitus, *De Ceremoniis.* 2 vols. Ed. J. J. Reiski. *Corpus Scriptorum Historiae Byzantinae.* Bonn, 1828–97.

Conrads, Ulric. *Programs and Manifestoes on XXth Century Architecture.* Cambridge, 1970.

Coomaraswamy, Ananda. *History of Indian and Indonesian Art.* 1927. Reprint. New York, 1965.

Cooper, Douglas (ed.). *Great Private Collections.* New York, 1963.

Cooper, Thomas Sidney. *My Life.* 2 vols. London, 1890.

Corti, Count Egon Caesar. *The Rise of the House of Rothschild 1770–1830.* Trans. Brian and Beatrix Lunn. 1928. Reprint. New York, 1972.

Coulton, G. G. *Art and the Reformation.* 1928. Reprint. Hamden, Conn., 1969.

Coulton, J. J. *Greek Architects at Work.* London, 1977.

Courajod, Louis. *Alexandre Lenoir, son journal et le Musée des Monuments Français.* 3 vols. Paris, 1878–87.

Cox-Rearick, Janet (ed.). *La Collection de François Ier.* Musée du Louvre. Les Dossiers du Département des Peintures 5. Paris, 1972.

Craven, Roy C. *A Concise History of Indian Art.* London, 1976.

Creel, H. G. *Confucius and the Chinese Way.* 1949 (publ. as *Confucius: The Man and the Myth*). Reprint. New York, 1960.

————. *The Origins of Statecraft in China.* I, *The Western Chou Empire.* Chicago, 1970.

Croce, Benedetto. *Theory and History of Historiography.* Trans. Douglas Ainslie. London, 1921.

Crowe, J. A., and Cavalcaselle, G. B. *A History of Painting in North Italy.* 2nd ed. Vol. II. London, 1912.

————. *Titian: His Life and Times.* 2 vols. London, 1877.

Curtius, E.; Adler, F.; Hirschfeld, G. *Die Ausgrabungen zu Olympia.* 4 vols. Berlin, 1876–81.

Curtius, Ludwig. *Johann Joachim Winckelmann 1768/1968.* Bad Godesberg, 1968.

Dacos, Nicole; Giuliano, Antonio; Pannuti, Ulrico. *Il tesoro di Lorenzo il Magnifico.* I, *Le gemme.* Florence, 1973.

Dan, Pierre. *Le Trésor des merveilles de la maison de Fontainebleau.* Paris, 1642.

Dance, Peter. *Shell Collecting.* Berkeley, 1966.

D'Arco, Carlo. *Dell'arte e degli artefici di Mantova.* 2 vols. Rome, 1857–59.

David, Henry. *Claus Sluter.* Paris, 1951.

David, Sir Percival (ed. and trans.). *Chinese Connoisseurship. The Ko-Ku Yao-Lun. The Essential Criteria of Antiquities.* London, 1971.

Davidson, Bernice, and Munhall, Edgar. *The Frick Collection: An Illustrated Catalogue.* II, *Paintings: French, Italian and Spanish.* New York, 1968.

Davies, G. S. *Ghirlandaio.* London, 1908.

Davies, M. *Rogier van der Weyden.* London, 1972.

Davies, N. de G. *The Rock Tombs of Deir el Gebrâwi.* Part I. Archaeological Survey of Egypt. Eleventh Memoir. Ed. F. Ll. Griffith. London, 1902.

Degenhart, B., and Schmitt, A. *Corpus der italienischen Zeichnungen 1300–1450.* Berlin, 1968.

Delbrück, R. *Spätantike Kaiserporträts.* Berlin, 1933.

Della Torre, Arnaldo. *Storia dell'Accademia Platonica di Firenze.* Florence, 1902.

Del Lungo, I. *Florentia.* Florence, 1897.

De Marinis, Tammaro. *La legatura artistica in Italia nei secoli XV e XVI.* 3 vols. Florence, 1960.

Demay, G. *Des pierres gravées employées dans les sceaux du Moyen Âge.* Paris, 1878.

Demus, Otto. *Byzantine Art and the West.* New York, 1970.

———. *The Church of San Marco in Venice: History, Architecture, Sculpture.* Washington, D.C., 1960.

Denucé, J. *Art Export in the 17th Century in Antwerp. The Firm Forchoudt.* Antwerp, 1931.

De Rossi, Giovanni Battista. *Inscriptiones Christianae Urbis Romae Septimo Saeculo Antiquiores.* 2 vols. Rome, 1861–88.

Detroit. *Flanders in the Fifteenth Century: Art and Civilization.* Exhibition catalogue. Detroit, 1960.

Dezzi Bardeschi, M. *La facciata di Santa Maria Novella a Firenze.* Pisa, 1970.

D'Harnoncourt, Anne, and McShine, Kynaston. *Marcel Duchamp.* New York, 1973.

Díaz del Castillo, Bernal. *The Discovery and Conquest of Mexico.* Trans. and intro. A. P. Maudslay. Ed. Irving A. Leonard. New York, 1956.

Dio Chrysostom. *Olympica.*

Diogenes Laertius. *Lives of the Philosophers.*

Dionysius of Fourna. *Le Guide de la peinture* in *Manuel d'iconographie chrétienne grecque et latine.* Trans. P. Durand. Paris, 1845. Reprint. New York, 1963.

Dodwell, C. R. *Painting in Europe 800–1200.* Penguin ed. Harmondsworth, 1971.

Doren, A. *Studien aus der Florentiner Wirtschaftsgeschichte,* 2 vols. Stuttgart and Berlin, 1901–08.

Dörig, José. *Onatas of Aegina.* Monumenta Graeca et Romana. 1. Ed. H. F. Mussche. Leyden, 1977.

Dube, Wolf-Dieter (intro.). *Pinakothek. Munich.* Great Museums of the World. New York, 1969.

Dubs, Homer H. *A Roman City in Ancient China.* London, 1957.

Duchesnes, L. (ed.). *Liber Pontificalis.* Paris, 1955.

Ducret, S. *German Porcelain and Faience.* London, 1962.

Dütschke, Hans, *Antike Bildwerke in Oberitalien.* 5 vols. Leipzig, 1874–82.

Duncan-Jones, Richard. *The Economy of the Roman Empire*. Cambridge, 1974.

Durant, David. *Bess of Hardwick*. London, 1977.

Dussler, Luitpold. *Benedetto da Maiano*. Munich, 1924.

———. *Raphael: A Critical Catalogue of His Pictures, Wall-Paintings and Tapestries*. Trans. Sebastian Cruft. London and New York, 1971.

Duyvendak, J. J. L. (trans.). *The Book of Lord Shang: A Classic of the Chinese School of Law*. Chicago, 1963.

Eccles, Lord. *On Collecting*. London, 1968.

Edwards, I. E. S. (intro.). *Treasures of Tutankhamen*. Exhibition catalogue. British Museum. London, 1972.

———; Gadd, C. J.; Hammond, N. G. L. (eds.). *The Cambridge Ancient History*. Vol. I, Part 2, *Early History of the Middle East*. Cambridge, 1971.

Edwards, Richard, and Clapp, Ann. *The Art of Wen Cheng-Ming 1470–1559*. Exhibition catalogue. New York, 1975.

Egger, Hermann. *Codex Escurialensis: Ein Skizzenbuch aus der Werkstatt Domenico Ghirlandaios*. Vienna, 1906.

Eiga Monogatari. Ed. Matsumura Hakushi. Nihon Koten Zensho, 58. Tokyo, 1962.

Emiliani, A. *Leggi, bandi e provedimenti per la tutela dei beni artistici e culturali negli antichi stati italiani 1571–1860*. Bologna, 1978.

Enciclopedia italiana di scienze, lettere ed arti. 1st ed. Vols. III, XXI, XXXI. Rome, 1929, 1934, 1936. 2nd ed. Vol. III. Rome, 1950.

Encyclopedia Britannica. 11th ed. New York, 1911.

Encyclopedia of Islam. 2nd ed. Leyden, 1960.

Esch, Arnold. *Bonifaz IX. und der Kirchenstaat*. Tübingen, 1969.

Essling, Prince de, and Müntz, Eugène. *Pétrarque: ses études d'art, son influence sur les artistes*. Paris, 1902.

Ettlinger, Leopold D. *Antonio and Piero Pollaiuolo*. Oxford, 1978.

Euripides. *Ion*.

Eusebius. *Vita Constantini* in *Die griechischen christlichen Schriftsleiter der ersten drei Jahrhunderte*. Vol. 7. Ed. Friedhelm Winckelmann. Berlin, 1975.

Evans, R. J. W. *Rudolf II and His World: A Study in Intellectual History 1576–1612*. Oxford, 1973.

Evelyn, John. *The Diary of John Evelyn*. 4 vols. London, 1906.

———. *The Diary of John Evelyn*. Ed. E. S. de Beer. London, 1959.

Exuviae Sacrae Constantinopolitanae. Ed. P. Riant and F. de Mély. 3 vols. Paris, 1877–1904.

Fabroni, A. *Laurentii Medicis Magnifici Vita*. vols. Pisa, 1784.

Faris, James. *Nuba Personal Art*. London, 1972.

Fazio, Bartolomeo. *De Viris Illustribus*. Ed. L. Mehus. Florence, 1745.

Federici, Domenico Maria. *Memorie trevigiane sulle opere di disegno*. Venice, 1803.

Félibien, André. *Entretiens sur les vies et sur les ouvrages des plus excellents peintres anciens et modernes; avec la vie des architectes*. Rev. ed. with parts of vols. 5 and 6 by J.-F. Félibien. Paris, 1725.

Fenollosa, Ernest. *Epochs of Chinese and Japanese Art*. Rev. ed. New York and London, 1921.

Ficino, Marsilio. *Opera Omnia*. 2nd ed. 2 vols. 1576. Reprint. Turin, 1959.

Filarete. *Trattato di architettura*. Ed. Anna Maria Finoli and Liliana Grassi. Milan, 1972.

———. *Treatise on Architecture*. 2 vols. Ed. John Spencer. New Haven, 1965.

Fillitz, Hermann. *Katalog der weltlichen und der geistlichen Schatzkammer*. 3rd rev. ed. Führer durch das Kunsthistorische Museum no. 2. Vienna, 1961.

————. *Das Mittelalter I.* Propyläen Kunstgeschichte, 5. Berlin, 1969.

————. *Trésor sacre et profane de Vienne.* Trans. André Espiau de la Maistre. 2nd rev. ed. Vienna, 1963.

Finot, Louis (intro.). *Le Temple d'Angkor Vat. 1ᵉ Ptie.* École Française d'Extrême-Orient. Mémoires Archéologiques 2. Paris, 1929.

Firmenich-Richartz, E. *Die Brüder Boiserée.* Jena, 1916.

Firth, C. M., and Quibell, J. E. *Excavations at Saqqara. The Step Pyramid.* Service des Antiquités de l'Égypte. Cairo, 1935.

Fitzgerald, C. P. *China.* Ed. C. G. Seligman. London, 1935.

Floerke, H. *Studien zur niederländischen Kunst- und Kulturgeschichte.* Munich, 1905.

Florence: Galleria degli Uffizi. *Catalogo dei dipinti.* Florence, 1948.

Florence: Museo dell'Accademia and Museo di San Marco. *Lorenzo Ghiberti.* Exhibition catalogue. Florence, 1978–79.

Florence. Palazzo Vecchio. *Committenza e collezionismo medicei.* Exhibition catalogue. Florence, 1980.

Fong, Wen (ed.). *The Great Bronze Age of China: An Exhibition from the People's Republic of China.* Metropolitan Museum of Art. New York, 1980.

Fontein, Jan, and Wu Tung. *Han and T'ang Murals Discovered in Tombs in the People's Republic of China and Copied by Contemporary Chinese Painters.* Exhibition catalogue. Museum of Fine Arts. Boston, 1976.

————. *Unearthing China's Past.* Museum of Fine Arts, Boston. Greenwich, Conn., 1973.

Force, Roland W. and Maryanne. *Art and Artifacts of the 18th Century.* Honolulu, 1968.

Forlati Tamaro, Bruna. *L'origine della raccolta Grimani.* Venice, n.d.

Forster, K. W. *Pontormo.* Munich, 1966.

Forsyth, George, and Weitzmann, Kurt. *The Monastery of Saint Catherine at Mount Sinai, the Church and Fortress of Justinian.* Ann Arbor, 1966.

Foster, Phillip. "A Study of Lorenzo de' Medici's Villa at Poggio a Caiano." Ph.D. dissertation, Yale University, 1976.

Fowles, Edward. *Memories of Duveen Brothers.* New York, 1976.

Fränkel, Max (ed.). *Die Inschriften von Pergamon.* Berlin, 1890–95.

Frankl, Paul. *The Gothic: Literary Sources and Interpretations.* Princeton, 1960.

————. *Gothic Architecture.* Penguin ed. Harmondsworth, 1962.

Fraser, P. M. *Ptolemaic Alexandria.* Vols. I–III. Oxford, 1972.

Frazer, J. G. (ed.). *Pausanias's Description of Greece.* 6 vols. London, 1898.

Freedberg, Sydney. *Andrea del Sarto: Catalogue Raisonné.* Cambridge, Mass., 1963.

Frey, Karl. (ed.). *Il carteggio di Giorgio Vasari.* Arezzo, 1941.

————. (ed.). *Il codice magliabechiano.* Berlin, 1892.

————. (ed.). *Il libro di Antonio Billi.* Berlin, 1892.

————. (ed.). *Michelagniolo Buonarotti. Quellen und Forschungen.* Berlin, 1907.

Friedenthal, Richard. *Luther: His Life and Times.* Trans. John Nowell. New York, 1970.

Friedländer, Max J. *Early Netherlandish Painting.* 10 vols. Trans. Heinz Norden. Leyden, 1967–73.

Froissart, Jean. *Oeuvres.* 25 vols. in 26. Ed. K. de Lettenhove. Brussels, 1867–77.

Fu, Shen C. Y.; Fu, Marilyn; Neill, Mary; Clark, Mary Jane. *Traces of the Brush. Studies in Chinese Calligraphy.* New Haven, 1977.

, Fuchs, Werner. *Der Schiffsfund von Mahdia.* Bilderhefte des deutschen Archäologischen Instituts, Rom. No. 2. Tübingen, 1963.

Fueter, Eduard. *Geschichte der neuren Historiographie.* 3rd ed. New York, 1968.

————. *Histoire de l'historiographie moderne.* Trans. Émile Jeanmaire. Paris, 1914.

Fujita Tsuneo. *Kōkan Bijutsu Shiryō: Jiin Hen* [Printed Historical Records on Japanese Art: Temples]. Tokyo, 1975.

Furtwängler, Adolf. *Masterpieces of Greek Sculpture.* Chicago, 1964.

———. (ed.). *Olympia. Ergebnisse der von dem Deutschen Reich veranstalteten Ausgrabungen.* IV, *Die Bronzen.* Berlin, 1890.

Gadd, C. J. *History and Monuments of Ur.* London, 1929.

Galen. *Commentaria in Hippocratis Epidemia III.*

———. *De Placitis Hippocratis et Platonis.*

Gardner, Ernest. *Six Greek Sculptors.* London, 1910.

Gargan, Luciano. *Cultura e arte nel Veneto al tempo del Petrarca.* Padua, 1978.

Garin, Eugenio. *La cultura del Rinascimento. Profilo storico.* Bari, 1967.

———. (ed.). *Prosatori latini del Quattrocento.* Milan, 1952.

Gautier, Marie-Madeleine. *Émaux du Moyen Âge occidental.* Fribourg, 1972.

———. *Rouergue roman.* La Pierre-qui-vive, 1963.

Gaye, Giovanni. *Carteggio inedito d'artisti dei secoli XIV, XV, XVI.* Vols. I and II. Florence, 1839–40.

Geiger, Benno. *I dipinti ghiribizzosi di Giuseppe Arcimboldi.* Florence, 1954.

Gerson, Horst. *Rembrandt Paintings.* Trans. Heinz Norden. Amsterdam, 1968.

Gervase of Canterbury. *Tractatus de Combustione et Reparatione Cantuarensis Ecclesiae.* Ed. William Stubbs in *The Historical Works of Gervase of Canterbury.* Vol. I. London, 1879.

Gheltof, G. M. de. *La collezione del doge Marino Falier e i tesori di Marco Polo.* Venice, 1881.

Ghiberti, Lorenzo. *I Commentarii.* Ed. Julius von Schlosser in *Lorenzo Ghibertis Denkwürdigkeiten.* 2 vols. Berlin, 1912. (Referred to as "Ghiberti-Schlosser" in the notes.)

Gibbon, Edward. *The Decline and Fall of the Roman Empire.* 2 vols. Modern Library ed. New York, n.d.

Gilliard, E. T. *Birds of Paradise and Bower Birds.* London, 1969.

Gimpel, René. *Diary of an Art Dealer.* Trans. John Rosenberg. London, 1963.

Giovanni da Prato. *Il paradiso degli Alberti.* Ed. A. Wesselofsky. 3 vols. in 4. Bologna, 1867.

Girouard, Mark. *Life in the English Country House.* New Haven and London, 1978.

———. *Robert Smythson.* London, 1966.

Giteau, Madeline. *Khmer Sculpture and the Angkor Civilization.* New York, 1965.

Giuffrey, Jules (ed.). *Inventaires de Jean Duc de Berry.* 2 vols. Paris, 1894–96.

Glasser, Hannelore. *Artists' Contracts of the Early Renaissance.* New York and London, 1977.

Glück, Gustav. *The Picture Gallery of the Vienna Art Museum.* Vienna, 1931.

———. *Van Dyck des Meisters Gemälde.* Klassiker der Kunst. Stuttgart, 1931.

Goethe, Johann Wolfgang von. *Essays on Art.* Trans. Samuel Gray Ward. Boston, 1845.

———. *Goethe's Autobiography: Poetry and Truth from My Life.* Trans. R. O. Moon. 1932. Reprint. Washington, D.C., 1949.

———. *Italian Journey.* Trans. W. H. Auden and E. Mayer. Penguin ed. Harmondsworth, 1962.

———. *Philostrats Gemaelde* in *Werke.* Vol. XXVI. Stuttgart, 1886.

———. *Der Sammler und die Seinigen* in *Schriften zur Kunst.* Ed. E. Beutler. Zurich, 1954.

———. *Über Kunst und Altertum.* Stuttgart, 1818.

Goitein, S. D. *A Mediterranean Society: The Jewish Communities of the Arab World as Portrayed in the Documents of the Cairo Geniza.* 3 vols. Berkeley, 1967–78.

Goldwater, Robert. *Primitivism in Modern Painting.* New York, 1938.

———, and Treves, Marco (eds.). *Artists on Art from the XIV to the XX Century.* 3rd ed. New York, 1958.

Golzio, V. *Raffaello.* Vatican City, 1936.

Gomaà, Farouk. *Chaemwese. Sohn Ramses' II. und Hoherpriester von Memphis.* Ägyptologische Abhandlungen 27. Wiesbaden, 1973.

Gombrich, E. H. *Art and Illusion.* London, 1968.

——. *The Heritage of Apelles.* London, 1976.

——. *Ideals and Idols.* London, 1979.

——. *Meditations on a Hobby Horse.* 2nd ed. London, 1971.

——. *Norm and Form.* London, 1966.

——. *The Story of Art.* 3rd ed. London, 1950.

——. *Symbolic Images.* London, 1972.

González de Clavijo, Ruy. *Embassy to Tamerlane.* Trans. Guy le Strange. London, 1928.

Goode, James. *The Outdoor Sculpture of Washington, D.C.: A Comprehensive Historical Guide.* Washington, D.C., 1974.

Gordan, Phyllis. *Two Renaissance Book Hunters.* New York, 1974.

Gori, Antonio Francesco. *La Toscana illustrata.* Vol. I. Leghorn, 1755.

Gotti, Aurelio. *Le galleriee i musei di Firenze.* 2nd ed. Florence, 1877.

Gould, Cecil. *Correggio.* London, 1976.

——. *Raphael's Portrait of Julius II.* London, 1970.

——. *The Sixteenth Century Italian Schools.* National Gallery Catalogue. London, 1975.

——. *Trophy of Conquest: The Musée Napoléon and the Creation of the Louvre.* London, 1965.

Grabar, André. *L'Iconoclasme byzantin.* Paris, 1957.

—— and Nordenfalk, Carl. *Early Medieval Painting.* 2 books in 1. Trans. Stuart Gilbert. London, 1957.

Grabar, Oleg. *The Formation of Islamic Art.* New Haven and London, 1973.

Graf, Arturo. *Roma nella memoria e nelle immaginazioni del Medio Evo.* Turin, 1923.

Graham, F. Lanier. *Hector Guimard.* Exhibition catalogue. Museum of Modern Art. New York, 1970.

Graham-Campbell, James, and Kidd, Dafydd. *The Vikings.* London and New York, 1980.

Grant, Michael. *Cities of Vesuvius: Pompeii and Herculaneum.* London, 1971.

Gray, Basil. *Admonitions of the Instructress to the Ladies in the Palace.* British Museum. London, 1966.

——. *Persian Painting.* Geneva, 1961. Reprint. New York, 1977.

Great Britain. Parliament. House of Commons. *Report from the Select Committee of the House of Commons on the Earl of Elgin's Collection of Sculptured Marbles.* London, 1816.

Gredt, Josephus. *Elementa Philosophiae. II, Metaphysica.* Barcelona, 1946.

Gregorius, Magister. *Narracio de Mirabilibus Urbis Romae.* Ed. R. Huygens. Leyden, 1970.

Gregorovius, Ferdinand. *Geschichte der Stadt Rom im Mittelalter vom V. bis XVI. Jahrhundert.* Reprint. Darmstadt, 1963.

——. *History of the City of Rome in the Middle Ages.* 2nd rev. ed. 8 vols. Trans. Mrs. Gustavus W. Hamilton. London, 1900–02.

Grimal, Pierre. *Les Jardins romains.* Paris, 1969.

Grinten, E. F. van der. *Elements of Art Historiography in Medieval Texts.* The Hague, 1969.

Grivot, D., and Zarnecki, G. *Gislebertus Sculptor of Autun.* London, 1961.

Grohskopf, Bernice. *The Treasure of Sutton Hoo.* New York, 1970.

Gronau, Georg. *Titian.* Trans. Alice Todd. London, 1904.

Grosley, Pierre-Jean. *Nouveaux Mémoires, ou Observations sur l'Italie, et sur les Italiens.* Vol. II. London, 1764.

Groslier, Bernard, and Arthaud, Jacques. *Angkor Art and Civilization.* Rev. ed. New York and Washington, D.C., 1966.

Grosse, Ernst. *Die Anfänge der Kunst.* Freiburg i.B., 1894.

Guarino da Varona. *Epistolario.* Ed. R. Sabbadini. 3 vols. Venice, 1915–19.

Guibert de Nogent. *The Autobiography of Guibert: Abbot of Nogent-Sous-Coucy.* Trans. C. C. Swinton Bland. London, 1926.

———. *De Pignoribus Sanctorum.* In *Patrologia Latina,* ed. J.-P. Migne. Vol. 156, Paris, 1880.

Guicciardini, Francesco. *The History of Italy.* Trans. Sydney Alexander. New York, 1969.

———. *Storia d'Italia.* Ed. S. Seidel Menchi. Turin, 1971.

Guilbert, Abbé Pierre. *Description historique des château, bourg, et forêt de Fontainebleau.* 2 vols. Paris, 1731.

Gulik, Robert H. van. *Chinese Pictorial Art as Viewed by the Connoisseur.* Serie Orientale Roma 19. Rome, 1958.

Haftmann, Werner. *Das italienische Säulenmonument.* Leipzig, 1939.

Hahnloser, Hans R. *Villard de Honnecourt.* 2nd rev. ed. Graz, 1972.

Halm, Philipp Maria, and Berliner, Rudolph. *Das Hallesche Heiltum.* Berlin, 1931.

Hamilton, William Richard. *Second Letter to the Earl of Elgin on the Propriety of Adopting the Greek Style of Architecture in the New Houses of Parliament.* London, 1836.

Hanfmann, George M. A. *Classical Sculpture.* London, 1967.

———. *From Croesus to Constantine.* Ann Arbor, 1975.

Hansen, E. V. *The Attalids of Pergamon.* 2nd ed. Ithaca and London, 1971.

Harada Jiro. *English Catalogue of Treasures in the Imperial Repository Shōsōin.* Tokyo, 1932.

———. "Tōdaiji Kenmotusuchō, Shussō Kiroku" [Record of Removals from the Repository]. Supplement to Fujita Tsuneo, *Kōkan Bijutsu Shiryō: Jiin Hen.* Tokyo, 1975.

Harris, John; Orgel, Stephen; Strong, Roy. *The King's Arcadia; Inigo Jones and the Stuart Court.* Exhibition catalogue. London, 1973.

Hartner, Willy. *Die Goldhörner von Gallehus.* Wiesbaden, 1969.

Hartt, Frederick. *Giulio Romano.* 2 vols. New Haven, 1958.

Harvey, John. *English Medieval Architects.* London, 1954.

———. *The Gothic World: 1100–1600. A Survey of Architecture and Art.* London, 1950.

———. *Henry Yevele.* London, 1944.

Haskell, Francis. *An Italian Patron of French Neoclassical Art.* Oxford, 1972.

———. *Patrons and Painters.* New York, 1963.

———. *Rediscoveries in Art: Some Aspects of Taste, Fashion and Collecting in England and France.* Ithaca, 1976.

———, and Penny, Nicholas. *Taste and the Antique.* New Haven and London, 1981.

Hautecoeur, Louis. *Catalogue des peintures exposées dans les galeries du Musée National du Louvre.* II, *École italienne et école espagnole.* Paris, 1926.

Havard, Henry. *Dictionnaire de l'ameublement et de la décoration depuis le XIIIe siècle jusqu'à nos jours.* 4 vols. Paris, 1887–90.

Havemeyer, Louisine W. *Sixteen to Sixty: Memoirs of a Collector.* Private publication. New York, 1961.

Hawkes, David (trans.). *Ch'u Tz'u: The Songs of the South.* Oxford, 1959. Reprint. Boston, 1962.

Hayashiya Tatsusaburō. *Tenka Ittō* [Unifying Everything Under Heaven], in *Nihon no Rekishi* [History of Japan] 12. Tokyo, 1974.

Haynes, D. E. L. *The Arundel Marbles.* Oxford, 1975.

He Yanzhi. *Lan ting ji* [History of the Lan ting xu]. A.D. 714. Yishu cong bian ed. Taipei, 1968–71.

Hecker, Oskar. *Boccaccio-Funde.* Brunswick, 1902.

Hecksher, W. S. *Sixtus IIII Aeneas Insignes Statuas Romano Populo Restituendas Censuit.* The Hague, 1955.

Heikamp, Detlef. *Mexico and the Medici.* Florence, 1972.

————, and Grote, Andreas. *Il tesoro di Lorenzo il Magnifico*. II, *I vasi*. Florence, 1974.

Heike Monogatari: The Tale of the Heike. Trans. Hiroshi Kitagawa and Bruce T. Tsuchida. Tokyo, 1975.

Helbig, Wolfgang. *Führer durch die öffentlichen Sammlungen klassischer Altertümer in Rom*. 4th ed. Ed. Hermine Speier. Vol. I, Tübingen, 1963; Vol. III, 1969.

Held, Julius. *Rubens: Selected Drawings*. London, 1959.

Hendy, Philip. *European and American Painting in the Isabella Stewart Gardner Museum*. Boston, 1974.

Hennequin, Émile. *La Critique scientifique*. Paris, 1888.

Heraclius. *De Coloribus et Artibus Romanorum*. Ed. Albert Ilg in *Heraclius. Von den Farben und Künsten der Römer*. Quellenschriften für Kunstgeschichte 4. Vienna, 1873.

————. *Manuscripts of Eraclius—De Coloribus et Artibus Romanorum*. Ed. Mrs. Merrifield. Original Treatises on the Arts of Painting 1. London, 1849.

Herbert, Félix. *Le Château de Fontainebleau*. Paris, 1937.

Hermanin, Federico. *L'arte in Roma del secolo VIII al XIV*. Bologna, 1945.

Herodas. *Mimes*.

Herodotus. *History*.

Herrmann, Frank (ed.). *The English as Collectors*. London, 1972.

Hersey, G. *Alfonso II and the Artistic Renewal of Naples 1485–1495*. New Haven, 1969.

Hervey, Mary F. S. *The Life, Correspondence and Collections of Thomas Howard, Earl of Arundel*. Cambridge, 1921.

Hill, G. F. *A Corpus of Italian Medals of the Renaissance*. 2 vols. London, 1930.

————, and Pollard, Graham. *Medals of the Renaissance*. Rev. enl. ed. London, 1978.

Hinks, Roger. *Carolingian Art*. 1935. Reprint. Ann Arbor, 1962.

Hinz, Walther. *The Lost World of Elam*. Trans. J. Barnes. London, 1972.

Hirn, Yrjo. *Origins of Art*. 1900. Reprint. New York, 1971.

Hiroa, Te Rangi [Sir Peter Buck]. *The Coming of the Maori*. Wellington, 1952.

Hirschfeld, Peter. *Mäzene. Die Rolle des Auftraggebers in der Kunst*. Berlin, 1968.

Historia Augusta.

Ho Ping-Ti. *The Cradle of the East*. Hong Kong, 1977.

Hobson, Anthony. *Great Libraries*. New York, 1970.

Hollanda, Francisco de. *Four Dialogues on Painting*. Trans. Aubrey F. G. Bell. London, 1928.

Holmes, George. *The Florentine Enlightenment 1400–1450*. London, 1969.

Holst, Niels von. *Creators, Collectors and Connoisseurs*. New York, 1967.

Horace. *Ars Poetica*.

————. *Satires*.

Horne, Herbert. *Botticelli: Painter of Florence*. London, 1908. Reprint with new introduction. Princeton, 1980.

Houssaye, Arsène. *Un Hôtel célèbre sous le Second Empire. L'Hôtel Paiva ses merveilles précédé de l'ancien hôtel de la Marquise de Paiva*. Paris, n.d.

Hubert, Jean. *Arts et vie sociale de la fin du monde antique au Moyen Âge*. Mémoires de documents publiés par la Société de l'École des Chartes 24. Geneva, 1977.

————; Porcher, J.; Volbach, W. F. *The Carolingian Renaissance*. New York, 1970.

Hülsen, Hans von. *Römische Funde*. 2nd rev. ed. Darmstadt, 1966.

Huntley, G. M. *Andrea Sansovino*. Cambridge, 1935.

Hutton, Edward. *The Cosmati*. London, 1950.

Hyman, I. "Fifteenth Century Florentine Studies." Ph.D. dissertation, New York University, 1968.

Ikeuchi Hiroshi and Umehara Sueji. *T'ung-Kou*. 2 vols. Tokyo and Xinjing, 1938–40.

Ilg, Albert (ed.). *Quellenschriften für Kunstgeschichte und Kunsttechnik des Mittelalters und der Neuzeit*. n.s. I. Vienna, 1888.

"Inventario del palagio di Firenze et sua masseritie" [1512 copy of Medici inventory of 1492]. Typescript. Warburg Institute. London.

"Inventory of the Goods of Charles I." Commonwealth Sale Catalogue. PS 1846, Harleian 7352. British Museum. London.

Ipşiroğlu, M. S. *Painting and Culture of the Mongols.* New York, 1966.

Iredale, T. *Birds of Paradise and Bower Birds.* Melbourne, 1950.

Irving, Clifford. *Fake!* New York, 1969.

Ishida Mosaku. *Shōsōin Gigakumen no Kenkyū* [Studies of Gigaku Masks in the Shōsōin]. Tokyo, 1955.

———. *Shōsōin to Tōdaiji.* Tokyo, 1962.

———, and Wada Gunichi. *The Shōsōin.* Eng. résumé Harada Jiro. Tokyo, Osaka, Moji, 1954.

Iversen, Erik. *Canon and Proportions in Egyptian Art.* 2nd rev. ed. Warminster, 1975.

Jaffé, Michael. *Rubens and Italy.* Oxford, 1977.

Jameson, Mrs. A. B.*Companion to the Most Celebrated Private Galleries of Art in London.* London, 1844.

———. *Handbook to the Public Galleries of Art in and near London.* London, 1845.

Janson, H. W. *The Sculpture of Donatello.* 2nd ed. Princeton, 1963.

Jerome, Saint. *Chronicon.* Ed. J. K. Fotheringham. London, 1923.

Jettmar, Karl. *Art of the Steppes. The Eurasian Animal Style.* London, 1967.

Jex-Blake, K. (trans.), and Sellers, E. (comm. and intro.). *The Elder Pliny's Chapters on the History of Art.* 1896. American ed. Chicago, 1968.

John Quinn 1870–1925. Collection of Paintings, Water Colors, Drawings and Sculpture. Huntington, N.Y., 1926.

John of Salisbury. *Historia Pontificalis.* Ed. R. L. Poole. Oxford, 1927.

———. *Memoirs of the Papal Court.* Trans. Marjorie Chibnall. London, 1956.

Jones, H. Stuart (ed.). *A Catalogue of the Ancient Sculptures Preserved in the Municipal Collections of Rome: The Sculptures of the Museo Capitolino.* Oxford, 1912.

Justi, Carl. *Winckelmann und seine Zeitgenossen.* 5th ed. Cologne, 1956.

Juvenal. *Satires.*

Kaeppler, Adrienne. *"Artificial Curiosities" Being an Exposition of Native Manufactures Collected on the Three Pacific Voyages of Captain James Cook, R.N.* Bishop Museum Special Publication, 65. Honolulu, 1978.

Kanda Kiichiro. *Shōsō-in no Shoseki* [On the Calligraphies Conserved in the Shōsōin]. Shōsōin Jimusho, Tokyo, 1964.

Kan-Ko-Cho [Mirror of Antiquity]. Collection of Reproductions from Treasures of the Shōsōin Catalogue, issued at Takashima. Osaka, 1928.

Kansas City: Nelson Gallery of Art–Atkins Museum. *The Chinese Exhibition: The Exhibition of Archaeological Finds of the People's Republic of China.* Kansas City, 1975.

Kant, Immanuel. *Critique of Aesthetic Judgment.* Trans. James Creed Meredith. Oxford, 1911.

———. *Kritik der Urtheilskraft.* Leipzig, 1880.

Kantorowicz, Ernst. *Frederick the Second 1194–1250.* Trans. E. O. Lorimer. London, 1957.

Kato Shuichi. *A History of Japanese Literature: The First Thousand Years.* Trans. David Chibett. Tokyo, New York, and San Francisco, 1979.

Kaufmann, Thomas DaCosta. *Variations on the Imperial Theme in the Age of Maximilian II and Rudolf II.* New York, 1978.

Keen, Geraldine. *The Sale of Works of Art: A Study Based on the Times-Sotheby Index.* London, 1971.

Kees, H. *Ancient Egypt. A Cultural Topography.* Ed. T. G. H. James. Trans. I. F. D. Morrow. London, 1961.

Kennedy, C.; Wilder, E.; Bacci, P. *The Unfinished Monument by Andrea del Verrocchio*

to Cardinal Niccolò Forteguerri at Pistoia. Northampton, Mass., 1932.

Kent, Dale. *The Rise of the Medici.* Oxford, 1978.

Kent, Francis William. *Household and Lineage in Renaissance Florence.* Princeton, 1977.

Khaldūn, Ibn. *The Muqaddimah: An Introduction to History.* 3 vols. Trans. F. Rosenthal. New York, 1958.

Kiepert, H., and Hueben, Ch. *Formae Urbis Romae Antiquae. Nomenclator Topographicus.* Berlin, 1896.

Kim Chewon, and Kim Won-Yong. *The Arts of Korea.* London, 1956.

King, Donald (intro.). *Opus Anglicanum: English Medieval Embroidery.* Victoria and Albert Museum. London, 1963.

Kitson, Michael (intro.). *Salvator Rosa.* Exhibition catalogue. Hayward Gallery. London, 1973.

Kitzinger, Ernst. *The Art of Byzantium and the Medieval West: Selected Studies.* Bloomington, Ind. 1976.

Kleiner, Gerhard. *Die Begegnungen Michelangelos mit der Antike.* Berlin, 1950.

Kluge, Kurt and Lehmann-Hartleben, Karl. *Die Antiken Grossbronzen.* II, *Grossbronzen der römischen Kaiserzeit.* Berlin and Leipzig, 1927.

Koldewey, Robert. *Das wiedererstehende Babylon. Die bisherigen Ergebnisse der deutschen Ausgrabungen.* Leipzig, 1913.

Kraay, Colin, and Hirmer, Max. *Greek Coins.* London, 1966.

Kramrisch, Stella (ed. and trans.). *The Vishnudharmottara (Part III). A Treatise on Indian Painting and Image-Making.* 2nd rev. ed. Calcutta, 1928.

Krautheimer, Richard with Krautheimer-Hess, Trude. *Lorenzo Ghiberti.* 2nd ed. 2 vols. Princeton, 1970.

Kris, E. *Meister und Meisterwerke der Steinschneidekunst.* 2 vols. Vienna, 1929.

——, and Kurz, O. *Legend, Myth and Magic in the Image of the Artist.* New Haven and London, 1979.

Kristeller, Paul. *Andrea Mantegna.* London, 1901.

Krusch, W. (ed.). *Vita Eligii Episcopi Noviomagensis.* In *Monumenta Germaniae Historica.* Rerum Merovingicarum Scriptores. Vol. IV. Hanover and Leipzig, 1902.

Kubler, George. *The Shape of Time.* New Haven, 1962.

Küppers, P. E. *Domenico Ghirlandaio.* Strassburg, 1916.

Kurata Bunsaku. *Hōryū-ji: Temple of the Exalted Law.* Trans. W. Chie Ishibashi. Exhibition catalogue. Japan Society. New York, 1981.

Laborde, Léon de. *Les Ducs de Bourgogne, études sur les lettres, les arts et l'industrie pendant le XVe siècle.* 3 vols. Vol. I. Paris, 1849.

——. *La Renaissance des arts à la cour de France, études sur le XVIe siècle.* 2 vols. 1850–55. Reprint. New York, 1966.

La Bruyère, Jean de. *Les Caractères, ou Les Moeurs de ce siècle.* Ed. Pierre Kuentz. Paris, 1969.

Lactantius. *Divinae Institutiones.*

Ladendorf, Heinz. *Antikenstudium und Antikenkopie.* Berlin, 1953.

Lami, G. *Deliciae Eruditorum.* Florence, 1742.

Lanciani, Rodolfo. *The Destruction of Ancient Rome.* New York, 1899.

——. *La distruzione di Roma antica.* Trans. and reprint. Milan, 1971.

——. *The Ruins and Excavations of Ancient Rome.* London, 1897.

——. *Storia degli scavi di Roma.* 4 vols. Rome, 1902–13.

Landucci, Luca. *Diario fiorentino.* Florence, 1883.

Lane, Frederic. *Venice: A Maritime Republic.* Baltimore, 1973.

Lanson, René. *Le Goût du Moyen Âge en France au XVIIIe siècle.* Paris and Brussels, 1926.

Lanzi, Luigi. *The History of Painting in Italy*. 6 vols. Trans. Thomas Roscoe. London, 1828.

————. *La Real Galleria di Firenze accresciuta e riordinata per comando di S.A.R. l'Arciduca Granduca di Toscana*. Florence, 1782.

————. *Saggio di lingua etrusca e di altre antiche d'Italia*. Rome, 1789.

————. *Storia pittorica dell'Italia*. 3 vols. Bassano, 1795–96.

————. *Storia pittorica della Italia inferiore*. Florence, 1792.

Larner, John. *Culture and Society in Italy 1290–1420*. London, 1971.

Lasko, Peter. *Ars Sacra: 800–1200*. Penguin ed. Harmondsworth, 1972.

Lauer, Jean-Philippe. *Saqqara*. London, 1976.

Lauts, Jan. *Antonello da Messina*. Vienna, 1940.

Lawrence, Arnold. *Greek and Roman Sculpture*. Rev. ed. London, 1972.

Lawton, Thomas. *Freer Gallery of Art Fiftieth Anniversary Exhibition*. II, *Chinese Figure Painting*. Washington, D.C., 1973.

Ledderose, Lothar, *Mi Fu and the Classical Tradition of Chinese Calligraphy*. Princeton, 1979.

Lee, Sherman. *Tea Taste in Japanese Art*. New York, 1963.

Lefebvre d'Argencé, René-Yvon. *Bronze Vessels of Ancient China in the Avery Brundage Collection*. San Francisco, 1977.

Legge, James (ed. and trans.). *The Chinese Classics*. 5 vols. Hong Kong, 1893–95. Reprint. 1960.

———— (ed. and trans.). *The Four Books*. 1930. New York, 1966.

Legrand, F. C., and Sluys, F. *Arcimboldo et les arcimboldesques*. Paris, 1955.

Lehmann-Brockhaus, Otto. *Lateinische Schriftquellen zur Kunst in England, Wales und Schottland vom Jahre 901 bis zum Jahre 1307*. 5 vols. Munich, 1955–60.

————. *Schriftquellen zur Kunstgeschichte des 11. und 12. Jahrhunderts für Deutschland, Lothringen und Italien*. Berlin, 1938.

Le May, Reginald. *The Culture of South-East Asia: The Heritage of India*. London, 1954.

Lemerle, Paul. *Le Premier Humanisme byzantin*. Paris, 1971.

Lenoir, Alexandre. *Description historique et chronologique des monuments de sculpture, réunis au Musée des Monuments Français*. 6th ed. Paris, 1802.

Leonardo, Camillo. *Specchio delle pietre*. Venice, 1502.

Leonardo da Vinci. *Treatise on Painting*. Trans. A. Philip McMahon. 2 vols. Princeton, 1956.

Lerner-Lehmkuhl, Hanna. *Zur Struktur und Geschichte des Florentinischen Kunstmarktes im 15. Jahrhundert*. Wattenscheid, 1936.

Leroi-Gourhan, André. *Treasures of Prehistoric Art*. Trans. N. Guterman. New York, 1967.

Lesne, Émile. *Histoire de la propriété ecclésiastique en France*. Vol. III. Lille, 1936.

Lethaby, W. R. *Westminster Abbey and the King's Craftsmen*. London, 1906.

————. *Westminster Abbey Re-examined*. 1925. Reprint. New York, 1972.

Levey, Michael (intro.). *National Gallery. London*. Great Museums of the World. New York, 1969.

Levi, Augusto Cesare. *Le collezioni veneziane d'arte e d'antichità dal secolo XIV ai nostri giorni*. Venice, 1900.

Levy, Julien. *Memoir of an Art Gallery*. New York, 1977.

Lewis, Wilmarth S. *See for Yourself*. New York, 1971.

Lhotsky, Alfons. *Festschrift des Kunsthistorischen Museums zur Feier des fünfzigjährigen Bestandes*. Part II, *Die Geschichte der Sammlungen*. Vienna, 1941–45.

Lhuillier, Alberto Ruz. *El Templo de las Inscripciones Palenque*. Colección Científica Arqueología 7. Mexico City, 1973.

Li Sizhen. *Shu hou pin* in *Fa shu yao lu* [Essential Records of Calligraphy]. Ed. Zhang Yanyuan. Yishu cong bian ed. Taipei, 1968–71.

Liebenwein, Wolfgang. *Studiolo.* Berlin, 1977.

Lightbown, Ronald W. *Sandro Botticelli.* 2 vols. London, 1978.

Lindsay, Alexander William Crawford. *Sketches of the History of Christian Art.* 3 vols. London, 1847.

Lindsay, Jack. *Cézanne: His Life and Art.* New York, 1969.

Lings, Martin. *The Quranic Art of Calligraphy and Illumination.* London, 1976.

Lipman, Jean, et al. (comp.). *The Collector in America.* 1961. Reprint. London, 1971.

Lippold, Georg. *Kopien und Umbildungen griechischer Statuen.* Munich, 1923.

Lipschutz, Ilse Hempel. *Spanish Painting and the French Romantics.* Cambridge, Mass., 1972.

Lister, Martin. *A Journey to Paris in 1698.* London, 1698. Reprint. New York, 1971.

Livi, G. *Dall'archivio di Francesco Datini, mercante pratese.* Florence, 1910.

Livy. *Ab Urbe Condita.*

Loehr, Max. *Chinese Bronze Age Weapons.* Ann Arbor, 1956.

———. *Chinese Painting After Sung.* Yale University, Ryerson Lecture, March 1967.

———. *Ritual Vessels of Bronze Age China.* New York, 1968.

Loménie, Louis-Henri de. *Mémoires inédits de Louis-Henri de Loménie, Comte de Brienne.* Vol. II. Ed. F. Barrière. Paris, 1828.

London: The Arts Council of Great Britain. *The Age of Neoclassicism.* Exhibition catalogue. London, 1972.

London: The Queen's Gallery, Buckingham Palace. *George IV and the Arts of France.* Exhibition catalogue. London, 1966.

Lu Shihua. *Scrapbook for Chinese Collectors: Shu Hua Shuo Ling.* Trans. Robert H. van Gulik. Beirut, 1958.

Lucian. *Amores.*

———. *Iuppiter Tragoedus.*

———. *Timon.*

Lugli, G. *I monumenti antichi di Roma.* 3 vols. Rome, 1930–38.

Lugt, Frits. *Répertoire des catalogues de ventes publiques, première période, vers 1600–1825.* The Hague, 1938.

Luzio, Alessandro. *La galleria dei Gonzaga venduta all'Inghilterra nel 1627–28.* Milan, 1913.

Macco, Michela di. *Il colosseo: funzione simbolica, storica, urbana.* Rome, 1971.

Machiavelli, Niccolò. *Istorie fiorentine.* Ed. F. Gaeta. Milan, 1962.

Maclaren, Neil. *The Dutch School.* National Gallery Catalogue. London, 1960.

Macquoid, Percy. *A History of English Furniture.* 4 vols. London, 1904–08.

Magurn, Ruth Saunders (trans. and ed.). *The Letters of Peter Paul Rubens.* Cambridge, Mass., 1955.

Mahoney, Michael. *The Drawings of Salvator Rosa.* New York, and London, 1977.

Mâle, Émile. *L'Art religieux du XIIIe siècle en France.* 2 vols. 1898. Reprint. Paris, 1958.

Malraux, André. *Le Musée imaginaire.* Geneva, 1947.

———. *La Voie royale.* Paris, 1951.

Mancini, Girolamo. *Vita di Leon Battista Alberti.* 2nd ed. Florence, 1911.

Mancini, Giulio. *Considerazioni sulla pittura.* 2 vols. Ed. A. Marucchi. Accademia Nazionale dei Lincei: Fonti e documenti inediti per la storia dell'arte. Rome, 1956.

Mander, Carel van. *Dutch and Flemish Painters.* Trans. Constant van de Wall. New York, 1936.

Mandowsky, Erna, and Mitchell, Charles. *Pirro Ligorio's Roman Antiquities.* London, 1963.

Manetti, Antonio de Tuccio. *I XIV uomini singhulary in Firenze dal 1400 innanzi.* Florence, c.1494–97.

Mango, Cyril. (ed.). *The Art of the Byzantine Empire, 315–1453.* Englewood Cliffs, N.J., 1972.

———. *Byzantium: The Empire of New Rome.* New York, 1980.

Mann, Horace Kinder. *The Lives of the Popes in the Middle Ages.* Vol. IX. London, 1925.

Mansi, Giovanni Domenico. *Sacrorum Conciliorum Nova et Amplissima Collectio.* 31 vols. I–XIII: Florence; XIV–XXXI: Venice. 1759–98.

Marchini, G. *Giuliano da Maiano.* Florence, 1958–59.

———. *Giuliano da Sangallo.* Florence, 1942.

Mariette, P.-J. *Abecedario* in *Archives de l'Art Français.* Vols. 2, 4, 6, 8, 10, 12. Paris, 1851–60. Reprinted as *Abecedario et autres notes inédites.* 6 vols. Paris, 1964.

Marle, R. van. *Simone Martini.* Strassburg, 1920.

Marshall, A. J. *Bower Birds. Their Display and Breeding Cycles.* Oxford, 1954.

Martial. *Epigrammata.*

Martin, Alfred von. *Mittelalterliche Welt- und Lebensanschauung im Spiegel der Schriften Coluccio Salutatis.* Munich, 1913.

Martines, Lauro. *The Social World of the Florentine Humanists 1390–1460.* London, 1963.

Mazzi, Curzio. *Argenti degli Acciaiuoli.* Siena, 1895.

McCallum, Henry and Frances. *The Wire that Fenced the West.* Norman, Oklahoma, 1965.

McElwee, William. *The Murder of Sir Thomas Overbury.* London, 1952.

Medley, Margaret. *The Chinese Potter.* New York, 1976.

Meiggs, Russell, and Lewis, David (eds.). *A Selection of Greek Historical Inscriptions.* Oxford, 1975.

Meiss, Millard. *French Painting in the Time of Jean de Berry: The Late XIV Century and the Patronage of the Duke.* 2 vols. London, 1967.

———. *French Painting in the Time of Jean de Berry: The Limbourgs and Their Contemporaries.* 2 vols. New York, 1974.

———. *Painting in Florence and Siena After the Black Death.* New York, 1964.

Mellaart, James. *Çatal Hüyük: A Neolithic Town in Anatolia.* London, 1967.

———. *The Neolithic of the Near East.* New York, 1975.

Mellen, Peter. *Jean Clouet.* London, 1971.

Mély, Fernand de. *Les Primitifs et leurs signatures: les miniaturistes.* Paris, 1913.

Memmo, Andrea. *Elementi d'architettura lodoliana ossia l'arte del fabbricare con solidità scientifica e con eleganza non capricciosa.* 2 vols. Rome, 1786. Rev. 2nd ed., Zara, 1833–34. Reprint. Milan, 1973.

Menzhausen, Joachim. *The Green Vaults.* Leipzig, 1970.

Meulen, Marjon van der. *Petrus Paulus Rubens Antiquarius: Collector and Copyist of Antique Gems.* Dissertation, Utrecht, 1975. Alphen aan den Rijn, 1975.

Meyer, Karl. *The Art Museum: Power, Money, Ethics.* A Twentieth Century Fund Report. New York, 1979.

———. *The Plundered Past.* New York, 1973.

Mi Fu. *Hua shi* [History of Painting]. Yishu cong bian ed. Taipei, 1968–71.

———. *Mi Fu on Ink Stones.* Trans. Robert H. van Gulik. Beijing, 1938.

———. *Shu shi* [History of Calligraphy]. Yishu cong bian ed. Taipei, 1968–71.

Michaelis, Adolf. *Ancient Marbles in Great Britain.* Trans. C. A. M. Fennell. Cambridge, 1882.

Michiel, Marcantonio. *The Anonimo.* Trans. P. Mussi. 1903. Reprint. New York, 1969.

Milanesi, Gaetano. *Nuovi documenti per la storia dell'arte toscana.* Florence, 1901.

Millar, Oliver (ed.). *Abraham van der Doort's Catalogue of the Collections of Charles I.* Published as Vol. 37 of *The Walpole Society.* Glasgow, 1958–60.

———. Introduction to *Dutch Pictures from the Royal Collection.* The Queen's Gallery, Buckingham Palace. London, 1971.

———. (ed.). *The Inventories and Valuations of the King's Goods 1649–1651.* Published as Vol. 43 of *The Walpole Society.* Glasgow, 1970–72.

———. *The Queen's Pictures.* London, 1977.

———. *Rubens. The Whitehall Ceiling.* London, 1958.

Miller, Walter. *Daedalus and Thespis.* Vol. III. Columbia, Miss., 1932.

Millet, Simon Germain. *Le Trésor sacré, ou Inventaire des sainctes reliques et autres précieux joyaux qui se voyent en l'église & au trésor de l'abaye royale de S. Denis et en France.* 2nd ed. Paris, 1638.

Minerbetti, Andrea. "Ricordanze." Florence, Biblioteca Laurenziana. Ms. Aquisti e Doni, 229, vol. 2.

Mirot, Léon. *Roger de Piles.* Paris, 1924.

Mitchell, Peter. *An Introduction to Picture Collecting.* London, 1968.

Mommsen, Theodor (ed.). *Petrarch's Testament.* Ithaca, N.Y., 1957.

Montesquiou-Fezensac, Blaise de, with Gaborit-Chopin, Danielle. *Le Trésor de Saint-Denis: Inventaire de 1634.* Paris, 1973.

Montini, R. *Le tombe dei papi.* Rome, 1957.

Mordaunt Crook, J. *The British Museum.* London, 1972.

Morelli, Giacomo. *Di Giovanni Dondi dall'Orologio, medico di Padova, e dei monumenti antichi da lui esaminati a Roma, e di alcuni scritti inediti del medesimo.* Padua, 1850.

Morelli, Giovanni di Pagolo. *Ricordi.* 2nd ed. Ed. Vittore Branca. Florence, 1969.

Morelli, Jacopo. *De Joanne Dondio.* Operette. Vol. II. Padua, 1820.

——— (ed.). *Notizia d'opere di disegno.* Bassano, 1800.

Moreni, Domenico (ed.). *Memorie istoriche dell'ambrosiana imperiale basilica di S. Lorenzo.* 3 vols. Florence, 1804–17.

Moroni, G. *Dizionario di erudizione storico-ecclesiastica.* 103 vols. in 53. Venice, 1840–61.

Mortet, Victor, and Deschamps, P. (eds.). *Recueil de textes relatifs à l'architecture et la condition des architectes en France au Moyen Âge.* 2 vols. Paris, 1911–29.

Müntz, Eugène. *Les Arts à la cour des papes pendant le XVe et le XVIe siècle.* 3 vols. Paris, 1878–82.

———. *Les Collections de Médicis au XVe siècle.* Paris, 1888.

———. *Histoire de l'art pendant la Renaissance.* Vol. II. Paris, 1891.

———. *Les Précurseurs de la Renaissance.* Paris, 1882.

———, and Fabre, P. *La Bibliothèque du Vatican au XVe siècle.* Paris, 1887.

Muller, Jeffrey. *Rubens's Museum.* Forthcoming.

Munsey, Cecil. *The Illustrated Guide to Collectibles of Coca-Cola.* New York, 1972.

Murasaki Shikibu. *The Tale of Genji.* Trans. Edward Seidensticker. 2 vols. New York, 1977.

———. *The Tale of Genji.* Trans. Arthur Waley. London, 1957.

Mustoxidi, Andrea. *Lettera sui quattro cavalli della basilica di S. Marco in Venezia.* Padua, 1816.

al-Nadīm, Muḥammad ibn Isḥāq. *The Fihrist of al-Nadīm: A Tenth Century Survey of Muslim Culture.* 2 vols. Trans. and ed. Bayard Dodge. New York and London, 1970.

———. *Kitāb al-Fihrist.* 2 vols. Ed. Gustav Flügel. Leipzig, 1871–72.

Nagaya Kenzō. *Shōsōin Gakki nō Kekyū* [A Study of Musical Instruments in the Shōsōin]. Tokyo, 1964.

Narbeth & Lyon. *Successful Investing in Stamps and Bank-Notes*. London, 1975.

Nash, E. *Pictorial Dictionary of Ancient Rome*. London, 1962.

Natali, Giulio. *Storia letteraria d'Italia: il Settecento*. 2 vols. Milan, 1929.

Nava, A. *Memorie e documenti storici intorno all'origine, alle vicende ed ai riti del Duomo di Milano*. Milan, 1854.

Neilson, K. *Filippino Lippi*. Cambridge, 1938.

Neri, F.; Sapegno, N.; Bianchi, E.; Martellotti, G. *Poesie di Petrarca*. Milan and Naples, 1951.

New York: *Catalog of the Gallery of Art of the New-York Historical Society*. New York, 1915.

New York: Metropolitan Museum of Art. *From the Lands of the Scythians: Ancient Treasures from the Museums of the U.S.S.R. 3000 B.C. to 100 B.C.* Exhibition catalogue. New York, 1975.

Nichols, Francis Morgan (trans.). *The Marvels of Rome*. London and Rome, 1889.

Noguchi Yone. *Emperor Shōmu and the Shōsōin*. Tokyo, 1941.

Nolhac, Pierre de. *Pétrarque et l'humanisme*. Paris, 1892.

Nowotny, Karl. *Mexikanische Kostbarkeiten aus Kunstkammern der Renaissance im Museum für Völkerkunde Wien und in der Nationalbibliothek*. Vienna, 1960.

Oakeshott, R. Ewart. *The Archaeology of Weapons*. New York, 1960.

Oakeshott, W. *Classical Inspiration in Medieval Art*. London, 1959.

Oberhuber, Konrad. *Raphaels Zeichnungen*. Abteilung IX. Berlin, 1972.

Okada Jō (intro.). *National Museum. Tokyo*. Great Museums of the World. New York, 1968.

Ōkagami. The Great Mirror: Fujiwara Michinaga (966–1027) and His Times. Trans. Helen Craig McCullough. Princeton, 1980.

Onofrio, Cesare. *Castel S. Angelo*. Rome, 1971.

Oriental Ceramics: The World's Great Collections, X, The Freer Gallery of Art. Tokyo, 1975.

Origo, Iris. *The Merchant of Prato: Francesco di Marco Datini 1335–1410*. London, 1957.

Orlandi, Stefano. *Necrologia di Santa Maria Novella*. 2 vols. Florence, 1955.

Ovid. *Tristia*.

Paatz, W. and E. *Die Kirchen von Florenz*. 6 vols. Frankfurt a.M., 1952–55.

Pagliucchi, Pio. *I castellani di Castel S. Angelo*. Rome, 1973.

Panofsky, Erwin (ed.). *Abbot Suger on the Abbey Church of St.-Denis and Its Art Treasures*. Princeton, 1946.

———. *Early Netherlandish Painting*. Cambridge, Mass., 1953.

———. *Meaning in the Visual Arts*. Garden City, N.Y., 1955.

———. *Renaissance and Renascences in Western Art*. Stockholm, 1960.

———. *Tomb Sculpture*. New York, 1964.

Paris: Hôtel de Sully. *Le "Gothique" retrouvé avant Viollet-le-Duc*. Exhibition catalogue. Caisse Nationale des Monuments Historiques et des Sites. Paris, 1979.

Paris: Musée des Arts Decoratifs. *Les Trésors des églises de France*. Exhibition catalogue. Paris, 1965.

Paris: Musée National du Louvre. *Catalogue sommaire des sculptures du Moyen Âge, de la Renaissance et des temps modernes*. Paris, 1897.

Paris: Musée Royal. *Notice des tableaux des écoles primitives de l'Italie, de l'Allemagne, et de plusieurs autres tableaux de differentes écoles, exposés dans le Grand Salon du Musée Royal*. Paris, 1815.

Paris: Orangerie des Tuileries. *Georges de la Tour.* 2nd ed. Exhibition catalogue. Paris, 1972.

Paris, Matthew. *English History.* Trans. J. A. Giles. London, 1853.

Parker, K. T. *The Drawings of Antonio Canaletto in the Collection of His Majesty the King at Windsor Castle.* Oxford and London, 1948.

Parks, George B. *The English Traveler to Italy.* Vol. I. Rome, 1954.

Parrot, André. *Mari capitale fabuleuse.* Paris, 1974.

Passavant, Günter. *Verrocchio.* London, 1969.

Passavant, J.-D. *Rafael von Urbino.* Leipzig, 1839.

——. *Raphael d'Urbin.* Rev. and annot. Paul Lacroix. Paris, 1860.

Pastor, Ludwig. *Geschichte der Päpste.* Vol. I., 3rd and 4th eds., Freiburg i.B., 1901. Vol. IV–2, 1st and 4th eds., Freiburg i.B., 1907.

Paul the Deacon. *History of the Langobards.* Trans. William Dudley Foulke. Philadelphia, 1907.

Pauly, A. F. von. *Der Kleine Pauly.* Ed. K. Ziegler and W. Sontheimer. Vol. V. Munich, 1973.

——, and Wissowa, G. *Real Encyclopädie der classischen Altertumswissenschaft.* Vol. II: Zweite Reihe, Stuttgart, 1923. Vol. XVI, Stuttgart, 1935.

Pausanias. *Descriptio Graecae.* Ed. J. G. Frazer in *Pausanias's Description of Greece.* 6 vols. London, 1898.

Peacham, Henry. *The Compleat Gentleman.* 1st ed. 1622. Oxford, 1906.

Pelli, Giuseppe Bencivenni. *Saggio istorico sulla Reale Galleria di Firenze.* 2 vols. Florence, 1779.

Peltzer, A. R. (ed.). *Joachim von Sandrart's Academie der Bau-, Bild-, und Mahlerey-Künste.* Munich, 1925.

Perdigão, José de Azeredo. *Calouste Gulbenkian.* Lisbon, 1969.

Perosa, A. (ed.). *Giovanni Rucellai ed il suo Zibaldone.* London, 1960.

Petrarca, Francesco. *Africa.* Ed. N. Festa. Florence, 1926.

——. *Epistolae Familiares.* Ed. S. Manilius. Venice, 1492.

——. *Le familiari.* Ed. Vittorio Rossi. Florence, 1934.

——. *Opera Omnia.* Basel, 1554. Reprint. Ridgewood, N.J., 1965.

——. *Rerum Familiarum Libri.* Trans. Aldo S. Bernardo. Albany, 1975.

Petrocchi, Massimo. *Razionalismo architettonico e razionalismo storiografico.* Rome, 1947.

Petronius, *Satyricon.*

Pevsner, Nikolaus. *Some Architectural Writers of the Nineteenth Century.* Oxford, 1972.

Phaedrus. *Fabulae.*

Pharr, Clyde (trans.). *The Theodosian Code.* Princeton, 1952.

Phillips, Marjorie. *Duncan Phillips and His Collection.* Boston and Toronto, 1970.

Philostratus. *Imagines.*

——. *Life of Apollonius of Tyana.*

Pieraccini, G. *La stirpe de' Medici di Cafaggiolo.* Florence, 1924.

Pignatti, Terisio. *Giorgione.* Trans. Clovis Whitfield. London, 1971.

Pignoria, Lorenzo. *Le vere et nove imagini dei indiani* in V. Cartari, *Imagini delli dei degl'antichi.* 1647. Reprint. Graz, 1963.

Piles, Roger de. *Abrégé de la vie des peintres.* Paris, 1699.

——. *Le Cabinet de Monseigneur le duc de Richelieu.* 1676.

——. *Cours de peinture par principes.* 1708. Reprint. Geneva, 1969.

——. *Dissertation sur les ouvrages des plus fameux peintres, dédiée a Monseigneur le duc de Richelieu.* Paris, 1681.

——. *Oeuvres diverses.* Paris, 1767.

Piot, E. *Le Cabinet de l'amateur*. Paris, 1863.

Piranesi, G.-B. *Della magnificenza ed architettura de' romani*. Rome, 1761.

———. *Parere su l'architettura*. Rome, 1765.

Platner, S. B. *Topography and Monuments of Ancient Rome*. Boston and Chicago, 1904.

———, and Ashby, Thomas. *A Topographical Dictionary of Ancient Rome*. Oxford, 1929.

Plato. *Gorgias*.

———. *Hippias Major*.

———. *Laws*.

———. *Republic*.

———. *The Sophist*.

———. *Symposium*.

Pliny the Elder. *Naturalis Historia*.

———. *The Elder Pliny's Chapters on the History of Art*. Trans. K. Jex-Blake and E. Sellers, 1896. Chicago, 1968.

Pliny the Younger. *Epistulae*.

Plotinus. *Enneads*.

Plutarch. *The Lives of the Noble Grecians and Romans*. Ed. Arthur Hugh Clough. Trans. John Dryden. Modern Library ed. New York, n.d.

———. *Moralia*.

Pollitt, J. J. *The Ancient View of Greek Art*. New Haven and London, 1974.

———. *Art and Experience in Classical Greece*. Cambridge, 1972.

———. (ed.). *The Art of Greece*. *1400–31* B.C. Englewood Cliffs, N.J., 1965.

Polybius. *Histories*.

Pope-Hennessy, John. *Catalogue of Italian Sculpture in the Victoria and Albert Museum*. Vol. I. London, 1964.

———. *The Complete Work of Paolo Uccello*. 1950. 2nd ed. London, 1969.

———. *Fra Angelico*. 2nd ed. London, 1974.

———. *Italian Gothic Sculpture*. 2nd ed. London and New York, 1972.

———. *Luca della Robbia*. Oxford, 1980.

———. *Raphael*. New York, 1970.

———. *The Study and Criticism of Italian Sculpture*. New York, 1980.

Porter, Arthur Kingsley. *Lombard Architecture*. 3 vols. 1917. Reprint. New York, 1967.

Posener, Georges. *La Première Domination perse en Égypte: recueil d'inscriptions hiéroglyphiques*, Bibliothèque d'Étude 11. Cairo, 1936.

Pottle, Frederick (ed.). *Boswell on the Grand Tour. Germany and Switzerland, 1764*. New York, 1953.

Pouilloux, J. *Choix d'inscriptions grecques*. Paris, 1960.

Previtali, Giovanni. *La fortuna dei primitivi*. Turin, 1964.

Prévost, M. and D'Amat, Roman (eds.). *Dictionnaire de biographie française*. Vol. VI. Paris, 1954.

Prinz, Wolfram. *Die Entstehung der Galerie in Frankreich und Italien*. Berlin, 1970.

Procopius. *De Aedificiis*.

———. *History of the Wars*.

———. *Procopii Caesariensis Opera*. Vol. III/2. Ed. J. Haury. Leipzig, 1913.

Proust, Marcel. *À la recherche du temps perdu*. 3 vols. Pléiade ed. Paris, 1954.

Pseudo-Andocides. *Contra Alcibiades*.

Pugin, Augustus Welby. *The True Principles of Pointed or Christian Architecture*. London, 1853.

Qiu Fu. *Li Xi xi li qiao fu ge song*, A.D. *172* in *Shodō zenshū*. Vol. 2. Tokyo, 1965.

Qiu Jing. *Wu du tai shou Li Xi xixia song*, A.D. *171* in *Shodō zenshū*. Vol. 2. Tokyo, 1965.

Quatremère de Quincy, A.-C. *Canova et ses ouvrages.* 2nd ed. Paris, 1836.

————. *Lettres sur l'enlèvement des ouvrages de l'art antique à Athènes et à Rome, écrites les unes au célèbre Canova les autres au General Miranda.* Paris, 1836.

Quintilian. *Institutio Oratoria.*

Raczynski, Le Comte A. *Les Arts en Portugal.* Paris, 1846.

Ragghianti, Licia Collobi. *Il libro de' disegni del Vasari.* 2 vols. Florence, 1974.

Ragué, Beatrix von. *A History of Japanese Lacquerwork.* Toronto and Buffalo, 1976.

Rambaldi da Imola, Benvenuto. *Commento latino sulla Divina Commedia di Dante Alighieri.* Imola, 1856.

Raynal, Louis. *L'Histoire du Berry depuis les temps les plus anciens jusqu'en 1789.* 4 vols. Bourges, 1844–47.

Read, Charles Hercules. *The Waddesdon Bequest. Catalogue of Works of Art Bequeathed to the British Museum by Baron Ferdinand Rothschild, M. P. 1898.* London, 1902.

Read, Louisa McDonald. "The Masculine and Feminine Modes of Heian Secular Painting and Their Relationship to Chinese Painting—A Re-definition of Yamato-e." Dissertation, Stanford University, 1975.

Réau, Louis. *Les Monuments détruits de l'art français.* 2 vols. Paris, 1959.

Redford, Donald B. *History and Chronology of the Eighteenth Dynasty of Egypt. Seven Studies.* Toronto, 1967.

Redlich, Paul. *Cardinal Albrecht von Brandenburg und das neue Stift zu Halle 1520–1541.* Mainz, 1900.

Reitlinger, Gerald. *The Economics of Taste.* 3 vols. London, 1961–70.

Reynolds, Joshua. *The Discourses of Sir Joshua Reynolds.* Ed. John Burnet. London, 1842.

Rheims, Maurice. *Art on the Market.* Trans. David Pryce-Jones. London, 1961.

Riant, P. *Des dépouilles religieuses enlevées à Constantinople au XIIIe siècle par les Latins, et des documents historiques nés de leur transport en Occident.* Mémoires de la Société Nationale d'Antiquaires de France 36. Paris, 1875.

Ricci, Seymour de. *Description raisonnée des peintures du Louvre.* Paris, 1913.

Riccobaldo Ferrarese. *Compilatio Cronologica.* Rome, 1474.

Rice, D. S. *The Unique Ibn al-Bawwāb Manuscript in the Chester Beatty Library.* Dublin, 1955.

Richard, Abbé Jérôme. *Description historique et critique de l'Italie, ou Nouveaux mémoires sur l'état actuel de son gouvernement, des sciences, des arts, du commerce de la population et de l'histoire naturelle.* Vol. III. Dijon, Paris, 1766.

Richter, Gisela M. A. *The Furniture of the Greeks, Etruscans and Romans.* London, 1966.

————. *The Sculpture and Sculptors of the Greeks.* 4th rev. ed. New Haven and London, 1970.

————. *Three Critical Periods in Greek Sculpture.* Oxford, 1951.

————, and Irma A. *Kouroi: Archaic Greek Youths.* London, 1960.

Ridgway, Brunilde Sismondo. *The Archaic Style in Greek Sculpture.* Princeton, 1977.

————. *The Severe Style in Greek Sculpture.* Princeton, 1970.

Riegl, Alois. *Stilfragen.* 2nd ed. Berlin, 1923.

Riley, Henry Thomas (ed.). *Gesta Abbatum Monasterii Sancti Albani (Cottonian Ms. Claudius E.IV. British Museum).* London, 1867.

Ripley, Dillon. *The Trail of the Money Bird.* New York, 1942.

Ristoro d'Arezzo. *Della composizione del mondo.* Ed. E. Narducci. Milan, 1864.

Robertson, Giles. *Giovanni Bellini.* Oxford, 1968.

Robertson, Martin. *A History of Greek Art.* 2 vols. London, 1975.

————. *The Parthenon Frieze.* London, 1975.

Robinson, David, and Fluck, Edward. *A Study of the Greek Love-Names.* Baltimore, 1937.

Röhrig, Floridus. *Der Verduner Altar.* 3rd ed. Vienna, 1964.

Rohault de Fleury, Charles. *Mémoire sur les instruments de la passion de N.-S. J.-C.* Paris, 1870.

Rome: Palazzo Venezia. *Paolo II e le fabbriche di San Marco.* Exhibition catalogue. Rome, 1980.

Roover, Raymond de. *The Rise and Decline of the Medici Bank, 1397–1494.* Cambridge, Mass., 1963.

Rosati, Franco Panvini. *Medaglie e placchette italiane dal Rinascimento al XVIII secolo.* Exhibition catalogue. Rome, 1968.

Roscoe, William. *The Life of Lorenzo de' Medici.* 3rd ed. 2 vols. London, 1797.

Rose, P. L. *The Italian Renaissance of Mathematics.* Geneva, 1975.

Roselius, Ludwig. *Deutsche Kunst.* Vol. 3. Bremen and Berlin, 1935.

Rosenberg, Pierre. *Chardin 1699–1779.* Exhibition catalogue. Museum of Art. Cleveland, 1979.

Rosenfeld, Myra Nan. *Sebastiano Serlio (1475–1555).* Exhibition catalogue. Low Memorial Library, Columbia University. New York, 1975.

Roux, Georges. *Ancient Iraq.* Penguin ed. Harmondsworth, 1967.

Rowley, George. *Principles of Chinese Painting.* Princeton, 1947.

Royal Commission on Ancient and Historical Monuments. *Inventory of Westminster Abbey.* London, 1924.

Rubens, Peter Paul. *Correspondance de Rubens et documents épistolaires.* 6 vols. Ed. Charles Ruelens and Max Rooses. Antwerp, 1887–1909.

————. *De Imitatione Antiquarum Statuarum* in Roger de Piles, *Cours de peinture par principes.* Paris, 1708.

Rubin, William (ed.). *Pablo Picasso: A Retrospective.* Exhibition catalogue. The Museum of Modern Art. New York, 1980.

Rudenko, Sergei I. *Frozen Tombs of Siberia.* Trans. M. W. Thompson. Berkeley and Los Angeles, 1970.

Rupprich, Hans (ed.). *Dürer schriftlicher Nachlass.* 3 vols. Berlin, 1956–69.

Ruskin, John. *The Lamp of Beauty.* Ed. Joan Evans. Garden City, N.Y., 1959.

Russoli, Franco (intro.). *Brera. Milan.* Great Museums of the World. New York, 1970.

Saarinen, Aline B. *The Proud Possessors.* New York, 1958.

Sabbadini, Remigio. *Le scoperte dei codici latini e greci ne' secoli XIV e XV.* 2 vols. 1905–14. Reprint. Florence, 1967.

Sacchetti, Franco. *Il trecentonovelle.* Ed. Emilio Faccioli. Turin, 1970.

Sachs, Hannelore. *Sammler und Mäzene.* Leipzig, n.d.

Safadi, Y. H. *Islamic Calligraphy.* London, 1978.

Sahagun, Fray Bernardino de. *Florentine Codex. General History of the Things of New Spain.* Trans. A. J. O. Anderson and C. E. Dibble. Santa Fe, N.M. 1951.

————. *The War of Conquest. How It Was Waged Here in Mexico.* Trans. A. J. O. Anderson and C. E. Dibble. Salt Lake City, 1978.

Sainsbury, W. Noël. (ed.) *Original Unpublished Papers Illustrative of the Life of Sir Peter Paul Rubens as an Artist and a Diplomatist.* London, 1859.

St. Clair, William. *Lord Elgin and the Marbles.* London, 1967.

Saint-Simon, Louis Duc de. *Mémoires.* Ed. Gonzague Truc. 7 vols. Paris, 1947–61.

Sale, John R. "The Strozzi Chapel by Filippino Lippi in Santa Maria Novella." Ph.D. dissertation, University of Pennsylvania, 1976.

Salis, Arnold von. *Antike und Renaissance.* Zurich, 1947.

Salvini, Roberto. *Giotto bibliografia.* Rome, 1938.

Samuels, Ernest. *Bernard Berenson: The Making of a Connoisseur.* Cambridge, Mass., and London, 1979.

Sang Zhichang. *Lan ting kao.* Preface dated 1208. Yishu cong bian ed. Taipei, 1968–71.

Sansom, George. *A History of Japan 1334–1615.* London, 1961.

———. *Japan: A Short Cultural History.* Rev. ed. New York, 1943.

Sansovino, Francesco. *Venetia città nobilissima et singolare.* Venice, 1581.

Santi, Bruno (ed.). *Neri di Bicci: Le ricordanze.* Pisa, 1976.

Santi, Giovanni. *Cronaco rimata delle imprese del duca Federigo d'Urbino.* Urbino, after 1482.

Sanudo, Mario. *Vitae Ducum Venetorum Italice Scriptae ab Origine Urbis.* Milan, 1733.

Sauerländer, Willibald. *Gothic Sculpture in France 1140–1270.* Trans. J. Sondheimer. London, 1972.

———. *Gotische Skulptur in Frankreich 1140–1270.* Munich, 1970.

Saunier, Charles. *Les Conquêtes artistiques de la révolution et de l'empire.* Paris, 1902.

Saville, Marshall H. *The Goldsmith's Art in Ancient Mexico.* New York, 1920.

Savonarola, Michele. *Libellus de Magnificis Ornamentis Regie Civitatis Padue.* c.1446.

Scalamonti, Francesco. *Commentario premesso alla vita di Ciriaco Anconitano* in Giuseppe Colucci, *Delle antichità picene.* Vol. XV. Fermo, 1792.

Scamozzi, Vincenzo. *L'idea della architettura universale.* Venice, 1615.

Schapiro, Meyer. *Late Antique, Early Christian and Mediaeval Art.* (Selected Papers, vol. III). New York, 1979.

———. *Modern Art: Nineteenth and Twentieth Centuries.* (Selected Papers, vol. II). New York, 1978.

———. *Romanesque Art.* (Selected Papers, vol. I). New York, 1977.

Scharf, A. *Filippino Lippi.* Vienna, 1950.

Schefold, Karl. *Die Griechen und ihre Nachbarn.* Propyläen Kunstgeschichte, 1. Berlin, 1967.

Scheicher, E. *Die Kunst- und Wunderkammern der Habsburger.* Vienna, 1979.

Scheltema, F. Adama van. *Die altnordische Kunst.* 2nd ed. Berlin, 1924.

Schiaparelli, Attilio. *La casa fiorentina e i suoi arredi nei secoli XIV e XV.* Florence, 1908.

Schiller, Friedrich. *Über die ästhetische Erziehung des Menschen.* Ed. Wolfart Henckmann. Munich, 1967.

Schimmel, Annemarie. *Islamic Calligraphy.* Leyden, 1970.

Schlosser, Julius von. *Die Kunst- und Wunderkammern der Spätrenaissance.* Leipzig, 1908.

———. *Leben und Meinungen des Florentinischen Bildners Lorenzo Ghiberti.* Basel, 1941.

———. (ed.). *Quellenbuch zur Kunstgeschichte des abendländischen Mittelalters.* Quellenschriften für Kunstgeschichte n.s. 7. Vienna, 1896.

———. (ed.). *Schriftquellen zur Geschichte der karolingischen Kunst.* Quellenschriften für Kunstgeschichte n.s. 4. Vienna, 1892.

Schlosser-Magnino, Julius. *La letteratura artistica.* Florence, 1956.

Schneider, Fedor. *Rom und Romgedanke im Mittelalter.* 1925. Reprint. Cologne, 1959.

Schober, Arnold. *Die Kunst von Pergamon.* Vienna, 1951.

Schönberger, Otto. *Philostratus: Die Bilder.* Munich, 1958.

Schramm, P. E. *Kaiser, Rom und Renovatio.* Leipzig, 1929.

———, and Mütherich, F. *Denkmale der deutschen Könige und Kaiser.* Munich, 1962.

Schudt, Ludwig. *Italienreisen im 17. und 18. Jahrhundert.* Vienna, 1959.

Segrè, Ugo. *Luigi Lanzi e le sue opere.* Assisi, 1904.

Seizansō seishō. Illustrated Catalogue of the Nezu Collection. 10 vols. Tokyo, 1939–43.

Seldes, Lee. *The Legacy of Mark Rothko.* New York, 1978.

Seligman, Germain. *Merchants of Art: 1880–1960. Eighty Years of Collecting.* New York, 1961.

Seneca. *Dialogues.*

Serena, Augusto. *La cultura umanistica a Treviso nel secolo decimoquinto.* Venice, 1912.

Seroux D'Agincourt, J.-B. L.-G. *Histoire de l'art par les monuments depuis sa décadence au IVe siècle jusqu'à son renouvellement au XVe.* 6 vols. in 3. Paris, 1810–23.

Seters, J. van. *The Hyksos. A New Investigation.* New Haven and London, 1966.

Sévigné, Madame de. *Lettres.* 3 vols. Paris, 1953–57.

Seymour, Charles. *Verrocchio.* London, 1971.

Shapley, F. R. *Paintings from the Samuel H. Kress Collection. Italian Schools XIII–XV Century.* London, 1966.

Shaw, William Arthur (ed.). *Three Inventories of the Years 1542, 1547 and 1549–50 of Pictures in the Collections of Henry VIII and Edward VI.* London, 1937.

Shearman, John. *Andrea del Sarto.* Oxford, 1965.

Shepherd, Rev. William. *Vita di Poggio Bracciolini.* Trans. T. Tonelli. Florence, 1825.

———. *Paris, in Eighteen Hundred and Two, and Eighteen Hundred and Fourteen.* London, 1814.

Shimizu Yoshiaki, and Wheelwright, Carolyn (eds.). *Japanese Ink Paintings.* Princeton, 1976.

Shodō zenshū. 3rd ed. 26 vols. Tokyo, 1966–67.

Shōsōin Jimusho (comp.). *Shōsōin Hōmotsu: Chūsō* [Treasures of the Shōsōin: The Middle Section]. Tokyo, 1960.

——— (comp.). *Shōsōin Hōmotsu: Hokusō* [Treasures of the Shōsōin: The North Section]. Tokyo, 1962.

——— (comp.). *Shōsōin Hōmotsu: Nansō* [Treasures of the Shōsōin: The South Section]. Tokyo, 1961.

——— (comp.). *Shōsōin no Tōki* [Ceramic Objects in the Shōsōin]. Tokyo, 1971.

Sickman, Laurence, and Soper, Alexander. *The Art and Architecture of China.* 2nd ed. Penguin ed. Harmondsworth, 1960.

Sidonius Apollinaris. *Epistulae.*

Sima Qian. *Shi ji.* Beijing, 1959.

Simeoni, Luigi. *Verona.* New ed. Verona, 1953.

Simon, Erika. *Die Geburt der Aphrodite.* Berlin, 1969.

Simson, Otto von. *The Gothic Cathedral.* 1956. Rev. ed. New York, 1962.

Singer C., and Holmyard, E. J. (eds.). *A History of Technology.* 5 vols. Oxford, 1954–58.

Sirén, Osvald. *Chinese Painting: Leading Masters and Principles.* 7 vols. London and Bradford, 1956–58.

Skalet, Charles. *Ancient Sicyon.* Baltimore, 1948.

Smith, A. H. (ed.). *Lansdowne House, London: A Catalogue of the Ancient Marbles Based on the Work of Adolf Michaelis.* London, 1889.

Smith, John Thomas. *Nollekens and His Times.* 2 vols. London, 1828.

Smith, W. S. *The Art and Architecture of Ancient Egypt.* Penguin ed. Baltimore, 1958.

Solerti, A. *Le vite di Dante, Petrarca e Boccaccio.* Milan, 1904.

Sommerard, André du. *Les Arts au Moyen Âge.* Paris, 1843.

Soonsawad, Thong-in. *Panorama of Thailand: A Guide to the Wonders and Highlights of Thailand.* 2nd rev. ed. Wichita, Kan., 1966.

Soper, Alexander (trans.). *Kuo Jo-Hsu's Experiences in Painting (T'u-Hua Chien-Wen Chih).* Washington, D.C., 1951.

Sotheby Parke Bernet. *Masterpieces from the Robert von Hirsch Sale at Sotheby's.* Westerham, Kent, 1978.

———. *Mentmore*. 5 vols. London, 1977.

Spallanzani, Marco. *Ceramiche orientali a Firenze nel Rinascimento*. Florence, 1978.

Spencer, Herbert. *The Principles of Psychology*. 3rd ed. 2 vols. London, 1890.

Speth-Holterhoff, S. *Les Peintres flamands de cabinets d'amateurs au XVIIe siècle*. Brussels, 1957.

Sprigge, Sylvia. *Berenson: A Biography*. Boston, 1960.

Springell, Francis. *Connoisseur & Diplomat: The Earl of Arundel's Embassy to Germany in 1636 as Recounted in William Crowne's Diary, the Earl's Letters and Other Contemporary Sources*. London, 1963.

Stangl, Thomas (ed.). *Ciceronis Orationum Scholiastae*. Hildesheim, 1964.

Statius. *Silvae*.

Stchoukine, Ivan. *La Peinture iranienne sous les derniers Abbasides et les Ilkhans*. Bruges, 1936.

———. *Les Peintures des manuscrits tîmurîdes*. Paris, 1954.

Stechow, Wolfgang. *Dürer and America*. Washington, D.C., 1971.

——— (ed.). *Northern Renaissance Art 1400–1600: Sources and Documents*. Englewood Cliffs, N.J., 1966.

———. *Rubens and the Classical Tradition*. Cambridge, Mass., 1968.

Steegman, John. *The Rule of Taste from George I to George IV*. 1936. Reprint. London, 1968.

Stein, Henri. *Les Architectes des cathédrales gothiques*. Paris, 1909.

Stephens, John L. *Incidents of Travel in Yucatan*. 2 vols. 1843. Reprint. New York, 1963.

Strabo. *Geographia*.

Strong, Donald. *Roman Art*. Penguin ed. Harmondsworth, 1976.

Strong, Roy. *And When Did You Last See Your Father? The Victorian Painter and British History*. London, 1978.

———. *The English Icon: Elizabethan and Jacobean Portraiture*. London, 1969.

———. *Festival Designs by Inigo Jones*. Exhibition catalogue. Washington D.C., 1967–68.

———. *Splendor at Court: Renaissance Spectacle and the Theater of Power*. Boston, 1973.

Stuart, James, and Revett, Nicholas. *The Antiquities of Athens*. 3 vols. 1762. Reprint. New York, 1968.

Stubbs, William (ed.). *The Historical Works of Gervase of Canterbury*. 2 vols. London, 1879–80.

Stuttgart: Württembergisches Landesmuseum. *Die Zeit der Staufer*. Exhibition catalogue. 5 vols. Stuttgart, 1977.

Suetonius. *The Lives of the Caesars*.

Sullivan, Michael. *The Arts of China*. Berkeley, 1977.

Summerson, John. *Architecture in Britain 1530–1830*. 4th rev. ed. Penguin ed. Harmondsworth, 1963.

Sun Guoting. *Shu pu*. A.D. 687. Yishu cong bian ed. Taipei, 1968–71.

Swarzenski, H. *Monuments of Romanesque Art*. London, 1954. 2nd ed. Chicago and London, 1967.

Targioni-Tozzetti, G. *Relazioni d'alcuni viaggi fatti in diverse parti della Toscana*. 2nd ed. 12 vols. Florence, 1768–79.

Tatham, R. *Francesco Petrarca, the First Modern Man of Letters: His Life and Letters*. 2 vols. London, 1926.

Taylor, Francis Henry. *The Taste of Angels*. Boston, 1948.

Taylor, Joshua C. *Futurism*. New York, 1961.

Teyssèdre, Bernard. *L'Histoire de l'art vue du grand siècle*. Paris, 1964.

————. *Roger de Piles et les débats sur le coloris au siècle de Louis XIV.* Paris, 1957.

Thangmar. *Vita Bernwardi Episcopi Hildesheimensis.* Ed. H. G. Pertz. In *Monumenta Germaniae Historica.* Scriptores in Folio. Vol. IV. Hanover, 1841.

Tharp, Louise Hall. *Mrs. Jack.* Boston, 1965.

Themistius. *Orationes.* Ed. Wilhelm Dindorf. Hildesheim, 1961.

Theophanes. *Theophanes Continuatus.* 2 vols. Ed. Immanuel Bekker. *Corpus Scriptorum Historiae Byzantinae.* Bonn, 1828–97.

Théophile, prêtre et moine. Essai sur divers arts. Ed. Charles de l'Escapolier. Intro. J.-M. Guichard. 1843. Reprint. Nogent-le-Roi, 1977.

Theophilus. *On Divers Arts.* Trans. and annot. J. G. Hawthorne and C. S. Smith. Chicago, 1963.

————. *The Various Arts.* Trans. and annot. C. R. Dodwell. London, 1961.

Thieme, U., and Becker, F. *Allgemeines Lexikon der bildenden Künstler.* 37 vols. Leipzig, 1907–50.

Thomas Aquinas, Saint. *Summa Theologica.* Rome, 1923.

Thorndike, Lynn. *A History of Magic and Experimental Science.* 8 vols. New York, 1923–58.

Thurston, Herbert, and Attwater, Donald (eds.). *Butler's Lives of the Saints.* Rev. ed. 4 vols. New York, 1956.

Tiraboschi, G. *Storia della letteratura italiana.* 9 vols. in 16. Milan, 1822–24.

Todorow, Maria Fossi. *Palazzo Davanzati.* Biblioteca de 'Lo Studiolo' 2. Florence, 1979.

Tokyo: National Museum. *Chūka jinmin kyōwakoku kodai seidōki ten* [Exhibition of Ancient Bronzes of the People's Republic of China]. Tokyo, 1976.

Tolnay, Charles de. *Hieronymus Bosch.* Rev. ed. London, 1966.

————. *Michelangelo.* 2nd ed. 5 vols. Princeton, 1969–71.

Tomkins, Calvin. *Merchants and Masterpieces: The Story of the Metropolitan Museum of Art.* London and Harlow, 1970.

Torcellan, Gianfranco. *Una figura della Venezia settecentesca: Andrea Memmo.* Venice and Rome, 1963.

Torres de Mendoza, L. *Colección de documentos inéditos relativos al descubrimento, conquista y organización de las antiguas posesiones españolas,* Vol. XII. Madrid, 1869.

Torri, A. (ed.). *L'ottimo commento della Divina Commedia, d'un contemporaneo di Dante.* Vol. II. Pisa, 1828.

Toynbee, J. M. C. *The Hadrianic School.* Cambridge, 1934.

Traversari, Ambrogio. *Latinae Epistolae.* 2 vols. Ed. L. Mehus. Florence, 1711. Reprint. Bologna, 1968.

Travlos, John. *Pictorial Dictionary of Ancient Athens.* London, 1971.

Trevor-Roper, Hugh. *The Plunder of the Arts in the Seventeenth Century.* London, 1970.

————. *Princes and Artists: Patronage and Ideology at Four Hapsburg Courts 1517–1633.* New York, 1976.

Troeschev, Georg. *Claus Sluter.* Freiburg, i.B., 1932.

Tschan, Francis J. *Saint Bernward of Hildesheim.* 3 vols. South Bend, Ind., 1942–52.

Turner, T. Hudson. *Some Accounts of Domestic Architecture in England.* Oxford, 1851.

Ullman, B. L. *Studies in the Italian Renaissance.* 2nd ed. Rome, 1973.

————, and Stadler, P. *The Public Library of Renaissance Florence.* Padua, 1972.

Underwood, Paul A. *The Kariye Djami.* I, *Historical Introduction and Description of the Mosaics and Frescoes.* New York, 1966.

Unger, Friedrich Wilhelm. (ed.). *Quellenschriften der byzantinischen Kunstgeschichte.* Quellenschriften für Kunstgeschichte 12. Vienna 1878. Reprint. Osnabrück, 1970.

United States Department of State. *Foreign Relations of the United States: Paris Peace Conference 1919.* Dept. of State, vol. 13. Washington, D.C., 1947.

Vacca, Flaminio. *Memorie di varie antichità trovate in diversi luoghi della città di Roma.* Rome, 1594.

Valentinelli, Giuseppe. *Marmi scolpiti del Museo Archeologico della Marciana di Venezia.* Prato, 1866.

Valentiner, William R., and Wescher, Paul. *The J. Paul Getty Museum Guidebook.* 2nd ed. Los Angeles, 1956.

Vasari, Giorgio. *Le opere.* 9 vols. Ed. Gaetano Milanesi. Florence, 1879–85. Reprint. 1973. (Referred to as "Vasari-Milanesi" in the notes.)

Velleius Paterculus. *Historiae Romanae.*

Verheyen, Egon. *The Paintings in the Studiolo of Isabella d'Este at Mantua.* New York, 1971.

———. *The Palazzo del Te in Mantua.* Baltimore, 1977.

Verino, Ugolino. *De Illustratione Urbis Florentiae.* 3 bks. Florence, after 1502.

Verlet, Pierre. *Le Mobilier royal français. Meubles de la Couronne conservés en France.* Paris, 1945.

———. *Versailles.* Paris, 1961.

Vermeule, Cornelius. *European Art and the Classical Past.* Cambridge, Mass., 1964.

Verona e il suo territorio. Vol. III.1. Verona, 1975.

Vespasiano da Bisticci. *Le vite.* 2 vols. Ed. Aulo Greco. Florence, 1970–76.

Veth, J. P., and Müller, Samuel. *Albrecht Dürers niederländische Reise.* 2 vols. Berlin, 1918.

Vielliard, Jeanne (ed.). *Le Guide du pélerin à Saint-Jacques Compostelle.* 4th ed. Macon, 1969.

Vienna: Kunsthistorisches Museum. *Katalog der Gemäldegalerie.* II, *Vlamen, Holländer, Deutsche, Franzosen.* Vienna, 1958.

Vienna: Museum für Völkerkunde. *Präkolumbische Kunst aus Mexiko und Mittelamerika.* Exhibition catalogue. Vienna, 1959–60.

Villani, Filippo. *Liber De Civitatis Florentiae Famosis Civibus.* Ed. G. C. Galletti. Florence, 1847.

———. *De Origine Civitatis Florentiae et Eiusdem Famosis Civibus* in Karl Frey (ed.), *Il libro di Antonio Billi.* Berlin, 1892.

———. *Le vite d'uomini illustri fiorentini.* 2nd ed. Ed. G. Mazzuchelli. Florence, 1847.

Villani, Giovanni. *Cronica.* Ed. F. Gherardi Dragomanni. Florence, 1844–45.

Vitruvius. *De Architectura.*

Vitry, Paul. *Michel Colombe et la sculpture française de son temps.* Paris, 1901.

Voigt, G. *Die Wiederbelebung des classischen Alterthums.* 2 vols. 4th ed. Berlin, 1960.

Volterrano, Raffaele. *Antropologia.* Rome, 1506.

Vosmaer, C. *Rembrandt, sa vie et ses oeuvres.* Paris, 1877.

Waagen, G. *Treasures of Art in Great Britain.* London, 1854.

Wackernagel, Martin. *Der Lebensraum des Künstlers in der Florentinischen Renaissance.* Leipzig, 1938.

Waley, Arthur. *An Introduction to the Study of Chinese Painting.* 1923. Reprint. London, 1958.

———. *The Way and Its Power: A Study of the Tao Te Ching and Its Place in Chinese Thought.* 1934. Reprint. London, 1949.

Walker, John. *Bellini and Titian at Ferrara.* London, 1956.

———. "Onward and Upward with the Arts: Reflections on the Museum Profession." Unpublished manuscript.

———. *Self-portrait with Donors.* Boston and Toronto, 1974.

Walpole, Horace. *Anecdotes of Painting in England.* 4 vols. Ed. R. Wornum. 1876. Reprint. New York, 1969.

————. *Description of Strawberry Hill*. Strawberry Hill, 1784.

————. *Horace Walpole's Correspondence*. 42 vols. Ed. Wilmarth S. Lewis. New Haven, 1937–80.

Walser, Ernst. *Poggius Florentinus. Leben und Werke*. Leipzig, 1914.

Wang Sengqian. *Lun shu* [Discussing Calligraphy] in *Fa shu yao lu* [Essential Records of Calligraphy]. Ed. Zhang Yanyuan. Yishu cong bian ed. Taipei, 1968–71.

Ward, Mary Ann Jack. "The 'Accademia del Disegno' in Sixteenth Century Florence: A Study of an Artists' Institution." Ph.D. dissertation, University of Chicago, 1972.

Washington, D.C.: Dumbarton Oaks. *Handbook of the Robert Woods Bliss Collection of Pre-Columbian Art*. Washington, D.C., 1963.

Washington, D.C.: *Freer Gallery of Art*. I, *China*. Washington, D.C., 1972.

Washington, D.C.: Freer Gallery of Art. *Masterpieces of Chinese and Japanese Art*. Washington, D.C., 1976.

Washington, D.C.: National Gallery of Art. *European Paintings: An Illustrated Summary Catalogue*. Washington, D.C., 1975.

Watson, Burton (trans.). *Records of the Grand Historian of China, Translated from the Shih Chi of Ssu-Ma Ch'ien*. 2 vols. New York and London, 1968.

Watson, F. J. B. *Furniture*. The Wallace Collection Catalogues. London, 1956.

————. *The Wrightsman Collection*. 5 vols. The Metropolitan Museum of Art. Greenwich, Conn., 1966.

Watson, William. *The Genius of China*. London, 1973.

————. *Style in the Arts of China*. London, 1974.

Weiner, Sheila. *Ajanta: Its Place in Buddhist Art*. Berkeley, 1977.

Weiss, Roberto. *The Renaissance Discovery of Classical Antiquity*. Oxford, 1969.

————. *Un umanista veneziano: Papa Paolo II*. Venice and Rome, 1958.

Weitzmann, Kurt. *The Monastery of Saint Catherine at Mount Sinai: The Icons*. I, *From the Sixth to the First Century*. Princeton, 1976.

————. *Studies in Classical and Byzantine Manuscript Illumination*. Chicago and London, 1971.

Welch, Anthony. *Calligraphy in the Arts of the Muslim World*. Austin and New York, 1979.

Welch, Stuart Cary. *A King's Book of Kings*. New York, 1972.

————. *Persian Painting: Five Royal Safavid Manuscripts of the Sixteenth Century*. New York, 1976.

————. *Wonders of the Age: Masterpieces of Early Safavid Painting, 1501–1576*. Cambridge, Mass., 1979.

Wethey, Harold. *The Paintings of Titian*. 3 vols. London, 1969–75.

Wibald, Abbot of Stavelot. *Epistolae Wibaldis Abbatis* in *Patrologia Latina*. Vol. 189. Ed. J.-P. Migne. Paris, 1854.

Wilde, Johannes. *Venetian Art from Bellini to Titian*. Oxford, 1974.

Wildung, D. *Egyptian Saints: Deification in Pharaonic Egypt*. New York, 1977.

————. *Imhotep und Amenhotep*. Münchner Aegyptologische Studien, 36. Berlin, 1977.

Will, Édouard. *Histoire politique du monde hellénistique*. Vol. I. Nancy, 1966.

Willemsen, C. A. *Kaiser Friedrichs II. Triumphtor zu Capua*. Wiesbaden, 1953.

Willets, William. *Foundations in Chinese Art, from Neolithic Pottery to Modern Architecture*. London, 1965.

William of Tyre. *Historia Rerum in Partibus Transmarinis Gestarum a Tempore Successorum Mahumeth usque ad Annum Domini 1184* in *Recueil des historiens des croisades*. Vol. I/2. Paris, 1844.

Williams, L. N. and M. *Stamps of Fame*. London, 1949.

Willis, Rev. Robert. *The Architectural History of Canterbury Cathedral*. London, 1845.

———— (ed.). *Facsimile of the Sketch-book of Wilars de Honecort, an Architect of the Thirteenth Century; with Commentaries and Descriptions by M. J. B. A. Lassus and M. J. Quicherat.* London, 1859.

Wilm, Hubert. *Kunstsammler und Kunstmarkt.* Munich, 1930.

Winckelmann, Johann Joachim. *Winckelmann: Writings on Art.* Ed. David Irwin. London, 1972.

Winlock, Herbert Eustis. *Excavations at Deir el Bahri, 1911–1931.* New York, 1942.

Wittkower, Rudolf. *Gian Lorenzo Bernini.* 2nd ed. London, 1966.

————. *Gothic versus Classic: Architectural Projects in Seventeenth Century Italy.* London, 1974.

———— and Margot. *Born Under Saturn.* New York, 1963.

Wixom, William. *Treasures from Medieval France.* Exhibition catalogue. Cleveland Museum of Art, 1967.

Wolfe, Bertram. *The Fabulous Life of Diego Rivera.* New York, 1963.

Woodhouse, Charles Platten. *Investment in Antiques and Art: What, Where and How to Buy.* London, 1969.

Woolley, Sir Charles Leonard. *Excavations at Ur.* London, 1954.

————, and Mallowan, M. E. L. *Ur Excavations.* IX, *The Neo-Babylonian and Persian Periods.* London, 1962.

Wraight, Robert. *The Art Game.* London, 1965.

Wright, Arthur. *The Sui Dynasty.* New York, 1978.

Xenophon. *Memorabilia.*

Xu Hao. *Gu ji ji* [Record of Ancient Works] in *Fa shu yao lu* [Essential Records of Calligraphy]. Ed. Zhang Yanyuan. Yishu cong bian ed. Taipei, 1968–71.

Xun Zi. *Hsun Tzu: Basic Writings.* Trans. Burton Watson. New York, 1963.

Yang, Hsienyi and Gladys (trans.). *Selections from Records of the Historian.* Beijing, 1979.

Yang Xin. *Gu lai neng shu ren ming* [Names of Skilled Calligraphers from Antiquity to the Present] in *Fa shu yao lu* [Essential Records of Calligraphy]. Ed. Zhang Yanyuan. Yishu cong bian ed. Taipei, 1968–71.

Yoshida Tetsuro. *The Japanese House and Garden.* Trans. M. G. Sims. London, 1963.

Yriarte, Charles. *Rimini.* Paris, 1882.

Yu He. *Lun shu biao* [Memorial on Calligraphy] in *Fa shu yao lu* [Essential Records of Calligraphy]. Ed. Zhang Yanyuan. Yishu cong bian ed. Taipei, 1968–71.

Zanetti, Antonio Maria. *Della pittura veneziana.* 2 vols. Venice, 1797.

Zanker, Paul. *Klassizistische Statuen.* Mainz, 1974.

Zastron, Oleg. *L'oreficeria in Lombardia.* Milan, 1978.

Zhang Yanyuan. *Li dai ming hua ji* in *Some T'ang and Pre-T'ang Texts on Chinese Paintings.* Trans. and annot. William R. B. Acker. Sinica Leidensia 8. Leyden, 1954.

Zhao Xigu. *Dong tian qing lu ji.* Yishu cong bian ed. Taipei, 1968–71.

Zhu Deng. *Wei Weiqing Heng Fang bei,* A.D. 168 in *Shodō zenshū.* Vol. 2. Tokyo, 1965.

Zhu Jingxuan. *Tang chao ming hua lu.* Yishu cong bian ed. Taipei, 1968–71.

Zippel, Giuseppe. *Nicolò Niccoli.* Florence, 1890.

Zonaras, Johannes. *Annales.* 3 vols. Ed. M. Pinder. *Corpus Scriptorum Historiae Byzantinae.* Bonn, 1828–97

al-Zubayr, al-Qāḍī al Rashīd ibn. *Kitāb al-dhakhā'ir wa-l-tuḥāf.* Ed. M. Hamidullah. Kuwait, 1959.

ARTICLES AND ESSAYS

Abbot, N. "The Contribution of Ibn Muḳlah to the North Arabic Script." *American Journal of Semitic Languages and Literature,* 56 (1939).

Ackerman, James. " 'Ars sine scientia nihil est.' Gothic Theory of Architecture at the Cathedral of Milan." *Art Bulletin*, 31 (June 1949).

———. "Marcus Aurelius on the Capitoline Hill." *Renaissance News*, 10 (1957).

Adhémar, Jean. "Les Tombeaux de la collection Gaignières." *Gazette des Beaux-Arts*, 84 (July–Sept. 1974); 88 (July–Aug. 1976); 90 (July–Aug. 1977).

Ahn Hwi Joon. "An Kwon and 'A Dream Visit to the Peach Blossom Land.' " *Oriental Art*, n.s. 26, no. 1 (Spring 1980).

———. "Importation of Chinese Painting into Korea during the Koryŏ and the Early Yi Dynasties." *Yamato Bunka*, 62 (July 1967).

Alsop, Joseph. "A Condition of Enormous Improbability." *The New Yorker*, 8 March 1969.

Alsop, Stewart. "America's New Big Rich." *Saturday Evening Post*, 17 July 1965.

Anders, Ferdinand. "Der Federkasten der Ambraser Kunstkammer." *Jahrbuch der Kunsthistorischen Sammlungen in Wien*, 61 (1965).

Anon. "The Arts in Europe: The Royal Statues of Notre Dame Uncovered." *Connoisseur*, 196 (November 1977).

Anon. "Cleveland Museum Says Its Grünewald Is a Fake." *New York Times*, 28 October 1977.

Anon. "The Getty Museum: A Magnificent Inheritance." *Washington Post*, 21 June 1976.

Anon. "Italian Dealer Accused of Smuggling Hub's Raphael." *Boston Globe AM*, 28 February 1970.

Anon. "Ji pi Lin pi Kong yilai wenwu gongzuo di chongda shouhuo" [Brief Notes on the Relics Excavated During the Movement to Criticize Confucius and Lin Biao]. *Wenwu*, no. 1 (1975).

Anon. "The Maltese Falcon Revisited." *Boston Globe PM*, 12 February 1971.

Anon. "Quick Grab Shovel, Collectors Pay Lots for Ancient Bottles." *Wall Street Journal*, 9 January 1970.

Anon. "Rockefeller Center Ousts Rivera over Painting of Lenin." *New York Herald Tribune*, 10 May 1933.

Anon. "Saving the Mentmore Fragonard." *Country Life*, 163 (25 May 1978).

Anon. "Sharp-eyed Collectors Searching for Barbed Wire." *New York Times*, 5 May 1974.

Anon. "2 Museum Officials Testify on 'Raphael.' " *Boston Globe PM*, 11 February 1971.

Apolloni, B. M. "La casa dei Crescenzi nell'architettura e nell'arte di Roma medioevale." In *Il Centro di Studi di Storia dell'Architettura*. Rome, 1940.

Apple, R. W., Jr. "Record $13.4 Million Session Held in London Art Auction." *New York Times*, 23 June 1978.

Archeological Team of Beijing City. "Beijing Huairou cheng bei Dong Zhou liang Han muzang" [Eastern Zhou and Han Tombs to the North of Huairou near Beijing]. *Kaogu*, no. 5 (1962).

Archeological Team of the Bureau of Culture, Tianjin City. "Tianjin Dongjiao Zhanggui zhuang Zhan Guo mu di er ce fajue" [The Second Excavation of a Warring States Tomb at Zhanggui Zhuang in the Eastern Suburbs of Tianjin]. *Kaogu*, no. 2 (1965).

Archeological Team of the Qin Pit of Pottery Figures. "Lintong Xian Qin yongkeng shijue diyi hao jianbao" [Excavations of the Qin Dynasty Pit Containing Pottery Figures of Warriors and Horses at Lintong, Shaanxi Province]. *Wenwu*, no. 11 (1975).

Arnold, Thomas. "Mīrzā Muḥammad Ḥaydar Dughlāt on the Harāt School of Painters." *Bulletin of the School of Oriental Studies*, 5 (1930).

Ashmole, Bernard. "Cyriac of Ancona." *Proceedings of the British Academy*, 45 (1959).

———. "Cyriac of Ancona and the Temple of Hadrian at Cyzicus." *Journal of the Warburg and Courtauld Institutes*, 19 (1956).

Avena, A. "I libri del notaio veronese Bartolomeo Squarceti da Cavajon (1420)." *La bibliofilia*, 13 (1911).

Avogaro, Rambaldo degli Azzoni. "Della zecca, e delle monete ch'ebbero corso in Trivigi."

In Guid'-Antonio Zanetti, *Nuova raccolta delle monete e zecche d'Italia.* Vol. IV. Bologna, 1786.

Babinger, F. "Mehmed der Eroberer in östlicher und westlicher Beleuchtung." *Südost-Forschungen*, 22 (1963).

Badawy, Alexander. "The Stela of Irtysen." *Chronique d'Égypte*, 35 (July 1961).

Badian, E. "Rome and Antiochus the Great." *Classical Philology*, 54 (1959).

Bandmann, Günter. "Die Vorbilder der Aachener Pfalzkapelle." In *Karl der Grosse.* III, *Karolingische Kunst.* Düsseldorf, 1965.

Barkova, L. L. "The Frozen Tombs of the Altai." In *Frozen Tombs: The Culture and Art of the Ancient Tribes of Siberia.* Exhibition catalogue. British Museum. London, 1978.

Barnhart, Richard. "Li Kung-Lin's Use of Past Styles." In *Artists and Traditions.* Ed. Christian F. Murck. Princeton, 1976.

Barocchi, Paola: "Collectionismo dal Vasari al Lanzi." In *Storica dell' Arte Italiana.* Vol. 2. Turin, 1979.

Barthélemy, Anatole de. "Liste des noms d'hommes gravés sur les monnaies de l'époque mérovingienne." *Bibliothèque de l'École de Chartes*, 42 (1881).

Bellaigue, Geoffrey de. "George IV and French Furniture." *Connoisseur*, 195 (June 1977).

Benaducci, G. "Prose e poesie volgari di Francesco Filelfo." *Atti e memorie della R. Deputazione di Storia Patria per le Province delle Marche*, 5 (1901).

Benedetto, Filippo di. "Learzio, Omero e le 'Pandette.'" *Italia medioevale e umanistica*, 12 (1969).

Beumann, H. "Grab und Thron Karls des Grossen zu Aachen." In *Karl der Grosse.* IV, *Das Nachleben.* Düsseldorf, 1967.

Bieber, M. "Pliny and Graeco-Roman Art." In *Hommages à Joseph Bidez et Franz Cumont.* Brussels, 1949.

Biermann, H. "Das Palastmodell Giuliano da Sangallos für Ferdinand I, König von Neapel." *Wiener Jahrbuch für Kunstgeschichte*, 23 (1970).

Billanovich, Giuseppe. "Gli umanisti e le cronache medioevali." *Italia medioevale e umanistica*, 1 (1958).

Binyon, Laurence. "A Chinese Painting of the Fourth Century." *Burlington Magazine*, 4 (January 1904).

Bissing, W. F. von. "Das Verhältnis des Ibi-Grabes in Theben zu dem Ibi-Grabe von Deir el Gebrâwi." *Archiv für Orientforschung*, 3 (March–June 1926).

Blank, Horst. "Eine persische Pinselzeichnung nach der Tazza Farnese." *Archäologischer Anzeiger*, 79, 2 (1962).

Blumer, Marie-Louise. "Catalogue des peintures transportées d'Italie en France de 1796 à 1814." *Bulletin de la Société de l'Histoire de l'Art Français*, fasc. 2 (1936).

Bol, Peter Cornelius. "Die Skulpturen des Schiffsfundes von Antikythera." *Mitteilungen des deutschen Archäologischen Instituts. Athenische Abteilung*, Beiheft 2 (1972).

Bonnaffé, Edmond. "Sabba da Castiglione." *Gazette des Beaux-Arts*, 30 (1884).

Borenius, Tancred. "The Cycle of Images in the Palaces and Castles of Henry III." *Journal of the Warburg and Courtauld Institutes*, 6 (1943).

———. "The Rediscovery of the Primitives." *Quarterly Review*, no. 475 (April 1923).

Borgo, Ludovico. "Giuliano da Maiano's Santa Maria del Sasso." *Burlington Magazine*, 114 (1972).

Borsook, Eve. "Documents for Filippo Strozzi's Chapel in Santa Maria Novella and Other Related Papers." *Burlington Magazine*, 112 (1970).

———. "Notizie su due capelle in Santa Croce a Firenze." *Rivista d'arte*, 36 (1961–62).

Bothmer, Bernard V. "A New Fragment of an Old Palette." *Journal of the American Research Center in Egypt*, 8 (1969–70).

Bovini, G. "Le vicende del 'Regisole' statua equestre ravennate." *Felix Ravenna*, ser. 3, 36 (1963).

Boyer, Ferdinand. "Napoléon et les collections d'antiques en Italie." *Information Historique*, 21 (January–February 1959).

———. "Les Responsabilités de Napoléon dans le transfert à Paris des oeuvres d'art de l'étranger." *Revue d'Histoire Moderne et Contemporaine*, 11 (October–December 1964).

Braunfels, Wolfgang. "I quadri di Tiziano nello studio a Biri Grande (1530–1576)." In *Tiziano e Venezia*. Convegno Internazionale di Studi, Venezia 1976. Vicenza, 1980.

———. "Karls des Grossen Bronzewerkstatt." In *Karl der Grosse*. III, *Karolingische Kunst*. Düsseldorf, 1965.

Brown, Clifford M. "Cardinal Francesco Gonzaga's Collection of Antique Intagli and Cameos: Questions of Provenance, Identification and Dispersal." Unpublished paper.

———. "The Grotta of Isabella d'Este." *Gazette des Beaux-Arts*, 89 (1977); 91 (1978).

———. " 'Lo insaciabile desiderio nostro de cose antique:' New Documents on Isabella d'Este's Collection of Antiquities." In *Cultural Aspects of the Italian Renaissance: Essays in Honour of Paul Oskar Kristeller*. Ed. Cecil H. Clough. Manchester, 1976.

———. "Little Known and Unpublished Documents Concerning Andrea Mantegna, Bernardino Parentino, Pietro Lombardo, Leonardo da Vinci and Filippo Benintendi." *L'arte*, 7/8 (1969).

Brun, Robert. "Notes sur le commerce des objets d'art en France et principalement à Avignon à la fin du XIVe siècle." *Bibliothèque de l'École des Chartes*, 95 (1934).

Buddensieg, Tilmann. "Gregory the Great, the Destroyer of Pagan Idols." *Journal of the Warburg and Courtauld Institutes*, 28 (1965).

Bürger (Thoré-Bürger), W. "Van Der Meer de Delft." *Gazette des Beaux-Arts*, 21 (October–December 1866).

Bulst, Wolfger. "Die ursprüngliche innere Aufteilung des Palazzo Medici in Florenz." *Mitteilungen des Kunsthistorischen Institutes in Florenz*, 14 (1970).

Burger, Richard. "The Moche Sources of Archaism in Chimu Ceramics." *Nawpa Pacha*, 4 (1976).

Buschhausen, Helmut. "The Klosterneuberg Altar of Nicholas of Verdun: Art, Theology and Politics." *Journal of the Warburg and Courtauld Institutes*, 37 (1974).

Bush, Susan. "Two Fifth-Century Texts on Landscape Painting and the 'Landscape Buddhism' of Mount Lu." Paper written for an ACLS-sponsored conference on "Theories of the Arts in China," June 6–12, 1979. Forthcoming.

Byrne, Eugene. "Some Medieval Gems and Relative Values." *Speculum*, 10 (1935).

Cahill, James. "Collecting Paintings in China." *Arts Magazine*, 37 (April 1963).

———. "The Six Laws and How to Read Them." *Ars Orientalis*, 4 (1961).

Caley, Earl R. "Chemical Composition of Greek and Roman Statuary Bronzes." In *Art and Technology: A Symposium on Classical Bronzes*. Ed. S. Doeringer, D. G. Mitten, A. Steinberg. Cambridge, Mass., 1970.

Campbell, Lorne. "The Art Market in the Southern Netherlands in the Fifteenth Century." *Burlington Magazine*, 118 (April 1976).

Carley, William. "Some of the Looters of Archaeological Sites Now Turn to Murder." *Wall Street Journal*, 30 November 1971.

Carritt, David. "The Case for the Lost Psyche." *The Times*, 2 July 1977.

Cecchetti, B. "Libri, scuole, maestri, sussidii allo studio in Venezia nei secoli XIV e XV." *Archivio veneto*, 32 (1886).

Chaffer, Norman. "Bower Building and Display of the Satin Bower-bird." *Australian Zoologist*, 12 (1959).

Chang, K. C. "The Chinese Bronze Age, a Modern Synthesis." In *The Great Bronze Age of China*. Ed. Wen Fong. New York, 1980.

————. "Pre-historic and Shang Pottery Incriptions: An Aspect of the Early History of Writing and Calligraphy." Draft paper.

Chastel, André. "Vasari et la légende médicíenne: l'école du jardin de Saint-Marc." In *Studi vasariani.* Atti del Convegno per il IV Centenario della Prima Edizione delle "Vite" del Vasari 1950. Florence, 1952.

Chiappelli, L. "Una notevole libreria napoletana del Trecento." *Studi medievali*, n.s.1 (1928).

Chiarini de Anna, Gloria. "Leopoldo de' Medici e la sua raccolta di disegni nel Carteggio d'Artisti dell'Archivio di Stato di Firenze." *Paragone*, 26 (1975).

Clark, J. Desmond. "Africa in Prehistory: Peripheral or Paramount." *Man*, n.s. 10 (1975).

————. "African Origins of Man the Toolmaker." In *Human Origins*. Ed. G. Isaac and E. McCown. Perspectives of Human Evolution 3. Menlo Park, Calif., 1970.

Claussen, P. C. "Antike und gotische Skulptur in Frankreich um 1200." *Wallraf-Richartz-Jahrbuch*, 25 (1973).

Cocks, Anna Somers. "The Myth of 'Burgundian' Goldsmithing." *Connoisseur*, 194 (March 1977).

Coe, Michael. "Olmec and Maya: A Study in Relationships." In *The Origins of Maya Civilization*. Ed. R. E. W. Adams. Albuquerque, 1977.

Coedès, George. "La Stèle du Práh Khăn D'Ańkor." *Bulletin de l'École Française d'Extrême-Orient*, 41 (1941).

————. "La Stèle de Ta-Prohm." *Bulletin de l'École Française d'Extrême-Orient*, 6 (1906).

Cole, Bruce. "The Interior Decoration of the Palazzo Datini in Prato." *Mitteilungen des Kunsthistorischen Institutes in Florenz* 13 (1967–68).

————, and Middeldorf, Ulrich. "Masaccio, Lippi, or Hugford." *Burlington Magazine*, 113 (September 1971).

Compton, Michael. "William Roscoe and Early Collectors of Italian Primitives." *Liverpool Bulletin*, 9 (1960–61).

Connell, S. "Books and Their Owners in Venice, 1345–1480." *Journal of the Warburg and Courtauld Institutes*, 35 (1972).

Conti, Alessandro. "Francesco Petrarca e Madonna Laura: uno strano ritratto." *Prospettiva*, 5 (April 1976).

Conway, W. Martin. "The Abbey Church of Saint-Denis and Its Ancient Treasures." *Archaeologia*, 66, 2nd ser. 16 (1914–15).

Corti, Gino. "Sul commercio dei quadri a Firenze verso la fine del secolo XIV." *Commentari*, 22 (Jan.–March 1971).

————, and Hartt, Frederick. "New Documents Concerning Donatello, Luca and Andrea Della Robbia, Desiderio, Mino, Uccello, Pollaiuolo, Filippo Lippi, Baldovinetti, and Others." *Art Bulletin*, 44 (June 1962).

Costello, Jane. "The Twelve Pictures 'Ordered by Velasquez' and the Trial of Valguarnera." *Journal of the Warburg and Courtauld Institutes*, 13 (1950).

Covi, Dario. "Lettering in Fifteenth Century Florentine Painting." *Art Bulletin*, 45 (1963).

Creel, H. G. "The Role of the Horse in Chinese History." In *What is Taoism? And Other Studies in Chinese Cultural History*. Chicago and London, 1970.

Cullinan, Helen. "Museum's Prize Termed a Fake." *Cleveland Plain-Dealer*, 28 October 1977.

Cust, L. "The Painter H.E. ('Hans Eworth')." *Walpole Society*, 2 (1912–13).

David, Sir Percival. "The Shōsōin." *Transactions and Proceedings of the Japan Society*, 28 (1932).

Davis, Frank. "Horses from the Tomb." *Country Life*, 164 (19 October 1978).

Demus, Otto. "Neue Funde an den Emails des Nikolaus von Verdun in Klosterneuberg." *Oesterreichische Zeitschrift für Kunst und Denkmalpflege*, 5 (1951).

De Rossi, Giovanni Battista. "Le prime raccolte d'antiche iscrizioni compilate in Roma tra il finir del secolo XIV, ed il cominciare del XV." *Giornale arcadico*, 127 (April–June 1852).

Dezzi Bardeschi, M. "Il complesso monumentale di S. Pancrazio a Firenze ed il suo restauro." *Quaderni dell'Istituto di Storia dell'Architettura*, ser. 13, 73–78 (1966).

Dien, Albert E. "Excavations of the Ch'in Dynasty Pit Containing Pottery Figures of Warriors and Horses at Lin-tung, Shensi Province." *Chinese Studies in Archaeology*, 1 (Summer 1979).

———. "First Report on the Exploratory Excavations of the Ch'in Pit of Pottery Figures at Lin-t'ung hsien." *Chinese Sociology and Anthropology*, 10 (Winter 1977–78).

———, and Reigel, Jeffrey. Abstract of excavation report. *Early China*, 3 (1977).

Dimier, L. "Benvenuto Cellini à la cour de France." *Revue Archéologique*, 1 (1898).

———. "Une Pièce inédite sur le séjour de Benvenuto Cellini à la cour de France." *Revue Archéologique*, 2 (1902).

Doi Keizo. "Shōsōin Yakushu no Shiteki Ronsatsu" [Medicines in Ancient Japan: Study of Some Drugs Preserved in the Imperial Treasure House at Nara]. *Neiraku (Nara)*, 15 (1932).

Donath, Adolph. "Psychologie des Kunstsammelns." *Bibliothek für Kunst- und Antiquitätensammler*, 9 (1911).

D'Onofrio, Cesare. "Priorità della biografia di Domenico Bernini su quella del Baldinucci." *Palatino*, 9 (1966).

Driscoll, Edgar J., Jr. "Raphael's Eleonora Awaits Italy's Move." *Boston Globe*, 28 March 1971.

Duchesnes, L. "L'Auteur des Mirabilia." *Mélanges d'Archéologie et d'Histoire*, 24 (1904).

Durant, David. "The Men Who Built Hardwick." *National Trust*, 29 (Spring 1978).

Eckman, Fern Marja. "Stolen Statue of Shiva Bought by Simon." *New York Post*, 11 May 1973.

Edwards, Stephen. "Non-utilitarian Activities in the Lower Paleolithic: A Look at Two Kinds of Evidence." *Current Anthropology*, 19 (1978).

Eiche, Sabine. "The Return of Baldassare Castiglione." *Burlington Magazine*, 123 (March 1981).

Einem, Herbert von. "Michelangelo und die Antike." In *Stil und Überlieferung: Aufsätze zur Kunstgeschichte des Abendlandes*. Ed. T. W. Gaehtgens and R. Hauserr. Düsseldorf, 1971.

Esch, Arnold. "Spolien. Zur Wiederverwendung antiker Baustücke und Skulpturen im mittelalterlichen Italien." *Archiv für Kulturgeschichte*, 51 (1969).

Evan, William. "Role Strain and the Norm of Reciprocity in Research Organization." *American Journal of Sociology*, 68 (1962).

Evans, J. A. S. "Redating Prehistory in Europe." *Archaeology*, 30 (March 1977).

Evans, Joan. "Die Adlervase des Sugerius." *Pantheon*, 10 (1932).

Fabriczy, C. von. "Giuliano da Maiano." *Jahrbuch der königlich Preussischen Kunstsammlungen*, 24, Beiheft (1903).

———. "Giuliano da Sangallo." *Jahrbuch der königlich Preussischen Kunstsammlungen*, 23, Beiheft (1902).

Fasola, Giusta Nicco. "Luigi Lanzi, C. Giuseppe Ratti e la pittura genovese." In *Miscellanea di storia ligure in onore di Giorgio Falco*. Milan, 1962.

Fedele, P. "Il culto di Roma nel medio evo e la casa di Niccolò di Crescenzio." In *Il Centro di Studi di Storia dell'Architettura*. Rome, 1940.

———. "Sul commercio delle antichità in Roma nel XII secolo." *Archivio della Società Romana di Storia Patria*, 32 (1909).

Ferrante, Giuseppina. "Lombardo della Seta umanistica padovano." *Atti del Real Istituto Veneto di Scienze, Lettere ed Arti*, 92, 2 (1933–34).

Fleming, John. "The Hugfords of Florence. Part II. With a Provisional Catalogue of the Collection of Ignazio Enrico Hugford." *Connoisseur*, 136 (November 1955).

Fletcher, J. M. "Isabella d'Este and Giovanni Bellini's Presepio." *Burlington Magazine*, 113 (December 1971).

Florencourt, Chassot von. "Der gesteinigte Venustorso zu St. Matthias bei Trier." *Jahrbuch des Vereins von Alterthumsfreunden im Rheinlande*, 13 (1848).

Foffano, Tino. "Niccoli, Cosimo e le ricerche di Poggio nelle biblioteche francesi." *Italia medioevale e umanistica*, 12 (1969).

Fong, Wen. "Archaism as a 'Primitive' Style." In *Artists and Traditions*. Ed. Christian F. Murck. Princeton, 1967.

———. "The Problem of Forgeries in Chinese Painting: Part One." *Artibus Asiae*, 22 (1965).

Ford, Brinsley, "Thomas Jenkins: Banker, Dealer and Unofficial English Agent." *Apollo*, 99 (June 1974).

Forlati Tamaro, Bruna. "Nuovi ipotesi sui cavalli di S. Marco." *Rendiconti degli atti della Pontificia Accademia Romana di Archeologia*, ser. III, 37 (1964–65).

Foshag, William. "Mineralogical Studies of Guatemalan Jade." *Smithsonian Miscellaneous Collections*, 135 (December 1957).

Foti, Giuseppe. "Relitti di navi greche e romane nei mari della Calabria." *Calabria turismo*, 18 (October–December 1973).

Frankel, Hans. "Poetry and Painting: Chinese and Western Views of Their Convertibility." *Comparative Literature*, 9 (Fall 1957).

Frantz, Alison. "From Paganism to Christianity in the Temples of Athens." *Dumbarton Oaks Papers*, 19 (1965).

———. "Pagan Philosophers in Christian Athens." *Proceedings of the American Philosophical Society*, 119 (February 1975).

Frederickson, B., and Hladka, A. "New Information on Raphael's 'Madonna di Loreto.' " *J. Paul Getty Museum Journal*, no. 3 (1976).

Frothingham, A. L., Jr. "Byzantine Artists in Italy from the Sixth to the Fifteenth Century." *American Journal of Archaeology*, 9 (1894).

Gage, Nicholas. "Met Finds Vase Purchase 'Legal.' " *New York Times*, 7 March 1974.

Gallo, Rodolfo. "Le donazioni alla Serenissima di Domenico e Giovanni Grimani." *Archivio veneto*, ser. 5, 82, nos. 85–86 (1953).

Gardner, Julian. "The Decoration of the Baroncelli Chapel in Santa Croce." *Zeitschrift für Kunstgeschichte*, 34 (1971).

Gargan, Luciano. "Cultura e arte a Treviso al tempo di Tomaso." In *Tomaso da Modena*. Exhibition catalogue. Treviso, 1979.

———. "La cultura umanistica a Treviso nel Trecento." In *Tomaso da Modena e il suo tempo*. Treviso, 1980.

———. "Oliviero Forzetta e la diffusione dei testi classici nel Veneto al tempo del Petrarca." In *Classical Influences on European Culture A.D. 500–1500*. Ed. R. R. Bolgar. Cambridge, 1971.

Gauchery, Paul. "Le Palais du Duc Jean et la Sainte-Chapelle de Bourges. Nouᵛ aux documents sur leur état primitif, leur mutilation, ou leur destruction." *Mémoires de la Société des Antiquaires du Centre*, 39 (1919–20).

Gibbons, Felton. "Practices in Giovanni Bellini's Workshop." *Pantheon*, 23 (1965).

Gilbert, Creighton. "Cecco d'Ascoli e la pittura di Giotto." *Commentari*, 24 (January–June 1973).

Gilbert, Neal. "A Letter of Giovanni Dondi dall'Orologio to Fra Guglielmo Centueri: A

Fourteenth Century Episode in the Quarrel of the Ancients and Moderns." *Viator*, 8 (1977).

Gloria, A. "I due orologi meravigliosi inventati da Jacopo e Giovanni Dondi." *Atti del R. Istituto Veneto di Scienze, Lettere ed Arti*, 54 (1895/96); 55 (1896/97).

Glueck, Grace. "Boston Aide Quits in Dispute." *New York Times*, 18 December 1971.

Goldthwaite, Richard. "The Florentine Palace as Domestic Architecture." *American Historical Review*, 77 (October 1972).

Gombrich, E. H. "Art Transplant." *New York Review of Books*, 12 (19 June 1969).

———. "Botticelli's Mythologies: A Study in the Neoplatonic Symbolism of his Circle." *Journal of the Warburg and Courtauld Institutes*, 8 (1945).

———. "The Early Medici as Patrons of Art." In *Italian Renaissance Studies. A Tribute to the Late Cecilia M. Ady*. Ed. E. F. Jacob. London, 1960. Reprinted in *Norm and Form*. London, 1966.

———. "From the Revival of Letters to the Reform of the Arts: Niccolò Niccoli and Filippo Brunelleschi." In *The Heritage of Apelles*. Oxford, 1976.

———. "The Renaissance Concept of Artistic Progress and Its Consequences." In *Norm and Form*. London, 1966.

Gould, Cecil. "Afterthoughts on Raphael's So-called Loreto Madonna." *Burlington Magazine*, 122 (May 1980).

———. "The Raphael Portrait of Julius II." *Apollo*, 92 (1970).

Grimme, E. G. "Der Aachener Domschatz." *Aachener Kunstblätter*, 42, 2nd ed. (1973).

Grummond, Nancy T. de. "A Seventeenth-Century Book on Classical Gems." *Archeology*, 30 (January 1977).

Guo Moruo. "Gudai wenzi zhi bianzheng di fazhan" [A Demonstration of the Development of Ancient Writing]. *Kaogu*, no. 3 (1972).

———. "Xinjiang xin chutu di Jin ren xieben 'San Guo Zhi' can zhuan" [A Fragmentary Manuscript of "The Three Kingdoms" of the Jin Period Recently Excavated in Xinjiang]. *Wenwu*, no. 8 (1972).

———. "You Wang Xie muzhi di chutu landao Lan Ting xu di zhen wei" [The Authenticity of the Lan Ting Preface in Light of the Epitaphs of Wang Xingzhi and Xie Kun]. *Wenwu*, no. 6 (1965).

Guralnick, Eleanor. "Kouroi, Canon and Men: A Computer Study of Proportions." *Computer Studies in the Humanities and Verbal Behavior*, 4 (1973).

Habachi, Labib. "Varia from the Reign of King Akhenaten." *Mitteilungen des deutschen Archäologischen Instituts. Abteilung Kairo*, 20 (1965).

Hadley, Rollin van N. "What Might Have Been: Pictures Mrs. Gardner Did Not Acquire." In *Fenway Court 1979*. Boston, 1980.

Halm, P. "Das unvollendete Fresko des Filippino Lippi in Poggio a Caiano." *Mitteilungen des Kunsthistorischen Institutes in Florenz* 7 (1931).

Hamann-MacLean, R. "Antikenstudium in der Kunst des Mittelalters." *Marburger Jahrbuch für Kunstwissenschaft*, 15 (1949/50).

Hamberg, P. G. "The Villa of Lorenzo il Magnifico at Poggio a Caiano and the Origin of Palladianism." In *Idea and Form*. Ed. Åke Bengtsson. Stockholm, 1959.

Han Chuang (John Hay). "Hsiao I Gets the Lan-t'ing Manuscript by a Confidence Trick." *National Palace Museum Bulletin*, 5, no. 3 (July–August 1970); no. 6 (January–February 1971).

Harada Jiro. "Chronological Reference Table." In *English Catalogue of Treasures in the Imperial Repository Shōsōin*. Tokyo, 1932.

Hartig, O. "Die Kunsttätigkeit in München unter Wilhelm IV. und Albrecht V. 1520–1579." *Münchner Jahrbuch*, n.s. 10 (1933).

Haskell, Francis. "Consul Smith and His Patronage." *Apollo*, 82 (August 1965).

————. "Reinventing the Eighteenth Century." *New York Review of Books*, 27 (9 October 1980).

Hatfield, Rab. "Some Unknown Descriptions of the Medici Palace in 1459." *Art Bulletin*, 52 (1970).

Hayer, William. "Varia from the Time of Hatshepsut." *Mitteilungen des deutschen Archäologischen Instituts. Abteilung Kairo*, 15 (1957).

Hayward, J. F. "Jacopo da Strada, XVI Century Antique Dealer." In *Art at Auction. The Year at Sotheby Parke Bernet 1971–72*. New York, 1973.

Hearn, Maxwell. "The Terracotta Army of the First Emperor of Qin (221–206 B.C.)." In *The Great Bronze Age of China*. Ed. Wen Fong. New York, 1980.

Hecht, Ilse. "The Infants Christ and St. John Embracing: Notes on a Composition by Joos van Cleve." *Apollo*, 113 (April 1981).

Heckscher, W. "Dornauszieher." In *Reallexikon zur deutschen Kunstgeschichte*. Ed. Otto Schmitt. Vol. IV. Stuttgart, 1958.

————. "Relics of Pagan Antiquities in Medieval Settings." *Journal of the Warburg Institute*, 1 (1937/38).

Heikamp, Detlef. "La Tribuna degli Uffizi come era nel Cinquecento." *Antichità viva*, 3 (1964).

————, and Anders, Ferdinand. "Mexikanische Altertümer aus süddeutschen Kunstkammern." *Pantheon*, 28 (May–June 1970).

Herlihy, David. "Treasure Hoards in the Italian Economy 960–1139." *Economic History Review*, ser. 2, 10, (1957).

Herrmann, Frank. "Who Was Solly?" *Connoisseur*, 164 (April 1967); 165 (May 1967); 165 (July 1967); 166 (September 1967); 169 (September 1968).

Hersey, G. "Poggioreale: Notes on a Reconstruction and an Early Replication." *Architectura* (1973).

Ho Ping-Ti. "The Salt Merchants of Yang-Chou: A Study of Commercial Capitalism in Eighteenth Century China." *Harvard Journal of Asiatic Studies*, 17 (1954).

Hoffman, Harmut. "Die Aachener Theoderichstatue." In *Das erste Jahrtausend*. Ed. V. H. Elbern. Düsseldorf, 1962.

Hofmann, Paul. "Team of Italians to Examine Vase." *New York Times*, 12 March 1974.

Horiike Haruo. "Shōsōin no Nusubito" [Shōsōin Robbers]. *Rekishi Hyōron*, 109 (September 1959).

Horne, Herbert. "The Battle Piece by Paolo Uccello in the National Gallery." *Monthly Review*, 5 (1901).

Howells, William. "Hawaiian Crested Helmet." In *Masterpieces of the Peabody Museum*. Exhibition catalogue. Harvard University. Cambridge, Mass., 1978.

————. "Hawaiian Feather Cape." In *Masterpieces of the Peabody Museum*. Exhibition catalogue. Harvard University. Cambridge, Mass., 1978.

Hsu Kai-Yu. "The Poems of Li Ch'ing Chao (1084–1141)." *Publications of the Modern Language Association*, 77 (December 1962).

Huang Siu-Chi. "Musical Art in Early Confucian Philosophy." *Philosophy East and West*, 13 (April 1963).

Huard, M. Georges. "Alexandre Lenoir et les 'Esclaves' de Michel-Ange." In *Mélanges en hommage à la mémoire de Fr. Martroye*. Paris, 1940.

Hubala, E. "Ein Entwurf für das Antiquarium der Münchner Residenz 1568." *Münchner Jahrbuch*, ser. 3, 9/10 (1958/59).

Hughes, Robert. "Softer De Koonings." *Time*, 6 March 1978.

Huntington, David C. "Church and Luminism: Light for America's Elect." In *American Light, the Luminist Movement 1850–1875*. Ed. John Wilmerding et al. Exhibition catalogue. National Gallery of Art. Washington, D.C., 1980.

Hutchinson, G. E. "Marginalia." *American Scientist*, 40, no. 1 (1952).

Hyman, I. "Notes and Speculations on S. Lorenzo, Palazzo Medici, and an Urban Project by Brunelleschi." *Journal of the Society of Architectural Historians*, 34 (1975).

Iijima Isamu. "Torige Ritsujo Byōbu ni Atarashitaru Shiron o Kuwaete" [Again on the Screen "Figures of Ladies Decorated with Bird's Feathers"]. *Museum*, 113 (August 1960).

————. "Torige Ritsujo Byōbu no Mondai Ten" [Some Problems Concerning the Screen "Figures of Ladies Decorated with Bird's Feathers"]. *Museum*, 105 (December 1959).

————. "Torige Ritsujo Byōbu Sairon" [Again on the Screen "Figures of Ladies Decorated with Bird's Feathers" in the Shōsōin]. *Museum*, 106 (January 1960).

Inal, Güner. "Artistic Relationship Between the Far and the Near East as Reflected in the Miniatures of the Ğāmi' al-Tawārīḫ." *Kunst des Orients*, 10 (1975).

Jacob, E. F. "Some Aspects of Classical Influence in Mediaeval England." In *Vorträge der Bibliothek Warburg 1930/31*. Leipzig, 1932.

Jenkins, A. D. Fraser. "Cosimo de' Medici's Patronage of Architecture and the Theory of Magnificence." *Journal of the Warburg and Courtauld Institutes*, 33 (1970).

Jenkins, R. J. H. "The Bronze Athena at Byzantium." *Journal of Hellenic Studies*, 67 (1947).

Jensen, Chris. "Fake!" *Cleveland Plain-Dealer*, Sunday Magazine, 5 March 1978.

Joannides, Paul. "Michelangelo's Lost Hercules." *Burlington Magazine*, 119 (August 1977).

Joppi, Vincenzo. "Inventario delle cose preziose lasciate dal Patriarca d'Aquileia." *Archivio storico Trieste: l'Istria e il Trentino*, 1 (1881/82).

Kahsnitz, Rainer. "Barbarossa's *Armilla*." *Connoisseur*, 199 (November 1978).

Kameda Tsutomu. "Mafu Sumi-e Bosatzu Zō to Ninnō-e" [An Image of Bosatsu in the Shōsōin and the Ninnō-e Rite]. *Kokka*, 659, 660 (1947).

Kanamori Jun. "Shōsōin Gigakumen ni Tsuite" [On the Ancient Dance Masks in the Collection of the Shōsōin Imperial Repository]. *Kokka*, 552, 553 (November–December 1936).

Karlgren, Bernhard. "The Early History of the Chou Li and Tso Chuan Texts." *Bulletin of the Museum of Far Eastern Antiquities*, 1 (Stockholm, 1929).

Kidder, A. V. Division of Historical Research. *Annual Report of the Chairman of the Division of Historical Research, Carnegie Institution of Washington Year Book* 46 (1946–47).

Kitzinger, Ernst. "The Byzantine Contribution to Western Art of the Twelfth and Thirteenth Centuries." *Dumbarton Oaks Papers*, 20 (1966).

Klimburg-Salter, Deborah E. "A Sufi Theme in Persian Painting: The Diwan of Sultan Ahmad Gala'ir in the Freer Gallery of Art, Washington, D.C." *Kunst des Orients*, 11 (1976/77).

Kobayashi Taichiro. "Shōsōin no Kigen" [On the Origin of the Shōsōin]. *Kokka*, 659 (1947).

Koch, Herbert. "Bronzestatue in Barletta." *Antike Denkmäler*, 3 (1912–13).

Kosegarten, Antje Middeldorf. "The Origins of Artistic Competitions in Italy." In *Lorenzo Ghiberti nel suo tempo*. Atti del convegno 1978. Florence, 1980.

Kotkin, Joel. "The Problems of Having $720 Million." *Washington Post*, 6 February 1977.

Koven, Ronald. "Broken: Art-Theft Pipeline." *Washington Post*, 18 April 1979.

Kramer, Hilton. "Altering of Smith's Work Stirs Dispute." *New York Times*, 13 September 1974.

————. "Art: De Kooning of East Hampton." *New York Times*, 10 February 1978.

————. "Questions Raised by Art Alteration." *New York Times*, 14 September 1974.

Krautheimer, Richard. "Carolingian Revival of Early Christian Architecture." *Art Bulletin*, 24 (1942).

————. "Ghiberti and Master Gusmin." *Art Bulletin*, 29 (March 1947).

Krautheimer-Hess, Trude. "More Ghibertiana." *Art Bulletin*, 46 (1964).

Kriegsman, Alan. "Boston's Raphael Smuggled?" *Washington Post*, 8 January 1971.

Kristeller, P. O. "Lay Religious Traditions and Florentine Platonism." In *Studies in Renaissance Thought and Letters*. Rome, 1956.

Kurkjian, Stephen. "Italy Probes Boston Painting." *Boston Globe AM*, 23 January 1970.

Lamy, M. "La Découverte des primitifs italiens au XIXe siècle, Seroux d'Agincourt et son influence sur les collectionneurs, critiques et artistes français." *La Revue de l'Art, Ancien et Modern*, 39, no. 224 (March 1921); 40, no. 229 (September–October 1921).

Lawton, Thomas. "An Introduction to the Sian Pei-Lin ('Forest of Stelae')." Paper at Symposium on Chinese Calligraphy at Yale University, 8–10 April 1977.

Lazzarini, Vittorio. "I libri, gli argenti, le vesti di Giovanni Dondi dall'Orologio." *Bollettino del Museo Civico di Padova*, n.s. 1 (1925).

Le Blant, Edmond. "De quelques statues cachées par les anciens." *Mélanges d'Archéologie et d'Histoire*, 10 (1890).

Ledderose, Lothar. "Die kaiserliche Sammlung als Instrument der Kunstpolitik in China." In *Zeitschrift der deutschen morgenländischen Gesellschaft*. Supplement III.2. *XIX. deutscher Orientalistentag*. Wiesbaden, 1977.

Lee, Sherman E. "Mu-ch'i." In *Encyclopedia of World Art*. Vol. X. New York, 1965.

Lehmann, P. W. "Cyriacus of Ancona's Visit to Samothrace." In *Samothracian Reflections*. Princeton, 1973.

Lerner, Martin. "Shiva, Lord of Dance." *Connoisseur*, 193 (November 1976).

Lestoquoy, J. "Le Commerce des oeuvres d'art au Moyen Âge." *Annales d'Histoire Sociale*, 3 (1943).

Lethaby, W. R. "English Primitives. The Painted Chamber and the Early Masters of the Westminster School." *Burlington Magazine*, 8 (July 1905).

———. "The English Primitives—VIII." *Burlington Magazine*, 33 (July 1918).

Levin, Kim. "The Male Figure in Egyptian and Greek Sculpture of the Seventh and Sixth Centuries B.C." *American Journal of Archaeology*, 68 (1964).

Lewis, Wilmarth S. "The Genesis of Strawberry Hill." *Metropolitan Museum Studies*, 5 (1934–36).

Lightbown, Ronald W. "Oriental Art and the Orient in Late Renaissance and Baroque Italy." *Journal of the Warburg and Courtauld Institutes*, 32 (1969).

Lindsey, Robert. "Getty Museum Ponders How to Spend $800 Million." *New York Times*, 9 January 1978.

Lippold, Georg. "Copie e copisti." In *Enciclopedia dell'arte antica*. Vol. II. Rome, 1959.

———. "Die griechische Plastik." In *Handbuch der Archäologie*. Ed. Walter Otto and Reinhard Herbig. No. 5, vol. III. 1. Munich, 1950.

Loehr, Max. "Chinese Painting." In *Catalogue of the Exhibition of Chinese Calligraphy and Painting in the Collection of John M. Crawford, Jr.* Ed. Laurence Sickman et al. New York, 1962.

———. "Chinese Paintings with Sung Dated Inscriptions." *Ars Orientalis*, 4 (1961).

———. "The Question of Individualism in Chinese Art." *Journal of the History of Ideas*, 22, no. 2 (April–June 1961).

———. "Some Fundamental Issues in the History of Chinese Painting." *Journal of Asian Studies*, 23, no. 2 (February 1964).

Longhi, Roberto. "Proposte per una critica d'arte." *Paragone*, 1 (1950).

Lorey, Eustache de. "L'École de Tabriz: l'Islam aux prises avec la Chine." *Revue des Arts Asiatiques*, 9 (1935).

Love, Iris. "A Preliminary Report of the Excavations at Knidos, 1969." *American Journal of Archaeology*, 74 (1970).

Lugt, Frits. "Italiaansche kunstwerken in Nederlandsche verzamelingen van vroeger tijden." *Oud Holland,* 53 (1936).

Lui Shou Kwan. "The Six Canons of Hsieh Ho Re-examined by a Contemporary Chinese Painter." *Oriental Art,* 17, nos. 2 and 3 (Summer, Autumn 1971).

Luzio, Alessandro. "Ancora Leonardo da Vinci e Isabella d'Este." *Archivio storico dell'arte,* 1 (1888).

——. "Federico Gonzaga ostaggio alla corte di Giulio II." *Archivio della Società Romana di Storia Patria,* 9 (1886).

——. "Isabella d'Este e due grandi quadri di Giorgione." *Archivio storico dell'arte,* 1 (1888).

——. "Isabella d'Este e il sacco di Roma." *Archivio storico lombardo,* 9/10 (1908).

——. "Lettere inedite di Fra Sabba da Castiglione." *Archivio storico lombardo,* ser. 2, 13 (1886).

——. "Il lusso d'Isabella d'Este." *Nuova antologia,* 63 (1896).

Lynch, James B., Jr. "The History of Raphael's Saint George in the Louvre." *Gazette des Beaux-Arts,* 59 (April 1962).

Ma Chengyuan. "The Splendor of Ancient Chinese Bronzes." In *The Great Bronze Age of China.* Ed. Wen Fong. New York, 1980.

Mack, C. R. "The Rucellai Palace: Some New Proposals." *Art Bulletin,* 56 (1974).

Magnaguti, Alessandro. "Il Petrarca numismatico." *Rivista italiana di numismatica,* 20 (1907).

Maiuri, A. "Una nuova poesia di Theodoro Prodromo." *Byzantinische Zeitschrift,* 23 (1920).

Mango, Cyril. "Antique Statuary and the Byzantine Beholder." *Dumbarton Oaks Papers,* 17 (1963).

Marinetti, F. T. "Manifesto del Futurismo." In *Archivi del Futurismo.* Vol. I. Ed. Maria Drudi Gambillo and Tersa Fiori. Rome, 1958.

Marle, R. van. "Overzicht der voornaamste beschrijvingen von Rome uit den vroeg-christelijken tijd, middeleeuwen en renaissance." *Mededeelingen van het Nederlandisch Historisch Instituut te Rome,* 3 (1923); 4 (1924).

Marshall, A. J. "Bower Birds." *Scientific American,* 194 (June 1956).

Martelli, M. "I pensieri architettonici del Magnifico." *Commentari,* 17 (1966).

Martin, Gregory. "The Founding of the National Gallery in London. Part II." *Connoisseur,* 186 (May 1974).

Martindale, Andrew. "The Patronage of Isabella d'Este at Mantua." *Apollo,* 79 (1964).

Maser, Edward. "Giotto, Masaccio, Ghiberti and Thomas Patch." In *Festschrift Klaus Lankheit zum 20. Mai 1973.* Ed. Wolfgang Hartmann. Cologne, 1973.

Massaroli, Ignazio. "Fra Sabba da Castiglione e i suoi ricordi." *Archivio storico lombardo,* ser. 2, 16 (1889).

Matsumoto Eiichi. "Shōsōin Sansui Zu no Kenkyū" [On the Landscape Paintings in the Shōsōin Repository]. *Kokka,* nos. 596, 597, 598, 602, 604, 605, 606, 608 (1941).

McDonald, Gregory. "Rathbone Quits as Director of Art Museum." *Boston Globe AM,* 18 December 1971.

Meiss, Millard. "Italian Primitives at Konopiste." *Art Bulletin,* 28 (March 1946).

Mellaart, James. "Excavations at Çatal Hüyük, 1963. Third Preliminary Report." *Anatolian Studies,* 14 (1964).

Mellow, James. "A New (6th Century B.C.) Greek Vase for New York." *New York Times Magazine,* 12 November 1972.

Mengel, Dorothy. "Archaism on the South Coast of Peru." In *Selected Papers of the Fifth International Congress of Archaeological and Ethnological Sciences.* Ed. A. Wallace. Philadelphia, 1960.

Menzhausen, Joachim. "Five Centuries of Art Collecting in Dresden." In *The Splendour of Dresden: Five Centuries of Art Collecting.* Exhibition catalogue. New York, 1978.

Mesarites, Nikolas. "Descriptions of the Church of the Holy Apostles at Constantinople." Ed. and trans. G. Downey. *Transactions of the American Philosophical Society,* 47 (1957).

Meyerowitz, Eva. "The Taste for African Art." *Apollo,* 107 (March 1978).

Middeldorf, U. "Girolamo, Aurelio and Ludovico Lombardi and the Base of the 'Idolino.' " *Burlington Magazine,* 73 (1938).

———. "On the Dilettante Sculptor." *Apollo,* 107 (1978).

———. "Die zwölf Caesaren von Desiderio da Settignano." *Mitteilungen des Kunsthistorischen Institutes in Florenz* 23 (1979).

———. Review of H. Kav'fman, *Donatello.* In *Art Bulletin,* 18 (1936).

———. Review of *Neri di Bicci: Le ricordanze,* ed. Bruno Santi. *Renaissance Quarterly,* 31 (Summer 1978).

Miesel, Victor. "Rubens, Ancient Art and the Critics." *Criticism,* 5 (1963).

———. "Rubens' Study Drawings After Ancient Sculpture." *Gazette des Beaux-Arts,* 61 (1963).

Millar, Oliver. "The Whitehall Ceiling." *Burlington Magazine,* 98 (August 1956).

Miller, James. "American Paintings in Europe." In *Art at Auction. The Year at Sotheby Park Bernet 1979–1980.* London, 1980.

Momigliano, Arnaldo. "Ancient History and the Antiquarian." In *Contributo alla storia degli studi classici.* Rome, 1955.

———. "Cassiodoro." In *Dizionario biografico degli italiani.* Vol. 21. Rome, 1978.

———. "Cassiodorus and Italian Culture of His Time." *Proceedings of the British Academy,* 41 (1955).

Mommsen, Theodor. "Petrarch's Conception of the 'Dark Ages.' " In *Medieval and Renaissance Studies.* Ed. Eugene F. Rice. Ithaca, 1959.

———. "Petrarch and the Decoration of the Sala Virorum Illustrium in Padua." *Art Bulletin,* 34 (1952).

Montaiglon, Anatole de. "État des gages des ouvriers italiens employés par Charles VIII." *Archives de l'Art Français* 1 (1851–52).

Moore, Frank. "The Gilt-Bronze Tiles of the Pantheon." *American Journal of Archaeology,* ser. 2, 3 (1899).

Morisani, Ottavio. "Art Historians and Art Critics. III. Cristoforo Landino." *Burlington Magazine,* 95 (1953).

Müller-Hofstede, Justus. "Beiträge zum zeichnerischen Werk von Rubens." *Wallraf-Richartz-Jahrbuch,* 27 (1965).

Müntz, Eugène. "Inventaire des camées antiques de la collection du Pape Paul II." *Revue archéologique,* 36 (1878).

———. "Nuovi documenti." *Archivio storico dell'arte,* 2 (1889).

———. "La tiare pontificale du VIIIe au XVIe siècle." *Mémoires de l'Académie des Inscriptions et Belles-lettres,* 26 (1898).

———, and Molinier, Em. "Le Château de Fontainebleau au XVIIe siècle d'après des documents inédits." *Mémoires de la Société de l'Histoire de Paris et de l'Île-de-France,* 12 (1885).

Muller, Jeffrey. "Rubens's Museum of Antique Sculpture: An Introduction." *Art Bulletin,* 59 (December 1977).

Muratova, Xenia. "Paris." *Burlington Magazine,* 119 (October 1977).

Murray, Peter. "Notes on Some Early Giotto Sources." *Journal of the Warburg and Courtauld Institutes,* 16 (1953).

Nagy, I. "Remarques sur le souçi d'archäisme en Égypte à l'époque säite." *Acta Antiqua Academiae Scientiarum Hungaricae*, 21 (1973).

Nash, Judith. "Salesrooms: Primitive Art." *Connoisseur*, 199 (September 1978).

Naylor, Gillian. "Hector Guimard—Romantic Rationalist?" In *Hector Guimard*. Architectural Monographs 2. London, 1978.

Newman, Harold. "Bourdalous. Part 2: Some Continental Examples." *Connoisseur*, 177 (May 1971).

Nicolai, Jürgen. "Der Brutparasytismus der Viduinae als ethologisches Problem." *Zeitschrift für Tierpsychologie*, 21 (1964).

Nordenfalk, Carl. "Der Meister des Registrum Gregorii." *Münchner Jahrbuch der bildenden Kunst*, ser. 3, 1 (1950).

Norman, Geraldine. "£8,000 Mentmore Painting May Be £600,000 Fragonard." *The Times*, 17 June 1977.

———. "Record £30,000 for Clichy Convolvulus Paperweight." *The Times*, 5 July 1977.

Norris, Christopher. "Rubens and the Great Cameo." *Phoenix. Maandschrift voor Beeldende Kunst*, 3 (1948).

Norton, Paul. "The Lost Sleeping Cupid of Michelangelo." *Art Bulletin*, 39 (1957).

Nuttall, W. L. F. "King Charles I's Pictures and the Commonwealth Sale." *Apollo*, 82 (October 1965).

Oberhuber, Konrad. "Raphael and the State Portrait—I: The Portrait of Julius II." *Burlington Magazine*, 113 (1971).

Osward, Arthur. "Canterbury Cathedral: The Nave and Its Designer." *Burlington Magazine*, 75 (December 1939).

Oursel, Charles. "Les 'Pleurants' disparus des tombeaux des ducs de Bourgogne au Musée de Dijon." *Bulletin Archéologique du Comité des Travaux Historiques et Scientifiques*, (1909).

Paatz, Walter. "Die Gestalt Giottos im Spiegel einer zeitgenössischen Urkunde." In *Festschrift Carl Georg Heise*. Ed. Erich Meyer. Berlin, 1950.

Papadopoulos-Kerameus, A. "Nikephonos Kallistosxanthopoulos." *Byzantinische Zeitschrift*, 11 (1902).

Parronchi, Alessandro. "Sul probabile tipo del 'Cupido dormiente' di Michelangelo." *Arte antica e moderna*, 27 (1964).

Paschini, Pio. "Il mecenatismo artistico del patriarca Giovanni Grimani." In *Studi in onore di Aristide Calderini e Roberto Paribeni*. III. *Studi di archeologia e di storia dell' arte antica*. Milan, 1956.

Pasqui, U. "La biblioteca d'un notaio aretino del secolo XIV." *Archivio storico italiano*, 4 (1889).

Pedretti, Carlo. "The Sforza Sepulchre." *Gazette des Beaux-Arts*, 89 (April 1977).

Pellizzari, A. "Heraclii Sapientissimi Viri. De Coloribus et Artibus Romanorum." In *I trattati attorno le arti figurative*. Vol. I. Naples, 1915.

Perry, Marilyn. "Cardinal Domenico Grimani's Legacy of Ancient Art to Venice." *Journal of the Warburg and Courtauld Institutes*, 41 (1978).

———. "A Greek Bronze in Renaissance Venice." *Burlington Magazine*, 117 (March 1975).

———. "A Renaissance Showplace of Art: The Palazzo Grimani at Santa Maria Formosa, Venice." *Apollo*, 113 (April 1981).

———. "Saint Mark's Trophies: Legend, Superstition and Archaeology in Renaissance Venice." *Journal of the Warburg and Courtauld Institutes*, 40 (1977).

———. "The Statuario Pubblico of the Venetian Republic." *Saggi e memorie di storia dell'arte*, 8 (1972).

Pesce, G. "Gemme medicee del Museo Nazionale di Napoli." *Rivista del Reale Istituto d'Archeologia e Storia dell'Arte*, 5 (1937).

Petrucci, F. "Sabba da Castiglione." In *Dizionario biografico degli italiani*. Vol. 22. Rome, 1979.

Phillips, Claude. "The Picture Gallery of Charles I." *Portfolio*, 25 (January 1896).

Piattoli, R. "Un mercante del Trecento e gli artisti del tempo suo." *Rivista d'arte*, 11 (1929).

Piotrovsky, Boris. "Early Cultures of the Lands of the Scythians." In *From the Lands of the Scythians. Ancient Treasure from the Museums of the U.S.S.R. 3000 B.C.–100 B.C.* Exhibition catalogue. Metropolitan Museum of Art and Los Angeles County Museum of Art. New York, 1975.

Poggioli, Renato. "The Artist in the Modern World." *Graduate Journal*, 6, no. 1 (Winter 1964).

Pope-Hennessy, John. "The Forging of Italian Renaissance Sculpture." *Apollo*, 99 (April 1974).

———. "The Madonna Reliefs of Donatello." *Apollo*, 103 (1976).

Popham, A. E. "Sebastiano Resta and His Collections." *Old Master Drawings*, 11 (June 1936).

Priest, Alan. "The Masters of the West Façade of Chartres." *Art Studies*, 1 (1923).

Procacci, Ugo. "Cosimo de' Medici e la Badia Fiesolana." *Commentari*, 19 (1968).

Qin Dynasty Pit Archeological Team. "Qin Shihuang Ling dongce di er hao bing ma yongkeng zuan tan shijue jianbao" [Excavations of the Qin Dynasty Pit Containing Pottery Figures of Warriors and Horses at Lintong, Shaanxi Province]. *Wenwu*, no. 5 (1978).

Qin Ming. "Qin yongkeng bing ma yongjun chen neirong ji bingqi shitan" [Notes on the Arrangement of the Qin Dynasty Pottery Figures of Warriors and Horses from Lintong]. *Wenwu*, no. 11 (1975).

Quicherat, Jules. "Notice sur l'album de Villard de Honnecourt." *Revue Archéologique*, 6 (1849).

Rademacher, L. "Venus in Ketten." *Westdeutsche Zeitschrift*, 24 (1905).

Raggio, Olga. "Canova's Triumphant 'Perseus.'" *Connoisseur*, 172 (November 1969).

Rands, Robert. "The Rise of Classic Maya Civilization in the Northwestern Zone: Isolation and Integration." In *The Origins of Maya Civilization*. Ed. R. E. W. Adams. Albuquerque, 1977.

Read, Sir Herbert. "Pioneering in Art Collecting." In *Pioneering in Art Collecting*. Ed. D. D. Galloway. Buffalo, 1962.

Reif, Rita. "Books to Bring Joy to Toy Collectors." *New York Times*, 21 December 1980.

———. "A Turner Sells for Record $6.4 Million." *New York Times*, 30 May 1980.

Reinhold, Robert. "Traffic in Looted Maya Art is Diverse and Profitable." *New York Times*, 29 March 1973.

Renfrew, Colin; Dixon, J. E.; Cann, J. R. "Obsidian and Early Cultural Contact in the Near East." *Proceedings of the Prehistoric Society*, 32 (1966).

Ricci, Seymour de. "Gli 'Augustali' di Federico II." *Studi medievali*, n.s. 1 (1928).

———. "Un Chalice du trésor de St.-Denis." *Académie des Inscriptions et Belles Lettres. Comptes-Rendus* (1923).

Rice, Howard. "James Swan Agent of the French Republic 1794–1796." *New England Quarterly*, 10 (September 1937).

Richter, Gisela M. A. "Silk in Greece." *American Journal of Archaeology*, 2nd ser., 33 (1929).

Ridgway, Brunilde Sismondo. "The Aphrodite of Arles." *American Journal of Archaeology*, 80 (Spring 1976).

Riegl, Alois. "Über antike und moderne Kunstfreunde." In *Gesammelte Aufsätze*. Vienna, 1929.

Ritchie, Neil. "The Riace Bronzes: Masterpieces of Greek Art." *Apollo*, 113 (1981).

Rizzoli, L. "Il cardinale Lodovico Scarampo Mezzarota." *Atti e memorie della R. Accademia di Scienze, Lettere ed Arte in Padova*, n.s. 17 (1900).

Robertson, Martin. "Beazley and After." *Münchner Jahrbuch der bildenden Kunst*, 27 (1976).

Ronig, F. "Godefridus von Huy in Verdun." *Aachener Kunstblätter*, 32 (1966).

Rosand, David. "Titian and the Bed of Polyclitus." *Burlington Magazine*, 117 (April 1975).

————. "Titian in the Frari." *Art Bulletin*, 53 (1971).

————. "Titian's Light as Form and Symbol." *Art Bulletin*, 57 (1975).

————. "Titian's Presentation of the Virgin in the Temple and the Scuola della Carità." *Art Bulletin*, 58 (1976).

Rose, P. L. "Humanist Culture and Renaissance Mathematics: The Italian Libraries of the 'Quattrocento.'" *Studies in the Renaissance*, 20 (1973).

Rosenberg, M. "Ein wiedergefundener Kelch." In *Festschrift zum sechzigsten Geburtstag von Paul Clemen*. Ed. W. Worringer, H. Reiners, and L. Seligmann. Bonn, 1926.

Rosenfeld, Myra Nan. "Sebastiano Serlio's Drawings in the Nationalbibliothek in Vienna for his 'Seventh Book of Architecture.'" *Art Bulletin*, 56 (1974).

Rosenthal, Earl. "The House of Andrea Mantegna in Mantua." *Gazette des Beaux-Arts*, 60 (1962).

Ross, James Bruce. "A Study of Twelfth Century Interest in the Antiquities of Rome." In *Medieval and Historiographical Essays in Honor of James Westfall Thompson*. Ed. J. L. Cate and E. N. Anderson. Chicago, 1938.

Ross, Marvin Chauncey. "Monumental Sculptures from St.-Denis. An Identification of Fragments from the Portal." *Journal of the Walters Art Gallery*, 3 (1940).

Rostron, Bryan. "Smuggled." *Saturday Review*, 31 March 1979.

Rubin, James Henry. "Roger de Piles and Antiquity." *Journal of Aesthetics and Art Criticism*, 34 (1975).

Rudolph, R. C. "Preliminary Notes on Sung Archaeology." *Journal of Asian Studies*, 22 (February 1963).

Sabbe, E. "L'Importation des tissus orientaux en Europe occidentale au haut Moyen Âge (IXe et Xe siècles), 1e partie." *Revue Belge de Philologie et d'Histoire*, 14 (July–September 1935).

Sager, Walter de. "Treasures of the Abbey of St.-Maurice d'Agaune." *Connoisseur*, 175 (October 1970).

Samaltanou-Tsiakma, Ekaterini. "A Renaissance Problem of Archaeology." *Gazette des Beaux-Arts*, 78 (1971).

Schaber, Arnold. "Eine neue Satyrgruppe." *Mitteilungen des deutschen Archaeologischen Instituts. Römische Abteilung*, 52 (1937).

Schapiro, Meyer. "Diderot and the Artist and Society." *Diderot Studies*, 5 (1964).

————. "Introduction of Modern Art in America: The Armory Show." In *Modern Art: Ninteenth and Twentieth Centuries*. (Selected Papers, vol. II). New York, 1978.

————. "On the Aesthetic Attitude in Romanesque Art." In *Romanesque Art*. (Selected Papers, vol. I). New York, 1977.

————. "On the Relation of Patron and Artist: Comments on a Proposed Model for the Scientist." *American Journal of Sociology*, 70 (1964).

————. "Wolvinius Magister Phaber: The Crowning of an Artist in the Early Middle Ages." Unpublished paper.

Schlosser, Julius von. "Die ältesten Medaillen und die Antike." *Jahrbuch der Kunsthistorischen Sammlungen des Allerhöchsten Kaiserhauses*, 18 (1897).

————. "Über einige Antiken Ghibertis." *Jahrbuch der Kunsthistorischen Sammlungen des Allerhöchsten Kaiserhauses*, 24 (1904).

————. "Zur 'Philosophie' des Kunstsammelns." In *Präludien, Vorträge und Aufsätze*. Berlin, 1927.

Schmitt, Annegrit. "Zur Wiederbelebung der Antike im Trecento." *Mitteilungen des Kunsthistorischen Institutes in Florenz* 18 (1974).

Schneebalg-Perelman, S. "Le Rôle de la banque de Médicis dans la diffusion des tapisseries flamandes." *Revue Belge d'Archéologie et d'Histoire de l'Art*, 38 (1969).

Schroeder, Eric. "Ahmed Musa and Shams al-Dīn: A Review of 14th Century Painting." *Ars Islamica*, 6 (1939).

Schulman, Alan. "Some Remarks on the Alleged 'Fall' of Senmūt." *Journal of the American Research Institute in Egypt*, 8 (1969–70).

Schweitzer, Bernhard. "Xenokrates von Athen." In *Die Kunst der Antike.* Vol. I. Tübingen, 1963.

Shear, Leslie T., Jr. "The Athenian Agora: Excavations of 1970." *Hesperia*, 40 (1971).

Shearman, John. "The Chigi Chapel in S. Maria del Popolo." *Journal of the Warburg and Courtauld Institutes*, 24 (1961).

———. "Die Loggia der Psyche in der Villa Farnesina und die Probleme der letzten Phase von Raffaels graphischem Stil." *Jahrbuch der Kunsthistorischen Sammlungen in Wien*, 60 (1964).

Shenker, Israel. "A Pollock Sold for $2 Million, Record for American Painting." *New York Times*, 22 September 1973.

Shimada Shujiro. "Concerning the I-p'in Style of Painting. I." Trans. James Cahill. *Oriental Art*, n.s. 7 (1961).

Sickman, Laurence. "Introduction." In *Catalogue of the Exhibition of Chinese Calligraphy and Painting in the Collection of John M. Crawford, Jr.* Ed. Sickman et al. New York, 1962.

Simons, Marlise. "It Takes Expertise or a Gun (or a Bribe) to Plunder the Treasure of the Mayans, Toltecs (or Olmecs) in Oaxtepec or Cuernavaca." *Washington Post*, 5 August 1967.

So, Jenny F. "The Waning of the Bronze Age: The Western Han Period (206 B.C.–A.D. 8)." In *The Great Bronze Age of China.* Ed. Wen Fong. New York, 1980.

Soper, Alexander. "Early, Middle and Late Shang: A Note." *Artibus Asiae*, 28 (1966).

———. "The First Two Laws of Hsieh Ho." *Far Eastern Quarterly*, 8 (August 1949).

———. "Life-Motion and the Sense of Space in Early Chinese Representational Art." *Art Bulletin*, 30 (1948).

———. "The Relationship of Early Chinese Painting to Its Own Past." In *Artists and Traditions.* Ed. Christian F. Murck. Princeton, 1976.

———. "The Rise of Yamato-e." *Art Bulletin*, 24 (December 1942).

———. "Shih K'o and the I-p'in." *Archives of Asian Art*, 29 (1975–6).

———. "T'ang Ch'ao Ming Hua Lu (The Famous Painters of the T'ang Dynasty)." *Archives of the Chinese Art Society of America*, 4 (1950).

Srejović, Dragoslav. "Lepenski Vir: Protoneolithic and Early Neolithic Settlements." *Archaeology*, 22 (January 1969).

Steinmann, U. "Der Bilderschmuck der Stiftskirche zu Halle." *Staatliche Museen zu Berlin: Forschungen und Berichte*, 2 (1968).

Stevens, Elizabeth. "Indian Art, Out of Context." *Wall Street Journal*, 23 December 1971.

Stewart, Donald R. "James Essex." *Architectural Review*, 108 (1950).

Stix, Alfred. "Die Aufstellung der ehedem Kaiserlichen Gemäldegalerie in Wien im 18. Jahrhundert." *Museion* (Vienna, Prague, and Leipzig, 1922).

Sutton, Denys. "Treasures from Leningrad." In *Master Paintings from the Hermitage and the State Russian Museum, Leningrad.* National Gallery of Art, et al. New York, 1975.

Svornos, J. N. "Die Funde von Antikythera." *Das Athener National Museum*, 1 (1903).

Taralon, Jean. "La Majesté d'Or de Sainte Foy du trésor de Conques." *Revue de l'Art*, nos. 40–41 (1978).

————. "La Nouvelle Présentation du trésor de Conques." *Les Monuments Historiques de la France,* n.s. 1, no. 3 (1955).

Thornton, Lynne. "Guimard & the Metro." *Connoisseur,* 204 (August 1980).

Tittle, Diana. "The Agony and the Ecstasy of Sherman E. Lee." *Cleveland Magazine,* (January 1969).

Todorow, Maria Fossi. "Il museo della casa fiorentina antica in Palazzo Davanzati." *Atti della "Società Leonardo da Vinci" (1973–74).*

Tomkins, Calvin. "The Art World: Rocks." *The New Yorker,* 24 March 1980.

Trapier, Elizabeth du Gué. "Sir Arthur Hopton and the Interchange of Paintings Between Spain and England in the Seventeenth Century: Part 1." *Connoisseur,* 164 (April 1967).

Tréheux, Jacques. "L'Inventaire des Clérouques d'Imbros." *Bulletin de Correspondances Hellénique,* 80 (1956).

Turner, D. H. " 'The Odalricus Peccator' Manuscript in the British Museum." *British Museum Quarterly,* 25, nos. 1–2 (1962).

Varley, H. Paul. "Ashikaga Yoshimitsu and the World of Kitayama: Social Change and Shogunal Patronage in Early Muromachi Japan." In *Japan in the Muromachi Age.* Ed. John W. Hall and Toyoda Takeshi. Berkeley, 1977.

Venturi, A. "Gian Cristoforo Romano." *Archivio storico dell'arte,* 1 (1888).

Venturi, Lionello. "La critica d'arte e Francesco Petrarca." *L'arte,* 25 (1922).

Verheyen, Egon. "Correggio's 'Amori di Giove.' " *Journal of the Warburg and Courtauld Institutes,* 29 (1966).

Vermeule, Cornelius. "Graeco-Roman Statues: Purpose and Settings. I." *Burlington Magazine,* 110 (1968).

Vittori, Ottavio, and Mestitz, Anna. "Artistic Purpose of Some Features of Corrosion on the Golden Horses of Venice." *Burlington Magazine,* 117 (March 1975).

Wackernagel, Martin. "Giovanni della Palla, der erste Kunsthändler." *Die Kunst,* 73 (1936).

Wada Gunichi. "Shōsōin no Chokofū" [Imperial Sealing of the Shōsōin Repository]. *Yamato Bunka,* 11 (September 1953).

Warburg, Aby. "Flandrische Kunst und Florentinische Frührenaissance." In *Gesammelte Schriften.* Vol. I. Leipzig, 1932.

Ware, Edith Williams. "Egyptian Artists' Signatures." *American Journal of Semitic Languages and Literatures,* 43 (1927).

Watson, F. J. B. "The English as Collectors of French Furniture." *Connoisseur,* 186 (June 1974).

————. "French Furniture in the Salesrooms, the Early Period 1660–1830." In *Art at Auction: The Year at Sotheby Parke Bernet 1972–73.* New York, 1974.

————. "French Tapestry Chair Coverings: A Popular Fallacy Re-examined." *Connoisseur,* 148 (October 1961).

————. "George IV as an Art Collector." *Apollo,* 83 (June 1966).

————. "Mentmore and Its Art Collections." In *Mentmore.* Sotheby Parke Bernet. London, 1977.

————. "Some Royal French Furnitures in the English Royal Collections." In *The Connoisseur Coronation Book.* London, 1953.

————. "Thomas Patch (1725–1782), Notes on His Life, Together with a Catalogue of His Known Works." *Walpole Society,* 28 (1939–40).

Weintraub, Bernard. "A Raphael in Boston Arouses Skepticism." *New York Times,* 29 April 1970.

Weiss, Roberto. "Jacopo Angeli da Scarperia (c.1360–1410/11)." In *Medieval and Humanist Greek.* Padua, 1977.

————. "Jan Van Eyck and the Italians." *Italian Studies,* 11 (1956); 12 (1957).

————. "Lineamenti per una storia degli studi antiquari in Italia." *Rinascimento,* 9 (1958).

————. "Petrarca e il mondo greco." In *Medieval and Humanist Greek.* Padua, 1977.

———. "Petrarch and Homer." In *Medieval and Humanist Greek*. Padua, 1977.

———. "Petrarch the Antiquarian." In *Classical, Medieval and Renaissance Studies in Honor of Berthold Louis Ullman*. Ed. Charles Henderson. Vol. II. Rome, 1964.

Weitzmann, Kurt. "Various Aspects of Byzantine Influence on the Latin Countries from the Sixth to the Twelfth Century." *Dumbarton Oaks Papers*, 20 (1966).

Wen Meiyan and Qin Zhongxing. "Qin Yong Yishu" [The Sculptural Arts of the Qin Dynasty Pottery Figures]. *Wenwu*, no. 11 (1975).

Wenley, Archibald. "A Hsi Tsun in the Avery Brundage Collection." *Archives of the Chinese Art Society of America*, 6 (1952).

Wente, Edward. "Tutankhamun and His World." In *Treasures of Tutankhamun*. Exhibition catalogue. National Gallery of Art, et al. New York, 1976.

Wentzel, Hans. "Der Augustalis Friedrichs II. und die abendländische Glyptik des 13. Jahrhunderts." *Zeitschrift für Kunstgeschichte*, 15 (1952).

———. "Mittelalter und Antike im Spiegel kleiner Kunstwerke des 13. Jahrhunderts." In *Studien tillägnade Henrik Cornell på 60 årsdagen*. Ed. M. Olsson, O. Reuterswärd, S. Wallin. Stockholm, 1950.

———. "Portraits 'à l'antique' on French Medieval Gems and Seals." *Journal of the Warburg and Courtauld Institutes*, 16 (1953).

———. " 'Staatskameen' im Mittelalter." *Jahrbuch der Berliner Museen*, 4 (1962).

Wescher, Paul. "Vivant Denon and the Musée Napoléon." *Apollo*, 80 (September 1964).

Wester, U. "Die Reliefmedaillons im Hofe des Palazzo Medici zu Florenz." *Jahrbuch der Berliner Museen*, 7 (1965).

Wetzel, Friedrich. "Kriegstrophäen und anderer Schmuck des Palastes." In *Königsburgen von Babylon*. II, *Die Hauptburg und der Sommerpalast Nebukadnezars im Hügel Babil*. Ed. R. Koldewey and F. Wetzel. Leipzig, 1932.

Wildenstein, Daniel. "Sur 'Le Verrou' de Fragonard." *Gazette des Beaux-Arts*, 85, Supplement (January 1975).

Willey, Gordon R. "The Maize God: Maya Sculptured Stone Head." In *Masterpieces of the Peabody Museum*. Exhibition catalogue. Harvard University. Cambridge, Mass., 1978.

Willis, Robert. "On the Construction of Vaults in the Middle Ages." *Transactions of the Royal Institute of Architects*, 1, Part 2 (1842).

Wittkower, Rudolf. "Alberti's Approach to Antiquity in Architecture." *Journal of the Warburg and Courtauld Institutes*, 4 (1940).

———. "Piranesi's 'Parere su l'architettura.' " *Journal of the Warburg Institute*, 2 (1938–39).

———. "The Role of Classical Models in Bernini's and Poussin's Preparatory Work." In *Acts of the Twentieth International Congress of the History of Art*. Vol. III. Princeton, 1963.

Workers Theoretical Study Group, Beijing Automobile Plant and Department of Art History, Academy of Fine Arts, Central May Seventh University. "Lue lun Qin Shihuang Shi dai di yishu chengjiu" [Artistic Achievement in the Age of Qin Shihuangdi]. *Kaogu*, no. 6 (1975).

Wormald, Francis. "The Wilton Diptych." *Journal of the Warburg and Courtauld Institutes*, 17 (1954).

Wright, Thomas. "On Antiquarian Excavations and Researches in the Middle Ages." *Archaeologia*, 30 (1844).

Wycherley, R. E. "The Athenian Agora. III." In *Literary and Epigraphical Testimonia*. The American School of Classical Studies at Athens. Princeton, 1957.

Yakobson, Sergius. "Russian Art Collectors and Philanthropists: The Shchukins and the Morozovs of Moscow." *National Gallery of Art: Studies in the History of Art*, 6 (1974).

Yang Lien-Sheng. "Chinese Calligraphy." In *Catalogue of the Exhibition of Chinese Calligraphy and Painting in the Collection of John M. Crawford, Jr.* Ed. Laurence Sickman et al. New York, 1962.

Yonezawa Yoshio. "Tōchō Kaiga ni Okeru Keijishugi to Kizō Kogaku Zu no Gafū" [Mimesis in Tang Painting and the Style of "A Lute Player on a Camel's Back"]. *Kokka,* 658 (Jan. 1947).

Yriarte, Charles. "Isabelle d'Este et les artistes de son temps." *Gazette des Beaux-Arts,* 13 (1895), 14 (1895), 15 (1896).

Zama, Giovanni. "I ricordi di Sabba Castiglione." *Studi romagnoli,* 6 (1955).

Zavitukhina, M. P. "The Siberian Collection of Peter the Great." In *Frozen Tombs: The Culture and Art of the Ancient Tribes of Siberia.* Exhibition catalogue. British Museum. London, 1978.

Zavoral, Nolan. "Beer-Can Barter." *Washington Post,* 26 September 1978.

Ziebarth, Erich. "Cyriacus von Ancona als Begründer der Inschriftenforschung." *Neue Jahrbücher für das klassische Altertum,* 9 (1902).

Zippel, G. "L'invettiva di Lorenzo di Marco Benvenuti contro Niccolò Niccoli." *Giornale storico della letteratura italiana,* 24 (1894).

Zürcher, E. "Imitation and Forgery in Ancient Chinese Painting and Calligraphy." *Oriental Art,* n.s. 1 (1955).

INDEX

Aachen, 260, 288
Abbey of San Giusto, 386
Abbundantia, Duomo, 315, 320
Abecedario (Mariette), 125, 151
Abraham, 136
Abstract Expressionists, 146
Academic painters, 234
"Academy of the Valdarno,"
 350, 358
Accademia del Disegno, 113
Acciaiuolo, Madonna
 Margherita, 362
Acciaiuolo, Niccolò, 362
Acerba (Cecco d'Ascoli), 287
Achaean League, 193, 204
Achaemenids, 173
Acheulian, 33, 35, 36, 37, 80,
 170
Acropolis, Athens, 59, 190, 198,
 209, 228, 343
Admonitions of the Instructress
 to the Ladies of the Palace
 (Gu Kaiji), 229
Adoration of the Magi (Fra
 Angelico, Fra Filippo Lippi),
 397, 403
Adoration of the Lamb (Van
 Eyck), 124
Aegina, 192
Aeolian League, 192
Aeschylus, 193
Aesop, 197
Aert de Gelder, 131, 132
Aethelthryth, Queen of
 Northumbria, 261, 262
Africa (Petrarch), 305
African art, 49, 314

African waxbills, 78–79
Agatharchus, 184, 190
Aglaophon, 202
Agricultural methods vs. art,
 467
Agrippa, Marcus Vipsanius, 198
Aḥmad, Qāḍī, 109, 255
Ahmose, 174, 178
Aholiab, 133
Ajanta cave shrines, 38
Ajax (Apollodorus), 192
Akhenaton, Pharaoh of Egypt,
 60, 184
Alba, 349
Albano, Taddeo, 435
Albergati, Cardinal, 346
Alberti, Leon Battista, 111, 187,
 204, 337, 338, 342, 379,
 380, 388, 414
Albertina, the, 447
Albertini, Francesco, 425
Alberto di Arnoldo, 289
Albizzi, Benedetto di Banco
 degli, 44
Albrecht, Duke of Bavaria, 446,
 447
Albrecht of Brandenburg,
 Cardinal, 56, 72, 97
Alcibiades, 89, 190
Alcmaeonids, 365
Alcuin, 260
Aldobrandini, Cardinal, 92
Aldovrandi, Ulisse, 346, 425
Alexander the Great, 140, 152,
 156, 190, 191, 207, 224,
 228, 311, 347, 385

Alexandrian library, 163, 191,
 193
Alfonso, King of Spain, 282
Alice in Wonderland (Carroll),
 252
'Ali, Mir, 254
Allegories of Virtue and Vice
 (Correggio), 436, 437
All Souls College, Oxford, 12
Alphabet, modern, 328
Alsop, Stewart, 18
Altamira, 57
Altar of Zeus, Pergamum, 191
Altarpieces, 45, 88, 124, 154,
 400
Altman, Benjamin, 333
Amadori, Alessandro, 440
Ambrose, St., 53, 272
Amenemhat III, 178
Amenhotep III, Pharaoh, 174
American Indian artifacts, 22
*American Journal of Sociology,
 The,* 41
American School of Classical
 Studies, 257
Amiens Cathedral, 276
Amlash pots, 132
Ammianus Marcellinus, 295,
 344
Analects (Lun yu)
 (Confucius), 215
Analytic history, 295
Ancestor lists, 294
Andhra period, 133
Andrea da Murano, 116
Andrea del Castagno, 121, 379,
 403

Andrians (Titian), 92, 94
Anet, Chateau, 128
Angelico, Fra, 119, 121, 363, 364, 383, 384, 397, 403, 410
Angerstein, Sir John Julius, 166, 448
Angilbertus II, Archbishop of Milan, 53, 86, 272, 430
Angiolo, Magister, 340
Angkor Thom, 85
Angkor Wat, 26, 27, 85, 452
Anglo-Saxons, 51
Anjou, Louis, Duc d', 55
Annals, written, 294
Annals of the Former Han (Ban Gu), 225
Annius Severus, 196
Annunciation (Bouts), 152
Anonimo, L' (Michiel), 425
Anonimo magliabechiano, 134
Ansidei Madonna (Raphael), 163
Anthemius of Tralles, 108, 132
Anti-art, 18, 19
Anticythera Boy, 142
Antigonus of Carystus, 194
Antiquarianism, 172, 173, 174
Antiquarium (Munich), 446
Antique, Florentine fashion for, 1390–1402/03, 316, 317, 318, 323
Antique collecting, 17, 159–162
 Chinese, 249, 250
 Roman, 207
Antiques, 17
Antiquitez de Castries (Borel), 465
Antonello da Messina, 428
Antonio, Giovanni, 394
Antony, Mark, 205, 206
Apelles, 184, 188, 189, 193, 197, 199, 200, 207, 224, 228, 266, 290, 415
Aphrodisias sculpture workshops, 270
Aphrodite, Petworth, 8
Aphrodite Clothed and Aphrodite Naked (Praxiteles), 42, 210
Apollinaris, Sidonius, 209
Apollo (Myron), 205
Apollo (Onatus), 192
Apollo, Piraeus, 142, 204

Apollo and Daphne (Bernini), 3
Apollo Belvedere, 2, 3, 4, 6, 14, 99, 172, 376, 432
 fall of, 10, 11
 glory of, 7–10
 uses of, 9, 10
Apollodorus, 185, 192
Apotheosis of James I (Rubens), 47
Apoxyomenos (Lysippus), 194, 198, 199, 200, 260
Appartements des Bains (Fontainebleau), 166
Arab silk, 43
Aratus of Sicyon, 193
Arcadius, Emperor, 209
Archa, L', 302, 404
Archbold's bower bird, 77
Archelaus, King of Macedon, 190
Archeologists, 170, 349
Archeology, modern, 344
Archimedes, 203
Architect—master masons, 273, 276, 277
Architects, 108, 184, 459
Architecture, 11, 40, 115, 325, 447
 Chinese, 214, 223
 Gothic, 58, 111, 273, 276, 277
 Greek, 352
 Italian Romanesque, 111
 medieval, 277
 Renaissance, 332, 365, 368, 458
 Roman, 352
 Romanesque, 273
Arena Chapel frescoes (Giotto), 250
Arcimboldo, Giuseppe, 114
Arethas, 327
Arethusa, 52
Aretine pottery, 303
Aretino, Giovanni Medico, 323
Aretino, Pietro, 46, 446
Aristides, 195, 203
Aristotle, 184, 185, 231, 299, 324
Ark of the Covenant, 133
Armilla of Frederick Barbarossa, 99, 332
Armory Show, 313
Arnardus, 272
Arnolfini Wedding (Van Eyck), 114

Art
as-an-end-in-itself, 36, 37, 49, 52, 67, 265
as-investment, 147
as luxury, 44
as relic, 129–132
by-products of, 1, 2, 14, 15, 16, 18, 20, 25, 31, 102, 104, 105, 106, 156, 168, 169, 467–473
change in, 177–179, 267, 268
commissioned works, 40, 41, 42, 45, 46, 47, 50
comparative studies of world, 82
concepts of beauty, 33, 34
definition, 23
effect of collecting and history, 145
effect of high-tech society, 20, 21
five rare traditions, 29, 30, 31, 32, 37, 84, 89, 100, 101, 107, 133, 265, 283, 284, 285, 293–297, 467–473
for architectural use, 40
for the market, 42–45
for the market's rise, 45–49
for-use-plus-beauty, 35, 37, 49, 56, 59, 67, 131, 265, 360
historical identification, 128
historical response to in 14th century, 289, 290, 417
historic/esthetic response to, 131, 417, 469
independent traditions, 20, 21, 22
Korean, 21, 29, 251, 252
making with, 35
modern situation of, 41, 44
movement of works of, 452, 453, 457
place in religion, 272
primitive, 145
response to, 127–129
secular, 48, 306
Spanish, 127
super-prices for, 17, 18
surroundings for, 93–95
theoretical writing about, 183, 184
way of thinking about, 37, 38, 39, 105, 212, 216, 262, 263–265, 267, 283, 291, 292, 469, 470

Art (cont'd)
 writing about, 107, 108, 109,
 183, 184, 231, 272, 273, 274
Arte del Cambio, 355
Arte della Lana. See Wool Guild
Artemis fund, 138, 141
Art historians, 14, 17, 57, 458,
 472
 effects of art market on, 152–
 156
 in five rare art traditions, 107
 search for classical models by,
 319, 320, 321
Art history, 1, 15, 16, 22, 24,
 27, 32, 40, 43, 49, 57, 107–
 110, 469
 begins, 187–189
 Chinese, 242, 246–248
 collecting's role, 335
 early Renaissance, 330
 handbooks and, 108, 109
 interaction with art collecting,
 109, 110, 122, 126, 127,
 135, 139
 Japanese, 253
 medieval, 265–267, 277, 278
 reconstitution of, 277–283
 unwritten, 107
 ways of seeing, 125
 written, 108, 109
"Art investors," 68, 146, 147
Artisans, 228
Artist in His Studio (Vermeer),
 146
Artists
 art market effect on, 148
 avant-gardes, 49, 312, 313
 modern freedom for, 41
 19th-century American, 159
 status, 223–225, 285, 288–
 293, 442
Art market, 1, 15, 16, 19, 25
 collectors', 103, 104
 danger to ancient monuments,
 25, 26
 effect on artists, 148
 for the rise, 45–49
 Greek, 194–197
 late 20th century, 141
 luxury, 139
 modern situation, 41, 44, 49,
 155
 origins of, 42–49, 443–447
 prices, 10, 11, 15, 17, 18, 19,
 22, 138, 139, 141, 144, 145,
 243, 333, 334, 394, 395,

 396, 401, 432, 433, 460,
 463, 464
 revaluation and, 159
 supply and demand, 21, 22,
 24, 156
 transmutes works of art, 145,
 146, 148, 155
Art Nouveau, 58
"Art Scene, The," 19
Art specialists, 44
Art Theory, 183, 184
Art traditions. See Traditions,
 the five rare art
Arundel, Earl of, 149, 459, 460,
 461, 462, 465, 466
Arundel House, 460, 462
Ashikaga Shogunate, 105, 423
Ashikaga Yoshimasa, Shogun, 63
Ashikaga Yoshimitsu, Shogun,
 253
Assyria, 156, 172, 173, 186
Atahualpa, Inca, 156
Athena (Dipoenus, Scyllis),
 210, 211
Athena, Parthenon (Phidias), 39
Athenaeus, 329
Athena Promachus (Phidias),
 209, 343
Attalids, the, 99, 190–195, 339
Atrium Libertatis, 198
Attalus I, King of Pergamum, 28,
 190–192, 193, 194
Attalus II, King of Pergamum,
 191, 195, 203, 206
Attalus III, King of Pergamum,
 191, 194
Atticus, 196
Auctions
 Corinth, 194, 195
 Forum of Trajan, 208
 furniture, 160
 jewel, 86
 Lansdowne, 10
 Mentmore, 137, 138, 139
Auden, W. H., 473
Augustales, 302
Augustus, Emperor of Rome,
 197, 198, 206, 241, 392
Augustus III, King of Saxony
 and Poland, 36, 163
Authenticity, 129–132
Avant-garde artists, 49, 312, 313
Averroes, 299
Avianius Evander, 195
Avogadro, 366

Aztecs, the, 33, 172, 224, 442
 feather crown, 448
 gold, 6, 7, 50
 green jade, 50
 sculpture, 7, 33

Babur, 1st Mogul emperor, 255
Bacchantes, 196, 208
Bacchus (Michelangelo), 408,
 409
Bacchus and Ariadne (Titian),
 92
Bacci, Luigi, 91
Badia of Fresole, 364, 365
Bak, 174
Balance des peintres (Piles), 125
Balazs, Étienne, 220
Baldassare del Milanese, 408,
 409, 444
Baldinucci, Filippo, 457, 458
Baldwin II, Emperor of
 Byzantium, 72
Balzac, Honoré de, 146
Bambⁱⁱcⁱⁱanti, 48
Ban (Pan), Lady, 228, 229
Ban Gu (Pan Ku), 225, 239
Banqueting House, Whitehall,
 47, 460
Baptistery, Florence, 3, 13, 52,
 53, 54, 315, 316, 335, 365
Barbarian, The, 102
Barbaro, Francesco, 326, 329
Barbed wire, 102
Barberini, Cardinal, 91, 95
Barberino, Luigi d'Andrea Lotti
 di, 394
Barbo, Pietro Cardinal. See Paul
 II, Pope
Bardi Bank, 330
Bardi Chapel, 383
Barletta, Colossus of, 143
Barnes, Dr. Albert C., 89, 90, 94,
 97, 98, 110, 190, 312, 380,
 413, 418
 "future old masters," 97, 98
Barnes collection, 89, 97, 98
Barnes Foundation, 312
Baron, Hans, 344
Baroncelli, Gherardo, 361
Baroncelli, Martino, 361
Baroncelli, Tano, 361
Barrows. See Kurgans
Bartolomeo, Fra, 113, 444
Basaiti, 116
Bass, Major Edward, 455

Bastianini, 158, 201
Baths of Agrippa, 198, 199, 200
Baton de Commandement, 59
Bauhaus, 183
Baxandall, Michael, 290
Bawwāb, ibn al-, 253, 254
Beauclerck Tower, Strawberry
 Hill, 276
Beauneveu, André, 284, 285,
 291
Beaux Arts (style), 183
Bede, Venerable, 93, 261, 295,
 297
Beauty, concepts of, 33, 34
Beccafumi, Domenico, 113
Beer cans, 72, 73, 75
Belisarius, 259, 260
Bellini, Giovanni, 13, 45, 92,
 113, 116, 199, 421, 427,
 432, 439, 440, 462
Bellini, the, 116, 427
Bel-shalti-Nannar, 173
Belshazzar, 172, 173
Belvedere Court, Vatican, 3
Belvedere Palace, Vienna, 120,
 166
Belvedere Torso, 3, 8
Bembo, Cardinal Pietro, 426,
 439, 446
Bembo, Torquato, 446
Bembo collection, 426, 427
Benin, 14, 156
Benois, 161
Bentivoglio, Giovanni, 435
Bentivoglio collection, 435
Benvenuti, Lorenzo di Marco,
 325
Berchem, Nicholas, 126
Berenson, Bernard, 96, 154, 163,
 333
Berlin Painter, 182
Bernardo, Messer, 393, 397
Bernard of Clairvaux, St., 92
Bernard the Elder (architect),
 282
Bernini, Giovanni Lorenzo, 3,
 11, 413
Bernward of Hildesheim, St.,
 134, 282
Berry, Jean Duc de, 55, 87, 284,
 311, 364, 369, 375, 392,
 434
Bertini, Giovanni, 379
Bertoldo di Giovanni, 386, 388,
 389
Besançon, Museum at, 164, 165

Bess of Hardwick, 95, 98
Bezaleel, 133
Biancai (Pien T'sai), 230
Biblioteca Marciana, 164
Bicci di Lorenzo, 361
Bieber, Margarete, 190
Bierstadt, Albert, 74, 159, 412
Bihzad, Kamāl al-din, 254
Biondo, Flavio, 344
Birth of Venus (Botticelli), 405
Biscop, Benedict, 93
Bismarck, Otto von, Prince, 385
Bisticci, Vespasiano da, 324, 325,
 327, 328, 333, 334, 335,
 352
Bizen ware, 22
Black Death, 330
Blanc, Charles, 152
Boccaccio, Giovanni, 5, 250,
 287, 288, 289, 298, 305,
 306, 317, 323, 334
Body painting, 30, 31, 57
Boghaz Koy, 186
Boisot, Monsignor J.-P., 164, 165
Boisserée brothers, 123, 125
Bologna, Franco da, 285
Bonampak frescoes, 38
Bonaparteana, 73
Bonnaffé, Edmond, 422
Book burning, 214
Book collecting, 303, 304, 308,
 327, 367
Book of Lord Shang, The (Shang
 Wei-yang, trans.
 Duyvendak), 214
Book of Rites, 215
Borel, Pierre, 465
Borgherini, Madonna
 Margherita, 444, 445
Borgherini, Pier Francesco, 444
Borghese, Cardinal Scipione, 449
Borghese Collection, 449, 450
Borghini, Rafaello, 111, 428
Borgia, Cesare, 420, 432, 435,
 436, 454
Bosch, Hieronymus, 88, 401
Boschini, Marco, 95, 96, 241
Boston Museum, 96, 97
Boswell, James, 165
Botticelli, Alessandro di Filipepi,
 12, 113, 114, 116, 119, 121,
 383, 384, 386, 403, 404,
 405, 406, 416, 426, 427,
 428, 429, 430, 432, 437
Bouguereau, Guillaume
 Adolphe, 411, 412

Boucher, François, 35
Boucheron, 54
Boulle, André-Charles, 159, 160,
 161
Bourdaloue, Père Louis, 23
Bourdalous, 23, 35, 39, 60
Bouts, Dieric, 45, 152
Bouts, Elizabeth, 45
Bower birds, 77–79, 82
Boy with a Dolphin
 (Verrocchio), 386, 401, 402
Bozzi, Lotto di Tanino, 382
Bracciolini, Francesco, 91
Bracciolini, Poggio, 323, 324,
 326, 328, 329, 330, 331,
 333, 341, 344, 345, 346,
 347, 357, 358, 393
 collecting, 348–352
Brahmins, 108
Bramante, 3
Brancacci Chapel frescoes, 123
Braque, Georges, 473
Bristol, Hervey, Earl of, Bishop
 of Derry, 122, 123
Bristol and Derry collection,
 122, 123
British Museum, 55, 166, 210,
 229, 230, 236, 254, 407
British Secret Service, 124
Bronze Age, 170
Bronze David (Michelangelo),
 443
Bronze founders, 259, 261
Bronzes, 141–146, 213, 215,
 219, 223, 249
Bronze seekers, 144
Bronzino, Agnolo Allori, 113,
 415, 426, 428
Brooklyn Museum, 174
Brosses, Président Charles de, 13,
 117
Bruce, Ailsa Mellon, 17
Bruegel, Pieter, 98, 127, 461
Bruges Madonna
 (Michelangelo), 456
Brundage collection, 218
Brunelleschi, Filippo, 315, 325,
 327, 338, 339, 353, 364,
 366, 374, 380
Brunelleschi houses, 307
Bruni, Leonardo, 317, 323, 325,
 326, 327, 331, 332, 333,
 344, 345, 346, 353
Brutus, Marcus, 204
Brutus (Cicero), 201
Bryan, Thomas Jefferson, 122

Bryan collection, 122
Buckingham, Duke of, 48, 149, 460
Buddha, Tōdaiji, Nara, 62, 63
Buddha image, Phnom Penh, 27
Buddhism, 38, 222, 252
Buffalmacco, Bonamico, 289
Buontalenti, Bernardo, 165
Bupalus, 192
Burchard, Dr. Ludwig, 153
Burckhardt, Jacob, 44, 69, 70, 74, 94
Burgundy, Dukes of, 279
Burlamachi, Sir Philip, 149, 150, 151
Burmese royal regalia, 172
Buschetto, 276, 308
By-products of art, 1, 2, 14, 15, 18, 20, 25, 31, 467
 cultural-behavioral patterns, 293–297, 467, 468, 469
 eight, 156
 primary, 16, 102, 106
 reasons for existence, 168, 169
 recurring factors in, 468–470
 rewards and penalties, 470–473
 secondary, 16, 104, 105, 106
Byzantine art, 43, 110, 139, 143, 177, 179, 241, 258, 275, 390, 473
Byzantine empire, 258, 260, 343

Cabinet des Estampes, 466
Cabinet painters, 125, 126
Cacault, François, 123
Caesar, Gaius Julius, 42, 195, 198, 205, 206, 385
Caesar Relief (Desiderio), 397
Cairo Geniza, the, 344
Cai Tao (Cai Ts'ai), 146, 147
Calamis, 11
Calcedonio, Il, 329, 332, 334, 335, 356, 357, 367, 391, 392, 394, 410
Calimala, 315, 316, 318, 335, 365
Calixtus III, Pope, 55, 390
Calligraphers, 231, 233
Calligraphy, 41, 61, 62, 63, 65, 135, 157, 214, 216, 217, 220, 222, 223, 225–228, 253, 254, 255, 417
Calligraphy Dealer (Zhang Huai Han), 242

Callimachus, 193
Callistratus, 202, 270
Callot, Jacques, 466
Camaldolese Order, 324, 326
Cambridge University, 277
Camerino d'Alabastro (Ferrara), 92, 94, 208
Campo Santo, Pisa, 319, 386
Canon, The (Polyclitus), 184, 274
Canova, Antonio, 4
Canterbury Cathedral, 277, 279
Cao Zhao (Ts'ao Chao), 249
Caractères (La Bruyère), 466
Caradosso, 433
Caraffa, Cardinal Oliviero, 357, 396
Caravaggio, Michelangelo Merisi da, 461, 462
Card Players (Cézanne), 90
Careggi, Villa, 364, 386, 401
Carleton, Sir Dudley, 9, 47, 48, 148
Carolingian jewelry, 272
Carolingian miniscule, 328
Carolingian Renascence, 260, 302
Carpaccio, Vittore, 116
Carr, Robert, Earl of Somerset, 148, 459
Carracci, Annibale, 112, 462, 475
Carracci, the, 114, 122, 248
Carrara, Francesco da, 288, 306, 340
Carrara family, 311
Carritt, David, 138, 141
Carta del navegar pitoresco (Boschini), 95, 96
Carter, Jimmy, president, 102
Cartier, jeweler, 54
Cary, Thomas, 150, 151
Casa Contarini, Venice, 144
Casa Morosini, Venice, 144
Casino Mediceo, 388, 389, 398
Casket of Teuderigus, 272
Cassiano del Pozzo, 160
Cassiodorus, 258, 259, 260
Castel Sant'Angelo, 259
Castiglione, Baldassare, 441, 456, 459, 461
Castiglione, Fra Sabba da, 419–425, 433, 434
 knowledge of, 427
 painters list, 421, 422, 426
Çatal Hüyük, 171

Catalogues, collection, 250, 251
Catasto, 383
Catena, Vincenzo, 116
Cathedral of Autun, 278
Cathedral of Milan, 273
Cathedral of Pisa, 111, 276
Cathedral of St. Bavo, 124
Cathedral of Ste.-Croix, 11
Cathedral of San Jacopo, 387
Cathedral of Sens, 279
Cathedrals, 11, 12, 108, 111, 124, 273, 276, 278, 279, 280, 387, 388
Catherine the Great, 464
Catherwood, Frederick, 38
Cato, Marcus Porcius, 204, 347, 370
Cattaneo, Marchesa, 154, 155
Cavalcaselle, G. B., 446
Cave of the Hyena, 71
Caves
 Altamira, 57, 170
 of the Hyena, 71
 Lascaux, 57, 170
 Paleolithic, 30, 31, 39, 57
Cecco d'Ascoli, 287
Cedrenus, Georgius, 210
Celadon ware, 81
Cellini, Benvenuto, 56, 425, 428
Cennini, Cennino, 290, 340
Cephisodotus, 192, 202
Ceresara, Paride da, 438
Cerveteri, 43
Cesarini, Cardinal, 346
Cézanne, Paul, 90, 98, 313, 411, 412, 470
Chaemwese, Prince, 174
Chalchihuitls, 50
Chalice of Abbot Suger, 57
Chantilly ware, 23
Chardin, Jean-Siméon, 139
Charioteer, Delphic, 11, 66, 142, 144, 200
Charity (Del Sarto), 444
Charlemagne, 132, 260, 261, 262, 271, 272, 276, 288
Charles I, King of England, 149, 150, 151, 161, 162, 163, 433, 434, 436, 442, 453, 454, 456, 458, 465
 collection, 458–465
 inventory, 455, 463
Charles IV, Emperor, 307
Charles V, Emperor, 6, 46, 114, 224, 445, 448

Charles VIII, King of France, 408, 443
Charles of Anjou, King of Naples, 143
Charles the Bald, 54
Charterhouse (Certosa), the, 362
Chartres Cathedral, 12, 263, 264, 269, 273, 283
Chartreuse de Champmol, 12, 279
Chase Manhattan Plaza, 89, 90
Château de Maisons, 13
Cheng (Ch'eng), Emperor of China, 228, 229
Cheng Falun (Ch'eng Fa-lun), 243
Chen Zun (Ch'en Tsun), 225, 238, 239, 240
Chersiphron, 184
Chesterfield, Earl of, 6
Chigi, Agostino, 409, 431
Chinese art tradition, 18, 19, 21, 22, 29, 31, 40, 41, 50, 62, 80, 133, 134, 169, 212, 213, 318, 467, 472
 bronzes, 213, 215, 219, 223, 249
 calligraphy, 41, 61, 62, 214, 217, 220, 222, 223, 225–228, 232, 417
 Chinoiserie, 343
 collecting, 217, 240–243, 250, 417, 422, 423
 collecting's consequences, 243–246
 Communism and, 220
 Confucianism, 213, 221–223
 display technique, 105
 faking of paintings, 158, 159
 first era, 216, 217
 gold and silver, 223
 hierarchy of classes, effect of, 223
 historians, 295
 history, 109, 217, 242, 246–248
 innovation, 233–237
 iron age, 213
 jade, 215, 216
 lacquer, 219, 223
 Legalist School, 214
 music, 215
 oracle bones, 226
 painting, 214, 216, 220, 222, 223, 225, 227, 232

political history, 220
porcelains, 17, 22, 39, 214, 223, 321
proto-Stalinist roots, 213–214
public museums, 250
rank of, artists, 223–225
remembered masters, 239, 240
representation in, 218, 219
revaluation, 250
scholar officials, 220–223, 312–313
second era, 216, 217–220, 232
sculpture, 219, 223
signatures, 237, 238
traditional music, 215
writing brush, 222
writing on, 186, 219, 231
Chinese empire, art history, 213, 214, 216, 217, 220
 foundation of, 213, 214, 220
 imperial court, 221
Chippendale, 161
Chomsky, Professor Noam, 35, 82
Choniates, Nicetas, 343
Christ Carrying the Cross (Giorgione), 153, 154
Christus, Petrus, 376, 403
Chronicles (Froissart), 284
Chrysoloras, Demetrius, 341
Chrysoloras, Emmanuel, 317, 331, 341, 342, 343, 350, 370
Chu (Ch'u), State of, 216, 219
Church, Frederic Edwin, 74, 75, 159, 412
Churches. See Saints
Cicero, Marcus Tullius, 104, 195, 196, 198, 201, 205, 206, 208, 266, 299, 344, 349
Cimabue, Giovanni, 12, 13, 111, 113, 114, 116, 121, 122, 134, 246, 285, 286, 289, 290, 409, 410, 414, 427, 429
Ciompi revolt, 330
Ciriaco d'Ancona, 329, 344, 347, 352, 353, 354, 355, 357, 443
Ciuffagni, Bernardo di Piero, 52
Civilizations, higher early, 170–172
Clark, Kenneth, Lord, 14
Classical art tradition, 164, 256,

432, 472. See also Western art tradition
 absence of art history, 265–267
 collecting, 110, 260, 262, 314, 370–372, 376
 collections, 110, 257, 262, 263, 264, 328, 424–426
 competition for works, 393
 decline of, 257, 258
 effects of war, 258, 259
 innovation in, 267
 manuscripts, 269
 medieval view of, 306
 new ways of seeing, 307
 signatures, 267–272
 three stages of collecting, 309, 310
 in Western Europe, 267
Classical learning, revival of, 303, 304, 307
Clement VII, Pope, 129, 417, 445
Clement VIII, Pope, 92
Cleve, Joos van, 47
Cleveland Museum of Art, 75, 76, 83, 95, 96, 158, 279
Clodius Pulcher, 349
Clothing, Renaissance, 384
Clouets, the, 279, 284
Cluny abbey church, 12
Clyton, 185
Cnidus, 42, 210
Coca-Cola bottles, 102, 103, 104
Coca-Cola Company, 104
Coccale, 197
Codex hunters, 346
Codices, 364, 394
Coins, 52, 271, 303, 424, 425. See also Medal and coin collecting
Cole, Thomas, 159
Collectibles, miscellaneous, 102–104
Collecting, 1, 2, 15, 16, 20, 22, 24, 40, 42, 49–56
 art-as-an-end-itself, 36, 37, 67
 art-historically motivated, 125
 art history's role, 335
 book, 298–301, 303
 bower birds, 77–79
 categories, 71, 73, 74, 75
 Chinese, 105, 217, 240–243, 417, 422, 423
 Chinese tomb figures, 250

Collecting (cont'd)
 classical art, 110, 260, 262, 314, 370–372, 376
 consequences, Chinese, 243–246
 creating world eddy, 452, 453, 457
 cross-cultural, 81
 decorating factor in, 422–424
 defined, 32, 36, 37, 68, 69, 70, 76, 77, 83
 disappearance from circulation effect, 321
 earliest, 28, 114
 early Western, 413, 414
 effect of 15th-century Italian-magnate, 370–372
 effect of the Medicis, 369
 esthetic sense in, 79, 80
 in 15th-century Florence, 337, 338
 general laws, 73–76
 Greek, 190–194
 historical response to art and, 417, 469
 history of, 20, 25, 28, 29
 the impulse, 70–73
 Indian, 255
 interaction with art history, 109, 110, 122, 126, 127, 135, 139
 Islamic, 418, 423
 Japanese, 252, 253, 423
 later 14th century, 311–314
 later 16th century, 447–450
 literature on, 68
 magnates', 339
 museum branch of, 28
 nature of, 95–99
 in Paris, 311, 312
 vs. patronage, 89–94
 priorities in 16th century, 424–426
 rarities, 74, 75
 repeating pattern in five traditions, 467, 468, 469
 role of learning in, 80–83
 Roman, 202–208
 seeds of, 173–175
 17th century, 450, 453
 tests for true, 86–100
 by 1375, 307–311
 three stages of, 309, 310
 transition to Renaissance, 411, 429, 430
 universal, 465–467

 Western, 27, 206, 318, 334, 335, 451
Collections, 15, 38, 61, 67, 89, 97, 98, 99
 Abbot Suger, 12, 53, 56–59, 84, 86, 87, 90, 92, 93, 107, 108, 177
 Bembo, 426
 Bracciolini, 348–352
 Bristol and Derry, 122
 Bryan, 122
 Buckingham, 48, 149, 460
 catalogues of, 250, 251
 Charles I, 458–465
 Chinese imperial, 240–246
 classical, 110, 257, 262, 263, 264, 328, 424–426
 de Montor, 122
 drawings, 114
 Earl–Bishop of, see Bristol
 early, 110, 111, 123, 124
 early 15th century, 322
 Elgin, 10, 15, 26, 58
 English, 126
 English royal, 166
 Facciolati, 117
 French royal, 128, 454, 457
 Gonzaga, 416, 417, 436, 453
 Hapsburg, 118, 119
 Hirsch, 99
 Japanese, 253
 Lansdowne, 10, 11, 120
 Liechtenstein, 166
 Lodoli, 115–117
 Marolles, 465, 466
 medal and coin, 52, 271, 303, 311, 328, 333, 347, 357, 359, 375, 399, 400, 401, 421, 424, 425, 467
 Medici, 118–122, 433
 Pergamene, 192
 print, 466
 products of antiquity, 339
 Sanson, 466
 Schloss Ambras, 448
 Sirigatti, 428
 stamp, 72, 73, 74, 75, 466
 Vecchietti, 428
Collections des Médicis au XVe siècle (Müntz), 406
Collectors, 14, 17, 19, 23, 45, 49, 67
 agents for, 393, 394
 art produced for, 47
 classical, 110, 256, 262, 263, 264

 competition among, 407
 display by, 104, 105
 drawing, 114, 116
 early Italian, 110, 115
 effects of art market on, 152–156
 effect of Italian magnate, 370
 England's first, 459
 14th century, 340
 Greek, 190–194
 importance of surroundings, 93–95
 interest in antiquity, 339
 market, 103, 104
 mistaken with patrons, 140
 opportunities, 434–436
 tests for true, 86–100
 use vs. beauty to the, 91–93
Colombe, Michel, 280
Colonna, Fra Giovanni, 306
Colonna family, 262
Colonna, Stephano, 306
Colossus of Barletta, 143
Columbus, Christopher, 212
Columella, 344
Column of Trajan, 270
Commentarii (Ghiberti), 54, 304, 355
Commentarium (Niccoli), 346
Commission des Subsistences, 160
Commissions, 40, 41, 42, 45, 46, 47, 50
Commonwealth dispersal (or sale), 162–163, 453, 460–461, 463, 464
Communists, 27
Concert (Vermeer), 146
Concert Champêtre (Titian), 163
Condivi, Ascanio, 368, 388, 389, 408, 417
Confucianism, 213, 214, 221, 222, 223, 224, 240
Confucius, 185, 215, 220, 226, 237, 240
Connoisseurship, 98, 99, 347, 348
Considerazione sulla pittura (Mancini), 96
Constans II, Byzantine Emperor, 260
Constantine the Great, Emperor, 144, 209, 261, 305, 306, 342

Convent of San Marco library, 359

Conyngham, Marchioness of, 137

Cook, Captain James, 60

Cooper, Thomas Sidney, 48

Copying, 2, 99, 100, 131, 132, 135, 231, 444. *See also* Faking

Corbusier, Le, 183

Corinth, sack of, 194, 195, 203, 204

Correggio, Antonio Allegri, 113, 115, 122, 200, 416, 427, 437, 438, 440, 442, 462

Cortez, Hernàn, 6, 7, 21, 50, 448

Corti, Gino, 397

Cortona, Pietro da, 47, 91, 95

Cosmati, 262, 269

Costa, Lorenzo, 435, 438

Cotte, Robert de, 11

Coulanges, Philippe-Emmanuel de, 147, 148, 413

Coulton, G. G., 268

Council of Constance, 345

Council of Nicaea, 177

Country houses, English, 60

Courtier (Castiglione), 461

Cousin Pons, Le (Balzac), 147

Crassus, Lucius, 204, 207

Crawford, 25th Earl of, and 8th Earl of Balcarres, 124

Crawford, 29th Earl of, 124

Crescenzi family, 262

Cressent, Charles, 160, 161

Critian Boy, 183, 200

Criticism, 202, 286

Croce, Benedetto, 307

Cromwell, Oliver, 456

Crowe, J. A., 446

Crown of England, 53

Crown of Thorns, reliquary, 12, 18, 55, 72, 75

Crozat, Antoine, 151

Crozat, Pierre, 151

Crucifixion (Duccio), 124

Crusades, 57, 343

Cui Duan (Ts'ui Tuan), 241

Cunachus, 407

Cupid (Praxiteles), 150, 433, 436

Curators, early, 457, 458
museum, 14, 49

Cynno, 197

Cyrus the Great, 173

Dada, 18

Dagobert, King, 90

Dai Kui (Tai K'uei), 235

da Imola, Benvenuto Rambaldi. *See* Rambaldi

Damasippus, 195, 196, 262

Dame de Volupté, 125–127

Damophon, 201

Daniele da Volterra, 113

Daniel in the Lions' Den (Rubens), 48

Dante Alighieri, 261, 285–287, 291, 323, 331, 375, 413

"Daoist from Nanzhou" (Taoist from Nan-chou), 241

Dao Ji (Tao Chi), 158

Dark Ages, 29, 43, 56, 90, 111, 260, 261, 262, 263, 265, 267, 269, 271, 272, 274, 280, 291, 305, 338

Dasson, 131, 132

Datini, Francesco di Marco, 44, 289, 301, 340, 361

Datini firm, 44

David (Donatello), 356, 357, 363, 366, 367, 398

Davies, Marion, 94

Dead Christ (Mantegna), 462

De Aedificiis (Procopius), 107, 108

Dealers, 41, 44, 127, 148–152, 352, 377, 443–447, 453, 456
in Renaissance works, 382

De Coloribus et Artibus Romanorum ("Heraclius"), 273

Dedalus and Icarus, 395

De Diversis Artibus ("Theophilus"), 273

Degas, Edgar, 81, 95

De Imitatione Antiquarum Statuarum (Rubens), 9

Delfin, Giovanni, 347

Demareteion, 52

Démocède, 466

Democritus of Abdera, 185

Demoiselles d'Avignon (Picasso), 314

Demus, Professor Otto, 143

De Nobilitate (Bracciolini), 323

Denon, Baron Vivant, 121, 123

De Pignoribus Sanctorum (Guibert de Nogent), 130

Derby Day (Frith), 250

De Remediis (Petrarch), 306

De Re Rustica (Cato), 347

de Roover, Raymond, 400

Descriptiones (Callistratus), 202

Desiderio da Settignano, 44, 379, 397, 398, 403

Determinism, historical, 467, 468

De Varietate Fortunae (Bracciolini), 344, 349

De Viris Illustribus (Petrarch), 306

Devotional pictures, 44, 95

Devoucoux, Abbé, 278

Dialogi ad Petrum Paulum Histrum (Bruni), 323

Diana (Houdon), 152

"di Bruggia, Giovanni," 432, 434

Dichtung und Wahrheit, (Goethe), 3

Die Sammler (Burckhardt), 69

Digby, Sir Kenelm, 461

Diognète, 466

Dionysus (Aristides), 195

Dionysius of Fourna, 109

Dioscuri, 266, 270, 271, 319, 342

Dipoenus, 210, 211, 414

Discobolus (Myron), 200

Discrimination, 82

Display practices, 104, 105

Divina Commedia (Dante), 285–287

Domenichino, Domenico Zampieri, 122

Donatello, Donato de'Bardi, 52, 111, 279, 327, 338, 339, 349, 354, 356, 357, 359, 363, 367, 371, 375, 378, 380, 382, 384, 386, 397, 398, 400, 403, 421, 422, 424, 426

Dondi dall' Orologio, Giovanni, 308, 309, 310, 313, 331, 334, 336, 338

Dong Boren (Tung Po-jen), 243

Donne, John, 457

Doors of Paradise (Ghiberti), Florence, 3, 13, 52, 54, 319, 327

Doort, Abraham van der, 455, 457, 458, 459

Dossena, Alceo, 158

Dou, Gerard, 126
Dow Jones Index, 68
Drawings, 114, 116
Drunken Woman, 196
Dubuffet, Jean, 89, 90, 91, 95
Duccio di Buoninsegna, 124, 230
Duchamp, Marcel, 18
Duchiê, Jacques, 420
Dürer, Albrecht, 6, 7, 9, 75, 82, 98, 422, 447, 448, 462
Dufourny, Léon, 123
Du Fu (Tu Fu), 224
Dumbarton Oaks, 7
Dunhuang (Tun Huang), 231
Duomo, Florence, 5, 289, 315, 323, 350, 357, 363, 388
Duris of Samos, 187, 188, 202
Dwelling in the Fuchun Mts. (Huang), 249
Dying Gaul, 191

Eadmer, 277
Eagle of Abbot Suger, 53, 54, 56, 57, 86, 87
Eastern Chou dynasty, 297
East-West communication, 212
Ebbo Master, 278
Ebla, 186
École des Elèves Protégés, 138
Écouen, 128
Écrin de Charlemagne, 54, 132, 271
Egbert Master, 278
Egyptian art, 108, 133, 134, 173, 174, 426
 art collecting, 175
 court sculptors, 174
 graffiti, 174
 signatures, 181–183
Egyptian Museum, Turin, 426
Einhard, 260
Ekkehard of St.-Gall, 282
Ekphrases, 276
Elamites, 122
Electors of Saxony, 54
Elgin, Earl of, 10, 11, 15, 26, 58, 127
Elgin marbles, 10, 15, 26, 58, 124
Eliot, T. S., 473
Elizabeth II, Queen of England, 166
Ello, 272

Eloy (Eligius), St., 134, 271, 282
Emerald Buddha, 210
Emi no Oshikatsu, 63
Emperor Commodus as Hercules, 424
Enamels, 43
Encolpius, 199
English royal collection, 166
Epigraphical studies, modern, 344
Eremitani inventory, 299
Eremitani of Santa Margherita, the, 13, 299, 301
Escoffier, 274
Espina, Don Juan de, 466
Essex, James, 276, 277
Este, Alfonso d', Duke of Ferrara, 92, 94
Este, Beatrice d', 430
Este, Ippolito d', Cardinal, 435
Este, Ercole I d', Duke of Ferrara, 431
Este, Isabella d', Marchioness of Mantua, 94, 112, 420, 421, 425, 430–446
 attitude toward classical, 432
 as collector, 431, 432, 433, 434, 435, 436, 438–443
 described, 431
 as patron, 436, 437, 438
Ethologists, 70
Etruscan art, 43, 88, 139, 203
Euclid, 299
Eugenius IV, Pope, 53, 54, 334, 356, 390
Eumenes I, 191
Eumenes II, King of Pergamum, 191, 192
Eumolpus, 199
Euodos, 271
Euphronius crater, 17, 43, 86, 100, 139, 357
Euric, King of the Visigoths, 209
Euripides, 193
Eusebius, 209, 343
Euthycartides, 182
Eutyches, 347
Evelyn, John, 48, 465
Eworth, Hans, 458
Exhibitions, art, 451
Exuperius, St., 130
Eyck, Jan van, 88, 98, 114, 120, 124, 284, 376, 403, 427, 432

Fabius, Gallus, 195, 196, 208
Fabius Maximus Verrucosus, 203
Fables (Aesop), 197
Fabri de Peiresc, N.-C., 9
Facciolati, Abate, 117
Facciolati collection, 117
Fairings, 43
Fakers, 156–159, 197, 241, 244
Faking, 1, 16, 96, 117, 118, 129, 156, 196, 241, 244, 248, 249
Faldstool, 90
Falier, Doge Marino, 301
Fan Kuan (K'uan), 234, 238
Farm tools, 22
Farnese family, 446
Farnese Hercules, 2, 270
Fatimids, 156, 254, 391
Fauns and Serpents, 395, 403
Fazio, Bartolomeo, 88
Feast of the Gods (Bellini, Titian), 92
Federigo II, Mantua, 129, 135, 416, 417, 418
Félibien, André, 276
Félibien, J. F., 276
Fenollosa, Ernest, 82
Fenway Court, 262, 368
Ferdinand I, Austrian Emperor, 446, 448
Ferdinand II, Archduke of Austria, 447, 448
Ferentino, 349
Ferrante of Aragon, 400, 410
Ferrara, Duke of. See d'Este, Alfonso
Ferrarese, Ricobaldo, 289
"Fête de la Liberté et des Arts," 3
Ficino, Marsilio, 364, 385
Fihrist (al-Nadīm), 254
Filarete, Antonio Averlino, 11, 111, 373, 374, 375, 392
Filelfo, Francesco, 325, 326, 353
Flinck, Govaert, 131
Florence bankruptcies, 330
Florentine Academy, 113, 388
Florentine School, 116
Fontainebleau, 165, 425, 444
Fonte Gaia, Siena, 304
Forchoudt family, 48
Forgery. See Copying; Fakers; Faking
Forteguerri, Cardinal Niccolò, 387

Forum of Trajan, 208
Forzetta, Aquilia, 298
Forzetta, Nicolò, 298
Forzetta, Oliviero, 298–301,
 302, 307, 310, 311, 321,
 340, 452
Fosdick, Dr. Harry Emerson, 58
Fourth Crusade, 343
Fragonard, Jean-Honoré, 138,
 139
Francesco da Pistoia, Fra, 332,
 333, 350, 351, 352, 355,
 358, 393, 408, 443
Franciabigio, Francesco di
 Cristofano, 113
Franco da Bologna, 385
François I, King of France, 8, 56,
 88, 165, 425, 443, 445
Frati Minori di S. Francesco, 299,
 301
Fréart de Chantelou, 89
Frederick Barbarossa, Emperor,
 99, 332
Frederick the Wise, Saxony, 72
Frederick II, Hohenstaufen,
 Holy Roman Emperor, 302,
 303, 448
Freedberg, Sydney, 97
Freer Gallery, 254
French, Daniel Chester, 58
French Academy, 9
French crystal, 43, 86
French Revolution, 12, 18, 53,
 68, 120, 128, 129, 160, 161,
 279, 466
French royal collection, 128,
 454, 457
French scholarship, 27
Frescoes, 38, 399, 402
Frick, Henry Clay, 333
Frick Collection, 165
Friedrich Wilhelm II, King of
 Prussia, 124
Frith, William, 250
Froissart, Jean, 284, 291
Frontinus, 349
Fueter, Eduard, 295, 297, 305,
 468, 469
Fujiwara, Michinaga, Imperial
 Regent of Japan, 64
Fujiwara family, 62, 63
Fujiwara no Fubito, 62
Furniture
 auctions, 160
 English, 161

French, 93, 137, 159, 160, 161
 Russian, 160

Gaddi, Agnolo, 121, 290, 361
Gaddi, Cavaliere, 114
Gaddi, Taddeo, 121, 289, 290,
 361
Gagarin, Prince M. P., 113
Galatians, 191
Galba, Emperor, 311
Galen, 84
Galerie Matthiesen, 153
Gang of Four, 221
Gardner, Mrs. Jack (Isabella
 Stewart), 154, 163, 262,
 333, 368
Gardner bower birds, 77, 79
Gardner collection, 146, 153,
 154, 165
Gattemalata (Donatello), 421
Gauls, 191
Gauzlin, Abbot, 272
Gazette des Beaux-Arts, 126,
 146
Ge gu yao lun (Ko Ku Yao Lun)
 (Cao), 249
Gelder, Aert de, 131, 132
Gem collections, 302, 303, 329,
 333, 353, 355, 356, 357,
 359, 367, 375, 391, 392,
 399, 400, 401, 409, 410,
 421, 424. See also Jewelry
Gemma Augustea, 392
Genghis Khan, 254
Genji, Prince, 252
Genre, 48, 125
Gentile da Fabriano, 116
George III, King of England, 115
George IV, King of England, 126,
 137, 161
Gerini, Niccolò di Piero, 361
Gerson, Dr. Horst, 66
Gervase of Canterbury, 277, 281
Geschichte der Neuren
 Historiographie (Fueter),
 295
Getty, J. Paul, 10, 141
Getty Bronze, 140–45, 183
Getty Museum, 140, 141, 142,
 144, 183
Ghiberti, Lorenzo, 3, 13, 52, 53,
 54, 55, 111, 119, 279, 304,
 306, 307, 311, 315, 316,
 319, 321, 323, 327, 329,
 330, 334, 335, 338, 339,

 354, 355, 380, 404, 413,
 414
 classical models used by, 319,
 320
Ghiberti, Vittorio di Lorenzo,
 370
Ghirlandaio, Domenico, 91,
 113, 114, 378, 386, 441,
 460
Ghirlandaio, Ridolfo, 428, 444
Ghirlandaio shop, 389
Ginevra de' Benci (Leonardo),
 17
Gioacchino, 340
Giorgione da Castelfranco, 116,
 154, 427, 435, 462
Giotto di Bondone, 5, 12, 13, 80,
 111, 113, 114, 115, 116,
 121, 122, 124, 134, 200,
 229, 237, 250, 281, 284,
 285, 286, 287, 288, 289,
 290, 291, 305, 306, 340,
 341, 363, 388, 402, 409,
 429
Girolamo da Trevigi, 421, 422
Giscard d'Estaing, President of
 France, 200
Gislebertus, 278, 279, 280
Giustiniani, Andreolo, 351, 356
Glass
 Byzantine, 139
 French, 43, 86
 paperweights, 17
Glorification of Urban VIII
 (Pietro da Cortona), 91
Gloucester, Duke Humfrey of,
 327
Glück, Dr. Gustav, 153
Glycon, 2, 270
Go-Daigo, Emperor of Japan, 156
Godefroid de Clair (or de Huy),
 99, 281
Goes, Hugo van der, 88
Goethe, Johann Wolfgang von,
 3, 4, 10, 37, 68, 165, 208
Goitein, S. D., 344
Gold, 113, 223, 471
Golden Horns of Gallehus, 271
Goldsmiths, 53, 54, 55, 56, 99,
 271, 272, 433, 471
Gölnitz, Abraham, 465
Gombrich, Sir E. H., 99, 100,
 135, 179, 232, 237, 268,
 275, 328, 366, 415, 416
Gompers, Samuel, 66, 144

Gonzaga, Elisabetta, Duchess of Urbino, 432, 435, 454
Gonzaga, Federigo II, Duke of Mantua, 129, 135, 416, 417, 418, 431, 437, 440, 442, 443
Gonzaga, Ferrante, 46
Gonzaga, Francesco, Cardinal, 392, 401, 409
Gonzaga, Francesco, Marquis of Mantua, 431
Gonzaga collection, 416, 417, 436, 453
González de Clavijo, Ruy, 391
Gorizia, Count of, 299
Gothic architecture, 58, 111, 273, 276, 277
Gothic art, 11, 12, 127, 177, 219, 266, 429, 463
Gothic Revival, 11, 12, 13, 14, 112, 123, 127, 159, 275
Gould, Cecil, 449
Gozzoli, Benozzo, 367, 375, 386, 398, 399
Graces (Bupalus), 192
Graffiti, 174
Grammont, Maréchal de, 466
Granacci, Francesco, 100, 389
Granicus monument (Lysippus), 199
Granvelle, Cardinal de, 46
Greco-Roman art, 2, 3, 6, 8, 10, 11, 18, 148, 463
Greek art tradition, 2, 7, 8, 11, 26, 28, 39, 42, 52, 66, 133, 134, 169, 414, 415, 467, 471
 Archaic sculpture, 232
 Athenian Agora, 257
 Athenian philosophic schools, 257
 Athenian Stoa Poikile, 58
 auctions, 194, 195
 bronzes, 141–146
 collecting, 190–194
 first remembered masters, 184–187
 four special behavioral traits, 176
 historians, 295
 literature, 194
 market, 194–197
 mathematics, 344
 "miracle" of, 175, 176
 museums, 197–200
 mythology, 473

origination of by-products of art, 176
 Pergamene school, 191
 rank of artists, 224
 revaluation in, 200–202
 sculptural innovation, 179–181
 Sicyonian school, 193, 194
 signatures, 181–183
 stone sculpture, 176
 writers on theory, 183, 184
Greene, George, 455
Gregorius, Magister, 261, 266
Gregory XIV, Pope, 449
Gregory the Great, Pope, St., 261, 299
Grignan, Comtesse de, 147, 148
Grimani, Cardinal Domenico, 164
Grimani, Giovanni, Patriarch of Aquileia, 164, 165
Gritti, Andrea, Doge (Titian), 460
Grosley, P.-J., 117
Grottaferrata, 349
Group of Four Trees (Dubuffet), 89, 90, 95
Grüne Gewolbe, 54
Grünewald, Matthias, 75, 76, 83, 95, 96, 158, 197
Gryaznov, M. P., 28
Grynder, Ralph, 455
Gu (Ku), Master, 18, 19
Guardaroba, the, 118, 119, 121, 122
Guarino da Verona, 317, 325, 332
Guermantes, the, 6
Guglielmo da Cremona, Fra, 308, 309
Guicciardini, Francesco, 295, 297, 385
Guidebooks, 266, 282, 425, 465
Guillebert de Metz, 420
Guimard, Hector, 58
Gu Kaizhi (Ku K'ai-chih), 229, 230, 239, 242, 243, 246, 247
Gukanshō (Abbot Jien), 296
Gulbenkian, Calouste, 152, 153
Gulbenkian Museum, 178
Gu Moruo (Kuo Mo-jo), 231
Gundesindus, Abbot Lord, 282
Guo Ruoxu (Kuo Jo-hsu), 246, 247
Gusmin of Cologne, 55

Hadrian, Emperor of Rome, 15, 259, 266
Hagia Sophia, Constantinople, 108, 132
Hallesche Heiltum, 56
Hall of Paintings, Han, 228
Hamilton, Gavin, 120
Hammurabi, 172
Handbooks, craftsmen's, 108, 109, 183, 184, 268, 273, 274, 290
Han dynasty, 228, 229, 239, 241, 242, 245, 247
Han Gan (Han Kan), 224
Han Lin Academy, 251
Hannemann, Adrien, 153
Han Wu Di (Ti), Emperor, 221, 222
Hapsburg collection, 54, 118, 119, 120
Harappa, 171
Hardwick Hall, 95
Harris, Moss, 161
Hartburt, Abbot, 272
Hartt, Frederick, 397
Harvard University, 97, 218, 448
Haskell, Professor Francis, 14
Hatshepsut, Queen of Egypt, 174, 181, 182
Hauptburg, Babylon, 173
Hausandachtsbilder, 44
Hawaiian cloaks and helmets, 60
Hawksmoor, Nicholas, 12
Hawkwood, Sir John (Ucello), 356
Ḥaydar, Mirzā Muḥammad, 255
Hayy, Khwājah 'Abd al-, 254
Hearst, William Randolph, 94
Hebrew artists, 133, 185
Heian Court, 252, 253
Heike Monogatari, 134, 296, 423
Heimskringla (Sturluson), 295
Heirlooms, 51
Heirs, 205
Helena Fourment (Rubens), 152
Helst, Bartholomeus van der, 66
Henry II, King of France, 128
Henry III, King of England, 277, 278, 279
Henry VII, King of England, 459
 tomb of, 458
Henry VIII, King of England, 458, 463
Henry of Blois, 262, 263, 302
Henry, Prince of Wales, 459

Heraclius, Byzantine Emperor, 143
Heraclius (handbook writer), 273
Herakleion Museum, 245
Hercules (Lansdowne), 10, 11
Hercules (Lysippus), 207
Hercules Master, 315, 320, 323, 330, 336
Heritage. *See* National heritage, protection of
Hermaphrodite, Louvre, 413
Hermitage, the, 152, 153, 166, 452
Herodas, 197, 289
Herodotus, 136, 295, 297
Hideyoshi Toyotomi, 423
Hippodrome, Constantinople, 143, 144, 209
Hirohito, Emperor of Japan, 63
Hirsch, Robert von, 99, 332
Hirsch collection, 99
Histoire de l'art (Seroux d'Agincourt), 122, 123
Historia Augusta, 208
Historical determinism, 467, 468
Hitler, Adolf, 161, 172, 464
Hittites, 85, 173
Hlewagastir, 271
Hobbema, Meindert, 48
Hohenstaufen pastiches, 302, 404
Holbein, Hans the Younger, 457, 458, 459, 462
Holbein Chamber, Strawberry Hill, 159
Holy relics, faking of, 130
Homer, 317, 331
Homo erectus, 33, 34, 35, 71
Homogenization, cultural, 21, 24, 30, 83, 105, 107, 109, 164, 270, 296
Homo sapiens sapiens, 33, 35, 71
Honnecourt, Villard de, 108, 183, 273, 274, 280
Honorius, Prefect, 258
Horace (Q. Horatius Flaccus), 196, 206, 224, 262, 299
Horne, Herbert H., 114, 406, 427, 429
Horses of St. Mark, 143, 144
Horse tamers, *see* Dioscuri
Hortensius, Quintus Hortalus, 205
Hory, Elmyr de, 67

Hotel Richelieu, Paris, 128
Houdon, J.-A., 152
Howard, Thomas, 462
Huang Gongwang (Huang Kung-wang), 249
Hudson River School, 74
Hugford, Ignazio Enrico, 117, 118, 119
Huguenots, the, 55
Hui, Marquis of, 157
Hui Zong (Tsung), Emperor of China, 236, 245, 249, 251
Hūlāgū Khan, 254
Humanists, the, 343–345, 357, 358
 Italian, 296, 297, 305, 318, 327, 344
 network, 345–348
Hunt, Lamar, 74

Ibi, Sinibaldo, 97
Ica pottery, 173
Icebergs (Church), 74, 75
Identification. *See* Authenticity
Idolatry, 305, 306
Iga ware, 23
Ilkhanate of Persia, 254
Illuminators, manuscript, 269, 271, 285
Illustrated Guide to the Collectibles of Coca-Cola (Munsey), 102, 104
Imagines (Philostratus), 92, 94, 208
Imhotep, 181, 182, 185
"Imitation of Greek Works, The" (Winckelmann), 9
Immaculate Conception (Piero di Cosimo), 116
Impressionists, 81, 126, 159, 313
Inca annals, 294
Indian art, 108, 109, 133, 205
 collecting, 255
 writings, 186
Indians, American, 21, 22
Ingelheim, Palace of, 276
In Magnificentiae Cosmi Medicei Detractores (Maffei), 365
Innovation, 176, 177, 178, 180, 181, 212
 in Chinese painting, 233–237
 in classical art, 267, 268, 274, 312, 313

compulsive, 179, 232, 233, 470, 472
Italian masters, 319
in the Palazzo Medici, 369
Institutio Oratoria (Quintilian), 202, 345
Interior decoration, 420, 421, 422, 424
Internal Revenue Service, 71
Inventory
 Lorenzo de' Medici, 363, 382, 383, 384, 395–401
 contents, 402–404
 contrasts in value of contents, 401–404
 frescoes, 399, 402
 gems, medals, etc., 399, 400, 401
 sculpture, 398, 399
 Niccolò da Uzzano, 361, 363
Irtysen, 173, 178
Isabella Stewart Gardner Museum, 165
Isidorus of Miletus, 108, 132
Islamic art tradition, 29, 31, 133, 134, 169, 251, 467
 art history in, 255
 calligraphy collecting, 253, 254, 255
 Chinese influence, 254
 collecting, 418, 423
 display technique, 105
 miniatures, 254, 255
Islamic historians, 296
Italian cities, differences in taste, 340
Italian primitive painters, 111, 117, 124
Italian Renaissance art, 15th c. neglect of, 414
Italienische Reise (Goethe), 3
Itinerarium Galliae (Zinzerling), 465

Jabach, Evrard, 455
Jacob, Georges, 93, 161
Jacobello del Fiore, 116
Jacobellus, 301
Jacopo da Scarperia, 317
Jacquemart-André Museum, 165
Jade, 215, 216
James, Henry, 138
James I, King of England, 148, 162, 459
Janson, H. W., 356, 422, 426

Japanese art tradition, 22, 23, 29, 31, 134, 156, 157, 170, 467
collecting, 252, 253, 423
display technique, 105
history, 109, 253
importation of Chinese culture, 251, 252
tea-ceremony, 22, 23, 252, 253
Yamato-e, 252
Japanese historians, 296
Japanese imperial regalia, 156
Japanese prints, 81
Jarrow, 93
Jayavarman VII, Khmer emperor, 178
Jean de Chelles, 280
Jean Sans Peur, Duke of Burgundy, 55
Jefferson, Thomas, 160
Jewelry, 50, 53, 54, 55, 56, 81, 86, 261, 272. *See also* Gem collections
Jex-Blake, K., 188
Jiang Mengying (Chiang Meng-ying), 226
Jien, Abbot, 296
Jin (Chin) dynasty, 228, 242
Jockey and Horse, 142
John (Medieval artist), 282, 284
John VIII Paleologus, Emperor, 353
Jones, Inigo, 459, 460
Jonson, Ben, 459
Josef II of Austria, Emperor, 118, 120, 121, 166
Joyce, James, 473
Juan de Pareja (Velázquez), 17
Judith (Squarcione), 404
Judith and Holofernes (Donatello), 367, 371, 375, 398
Julia cameo, 271
Julius II, Pope, 3, 36, 128, 394, 435, 440, 448, 449
Junayd, Ustād, 254
Junk collectors, 115, 127, 377
Jupiter (Cellini), 425
Jupiter and Antiope (Correggio), 200, 437
Jurchen Tartar invasion, 245
Juro-jin, 23
Justice of the Emperor Otto (Bouts), 45

Justinian, Emperor, 107, 108, 132, 177, 257, 258, 345
Juvenal (Decimus Junius Juvenalis), 206, 299

Kairos (Lysippus), 210
Kakiemon porcelain, 81
Kalos inscriptions, 43
Kanaoka, *see* Kose no Kanaoka
Kang Xi (Hsi), Emperor of China, 84, 318
Kang Xin (K'ang Hsin), 241
Kano Ikkei, 109
Kant, Immanuel, 34, 37
Kara-e, 252
Kariye Djami, 116, 177
Khaldūn, Ibn, 296, 468
Khānum, Gauhar Sultān, 255
Khaṭṭ al-mansūb, 253
Khmer art, 26, 27, 452
Khmer monuments, 38, 85, 452
Khmers, the, 26, 27, 85, 108, 178, 452
Khnum-Ibre, 174
Khrushchev, Nikita S., 215
Kimono stand, 39, 65
Klassiker der Kunst, 153
Klenze, Leo von, 166
Klosterneuburg Altar, 53, 282
Knight, Richard Payne, 10, 11
Knights of St. John of Jerusalem, 419, 420
Knoedler's, 152, 153
Kōmyō, Empress of Japan, 62, 63, 64, 65
Kooning, Willem de, 49
Korean art, 21, 29, 251, 252
Korin, 23
Kose no Kanaoka, 134, 252, 423
Kouroi, 176, 179, 232, 235
Krautheimer, Richard, 315, 316, 319, 320, 321, 322, 323, 330, 332
Krautheimer-Hess, Trude, 315, 320
Kris, Ernst, 134
Kublai Khan, 301, 302
Kufic script, 254
Kul Tepe, 186
Kundaikan, 109
Kunstfreund, 69
Kunsthistorisches Museum, Vienna, 166, 461
Kurgans, 27, 28, 38, 85, 471
Kurz, Otto, 134

Laborde, Comte Léon de, 279
Labors of Hercules (Pollaiuolo), 367, 375, 382, 383, 444
La Bruyère, Jean de, 466
Lagbayi, 133
Lambert, Baron Léon, 141
Lançut, Palace of, 160, 161
Lanier, Nicholas, 149, 162, 163
Lansdowne, 1st Marquess of, 10, 120
Lansdowne collection, 10, 11, 120
Lanzi, Abate Luigi, 119, 120, 121, 122, 123, 125, 136, 429, 430
Laocoön, 3, 8, 9, 376, 424
Lascaris, John, 346, 394, 407
Lascaux, 57, 170
Last Judgment (Michelangelo), 3
Last Judgment, Notre Dame, 11
Last Supper (Leonardo), 421
Latin historians, 295
La Tour, Georges de, 127
Laurentian library, 328, 359, 378
Lauseum, Constantinople, 140, 210, 257
Lausus, 209, 210, 211
Leagrus, 43
Leda and the Swan (Leonardo), 166
Legend, Myth, and Magic in the Image of the Artist (Kris and Kurz), 134
Legend of the True Cross (Piero), 91
Legros, Fernand, 67
Lenoir, Alexandre, 128, 129
Leo X, Pope, 129, 407
Leo X, Pope, portrait (Raphael), 129, 130, 417
Leo X, Pope, portrait (Del Sarto), 129, 130, 417
Leochares, 2
Leonardo da Vinci, 17, 112, 113, 151, 158, 166, 187, 189, 195, 200, 211, 224, 387, 388, 405, 415, 416, 417, 421, 427, 428, 432, 433, 440, 441, 454, 457, 465
Leopold Wilhelm, Hapsburg Archduke, Regent of the Netherlands, 162, 453, 461
Leroi-Gourhan, André, 71
Lessard, Réal, 67
"*Letto di Policleto,*" 334
Letters (Lord Chesterfield), 6

Lettres (Mme de Sévigné), 467
Liang dynasty, 242, 246
Liang Kongda (Liang K'ung-ta), 226
Libergier, Hugues, 276
Libro de' disegni (Vasari), 114
Libro dell' arte (Cennini), 290
Li dai ming hua ji (Li Tai Ming Hua Chi) (Zhang Yanyuan), 109, 247
Liechtenstein, Prince, 17, 161
Liechtenstein collection, 166
Lightbown, R. W., 406
Li Gonglin (Li Kung-lin), 237
Limbourg brothers, 87
Lime burners, 259, 261
Linaiuoli Tabernacle (Fra Angelico), 119, 383
Lincoln Memorial, 58
Lindsay, Lord, *see* Crawford, 25th Earl of
Lippi, Filippino, 113, 117, 360, 386, 387, 388, 416, 421
Lippi, Filippo, Fra, 121, 123, 378, 379, 388, 397, 421, 427
Li Qingzhao (Li Ch'ing-chao), 245
Li Si (Ssu), 214, 215, 218, 221, 222, 226, 239
Lister, Martin, 465
Literature, general, 281, 282
Lives of the Most Excellent Artists (Vasari), 5, 109, 111, 193, 247, 415, 447
Liu Song (Sung) dynasty, 157, 241, 242
Livy, Titus Livius, 203, 295, 299
Li Yangbing (Yang-ping), 237
Lloyd, Frank, 152, 156
Lloyds of London, 166, 448
Lodoli, Fra Carlo, 115–117, 121, 122, 124, 125, 127, 159
Lodoli collection, 115–117
Loehr, Max, 218, 237
Loggia de' Lanzi, 164
Lombard brooch, Munich, 272
"Lombard School, The," 117
Lombardo, Alfonso, 421, 422
Loménie de Brienne, 474, 475
Lombardo della Seta, 307, 308, 310, 311, 358, 371, 413
London (Mayhew), 161
London University, 218
Longhi, Roberto, 286
Lopez, Antonio, 456
Lord Elgin. *See* Elgin, Earl of

Loredano, Andrea, 435, 446
Lorenzetti, Ambrogio, 304
Lorenzo da Pavia, 421
Lorenzo Ghiberti (Krautheimer), 315
Lote, Stephen, 277
Louis IX, King of France, 72
Louis XI, King of France, 443
Louis XIII, King of France, 128
Louis XIV, King of France, 72, 84, 147, 159, 466
Louis XV, King of France, 138
Louis XVI, King of France, 160
Louis, Duc d'Anjou, 55
Louis, St., King of France, 12, 72, 75
Louis the Pious, King of France, 276
Love, Iris, 210
Loves of Jupiter (Correggio), 437
Low Countries art, 44, 45, 47, 48, 66, 88, 111, 114, 125, 340, 376, 378, 381, 403, 427, 444, 465
Lu (state of), 220
Lucan (Marcus Annaeus Lucanus), 299
Lucas van Leyden, 422
Lucian of Samosata, 199
Lucretius, 344
Ludovisi Throne, 198, 200
Ludovico "Il Moro," *see* Sforza, Ludovico
Ludwig I, King of Bavaria, 121
Lugt, Frits, 12, 13, 113, 116, 432
"Luminists, the," 74, 75
Luo (Lo) River, 226
Lussemburgo, Niccolò di, 299
Lu Tanwei (Lu T'an-wei), 229, 242, 243, 247
Luther, Martin, 72
Luynes, Duc de, 126
Lysimachus, 191, 347
Lysippus, 140, 141, 144, 180, 184, 188, 189, 192, 198, 199, 200, 202, 203, 207, 210, 224, 228, 260, 304, 320, 323, 330, 407, 412, 415

Macedonian Renaissance, 177
Madonna and Child (Donatello), 382
Madonna of Impruneta, 117

Madonna of Loreto (Raphael), 450
Madonna of the Pomegranate (Botticelli), 116
"Madonna Verona," 305
Madonna with Two St. Johns (Botticelli), 383
Madonnieri, 44, 45
Machiavelli, Niccolo, 295, 297
Maffei, Scipione, 115
Maffei, Timoteo, 365
Magdalen (Titian), 442
Maghreb, 301
Maiano, Benedetto da, 360
Maiano, Giuliano da, 379, 386, 387
Majesté de Ste. Foy, Conques, 261
Malatesta, Francesco, 432, 433, 437
Mâle, Émile, 268
Malraux, André, 9, 27
Mamurra, 196
Mancini, Giulio, 96, 157, 241
Manet, Edouard, 159
Manetti, Antonio, 324
Manilius, Marcus, 344
Mankind, origins of, 33, 34
Mantegna, Andrea, 13, 113, 116, 149, 388, 392, 403, 421, 425, 427, 432, 435, 437, 438, 462, 463
Mantua, Duke of, 149
Mantua sale, 149–157
Maori club, 145
Mao Zedong (Tse-tung), 218, 221, 225, 226, 240, 249, 472
Maquoid, Percy, 161
Marcellus, M. Claudius, 203, 204
Marchioness of Mantua. *See* d'Este, Isabella
Marcomannic Wars, 208
Marcus Aurelius, Emperor of Rome, 208, 261, 319
Margaret of Austria, Regent for Charles V as boy emperor, 6, 114
Mari, 186
Marie-Louise, Empress of France, 160
Mariette, P.-J., 125, 151, 152, 155, 156
Marinus de Gallera, 303
Marlborough, Duke of, 163

Marlborough Gallery, 151, 152, 156

Marolles, Abbé de, 465, 466

Marolles collection, 465, 466

Mars statue, Florence, 201

Marsyas statues, 359

Marsuppini, Carlo, 326, 354

Martelli, Ugolino, 426

Martial (Marcus Valerius Martialis), 196, 206, 207

Martindale, Andrew, 436

Martini, Simone, 154, 289, 306

Mary, Queen of England, 458

Masaccio, Tommaso di Giovanni, 13, 80, 117, 119, 123, 188, 202, 237, 312, 338, 339, 340, 363, 380, 402–404, 406, 407, 410

Mask of Blacknesse (Jonson), 459

Maso di Finiguerra, 379

Masolino da Panicale, Tommaso di Cristoforo Fini, 123

Master Gu. *See* Gu Moruo

Master of Chartres Cathedral, 269, 283

Master of the Bouçicaut Hours, 278

Master of the Registrum Gregorii, 278, 282

Masters
 first old, 110
 first remembered, 285–288, 290
 innovating Italian, 319
 Italian remembered, 414
 medieval, 278
 remembered, 132–136, 281–283
 remembered Chinese, 239, 240
 remembered in Dark and Middle Ages, 275–277, 284, 285
 remembered Greek, 184–187, 414
 rise of early, 122–125
 Western art tradition's remembered, 284

Mathew, Tobie, 47

Matisse, Henri, 4, 67, 89, 90, 98, 129, 190, 309, 380, 473

Mauritius blue stamp, 72, 75

Mauritshuis, 127

Mauro, Lucio, 425

Mausoleum of Halicarnassus, 434

Maximilian II, Holy Roman Emperor, 446

Mayan art, 38, 132, 145, 186, 412

Mayan glyphs, 186

Mayan monuments, 38, 132

Mazarin, Cardinal, 162, 453, 455, 456, 461, 474

McCallum, Frances T., 102, 103

McCallum, Henry D., 102, 103

Meadows, Algur Hurtle, 67

Mechel, Christian von, 118, 120

Medal and coin collecting, 311, 328, 333, 347, 357, 359, 375, 393, 399, 400, 401, 421, 424. *See also* Coins

Medici, Anna Maria Luisa de', 118

Medici, Cardinal Leopoldo de', 98, 114, 116, 430, 457

Medici, Carlo de', 393

Medici, Clarice Orsini de', 388, 398

Medici, Cosimo de', Pater Patriae, 87, 121, 324, 326, 327, 331, 344, 383, 398
 as collector, 338, 339, 351, 352, 353, 354, 357–360, 371, 372
 collecting begins, 355–357
 humanists and, 358
 Palazzo Medici and, 365–368
 as patron, 362–365, 369

Medici, Don Ottaviano de', 129

Medici, Giovanni de', 359, 363, 367, 375, 376, 393, 397, 398, 407

Medici, Giovanni di Bicci de', 361, 364

Medici, Giuliano de', 391, 392

Medici, Grand Duke Cosimo I de', 429

Medici, Grand Duke Ferdinando I de', 112, 113, 429, 432

Medici, Grand Duke Francesco I de', 165

Medici, Lorenzo de' (the first), 356, 364

Medici, Lorenzo de', the Magnificent, 302, 340, 414, 434, 438, 443
 as arbiter, 387–390
 as collector, 338, 339, 340, 346, 359, 390–395, 416

death of, 317, 338, 362, 409
 described, 385
 as patron, 385, 386, 387, 405, 416
 posthumous inventory, 363, 382, 383, 384, 395–409
 ricordo, 364, 365, 392
 taste of, 396

Medici, Lorenzo di Pierfrancesco de', 408, 454

Medici, Marie de', 10, 47

Medici, Nannina de', 378

Medici, Piero de', the Gouty, 81, 338, 339, 340, 359, 363, 373, 374, 375, 397, 398, 399, 407
 as collector, 338, 339, 340, 367, 376
 as patron, 376

Medici, Piero de', the Unfortunate, 338, 409, 410

Medici Bank, 45, 88, 327, 358, 382, 396, 400, 401

Medici-Riccardi Palace, 366

Medici Venus, 376

Mehmet the Conqueror, 390

Meiji, Emperor of Japan, 63, 156

"Meiji, fakes," 156, 157

Meiji Restoration, 62, 63, 64, 81, 156

Meiss, Millard, 54

Meissen porcelain, 23, 39, 81

Meissonnier, Juste-Aurèle, 17, 153

Melch, Monastery, 139

Melior of Pisa, Cardinal, 264

Mellaart, James, 171

Mellon, Andrew W., 153, 452, 464

Melozzo da Forlì, 422

Memling, Hans, 427

Memmo, Andrea, 115, 116

Mémoires (Loménie de Brienne), 474, 475

Mémoire sur l'architecture gothique (Soufflot), 11, 12

Memorabilia (Xenophon), 185

Memory, general cultural, 281–285

Memphis, Egypt, 156

Men, 174

Mentmore, 137, 138

Mentor, 204, 207, 407

Mentuhotep II, King of Egypt, 174, 178

Menzocchi, Francesco, 421, 422

Merovingian period, 271
Mesolithic Age, 170
Mesopotamian civilization, 172,
 173, 184, 297
 writing in, 186
Messina, Antonello da, 462
Metagenes, 184
Metalworkers, 271
Metellus, M. Caecilius
 Macedonicus, 199, 207
Metropolitan Museum of Art,
 14, 17, 43, 60, 86, 97, 100,
 167, 176, 179, 357
Michelangelo Buonarroti, 3, 4,
 11, 33–35, 45, 88, 112–114,
 125, 128, 129, 141, 150,
 151, 154, 182, 189, 227,
 247, 339, 368, 388, 389,
 390, 396, 408, 409, 410,
 415, 417, 421, 424, 426,
 428, 433, 436, 441, 442,
 443, 444, 446, 454–457,
 458
Michelozzo Michelozzi, 52, 366
Michiel, Marcantonio, 111, 425,
 427, 428, 432
Micon, 58
Middle Ages, 29, 56, 71, 72, 90,
 111, 134, 260, 261, 262,
 263, 265, 267, 269, 271,
 272, 280, 291, 304, 319,
 324
Middeldorf, Ulrich, 118
Mi Fu, 235, 236, 244, 249
Millar, Sir Oliver, 463
Mime IV of Herodas, 197, 289
Minamoto, the, 63
Minerbetti, Andrea, 377, 378
Minerbetti, Bernadetto, 378
Minerbetti, Francesco, 378
Ming dynasty, 249, 250, 318
Ming porcelain, 81, 318
Minoan culture, 136, 171, 173,
 175, 245
Mirabilia Urbis Romae, 266,
 306
Mirandola, Pico della, 385
Mirror, the Seal, and the Sword,
 156
Mirzā, Prince Ibrahim, 255
Miss O'Morphy (Boucher), 35
Mobiliers, 93
Mochica pottery, 129
Moderna Museet, 52
Modigliani, Amadeo, 129
Mogul dynasty, 133, 186, 255

Mohenjo-Daro, 171
Mommsen, Theodor E., 307
Mona Lisa (Leonardo), 4, 211
Monastery of St. Catherine, 177
Monet, Claude, 159
Mongol Ilkhanate of Persia, 254
Mongols, 254
Monogram (Rauschenberg), 52
"Monsieur de Paris," 466
Montalto, Cardinal, 158
Monte Cassino, 349
Montefeltro, Guidobaldo da,
 Duke of Urbino, 432, 459
Montesquieu, Baron Charles de,
 115
Montezuma, 172, 448
Montigny, 160
Montmorency, Connétable de,
 128
Montor, Artaud de, 122, 123
Monuments, 25, 26, 27, 28, 51,
 85, 325
 Athenian Stoa Poikile, 58
 Khmer, 38
 Lincoln Memorial, 58
 Mayan, 38
 Roman, 262, 266, 309, 319
Mor, Anthonis, 458
Moran, Thomas, 74
Morelli, Giovanni di Pagolo,
 289, 340
Morellian connoisseurship, 96,
 157
Morelli-Lermolieff, Giovanni, 96
Morgan, J. P., 333
Morosini, Domenico, 143, 144
Morozov, I. A., 312
Morris, Gouverneur, 160
Moses, 133
Moss Harris Ltd., 161
Motorcars, old, 73
Mouhot, Henri, 27
Mourners (Sluter), 12, 279
Mouseion, Alexandria, 163, 193
Müntz, Eugène, 300, 358, 384,
 396, 399, 401, 406
Muhammad, Dūst, 255
Mummius, Lucius Achaicus,
 195, 199, 203, 204
Munsey, Cecil, 102, 103, 104
Muqaddimah (Khaldūn), 296
Mu Qi (Ch'i), 253
Muqla, Abū 'Ali Muḥammad
 ibn 'Ali ibn, 253, 254
Murasaki, Lady, 64, 253
Muromachi period, 253

Musée Condé, Chantilly, 450
Musée des Monuments de l'Art
 Français, 128
Musée Imaginaire, 8, 9, 13, 286
Musée Napoléon, 123, 464
Musée National du Louvre, 53,
 57, 97, 120, 121, 123, 128,
 139, 163, 167, 397, 413,
 437, 456
Museo Archeologico, Venice,
 164, 300, 321
Museo Capitolino, 164
Museo Pio-Clementino, 2
Museum für Völkerkunde,
 Vienna, 448
Museums, 1, 14, 16, 17, 19, 23,
 24, 38, 49, 52, 57, 104
 American, 166, 167
 Cleveland Museum of Art, 75,
 76, 83
 Dresden, 37, 54
 Greek, 197–200
 history of public, 451
 Japanese, 62, 253
 King Charles I's collection in,
 464
 Kunsthistorisches, 166, 461
 Nezu, 23, 165
 Philadelphia, 18
 Pitti Palace, 118, 119, 429
 Prado, 166
 public, 163–167, 329
 public in China, 250
 in Rome, 198, 199
 Soviet, 28
 Sunday visits, 167
 as tombs, 20
 Uffizi, 117, 118, 119, 120,
 121, 130, 165, 166, 429,
 449
 Vienna and Florence, 37
Music, 215
Musical instruments, 420, 421,
 427
Mycenaean culture, 85, 136, 171
Myron, 188, 192, 197, 199, 200,
 205, 290, 407

Nabupolassar, King of Babylon,
 172, 173
Napoleon, Emperor, 3, 73, 123,
 160, 172
Narcissus gem, 332, 333
Narmer, Egyptian king, 178
Narrative history, 295

National Collection of Fine Arts, 52
National Gallery of Art, London, 138, 146, 163, 166, 167, 448, 449
National Gallery of Art, Washington, 17, 48, 57, 75, 153, 167, 397, 403, 452, 459, 461
National heritage, protection of, 112, 113, 430, 431
National Library, Cairo, 254
National Museum, Tokyo, 253
Naturalis Historia (Pliny), 109, 188
Navagiero and Beazzano, portrait (Raphael), 427
Nazarene painters, 123
Nebuchadnezzar, King of Babylon, 173
Necrology of the Monastery of Neufmoutiers, 281
Neferu, Queen of Egypt, 174
Negroponte, Giorgio di, 425, 434
Nelson, Horatio Admiral Lord, 163
Neolithic age, 50, 51, 139, 238, 170, 171
Neri di Bicci, 44, 354, 381, 382
Nevers, Duc de, 149
New Hermitage, 166
New York "art scene," 146
New-York Historical Society, 122
Nezu Museum, 23, 165
Niccoli, Niccoló, 322–326, 334–36, 341, 343, 344, 345, 346, 347, 348, 349, 350, 352, 353, 354, 356, 357, 363, 391, 410
 dates, 330–334
 as fashion setter, 326–330
 as friend to Cosimo de' Medici, 356, 357, 358
Niccoli library, 327, 328, 359
Niccolini, Archbishop, 391
Nicholas I, Tsar of Russia, 166
Nicholas V, Pope, 346, 370
Nicholas of Verdun, 53, 282
Nicias, 193, 194
Nicodemus, 373, 375
Nicomachean Ethics (Aristotle), 185
Nicomedes IV, King of Bithynia, 42

Nigellus, Ermoldus, 276
Nijo-in, Kyoto, 420
Nine Classics, 243
Nineveh, 173
Nishi-Honganji temple, 423
Ni Zan (Ni Tsan), 236
Noche Triste, 50
Nogent, Guibert de, 130, 131, 260, 261, 266, 304, 305
Noguchi, Isamu, 49
Notebooks (Leonardo), 416
Notre Dame, Paris, 264
 desecrations of, 11, 12
Novellara, Pietro da, Carmelite Vicar General, 440
Novelle (Sacchetti), 289
Novi homines, 195
Novius Vindex, 412
Nuremberg Museum, 99
Nys, Daniel, 148, 149, 150, 151, 155, 156, 162, 436, 453, 454, 455

Oberhuber, Konrad, 448, 449
Obsidian, 50, 139
Occam's Razor, 336
Oda Nobunaga, 63
Oderisi of Gubbio, 285
Oeben, J.-F., 161
Ogunwale, Chieftain, 107, 133
Olaf, Saint-King, 295
Olbia, 471
Oldenberg, Claes, 132
"Old master," use of phrase, 97, 98
Old masters vs. remembered masters, 411, 412
Old Record of the Classification of Painters (Xie He), 229
Olmec sculpture, 85, 145, 171
Olympiads, 186
Onatus of Aegina, 192
Onetorides, 43
Opus Anglicanum, 43, 139
Opusculum (Albertini), 425
Oracle bones, 226
Orcagna, Andrea di Cione, 121, 289
Orchid Pavilion Preface (Wang), 230, 231
Orcus, 192
Origen, codex of, 346
Orléans, Gaston d', 128
Orosius, 299
Orsanmichele, 355, 421

Ospedale de' Battuti, 301
Osservatori Minori, 115
Ostia, 358, 394
Ostrogoths, the, 258, 259
Ottimo Commento, 286
Ottley, William Young, 123
Otto III, Emperor, 282, 284
Ottomans, the, 343
Overbury, Sir Thomas, 148
Ovid (P. Ovidius Naso), 299
Oxford University, 12, 14, 327
Ozymandias, 178

Pacal the Great, ruler of Palenque, 38, 84, 85
Pacific Oceania, 146
Paganism, 305
Painter's Manual (Dionysius), 109
"Paiva, La," 60
Palatine Chapel, Aachen, 260, 288
Palazzo Barberini, 91, 95
Palazzo Borgherini, 100, 444
Palazzo Colonna, 262
Palazzo Davanzati, 361
Palazzo della Cancelleria, 408
Palazzo del Te, 416
Palazzo de' Priori (or Vecchio), 354
Palazzo Medici, 362, 363, 365–368, 371, 373, 379, 384, 389, 396, 398, 402, 405, 407, 444
 end, 409, 410, 426
 furnishings, 405, 406
 influence of, 368–370
 library, 375
Palazzo Minerbetti, 377
Palazzo Pitti. *See* Pitti Palace
Palazzo Rucellai, 382, 384
Palazzo Uzzano, 361, 363, 368
Palazzo Vecchio, 164, 444
Palazzo Venezia, 390
Palenque, 38, 84
Paleoanthropologists, 33, 35
Paleolithic art, 30, 31, 39, 59, 170, 175
Paleolithic painted caves, 30, 31, 39, 57, 170, 171
Paleologan art, 177
Palette of King Narmer, 178
Paliotto of St. Ambrose, 53, 86, 272

Palla, Giovanni Battista della, 444, 445
Palladian villas, 387
Pamphilus, 193
Panaenus, 58
Panciatichi brothers, 383
Pandects (Justinian), 354, 381
Panofsky, Erwin, 57
Pantheon, Rome, 26, 260
Paris, Matthew, 281, 284
Parker, Dorothy, 94
Parler, Heinrich, 273, 280
Parler, Peter, 280
Parmigianino, Francesco Mazzola, 113
Parnassus (Mantegna), 437
Parrhasius, 185
Parthenon, 12, 15, 26, 39, 40, 58, 59, 209, 283, 329, 343
Pascin, Jules, 98
Patch, Thomas, 123
Patterns, historically repeating, 468, 469
Patronage, 32, 40, 41, 43, 49, 263
 of art in Florence, 360–362, 379–381
 vs. art collecting, 89–94
 changeover to collecting, 411
 commemoration of, 107
 English, 277
 esthetic discrimination in, 66, 67
 in 14th century, 340
 Medici, 362–365, 369, 374, 376, 377
 in modern times, 86, 87
 private, 59–66
 public, 56–59
 with religious emphasis, 365
Paulus, L. Aemilius, 204
Paul II, Pope, 371, 390, 391, 393, 399, 400
Pausanias, 192, 195, 198
Pauson, 185
Paxton, Joseph, 137
Pazyryk, 27, 28, 85
Pazyryk Kurgans, 38
Pazzi conspiracy, 391, 400
Peacham, Henry, 461
Peel, Sir Robert, 126
Pei, I. M., 80
Pella, Macedonia, 190
Pelli, Giuseppe Bencîvenni, 119, 121, 122, 429
Pembroke, Earl of, 149, 459, 460

Penni, Francesco, 450
Perenzolo, 300, 303, 340
Pergamene collection, 190–193, 194, 195, 339
Pergamene Library, 424
Pergamum, ruins of, 343
Pericles, 40, 59, 190, 283, 365
Perino del Vaga, 113, 428
"Perla, La" (Giulio Romano), 162, 460
Perseus with the Head of Medusa (Canova), 4
"Persian" miniatures, 254
Persimmons (Mu Qi), 253
Persius (Aulus Persius Flaccus), 299
Perugino, Pietro Vannucci, 112, 113, 386, 416, 421, 432, 437, 438, 439, 440
Peruvian tribes, 173
Peruzzi bank, 330, 361
Pesellino, Francesco di Stefano, 363, 382, 403, 404, 438
Peter of Spain, 278, 279
Peter the Great, Tsar of Russia, 112, 113
Petrarch, Francesco Petrarca, 5, 288, 289, 295, 298, 301, 305, 306, 307, 308, 311, 313, 317, 323, 328, 340, 346, 404, 413
Petronius Arbiter, 199
Petty, William, 461
Phaedrus, 196, 197, 241
Phaethon, 410
Phidias, 15, 33, 39, 40, 134, 184, 185, 189, 199, 200, 201, 202, 208, 209, 210, 224, 260, 266, 267, 270, 271, 281, 342, 343, 374
Philadelphia Museum of Art, 18
Philetaerus, 191
Philip II, King of Spain, 88, 445, 458
Philip IV, King of Spain, 162, 442, 453, 455, 460
Philip II of Macedon, 347
Philostratus, 92, 94, 208, 270
Phnom Penh Museum, 27, 178
Phoenicians, 176
Phoenix, 407
Phoenix cone-tops, 73, 75
Photius, Patriarch, 327
Piazza San Marco, Venice, 300
Picasso, Pablo, 4, 67, 98, 287, 309, 314, 473

Pichon, Baron, 76
Piero della Francesca, 12, 13, 23, 81, 91, 119, 124, 199, 200, 211, 339, 381, 388, 405, 421, 432, 435
Piero di Cosimo, 116, 432, 437
Pietà (Michelangelo), 34, 35, 182
Pieter de Hooch, 146
Pietro Leopoldo, Grand Duke, 118, 119, 120, 121, 166
Pignatti, Dr. Terisio, 154
Piles, Roger de, 9, 125, 147
Pinacotheca, Athens, 198
Pindar, 203
Piranesi, Giovanni Battista, 11
Pisanello, Antonio Pisano, 393
Pisano, Andrea, 315
Pisano, Nicola, 111, 319, 414
Pisistratus, 365
Pitti, Luca, 373
Pitti Palace, 118, 119, 429
Pizarro, 21
Plague of Ashdod (Poussin), 47, 147
Plataea tripod, 209
Plate, pieces of, 362, 375
Platina, 390
Plato, 184, 185, 186, 299, 331
Platonic Academy, 364
Platonism, 364
Plethon, Gemistus, 364
Pliny the Elder, Gaius Plinius, 109, 140, 141, 187, 188, 189, 204, 206, 207, 266, 270
Pliny the Younger, Gaius Plinius Secundus, 196
Plutarch, 187, 203, 224
Poetics (Aristotle), 185
Poggio a Caiano, 386, 387, 405
Poggio Imperiale, 119
Polemic Against the Cursive Script (Zhao Yi), 225, 226, 238
Poliziano, Angelo, 363, 385, 388
Pollaiuolo, Antonio, 121, 367, 375, 379, 382, 383, 384, 385, 398, 403, 405, 407, 416, 421, 424, 444
Pollaiuolo, Piero, 121, 387, 388
Pollio, Asinius, 198
Pollio, Vedius, 206
Pollitt, J. J., 180
Pollock, Jackson, 22
Polo, Marco, 301

Polybius, 204, 295
Polycles, 407
Polyclitus, 134, 184, 185, 196, 200, 202, 205, 224, 274, 334, 355
Polycrates, 26, 190
Polygnotus, 58, 185, 202
Polynesian culture, 177, 178
Pomponio, son of Titian, 46
Ponte Vecchio, Florence, 261
Pontormo, Jacopo Carucci, 100, 113, 428, 444
Porcari, Stefano, 370
Porcelains and pottery
 Aretine pottery, 303
 Chinese, 17, 22, 39, 81, 214, 223, 238, 321
 French, 17, 23
 Greek, 17, 43, 182
 Ica, 173
 Japanese, 22, 23, 81
 Neolithic, 238
 pottery tomb figures, 218, 219, 220
Porta della Mandorla, Florence, 315, 320, 323, 336
Portal of St. Anne, Notre Dame, Paris, 264
Porticus Octaviae, 199
Portinari, Tommaso, 88, 400
Portinari altarpiece, 400
Portraiture, 66
 Chinese ancestor, 223
 Chinese rulers, 428
 self-portraits, 117
Poseidon-Zeus from Artemision, 11, 142
Postage stamps, 72–74
Post-Impressionists, 309, 313
Potocka, Countess Betka, 160, 161
Potocki, Count Alfred, 160
Pottery. See Porcelains and pottery
Pottery armies, China, 218, 220, 231, 238
Poussin, Nicholas, 6, 9, 47, 89, 114, 147, 372, 470
Pozzo, Cassiano del, 166
Prado, 166
Prague Cathedral, 280
Praxiteles, 8, 42, 180, 192, 193, 197, 202, 205, 266, 267, 270, 271, 290, 300, 342, 374, 407, 433, 436
Pre-Columbian art, 6, 7, 21, 39

Pre-Raphaelites, 123
Presentation of the Virgin (Titian), 91
Prices, art market, 10, 11, 15, 17, 18, 19, 22, 139, 141, 144, 145, 460
 Chinese, 243
 for classical works, 333, 334, 394, 395, 432, 433
 King Charles I's pictures, 463, 464
 price differentials, 395, 396, 401
Primaticcio, Francesco, 8, 425
Primavera (Botticelli), 405
Primitive art, 145
Prints, 81, 422, 466
Probus, Valerius, 344
Procopius, 107, 108, 260, 295
Propylaeum, Athens, 198
Protogenes, 199
Proust, Marcel, 6, 473
Provence, Comtesse de, 160
Ptolemy I Soter, 163, 191, 193
Ptolemy II Philadelphus, 193, 194, 329
Ptolemy III Euergetes, 193, 194, 198
Public art museums, 163–167
Pucelle, Jean, 87, 291
Pugin, Augustus Welby, 12
Purgatorio (Dante), 285, 286, 287
Pyrgoteles, 354, 355

Qi (Ch'i) state, 215
Qian Long (Ch'ien Lung), Emperor of China, 249, 251
Qin (Ch'in) State, dynasty, 213, 214, 215, 219, 221, 222, 226
Qing (Ch'ing) dynasty, 246
Qin Shihuangdi (Ch'in Hsih Huang Ti), Emperor of China, 213, 214, 217, 218, 219, 220, 221, 222, 231, 238
 tomb of, 218, 219, 220
Quarto Gabinetto, Uffizi, 121, 429, 430
Quintilian, Marcus Quintilianus Fabius, 140, 202, 206, 266, 299, 344, 345
Qur'an, 254, 423

Ra, Egyptian God, 174
Raedwald, King of East Anglia, 51, 52
Rama IV, King of Thailand, 27
Rambaldi da Imola, Benvenuto, 286, 287, 310, 322
Rameses II, Pharaoh, 174
Ranjatai, the, 63, 65
Rape of Europa (Titian), 163
Raphael, Raffaello Sanzio, 13, 36, 39, 96, 97, 112, 113, 115, 122, 129, 130, 131, 132, 135, 150, 151, 158, 163, 182, 189, 195, 199, 200, 237, 312, 415, 416, 417, 421, 427, 431, 440, 441, 442, 447, 448, 449, 450, 452, 454, 456, 459, 460, 462, 463, 464
Rauschenberg, Robert, 52
Raw materials, 51, 52, 53, 67
 demand for, 259, 260
Real Galleria di Firenze (Lanzi), 429
Realism
 in Chinese art, 233
 deceptive, 234
Record of Famous Painters of All the Dynasties. See Li dai ming hua ji
Recherches des antiquités et curiosités de Lyon (Borel), 465
Regisol, Pavia, 319
Reisener, J.-H., 131, 147, 161
Religion, art's place in, 272
Rembrandt Harmensz. van Rijn, 6, 13, 18, 66, 125, 131, 132, 137, 152, 248, 333, 456, 457, 461, 462, 463
Renaissance, 5, 8, 11, 29, 32, 33, 54, 69, 72, 169, 284, 417, 418, 452
 architecture, 332, 365, 368, 458
 in England, 458–462
 Italian origins, 318, 322, 335, 336
 in Northern Italy, 340
 role of 14th-century collecting in origins, 314–316
Renaud de Mouçon, Bishop of Chartres, 264
Renault de Cormont, 276

Reni, Guido, 112, 114, 122
Renoir, Pierre Auguste, 98
Response, historical/esthetic,
 131, 135
 historical defined, 132, 135
Resta, Padre Sebastiano, 116
Restoration, 8
Restorers, 8
Revaluation, 14, 15, 16, 21, 22
 Chinese art, 250
 in classical times, 200–202
 in Greek art, 200–202
Reynolds, Sir Joshua, 13
Rhinoceros, Brundage
 collection, 218
Rhoecus, 184
Riario, Cardinal, 408, 409, 436,
 454
Richelieu, Cardinal, 128, 147,
 385, 453
Richelieu, Duc de (17th c.), 147
Richelieu, Duc de (late 18th c.),
 128
Richter, Gisela M. A., 232, 235
Ricordanze (Minerbetti), 378
Ricordanze (Neri di Bicci), 44,
 381
Ricordi (Castiglione), 419, 420,
 421, 422, 425
Ricordi (Morelli), 289
Riegl, Alois, 30, 69, 177
Rienzi, Cola di, 344
Rigattieri, 115, 377
Rinuccini, Cino, 325
Ripley, Dr. Dillon, 78, 79
Riposo, Il (Borghini), 111, 114,
 428, 429, 432
Risen Christ (Piero), 23, 211
Ristoro d'Arezzo, 303
Riverside Church, 58
Robbia, Luca della, 327, 338,
 367, 380
Robbia, della, shop, 377, 378, 382
Robert (Medieval artist), 282
Robert, Hubert, 152
Robert de Luzarches, 276
Rockefeller, David, 89, 90, 91,
 94, 95
Rockefeller, John D., Jr., 58, 59
Rockefeller, John D., Sr., 91
Rococo, 115
Roger II d'Hauteville, 448
Roger of Helmershausen, 274
Rogerus, 269
Roland, Jean-Marie, 120

Roman empire, decline and fall,
 259, 260, 267, 268, 472
Romanesque architecture, 111,
 273, 278
Romanesque sculptors, 277, 278
Roman Imperial mints, 271, 348
Roman Imperial style, revival of,
 260
Romano, Gian Cristoforo, 421,
 433, 434
Romano, Giulio, 122, 129, 130,
 162, 416, 417, 421, 442,
 446, 447
Roman portrait busts, 257
Rome, Count of, 259
Rosa, Salvator, 47, 445
Roscoe, William, 123
Rosebery, 6th Earl of, 138
Rosso Fiorentino, Giovanni
 Battista di Jacopo, 113
Rothko, Mark, 49, 151, 152
Rothschild, Baron James de, 137
Rothschild, Baron Mayer
 Amschel de, 137, 138
Rout of San Romano (Uccello),
 121, 367, 382, 403, 404
Rovere Arms, della, 36
Rowlandson, Thomas, 150, 151
Royal Academy, London, 48
Royal Portal, Chartres, 269
Rubens, Peter Paul, 6, 9, 10, 11,
 47, 48, 81, 98, 114, 125,
 126, 147, 148, 152, 248,
 312, 338, 460, 462
Rucellai, Bernardo, 378, 382
Rucellai, Giovanni, 378–385
Rucellai Madonna (Duccio), 13,
 117
Rudenko, S. I., 28
Rudolph II, Holy Roman
 Emperor, 446
Ruskin, John, 34
Ruysdael, Jacob van, 48

Sacchetti, Franco, 289
Sacrifice of Isaac (Del Sarto),
 444
Saepta Julia, 196
Safavids, 255
Saga, Emperor of Japan, 63, 65,
 252
Sahagun, Fray Bernardino de,
 172
Saïte period, Egypt, 175

Saint Albans Monastery, 281,
 284
St. Ambrose, Church of, 53
St.-Benoît-sur-Loire, France, 272
St. Catherine, Monastery of,
 Sinai, 176
St.-Denis, Abbey Church of, 12,
 53, 54, 56, 57, 84, 92, 107,
 128, 177, 219, 267
Sainte-Chapelle, Bourges, 55
Sainte-Chapelle, Paris, 12, 18,
 55, 72
St.-Gall Monastery, Switzerland,
 282, 284
Saint George and the Dragon
 (Raphael), 459, 460
Saint Jerome (Lombardo), 422
Saint John the Baptist, Head of
 (Donatello), 422, 426
Saint Matthew (Ghiberti), 355
St.-Maurice d'Agaune,
 Monastery, Switzerland,
 272
St.-Medard, monks of, 343
St.-Niçaise, Church of, Rheims,
 276
St. Peter's, Rome, 12, 34, 93
Saint Sebastian (Fra
 Bartolommeo), 444
Saint-Simon, Louis Duc de, 126
Saints Peter and Paul
 (Masaccio), 402, 406
St.-Vincent de Besançon,
 Monastery, 164
Sala Virorum Illustrium, Padua,
 306
Salisbury Cathedral, 346
Salles des Écoles Primitives, 121,
 123
Sallust, Gaius Sallustius Crispus,
 198, 200, 295, 299
Salt (Cellini), 56
Salutati, Coluccio, 316, 317,
 318, 322, 323, 328, 330,
 331, 344, 346
Salviati, Francesco de Rossi
 Cecchino, 113
Sanchi, India, 133, 186, 270
Sancta Camisia, 264
Sangallo, Giuliano da, 384, 386,
 387
San Giusto, Abbey, Volterra,
 386
San Jacopo, Pistoia, 387
San Lorenzo, Florence, 362, 364

San Marco, Cathedral, Venice, 143
San Marco, Church, Florence, 364, 444. *See also* Convent of San Marco library
Sanraedam, 48
San Sisto, Monastery, 36, 163
Sanson, "Monsieur de Paris," 466
Sansovino, Andrea, 150, 164, 387
Santa Croce, 361
Santa Maria della Pace, Rome, 431
Santa Maria del Popolo, Rome, 431, 449
Santa Maria del Sasso, Bibbiena, 386
Santa Maria de'Miracoli, Venice, 300
Santa Maria Novella, Florence, 91, 113, 379
Santa Trínita, Florence, 377
Santiago de Compostela, 282
Santo Spirito, Florence, 383
San Vitale, Ravenna, 300
Saqqara, Egypt, 178, 181
Sarcophagi, 261, 262, 317, 319, 367
Sarto, Andrea del, 100, 113, 122, 129, 130, 135, 417, 425, 428, 442, 444
Sarzana, Tommaso da, 346
Sassanian Empire, 257
Satin bower birds, 78, 79
Satyricon (Petronius), 199
Savonarola, Fra Girolamo, 338, 396, 407, 410
Savoy, Duke of, 126
Scala, Cansignorio della, 305
Scalamonti, 354
Scamozzi, Vincenzo, 164, 165
Scarampi Mezzarota, Luigi, Patriarch, Cardinal, 334, 335, 356, 357, 391, 395
Schapiro, Professor Meyer, 40, 41, 43, 136, 273
Schatzkammer, Vienna, 448
Schiaparelli, Attilio, 377, 378
Schloss Ambras collection, 447, 448
Schlumberger, Jean, 56
School of Love (Correggio), 437
Schweitzer, Bernhard, 188
Scopas, 320, 323, 330

Script
medieval, 328
Renaissance, 328
Sculpture, 26, 454–457, 461
Aztec, 7, 33
Chinese, 219, 223
classical, 333, 342, 349, 350, 351, 371, 374, 375, 388, 398, 399, 424–426, 433
devotional, 361, 362
Greco-Roman, 257, 372, 424, 425, 428
Greek archaic, 232
reproduction of pieces of, 382
Roman, 257, 259, 261
Romanesque, 277, 278
Scuola della Carità, 91
Scyllis, 210, 211, 414
Scythian antiquities, 113
Scythian gold, 113, 471
Scythians, 113, 136, 471, 472
"Seal of Nero," carved gem, 355, 356, 367, 404, 410
Sebastiano del Piombo, Luciani, 113
Second Crusade, 57
Seashells, 72
Secondhand dealers. *See* Junk collectors
Second Punic War, 203, 205
Sed festival, 174
Seeing, ways of
art history and, 125
changes in, 2, 4, 11, 13, 21, 448
classical art, 307
in different times, 5, 6, 7, 12, 13
split in way of, 288
Western, 11, 14, 22
Seferidus, Canon Lord, 282
Self-portraits, 117
Sellers, E., 188
Senate, Roman, 191, 266
Senate, U.S., 59
Sené, J.-B., 93, 161
Seneca, 206, 299
Senenmut, 181, 182
Serlio, Sebastiano, 447
Seroux d'Agincourt, J.-B., 122, 123
Serragli, Bartolomeo di Paolo, 44, 397, 398
Sert, José-Maria, 380
Service des Monuments Historiques, 264, 278

Sesto, Lorenzo, 311
Sesto, Marco, 311
Seven Sacraments (Poussin), 89
Seventh Book of Architecture (Serlio), 447
Severe Style (Greek), 66, 192, 200, 201
Sévigné, Marquise de (or Madame de), 147, 413, 467
Sfondrati, Cardinal, 449
Sforza, Francesco, Duke of Milan, 366, 373
Sforza, Galeazzo, 366, 368, 371, 375, 384, 403, 407, 408
Sforza, Ludovico, "Il Moro," 387, 396, 430, 433
Shang, Lord, 214, 215
Shang bronzes, China, 23, 129
Shang dynasty, 171, 186, 213, 218, 240
Shchukin, S., 312
Shearman, Dr. John, 97
Shi Ji (Shi Chi) (Sima Qian), 297
Shimada Shujiro, Professor, 19
Shi Qu Baoji (Shih-Ch'u Pao-chi), 251
Shiva, Lord of Dance, 155
Shōmu, Emperor of Japan, 62, 63, 64, 65, 90
Shōsōin, the, 61–66, 90, 228, 231, 252, 253
Sicyonian school, 188, 193, 194, 197, 329
Signatures, 212
in Chinese art, 237, 238
in Egyptian art, 181–183
Greek, 181–183
in medieval times, 267–272, 287
Silanion, 192
Silpasastras, 108
Silversmiths and silver, 76, 204, 207, 209
Sima Qian (Ssu-Ma Ch'ien), 295, 297
Simon, Magister, 300
Simon, Norton, 155
Simonides, 224
Simson, Otto von, 269, 278
Simpson, Wallis Warfield, 137
Sirén, Osvald, 230
Sirigatti, Ridolfo, 428
Sistine Madonna (Raphael), 36, 39
Six, Jan, 66

Six Foundation, 66
Six Principles (Xie He), 238, 274
Sixtus IV, Pope, 112, 164, 390, 391, 392, 400
Sketchbook (Villard de Honnecourt), 108, 183, 273, 274, 280
Slaves (Michelangelo), 128, 129
Sleeping Cupid (Michelangelo), 45, 141, 408, 409, 433, 435, 436, 443, 444, 454–457
Sluter, Claus, 12, 279, 280, 284
Smith, David, 129
Smith, Joseph, 115, 117
Smithsonian Institution, 78
"Smoked old" paintings, 96
Smuggling, 154, 155
Smythson, Robert, 95
Sodoma, Giovanni Antonio Bazzi, 113
Solidi, coins, 348
Solly, Edward, 124
Somerset, Earl of. *See* Carr, Robert, Earl of Somerset
Song (Sung) dynasty, 22, 39, 50, 146, 231, 234, 235, 236, 237, 238, 244, 245, 246, 249, 250, 318
Sophilus, 182
Sophocles, 143, 348
Sotheby Parke Bernet, 137, 138, 156
Soufflot, J.-G., 11, 12
Southeastern Nuba, 30, 31, 170
Southern Song (Sung) dynasty, 238, 250, 253
Soviet Antikvariat, 160
Spanish art, 127
Spedaletto, Lo, 386, 405, 416
Spinario, Rome, 319
Spoleto Cathedral, 388
Spon, Jacob, 465
Spring and Autumn Annals, 297
Squarcione, Francesco, 117, 403
Stalin, Josef, 152, 452, 464
Stallburg, Vienna, 418, 420, 424
Stamp collections, 72, 73, 74, 75, 466
Standard Bearer (Rembrandt), 137
Stanhope, Philip, 6
Starnina Triptych, 124
Statius, Publius Papinius, 206
Statuario Pubblico, 164, 166

Steegman, John, 95
Stein, Gertrude, 4, 312
Stein, Leo, 312
Stephen, King of England, 262
Stephens, John L., 38
Steppe art, 27, 28
Still, Clyfford, 49
Stoa Poikile, Athens, 58, 198
Stone, Robert, 455
Stone Age, Old, 71, 170
Stone Age, New, 50
Stoppio, Niccolò, 446
Storia pittorica dell' Italia, (Lanzi), 123
Strada, Jacopo, 445, 446, 447
Strada, Katharina, 446
Strawberry Hill, 159, 276
Strozzi, Filippo, 360
Strozzi, Palla di Nofri, 317, 331, 335, 353, 360, 383
Strozzi Chapel, 360
Sturluson, Snorri, 295
Style, 231, 233
 Gothic, 266
 International, 316, 319
 Renaissance, 365, 368, 379
Suan He Hua Bu (Hsuan-ho Hua-pu), 251
Su Dongpo (Tung-p'o), 224
Suffretus, 350, 351
Suger, Abbot, 12, 53, 56, 57, 58, 59, 84, 86, 87, 90, 92, 93, 107, 108, 177, 183, 267
Sui dynasty, 221, 245, 246
Sulla, 205, 207
Sumer, 171
Summa Theologica (St. Thomas Aquinas), 33
Summerard, A. du, 278
Sun Shangze (Sun Shang-ssu), 243
Super-prices, 17, 18, 159, 162–163, 194, 309, 357. *See also* Prices, art market
Susa, 172
Sutton Hoo, 51
Swan, Colonel James, 160

Tacitus, Cornelius, 295
Tahmāsp, Shah, 255
Taira, the, 63
Tale of Genji, The (Murasaki), 62, 64, 252
Tanagra figurines, 43

Tancila, Senator, 259
Tang (T'ang) dynasty, 18, 19, 50, 158, 231, 235, 236, 238, 244
Tang Gao Zong (T'ang Kao-tsung), Emperor of China, 244
Tang Tai Zong (T'ang T'ai-tsung), 230, 231
Taoists, 222
Tarquinia, Italy, 43, 88
Taylor, Francis Henry, 60
Tazza Farnese, 391, 392, 404, 407, 410, 438
Temples, 26, 27, 39, 61, 174
 Amun, Karnak, 174
 Artemis, Ephesus, 184
 Asclepius, Agrigento, 205
 Asclepius, Cos, 197
 Çatal Hüyük, 171
 Chinese, 235
 Coacalco, 172
 the Emerald Buddha, Bangkok, 27
 Greek, 197, 205
 Hera, Samos, 26, 184, 205, 210
 the Inscriptions, Palenque, 38
 Japanese, 423
 Juno Regina, Rome, 199
 Jupiter Optimus Maximus, Rome, 207, 266
 Jupiter Stator, Rome, 199
 Roman, 203, 262, 266
 Serapis, Rome, 262
 Zeus, Olympia, 39
Teniers, David, 48, 125, 126
Terenzio, 157, 158
Thais, the, 26, 27
Themistius, 210
Theodahad, King of Italy, 258
Theodore II Lascaris, Byzantine Emperor, 343
Theodoric, King of Italy, 258, 259, 260
Theodorus, 184
Theodosius I, Emperor, 306
Theodosius II, Emperor, 209
"Theophilus," 273, 274
Theory, visual arts, 212, 223
 Chinese, 238, 239
 Dark and Middle Ages, 272, 273, 274
 Greek, 183, 184
Theron, 192

Thinking, ways of, 37, 38, 39, 105, 212, 216, 262, 469, 470
14th century vs. medieval past, 263–265, 267, 283, 291, 292
Third Macedonian War, 204
Thomas Aquinas, St., 33, 34, 299
Thomas de Cormont, 276
Thoré-Bürger, Théophile, 126, 127, 146, 333
Three Histories, 243
Three Kingdoms, 242
Throne of King Dagobert, 90
Thucydides, 295
Tiang Sengliang (T'ien Sengliang), 243
Tiberius, Emperor of Rome, 199, 200, 260, 266, 267
Tiffany & Co., 58
Times, London, 138, 139
Timur the Lame, 391
Tintoretto, Jacopo Robusti, 113, 148
Titian (Tiziano Vecellio), 4, 13, 45, 46, 81, 88, 91, 92, 94, 112, 113, 115, 116, 150, 163, 208, 224, 415, 416, 427, 442, 445, 446, 447, 454, 457, 458, 460, 461, 462, 463, 465
Titus, son of Rembrandt, as Alexander the Great (Rembrandt), 152
Titus, Emperor, 271
Tlazolteotl, 33
Tödaiji Temple, Nara, 61, 62, 63
Toilet of Psyche (Fragonard), 138, 139
Tokonoma, 105
Tokugawa Shoguns, 423
Tolstoya Mogila Kurgan, 471
Tomb figures, Chinese, 250
Tombs, 26, 51
Chinese, 218, 219, 220
Duke John the Fearless, 280
Duke Philip the Bold, 279
Etruscan, 43
Henry VII, King of England, 458
Korean, 252
robbing of, 27, 28
Tutankhamen, 60–65, 85
Topkapı Sarayı, 254, 255

Tornabuoni, Giovanni, 91, 401, 441
Tornabuoni Chapel, 91
Torrigiano, Pietro, 458
Toynbee, Arnold, 468
Trademark painting, 48, 49
Traditions, art
in higher civilizations, 171, 172
limits, 472
mass massacre of, 20, 21, 22
number of, 30, 31
Traditions, art, five rare, 1, 2, 25, 29, 32, 37, 84, 89, 100, 101, 107, 133, 134, 168, 169, 265
complexity of, 283, 284, 285
cultural/behavioral systems common to all, 293–297, 467, 468, 469
developed historical sense, 294–297
recurring factors in, 468–470
rewards and penalties, 470–473
Transmutation of works of art, 145, 146, 148, 155
Trattato dell'Architettura (Filarete), 373
Travelers Amongst Mountains and Streams (Fan Kuan), 234
Traveller's Club of Paris, 60
Traversari, Ambrogio, 324, 326, 329, 332, 345, 346, 347, 348, 350, 353, 356, 358
Traversari, Jerome, 326, 347
Treasure gathering, 49–56. See also Collecting
Treasure of the Two Sicilies, 137
Treaty of Versailles, 124
Très Riches Heures (Limbourg brothers), 87
Tribolo, Niccolo Pericoli, 444
Triumph of Caesar (Mantegna), 149, 462, 463
Triumph of Virtue (Mantegna), 437
Tubal Cain, 133
Tuileries, Palace, 123
Tunis Youth, 142
Tuotilo of St.-Gall, 282, 284
Tutankhamen's tomb, 60, 61, 62, 64, 65, 85
Tuthmosis III, Pharaoh, 182

Twelve Emperors (Titian), 445
Tyi, Queen of Egypt, 60, 174

Uccello, Paolo di Dono, 52, 121, 356, 363, 367, 379, 381, 382, 403, 404, 406, 416, 438, 430
Über antike und moderne Kunstfreunde (Riegl), 69
Uffila, 272
Uffizi, the, 117, 118, 119, 120, 121, 122, 130, 165, 166, 429, 449
Ulysses Belgico-Gallicus (Gölnitz), 465
Undiho, 272
University of Padua, 117
Upper Paleolithic art, 170, 175
Ur, or Ur of the Chaldees, 136, 173
Urartu, 176
Urban VIII, Pope, 91
Urbino, Duke of, 435, 436, 454
Urbino, Palazzo at, 369
Urbino Diptych (Piero), 119
Ursula, St., 97
Uzzano, Niccolò da, 353, 361

Vaduz, Liechtenstein, 166
Valguarnera, Fabrizio, 47, 147
Valla, Lorenzo, 323
Van Cleef and Arpels, jewelers, 54
Van der Weyden, Rogier, 88, 124, 376, 402, 427
Van Dyck, Sir Anthony, 153, 154, 454, 460, 462
Van Loo, Charles André, 138
Van Meegeren, Hans, 158
Van Uffelen, Lucas, 456
Variae (Cassiodorus), 258
Varro, Marcus Terentius, 206
Vasari, Giorgio, 5, 11, 16, 91, 109, 111, 112, 113, 114, 115, 119, 125, 129, 134, 165, 187, 188, 189, 192, 193, 200, 235, 246, 247, 248, 276, 286, 288, 290, 356, 357, 360, 378, 386, 388, 414, 415, 416, 428, 429, 432, 444, 445, 447
Libro de' disegni, 114
"Lives of the Most Excellent

Vasari, Giorgio, *(cont'd)*
 Artists," 5, 109, 111, 193,
 247, 415, 428, 447
Vasarian Canon, 124, 125, 200,
 201, 419, 429, 430, 450
 beginning, 110–112
 decline of, 115–118, 121, 127
 impact of, 112–115
 three main elements, 428
Vatican, 2
Vatican Library, 55, 346
Vatican Obelisk, 276, 308
Vecchietti, Bernardo, 428, 432
Velázquez, Diego Rivera de Silva
 y, 17
Venerable Bede, the, 93, 261,
 295
Venetian Arsenal, 143, 144
Venetian School, 116
Veneziano, Domenico, 379
Veneziano, Donato, 116
Venier, Cardinal, 387
Venus and Adonis (Titian), 458
Venus statues
 bought Della Seta, 306, 307,
 358, 371
 noted Rambaldi da Imola, 310,
 322
 Rome, 261, 266
 Siena, 304, 305, 307, 313
Venus Worship (Titian), 92, 94
Vermeer, Jan, 126, 127, 146, 333
Veronese, Paolo Caliari, 113,
 115, 148
Verres, Gaius, 26, 205, 206, 207,
 244
Verrine orations (Cicero), 205
Verrocchio, Andrea de Cione,
 359, 378, 386, 387, 388,
 401, 421, 424
Verrou, Le (Fragonard), 139
Versailles Palace, 138, 160, 165
Vertue, George, 463
Verue, Comte de, 126
Verue, Comtesse de. *See* Dame
 de Volupté
Vianello, Michele, 434, 439
Via Sacra, bronze elephants on,
 258
Victoria and Albert Museum,
 172
Vietnam, culture of, 21, 251,
 252
View of Delft (Vermeer), 126,
 146
Villani, Giovanni, 289

Villani, Filippo, 134, 290, 291,
 340
Vindex, Novius, 206, 207
Virgil, Publius Virgilius Maro,
 289, 299
Virgin Annunciate (Hercules
 Master), 315, 320, 330
Virtues and Vices, Notre Dame,
 303
Visconti Palace, Pavia, 308
Vishnudharmottara, 108, 109,
 183
Visigoths, 209
Vision. *See* Seeing
Vite di uomini illustri
 (Bisticci), 324
Vitruvius, 184, 206, 308, 344
Vivarini, Bartolomeo, 98, 116
Vivarini da Murano, 116

Wackernagel, Martin, 100, 167,
 360, 443, 444
Wallace Collection, 165
Walpole, Horace, 112, 127, 159,
 161, 276, 463
Walpole Society, 463
Walters Art Gallery, 57
Wang Mang, Emperor of China,
 225
Wang Xianzhi (Hsien-chih), 61,
 62, 134, 135, 228, 231, 233,
 241
Wang Xizhi (Hsi-chih), 61, 62,
 134, 135, 228, 230, 231,
 233, 237, 241, 249
Warburg Institute, 384, 396
Warring States, 213, 219, 221,
 238
Watson, Sir Francis J. B., 68
Watson, William, 218
Watteau, Jean-Antoine, 139
Wei dynasty, 242
Weiss, Roberto, 300, 306
Wei Tan (T'an), 227, 228
Weitzmann, Professor Kurt, 177
Weltje, 161
Wemyss, Earl of, 158
Wentzel, H., 302, 303
Wernher, Prior (Gwernharus),
 53, 282
Western art historians, 296, 297
Western art tradition, 31, 170,
 186
 artists' rank, 224, 225

birth of, 318, 447
changes in way of seeing, 448
collecting, 27, 206, 318, 334,
 335, 451
collecting maturity, 467
deceptive realism, 234
decorating factor in collecting,
 422–424
direction of, 314
early, 413, 414
effect of early Italian
 collecting, 355
future?, 473
history, 248
magnates' collecting influence
 on, 339
post-classical, 473
post-Medici transition, 419–
 422, 429, 430
remembered masters, 284
status of successful artists, 442
unique feature of, 413, 414
ways of seeing, 11, 14, 22
writing about, 5, 109, 111,
 114, 187
Western mathematics, 344
Westminster Abbey, 12, 277,
 278
Wharton, Edith, 379
Wheelock, Arthur K., 153
Whistler, Rex, 380
Whitehall, 47, 162, 453, 460
Whydahs, 78, 79
Wibald of Stavelot, Abbot, 281
Wicartus, Lord, 282
Widener, P. A. B., 154, 155
Wigerig, 272
Wildenstein & Company Inc.,
 17, 153, 156, 445
William of St.-Thierry, 92
William of Sens, 277, 279, 280
William of Winchester, 277
William the Englishman, 277,
 280
Willis, Reverend Robert, 277,
 281
Wilton diptych, 44, 457, 462
Winckelmann, Johann Joachim,
 9, 11, 118, 127
Winter Palace, St. Petersburg,
 166
*Wire That Fenced the West,
 The* (McCallum), 102, 103
Witegifil, 272
Wittkower, Margot, 379
Wittkower, Rudolf, 379

Wool Guild, 315, 316, 323
Woolley, Sir Leonard, 172
World War I, 311
World War II, 18, 64, 80, 124,
 139, 163, 172
Wright, Frank Lloyd, 57
Wu, Empress of China, 244
Wu Daozi (Wu Tao-tzu), 227,
 235, 236, 243, 247, 281
Wuffingas, the, 51
Wunderkammer-house, 420
Wunderkammern, 7, 72, 163,
 165, 428, 447, 448
"Wuolvinius Phaber," 53, 272

Xenocrates, 188, 189, 192, 194,
 200, 201, 248, 414, 415,
 416
Xenophon, 185
Xian (Sian), 218
Xiao (Hsiao) Wu, Emperor of
 China, 157
Xie He (Hsieh Ho), 229, 230,
 235, 238, 239, 246, 274
Xien Yang (Hsien Yang), 218,
 219
Xun Zi (Hsun Tzu), 215

Yamato-e, 252
Yang Qidan (Yang Ch'i-tan), 243

Yang Zehua (Yang Tze-hua),
 243
Yangji (Yangtze) Valley, 216,
 219
Yan (Yen) Hui, 226
Yan Liban (Yen Li-pen), 227,
 234, 243
Yazilikaya, Turkey, 173
Yellow River, 226, 245
Yen Lite (Yen Li-teh), 243
Yevele, Henry, 277
Yi-Pin (I-pin) painters, 18, 19
Yong Le (Yung Lo), Emperor, 17
York House, 460
Yoruba praise chant, 107, 133,
 186
Youchi Iseng (Yu-ch'ih I-sing),
 243
Young St. John (Leonardo), 454
Yuan Di (Ti), Emperor of China,
 246
Yuan (Yüan) dynasty, 236, 237,
 238, 248, 249, 318, 321
Yue (Yueh) peoples, 21
Yu He (Yü Ho), 157, 241

Zapparini, Guglielmo, 300
Zatzenstein, M., 153
Zeus (Phidias), 39, 199, 200,
 201, 202, 210

Zeuxis, 185, 187, 197, 199, 290
Zhang Sengyou (Chang Sang-
 yu), 242, 243
Zhang Xu (Chang Hsu), 247
Zhang Yanyuan (Chang Yen-
 yuan), 109, 231, 232, 242,
 243, 246, 247, 248
Zhang Zeqian (Chan Tze-
 ch'ien), 243
Zhang Zhi (Chang Chih), 226,
 233, 241
Zhao Yi (Chao I), 225, 226, 227,
 233, 238, 239, 240, 241,
 313
Zhen Fashi (Cheng Fa-hsih), 243
Zheng Yizhi (Cheng I-chih), 244
Zhiyong (Chih-yung), 230
Zhou (Chou) dynasty, 171, 186,
 213, 215, 226
Zhukov, Marshal, 160
Zibaldone (Rucellai), 379
Zinzerling, Just, 465
Zoppo, Messer Paolo, 440
Zoser, King of Egypt, 174, 267
Zuccaro, Federigo, 428, 458
Zuo Zhuan (Tso Chuan), 215,
 216, 297